CHRONICLES
of the
CIVIL WAR

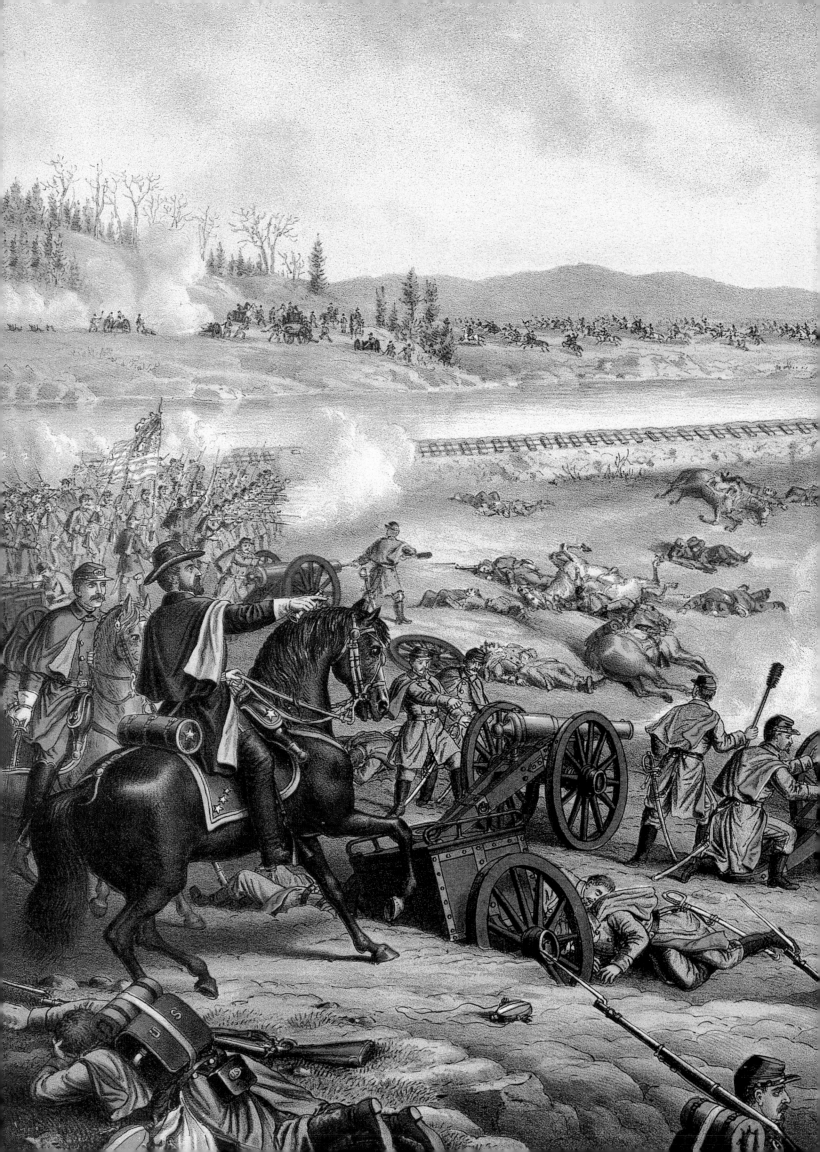

CHRONICLES
of the
CIVIL WAR

*An Illustrated Almanac and Encyclopedia
of America's Bloodiest War*

JOHN BOWMAN, *General Editor*

JG
PRESS

Published by World Publications Group, Inc.
140 Laurel Street
East Bridgewater, MA 02333
www.wrldpub.com

Reprinted 2011 by World Publications Group, Inc.
Copyright © 2005

ISBN-13: 978-1-57215-817-7
ISBN-10: 1-57215-817-4

Printed and bound in China
by Toppan Leefung Printing Limited.

2 3 4 5 06 05 03

Pages 2-3: A scene from the Battle of Gettysburg
depicting the defeat of Pickett's ill-starred attack
on the Union line.
Pages 4-5: Union gunners practice their drill.

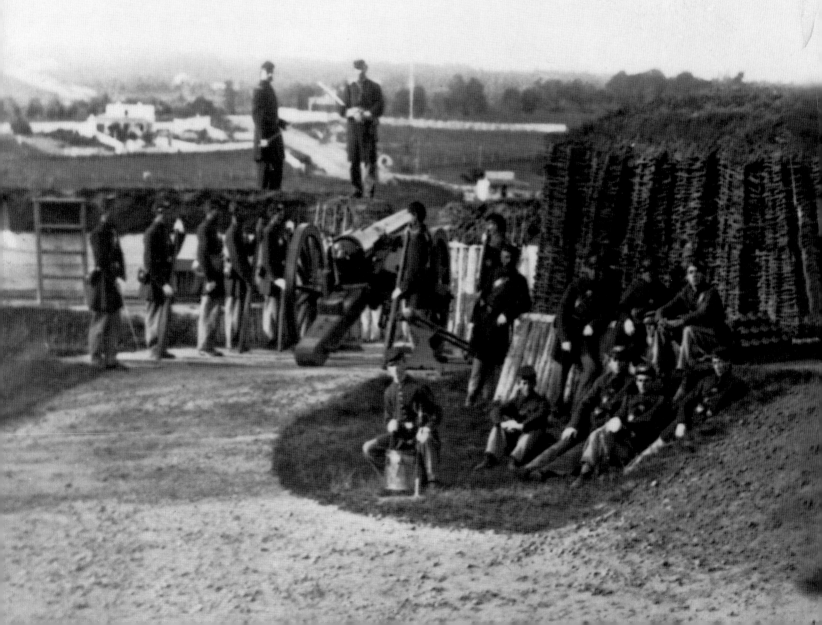

Contents

Introduction

The American Civil War commenced at 4:30 a.m. on April 12, 1861, with Confederate artillery rounds firing into the squat masonry mass of Fort Sumter in Charleston Harbor. The first shell landed harmlessly on the parade ground. For all practical purposes, the war ended three years and 362 days later with Robert E. Lee's surrender of the Army of Northern Virginia at Appomattox Court House. In between, Union and Confederate forces fought 10,000 battles, engagements, skirmishes and affrays. Fighting and disease claimed more than 600,000 dead; another one million Americans were wounded. For a half-century after the guns fell silent, maimed veterans used to gather on Decoration Day in town and village squares and at county courthouses from Maine to Texas, a repeated and always poignant reminder of the war's exactions.

From the perspective of historical causation, of course, the Civil War began long before General P.G.T. Beauregard's cannoneers calculated range, angle and deflection in taking aim at Fort Sumter. The causes of what one prominent historian has called America's near national suicide were complex and of long gestation: diverging economic systems, local and agrarian Southern folkways set against the cosmopolitan culture of the rapidly industrializing and urbanizing North; abstruse and pettifogging Constitutional questions involving states' rights versus federal authority.

But as Abraham Lincoln emphasized in his Second Inaugural Address in March 1865, slavery was the primary cause. Each contestant bore responsibility for its curse. Other irritants doubtless could have been resolved – or ignored – short of bloody civil war. Slavery, as Lincoln observed, represented "a peculiar and powerful interest," eclipsing all other matters of dispute. All knew that this interest was somehow the cause of the war. The South had responded with secession to Northern attempts to check the spread of slavery and to the threat posed by Lincoln's election in 1860. The North responded with a series of calibrated moves intended to forcibly preserve the Union. In the view of a chastened and weary Lincoln, the terrible war that followed was God's punishment for the sin of *American* slavery.

As the president asserted on the steps of the Capitol on that cold inauguration day, "Both parties deprecated war, but one of them would *make* war rather than let the nation survive, and the other would *accept* war rather than let it perish, and the war came."

And the war came. Americans retain a passionate interest in the Civil War, both for what it irrevocably settled and for what it left ambiguously unresolved. The collapse of Confederate resistance in the spring of 1865 answered two compelling questions forever. The Northern triumph meant the Union would be perpetual and indivisible, and it removed the fatal contradiction of slavery in a nation founded on principles of equality. It left unanswered the problem of the place in national life of some four million former slaves – an irresolution that continues to haunt America and betray its promise down to our own time.

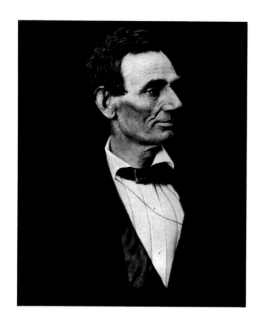

For most of us, however, the fascination lies less in the sweep of grand historical causes and effects than in the protean details, such as those recorded in this Almanac of day-to-day events of the Civil War, and in the battles, weapons and personalities

of a great conflict, as limned in the Encyclopedia that accompanies it. These works, assembled under the editorship of the independent scholar John S. Bowman, are here published together for the first time. Designed to be consulted in tandem, one informing the other, they are complementary, comprehensive and reliable; in short, they are an indispensable guide and companion to an understanding of the most dramatic, compelling and far-reaching event in American history.

Both works conjure up the imperishable images imprinted upon our historical memory. Here is Thomas Jonathan Jackson "standing like a stone wall" as Union infantry swarmed up Henry House Hill at the climax of the first battle of Bull Run in July 1861. Here is Robert E. Lee lamenting, in a letter to his wife, the incompleteness of his victory at Fredericksburg in December 1862: "They went as they came – in the night. They suffered heavily as far as the battle went, but it did not go far enough to satisfy me." Here is Lincoln in an agony of despair as he absorbed the news of Fredericksburg: "If there is a worse place than hell," he told his secretary, "I am in it."

On to Chancellorsville, Lee's masterpiece, where the Army of Northern Virginia mystified and ultimately humiliated the Union commander Lee derisively addressed as Mr. F.J. Hooker (the initials representing Hooker's sobriquet "Fighting Joe," the ironic connotation inescapable after this battle), and where a panicked nighttime volley from friendly troops cut down the incomparable Jackson. On to the pathos of Gettysburg, where Union defenders bent but did not break on the crest of Little Round Top and where the ill-omened Confederate assault known as Pickett's Charge dissolved in a welter of blood. ("Move on, cousins," the men of one of General George Pickett's Tennessee regiments called out to the Virginians on their flank as the slow-motion disaster developed, "you are drawing the fire our way.") On to the killing grounds of Chickamauga, where Union general George Thomas stood like a rock; to Vicksburg on the Mississippi, where the relentless Ulysses S. Grant cut the Confederacy in two; to the Wilderness and Cold Harbor, where Union attacking troops, anticipating their doom, pinned their names to their jerseys so their corpses could be identified and their remains sent home; and to Atlanta, which Union general William T. Sherman methodically destroyed before setting out on his remorseless March to the Sea.

Nearly four years of epic struggle ended in Grant's brief early afternoon meeting with Lee in the parlor of the McLean house in the village of Appomattox Court House, Virginia. Belying his ferocious reputation, Grant offered the beaten Confederates generous terms. Lee returned to his lines and briefly addressed the remnants of the army. "Go to your homes and resume your occupations," Lee told his ragged, hungry and disconsolate veterans. "Obey the laws and become as good citizens as you were soldiers."

Most of us imagine a war of romantic heroism, eager volunteers marching into battle to the blare of "The Battle Hymn of the Republic" or "Maryland, My Maryland." We remember Jackson and his irrepressible "foot cavalry" in the Shenandoah Valley, the granitic Joshua L. Chamberlain on Little Round Top, the unflappable Grant's telegraphic instruction to Philip Sheridan before the third battle of Winchester – "Go in." We sometimes forget, or edit out, the squalor of Gettysburg, where the wounded gasped and broiled under the July sun for days after the fighting ended; the physical and psychological wreckage of prison camps such as Andersonville in Georgia,

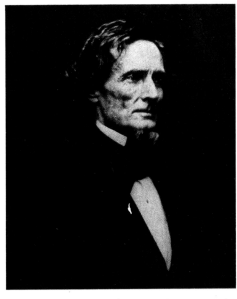

Opposite: President Abraham Lincoln, committed to preserving the Union.
Above: President Jefferson Davis of the South.

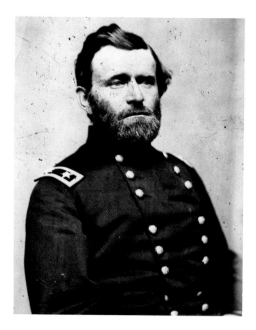

Above: The North's finest general, Ulysses S. Grant.

where hunger, exposure and disease turned men into barbarians; and the cruelties of Fort Pillow, Tennessee, where Confederates dealt red-handed on the battlefield with surrendering black troops. This was history's first modern war, the first *total* war in which the full resources of the nation were engaged, and mass citizen armies sought to kill from ever-increasing ranges. The telegraph carried orders and news of battles. Balloons provided a bird's-eye view of the battlefield. The world's first ironclad vessels fought to a draw off Hampton Roads, Virginia. Senior commanders used railroads strategically to move troops into battle, most notably in September 1863, when the Confederates shifted General James Longstreet's powerful army corps from Virginia to north Georgia in time for the battle of Chickamauga. Though the campaign appears tame by 20th-century standards, Sherman's forces deliberately targeted civilians in Georgia and South Carolina. Rather than glancing back to earlier and tamer conflicts, the American Civil War, with its trench systems and wire barriers, adumbrated the pitiless Western Front in the First World War. These elements, too, are present in the pages that follow.

The Almanac, a combination chronology, statistical register and atlas, opens in August 1619 with English Virginia colonists' first recorded purchase of Africans as indentured servants. For black Virginians, indenture soon evolved into the permanent condition of enslavement. As the Almanac duly notes, the new United States formally sanctioned slavery with the Constitution of 1789, ignoring Virginia delegate George Mason's prophecy that bondage brings "the judgment of heaven on a Country." It notes, too, Eli Whitney's application for a patent on a cotton "engine" (the gin), a machine for separating cotton fiber from seed. The invention made cotton king, entrenched slavery throughout the South, and implicated the powerful and lucrative Northern textile industry in its dependence on Southern raw materials.

The concluding Almanac entry predates the era of Reconstruction, America's brief experiment with multiracial democracy in the South, when President Rutherford B. Hayes withdrew Federal occupation troops from South Carolina and Louisiana in the spring of 1877 and returned full political power to the white elites.

On *27 April 1861*, President Lincoln suspended the writ of habeas corpus in an area stretching from Philadelphia south to the nation's capital; those suspected of disloyalty could be held indefinitely in prison without charge. The president on this day also extended the Federal blockade of Southern ports to include Virginia and North Carolina.

On the morning of *17 September 1862*, General George B. McClellan's Army of the Potomac launched an attack along Antietam Creek in western Maryland that touched off the bloodiest single day of the Civil War – and of American military history. In some of the fiercest fighting of the day, a Federal soldier reported the curious optical phenomenon of "a landscape turned red." More than 26,000 men on both sides were killed, wounded or missing at Antietam.

In mid-*July 1863*, the posting of draft notices together with the publication of casualty reports from the battle of Gettysburg ignited three days of rioting in New York City; the mobs directed much of their fury at the city's African American population. Troops from the front-line Army of the Potomac were called in to restore order; more than a thousand rioters were killed or injured.

On *30 July 1864*, Federal engineers detonated a mine beneath the Confederate defenses outside Petersburg, Virginia; the explosion destroyed some 250 of the enemy. But incompetent Federal leadership bungled the ensuing assault, which turned into a disaster for the attacking troops – nearly 3,500 killed and wounded out of some 20,000 engaged.

Finally, on *28 April 1865*, 50,000 citizens turned out to view the slain President Lincoln's body when his funeral train stopped in Cleveland, Ohio, on its long and lachrymose journey to Lincoln's final resting place in Springfield, Illinois.

The Encyclopedia contains more than a thousand entries and three hundred illustrations, from *Abercrombie, John Joseph (1802-1877)*, a Union brigade commander in

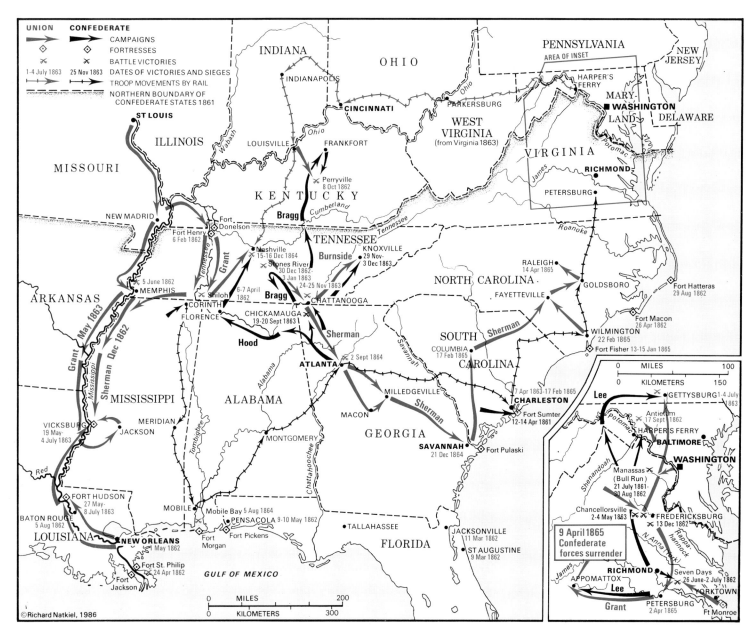

the Peninsular Campaign of 1862, to *Zouaves*, ornamental Northern and Southern militia regiments whose acrobatic drill and colorful uniforms – turbans, baggy trousers, frogged jackets – were patterned after French colonial Algerian troops.

In between, there are long entries on all the major campaigns and battles, as well as biographical sketches of the leading commanders. Lesser engagements and subordinate figures receive abbreviated treatment, but here too coverage is comprehensive – the Poplar Springs Church reconnaissance in force of 1864 merits an entry, as does the Confederate general Daniel Smith Donelson. There are entries, too, on wire entanglements, the Coehorn mortar, brevet rank, the Hampton Roads peace conference, machine guns, the Sharps carbine, and the institution of the vivandiere.

The works that follow present a vivid, colorful and often moving introduction to the most traumatic episode in the history of the United States. As one browses, stopping here and there to read an entry or to study a print, a map or an astonishingly, eerily, alive Mathew Brady photograph, it is well to remember that, in the end, the truest meaning of the heroism, suffering and loss in this glorious and terrible Civil War is that it resolved the contradiction – the war destroyed slavery, so that the nation could now honestly call itself free. From our vantage we can see that, in consequence of these bitter four years, America at last began to live up to its own best ideals.

—MICHAEL GOLAY

Above: The war's major campaigns.
Below: Robert E. Lee of the Army of Northern Virginia.

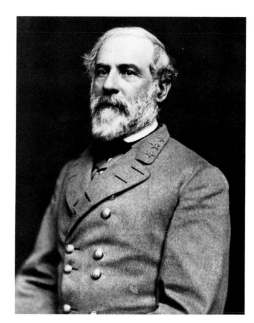

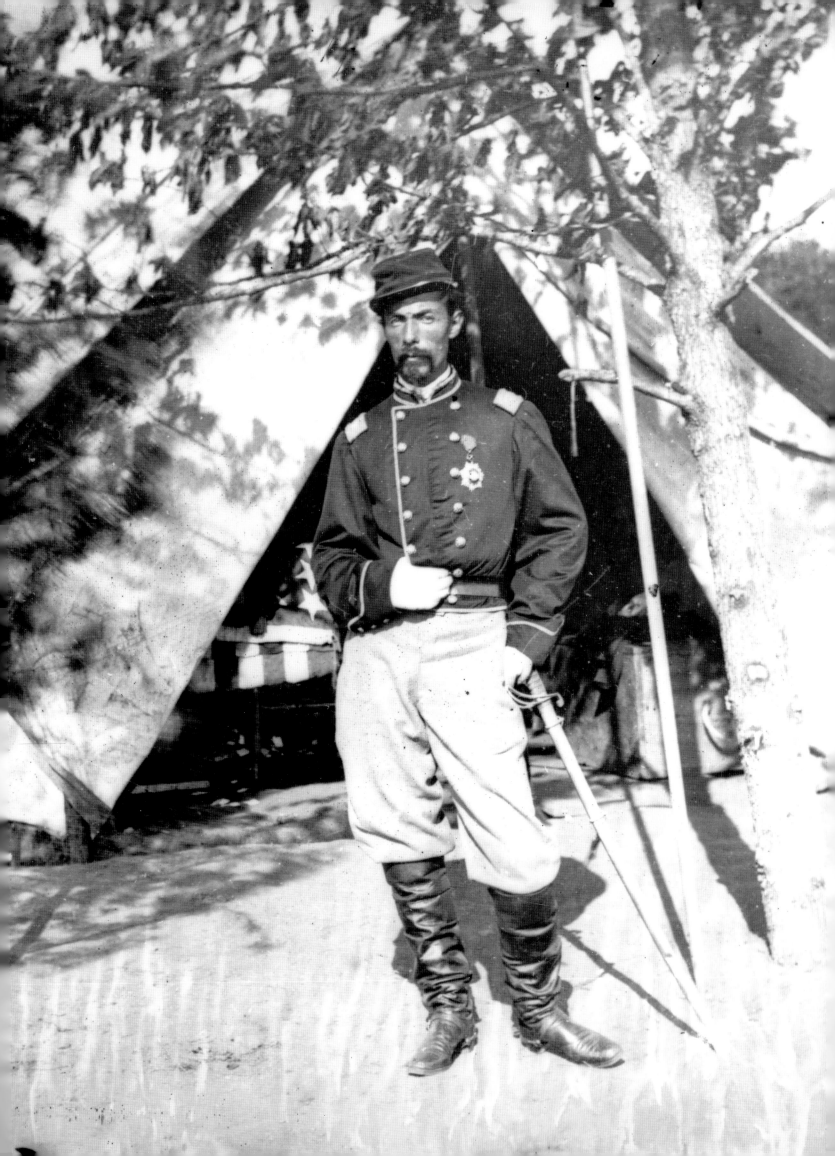

An Illustrated
ALMANAC
of the
CIVILWAR

Opposite: Col. Alfred N. Duffie, 1st Rhode Island Cavalry, USA.

August 1619

English settlers in Jamestown, Virginia, purchase 20 black Africans from a Dutch frigate. Although these particular Africans are treated as indentured servants, it is not long before European colonists in North America are treating black Africans as slaves: they are imported, bought and sold as though material property, and their children are condemned to a life of slavery. Most of these black Africans are held in the Southern colonies, but many thousands are also held by Northerners – and many Northerners profit directly and indirectly from the slave trade. In the ensuing decades, as the number of slaves increases to hundreds of thousands, slavery itself evolves into a legally sanctioned system.

July 1776

The Declaration of Independence – with its resounding 'self-evident' truth 'that all men are created equal' – is adopted on 4 July. It is largely the work of Thomas Jefferson, himself a slaveowner, and it will be signed by many men who are also slaveowners.

1780-1804

In the Northern states, various laws are passed and court decisions handed down that effectively abolish slavery. In the South, however, where slavery has become inextricably involved in the economy and a total way of life, it remains legally sanctioned and sustained.

May-September 1787

In Philadelphia, 55 delegates from 12 states (Rhode Island refuses to participate) meet to draw up a Federal Constitution for a United States. The resultant document is in many ways a compromise among various conflicting views – sectional, economic, social, philosophical and otherwise. One of the major splits is between the Southern and the Northern states over the issue of allowing slavery to continue. But several Southern states refuse to join in any Union if slavery is not allowed, so despite the warning of George Mason, a

Below: The signing of the Declaration of Independence on 4 July 1776. Many of the signatories were slaveowners.

delegate from Virginia, that slaves 'bring the judgment of Heaven on a country,' the Constitution includes three clauses that effectively sanction the continuation of slavery: (1) Fugitive slaves are to be returned to their owners; (2) Slave trade (that is, new Africans from abroad) is to be permitted until 1808; and (3) For the purpose of apportioning congressional representatives on the basis of population, a slave is to be counted as three-fifths of a white person. In the debate that ensues in the states, most of the Northerners as well as Southerners who are opposed to ratifying the Constitution are simply against placing so much power in a national government and denying powers to the states.

July 1787

Meeting in New York City as the fading government under the Articles of Confederation, the Congress passes its last major act, the Territorial, or Northwest, Ordinance. One of its clauses states that 'there shall be neither slavery nor involuntary servitude in said territory.' Although immediately applicable only to the territory that will eventually be subdivided into the states of Ohio, Indiana, Illinois, Michigan and Wisconsin, the ordinance suggests a national policy of designating all new territories and states as 'free soil' – that is, as off limits to slavery.

December 1791

The first 10 amendments to the Constitution – known as the Bill of Rights – are put into effect. They guarantee many individual rights but say nothing about slavery or the rights of black Americans.

October 1793

Eli Whitney applies for a patent on a cotton gin, a device that greatly increases the speed and ease with which cotton fibers are separated from the seeds. This machine will soon increase the need for labor to produce more cotton, and since most of the cotton is grown in the Southern states, this will lead to the need for more slaves.

November-December 1798

The legislatures of Kentucky and Virginia adopt resolutions contending that the Alien and Sedition Acts are unconstitutional and

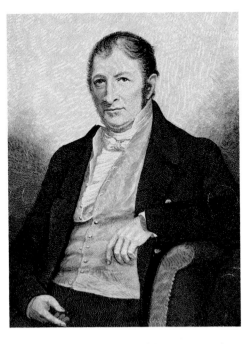

Above: Eli Whitney, creator of the cotton gin that greatly increased the demand for slaves.

that individual states retain the right to determine this. These acts are passed in June and July by a Congress controlled by the Federalist Party desirous of restricting the growth and freedoms of the Jeffersonian Republicans. What is particularly significant is that these resolutions, defiant expressions of states' rights, were written by Thomas Jefferson and James Madison, both of whom would become president of the United States.

November 1799

The Kentucky legislature passes another resolution reaffirming that of 1798 but adding that 'the remedy for [what states consider] infractions of the constitution' is 'nullification.'

August 1800

Gabriel Prosser, a black slave coachman, plans a revolt to liberate thousands of slaves in the Richmond, Virginia, area. On the day when the uprising is scheduled, a heavy thunderstorm washes away the bridge over which about 1000 armed slaves were to pass. Meanwhile, the state authorities have been following events thanks to an informer and they move in and arrest Prosser and many of his followers. Prosser and at least 37 others are executed. Although this is but one of more than 250 rebellions by slaves during some two centuries up to 1861, it is one of the more ambitious ones and convinces many Southerners that only strict measures can maintain the institution of slavery.

January 1808

From the first day of the new year, the importation of slaves from abroad into the United States is legally ended, as called for by the Constitution. But the buying and selling of slaves within the United States continues, and in practice many new slaves continue to be smuggled into the states. The enabling legislation itself provides that these smuggled slaves, when apprehended, are to be turned over to the state authorities and that the states may then sell the slaves.

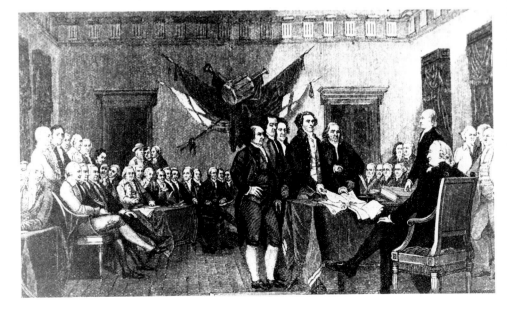

December 1814-January 1815

A number of prominent New Englanders, strongly opposed to the war that the United States has been fighting against England since 1812, gather for secret meetings in Hartford, Connecticut. Various propositions are considered, including seceding from the Union, but by the end the only course those attending can agree on is to propose certain amendments to the Constitution. Meanwhile, on 14 December, the Treaty of Ghent is signed, ending the war, so the Hartford Convention's recommendations become moot. What is not moot, however, is the notion that representatives from a section of the United States might see their states' rights taking precedence over the Union and its federal Constitution.

December 1816-January 1817

The American Colonization Society is founded in Washington, DC, to aid in settling freed slaves in Africa. Although it will eventually obtain indirect aid from the United States government and will help in moving 11,000 blacks to the new African country of Liberia, the society is by no means endorsed by either black Americans or white abolitionists. Many from both of these groups see the goals of this society as merely avoiding the issue of slavery and the rights of blacks in America.

January-March 1820

The House of Representatives passes a bill calling for the admission of Maine to the United States. Since there are 11 free (that is, non-slave) states and 11 slave states, the admission of Maine as a free state would upset the balance that is jealously guarded by all parties in the Union. Therefore, the Senate adopts a bill that combines the admission of Maine with the admission of Missouri as a slave state. In addition, the Senate adopts a further compromise, an amendment that would bar slavery in the rest of the Louisiana Purchase north of 36° 30' latitude. The House of Representatives then votes to accept the Senate bill with its amendment, and this legislation becomes known as the Missouri Compromise.

May 1822

Denmark Vesey, a former slave who had purchased his own freedom in 1800, is arrested, convicted and executed for planning an uprising of slaves in the area around Charleston, South Carolina. Vesey's original plan called for an attack on Charleston on a Sunday in July, a time when many white people would be out of the city. But Vesey is betrayed by a black slave and is apprehended before he and his followers can do much more than make a few weapons. Vesey is hanged along with 34 other blacks. As word of the planned revolt spreads, various slave states and border states pass 'black codes,' laws greatly restricting the freedom of movement and general conduct of slaves.

May 1824

Congress passes another Protective Tariff Act, but it still leaves the South feeling discriminated against even though Northern manufacturers are unsatisfied with the law. By 1827, this law will have prompted such

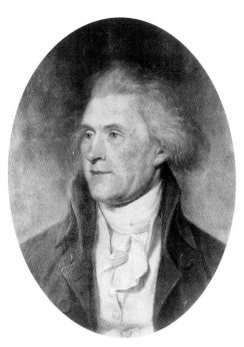

Above: Thomas Jefferson upheld the rights of individual states against Federal power.

protests as the anti-tariff meeting in Columbia, South Carolina, where Thomas Cooper, president of South Carolina College, will ask in his speech: 'Is it worth while to continue this Union of States, where the North demands to be our masters and we are required to be their tributaries?'

Below: The Battle of New Orleans (8 January 1815) was fought after peace had been declared.

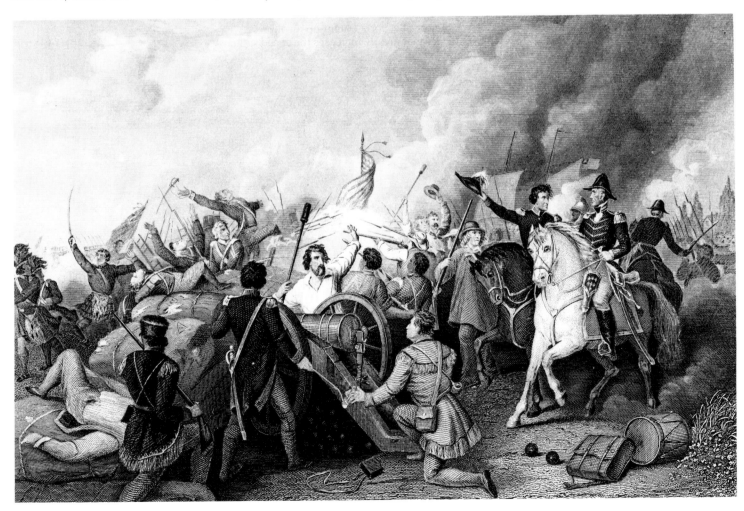

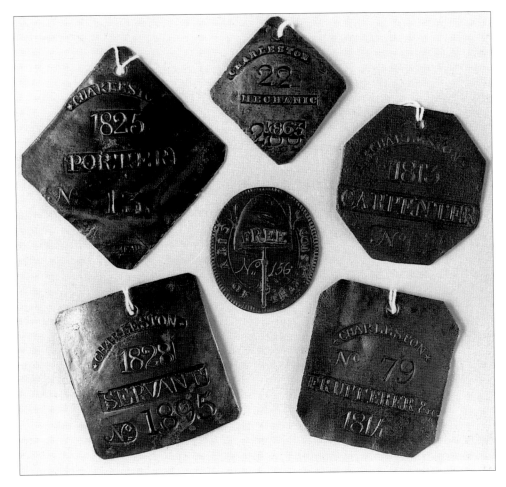

Above: Slave tags used to identify Charleston slaves by number and occupation. The central medallion is that of a freedman.

April-May 1828

Congress passes another Tariff Act, one calling for relatively high duties on a variety of goods but affecting raw materials more than manufactured goods. The promoters of the bill are motivated at least in part by a desire to embarrass President John Quincy Adams, but he ends up signing it. Very soon it becomes known to Southerners as the 'tariff of abominations' and leads to widespread protests and demands by some that the Southern states separate from the union.

December 1828

The South Carolina legislature adopts a series of resolutions condemning the Tariff Act of 1828 and questioning its constitutionality. Appended to the formal resolutions is an unsigned essay, 'South Carolina Exposition and Protest,' which argues that any federal laws considered unconstitutional may be 'nullified' by a state convention. What makes this document so significant, aside from its support for the absolute sovereignty of the individual states, is the fact that its author is John C Calhoun, previously a strong nationalist, and now the vice-president of the United States. The Georgia legislature also adopts a number of resolutions against the Tariff Act of 1828.

January 1830

The Senate is debating the issue of the sale of the vast lands of the American West, but it soon becomes apparent that the real subject under discussion is that of states' rights ver-

sus federal power. This sets Southern senators against Northern senators, and in his climax to his defense of the latter, Daniel Webster concludes, 'Liberty and Union, now and forever, one and inseparable!'

January 1831

William Lloyd Garrison, among the more radical of the abolitionists, begins publishing in Boston *The Liberator,* a newspaper dedicated to the abolition of slavery.

August 1831

Nat Turner, a pious but radical slave preacher, leads an uprising of slaves in Southampton County, Virginia. At least 60 whites are killed before soldiers put down the rebellion. Turner and 12 of his followers are executed, while about 100 blacks are killed during the search for the rebels.

July 1832

Another Tariff Act is adopted by Congress. Although more moderate than that of 1828, it still leaves the South dissatisfied.

November 1832

A special state convention meets in South Carolina, one of the most outspoken of the Southern states, and adopts an ordinance that nullifies the Tariff Acts of 1828 and 1832. The South Carolina legislature then adopts measures to enforce this ordinance – even allowing for secession if the Federal government resorts to force.

December 1832

President Jackson issues a proclamation – after reinforcing the Federal forts off Charleston – warning the people of South Carolina

that no state can secede from the union 'because each secession . . . destroys the unity of a nation.'

January-March 1833

In the uproar that follows President Jackson's proclamation, the South Carolina legislature defies 'King Jackson' and even raises a volunteer unit to repel any 'invasion.' Jackson then asks Congress to adopt a 'force bill' to enable him to enforce the provisions of the Tariff Acts of 1828 and 1832. But Henry Clay, always anxious to work out a compromise that will save the Union, draws up a new tariff bill that is presented to the House of Representatives. The bill includes a gradual cutback in tariffs, and when word of its probable acceptance is passed to South Carolina, the legislature suspends its nullification ordinance. Congress then adopts both the tariff compromise and the force bill and President Jackson signs them within 24 hours. The confrontation is averted.

December 1833

The American Anti-Slavery Society is organized due primarily to the efforts of Arthur and Lewis Tappan, wealthy New York City merchants, and Theodore Weld, a prominent abolitionist minister. Weld, through his writings and speeches, will continue to play a major role in convincing many Americans of the necessity and justice of abolishing slavery.

October 1835

In Boston, a mob parades William Lloyd Garrison through the streets with a rope around his neck to express their disgust with his extreme views on slavery. And in Utica, New York, people meeting to organize an anti-slavery society are attacked by a mob (said to be led by a judge and a congressman).

December 1835

Santa Anna, president of Mexico, proclaims a unified constitution for all territories of Mexico. The North American settlers in

Below: Abolitionist Theodore Weld helped create the American Anti-Slavery Society in late 1833.

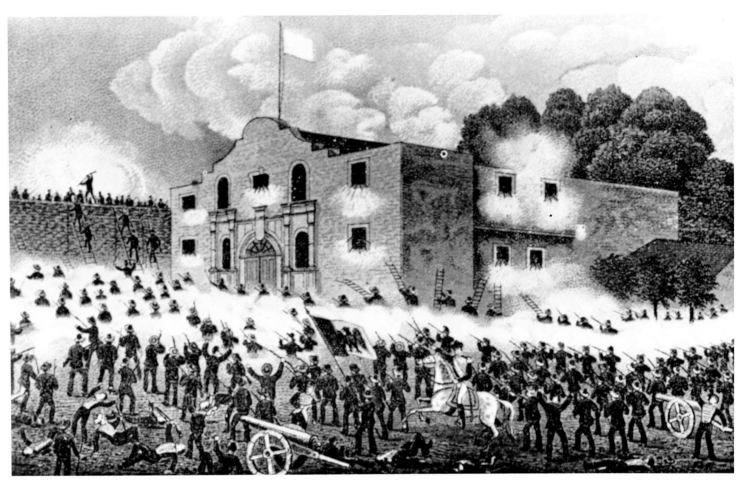

Above: The heroic defense of the Alamo in 1836. (Note that rounded parapet on the front was not there at the time.)

Texas announce that they intend to secede from Mexico rather than give up their 'right' to slavery, which Mexico has abolished.

February-March 1836

Santa Anna leads the siege of the Alamo, where 182 Texans are finally killed when the Mexicans overwhelm the fort. The heroic defense, however, inspires the North American settlers to meet in a convention, declare their independence from Mexico and draft a constitution.

Below: President John Adams was forced to sign the 'tariff of abominations' in 1828.

April 1836

Under General Sam Houston, Texans defeat the Mexicans and capture Santa Anna at the Battle of San Jacinto. The Texans ratify their own constitution, elect Sam Houston as president and send an envoy to Washington to demand annexation by the United States or recognition of the independent Republic of Texas. Since they intend to legalize slavery in any case, the debate that follows in Congress once again pits pro-slavery Southerners against anti-slavery Northerners.

May 1836

Southern members of the House of Representatives get a majority to vote for a 'gag' resolution, one that declares that all petitions or papers that in any way involve the issue of slavery should be 'laid on the table' – that is, there should be no discussion. The House of Representatives will continue to vote such a 'gag rule' at the outset of every session until 1844, but instead of burying the issue of slavery it only sharpens the difference between the two sides.

March 1837

On his last day in office, President Jackson recognizes the independent Lone Star Republic of Texas. Jackson has been avoiding this decision for many months, not wanting to aggravate the problems that already separate the South and the North. This leaves a Union of 13 free states and 13 slave states, but of the large territories that remain to be converted into states, only one – Florida – is controlled by slaveholders, while three non-slave territories still exist. A movement to admit Texas as a 'slave territory' to balance out these free territories is defeated.

August 1839

The Spanish slave-ship *Amistad,* carrying 53 African slaves between two Cuban ports, is taken over in a mutiny led by Cinque, one of the slaves. They kill the captain and the crew except for two who are forced to navigate the ship to North American waters, where a United States warship brings the *Amistad* into a Connecticut port. Spain immediately demands that the slaves be returned, but Americans force the case into the courts. Eventually it will be taken all the way to the Supreme Court, where John Quincy Adams argues for their right to be freed. In March 1841 the Supreme Court rules, and Cinque and the others are returned to Africa.

April 1841

William Henry Harrison, ninth president of the United States, dies after one month in office and is succeeded by Vice-President John Tyler. When Tyler declares a Sunday as a 'day of national prayer,' various speakers use the occasion to speak out on the issue of slavery.

January 1842

The United States Supreme Court rules, in *Prigg v. Commonwealth of Pennsylvania,* that a Pennsylvania law forbidding the seizure of fugitive slaves in that state is unconstitutional. But the opinion goes on to state that the enforcement of fugitive slave laws is entirely a Federal responsibility, so various Northern states use this as a loophole and adopt personal liberty laws.

Above: James Polk defeated Henry Clay to the presidency in November 1844.

April 1844

A treaty agreeing to the annexation of Texas by the United States, negotiated by John C Calhoun, now secretary of state, is signed and President Tyler submits it to the Senate.

June 1844

The Texas Annexation Treaty is rejected by the Senate, where anti-slavery forces convince a majority that admitting a slave state

Below: A cartoon showing Polk (seated, right) surveying expansionists as they move to incorporate Oregon into the Union.

will simply lead to another confrontation between the South and the North.

November 1844

James K Polk defeats Henry Clay for the presidency. Polk is virtually an unknown politician, but his somewhat aggressive-expansionist views on acquiring Texas, Oregon and California strike a receptive chord among Americans. He owes his very nomination, in part, to the fact that the more obvious Democratic candidate, Martin Van Buren, had earlier in the year published a letter opposing the annexation of Texas. Clay had published a similar letter, and it is agreed that this contributed to his defeat.

February-March 1845

The House of Representatives and the Senate, acting on the proposal of President-elect Polk, adopt a joint resolution for the annexation of Texas. This is essentially a procedure to bypass the requirement of a two to three vote of the Senate alone, traditionally used to ratify a treaty. The resolution also authorizes the president to negotiate a new treaty with Texas that could be approved by either procedure, but the president does not immediately exercise this choice. Mexico, however, severs diplomatic relations with the United States as soon as the resolution is adopted.

July 1845

Texas formally agrees to annexation, so President Polk simply decides to treat it as a state, even though it remains Mexican territory under international law. Polk sends a detach-

ment of the United States Army, led by General Zachary Taylor, to the south-western border of Texas to guard the state against an 'invasion' from Mexico.

March-April 1846

General Taylor takes his troops onto the left bank of the Rio Grande, always recognized as Mexican territory, on the orders of President Polk. Despite Mexico's evident desire to find some face-saving way of negotiating its way out of an armed conflict, President Polk persists in seeking an excuse for a war. It comes in late April when a small Mexican cavalry unit inflicts a few casualties on United States troops blockading a Mexican town.

May 1846

At the request of President Polk, Congress approves a declaration stating that 'By the act of the Republic of Mexico, a state of war exists between that Government and the United States.' But in the debate leading up to this declaration, and in the months to follow, it is clear that this war with Mexico is yet another divisive issue between the North and the South: Southerners tend to support the war as they see it leading to more territory to be worked by slaves, while Northerners oppose the war for that very reason.

June 1846

North American settlers in California, long seeking to break away from the rule of Mexico, proclaim the existence of the Republic of California. Meanwhile, there has long been simmering a dispute between the

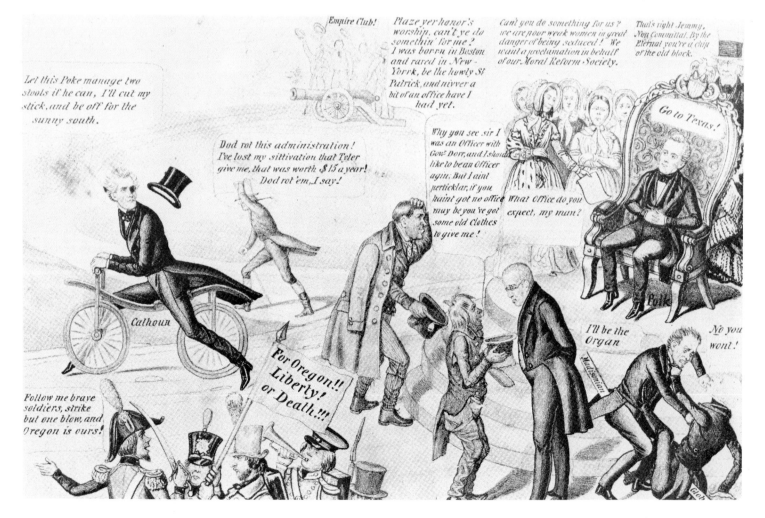

United States and Great Britain over the border between the Oregon Territory and Canada. President Polk, anxious to gain support for the widening war with Mexico, submits to the Senate a treaty that extends the international boundary along latitude 49° to Puget Sound and then to the ocean through the Juan de Fuca Strait. In return for Southern support for the treaty, President Polk agrees to reduce certain tariffs. The Senate ratifies the treaty.

August 1846

President Polk asks Congress to appropriate $2 million to help purchase territory from Mexico in negotiations that he assumes will follow any fighting. The appropriation bill comes to the House where it is amended to include what is known as the Wilmot Proviso, so named after an otherwise obscure Pennsylvanian representative, David Wilmot, who introduces the amendment. Using words taken verbatim from the Northwest Ordinance of 1787, the Wilmot Proviso states that 'neither slavery nor involuntary servitude shall ever exist in any part of' the territories that might be acquired from Mexico. The House passes the appropriation with this amendment, but the lines between Northerners and Southerners are once more sharply drawn.

February-March 1847

The Senate takes up the appropriation bill with the Wilmot Proviso, and ends up passing the former without the latter. The House then approves the Senate version of the appropriation bill, so that the question of slavery within the territories remains open. But during the Senate's debate on the Wilmot Proviso, John Calhoun introduces four resolutions that attempt to provide justification for the Southern position. Essentially Calhoun argues that Congress has no right to limit existent or prospective states in matters of laws pertaining to slavery. Furthermore,

Below: General Zachary Taylor, hero of the war against Mexico in the 1840s.

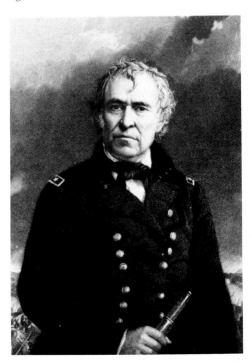

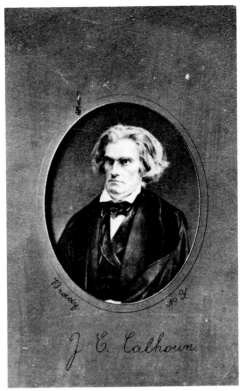

Above: John Calhoun argued that Congress had no right to interfere with slave states.

since slaves are like any property that might be taken into a territory, Congress has the obligation to protect slavery. Calhoun's doctrine effectively sets aside the Missouri Compromise of 1820, and although the Senate in no way endorses it, the doctrine is in the air.

September 1847

General Winfield Scott marches victorious into Mexico City after a whirlwind campaign since landing at Vera Cruz in May.

December 1847

Senator Lewis Cass of Michigan, in a letter to A P Nicholson, a Tennessee politician, sets forth the doctrine that slavery should be left to the decision of the territorial government. Because Cass is an influential politician – he will run for president in 1848 – his proposal is given serious consideration. It will become known as the doctrine of 'popular sovereignty' and will attract many supporters anxious to sidestep either the constitutional or the moral issues of slavery.

February 1848

The United States signs the Treaty of Guadalupe Hidalgo, ending the war with Mexico. The United States gets over 500,000 square miles that include what will become the states of California, Nevada, Utah, most of New Mexico and Arizona, and parts of Wyoming and Colorado. Texas is also conceded to the United States, with the boundary at the Rio Grande. This makes the United States a transcontinental republic, but it also opens up new land to be disputed by pro- and anti-slavery forces.

March 1848

The Senate ratifies the treaty, and President Polk gets an appropriation bill to pay Mexico – but without the Wilmot Proviso.

August 1848

President Polk signs the bill organizing the Oregon Territory without slavery. The bill has passed with the support of Southern senators, who clearly are willing to concede Oregon to the 'free-soilers' with the understanding that other territory belongs to the slaveholders.

November 1848

Zachary Taylor, hero of the Mexican War, is elected president. Taylor is a slaveholder but is not especially committed to the principle of slavery.

September-October 1849

Californians gather at a convention in Monterey and adopt a constitution that establishes a state forbidding slavery. They then ask for admission into the Union.

December 1849

President Taylor asks Congress to admit California as a state. Southerners object because, as another free state, this will leave the slave states in a minority. There is talk again among some, such as Calhoun, of secession, but Taylor says he will crush secession even if he himself has to take to the field again.

January 1850

The aging Senator Henry Clay, who has dedicated his career to preserving the Union, is annoyed at the extremists from both the South and North who threaten to resort to force. He offers to the Senate a series of resolutions that he hopes all sides can agree to. The resolutions involve admitting California as a free state on the grounds that this is its people's own wish; meanwhile, no decision will be made at this time in regard to slavery in the other territory gained from Mexico – but the clear implication is that it will later be made according to the settlers' wishes. Other topics in Clay's resolutions include a strict

Below: Future Confederate general David E Twiggs fought in the Mexican War of 1846-47.

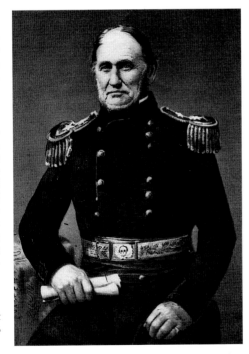

Above: A scene from *Uncle Tom's Cabin.* The anti-slavery message aroused strong feelings in both the North and South.

new fugitive slave law and the barring of trade in slaves – but not slavery itself – from Washington, DC.

February-March 1850

In opening the Senate debate on his resolutions, Clay pleads for a compromise by both sides. But the strongest advocates of both sides oppose compromise – Senator William Seward of New York arguing that 'there is a higher law than the Constitution which regulates our authority' while Senator John Calhoun of South Carolina argues that not only must the North concede the right of extending slavery but must also 'cease the agitation of the slave question.' (Calhoun is so ill that his speech is read for him by Senator James Mason of Virginia.) But the decisive speech is made by the senator from Massachusetts, Daniel Webster, long a political opponent of Clay and a moral opponent of slavery. 'I speak today for the preservation of

Below: Jefferson Davis, Secretary of War under Pierce; later leader of the Southern states.

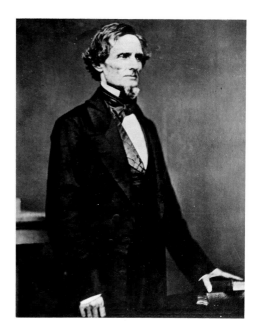

the union,' he begins, and he proceeds to argue that the North must be ready to accept even slavery for this cause. Webster does not convert everyone immediately, but the spirit of compromise is now abroad.

June 1850

Leaders from nine Southern states convene in Nashville, Tennessee, to discuss the issues of slavery and states' rights. Although some delegates openly advocate secession, the moderates prevail. The convention ends when they adopt several modest resolutions, but one calls for extending the Missouri Compromise line of 36° 30′ all the way across the new territories to the Pacific coast.

July 1850

President Taylor, who has opposed the compromise measures of Clay, dies and Vice-President Millard Fillmore assumes office.

September 1850

Congress adopts five bills based on the original resolutions of Henry Clay, and they come to be known as the Compromise of 1850. The one that continues to give Northerners the most trouble is the strict Fugitive Slave Act. President Fillmore signs all of the new acts.

November 1850

Southern leaders reconvene in Nashville, and since the more extreme delegates hold the majority there is much talk of the South's right to secede.

December 1850

A state convention in Georgia votes its desire to remain in the Union – but declares that the state will secede if the Compromise of 1850 is not observed by the North.

June 1851

Uncle Tom's Cabin by Harriet Beecher Stowe begins to appear as a serial in the *National Era,* an anti-slavery paper published in Washington, DC.

March 1852

The complete novel *Uncle Tom's Cabin,* or *Life Among the Lowly,* is published in Boston. Within a year it will sell over one million

copies and its portrayal of slave life serves to arouse both Northerners and Southerners.

November 1852

Franklin Pierce defeats General Winfield Scott for the presidency on a Democratic Party platform that supports the Compromise of 1850.

January 1854

A national competition for the lucrative transcontinental railroad route has been underway for some time. Senator Stephen A Douglas of Illinois, hoping to have the route pass through the Great Plains region, supports a bill that he hopes will win over proponents of the southern route (promoted, among others, by Jefferson Davis, now secretary of war under President Pierce). Douglas agrees to divide the central territory into two, Kansas Territory and Nebraska Territory; the assumption is that one will be settled by pro-slavery people and the other by anti-slavery people. Since Douglas endorses the concept of 'popular sovereignty,' which means that the settlers will be able to decide for themselves, the bill effectively repeals the Missouri Compromise of 1820, as both Kansas and Nebraska lie above latitude 36° 30′. The debate that follows once again pits pro-slavery Southerners against anti-slavery Northerners.

February 1854

At Ripon, Wisconsin, anti-slavery opponents of the Kansas-Nebraska bill meet and recommend forming a new political party, the Republican Party. In the months that follow, others meeting in various Northern states join in the formation of the new party.

April 1854

The Emigrant Aid Society is formed in Massachusetts to encourage anti-slavery supporters to settle in Kansas and thus 'save' it as a free state. Relatively soon, about 2000 people go under the auspices of this project.

May 1854

The Kansas-Nebraska Act, creating the two new territories, is adopted by Congress with a clear majority, and President Pierce signs it. But many Northerners, even those who had previously advocated moderation, denounce this new development. In particular, Northerners threaten to stop obeying the Fugitive Slave Act of 1850.

July 1854

In Michigan, anti-slavery men meeting to join the new Republican Party demand that both the Kansas-Nebraska Act and the Fugitive Slave Act be repealed. In the Kansas Territory, the Federal government opens an office to supervise the distribution of land, but pro-slavery and anti-slavery settlers are staking claims and fighting each other with little regard for any laws.

March 1855

Elections for a territorial legislature are held in Kansas. Several thousand pro-slavery Missourians cross into Kansas and vote, thus electing a pro-slavery legislature. The election is recognized by the Federal governor of the territory.

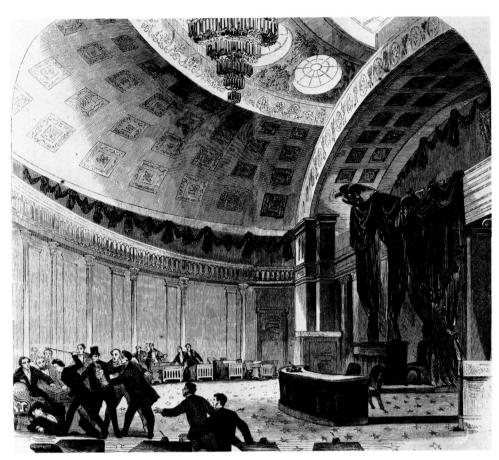

Above: Senator Charles Sumner, an outspoken abolitionist, being attacked by South Carolina representative Preston Brooks in the Senate Chamber, May 1856.

July 1855

The Kansas legislature meets and not only adopts an extremely strict series of pro-slavery laws but also expels the anti-slavery legislators.

October-November 1855

Free-Soil Kansans hold a convention of their own in Topeka and adopt a constitution that outlaws slavery. (But they will also adopt a law that bars all blacks from Kansas.) A virtual civil war now exists, with frequent clashes between the pro- and anti-slavery elements in Kansas.

December 1855

The Free-Soil people of Kansas approve the Topeka constitution (and the law banning blacks).

May 1856

Charles Sumner, the senator from Massachusetts and an outspoken anti-slavery man, gives a vituperative speech against the pro-slavery elements in the Senate. Three days later, as Sumner is sitting at his Senate desk, a South Carolina representative, Preston Brooks, beats Sumner with a stick. It will be three years before Sumner fully recovers, but he is regarded as a martyr by Northern abolitionists – while many Southerners praise Congressman Brooks. In Kansas, late in May, pro-slavery men attack Lawrence, center of the anti-slavery settlers, and kill one man. In retaliation, a band of anti-slavery men, led by the fiery abolitionist John Brown, kill five pro-slavery men at Pottawotamie Creek.

July 1856

The House of Representatives votes to admit Kansas as a state with its anti-slavery Topeka constitution, but the Senate rejects this, so the issue is left open. Kansas, however, will later take an anti-slavery stance.

November 1856

James Buchanan, the Democratic candidate, defeats John Frémont, the Republican candidate, for the presidency in a contest that is fought quite openly along the lines of South versus North, pro-slavery versus anti-slavery.

March 1857

The Supreme Court hands down its decision in the Dred Scott case, and a majority declare that the Missouri Compromise of 1820 is unconstitutional. Scott is a black slave whose owner took him from the slave state of Missouri into the free state of Illinois and territory north of the latitude 36° 30', and then back to Missouri. Scott sued for his freedom, but the Court rules that he had never ceased to be a slave and so could not be considered a citizen with the right to sue in a Federal court. But the most far-reaching impact of the decision comes from the claim that Congress has no right to deprive citizens of their property – such as slaves – anywhere within the United States. An outburst of protest from Northerners and Republicans greets the decision.

December 1857

A pro-slavery constitution for Kansas is approved by the territorial legislature meeting at Lecompton, Kansas.

January-April 1858

Kansans reject the pro-slavery Lecompton constitution, but President Buchanan proceeds to ask Congress to admit Kansas as a state under this constitution. After considerable opposition by individual congressmen and several revisions, a bill is passed by both houses that allows for another popular vote by Kansans on their constitution.

June 1858

The Republican Party of Illinois nominates a former one-term representative, Abraham Lincoln, to challenge the incumbent, Senator Stephen A Douglas. Although personally opposed to slavery, Douglas has tried to straddle the issue in order to hold the Democratic Party together, but his promotion of popular sovereignty – that is, allowing each territory or state to decide the issue for itself – has only antagonized many staunch pro-slavery Democrats from the South. Lincoln, however, chooses to meet the issue head on, and in his acceptance speech at the convention he asserts, 'I believe this government cannot endure half slave and half free.'

Below: Dred Scott, a runaway slave, was returned to his owner after a Supreme Court ruling that provoked outrage in the North.

Above: Incumbent Republican Senator Stephen Douglas of Illinois attempts to stave off the challenge of Abraham Lincoln.

August-October 1858

Lincoln and Douglas meet in towns across Illinois in a series of seven debates. Although Lincoln is little known outside Illinois and Douglas is a national figure desperately trying to placate his own party, the debates help to define the most pressing issue confronting the nation. Lincoln takes a strong stand against slavery, on moral, social and political grounds, while Douglas defends not slavery as such but the right of Americans to vote their preference. Douglas will be elected senator by the Democratic majority in the Illinois legislature, but Lincoln emerges on the national stage as an articulate and respected spokesman for the anti-slavery position in the North.

March 1859

The Supreme Court reverses a decision of the Wisconsin Supreme Court in *Ableman v. Booth* and rules that state courts may not free Federal prisoners. Booth had been convicted in a Federal court for having rescued a fugitive slave, and in upholding this conviction, the United States Supreme Court confirmed the constitutionality of the Fugitive Slave Act of 1850. The Wisconsin legislature declares that 'this assumption of jurisdiction by the Federal judiciary . . . is an act of undelegated power, void and of no force.' Although in this instance it is an anti-slavery state defying the Federal authority, this is yet another case of a state asserting its rights. In any case, the Federal government rearrests and imprisons Booth.

May 1859

The Annual Southern Commercial Convention, an organization designed to promote economic development, after many years of considering the issue of re-opening the African slave trade, votes to approve the following: 'In the opinion of this Convention, all laws, State or Federal, prohibiting the African Slave Trade, ought to be repealed.'

October 1859

Kansans vote to ratify an anti-slavery constitution. At Harper's Ferry, Virginia, (now West Virginia) John Brown, one of the most radical of the abolitionists, leads an armed group (five black, 13 white men) that seizes the Federal arsenal. Although this is the first action in his vague plan to establish a 'country' for fugitive slaves in the Appalachians, there is no support from outside people. Within 24 hours he and four other survivors are captured by a force of United States Marines led by Colonel Robert E Lee. Within six weeks he is tried for criminal conspiracy and treason, convicted and hanged. Although most Northerners condemn the way that Brown went about his plan, Southerners note that many Northerners admire Brown and his goals. They see Brown's raid as confirming their worst fears about the violence and upheaval that would prevail if the blacks are not held down firmly.

February 1860

Jefferson Davis, the senator from Mississippi, presents a set of resolutions to the Senate to affirm that the Federal government cannot prohibit slavery in the territories but must actually protect slaveholders there. But Davis is less interested in getting the whole Senate's approval than that of the Democratic members, for he is anticipating the forthcoming Democratic Party convention and presidential election. Davis wants to commit the Democratic Party against Stephen Douglas and his concept of popular sovereignty.

April-May 1860

The Democratic Party holds its convention in Charleston, South Carolina. When the pro-slavery platform is rejected, delegates from eight Southern states depart. But the remaining delegates are unable to agree on a candidate, so the convention adjourns.

May 1860

In Chicago, the Republican Party, on its third ballot, nominates Abraham Lincoln as its presidential candidate. To gain the nomination, Lincoln has had to present himself as fairly moderate on the question of slavery, and the party's platform declares that it is for prohibiting it in the territories but against interfering with slavery in the states.

June 1860

The Democratic Party reconvenes, this time in Baltimore, and after another walkout by the anti-Douglas forces, he is nominated for the presidency. Later, the Southern Democrats convene in Baltimore and nominate Vice-President John C Breckinridge to run for president on a platform that calls for the protection of the right to own slaves.

Below: Abolitionist John Brown defying the Federal authorities at Harper's Ferry. His attempt to establish a 'country' for fugitive slaves failed; he was later executed.

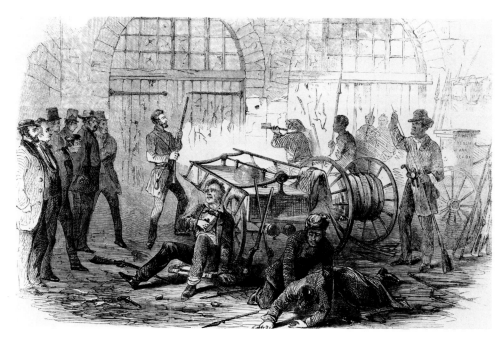

July-October 1860

In the campaign the issues are reduced to slavery and sectionalism. Extremists on both sides do little except fan the fears of people, North and South. Only Stephen Douglas of the candidates even bothers to travel to all sections in an attempt to broaden his appeal, but even he soon realizes that his cause is lost because of the split within his own party. Various Southern spokesmen make it clear that secession will follow if Lincoln is elected.

November 1860

Abraham Lincoln is elected president with a clear majority of the electoral college votes but only a plurality of the popular votes. Although Lincoln had deliberately muffled his message of attacking slavery, there is no mistaking the fact that for the first time in its history the United States has a president of a party that declares that 'the normal condition of all the territory of the United States is that of freedom.' Within days of Lincoln's election Southern leaders are speaking of secession as an inevitable necessity.

December 1860

South Carolina, long a leader in threatening secession, holds a state convention that votes to secede from the Union. Meanwhile, Congress convenes and in an effort to work out some compromise each house appoints a special committee. A member of the Senate's committee, John J Crittenden of Kentucky, introduces a series of proposals, the chief of which calls for a constitutional amendment that restores the Missouri Compromise line across the continent and for all time. Although Crittenden's proposals and various others will eventually be brought before both houses, they will prove to be ineffectual in the face of events. Members of President Buchanan's cabinet are quitting in December to protest either his actions or inaction. And Major Robert A Anderson, in command of the Federal forts in the harbor of Charleston, South Carolina, moves his entire force to the larger and more defensible of the two, Fort Sumter. A delegation from South Carolina comes to Washington and demands that President Buchanan remove all Federal troops from Charleston. Buchanan, who has always been sympathetic to the Southern position on slavery and states' rights, cannot accede to such a demand. He announces that Fort Sumter will be defended 'against hostile attacks, from whatever quarter,' and authorizes preparation of a relief expedition by sea. In Illinois, President-elect Lincoln tries to avoid taking any position that will exacerbate the situation, but at the same time he has made himself clear: 'Let there be no compromise on the question of *extending* slavery.'

Right: A handbill announcing the secession of South Carolina from the Union – the final split leading to civil war.
Below: The violent expulsion of blacks and abolitionists from Tremont Temple, Boston, on 3 December 1860.

CHARLESTON MERCURY

EXTRA:

Passed unanimously at 1.15 o'clock, P. M. December 20th, 1860.

AN ORDINANCE

To dissolve the Union between the State of South Carolina and other States united with her under the compact entitled "The Constitution of the United States of America."

We, the People of the State of South Carolina, in Convention assembled, do declare and ordain, and it is hereby declared and ordained,

That the Ordinance adopted by us in Convention, on the twenty-third day of May, in the year of our Lord one thousand seven hundred and eighty-eight, whereby the Constitution of the United States of America was ratified, and also, all Acts and parts of Acts of the General Assembly of this State, ratifying amendments of the said Constitution, are hereby repealed; and that the union now subsisting between South Carolina and other States, under the name of "The United States of America," is hereby dissolved.

THE UNION IS DISSOLVED!

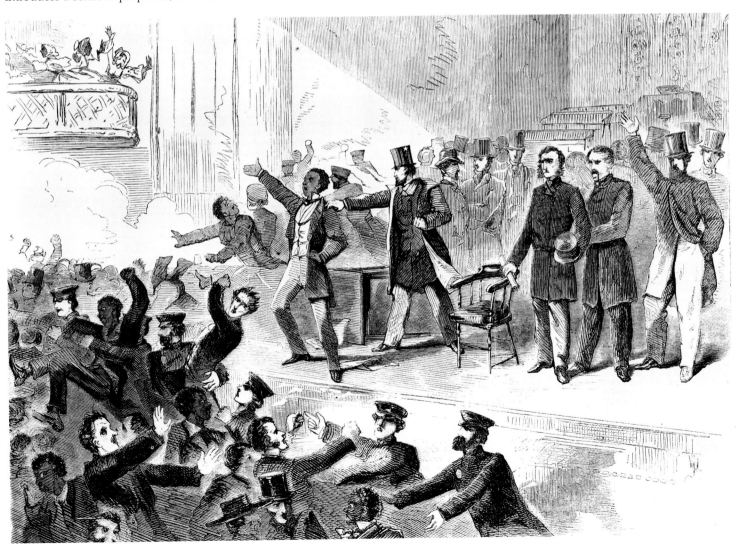

2 January 1861

Washington After South Carolina's vote to secede and Charleston's initiating war preparations, President Buchanan refuses to acknowledge officially a letter received from South Carolina commissioners. This letter, concerning Major Anderson's decision to hold Fort Sumter with a garrison of Federal troops, prompts the cabinet to order reinforcement of the fort.

Military The USS *Brooklyn* is readied at Norfolk, Virginia, despite General Winfield Scott's preference for a non-naval vessel to aid Fort Sumter. That same day, South Carolina seizes the inactive Fort Johnson in Charleston Harbor. Defense of the capital is placed in the hands of Colonel Charles Stone, who is charged with organizing the District of Columbia militia.

3 January 1861

Washington The compromise plan authored by Senator John J Crittenden is considered for submission to public referendum, an idea receiving only lukewarm support in Congress.

Military Former Secretary of War Floyd's orders to remove guns from Pittsburgh, Pennsylvania, on down through forts in the South are reversed by the War Department. With future defense in mind, Georgia state troops take over Fort Pulaski on the Savannah River.

5 January 1861

Washington In the nation's capital, senators from seven Southern states meet, afterward advising secession for their states – Alabama, Arkansas, Florida, Georgia, Louisiana, Mississippi and Texas.

Military Alabama further commits herself to the Southern course by seizing Forts Morgan and Gaines in order to defend Mobile. Meanwhile, 250 troops are on their way to Fort Sumter. The use of the *Brooklyn* having been vetoed by General Scott, the merchant ship *Star of the West* is called into service and sails from New York with those Federal troops.

6 January 1861

Military Florida troops seize the Federal arsenal at Apalachicola.

7 January 1861

Washington Senator Crittenden speaks for conciliation and moderation, although he is against secession. He addresses the Senate, saying 'I am for the Union; but, my friends, I must also be for the equal rights of my State under the great Constitution and in this great Union.'

Military The takeover of Fort Marion at St Augustine, Florida, is accomplished by state troops. Like all such actions, this meets with little, if any, opposition; most of the arsenals and forts are unmanned, and the Federal government is loath to provoke confrontation by making outright defense preparations for the moment.

8 January 1861

Washington President Buchanan urges adoption of the Crittenden Compromise, which would use the Missouri Compromise line to divide the proposed slave and non-slave territories. Jacob Thompson of Mississippi, Buchanan's secretary of the interior, resigns and is replaced by Chief Clerk Moses Kelley as acting secretary.

Military In Florida, Federal troops at Fort Barrancas open fire on a handful of men who advance on the Pensacola site.

9 January 1861

Secession Despite Buchanan's pleas, Southern sentiment runs high in favor of secession; Mississippi votes 84-15 to leave the Union, a move greeted with widespread public celebration.

Military The *Star of the West* approaches Charleston Harbor but is fired on prior to reaching Fort Sumter. No damage is done to the ship but it quickly retreats, heading back to New York. Although some officers at Fort Sumter are anxious to return the fire opened on the relief vessel, Major Anderson forbids this action. He complains to Governor Pickens about volleys fired on a ship bearing the United States flag. The South Carolina governor replies that a United States ship represents a hostile presence that the now-independent state cannot tolerate. Anderson soon appeals to Washington, but there is little change in the situation, although Charleston reacts excitedly to this near outbreak of war. Fort Sumter remains under United States control.

10 January 1861

Washington Jefferson Davis addresses the Senate, calling for a decisive response to Southern demands. He decries the use of 'physical force' to settle those demands, asking instead that United States authority be maintained 'by constitutional agreement between the States.'

Military Lieutenant A G Slemmer transfers Federal troops from Fort Barrancas to Fort Pickens on Santa Rosa Island after Florida votes 62-7 to secede. Orders to Major Anderson at Fort Sumter emphasize defensive preparations, despite the continual seizure, elsewhere, of Federal properties. Forts Jackson and St Philip in Louisiana are taken over by state troops, as is the large and valuable arsenal at Baton Rouge.

11 January 1861

Secession Furthering the Southern cause, Alabama's State Convention votes 61-39 to secede. Conversely, the New York legislature votes for pro-Union resolutions.

Military Louisiana's troops occupy the United States Marine Hospital near New Orleans. President-elect Lincoln writes a letter to James T Hale of Pennsylvania that 'if we surrender, it is the end of us, and of the government.'

12 January 1861

Washington Mississippi representatives leave the House. In an appeal to the Senate, New York's Senator Seward states, 'I do not know what the Union would be worth if saved by the use of the sword.'

Military In Florida, state troops demand the surrender of Fort Pickens and its garrison after having seized Fort Barrancas and its barracks, Fort McRee and the naval yard at Pensacola. Fort Pickens remains firmly in Federal hands, however.

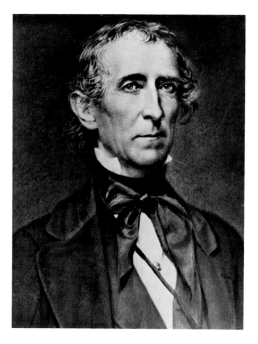

Above: Former President John Tyler headed the Peace Convention in February 1861 in a last-minute attempt to save the Union.

13 January 1861

Washington Buchanan receives envoys from both Major Anderson and Governor Pickens concerning the disposition of Fort Sumter. The president emphasizes that the fort will not be turned over to South Carolina authorities.

14 January 1861

Military Fort Taylor at Key West, Florida, is garrisoned by United States troops. This effectively prevents its future takeover by the South. Fort Taylor represents a major Gulf Coast base for Union operations and will become an important coaling station for blockaders during the war. Fort Pike near New Orleans, Louisiana, falls into state hands.

16 January 1861

Washington The Senate, resolving that the Constitution should not be amended, virtually kills the Crittenden Compromise.

19 January 1861

Secession Georgia secedes on a vote of 208-89 despite indications of Union support. Moderate leaders in that state include Alexander Stephens, later to be vice-president of the Southern Confederacy. This type of moderate not withstanding, the move to secede is a strong one, prompted by the earlier election of Lincoln to the presidency.

20 January 1861

Military Mississippi troops take Fort Massachusetts on Ship Island in the Mississippi Gulf after several previously unsuccessful attempts at seizure of this important military installation.

21 January 1861

Washington Five senators representing the states of Alabama, Florida and Mississippi withdraw from the chamber. All make farewell speeches, Jefferson Davis among them, who asserts 'I concur in the action of the

people of Mississippi believing it to be necessary and proper.' Davis is severely downcast by this exigency, that night praying for peace, according to his wife.

Slavery Boston, Massachusetts, is the site of an address by Wendell Phillips, an ardent abolitionist. His message hails the secession of slave states, for which he had little use or respect since they seemed to be only disruptive forces in the Federal Union.

24 January 1861

Military The arsenal at Augusta, Georgia, falls into state hands. Federal troops from Fort Monroe, Virginia, are sent to reinforce Fort Pickens in Florida.

26 January 1861

Secession An ordinance of secession passes the Louisiana State Convention 114-17.
Military In Savannah, Georgia, both Fort Jackson and the Oglethorpe Barracks are taken by state troops.

29 January 1861

Washington Kansas, with a constitution that prohibits slavery, receives the necessary congressional approval to become the Union's 34th state. This action is the outcome of several years of bitter fighting between pro- and anti-slavery factions in that former territory.

31 January 1861

Military New Orleans, Louisiana, is the scene of further takeovers. The United States Branch Mint and Customs House and the schooner *Washington* are seized by the state, ending a month of similar events throughout the South. The defiance of secessionists continues unabated and Washington seems unable, or unwilling, to still the confusion and unrest engendered by Southern actions.

1 February 1861

Washington William H Seward, secretary of state-designate, is the recipient of a letter from Lincoln in which the latter states, 'I am inflexible' in reference to extending slavery in the territories.
Secession With a vote of 166-7 at the State Convention, Texas secedes from the Union, the seventh state to do so.

4 February 1861

Washington The Peace Convention meets at the nation's capital, with 131 members from 21 states, although none of the seceded states send any delegates to this assembly. The convention is headed by former President John Tyler, who joins with others of like mind in a last desperate effort to compromise and save the Union.
Secession At Montgomery, Alabama, a convention of representatives assembles. This is the initial meeting of the Provisional Congress of the Confederate States of America, attended by many former United States senators, among them Louisiana's Judah Benjamin and John Slidell. Benjamin is later to become attorney general, then secretary of war, in Jefferson Davis' cabinet. He and Slidell have been law partners together in New Orleans. Slidell later becomes famous for his involvement in an international incident, the *Trent* affair.

5 February 1861

Washington Fort Sumter is again the subject of attention as the president summarily dismisses any notions held by South Carolina that the United States will give up its jurisdiction over the fort. Meanwhile, the Peace Convention attempts to arrange a settlement of differences between the secessionists and those who wish to uphold the Union. Speaking to the delegates, John Tyler indicates that 'the eyes of the whole country are turned to this assembly, in expectation and hope.'
Secession At Montgomery, Alabama, plans proceed for the establishment of 'a Confederacy of the States which have seceded from the Federal Union,' according to Christopher Memminger of South Carolina. Memminger is destined to be the Confederacy's treasury secretary.

8 February 1861

Secession A constitution is provisionally adopted by the Montgomery convention. With several significant changes, the document closely resembles the United States Constitution, those changes having to do with the right to own slaves, the treatment of fugitive slaves and the power of sovereign states in the South.

9 February 1861

Secession In a unanimous decision, Jefferson Davis of Mississippi is elected provisional president of the Confederate States of America. Alexander Stephens joins him as provisional vice-president. These two are moderate enough in their public views to please the border states and it is hoped that those states not yet seceded will soon do so now that the Confederacy has chosen able, and not fanatic, leaders. In a further move to preserve order and prevent a radical break, the Provisional Congress at Montgomery states that the laws of the United States of America are to remain valid unless they interfere with stated laws of the Confederacy. Tennessee declines the opportunity to hold a state convention which would rule on secession; the popular vote on this decision is 68,282 to 59,449.
Military Fort Pickens, Florida, does not receive the reinforcements that arrive on the USS *Brooklyn* because of the desire of both Federal and state authorities that the balance of power not be disturbed.

Below: The inauguration of Jefferson Davis as president of the Confederacy in front of Montgomery's State Capitol.

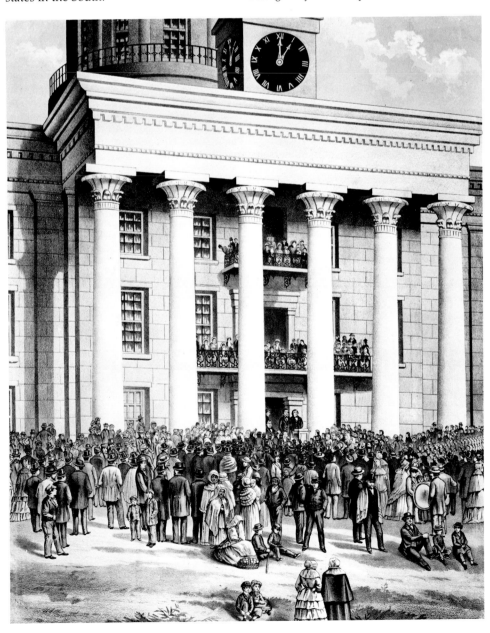

10 February 1861

Secession The arrival of a telegram announcing his election to the presidency of the newly-formed Confederacy catches Jefferson Davis by surprise in Mississippi. He is immediately involved in plans for a trip to the capital at Montgomery, Alabama, in order to take part in his inauguration, which the Confederacy clearly hopes to hold before Lincoln can take over the Federal government.

11 February 1861

Washington Preparations are made for the inauguration as President-elect Lincoln leaves Springfield, Illinois, on his journey to the Federal capital.
Secession Jefferson Davis leaves his Mississippi plantation, Brierfield, and at Montgomery, Alabama, Vice-President Alexander Stephens is sworn in but does not take advantage of the occasion to make any official statements.

12 February 1861

Secession As Lincoln travels to his inauguration in Washington, DC, he makes numerous stops along the way. Speaking before various groups, the president-elect is cautious in expressing his opinions. To German-Americans at Cincinnati, Ohio, he states his earlier intention of remaining silent about 'national difficulties.' Earlier, in that same city he asked the citizenry to remain loyal to the Constitution. Jefferson Davis is making his way to the Confederate capital and, like Lincoln, speaks to the crowds gathering along the way. He observes that a possible outcome of secession is war.
Military State troops take possession of United States munitions stored at Napoleon, Arkansas.

15 February 1861

Washington The Peace Conference drags on, attending to each detail with discussion and debate. Many Federal military officers, such as Raphael Semmes of the navy, are resigning their posts to become part of Southern military and naval forces.
Secession Again, Lincoln makes a cryptic observation, this time at Pittsburgh, Pennsylvania, that 'there is really no crisis except an *artificial* one!' Similar comments accompanied his address earlier to a crowd in Cleveland, Ohio.

18 February 1861

Secession At his inauguration, Jefferson Davis points out 'the American idea that governments rest on the consent of the governed.' It is clear that he would like to avoid armed conflict, but it is also apparent that he holds the Southern position to be sacred. His words – 'obstacles may retard, but they cannot long prevent, the progress of a movement sanctified by its justice' – leave little doubt as to his dedication. Elsewhere, Lincoln progresses from Buffalo eastward to Albany, New York.

19 February 1861

Secession A Confederate cabinet takes shape in Montgomery, Alabama. Secretaries of State, War and the Treasury, Toombs, Walker and Memminger are joined by Judah Benjamin as attorney general, Stephen Mal-

lory as secretary of the navy, and John Reagan as postmaster general. At New York City, an estimated 500,000 persons greet Lincoln as he arrives in that Northern city.
Military Louisiana obtains control of the United States paymaster's office located at New Orleans.

20 February 1861

Military The Department of the Navy of the Confederacy is established. In addition, the Provisional Congress empowers President Davis to contract for the manufacture and purchase of war goods.

22 February 1861

Secession At a Washington's birthday celebration in Philadelphia, Pennsylvania, Lincoln points out that 'there is no need of bloodshed and war.' After having received an assassination threat the previous day, Lincoln leaves with a bodyguard for the nation's capital. It is arranged that he, detective Allan Pinkerton and a friend will travel by a revised schedule and route.

23 February 1861

Washington The president-elect arrives safely in the city at 0600 hours. Various delegations greet him throughout the day, including members of the Peace Convention.
Secession In Texas, voters respond favorably to appeals for secession in a popular public referendum.

27 February 1861

Washington At the Peace Conference, deliberations result in six proposed constitutional amendments. Although the proposals have no chance of acceptance, they are sincerely conceived. Meanwhile, United States representatives strike down plans for a constitutional convention, vote against amendments to interfere with slavery and against the Crittenden Compromise.
Secession Jefferson Davis, now head of the Confederacy, appoints three men to approach officials in the Federal capital with offers of peaceful negotiation of differences. Davis also receives missives from Governor Pickens in Charleston, South Carolina; the head of that state observes the need for Confederate takeover of Fort Sumter to preserve 'honor and safety.'

28 February 1861

Secession Missouri holds a State Convention: its purpose is to debate secession. North Carolina comes out in favor of the Union at its election concerning the possibility of a State Convention; secessionists garner 46,409 votes in favor of holding such a convention, those against the assembly tally 46,603 votes.
Military The stalemate at Fort Sumter continues, Major Robert Anderson staying in nearly constant communication with Washington. States that have seceded and formed the Confederacy grow increasingly more willing to confirm their independent status. With the inauguration only days away, the mood in Washington is expectant but subdued; there is little real action as the incoming administration awaits the beginning of its tenure. However, relations between the North and South are deteriorating, making war more likely.

Above: Charles Memminger, secretary of the treasury in the Confederate cabinet from 19 February 1861.

2 March 1861

Washington Senator John J Crittenden of Kentucky attempts to push a constitutional amendment through the Senate, but fails. This amendment, a culmination of Peace Convention efforts, is the final compromise issue supported by Crittenden, who now directs his energies at monitoring the inevitable conflict between North and South.

3 March 1861

Military General Winfield Scott, head of the United States Army, indicates in a letter to Secretary of State Seward that relief of Fort Sumter is not practical.

4 March 1861

Washington Abraham Lincoln is inaugurated as the 16th president of the United States of America at the nation's capital where some 30,000 people are assembled. Because of threats against the president's life, troops are everywhere. In his address to the nation on this momentous occasion, Lincoln emphasizes his position on slavery, stating that he is not opposed to the institution where it is already established. He further points out that the states voting for secession are in error, since 'the Union of these States is perpetual.' Taking the stance that acts against the Federal government are 'insurrectionary or revolutionary,' Lincoln vows to uphold the Union, saying to refractory Southerners, 'in *your* hands, my dissatisfied fellow countrymen, and not in *mine,* is the momentous issue of civil war.'

5 March 1861

Military Fort Sumter, again the subject of concern on both Northern and Southern sides, becomes a point of intense discussion between Lincoln and General Scott. It appears from Major Anderson's messages that the fort cannot be maintained without replacements and reinforcements, and the estimated number of troops needed at the South Carolina site hovers around 20,000. Both Scott and Lincoln agree that the disposition of Fort Sumter should be confronted soon.

6 March 1861

Washington Despite Lincoln's refusal to deal with them, the Confederate commissioners appointed by Jefferson Davis try to establish negotiations with the Republicans now in office.

7 March 1861

Washington Martin J Crawford, John Forsyth and A B Roman, the men Davis has sent to represent the Confederacy in the United States capital, continue to press for an appointment with Lincoln's administration. In addition, they contact influential individuals in Washington who express some support for the Southern position, or who are known to be on the side of peaceful negotiation rather than armed conflict.

11 March 1861

Military Lincoln is told by General Scott that the army can no longer be responsible for the immediate reinforcement of Fort Sumter. He tells the president that the situation at Charleston is reaching crisis proportions which the army alone cannot effectively handle.

13 March 1861

Washington Since Lincoln is averse to validating the Confederate nation in any respect, he counsels Secretary of State Seward to refuse meetings with Confederate ambassadors on any grounds. In avoiding such a conference, the president hopes to sidestep the question of whether or not those Southern states forming the Confederacy have actually left the Union.

15 March 1861

Military In the hope of avoiding armed conflict, Seward does not support the reinforcement of Fort Sumter since that move would, he feels, most definitely precipitate a response from the Confederacy. Lincoln, in the midst of the varying opinions of his cabinet, delays any final word concerning the issue in South Carolina.

16 March 1861

Secession Another state, Arizona, votes to leave the Union and join the Confederacy, in a convention at Mesilla. The Confederate government later establishes a territorial government for Arizona.
International The Confederacy, knowing that its future depends greatly on recognition, appoints commissioners to Britain.

18 March 1861

Secession A State Convention having turned down a move to secede 39-35, Arkan-

Below: A crowd of some 30,000 looks on as Abraham Lincoln is inaugurated as the 16th president of the United States.

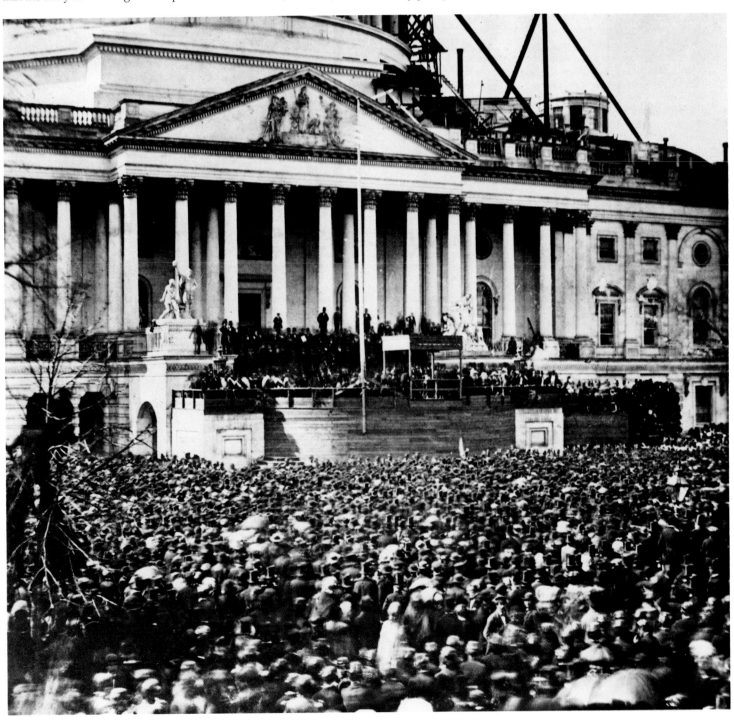

sas agrees to an election later in the summer which will allow for public voting on the secession question.

Military While Confederate President Jefferson Davis hopes that Federal troops under Major Robert Anderson will withdraw, the president nevertheless communicates with Governor Pickens concerning the fortification of the area around Charleston, South Carolina. Davis points out that it is unlikely that 'the enemy would retire peacefully from your harbor.'

25 March 1861

Washington The capital is alive with rumors from Charleston, South Carolina, but there is little reliable information about the situation there. The next day, President Lincoln and his cabinet meet to discuss Fort Sumter and how to best deal with the mounting crisis.

29 March 1861

Washington The president finally announces his plan for Fort Sumter. An evacuation of that installation would not be attempted, but instead, a force would be sent to supply and support the troops already stationed there. It is Lincoln's preference that this force should be in readiness 'as early as the 6th April.' The cabinet's support of President Lincoln's decision to keep Fort Sumter in Federal hands is three to two in favor, Secretary of War Simon Cameron keeping silent about his wishes in this matter.

31 March 1861

Washington President Lincoln, having taken a stance on Fort Sumter, now prepares

Below: Major Robert Anderson, the commander of the Northern forces at Fort Sumter.

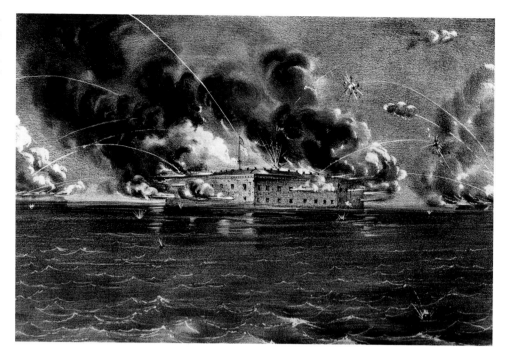

to act on Fort Pickens' dilemma. A force is ordered to Florida to relieve the latter military post, while rumors fly in the capital that Fort Sumter is to be abandoned; there is no truth to these rumors, as Lincoln's orders of 29 March prove.

Military Yet another Federal outpost, Fort Bliss in Texas, surrenders its jurisdiction to state troops. The toll of Federal property lost to Southern hands continues to mount, and the mood in both the Union and the Confederacy is pessimistic as to the outcome of the current problems. The Lincoln administration has taken steps which it feels are both emphatic yet non-provoking.

1 April 1861

Washington President Lincoln receives a message from Secretary of State Seward in which the latter speaks of relations between the United States and France, Britain, Spain and Russia. Seward indicates his willingness to assume responsibility for dealing with the Confederacy. In addition, the secretary of state tells the president that the issue with the Confederacy ought to center around union or disunion rather than slavery, and advises that Fort Sumter be abandoned while Federal occupation of other forts should continue. Lincoln's tactful yet firm response proves that he, and not Seward, will continue to make policy decisions. In a separate action, the president orders the USS *Powhatan* to proceed to Florida where it can then aid Fort Pickens. This effectively removes the *Powhatan* from the Fort Sumter rescue efforts. Secretary of State Seward has advised this course of action but it is not made clear to the Department of the Navy, introducing some later confusion when the Fort Sumter expedition is finally under way.

3 April 1861

Washington The president meets with his cabinet concerning Fort Sumter and issues related to the relief and reinforcement of that Federal installation.

Military In Charleston Harbor, the Federal schooner *Rhoda H Shannon* is fired on by Confederate batteries.

Above: A dramatic reconstruction of the bombardment of Fort Sumter in Charleston Harbor, South Carolina.

4 April 1861

Washington Lincoln writes to Major Anderson, informing him of the upcoming relief of Fort Sumter, saying 'the expedition will go forward.' Anderson is told to maintain the situation as it now stands, if possible, but he has been given the freedom to decide what the response would be to an attack by the Confederates.

Secession At its State Convention, Virginia votes 89-45 against holding a referendum on the most important secession question.

5 April 1861

Washington Formal orders are given by the secretary of the navy concerning the Fort Sumter expedition. Four vessels are told to provision the fort, but among these is the *Powhatan* which is already on its way to Fort Pickens, Florida, under direct orders from the president.

6 April 1861

Washington State Department Clerk Robert S Chew carries a message to South Carolina Governor Pickens regarding Fort Sumter: the Federal action will be one of provisioning rather than reinforcing on the condition that there be no resistance to or interference with the supply efforts. Lincoln directs Seward to reverse former orders concerning the USS *Powhatan* but it is too late to do so.

7 April 1861

Secession General Beauregard conveys the message to Major Anderson that no further communication between Fort Sumter and Charleston will be permitted by Confederate authorities.

8 April 1861

Secession In response to Lincoln's 6 April message concerning the supply of Fort Sumter, the Confederacy readies its forces in the vicinity of Charleston Harbor.

Military The Federal cutter *Harriet Lane* leaves New York for Fort Sumter.

9 April 1861

Military From New York, two more vessels sail for Charleston Harbor; one, the steamer *Baltic*, carries naval agent Gustavus Fox, a former officer who later becomes President Lincoln's assistant secretary of the navy.

10 April 1861

Military Beauregard receives word from Confederate Secretary of War Leroy Pope Walker that he is to require the surrender of Fort Sumter from the Federals. All around the fort, Confederate troops prepare for the expected conflict; a floating battery is stationed by rebels off Sullivan's Island in Charleston Harbor.

11 April 1861

Washington Three Confederate commissioners sent to the Federal capital leave for the South and carry with them the conviction that their government will not be recognized by Lincoln.

Military Major Anderson receives messengers from General Beauregard – Confederate Colonel James Chesnut, formerly a United States senator; Colonel A R Chisolm, Governor Pickens' representative, and Captain Stephen D Lee, formerly of the United States Army. These three men convey to Anderson that Beauregard is 'ordered by the Government of the Confederate States of America to demand the evacuation of Fort Sumter.' Anderson's refusal prompts Beauregard to contact War Secretary Walker; the latter encourages the Confederate general to wait and see whether Anderson evacuates so as to 'avoid the effusion of blood.' The Confederacy appears willing to hold its fire on Fort Sumter if the Federal garrison does nothing to further precipitate armed conflict.

12 April 1861

Military The three Confederate messengers to Fort Sumter, Chesnut, Chisolm and Lee, return to Major Anderson once more after speaking with General Beauregard. They try once more to ask for a time of probable evacuation of the fort by Federal troops. The major indicates 2400 hours 15 April as a target time in the event that he receives no supplies or orders from Washington. The Confederacy, knowing that help is undoubtedly on its way, refuses to accept this statement from Major Anderson and gives the Federal commander written notification of an attack to commence in one hour's time. At Fort Johnson, Captain George S James signals the other harbor batteries to open fire. At 0430 a rotation of fire proceeds against Fort Sumter, continuing through the day and at intervals through the night. The city of Charleston reacts with excitement, many people watching the bombardment from rooftops. The Federal vessels sent by Washington are visible at sea, prompting further speculation as to the outcome of the Southern attack. At Fort Pickens on Santa Rosa Island in Florida, the United States Navy lands troops to reinforce the existing garrison. This action prevents the Confederacy from gaining control of this important Gulf Coast fortification.

13 April 1861

Washington The president, as yet unaware of the battle at Fort Sumter, states that 'I shall hold myself at liberty to repossess places like Fort Sumter if taken from Federal control.

Military The Federal garrison at Fort Sumter is left with no option but to surrender to Confederate officers. This action is declared at 1430 hours. Major Robert Anderson, with no remaining food and an insufficient number of men, concludes that further conflict is purposeless and that his troops have done their best under difficult conditions. No lives have been lost and the wounded are few on both sides, despite the firing of some 40,000 shells during the battle.

14 April 1861

Washington The cabinet and President Lincoln meet after receiving official notice of the surrender at Fort Sumter. The chief executive calls for 75,000 volunteers, and also for a session of Congress to meet on 4 July 1861.

Military Major Anderson and his men leave Fort Sumter and proceed northward by sea after a ceremony of surrender. On this occasion, an accidental blast kills two and injures four Union soldiers as a stockpile of ammunition is inadvertently detonated.

15 April 1861

Washington Lincoln issues a public proclamation calling for 75,000 militia to still the insurrection in South Carolina, eliciting an in-

Below: With little hope of being relieved, the troops inside Fort Sumter were forced to surrender on 13 April.

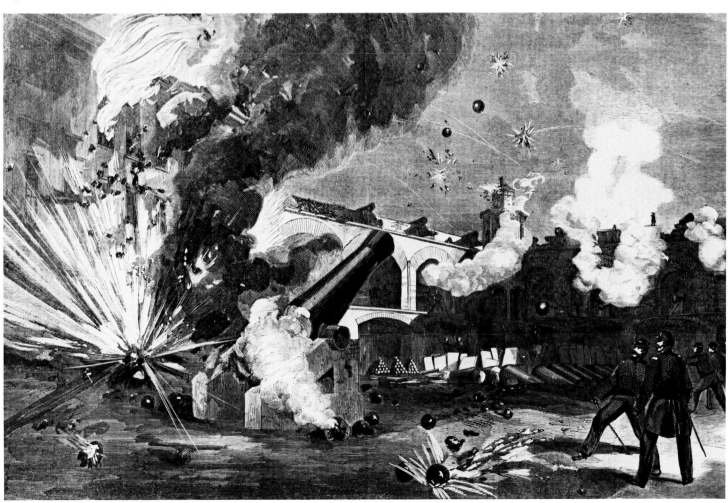

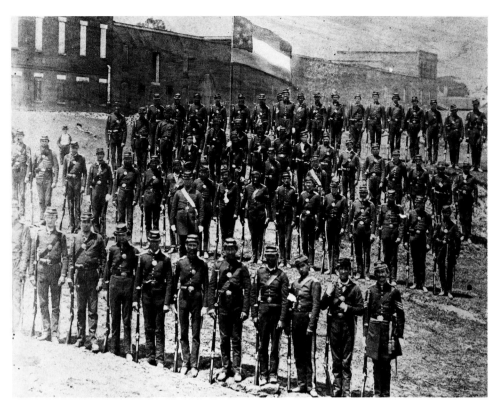

Above: A photograph showing members of Company K, 4th Georgia Volunteers, one of the militia regiments raised to protect the Confederacy in the early stages of the war.

stant supportive response from Northern states. Border states such as Kentucky, Maryland, Missouri, North Carolina and Virginia are areas of discontent and uncertainty. Kentucky and North Carolina ultimately refuse to respond to Lincoln's appeal while the New York legislature commits $3 million in aid for the Northern cause.

17 April 1861

Secession Baltimore, Maryland, is the setting for a meeting held by secessionists. Missouri and Tennessee decide against meeting Lincoln's requests for volunteers, and at Richmond, Virginia, the State Convention passes 88-55 a secession ordinance. A public referendum is to be held in that state on 23 May for a final decision on the secession question. For all intents and purposes, Virginia is now viewed by the rest of the nation as a part of the Confederacy.
The Confederacy President Jefferson Davis announces that the Confederate government will accept applications for letters of marque, a move which will permit privateering, a practice that to many seems little better than legalized piracy.
Naval At Indianola, Texas, the steamer *Star of the West* is taken in Gulf waters by Confederate troops under General Van Dorn; the ship will later become a receiving vessel in the Confederate navy.

18 April 1861

Washington At the capital, the president is informed by eyewitnesses as to the events at Fort Sumter. It is alleged that Lincoln has approached Colonel Robert E Lee and has asked him to command the Union army; Lee has purportedly declined the offer. It is clear that while there are staunch supporters for

both the Union and the Confederacy, there are also those who prefer to avoid further conflict.

19 April 1861

Washington The president makes one of his strongest moves up to this time, ordering the blockade of all ports in the Confederate states. This order immediately causes the Federal Department of the Navy to place its ships outside all critical ports, and the blockade is soon extended to include North Carolina and Virginia. It is one effort which proves effective, though in varying degrees, throughout the war.
The North In New York, the 6th Massachusetts Regiment travels toward Washington, pausing at Baltimore, Maryland. A vital railroad nexus, this city is important for both the supply and defense of the Federal capital. As the Massachusetts troops move through Baltimore on their way to the Washington depot, they are attacked by rioters carrying Confederate flags. Nine civilians and four soldiers are killed in the melee. The troops reach the capital and are ultimately quartered in the Senate Chamber. It appears that Washington will lose a railroad link with the North as a result of this Baltimore riot, causing the Federal navy to carry troops to Washington via Philadelphia and Annapolis.

20 April 1861

The North A move later censured by Union officials is that of Commandant Charles S McCauley giving orders to burn the Federal Gosport Naval Yard near Norfolk, Virginia. Calculated to prevent the property from falling into Confederate hands, the base has been an important Federal military installation and its loss creates difficulty for Union operations along the coast. The 4th Massachusetts Regiment arrives to support Fort Monroe.
The Confederacy Robert E Lee resigns his post with the Federal army, choosing to side

with the South. Many Confederate merchants are now repudiating debts to the North.

21 April 1861

The North In Baltimore, Maryland, rioting continues while the president meets with that city's mayor to discuss ways of ending the violence.
Secession Monongahela County in the western part of Virginia hosts meetings of anti-secessionists, who resolve to support the Union despite the stand taken by the remainder of the state.

22 April 1861

Washington The difficulties in Baltimore have continued to threaten the Federal capital because troops heading for Washington must go through Maryland. Lincoln's words to the Baltimore YMCA – 'you ... would not lay a straw in the way of those who are organizing ... to capture this city' – indicate his concern for the defense of Washington.
The Confederacy Jefferson Davis is in communication with Virginia's Governor John Letcher and hopes that the latter will be able to 'sustain Baltimore if practicable.'
Western Theater Cairo, Illinois, is garrisoned by state troops.
Trans-Mississippi Arkansas Governor H M Rector refuses to send troops to support the Union. The Federal arsenal at Fayetteville, Arkansas, is taken by North Carolina state troops.

24 April 1861

Washington The president continues to worry about the security of the capital city as invasion from the South looms on the horizon. In writing to Reverdy Johnson, a Maryland political leader, Lincoln says, 'I do not mean to let them invade us without striking back.'

25 April 1861

Washington The 7th New York Regiment arrives in Washington, much to President Lincoln's relief.
Trans-Mississippi In a secret action against the pro-secessionists in Missouri, Captain James H Stokes of Chicago, Illinois, goes to St Louis from Alton, Illinois. Upon arrival, he and his men remove 10,000 muskets from the arsenal, returning to Alton the next morning with munitions for Illinois troops.

27 April 1861

Washington In a bold action, Lincoln suspends the writ of habeas corpus in an area stretching from Philadelphia, Pennsylvania, to Washington, DC, and then leaves General Scott in charge of supervising any incidents arising out of that suspension. Lincoln does this in part to provide for a cessation of the turmoil that has been plaguing Baltimore, Maryland, and causing troop transport to be severely disrupted because of it. In addition, the president extends the Federal blockade of Southern ports to include Virginia and North Carolina.
The Confederacy Richmond is offered by the Virginia Convention as a possible site for a new capital for the Confederacy to replace Montgomery, Alabama.

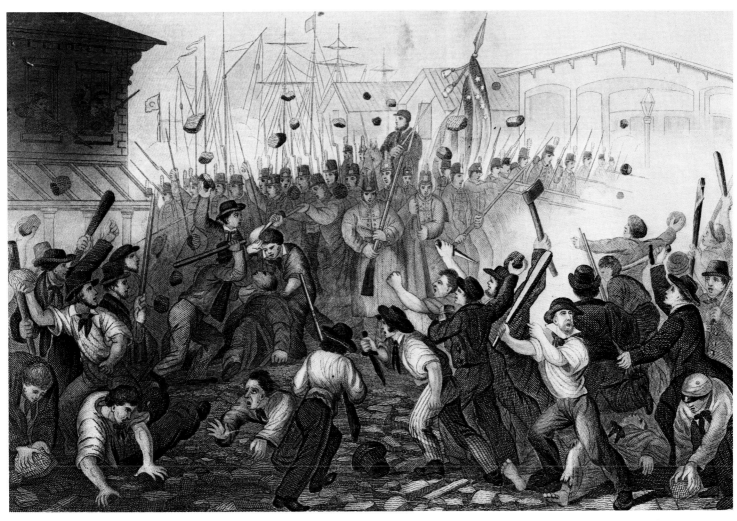

29 April 1861

Secession The state legislature of Maryland repudiates secession with a vote of 53-13.

The Confederacy Jefferson Davis speaks at the second session of the Confederate Provisional Congress. Explaining reasons for secession, the Confederate leader says, 'we protest solemnly in the face of mankind that we desire peace at any sacrifice save that of honor and independence.'

30 April 1861

Washington Complying with orders from the president, Federal troops evacuate Indian Territory forts, leaving the Five Civilized Nations – Cherokees, Chickasaws, Choctaws, Creeks and Seminoles – virtually under Confederate jurisdiction and control.

1 May 1861

The North Soldiers killed in the Baltimore riots are honored at ceremonies in Boston, Massachusetts. A call for volunteers to support the Union is publicized in the Nebraska Territory.

Eastern Theater Confederate troops under Colonel T J Jackson are sent to Harper's Ferry, Virginia, by General Robert E Lee.

Naval Federals seize two Confederate ships in Atlantic waters, and the United States Navy blockades the mouth of the James River.

3 May 1861

Washington Making preparations for the war which now appears inevitable, Lincoln sends out a call for 42,000 volunteers and another 18,000 seamen. He also forms the Department of the Ohio, to be commanded by George Brinton McClellan. General Winfield Scott, the general in chief of the Federal army, explains that, with the aid of a powerful blockade, it is possible to 'envelop' the states along the entire length of the Mississippi River and provide for the subjugation of insurgents in this way. The arrangement is known as the Anaconda Plan.

International The Confederacy has sent commissioners to London, England, to meet with the British foreign minister in the attempt to gain recognition for their government in the South. The United States complains to the British ministry about this meeting although it is an unofficial one, according to the British, who are not interested in upsetting their delicate relations with the United States.

Above: Rioters with pro-Southern sympathies attack members of the 6th Massachusetts Regiment as they pass through Baltimore.

Below: A view of Norfolk after it was wrecked and abandoned by its Union garrison on 20 April, a loss that was deemed unnecessary.

5 May 1861

The Confederacy State troops abandon, temporarily, the city of Alexandria, Virginia, which lies across the Potomac River from the Federal capital.

6 May 1861

Secession At Little Rock, Arkansas, the state legislature votes 69-1 in favor of secession. Elsewhere, Tennessee votes to set a public referendum on secession; while the 8 June deadline for this election is one month away, the state legislature's 66-25 vote in favor of secession confirms the direction that Tennessee will take in the upcoming conflict.
The Confederacy Jefferson Davis gives approval to the Confederate congressional bill declaring a state of war between the United States and the Confederate States.

7 May 1861

Washington Major Robert Anderson, who had gained national recognition as the commander in charge of Union forces at Fort Sumter, South Carolina, is assigned to recruit

Right: US Marines return to barracks after a parade through Washington, DC.
Below: The death of Union officer Elmer Ellsworth during an attempt to remove a Southern flag provoked outrage on both sides.

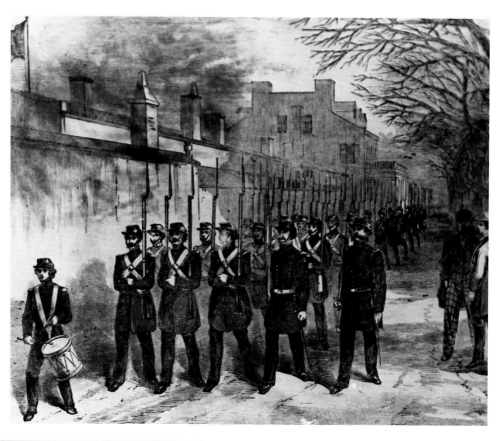

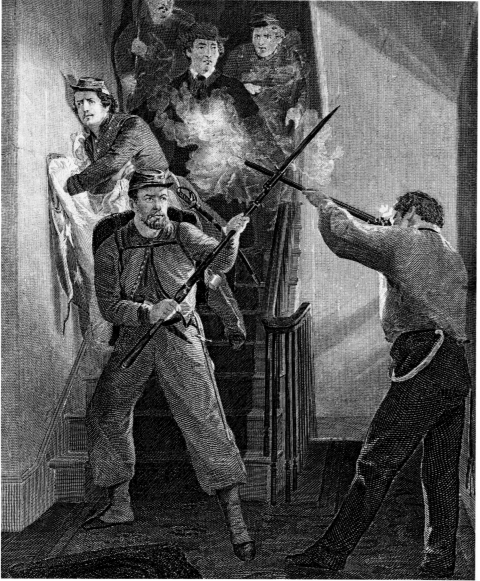

troops for the Federal cause. President Lincoln asks Anderson to obtain Union volunteers from Kentucky and western Virginia.
Border States Conflicting sentiments cause a riot at Knoxville, Tennessee; pro-secessionists clash with Union supporters, resulting in injuries and one fatality.

9 May 1861

The North At Newport, Rhode Island, the USS *Constitution* and the steamer *Baltic* are preparing to set up the United States Naval Academy since it can no longer be based in Annapolis, Maryland, due to the uncertain nature of that area's political sentiments. It seems important to locate the academy in an area which is solidly pro-Union.
The Confederacy James D Bullock is charged with purchasing arms and vessels from the British for the Confederate cause.
Naval The Virginia blockade precipitates gunfire between Confederate batteries on shore at Gloucester Point and the Federal vessel *Yankee.*

10 May 1861

The Confederacy President Jefferson Davis orders the purchase of warships and munitions for the Confederacy. Naval Secretary Mallory suggests ironclads as logical additions to the small Confederate navy, hoping that this will favor the Southerners, for their Union opponents have a much larger and more diverse fleet.
Secession A riot in St Louis, Missouri, results when United States troops clash with pro-secessionist state militia. While Federal forces do not provoke the attack, under the leadership of Captain Nathaniel Lyon they march to the state militia barracks at Camp Jackson where armaments for secessionists are allegedly stored. The state forces led by General D M Frost surrender peacefully, but during the ensuing march, curious crowds

trigger further violence. In the fracas, a reported 29 are killed or fatally injured.

11 May 1861

The North Both Wheeling in western Virginia and San Francisco, California, are scenes of pro-Union demonstrations, even though a strong secessionist element remains in the latter area.

Secession At St Louis, the unrest continues. Fights between civilians and the 5th Reserve Regiment result in seven more deaths. Eventually, Federal control is resumed and the secessionists slowly back down.

13 May 1861

The North General Benjamin F Butler moves Federal troops into Baltimore without official authorization. Butler has received notice of possible riots in that Maryland city.
International Britain's Queen Victoria announces her nation's position of neutrality. She further states that the British will assist neither side, but will give each the rights accorded belligerents.

14 May 1861

The North General Butler continues his occupation of the city of Baltimore.
Western Theater Major Robert Anderson receives word from President Lincoln that Kentucky Unionists are to be given aid, despite their state's neutral position.

16 May 1861

Washington Orders go out to Commander John Rodgers to take charge of the United States naval operations on rivers in the West.
Secession In Kentucky, the legislature proposes its intention that the state retain its neutral status.

18 May 1861

Eastern Theater In its first offensive against the South, the Union engages rebel batteries at Sewall's Point, Virginia.
Naval The blockade of Virginia is complete with the sealing off of the Rappahannock River.

20 May 1861

Secession North Carolina assembles a convention at Raleigh, voting for secession.
The North In order to reveal pro-secessionist evidence, United States marshals in the North appropriate the previous year's telegraph dispatches.
The Confederacy Confederate provisional congressmen vote to relocate their nation's capital at Richmond, Virginia.

23 May 1861

Secession In a vote of 97,000 to 32,000, Virginia moves in favor of secession. The western portion of the state, however, is clearly pro-Union and has been for some time contemplating a formal break with the rest of the state.

24 May 1861

Eastern Theater Alexandria, Virginia, is occupied by Federal troops moving quietly across the Potomac River. In this way the Union begins to defend Washington. Virginia troops display little resistance. The first

Union combat fatality of the Civil War occurs during this move: 24-year-old Elmer Ellsworth, head of the 11th New York Regiment, dies in an attempt to remove a Confederate flag from a hotel roof. The man who shot Ellsworth, the hotel keeper James Jackson, is then shot by a Union soldier. Both the North and the South have martyrs for their respective causes. Newspapers give full play to the emotions in reporting the events – 'Jackson perished amid the pack of wolves' was the way one Southern newspaper chose to describe the killing.
Slavery In an action provoking questions as to the disposition of slaves by the North, General Benjamin F Butler holds three slaves at Fort Monroe. The issue is quickly interpreted as one of whether slaves are to be regarded as contraband. This will become an increasingly difficult controversy, ultimately ruled on by Secretary of War Cameron in July 1861.

26 May 1861

Washington Lincoln's Postmaster General Blair announces the cutting of postal connections with the Confederate States as of 31 May 1861.
Naval Additional blockades are established: one at Mobile, Alabama, and one at New Orleans, Louisiana.

27 May 1861

Washington In a case concerning the legality of Lincoln's suspension of the writ of habeas corpus, Chief Justice Roger B Taney decrees the arrest of John Merryman illegal. Merryman was imprisoned for recruiting Confederate soldiers; the arrest was made by General Cadwalader, who argued that Lincoln's proclamation allowed such action. It is Lincoln's view that in time of rebellion such moves are required in order to preserve public safety.

29 May 1861

Washington Dorothea Dix is received by Secretary of War Cameron, who accepts her offer of help in setting up hospitals for the Union Army.

30 May 1861

The North Grafton, Virginia, in the western part of the state, is occupied by Union troops who are sent to protect citizens and to guard the Baltimore & Ohio Railroad line.

31 May 1861

The North Union troops, which have evacuated forts in Indian territory, reach Fort Leavenworth, Kansas. The path they travel is later known as the Chisholm Trail after one of their guides, Jesse Chisholm.
The Confederacy General Beauregard is given command of the Confederate forces in northern Virginia.

1 June 1861

Eastern Theater Northern Virginia is the scene of fighting at Arlington Mills and Fairfax County Courthouse. A Confederate captain, John Q Marr, is killed in this minor skirmish, one of the early Southern fatalities.
International British territorial waters and ports are proclaimed off-limits to belligerents carrying spoils of war.

3 June 1861

The North Forty-eight-year-old Stephen A Douglas dies, probably of typhoid fever. The Democrats lose a staunch, committed leader, and the Union, a strong supporter. In the nation's capital, President Lincoln mourns the 'Little Giant' who defeated him in the race for a Senate seat, but who lost his bid for the presidency.
Eastern Theater Western Virginia is again the focus of conflict, Union forces surprising Confederates at Philippi. The rebels, under Colonel G A Porterfield, flee. This Northern triumph, so easily accomplished, came to be known as the 'Philippi Races' due to the Confederates' rapid retreat under fire. It was in some ways responsible for western Virginia's later break with the main part of the state. With Confederate troops no longer in

Below: The scene inside a Northern recruiting office. Lack of a standing army ensured that both North and South would have to rely on civilians to fill the ranks.

the vicinity, the majority of western Virginians, who were pro-Union, could more easily express their support for the North.

5 June 1861

The North Arms and gunpowder are seized by Federal marshals at the Du Pont works in Delaware and at Merrill & Thomas, a gun factory in Baltimore.

6 June 1861

Washington Lincoln's cabinet declares that the Union government will pay for all war expenses that are incurred once the states have mobilized their volunteers.

8 June 1861

Washington The United States Sanitary Commission is given executive approval. This board will help maintain healthy conditions for Union troops.
Secession In a public referendum, Tennessee favors secession by 104,913 votes to 47,238. This popular action serves to formalize the course already chosen for the state by its legislature.

10 June 1861

Eastern Theater At Bethel Church, Virginia, Federal troops are forced into retreat by aggressive Confederates. Union fatalities total 18, with 53 wounded. The Southerners lose only one man and sustain seven injured. Colonel Charles Stone and his forces head out on an expedition which is part of the planned defense of the Federal capital.

11 June 1861

Trans-Mississippi Troubles in St Louis, Missouri, continue as General Nathaniel Lyon meets with a pro-Southern state government. Lyon is angered over what he feels is local intervention in orders given to Federal troops.

Below: Professor Thaddeus Lowe, an enthusiastic proponent of hot-air balloons in warfare.

12 June 1861

Trans-Mississippi In a further effort to promote the Confederacy in his state, Governor Claiborne Jackson of Missouri puts out a call for 50,000 volunteers. He hopes to repel what he perceives as attempts by Federals to take over the state.

14 June 1861

Eastern Theater Harper's Ferry, Virginia, is abandoned by rebels hoping to avoid being cut off by McClellan and Patterson who are advancing from the west and the north.

17 June 1861

Washington The president observes Professor Thaddeus S C Lowe demonstrate the use of a hot-air balloon. Some military advisors hope to employ balloons for observation of enemy movements during the war.
Trans-Mississippi In Missouri, Union troops establish themselves in the state capital at Jefferson City. Elsewhere, pro-Confederate troops are defeated at Boonville, thus providing Federals with further control of the Missouri River.

19 June 1861

The North A meeting of Virginians loyal to the Union elects Francis H Pierpont as provisional governor of what will soon be West Virginia.

24 June 1861

Eastern Theater At Mathias Point, Virginia, Confederate batteries are attacked by Federal gunboats. Three days later, Confederates repel spirited Union attempts to land troops at this position.

27 June 1861

Washington In order to plan military strategies for the Southern coast, delegates from the army, navy and coast survey convene in the Federal capital. This body was later to make valuable recommendations throughout the war.

29 June 1861

Washington President Lincoln and his cabinet meet with key military leaders to examine the future course to be taken by Union forces. Generals McDowell and Scott describe their plans, recognizing the importance of maintaining widespread public support and enthusiasm.

30 June 1861

Naval The CSS *Sumter* successfully slips past the Union blockade, despite efforts by the USS *Brooklyn* to prevent it.

1 July 1861

Washington In order to fill the need for Federal troops, the War Department decrees that both Kentucky and Tennessee are to be canvassed for volunteers. This despite the fact that Tennessee has joined the Confederacy, having voted to secede at the 6 May State Convention, a vote confirmed by public referendum in June. Kentucky has, at this point in time, voted to remain neutral.

2 July 1861

Washington General John Frémont meets with President Lincoln. The two discuss Fré-

mont's upcoming command of the Missouri forces in an area of violent unrest.
The North At Wheeling, West Virginia, the new legislature convenes, having been recognized by the United States.
Eastern Theater Federal troops under General Robert Patterson head for the Shenandoah Valley where they intend to curtail the movement of Confederates toward Manassas, Virginia. At Hoke's Run in West Virginia Union forces clash with rebel troops resulting in a Federal victory.

3 July 1861

Eastern Theater Patterson's soldiers march to Martinsburg, Virginia, causing the Confederates, who are commanded by General Joseph E Johnston, to pull back.

4 July 1861

Washington It is Independence Day and in the Federal capital a special session of the 27th Congress meets. Called by the president, this session is to handle war measures partially sketched out by Lincoln in a message directed to the assembled body. According to the president, the North has done everything in its power to maintain peace and has attempted to solve problems precipitated by the South without resorting to war. Blaming Southerners for the Fort Sumter affair, the chief executive emphasizes that the questions facing the nation have to do with the United States maintaining 'its territorial integrity, against its own domestic foes.' Lincoln reiterates his position concerning the indivisibility of the Federal Union, once again making clear his stance on declar-

Above right: Uniforms of Northern and Southern forces at the outset of war.
Right: The Governor of Pennsylvania inspecting Union volunteers.
Below: John Bankhead Magruder, an experienced officer, sided with the Confederacy and was responsible for the victory at Bethel Church, Virginia, in June 1861.

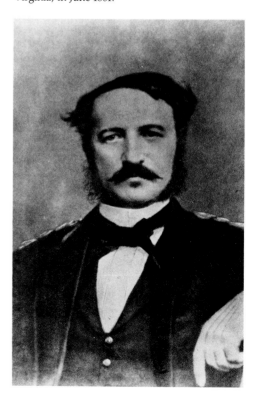

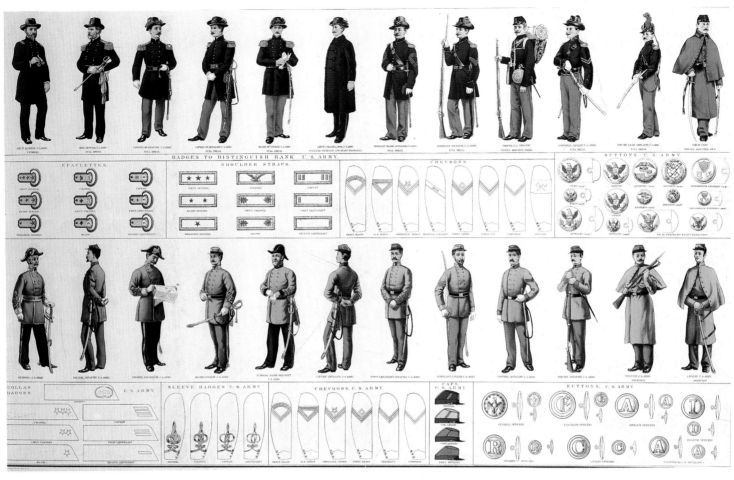

Above: Troopers of the 1st Virginia Cavalry at a halt during the last few days before the First Battle of Bull Run.

Above: Confederate Simon Bolivar Buckner, the inspector general of Kentucky's militia in the first months of the civil war.

ing war against the Confederacy. He makes a request for an additional 400,000 men to aid the Union.

Eastern Theater Harper's Ferry is the site of a brief engagement between Confederates and Northern troops as the latter stream into the Shenandoah Valley.

5 July 1861

Trans-Mississippi Carthage, Missouri, witnesses an attack by Federal forces on pro-secessionist Missouri troops under the command of Governor Claiborne Jackson, a staunch Confederate. While the Missouri troops are less well organized than the Union forces, they outnumber the latter three to one. As the Southern cavalry attacks both sides of the Union line, the Northern troops under Franz Sigel fall back. Total losses are tallied at 40 to 50 Confederates killed and 120 wounded, while the Union reports 13 deaths and 31 wounded. In spite of this, the battle is considered a Confederate victory. It slows considerably the Federal push into southwest Missouri and provides the South with a triumph important to Confederate morale.

8 July 1861

Trans-Mississippi The Confederacy, anxious to remove all Federal presence from the New Mexico Territory, places General Henry Hopkins Sibley in command of rebel troops in that area. In Florida, Missouri, an encampment of Confederates is attacked and dispersed by Federal troops.

10 July 1861

Washington President Lincoln, in a letter to the Inspector General of Kentucky's militia, Simon B Buckner, indicates that the Union forces will not enter that neutral state.

Eastern Theater General McClellan in West Virginia sends troops forward to meet Confederates at Rich Mountain. This force of four

regiments and a cavalry unit is under the command of General William S Rosecrans. In addition to this movement, General T A Morris is sent by McClellan to meet rebels at Laurel Hill, Virginia.

11 July 1861

Eastern Theater The road to Beverly, Virginia, is opened by General Rosecrans' troops. Attacking Colonel John Pegram's Confederates, Rosecrans forces the rebels to surrender at Rich Mountain. At Laurel Mountain, General Garnett's forces have evacuated their posts, heading for the Cheat River valley after General Morris attacks the Laurel Mountain position. Altogether the Union fatalities for these two engagements are listed at 12, with 49 wounded. The Confederate estimates are not available.

12 July 1861

Western Theater As McClellan occupies Beverly in West Virginia, the Confederate troops retreat from Laurel Hill. To the west and south of this position, another group of Union soldiers, under the command of Jacob Cox, is moving in to meet with rebels in the Great Kanawah valley. These Southern troops are under the command of former Virginia Governor General Henry Wise.

13 July 1861

Washington Missouri representative John Clark is expelled from the House by a vote of 94 to 45.

Western Theater At Carrickford, Virginia, Union troops crush the Confederate forces of General Robert S Garnett who is killed in the ensuing battle. McClellan has now enabled Federals to take control of the entire area in West Virginia, an important move forward for the Union due to the communications links, including railroads, found there. It also provides Union troops with a base of operations from which to launch raids into Virginia proper. The number of rebels killed at Carrickford totals 20 compared to a grand total of 53 Union lost.

14 July 1861

Western Theater After the Rich Mountain and Laurel Hill battles, the North is anxious to press farther into Virginia. Toward this end, General McDowell advances on Fairfax Courthouse, Virginia, with 40,000 Union troops.

Naval In the harbor at Wilmington, North Carolina, the USS *Daylight* establishes a blockade. This effort is only partially effective and soon demands additional ships to make it successful.

17 July 1861

Western Theater General Beauregard requests aid in repulsing the Federal advance into Virginia. Beauregard is stationed near Manassas, Virginia, with a force of about 22,000 men. Confederate President Jefferson Davis orders General Joseph Johnston to Manassas so as to meet Beauregard's request for more troops.

18 July 1861

Eastern Theater Blackburn's Ford, Virginia, proves to be a test for the upcoming battle at Manassas, Virginia. McDowell's Union forces are encamped at nearby Centreville, and a small party of soldiers is sent forward to examine the area around Blackburn's Ford. The men meet Confederates under the command of James Longstreet and heavy skirmishing ensues during which the Federals lose 19 men and sustain 38 wounded. The rebels have 15 fatalities and 53 injured but succeed in pushing the Union troops back. In addition, a small clash occurs at Mitchell's Ford. Jefferson Davis, upon hearing of the Confederate success at Blackburn's Ford, says to Beauregard, 'God be praised for your successful beginning.' Blackburn's Ford is, however, only the first round in the campaign; a major battle has yet to be fought by both sides.

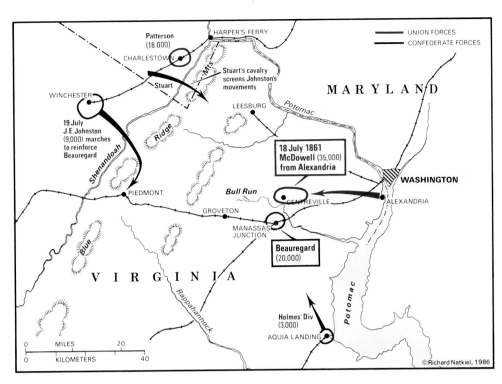

©Richard Natkiel, 1986

20 July 1861

Eastern Theater Both Union and Confederate forces prepare for the imminent battle, Johnston's 1400 troops having joined those 2500 of Jackson at Manassas. McDowell is situated with around 1300 men near Sudley Ford on Bull Run, a creek running by Manassas; this creek will make the battle known as First Bull Run to Northerners, while Southerners know it as First Manassas – a second battle at this locale being fought in August 1862. Other Union troops are to travel by the Stone Bridge over Bull Run. There is little time left – one Union soldier comments on the 'ominous stillness.'

21 July 1861

Eastern Theater Unknown to McDowell's troops, which are situated at Sudley Ford on Bull Run, Johnston has combined forces with Jackson. McDowell hopes to surprise the

Left: The movement of the rival forces prior to the Bull Run engagement.
Below: General Thomas Jackson wins his nickname of 'Stonewall' during a perilous moment for the South during the Bull Run battle.

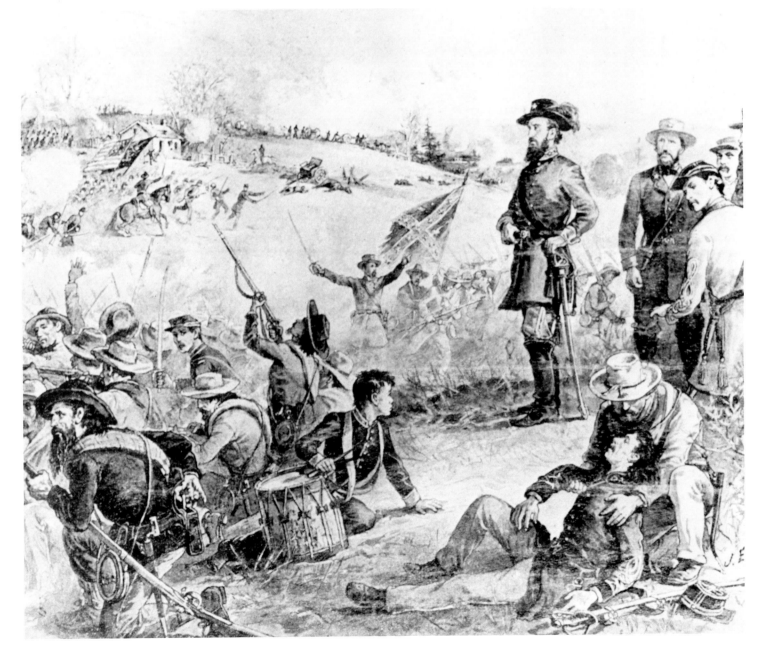

rebels by striking them on the left flank of their position at the Stone Bridge, but after Northern artillery begins at about 0500 hours, the Confederates learn of the Union advance. Accordingly, General N G Evans meets McDowell's troops as the latter approach from Sudley Ford, holding the Southern position until around noon. The Confederates then fall back to Henry House Hill where Evans and others, Jackson among them, make a strong stand. (It is because of his unit's stout defense that Jackson will thereafter be known as 'Stonewall.') McDowell's forces advance on this Confederate position at Henry House Hill around 1400, Beauregard and Johnston aiding Evans' beleaguered troops. Despite Union attempts to charge this position, the rebels hold fast and are successful in driving the Federals back in defeat. As McDowell's men pull away, panic strikes when a shell destroys a wagon; the main road of retreat is blocked and the Union troops scatter. The Confederate victory is observed by Jefferson Davis from Manassas, Virginia. It is a costly triumph: the rebels list 387 dead, 1582 wounded, 13 missing; Union troops lose 460 men, sustain 1124 injuries and list 1312 as missing. Lincoln, learning of the defeat, immediately closets himself with his cabinet, and throughout the North runs the conviction that the war has begun in earnest.

Below: Bull Run (Manassas) was the first major land battle of the civil war.

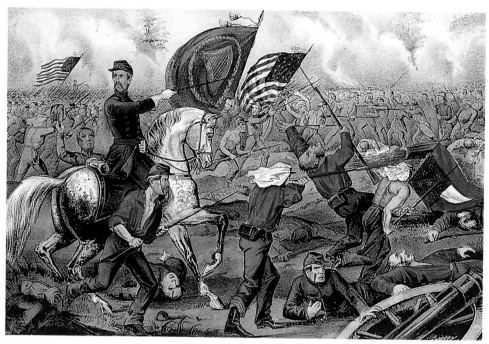

22 July 1861

Secession Confusion continues in Missouri as the State Convention meets at Jefferson City, voting to uphold the Union and providing for a new government to be established at St Louis. Pro-South Governor Claiborne Jackson continues to claim that his administration is the only legal body in the state.

Above: Irish troops under the command of Colonel Michael Corcoran lead a Union attack during the Battle of Bull Run.

24 July 1861

Eastern Theater In West Virginia, Union General Jacob Cox attacks Confederates who are commanded by General Henry Wise. This action at Tyler Mountain causes Wise to evacuate the area around Charleston and to pull back to Gauley Bridge.

25 July 1861

Washington The Crittenden Resolution passes, 30-5. This bill states that the war is to be fought to preserve the Union and uphold the Constitution, not to alter slavery in its established form.

Trans-Mississippi Missouri remains an area of unrest. Fighting breaks out at Harrisville and at Dug Springs. Confederates in the New Mexico Territory clash with Union troops from Fort Fillmore; the rebels, under Captain John Baylor, hope to press the Federals to leave the Southwest, which would open the area to Confederate control. The Union soldiers are able to push the rebels back, however. The following day, the same Union troops, under the command of Major Isaac Lynde, are confronted at Fort Fillmore by Baylor's troops and Lynde abandons the position. This despite the fact that Lynde's forces outnumber Baylor's, the rebels having but 250 men to the Federals' 500. Lynde is subsequently discharged from the army for this action, but after the war is placed on the retirement list.

27 July 1861

Washington At the Northern capital, President Lincoln hands over command of the Federal Army of the Potomac to General

Above right: Major-General Irwin McDowell, the ill-fated Union commander at Bull Run.
Above, far right: George Brinton McClellan, Union general-in-chief from November 1861.
Right: Union troops on the retreat at Bull Run. Although the Union forces had a clever plan, the raw troops were unable to carry it out.

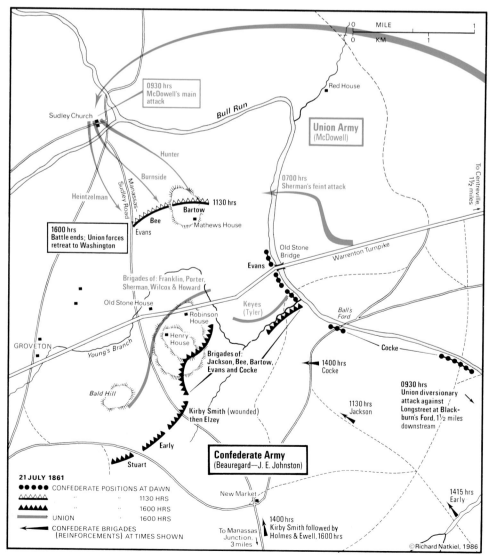

0930 hrs
McDowell's main
attack

Red House

Sudley Church

Bull Run

Union Army
(McDowell)

Hunter

Burnside

0700 hrs
Sherman's feint attack

Heintzelman

Manassas–Sudley Road

1130 hrs

Bartow

To Centreville,
1½ miles

**1600 hrs
Battle ends; Union forces
retreat to Washington**

Bee
Evans

Mathews House

Old Stone
Bridge

Warrenton Turnpike

Evans

Brigades of: Franklin, Porter,
Sherman, Wilcox & Howard

Keyes
(Tyler)

Ball's
Ford

Old Stone House

Robinson
House

GROVETON

Henry
House

Young's Branch

Cocke

Brigades of:
Jackson, Bee, Bartow,
Evans and Cocke

1400 hrs
Cocke

0930 hrs
Union diversionary
attack against
Longstreet at Black-
burn's Ford, 1½ miles
downstream

Bald Hill

1130 hrs
Jackson

Kirby Smith (wounded)
then Elzey

Early

Stuart

Confederate Army
(Beauregard—J. E. Johnston)

21 JULY 1861
●●●●● CONFEDERATE POSITIONS AT DAWN
△△△△△ " " 1130 HRS
▲▲▲▲▲ " " 1600 HRS
——— UNION 1600 HRS
◀—— CONFEDERATE BRIGADES
 (REINFORCEMENTS) AT TIMES SHOWN

New Market

1415 hrs
Early

1400 hrs
Kirby Smith followed by
Holmes & Ewell, 1600 hrs

To Manassas
Junction,
3 miles

©Richard Natkiel, 1986

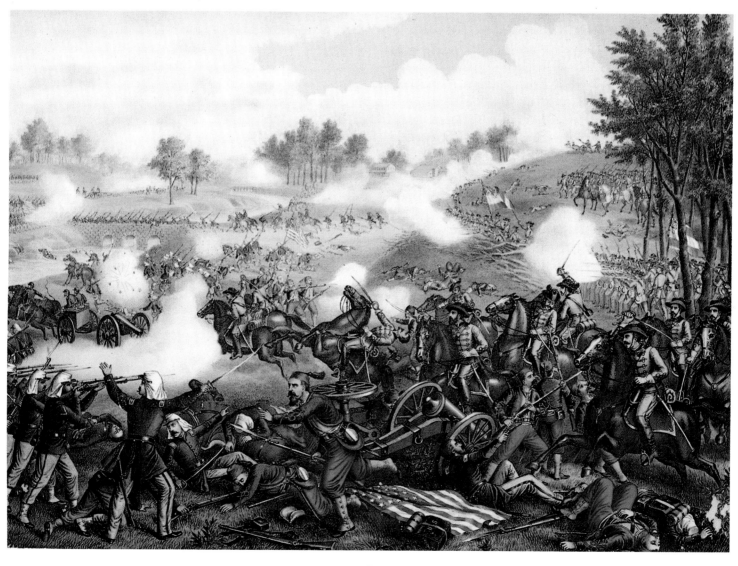

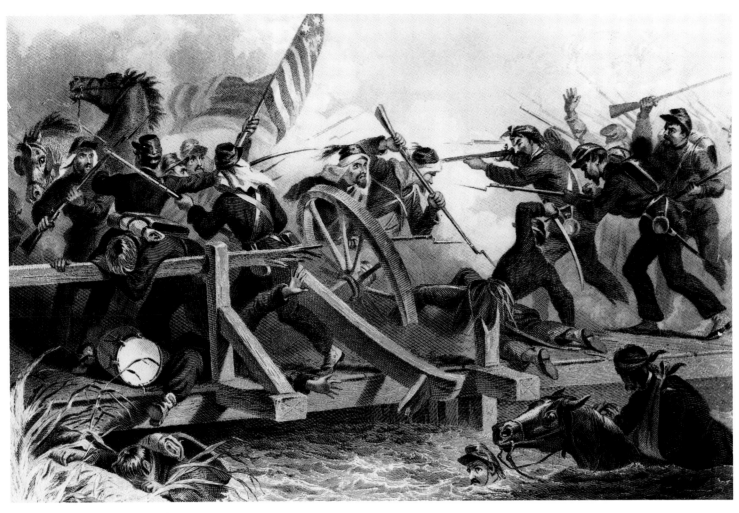

Above: Union troops attempt to prevent the widespread retreat from Bull Run turning into a complete rout.

George McClellan. The latter replaces McDowell, whose forces had been so badly beaten at Bull Run. Lincoln indicates that Union forces should push toward Tennessee by seizing Manassas Junction, Virginia, and Strasburg, Kentucky, in the strategically vital Shenandoah Valley.

30 July 1861

Washington Secretary of War Simon Cameron is pressed by General Benjamin Butler at Fort Monroe, Virginia, to make a determined policy concerning former slaves now in Federal hands. Butler by now has about 900 former slaves and is unclear as to their status as property. He asks Cameron, 'What shall be done with them?'

Secession In Missouri, the State Convention votes 56-25 to declare the governor's office open. In addition, the secretary of state and lieutenant governor's offices are now vacant, as are the seats in the legislature. Most of those holding office in Missouri were pro-Confederate. The following day, Hamilton Gamble is elected governor of pro-Union Missouri.

31 July 1861

Washington President Lincoln names Ulysses S Grant stationed in Illinois as a general of volunteers. The month has seen a variety of military activity at Bull Run and elsewhere. The Federal blockade is fairly successful, although Confederate privateers are

still quite active. Throughout the North and the South civilians and soldiers alike prepare for further action as it becomes clear that the war will not be over in a short time but is likely to continue for some months.

1 August 1861

The Confederacy Captain John Baylor, who successfully routed Union troops at Fort Fillmore, decrees that all territory in Arizona and New Mexico south of the 34th parallel belongs to the Confederate States of America. There is some dissent among pro-Unionists in New Mexico who object to the wholesale takeover of their territory. Advising General Johnston to take advantage of 'the weakness' which would be felt by the Union forces after their defeat at Bull Run, Confederate President Jefferson Davis urges further action in Virginia. He sends General Robert E Lee to take top command of forces in the area of West Virginia after General Garnett's defeat at Carrickford.

2 August 1861

Washington For the first time in United States history, the Congress passes a national income tax bill which provides also for tariffs to aid in the war effort. These congressional measures are to raise $500 million for Union support. The income tax of three percent is applicable to incomes exceeding $800 per year, but is never actually put into effect.

Trans-Mississippi Another fort in the Southwest, Fort Stanton, in the New Mexico Territory, is evacuated by Federal troops as a result of Baylor's Confederates. Further disturbances occur in Missouri; Dug Springs is

the site of a small clash between Federals led by Nathaniel Lyon and pro-secessionists under General McCulloch's command. General Frémont sends reinforcements to General Lyon who anticipates continued unrest in southwestern Missouri.

5 August 1861

Trans-Mississippi In Missouri, General Nathaniel Lyon pulls his troops out of Dug Springs as reports indicate that Confederates are advancing in large numbers.

Naval The USS *Vincennes* captures a rebel blockade-runner, the *Alvarado*, and burns it off the coast of Florida near Fernandina.

6 August 1861

Washington Lincoln is empowered by Congress to pass measures concerning army and navy actions. The president decides that slaves used by the South against the North will be freed. Since there is some dispute as to Kentucky's neutral position, a Union military camp is established near Lexington in a show of Federal force.

7 August 1861

Eastern Theater In Virginia, where General Benjamin Butler is in command at Fort Monroe, the town of Hampton is burned by Confederates. The commander, General John Bankhead Magruder, indicates that the action is partially in response to Butler's quartering of runaway slaves.

Naval In a further attempt to improve Union naval operations, a new version of ironclad is put into production and later proves to be a vital part of Union operations.

8 August 1861

Washington In further reply to General Butler's queries, Secretary of War Simon Cameron points out the need for Union troops to adhere to fugitive slave laws, but only in Union territory. Those states in insurrection were exempt from this protection. Further, Cameron tells Butler that escaped slaves cannot be returned to owners in the Confederate states.

10 August 1861

Trans-Mississippi General Nathaniel Lyon is killed at Wilson's Creek, Missouri, where he has led 5200 men to meet rebel troops under the command of General Benjamin McCulloch. The Confederates are joined in this encounter by pro-southern Missouri militia under the command of Sterling Price. While Union troops are defeated at Wilson's Creek, they put up a valiant fight, pushing back two rebel charges on Bloody Ridge, the spot where Lyon falls. After this fatality, the Federals pull back, commanded now by Major Samuel Sturgis, and march to Rolla, Missouri, to the southwest of St Louis. The Confederates' force of 15,000 was depleted by 421 deaths and 1300 wounded as compared to Federal losses of 263 fatalities and 721 injuries. The Battle of Wilson's Creek is the second important clash between the two enemies and gives the South another significant victory over the North following that of Bull Run in Virginia.

12 August 1861

Trans-Mississippi In Texas, Confederates are attacked by Apache Indians who kill 15. It is not Confederate practice to make war with the Indians, engaged as they are in efforts to gain control of the Southwest for the benefit of the Confederacy.

14 August 1861

Eastern Theater Grievances among the troops of the 79th New York Regiment provoke mutiny by these volunteers. Among other things, the men requested, and had been denied, a furlough, precipitating an action that results in several arrests and places the entire unit under armed guard.
Trans-Mississippi Due to the unsettled conditions in St Louis, Missouri, General John Frémont issues a declaration of martial law in that city.

15 August 1861

Eastern Theater Another group of soldiers, the 2nd Maine Volunteers, mutinies. Altogether 60 men are assigned to duty on Dry Tortugas off Key West, Florida, as a disciplinary measure.
Trans-Mississippi General Frémont fears continuing conflict in Missouri, so he requests aid from Washington. Lincoln recognizes threats posed by McCulloch and Price, who can easily invade with Confederate forces. The president therefore directs the War Department to arrange reinforcements for Frémont.

16 August 1861

The North In several separate cases, certain newspapers in the Union states are brought to court for alleged pro-Confederate leanings, among them the Brooklyn *Eagle,* the

New York *Journal of Commerce* and the New York *Daily News.*
Trans-Mississippi Missouri continues to experience clashes between Northern and Southern forces, this time near Fredericktown and Kirkville.

19 August 1861

The North Seizure of pro-South newspapers continues as offices in West Chester and Easton, Pennsylvania, are attacked by loyal Unionists. An *Essex County Democrat* editor in Haverhill, Massachusetts, is tarred and feathered for similar Southern sympathies expressed in the newspaper.
The Confederacy In an action which does little to settle the discord in Missouri, the Congress of the Confederacy allies with that state, essentially providing for the establishment of a Confederate state government.

20 August 1861

The Confederacy President Jefferson Davis approves the addition of more commissioners to represent the Confederacy in Europe. It is hoped that supplies and armaments so necessary to Southern victory will be obtained from France, Britain and Spain.
Trans-Mississippi Skirmishing continues in Missouri: Jonesboro is the site of fighting which follows clashes between Union and Confederate forces at Klapsford several days earlier.

24 August 1861

The Confederacy At Richmond, Virginia, three new Confederate commissioners to Europe are appointed: John Slidell to France; James Mason to Britain; and Pierre Rost to Spain.

26 August 1861

Eastern Theater Virginia is a scene of much action as skirmishing breaks out at Wayne Court House and Blue's House in the western regions of the state.
Naval At Hampton Roads, Virginia, Union vessels move out toward Cape Hatteras, North Carolina, in preparation for a Federal assault on Confederate fortifications there. This operation is under the command of Commodore Silas Stringham and General Benjamin Butler who have eight vessels and 900 men at their disposal.

27 August 1861

Eastern Theater The Union expeditionary force at Cape Hatteras, North Carolina, lands troops under fire. Confederate batteries attempt to prevent a Federal takeover of the area, without sucess. The rebels had established two positions, Fort Clark and Fort Hatteras, but abandon the former, enabling the Union to occupy it with no resistance. The following days sees the surrender of Fort Hatteras, which sustains considerable damage from Federal batteries. There are few casualties among Union or Confederate troops. The successful takeover by the Federals of this strategic point on Hatteras Inlet gives the North an important advantage in its efforts to crush the blockade-runners, since the area commands control of an important route used by those Confederate vessels. The blockade is rapidly becoming one of the North's best strategies in the war.

30 August 1861

Trans-Mississippi General John Frémont, in an action which Lincoln later terms 'dictatorial,' declares martial law throughout Missouri. In an unauthorized act, Frémont allowed for the confiscation of property belonging to 'those who shall take up arms against the United States,' and also makes an emancipation proclamation concerning slaves of pro-Southerners: 'their slaves . . . are hereby declared free men.' In defense of this extremely unpopular move, Frémont explains that Missouri suffers from 'helplessness of civil authority and total insecurity of life.'

1 September 1861

Eastern Theater Western Virginia is again an area of light military activity, Blue Creek, Boone Court House and Burlington all witnessing their share of brief skirmishing.
Trans-Mississippi Jefferson County, Missouri, is the focus of action in the West. At Cape Girardeau in Missouri, General Ulysses S Grant assumes command of Federal forces.

2 September 1861

Washington In response to General Frémont's proclamations concerning martial law and emancipation of slaves, President Lincoln communicates to the general his concerns that the actions are precipitate. The president feels that there is a danger of alienating Southern Federal sympathizers and 'perhaps ruin our rather fair prospect for Kentucky.'

3 September 1861

Western Theater General Polk orders Southern troops into Kentucky in order to hold Confederate positions there. These forces are under the command of Gideon Pillow, and the move effectively terminates Kentucky's neutral status. General Polk's orders result in part from the belief held by Confederates that the Union would soon attempt to take military control of Kentucky.

Below: Union officer General Nathaniel Lyon was killed at Wilson's Creek, Missouri, in a battle with Confederates under McCulloch.

Above: The US Mail continued to go through during the hostilities, bringing both good news and bad to soldiers and their families.

5 September 1861

Washington The president and the cabinet confer with General Scott, discussing General Frémont's conduct and future position in the Army.
Western Theater General Grant, upon hearing of Polk's move into Columbus, Kentucky, begins preparations for an expedition to Paducah, Kentucky, which is near the mouth of the Cumberland River.

6 September 1861

Western Theater General Grant's forces move into Paducah, Kentucky, in order to prevent Confederates from seizing the city. The action, provoking no fighting or bloodshed, proves to be strategically critical as it allows Federals an important foothold in an area that will be central to the western river campaign in the upcoming year. General Charles F Smith is given command of forces in western Kentucky as General Grant leaves for his headquarters at Cairo, Illinois.

9 September 1861

Washington General Frémont's conduct in Missouri continues to worry President Lincoln, who is advised by some military officials to relieve Frémont of his command there. The president directs General David Hunter to go to Missouri to provide Frémont with aid.

Eastern Theater General Rosecrans' troops advance on Confederates near Carnifex Ferry, Virginia, where skirmishing has been continuing, indicating the probability of a battle in that area in the future.

10 September 1861

Washington The president receives Mrs John Frémont, wife of the general; she has traveled to the Union capital to provide support for her husband's position in Missouri. She is concerned about Lincoln's being in-fluenced against General Frémont, and the interview, by some accounts, is not a calm one.
Eastern Theater Confederates at Carnifex Ferry, Virginia, fall back after being attacked by General Rosecrans. The Union troops outnumber the Southerners, and the Northern victory is instrumental in helping to preserve western Virginia for the Union.

11 September 1861

Washington The proclamations issued by General Frémont concerning property confiscation and the emancipation of slaves in Missouri, issued on 30 August 1861, prompt President Lincoln to write to the general. Lincoln tells Frémont that the proclamations must be altered in order to align them with Federal Acts of Congress, otherwise they remain unacceptable.
Eastern Theater Fighting breaks out at Cheat Mountain, western Virginia, between General Lee's forces and those of General John Reynolds. Although Lee has planned a surprise attack on Reynolds' Union forces at Cheat Mountain and at Elkwater, severe precipitation and the difficult terrain prevent Confederates from carrying out the assault as designed. Federal troops hold their ground as the rebels pull back, and this Union victory at Cheat Mountain secures the area of West Virginia for the North. Estimates of Confederate casualties total near 100; Federals killed and wounded tally only 21 men.

12 September 1861

Washington Lincoln communicates with Mrs Frémont about her husband, assuring her that he, the president, is not 'acting in any hostility' toward the general. Accordingly, he dispatches Judge Joseph Holt to St Louis, Missouri, with instructions to urge moderation and modification of Frémont's proclamation of 30 August.

16 September 1861

Western Theater In Kentucky, the Cumberland River is the scene of intensified action as the USS *Conestoga* takes two Confederate ves-

Below: Southern recruits head off for their initial military training.

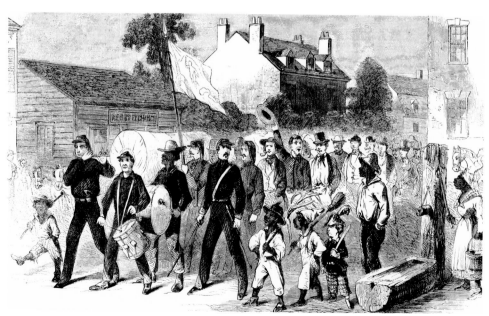

sels. Ship Island, Mississippi, is evacuated by rebel forces, leaving the area open to subsequent occupation by Union troops. The North is to use Ship Island as an operating base for action along the Gulf Coast.

Trans-Mississippi In Missouri, Confederate General Price continues to press Colonel Mulligan's troops at Lexington; the latter is waiting for help from General Frémont.

18 September 1861

Washington The president meets with his cabinet; General Frémont is once again the topic of discussion as reports concerning his command in the West are presented. The secretary of the navy receives word that Federal expeditions to the Southern coast are to commence within the month.

The North Another publication, the Louisville, Kentucky, *Courier,* is prevented from using the postal service. The newspaper has indicated an alleged hostility to the Union

Below: A Union call for volunteers. Bull Run shattered the myth that the war would end within a few months.

cause and several employees are arrested by Federal officials when the headquarters of the *Courier* are seized.

19 September 1861

Western Theater In Kentucky, the Confederates are making a strong defense along a line including the area around Cumberland Gap, Bowling Green and Columbus. Pro-Union Kentucky troops are driven out of the vicinity of Barboursville, Kentucky, by General Felix Zollicoffer's rebel forces.

Trans-Mississippi Beleaguered Union troops at Lexington, Missouri, are acutely aware of their precarious position as Price's forces continue to lay siege to the city. Unless reinforcements appear, surrender is clearly inevitable.

20 September 1861

Trans-Mississippi General John Frémont's inaction in bringing relief to Colonel Mulligan's troops at Lexington, Missouri, leads to the enforced surrender of those forces after more than a week of siege. General Sterling Price, the Confederate officer who led the

offensive, lost 25 men out of 18,000 troops, while Mulligan's force of 3600 Federals was reduced by 39 fatalities. Because of Frémont's failure to send reinforcements, the general receives further criticism of his already questionable behavior in handling matters.

23 September 1861

Trans-Mississippi General Frémont's sensitivity to criticism provokes him to close the offices of the St Louis *Evening News* and to arrest the editor of that publication. The latter raised some questions about Frémont's inaction during the recent siege of Lexington, Missouri.

25 September 1861

Eastern Theater Forces led by General Lee and General Rosecrans continue to converge on the Kanawha Valley of western Virginia.

Western Theater Minor clashes occur between Union and Confederate troops near the Cumberland River in Kentucky and also near Lewinsville, Virginia; and at Canada Alamosa, New Mexico Territory.

27 September 1861

Washington In a meeting with the cabinet, President Lincoln and General McClellan confer over plans for an offensive in Virginia. There is much public pressure for increased action in this area.

30 September 1861

Washington After four weeks of brief engagements but no major battles between Union and Confederate forces, President Lincoln is left anxious to establish firm control in Kentucky and settle matters with General Frémont in Missouri. In addition, the lack of military action in Virginia continues to draw criticism from both civilian and military observers.

1 October 1861

Washington President Lincoln appoints General Benjamin Butler to the post of commander of the Department of New England; this branch of the army is used largely to recruit and train soldiers for upcoming campaigns. The cabinet confers with Generals Scott and McClellan. In addition, the chief executive directs his cabinet to make preparations for the implementation of an east coast expedition to commence in November. This eventually is known as the Port Royal, South Carolina, operation under the command of General Thomas S Sherman.

The Confederacy Centreville, Virginia, is the site of a strategy planning session between Confederate President Jefferson Davis and Generals Johnston, Beauregard and Smith. They meet to discuss a possible solution to problems posed by the Southern offensive in Virginia which is what the citizenry of the Confederate nation are currently demanding. An assessment of the army's capabilities leads to the conclusion that such a move to attack the North at this time would be foolhardy. Southern troops are neither sufficiently provisioned nor available in the numbers necessary for an offensive; the consensus is to wait until spring and watch further developments on all fronts, not just in Virginia.

Naval Confederates seize the Federal sup-

FOURTH REGIMENT
NEW HAMPSHIRE

DOWN WITH THE REBELLION.

VOLUNTEERS.

ABLE BODIED MEN WANTED
FOR THE FOURTH REGIMENT.

The subscribers having been appointed Recruiting Officers, will open a Recruiting Office at

Where they will enlist all who would like to rally around the OLD STARS AND STRIPES, the emblem of America's Freedom.

$10 BOUNTY WILL BE ALLOWED!

Regular Army pay and Rations to commence on taking the oath.

Lieut. J. M. CLOUGH,
Sergt. W. B. ROWE.

Sept. 1861.

Fogg, Hadley & Co., Printers, Concord.

Above: Naval designer John Ericsson was the creator of the *Monitor*, the world's first battle-tested ironclad and a vessel which heralded a new era of sea warfare.

ply steamer *Fanny* at Pamlico Sound, North Carolina. In this capture, 31 Union soldiers are taken, along with a large amount of military supplies.

2 October 1861

Eastern Theater Confederates are defeated at Chapmansville, Virginia; there is also skirmishing at Springfield Station in that same state.

Trans-Mississippi Union troops succeed in disrupting a rebel camp at Charleston, Missouri, where clashes between pro-Union and secession groups have been occurring for several days.

3 October 1861

The Confederacy The governor of Louisiana, Thomas O Moore, bans the shipment of cotton to Europe in order to place pressure on European nations. It is hoped that this may sway opinion in favor of recognizing the Confederacy.

Eastern Theater Greenbriar, Virginia, sees the rout of Confederate troops. This victory enables the Northern forces, which have made this reconnaissance from their Cheat Mountain encampment, to take possession of valuable cattle and horses. The Pohick Church, Virginia, area is occupied by Federal forces.

4 October 1861

Washington The president observes another balloon ascension by Thaddeus Lowe. The chief executive also meets with military and government officials concerning General Frémont's duties in the Department of the West. John Ericsson of New York submits a contract, which is approved by the

cabinet, to build ironclad warships for the Union navy. The vessels ultimately constructed include the *Monitor*, which is later to take part in the first naval battle involving ironclads.

The Confederacy Treaties are signed by the Confederates with the Cherokee, Shawnee and Seneca Indian tribes; this enables the rebels to utilize willing Indians in their confrontations with Union troops.

Naval Two more Confederate vessels fail in an attempt to slip by the Federal blockade. The USS *South Carolina* seizes the rebel ships off Southwest Pass near New Orleans, Louisiana. The Southern forces attack Federal troops near the Hatteras Inlet forts, but with no success in their attempt to retake those critically positioned bases now in Union hands.

5 October 1861

Trans-Mississippi In California, Federal troops carry out an expedition to Oak Grove and Temecula Ranch; their objective is to reveal the position of alleged pro-Confederates in the state.

International Disputes about whether the British should or should not support the Confederacy's claim are in evidence as the London *Times* shows sympathy with the Union; the London *Post* speaks out in favor of recognizing the Confederacy.

7 October 1861

Washington After discussion with his cabinet and military advisors, President Lincoln has sent Secretary of War Simon Cameron to investigate conditions in the West. Cameron carries a letter to General Samuel R Curtis from the president in which the latter asks for an assessment of General Frémont's ability to command.

Trans-Mississippi In Missouri, General Frémont has gathered troops and set out on a mission to intercept Confederate General Sterling Price. This belated action ultimately does little to redeem Frémont in the eyes of the president and his advisors.

8 October 1861

Eastern Theater General Robert Anderson, the former hero of Fort Sumter and currently in command of the Union Department of the Cumberland, is relieved of his post and replaced by General Sherman. Anderson has for a period of time been suffering from nervous strain and is unable to continue his military duties; after his departure from this last post, he never again resumes military active duty. Soon, General Sherman experiences similar exhaustion in the demanding position of head of the Cumberland troops, although Sherman remains in command at Louisville, Kentucky.

9 October 1861

Western Theater Santa Rosa Island in Pensacola Bay, Florida, is the scene of a Confederate assault on Union batteries. A force of 1000 troops under the command of General Richard Heron Anderson tries unsuccessfully to destroy the Federal shore batteries and is obliged to withdraw. Troops from Fort Pickens on Santa Rosa Island are instrumental in the rebuff of this Southern force.

10 October 1861

The Confederacy Confederate President Jefferson Davis expresses his concerns about troop organization, railroad transportation in the South and the use of blacks as laborers for the Confederate army, in a letter to General G W Smith. Later to come out in favor of their employment by the military, Davis at this early date is unable to speak with conviction for the use of slaves as regular soldiers.

12 October 1861

Trans-Mississippi Minor clashes take place in Missouri which continues to be in an uproar, partly as a result of Frémont's orders. Fighting goes on for two days near Clintonville and Pomme de Terre, Missouri, and

Below: Confederate vessels attempt to break through the Union blockade at the mouth of the Mississippi, 12 October 1861.

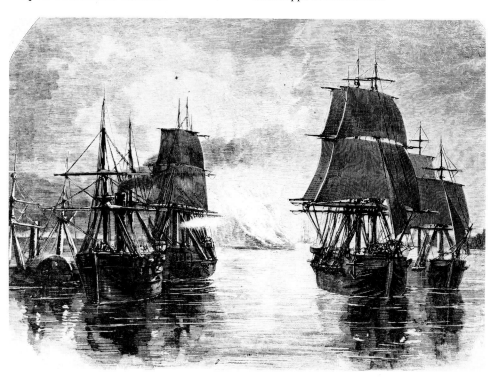

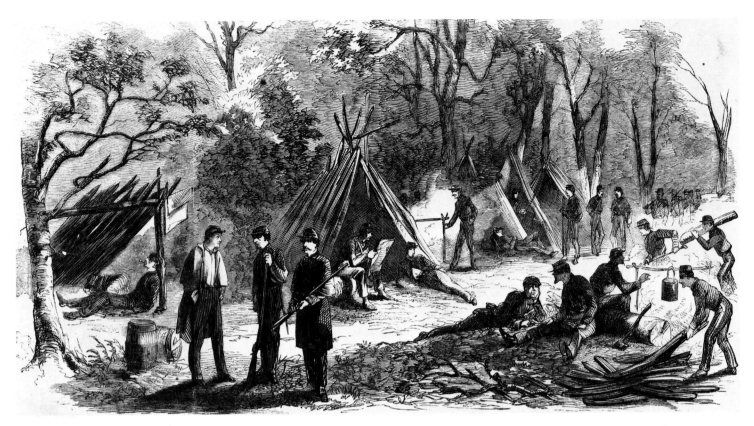

Southern raiders under former Virginian and now partisan fighter, Jeff Thompson, push into the Ironton area of the state from Stoddard County.
Naval At the mouth of the Mississippi River the Confederate ironclad *Manassas* confronts the USS *Richmond* as well as the USS *Vincennes*. Despite the fact that both the *Richmond* and the *Vincennes* are run aground, they manage to escape. The Federal blockade resumes after a short time, but the clash is one that puts the Union at a psychological disadvantage.
International John Slidell, Confederate commissioner to France, and James Mason, commissioner to Britain, successfully slip past the Union blockade of Charleston, South Carolina, on the *Theodora*. Their next stop is Cuba, but they are en route to Europe in order to help their government buy armaments and to work for recognition of the Confederacy by European powers.

14 October 1861

Washington President Lincoln once again places himself in a vulnerable position, although one that he feels is defensible, when he orders General Winfield Scott to suspend the writ of habeas corpus. Scott is given the authority to implement suspension from points in Maine to the Federal capital.
Trans-Mississippi Jeff Thompson, one-time mayor of St Louis and now a pro-secessionist in the Missouri state militia, establishes southeastern Missouri as an area which he and his troops are determined to rid of Federal 'invaders.'

15 October 1861

Trans-Mississippi In Missouri, Thompson's raiders again strike a party of Union soldiers near Potosi, capture 50 and burn the Big River Bridge.
Naval In order to overtake the vessel that allegedly carries John Slidell and James

Mason, three Union gunboats leave New York in search of the *Nashville*, despite the fact that the commissioners are sailing to Cuba on the *Theodora*.

16 October 1861

The Confederacy Jefferson Davis encounters difficulties with Confederate army soldiers who are concerned with their states' defenses. The Confederate president is besieged with requests from regular soldiers who want to return home to aid their state militia. Davis feels it a matter of principle and public interest to deny these requests.
Eastern Theater Near Harper's Ferry, Virginia, there is a clash between Federals and rebels.
Trans-Mississippi Lexington, Missouri, is taken over by Union forces. The town had been under the control of a rebel garrison, although most of the Confederates have already evacuated the area.

18 October 1861

Washington The president meets with his cabinet to discuss General Winfield Scott's future military service. The aging commander of the army is now being considered for retirement of a voluntary nature, although it is clear that there are those who would be glad to see Scott leave active military duty, General McClellan among them. Lincoln is called upon to settle disagreements between McClellan and General Sherman; a coastal expedition to the South is being planned and McClellan is reluctant to furnish Sherman with the necessary troops for such a foray.
Western Theater Federals make a gunboat expedition down the Mississippi River, and minor fighting breaks out in Kentucky near Rockcastle Hills.
Trans-Mississippi Jeff Thompson's forces in Missouri clash with Northern troops from Cape Girardeau as the Ironton area continues

Above: A typical scene in an army camp. Supply services of both sides were rather rudimentary during the early part of the war.

to experience the effects of a great deal of action and unrest.

20 October 1861

Eastern Theater The Potomac River area, under the command of Union General Nathaniel Banks, contains several important crossings, among them Edward's Ferry and Conrad's Ferry. Both of these are situated near Leesburg, Virginia, where Confederate General Nathan Evans is positioned. Federal activity in the area includes the occupation of Drainesville, Virginia, by General George McCall's troops. General Charles Stone is ordered by General McClellan to engage in a 'slight demonstration' so as to provoke the Confederates at Leesburg to some action. Although Stone complies, taking troops into the area, he pulls back after no conclusive engagement has taken place.

21 October 1861

Eastern Theater Leesburg, Virginia, witnesses battling between rebels and Federal troops, the latter under General Charles Stone's command. Stone is pushing toward Leesburg on orders from Washington and is assisted by Colonel Edward Baker, who is shuttling troops across the Potomac River from Ball's Bluff and Edward's Ferry. When fire from Confederate troops succeeds in pushing the Union troops back at Ball's Bluff and a retreat is in order, Colonel Baker is killed. The men attempt to withdraw but panic and confusion, as well as steep and hilly terrain along the river bank, prevent an orderly retreat. Men are drowned and shot as boats swamp and as the Union troops attempt to escape via the steep cliffs. Losses are severe: 49 killed, 158 wounded, 714 missing and presumed drowned; Confederates

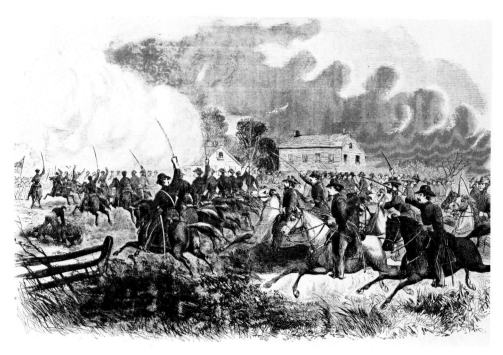

Above: Union General Frémont's cavalry charge through Springfield, Missouri. Frémont was later sacked for excessive lethargy.

tally their casualties at 36 dead, 117 wounded, 12 missing. The disorderly and costly defeat of the Union troops causes a public outcry against General Stone who was charged by the press as being a inept commander, friendly toward the enemy and a traitor to the Northern cause. Colonel Baker, a former senator from Oregon and a friend of President Lincoln, is considered a martyr. There is little criticism aimed at General McClellan under whose orders the entire operation was carried out. The South is overjoyed at the victory and General Nathan Evans is given wide public acclaim as the hero of this Battle of Leesburg, or Ball's Bluff, Virginia.

22 October 1861

Washington The cabinet and President Lincoln meet to confer about General Frémont's situation in the west, and also to discuss the defeat at Ball's Bluff. In addition, it is learned that the Confederates are in control of all important points on the Potomac River south of Alexandria.

23 October 1861

Washington The writ of habeas corpus is suspended in the District of Columbia for all military-related cases.
Western Theater Skirmishing breaks out in Kentucky near West Liberty and at Hodgenville. This line of Confederate troops in Kentucky is a matter of grave concern to the Union and to General Sherman in particular as he does not want the Confederates to advance deeper into Kentucky.

24 October 1861

Washington President Lincoln reaches a decision concerning the termination of General John Frémont's command in the Western Department. Via General S R Curtis, he sends orders that relieve Frémont of his position and hand over control of the western troops to General David Hunter. Lincoln advises Curtis to withhold delivery of these

orders if Frémont should 'be in the immediate presence of the enemy, in expectation of a battle.' Lincoln attends the funeral of Colonel Baker who was killed at Ball's Bluff, Virginia.

25 October 1861

Trans-Mississippi In Missouri, General Frémont's forces are on an expedition to rout Confederates under Sterling Price and are occupying Springfield, far from Price's location near Lexington. Frémont is aware that orders are on their way from Washington

which will remove him from his command, and he is anxious to prevent or delay their delivery for as long as possible.
Naval An important project begins at Greenpoint, Long Island, with the laying of the keel of the USS *Monitor*. Although it is not the first ironclad vessel for either side, the *Monitor* will later earn a role in naval history because of its crucial battle with the Confederate ironclad, *Merrimack* (9 March 1862).

26 October 1861

Eastern Theater South Branch Bridge in western Virginia is an area of some minor skirmishing between Union and rebel soldiers. Romney, in the northern reaches of western Virginia, is the scene of Union action against Confederate forces, which are cleaned out with few casualties.

27 October 1861

Trans-Mississippi General Frémont is now in pursuit of Confederate General Sterling Price, whom Frémont believes to be moving toward Springfield, Missouri. In actuality, Price is not in that area, and Frémont's intended confrontation is not an immediate possibility.

29 October 1861

Eastern Theater An expedition to the Confederate coast leaves Hampton Roads, Virginia, under the command of Federal General Thomas W Sherman and Flag Officer Samuel Du Pont. This fleet of 77 vessels carries one of

Below: General Winfield Scott tenders his resignation to Lincoln and his cabinet on 1 November 1861.

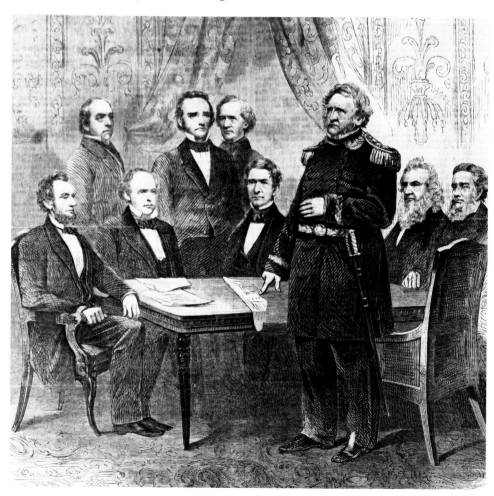

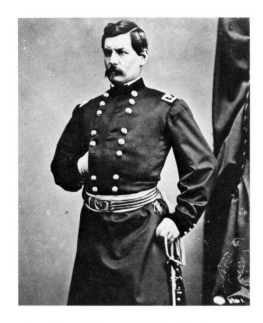

Above: General George McClellan, Scott's replacement as head of the Union forces.

the largest forces yet assembled by the United States, consisting of about 12,000 men. The ships soon experience difficult weather in storms off Cape Hatteras, North Carolina.

31 October 1861

Washington General Winfield Scott makes a formal petition to President Lincoln concerning resignation from his position as general in chief of the Union army. Despite his experience – he is a veteran of both the War of 1812 and the Mexican War – Scott is prompted to this action by his advancing age and personality clashes with younger, ambitious military personnel. Scott convinces Lincoln to grant his retirement request and is succeeded by General McClellan.

Western Theater Fighting of a minor nature breaks out in Morgantown, Kentucky, with an attack on a Federal encampment by rebel soldiers. The Union troops are able to withstand this attack although the Confederates suffer moderate losses. The month ends with no major realignment on the part of either the North or the South; both sides are waiting for spring weather. Frémont continues to pursue Price's Confederates in Missouri.

1 November 1861

Washington General Winfield Scott voluntarily relinquishes his post as general in chief of the United States Army. Scott's decision allows 34-year-old General George Brinton McClellan to assume control of the army; President Lincoln and the cabinet bid General Scott farewell as the aging war hero makes his way to retirement at West Point. There is a great deal of enthusiasm for the younger McClellan, who appears to be eminently suited for the position he now assumes.

Eastern Theater In western Virginia, near Gauley Bridge and Cotton Hill, Confederates attack General Rosecrans' troops. The rebel force, under the command of General John B Floyd, clashes with Federals for three days but ultimately withdraws without achieving success.

Trans-Mississippi General Frémont, in Missouri, communicates with General Price's messengers, agreeing to exchange prisoners. This decision is made without Lincoln's authorization and the president later abrogates the arrangement.

Naval Off Cape Hatteras, North Carolina, a storm has scattered the Port Royal expedition ships, leaving a badly damaged fleet to make its way to its destination as best it can. The USS *Sabine* is lost in this heavy weather, the marines aboard escaping to safety before the vessel goes down.

4 November 1861

The Confederacy President Davis and General Beauregard continue to disagree over what was appropriate at Manassas, or Bull Run, Virginia. Davis contacts Generals Lee and Cooper in order to gain their support for his position as the president is aware of rumors circulating about his administration's ineptitude.

6 November 1861

The Confederacy The South holds elections, and the results of these prove that Jefferson Davis is as popular and respected a leader as when first chosen provisional president. He is elected to a six-year term of office as president of the Confederacy and is once again joined by Alexander Stephens as vice-president.

7 November 1861

Western Theater Cairo, Illinois, sees the departure of a force of 3500 Union soldiers under the command of General Ulysses S

Below: Union vessels bombard Southern forts at Port Royal; a successful operation that saw the Confederates abandon their positions at considerable cost.

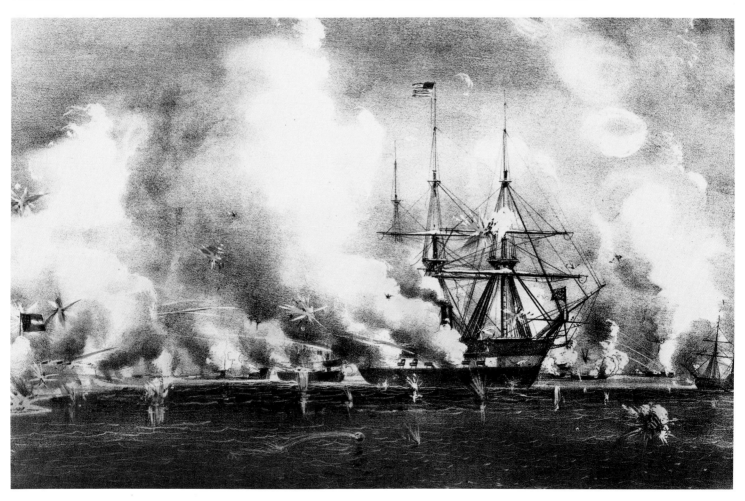

Grant, which leaves for a point near Columbus, Kentucky, on the Mississippi. The troops travel in two gunboats and four other vessels, disembarking at Belmont, Missouri, opposite Confederate defenses at Columbus. Rebel General Leonidas Polk quickly crosses the river with a force of Confederates and pushes the Union troops back to their boats which carry them northward again. This inconclusive raid was accompanied by another reconnaissance from Paducah, Kentucky, to Columbus, but neither of these two actions results in gain for the North. There are casualties, however; Federal losses tally at 120 killed and 383 wounded. The rebels lose 105, with 494 wounded. The strategic value of this operation at Belmont, Missouri, is insignificant but it does allow General Grant to exercise his military capabilities without having to deal with the stress and danger of a major battle with the Confederates.

Naval The Port Royal operation under Flag Officer S F Du Pont is under way, the Union squadron easily evading the relatively weak Confederate defenses as it sails into Port Royal Sound between Forts Beauregard and Walker. The ensuing exchange of fire between the Federal vessels and the shore batteries sees the rebels retreat from the two fortifications to take up positions inland. The North loses eight men in the battle, with 23 wounded, and Confederate losses are similarly light – 11 killed, 48 wounded, three captured, four missing. The Port Royal expedition is considered a success as it places Union troops in a strategically critical area between Savannah and Charleston, and Port Royal

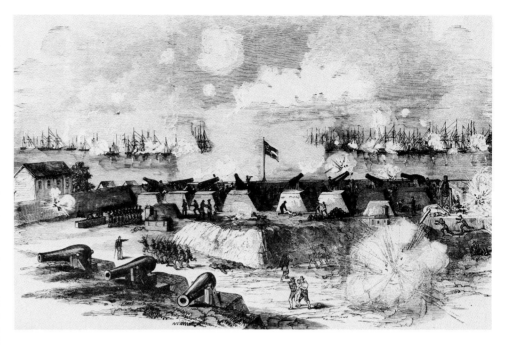

Above: Confederate batteries at Fort Walker reply to Union fire during the fighting around Port Royal, 7 November 1861.

Below: Union troops land at Fort Walker to carry out mopping-up operations after the retreat of the Southern garrison.

proves to be important as a refueling depot for the large number of Federal blockaders operating in the area.

8 November 1861

Western Theater In Kentucky, pro-Unionists rise up against rebel troops in the eastern region of the state. The Confederate commander in charge there, General Felix Zollicoffer, is obliged to request reinforcements due to the disruption caused by these ardent mountaineer Unionists.

The Confederacy The Port Royal operation causes telegraph offices in the South to be besieged with people wanting information about the Union invasion. Newspapers seize

the opportunity to promote unity for the cause. The Charleston *Mercury* states, 'Our Yankee enemies will, sooner or later, learn to their cost the difference between invaders for spoils and power.' Despite this bravado, many civilians fear the possible outcome of this recent military action and hundreds prepare to evacuate the Atlantic coastal area.

International The USS *San Jacinto,* under the command of Captain Charles Wilkes, stops at Havana, Cuba, and finds the two Confederate commissioners, James Mason

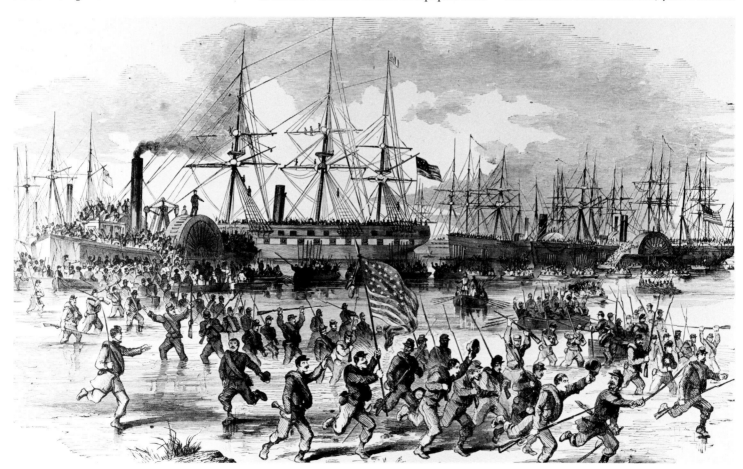

and John Slidell, awaiting passage to Europe on the British packet *Trent*. As the *Trent* sails into open waters in the Old Bahama Channel, the *San Jacinto* forces the British vessel to stop. Wilkes demands that Mason and Slidell be turned over to him. This accomplished, the *San Jacinto* sails to Hampton Roads, Virginia, with the two commissioners under armed guard. The British captain and crew make their way back to Britain with the families of Mason and Slidell still aboard the *Trent*. More immediately it becomes an international *cause célèbre* of such magnitude as to provoke the possibility of armed conflict between the United States and Britain, and it also creates an incident which the Confederacy can use against the Federals.

11 November 1861

Washington A celebration in honor of the new general in chief of the United States Army, General George Brinton McClellan, includes a torchlight parade in the nation's capital. On the Potomac, further balloon ascents take place under the direction of Professor Thaddeus Lowe.

13 November 1861

Washington President Lincoln calls on General McClellan at his home, waiting to speak with the new commander of the Union army. McClellan retires without acknowledging the president.

15 November 1861

Washington The war effort on the home front receives aid from the Young Men's Christian Association. A committee known as the US Christian Commission will help provide nurses for war hospitals, supplies and various other services to the Union forces.
International The larger ramifications of the *Trent* affair become apparent to both the North and South as the USS *San Jacinto* arrives at Fort Monroe, Virginia. Slidell and Mason are to be transferred to a prison at Fort Warren in Boston Harbor, Massachusetts. Captain Wilkes, the hero of the hour for his courageous and daring action in seizing the Confederate commissioners, is soon to receive more subdued acclaim as the cabinet and other advisors to the president recognize the seriousness of Wilkes' action. Not only does this *Trent* affair provide the Confederacy with an incident which might garner foreign support, it also places relations between Britain, France and the United States in a precarious position.

16 November 1861

Washington Postmaster General Montgomery Blair speaks out against Wilkes' action in capturing James Mason and John Slidell. He is joined in this protest by Senator Charles Sumner of Massachusetts; both men urge the surrender of the two Confederate commissioners.

18 November 1861

Washington In order to arrange for a Federal expedition to New Orleans, Commodore David Dixon Porter is charged with obtaining and provisioning gunboats for the Union.
Secession At Hatteras, North Carolina, a convention of pro-Union delegates from 42 counties meets and repudiates the order of 20 May 1861 concerning that state's secession from the Union. The convention appoints Marble Nash Taylor as provisional governor of North Carolina. In Kentucky, Confederate soldiers convene at Russellville and adopt a secession ordinance which results in Kentucky's having two state governments, one pro-North and the other pro-secession, just as in Missouri.
The Confederacy The Provisional Government of the Confederate States of America convenes in its fifth session at Richmond, Virginia.

20 November 1861

Washington General McClellan reviews some 60,000 troops in the nation's capital.
Trans-Mississippi Brief confrontations break out at Butler, Missouri. In California, Federal forces begin pursuit of a Confederate group, the Showalter Party, and several days later the troops capture 18 men including the leader, Daniel Showalter, southeast of Los Angeles, California
Eastern Theater Confederate General John B Floyd pulls his troops out of an encampment near Gauley River, Virginia, destroying tents and equipment in his quick withdrawal from the area.

21 November 1861

The Confederacy Reorganization of the Confederate cabinet places Judah Benjamin in the post of secretary of war. Benjamin succeeds Leroy Pope Walker in this slot, the latter having encountered a fair amount of criticism for what was considered an ineffectual handling of some military issues. The attorney general's position goes to Thomas Bragg. General Lloyd Tilighman is appointed commander of Forts Henry and Donelson on the Tennessee and Cumberland Rivers. These two positions are strategically located and are important to the Confederates because of their value to the South's defense against invasion.

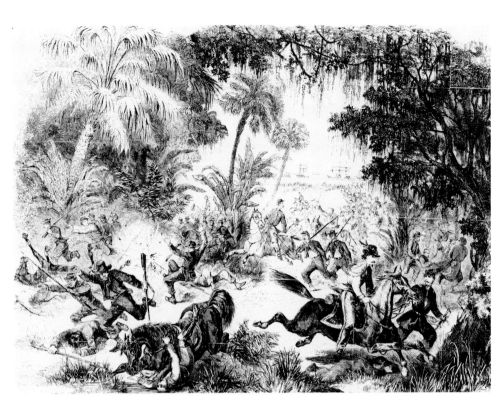

Above: The fall of Port Royal allowed Union blockaders to use its facilities during the operations against Charleston and Savannah.

22 November 1861

Naval An engagement begins between Federal batteries at Fort Pickens, Florida, and Confederates at Forts McRee and Barrancas as well as the Pensacola Naval Yard. The Union ground forces are aided by the USS *Niagara* and the USS *Richmond* on the first day of the barrage. There is damage to both sides but it proves to be an ultimately inconclusive exchange.

24 November 1861

Washington Lincoln and his cabinet meet to discuss the *Trent* affair and its significance to the Northern war effort. The two Confederate commissioners, Slidell and Mason, arrive at Fort Warren in Boston, Massachusetts, on the USS *San Jacinto*.
Western Theater Federal troops achieve a foothold on Tybee Island in Georgia. This location on the Savannah River is of great strategic importance as it controls the entrance to the harbor and access to Fort Pulaski, the main fortification protecting Savannah from attack.

25 November 1861

Naval The Confederate Naval Department prepares to convert the former USS *Merrimack*, now the CSS *Virginia*, to an ironclad vessel. The CSS *Sumter* seizes a Federal ship while Union vessels succeed in capturing a blockade-runner in an action off the coast of South Carolina.

26 November 1861

The North At Wheeling in western Virginia a convention adopts a new constitution calling for the formation of West Virginia after that area's secession from the rest of the state. In Boston, Captain Wilkes, the instigator of the *Trent* affair, is honored for his accomplishments at a special banquet.

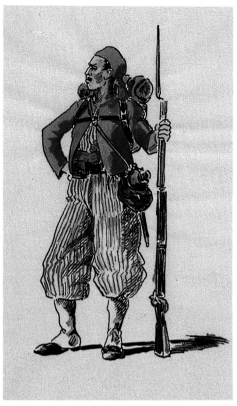

Above: A Southern zouave dressed in his French-inspired uniform.
Above right: A Louisiana Tiger zouave, a member of a unit with a fearsome reputation.

Naval The CSS *Sumter* seizes yet another Federal vessel in the Atlantic, while at Savannah, Georgia, rebels try without success to engage Union ships in fire from Fort Pulaski.

27 November 1861

Western Theater Ship Island, Mississippi, is the destination of a Union expeditionary force from Hampton Roads, Virginia. The intent is to set up a base of operations against New Orleans, Louisiana, and the general Gulf Coast area.
International The *Trent* affair is becoming more serious as word of the unlawful seizure of Confederate diplomats reaches Great Britain. In London, signs reading 'Outrage on the British Flag' begin to appear.

28 November 1861

The Confederacy The Provisional Congress at Richmond formally admits Missouri to the Confederacy.
Eastern Theater Federal officials in the Port Royal, South Carolina, vicinity are given authorization by Washington to seize agricultural products and slaves. The latter will work for the Federal defense of the area.

30 November 1861

International In a letter to Great Britain's minister to the United States, Lord Lyons, the British Foreign Secretary, Lord John Russell, communicates Britain's displeasure at the seizure of Confederate diplomats John Slidell and James Mason. He further requests that the Union apologize for the seizure and release the two diplomats to Britain's jurisdiction. The British navy is placed on alert but is told to avoid any hostilities. Lyons is directed to leave Washington, DC, in one

week's time if there is no satisfactory response to Britain's request for redress of the affair.

1 December 1861

Washington In a communication to General McClellan, President Lincoln questions the new chief about the army's movement. The president is somewhat concerned that little action has taken place. He asks of the Army of the Potomac, 'How *long* would it require to actually get it in motion?'
Naval Successfully preventing the blockade-runner *Albion* from carrying supplies to the Confederates, the United States gunboat *Penguin* seizes the vessel and its cargo, which includes armaments, various foodstuffs, tin, copper, and military equipment valued near $100,000.

2 December 1861

Washington The 37th Congress meets in the nation's capital for its regularly scheduled session. The mood here is a less positive one than it had been in July when the Congress last met. There is continued concern over repercussions stemming from the *Trent* affair and there are some who feel that the army in Virginia ought to have made an offensive prior to the coming of winter. In general, there are criticisms of Lincoln's current military plans which are made up of a three-fold strategy: the plans call basically for the re-accession of Tennessee to facilitate the position of the army in the heart of the Confederacy; taking control of the Mississippi River and focusing on the eastern theater of war, especially between Richmond, Virginia, and Washington, DC.
Western Theater Federal General Henry Halleck is authorized to suspend the writ of habeas corpus in the area commanded by the Department of the Missouri.
Naval Newport News, Virginia, is the setting for a naval skirmish between four Union

gunboats and the Confederate vessel *Patrick Henry*. As a result of the exchange, the *Patrick Henry* sustains considerable damage.

3 December 1861

Washington President Lincoln makes his State of the Union address to Congress. In this message the chief executive stresses that 'the Union must be preserved, and hence all indispensable means must be employed.'
Western Theater At Ship Island, Mississippi, the first of the troops in General Butler's expedition to the Gulf Coast area are landed. The Federal steamship *Constitution* carries this initial offensive force, made up of the 26th Massachusetts Regiment and the 9th Connecticut Regiment.

4 December 1861

Washington Another Federal office holder, Senator John Breckenridge of Kentucky, is expelled from his position, in this case by a vote of 36-0. Formerly Buchanan's vice-president, Breckenridge had joined the rebel army in November after exhausting all possibilities for the negotiation of peace between the two opposing forces.
Trans-Mississippi General Henry Halleck authorizes the arrest of any persons found helping the pro-secessionist movement in St Louis, Missouri. Those arrested for aiding the enemy are to be executed by the military.
International Britain's Queen Victoria issues a statement prohibiting any exports to the United States including armaments or materials for their production.

5 December 1861

Washington Congress considers several bills which would abolish slavery, particularly in territory 'in rebellion.' The secretary of war reports that the regular army has 20,334 men, and volunteers total 640,637. Naval Secretary Gideon Welles shows that the Federal navy tallies 22,000 sailors and marines.

7 December 1861

Eastern Theater The Potomac River Dam Number Five is the site of a small clash between Federals and rebel soldiers.
Western Theater Further military activity takes place as a group of Confederate troops takes Glasgow, Missouri.
Naval In a move to prevent the Confederate evasion of the blockade, the USS *Santiago de Cuba* stops the English ship *Eugenia Smith*. The Union vessel, under the command of Daniel Ridgely, succeeds in seizing J W Zacharie of New Orleans, Louisiana. Zacharie is a known Confederate purchasing agent and this incident serves to increase the agitation engendered by the *Trent* affair.

8 December 1861

Naval The Northern whaling industry is now affected by the conflict: the CSS *Sumter* seizes the whaler *Eben Dodge* in Atlantic waters.

9 December 1861

Washington To replace John Breckenridge as senator from Kentucky, Garret Davis is elected. As a result of criticism and debate over military defeats such as that at Ball's Bluff, the United States Senate calls for the

establishment of the Joint Committee on the Conduct of the War. In a vote of 33-3, the approval of this committee paves the way for a series of investigations and interrogations which are uneven, though useful, in terms of resulting reports.

The Confederacy Along the southern Atlantic coast, plantation owners burn their cotton crops to prevent confiscation by the Union. Seizing every opportunity to enlarge upon the significance of such acts and the threats posed by the anticipated Union advance, the Charleston *Courier* asserts that by destroying the cotton, planters prevent the North from enjoying 'the extensive spoils with which they have feasted their imagination, and the obtainment of which was one of their chief objects.'

Trans-Mississippi Missouri remains the scene of brief and minor encounters between the Union and the Confederacy. Union Mills, Missouri, witnesses skirmishing, and in the Indian Territory, pro-South forces made up largely of Indians push pro-Union Creek Indians out of the vicinity of Chusto-Talasah, or Bird Creek, later to be known as Tulsa,

Below: Harriet Beecher Stowe, the abolitionist author whose novel *Uncle Tom's Cabin* (1851) sold more than a million copies within ten years.

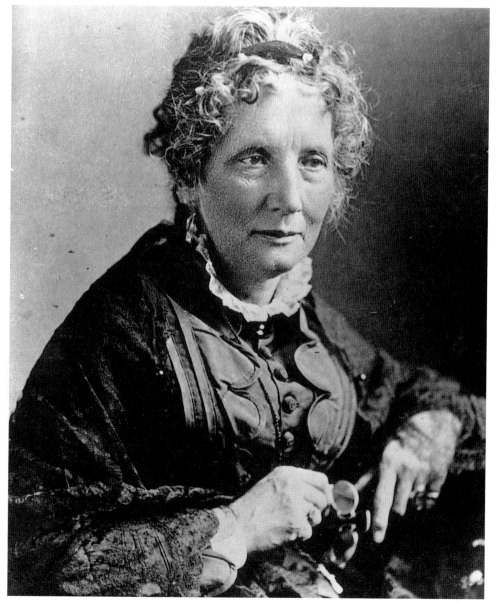

Oklahoma. The Confederate efforts are soon briefly discontinued, however, due to a shortage of adequate provisions and to the tenacity of the Creeks.

10 December 1861

Washington The proposal which will set up the Joint Committee on the Conduct of the War is finally approved by the Federal House of Representatives.

The Confederacy The Congress of the Confederacy admits Kentucky to the rebels' jurisdiction as their 13th state. This despite the sentiment of a majority of Kentucky's citizens against such a move. The tenure of Kentucky in the Confederacy is short-lived; barely one month later, the rebel forces have virtually relinquished claim on that state, preferring to try to hold Tennessee.

11 December 1861

The Confederacy Charleston, South Carolina, is ravaged by fire, and half of the city is destroyed, including much of the business district. Such an occurrence does psychological damage to the Confederacy, as Charleston is an important center of operations in the South. Combined with the Hilton Head Island occupation by Union troops and the relatively effective Federal blockade, the fire

proves to be extremely fortuitous to the strategy of the North.

13 December 1861

Eastern Theater Heavy fighting breaks out at Camp Allegheny, Buffalo Mountain, in western Virginia. Union troops under General R H Milroy attack the rebel encampment. Casualties in the Federal camp total 137, causing the force to fall back to Cheat Mountain. The Confederates suffer equally heavy losses (146 casualties) and they, too, retreat to Staunton, Virginia, in the Shenandoah Valley.

14 December 1861

International Britain falls into mourning at the unexpected death of Queen Victoria's husband and consort, His Royal Highness Prince Albert. Two weeks previously the prince had prepared correspondence relevant to the *Trent* affair and the seizure of Confederate diplomats Mason and Slidell; he had recommended a moderate course of action and the avoidance of outright hostilities with the United States over the affair. Despite this, there remains great apprehension over possible war between the United States and Britain.

17 December 1861

Eastern Theater Various military operations of a minor nature occur on this day. At Chisolm Island, South Carolina, there is skirmishing, and at Rockville in that state confrontations between Union soldiers and rebels take place. The Union garrison at Hilton Head poses such a threat to Confederates at Rockville that the Southerners leave the vicinity. Near Harper's Ferry, General 'Stonewall' Jackson carries out maneuvers along the Potomac River with his Confederate troops.

Naval Savannah Harbor is the scene of efforts by Federals to prevent shipping access: seven stone-laden vessels are sunk in the harbor entrance. On Green River in Kentucky, there is a battle which leaves 10 Union soldiers dead and 17 wounded. Confederate losses in this exchange total 33 killed and 55 wounded.

18 December 1861

Washington President Lincoln and his cabinet meet to discuss the *Trent* affair. Meanwhile, Lord Lyons, the British minister in Washington, receives his orders from London concerning Britain's demands for Slidell and Mason's immediate release. General McClellan and the president confer at the general's house about upcoming military strategy concerning the Union army.

19 December 1861

International A meeting between United States Secretary of State Seward and the British Minister Lord Lyons results in an exchange of information and terms over the *Trent* affair. Lyons explains Britain's position and gives the United States seven days in which to respond to those demands.

20 December 1861

Naval In the shipping lanes off Charleston, North Carolina, 16 outmoded whaling vessels are sunk in order to prevent access to the

city harbor by blockade-runners. Although the Union efforts in this respect were often repeated, they were of only limited effectiveness overall.

International The British navy sends two ships to Canada in order to have forces in readiness if the *Trent* affair should necessitate formal military action against the United States.

21 December 1861

Washington Further meetings between Lord Lyons and Secretary of State Seward result in a communication several days later to Lord Russell, British foreign minister. In this letter, Lyons asserts: 'I am so concerned that unless we give our friends here a good lesson this time, we shall have the same trouble with them again very soon . . . Surrender or war will have a very good effect on them.' It appears that there is, in fact, some sentiment in favor of a stepped-up confrontation between the two countries, although Britain continues to exhibit restraint in the matter. The Confederacy's attitude is one of hopeful anticipation, newspapers in the South promoting the possibility of armed conflict between the United States and Britain, and commenting on its favorable effects for the Confederacy.

Left: Battery Rogers on the Potomac, one of an impressive series of forts placed to prevent any seaborne assault against the Union capital.
Below: The 24-pounders of the 1st Connecticut Artillery protect Fort Richardson, Virginia.

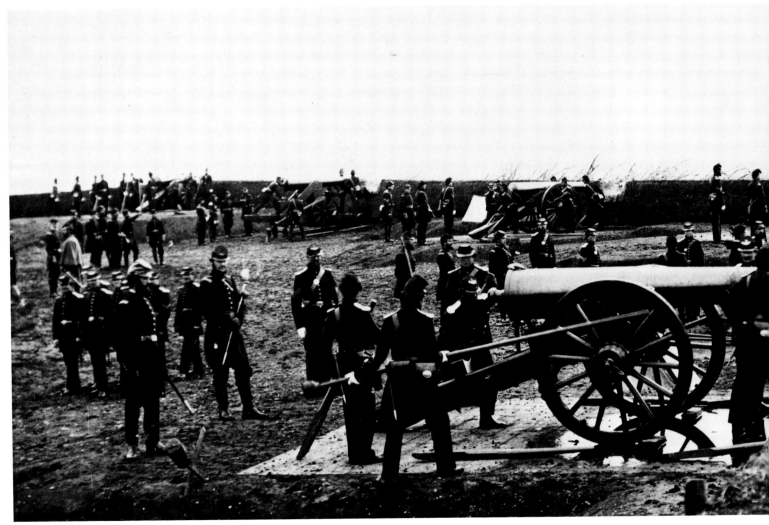

23 December 1861

Washington Once again, Lord Lyons requests the surrender of Slidell and Mason in a communication with Seward. The cabinet meets with President Lincoln to discuss the matter further. After the latter conference, Massachusetts Senator Charles Sumner counsels the president on the advisability of releasing the two Confederate commissioners as soon as possible.

24 December 1861

Washington In the Federal capital, Congress passes duties on such luxury items as coffee, tea, sugar and molasses. At the War Department orders are given which suspend enlistment of cavalry soldiers. The president prepares for a full Christmas day, with expected meetings between members of the cabinet and himself on means of resolving the *Trent* affair.

25 December 1861

Washington Although the president and Mrs. Lincoln entertain guests for Christmas dinner, a decision concerning the disposition of Mason and Slidell is the focus of the day. The decision is to be forthcoming within the next 24 hours.
Eastern Theater The fighting continues at Cherry in western Virginia and near Fort Frederick, Maryland.

26 December 1861

Washington The United States agrees to surrender Confederate commissioners James

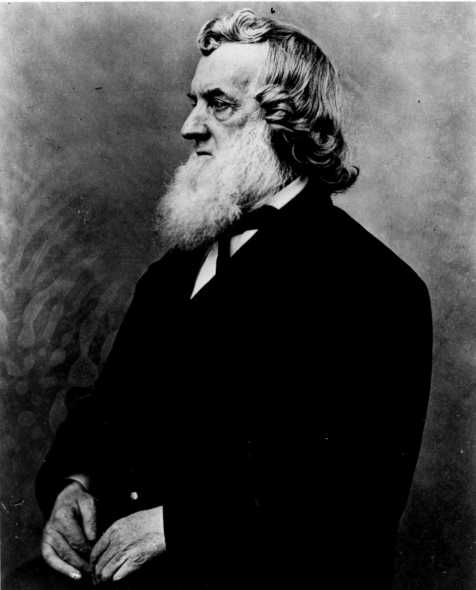

Mason and John Slidell into the keeping of Great Britain. After many meetings the cabinet acknowledges the seizure of the diplomats as illegal and terms the action a misunderstanding on the part of Captain Charles Wilkes. Lord Lyons receives the statement made by United States officials, and Secretary of State Seward orders the men released from their incarceration at Fort Warren in Massachusetts.
Trans-Mississippi St Louis, Missouri, is placed under martial law, a ruling which also extends to all railroads in that state. General Henry Halleck gives this order, which is unpopular at best. Clashes between pro-Union Creek Indians and Confederates occur at Christenahlah in Indian Territory. The retreating Creeks flee to Kansas after suffering extensive losses.
Naval Union blockaders are attacked by a small group of Confederate vessels at the mouth of the Savannah River. Despite its intent, the rebel offensive succeeds in dislodging the blockade only temporarily.

27 December 1861

Trans-Mississippi Skirmishes break out at Hallsville. Missouri, and a clash between rebels and Union soldiers, under the command of General Benjamin Prentiss at Mount

Above: Secretary of the Navy Gideon Welles was the mastermind behind the Union blockade of the South's major ports.

Sion, Missouri, results in the dispersion of the 900 Confederates who had been stationed there.

29 December 1861

Trans-Mississippi In Missouri, Jeff Thompson's rebels continue to be active against pro-Union forces in that state. The rebels there fight forces in Commerce and also attempt an attack against the steamer *City of Alton*.

30 December 1861

International James Mason and John Slidell are transferred to the custody of Lord Lyons, the British minister to the United States.

31 December 1861

Washington President Lincoln, due to the fact that General McClellan is ill, contacts General Halleck in Missouri. The chief executive is concerned that the Union army seems to lack direction and focus. He asks Halleck, 'are General Buell and yourself in concert?' hoping that the Western Department will be pressed into action of some sort.

1 January 1862

Eastern Theater From Fort Pickens, Florida, Union troops fire on Confederate batteries at Pensacola. At Fort Barrancas there is a similar exchange of fire. The Port Royal area in South Carolina witnesses skirmishing as Federals continue their move to establish a permanent base at this important coastal location; this latter conflict results in rebel batteries being pushed out of their positions on Port Royal Island, South Carolina.

Western Theater While skirmishes at Dayton, Missouri, cause some extensive damage to that town, General Halleck receives communications from Washington concerning the army's inactivity. Halleck is encouraged to advance with his own troops, as well as with forces under General Buell, on Nashville, Tennessee, and Columbus, Kentucky.

International James Mason and John Slidell, the two Confederate commissioners seized on the *Trent* and now released by the Union government, board a British schooner off Provincetown, Massachusetts, in the first leg of their journey to England. The British vessel *Rinaldo* will take the two men to London where they will continue their interrupted attempt to gain recognition and support for the Confederacy. With their departure, the *Trent* affair, which caused so much consternation in Washington, DC, and which carried with it the possibility of a serious conflict between the British and American governments, is effectively closed.

3 January 1862

The Confederacy The Confederate president, Jefferson Davis, expresses worry over the Union presence on Ship Island, Mississippi. In a letter to that state's governor, the president says that the troops stationed at Ship Island have planned an offensive which 'no doubt, is intended against Mobile or New Orleans.'

Eastern Theater There is some movement of Union troops in Virginia as General Jackson's forces leave Winchester. The object of

Below: Edwin Stanton replaced Simon Cameron as Union war secretary on 15 January 1861.

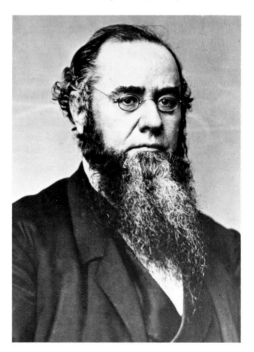

this winter march, termed the Romney campaign, is the destruction of the lines of the Baltimore & Ohio Railroad and the dams along the Chesapeake and Ohio Canal. There is skirmishing at Big Bethel, Virginia, as the Union troops seize the town and Confederates fall back, evacuating the area.

5 January 1862

Eastern Theater The operations around Hancock, Maryland, continue unabated as Confederate troops try to rout the Federals who have retreated to this position. The rebel batteries are located at positions along the Potomac River.

6 January 1862

Washington There is growing sentiment in official circles against General McClellan as he appears to be reluctant to commit troops to any concerted action. Accordingly, a group of senators approach President Lincoln with the suggestion that McClellan be replaced. Lincoln rejects this proposal, and in like concern over what seems to be a general lack of intent, the president communicates with General Buell, who is positioned in Kentucky. The president makes strong recommendations that the Union forces advance in order to provide support for 'our friends in East Tennessee.'

7 January 1862

Eastern Theater The troops which have been positioned at Hancock, Maryland, are now directed away from the vicinity of the Potomac, moving toward Romney, Virginia. A result of this is skirmishing between Federals and rebel soldiers at Blue's Gap, Virginia, where Colonel Dunning's Northern troops rout Confederates and seize two of their cannon.

9 January 1862

Washington It is a matter of intense concern to the president that neither General Buell nor Halleck has responded to the administration's urging that the western troops advance. Lincoln discusses the issue with General McClellan who continues to recuperate from probable typhoid fever. The United States Congress is absorbed by discussions of the slavery problem, petitions being submitted which would curtail or terminate that institution. Some measures suggested include the possible colonization of former slaves elsewhere in the world; reimbursing owners for the loss of their property; emancipation of slaves; and various combinations of all these solutions.

10 January 1862

Western Theater At Cairo, Illinois, General Grant's troops make preparations for an expedition into Kentucky by way of the Mississippi River. Near Prestonburg, Kentucky, Union forces under General Garfield clash with Humphrey Marshall's Confederates at the forks of Middle Creek. The result of this encounter is not completely decisive; both sides retreat but feel that they have won.

Eastern Theater Romney, Virginia, is evacuated as General Jackson's troops push into the vicinity of western Virginia. The town is taken over by Confederates who will camp there during the cold weather.

11 January 1862

Washington After considerable difficulty with the War Department's administration, President Lincoln accepts the resignation of Simon Cameron as war secretary. As a conciliatory gesture, Lincoln suggests appointing him to the post of minister to Russia. While Cameron and his department have been under considerable criticism for fraudulent actions and general incompetence, there has been little actual evidence that Cameron himself is a corrupt individual.

Eastern Theater The Northern navy carries 15,000 troops under the command of General Ambrose Burnside to the coast of North Carolina. Commodore Louis Goldsborough is in charge of the naval squadron consisting of approximately 100 ships. These forces will augment the troops which have already established a firm hold in the Port Royal environs, causing further threat to Confederates in that area.

13 January 1862

Washington To fill the position in his cabinet vacated by Simon Cameron, the president chooses Edwin Stanton. He was the attorney general in Buchanan's administration and is now a lawyer in the nation's capital. In a continuing effort to spur General Buell and General Halleck to action in the West, President Lincoln writes to both men, stating his wish to press the Confederacy, 'menacing him with superior forces at *different* points, at the *same* time.'

15 January 1862

Washington Edwin Stanton receives the Senate's approval and becomes Lincoln's secretary of war. Stanton is an anti-slavery man and is a personal friend of General McClellan.

Western Theater General Grant moves into the Kentucky-Tennessee area as gunboats on the Tennessee River reach toward Fort Henry. Both the naval and land forces work in tandem for a period of 10 days, pressing farther into Confederate territory, gathering information about enemy positions.

16 January 1862

Western Theater Confederate troops under General Felix Zollicoffer are positioned north of the Cumberland River despite General Crittenden's orders to the contrary. This arrangement proves later to be an unsatisfactory one. Union troops are said to be pushing forward toward this rebel encampment.

Naval Cedar Keys, Florida, sees the burning of blockade-runners, as well as dockside property, by the Federal navy.

17 January 1862

Naval General Charles Smith attacks the area around Fort Henry on the Tennessee River.

18 January 1862

Western Theater Union troops are beginning to close in on Confederate troops at Mill Springs and Somerset on the Cumberland River in Kentucky. General Crittenden's troops should be partially protected by Zollicoffer's soldiers, but they are not because of the latter's careless positioning of his men north of the Cumberland River.

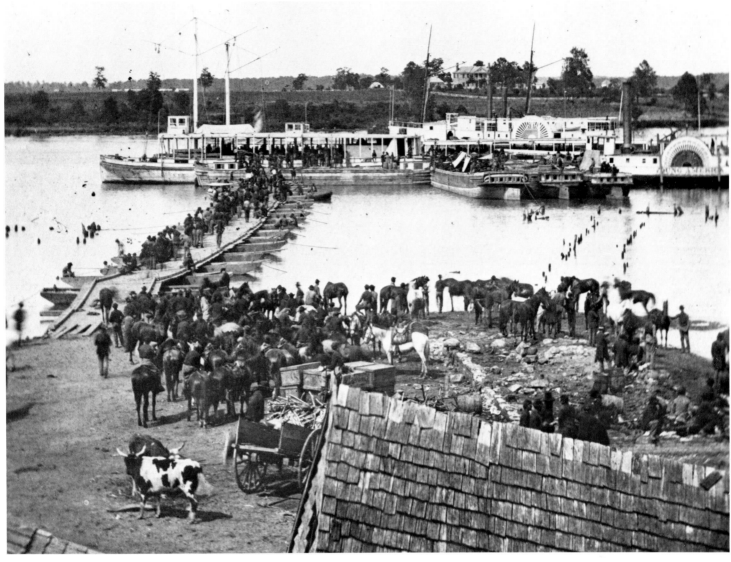

19 January 1862

Western Theater Rebels are defeated at Mill Springs, Kentucky, by Northern soldiers in a battle that claims 39 Union lives, wounds 207 and totals 15 Federals captured. The Southern forces indicate 125 killed, 309 wounded and 99 missing. Due to Zollicoffer's poor strategy, the rebels are obliged to retreat across the Cumberland River when Union General Thomas' men force them to fall back. Zollicoffer is killed in this battle; Crittenden, as senior officer, is castigated for having lost control of the positioning of troops. This exchange is perhaps most significant because the rebel defeat means a gap in the Confederate line of defense in the Tennessee-Kentucky area. This clash proves invaluable to the North as it enables the capture of 10 cannon, 100 wagons, over 1000 horses and a large number of boats as well as munitions and provisions.

20 January 1862

Naval Federals attempt to disrupt rebel blockade running by sinking stone-laden vessels in the harbor at Charleston, South Carolina. Off the coast of Alabama, a Confederate ship trying to run the Union blockade is halted; running the *J W Wilder* ashore, Federals make an effort to board the vessel but are prevented from doing so by rebel troops in the area. However, the blockade-runner is put out of commission.

Above: Union troops disembark near Port Royal, a move which threatened the Confederate forces on Roanoke Island.
Right: Confederate General Henry Wise was placed in command of Southern forces on Roanoke Island on 22 January 1862.

21 January 1862

Western Theater Union forces under General McClernand return to the Columbus, Kentucky, vicinity. Although this group of about 5000 men had only minimal contact with the rebels, their presence served to alert the Confederacy as to the strength of the Federal army in the area; in this respect it was a significant operation.

22 January 1862

Eastern Theater The Port Royal force poses an important threat to Roanoke Island near Hatteras Inlet, South Carolina. The Union troops under General Burnside are gathering strength and it is thought that, by naming General Henry Wise to the rebel command on Roanoke, the Federals may be deterred from seizing yet another position in Confederate territory.

23 January 1862

Trans-Mississippi Martial law in St Louis provides for seizure of pro-South property in the event that its owners have refused to support pro-Union fugitives. General Halleck,

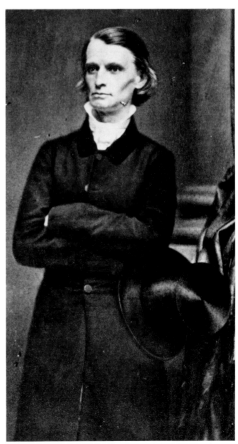

Above: General Grant directing the Union assault on Fort Donelson near Dover, Tennessee. Its capture heralded Grant's rise to power.

who has strengthened these martial law orders, allows for the arrest of persons attempting to subvert the law.

Naval Another group of stone-laden ships is sunk in Charleston Harbor to prevent Confederate shipping from entering the port. A clash between Union blockaders and the rebel vessel *Calhoun* near the mouth of the Mississippi River results in that vessel being taken by the North. The following day two more Confederate ships are run aground and burned as they try to slip away from Federals at this Mississippi point near the Southwest Pass.

27 January 1862

Washington After months of delay and frustration, President Lincoln issues *General War Order Number One:* 'that the 22nd February 1862, be the day for a general movement of the Land and Naval forces of the United States against the insurgent forces.' The president does this only after exhortations by military and civilian advisors and in the hope that the Union armies as well as the Gulf naval forces will come to some conclusive action with the Confederates.

30 January 1862

The North In a brief ceremony at Greenpoint, Long Island, the ironclad *Monitor* is launched. John Ericsson, the Swedish-born designer of this ship and others like it, states that such vessels are critical to the Northern efforts and 'will admonish the leaders of the Southern Rebellion that the batteries on the banks of their rivers will no longer present barriers to the entrance of the Union forces.'

International The two Confederate commissioners from the *Trent* affair, James Mason and John Slidell, arrive in England after their delayed voyage is completed.

31 January 1862

Washington Another statement, the president's *Special War Order Number One,* is issued in the Federal capital (this special order supplemented Lincoln's *General War*

Order Number One of 27 January 1862). Lincoln hopes to press the Army of the Potomac to confront the Confederates in Virginia as the Union troops in the area are told to take possession of 'a point upon the railroad south westward of what is known as Manassas Junction.'

International In Britain, Queen Victoria makes known once more the position of neutrality being observed by her country in the matter of the American Civil War. This statement does little to encourage the Confederacy, which hopes for support from European powers and which is now experiencing further doubts and diminished expectations as Federal forces seem to gather strength on all fronts.

1 February 1862

Western Theater Cairo, Illinois, sees preparations for an expedition under General Grant. This campaign will aim for the seizure of Fort Henry, a Confederate position on the Tennessee River. General Halleck in St Louis, Missouri, has approved of this movement and Grant's troops are now readying for the upcoming action.

3 February 1862

Washington President Lincoln communicates with General McClellan, who continues to disagree, both in public and private, with the chief executive. The two men have different preferences for the disposition of the Virginia forces: Lincoln favors a direct overland movement, his general in chief wishes to land troops on the coast and then march inland to the Confederate capital at Richmond, Virginia.

Western Theater General Grant's operation to Fort Henry gets under way as a Federal fleet moves up the Tennessee River and transports head for Paducah, Kentucky, from Cairo, Illinois.

International At Southampton in England, the Confederate steamer *Nashville* prepares to leave port for the United States. A Federal gunboat, the *Tuscarora,* sets off to capture the Southern vessel. Such an action is prevented, however, by the British ship HMS *Shannon.* The question of Southern blockade-runners using British ports remained contentious.

4 February 1862

The Confederacy Confederate House Delegates at the capital in Richmond, Virginia, enter into a debate concerning free blacks' enlistment in the Southern army. The *Examiner,* a Richmond newspaper, exhorts citizens to support the cause by re-enrollment in the army and a stronger commitment to the struggle between the North and South. Some observers are worried that Southerners are becoming tired and are 'not sufficiently alive to the necessity of exertion.'

5 February 1862

Western Theater General Grant's force is scheduled to open its attack on Fort Henry on the Tennessee River within 24 hours. General Charles Smith's men seize an evacuated Fort Heiman near Fort Henry, establishing Union troops there. Meanwhile, 3000 Confederates under General Lloyd Tilighman prepare as best they can for the upcoming attack on Fort Henry.

6 February 1862

Western Theater The Confederate position at Fort Henry is attacked by Federals. The Southern General Tilighman removes the bulk of his troops from the fort and remains behind with a handful of men to try to defend the post. At around 1100 hours the Union forces strike, shelling the fort from gunboats. The troops at the fort respond with their artillery, striking both the *Essex* and the *Cincinnati;* by 1400 hours the battle is over as the Confederate guns are destroyed by Union fire. Tilighman surrenders 78 soldiers and 16 hospital patients to Flag Officer Andrew Foote. Southern losses tally at five killed, 11 wounded and five missing; the Federals lose 11 men and sustain 31 injuries. The ground troops, some 15,000 strong, under General

Below: Andrew Foote led the Union gunboats during the attack on Fort Henry.

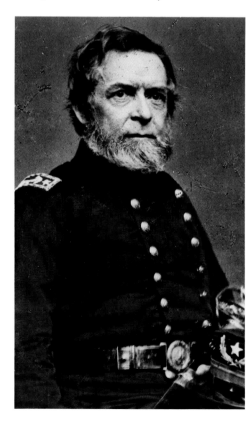

Grant, arrive too late to engage in the fighting. Having sent the major portion of his garrison to Fort Donelson on the Cumberland River, General Tilighman has at least prevented the Union force from easily taking immediate possession of the entire area. The Federals move from the vicinity to fortify their vessels as Confederate General Bushrod Johnson assumes command of Fort Donelson and makes a request for reinforcements and provisions.

7 February 1862

Western Theater Federal troops under General Grant himself start an expedition to Fort Donelson near Dover, Tennessee, in preparation for the upcoming attempt to seize that Confederate position. Confederate troops are ordered into the area as the Kentucky defenses further deteriorate. Meetings among Confederate Generals Johnston, Beauregard and Hardee attest to the severity of this most recent military development between North and South. Roanoke Island sees the advance of General Burnside's forces. Commodore Goldsborough succeeds in overcoming some minor Southern positions there, and later in the day Burnside's troops land. On the Tennessee River, Union guns destroy two Confederate transports.

8 February 1862

Washington Lincoln confers with General McClellan, asking for information about the Department of the West, and for reports on vessels sent toward Harper's Ferry on the Potomac River. The president, beset with worry over the nation's military strength, is

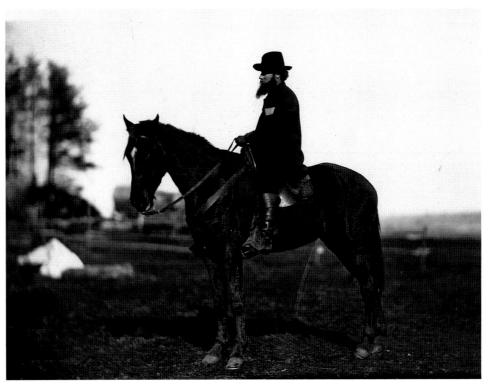

also filled with concern for his son, Willie, who lies ill with typhoid.

Western Theater The Confederates at Roanoke Island are moved to the northern end of their position as General Burnside's 7500 Union soldiers attack. Colonel Shaw's Confederates are seriously outnumbered and their regular commander, General Henry

Above: Alfred R Waud, war artist and correspondent for *Harper's Weekly,* on horseback in the field. Waud produced hundreds of sketches from the front lines during the Civil War. His brother William was also a war artist.
Below: Union troops under the leadership of General Ambrose Burnside storm the Confederate defenses on Roanoke Island. Its loss proved a serious setback for the South.

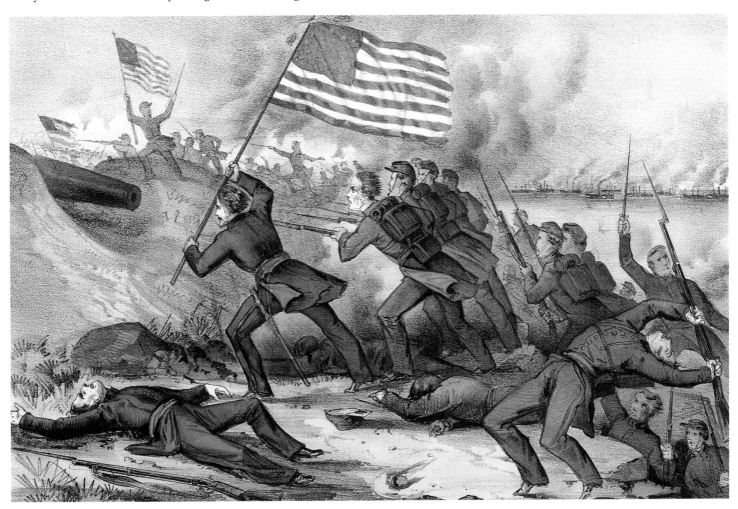

Wise, is too ill to be in charge, necessitating the temporary command of Shaw. The latter makes an attempt to hold the Southern position, but it is an exercise in futility. He surrenders after 23 men are killed and 62 are wounded. The Confederates relinquish 30 guns in this takeover and lose an important position on the Atlantic coast, a severe blow to the Southern war effort. Union losses in this exchange are totaled at 37 killed, 214 wounded and 13 missing.

Naval Two Confederate vessels, the *Sallie Wood* and the *Muscle,* are taken by the Federals at Chickasaw, Mississippi. In a follow-up of Confederates fleeing the Roanoke Island battle, 13 Union gunboats traverse the Pasquotank River in the direction of Elizabeth City, North Carolina.

10 February 1862

Western Theater Clean-up operations at Roanoke Island, North Carolina, are finished and General Burnside, now firmly established at this position, prepares for further campaigning against the Confederates in the area of New Berne. General Grant completes preparations for his offensive against Fort Donelson.

Naval Gunboats under Union control meet Confederates at Elizabeth City, North Carolina, and demolish the remaining vessels in the Confederate fleet. On the Tennessee River, Union gunboats capture three Confederate vessels while six more are burned by secessionists to prevent their falling into Union hands.

11 February 1862

Western Theater The action against Fort Donelson commences as General Grant's troops begin to march and General McClernand's Union forces move out from their position at Fort Henry. Federal gunboats travel up the Cumberland River. This Union activity provokes the evacuation by Confederates of Bowling Green, Kentucky, and

Below: Men of the 9th New York Regiment, one of the North's zouave units, storm a Southern entrenchment on Roanoke Island.

renders the previously fortified Kentucky line defenseless; only Columbus, Kentucky, remains relatively secure.

12 February 1862

Western Theater As Grant's force of 40,000 encircles the hills around Fort Donelson and the town of Dover, Tennessee, the Federal gunboats move into position to attack from the river. Confederates at the fort number about 18,000. Further action in the Roanoke Island vicinity results in the possession of Edenton, North Carolina, by Union forces.

13 February 1862

Western Theater The awaited attack on Fort Donelson occurs. The Confederate command has transferred to General John Floyd, whose arrival with Confederate reinforcements proves to be ultimately useless. The Federal attack from the right and left is led by General C F Smith and General McClernand, respectively, and Grant receives further aid from auxiliary troops by the end of the day. Fort Heiman nearby sees some brief action and portions of Bowling Green, Kentucky, are burned as the Southern evacuation of the area continues.

Above: Union vessels bombard Fort Donelson prior to the Confederates' unconditional surrender to General Grant's forces on 16 February.

14 February 1862

Washington The war secretary, with the president's approval, issues orders releasing political prisoners who will take the oath of allegiance to the United States. A general amnesty is proclaimed for all those who comply with the oath and who agree to give no further aid to the rebellion.

Western Theater The battle at Fort Donelson in the Cumberland River area is expanded by the arrival of four Union ironclads and several wooden vessels, although the easy victory which Grant anticipated is not forthcoming. The Union general sees a temporary withdrawal of this river force as shore batteries threaten serious damage to the Federal vessels. The Union ironclads *St Louis* and *Louisville* are badly hit and rendered virtually useless. Flag Officer Andrew Foote, who so ably performed at Fort Henry, is wounded in this rain of Southern shelling. Bowling Green, Kentucky, is taken by Federals. A meeting of Confederate commanders recommends that Gideon Pillow's forces attack the Federal right flank which lies to the south of Fort Donelson.

15 February 1862

Western Theater Fighting continues on the Cumberland River as Confederates under General Gideon Pillow attempt to break through Federal lines which surround Fort Donelson. The Southerners succeed in this effort, providing their troops with an escape route toward Nashville, Tennessee. Hesitation on the part of several commanders places the Confederates back at their posts, while Grant tries to close the line with the help of Generals Smith and McClernand. He is partially successful in this attempt. In Dover, Tennessee, Confederate generals discuss their options; surrender seems inevitable but there is resistance from General Floyd. In the end, Floyd does leave the battle area with General Pillow, placing General Buckner in the position of having to surrender the fort. Given Union local superiority the garrison can do little to prevent the fort's capture.

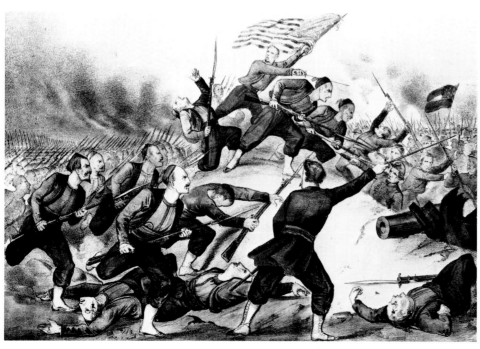

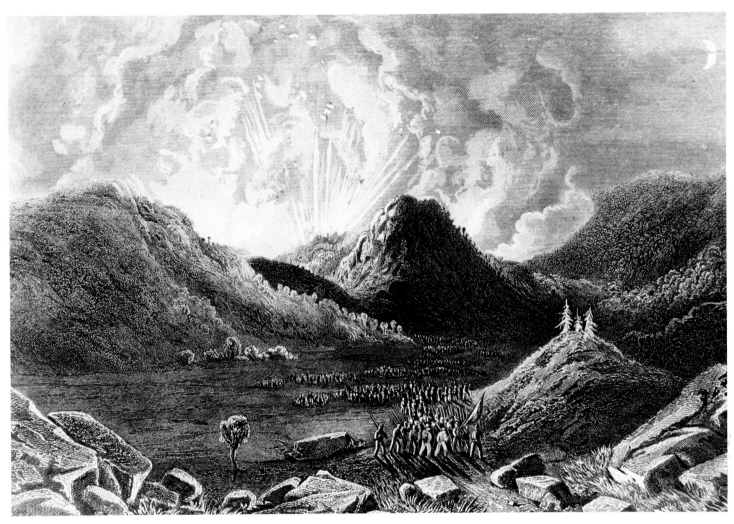

16 February 1862

Western Theater In a statement which leaves the Southerners no room for negotiation, General Grant issues his terms for the disposition of Fort Donelson: 'No terms except unconditional and immediate surrender can be accepted. I propose to move immediately upon your works.' General Buckner is left with no alternative, and so relinquishes possession of the military position which had proved to be a costly one to hold. Estimates of Southern casualties hover around 1500, and it appears that somewhere near 1200 soldiers surrendered. Union troops under General Grant show losses of 500 killed, 2100 wounded and 224 missing out of a total fighting force of 27,000. Needless to say, this victory for the North is of major importance and proves to be similarly significant a defeat in Southern eyes. Tennessee and Kentucky are lost and the Cumberland and Tennessee Rivers are in Union control now. The following day, news of the battle reaches Washington, DC, where there is rejoicing over the outcome. The battle proves to be important to General Grant's career – he is now promoted to major general of volunteers. The Confederacy sees disruption throughout Tennessee as civilians attempt to flee the area occupied by Federal troops.

18 February 1862

The Confederacy The dismissal on the previous day of the Provisional Congress of the Confederacy is followed by the initial meeting of the 1st Congress of the Confederate States of America. Structured now as a two-part government, the Congress is composed of representatives exclusively from slave-holding states in the South, with the exception of Delaware and Maryland.

20 February 1862

Washington President and Mrs Lincoln suffer the tragedy of losing their 12-year-old son, Willie, to typhoid fever. This personal stress is compounded by news of fatalities at Fort Donelson; the president seems engulfed by sorrow.

Western Theater Further pullbacks of Confederate troops result in the evacuation of Columbus, Kentucky. In Tennessee, the Confederate Governor Isham Harris decrees that the state capital will be fixed at Memphis as Nashville is in the line of Union troop advances. At the latter location, the Southern army is commanded by General Albert Johnston to move to a position southeast of the city near Murfreesboro. A group of 1000 late arrivals to the Southern defense at Fort Donelson is captured by Union troops.

21 February 1862

The North The convicted slave trader Nathaniel Gordon is hanged at New York City, the first time the Union has ever imposed this punishment.

Trans-Mississippi A Confederate victory results when the forces of General H H Sibley attack Union troops near Fort Craig at Valverde, New Mexico Territory. The Federals under the command of Colonel E R S Canby lose 68 men, with 160 wounded and 35 missing out of a total of 3810 men. Southerners

Above: Confederate troops pull back through the Cumberland Gap after Grant's victory at Fort Donelson.

numbering 2600 suffer 31 deaths, 154 wounded and one missing. The Confederates move toward Santa Fe after seizing six pieces of Union artillery.

22 February 1862

The Confederacy After his election to the presidency of the Confederacy (up to now he has been provisional president), Jefferson Davis' inauguration is held at Richmond, Virginia. In his address to the Confederate nation, Davis says, 'We are in arms to renew such sacrifices as our fathers made to the holy cause of constitutional liberty.'

24 February 1862

Eastern Theater Harper's Ferry is taken over by General Banks' Union soldiers. Near Pohick Church, Virginia, there is minor skirmishing between Southern and Northern troops.

Western Theater At Nashville, Tennessee, Buell's Federals take over and the Confederate cavalry troops there under General Nathan Forrest are forced to retreat.

27 February 1862

The Confederacy Jefferson Davis is given authorization by the Confederate Congress to suspend the privilege of habeas corpus. The Confederate president issues a call for martial law in both Norfolk and Portsmouth, Virginia.

Naval The Federal ironclad *Monitor* leaves its New York harbor under sealed orders.

28 February 1862

The Confederacy Southerners hold a day of fasting at the request of President Davis. In writing to his commander of the Army of Northern Virginia, General Joseph Johnston, Jefferson Davis observes that there is a need for thoughtful, planned defense. He tells Johnston that 'traitors show the tendencies heretofore concealed, and the selfish grow clamorous . . . at such an hour, the wisdom of the trained, and the steadiness of the brave, possess a double value.'

Eastern Theater Charleston, Virginia, is occupied by Federal troops.

1 March 1862

The Confederacy Richmond, Virginia, witnesses the arrest of John Minor Botts for treason against the Confederacy. Botts, a former Virginian congressman and avowed neutral, is seized along with 30 others, among them the Reverend Alden Bosserman, a Universalist minister. The latter has prayed for an end to 'this unholy rebellion.' The Confederate capital is now under martial law, President Jefferson Davis placing General John Winder in control of the city.

Western Theater General Beauregard positions troops along the Mississippi River while General Henry Halleck directs General Grant to take his forces toward Eastport, Mississippi. There are brief clashes between Union and Confederate soldiers at Pittsburg Landing, where gunboats have traveled up the Tennessee River. They destroy a Confederate battery positioned there by General Beauregard's troops.

3 March 1862

Western Theater Accusations are leveled at General Ulysses Grant by General Henry Halleck concerning Grant's tardy appearance

Below: The clash at Pea Ridge, Arkansas, ended after a series of spirited Southern attacks were repulsed by Union forces under General Curtis.

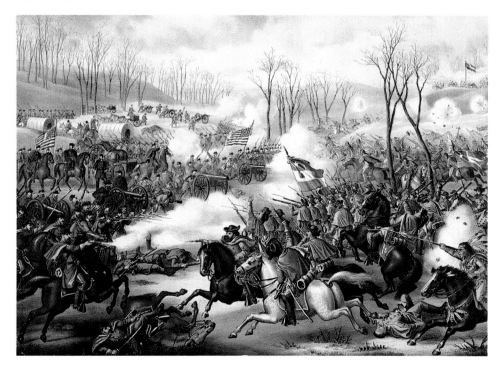

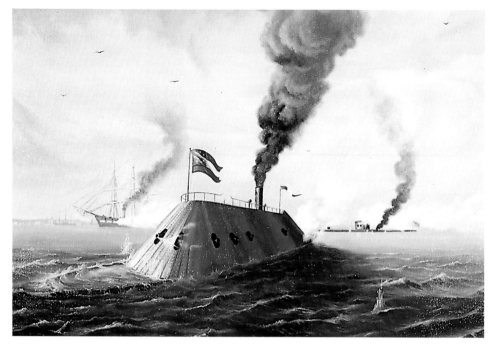

during the Fort Donelson takeover. Halleck is given permission by President Lincoln to transfer General C F Smith to command the troops going up the Tennessee River out of Fort Henry; it is felt that Grant's recent conduct does not warrant his taking responsibility for the upcoming action.

4 March 1862

Washington General Andrew Johnson receives Senate approval as the military governor of Tennessee.

The Confederacy General Robert E Lee is replaced by General John Pemberton as commander of the Confederate Department of South Carolina, Georgia and East Florida. Lee has been called to Richmond by President Jefferson Davis to assume duties as a military advisor in Virginia. The Confederate president runs into problems with various congressmen dissatisfied with the defense of the Mississippi River. These congressmen demand additional batteries to cover the river

Above: The CSS *Merrimack* steams toward the USS *Monitor* during the Battle of Hampton Roads, the first encounter between ironclads.

despite the efforts of Davis' administration to provide the best defenses possible.

5 March 1862

Western Theater At Jackson, Tennessee, General Beauregard takes charge of defenses along the Mississippi valley. Federals begin to position themselves around Savannah, Tennessee, as General Johnston's Confederates begin a move to prevent the further entrenchment of Union forces in the area. General C F Smith's Federals at Savannah are quickly joined by three gunboats and 80 troop transports.

Trans-Mississippi Fighting continues in Arkansas as Sterling Price's Southerners combine with General Van Dorn's forces against Union General Samuel Curtis. An attack is imminent, Van Dorn positioning his troops just past Fayetteville and Elm Springs, Arkansas.

6 March 1862

Washington President Lincoln, in part responding to suggestions from various senators, requests the states' cooperation in devising ways to abolish slavery. This message to Congress indicates the availability of Federal financial funding for aiding emancipation efforts in individual states.

The Confederacy A proclamation is issued by the Confederate Congress concerning the destruction of valuable cotton and tobacco crops in the event that Northern troops advance farther into Virginia. Military authorities are charged with the responsibility for carrying out this disposal of Confederate property if the need arises.

Trans-Mississippi In Arkansas, near Fayetteville, forces under Confederate General Earl Van Dorn clash with Union soldiers under General Samuel Curtis. While this fighting is limited, it presages an upcoming battle. Van Dorn is anxious to gain an optimum position and therefore moves his troops to Pea Ridge.

Above: Albert Johnston, one of the South's best-remembered generals.
Right: The Battle of Hampton Roads saw Southern hopes of smashing the Union blockade dashed due to the arrival of the USS *Monitor*.

7 March 1862

Eastern Theater McClellan takes the Federal Army of the Potomac toward the southwestern region of Virginia where General Joseph Johnston's Confederates are encamped at Manassas. The Union soldiers are well positioned and are prepared to do battle with the Confederates whom they expect to vanquish easily. In Winchester, Virginia, there is skirmishing.

Trans-Mississippi The Federal forces at Pea Ridge, or Elkhorn Tavern, Arkansas, are surprised by General Van Dorn's Confederate troops in an attack from the latter's northern position. About 17,000 Confederates, including some Indian troops, make valiant attempts to rout the Union soldiers, but the North is ultimately victorious. Van Dorn's forces are made up of Missouri state guards under Sterling Price, as well as General McCulloch's division and General Pike's troops which are comprised of three Indian regiments.

8 March 1862

Washington The president and General McClellan discuss plans for the Army of the Potomac, and other military advisors concur with McClellan's desire to enter Virginia by way of the peninsula southeast of Richmond. In *General War Order Number Two*, the chief executive provides for certain of the Union troops to be positioned for defense of the Federal capital during the upcoming campaign, despite the fact that this will draw off troops from the offensive.

Trans-Mississippi The Battle of Pea Ridge, Arkansas, the most significant of Civil War battles in the Trans-Mississippi west, sees the death of both Generals McCulloch and McIntosh, depriving the Confederacy of two able commanders. Federals under General Curtis continue to hold out for a second day of fighting, which ends as Van Dorn and his

men retreat to the Arkansas River with orders to leave the state and head for the Mississippi River to aid in the defense of Confederate positions there. The tally of casualties shows that the Confederacy has lost around 800 men, while the North suffers 1384 dead and wounded.

Naval In Virginia, at Hampton Roads, the ironclad *Merrimack* approaches a squadron of

Federal vessels, all much less well defended and ill-equipped to battle with the heavily armored Confederate ship. In the ensuing encounter, two Union vessels are put out of commission – the USS *Cumberland* and the USS *Roanoke* – and the USS *Minnesota* is heavily damaged. Flag Officer Franklin Buchanan of the *Merrimack* is slightly wounded during the fight, though in

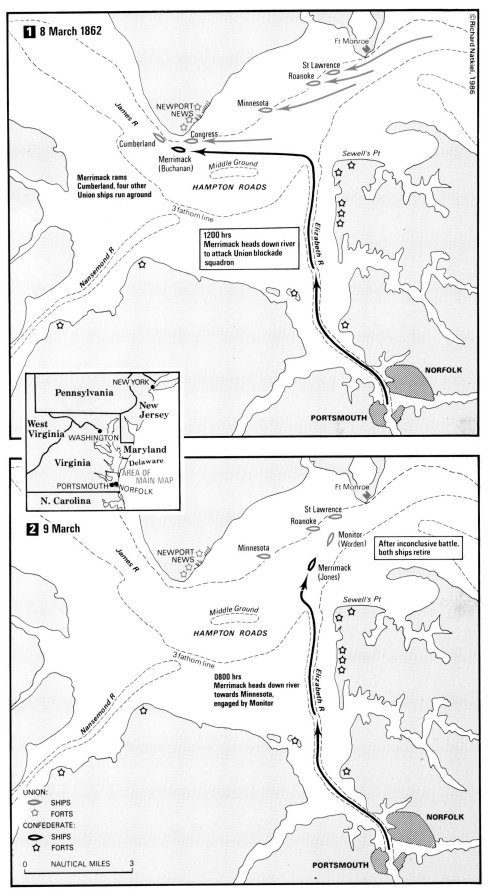

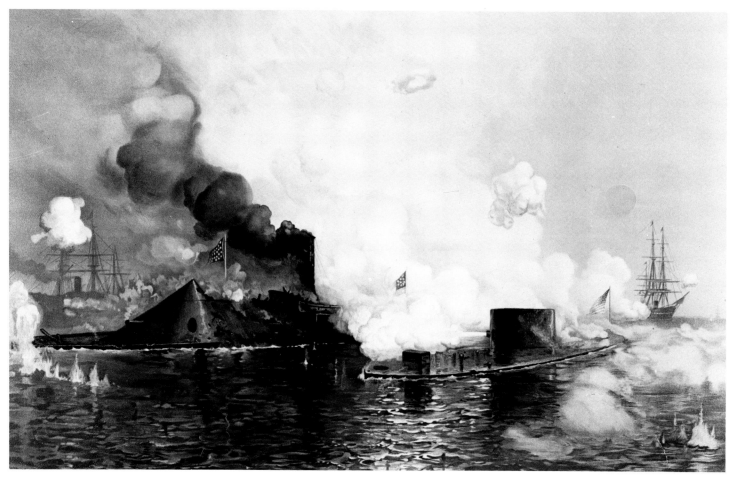

Above: The USS *Monitor* (foreground) and the CSS *Merrimack* exchange broadsides at close quarters on 9 March.

general, few Confederates suffer serious injury. The Union forces suffer a greater number of casualties and damage to their ships is especially severe. A Confederate military observer notes, 'Pains, death, wounds, glory – that was the sum of it.' Late in the day of the battle between the *Merrimack* and these various Federal vessels, the USS *Monitor* appears in the harbor at Hampton Roads after a difficult journey south from New York.

9 March 1862

Eastern Theater The Confederate army in Virginia under General Joseph Johnston moves near a position at Rappahannock Station close to the Rappahannock River. Union soldiers under McClellan move out, but do not engage rebels in any fighting. They soon return to Alexandria after finding only empty camps left behind by the Confederates.
Naval In a battle of special significance to naval warfare, the CSS *Merrimack* and the USS *Monitor* clash in the harbor at Hampton Roads. Beginning around 0900 hours fighting continues for nearly two hours until injuries force both commanders to pull back. While the exchange of fire is impressive, there is relatively little damage done to either vessel and the battle has no real victor. Federals are considered to have a stronger position as the *Merrimack* is unable to easily maneuver due to its unwieldy construction. There is concern that the Confederate vessel may make its way to Washington, DC, or New York City, but this worry is soon dispelled.

11 March 1862

Washington In issuing another major military order, *General War Order Number Three*, President Lincoln removes General George McClellan from his command as general in chief of the Union army. McClellan is given the Army of the Potomac and he, along with other generals, will be under the direction of the secretary of war; no general in chief is yet to be appointed.
The Confederacy After their flight from the military action at Fort Donelson, Generals Floyd and Pillow submit reports to Confederate President Jefferson Davis. The president does not accept these reports and removes both Pillow and Floyd from their commands.
Eastern Theater Manassas Junction, Virginia, is investigated by Union troops, who find little of value left in the wake of retreating Confederate soldiers. At Winchester, Virginia, 4600 Confederates are under the command of General Jackson who takes his troops southward.

13 March 1862

The Confederacy General Robert E Lee is given the responsibility of overseeing Confederate military positions. Confederate President Jefferson Davis does not define the specific nature of this advisory post held by Lee.
Eastern Theater Meetings between General McClellan and his staff provide a clearing house for plans concerning placement of the Army of the Potomac. General Johnston is situated near the Rappahannock and there is great concern to avoid direct confrontation there as Federals march on Richmond, Virginia. McClellan intends to bring troops to the Confederate capital via the York and James

Rivers. McClellan, intent on moving via the peninsula, is warned by President Lincoln's secretary of war that Washington, DC, must remain protected, as must Manassas Junction, Virginia. General McClellan is told to 'at all events, move such remainder of the army at once in pursuit of the enemy.'
Western Theater General Burnside's troops disembark at New Berne, North Carolina, on the western branch of the Neuse River.
Trans-Mississippi Skirmishing occurs at Point Pleasant, Missouri, leading to the area's capture by General Pope who also provokes the evacuation of New Madrid by his military actions. In this move, the Confederates abandon large quantities of arms and provisions estimated at a value of $1 million.

14 March 1862

Washington In a continuing discussion of his position concerning slavery, President Lincoln attempts to justify the proposed financial compensation to slaveholders. Lincoln feels that such recompense 'would not be half as onerous as would be an equal sum, raised *now,* for the indefinite prosecution of the war.'
Western Theater In North Carolina, the town of New Berne is taken by General Burnside's 11,000 men, who push General Branch's 14,000 Confederates out. This position is maintained by Federals for the duration of the war, proving an effective point of departure for inland expeditions. There are some 600 Confederate casualties after this battle, including 64 deaths. Union troops suffer 90 killed with 380 wounded.
Trans-Mississippi The capture of New Madrid, Missouri, by General John Pope's Federals places the Northern forces in a posi-

tion which will enable them to make an assault on Island Number Ten in the Mississippi River. This latter Confederate post defends east Tennessee.

15 March 1862

Western Theater General Grant resumes command of field forces in Tennessee after General Halleck absolves Grant of charges of misconduct at Fort Donelson.

17 March 1862

Eastern Theater General McClellan and the Army of the Potomac move out on the Peninsular campaign, heading for the James and York Rivers.

18 March 1862

The Confederacy Jefferson Davis names Judah Benjamin secretary of state. Benjamin has up until now served as war secretary and has been under criticism in that position.
Eastern Theater At Aquia Creek, Virginia, Confederates occupy the town.
Western Theater General Albert Johnston's Confederates begin arriving in Corinth, Mississippi, from Murfreesboro.

20 March 1862

Eastern Theater, Peninsular Campaign At Strasburg, Virginia, where the day before there had been some action, there is a general pullback of Federals as General Jackson's forces advance. At Philippi, western Virginia, there is light skirmishing.

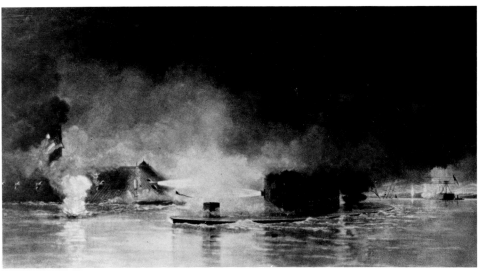

22 March 1862

Eastern Theater, Peninsular Campaign Light fighting takes place at the town of Kernstown, Virginia, between General Shields' Union soldiers and General Jackson's advancing Confederates.

23 March 1862

Eastern Theater, Peninsular Campaign About 9000 Union troops clash with 4200 Confederates at Kernstown, Virginia. Skirmishing of the previous day has led the Confederates to assume a smaller enemy force but, although outnumbered, Jackson's

Above: Despite several hours of heavy firing neither the *Monitor* nor the *Merrimack* suffered major damage at Hampton Roads.

troops perform admirably. They retreat, ultimately, after suffering 80 killed, 375 wounded, 263 missing, compared to Union losses of 118 killed, 450 injured and 22 missing. This battle is the preliminary to the Shenandoah Valley campaign. Militarily import-

Below: The ruins of Manassas Junction, Virginia, abandoned by Confederate troops on 11 March in the face of larger Union forces.

ant, the battle provides a diversion central to Southern strategy: Lincoln, now fearing an offensive on the Federal capital, issues orders that General McDowell's troops remain as part of Washington's defense. This means fewer troops for the peninsular campaign. In addition, this assault at Kernstown suggests the possibility of a threat on Harper's Ferry, and General Banks' troops are ordered to return to that vicinity rather than join forces with McClellan.

Western Theater Fort Macon at Beaufort, North Carolina, is the object of the next move by Burnside's Federals. The following day sees General John Parke's soldiers approach Fort Macon and request its surrender. The subsequent refusal results in a Union siege of that Confederate position.

24 March 1862

Slavery The emancipation issue continues to be one fraught with emotion. In Cincinnati, Ohio, the abolitionist Wendell Phillips speaks and is greeted with a barrage of eggs and rocks. Lincoln, commenting on the prospect of compensated emancipation, notes in a letter to newspaperman Horace Greeley that 'we should urge it persuasively, and not menacingly, upon the South.'

26 March 1862

Trans-Mississippi State militia in Missouri clash at Hammondsville with Confederate forces; at Warrensburg pro-Unionists con-

Below: Union and Confederate troops exchange volley fire at the height of the fighting at Shiloh, one of the war's most costly battles.

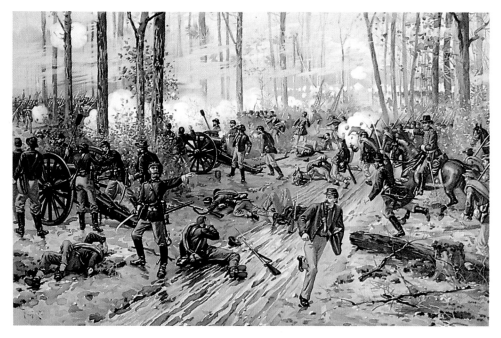

front Confederates; the latter are repelled in both cases. In Colorado Territory there is an encounter between Southern cavalry and Union forces near Denver City resulting in the capture of 50 Confederate cavalrymen. In New Mexico Territory, Confederates meet a troop of Union soldiers coming toward Santa Fe from Fort Union. There is a fight between the two forces at Apache Canyon, resulting in a victory for Union troops who fall back to an area near Glorietta. Confederate troops regroup after the skirmish and follow the victorious Union forces.

Above: Union reinforcements arrive to stem a Confederate attack during the bloody Battle of Shiloh, or Pittsburgh Landing.

28 March 1862

Eastern Theater, Peninsular Campaign Brief fighting occurs along the Orange and Alexandria Railroad in Virginia over a period of several days. Shipping Point, Virginia, is occupied by Federal troops.

Trans-Mississippi The New Mexico Territory sees a major battle between North and South at La Glorietta Pass. Union troops

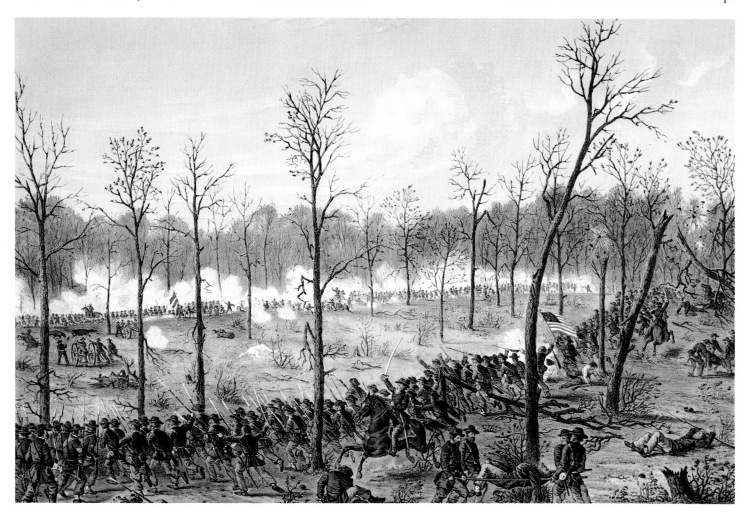

under Colonel John Slough clash with Confederates under Colonel W R Scurry, pushing the Federals back. Confederate supply wagons at nearby Johnson's Ranch are attacked by Major John Chivington's men, causing the Confederates to fall back to Santa Fe and effectively stopping the Southern invasion. Of 1100 Confederates, 36 are killed, 60 wounded; Union troops totalling 1324 lose 31 with over 50 wounded.

29 March 1862

Eastern Theater, Peninsular Campaign In western Virginia, William Rosecrans' command of the Mountain Department is given over to General Frémont. Middlebury, Virginia, witnesses a cavalry charge by Union troops in pursuit of a fleeing Confederate detachment.
Western Theater General Albert Johnston pulls the Confederate forces together at Corinth, Mississippi; General Beauregard is his next in command. Generals Polk, Bragg, Hardee and Crittenden are also there with their troops.

1 April 1862

Eastern Theater, Peninsular Campaign General John Wool's force of 12,000 men at Fort Monroe, Virginia, is supplemented by General McClellan's movement of 12 divisions from the Northern Army of the Potomac. In addition, the Federal Shenandoah forces are pushing toward General Jackson's troops in position near Woodstock and Edenburg, Virginia.
Naval Northern troops move, via gunboats, up the Tennessee River and Federal forces are able to complete a mission at Island Number Ten on the Mississippi River.

2 April 1862

Washington President Lincoln's suggestions about compensated emancipation receive favorable attention in the United States Senate. This plan – which would allow Federal financial support to Northern states willing to provide compensation – is intended as a means to encourage the freeing of slaves. Although proposed by Lincoln it is a plan which will never be implemented.
Western Theater Shiloh, or Pittsburgh Landing, in Tennessee, is the goal that General A S Johnston's Confederates have in mind as they are ordered to move out to the Federal position from Corinth, Mississippi. Confederate troops succeed in encircling a portion of the 2nd Illinois Cavalry at Farmington, Mississippi. The Northern troops are able, however, to break through the enemy lines and escape.
Trans-Mississippi In Missouri, various military actions continue as Confederates and Northern soldiers skirmish at Walkersville, and as a Union reconnaissance force sets out for Jackson, Whitewater and Dallas from Cape Girardeau. Along the Mississippi River, from Cairo, Illinois, to New Madrid, Missouri, there is a great deal of damage done to various installations as a result of severe tornadoes.

3 April 1862

Washington The United States Senate passes a bill, 29-14, to abolish slavery in the District of Columbia. President Lincoln is gravely concerned about the defense of the nation's capital. He finds that General McClellan has arranged for the distribution of troops so as to leave less than 20,000 men in the Washington area. Accordingly, the chief executive orders the retention of an additional corps to ensure the safety of the Northern capital; the impact on McClellan's troop strength for the peninsular campaign is negligible, as McClellan has nearly 112,000 men for his siege of Yorktown.
Western Theater General A S Johnston's Confederates move to attack Shiloh on the Tennessee River, where General Grant's Northern troops are encamped. Apalachicola, Florida, surrenders to Federal troops.

4 April 1862

Eastern Theater, Peninsular Campaign The campaign continues to take shape as General McClellan proceeds to bear down on Yorktown. The Southern forces are greatly outnumbered; General Johnston's troops total around 17,000 as compared to McClellan's enormous Army of the Potomac consisting of over 100,000 troops. Much of the Confederate Army of Northern Virginia has been shifted into position on the Peninsula to afford some increased defense of the Southern position there. The Confederate line of defense stretches along an eight-mile front; the prospects for the South are not good.

5 April 1862

The North Difficulties over the oath of allegiance to the Union occur between the military governor of Tennessee, Andrew Johnson, and city officials of Nashville. The result is the suspension of the mayor, aldermen and councilmen of that occupied area.
Eastern Theater, Peninsular Campaign In a valiant, but seemingly futile effort, General Joseph Johnston's troops continue to gather reinforcements for the imminent conflict at Yorktown, Virginia. The Confederates are outnumbered by McClellan's stronger and larger Army of the Potomac.
Western Theater General Grant's forces continue to be relatively unaware of the Confederate troops bearing down on their position at Shiloh, Tennessee.

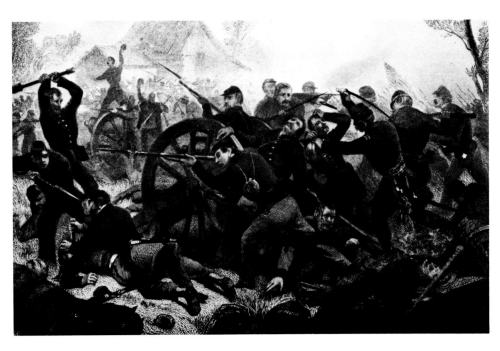

Above: Union infantry recapture an artillery battery at the point of the bayonet during the Shiloh battle.

6 April 1862

Western Theater The Battle of Shiloh, or Pittsburgh Landing, comes after several days of Confederate preparations which have gone largely unnoticed by the Federals. General Grant's troops fall back after several hours, despite the fierce defense of their position at the Hornet's Nest, a defense orchestrated by General Prentiss' division. While the initial force of Confederates under General Johnston presses General William Nelson's Federals to breaking point, the day ends without any conclusive victory for either the North or the South. The following day sees the destruction of Prentiss' division and the concurrent wearing down of Beauregard's troops. The Confederate command has been assumed by Beauregard after General Johnston was killed on the previous day. Fresh troops from Union General Wallace's division and from Generals Nelson and Crittenden give Grant's forces the necessary reinforcement and bolstering. In like manner, General Beauregard is waiting for 20,000 men under General Van Dorn, hoping to make another offensive for the Confederates; without Van Dorn's forces this is clearly impossible. Unfortunately for the Confederates, Van Dorn's men do not arrive; Beauregard orders a retreat to Corinth, Mississippi, leaving Northern troops to remain in much the same position they had occupied prior to the Battle of Shiloh. While it is unclear whether or not the Union has gained a great deal from the two-day clash, the Federals have maintained a firm hold on positions that they had previously taken, and they also achieve a splitting of the rebel forces along the Mississippi River and an evacuation of much of the Confederate force in Tennessee. Losses at the Battle of Shiloh total 13,047 for the North; 10,694 for the Confederates.

7 April 1862

Naval The Federal gunboats *Carandolet* and *Pittsburgh* run the Confederate installations at Island Number Ten in the Mississippi

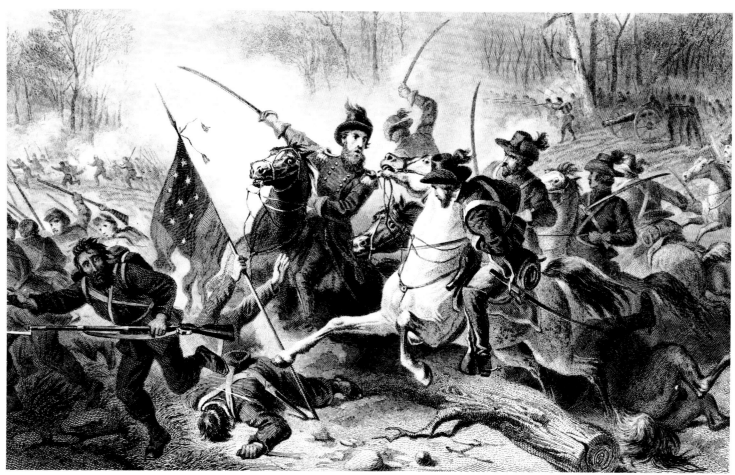

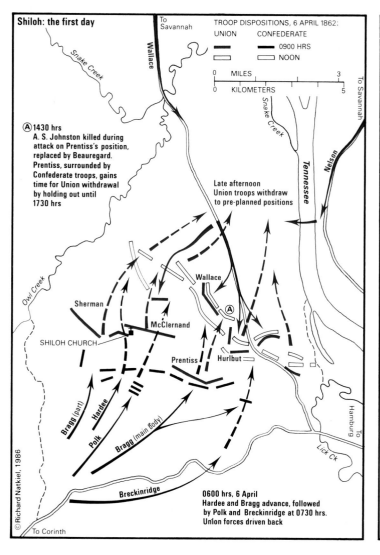

Shiloh: the first day

To Savannah

Snake Creek

Wallace

TROOP DISPOSITIONS, 6 APRIL 1862:

UNION CONFEDERATE

0900 HRS

NOON

0 MILES 3

0 KILOMETERS 5

Snake Creek

Tennessee

Nelson

Ⓐ 1430 hrs
A. S. Johnston killed during
attack on Prentiss's position,
replaced by Beauregard.
Prentiss, surrounded by
Confederate troops, gains
time for Union withdrawal
by holding out until
1730 hrs

Late afternoon
Union troops withdraw
to pre-planned positions

Owl Creek

Sherman

McClernand

SHILOH CHURCH

Wallace

Ⓐ

Prentiss

Hurlbut

Bragg (part)

Hardee

Polk

Bragg (main body)

Breckinridge

To Hamburg

Lick Ck

© Richard Natkiel, 1986

0600 hrs, 6 April
Hardee and Bragg advance, followed
by Polk and Breckinridge at 0730 hrs.
Union forces driven back

To Corinth

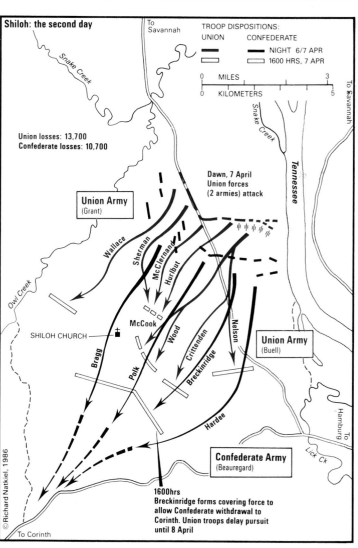

Shiloh: the second day

To Savannah

Snake Creek

Wallace

TROOP DISPOSITIONS:

UNION CONFEDERATE

NIGHT 6/7 APR

1600 HRS, 7 APR

0 MILES 3

0 KILOMETERS 5

Snake Creek

Tennessee

Union losses: 13,700
Confederate losses: 10,700

Dawn, 7 April
Union forces
(2 armies) attack

Union Army
(Grant)

Owl Creek

Sherman

McClernand

Hurlbut

Wallace

SHILOH CHURCH

McCook

Bragg

Polk

Wood

Crittenden

Breckinridge

Nelson

Union Army
(Buell)

Hardee

Confederate Army
(Beauregard)

To Hamburg

Lick Ck

© Richard Natkiel, 1986

1600hrs
Breckinridge forms covering force to
allow Confederate withdrawal to
Corinth. Union troops delay pursuit
until 8 April

To Corinth

River near New Madrid, Missouri. Under the direction of General John Pope, troops succeed in cutting a canal through the marshy area near the island, thus allowing the Federal vessels to go southward around the island and land four regiments in Tennessee below the Confederate position on Island Number Ten.

10 April 1862

Western Theater Skirmishing occurs at Fernandina, Florida, and in Illinois. Union General W H L Wallace succumbs to injuries he received at the Battle of Shiloh. In the harbor of Savannah, Georgia, Fort Pulaski readies itself for an attack by Federals. Commanded by General Quincy Adams Gillmore, the Northern assault takes place from a position opposite the fort on Tybee Island. The Confederates have about 40 guns but the Federals' long range guns and penetrating shells are a match for the masonry fort, which sustains heavy damage. The bombardment at Fort Pulaski begins at 0800 hours and continues throughout the night, the Federal guns at Tybee Island being stilled the following day at around 1400. Three hundred and sixty Confederates are taken prisoner; one Union soldier is killed, as is one Southerner.

11 April 1862

Washington In a vote of 93-39, the House of Representatives passes a bill which calls for the gradual abolition of slavery in the District of Columbia.
Western Theater In Tennessee, several hundred Confederates are captured when the town of Huntsville is occupied by Federals. The Memphis and Charleston Railroad is near to this site. The South is slowly losing its grip on Tennessee. The Union begins to marshal its forces for a push toward Confederate positions at Corinth, Mississippi. General Henry Halleck has assumed command of these troops with Generals Buell, Grant and Pope directly beneath him.
Naval At Newport News, Virginia, the *Merrimack*, the South's ironclad, seizes three small merchant ships but does not engage in conflict with the Federal vessel *Monitor* as anticipated. The *Monitor* has been awaiting the approach of the Confederate vessel, but then gives no indication of desiring an actual encounter.

12 April 1862

The North James Andrews, a spy for the Union, had led a group of 21 men through the Confederate lines in order to seize a train on the Western and Atlantic Railroad. Taking the locomotive, the *General*, Andrews and his men head northward, followed by Confederates in the locomotive *Texas*. Andrews and his men are caught by the Southern forces and are eventually executed, with the exception of 14 who are imprisoned.
Eastern Theater, Peninsular Campaign General Joseph Johnston sends troops to support besieged Yorktown, Virginia. The

Above left: General Grant leads infantry and cavalry during the decisive phase of the Battle of Shiloh.
Left: The Battle of Shiloh, showing the initial Southern advance and the subsequent attacks of Grant's Northern forces.

situation in the peninsular campaign is still one which bodes ill for the vastly outnumbered Confederates.

13 April 1862

Western Theater Fort Pulaski, Georgia, is termed a free area by General David Hunter, providing for the confiscation and setting free of all salves in the vicinity.
Trans-Mississippi The evacuation of New Mexico Territory by Confederates continues with Union soldiers pressing Southern troops back as far as El Paso.

16 April 1862

Washington President Lincoln signs a bill which will prohibit slavery in the District of Columbia.
The Confederacy In a culmination of several weeks' preparations, President Jefferson Davis gives his approval to a congressional proposal that will require a military draft in the Confederate states. This law states that 'all persons residing within the Confederate states, between the ages of 18 and 35 years . . . shall be held to be in the military service.' This action, while believed to be necessary by many due to the critical need to upgrade the military strength of the Confederacy, is nevertheless a move which is at variance with the generally accepted traditions embracing states' rights and the rugged individualism endorsed by many people in the Confederacy.

17 April 1862

Western Theater Confederate attention is focused on the increase in military strength of Federal troops at Ship Island, Mississippi, which is now supplemented by Union vessels on the Mississippi River. The latter include a fleet under Flag Officer David Farragut and Commander David Porter with a mortar fleet. The intention of these Union forces is the takeover of New Orleans, Louisiana, which is situated in what is rapidly becoming a vulnerable and defenseless position up-river.

Above left: Ormsby MacKnight Mitchel, commander of the Federal forces that captured Huntsville on 11 April 1862.
Above: Commander, later Admiral, David Porter, the North's outstanding naval leader.

18 April 1862

Eastern Theater, Peninsular Campaign Northern troops under General McDowell occupy Falmouth, Virginia, and at Yorktown a Confederate attack on Union troops is unsuccessful, the latter forces pushing the Southern troops back.
Naval As they had feared, the Confederates at Ship Island are subject to a barrage of mortar fire from Federal gunboats.

20 April 1862

Naval In a continuing bombardment of the Fort Jackson and Fort St Philip area, Federal troops attempt to open the river by removing obstructions placed there by Confederates.

23 April 1862

Naval Flag Officer David Farragut orders the Federal fleet on the Mississippi River to move past Forts Jackson and St Philip. Due to the inconclusive nature of the recent attacks on these two fortifications, it seems appropriate that the North push onward to its ultimate goal of New Orleans, Louisiana.

24 April 1862

Naval Farragut's fleet is able to slip past the Confederate forts on the Mississippi despite valiant attempts on the part of Southern forces to prevent this. The Union force makes its way up-river toward New Orleans. Encountering further Confederate resistance in the form of a ram, *Manassas*, Federals counter with their own fire, ultimately losing only the ship *Varuna* and 36 men. The Confederates lose eight ships and 61 men.

25 April 1862

Western Theater North Carolina's Fort Macon under Confederate Colonel Moses White surrenders to the Federal forces which

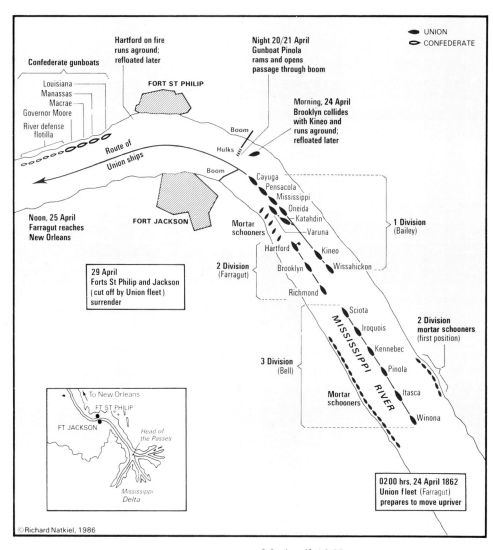

Confederate gunboats
- Louisiana
- Manassas
- Macrae
- Governor Moore
- River defense flotilla

Hartford on fire runs aground; refloated later

FORT ST PHILIP

Night 20/21 April Gunboat Pinola rams and opens passage through boom

● UNION
○ CONFEDERATE

Morning, 24 April Brooklyn collides with Kineo and runs aground; refloated later

Route of Union ships

Boom

Hulks

Boom

Noon, 25 April Farragut reaches New Orleans

FORT JACKSON

Cayuga
Pensacola
Mississippi
Oneida
Katahdin
Varuna

Mortar schooners

1 Division (Bailey)

29 April Forts St Philip and Jackson (cut off by Union fleet) surrender

2 Division (Farragut)

Hartford
Brooklyn
Richmond

Kineo
Wissahickon

Sciota
Iroquois
Kennebec
Pinola
Itasca
Winona

MISSISSIPPI RIVER

2 Division mortar schooners (first position)

3 Division (Bell)

Mortar schooners

To New Orleans
FT ST PHILIP
FT JACKSON
Head of the Passes
Mississippi Delta

© Richard Natkiel, 1986

0200 hrs, 24 April 1862 Union fleet (Farragut) prepares to move upriver

Above: The Battle of New Orleans, a successful Union attempt to force the Mississippi.

have been besieging it for nearly a month. The next day, formal ceremonies relinquish Southern jurisdiction of Fort Macon to Union General John Parke, and 400 Confederate soldiers become Northern prisoners-of-war. **Naval** Farragut's forces seize the city of New Orleans, Louisiana, which has been left defenseless after Confederate General Mansfield Lovell and his 4000 troops withdraw. There is little resistance to the Union takeover by the civilian population and four days later, on 29 April, New Orleans is formally surrendered to Federal forces.

27 April 1862

Western Theater As a result of the capture several days earlier of New Orleans, four Confederate forts – Livingston, Quitman, Pike and Wood – surrender to the North. At Fort Jackson to the south, Confederate troops mutiny against their own officers and many flee in the face of their impending imprisonment. The following day both Forts Jackson and St Philip surrender, totally removing any Confederate resistance to Northern action on the Mississippi River as far up as New Orleans. General Benjamin Butler arrives with troops, landing just north of Fort St Philip. Butler will see to the management of the captured city which is, according to his written observation of several days later, a 'city under the dominion of the mob.'

28 April 1862

Western Theater In Mississippi, General Halleck is preparing to move on General Beauregard's position at Corinth.

29 April 1862

Western Theater General Halleck continues to ready his army of over 100,000 troops so as to attack Beauregard, whose forces are considerably smaller. Skirmishing breaks out at Cumberland Gap, Kentucky, and near Bridgeport, Alabama. The conquering Federals at New Orleans post a United

States flag on the New Orleans Custom House and on the City Hall, much to the sorrow and anger of the citizenry.

1 May 1862

Eastern Theater, Peninsular Campaign The siege of Yorktown, Viriginia, continues as Federals under McClellan prepare to attack. Guns are readied for the assault scheduled to begin in several days.

3 May 1862

Eastern Theater, Peninsular Campaign Yorktown, Virginia, is evacuated by General Joseph Johnston's troops. The enormous force of the Army of the Potomac has overwhelmed the Confederates without a major battle, and the Southern troops now move toward Richmond. McClellan's forces have been successful with their siege tactics, and they enter Yorktown the following day.
Western Theater Near Corinth, Mississippi, where General Beauregard's troops are stationed, there is minor skirmishing at Farmington. General Halleck's Federals are moving now in the direction of Corinth, hoping to arrive there on the following day.

5 May 1862

Washington President Lincoln and his Secretaries of War and the Treasury, Stanton and Chase, leave the capital. They travel by ship to Fort Monroe where they will observe the Federal troops' advance into Virginia.
Eastern Theater, Peninsular Campaign As a result of the Confederate evacuation of Yorktown, there is serious fighting between advancing Federals and retreating Confederates at Williamsburg. In all, 1703 Southern soldiers are lost during the encounter which claims 456 Union troops, with 373 listed as missing.

7 May 1862

Eastern Theater, Peninsular Campaign Further clashes occur in the Shenandoah Valley; General Franklin's Federals are attacked by General G W Smith's Confederates who hope to keep the road from Williamsburg to Yorktown protected. This clash at Eltham's

Below: A Union 13-inch mortar battery prepares to open fire on Yorktown during the Peninsular campaign.

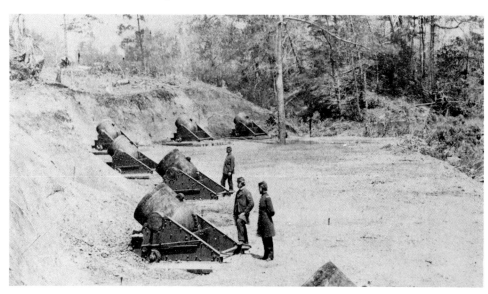

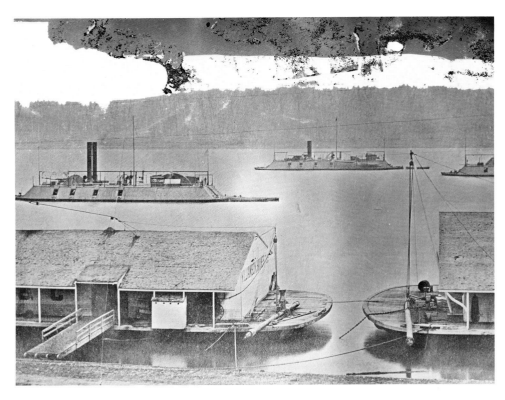

Above: The Union gunboats *Mound City* and *Cincinnati* (background) were sunk by Southern vessels on 10 May 1862.

Landing, Virginia, foreshadows the events of the upcoming week. In order to boost morale and to help encourage General McClellan to move on to Richmond, President Lincoln visits the *Monitor* and meets with various military officials.

8 May 1862

Eastern Theater The Battle of McDowell, a major encounter in the Shenandoah Valley Campaign, sees General Stonewall Jackson's Confederates repulse an attack by Federals under the command of General Robert Schenck. The Southern troops, numbering around 10,000, outfight the 6000 Union troops. Jackson's forces pursue the fleeing Federals toward Franklin, West Virginia, but continue only for several days before returning to the Shenandoah.

9 May 1862

Eastern Theater, Peninsular Campaign President Lincoln meets with General McClellan, who is advancing slowly toward Richmond, Virginia. The chief executive admonishes McClellan for his difficulties in maintaining cooperation between himself and his corps leaders. Norfolk, Virginia, is evacuated by Confederates in a costly move. While they destroy much of their supplies and equipment, they still leave a large amount of valuable material to the Federals pushing into the area the following day.
Western Theater At Hilton Head, South Carolina, General David Hunter, commander of the Department of the South, frees slaves in South Carolina, Florida and Georgia. This move, not given congressional authorization or approval by President Lincoln, is later repudiated by the chief executive. Mississippi is the scene of clashes between Confederates and advancing Federals near Corinth. Pensacola, Florida, is evac-

uated by Confederates and within three days the Union army has taken hold of the area.

10 May 1862

Eastern Theater The Federal push to gain further control in Virginia continues unabated. Jackson moves in on Franklin, West Virginia; Norfolk and Portsmouth are occupied by 5000 Union troops. This operation began with troops landing at Willoughby Point and involved, among other things, the burning of the naval yard at Gosport, Virginia. President Lincoln is personally involved in this action in that he superintends the movement of this Federal expeditionary force.
Naval At Fort Pillow, Tennessee, on the Mississippi River, a Confederate force of eight gunboats attacks seven Union vessels, the latter made up of sturdy ironclads. The Confederate flotilla is singularly ill-equipped to make this offensive at Plum Run Bend a successful one, but Captain James Montgomery commands the Confederates in a valiant manner and under his direction the Southern boats succeed in sinking the Union ironclads *Cincinnati* and *Mound City*. Despite this, the Confederate gunboats are forced, ultimately, to retreat to Memphis, Tennessee, after the Union guns disable their ships.

11 May 1862

Naval The Confederate ironclad *Merrimack*, after having confronted the Union ironclad *Monitor* in a spectacular stand-off on 9 March 1862, is destroyed by the Confederate navy. The Union troops advancing on Virginia have placed the Confederates in a situation requiring destruction of a valuable naval vessel, which would otherwise fall into enemy hands.

12 May 1862

Washington In a reversal of his blockade order, President Lincoln issues a proclamation which opens the ports of Beaufort, North Carolina; Port Royal, South Carolina; and

New Orleans, Louisiana. This order will take effect on 1 June 1862 and will provide for the resumption of commercial operations at these formerly Confederate-held ports.

13 May 1862

The Confederacy The situation at the Confederate capital of Richmond, Virginia, assumes crisis proportions in the face of advancing Federal troops. As McClellan's Army of the Potomac presses the Southerners, President Davis' wife, Varina, joins many others who leave the city.
Eastern Theater General Jackson prepares to confront Federal General Nathaniel Banks and his troops at Strasburg, Kentucky, as part of the Shenandoah Valley campaign.
Naval The Confederate steamer *Planter* is seized in Charleston Harbor by eight blacks. They pilot the vessel, which has seven guns, out of the harbor. At Natchez, Mississippi, Union gunboats under David Farragut take over jurisdiction of the city.

15 May 1862

Eastern Theater, Peninsular Campaign Land forces pressing in on Richmond, Virginia, move closer to the Confederate capital. Nearby, General Joseph Johnston's troops are moving back across the Chickahominy River. In West Virginia, at Ravenswood and Princeton, minor skirmishing occupies Confederate and Federal troops. Major fighting breaks out at Drewry's Bluff in Virginia, where Federals moving near the Confederate capital deal with gunfire from Fort Darling.
Naval The battle at Drewry's Bluff involves the Northern ironclad *Monitor* and the gunboat *Galena*. The Union force is eventually forced to retreat as the Confederate defenses at Fort Darling prove adequate.

Below: Union General Robert Schenck led his forces to defeat at McDowell during Jackson's campaign in the Shenandoah Valley.

Above: Front Royal, West Virginia, scene of a Southern victory during Jackson's onslaught against Union troops in the area.

16 May 1862

Western Theater In one of his most controversial actions to date, General Benjamin Butler at New Orleans, Louisiana, issues what is known as the 'Woman Order.' The full text of this *General Order Number 28* is indicative of Butler's complete disregard for convention and his, at times, tyrannical attitude toward the citizens of this vanquished city. The order reads, in part, 'As the officers and soldiers of the United States have been subjected to repeated insults from the women (calling themselves ladies) of New Orleans . . . when any female shall . . . show contempt for the United States, she shall be regarded as a woman of the town plying her avocation.' The Woman Order, while not revoked by the Lincoln administration, helped to set the stage for Butler's removal from the military governorship of New Orleans on 16 December 1862. The day after the issuance of the Woman Order, Butler stops the New Orleans newspapers *Bee* and *Delta* under the control of Federal authorities.

17 May 1862

Eastern Theater, Peninsular Campaign General McDowell is at Fredericksburg, Virginia, and receives orders to advance toward the Confederate capital in order to be in concert with McClellan's forces.

18 May 1862

Eastern Theater, Peninsular Campaign In Virginia, Union troops press closer to Richmond, taking Suffolk and occupying that town 17 miles south of Norfolk. In the Shenandoah Valley, Confederate General Stonewall Jackson continues to harry the Federals, clashing with General Nathaniel Banks.
Naval Vicksburg on the Mississippi River is the object of David Farragut's advance with a Federal fleet, the city being under the protection of Confederate General M L Smith who will not surrender jurisdiction to the North. It is important to the Federals to take possession of this large Confederate city since it

commands an important strategic position on the Mississippi.

19 May 1862

Washington In an action reversing an earlier decision made by General David Hunter, President Lincoln countermands the order of 9 May 1862 which liberated slaves in the Department of the South. Lincoln's position is that General Hunter had exceeded his official authority in issuing such a liberation order, and that such decisions are to be made only by the chief executive.
The Confederacy President Jefferson Davis, in continued communication with his wife, indicates the Confederate position concerning preparation for the Federal offensive on Richmond, Virginia: 'We are uncertain of everything except that a battle must be near at hand.'
Eastern Theater, Peninsular Campaign There is little change in the continuing build-up of Union troop strength in the area surrounding Richmond, Virginia.

20 May 1862

Washington President Lincoln signs a bill authorizing the Homestead Act. Designed to aid the private citizen who wishes to obtain quality land at affordable rates, the Homestead Act also makes 160-acre quarter sections available for a nominal fee to those who can improve the parcel of land for five years. This is later to be considered a critical instrument in the settlement of the West and the development of western agricultural lands.
Eastern Theater, Peninsular Campaign The Army of the Potomac under General McClellan is now only eight miles from Richmond, Virginia, the Confederate capital. In an attempt to prevent Union General Nathaniel Banks from moving troops to meet and support McClellan, Confederate Generals Stonewall Jackson and Richard Ewell take their 16,000 men into the Luray Valley area of the Shenandoah. By moving north Jackson hopes to block Banks' path out of the western reaches of the Shenandoah. The Virginia Central Railroad is attacked by Union troops at Jackson's River Depot.

21 May 1862

Eastern Theater, Peninsular Campaign General McClellan continues to ask President Lincoln for more troops to augment the Army of the Potomac; this time he requests help from McDowell's forces which are en route to Richmond, Virginia.

22 May 1862

Eastern Theater, Peninsular Campaign General Stonewall Jackson pushes nearer Front Royal, West Virginia, in preparation for a major engagement with Federals on the following day.
Western Theater General Henry Halleck continues to direct his troops in the skirmishing which occurs at Corinth, Mississippi, between the Federals and the Confederate forces under General Beauregard.

23 May 1862

Eastern Theater After having journeyed to Fredericksburg, Virginia, President Lincoln confers with General McDowell who is positioned at Aquia Creek and Fredericksburg. The following day, Lincoln sends orders to McDowell, telling the general to direct 20,000 troops into the Shenandoah area in order to prevent Confederates from moving their forces any closer to Banks' troops of the Army of the Potomac. Lincoln tells McDowell, 'Your object will be to capture the forces of Jackson and Ewell.' At Front Royal, West Virginia, General Jackson's troops encounter 8000 Union soldiers and take the area from Federal control. This victory is a relatively easy one and does little to improve Banks' position, which is now seriously threatened.

24 May 1862

Washington President Lincoln confers with his cabinet; the result of this discussion is the issuance of new military orders to General Frémont. The general is instructed to

Below: Union General Benjamin Butler, the highly unpopular officer in charge of affairs in New Orleans, Louisiana.

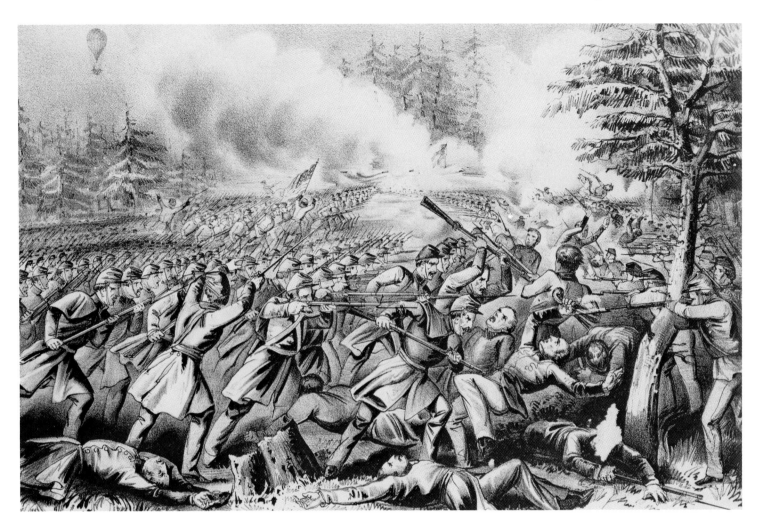

advance against General Jackson's forces in the Shenandoah Valley. Because of Lincoln's new orders to General McDowell, also concerning Jackson, the president communicates the information to General McClellan that an increase in his strength is impossible.

25 May 1862

Washington Communications between the president and General McClellan continue as Lincoln presses his general in chief to 'either attack Richmond or give up the job and come to the defense of Washington.' The Union Secretary of War Edwin Stanton puts out a call for additional men to be supplied by any state that can spare more troops. Orders go out to give military transport top priority on railroad lines in the North.

Eastern Theater In the Shenandoah Valley, at Winchester, Virginia, General Stonewall Jackson attacks Federal positions. While the Federals maintain their stance for a time, the offensive on the right, by troops under the command of Jackson, and on the left by Ewell's troops, eventually compel General Nathaniel Banks' forces to pull back in a retreat toward Harper's Ferry, Virginia. This encounter at Winchester claims 400 Confederate casualties – 68 dead, 329 wounded, three missing. General Banks' troops had totaled nearly 8000 at the start of this clash; he lost 62 men, with 243 wounded and 1714 either missing or captured.

26 May 1862

Washington The discussion over allocation of troop strength and movement continues as President Lincoln asks General McClellan,

'Can you get near enough to throw shells into the city?'

Eastern Theater There is little that Union General Nathaniel Banks can do but continue to move back away from Jackson's Confederates after the defeat at Winchester, Virginia. Banks moves the following day across the Potomac River into Federal territory near Williamsport.

29 May 1862

Eastern Theater, Peninsular Campaign Various actions occur to consolidate the Federal position near Richmond, Virginia. Approximately 40,000 Union troops gather near Jackson's Confederates at Harper's Ferry. There is skirmishing at the South Anna River in Virginia, where Federals burn a 500-foot bridge and ultimately capture the nearby town of Ashland.

Western Theater The pressure that General Halleck's Federals have put on General Beauregard's troops at Corinth, Mississippi, has finally caused the Confederate general to give orders for his men to retreat toward Tupelo, Mississippi.

30 May 1862

Eastern Theater, Peninsular Campaign At Front Royal in West Virginia Union troops under General Shields occupy the town after a minor clash with General Jackson's retreating Confederates. Jackson is pulling away from the Harper's Ferry area so as to avoid being cut off by Frémont and McDowell.

Western Theater At Corinth, Mississippi, over 2000 prisoners are taken by Federal troops moving into the city. General Beaure-

Above: The Battle of Fair Oaks, Virginia, did little to ease the pressure on Richmond despite being a Southern victory.

gard's Confederates have destroyed much of value that could not be taken out of Corinth; General Halleck's success in occupying the city is a real one but it is a success which lacks some degree of triumph simply because the campaign has taken over one month to reach fruition.

31 May 1862

Eastern Theater, Peninsular Campaign Movements by Confederate General Joseph Johnston and McClellan's Army of the Potomac result in a major operation at the Battle of Fair Oaks, or Seven Pines. This somewhat delayed offensive by Johnston is only marginally effective strategically, causing the Federal troops to pull back on the following day, but doing little to lessen the threat posed to the Confederate capital at Richmond, Virginia. In all, Confederate losses are 6134 while Union troops lose 5031. General Johnston is wounded in this battle, causing Confederate President Jefferson Davis to name General Robert E Lee as commander of the Army of Northern Virginia.

1 June 1862

Washington President Lincoln sends a telegram to General McClellan concerning the situation at Richmond, Virginia. He tells the general: 'Hold all your ground, or yield any only inch by inch and in good order.'

Eastern Theater, Peninsular Campaign General Jackson's Confederate troops meet

those of Union General McDowell as Jackson continues to retreat to a position near Harrisonburg, Virginia.

3 June 1862

Western Theater The Confederate garrison at Fort Pillow near Memphis, Tennessee, evacuates its position, leaving the city helpless in the face of advancing Union troops which have already taken Corinth, Mississippi. McClellan's forces meet and skirmish with Confederates on James Island, South Carolina. This is a position near Charleston, which is the object of the Federal advance in that area.

4 June 1862

Eastern Theater, Peninsular Campaign Richmond, Virginia, remains threatened by the Army of the Potomac which is resting after the Fair Oaks battle earlier in the week. Some skirmishing does occur, however, mainly in West Virginia, near Big Bend. General Stonewall Jackson and his Confederate troops continue to pull back into the Shenandoah Valley.

5 June 1862

Eastern Theater, Peninsular Campaign Inclement weather prevents General McClellan's forces from pushing toward Richmond, Virginia, where the Confederates anticipate attack from the Union army and where Confederate General Robert E Lee is preparing a defensive operation with the Army of Northern Virginia.
Trans-Mississippi Skirmishing breaks out at various locations – Sedalia, Missouri; Round Grove, in Indian Territory; and near the Little Red River in Arkansas.
Naval The Federal fleet which is moving toward Memphis, Tennessee passes Fort Wright and Fort Randolph unharrassed. The

Below: Frame House, the site of a Union field hospital during and after the Battle of Fair Oaks, Virginia.

five ironclads and four rams making up the Union flotilla are under the direction of Commodore Charles Davis. They come to rest at anchor two miles above Memphis.

6 June 1862

Naval Confederate Captain James Montgomery, with an inadequate force of gunboats, engages the Union flotilla at a point near Memphis, Tennessee. Commodore Davis' resources far exceed those of the Confederates, who have only 28 guns compared to the Union strength of 68 guns. As crowds gather in the pre-dawn hours, the Federals and Confederates clash, and within two hours the latter force has been almost completely disabled. The one vessel, *Van Dorn,* left to the Confederates after the river battle,

Above: General George Stoneman and his staff pose for the camera in the vicinity of Fair Oaks in June 1862.

escapes. Triumphant Federals accept the surrender of Memphis shortly before noon. This battle is significant in that it opens the Mississippi region.

7 June 1862

Eastern Theater, Peninsular Campaign As Confederates retreat, coming closer to Harrisburg, skirmishing breaks out at Union Church, Virginia, when they meet advancing Northern troops. Reconnaissance efforts on the part of Federals at Chickahominy Creek bring those troops close to the Confederate capital of Richmond, where General Lee is readying his Confederates for an offensive, as well as for the defense of the city.
Western Theater The difficult relations engendered by Union General Benjamin Butler's treatment of New Orleans citizens are made even more uncomfortable when Butler orders William Mumford hanged. Mumford, having removed and destroyed the United States flag on display over the New Orleans Mint, was seized, imprisoned, tried and found guilty of treason against the Federal government.

8 June 1862

Eastern Theater, Peninsular Campaign Near Port Republic, Virginia, the Battle of Cross Keys nearly causes the retreat of Confederate forces. While Jackson's troops are advancing against General Frémont's Federals, Confederate General R S Ewell is the commander of forces which are able to hold off the Union troops and defend General Jackson's men. The Federals, numbering 10,500, are held off by 6500 of Ewell's troops.

9 June 1862

Eastern Theater, Peninsular Campaign Fighting continues in the area of Cross Keys, Virginia, but the battle today between Jack-

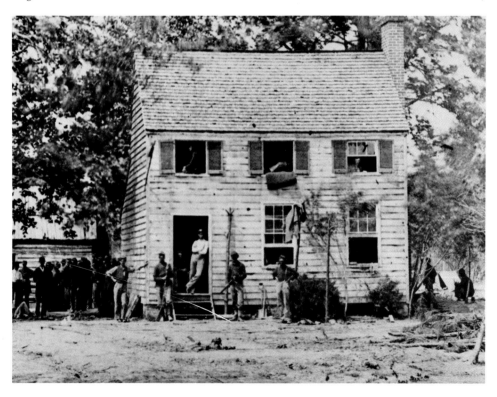

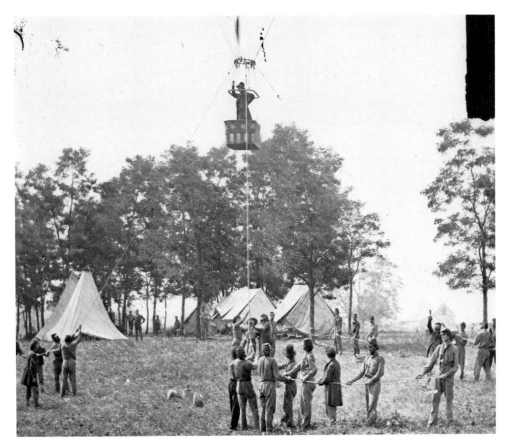

Above: A Union observation balloon rises into the sky to carry out intelligence duties during the Peninsular campaign.

son's troops and those of Frémont and Shields takes place at Port Republic. The Confederates make a strong stand and eventually push the Northern troops back. General Ewell's Confederates are an important resource in this offensive as they hold Frémont's men away from Jackson's main force. The battle here at Port Royal and the previous day's encounter at Cross Keys signal the end of Jackson's current campaign in the Shenandoah.

12 June 1862

Eastern Theater, Peninsular Campaign In one of the more flamboyant moves of the war, Confederate General J E B Stuart takes a force of cavalry and artillery out on a reconnaissance of the Federal positions on the Peninsula. This action, which covers a period of several days, is an important one as it disturbs supply and communication networks. Riding completely around McClellan's Union army force, General Stuart seriously undermines the morale of the Federals who feel threatened by what is a seemingly larger enemy force than actually exists. This move (which comes to be known as Stuart's First Ride Around McClellan) is responsible for encouraging Southerners who have been suffering from numerous defeats and invasions over the past months. Stuart's move is buttressed by Jackson's forces who are reinforced at Lee's command and add to the threat posed by cavalry under Stuart.

16 June 1862

Western Theater At James Island, South Carolina, Federal troops engage in a battle at Secessionville. The losses are significant,

Union General H W Benham's forces losing 107 men, with 487 wounded and 89 missing. The Confederates under General N G Evans lose 52, with 144 injured and eight missing. The Union force is repulsed despite its vigorous assault on a position which is critical to the control of Charleston Harbor. In Winchester, Tennessee, skirmishes break out.

17 June 1862

Washington President Lincoln oversees the reorganization of commands in the East. Resentful at being placed under General John Pope, General John Frémont resigns from the new Army of Virginia. General Franz Sigel steps into the vacancy created by Frémont's resignation. This move by Frémont places him in a position of ambiguity and he spends the remainder of the war in New York, hoping for further orders.

Naval In Arkansas, on the White River, Union gunboats draw fire from Confederate batteries positioned at St Charles. The Federal steamer *Mound City* is severely damaged when her boiler explodes, killing and wounding 125 men.

19 June 1862

Washington President Lincoln outlines his controversial Emancipation Proclamation which outlaws slavery in all the states which continue to be in rebellion against the Federal government.

20 June 1862

Western Theater The Federal advance against Vicksburg, Mississippi, has begun under the command of General Thomas Williams. Admiral David Farragut aids in the attempt by providing gunboat protection. Confederates under General Van Dorn, who commands the Department of Southern Mississippi and Louisiana, attempt to further fortify the city.

21 June 1862

Eastern Theater, Peninsular Campaign While the Richmond, Virginia, area remains calm and quiet as a whole, there is some minor skirmishing between Federals and Confederates at the Chickahominy Creek. The Northern and Confederate armies are both awaiting the inevitable battle; as President of the Confederacy Jefferson Davis points out in a letter, 'A total defeat of McClellan will relieve the Confederacy of its embarrassments in the East.'

Below: Union engineers put the finishing touches to a bridge on the Chickahominy, 18 June 1862, prior to the Seven Days campaign.

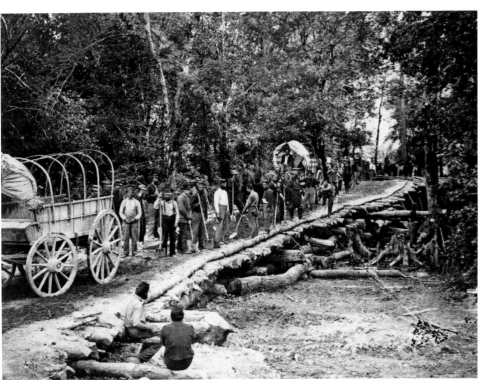

Above: President Lincoln reads a draft of his Emancipation Proclamation to members of his government.

23 June 1862

Washington President Lincoln leaves the Federal capital on a trip to New York and West Point. The president intends to discuss current and future military strategies with the retired General Winfield Scott.

24 June 1862

Eastern Theater, Peninsular Campaign White House, Virginia, is evacuated as McClellan's troops press forward, and at Mechanicsville there is minor skirmishing between Confederate and Union soldiers.
Western Theater General Van Dorn's troops are at beleaguered Vicksburg, Mississippi, where 3000 Federals are encamped close-by.

25 June 1862

Eastern Theater, Peninsular Campaign An effort by Confederates to deflect what they fear will be a crippling blow to Richmond, the Confederate capital, begins with the Seven Days campaign. The first of a series of engagements, at Oak Grove, sees Confederate General John Magruder conduct operations calculated to confuse Federals into assuming a larger Confederate force than is actually assembled. While Magruder attempts this, General Lee attacks McClellan's forces gathered east of Richmond; despite a relatively ineffective assault on the Union troops, General McClellan is considerably more concerned than he had previously been about his army's safety. A total of 51 killed, 401 wounded and 64 missing on the Federal side results from this engagement; Confederates lose 40 men with 263 injuries and 13 missing.

27 June 1862

Eastern Theater, Peninsular Campaign The Battle of Gaines' Mills, the third in a series in the Seven Days campaign, sees General Lee's troops break through Federal lines and follow the Northern force as it heads for Harrison's Landing, Virginia. The Federals are undaunted, however, and the Confederate

command is not able to take advantage of the weaknesses in the Union lines. General Porter takes his Federal troops back across the Chickahominy to rejoin McClellan's main army. General Magruder, south of the Chickahominy, continues to press the Union troops there with a greatly outnumbered force of Confederates. The results of the Gaines' Mills battle is a total of 6837 casualties for the North as compared to 8750 for the South. As McClellan pulls his army back, the Confederates see some relief in the strain placed on their defenses at Richmond.

28 June 1862

Eastern Theater, Peninsular Campaign At Garnett's and Golding's Farms, fighting between Confederate and Union troops continues in Virginia. The Northern forces are pulling away from Richmond in the direction of the Potomac River. At White House Landing, Northern troops destroy supplies and equipment as they complete their evacuation of the area.

Naval Admiral David Farragut takes his fleet past Confederate shore batteries at Vicksburg, Mississippi, losing 15 men and sustaining injuries to 30 others. All but three Federal vessels succeed in slipping past the Confederate fortifications but this in no way indicates an easy victory over the Confederates at Vicksburg. The Northern offensive will continue for over a year.

29 June 1862

Eastern Theater, Peninsular Campaign The Seven Days campaign continues as Southern troops clash with Union forces at Savage's Station. This battle sees Federals withdraw east of Richmond, Virginia, toward the James River, leaving behind over 2000 injured and ailing soldiers. It is a battle that can only be considered inconclusive.

30 June 1862

Eastern Theater, Peninsular Campaign At White Oak Swamp, Virginia, the sixth in a series of battles occurs as Union soldiers under General McClellan attempt to consolidate their positions, succeeding to a certain degree in comparison to Longstreet's and Jackson's troops which seem plagued by confusion. It is in part this confusion and lack of coordination which allows McClellan to assume a safely entrenched position on Malvern Hill to the north of the James River.

1 July 1862

Washington President Lincoln signs into law a Federal tax which levies a three percent rate on annual incomes of $600 to $10,000 and five percent on incomes above $10,000. Unlike a similar act passed in the previous year, this one actually goes into effect.
Eastern Theater, Peninsular Campaign The defeat of Confederate troops after a short battle at Malvern Hill spells the end of the Seven Days campaign in Virginia. Confeder-

Below: A sign of war weariness in the South during the second year of the conflict; the issue of conscription was hotly debated on both sides during the civil war.

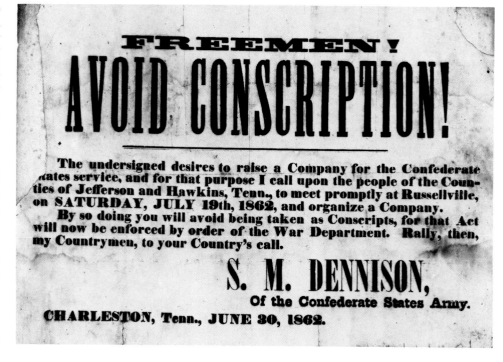

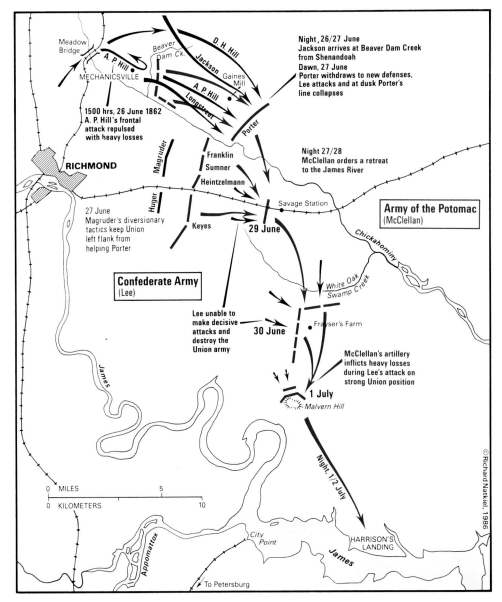

Above: Union attempts to capture Richmond during the Seven Days battles.

Eastern Theater, Peninsular Campaign Harrison's Landing, Virginia, is the goal of McClellan's army which is retreating from its recent battle at Malvern Hill. Some minor skirmishing breaks out as the Union forces pull away.

ate troops under General Lee attack McClellan's Army of the Potomac at a point north of Richmond, Malvern Hill. In this battle, the Confederate forces appear disorganized and make only minimal impact on Union troops which are equipped with better guns. Despite this final assault which goes badly for the South, the Northern army is prevented from taking the Southern capital of Richmond, Virginia. And despite the ability of Lee's forces to hold the Federals at bay, the Union Army of the Potomac is not destroyed or even seriously disabled. Throughout the Seven Days campaign there are thousands of casualties – the North tallying nearly 16,000 dead, injured and missing. Confederates estimate over 20,000 casualties.

2 July 1862

Washington In a move which is later to become important to the further development of vast agricultural lands in the West, President Lincoln signs the Morrill Land Grant Act. This law will give states apportionments of public land on which to build agricultural colleges. This important act is introduced in Congress by Senator Justin Morrill of Vermont.

4 July 1862

Washington This 86th celebration of Independence Day is observed with more than the usual enthusiasm.

Western Theater In Kentucky, Confederate Colonel John Hunt Morgan begins a series of raids which later earn him recognition from the Confederate Congress for his 'varied, heroic and invaluable services in Tennessee and Kentucky.'

7 July 1862

The North General McClellan, having reached Harrison's Landing on the James River, is visited by President Lincoln. In view of the recent difficulties faced by the Army of the Potomac which were, in McClellan's opinion, exacerbated by Lincoln's refusal to send more troops to aid in the peninsular campaign, the general delivers a letter to the president. In this letter, General McClellan points out what he perceives as weaknesses in Lincoln's current military and political strategies. He attempts to persuade the president to maintain a more conservative approach in conducting the war, urging that the war 'should not be at all a war upon population, but against armed forces and political organizations.'

9 July 1862

Western Theater Confederate John Hunt Morgan seizes Tompkinsville, Kentucky. The Confederate colonel and his cavalry unit are continuing to carry out a series of raids against Federal positions.

Naval At Hamilton, North Carolina, Confederate positions on the banks of the Roanoke River fall into Federal hands. Several Confederate vessels are taken by the North, and about 35 Southerners are killed. The Federals lose two men and sustain 10 injuries.

10 July 1862

Eastern Theater The Northern Army of Virginia commanded by General John Pope is positioned in the Shenandoah Valley.

Below: A scene from the inconclusive Battle of White Oak Swamp during the Union drive to reach the Confederate capital.

General Pope makes clear that civilians in the area are obligated to give aid to and prevent disruption of the Federal military efforts there. Pope prescribes harsh treatment in response to any resistance from the people in the Shenandoah Valley.

Western Theater Colonel Morgan and his raiders press Federals in Kentucky, and the Southern commander urges the people of the area to 'rise and arm, and drive the Hessian invaders from their soil.'

11 July 1862

Washington President Lincoln appoints General Henry Halleck to the position of general in chief of the Federal army. Halleck has proven to be an able and far-sighted leader, and his most recent actions at the successful seizure of Corinth, Mississippi, suggest that he will continue to exhibit sound judgment in military matters.

Below: General Henry Halleck was promoted to the position of Union general-in-chief by Lincoln on 11 July 1862.

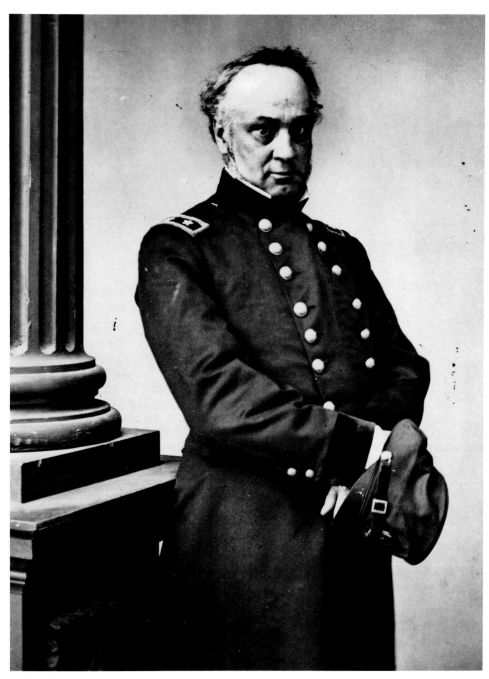

13 July 1862

Washington President Lincoln is in correspondence with General McClellan over the allotment of soldiers for the attempted seizure of Richmond, Virginia. It is becoming increasingly difficult for Lincoln to ignore the fact that McClellan has yet to launch an effective offensive on the Peninsula.

Eastern Theater Movement of General Lee's Confederates away from Richmond, Virginia, suggests the beginning of another campaign against the threatening Northern forces. A bridge near Rapidan Station, Virginia, is destroyed by Northern troops as they skirmish with Confederates at this point on the Rapidan River.

Western Theater At Murfreesboro, Tennessee, Federal forces are defeated by General Nathan Bedford Forrest's 1000 troops. Northern General Thomas Crittenden and his men make a valiant defense but are overpowered and nearly all are captured by the Confederates. The North loses a large amount of valuable military equipment and supplies in this raid on their position at Murfreesboro.

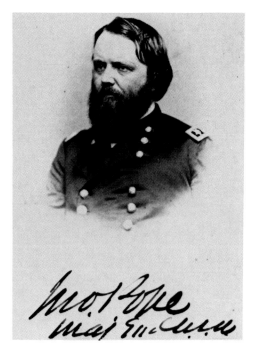

Above: Union General John Pope, commander of the North's Army of Virginia during the Shenandoah Valley battles.

14 July 1862

Washington President Lincoln asks Congress to approve a law which will compensate 'any state which may abolish slavery within its limits.' The congressional approval that Lincoln seeks is not forthcoming, however, as 20 border states disagree with the president's plan. In a separate action, Congress passes a law creating the state of West Virginia which has seceded from the state of Virginia as a result of the split between North and South.

Eastern Theater The Union Army of Virginia under General John Pope's command receives orders from him concerning its conduct toward the enemy. In this famous address to the Northern troops, General Pope makes clear his stance and that which he expects his army to take: 'The strongest position a soldier should desire to occupy is one from which he can most easily advance against the enemy.'

15 July 1862

Naval In a spectacular battle on the Mississippi, the Southern ironclad *Arkansas* engages three Federal vessels, and proceeds down river. Near the City of Vicksburg, Admiral David Farragut atttacks the *Arkansas* with the Federal fleet but to no avail. The Union loses 18 men, sustains 50 injuries and lists 10 men as missing. Confederates tally 10 killed and 15 wounded.

17 July 1862

Washington The Second Confiscation Act is signed into law by President Lincoln. This act provides for the freedom of those slaves coming into Federal jurisdiction from outside the Union, and also gives the president certain powers to grant amnesty and pardon in cases where he deems such actions appropriate. (This act supplements, in many ways, the Emancipation Proclamation as it deals with slaves outside the Confederacy. The Emancipation Proclamation is concerned

with the disposition of those slaves who are in the territories in rebellion.)

Western Theater Confederate raiders under Colonel John Hunt Morgan make a surprise attack on Northern troops at Cynthiana, Kentucky. After several hours of fighting to defend their positions there, the Federals are overcome and Southern troops occupy the town. At this engagement, 17 Federal soldiers and 24 Confederates are killed. Skirmishing also occurs at Columbia, Tennessee.

20 July 1862

Western Theater Colonel Morgan's Confederate raiders are surprised by Union cavalry near Owensville, Kentucky, with the result that the Southern soldiers are dispersed, the Federals taking horses and equipment from them.

22 July 1862

Washington President Lincoln presents his Emancipation Proclamation to his cabinet. This action produces surprise in most quarters. The War Department announces that the military is empowered to employ as paid laborers any persons of African descent.

23 July 1862

Eastern Theater Confederates near Carmel Church, Virginia, are attacked by Federal cavalry. In Northern Virginia, General John Pope announces that all disloyal citizens within his jurisdiction are to be arrested.

Western Theater Confederate troops under General Braxton Bragg are advancing on Chattanooga, Tennessee, from their base at Tupelo, Mississippi.

27 July 1862

Trans-Mississippi There is skirmishing at various points between Federals and Confederates: near Brown's Spring, Missouri; in Carroll, Ray and Livingston counties in that state; and in Indian Territory.

28 July 1862

Trans-Mississippi Confederates lose 10 men at Bollinger's Mills, Missouri, as Federal forces make a successful assault on the Southern position there.

29 July 1862

Trans-Mississippi At Moore's Mills in Missouri, Confederates are routed by Union guerrillas. Southern losses tally at 62 dead, 100 wounded. Federals lose 16 men and sustain 30 injuries.

International Union officials in England are unsuccessful in an attempt to prevent the Confederate vessel *Alabama* from sailing out of Liverpool. Commanded by Captain Raphael Semmes, the *Alabama* will inflict much damage on Federal vessels in Atlantic waters, and is the ship responsible for a series of claims against the British government brought by United States ambassador Charles F Adams.

1 August 1862

Eastern Theater Federal troops under General McClellan, stationed at Harrison's Landing, Virginia, are bombarded by Confederate batteries. The Federals return the fire and silence the Confederate guns.

Trans-Mississippi Skirmishing breaks out in Missouri at Ozark, Grand River and Carrolton. In addition, at Newark, Missouri, Northern soldiers battle unsuccessfully with Southern troops resulting in the former's capitulation after several hours. About 70 Federals surrender to the Confederates in this action, while Southern casualties tally over 100 dead and injured.

2 August 1862

Washington Secretary of State Seward communicates the Federal government's position on mediation offers from Britain. Seward counsels United States ambassador to Britain, Charles F Adams, to decline any suggested mediation of the ongoing civil conflict in the United States.

Eastern Theater Orange Court House, Virginia, having been occupied by several Southern cavalry regiments, is seized by troops from General John Pope's Army of Virginia. These forces cross the Rapidan River, clashing with Confederates who lose 11 men and see 52 taken as prisoners; the Federals sustain five casualties in this encounter. Malvern Hill, Virginia, is retaken by troops from General McClellan's Federal Army of the Potomac.

3 August 1862

Washington General in Chief Henry Halleck sends orders to General McClellan that the Army of the Potomac is to be relocated. In order to better provide for the defense of the Federal capital, McClellan's troops are to be stationed at Alexandria and at Aquia Landing in Virginia. This conflicts with McClellan's views of the military needs of the Peninsula, and the general clashes bitterly with Halleck over this order.

4 August 1862

Washington The president issues military orders which are to provide for a draft of upwards of 300,000 men. This order never goes into effect, but in a separate action Lincoln makes provision for the recognition and promotion of competent military personnel. President Lincoln also declines the opportunity to enlist two black regiments from Indiana.

5 August 1862

Western Theater At Baton Rouge, Louisiana, Confederate forces attack Union troops stationed there. General John Breckenridge and about 2600 Southerners fight with 2500 Union soldiers under the command of General Thomas Williams, who is subsequently killed. The Confederates are eventually pushed back to a point some 10 miles out of the city, due in part to the inability of the Southern gunboat *Arkansas* to relieve the land forces. At this battle, Federals lose 383 men, the South tallies 453 dead. In Tennessee, Fort Donelson is attacked and the Union troops garrisoned there push the Southerners back after a fierce fight.

7 August 1862

Eastern Theater Confederate troops in Virginia push toward Union positions at Culpeper Court House and Madison Court House. Federals pull back from their recently recovered position at Malvern Hill, and there

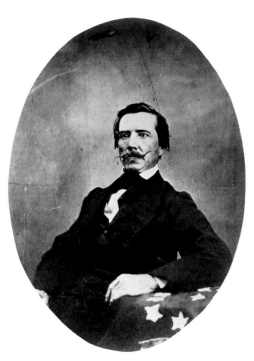

Above: Captain Raphael Semmes commanded the successful Southern commerce-raider *Alabama* during the civil war.

is skirmishing between Federals and Southern troops at Wolftown, Virginia.

Trans-Mississippi Fort Fillmore in the New Mexico Territory witnesses the routing of Confederate troops in the area by Federal forces under Colonel E R S Canby. Montevallo, Missouri, is the site of skirmishing.

8 August 1862

Washington Secretary of War Stanton orders that anyone attempting to evade military service shall be subject to arrest.

Western Theater At Cumberland Gap in Tennessee, Confederates and Federals engage each other in fighting which ultimately leaves the Southern troops the losers – they tally 125 killed and injured as compared to Union casualties of three dead and 15 wounded.

9 August 1862

Eastern Theater, Second Bull Run Campaign At Cedar Mountain, Virginia, General Jackson's Confederates are positioned near Culpeper, and intend to strike the Union forces under General John Pope. In what is ultimately an unsuccessful action, General Banks and his Federals attack Jackson. This attack is foiled by General A P Hill's arrival; the Confederate troops under Hill manage to push Banks' forces back. It is by now clear to General Jackson that McClellan's Army of the Potomac will be moving into the region with reinforcements for Pope's troops. At this Battle of Cedar Mountain, the beginning of the Second Bull Run campaign (also known as Second Manassas) that lasts until September 1862, Union losses tally at 314 dead, 1445 injured, 622 missing. Southern forces report 1341 casualties.

11 August 1862

Western Theater Various actions occur – near Columbia, Tennessee, there is minor fighting between Southern troops and

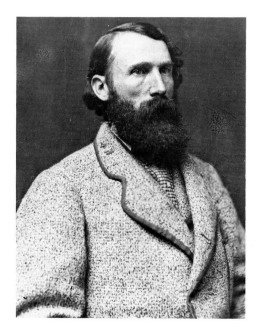

Above: General Ambrose Hill, one of the key figures in the South's victory at the Battle of Cedar Mountain, Virginia.

Northern forces while similar clashes occur near Williamsport, also in Tennessee. In Corinth, Mississippi, an announcement by Union General Ulysses Grant states that those fugitive slaves in the area under his jurisdiction shall be employed by the military authorities.

12 August 1862

Western Theater Confederate Colonel John Hunt Morgan carries out a raid on Gallatin, Tennessee, the result of which is the capture of the town where a Federal garrison, composed of four companies, is stationed. This takeover is short-lived, however, as Gallatin falls back into Union hands within 24 hours.

Below: Union troops storming Southern positions on the edge of a wood during the Cedar Mountain battle.

13 August 1862

Eastern Theater, Second Bull Run Campaign Various minor skirmishes occur between Southerners and Northern troops in Virginia near Orange Court House. General Robert E Lee's forces begin to advance on Gordonsville, where this Army of Northern Virginia will soon be immersed in the Second Battle of Bull Run.
Trans-Mississippi Confederates clash with, and are defeated by, Northern forces at Yellow Creek in Missouri. Around 60 Southern soldiers fall into Union hands after this engagement.
Naval The Potomac River is the site of a collision between two Federal steamers, the *George Peabody* and the *West Point.* A total of 83 lives is lost in this accident.

16 August 1862

Eastern Theater, Second Bull Run Campaign Following orders, General McClellan moves out of Harrison's Landing in Virginia with his Army of the Potomac. He proceeds northward to meet General Pope's Federals near Alexandria. Skirmishing breaks out in West Virginia at Wire Bridge.

17 August 1862

Trans-Mississippi Minnesota sees the beginning of a six-week uprising of Sioux Indians, who are in revolt because of living conditions on their reservations. After nearly 300 whites are massacred by the Indians, Federal forces led by General H H Sibley are finally able to quell the uprising which continues until 23 September 1862.

18 August 1862

Eastern Theater, Second Bull Run Campaign In order to protect his troops from Lee's advancing forces while waiting for the arrival of McClellan's army, General John Pope retreats to the north. At this time, information regarding Lee's movements has been captured by the Federals. Pope is now situated across the Rappahannock River from Lee's Army of Northern Virginia. Skirmish-

ing breaks out at Rapidan Station and Clark's Mountain in Virginia.
The Confederacy At Richmond, Virginia, the Second Session of the Confederate Congress assembles. President Jefferson Davis makes a statement concerning the Southern nation's progress. While railing against the Union army's treatment of Southerners, Davis also speaks encouragingly about 'our final triumph in the pending struggle against despotic usurpation.'
Western Theater In Tennessee, Clarksville is surrendered to Confederate forces. The Union commander there, Colonel R Mason, puts up no resistance to Southern troops prior to surrendering the city; he is later to be removed from military duty 'for repeated acts of cowardice.'

19 August 1862

The North Editor of the *New York Tribune* Horace Greeley speaks out on the slavery issue, criticizing President Lincoln's stance. In his letter to the *Tribune,* titled 'The Prayer of Twenty Millions,' Greeley says, 'All attempts to put down the Rebellion and at the same time uphold its inciting cause are preposterous and futile.'
Trans-Mississippi The Sioux Indians continue their uprising, creating major difficulties in Minnesota; the following day, Fort Ridgely is attacked by Indians but manages to withstand the assault.

20 August 1862

Eastern Theater, Second Bull Run Campaign General McClellan's Army of the Potomac continues to advance toward a position near Alexandria, Virginia, in order to reinforce General Pope's troops. The latter have encountered Jackson's men at various points in the area between Culpeper and the Rappahannock.

21 August 1862

Eastern Theater, Second Bull Run Campaign Confederate troops crossing the Rappahannock encounter strong resistance from

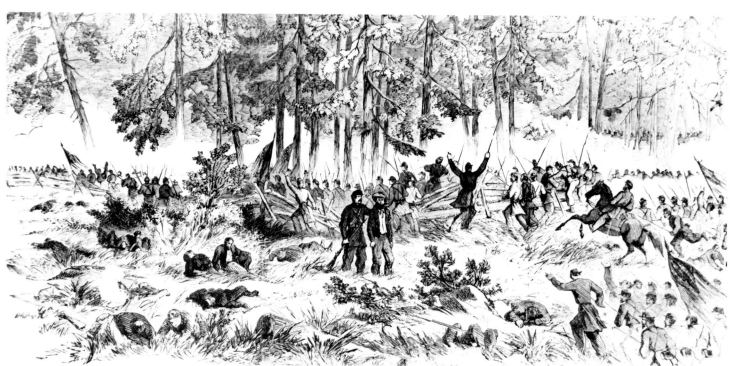

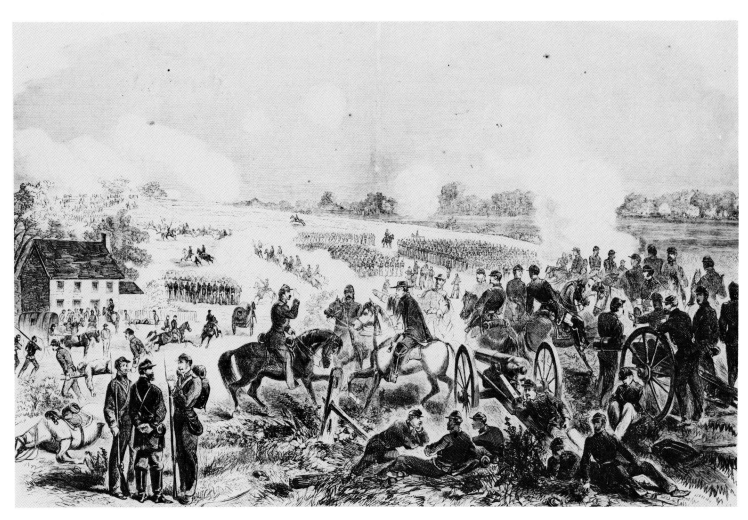

Federals; over 700 Southern soldiers lose their lives in this operation and nearly 2000 are captured by Union troops.

Western Theater In Tennessee, Confederate General Braxton Bragg moves his forces to a position above Chattanooga, and Gallatin is surrendered to the South by Union troops.

22 August 1862

Washington Responding to Horace Greeley's *New York Tribune* letter, 'The Prayer of Twenty Millions,' President Lincoln speaks in defense of his strategy. He points out his main objective, which is to preserve the Union, and that any and all efforts to achieve this preservation are, in his eyes, appropriate: 'I would save the Union. I would save it the shortest way under the Constitution . . . If I could save the Union without freeing *any* slave I would do it, and if I could save it by freeing *all* the slaves I would do it.'

23 August 1862

Eastern Theater A heavy barrage of Federal artillery opens along the Rappahannock, fire which is returned promptly by Southern batteries. After about five hours, this firing stops. Skirmishing occurs at Beverly Ford, Fant's Ford and at Smithfield Springs, all in Virginia.

25 August 1862

Washington Orders go out from Edwin Stanton, secretary of war, to the Southern Department. These orders provide for the enlistment of black soldiers, 'up to 5000 in number and to train them as guards for plantations and settlements.'

Eastern Theater, Second Bull Run Campaign At Waterloo Bridge, Virginia, there is heavy skirmishing between Confederates and Federals. The Southern forces under General Stonewall Jackson proceed out from their position on the Rappahannock, camping at Salem the following day and preparing for the impending battle with Union troops.

26 August 1862

Eastern Theater, Second Bull Run Campaign Also known as the Second Manassas, the campaign takes full shape as Confederates under General Jackson move in on Union General John Pope's troops. Manassas Junction and the railroad line there are seized by Southern forces. As Jackson divides his troops and encircles Pope's position, it becomes apparent to the latter that despite twice as many men, he may be forced to withdraw. Jackson's attempts to 'always mystify, mislead and surprise the enemy if possible' appear to be proving successful. General Pope does little while Jackson's men move into position near Sudley Mountain, on Stony Ridge. McClellan continues to move in to provide support for Pope's forces.

Trans-Mississippi In an effort which combines both land and naval forces, Union troops seize the Southern steamer *Fair Play* which is laden with arms and ammunition. This takeover occurs on the Yazoo River in Arkansas and is the result of an expedition led jointly by General Samuel Curtis and Commodore Charles Davis. In this venture, the Federals are rewarded with the acquisition of 1200 Enfield rifles, 4000 muskets and nearly 7000 pounds of powder.

Above: Union General Daniel Sickles directs his forces during Second Bull Run, a hard-fought encounter that saw the initially outnumbered Confederates repulse a succession of attacks before the Northerners finally conceded the battle to General Jackson's troops.

27 August 1862

Eastern Theater, Second Bull Run Campaign Kettle Run, Virginia, is one of several places which sees heavy skirmishing. General Hooker and his Federal troops are able to rout the Confederates at this point. Other sites of fighting in Virginia include Bull Run Bridge, Buckland Bridge and Waterford. The Confederates have now been able to interrupt communications between President Lincoln and General Pope. The latter is exhibiting some confusion as he pulls back from the formerly held positions along the Rappahannock River and moves slightly northward.

28 August 1862

Eastern Theater, Second Bull Run Campaign General Jackson's forces prepare to proceed to a point near Groveton, Virginia, and they engage Federals there who are commanded by General Rufus King. The fighting is extremely fierce at this Battle of Groveton, and many casualties are sustained by both North and South. General John Pope, operating under the mistaken assumption that Jackson is retreating toward the Shenandoah Valley, directs his troops to Groveton in order to rout the Confederates who remain there after the battle. Fredericksburg, Virginia, is evacuated by Union troops.

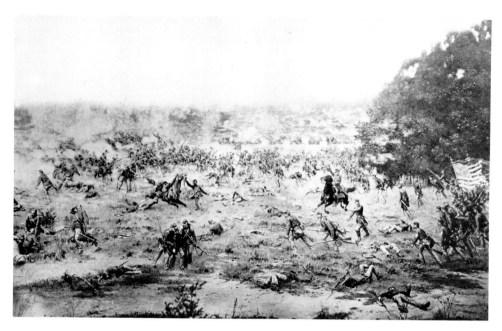

Above: Union troops assault a Confederate-held railroad embankment during the height of the fighting at Bull Run.

29 August 1862

Eastern Theater, Second Bull Run Campaign In a strategic error, General Pope allows his men to attack Jackson's Confederates so as to cut off the latter's retreat. Pope is unaware that the Southern forces have no intention of withdrawing, even though there are 20,000 Confederates to repel 62,000 Federals. This imbalance is soon minimized by the arrival of additional Southern troops under General Longstreet. Pope's somewhat disorganized troops are no match for the Confederates who have been anticipating and preparing for this, the Second Battle of Bull Run, or Manassas, for several days. Union General John Pope, oblivious to the fact that Longstreet has arrived with reinforcements, intends to pursue the fight further the following day. Unfortunately for the Northern troops, this gives Longstreet an opportunity to crush a portion of Pope's left flank, causing a retreat over the Bull Run but also saving a number of Federal soldiers.

31 August 1862

Eastern Theater, Second Bull Run Campaign There is minor skirmishing in the aftermath of the Union defeat at the Second Battle of Bull Run. General Pope consolidates his forces near Centreville, Virginia. Weldon, Virginia sees fighting – 110 Confederates were left dead and five Union soldiers were killed at this engagement.
Western Theater Minor fighting occurs in Alabama and Kentucky.

1 September 1862

Eastern Theater, Second Bull Run Campaign A battle at Chantilly, or Ox Hill, Virginia, proves to be the final clash between North and South in the Second Battle of Bull Run. The day-long engagement between 1300 Federals and 800 Confederates results in victory for the South. The defeat of the North is compounded by the deaths of Union Generals J J Stevens and Philip Kearney. General Pope finally retreats toward Washington, DC.

Western Theater In Kentucky, General E Kirby Smith and his Southern troops cause apprehension at Lexington since it is expected that the Confederates will try to take the city. The state legislature in Kentucky adjourns and moves to a more secure location at Louisville.

2 September 1862

Washington In an important command change, President Lincoln orders General McClellan to take over the Union Army of Virginia and the forces now defending Washington, DC. This is a move made without the full support of Lincoln's cabinet; notably, Secretary of War Edwin Stanton withholds his approval.

3 September 1862

Washington General Halleck is the recipient of a report made by General John Pope concerning the action of various officers at the Second Battle of Bull Run. Pope charges McClellan with lack of support, pointing out the need for reinforcements at the time Jackson was attacking and the tardiness with which McClellan's men arrived.
Western Theater Frankfort, Kentucky, is occupied by General E Kirby Smith's Confederates, and in the Geiger's Lake area there is minor skirmishing.

4 September 1862

Eastern Theater Various minor engagements occur as the Confederate Army of Northern Virginia under General Robert E Lee moves toward Maryland. General A G Jenkins conducts raids in West Virginia near Point Pleasant.
Naval The Federal blockade off Mobile Bay, Alabama, is unsuccessful in preventing the Confederate steamer *Oreto* from making it safely to port, despite the valiant efforts of the Union *Oneida*.

7 September 1862

Washington Due to the Confederate army's positioning itself at Frederick, Maryland, the Union capital at Washington, DC, is in turmoil. Many fear an immediate invasion there and citizens of other nearby cities – Baltimore and Hagerstown, Maryland, and

Harrisburg, Pennsylvania – make various arrangements to arm themselves against the alleged invaders. Many people evacuate their homes.
Western Theater Minor skirmishing breaks out at Murfreesboro and Pine Mountain Gap, Tennessee. General Bragg advances with his Confederates, Kentucky being their goal; Bowling Green is occupied by Union forces.

8 September 1862

Eastern Theater The Confederate Army of Northern Virginia under General Lee creates fear and confusion among the citizens of Maryland where Lee and his forces are encamped. In response to these feelings, Lee makes an attempt to explain the Southern position: 'We know no enemies among you, and will protect all, of every opinion. It is for you to decide your destiny freely, and without constraint. This army will respect your choice, whatever it may be.' Close to the Federal capital, General Nathaniel Banks takes charge of defense forces.

9 September 1862

Eastern Theater, Antietam Campaign Williamsburg, Virginia, is attacked by Confederates but Union troops there successfully repel the advance. General Longstreet receives orders to approach Boonesboro, Maryland, with his Confederates. Skirmishing occurs at Monocacy Church and Barnesville, both in Maryland.

10 September 1862

Eastern Theater, Antietam Campaign Gauley, Virginia, witnesses an attack on Union forces by Confederates posted in the area. Fayetteville, West Virginia, sees military action which results in a Southern victory. General McClellan continues to advance on Lee's army which is positioned near Frederick, Maryland.
Western Theater Cincinnati, Ohio, anticipates an invasion by Confederates and prepares to make defense of the city. Militia is called out to repel the imminent invasion.

12 September 1862

Eastern Theater, Antietam Campaign General McClellan pushes toward Frederick, Maryland, with the Army of the Potomac which has absorbed the Army of Virginia. Skirmishing continues in the vicinity.

13 September 1862

Eastern Theater, Antietam Campaign In what proves to be a stroke of luck for the Union forces, General Lee's orders for the Maryland invasion are discovered by Union soldiers. Due to this, General McClellan is able to approach with more accuracy the Confederate positions near Harper's Ferry, where Jackson has been posted; Hagerstown, where General Longstreet is to be stationed; and South Mountain, the location of Jeb Stuart's cavalry. It is now clear that McClellan can take advantage of the divided strength of Lee's army.

14 September 1862

Eastern Theater, Antietam Campaign The Battle of Crampton's Gap, the first of several engagements making up the Antietam campaign, occurs. As Confederate troops under

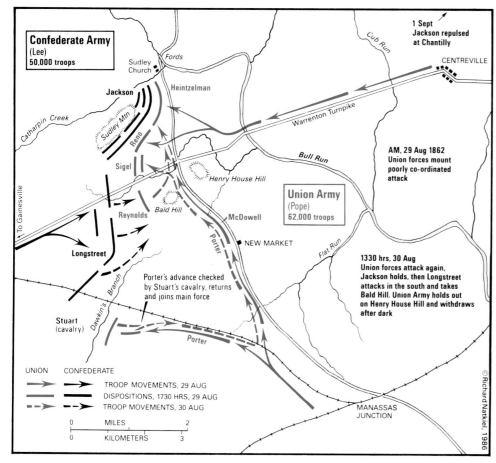

Confederate Army
(Lee)
50,000 troops

1 Sept
Jackson repulsed
at Chantilly

CENTREVILLE

Fords

Sudley
Church

Heintzelman

Jackson

Cub Run

Warrenton Turnpike

Catharpin Creek

Sudley Mtn

Reno

Sigel

Bull Run

AM, 29 Aug 1862
Union forces mount
poorly co-ordinated
attack

Henry House Hill

To Gainesville

Reynolds

Bald Hill

McDowell

Union Army
(Pope)
62,000 troops

Longstreet

Porter

NEW MARKET

Flat Run

1330 hrs, 30 Aug
Union forces attack again,
Jackson holds, then Longstreet
attacks in the south and takes
Bald Hill. Union Army holds out
on Henry House Hill and withdraws
after dark

Porter's advance checked
by Stuart's cavalry, returns
and joins main force

Dawkin's Branch

Stuart
(cavalry)

Porter

UNION CONFEDERATE

TROOP MOVEMENTS, 29 AUG
DISPOSITIONS, 1730 HRS, 29 AUG
TROOP MOVEMENTS, 30 AUG

0 MILES 2
0 KILOMETERS 3

MANASSAS
JUNCTION

the command of General LaFayette McLaws prepare to attack Harper's Ferry, Virginia, Union troops move in on them. Under General William Franklin this Union force is able, after a day of fighting, to cause the Confederates to pull back. The Union general is overcautious in his judgment of the Southern forces' abilities, even after their retreat. This results in the eventual capture of Harper's Ferry by the Confederates since Franklin's reluctance to engage McLaws again permits the latter to regroup and support Lee's assault on Harper's Ferry the following day. In a separate battle, that of South Mountain, Federals under General Alfred Pleasonton attack Confederates at Turner's Gap, Virginia. The engagement results in the Southern forces being pushed out of the higher ground. At this battle, the Union troops lose 325 men and sustain 1403 injuries. Likewise, the South sees 325 soldiers killed and 1561 wounded. The latter forces report 800 missing while Northern soldiers missing tally only 85.

15 September 1862

Eastern Theater, Antietam Campaign The fighting in northern Virginia continues as General Lee's Confederates, under General

Left: The movements of the rival armies prior to the Second Battle of Bull Run. Longstreet's sudden arrival helped the South win the battle.
Below: Union troops advance on the Southern line at the Battle of Antietam.

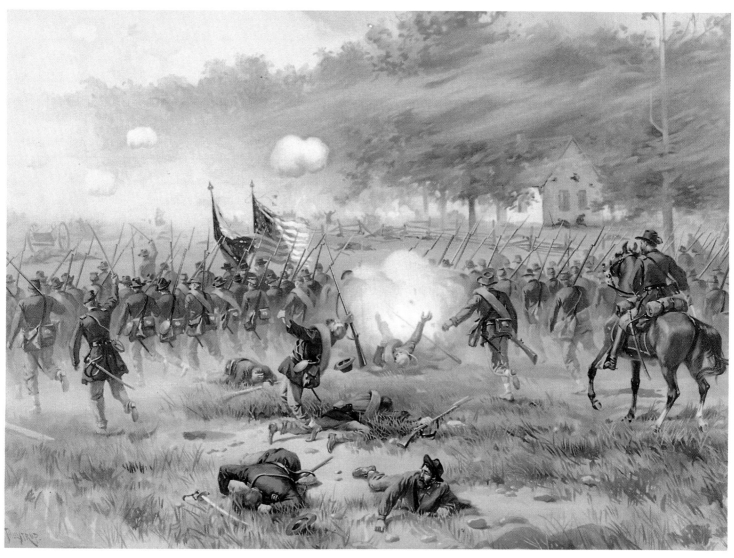

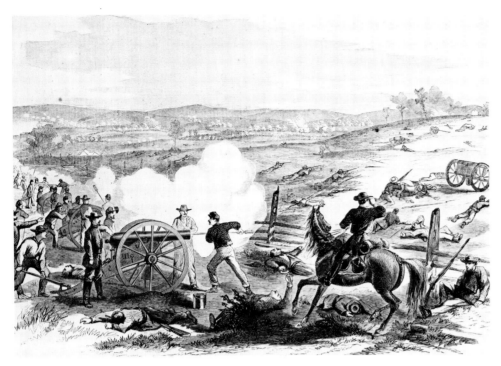

Stonewall Jackson's leadership, attack Harper's Ferry. This episode in the Antietam campaign sees Federal troops unable to withstand the fierce assault and nearly 12,000 Union soldiers are captured after relatively brief defense. The Federal commander at Harper's Ferry, General Dixon S Miles, is killed during this battle. At Sharpsburg, Southern forces arrive after having been pushed out of their position at South Mountain, Virginia. The Confederate Army under General Lee is now preparing to confront the Northern forces near Sharpsburg.

17 September 1862

Eastern Theater, Antietam Campaign
Despite the fact that the Southern forces are greatly outnumbered by General McClellan's Army of the Potomac, General Lee positions his troops for an attack along Antietam

Left: Artillery in action during the heavy fighting at Antietam.
Below: Union forces recross Burnside bridge after an attempt to turn the Southern flank at Antietam.

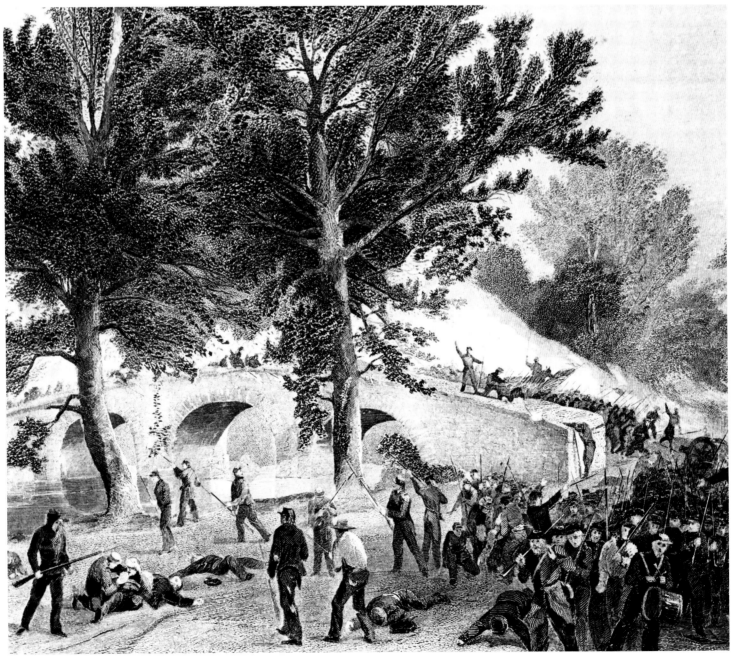

Creek. The Northern assault coming early in the day is disorganized and it allows the Confederates to rally somewhat. Union General Burnside attacks the southern right flank, pushing the Southern troops aside, crossing Burnside Bridge and advancing on Antietam, a movement which is halted by General A P Hill's arrival. The latter has been dealing with the surrender of Harper's Ferry and has only been able to join the rest of Lee's forces late in the day. Hill's advent on the battle scene prevents any further movements by the Federals and saves the Confederate right. At this Battle of Antietam, or Sharpsburg, the Confederates suffer heavy losses, as do the Union forces. However threatened General Lee's troops are in terms of manpower or positioning, they continue to hold their ground, a withdrawal not being considered until the following day. Casualties for the North are

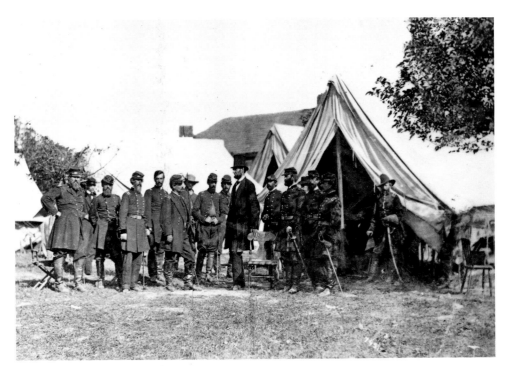

Left: Lincoln confers with McClellan at Harper's Ferry after Antietam.
Below: Confederate dead litter the floor of 'Bloody Lane,' scene of heavy fighting during the Battle of Antietam.

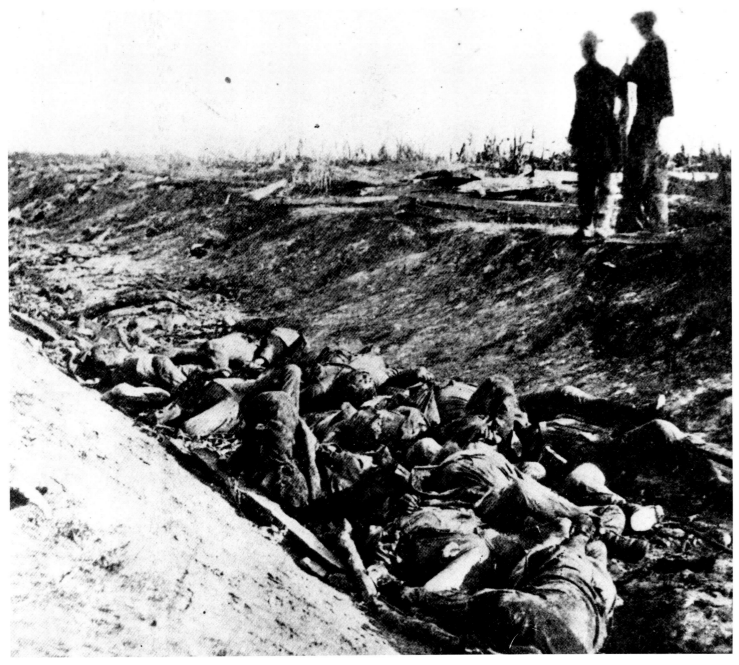

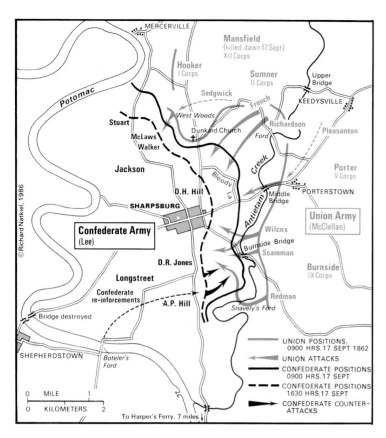

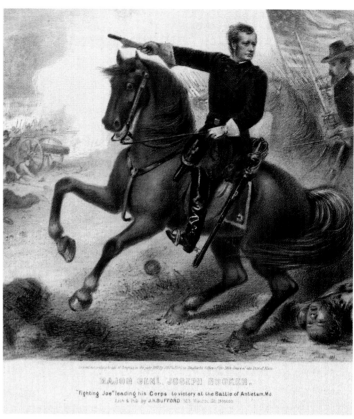

tallied at 2108 killed, 9549 wounded, 753 missing; for the South, estimates list 2700 killed, 9024 wounded, and 2000 missing. Antietam is considered by many to be 'the bloodiest single day of the war.'
Western Theater In the West, General Braxton Bragg accepts the surrender of Mumfordsville, Kentucky, as the Union commander, Colonel John Wilder, relinquishes control of that city.

18 September 1862

Eastern Theater, Antietam Campaign Late in the day, General Robert E Lee and his Army of Northern Virginia move out of Maryland after the engagement at Antietam the previous day. With this invasion of the North via Maryland in a shambles, the Confederates once more find themselves in a defensive posture.

19 September 1862

Eastern Theater Portions of Harper's Ferry, Virginia, are burned by retreating Confederates. Skirmishing occurs near Sharpsburg and Williamsport, Maryland.
Western Theater In a battle which claims 782 Federal casualties, Southern troops attack Union forces at Iuka, Mississippi. The Confederates, under General Sterling Price, number nearly 17,000. The Federals have around 9000 and are attacked as Union General Rosecrans leads a movement into the town. After several hours the Northerners have overwhelmed Price's forces and the latter retreat toward the south.

21 September 1862

Eastern Theater In Virginia, Federals crossing the Potomac engage in skirmishing with Southern troops at Shepherdstown. This results ultimately in a retreat by Union forces, which lose about 150 men.
Western Theater In Kentucky, General Braxton Bragg takes his Southern troops to Bardstown. The purpose of this is to enable Bragg's men to join with General E Kirby Smith's troops, but it allows Union General Buell to push forward to Louisville, Kentucky. At Mumfordsville, Kentucky, Union troops retake the town which had previously fallen to Confederates.

22 September 1862

Washington President Lincoln makes a move which is to help terminate slavery as a United States institution. In presenting the Emancipation Proclamation to his cabinet, Lincoln has chosen a time, after the Union success at Antietam, which he hopes will prove most advantageous.

24 September 1862

Washington President Lincoln suspends the writ of habeas corpus for any individuals who are deemed guilty of 'discouraging volunteer enlistments, resisting militia drafts, guilty of any disloyal practice or affording comfort to Rebels.'

Above, far left: The Battle of Antietam.
Above left: Union General 'Fightin' Joe' Hooker at Antietam.
Left: Confederate troops launch an assault against the Union Battery Robinett during the Battle of Corinth.

1 October 1862

Washington President Lincoln travels to Harper's Ferry to discuss the future of the Army of the Potomac with General McClellan.
The Confederacy At the Confederate capital of Richmond, Virginia, the newspaper *Whig* voices an opinion concerning Lincoln's recent Emancipation Proclamation, 'It is a dash of the pen to destroy four thousand millions of our property, and is as much a bid for . . . insurrection, with the assurance of aid from the . . . United States.'

2 October 1862

Western Theater Columbia, Mississippi, is the scene of a major battle between Federals and Confederates. The latter forces, under the command of Generals Van Dorn and Sterling Price, press Northern troops northwest of Corinth. On this first day of fighting, the Federals are forced on to the defensive.

4 October 1862

Western Theater Another day of intense fighting at Corinth, Mississippi, sees Federals under General Rosecrans hit hard by Van Dorn's Confederate troops. Despite this intense offensive, the Southerners are forced to withdraw before nightfall. Van Dorn's men are positioned, after this retreat, at Chewalla, Mississippi. Casualties at the close of the battle tally as follows: Union soldiers killed, 355; wounded, 1841; missing, 324. The Confederates estimate that they have lost 473 men here, have 1997 injured, and 1763 missing. The result of this battle at Corinth, Mississippi, does not give the South the satisfaction of securing the railroad center there, nor does it cause General Rosecrans to pull back toward Ohio. There is minor fighting in Kentucky at Bardstown and Clay Village. Middleton, Tennessee, also sees a brief engagement between rival forces of Federals and Confederates.

5 October 1862

Western Theater Outside of Corinth, Mississippi, Federals under General Rosecrans' command follow retreating Confederates, although Van Dorn's men are able to slip away from this Northern force. They are apprehended, however, by Federal General E O C Ord's men near the Hatchie River in Tennessee. This results in fighting of an intense, albeit brief, nature. The fighting associated with Corinth, Mississippi, ends as Confederates break free of Ord's troops and head for Holly Springs. In Kentucky, General Braxton Bragg and his Southern troops move away from Bardstown and are followed by General Buell's Federals.

6 October 1862

Western Theater General Braxton Bragg and his Confederates pull back toward Harrodsburg, Kentucky, pursued by General Buell's Northern troops. The latter occupy Bardstown, Kentucky.

8 October 1862

Eastern Theater Minor fighting breaks out near Fairfax in Virginia.
Western Theater The Battle of Perryville, Kentucky, occurs involving General Braxton Bragg's Confederates and General Don Car-

Above: General Earl Van Dorn led the Southern forces during the prolonged battle at Corinth, Mississippi, in October.

los Buell's Northern troops. The result of this encounter, the most significant of the battles fought in Kentucky, is that Bragg is compelled to retreat southeastward. Casualties are listed for the Federals at 845 dead, 2851 wounded, 515 missing, out of a total of 36,940 men. Confederates tally 510 killed, 2635 injured, 251 missing out of a total troop strength of 16,000.

9 October 1862

Eastern Theater At Chambersburg, Pennsylvania, Confederate General J E B Stuart begins several days of raiding which he carries as far as Cashtown, Pennsylvania. Stuart has crossed Federal lines in order to accomplish this and has ridden his 1800 troops in a circle around General McClellan's inactive Army of the Potomac.

10 October 1862

The Confederacy A request is made by Confederate President Jefferson Davis to draft 4500 blacks. The purpose of this is to further aid the Confederate army in its construction of fortifications around Richmond, Virginia.

11 October 1862

The Confederacy In Richmond, Virginia, the Confederate Congress passes a bill, approved by President Jefferson Davis, which amends the military draft law. According to the new regulations, anyone owning 20 or more slaves is exempt from service in the Confederate army. This law is publicized amid much controversy due to its selective nature, and serves to heighten a sense of class conflict in the Confederacy, some viewing the military situation as a 'rich man's war and a poor man's fight.'
Eastern Theater Chambersburg, Pennsylvania, witnesses the continued raiding by J E B Stuart's Confederates. They seize around

500 horses and destroy several trains before crossing the Potomac and returning to Virginia near Poolesville several days later.

12 October 1862

Trans-Mississippi Ozark, Missouri, is the jumping-off point for a Northern expeditionary force headed for Yellville, Arkansas. This mission lasts for seven days. There is light fighting near Arrow Rock in Missouri.

15 October 1862

Eastern Theater Part of the Army of the Potomac under General McClellan is involved in an expedition from Sharpsburg, Maryland, to Smithfield, West Virginia. They also take part in a reconnaissance beginning at Harper's Ferry and ending in Charlestown, West Virginia.

18 October 1862

Western Theater Confederate John Hunt Morgan with 1500 men routs Federal cavalry forces outside Lexington, Kentucky. The Southerners enter the city and seize an estimated 125 prisoners.

20 October 1862

Western Theater There are various episodes of minor skirmishing. Hermitage Ford, Tennessee, sees light action as does Wild Cat, Kentucky. Near Nashville, Tennessee,

Below: 'Teazer' gun on a Confederate gunboat. Such vessels were used in a wide variety of roles by both sides.

Union troops push back Confederates under the command of General Nathan Bedford Forrest. Near Bardstown, Kentucky, Southern forces manage to attack and destroy a line of 81 Federal wagons. The Confederates are subsequently able to seize yet another train of wagons several hours later in Bardstown itself.

21 October 1862

Washington An announcement by President Lincoln urges support in Tennessee for state elections. Lincoln entreats both civilian and military personnel to move to elect state government officials, a legislature and members of Congress.

22 October 1862

Western Theater Confederate General Braxton Bragg is successful in withdrawing Southern troops from Kentucky where Federals under General Buell continue to make their presence felt following the Battle of Perryville on 8-9 October 1862. There is a Union reconnaissance to Waverly, Tennessee, leaving from Fort Donelson. This expedition encounters Confederate forces, skirmishing several times during the next three days. Loudon, Kentucky, is seized by a force of Confederate cavalry under the command of Southern General Joseph Wheeler.

Trans-Mississippi At Maysville, Arkansas, what is known by some as the Second Battle of Pea Ridge is fought. Union forces are successful in pushing 5000 Confederates out of the area into the valley of the Arkansas.

Above: Confederate General Braxton Bragg managed to beat a skilful retreat after the Battle of Perryville.

Southerners suffer losses of artillery and horses at this encounter.

24 October 1862

Washington Because of his failure to prevent Bragg's Confederates from escaping from Kentucky, General Don Carlos Buell is relieved of command of Federal troops in Kentucky and Tennessee. President Lincoln

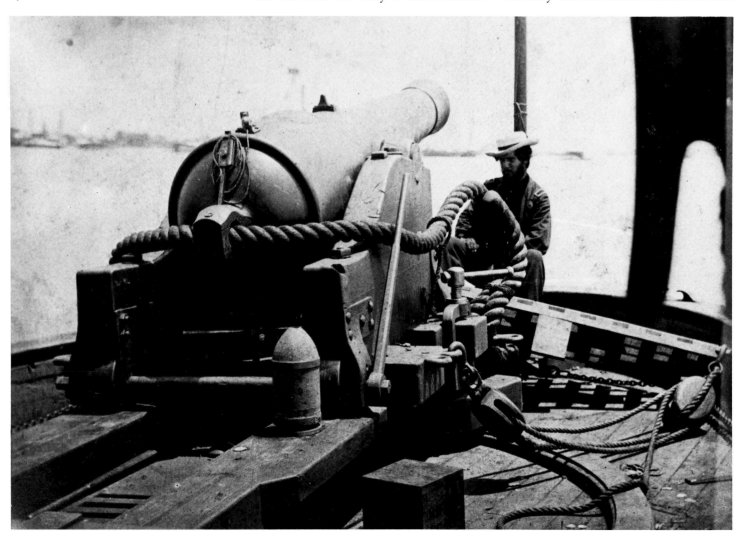

authorizes General William Rosecrans to take over the responsibility for these troops as well as Federal forces in the Department of the Cumberland.

Western Theater In Brownsville, Tennessee, Confederate forces are routed by Federals. At Morgantown, Kentucky, Union troops seize 16 Southern soldiers. On St Helena Island in South Carolina there is a brief skirmish between Union and Confederate troops.

Trans-Mississippi Fayetteville, Arkansas, sees light fighting and there is a Federal expedition from Independence, Missouri, which, in the course of its three-day maneuver, encounters several guerrilla forces around the settlements of Greenton, Chapel Hill and Hopewell.

25 October 1862

Washington President Lincoln is again in communication with General McClellan over the Army of the Potomac. The chief executive is becoming increasingly annoyed with the general's seeming inability to launch any major assault against Confederates in Virginia. As a telegram to McClellan indicates, Lincoln is not above venting his anger at the general's delays: 'Will you pardon me for asking what the horses of your army have done since the battle of Antietam that fatigue anything?' This is in response to a communication from McClellan about 'sore tongued and fatigued horses.'

26 October 1862

Eastern Theater General McClellan moves the Federal Army of the Potomac across the river into Virginia, causing the president to write from Washington, DC, that he 'rejoiced' in this overdue action.

27 October 1862

Western Theater In Louisiana, the Battle of Labadieville takes place on Bayou Lafourche. Confederates are routed at this action, losing six men, sustaining 15 wounded and reporting 208 taken prisoner. Federals report 18 dead and 74 wounded.

Naval Federal blockaders on Bull's Bay in South Carolina successfully seize the British steamer *Anglia*.

28 October 1862

Eastern Theater General McClellan is moving his Potomac Army troops toward Warrenton, Virginia, and this causes Confederate General Robert E Lee to push his troops slightly to the south. Lee wishes to prevent his forces from being encircled by McClellan's men. Union forces occupy Halltown, Virginia, and there is light skirmishing at Snicker's Gap.

Trans-Mississippi At Fayetteville, Arkansas, there is a clash between 1000 Union soldiers and about 3000 Confederates encamped there. The Federal forces follow the retreating Southerners into the area around the Boston Mountains.

31 October 1862

Western Theater The upcoming Federal action against Vicksburg, Mississippi, is foreshadowed by the gathering of Northern troops at Grand Junction, Tennessee. These troops are moving in from Corinth, Missis-

sippi and Bolivar, Tennessee. Union forces scheduled to act as relief for the garrison at Nashville, Tennessee, move through Bowling Green, Kentucky.

1 November 1862

Western Theater In New Orleans, Louisiana, military governor General Benjamin Butler tightens restrictions on movement to and from the city. In addition, Butler allows for the freeing of all imprisoned 'slaves not know to be the slaves of loyal owners.' Vicksburg, Mississippi, is the target of a campaign being planned by General Ulysses Grant.

4 November 1862

The North Congressional elections in Northern states prove advantageous to Democrats in New York, New Jersey, Illinois and Wisconsin. New York elects a Democrat as governor, Horatio Seymour. There are some Republican victories in border states, in California, Michigan and New England, however, which help the Republicans maintain control of the House of Representatives.

Western Theater In Mississippi, General Grant's Federals successfully occupy La Grange. This occupation, as well as a similar one at Grand Junction, Tennessee, is in preparation for the upcoming Vicksburg campaign. Union troops in Georgia destroy the Southern saltworks at Kingsbury.

5 November 1862

Washington In one of the more significant command changes of the war, President Lincoln removes General George Brinton McClellan from his post as head of the Army of the Potomac. After months of attempting to support McClellan, Lincoln is alleged to have said, 'sending reinforcements to McClellan is like shovelling flies across a barn.' The general has been extremely reluctant to make any offensives against Lee's army in Virginia, and any of his efforts in that direction are so minimal as to be virtually unnoticed. The official orders read: 'By direction of the President, it is ordered that Major General McClellan be relieved from the command of the Army of the Potomac; and that Major General Burnside take the command of

that Army.' In another shift in command, General Fitz John Porter is replaced by General Joseph Hooker.

7 November 1862

Eastern Theater General George McClellan is notified of his removal from the command of the Army of the Potomac. Completely surprised by this turn of events, he makes an extreme effort to prevent those around him from seeing how amazed he is to receive this news: 'I am sure that not the slightest expression of feeling was visible on my face.'

8 November 1862

Washington Further command changes see General Benjamin Butler replaced as head of the Department of the Gulf. Butler is succeeded by General Nathaniel Banks, whose orders include the directive that 'The President regards the opening of the Mississippi River as the first and most important of our military and naval operations.'

9 November 1862

Eastern Theater Virginia witnesses some light action in Greenbrier County, and at Warrenton, Virginia, General Burnside officially takes over command of the Army of the Potomac. A Union cavalry charge into Fredericksburg results in the taking of 34 Confederates as prisoners of war. Federals lose only one man out of a force of 54.

10 November 1862

Eastern Theater At Warrenton, Virginia, General George Brinton McClellan says his farewell respects to the Army of the Potomac there. Well-liked and respected by the troops, McClellan's departure is an occasion marked by near-idolization of 'Little Mac.'

13 November 1862

Western Theater Military actions of a minor, inconclusive nature continue. At Nashville, Tennessee, Union and Confederate soldiers engage in skirmishing. A railroad

Below: General Brinton McClellan takes his leave of the Army of the Potomac after being dismissed by Lincoln.

depot near Holly Springs, Mississippi, is taken by Federals. General Braxton Bragg, intent on joining forces with General Breckenridge, pushes his Army of Tennessee toward Murfreesboro from Chattanooga, Tennessee.

14 November 1862

Eastern Theater The newly-appointed chief of the Army of the Potomac, General Burnside, reorganizes his troops placing Generals Sumner, Hooker and Franklin in charge of three main divisions of the army. This is in preparation for an assault on the Confederate capital at Richmond, Virginia.

Western Theater General Braxton Bragg has positioned his Confederate troops at Tullahoma, near Nashville, Tennessee.

15 November 1862

Eastern Theater General Burnside moves his Potomac Army troops out of Warrenton, Virginia, and advances on Fredericksburg. There is an exchange of artillery fire between Union and Southern forces at Fayetteville, Virginia.

17 November 1862

Naval The Southern steamer *Alabama*, under the command of Captain Raphael Semmes, sails into the harbor at Martinique followed by the USS *San Jacinto*, although the latter vessel quickly leaves the harbor in order to lie in wait for the Confederate ship.

Left: General Ambrose Burnside, McClellan's replacement as head of the Army of the Potomac.
Below: Union troops embark on pontoons to begin the attack on Fredericksburg.

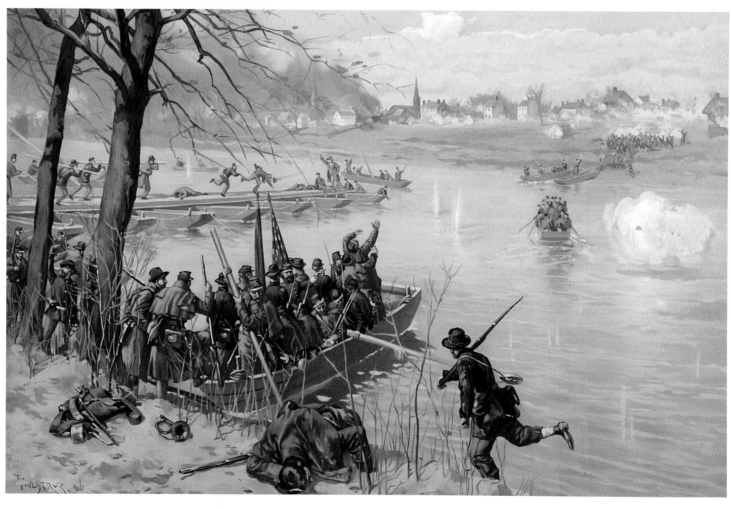

18 November 1862

Eastern Theater, Fredericksburg Campaign General Burnside and his Army of the Potomac arrive in Falmouth, Virginia, on the banks of the Rappahannock River across from Fredericksburg. Skirmishing breaks out between Union and Confederate soldiers at Rural Hill, Virginia.
Naval Despite the efforts of the *San Jacinto,* the Confederate *Alabama* manages to leave Martinique.

19 November 1862

Eastern Theater Both Union and Confederate forces are taking positions in the vicinity of Fredericksburg, Virginia. General Longstreet is established near Culpeper; General Burnside near Falmouth. The Confederate cavalry under J E B Stuart is positioned at Warrenton Junction, Virginia.
Western Theater General Ulysses Grant sends out reconnaissance forces to ascertain the strength of Confederate troops defending Vicksburg, Mississippi. Federal forces leave Grand Junction, Tennessee, on a two day expedition to Ripley, Mississippi.

20 November 1862

Eastern Theater The Confederates in Virginia stationed near Fredericksburg are heartened by the arrival of General Robert E Lee. Charlestown, Virginia, sees some minor skirmishing between North and South.

21 November 1862

Eastern Theater As military strength builds in the vicinity, the mayor of Fredericksburg, Virginia, is issued a request for surrender by General Burnside. Refusing to give in, the mayor is told to evacuate women, children and injured or infirm people from the town.

22 November 1862

Washington In the Federal capital orders go out from Secretary of War Stanton to release all those imprisoned for political reasons – those who had been found guilty of draft evasion, of discouraging others to enlist in the armed service and for other similar actions.
Eastern Theater In a reversal of Burnside's orders of the previous day, General Sumner tells the mayor of Fredericksburg, Virginia, that he will not fire on the town. This agreement is made in exchange for a promise of 'no hostile demonstrations' from the townspeople.

26 November 1862

Washington In order to meet with his recently-appointed general of the Potomac Army, President Lincoln leaves the Federal capital for Aquia Creek, Virginia.

27 November 1862

Eastern Theater President Lincoln confers with General Burnside. The two are not in total agreement about the proper strategy to employ in the current situation along the Rappahannock. The general ultimately decides not to defer to the president's wishes and instead follows his own plan for an assault on Fredericksburg where most of Lee's forces are concentrated. In the forthcoming campaign Burnside will be outfought by Lee's forces.

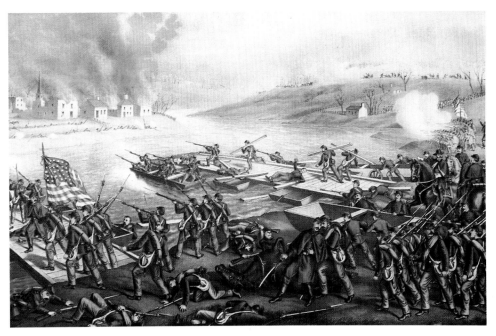

28 November 1862

Eastern Theater At Frankfort, Virginia, Confederate troops are routed by Union forces and some 110 Southerners are taken prisoner.
Trans-Mississippi General James Blunt and his Federals stage an attack on Confederate positions at Cane Hill, Arkansas. The 8000 Southern troops there are under the command of General John Marmaduke. Blunt's 5000 men pursue Marmaduke into the Boston Mountains after beating them back, but this chase is called off due to the strategic danger it creates for the Union forces. At this encounter, Federals tally losses at 40 men while the Southern total is considerably higher at 435.

30 November 1862

Naval The Confederate steamer *Alabama* continues to be elusive as it sails Atlantic waters and threatens Northern shipping. The Federal vessel *Vanderbilt* makes an attempt to capture the Southern vessel, but is unsuccessful.

1 December 1862

Washington Congress meets in the Federal capital; President Lincoln addresses this, the third session of the 37th Congress, giving his State of the Union message. In addition to remarks made about the North's progress in the war and the positive condition of the Federal economy, the chief executive discusses several constitutional amendments. These proposed amendments center around slavery, suggesting plans for colonization, and for financial compensation to previous slave owners as well as cooperating states. Lincoln points out that '. . . *we* cannot escape history, . . . In *giving* freedom to the *slave*, we *assure* freedom to the free.'

3 December 1862

Western Theater Near Nashville, Tennessee, Confederates attack Northern soldiers along the Hardin Pike. Grenada, Mississippi, is seized by General Hovey's Federals, who number about 20,000. This takeover occurs after Southerners have destroyed 15 locomotives and approximately 100 railroad cars.

Above: Northern forces crossing the Rappahannock in the first stages of the Battle of Fredericksburg.

4 December 1862

Eastern Theater, Fredericksburg Campaign Winchester, Virginia, falls into Union hands, resulting in the capture of 145 Southern soldiers. Near Fredericksburg, Virginia, Northern troops clash with Confederates on the Rappahannock River and also on Stone's River, near Stewart's Ferry.

6 December 1862

Washington As a result of the Indian uprisings in Minnesota during September, President Lincoln orders the execution of 39 Indians, the hangings to take place on 19 December 1862.
Trans-Mississippi There is an attack on Federal troops at Cane Hill, Arkansas.

7 December 1862

The Confederacy Confederate General John Pemberton receives a communication from President Jefferson Davis concerning

Below: John Hunt Morgan was renowned as a Confederate guerrilla leader.

the defense of Vicksburg, Mississippi. The Confederate president is worried about Pemberton's ability to hold out against an attack by Grant's men. Davis asks Pemberton: 'Are you in communication with General J E Johnston? Hope you will be reinforced in time.'

Western Theater Hartville, Tennessee, is the scene of yet another raid by John Hunt Morgan and his men. Federal forces under Colonel A B Moore suffer losses tallied at 2096, 1800 being taken prisoner by the Southern raiders.

Trans-Mississippi In Arkansas, the Battle of Prairie Grove takes place as Confederate General Thomas Hindman surprises 10,000 Northern troops. The latter, commanded by Generals James Blunt and Francis Herron, are unable, despite their combined forces, to repel the Confederates, who also number 10,000. The South suffers 164 fatalities, 817 injuries and reports 336 missing at this battle, whereas Federals report 175 dead, 813 wounded, 263 missing.

10 December 1862

Washington A bill creating the state of West Virginia passes the United States House of Representatives on a vote of 96-55. This follows a similar action by the Senate on 14 July 1862.

Eastern Theater, Fredericksburg Campaign The Union troops under General Burnside's command around Fredericksburg, Virginia, increase their preparation for an advance on that city. Port Royal, Virginia, is bombarded by Federal gunboats in retaliation for an attack on the latter by Confederate shore batteries.

11 December 1862

Eastern Theater, Fredericksburg Campaign Fredericksburg, Virginia, is occupied by Union forces under General Burnside. The Confederates in the vicinity are poised in readiness for the upcoming attack.

Below: Wave after wave of Union troops attempt to storm the Southern entrenchments on Marye's Heights behind Fredericksburg.

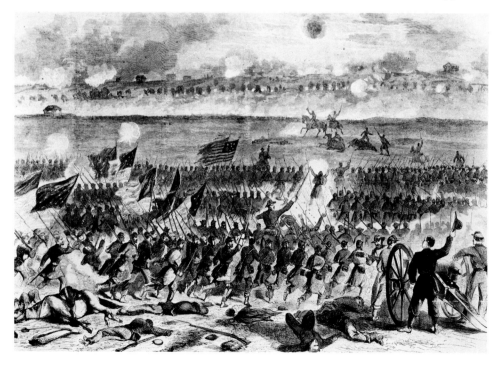

Western Theater More skirmishing breaks out near Nashville, Tennessee. At Columbia, Tennessee, Confederate General Nathan Bedford Forrest moves out with nearly 2500 men in an attempt to disrupt General Grant's lines of communication.

13 December 1862

Eastern Theater, Fredericksburg Campaign Approximately 72,000 Confederates under General Stonewall Jackson's command are attacked at Fredericksburg, Virginia, by Union troops totaling about 106,000. The forces under General William Franklin attack Southern positions just across the Rappahannock to the south of the city. Meanwhile, General Sumner advances on positions north of the city and is able initially to break through the Confederate defenses, but the result is that Union soldiers are now forced to attack Southern troops placed at the foot of Marye's Heights. The Confederates are firmly entrenched and it is impossible for Federals to do more than struggle along the base of the ridge where the South is positioned. The attempt by Northern troops is a genuine but futile one. One Union soldier comments: 'It was a great slaughter pen . . . they might as well have tried to take Hell.' The casualties are high – 12,700 killed and wounded among the Federals. The Confederates report 5300 dead or injured, among them, Generals Cobb and Gregg. General Robert E Lee remarks of this day's fight, 'I wish these people would go away and let us alone.'

Western Theater At Tuscumbia, Alabama, there is a clash between Federal and Southern troops as Union soldiers attack and rout Confederates there. Mississippi sees a six-day offensive staged by Federal forces on the Mobile and Ohio Railroad which runs between Tupelo and Corinth.

14 December 1862

Eastern Theater, Fredericksburg Campaign The Northern Army of the Potomac in and around Fredericksburg, Virginia, makes preparations to move back across the Rappahan-

nock River. Despite the Union army's vulnerable position after the Battle of Fredericksburg, the Southern forces under the command of General Lee do not attack Burnside's troops prior to their withdrawal.

15 December 1862

Western Theater In Tennessee, General Grant's forces, which are on their way to Vicksburg, Mississippi, experience difficulties with Confederate forces under General Nathan Bedford Forrest. The latter has, with approximately 2500 soldiers, started toward Vicksburg intending to interfere with the Federal communications along the way. New Orleans, Louisiana, sees the departure of General Benjamin Butler, who has been forced to step down as military governor. Few of the citizens of New Orleans are sorry to see him leave.

16 December 1862

Washington The execution of Sioux Indians, slated for 19 December 1862, has been delayed by President Lincoln. A new date of 26 December 1862 has been set.

Eastern Theater West Virginia witnesses an outbreak of skirmishing at Wardensville. General Burnside and the Army of the Potomac occupy Falmouth, Virginia. The general has made a statement concerning his part in the failure at Fredericksburg, a failure for which he assumes total responsibility.

Western Theater After General Butler's departure from New Orleans, Louisiana, General Nathaniel Banks takes command there, assuming responsibility for the Federal Department of the Gulf. Tennessee is the site of Confederate General N B Forrest's march against Grant. North Carolina sees skirmishing in various places, among them White Hall and Goshen Swamp.

17 December 1862

Washington President Lincoln experiences difficulties with the Federal cabinet. Secretary of the Treasury Salmon Chase is in conflict with Secretary of State Seward and also with Seward's son who is the latter's assistant. The result is that both Sewards submit their resignations to the chief executive although Lincoln will not accept them.

Western Theater General Grant makes public *General Order Number Eleven* concerning speculation but specifically singling out Jews as the object of the declaration against illegal trade: 'The Jews, as a class violating every regulation of trade established by the Treasury Department and also department orders, are hereby expelled from the department within twenty-four hours from the receipt of this order.' While the order is rescinded several weeks later, on 4 January 1863, Grant's reputation is damaged by the adverse publicity.

18 December 1862

Western Theater Lexington, Tennessee, is the site of a skirmish between cavalry under the command of Confederate Nathan Bedford Forrest and Union cavalry troops. The Confederates report 35 casualties compared to 17 listed by the Federals as killed or wounded. New Berne, North Carolina, sees the return of Northern expeditionary forces after eight days of minor skirmishing.

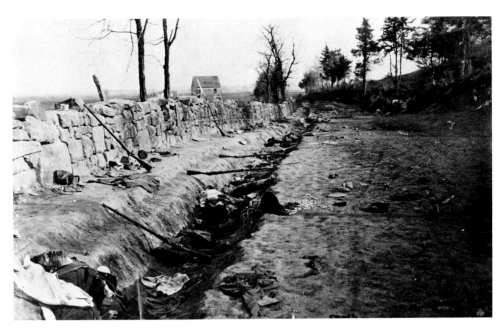

Above: The scene at the foot of Marye's Heights after the struggle for Fredericksburg, 13 December 1862.

19 December 1862

Washington President Lincoln convenes his cabinet to discuss the tendered resignation of Secretary of State Seward. Also at this meeting are members of the Senate Republican caucus committee.

Western Theater At Spring Creek in Tennessee there is an encounter between Northern and Southern troops, and another at Jackson in that same state.

20 December 1862

Washington Compounding the crisis in Lincoln's cabinet triggered by Seward's abruptly proferred resignation, Secretary of the Treasury Salmon Chase also submits a request to be permitted to step down from his post. After discussing the situation at length with his advisors and with the remaining cabinet members, Lincoln makes a decision not to accept the resignations. This effectively prevents any further upheaval but does little to alleviate the pressures stemming mainly from political differences experienced by the cabinet as a whole.

Western Theater Grand Junction, Tennessee, is attacked by Confederates with the result that the Federals tally 50 casualties. In Mississippi, at Holly Springs, Northern troops under General Grant are surprised by General Earl Van Dorn's Southerners. The latter capture an enormous supply of stores worth over $1 million and take about 1500 Northern soldiers prisoner. To prevent such a valuable commodity from falling into enemy hands, Confederates burn over 4000 bales of cotton. This attack on Holly Springs, Mississippi seriously hampers Union General Grant's efforts to move on Confederate positions near Vicksburg.

23 December 1862

The Confederacy Due to Union General Benjamin Butler's military governorship of New Orleans, Louisiana, and the intensely bitter feelings resulting from his tenure there, Confederate President Jefferson Davis brands the general a felon and an enemy of mankind. The chief executive suggests immediate execution of Butler if he should be seized by Confederates, and further states that any Federal army officers imprisoned by the Confederacy shall not be released prior to Butler's punishment.

25 December 1862

Washington As part of their observation of the Christmas holiday, the president and Mrs Lincoln pay visits to several military hospitals in the Federal capital where injured soldiers convalesce.

Western Theater In Tennessee, near Brentwood, there is some inconclusive fighting and similar activity along the Edmondson Pike. John Hunt Morgan's raiders clash with Union troops near Bear Wallow in Kentucky. Glasgow, Kentucky, is seized and occupied by Confederate troops. In Mississippi, north of Vicksburg, Sherman's forces conduct operations.

26 December 1862

Western Theater Vicksburg, Mississippi, is the goal of advancing Federal forces. These troops, under the command of General William Sherman, are positioned on the Yazoo River to the north of Vicksburg. In Tennessee, General William Rosecrans pushes toward the Confederate encampment at Murfreesboro. There is some minor fighting along the way, near La Vergne, Franklin and Knob Gap.

Trans-Mississippi As a result of the Sioux Indian uprising in Minnesota, causing the death of over 450 white settlers, 38 Indian participants in the uprising are executed at Mankato, Minnesota.

27 December 1862

Western Theater Near Vicksburg, the Federal advance troops of General Sherman clash with Confederates. In addition, Northern gunboats fire on Southern shore batteries positioned at Haine's Bluff, Mississippi. Efforts to disrupt communications between the Vicksburg troops and reinforcements include the destruction of the Vicksburg and Shreveport Railroad. In Kentucky, there is an attack on Confederate forces resulting in 17 dead or wounded, and 57 taken prisoner by the Federals. John Hunt Morgan's Confederate raiders complete a successful attack on Elizabethtown, Kentucky, which results in the capture of the Federal garrison there.

28 December 1862

Western Theater Mississippi witnesses minor fighting near Vicksburg, as General William T Sherman pushes closer to the city. In Kentucky, Confederate John Hunt Morgan and his men blow up a bridge at Muldraugh's Hill. Baton Rouge, Louisiana, is heavily damaged by fire.

Trans-Mississippi In Van Buren, Arkansas, there is an outbreak of fighting between Confederates and Federals. The latter are under the command of General James Blunt. The Union troops are successful in seizing 100 prisoners as well as many supplies and some equipment. In Missouri, Federal troops evacuate New Madrid.

29 December 1862

Western Theater The Federal forces gathering north of Vicksburg, Mississippi, clash with Confederates at Chickasaw Bayou. While Northern troops make a concerted effort to break through the Confederate defenses there at Chickasaw Bluffs, it is an operation that meets with no success. General Sherman, whose men are outnumbered by the Southern troops, says later: 'I reached Vicksburg at the time appointed, landed, assaulted and failed.' The Federal forces of 31,000 are reduced by 208 fatalities, 1005 wounded and 563 missing at this battle. Southern losses tally 63 dead, 134 injured, 10 missing out of a total fighting force of 14,000.

30 December 1862

Washington President Lincoln makes final preparations for the announcement of his Emancipation Proclamation. He submits drafts of the document to his cabinet in the hopes that he will be given practical advice as to the final wording.

Western Theater Confederate raider John Hunt Morgan and his men clash with Union troops as they pull out of the town of New Haven, Kentucky.

Naval In stormy waters off Cape Hatteras, the USS *Monitor* is lost after severe difficulties; this results in the death of 16 men and officers. The USS *Rhode Island* manages to rescue another 47 men.

31 December 1862

Washington President Lincoln meets with General Burnside to discuss the latter's role in the Union defeat of Fredericksburg, Virginia. In addition to this meeting, the president confers once again with his cabinet about the Emancipation Proclamation and signs a bill establishing West Virginia as the nation's 35th state.

Western Theater The Battle of Stone's River, or Murfreesboro, Tennessee, commences on the last day of the year as General Rosecrans' Federals face General Bragg's Confederates. The Southern attack on the Federal position comes at dawn and by noon, despite several vigorous counterattacks by the Union forces, the latter are on the defensive. By night time, General Rosecrans' troops are undefeated and awaiting a resumption of fighting on the following day.

1 January 1863

Washington President Lincoln signs the Emancipation Proclamation, stating that 'all persons held as slaves within said designated States, and parts of States, are, and henceforward shall be free.' Reactions are, for the most part, enthusiastic. The provisions for freed slaves include assurances that former slaves are to be permitted to serve in the military. Continued difficulties with General Burnside over the aftereffects of the Fredericksburg defeat still plague the president. After meeting with the chief executive, Burnside states in an open letter that he has felt little support from fellow officers and that he considers retirement in order to 'promote the public good.' Lincoln persuades Burnside to reconsider.

Western Theater Murfreesboro, Tennessee, is relatively stable after the previous day's fighting. Both Generals Bragg and Rosecrans re-position their troops and there is some minor skirmishing as the troops assume a more advantageous stance. In Mississippi, Union General Sherman makes preparations to pull troops out of the area north of Vicksburg, and elsewhere in that state there is a minor clash between Federals and Confederates at Bath Springs.

2 January 1863

Western Theater The second day of major fighting in the Battle of Stone's River, or Murfreesboro, Tennessee, sees General Breckenridge's Confederates badly defeated after

Below: Southern warships attempt to pierce the Union blockade outside Galveston, Texas, on 1 January 1863.

their attempt to establish a hold on high ground. Both of the armies pause once again, each anticipating a withdrawal by the other. General Sherman pulls away from the Yazoo River in Mississippi, putting aside any further attempts to seize the area north of Vicksburg.

3 January 1863

Western Theater General Braxton Bragg moves his Confederate Army of Tennessee away from Murfreesboro. This is in spite of the fact that the South remained in relative control after the Battle of Stone's River, or Murfreesboro, on 31 December 1862. This move is later to garner Bragg considerable criticism from military advisors.

4 January 1863

Western Theater Fort Hindman, Arkansas, is the goal of 30,000 Federal troops which, under the command of General McClernand, are transported north on the Mississippi in an unauthorized movement intended to implement seizure of the Confederate post. Skirmishing occurs in Tennessee in the wake of General Bragg's withdrawal from the area around Murfreesboro.

Naval The Union blockade continues to reap rewards as the USS *Quaker City* seizes yet another Confederate blockade-runner off the coast of Charleston, South Carolina.

7 January 1863

Trans-Mississippi There is a major attack on Springfield, Missouri, by Confederate troops under the command of Generals Marmaduke and Price. They move on and capture Ozark, Missouri.

8 January 1863

Western Theater Ripley, Tennessee, witnesses the capture of 46 Southern soldiers by Captain Moore's Union troops. In the skirmish there, the Union suffers three wounded. The Confederates, under Colonel Dawson's command, tally eight dead and 20 injured plus those taken prisoner. In a separate action, a six-day expedition and raid under Confederate General Joseph Wheeler threatens Mill Creek, Harpeth Shoals and Ashland.

9 January 1863

Eastern Theater Suffolk, Virginia, sees the defeat of Confederate forces under the command of General Pryor. Federals, under General Corcoran's command, lose 104 during this encounter. At Fairfax Court House, Virginia, there is minor skirmishing.

International The French minister to the United States confers with the minister of foreign affairs in France in order to clarify their country's role in a possible mediation attempt between the Confederacy and the Union.

10 January 1863

Washington President Lincoln writes to General Curtis in Missouri about the various ways to handle the slave problem in St Louis. In a separate action General Fitz John Porter is court-martialed and cashiered from the Federal army. This is due to Porter's failure to follow orders at the Battle of Second Manassas on 29 August 1862.

Trans-Mississippi At Galveston, Texas, Union gunboats positioned there bombard the city. An important operation under

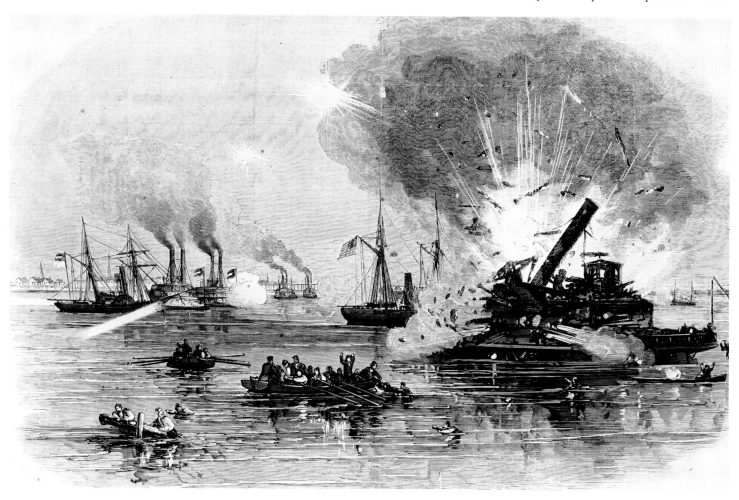

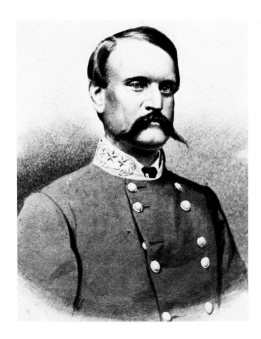

Above: General John Breckenridge led Southern forces to defeat at Stone's River.

General McClernand proceeds as Fort Hindman, on the Arkansas River, is surrounded by Union troops and gunboats effectively silence any Confederate artillery from the fort. Southern forces there are under the command of General T J Churchill. Elsewhere there is skirmishing of a minor variety near Carrollton, Arkansas.

11 January 1863

Trans-Mississippi Fort Hindman, Arkansas, is seized by Federal troops under General McClernand and Admiral David Porter. During this battle, the Union loses 134 men, suffers 898 wounded and 29 missing while Confederates tally 28 killed, 81 wounded and 4720 prisoners taken. In Missouri, Union Colonel Merrill engages Confederates under General Marmaduke in battle with a resulting 35-man loss for the Federals, who defeat the Southern troops. The latter lose 150 men.
Naval In three separate operations, the Confederacy is involved in confrontations with the Union. Off the coast of Memphis, Tennessee, the South sinks the USS *Grampers Number Two*. At Bayou Teche, Louisiana, the Confederate gunboat *Cotton* is seized and destroyed by General Weitzel. Again, proving its superiority, the Confederate cruiser *Alabama* attacks and sinks the Federal vessel *Hatteras* in waters off the coast of Texas.

12 January 1863

The Confederacy At the Confederate capital, Richmond, Virginia, the third session of the First Confederate Congress meets. President Jefferson Davis addresses the assembly, emphasizing his hopes for European recognition of the Southern nation.

15 January 1863

The Confederacy In a letter to General Braxton Bragg concerning the Confederate position in the Murfreesboro-Tullahoma area of Tennessee, President Jefferson Davis advises that the general should seek to 'select a strong position and fortifying it, to wait for an attack.'

16 January 1863

Western Theater In Alabama, the Confederate privateer *Florida* slips through the Union blockade and makes its way safely out of Mobile Bay. The vessel subsequently is responsible for the capture and destruction of 15 Federal ships before its own capture in waters off Bahia, Brazil.

19 January 1863

Eastern Theater The Federal Army of the Potomac is about to engage in its second attempt to gain control of Fredericksburg, Virginia. General Burnside makes preparations to cross the Rappahannock River with his troops and is aided by division commanders Hooker and Franklin. There is some minor skirmishing elsewhere in Virginia, near Williamsburg and Burnt Ordinary.

20 January 1863

Eastern Theater The Army of the Potomac continues its plans to sweep down on Fredericksburg, Virginia. A change in the weather conditions from snow to rain creates transportation difficulties. Reflecting on this change, General Burnside reports, 'From that moment we felt that the winter campaign had ended.' It becomes increasingly more difficult for the Federal forces to make any significant progress on this front.

21 January 1863

Washington President Lincoln communicates with General Halleck concerning orders given by General Grant. These orders, which are being revoked, concerned the expulsion of Jews from the Department of the Mississippi. Lincoln's position in this controversy is that revocation of such orders is necessary 'as it in terms proscribed an entire religious class, some of whom are fighting in our ranks.' The president, in a separate order, formally dismisses General Fitz John Porter from military service. (This presidential order will later be revoked after an 1879 review, and Porter subsequently is reinstated as a colonel in the Federal army.)
Eastern Theater The Federal Army of the Potomac is still stalled along the banks of the Rappahannock River in Virginia. General

Burnside is soon to be faced with a decision concerning effective withdrawal from the area, since the rain has been steadily falling for 30 hours. It is only a short time before Burnside realizes that crossing the river is impossible.

22 January 1863

Eastern Theater General Burnside, faced with extremely bad weather and mud everywhere, prepares to pull the Army of the Potomac back from its position – an admission that the Fredericksburg, Virginia, mission was not to be fruitful. Known as the 'mud march,' this withdrawal is described by a private in the 118th Pennsylvania Volunteers: 'Further progress was impracticable . . . It was some twelve miles back to the nearest camp. Pontoons, artillery trains could not be moved.'
Western Theater General Grant takes overall responsibility for Union troops in the region of Arkansas and its general vicinity. The upcoming push to take Vicksburg, Mississippi, is the goal of General Grant and he begins the preparations by resuming Federal efforts to dig a canal through the marshy area across from Vicksburg.

23 January 1863

Eastern Theater In an abrupt and stinging move, General Burnside issues orders which will take Generals Hooker, Franklin, Newton and Brooks out of command in the Army of the Potomac. Motivated in part by the frustration at the difficulties encountered because of poor weather, Burnside has not evidenced a total commitment to the command forced on him three months prior to now. The orders he has served on the generals are never actually approved by President Lincoln.

25 January 1863

Washington In a meeting with General Burnside, President Lincoln discusses the general's plans for the dismissal of Generals

Below: The Confederate raider *Alabama* uses a burning Union vessel to lure further Union ships into cannon range.

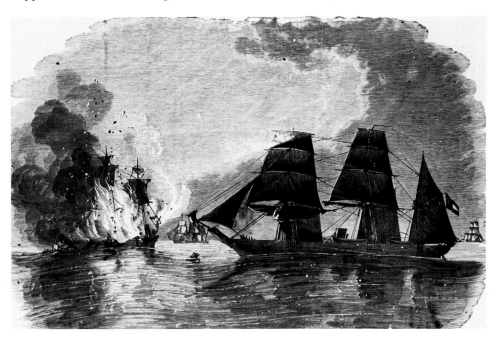

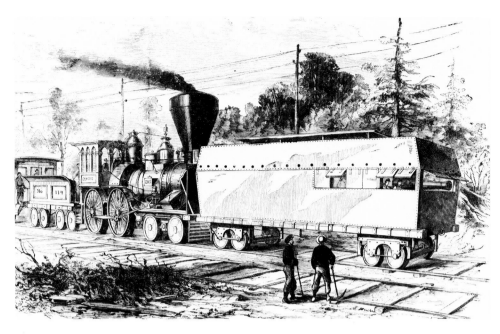

Above: An imaginative, if somewhat impractical, attempt to protect Union railroad workers from Confederate raiding parties.

Hooker, Franklin, Newton and Brooks. Later, the president confers with his cabinet and with General Halleck. The outcome is the removal of General Burnside from the command of the Army of the Potomac. In his place, General Joseph Hooker is appointed as general in chief of the Potomac Army. Burnside is apparently not displeased with this change, and will assume military responsibilities in the West.

26 January 1863

Eastern Theater General Joseph Hooker, 48-years-old and a West Point graduate, officially assumes command of the Union Army of the Potomac. It is hoped by the president as well as by the soldiers themselves, that 'Fightin' Joe' will prove to be both able and assertive, qualities which seemed lacking in the sincere but militarily inept General Burnside. In a letter to General Hooker, the president offers encouragement and cautions the general to avoid mixing 'politics with your profession.' Lincoln praises Hooker's confidence, 'which is a valuable, if not an indispensable quality.'

27 January 1863

The North A Philadelphia newspaperman, A D Boileau, is arrested on charges that his *Journal* is publishing anti-Union matter.
The Confederacy In a message to Georgia Governor Brown, President Jefferson Davis makes note of the urgent need to step up the cultivation of cotton and other produce. 'A short supply of provisions presents the greatest danger to a successful . . . war.'
Naval In a fierce bombardment from the ironclad USS *Montauk*, the Confederate Fort McAllister in Georgia sustains some damage. Firing from the Federal vessel in the Ogeechee River lasts for a better part of the day.

29 January 1863

The Confederacy Defense of Vicksburg, Mississippi, is uppermost in President Jefferson Davis' mind, since this city is critical to the control of an important stretch of the Mis-

sissippi River. Accordingly, the president sends a cable to General Pemberton at Vicksburg asking, 'Has anything or can anything be done to obstruct the navigation from Yazoo Pass down?' The Confederate president is well aware that General Grant means to press his Union troops on the city as soon as possible.
Eastern Theater Near Suffolk, Virginia, Union troops engage in minor skirmishing with Confederate forces. There is similar light fighting at Turner's Mills, also in Virginia.
Naval The Stono River in South Carolina is the site of an exchange between Confederate shore batteries and the Union gunboat *Isaac Smith*. The result is that the vessel first runs aground during the encounter and is then captured by the Confederates.

31 January 1863

Western Theater Despite the Confederate pullback from Murfreesboro, Tennessee, earlier in the month, there continues to be a series of minor confrontations between Union and Confederate soldiers in that vicinity. While on a reconnaissance mission from Murfreesboro to Franklin, Federals engage Southern troops at Unionville, Middleton and Dover. At the latter location, the North sustains five injuries while Confederates report 12 dead and 300 taken prisoner.
Naval At Charleston, South Carolina, there is a spectacular battle between Southern gunboats and Northern blockaders. The Confederate vessels *Chicora* and *Palmetto State*, both ironclads, succeed in damaging the Federal *Mercedita* and *Keystone State* extensively. The former vessel's crew suffer four killed and three injured, many of these casualties being the result of steam explosions from broken boilers. Despite this action, which does no damage to the Confederate ironclads, the harbor remains under the Federal blockade – although the South declares otherwise.

1 February 1863

The Confederacy Wartime inflation has made a serious impact on the Confederate currency so that it is estimated that the Confederate dollar has a buying power of only 20 cents.

Western Theater In Tennessee, Franklin is taken and occupied by Union troops. The Federal forces in New Berne, North Carolina, set off on an expedition which will last for 10 days and will take them to Plymouth.

2 February 1863

Eastern Theater The Union Army of the Potomac under the command of General Joseph Hooker encounters hostile fire as it gathers information about the area surrounding the Rappahannock River. There is skirmishing at Rappahannock Station.
Naval Vicksburg, Mississippi, is again the focus of action taken by the Union. The Federal vessel *Queen of the West* makes its way past Vicksburg, although the ram was fired on by Confederate shore batteries and sustained minor damage. The commanding officer of the vessel, Captain Charles Ellet, was hoping to destroy the Southern vessel *City of Vicksburg* and to put Confederate shipping in jeopardy. While unable to do this, Ellet succeeds in slipping by the shore batteries without losing his ship.

3 February 1863

Washington The Federal Congress recognizes naval Commodore John Worden's contribution to the Union war effort. Worden was the officer in charge of the USS *Monitor* at the time it battled the CSS *Merrimack* in March 1862. Worden was also in command of the *Monitor* when it foundered and was lost off Cape Hatteras, North Carolina, in December 1862. Secretary of State Seward confers with the French minister about the latter's handling of possible mediation. These mediation proposals are ultimately declined.
Western Theater In Tennessee, Fort Donelson is once again under attack, this time by Confederates under Generals Wheeler and Forrest. The Union troops garrisoned at the fort, under Colonel Harding, are able to hold out against the Southerners. Losses after the battle there indicate Northern dead at 12, with 30 injured. The Southern reports list 100 killed and 400 wounded, with 300 prisoners. Vicksburg, Mississippi, sees the *Queen of the West* attack and seize three Southern vessels. More Federal troops move out of Murfreesboro on a reconnaissance mission.
Trans-Mississippi In Missouri, Federal troops under Major Reeder engage in skirmishing with Southern forces at Mingo Swamp. The casualties reported by Confederates indicate nine dead and 20 wounded. At Yazoo Pass in Arkansas, Union soldiers are able to break through the levee, providing a passage for troops along the Yazoo River north of Vicksburg, Mississippi. It is intended that this channel will facilitate the Northern force's taking of the city at a date in the near future.

4 February 1863

Western Theater Union troops at Lake Providence, Louisiana, are routed by the forces of the Confederate 3rd Louisiana Division. The latter, however successful in this, sustains 30 casualties.

5 February 1863

International Queen Victoria makes an official statement concerning Great Britain's refusal to enter into mediation attempts be-

tween the Union and the Confederacy at this time. The reasons given include the observation that such matters cannot be 'attended with a probability of success.'

Eastern Theater General Joseph Hooker, appointed commander of the Union Army of the Potomac, reorganizes the force and makes a variety of command changes. There continues to be reconnaissance efforts around Rappahannock Bridge and Grove Church, Virginia. In West Virginia, Union troops embark on a four-day mission to Wyoming County from Camp Piatt.

6 February 1863

Washington After the re-establishment of the Federal Department of Washington, the command of said department is given to General S F Heintzelman. Secretary of State Seward makes official the Federal government's refusal of mediation offers from Napoleon III's government in France. Seward conveys this information to the French minister, M Mercier.

7 February 1863

Eastern Theater At Williamsburg, Virginia, Confederates ambush a Federal cavalry unit, resulting in the death and injury of 11 Union soldiers.

Naval Despite its secure hold on Southern ports, the Federal blockade fails in preventing three Confederate raiders from slipping through its cordon. The three vessels make it safely to port at Charleston, South Carolina. At Galveston, Texas, the South manages to remove the threat of the blockade, announcing the port there and at Sabine Pass to be open.

10 February 1863

Eastern Theater At Chantilly, Virginia, there is minor fighting between Union and Southern soldiers. In West Virginia, Northern troops embark on a three day reconnaissance, leaving from Beverly and heading for Pocahontas County. There is continued reconnaissance and exploration along the Rappahannock River as the Army of the Potomac reorganizes and assesses its position.

Western Theater Camp Sheldon, Mississippi, is once again the site of desultory skirmishing. In Louisiana, at Old River, Federal troops under Captain Tucker are successful in pushing back a force of Confederates. The resulting casualty list indicates that the South has 11 killed and wounded, with 25 men taken prisoner. The North reports eight dead and wounded.

12 February 1863

Western Theater Bolivar, Tennessee, witnesses the defeat of Union forces, resulting in four dead and five injured. At Sandy Ridge, North Carolina, some Union troops skirmish with Confederate troops.

Naval Captain Ellet's *Queen of the West* manages to fire on and destroy a number of Confederate wagon trains carrying supplies and ammunition, this taking place on the Red River. In Arkansas, the USS *Conestoga* takes two Southern steamers on the White River. The blockade-runner CSS *Florida* manages to seize and destroy the Yankee clipper *Jacob Bell* in the waters of the West Indies. The *Jacob Bell* was carrying a cargo of Chinese tea and

other goods of an estimated value of $2 million; the entire cargo is lost. Off Vicksburg, Mississippi, the Union ironclad gunboat *Indianola* successfully runs past Confederate shore batteries.

14 February 1863

Eastern Theater Annandale, Virginia, sees the defeat of a Federal cavalry unit at the hands of Confederate troops. Skirmishing breaks out along the Hillsborough Road and at Union Mills.

Trans-Mississippi Cypress Bend, Arkansas, is the site of light skirmishing between Federal and Confederate troops.

Naval Despite its recent success in avoiding serious damage or capture, the Union vessel *Queen of the West*, under the command of Captain Charles Ellet, finally suffers defeat. At first its operation on the Red River is successful and it manages to seize the Southern vessel *New Era Number Five*. Subsequently, however, the Federal ship runs aground and is abandoned by its crew when the boiler threatens to explode. The USS *De Soto* is in the vicinity and provides a safe escape vehicle for the *Queen of the West*'s crew who then transfer to the captured *New Era Number Five*. Ellet and his men take this vessel downstream where they connect with the ironclad *Indianola* on the following day, at a point just south of Natchez, Mississippi.

15 February 1863

Western Theater Minor fighting breaks out in Tennessee near Nolensville. The Federal force there under the command of Sergeant Holmes manages to defeat the Southern forces, killing eight, wounding 20 and taking four prisoners. There is also skirmishing at Cainsville, Tennessee, where Union Colonel Monroe is successful in holding off cavalry under Confederate General John Hunt Morgan. The tally of casualties shows two Federals killed, 12 injured; 20 Confederates dead, a large number wounded and six taken prisoner. Morgan's men were far from beaten in the fighting.

16 February 1863

Washington The Federal Senate passes the Conscription Act, which has yet to be signed into law by President Lincoln but which has the chief executive's full support. This new draft law is intended to fill the ranks of the Union army which is not adequately served by voluntary enlistment. In addition, desertion is found to be an increasingly serious problem. Late in 1862, Provost-Marshal General Simeon Draper estimated that around 100,000 soldiers had deserted their posts. This new draft law will, it is hoped, better provide for the interests of the Union than was the system in use until now.

Western Theater Skirmishing occurs at Yazoo Pass , Mississippi, as General Grant's men encounter Confederate opposition to the Federal preparation for a campaign against Vicksburg.

17 February 1863

Western Theater Lexington , Tennessee, is the starting point for a Federal expedition which will last five days and will take troops to Clifton, Tennessee. In Memphis, there is skirmishing between Union forces and Confederates.

Naval The Federal vessel *Indianola* is now in position near Vicksburg at the juncture of the Red and the Mississippi Rivers. The *Indianola* will carry on a harassing campaign against the Southern vessels headed upriver to Vicksburg. The USS *Hercules* is attacked by Confederates which prompts the burning of nearby Hopefield, Arkansas, in retaliation.

18 February 1863

Eastern Theater The Army of Northern Virginia sees several divisions of its Confederate troops removed from the vicinity of Fredericksburg, Virginia. These troops are to position themselves near Richmond, in order to protect the Southern capital from attack.

Below: The scene in a Southern camp during a lull in the fighting – a typical sight on both sides of the line.

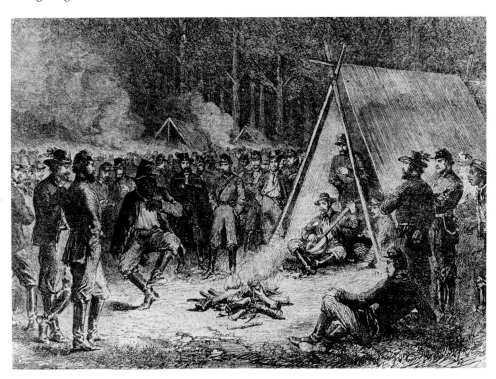

19 February 1863

The North In Iowa, Federal troops convalescing in a hospital in Keokuk become angry over the anti-Union sentiment expressed in the local newspaper the *Constitution*. Accordingly, the soldiers break into and ransack the news office.

The Confederacy President Jefferson Davis sends a letter to General Joseph Johnston, and in it the Confederate chief executive comments on his reluctance to remove General Braxton Bragg from command. Davis says to Johnston, 'It is scarcely possible for him to possess the requisite confidence of the troops.' Bragg's officers have expressed extreme dissatisfaction in his manner of command.

Western Theater At Coldwater, Mississippi, Southern troops under the command of Colonel Wood lose a minor confrontation with Federals. The results are six Confederate dead, three wounded, 15 taken prisoner.

20 February 1863

Western Theater Yazoo Pass, Mississippi, sees Union troops hold off an attack on their positions by Confederates. The casualty lists record five Northern soldiers wounded, six Confederates killed and 26 taken prisoner.

23 February 1863

Washington At the Federal capital, former War Department Secretary Simon Cameron hands in his resignation as minister to Russia.

Western Theater Skirmishing occurs at Athens, Kentucky, and in the vicinity of Fort Caswell in North Carolina.

24 February 1863

Western Theater In an unlooked-for blow to its river operations, the Federal navy suffers from the capture of its ironclad gunboat

Right: John Singleton Mosby, one of the South's greatest leaders of irregular forces.
Below: The destruction of the USS *Jacob Bell* by the Confederate raider *Florida* in West Indian waters, February 1863.

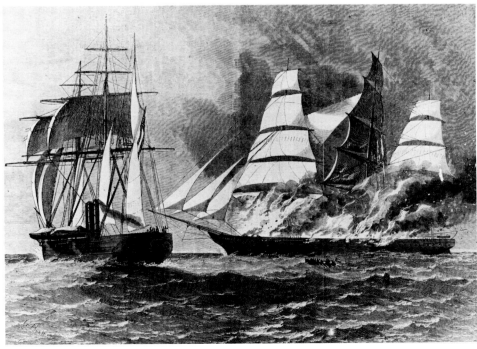

Indianola. After repeated ramming by the Confederates, the *Indianola* is forced to surrender, its commander Commodore George Brown terming it 'a partially sunken vessel.'

25 February 1863

The Confederacy Inflated prices continue to plague the Confederate nation, and reports from Charleston, South Carolina, indicate that a half-pound loaf of bread costs $25.00 and that flour is selling for $65.00 a barrel.

Eastern Theater There are repeated incidents of minor skirmishing in Virginia. These outbreaks between Federal and Confederate forces occur in Strasburg, Chantilly, near Winchester, and also at Hartwood Church.

26 February 1863

The North In an affirmation of support for the Union, the Cherokee Indian National Council repeals its former ordinance of secession.

The Confederacy President Jefferson Davis informs General T H Holmes that he is concerned for the welfare of Confederate citizens

in the Trans-Mississippi District. The chief executive feels that it is necessary to be diligent in both crop cultivation and military matters if the South wishes to maintain its hold on the area.

Eastern Theater Skirmishing occurs in Germantown, Virginia. At Woodstock, in that same state, Confederate forces clash with Union troops but are defeated, the latter suffering losses of 200 killed and wounded. General Longstreet takes command of Southern troops in the Confederate Department of Virginia and North Carolina.

28 February 1863

Western Theater On Georgia's Ogeechee River, the USS *Montauk* attacks and destroys the Confederate steamer *Nashville*. The *Montauk* is under the command of Commodore J L Worden, who commanded the Union's ironclad *Monitor* during its famous encounter with the Southern vessel *Merrimack*.

1 March 1863

Washington In order to discuss upcoming military appointments, some of which will be submitted for congressional approval within a few days, President Lincoln meets with Secretary of War Edwin Stanton and other advisors.

Western Theater In North Carolina, Union troops leave New Berne on a five-day reconnaissance to Swan Quarter. During the course of this expedition, there are numerous incidents of skirmishing.

2 March 1863

Washington While Congress approves several hundred military promotions and appointments that the president has submitted, actions are also taken to dismiss 33 army officers from the service as a result of their court-martials for a variety of charges.

Eastern Theater There is minor skirmishing in Virginia at Neosho and Aldie. The Army of the Potomac, under General Hooker, continues to make preparations to advance against General Robert E Lee's positions in Virginia.

Western Theater Tennessee sees skirmishing near Petersburg, the results of which are reports that Confederates suffer 12 dead and 20 wounded. Union troops set out on a three-week reconnaissance mission that begins in New Orleans, Louisiana, and will take them to the Rio Grande in Texas.

3 March 1863

Washington A number of comprehensive measures are passed by Congress, the most important of which is the new Enrollment Act, often called the Conscription Act, which calls for the enlistment in military service of all able-bodied male citizens between 20 and 45 years of age. This service will be for a three-year period, and the law also provides for these forces to be called up by Federal decree, without state intervention. On the whole, the Enrollment Act is well-received at least by the military. It passes both Houses of Congress. Generals Rosecrans, Sherman and Grant are particularly pleased about the prospect of receiving fresh troops as a result of this bill; the estimate of how many men would actually be drafted hovers around three million, but in reality, the first 10

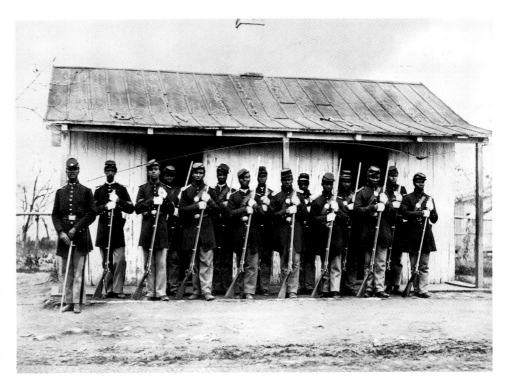

months of 1863 sees a total of only 21,331 new soldiers. The final tally of men enrolled during 1863-64 is about 170,000 – falling far short of original estimates but clearly benefitting the military in a moderate way. The Financial Bill passed by Congress at this time is intended to aid the Federal economy in part by the issuance of treasury notes. In addition, Congress authorizes suspension of the writ of habeas corpus throughout the entire Union. This measure is controversial and 36 Democratic representatives express their desire to go on record as protesting against such a sweeping move to curtail individual freedom, although this protest is not formally lodged. The Territory of Idaho is formed in the area which had previously been a portion of Washington.

4 March 1863

Washington The 37th Congress of the United States adjourns after completing its legislative activities. Among the final measures passed is one establishing the National Academy of Sciences to be based in Washington, DC.

Western Theater In Tennessee, near Spring Hill, General Van Dorn succeeds in capturing several of General Rosecrans' regiments. At Unionville, there is minor skirmishing, and a 10-day reconnaissance sets out from Murfreesboro, encountering considerable hostile fire from Confederates in the area.

5 March 1863

The North A newspaper office in Columbus, Ohio, that of the *Crisis*, is ransacked by Union troops after the publication of anti-Union sentiments.

Western Theater Vicksburg, Mississippi, continues to prepare and fortify against the inevitable battle looming ahead. Union forces are involved in constructing a canal across from the city; operations are occasionally interrupted by fire from Confederate shore batteries. Near Franklin, Tennessee, the Federal troops under Colonel Coburn's command are attacked and defeated by Confed-

Above: Members of the US 107th Colored Infantry Regiment pose for the camera outside their camp's guardhouse.

erates. The latter occupy the town, and Union losses are reported at 100 dead, 300 injured, 1306 taken prisoner. Southern casualties are tallied at 180 dead, 450 wounded.

7 March 1863

Western Theater The preparations for a campaign against Vicksburg, Mississippi, continue as Union General Banks advances toward Baton Rouge, Louisiana, in order to connect with General Ulysses Grant's plans for Vicksburg.

8 March 1863

Eastern Theater Fairfax County Court House in Virginia is the temporary headquarters of Union General E H Stoughton. The general and his men are captured there by Colonel Mosby's Confederates. This proves to be a valuable takeover for the South; they seize a number of prisoners, 58 horses, and large quantities of equipment and ammunition.

9 March 1863

Western Theater There are various incidents of minor skirmishing – at St Augustine, Florida, and in Tennessee near Salem. In Louisiana, near Port Hudson, General Nathaniel Banks' troops encounter Confederates as the former continue to move toward General Grant's position.

Trans-Mississippi Arkansas continues to see action near Chalk Bluff, and in Missouri a Federal expedition moves out from Bloomfield for a six-day reconnaissance mission which will take them to the towns of Kennett and Hornersville.

10 March 1863

Washington A proclamation of general amnesty is read by President Lincoln in order to encourage soldiers who are absent without leave to return to their regiments. This agree-

ment is that if these men report back to their units and active duty by 1 April 1863, they will not suffer any adverse consequences. The alternative is that these soldiers would be charged with desertion and arrested.

Western Theater Union forces commanded by Colonel Higginson and made up of predominantly black regiments occupy Jacksonville, Florida. Skirmishing breaks out in Tennessee near Covington, where Federal Colonel Grierson is successful in defeating Colonel Richardson's Southern troops.

11 March 1863

Western Theater In an effective action against the Northern preparations to move against Vicksburg, Mississippi, Confederate troops construct a defensive outpost known as Fort Pemberton. Union forces attempting to move past this position on the Yalobusha River, find that their gunboats are unable to withstand the fire from shore batteries at Fort Pemberton, where Confederates are under the command of General W W Loring. After six days of exchanging fire, the Union troops under General Grant are finally obliged to give up this preparatory effort of the Vicksburg campaign.

13 March 1863

The Confederacy Due to the carelessness of a factory worker who accidentally detonated a device on which she was working, the Confederate Ordnance Laboratory at Brown's Island near Richmond, Virginia, is the site of an explosion. As a result, 69 factory workers, of whom 62 are women, are either killed or injured. The fact that such a high proportion of casualties at an industrial site are women is a direct result of the Confederacy's response to wartime needs: not only are women taking the place of men on the farms, but when needed, they are taking over in both clerical and industrial roles to release men for military service.

14 March 1863

Naval Port Hudson, Louisiana, where Confederate troops are positioned north of Baton Rouge, is subject to bombardment from Union gunboats under Admiral David Farragut's command. This attempt by Federals to move past a Southern defense and head toward Vicksburg costs the navy the USS *Mississippi* which runs aground and is eventually burned. The USS *Hartford* and the *Albatross* are successful in making it past Port Hudson, but two other vessels in the flotilla, the *Monongahela* and the *Richmond*, sustain considerable damage and are forced to turn back. During this bombardment and destruction of one Federal ship, 65 men are listed as killed or missing.

15 March 1863

Western Theater In Mississippi, where Vicksburg residents and troops garrisoned there brace themselves for the seemingly inevitable Northern attack, Federal forces attempt to pass by Haines' Bluff but are unsuccessful.

Naval In the continuing blockade of Southern ports, the Federal navy is foiled once more as the *Britannia*, a British vessel, slips through the cordon off Wilmington, North Carolina. The Union blockade has been much

Above: Confederate shore batteries pound a Union flotilla attempting to reach Vicksburg, 14 March 1863.

more successful during the opening months of 1863, however, and authorities are pleased with their record of captures.

17 March 1863

Eastern Theater The Army of the Potomac sends a cavalry corps under the command of General William Wood Averell, to attack General Fitz Lee at Culpeper, Virginia. Taking 2100 men and six pieces of artillery, Averell engages 800 Southerners and four guns at the Battle of Kelly's Ford. After a full day of fighting, the Federals pull back from the site. Losses are tallied at 78 Union casualties to 133 for the Confederates.

19 March 1863

Naval Admiral Farragut has successfully maneuvered past Natchez, Mississippi, and is now moving past Confederate batteries at Grand Gulf with his two vessels, the *Hartford* and the ironclad *Albatross*. Farragut is now positioned just below Vicksburg.

20 March 1863

Western Theater In Florida there is some skirmishing at St Andrew's Bay. In Tennessee, near Milton, Confederates are attacked and defeated by Colonel Hall's Union troops who lose seven men and sustain three injuries. The South reports 40 dead, 140 wounded and 12 missing after this encounter. In Mississippi another Union attempt to reach Vicksburg, this time via Steele Bayou, proves unsuccessful as Admiral Porter takes 11 vessels along this water route, encountering Confederate fire at Rolling Fork. General Sherman has provided land reinforcements to help Porter's expedition and these reinforcements prove critical to the defense of Porter's fleet while it is under fire at Rolling Fork.

21 March 1863

Western Theater Tennessee witnesses various outbreaks of skirmishing: Union troops headed for Saulsbury on a reconnaissance from La Grange encounter hostile fire from Confederate forces, and there is fighting at Salem. Southern troops attack a Federal railroad train between Bolivar and Grand Junction, Tennessee. In Kentucky, Mount Sterling is seized by Confederates under the

command of Colonel Cluke. Several Federal expeditions begin – one from New Orleans headed to Ponchatoula, and one going from Bonnet Carre to the Amite River in Louisiana.

22 March 1863

Western Theater The area around Murfreesboro, Tennessee, continues to see much action between Federals and Confederate troops. In Kentucky there are several encounters between North and South as General John Hunt Morgan's cavalry attacks Federal positions there, and John Pegram's Confederates conduct operations against Union troops. These operations will continue throughout the rest of the month.

Trans-Mississippi In Missouri, Union forces are attacked and defeated by some irregular raiders near Blue Spring. In the sharp skirmishing, nine are killed, several are injured and five are taken prisoner.

23 March 1863

Western Theater The Union vessels *Hartford* and *Albatross*, positioned in waters just south of Vicksburg, make an attack on Confederate shore batteries at Warrenton. In Kentucky Union troops attack Mount Sterling where two days previously Confederates had seized the area. After brief fighting, Northern forces are once again in control there. Jacksonville, Florida, is the site of Federal reconnaissance efforts.

24 March 1863

Western Theater Northern troops attempt to make progress in their move toward Vicksburg, Mississippi, this time using Black Bayou as a passageway. This attempt is fruitless, however, both the geography and the Confederate troops posted in the area causing interminable delays. General Grant decides to terminate these efforts, and orders General Sherman to withdraw from the area in the final expedition in the Steele's Bayou area, the last of several endeavors to reach Vicksburg. Although fighting in the area draws to a close, Grant will later resume his efforts to capture the city.

25 March 1863

Washington President Lincoln approves command changes as General Burnside assumes responsibility for the Department of the Ohio. Burnside, formerly chief commander of the Army of the Potomac in Virginia, takes this new command after it is vacated by General Horatio Wright, who is transferred to the Army of the Potomac as a division commander.

Naval The final Union expedition to Vicksburg, that via Black Bayou, causes the North some difficulty as Confederates bombard the *Lancaster* and the *Switzerland*, two Northern rams, with artillery from shore. The *Lancaster* is destroyed and sinks; the *Switzerland* escapes, although it is badly damaged. Elsewhere, it is reported that Union ironclad vessels have left Hilton Head, North Carolina, and are making their way toward the habor at Charleston, South Carolina.

26 March 1863

Washington In a letter which reveals some of Lincoln's private sentiments concerning the former slave population, the chief executive says to Governor Andrew Johnson of Tennessee: 'The colored population is the great *available*, and yet unavailed of, force for restoring the Union. The bare sight of fifty thousand armed and drilled black soldiers on the banks of the Mississippi would end the rebellion at once.'

The North In West Virginia the citizens vote on and approve a referendum which will provide for the emancipation of slaves to be effected over a period of months.

27 March 1863

Washington President Lincoln meets with members of several American Indian tribes, advising them to turn to 'the cultivation of the earth' in order to provide economic stability for their people.

29 March 1863

Eastern Theater At Point Pleasant, West Virginia, there is some brief skirmishing which results in one Northern soldier dead, 12 Southerners killed and 14 wounded. There is also fighting at Williamsburg and Kelly's Ford, Virginia, where Confederates and Union troops clash.

Western Theater General Grant, anxious to establish a successful route to Vicksburg, Mississippi, directs General McClernand to open such a route from Milliken's Bend to an area just south of Vicksburg at New Carthage. McClernand is joined in this effort by Admiral Porter, who is to provide naval support - both troop transport and supply delivery. By combining both his naval and land forces, Grant is developing a strategy that will ultimately lead to the fall of Vicksburg.

30 March 1863

Washington President Lincoln announces the establishment of a day of fasting and prayer throughout the Union. This is set for 30 April 1863.

Western Theater Kentucky sees an encounter between North and South at Dutton Hill, where Confederates fight valiantly for five hours only to be defeated by a stronger Federal force. In North Carolina there is skirmishing at Rodman's Point.

31 March 1863

Eastern Theater Drainesville, Virginia, sees Union cavalry clash with Southerners under Colonel Mosby with the result that the Federals are defeated and lose 60 men.

Western Theater Union troops evacuate Jacksonville, Florida. At Eagleville, Tennessee, there is skirmishing and at Lexington in that state Northern forces begin a four-day reconnaissance mission heading for the Duck River.

Naval The CSS *Nashville* attempts to run the Union blockade in waters of the Savannah River. The vessel is sunk by a Northern ironclad. On the Mississippi, Union Admiral David Farragut is successful in taking the *Hartford*, the *Switzerland* and the *Albatross* past Confederate shore batteries at Grand Gulf, Mississippi.

2 April 1863

The Confederacy The Confederate capital of Richmond, Virginia, is the site of a bread riot – instigated by various factors, chief among them the very real specter of hunger facing many in the city and other parts of the Southern nation. A mob of people initially demand bread from a bakery wagon but soon harass nearby shops, destroying property and necessitating the call-out of local police; one store reports losses of $13,000 in merchandise. President Jefferson Davis makes a brave move, placing himself in the middle of the gathered crowd and stating, 'We do not desire to injure anyone, but this lawlessness must stop. I will give you five minutes to disperse, otherwise you will be fired upon' (this, in reference to the assembled militia nearby). When the mob recognizes that the intent of the militia is to fire, the crowd disperses and the riot ends without bloodshed, although a number of arrests are made.

3 April 1863

Washington The president makes preparations to visit the Army of the Potomac, where he will meet with General Hooker.

The Confederacy There are concerns on the part of President Jefferson Davis that the Trans-Mississippi area will fall into Federal hands unless the eastern bank of the Mississippi River can be adequately defended. In a letter to Arkansas Governor Harris Flanagin, Davis says, 'The defense of the fortified places on the Eastern bank is therefore regarded as the defense of Arkansas quite as much as that of Tennessee, Mississippi and Louisiana.'

4 April 1863

Washington President Lincoln leaves the Federal capital for Fredericksburg, Virginia, where he will meet with generals of the Army of the Potomac.

5 April 1863

International The British take action against several Confederate vessels, detaining them at Liverpool. One of these, the *Alexandria*, has been undergoing construction in preparation for its use as a blockade-runner in Confederate waters. The indication by this action is that Great Britain is changing its views regarding active support of the Federals. While the *Alexandria* is ultimately released, its seizure and detention serve to notify the Confederacy that they can expect less and less from Palmerston's government in terms of recognition or support.

6 April 1863

Washington After conferring with General Hooker at Potomac Army headquarters, President Lincoln notes, 'our prime object is the enemies [sic] army in front of us, and is not with, or about, Richmond.'

Western Theater As General Grant has ordered, General McClernand has proceeded to New Carthage, Mississippi. There is some brief fighting between Federals and Confederate troops as a result of this advance toward Vicksburg, Mississippi.

7 April 1863

Western Theater There are various episodes of minor skirmishing as Southern forces under General Wheeler conduct raids on several railroads in Tennessee. The Louisville and Nashville line and the run between Nashville and Chattanooga are the targets of these surprise Confederate attacks occurring for four days.

Below: The USS *Mississippi* burns after running aground during an unsuccessful attempt to pass the Southern batteries at Port Hudson.

Above: Nine Union ironclads under Flag Officer DuPont bombard Fort Sumter in an unsuccessful attempt to close Charleston harbor.

Naval The Union vessel *Barataria*, plying the waters of the Amitie River in Louisiana, is attacked and seized by Southern troops. At Charleston, South Carolina, Federal naval forces attack Fort Sumter with a fleet of nine ironclad vessels. These forces are led by Flag Officer Samuel DuPont, and the attack provokes both Fort Sumter and Fort Moultrie to retaliate. The USS *Weehawken* is hit, along with the *Passaic*, the *Montauk*, the *Nantucket* and the *Patapsco*. The Federals are unable to return the Confederate fire in any effective way, being too severely disabled. DuPont withdraws the remaining vessels, and both Confederates and Federals sustain extensive damage; the South reports seven dead, the North, two killed and 13 injured. The USS *Keokuk* is hit so badly as to be unsalvable and it sinks the following day. This action indicates to Federals that, despite their hopes, the important Southern port of Charleston cannot be taken by naval action alone, but will require an operation of combined land and sea forces.

8 April 1863

Western Theater McClernand's Union troops in Mississippi engage in skirmishing in the vicinity of New Carthage, near Milliken's Bend. The troops were carrying supplies and preparing a route for General Grant's upcoming operations against Vicksburg. A particularly sharp skirmish occurs at James' Plantation between McClernand's men and Southern forces in the area.

10 April 1863

Washington President Lincoln, after spending the morning reviewing Potomac Army troops at Falmouth, Virginia, disembarks at Aquia Creek and returns to the Federal capital late in the day.
The Confederacy In an emphatic statement concerning his beleaguered nation's needs, President Jefferson Davis points out that 'We must not forget . . . that the war is not yet ended.' He advises Confederates to concentrate their agricultural efforts on crops other than tobacco and cotton; these cash crops are considered less critical now than 'corn, oats, peas, potatoes and other food for man and beast.' It has become obvious to Davis, government authorities and the general citizenry, that the Southern economy is nearly at breaking point, that to purchase food and industrial products from abroad will be less and less feasible. The nation must redouble its efforts at self-sufficiency, as the recent bread riot in Richmond, Virginia, points out. Several months prior to this, a newspaper in the Confederate capital, the *Dispatch*, indicated that the cost of feeding a family increased over the first two years of the war from $6.65 to $68.25 per week.
Western Theater In Tennessee, near the town of Franklin, General Granger's troops attack Confederate forces under General Van Dorn and defeat the latter in a brief battle which leaves 100 Northern soldiers dead and injured. Confederate losses are tallied at 300 killed or wounded.

11 April 1863

Washington Having recently met with General Hooker and other Potomac Army officers in Virginia, President Lincoln now holds meetings with his cabinet and with General Halleck. At these meetings, the president discusses strategies for both the Eastern and Western Theaters with emphasis on the upcoming Vicksburg campaign under General Grant.
Eastern Theater In Virginia there is skirmishing near Williamsburg and near the Blackwater River. Confederate troops under Longstreet begin a month-long siege of Suffolk, Virginia.
Western Theater In Louisiana Federal General Nathaniel Banks takes 17,000 troops on an expedition toward the Red River, where Confederates are at Fort de Russy.

12 April 1863

Washington In a letter to President Lincoln, General Hooker indicates his desire to cross the Rappahannock River and outflank General Robert E Lee and his Confederates.
Western Theater The Amitie River in Louisiana is the site of a minor skirmish between Federals and Confederates. Stewartsborough, Tennessee, is the scene of brief skirmishing as Federal reconnaissance efforts are conducted in the area.

13 April 1863

Western Theater General Burnside, commander of the Department of the Ohio, issues a proclamation stating that Confederate sympathizers in the vicinity are to be deported to Southern lines. In addition he states that the death penalty is to be meted out to those convicted of aiding the Southern cause.

14 April 1863

Western Theater In Louisiana, at Bayou Teche, Union troops confront Confederates, resulting in 150 Northern casualties. The Southern tallies are not definitive, but in general it is agreed that their losses are much more substantial than Federal casualty figures. At this engagement, the *Queen of the West*, formerly a Union vessel but now in Confederate hands, is bombarded and destroyed by Northern fire.

15 April 1863

Eastern Theater In an estimate of troop strength, General Hooker, head of the Army of the Potomac, reports that he has nearly 130,000 men at his disposal. This contrasts with General Lee's forces in the area which number about 60,000. There is , once again, skirmishing at Norfleet House near Suffolk, Virginia.
Naval Two Federal whaling ships are seized by the CSS *Alabama* which continues

Below: General Grenville Dodge commanded the Northern forces during the Battle of Tuscumbia, Alabama, on 24 April 1863.

to ply Atlantic waters. The *Alabama* takes the two Union vessels off the coast of the Brazilian island of Fernando de Noronha.

16 April 1863

The Confederacy President Jefferson Davis puts his signature to a bill passed by Congress which will allow soldiers below the age of majority to hold military commissions.
Naval In a successful venture involving 12 vessels, Admiral David Porter runs the Confederate batteries at Vicksburg, Mississippi. There is but one ship lost as Porter's fleet sails through a heavy bombardment from the shore. The fleet comes to rest at Bruinsburg, Mississippi.

17 April 1863

Western Theater Colonel Benjamin Grierson leads 1700 men on a 16-day raiding mission that leaves La Grange, Tennessee, at dawn. Intended to divert Confederate strength and attention from the buildup of Federal forces near Vicksburg, Grierson's raid ultimately covers a 600-mile area of Mississippi.
Trans-Mississippi A raiding party that sets out from Arkansas is led by Confederate General John Marmaduke. These forces harass Federal positions throughout Missouri for a 16-day period.

18 April 1863

Western Theater There is minor activity near New Iberia, Louisiana, the location of a Southern saltworks. Federal troops seize and destroy this position. In Hartsville, Tennessee, there is continued skirmishing. Grierson's Union raiders encounter the first dis-

ruption in their line of march near the town of New Albany, Mississippi, where light skirmishing breaks out.
Trans-Mississippi Arkansas is the site of fighting as Southern troops attack Northern forces at Fayetteville, but with little success. In Missouri, Union troops conduct several reconnaissance missions.

19 April 1863

Washington In order to gather further information about the status of the Potomac Army, President Lincoln takes General Halleck and War Secretary Edwin Stanton to Aquia Creek, Virginia, on a one-day fact-finding mission.
Western Theater There is continued skirmishing in Mississippi connected with Grierson's raid, Pontotoc seeing a brief encounter between Federals and Confederates. In Tennessee there is skirmishing at Coldwater, where Colonel Bryant's Union forces successfully subdue Southern troops there.

20 April 1863

Washington After its approval by Congress, the bill allowing West Virginia to enter the Union is declared by President Lincoln as taking effect on 20 June 1863.
Western Theater In Louisiana, General Nathaniel Banks and his Northern troops successfully take Opelousas. During this ground operation, the Federal naval forces operating in the area take Butte-a-la-Rose. In Tennessee there is a Union reconnaissance from Murfreesboro to the area around McMinnville in an operation lasting for a 10-day period.
Trans-Mississippi In Missouri, there is an

Above: A view of Vicksburg, Mississippi, as it looked before its long siege and 1863 conquest by Union general U S Grant.

encounter between Northern and Southern troops at Patterson. The result of this action is the defeat of Federals under Colonel Smart, with an approximate 50 casualties. Bloomfield, Missouri also sees minor skirmishing.

22 April 1863

The Confederacy President Jefferson Davis communicates with General John Pemberton at Vicksburg, Mississippi. The Confederate president advises the general to consider disrupting Federal naval operations by sending fire rafts down the Mississippi River.
Eastern Theater In Virginia, near the town or Strasburg, Confederate troops are defeated by Majors McGee and White. The results of this minor encounter are that the Southerners lose five men, with nine injured and 25 taken prisoner. There are also outbreaks of fighting near Belle Plain, Virginia, as Union troops set out from there to Port Royal on a reconnaissance lasting three days.
Naval At Vicksburg, Mississippi, Federals make an attempt to send 18 vessels past Confederate shore batteries. There is some success in this venture; although the Union loses one transport and six barges, General Grant's troops receive the supplies carried by the 11 remaining vessels.

24 April 1863

The Confederacy In a controversial move, the Confederate Congress approves a fiscal measure which places an eight percent tax on all agricultural products grown in the pre-

Above: Union reinforcements arrive to complete the defeat of the South at the Battle of Tuscumbia, Alabama.

vious year. In addition, there is a 10 percent tax placed on profits made from the purchase or sale of most food, clothing and iron . Taxes on licenses are included in this bill, and a graduated income tax is instituted. Estimates of the revenues generated from the 10 percent tax-in-kind levied on agricultural products grown or slaughtered in 1863 hover around $62 million. This last component of the tax law is considered to be particularly difficult, some terming it confiscatory.

Western Theater In Alabama, Confederate troops encounter Northern forces under General Grenville Dodge at Tuscumbia, and

Below: Two scenes from the engagement at Chancellorsville, showing the repulse of Jackson's Southerners.

are defeated there. In Mississippi, Grierson's Federal raiders push deeper into Confederate territory and engage in fighting near Birmingham.

Trans-Mississippi On the Iron Mountain Railroad in Missouri, the North successfully routs Southern troops near St Louis. In addition, Confederate General John Marmaduke and his forces skirmish at Mill Creek in Missouri.

25 April 1863

Eastern Theater Fighting in West Virginia at Greenland Gap sees Federals clash with Southern forces. The former tally losses of 15 dead with 60 taken prisoner; the Confederates estimate close to 100 killed and a large but undetermined number of prisoners.

Western Theater In Mississippi the forces of General Grant, intent on taking possession of Vicksburg, engage in skirmishing near Hard Times Landing.

26 April 1863

Western Theater General Streight sends troops on a raid, leaving from Tuscumbia, Alabama. In Kentucky a band of Southern troops known as the Texan Legion surrenders at Franklin. There is a raid on Deer Creek, Mississippi, staged by Union forces.

Trans-Mississippi The Federal garrison at Cape Girardeau, Missouri, is attacked by Confederate raiders under the command of General John Marmaduke. The Union troops there successfully repel the Southern forces and the latter suffer 40 dead, 200 wounded. Union troops under the command of General John McNeil report six dead and six wounded at this encounter.

27 April 1863

Eastern Theater, Chancellorsville Campaign
The Federal Army of the Potomac under General Hooker's command moves along the Rappahannock River, heading in the direction of Chancellorsville, Virginia. Hooker has approximately 70,000 men with him. Staying behind is General Sedgwick, with 30,000 men, in position near the Confederate camp at Fredericksburg.

28 April 1863

Eastern Theater The Army of the Potomac crosses the Rappahannock River.

Western Theater In Georgia, there is a clash between Union and Confederate cavalry at Sand Mountain. The result of this is the defeat of the Southern forces.

29 April 1863

Eastern Theater, Chancellorsville Campaign
There is a severe threat to General Robert E

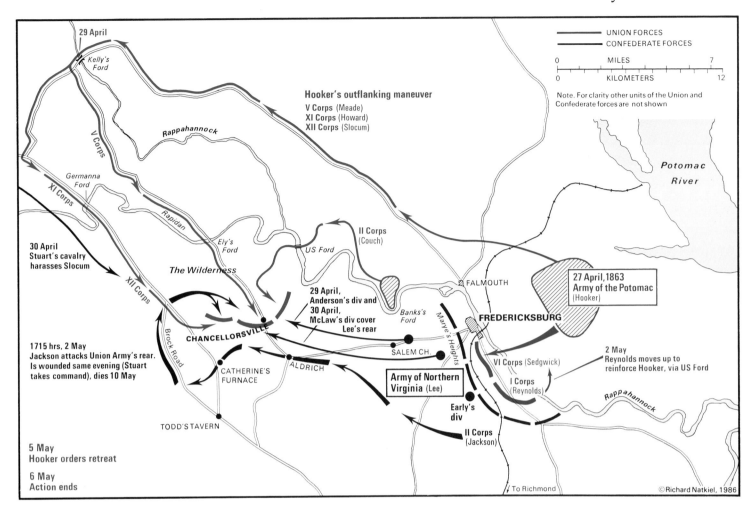

Lee's Confederates as the major portion of the Federal Army of the Potomac continues to cross the Rappahannock River. There is minor skirmishing near Fredericksburg and at Crook's Run near Kellysville, Virginia.
Western Theater Union troops conduct a reconnaissance that leaves La Grange, Tennessee, and moves into Mississippi several days later. At Vicksburg, Mississippi, Union troops under General Sherman stage an attack near Snyder's Mill in order to distract Confederate forces in the area.
Naval Union gunboats fire on Southern positions at Grand Gulf, Mississippi, although the effort, headed by Admiral David Porter, is ultimately useless in providing a clear route for the passage of General Grant's forces to Vicksburg.

30 April 1863

The Confederacy In order to try to save Vicksburg, Mississippi, from General Grant's imminent attack, President Jefferson Davis advises General Joseph E Johnston of General Pemberton's situation at the beleaguered city: 'General Pemberton telegraphs that unless he has more cavalry, the approaches to North Mississippi are almost unprotected.'
Eastern Theater, Chancellorsville Campaign General Stoneman and his detachment of Union cavalry lead a raid on the Confederate Army of Northern Virginia, destroying portions of the Virginia Central Railroad and cutting General Robert E Lee's communication lines. As a result of this operation, which lasts for seven days, the Union force, totaling about 10,000, suffers around 150 casualties. The South tallies its losses at about 100 killed

and injured, with 500 soldiers taken prisoner. General Hooker, encamped near Chancellorsville with the Army of the Potomac, reports that 'the operations of the last three days have determined that our enemy must ingloriously fly, or come out from behind their defenses.'
Western Theater In Mississippi, General McClernand's Union troops cross the Mississippi River near Bruinsburg. Near Vicksburg, General Grant prepares to push inland with his Federal forces stating, 'All the campaigns, labor, hardships . . . were for the accomplishment of this one object.'

1 May 1863

The Confederacy The First Confederate Congress establishes a provisional navy and draws up a resolution that will provide for the punishment of white Northern army officers captured while in command of Northern black military units.
Eastern Theater, Chancellorsville Campaign At Chancellorsville, Virginia, General Hooker's Army of the Potomac engages General Lee's Confederates in the early part of the day. Later, in the afternoon, Hooker's force of nearly 70,000 men pull away from the Southern forces and all of General Lee's 47,000 troops to take an offensive position. The Potomac Army gathers in an area of rather dense undergrowth known as the Virginia Wilderness where a portion of Lee's army, under the command of General Stonewall Jackson, will make a devastating attack on the Federal army's right flank.
Western Theater, Vicksburg Campaign After having crossed the Mississippi River the previous day, General McClernand's

Above: The Battle of Chancellorsville, May 1863, saw the death of Jackson.

Union troops advance on the Southern position at Fort Gibson. Under the command of Confederate General John Bowen, Southern troops march from Grand Gulf, Mississippi, to attempt to divert McClernand's advance but to no avail. The Federals push steadily forward, resulting in the Southern evacuation of the town of Port Gibson. The way becomes steadily more clear for Grant's forces to march on Vicksburg. The losses at this encounter are tallied at 131 Federals killed, 719 wounded and 25 missing. Confederates report 1150 casualties and 500 taken prisoner.

2 May 1863

Eastern Theater, Chancellorsville Campaign The Army of the Potomac continues to fight at Chancellorsville, Virginia. General Stonewall Jackson takes his Confederates past the Federal right flank to the west and attacks late in the day. This maneuver is aided by General Lee's fire on the Federal left into Union General Meade's men. While regrouping, General Stonewall Jackson is wounded in the arm by his own men; General A P Hill, another Confederate officer, is also wounded – J E B Stuart is now to take command. The Federals are dispersed and pushed back toward Chancellorsville, largely due to General Stonewall Jackson's brilliant outflanking strategy.
Western Theater, Vicksburg Campaign Bayou Pierre, Mississippi, sees fighting as Grant's men push inland to Vicksburg. Colonel Grierson's men are completing their

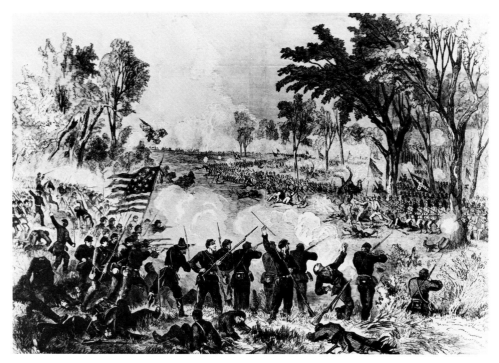

Above: Union troops attempt to stem a Southern attack during the fighting around the town of Chancellorsville.

600-mile raid, riding hard into Baton Rouge, Louisiana, after having skirmished at several points, including Robert's Ford on the Comite River. The total losses reported for this daring 16-day raid are three killed. seven wounded, nine missing and five men left sick. Grierson estimates that Confederates suffered 100 dead, 500 prisoners taken as a result of his raiders' efforts, and that the South has lost over 50 miles of railroad line and approximately 3000 guns.

3 May 1863

The North In Iowa, Catholic members of the pro-Confederate Knights of the Golden Circle are told by their bishop that they will be excommunicated if they do not resign from this fraternal order.

Eastern Theater, Chancellorsville Campaign
Fighting at Chancellorsville, Virginia, continues as the Confederates pound away at Northern positions. The latter are forced to pull back to Chancellor's House as General Lee's troops steadily shell the area from a position known as Hazel Grove. Late in the evening, General Hooker orders General Sedgwick to fire on Confederate positions at

Fredericksburg and the ensuing engagement becomes known as Second Fredericksburg. The Federals at first appear to gain the upper hand, but as they push through the weakened Confederate defense, General Lee opens a new attack on Sedgwick's men at Salem Church, Virginia, halting any further Union advance.

Western Theater, Vicksburg Campaign The Confederate positions at Grand Gulf, Mississippi, are evacuated as a result of General Grant's advance. There is continued skirmishing in the vicinity of Vicksburg as Northern troops encounter Confederates.

4 May 1863

Washington President Lincoln waits in the Federal capital for a word from General Hooker concerning the outcome of the battle at Chancellorsville, Virginia. The president fears the outcome and questions Hooker about the Federal positions at Fredericksburg, Virginia.

Eastern Theater, Chancellorsville Campaign
The Federal Army of the Potomac fails to take the offensive at Chancellorsville, and General Lee's Confederates continue to push Sedgwick's troops back, forcing them to cross the Rappahannock during the late evening. Fredericksburg is once again out of the Union's grasp. General Hooker, unwilling to risk another attack, orders the entire Potomac Army to withdraw across the river. At these Chancellorsville engagements, casualties are heavy – the North loses 1606 men, with 9762 injured and another 5919 counted as missing, all of these casualties occurring between 27 April and 4 May. The South reports 1665

Below: Units of Hooker's Army of the Potomac prevent a Confederate breakthrough at Chancellorsville, 3 May 1863.

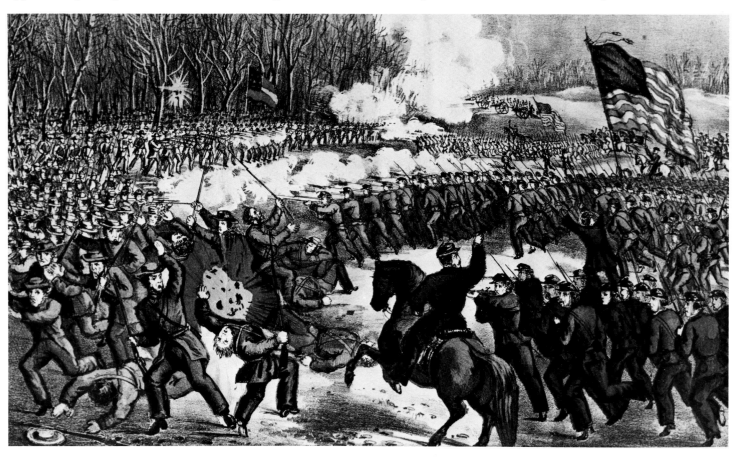

dead, 9081 wounded and 2018 missing. Among the casualties is General Stonewall Jackson, whose arm has now been amputated as a result of the wound received on 2 May; Davis contacts General Lee by telegraph and tells the victorious general that the nation has 'reverently united with you in giving praise to God for the success with which He has crowned your arms.'

Western Theater, Vicksburg Campaign General Grant pushes into the area south of Vicksburg and minor fighting occurs on the Big Black River.

Naval As part of the Vicksburg campaign, the *Albatross* and several other Union gunboats attack Fort De Russy on Louisiana's Red River. This effort proves fruitless and results in damage to the *Albatross*.

5 May 1863

The North In Dayton, Ohio, Clement Vallandigham, former congressman and a leading Copperhead, or Peace Democrat, having termed the war 'wicked and cruel,' is charged with treason and brought before a military commission by General Burnside, the arresting officer.

Trans-Mississippi In the Utah Territory the Union forces stage an operation, leaving Camp Douglas and intent on subduing pro-South Indians in the vicinity. This expedition heads toward the Bear River in Indian Territory.

6 May 1863

The North Clement Vallandigham is sentenced to close confinement for the duration of the war as a result of his inflammatory statements earlier in the week.

Eastern Theater Despite the defeat of the Federal Army of the Potomac at Chancellorsville, Virginia, General Joseph Hooker makes a public statement of congratulation to the army: 'The men are to be commended on the achievements of the past seven days.' President Lincoln and General Halleck visit Hooker to confer with him on military strategy. As Stonewall Jackson continues to suffer from his wounds, General A P Hill takes charge of II Corps of the Confederate Army of Northern Virginia.

Western Theater, Vicksburg Campaign In Mississippi, Tupelo is the scene of a clash between Union forces under Colonel Corwyn and Southerners commanded by General Ruggles. The latter are defeated and 90 Confederates are taken prisoner.

7 May 1863

Washington Full of concern over the turn of events in Virginia, President Lincoln has returned to the Federal capital after conferring with General Hooker in Virginia. Lincoln writes a letter to Hooker in which he says, 'If possible I would be very glad of another movement early enough to give us some benefit from the fact of the enemies [sic] communications being broken, but neither for this reason or any other, do I wish anything done in desperation or rashness.'

The Confederacy With the victory at Chancellorsville behind them, the Southern leaders turn to Vicksburg, Mississippi, with hope and concern. President Davis contacts the Confederate General John Pemberton saying, 'To hold both Vicksburg and Port

Hudson is necessary to our connection with Trans-Mississippi. You may expect whatever it is in my power to do for your aid.'

9 May 1863

The North In a response to General Hooker's congratulatory words to his Army of the Potomac on 6 May 1863, a *New York World* editorial makes the following remarks: 'Whoever knows the facts of the last two weeks will shudder as he reads this order. Whoever does not, let him credit it and believe that his ignorance is bliss.'

Western Theater, Vicksburg Campaign In Mississippi, where Vicksburg is threatened by General Grant's Federals, there is skirmishing near Utica and at Big Sandy Creek. In Louisiana, General Nathaniel Banks' Union troops arrive in Alexandria after having conducted a series of successful raids.

10 May 1863

The Confederacy Since the amputation of his arm, Confederate General Jackson has contracted pneumonia. His death today comes as a terrific blow to the Southern nation; psychologically as well as strategically, Jackson has been an important military figure. Beloved by his men and relied on heavily by General Lee, Jackson dies at the age of 39 at Guinea's Station, Virginia. A note from General Lee to General Jackson dated 3 May 1863, and sent in reference to the latter's injured arm, indicates the depth of Lee's regard for General Stonewall Jackson: 'I cannot express my regret at this occurrence. Could I have directed events I should have been disabled in your stead. I congratulate you upon the victory which is due to your skill and energy.'

11 May 1863

Washington In a continuing current of agitation and strained feelings, President Lincoln is once more caught between opposing political opinions, prompting Secretary of the Treasury Salmon Chase to present his resignation. The chief executive once more refuses to accept Chase's offer to step down.

The North Clement Vallandigham applies in Cincinnati, Ohio, for a writ of habeas cor-

Above: General John Pemberton was ordered to hold Vicksburg for the South by President Jefferson Davis.

pus but is turned down by the United States circuit court there.

12 May 1863

Western Theater, Vicksburg Campaign General Grant's Union troops move closer to Vicksburg, and a division under the command of General John Logan is positioned at Raymond. Logan's Federals are attacked at this point 15 miles from Vicksburg by Confederate forces under the command of General John Gregg. The fighting causes Southern troops to fall back toward Jackson, Mississippi, and each side reports upward of 500 casualties. This skirmish makes clear to General Grant that the South has sufficient

Below: Protected by earth and timber breastworks Union troops enjoy a break from the heavy fighting around Chancellorsville.

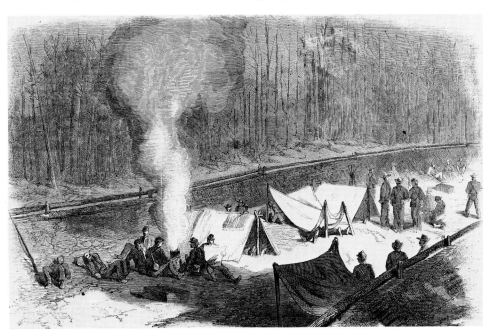

troop strength to defend Vicksburg and causes the Union commander to plan preliminary assaults on Confederate positions outside the city.

13 May 1863

Western Theater, Vicksburg Campaign General Pemberton, making preparations for the anticipated attack by Union forces, places Confederates in position at Edward's Station, or Edward's Depot, Mississippi. General Grant's men head toward this point and also toward Jackson, northeast of Vicksburg.
Trans-Mississippi In Missouri there is a Union reconnaissance effort out of Newtonia headed to Centre Creek; this operation lasts until 18 May.

14 May 1863

Eastern Theater There is much concern over the command of the Federal Army of the Potomac. President Lincoln is in contact with General Joseph Hooker, who has done little with the army since Chancellorsville. Lincoln writes to the General saying, 'Some of your troops and Division Commanders are not giving you their entire confidence.'
Western Theater Despite inclement weather, General Grant moves his troops nearer to Jackson, Mississippi, where Confederates have pulled back farther north.

Below: A map showing the movement of Grant's forces before the siege of Vicksburg.

This latter movement is deemed necessary by Confederate General Johnston since he knows his troops are vastly outnumbered. Grant strikes General Gregg's brigade first, and then that of General W H T Walker. By late afternoon, the Southern forces can no longer hold back the Union troops and the latter move in to occupy Jackson, Mississippi, around 1600 hours. To the south, Federal General Nathaniel Banks takes his forces out of Alexandria, Louisiana, heading for Port Hudson, north of Baton Rouge. Port Hudson is considered the second most critical Confederate position on the Mississippi River and its fall is vital to Federal plans.

15 May 1863

The North Union troops break into the office of the *Jeffersonian* at Richmond, Indiana, and wreck the facilities there. This action is precipitated by anti-Union sentiments published by the newspaper.
Western Theater, Vicksburg Campaign Both Confederates and Federals take positions near Edward's Station, Mississippi. General Pemberton has concentrated most of his Southern force here, with a garrison remaining at Vicksburg for the defense of that city. Pemberton is attempting to locate and destroy the Federal lines of communication, an attempt which is fruitless since Grant's strategy of concentrating his troops in the vicinity of Vicksburg precludes the necessity of such communications.

16 May 1863

Western Theater, Vicksburg Campaign The Battle of Champion's Hill, or Baker's Creek, Mississippi, occurs as Grant's Federals clash with Pemberton's Confederates. General McClernand leads his Union forces, attacking the Southern left flank, and McPherson advances on the right of Pemberton's troops. The position at Champion's Hill is held by about 20,000 Confederate soldiers but despite several occasions on which the 29,000 Federals are pushed back, the North ultimately gains possession of the hill. Pemberton's men retreat toward Vicksburg and the Big Black River in Mississippi. This battle at Champion's Hill is considered to be the most severe in the entire Vicksburg campaign. The reports of casualties are an indication of this: Union losses are tallied at 410 dead, 1884 wounded, 187 missing for a total of 2481 altogether out of the original 29,000 men. The Confederacy enters the battle with nearly 20,000 troops and reports 381 killed, approximately 1800 wounded and 1670 listed as missing. This is a total of 3851 casualties for the South.

17 May 1863

Western Theater, Vicksburg Campaign As Pemberton's Confederates continue their retreat, General Grant pursues and a fight at the Big Black River Bridge is the result. A short but fierce encounter, this battle sees Pemberton's men attempt to slow Grant's

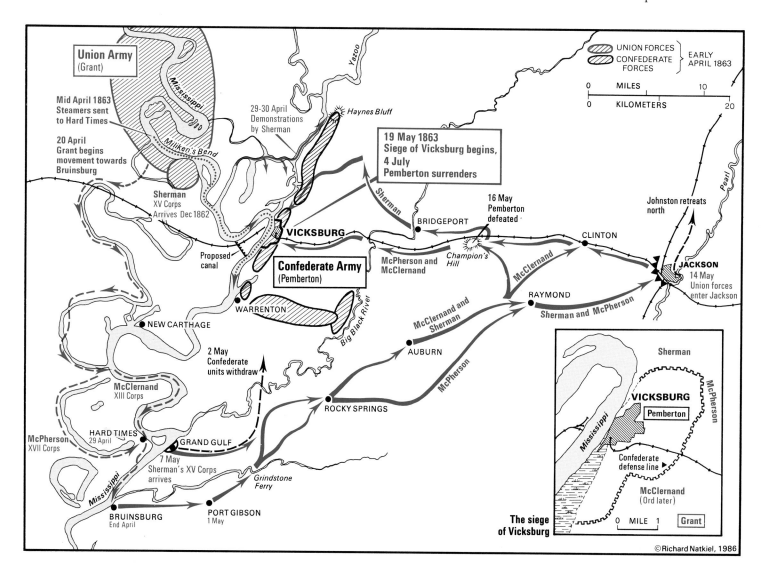

©Richard Natkiel, 1986

Above: Union forces make an abortive attack on strong Southern defenses around the vital city of Vicksburg.

progress by burning the bridges spanning the river, succeeding partially but at a cost of 1700 Confederates taken prisoner by the North. Federals report losses of 39 dead, 237 wounded and three missing out of a fighting force of nearly 10,000. The South stages their defense at this position with about 4000 men. Elsewhere, Union General Nathaniel Banks pushes to a point directly across the Mississippi River from Port Hudson, thereby threatening this vital position.

18 May 1863

The Confederacy Alarmed over the developments at Vicksburg, President Jefferson Davis exhorts civilians and militia in Mississippi to aid General Johnston's efforts and encourages the latter to join forces with Pemberton so as to make an effective attack on Federal forces threatening Vicksburg.
Western Theater, Vicksburg Campaign As General Grant moves his Federals closer to Vicksburg, crossing the Big Black River on reconstructed bridges, General John Pemberton decides to remain with his forces in the city. So begins the siege of Vicksburg, Mississippi, by the Federals.

19 May 1863

Washington The issues surrounding the arrest and imprisonment of Ohio congressman Clement Vallandigham have yet to be laid to rest. Secretary of War Edwin Stanton, carrying out President Lincoln's orders, directs that Vallandigham be sent outside of Federal military boundaries and not be allowed to return.
Western Theater, Vicksburg Campaign Anticipating a relatively easy access to the city, General Grant advances on Confederate fortifications outside Vicksburg, Mississippi. General John Pemberton's troops are well-positioned, however, and the Federals are unable to cut through Southern fortifications. Generals Sherman, McClernand and McPherson all attack with their troops, the result of which is the loss of nearly 1000 Federals in this initial assault on the Confederate positions around Vicksburg.

20 May 1863

Trans-Mississippi In Indian territory there is minor skirmishing between Union and Confederate troops at Fort Gibson.
Naval The Confederacy continues to foil the Union blockade efforts as two Southern vessels make it safely to the harbor at Charleston, South Carolina, from Nassau in the Bahamas. Federal blockaders are able, however, to capture two other Confederate ships, one off the coast of Nassau and one off the mouth of the Neuse River in North Carolina.

21 May 1863

Western Theater, Vicksburg Campaign Federal General Nathaniel Banks moves his troops into position in the area near Port Hudson, Louisiana. The bulk of this force is concentrated at Bayou Sara; other troops are moving along the Clinton Road from Baton Rouge; still others encounter hostile fire from Confederates near Plains Store. These maneuvers of Banks' troops mark the beginning of the siege of Port Hudson.
Naval At Yazoo City, Mississippi, the Confederates destroy a number of workshops in the navy yard and also destroy two steamboats and a gunboat. These actions are completed in the face of an advancing enemy flotilla heading toward the city on the Yazoo River.

22 May 1863

Washington President Lincoln meets with convalescing soldiers at the White House. At this meeting, the president points out that 'the men upon their crutches were orators; their very appearance spoke louder than tongues.'
Western Theater, Vicksburg Campaign Vicksburg, Mississippi, suffers a second attack from General Grant's Union forces. Despite the well-planned assault on Confederate positions there, Grant's men are unable to make any breakthrough. Generals Sherman and McClernand are each able to gain a brief hold at several points, one at Railroad Redoubt, but neither gains a permanent grasp. The Southern defenses are strong and are enhanced by the deep natural ravines surrounding the city. A Northern soldier, R B Scott of the 67th Indiana Volunteers, re-

counts the severity of the attack: 'Every experienced soldier . . . awaited the signal. It came, and in a moment the troops sprang forward, clenching their guns as they started on the charge . . . Twenty thousand muskets and 150 cannon belched forth death and destruction . . . Our ranks were now becoming decimated . . . The charge was a bloody failure.' This second attack on Vicksburg in three days results in heavy losses for the Union: 502 dead, 2550 injured, 147 missing out of a total troop strength of 45,000. Confederates report losses of less than 500 men. The number of casualties makes clear to Grant that direct attacks on the city are fruitless and he concludes that 'The work to be done was to make our position as strong against the enemy as his was against us.'

23 May 1863

Western Theater The Port Hudson, Louisiana, area is the site of fighting as the bulk of General Banks' Federals cross the Mississippi and head toward their goal. Haines' Bluff, Mississippi, sees minor skirmishing. At Vicksburg, the Southern forces continue to man their defenses as General Grant's Federals reinforce their positions.

24 May 1863

The Confederacy President Jefferson Davis is not in complete agreement with General Pemberton's decision to hold Vicksburg, Mississippi. The Confederate president telegraphs a message to General Johnston saying, 'the disparity of numbers renders prolonged defense dangerous.'
Eastern Theater At Fredericksburg, Virginia, the Federal Army of the Potomac, under General Hooker's command, continues to wait, facing the prospect of a clash with General Lee's Army of Northern Virginia.
Western Theater There is some minor reorganization of Union forces in the Murfreesboro area where General William Rosecrans and his men oppose Confederates under General Braxton Bragg at this Tennessee location. In Mississippi, the siege of Southern positions continues to take shape at Vicksburg, as does the siege of Port Hudson, Louisiana. Both of these hold the potential for the defeat of the Confederates in their desire to maintain control of the Mississippi River.

25 May 1863

The North After his sentence of imprisonment had been rescinded by President Lincoln, Ohio congressman Clement Vallandigham is given over to Confederates by Federal military officials in Tennessee. This entire episode is one which provokes outrage from both supporters of Vallandigham in the North and those loyal to the Union who wish to see actions such as his dealt with severely.
Western Theater, Vicksburg Campaign Federal attempts at direct attack being put aside, General Grant now devises a means by which to break through Confederate defenses at Vicksburg, Mississippi. The Union troops there dig a tunnel near the city into which they place, and detonate, 2200 pounds of gunpowder. This explosion is supposed to open up an access route to the city itself, but the Southern troops are waiting in another line of defense to prevent such an entry. General Grant explains: 'The effect was to

Above: General R S Ewell commanded II Corps of the Army of Northern Virginia during the Gettysburg campaign.

blow the top of the hill off and make a crater where it had stood. The breach, however, was not sufficient to enable us to pass a column through. In fact, the enemy had thrown up a line further back.'

Naval The Union navy is successful in capturing two Southern steamboats, the *Red Chief* and the *Starlight*, on the Mississippi River. In another action, the CSS *Alabama* seizes two vessels off the coast of Bahia, Brazil.

27 May 1863

Western Theater, Vicksburg Campaign The Federal siege of Port Hudson, Louisiana, begins as troops under General Banks stage an initial attack on Confederate defenses there. The latter troops are under the command of General Franklin Gardner and num-

ber around 4500. The Union assault is made by approximately 13,000 men, but despite their hopes for an easy victory, Banks' forces are unable to overcome their rather disorganized offensive and the strong repulse made by Gardner's men. The Union reports losses at this action against Confederates at Port Hudson to be 1995 – 293 killed, 1545 wounded, 157 missing. The South tallies casualties to be around 235. Once more, the Union is unable to gain an easy foothold in the vicinity of Vicksburg and Port Hudson.

Naval In an attempt to seize Fort Hill, a Southern position on the Mississippi, Admiral David Porter attacks with the Union gunboat *Cincinnati*. This action, directed by General William Sherman, is unsuccessful as Confederate shore batteries destroy the Union vessel, sinking it and killing or wounding 40 men. There is an attack on Union gunboats at Greenwood, Mississippi. In Georgia on the Chattahoochie River, the CSS *Chattahoochie* explodes by accident, killing 18 men.

28 May 1863

The North In a first for the Union, a regiment of black soldiers leaves Boston. The 54th Massachusetts Volunteers will train at Hilton Head, South Carolina.

29 May 1863

Washington President Lincoln receives a letter from General Burnside in which the latter proffers his resignation as commander of the Department of the Ohio. Burnside takes this step because of the release of Ohio congressman Clement Vallandigham and Lincoln's action rescinding Burnside's imprisonment orders. President Lincoln refuses to accept Burnside's resignation.

30 May 1863

The Confederacy General Robert E Lee and President Jefferson Davis meet to discuss the situation at Vicksburg, Mississippi. The president recognizes that General Johnston's failure to attack Grant's positions has perhaps cost the Confederacy its hold on Vicks-

burg. He says to Lee, 'General Johnston did not . . . attack Grant promptly and I fear the result is that which you anticipated if time was given.'

1 June 1863

The North There is heated opposition to an action taken by General Burnside in the Department of the Ohio. The general calls for the suppression of the *Chicago Times*. This because 'of the repeated expressions of disloyal and incendiary statements.' Citizens of Chicago, Illinois, and the city's mayor, F C Sherman, appeal to President Lincoln to strike down Burnside's orders.

2 June 1863

Washington President Lincoln, reviewing the information that he has concerning Mississippi, wires a message to General Grant asking, 'Are you in communication with General Banks?' It is the opinion of military advisors in Washington that Banks and Grant should combine their forces, but the two generals continue their separate operations.

Eastern Theater In Virginia there is some minor skirmishing around Upperville and Strasburg. General Lee's troops make preparations to move out of their current position in the Fredericksburg area. These Confederate troops of the Army of Northern Virginia number about 89,000 men organized into three corps plus a cavalry unit. The corps are under the command of Generals Longstreet, Ewell and Hill, with J E B Stuart in command of the cavalry's six brigades.

3 June 1863

Eastern Theater, Gettysburg Campaign General Robert E Lee's Confederate Army of Northern Virginia moves out of the Fredericksburg vicinity at the start of a month-long campaign which will culminate in the Battle of Gettysburg, Pennsylvania. Lee has come to the decision to stage an invasion of the North. As these Southern troops advance north, there is skirmishing near Fayetteville, Virginia. The Federal Army of the Potomac, under General Hooker's command, numbers

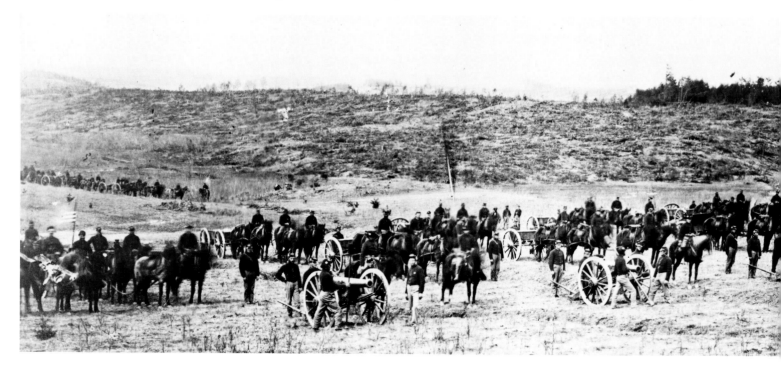

approximately 122,000 men; it has conducted various reconnaissance efforts prior to this date and Hooker is aware of Lee's intentions.

Western Theater, Vicksburg Campaign Various maneuvers take place; in Louisiana, Union troops conduct a reconnaissance around Clinton. Minor fighting breaks out at Simsport, Louisiana. General Grant receives some reinforcements in the Vicksburg area from IX Corps stationed until now to the north, in Kentucky.

4 June 1863

Eastern Theater, Gettysburg Campaign General Robert E Lee and his Confederates move toward Culpeper Court House with Generals Ewell and Longstreet and their two corps. General A P Hill and his corps remain in the Fredericksburg area. Union troops conduct reconnaissance efforts for two days, leaving Yorktown, Virginia, and heading for Walkerton and Aylett in that state.

Western Theater, Vicksburg Campaign In Mississippi, Confederates prepare to endure the siege which has been implemented by General Grant's Union forces.

5 June 1863

Eastern Theater, Gettysburg Campaign In the course of a reconnaissance effort in the Fredericksburg area by General Sedgwick's VI Corps of the Potomac Army, there is severe fighting in Virginia. This encounter, known as the Battle of Franklin's Crossing, or Deep Run, sees Union troops clash with Confederates positioned in trenches. The result of this fighting is that although the Federals take 35 prisoners and report six Confederates dead and 35 wounded, the Army of Northern Virginia is still very much in force at Fredericksburg. It is President Lincoln's advice to General Hooker that the Federal Army of the Potomac should concentrate on the portion of Lee's Confederates that is moving out from

Below: Union artillery going into action near the Rappahannock, part of a reconnaissance in force prior to Gettysburg.

Fredericksburg. It is apparent that to attack the Fredericksburg position would be less profitable.

6 June 1863

Eastern Theater, Gettysburg Campaign General Hooker is still attempting to pinpoint General Lee's destination and intention in moving most of the Confederate Army out of Fredericksburg, Virginia. General J E B Stuart and his Confederate cavalry corps stage a review at Brandy Station, Virginia.

7 June 1863

Western Theater, Vicksburg Campaign A serious clash between Federals and Confederates occur as the latter attack the Union troops garrisoned at Milliken's Bend in Louisiana. While Confederates under General McCulloch are successful in pushing the Federals back to the Mississippi, the Union troops, under General Thomas, are aided in their defense of the area by the intervention of two gunboats, the *Lexington* and the *Choctaw*. After the intervention, the Confederates pull back. Losses at this encounter at Milliken's Bend are reported by the Federals at 652 dead and injured, by Confederates at 185 casualties. The Brierfield plantation in Mississippi is burned by Union troops; Brierfield is the home of Confederate President Jefferson Davis.

8 June 1863

Eastern Theater, Gettysburg Campaign General Robert E Lee attends a cavalry review of General J E B Stuart's corps. This occurs at Culpeper Court House, Virginia.

Western Theater, Vicksburg Campaign At Vicksburg, Mississippi, General Grant's troops shell the city; this is a constant, 24-hour bombardment which causes residents to take cover in caves or remain hidden in their houses to avoid the destructive showers.

9 June 1863

Eastern Theater, Gettysburg Campaign In order to gain further information about Confederate positions, General Hooker directs cavalry under the command of General Alfred Pleasonton to conduct a reconnaissance in the area of the Rappahannock River at a location known as Brandy Station, Fleetwood Hill, or Beverly Ford. The battle occurring here between Pleasonton's 11,000 troops and Confederate General J E B Stuart's cavalry forces is considered to be the most severe cavalry fight of the entire war. It results in little real gain for the Federals, although General Hooker obtains some information about Confederate troop strength, movement and positions. Stuart's cavalry manages to hold the location at a cost of some 523 casualties out of nearly 10,000 troops engaged. The Union reports 81 dead, 403 wounded and 382 missing.

10 June 1863

Washington President Lincoln is in communication with General Hooker, advising him as to a course of action for the Federal Army of the Potomac in Virginia. According to Lincoln, the army's best strategy is to 'Fight him when the opportunity offers. If he stays where he is, fret him.'

The North There is a wave of alarm among communities north of the Potomac River as word of Lee's advancing Confederate army becomes available.

Eastern Theater, Gettysburg Campaign The Army of Northern Virginia moves its II Corps under General Ewell out of Culpeper, Virginia, on a northwestern course.

Naval The Federal vessel *Maple Leaf*, loaded with Confederates taken prisoner by Union troops, is forced ashore by its passengers near Cape Henry, Virginia. This group of prisoners is being transferred from Fort Monroe to Fort Delaware, but is successful in making its escape once the vessel reaches the coast.

11 June 1863

The North In Ohio, Peace Democrats submit the name of former congressman Clement Vallandigham for nomination as governor. This despite the fact that Vallandigham, convicted of treason against the Union, has been banished to the Confederacy and has been subsequently transferred by the Southern government to Canada.

Western Theater Once more, Triune, Tennessee, is the scene of skirmishing, this time as General Nathan Bedford Forrest's Confederates clash with Federals in that area of the state. Elsewhere, there is fighting in South Carolina at Little Folly Island and also in Mississippi, near Corinth.

12 June 1863

The North Because of an anticipated invasion and attack on the citizens of Pennsylvania, the governor of that state, Andrew Curtin, calls out the militia. He also requests aid from New York State to repel the assumed influx of Confederates under General Lee.

The Confederacy President Jefferson Davis receives an offer from Vice-President Alexander Stephens, concerning a possible mediation between the Confederacy and the Union. Stephens' suggestion has to do with a diplomatic effort to promote 'a correct understanding and agreement between the two Governments.'

Eastern Theater, Gettysburg Campaign As General Lee's Army of Northern Virginia moves north, passing the Blue Ridge and going into the Shenandoah Valley, the Confederate troops clash with Federals at Newtown, Cedarville and Middletown, Virginia.

13 June 1863

Eastern Theater, Gettysburg Campaign At Winchester, Virginia, there is skirmishing as Confederates under General Ewell push into the area, causing the second Battle of Winchester. Ewell takes over and occupies Berryville, Virginia. There is other fighting near Bunker Hill and White Post, Virginia. At Second Winchester the Federals, under General Milroy, lose 300 men in their encounter with the Southern forces, who report losses of 850 dead or wounded.

14 June 1863

Western Theater Northern General Nathaniel Banks tells Confederates at Port Hudson, Louisiana, to surrender. Failing this capitulation, Banks plans an assault to commence at daybreak. This Federal attack by about 6000 troops is carried out against 3750 Confederates, who hold off the Federals.

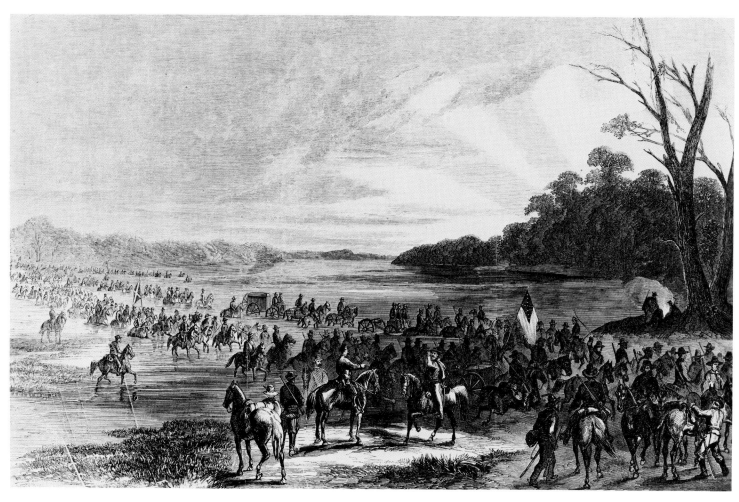

Above: Southern cavalry and artillery cross the Potomac into Maryland and Pennsylvania, 11 June 1863.

Trans-Mississippi In Arkansas there is an attack on the USS *Marmora* near Eunice. The town is nearly destroyed by fire following this action as Federals retaliate against the Confederate attack on the vessel.

15 June 1863

Washington In the Federal capital, President Lincoln seeks support from the state militia of Pennsylvania, Maryland, Ohio and West Virginia in the face of the northward advance of Lee's Confederates. The president asks the governors of these states to prvide 100,000 troops. In addition there is an order sent out by the Federal Department of the Navy to disable the CSS *Tacony*, a Southern vessel which has been successful in interfering with Northern shipping along the eastern coastline.

Eastern Theater, Gettysburg Campaign
There is a fierce attack on Federal positions at Winchester, Virginia, as General Milroy's 9000 Northern troops attempt to hold the area. General Ewell's Confederates are successful in pushing the Union force back in the direction of Harper's Ferry. In addition to the victory at Winchester, Southern troops also attack Federal positions at Berryville and Martinsburg. At the Winchester battle, Union losses are reported at 95 killed, 348 injured and over 4000 missing or captured; the Confederates losses are 47 killed, 219 wounded, 3 missing. The Confederacy seizes a large quantity of supplies and ammunition: 23 guns, 300 wagons, 300 horses and much

food. The Southern forces continue to press northward, arousing the inhabitants of Maryland and Pennsylvania, and achieving results which provoke Hooker's message to President Lincoln that indicates the Southern invasion is something 'it is not in my power to prevent.' There is a Confederate cavalry raid at Chambersburg, Pennsylvania; J E B Stuart's cavalry acts as a front line unit for General Longstreet's corps that is heading out from Culpeper Court House.

16 June 1863

Eastern Theater, Gettysburg Campaign
General Hooker takes his Federal Army of the Potomac and positions it at Fairfax Court House, Virginia, as General Lee and his Confederate Army of Northern Virginia cross the Potomac River.

17 June 1863

Eastern Theater, Gettysburg Campaign Skirmishing continues as General Lee's Confederates push north. The fighting on this day occurs at Point of Rocks, Maryland.
Western Theater, Vicksburg Campaign The siege of Vicksburg continues unabated. Union forces clash with Confederates as the

Below: The CSS *Atlanta* was forced to surrender to Union ironclads after an engagement on the Wilmington River, Georgia.

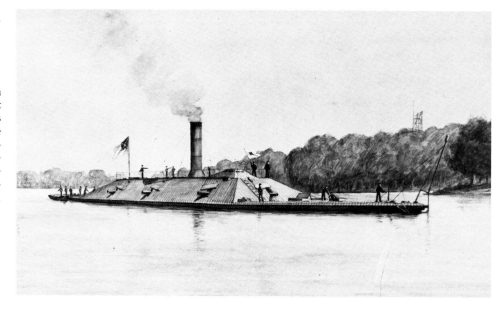

latter attack gunboats and land positions, the latter occurring today at a point near Commerce, Mississippi.

Naval On the Wilmington River in Warsaw Sound, Georgia, Captain John Rogers, commander of the Federal vessel *Weehawken*, is successful in forcing the surrender of the Confederate ironclad vessel *Atlanta*. The *Weehawken* and the *Nahant*, commanded by Captain John Downes, clash with the *Atlanta*, resulting in several casualties on either side.

18 June 1863

Eastern Theater, Gettysburg Campaign Further skirmishing breaks out at Aldie, Virginia, as Lee's Confederates push north. There is a Union reconnaissance in the Peninsular area of Virginia.

Western Theater, Vicksburg Campaign General John McClernand is relieved of his command of the XIII Corps by General Ulysses Grant. This is due to McClernand's repeated acts of insubordination and his apparent unwillingness to cooperate with the rest of the Army. He is replaced by General E O C Ord.

19 June 1863

Eastern Theater, Gettysburg Campaign Generals Ewell, Hill and Longstreet probe north as the Confederate Army of Northern Virginia continues its invasion. There are encounters between these Southern troops and Union forces, skirmishing breaking out at Middleburg, Virginia, as the North attempts to slow the progress made by Lee's Army.

Western Theater, Vicksburg Campaign There is continued skirmishing in the area of Vicksburg as the siege continues.

Below: Union batteries lobbing shells into Vicksburg during the siege.

20 June 1863

Washington President Lincoln issues a proclamation which declares West Virginia as the 35th state of the Union.

The North In an effort to provide some defense of the city, citizens in Baltimore, Maryland, erect fortifications to the north and west in order to repel any Confederate raids on the city.

Western Theater, Vicksburg Campaign Various incidents of skirmishing take place; in Louisiana, at La Forche Crossing there is minor fighting over a two day period. The Federal batteries around Vicksburg, Mississippi, shower that city with shells.

Trans-Mississippi In Missouri, a Union reconnaissance leaves Waynesville. At Government Springs in the Utah Territory Union forces clash with Indians.

21 June 1863

Eastern Theater, Gettysburg Campaign There is fierce but minor fighting in Virginia as General Hooker's Potomac Army encounters Lee's advancing Confederates at Upperville and Haymarket. In Maryland, where Union and Southern troops encounter each other, there are similar clashes near Frederick.

22 June 1863

Eastern Theater, Gettysburg Campaign The fighting continues to be minor and fragmentary as Lee's Army of Northern Virginia pushes on and engages Federals near Aldie, Virginia. At Greencastle, Pennsylvania, Union and Confederate troops clash. As General Lee moves in to Chambersburg, Pennsylvania, citizens in Philadelphia close down businesses and shops.

Naval The CSS *Tacony*, under the command of Lieutenant Charles Read, seizes five

Above: Lieutenant Charles Read commanded the CSS *Tacony* during the capture of five Union vessels off New England on 22 June 1863.

Federal fishing vessels in waters off the coast of New England, proving the fallibility of the Union blockade once again.

23 June 1863

Eastern Theater, Gettysburg Campaign General Joseph Hooker prepares his Federal Army of the Potomac to cross the river of the same name in Virginia. In Yorktown, Union troops begin a reconnaissance that lasts for five days and heads in the direction of South Anna Bridge.

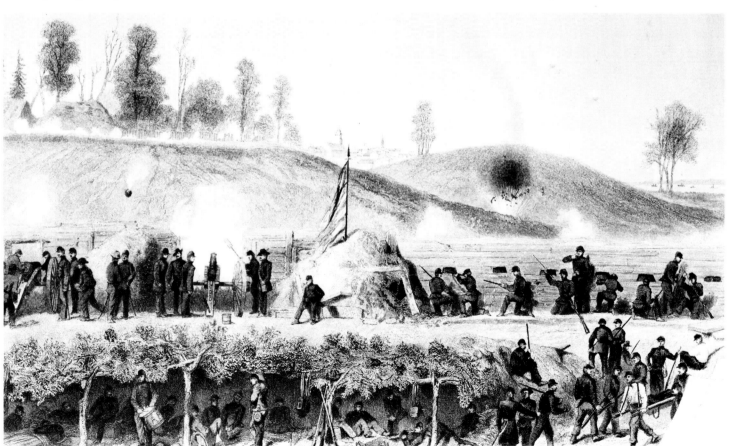

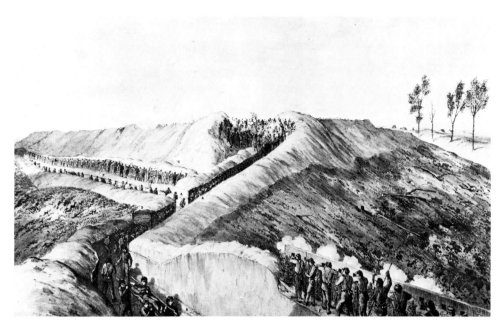

Above: Union troops, caught in a crater after the detonation of a mine, suffer heavy losses at the hands of Vicksburg's defenders.

Western Theater, Tullahoma Campaign
Under the command of General William Rosecrans, the Federal army begins a major, and a successful, effort to harass Confederates in the Tullahoma, or Middle Tennessee, campaign. By operating against General Braxton Bragg's Confederates in this effort, the Union general prevents Bragg from moving toward Vicksburg with reinforcements. In this way, Rosecrans is supporting General Grant's campaign at Vicksburg, Mississippi.
Trans-Mississippi In the Nebraska Territory there is fighting at Pawnee Agency. In

Below: Union supply officials weigh bread and meat prior to its distribution at Fairfax Court House, Virginia.

the Nevada Territory, Union soldiers engage Indians in combat near Canon Station. Sibley, Missouri, is the site of minor skirmishing.

24 June 1863

Eastern Theater, Gettysburg Campaign
Sharpsburg, Maryland, sees fighting as Hooker's Potomac Army clashes with troops under the command of Longstreet and Hill. The latter are moving to join forces with Confederate General Ewell, who has arrived in Maryland, and with whom they will advance on Pennsylvania.
Western Theater, Tullahoma Campaign
General Braxton Bragg encounters Federals near Bradyville and Big Springs Ranch in Tennessee, where General William Rosecrans is advancing into the middle of the state. There is also skirmishing at Middleton, Tennessee, and some brief but fierce action at

Hoover's Gap. At the latter engagement, Southern forces report a large number of casualties while the Union lists 45 dead and injured.
Western Theater, Vicksburg Campaign
There is a slight increase in the pressure placed on Confederates at the besieged city of Vicksburg; food is becoming scarcer and the shelling from Federal batteries has been stepped up. A civilian observer, Edward Gregory, describes the hardships suffered by those who had remained at Vicksburg to endure the constant attacks by General Grant's troops: 'Hardly any part of the city was outside the range of the enemy's artillery except the south . . . Just across the Mississippi, seven 11-inch and 13-inch mortars were put in position and trained directly on the homes of the people . . . how people subsisted was another wonder . . . There were some stores that had supplies, and prices climbed steadily, but first nobody had the money, and then nobody had the supplies.' In Louisiana, there is a Confederate raid at Berwick Bay where injured Union soldiers are convalescing. General Taylor's Southern troops, numbering approximately 4000, are easily able to seize the post at Berwick Bay and gain access to much needed supplies.

25 June 1863

The Confederacy A worried President Jefferson Davis contacts General Braxton Bragg in Tennessee. The president points out the urgent need for reinforcements at Vicksburg, where General Johnston is intent on harassing General Grant's forces to prevent the continued siege of the city. Davis also appeals to General Beauregard, located at Charleston, South Carolina, for additional troops for General Johnston. Davis fears that without these reinforcements, 'the Mississippi will be lost.'
Eastern Theater, Gettysburg Campaign This day marks the start of Confederate General

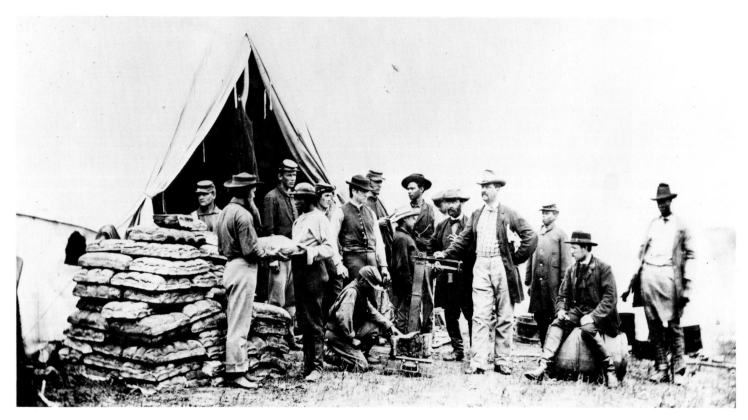

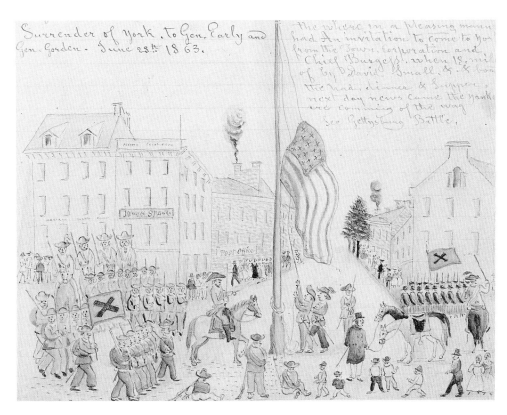

Above: The surrender of York to forces under the command of Southern Generals Early and Gordon in late June 1863.

J E B Stuart's Gettysburg raid (a maneuver that military historians would later criticize as it removed Stuart's Confederate cavalry from the vicinity of the upcoming battle at Gettysburg). Rather than follow strictly the directions provided by General Lee on 22 June 1863, Stuart takes a route around Hooker's rear and flank, avoiding the protection afforded by the Blue Ridge route to the west. Stuart, by this action, crosses the Potomac Army's main supply line and captures upward of 125 Federal wagons and takes more than 400 prisoners. However, although Stuart's raiding does cause some disruption, it will not prevent the concentration of the Federal army at Gettysburg.

26 June 1863

Eastern Theater, Gettysburg, Campaign
General Jubal Early and his Confederate forces move into Gettysburg, Pennsylvania, at first encountering some of Hooker's Potomac Army troops and skirmishing with them outside Gettysburg. Although General Hooker wires the president of his intention to move against Lee's Army of Northern Virginia, there is an indication that Lincoln is dubious about Hooker's abilities.

Western Theater, Tullahoma Campaign
There is minor skirmishing at Beech Grove, Tennessee. There is a fight between Rosecrans' Federals and Bragg's Confederates at Shelbyville, where the Northern casualty lists show 45 dead, 463 injured, 13 missing. The South reports 1634 casualties, plus many taken prisoner by the North.

Naval After having successfully taken 21 Federal vessels in less than three weeks, Confederate Lieutenant Charles Read in command of the schooner *Archer* attempts to seize the Federal cutter *Caleb Cushing* at anchor in the harbor at Portland, Maine. This attempt is foiled by Federal naval steamers; the *Archer* is destroyed and the Confederates taken prisoner.

27 June 1863

Washington After conferring with General Henry Halleck, President Lincoln decides to remove General Joseph Hooker from his command of the Army of the Potomac. It is decided that General George Meade will replace Hooker; Halleck sends word to Meade

Below: Union troops and civilians abandon Wrightsville and burn the Columbia railroad bridge in the face of Lee's forces.

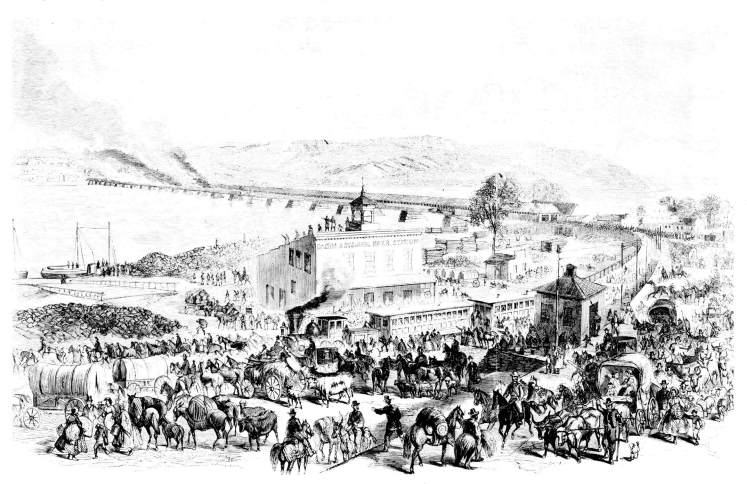

Above: Union side-wheelers and ironclads in action against Port Hudson, Louisiana, during late June 1863.

of this change. Meanwhile, General Hooker has sent a message to the president concerning the evacuation of Harper's Ferry, Virginia, which Hooker feels is critical. Hooker points out that unless this action is taken he can no longer act as head of the Potomac Army. When Halleck countermands the orders concerning Harper's Ferry, it leads to Hooker's decision to resign from command of the Army of the Potomac.

Eastern Theater, Gettysburg Campaign
General Robert E Lee's Army of Northern Virginia moves into Chambersburg, Pennsylvania, after having forced the surrender of York. The Southern army is headed for the state capital at Harrisburg. Elsewhere, J E B Stuart and his cavalry forces encounter Federals near Fairfax Court House, Virginia; in the fighting that ensues, all but 18 of the Union cavalrymen are captured by Stuart's Confederates.

Western Theater, Tullahoma Campaign At Guy's Gap and again at Shelbyville, Tennessee, there is skirmishing between Federal and Confederates. In that same vicinity General Rosecrans' Union forces occupy Manchester, forcing General Bragg to the decision to pull back with his Southern troops to Tullahoma.

28 June 1863

Washington General George Meade is appointed to replace Hooker. President Lincoln and General Halleck learn that, while the newly-appointed Potomac Army chief is uninformed as to the 'exact condition of the troops and the position of the enemy,' he is planning to move the Federal forces toward the Susquehanna River. Both Lincoln and Halleck feel much confidence in Meade, and hope that he will mount an attack on Lee's invading army. There are, at this point, around 100,000 Federal troops concentrated in the area around Frederick, Maryland.

Eastern Theater, Gettysburg Campaign
There is skirmishing at Chambersburg, Pennsylvania, where the forces of Generals Longstreet and Hill are positioned. General Ewell is at Carlisle; General Early at York. After learning that the Federal army is north

of the Potomac River, General Lee makes a change in his original plan to march on Harrisburg. The new strategy requires that Hill and Longstreet join Ewell and move on Gettysburg and Cashtown.

Western Theater, Vicksburg Campaign In Louisiana, at Donaldsville, the Southern forces under General Taylor attack local Federals. The latter garrison, under the command of Major J D Bulle, is able to withstand the assault with the help of Federal gunboats. Both Vicksburg, Mississippi, and Port Hudson, Louisiana, continue under siege.

29 June 1863

Eastern Theater, Gettysburg Campaign At Winchester, Maryland, there is a fierce cavalry skirmish between Confederates under J E B Stuart and Union forces under Major N B Knight. The Confederates are attacked by Knight's Federals, but because of Stuart's stronger force, the Southerners repel the assault. At this encounter, the North reports nine casualties; the South, 18 dead and

wounded. General George Meade moves his Union Army of the Potomac toward Gettysburg. General Robert E Lee's forces also push to this point in Pennsylvania.

Western Theater, Tullahoma Campaign
General Rosecrans continues to harass Southern forces in Tennessee, skirmishing breaking out at Hillsborough, Decherd and Lexington. Columbia, Kentucky, also sees fighting.

30 June 1863

Washington Despite pressure from supporters of the former Potomac Army chief, President Lincoln refuses to place General George Brinton McClellan back in command of that critical force which is only hours away from battle at Gettysburg, Pennsylvania

Eastern Theater, Gettysburg Campaign Confederate cavalry under General J E B Stuart once more engages Federal cavalry forces, this time at Hanover, Pennsylvania. General Kilpatrick's Federals are able to mount a serious counterattack which nearly results in the capture of Stuart. At this cavalry skirmish, the Union reports 19 killed, 73 wounded, 123 missing. Confederates list nine dead, 50 wounded, 58 missing. General Reynolds' Union troops are sent by General Meade to occupy Gettysburg.

Western Theater, Tullahoma Campaign Fighting continues in the mid-Tennessee area as General Braxton Bragg pulls his Confederates across the Tennessee River in a retreat from Tullahoma. General Rosecrans establishes his Federals at Chattahoochee, Tennessee.

1 July 1863

Eastern Theater, Gettysburg Campaign A three-day battle begins at Gettysburg, Pennsylvania as cavalry forces under Union

Below: The disastrous Pickett's Charge against Union lines on the crucial third day of the Battle of Gettysburg.

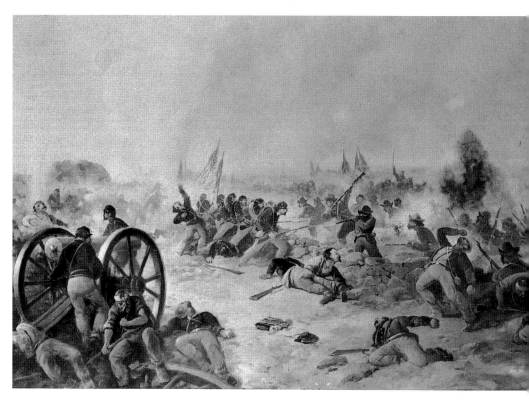

General Buford clash with General A P Hill's Confederate cavalry early in the day. This fighting occurs along the Chambersburg Road but moves closer to Gettysburg proper as the day wears on. Confederate General Ewell's troops join the battle by afternoon, with Longstreet and Hill's men, and make a strong push against the Union XI Corps which is commanded by Federal General O O Howard. This latter force is driven back from Gettysburg in a fierce clash of men and horses, toward the southeast, an area known as Cemetery Ridge and Cemetery Hill. The hard-fighting Federals, entrenched at this position by late in the day, are not harassed further by General Lee's army, however. This gives time for Union General Meade, commander of the Potomac Army, to reinforce Cemetery Hill with more Union troops. It is at this position that Generals Howard and Doubleday are strengthening their fortifications for the next attack by the Confederates. General Robert E Lee wishes that General Ewell make an attack on the Federals at Cemetery Hill immediately, prior to any further reinforcement. However, General Ewell chooses not to advance on the Union forces there on this first day of the Battle of Gettysburg. The Southern Army of Northern Virginia now holds the town of Gettysburg and is waiting for the arrival of General Longstreet's corps prior to making any more offensives against the Northern forces which outnumber them. Casualties at this engagement show that the Federals have suffered a great deal more than General Lee's forces: General O O Howard's Corps sees over 4000 taken prisoner. In addition, Federal General John Reynolds is killed in the mid-morning fighting which takes place along the Chambersburg Road by McPherson's Ridge. Meanwhile, the Confederate General Archer

Below: A posed photograph of a dead Southern sharpshooter in position behind a stone sangar at Gettysburg.

is taken prisoner. Archer is the first general officer in the Army of Northern Virginia to be taken by the Federals since General Robert E Lee assumed command of this Confederate force.

Western Theater, Tullahoma Campaign
While fighting continues in Tennessee along the Elk River, near Bethpage Bridge and in the Tullahoma vicinity where Rosecrans' Union troops now are positioned, the major thrust of the Federal campaign against Confederates under General Braxton Bragg is over. The Southern forces are pulling southward toward Chattanooga.

Western Theater, Vicksburg Campaign
There is skirmishing near Edward's Station in the vicinity of Vicksburg, Mississippi, as General Johnston's Confederates continue to fend off the harassing forces of General Grant's Union troops. Inside the city, General John Pemberton's men struggle, under increasingly poor conditions, to continue their defense of Vicksburg.

2 July 1863

Eastern Theater, Gettysburg Campaign The second day of fighting at this critical battle sees Federals positioned at Big Round Top and Little Round Top along Cemetery Ridge. Lee's forces are placed along Seminary Ridge, below the Union lines. Fighting breaks out late in the day as General Longstreet's I Corps pushes against General Daniel Sickles' Federals at the Peach Orchard and along the Emmitsburg Road. Meanwhile, General G K Warren successfully withstands a Confederate assault on Federal positions. Despite Confederate General Hood's forces pressing the Union troops on the Round Tops, the South is unable to do more than gain a slight foothold at the lower sections of these hills; the Federals hold fast to their superior vantage points on the summits. General Ewell's Confederate troops attack Union positions at Culp's Hill and Cemetery Hill, but only General Edward

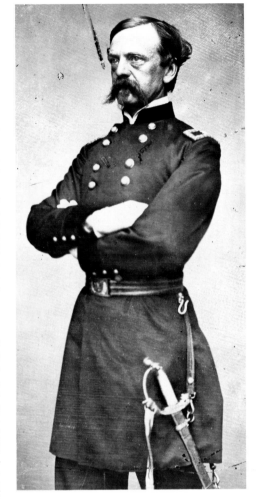

Above: General Daniel Sickles was involved in some of the heaviest fighting at Gettysburg and lost a leg during the battle.

Johnson's Confederates make any appreciable progress, that at the lower portion of Culp's Hill where they seize some positions not adequately defended by the XII Corps of the Federal Potomac Army. The latter has left this southeast section of Culp's Hill open while concentrating better Union defenses at the Round Tops.

Western Theater, Tullahoma Campaign
While Bragg's Southern troops continue their line of retreat, there is minor skirmishing around Morris' Ford, at Elk River and near Rock Creek Ford, all in Tennessee.

Western Theater, Vicksburg Campaign
There is little change in the situation at besieged Vicksburg, Mississippi, where General John Pemberton remains entrenched with his Confederates inside the city. There is some exchange of artillery fire between Pemberton's and Grant's troops.

3 July 1863

Washington There is an anxious vigil at the Federal capital as the president awaits information about the Battle of Gettysburg.

Eastern Theater, Gettysburg Campaign This final day of battle at Gettysburg, Pennsylvania, opens with the Federal Army of the Potomac, under the command of General George Meade, preparing for an attack by General Robert E Lee's Army of Northern Virginia. Despite General Longstreet's feeling that a Confederate offensive is risky due to the larger Federal force, General Lee is firmly

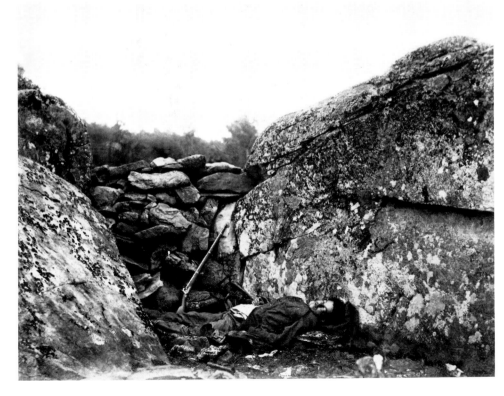

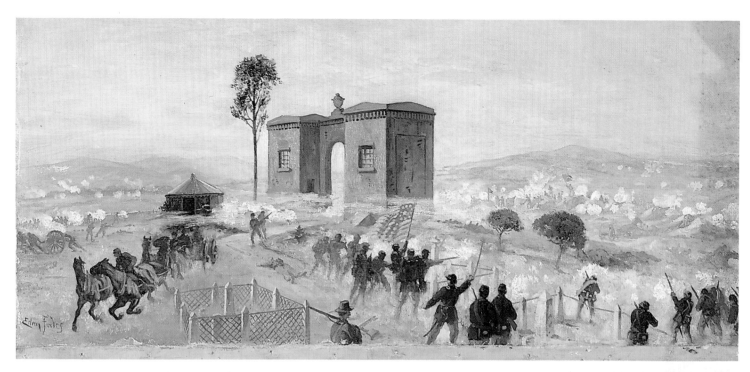

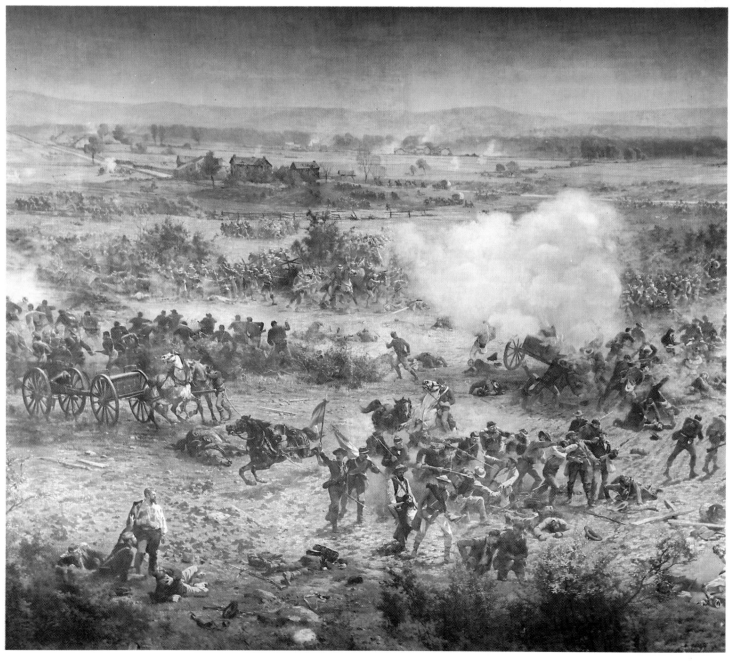

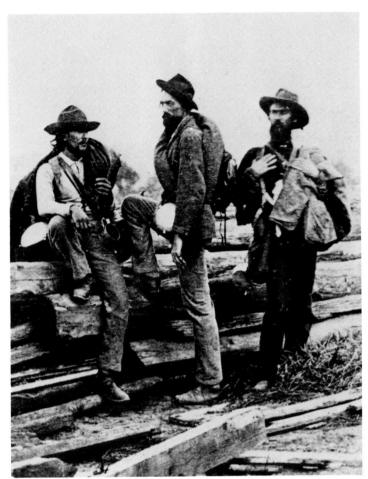

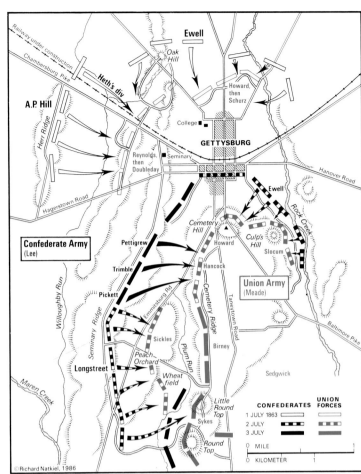

Above left: Fierce fighting around Cemetery Hill during Southern attempts to pierce the Union line at Gettysburg.
Left: The defeat of Pickett's Charge on the last day of the battle ended Southern hopes of victory at Gettysburg.
Above: A trio of ragged Confederate prisoners photographed before their march into captivity.
Above right: The three-day Battle of Gettysburg saw Lee's Army of Northern Virginia defeated by General Meade's forces.

committed to making an assault on the middle of Meade's forces. Accordingly, 15,000 troops are sent to make what will be the final Southern attempt against the Union at Gettysburg. In the early afternoon, Generals Pettigrew, Trimble and Pickett group their men and advance on Federals in the vicinity of the Emmitsburg Road. The Federals are strung out in a line, facing the advancing Confederates, from Culp's Hill to Big Round Top and Devil's Den. The famous Confederate maneuver (later to become known as Pickett's Charge, despite the fact that it is General Longstreet who is in command of this operation and General Pickett's men form only part of the attacking force) does little to save the South's army at Gettysburg, however, and the hand-to-hand combat which ensues sees the death of Confederate General Armistead. The Battle of Gettysburg ends with the Southern forces retreating and attempting to regroup as a counterattack is expected, although it never occurs. General Lee has ventured into a nearly untenable position on this final day of fighting; to send 15,000 men against what he knows to be a larger enemy force is a gamble, and Lee loses it.
Western Theater, Vicksburg Campaign The

situation in Mississippi mirrors that in Pennsylvania: after weeks of siege, the Confederate forces under the command of General John Pemberton display white truce flags. The decision to surrender has been made with understandable reluctance, but the Confederate general ventures forth to meet with Union General Ulysses Grant in order to work out terms of surrender, despite the fact that Grant has already dictated his terms: 'You will be allowed to march out, the officers taking with them their side arms and clothing, and the field, staff and cavalry officers

one horse each. The rank and file will be allowed all their clothing but no other property.' After the six-week siege, there is clearly no alternative for the South; they have almost no food and a continued entrenchment is pointless. The following day, Independence Day, is chosen for a formal surrender, and both North and South are well aware of its significance.

Below: Union artillery is rushed forward to prevent a breakthrough by the Confederates during the final day of Gettysburg.

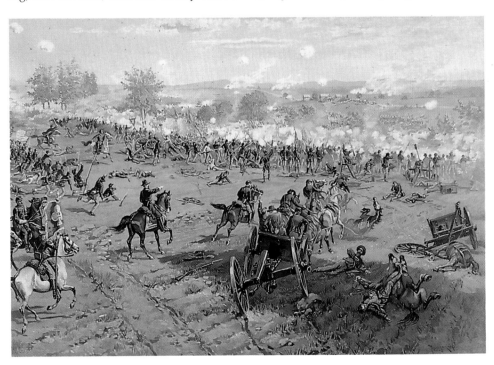

4 July 1863

Eastern Theater, Gettysburg Campaign The Confederate Army of Northern Virginia now heads slowly back toward Virginia, aided by poor weather as rain engulfs the area making it difficult for Meade's army to follow in pursuit, although the Union commander of the Potomac Army is later criticized for failing to do so. The casualty lists for the three-day encounter at Gettysburg, Pennsylvania, show that both the North and the South suffered terrible losses. The Confederate army reported 3903 dead, 18,735 injured and 5425 missing out of a total of 75,000 men – this means that 28,063, more than one-third of the Confederates at Gettysburg were listed as casualties. The North, having gone into battle with 88,289 men, sustained 3155 dead, 14,529 wounded and 5365 missing, a total of 23,049 casualties.

Western Theater, Vicksburg Campaign The Confederates formally surrender Vicksburg, Mississippi, to the Union army, and nearly 29,000 men under Pemberton's command march out of the city. It is hoped that news of this Union triumph will hasten the end of the Port Hudson siege, and that the entire region of the Mississippi will soon be under the control of the Federal army.

Below: Union troops repulse Pickett's men at the point of the bayonet, inflicting severe losses on Lee's forces.

5 July 1863

Eastern Theater, Gettysburg Campaign Lee's Army of Northern Virginia continues its retreat while Meade lags in pursuit. A few skirmishes, largely fought by cavalry, occur at towns in Pennsylvania and at Smithburg, Maryland.

Western Theater Grant begins to parole the Confederate defenders of Vicksburg, each prisoner signing a pledge not to fight again until he is duly exchanged for a Northern prisoner.

6 July 1863

Eastern Theater, Gettysburg Campaign Minor skirmishes continue along Lee's route of withdrawal, but the Federals cannot put together an organized pursuit. In one action, Federal cavalry officer Buford is repulsed by Lee's advance guard at Williamsport, Maryland.

Western Theater Federal General Sherman moves troops toward Jackson, Mississippi.

7 July 1863

Washington Lincoln is encouraged by news of the fall of Vicksburg but, worried that Lee will escape with his army, writes to Meade urging him to attack without delay.

Eastern Theater, Gettysburg Campaign Lee's army entrenches at Hagerstown, Maryland, ready to cross the storm-swollen Potomac as soon as the waters lower. Minor skirmishes continue in outlying towns and Federal forces move on Maryland Heights.

Western Theater Confederate General Braxton Bragg, driven from west Tennessee by Rosecrans' Army of the Cumberland, gathers his troops around Chattanooga.

8 July 1863

Eastern Theater, Gettysburg Campaign Lee's forces remain at Hagerstown, Maryland, and skirmishes occur at Boonsborough and Williamsport, Maryland. In spite of his recent defeat and present dangerous position, Lee writes to President Davis, 'I am not in the least discouraged.'

Western Theater Discouraged by the fall of Vicksburg, the besieged Confederate defenders of Port Hudson, Louisiana, surrender, leaving the whole of the Mississippi River under Federal control. In his diary, one Port Hudson resident notes that during the six weeks of the siege he and his friends consumed 'all the beef, all the dogs, and all the rats that were obtainable.' The fall of Port Hudson gives the Union over 6000 Confederate prisoners along with large quantities of arms and ammunition. Elsewhere, Confederate raider John H Morgan and 2500 men, beginning a sweep through Indiana and toward Ohio, cross the Ohio River into Indiana meeting only light Federal resistance. Many in Ohio fear that this action will galvanize rising Copperhead sentiment.

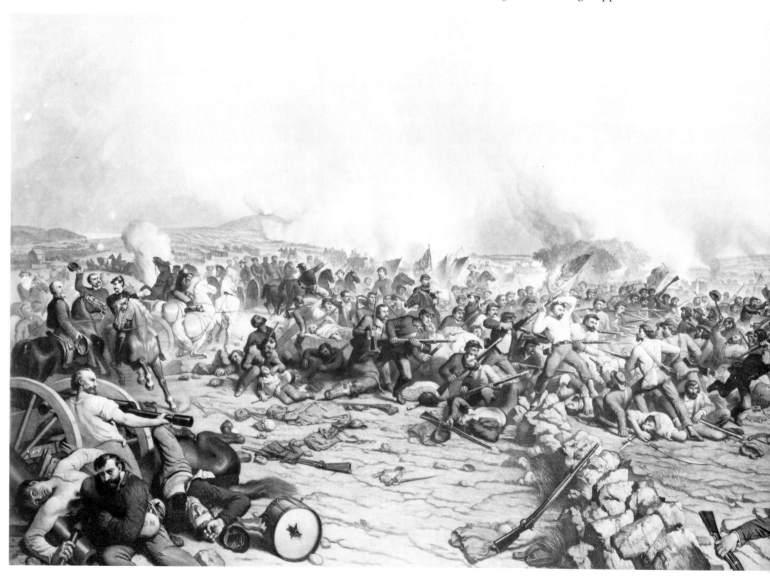

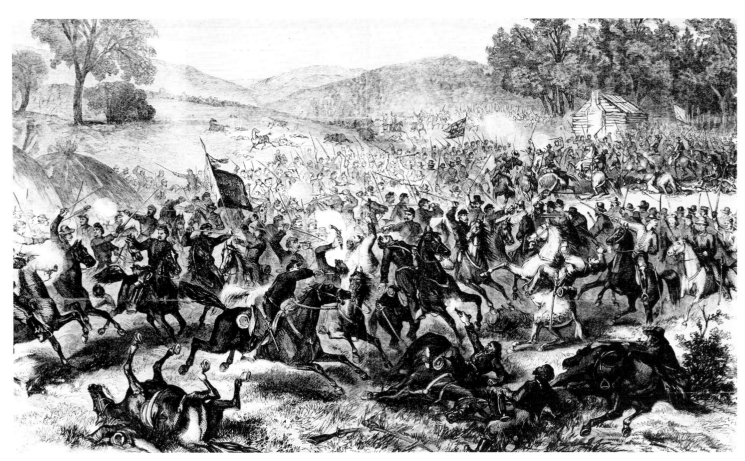

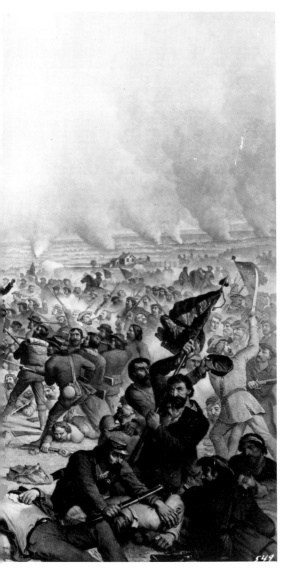

9 July 1863

Eastern Theater, Gettysburg Campaign
There is a small skirmish at Beaver Creek, Maryland, but Lee continues to have no substantial opposition.

Western Theater The Confederate leader of Port Hudson, General Gardner, formally surrenders to Federal General Nathaniel Banks. Though the Mississippi is now under Union control, Federal shipping will have continuing troubles with guerrilla attacks. Near Jackson, Mississippi, Sherman closes on General J E Johnston, commander of the Confederate Department of the West.

10 July 1863

Eastern Theater, Gettysburg Campaign
Meade's army begins to move with more determination toward Lee's forces, now gathering in Williamsport, Maryland; skirmishes erupt in several nearby towns, including a serious encounter at Falling Waters.

Western Theater Federal forces prepare for an assault on Battery Wagner, a Confederate defensive position on Morris Island in Charleston Harbor, South Carolina.

11 July 1863

The North Pursuant to the Union Enrollment Act of 3 March, the first names of draftees are drawn in New York.

Eastern Theater, Gettysburg Campaign
Meade begins preparing for an attack on Lee's forces which still await the lowering of the Potomac.

Western Theater Federal forces mount their first attack on Battery Wagner in Charleston Harbor, but are repulsed after gaining the parapets. In Mississippi, Sherman besieges some of Johnston's forces in West Jackson.

Above: The Battle of Boonesborough saw Union cavalry attempt to harry the rear-guard of Lee's Army of Northern Virginia.

12 July 1863

Eastern Theater, Gettysburg Campaign
Meade finally catches up to Lee's army, but engages only in light and ineffective reconnaissance. Lee, building fires to give the illusion of a settled camp, begins to move his troops over the now subdued Potomac on boats and a new pontoon bridge. Meade contemplates an attack the next day, but is dissuaded by his staff.

Western Theater Fighting is seen in Canton, near Jackson, Mississippi, between Sherman's and Johnston's forces. Moving through Indiana, Morgan's raiders meet increased resistance.

13 July 1863

The North, Draft Riots As a result of the first drawing of names for the draft in New York, resentment that has been growing toward the Federal Enrollment Act of 3 March boils over into a violent four-day riot. A mob of over 50,000 people, most of them Irish working men, swarm into the New York draft office, set it afire and nearly kill its superintendent. Over the next few days an evacuated black orphanage and the offices of Horace Greeley's *Tribune* are burned by the rioters. Increasingly, the violence is directed toward blacks, who are attacked, robbed and killed at random; but the rioters also loot businesses, beat to death a Union colonel, and assault the home of the mayor. At length, Federal troops just back from Gettysburg are called in and quell the mob, leaving over 1000 dead and wounded and ending what history will note as one of the darkest homefront episodes of the war and the worst

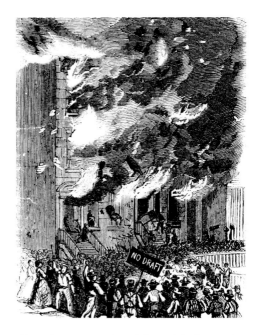

Above: A representation of the anti-draft riots that broke out in several Northern towns during the second week of July 1863.

race riot in American history. Less serious draft riots break out in Boston, in Troy, New York and other towns in the East and Ohio.

Eastern Theater, Gettysburg Campaign During the night, Lee and his Army of Northern Virginia complete their evacuation from Williamsport over the Potomac, their withdrawal again masked by campfires that also deceive the Union army.

14 July 1863

Eastern Theater, Gettysburg Campaign Finally pressing forward to attack, Meade's Army of the Potomac moves into Southern positions at Williamsport and discovers them

Below: The charge of the 6th Michigan Cavalry Regiment over Southern earthworks during the Battle of Falling Waters, 10 July 1863.

to be abandoned. Thus ends the North's best chance for a quick end to the war. This day Lincoln writes in an unsent letter to Meade, 'Your golden opportunity is gone, and I am distressed immeasurably because of it.' Nonetheless, Lee's last opportunity for an invasion of the North has been stopped.

Western Theater Confederate troops emerge on a sortie from Battery Wagner near Charleston, South Carolina. Clashes are also seen at Iuka, Mississippi, and Elk River in Tennessee.

Naval Federal ships extend their control over the James River in Virginia by taking Fort Powhatan.

15 July 1863

The Confederacy Stricken by the defeats at Gettysburg, Vicksburg and Port Hudson, and the dangerous situations in Charleston and Jackson, President Davis writes to one of his generals, 'The clouds are truly dark over us.'

Eastern Theater, Gettysburg Campaign Lee's army moves southward along the Shenandoah Valley of Virginia, in good condition though short of shoes and supplies.

16 July 1863

The North The Draft Riots subside in New York.

Eastern Theater Morgan's raiders continue their ill-defined exploits in Ohio, meeting with increasing Federal resistance.

Western Theater J E Johnston, fearing Sherman's superior forces, pulls his forces out of Jackson, Mississippi, and leaves the city to Union occupation.

18 July 1863

Western Theater Federal forces mount a second unsuccessful attack on Battery Wagner, South Carolina. After an extensive naval bombardment, a frontal attack is attempted by Federal forces, but the troops are turned back. By the end of the day Federal casualties total 1515 to the defenders' 174.

Losses to the 54th Massachusetts Colored Infantry are especially severe, and their commander, Colonel R G Shaw, is killed. After this action shows that a direct attack against the Battery is inadvisable, a siege is commenced by Federal troops and ships. The Confederates begin moving guns from Fort Sumter to strategic positions within Charleston Harbor.

19 July 1863

Eastern Theater, Gettysburg Campaign In pursuit of Lee, Meade's army crosses the Potomac at Harper's Ferry and Berlin, Maryland.

Western Theater In Ohio, Morgan's raiders, now greatly reduced by skirmishes and desertions, are overwhelmed by Hobson and Shackelford, who kill and capture over 800 of his men. With only 300 men left, Morgan escapes toward Pennsylvania with Hobson in pursuit.

20 July 1863

The North Merchants in New York meet to discuss the relief of black victims of the Draft Riots.

Eastern Theater, Gettysburg Campaign Moving away from the Potomac toward Lee's army, Meade sends parties to take over the passes of the Blue Ridge Mountains. Nearby, skirmishes erupt at Ashby's Gap and Berry's Ferry.

22 July 1863

Eastern Theater, Gettysburg Campaign Meade prepares an assault on Manassas Gap in the Blue Ridge Mountains, Virginia, hoping to open a route for his men into the Shenandoah Valley; there they could intercept Lee's column as it moves south through the valley.

23 July 1863

Eastern Theater, Gettysburg Campaign Federal forces under General W H French push through Manassas Gap only to meet

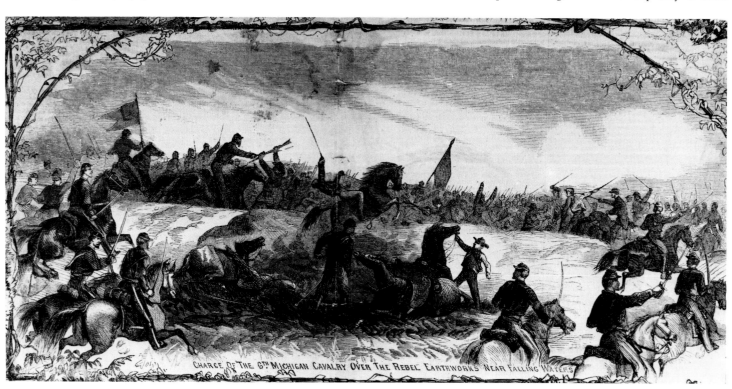

CHARGE OF THE 6TH MICHIGAN CAVALRY OVER THE REBEL EARTHWORKS NEAR FALLING WATERS

stiff resistance from Confederates; while French is delayed, the Southern corps of Longstreet and Hill move out of reach down the Shenandoah. Meade has thus failed to cut Lee's army in two.

24 July 1863

Eastern Theater, Gettysburg Campaign Meade's forces enter the Shenandoah Valley, Virginia, to find, as they did at Williamsport, that the enemy has gone; Union troops then continue to Warrenton.

Western Theater The Federal siege of Battery Wagner in Charleston Harbor continues with heavy shelling of the stronghold from Union ships. The remnants of Morgan's raiders continue to be harassed by Federal pursuers at Washington and Athens, Ohio.

26 July 1863

Western Theater Confederate raider John Hunt Morgan and the last of his men are brought to bay at New Lisbon, Ohio. Since crossing the Ohio River they have averaged 21 hours a day in the saddle and have covered large distances on what was nonetheless a strategically pointless expedition, especially since hoped-for Copperhead support in Ohio and Indiana has failed to materialize. As one commentator later observes, 'This reckless adventure . . . deprived [Morgan] of his well-earned reputation.' Morgan and his officers are sent to Ohio Penitentiary, from which he later escapes.

28 July 1863

Eastern Theater, Gettysburg Campaign Confederate partisan J S Mosby begins a series of daring harassing maneuvers around Meade's army; his raiders strike quickly and disappear.

1 August 1863

The Confederacy The growing incidence of desertion in the Confederate army, combined with the increasingly desperate need for manpower, leads President Davis to offer

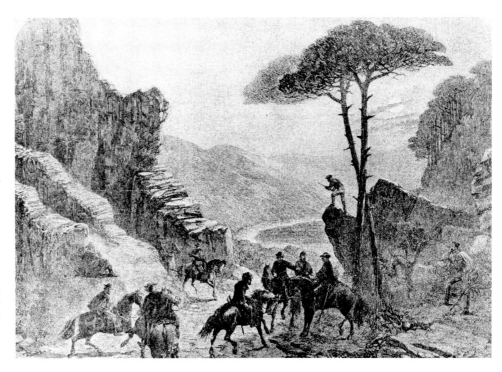

amnesty to those absent without leave. He then writes that the citizens of the South have no choice but 'victory, or subjugation, slavery and utter ruin of yourselves, your families, and your country.'

Eastern Theater, Gettysburg Campaign Brandy Station, scene of a June cavalry battle, sees another skirmish between the opposing cavalries of Lee and Meade, as minor encounters continue in the weeks after the major Southern defeat at Gettysburg.

Western Theater Federals begin organizing further troop action in Charleston Harbor, South Carolina, as part of their efforts to recapture Fort Sumter.

Naval Confederate raids on Federal shipping increase on the Mississippi; D D Porter is given command of Union naval forces on the river. Porter has recently been promoted to the rank of rear admiral.

Above: Members of Mosby's raiders rendezvous to plan an attack on a Union supply column in the Shenandoah.

4 August 1863

Western Theater Bombardment continues in Charleston Harbor, as Federals prepare for action the immense 'Swamp Angel,' a 200-pound Parrott gun which fires incendiary shells.

6 August 1863

Naval The British-built CSS *Alabama* captures the Federal bark *Sea Bride* near the Cape of Good Hope.

Below: Union cavalrymen pose for the camera. By the third year of the war, they could take on the South's horsemen on equal terms. Southern units were increasingly short of mounts.

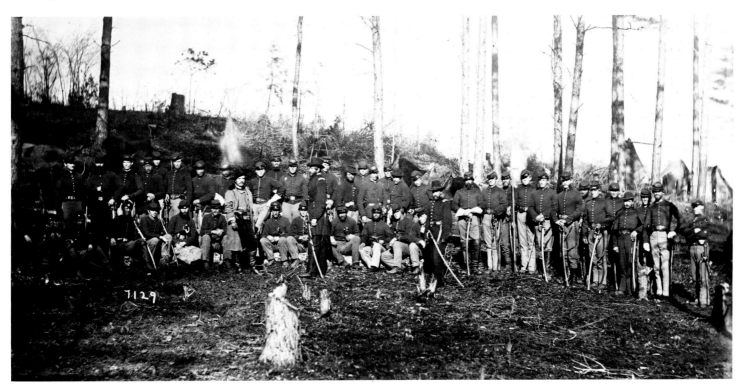

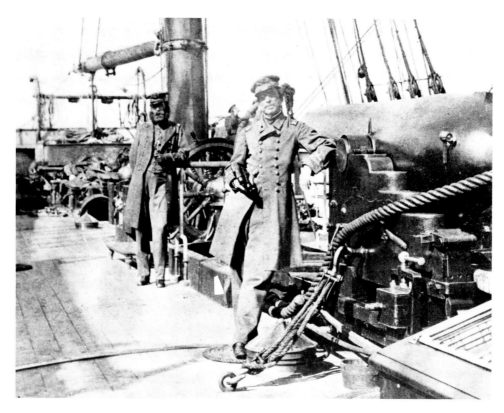

Above: Captain Raphael Semmes standing by the *Alabama's* 110-pounder rifled cannon during the ship's stay in Cape Town, August 1863.

8 August 1863

The Confederacy Lee, dejected and in ill health, writes President Davis offering his resignation as commander of the Army of Northern Virginia. Davis refuses the request, writing, 'our country could not bear to lose you.'

10 August 1863

Trans-Mississippi A Federal expedition to Little Rock, Arkansas, begins as troops led by General Frederick Steele leave Helena, Arkansas.

11 August 1863

Western Theater Federal preparations for an offensive in Charleston Harbor are stopped by heavy shelling from Fort Sumter and Battery Wagner.

12 August 1863

Western Theater Northern artillery, using their accurate Parrott guns, once again commence heavy shelling of the forts in Charleston Harbor, as a new offensive begins.

16 August 1863

Western Theater, Chickamauga Campaign After much delay and official prodding, the Federal Army of the Cumberland under Rosecrans moves eastward from Tullahoma toward the Tennessee River; the goal is Chattanooga and Braxton Bragg's Army of Tennessee. At the same time, Union General Burnside moves down from the Lexington, Kentucky, area toward eastern Tennessee. Rosecrans plans to envelop the Confederates between himself and Burnside; anticipating this strategy, Bragg reorganizes his troops, requesting all available reinforcements. South of Chattanooga, Federal Generals Thomas and McCook are brought up to threaten Bragg's only railroad link. The stage and the principal actors are now preparing for the complex, protracted, and bloody engagements of the Chickamauga and Chattanooga campaigns in southern Tennessee.

17 August 1863

Western Theater Fort Sumter in Charleston receives its first major bombardment from Union land and naval batteries. Its brick walls begin to fail but the 5009 shells rained on the fort in the next eight days cause few casualties among the defenders and no exploitable breaches in the walls.

18 August 1863

Washington President Lincoln fires a few test rounds of the Union's new Spencer Repeating Carbine, a rifle soon to give Federal soldiers an important advantage over the South's muzzle-loaders.

20 August 1863

Trans-Mississippi In Arizona Territory Colonel 'Kit' Carson moves against the Navaho Indians, who have been engaged in actions against settlers since the United States occupied New Mexico in 1846, after the war with Mexico.

21 August 1863

Western Theater, Chickamauga Campaign Rosecrans' forces reach the Tennessee River outside Chattanooga and begin preparations for the coming offensive.

Trans-Mississippi Around 450 irregular Confederate raiders under William Clarke Quantrill stage a dawn terrorist raid on Lawrence, Kansas, leaving 150 civilians dead, 30 wounded, and much of the town a smoking ruin. In 1862 Quantrill had been denied a commission by Confederate Secretary of War J A Seddon, who termed his notions of war 'barbarism.' For some time the town of Lawrence has been strongly Unionist and abolitionist, thus earning Quantrill's enmity. This strategically pointless raid demonstrates a certain Southern loss of faith in conventional military operations, and many of the South find this and later similar actions disturbing to their sense of divine approval for the Confederate cause: one raider has shouted into the window of a woman whose husband he has just murdered, 'We are friends from Hell!'

22 August 1863

Western Theater In Charleston Harbor, the Swamp Angel, pride of the Federal battery, blows itself up at the 36th round. As one observer later noted, 'The [gun] turned out to have been more destructive to Union gun crews than to Rebel property.'

23 August 1863

Western Theater Union batteries cease their first bombardment of Fort Sumter, leaving it a mass of rubble but still unconquered by the Northern besiegers.

Below: Confederate irregulars terrorize the inhabitants of a Western town. William Quantrill was the most feared leader of guerrillas.

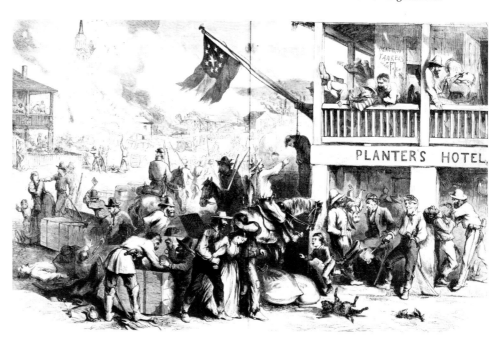

25 August 1863

Western Theater A Union offensive fails to overrun Confederate rifle pits before Battery Wagner in Charleston Harbor.

Trans-Mississippi In the wake of Quantrill's terrorist raid on Lawrence, Kansas, the Federal commander in Kansas City issues a misguided and ineffective anti-guerrilla directive ordering many civilians in the area out of their homes; much property and crops are destroyed, and 20,000 are left homeless. Resentment over these measures is to last for years.

26 August 1863

Western Theater Confederate rifle pits before Battery Wagner are captured in a second Union effort.

29 August 1863

Naval In Charleston Harbor, South Carolina, the experimental Confederate submarine *H L Hunley* sinks on a test cruise, drowning five crewmen. The ship is soon raised and is later to see action.

30 August 1863

Western Theater Heavy Federal shelling resumes on Fort Sumter. Confederates within the fort, meanwhile, are engaged in digging their cannon out of the rubble and moving them into Charleston for the anticipated defense of the city.

1 September 1863

Western Theater Union batteries pour 627 rounds into Fort Sumter near Charleston, reducing its walls to still smaller fragments but not dislodging its defenders.

Chickamauga Campaign Moving toward Chattanooga, Rosecrans' Army of the Cumberland begins a four-day crossing of the Tennessee River largely unopposed by Bragg's Army of Tennessee. Bragg, meanwhile, receives two divisions of much-needed reinforcements.

2 September 1863

Western Theater With no opposition, Federal General Burnside's troops occupy Knoxville, Tennessee, to remain there as a resource for Union forces operating in the vicinity of Chattanooga.

4 September 1863

Western Theater Union General Ulysses S Grant, in a perhaps inebriated state, is fallen on by his horse in New Orleans; the general, soon to be called to Chattanooga, will be partly lame for some weeks.

Chickamauga Campaign In Chattanooga, Rosecrans completes his army's crossing of the Tennessee, still nearly unopposed, and begins to suspect that Bragg is fleeing him. Elsewhere, dwindling supplies of food and clothing result in protests and looting by women in Mobile, Alabama.

5 September 1863

Western Theater, Chickamauga Campaign Rosecrans, convinced that Bragg's Army of Tennessee is evacuating Chattanooga, moves into the Georgia mountains south of the city. Determined to pursue the supposed Confederate retreat, the Union commander takes the risky step of separating his army into three groups in order to go as quickly as possible through three widely-spaced gaps in the mountains.

International Despite Federal protests, British shipbuilders have for some time been constructing vessels for the Confederacy, the most successful of which is the CSS *Alabama*; this ship has been preying on Federal commerce since mid-1862 and has captured or destroyed over 60 Union ships. Finally responding to Washington's protests, the British government on this day seizes in Liverpool's Laird shipyards two newly-built ironclads with ramming spars that have been ordered by the Confederacy. This seizure of the so-called 'Laird Rams' halts the growth of the Confederate navy and ends the last major diplomatic crisis between Washington and Britain during the war.

Below: The ruins of Fort Sumter after three years of war. For much of that time the position was under Union bombardment. Although the fort's walls were smashed, its garrison held out for most of the conflict.

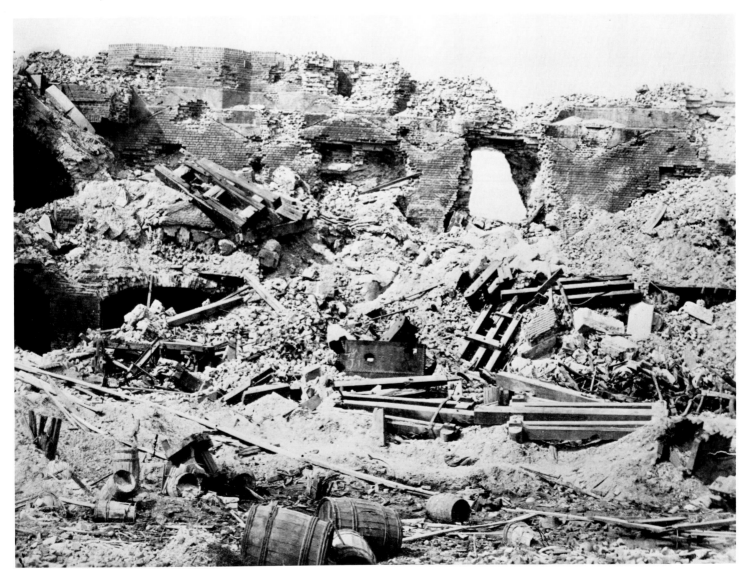

6 September 1863

Western Theater, Chickamauga Campaign
As Federal troops close around this city, General Bragg, perhaps fearing a repeat of the siege of Vicksburg, decides to evacuate Chattanooga. In Charleston, Confederate commander P G Beauregard decides that it would be too costly to fight the coming Union assault on Battery Wagner and Battery Gregg. He evacuates the forts. Fort Sumter, by now nearly a heap of brick, still holds out.

7 September 1863

Western Theater The Federal infantry assault on Batteries Wagner and Gregg finds the enemy evacuated.

8 September 1863

Trans-Mississippi Federal transports and three gunboats from New Orleans enter the Sabine Pass in Texas to attack a small Confederate defensive fort. Within an hour two Union ships have been disabled and one forced to surrender with a loss of some 70 men. The operation is soon abandoned, with the North having sustained a minor but embarrassing defeat that considerably boosts the spirits of western Confederates.

Western Theater, Chickamauga Campaign
Bragg's troops, now numbering some 65,000, march out of Chattanooga and withdraw toward Lafayette, Georgia.

9 September 1863

Western Theater, Chickamauga Campaign
The Federal Army of the Cumberland is now spread in three groups north to south across 40 miles of mountains. The northernmost group, under Crittenden (whose brother is a Southern general), advances through Chattanooga while the others, Thomas in the middle and McCook many miles to the south, pursue what Rosecrans believes to be a fleeing enemy. Indeed, by now the Federal commander is convinced he will chase Bragg to Atlanta if not to the sea. In fact, the Union

Below: A Union encampment at Culpepper, Virginia, occupied by Meade's forces on 13 September 1863 after its evacuation by Lee.

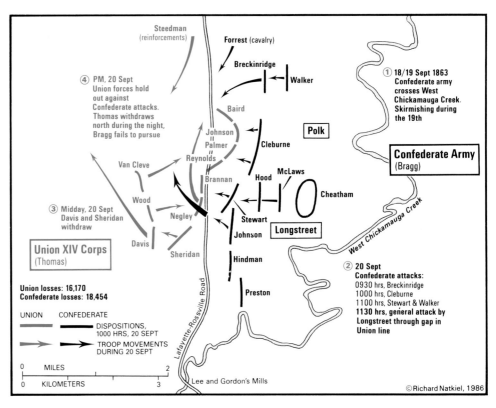

Above: The Battle of Chickamauga saw the Union forces narrowly avoid defeat.

army is racing into a very clever trap. Though some of Bragg's staff, who dislike their harsh and fractious commander and serve him badly, are later to insist he has not planned it, there is little doubt that Bragg has constructed his trap well, and that it has every chance of success: his army, now outnumbering Rosecrans', is gathering at Lafayette, Georgia, and preparing to defeat the widely-separated Federal forces one group at a time.

In Virginia, Longstreet's divisions have departed from Lee's army and are beginning a long railroad journey to reinforce Bragg; they will arrive on 18 and 19 September.

10 September 1863

Western Theater, Chickamauga Campaign
Having created a brilliant trap, Bragg and his staff now proceed to spring it ineptly and too soon. Before the Federals are totally committed, Bragg orders an attack on McLemore's Cove, but it fails to be mounted. During the day both Crittenden and Thomas discover strong parties of the enemy in their paths, and both are able to fall back and regroup. It is soon to become clear to the whole Federal staff that Bragg is by no means retreating.

Trans-Mississippi Federal forces occupy Little Rock, Arkansas, after Confederate forces evacuate; this development poses a serious threat to the Confederate Trans-Mississippi area.

11 September 1863

Western Theater, Chickamauga Campaign
Once again Bragg orders an attack on isolated Federal forces but it fails to materialize.

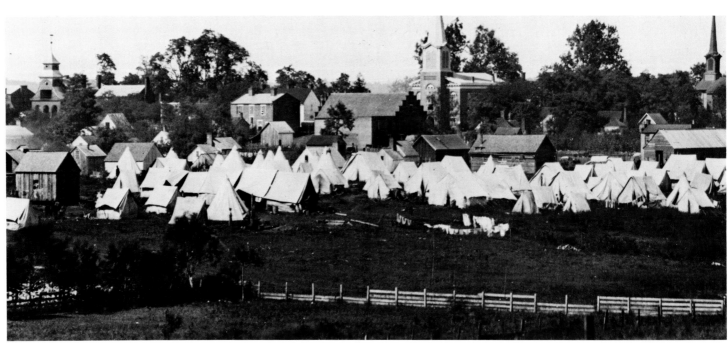

Knoxville Campaign Burnside, still occupying the city, offers his resignation to Lincoln; the president refuses the resignation and asks Andrew Johnson to form a Union state government.

12 September 1863

Western Theater, Chickamauga Campaign By this time Rosecrans has realized the perilous position of his armies, divided in the face of concentrated enemy forces. Urgent orders are issued to his wings to move toward the center. McCook's forces to the south begin after midnight an exhausting 57-mile journey through the mountains that will unite them with Thomas on the 17th. Meanwhile, Bragg has ordered General Polk to attack next day a part of Crittenden's forces at Lee and Gordon's Mill on Chickamauga Creek.

13 September 1863

Eastern Theater Weakened by Longstreet's removal to Tennessee, Lee's forces withdraw across the Rapidan River. Meade's army moves from the Rappahannock to the Rapidan, occupying Culpeper Court House.

Western Theater, Chickamauga Campaign Bragg arrives at Lee and Gordon's Mill expecting to find Crittenden's XXI Corps annihilated by Polk as planned in his orders; instead, he finds that Polk has made no move and that Crittenden has safely concentrated his forces. Yet again, Bragg's plans have been frustrated by his subordinates. His trap has failed. He and his army now wait for reinforcements and for the arrival of the enemy from the west.

15 September 1863

Washington As Meade's advance to the Rapidan is completed, Lincoln writes that the Union army should attack Lee at once.

17 September 1863

Western Theater, Chickamauga Campaign Union troops move toward concentration around Lee and Gordon's Mill on Chickamauga Creek. By the end of the day the divided forces are within supporting distance of one another. Bragg, now on the east bank of the creek, begins to develop his battle plan: he will turn the Union left flank and get behind Rosecrans' army, cutting off the roads to Chattanooga. The stage is now set for the bloodiest battle of the war in the Western Theater. It is prophetic that the ancient Cherokee Indian name for this creek is *Chickamauga*, meaning 'River of Death.'

18 September 1863

Western Theater, Chickamauga Campaign Bragg has planned a major attack this day, but cannot get his forces to the west bank of Chickamauga Creek in time. Extensive cavalry skirmishes break out at various locations. The first of Longstreet's forces arrive from Virginia. All day and night Rosecrans is busy concentrating and placing his troops, anticipating Bragg's plan to attack his left and get behind him. Because of the dense woods in the area, broken only by a few small fields, neither commander can determine the strength and position of his enemy; moreover, it is difficult for commanders to observe their own positions.

19 September 1863

Western Theater, Chickamauga Campaign Dawn finds both fronts solidly facing one another along a six-mile line. A Northern captain describes the feelings of the soldiers before the battle: 'Through that forenoon we saw the constantly moving columns of the enemy's infantry and saw battery after battery as they moved before us like a great panorama. In such moments men grow pale and lose their nerve. They are hungry but they can not eat; they are tired, but they can not sit down. You speak to them, and they answer as if half asleep; they laugh, but the laugh has no joy in it.' The fighting begins almost by accident. Thomas sends one of his divisions to reconnoiter near the creek on the Union left; these troops suddenly encounter the dismounted cavalry of Nathan Bedford Forrest, who return fire and call for infantry help. Soon hostilities have erupted along most of the battle line. Throughout the ensuing day of intermittent but fierce fighting, Bragg throws his strongest efforts against the Union left, pursuing his plan to get behind the enemy and cut them off from Chattanooga. Rosecrans responds by moving division after division to his left, extending his battle line north. By the end of the day losses are enormous on both sides, but neither has gained any significant advantage. The battle grinds to a standstill: dead men blanket the thick woods, wounded men crawl toward the

Below: General Henry Thomas, the 'Rock of Chickamauga,' (mounted, left) stems the Southern onslaught during the battle.

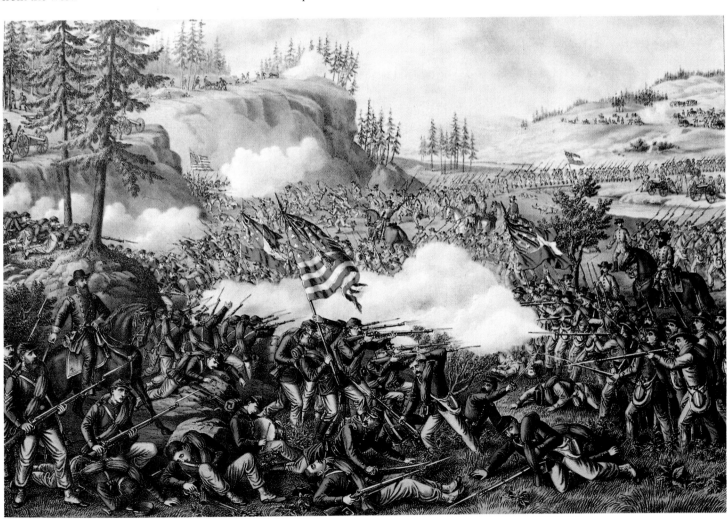

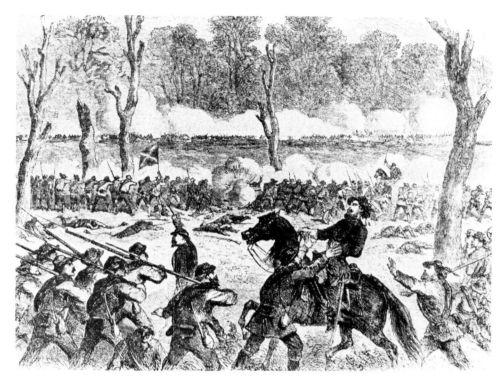

Above: Southern General John Hood was wounded at Chickamauga and subsequently had his right leg amputated.

rear, stretchermen carry hundreds to the overworked field hospitals which are soon marked by bloody heaps of amputated limbs.

During the afternoon Longstreet has arrived with the bulk of his troops; it takes him until 2300 hours to locate Bragg, who gets out of bed for a conference. The plan for the following day is decided upon: Polk will attack at dawn in the north, and the attack will be joined successively by units down the line southward, to climax with an all-out assault by Longstreet on the Union right. Meanwhile, Rosecrans decides on a defensive strategy and his men begin building rough breastworks along the six-mile length of the Union frontline.

20 September 1863

Western Theater, Chickamauga Campaign At dawn, Bragg, unable in the dense forest and morning fog to see his troops, waits for the sound of Polk's attack. After over an hour of inactivity, he sends a messenger to Polk, who is discovered to be comfortably breakfasting in a farmhouse. To the query about his attack, Polk replies, 'Do tell General Bragg that my heart is overflowing with anxiety for the attack – overflowing with anxiety, sir.' This being reported back to Bragg, the commander swears 'in a manner that would have powerfully assisted a mule team in getting up a mountain,' and at about 0930 hours orders his right flank into attack against Thomas on the Union left. Once again the Confederates struggle determinedly to outflank the Federals; but Thomas's men hold at the breastworks and, as it did the previous day, the fighting sways back and forth indecisively. Then at about 1100 there occurs a strange and fatal error.

Union commander Rosecrans, mistaken as to the location of his divisions in the thick brush, orders T J Wood to close up on and 'support' J J Reynolds, whom he supposes to be immediately on Wood's left; Rosecrans' order is thus intended to tighten his battle line. But in fact, there is another whole division between Wood and Reynolds. Wood, taking the order literally, pulls back out of line and moves left toward Reynolds, thereby leaving a gaping hole in the Union line. But before Wood has completed his withdrawal, Longstreet, whether because he has seen the withdrawal or whether through a coincidence fortuitous to say the least, charges in a solid column directly into this gap, with devastating effect.

The Union line has been cut in two, the right wing is in disorderly rout and Thomas's men are being pushed left toward Snodgrass Hill. Thousands of Federals are killed or captured, the rest are running. Along with McCook and Crittenden, a panicky and demoralized Rosecrans flees to Chattanooga, assuming his whole army is being destroyed. But Rosecrans is wrong. On the Federal left Thomas has maintained firm control of his troops, and assumes a virtually impregnable position on Snodgrass Hill. For the rest of the day, Thomas's men desperately turn back wave after wave of attacks, several of them hand-to-hand, as nearly the whole Confederate army swarms up the precipitous slopes. At 1500 hours when Thomas is nearly out of ammunition and is threatened from the rear, he is reinforced from the north by General Granger, who has fortunately violated his morning's orders to keep his Reserve Corps in place. With Granger's men and bullets, Thomas holds the position until nightfall and then withdraws in good order toward Chattanooga. His army's heroic defense has saved the Union forces from utter rout, and General George Henry Thomas will hereafter come to be known as the 'Rock of Chickamauga.'

The battle losses on both sides are staggering. In two days of fighting the Union has 1656 killed, 9756 wounded and 4757 missing, totaling 16,169 casualties; the Confederates have 2132 dead, 14,674 wounded, 1468 missing, totaling 18,274. Both sides have lost about 28 percent of their strength. The battle

is unusual in that the crucial decisions have been taken largely by subordinate officers.

21 September 1863

Western Theater, Chattanooga Campaign As the ragged and demoralized Union army gathers in Chattanooga, Bragg is urged by Longstreet to move quickly against the retreating enemy; but he does not give the orders until 1600 hours, too late to reach the city, thus giving the Federals time to organize their defenses. In Knoxville, Burnside receives a wire from Lincoln: 'Go to Rosecrans with your forces, without a moments delay.' Burnside, pressed by enemy forces, stays.

22 September 1863

Washington Lincoln mourns the death at Chickamauga of his brother-in-law, Confederate General Ben Hardin Helm.
Western Theater, Chattanooga Campaign Bragg orders an attack on Federal positions below Missionary Ridge in Chattanooga; the troops reach the area to find the enemy 'ready to receive and entertain us . . . we expected to be flung against the forts to certain destruction.' Realizing the Federals have now firmly dug in, Bragg cancels the attack. By failing to pursue the Federals before they can reorganize, Bragg has missed his second great opportunity to destroy the Union army. Now, as his forces occupy the commanding heights of Missionary Ridge and Lookout Mountain, his third and final opportunity takes shape. A few days after having thought they were chasing the Confederates to Atlanta, the Federals find themselves defeated and besieged.

Below: General J Reynolds was one of the Union commanders during the costly fighting at the Battle of Chickamauga.

23 September 1863

Washington Lincoln and his cabinet hold an urgent meeting about the crisis in Chattanooga. It is decided to send by rail Hooker's two corps from the Army of the Potomac, still in Virginia, to Alabama in support of Rosecrans. By 25 September the troops are entrained and moving south with extraordinary speed. By 15 November, 17,000 of these and other reinforcements will have arrived at Bridgeport, Alabama, along with thousands of horses and mules.

25 September 1863

Washington Lincoln, angry at Burnside's failure to aid Rosecrans, writes in an unsent letter that he has been 'struggling . . . to get you to assist General Rosecrans in an extremity, and you have repeatedly declared you would do it, and yet you steadily move the contrary way.'

28 September 1863

Western Theater, Chattanooga Campaign Bragg is informed by President Davis that Union reinforcements are on their way. Rosecrans, attempting to justify his handling of the battle – especially in regard to charges that he advanced recklessly and lost his nerve after Longstreet's attack – brings his own charges against subordinates McCook and Crittenden, who are ordered to Indianapolis for a court of inquiry. Eventually the two generals are exonerated, and history will tend to confirm the charges against Rosecrans, who is a hard-working and methodical leader but often excitable and ineffective on the battlefield.

Below: Positioned along the slopes of Snodgrass Hill, Union troops repel a spirited Confederate attack, 20 September 1863.

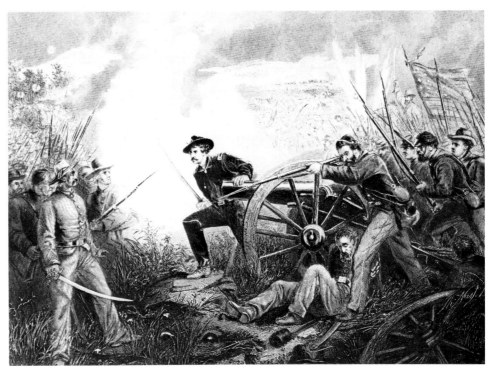

30 September 1863

Western Theater, Chattanooga Campaign Bragg has thought that Rosecrans might evacuate Chattanooga, but seeing that the Federals show no signs of leaving, he orders cavalry raids by Wheeler on Union lines of communication; these raids continue into October.

2 October 1863

Western Theater, Chattanooga Campaign Hooker's men begin to arrive in Bridgeport, Alabama, eventually to support Union forces in Chattanooga. During the next two days

Above: A Confederate attempt to capture a Union battery at Chickamauga is thwarted by men led by Lieutenant Van Pelt.

20,000 men and 3000 horses and mules will arrive, all having traveled 1159 miles by rail in just over a week. Meanwhile, Confederate cavalry troops continue to raid vital Union supply lines, closing the route between Bridgeport and Chattanooga and forcing Rosecrans to rely on a long, muddy and mountainous wagon road on the north side of the Tennessee River. A later Southern raid on this route destroys in one day 300 wagons

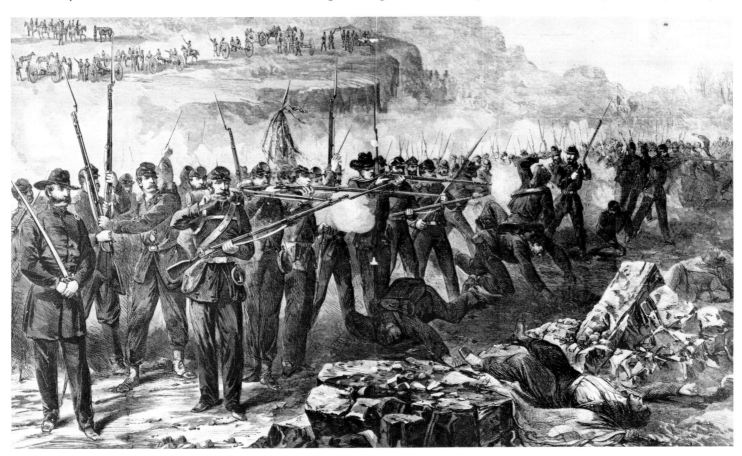

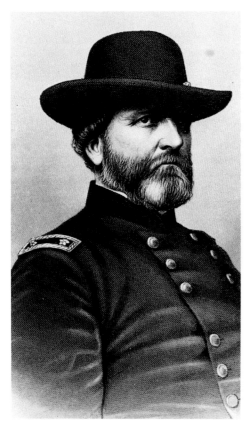

Above: General George Thomas, the hero of Chickamauga, became the commander of the Union forces in Chattanooga on 18 October 1863.

and 1800 mules. Though the Confederates cannot shut off Union supplies entirely, the specter of famine looms for the besieged Army of the Cumberland.

3 October 1863

Western Theater, Chattanooga Campaign Wheeler's cavalry raids continue on troops and supply routes around Chattanooga. A six-day bombardment of Fort Sumter in Charleston Harbor ends with 560 rounds having been fired to no particular effect.

5 October 1863

Western Theater, Chattanooga Campaign Wheeler's cavalry breaks a vital Union supply line by destroying a bridge at Stone's River, near Murfreesboro. The Confederate raiders will be very active in the coming days all around eastern Tennessee. In Chattanooga the famine deepens among Federal troops; draft mules are dying by the hundreds, with cavalry and artillery horses weakening. Soldiers are seen searching in the dust for grains of corn dropped by their animals.
Naval In an attempt to loosen the Federal blockade of Charleston Harbor, the Confederate semi-submersible steamship *David* hits the Federal ironclad *New Ironsides* with a spar torpedo. Damage to the Union ship is extensive but not critical, and two of the *David's* four crew are captured; the other two crew take the nearly-swamped ship back to Charleston. This is the first successful Southern semi-submersible attack of the war; the only Union attempt at a submersible, the *Alligator*, sank under tow in April 1863, after several unsuccessful trials. In general, the experimental submarines of both sides

throughout the war cause more fatalities to their crews than to their enemies.

9 October 1863

Eastern Theater, Bristoe Campaign Lee, still outnumbered but wishing to capitalize on Meade's loss of Hooker's troops sent to reinforce Alabama, moves his army from the Rapidan to the west and north. He is trying to flank Meade's army and drive them from the west. Over the next month Lee forces Meade to retreat some 40 miles for a time, but achieves little other than to destroy a railroad the Federals have been repairing.
Western Theater, Chattanooga Campaign Wheeler's Confederate cavalry raiders return to Chattanooga having attacked Rosecrans' supply and communication lines all around east Tennessee.

10 October 1863

Eastern Theater, Bristoe Campaign Skirmishes break out around the Rapidan in Virginia as Lee tries to get behind the right flank of the Army of the Potomac.
Western Theater, Chattanooga Campaign Confederate President Davis arrives on the scene near Chattanooga to survey the siege and to attempt mediation in the growing feud between Bragg and his generals.

12 October 1863

Eastern Theater, Bristoe Campaign Amid daily skirmishings, Lee's Army of Northern Virginia continues moving west and north toward Manassas and Washington. Meade slowly withdraws.

13 October 1863

The North Republican Union candidates are successful in a number of state elections. In Ohio Vallandigham, the Canadian-exiled

Copperhead candidate for governor, loses decisively but still receives a surprisingly large vote.

14 October 1863

Eastern Theater, Bristoe Campaign Lee attempts to cut off Meade's withdrawal with an attack under A P Hill on Union corps near Bristoe Station. There ensues a day of inconclusive but costly maneuvering which gains no clear results; though Meade is forced back near the Potomac, his column is not broken. Lee's forces lose 1900 captured and killed to Meade's 548.

15 October 1863

Western Theater For the second time, the Confederate submarine *H L Hunley* sinks during a practice dive in Charleston Harbor, this time drowning its inventor along with seven crew. The ship will be raised yet again.

16 October 1863

Washington The government announces sweeping changes in the organization of its army. The Departments of Ohio, Cumberland and Tennessee are combined into the Military Division of the Mississippi, the whole to be commanded by General Ulysses S Grant. The new commander, still limping from his horse accident, is ordered to leave his post at Vicksburg and go to Illinois; his eventual destination is Chattanooga. Meanwhile, Lincoln encourages Meade, through Halleck, to attack Lee immediately; Meade, however, is not to find during the Bristoe campaign an opportunity that suits him.

Below: The field headquarters of the *New York Herald*, August 1863. The civil war was one of the first widely reported and photographed conflicts of the modern era.

17 October 1863

Eastern Theater, Bristoe Campaign Not wishing to give Meade a chance for an attack, Lee's forces withdraw amid skirmishing from Bull Run and toward the Rappahannock.

Western Theater En route through Illinois to Louisville, Kentucky, Grant is given his instructions by Secretary of War Stanton. Grant has his choice of commanders for the Army of the Cumberland: retain Rosecrans, or replace him with Thomas. Without comment, Grant chooses Thomas; Rosecrans, as a result of his tarnished reputation after Chickamauga, has lost his most important command.

18 October 1863

Western Theater, Chattanooga Campaign General Thomas, succeeding Rosecrans in Chattanooga, declares: 'We will hold this town till we starve.' His army is close to starving as he speaks. Meanwhile, U S Grant officially takes over command of the Military Division of the Mississippi, thus being in charge of the whole area between the Mississippi River and the eastern mountains.

20 October 1863

Eastern Theater, Bristoe Campaign The Army of Northern Virginia gathers on its old line across the Rappahannock, the Bristoe Campaign having accomplished little except to add to the war's casualty statistics; between 10 and 21 October the South has lost 1381 in killed and wounded, the Union 2292 killed, wounded, and captured.

23 October 1863

The Confederacy President Davis removes another of Bragg's quarreling subordinates, General Leonidas Polk, sending him to Mississippi. Late in the day Grant arrives in Chattanooga after an exhausting ride from Bridgeport, during which he has experienced first-hand the difficulties of the Union supply line.

24 October 1863

Washington Once again President Lincoln prods Meade: 'With all possible expedition . . . get ready to attack Lee.'

Western Theater, Chattanooga Campaign In his memoirs, General Grant will describe his first day in Chattanooga: 'The men had been on half rations for a considerable time. The beef was so poor that the soldiers were in the habit of saying that they were living on "half rations of hard bread and *beef dried on the hoof*." It looked, indeed, as if but two courses were open: the one to starve, the other to surrender or be captured. As soon as I reached Chattanooga, I started out to make a personal inspection, taking Thomas with me. We crossed to the north side and reached the Tennessee at Brown's Ferry, some three miles below Lookout Mountain, unobserved by the enemy. Here we left our horses and approached the water on foot. There was a picket station of the enemy on the opposite side, in full view, and we were within easy range, but they did not fire upon us. They must have seen that we were all commissioned officers but, I suppose, they already looked on the garrison at Chattanooga as their prisoners of war. That night I issued orders for opening the route to Bridgeport – *a cracker line*, as the soldiers appropriately termed it.' The plan for the 'cracker line' is partly Grant's and partly Rosecrans' – by various means a river route to Bridgeport is to be opened. Meanwhile, from his position on Missionary Ridge, Bragg has become confident about his advantage over the Union army. His advantage, though, is shortly to be lessened.

26 October 1863

Western Theater, Chattanooga Campaign In the first step to opening the cracker line, Hooker's men from Virginia leave Bridgeport, Alabama, and move across the Tennessee toward Chattanooga. Elsewhere, another major Union bombardment commences in Charleston Harbor.

27 October 1863

Western Theater, Chattanooga Campaign At 0300 hours, 1500 Federals drift silently down the Tennessee River in pontoons to Brown's Ferry; the pontoons are destined to form a bridge for Hooker's men to enter Chattanooga. The plan works – with only light resistance Hazen's men are established on the far shore, the bridge is laid, and Hooker's forces move over it. The cracker line is now open and Chattanooga is reinforced; shortly, supplies will arrive from Bridgeport. Meanwhile, in Charleston Harbor, 625 shots are fired at Fort Sumter, which has now become more a symbol of Confederate resistance (as well as Federal persistence) than a military objective.

28 October 1863

Western Theater, Chattanooga Campaign General Bragg, having failed to prevent the establishment of the Union bridgehead at Brown's Ferry, orders troops under Longstreet to attack on this night an isolated division of Hooker's army at Wauhatchie. This being one of the rare night attacks of the war, the fighting is extremely confused; on both sides the officers scarcely know where the enemy is. After intensive fighting, the Con-

Below: The USS *St Louis* made naval history when she was refitted as the ironclad gunboat and renamed the *Baron de Kalb* in 1862.

Above: The staff and commander of a Union cavalry unit pose for the camera outside their field headquarters.

federates are driven back; each side suffers over 400 casualties. The cracker line will not be seriously challenged again.

29 October 1863

Western Theater Federal batteries send 2691 shells into Fort Sumter, killing 33 of the defenders. The stepped-up firing will continue for days, but the fort will not surrender.

30 October 1863

Western Theater, Chattanooga Campaign The little Federal steamship *Chattanooga*, built on the upper Tennessee River, arrives in Chattanooga with 40,000 rations and tons of feed. Union soldiers and animals are back on full rations and are no longer quite so firmly besieged. Although no men have starved during the siege, Chattanooga is covered with thousands of dead horses and mules, many of them having starved to death.

2 November 1863

Washington President Lincoln is invited to the dedication of a new cemetery at Gettysburg and asked to make 'a few appropriate remarks'; actually, his words are intended to be something of a benediction to the main address by orator and statesman Edward Everett. Lincoln, who rarely gets out of Washington these days, accepts the invitation.

4 November 1863

Western Theater, Chattanooga Campaign In a move that dangerously weakens his forces around Chattanooga, Bragg sends Longstreet's corps, including Wheeler's cavalry, to reinforce Confederate troops around Knoxville which is still occupied by Burn-

side's Union army. The decision to send these 20,000 men has in fact been made by President Davis, and is to some extent another response to friction among his generals – Bragg and Longstreet do not get along. This shifting of forces poses an immediate threat to Knoxville; Grant makes a tactical decision not to weaken his own army by reinforcing Burnside, but rather to attack the weakened Bragg as soon as possible and only then to mass his forces against Longstreet. Before he can attack, though, Grant must await the arrival by rail of Sherman's forces, now delayed by the necessity of repairing their own rail route.

6 November 1863

Eastern Theater Hostilities break out at Droop Mountain, West Virginia, where advancing Federal troops under Brigadier General W A Averell find a Confederate force holding the road. Averell manages to envelop the enemy and scatter them, after which he continues his raiding expedition against the remaining enemy troops and rail links in West Virginia.

7 November 1863

Eastern Theater, Bristoe Campaign In a maneuver against Lee's Confederate forces, Meade sends troops across the Rappahannock near Kelly's Ford. The first Union attacks do not move the enemy, but at dusk an advance by two Union brigades, including one of the rare bayonet attacks of the war, succeeds in overrunning the Confederate positions and taking a bridgehead. Two Confederate divisions lose 2023 in dead and captured, a figure which shocks the Southern Army. Lee withdraws to the Rapidan, and the contending armies have thus returned to the positions they held at the beginning of the Bristoe campaign. Neither side has gained from their operations.

9 November 1863

Washington Pursuing one of his favorite pastimes, President Lincoln attends the theater, he enjoys a play called *The Marble Heart*, starring John Wilkes Booth.

10 November 1863

Western Theater The unconquerable mound of rubble called Fort Sumter has received 1753 Federal rounds since 7 November. This bombardment has so far killed few defenders, but Union batteries keep firing.

12 November 1863

Western Theater, Knoxville Campaign Confederate General Longstreet arrives at Loudon, Tennessee; he and Wheeler are directed to organize an assault on Burnside and his troops at Knoxville.

15 November 1863

Western Theater, Chattanooga Campaign Federal General Sherman arrives, en route to Chattanooga, at Bridgeport, Alabama, with 17,000 men; they have moved 675 miles by boat, rail and foot. Sherman himself joins Grant in Chattanooga for briefings on the impending offensive. Wheeler's Confederate cavalrymen cross the Tennessee River and join Longstreet's infantry.

16 November 1863

Western Theater, Knoxville Campaign At Campbell's Station near Knoxville, Confederate General Longstreet tries and fails to cut off Burnside's retreat into Knoxville. The Federals are now driven back to the city, but Confederate forces lack the means of mounting a regular siege.

17 November 1863

Washington President Lincoln begins to write his speech for the dedication of the military cemetery at Gettysburg. Contrary to the

later tradition that the speech was written hastily on the train, his address is a carefully-considered statement.

18 November 1863

Washington A special train leaves the capital for Gettysburg carrying President Lincoln, Secretary of State Seward and other notables, including the French ambassador.

19 November 1863

The North, Gettysburg Address A crowd of 15,000 people gathers for the dedication of the military cemetery at Gettysburg. Edward Everett, the main speaker, gives a brilliant two-hour historical discourse on the battle, using information furnished by Meade and other Union officers. After Everett concludes, Lincoln rises and in his high toneless voice gives his 'little speech.' When he has finished, the reception is polite but unenthusiastic; the president considers the address a 'flat-failure.' Over the next few days it receives a few compliments, Everett assuring the president that the speech said more in two minutes than he said in two hours. It is perhaps natural that no one at the time can foresee that these 10 sentences would come to be considered one of the most moving and exquisite utterances in the language.

20 November 1863

Western Theater, Chattanooga Campaign Grant's plans have called for an attack on Confederate positions on the day following, but as Sherman's forces begin to arrive at Brown's Ferry near the city, heavy rains delay preparations for the battle.
Knoxville Campaign Confederate General Longstreet prepares an attack on the salient of Fort Sanders in Knoxville but delays the attack for over a week to await further reinforcements from Chattanooga and to have his plans checked by Bragg's chief engineer.

Below: Lincoln making the Gettysburg Address, 19 November 1863. Its significance was not widely recognized at the time.

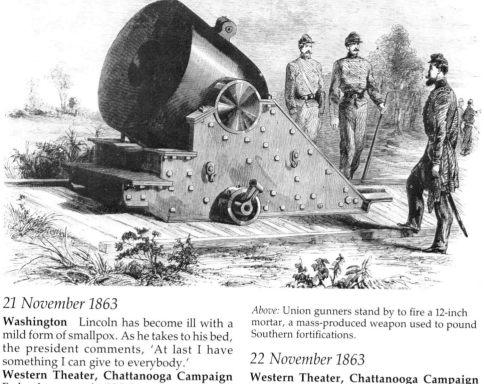

21 November 1863

Washington Lincoln has become ill with a mild form of smallpox. As he takes to his bed, the president comments, 'At last I have something I can give to everybody.'
Western Theater, Chattanooga Campaign Federal commander U S Grant has developed his plan of battle: Sherman's forces on the Union left wing will attempt to overrun the north end of Missionary Ridge; following this, Hooker will create a 'demonstration' on the right wing, moving part way up Lookout Mountain and diverting troops from the enemy center to meet his advance; after this Thomas will commence the main attack in the center of the Confederate entrenchments on the ridge. Bragg remains sanguine about his position, regarding his army as impregnable: even during the battle he will reassure an anxious bystander, 'Madam, are you mad? There are not enough Yankees in Chattanooga to come up here. Those are all my prisoners.' In accordance with Grant's plan, General Sherman's troops begin moving to the left flank.

Above: Union gunners stand by to fire a 12-inch mortar, a mass-produced weapon used to pound Southern fortifications.

22 November 1863

Western Theater, Chattanooga Campaign Changing plans on the eve of battle, Grant now orders Thomas's men to make a 'demonstration' in front of Missionary Ridge on the following day; the main engagement is to begin on 24 November.

23 November 1863

Western Theater, Battle of Chattanooga At dawn Union batteries open up on Missionary Ridge. Confederate cannon return the fire. Soon thereafter, Southern troops on the ridge are entertained by the appearance below their positions of 20,000 Union troops, clad in their best uniforms and marching in perfect ranks, bayonets gleaming, to the vigorous music of military bands. The rebels watch calmly, assuming a grand parade is under way. Suddenly the parade wheels and charges furiously up the slopes: the battle of Chattanooga has begun. In short order Federal troops overrun Orchard Knob, a hill between Chattanooga and Missionary Ridge. Grant orders reinforcements and entrenchments on the Knob, which will become his command post the following day. The Union has established a beachhead on Confederate positions.

24 November 1863

Western Theater, Battle of Chattanooga After midnight, Sherman's troops move across the Tennessee River. One of his men describes the operation: 'My regiment was in Sherman's corps. We had marched twenty miles a day. Now this corps was to form the left of Grant's forces, cross a deep river in the darkness and assault the nearly inaccessible position of Bragg's army. That night we lay in bivouac in the woods close by the Tennessee River. We knew that 116 rude pontoon boats had been built for us and were lying hidden in a creek nearby. We had almost no rations for the army. As for the horses and mules, they had already starved to death by the thousands and were lying around everywhere ... At two o'clock we heard some

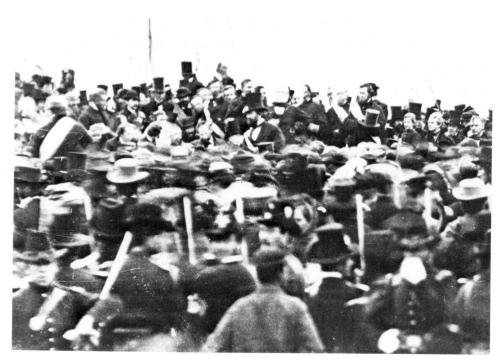

Left: A scene from the fighting around Lookout Mountain on 24 November 1863.
Below left: Shrouded by mist, Union troops storm the lightly held Southern positions on the upper slopes of Lookout Mountain.
Above: General Grant (standing, foreground) and his staff on Lookout Mountain plan the next stage of the Battle of Chattanooga.

splashing in the water . . . the boats had come for us . . . Quietly, two by two, we slipped down to the water's edge and stepped into the rude flatboats. ''There's room for thirty in a boat,'' said a tall man . . . who stood on the bank near us in the darkness. Few of us had ever before heard the voice of our beloved commander. Sherman's personal presence, his sharing the danger we were about to undertake, gave us confidence. In a quarter of an hour a thousand of us were out in the middle of the river afloat in the darkness. Silently we sat there, our rifles and our spades across our knees . . . In half an hour we were out on the opposite bank and creeping through the thicket, a spade in one hand and a rifle in the other . . . we formed in line of battle and commenced digging holes for ourselves. We worked like beavers, turn about: no spade was idle for one moment. Daylight found us there, two thousand strong, with rifle pits a mile in length. Other brigades got over the river, pontoons soon were down . . . What a sight for General Bragg when he woke up that morning at his headquarters perch on top of Missionary Ridge!'

By 1300 hours Sherman's forces are across the new pontoon bridge and moving to attack the north end of Missionary Ridge. Meanwhile, Hooker is initiating his 'demonstration' on Lookout Mountain, which is in fact only lightly occupied by Confederates. A dense fog enshrouds the slopes, and Hooker's advance is not discovered until his troops are a few yards away from the enemy. Federals steadily push the few defenders back up the rough and cloud-covered slopes; by noon a Confederate stand at Craven's Farm has been broken, and Hooker's troops entrench just below the summit. The remaining Confederates withdraw during the night. Hooker's advance, considerably exaggerated as to difficulty, is known to history as 'The Battle Above the Clouds,' on account of the heavy fog that obscures the fighting. On the left wing, Sherman has by 1600 hours encountered only enemy outposts as he seizes what his map tells him is the northern end of Missionary Ridge; he is surprised to discover that he has only occupied an outlying hill – a large and exposed ravine separates him from Missionary Ridge proper. Both he and the Confederates opposite on the ridge begin to strengthen their positions. By the end of the day Union forces are victorious all down the line of battle.

25 November 1863

Western Theater, Battle of Chattanooga
Before sunrise, Hooker sends detachments up the slopes of Lookout Mountain, from which the last defenders have withdrawn during the night; dawn reveals to the Union army below the Stars and Stripes flying at the summit, and soldiers cheer amid their preparations for battle. From his command post on Orchard Knob, Grant orders his wings to advance, Sherman in the north and Hooker in the south, and holds his main attack on the center until the flanks have gained some ground and diverted enemy forces. However, both these attacks soon bog down. Sherman is repulsed on the left as Bragg moves troops and cannon from the Confederate center to resist the attack.

The fighting between Sherman's and Bragg's forces sways back and forth until midafternoon, with Grant moving reinforcements from his center and Bragg moving troops and cannon from his center to resist the attack. Fearing that his main attack on the center is being fatally delayed, around 1500 Grant signals Thomas's men to begin the assault on the heavily entrenched enemy center at the top of Missionary Ridge. Certain there will be fierce resistance, Grant has ordered his troops to stop halfway up the slope and reorganize. In his memoirs, Grant will describe the attack: 'In an incredibly short time Generals Sheridan and Wood were driving the enemy before them toward Missionary Ridge . . . Our men drove the troops in front of the lower line of rifle pits so rapidly, and followed them so closely, that Rebel and Union troops went over the first line of works almost at the same time . . . The retreating hordes being between friends and pursuers caused the enemy to fire high to avoid killing their own men. In fact, on that occasion the Union soldier nearest the enemy was in the safest position.' This situation results in what seems to observers at the time to be an incomprehensible breach of orders. Rather than stopping to reorganize as ordered, Federal soldiers continue their charge up the ridge without pause; to do otherwise will leave them open to a murderous fire from the crest. Not understanding this, a furious Grant turns and asks Thomas, 'Who ordered those men up the hill?' Thomas speculates that they must have ordered themselves. Grant replies, 'Someone will suffer for it, if it turns out badly.' But the attack, one of the most spectacular of its kind in history, an advance up a heavily-occupied slope into the teeth of the enemy guns, turns out brilliantly for the Union. Shouting 'Chickamauga' as they charge, Federal soldiers overrun line after line of defenses until the rebels on the crest are desperately hurling rocks at the onrushing enemy.

The crest is, therefore, broached and the Confederates are in panic-stricken rout toward Chickamauga. Thousands are captured; Bragg himself barely escapes. Union troops gather at the top, cheering wildly as General Sheridan appears on his horse. 'What do you think at this, General?' someone shouts. 'I think you disobeyed orders, you damned rascals,' Sheridan replies happily. Meanwhile, Hooker is rolling up the Confederate positions to the south; Sherman is still meeting resistance in the north, but those Confederate defenders retreat that night toward where the defeated Army of Tennessee is gathering in Ringgold, Georgia. Grant later writes, 'The victory at Chattanooga was won more easily than expected by reason of Bragg's grave mistakes: first, in sending away Longstreet, his ablest corps commander, [in fact, this was President Davis's order, though perhaps requested by Bragg] . . .; second, in placing so much of his force on the plain in front of his impregnable positions.' Casualties are comparatively low for such a major battle. Union forces lose 5824 from all causes, 10 percent of their 56,359 effectives; the South loses 6667 of 64,165, about the same proportion. While the Confederacy has been bested in yet another major battle, their forces have not been vitally damaged.

26 November 1863

Eastern Theater Skirmishing breaks out around the Rapidan in Virginia as Federal forces begin an offensive against the greatly outnumbered Lee. Meade hopes now to turn the Confederate right flank and force the army back to Richmond.

Western Theater, Chattanooga Campaign
Bragg's retreating Army of Tennessee moves toward Ringgold, Georgia, with Federal troops under Thomas and Sherman in pursuit. Several clashes break out before the Union forces halt.

Knoxville Campaign Outside Knoxville, Confederate General Longstreet prepares his assault on Fort Sanders.

27 November 1863

Eastern Theater Parrying Meade's new initiative, Lee strengthens his right flank, as fighting breaks out near the Rapidan. At Mine Run, Meade finds Lee's forces strongly posted, and his offensive falters; it will not regain momentum in the following days. At Ohio State Penitentiary in Columbus, Confederate raider John Hunt Morgan and some of his officers escape and head south; the future career of Morgan, however, will be of less usefulness to the Confederacy.

29 November 1863

Western Theater, Knoxville Campaign
Longstreet finally launches his attack on Federal positions at Fort Sanders (called Fort Loudon by the Confederates), seeking to dislodge Burnside's army from nearby Knox-

Below: Union troops under the command of Thomas begin their assault on Southern positions along Missionary Ridge at Chattanooga.

ville. Rather than beginning with an artillery bombardment, which might have opened a breach in the steep sides of the parapet, Longstreet ill-advisedly commences with an infantry attack. The advance, made in bitter cold, is ineffective; the men are slowed by Union wire entanglements and then bog down in a ditch, lacking the scaling ladders needed to move onto the parapet. Unable to advance or retreat, Longstreet ends the attack, whereupon Federals capture 200 men in the ditch. It is a half-hearted and bungled operation, and the South's last chance to end the Union occupation of Knoxville. Chattanooga has fallen, and Union reinforcements are on the way.

30 November 1863

The Confederacy President Davis accepts the resignation of Braxton Bragg, the defeated commander of the Army of Tennessee. The month ends with a further sinking of Confederate hopes in the wake of a series of crucial defeats. The Confederate victory of Chickamauga is now made worthless; of the Chattanooga campaign only recriminations remain.

1 December 1863

Eastern Theater After the failure of their advance at Mine Run, Meade and the Army of the Potomac withdraw across the Rapidan and set up winter quarters.

2 December 1863

Western Theater Lieutenant General W H Hardee temporarily assumes command of the Army of Tennessee following Braxton Bragg's resignation. Bragg asks his army to support the new commander and suggests Davis consider a new offensive.

3 December 1863

Western Theater, Knoxville Campaign In the face of advancing Union reinforcements, Longstreet abandons his siege of Knoxville and moves his troops toward winter quarters at Greeneville, Tennessee. Thus ends the Knoxville campaign, a major Federal victory largely by default. Burnside, by failing now to pursue Longstreet, obliges Grant to keep a large force in Tennessee until spring.

6 December 1863

Naval In Charleston Harbor, South Carolina, a strong tide breaks over the Union blockade ironclad *Weehawken* and pours into an open hatch; the ship promptly sinks with two dozen of the crew.

7 December 1863

The Confederacy On the same day as the convening of the Union 38th Congress, the fourth session of the Confederate First Congress meets in Richmond. President Davis addresses the body, putting the most hopeful face he can on a discouraging year.

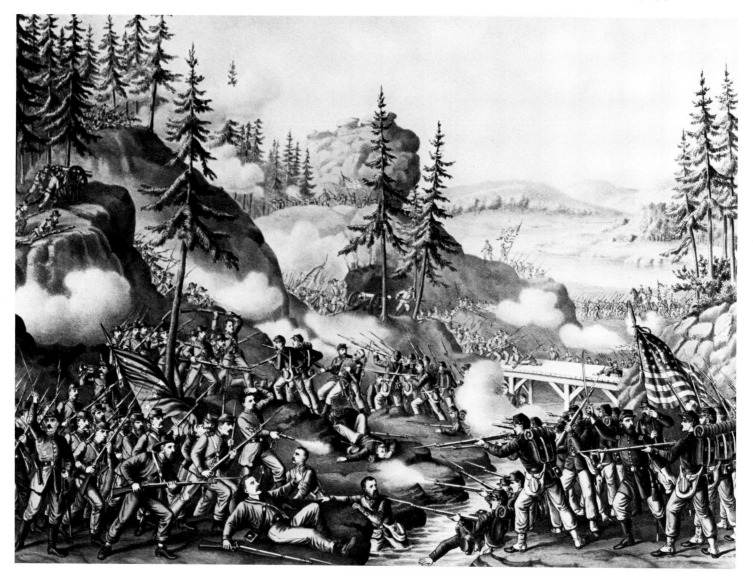

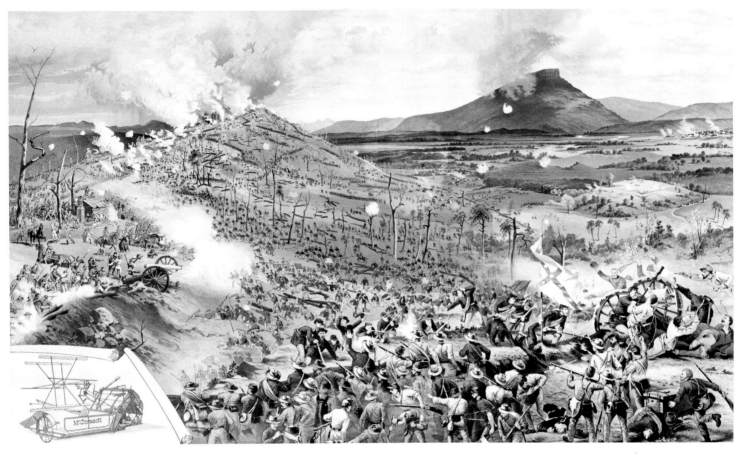

8 December 1863

Washington At the end of his annual message to Congress, President Lincoln makes his first major statement of reconstruction in a Proclamation of Amnesty and Reconstruction: a full pardon will be given to all Confederates, excepting government officials, high-ranking army officers, those who resigned the US military for the Confederacy, and those who have mistreated white or black prisoners of war (such as by enslaving the latter). All property except slaves will be restored to rebels. Pardons will be conditional on an oath of allegiance to the United

Below: General Meade, commander of the Army of the Potomac in many operations against Lee.

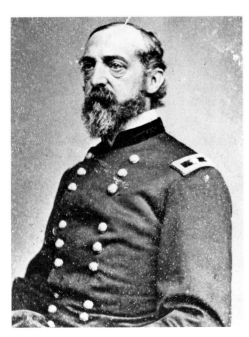

States. Federal statehood will be recognized in any seceded state if one-tenth of the citizens swear allegiance and forswear slavery. The president's statement is received with widespread approval in the North.
Naval A Northern Copperhead band seizes the Union merchant ship *Chesapeake* near Cape Cod; the vessel is pursued by Federal ships and retaken off the coast of Canada near Nova Scotia on 17 December.

9 December 1863

Western Theater At his own request, General Burnside is relieved as Federal commander at Knoxville and is succeeded by Major General J G Foster. Burnside has been much criticized for failing to help Rosecrans at Chattanooga and for not pursuing the retreat of Longstreet. It will be said of Burnside that it is to his discredit that he is a poor commander and to his credit that he knows it. Meanwhile on this day, Longstreet, covering his political flank, dismisses several of his staff pending his charges against them (later dismissed) for alleged failures in the Knoxville campaign.

11 December 1863

Western Theater In a day of comparatively light Federal bombardment of Fort Sumter, a chance shell blows up a powder magazine within the stronghold; 11 are killed and 41 wounded, but the defenders still do not give in to Northern pressure.

14 December 1863

Washington The widow of Confederate general B H Helm, who was killed in action at Chickamauga, is given amnesty by President Lincoln after she swears allegiance to the Union. Mrs Helm is the half-sister of Lincoln's wife, Mary Todd Lincoln.

Above: A panoramic view of the fighting along Missionary Ridge during the Battle of Chattanooga, a major Union victory.

16 December 1863

The Confederacy In spite of past differences between them regarding promotion, President Davis names General J E Johnston, formerly in Mississippi, as permanent successor to Bragg as commander of the Department of Tennessee. Bragg's former subordinate, General Leonidas Polk, is given charge of the Army of Mississippi.

25 December 1863

Winter Quarters Although minor hostilities continue in various theaters, all the military celebrate Christmas as best they can.
Western Theater In one of a continuing series of raids on Confederate saltworks, Federal troops destroy a factory at Bear Inlet, North Carolina. Skirmishes break out at Fort Brooke, Florida.
Trans-Mississippi Near Fort Gaston, California, Federal troops engage in skirmishes with Indians.
Naval Federal vessels see action at John's Island and Stone River, South Carolina, with the USS *Marblehead* being badly damaged by Confederate shore batteries.

31 December 1863

The Confederacy After a year of setbacks for the Confederate cause, the Richmond (Virginia) *Examiner* observes, 'Today closes the gloomiest year of our struggle.' Few in the South would disagree. The superior manpower and material resources of the North have begun to tell, and the Union army is soon to prepare for the first time a unified strategy for the final conquest of the ailing Confederacy.

1 January 1864

Winter Quarters Temperatures plunge below zero from the North well into the South and make for miserable conditions among the soldiers and sailors, but some minor actions are ordered on various fronts.

4 January 1864

The Confederacy In one of a series of increasingly stern orders that create new hardships for the citizens of the South, President Davis authorizes General Lee to commandeer food supplies in Virginia. The Confederate troops and animals in winter quarters are indeed seriously underfed, but the civilian population of the South has also suffered considerable deprivation. Such orders do not improve Davis' popularity.

6 January 1864

Western Theater In another Confederate guerrilla action against Federal shipping on the Mississippi River, the steamer *Delta* is attacked.
Trans-Mississippi Federal Colonel 'Kit' Carson continues his operations against the Navajo in New Mexico Territory, trapping a number of Indians in the Canyon de Chelly. In an infamous action, these Navajo will be forced on the 300-mile 'Long Walk' to Fort Sumner, New Mexico.

7 January 1864

Washington Desertion continues to be a serious problem in the North as well as in the South. Nonetheless, President Lincoln commutes the death sentence of an army deserter, commenting, 'I am trying to evade the butchering business lately.' He will commute a considerable number of such sentences.

8 January 1864

The Confederacy Confederate raider John Hunt Morgan, back from his escape from prison in Ohio, is feted by his government in Richmond.

Below: Members of the North's military railroads construction corps are photographed near the town of Chattanooga.

13 January 1864

Washington Pursuant to his Proclamation of Amnesty and Reconstruction of 8 December, President Lincoln urges Federal officials in Florida and Louisiana to form Union governments 'with all possible dispatch.'

14 January 1864

The Confederacy President Davis writes to General Johnston, now commander of the Department of Tennessee, observing that troops may need to be sent to Alabama or Mississippi. Davis is beginning to consider strategy for the coming year's struggle.

18 January 1864

The Confederacy All white males between 18 and 45 (shortly to be changed to 17 and 50) have been conscripted for service in the Southern army. Today there are protest meetings in North Carolina as opposition grows to the conscription law.

21 January 1864

Western Theater In another response to Lincoln's Proclamation of Amnesty and Reconstruction, pro-Union leaders in Tennessee plan a constitutional convention to set up a government and abolish slavery.

23 January 1864

Washington Lincoln gives his approval to a plan for dealing with freed slaves in which they will be hired for pay to work for their former masters.

25 January 1864

Western Theater Shelling continues on Confederate Fort Sumter in Charleston Harbor, South Carolina, the bombardment having been nearly continuous since 12 August 1863.

27 January 1864

The Confederacy Braxton Bragg is called to Richmond to confer with President Davis, if 'health permits.' Bragg suffers from serious headaches and has been accused of leading battles when both he and his troops would be better off if he were home in bed.

31 January 1864

Washington Implying that he will loosen the requirements stated in his Proclamation of Amnesty and Reconstruction, Lincoln writes to General Banks in New Orleans that Banks is 'at liberty to adopt any rule which shall admit to vote any unquestionably loyal free state men and none others. And yet I do wish they would all take the oath.'

1 February 1864

Washington The turmoil that followed the Enrollment Act of the previous year has to some extent subsided, so there is little resistance when President Lincoln calls for 500,000 additional draftees for the Union Army. A plan to colonize Île à Vache in San Domingo with American blacks is aborted, Lincoln sending a ship to bring back colonists wanting to return. Congress paves the way for Grant's promotion to general in chief of United States Army by reviving the rank of lieutenant general; this action has been ferried through a somewhat reluctant Congress by Grant's patron, Elihu Washburne, who will also assure Lincon that Grant has no presidential ambitions.
Western Theater Hostilities break out along Batchelder's Creek, the beginning of Confederate General Pickett's attempt to recapture New Berne, North Carolina. The attack is called off when Federals draw back to the inner defenses.

2 February 1864

Western Theater A group of Confederate soldiers under Pickett board the US gunboat *Underwriter* in the Neuse River near New Berne, North Carolina. The rebels kill the commander and three of the crew, capturing the remainder. Finding the boilers cold, they set fire to the vessel and, after some skirmishing, abandon the operation on the following day. This marks the end of Confederate efforts to recapture New Berne.

3 February 1864

The Confederacy Declining Southern fortunes in the war inspire increasingly severe actions from the government in Richmond.

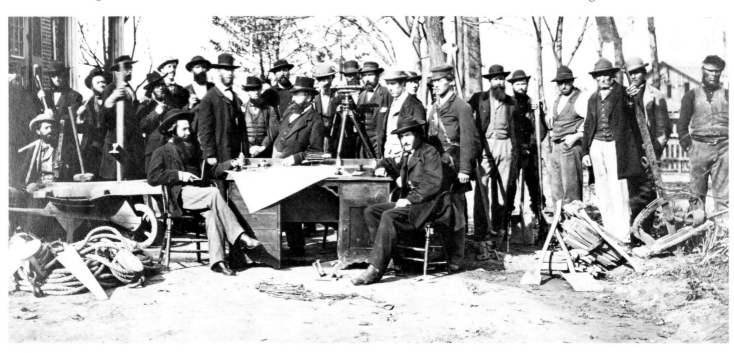

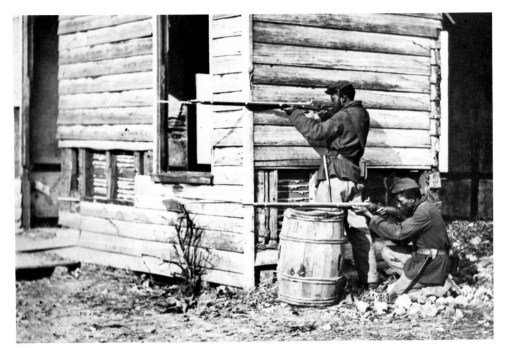

Eastern Theater Federal forces under Meade meet unexpected Confederate resistance on a foray across the Rapidan River in Virginia; held down all day by enemy fire, they retreat during the night.

Western Theater, Meridian Campaign Sherman's forces move out of Jackson, Mississippi, toward Meridian.

7 February 1864

Western Theater, Meridian Campaign General Polk continues his withdrawal before Sherman's advance toward Meridian; skirmishes break out at Brandon, Morton and Satartia, Mississippi. Elsewhere, Union troops take over Jacksonville, Florida, with little resistance from Confederates; over the next few days a Federal expedition will move out from Jacksonville to destroy Southern supply bases.

9 February 1864

Washington President Lincoln sits for several photographs (one of which is later to be used for the US five-dollar bill).

Above: A study of two black sharpshooters taken in the vicinity of Dutch Gap, Virginia.
Right: General Grant captured for posterity. By early 1864 he was poised to take charge of all Union forces in the war.

This day President Davis recommends suspension of writs of habeas corpus for those guilty of dissent of various kinds, spying, desertion and associating with the enemy.

Western Theater, Meridian Campaign After Vicksburg fell, Lincoln turned his attention to Louisiana and Arkansas. In order to drive the rebels entirely out of those states, a campaign is planned on the Red River; but this cannot be implemented until the rising of the river in March. General Sherman is orderd to commence preparations for this campaign. In the meantime, he decides to strengthen the Union position in Vicksburg by destroying the two primary railroads of central Mississippi. He leaves Vicksburg this day with 25,000 men. In conjunction with Sherman's move, a mounted column of 7000 is to leave Memphis, Tennessee, under General W Sooy Smith and attempt to drive Confederate cavalry from northern Mississippi, after which they will sweep down the rail line toward Meridian, Mississippi, and join Sherman around 10 February. The commander of Confederate forces in the area is General Leonidas Polk, formerly under Bragg in Tennessee, with about 20,000 widely scattered forces including cavalry under Nathan Bedford Forrest.

5 February 1864

Western Theater, Meridian Campaign Moving steadily toward Meridian, Mississippi, Sherman's men march into Jackson; minor skirmishes occur along the route.

6 February 1864

The Confederacy The fourth session of the First Confederate Congress continues its work, banning imports of luxuries and circulation of US currency; it also decrees that half of various food and tobacco shipments must be given to the government before ships may leave port.

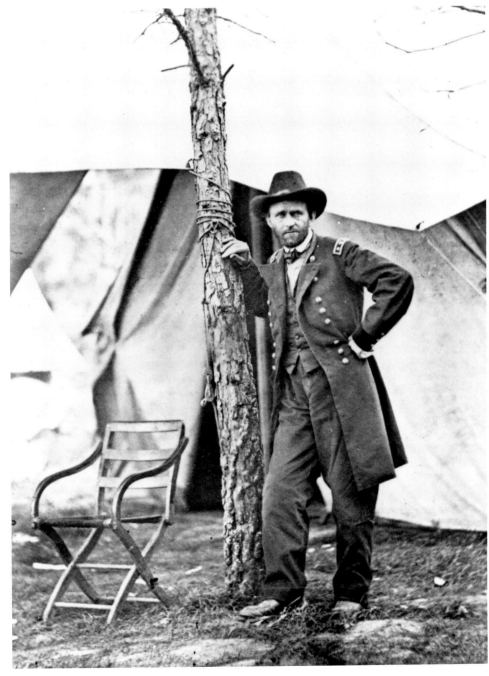

Above: Union troops survey the wreckage of a derailed train, a victim of an attack by Southern irregulars.

Western Theater In the largest and most dramatic escape of the war, Union prisoners dig their way out of Libby Prison in Richmond, Virginia. Formerly the candle warehouse of Libby and Sons, the large building has been used as a prison for captured Federal officers. While conditions in the camps of both sides are largely poor and growing worse throughout the war, those in Libby Prison are to be exceeded in infamy only by Andersonville. Of the 109 Union officers who escape this day, 48 are recaptured (including their leader, Colonel Thomas E Rose), two drown, and 59 reach Federal lines.

11 February 1864

Western Theater One day after he was originally ordered to have completed his advance in support of Sherman, General

Below: General Meade (fourth from right) and other senior Union commanders meet at Brandy Station, 18 February 1864.

Sooy Smith begins his advance, moving out of Collierville near Memphis, Tennessee. Heavy rains in the swampy countryside have delayed his preparations, and his progress is slow. He will encounter little enemy resistance until he reaches West Point on 20 February. In West Virginia another of the increasingly common incidents of Confederate guerrilla action is seen. Irregulars under Major H W Gilmore throw a train off its tracks, then proceed to rob the civilian crew and passengers.

12 February 1864

Western Theater, Meridian Campaign Now two Federal forces are closing in on Meridian, Mississippi, Sherman's from the west and Sooy Smith's from the north. Engagements break out at Decatur and Chunky Station along Sherman's route.

14 February 1864

Western Theater, Meridian Campaign With little opposition from General Polk, Sherman's army marches into Meridian, Mississippi. Sherman, in a preview of his tactics in Georgia, does considerably more than his

announced plan of dismantling railroad lines. In his own words: 'For five days, 10,000 men worked hard and with a will in that work of destruction . . . Meridian, with its depots, storehouses, arsenals, hospitals, offices, hotels and cantonments no longer exists.' He will spend several days engaged in this rampage (which of course included the railroads) while waiting for the arrival of Sooy Smith, who by now is much overdue. Meanwhile in Florida, a part of Gillmore's army occupies Gainesville.

15 February 1864

The Confederacy President Jefferson Davis becomes increasingly concerned that Sherman will continue from Meridian to Montgomery, Alabama.

16 February 1864

Western Theater, Meridian Campaign Minor fighting occurs between Sherman's and Polk's men at Lauderdale Springs, near Meridian. President Davis' apprehensions about a Federal move on Mobile, Alabama, are increased by Union forays around that city.
Trans-Mississippi A Union campaign against Indians is begun from Fort Walla Walla in Washington Federal Territory.
Naval Federal actions against blockade-runners continue as the Confederate ships *Pet* and *Spunky* are taken near Wilmington, North Carolina.

17 February 1864

The Confederacy The privilege of the writ of habeas corpus is suspended by the Confederate Congress, though this applies only to arrests made by authority of the president or the secretary of war. The Congress also extends the limits of conscription to men between 17 and 50, prompting Vice-President Stephens to write: 'Far better that our country should be overrun by the enemy, our cities sacked and burned, and our land laid desolate, than that the people should suffer the citadel of their liberties to be entered and taken by professed friends.' In short, the vice-president is accusing the president of betraying the most precious ideals of the nation. The hostility between these two men

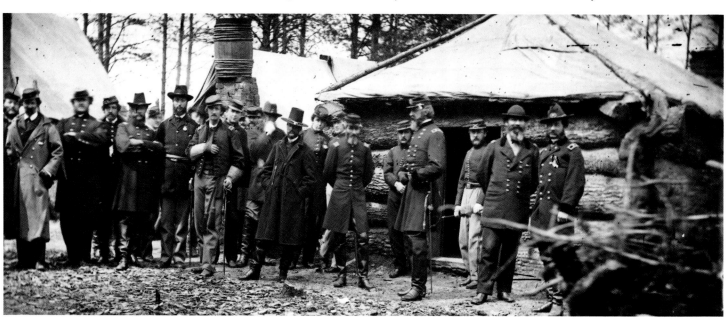

Above: A favored method of destroying crossties: once weakened by heat, they would bend under their own weight.

is an increasing handicap to the Confederacy. Within the whole South a desperate demand for peace is also simmering.

Western Theater A watchman on the sloop USS *Housatonic*, one of the largest blockade ships in Charleston harbor, sees 'something in the water' making its way toward the ship. The 'something' is the Confederate semi-submersible ship *H L Hunley*, which is armed with a spar torpedo. On impact the torpedo blows a hole in the *Housatonic*, and both vessels sink, the sloop losing five men and the submarine seven. The tiny *H L Hunley* is long, slim and cigar-shaped, and is hand-propelled by its crew, who lie down along its length; by the time of this, its final sinking, it has, during tests and its single action, drowned at least 33 sailors. Although this event sends trepidation through the Union blockading fleet, effective submarine warfare is still many years in the future.

18 February 1864

Western Theater, Meridian Campaign In Meridian, Mississippi, Sherman's soldiers continue dismantling the railroads and the town while waiting for their originally intended cooperation group, the cavalry under Sooy Smith, who have just reached the prairie region of eastern Mississippi and are engaged in minor skirmishes around Okolona.

20 February 1864

Western Theater, Meridian Campaign Giving up his wait for the arrival of Sooy Smith, Sherman begins a slow withdrawal from Meridian back to Vicksburg, Mississippi. His campaign has lost him only 21 killed, 68 wounded, and 81 missing. After he leaves, the Confederates begin repairing the railroad lines he has destroyed.

Florida, Battle of Olustee In January, President Lincoln has written to Major General Gillmore urging him to bring Florida under Union control and for a state government in time to be represented in the coming Republican presidential convention. After a series of forays from Jacksonville, the Federals have concentrated some 5500 troops near Olustee, or Ocean Pond, while the Confederates have 5200 infantry and cavalry near Lake City. In the morning of this day a Union cavalry brigade opens the battle at Olustee with a successful advance against Confederate outposts; but then two Federal regiments, after heavy fighting and serious casualties, break and flee in confusion. Other regiments replace the two that have run, holding ground with heavy losses until the rebels have nearly exhausted their ammunition. After dark, Union troops withdraw. Losses are high, particularly to Union black soldiers: a total of 1861 killed, wounded, captured and missing for the Union to the Confederate grand total of 934 casualties.

21 February 1864

Western Theater, Meridian Campaign Sooy Smith's cavalry runs into the Confederate troops of Nathan Bedford Forrest at West Point, Mississippi; thinking the enemy is stronger than it actually is, Smith precipitously orders a retreat after only light skirmishing. His men withdraw reluctantly.

22 February 1864

Washington President Lincoln has increasingly run foul of the extreme anti-slavery wing of his party, who are known as the Radical Republicans. Radical Horace Greeley, for example, will call for a new Republican presidential candidate. Secretary of the Treasury Chase has had a series of wrangles with Lincoln and has regularly offered to resign. On this day Chase is seriously compromised by what comes to be called the 'Pomeroy Circular' (named after the Kansas senator who initiated the paper), a Radical paper proposing Chase for president. The secretary admits to Lincoln that he knows of the proposal but denies having seen the circular. Later evidence suggests that he did know of it.

Western Theater, Meridian Campaign Overtaken by Forrest's pursuing cavalry near Okolona, Mississippi, Sooy Smith's retreating Federals attempt a stand against the enemy, but the 7th Indiana, seemingly about to be overwhelmed by a superior force, breaks precipitously and runs, leaving behind five guns of its battery without firing a shot. A series of delaying actions over a nine-mile line covers the Union retreat until 1700 hours, when a stand is mounted against Forrest's charging cavalry. The Union 4th Mississippi Cavalry mounts a charge against For-

Below: Lieutenant-Colonel Orson H Hart strikes an heroic pose for noted photographer Mathew Brady at Brandy Station, 1864.

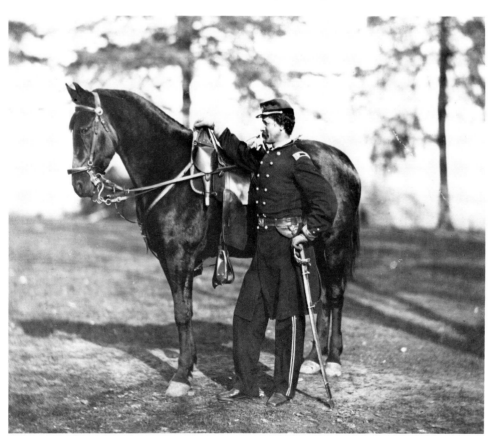

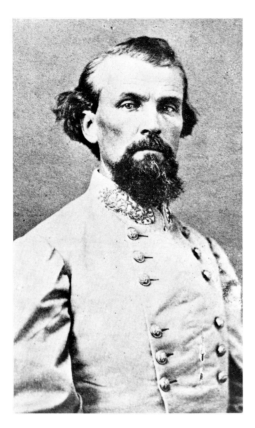

Above: Nathan Bedford Forrest, recognized as the most outstanding commander of guerrilla forces in the civil war.

rest which succeeds in checking his advance, but not significantly turning it back. The Union forces then withdraw in great disorder to Memphis.

Meanwhile in Tennessee, Thomas' Army of the Cumberland begins a reconnaissance of Johnston's Army of Tennessee in their winter quarters in Dalton, Georgia. In what will be called the Federal Demonstration on Dalton, Thomas is trying to find out if Johnston has weakened his army by reinforcing Polk and Longstreet.

23 February 1864

Washington As Lincoln ponders his response to the Pomeroy Circular, the cabinet meets without Chase.

24 February 1864

Washington Congress approves revival of the rank of lieutenant general, thus paving the way for U S Grant to become general in chief of the Union army. Among several other measures voted by Congress concerning enlistment and the draft, Lincoln approves a plan to free slaves who enlist, while paying their masters compensation.
The Confederacy In another unpopular move, President Davis appoints General Braxton Bragg to be in charge of 'the conduct of military operations in the army of the Confederacy'; in effect, Bragg is now chief of staff. Longstreet has accused Davis of approving failure and disparaging success; this accusation seems not exaggerated given Davis' continuing support of the inept Bragg and his disparagement of General Joe Johnston and other effective officers.
Western Theater The Demonstration on Dalton continues as Federals drive the enemy from outposts at Tunnel Hill, Georgia.

25 February 1864

Western Theater Thomas' forces near Dalton gather and attempt to force a way through Buzzard Roost Gap. Federals under Palmer try for an envelopment in the morning but are held off by a strong Confederate force. Union attempts are later made on the enemy right and center, but both fail and the latter incurs heavy casualties. It finally having become clear that Johnston's forces are by no means weakened, the Federals retreat and the reconnaissance is terminated. Union troops have lost 345 casualties to around 167 for the South.

26 February 1864

Western Theater In the wake of the Meridian campaign, Sooy Smith's routed cavalry straggle back into Memphis while Sherman's men skirmish around the settlement of Canton, Mississippi.

27 February 1964

The Confederacy At Andersonville, Georgia (near Americus), Federal enlisted men captured by the South begin to arrive at an unfinished prison compound called Camp Sumter. Built hastily when the numbers of Union war prisoners became unmanageable in Richmond, the prison consists of a 16½-acre log stockade, later enlarged, divided by a stream. Over the next year conditions in the prison will deteriorate until disease and death resulting from poor sanitation, crowding, exposure and inadequate diet become outrageous.
Western Theater The Federal Demonstration on Dalton, Georgia, finishes with a skirmish near Catoosa Station.

28 February 1864

Eastern Theater After reports of miserable conditions in war prisons in Richmond and light Confederate forces in the city, President Lincoln and Secretary of War Stanton have authorized a raid that will attempt to seize the Confederate capital by a surprise attack, free the prisoners and distribute amnesty proclamations. Pursuant to this plan, 3500 mounted raiders under General Judson Kil-

patrick drive off enemy outposts and cross the Rapidan at Ely's Ford this night. With Kilpatrick is one-legged (from a wound at Gettysburg) Colonel Ulric Dahlgren, a son of the Union navy commander Admiral Dahlgren. Kilpatrick, who has originated the plan for the raid, is a controversial leader; one report states that his 'notorious immoralities set so demoralizing an example to his troops that . . . his surbordinates could only mitigate its influence.' At the same time, Kilpatrick is noted for 'a dare-devil recklessness that dismayed his opponents and imparted his own daring to his men.'

29 February 1864

Eastern Theater The Kilpatrick-Dahlgren raid takes shape as the two leaders separate at Spotsylvania, Kilpatrick moving with the main body toward Richmond and Dahlgren heading for Goochland with 500 men. During the night the Confederate War Department in Richmond learns of the raid and orders emergency measures.
Trans-Mississippi In preparation for the impending Red River campaign, Union vessels begin to scout the Black and Ouachita Rivers in Louisiana.

1 March 1864

Washington Lincoln nominates U S Grant for lieutenant general, the rank recently revived for Grant by Congress.
Eastern Theater Federal raiders Kilpatrick and Dahlgren close in on Richmond. The Confederate capital is in fact lightly defended by regular forces but, word having arrived of the raiders' approach, a collection of Southern civilians, wounded soldiers and veterans gather to defend the city. Approaching Richmond, Kilpatrick runs into these defenders and takes them to be a major force of the enemy; he has no idea of the whereabouts of Dahlgren, who is supposed to have joined him. After light skirmishing, Kilpatrick decides the Confederate forces are too much

Below: Poor conditions at Andersonville led to the death of many Union prisoners. The camp opened on 27 February 1864.

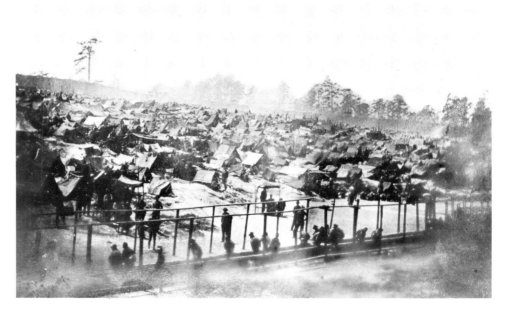

for him and withdraws across the Chickaho-miny River to await Dahlgren. Dahlgren, meanwhile, has had problems as well. In the morning he splits his force of 500 men, send-ing one group under Captain Mitchell down the north bank of the James River to destroy property and enter Richmond. Dahlgren, leading the other body of men, asks the assistance of a black youth to show him a place to ford the river. Deliberately or not, however, the youth leads Dahlgren to an un-fordable stretch of the James, delaying the raiders' advance considerably. Outraged and suspecting treachery, Dahlgren summarily hangs the youth before proceeding down the north bank of the James to join his other force at Short Pump, eight miles from Richmond. The party then advances, meeting increas-ingly stiff resistance, until by nightfall they are within two and one-half miles of the Con-federate capital. Despairing of continuing his advance after nightfall, Dahlgren at this point gives up the attempt on Richmond and orders a retreat.

2 March 1864

Washington The Senate confirms Grant's nomination as lieutenant general. Along with being the highest ranking officer, Grant will assume the title of general in chief of the United States Army.
Eastern Theater The forces of the failed Kil-patrick-Dahlgren raid continue their retreat,

Kilpatrick's rearguard still being harassed as he moves away and Dahlgren's men split into two groups, both seeking to join with Kil-patrick. Late in the evening, Captain Mitchell and his men will rejoin Kilpatrick. All day, Confederate cavalry under Lieutenant J Pol-lard pursue Dahlgren and his group, who are moving north. Late in the day the Confeder-ates circle ahead of Dahlgren and join Cap-tain E C Fox at Mantapike Hill, near King and Queen Court House, where they set up an ambush. Around 2300 hours Dahlgren and his men ride unsuspectingly into the trap. In short order Dahlgren is killed and 92 of his soldiers captured.

Then something is discovered that is soon to make Dahlgren's name notorious. A 13-year-old boy named William Littlepage finds two documents on the Union commander's body. One, signed by Dahlgren and ap-parently written as an address to his raiders, reads: 'We hope to relieve the prisoners from Belle Isle first, and having seen them fairly started, we will cross the James River into Richmond, destroying the bridges after us, and exhorting the released prisoners to des-troy and burn the hateful city; and do not allow the rebel leader, Davis, and his traito-rous crew to escape.' The second document, unsigned reads, 'once in the city it must be destroyed, and Jeff Davis and cabinet killed.' Lieutenant Pollard will forward these two documents to Robert E Lee, who will send

photographic copies of them to Federal General Meade with an inquiry as to their ori-gin. A subsequent Federal investigation into the matter leads nowhere, and Meade eventually replies to Lee: 'Neither the United States Government, myself, nor General Kil-patrick authorized, sanctioned or approved the burning of the city of Richmond and the killing of Mr Davis and his cabinet, nor any other act not required by military necessity and in accordance with the usages of war.' Whether Meade's declaration is a fact or a cover-up will never quite be decided, but the affair does damage to the honor of the Union.

4 March 1864

Washington Andrew Johnson is confirmed by the Senate as Federal military governor of Tennessee.
Eastern Theater Kilpatrick and his men raid around the area where Colonel Dahlgren was killed before they return to Meade's army. The Kilpatrick-Dahlgren raid has cost the Federals 340 men and 583 horses, as well as a large number of weapons including Spencer repeating rifles, a gun that has become in-creasingly important to the Northern army. The Confederates find they cannot use the

Below: The Battle of Olustee, Florida, saw a succession of Union attacks bloodily repulsed by Southern troops who held the field despite their shortage of ammunition.

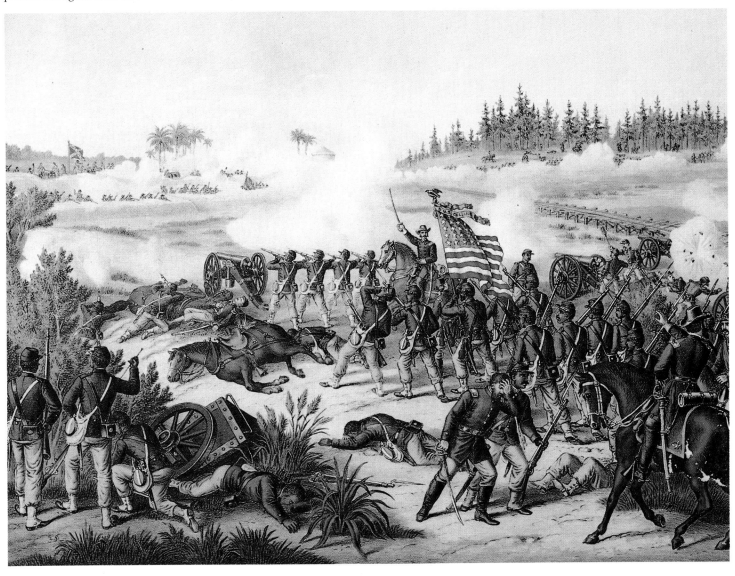

captured repeaters, however, because they lack the proper cartridges.

Western Theater Most of Federal General Sherman's men return to Vicksburg following their advance to Meridian, Mississippi. Fighting breaks out at Rodney, Mississippi.

5 March 1864

The Confederacy Attempting to reduce excessive profiteering from its blockade-runners as well as to improve its desparately low supplies, the government in Richmond issues orders requiring all vessels to give half their cargo space to government shipments.

8 March 1864

Washington At a White House reception, President Lincoln steps uncertainly up to a short, disheveled-looking military man and inquires, 'This is General Grant, is it?' 'Yes,' Grant replies. The soon-to-be lieutenant general has met his commander in chief for the first time. After a few pleasantries with Lincoln, Grant joins Secretary Seward in the East Room, where the general is obliged to stand on a sofa to shake hands with the cheering crowd. Following the reception, Lincoln, Grant and Secretary of War Stanton confer in the Blue Room, and the president makes some suggestions about Grant's remarks to be made on the morrow: 'Tomorrow, at such time as you may arrange with the Secretary of War, I desire to make you a formal presentation of your commission, as lieutenant general. I shall then make a very short speech, to which I desire you to reply . . . There are two points that I would like to have you make in your answer: first, to say something which shall prevent or obviate any jealousy of you from any of the other generals in the service, and secondly, something which shall put you on as good terms as possible with the Army of the Potomac.'

Below: Troopers of the 3rd Pennsylvania Cavalry Regiment pose with their sabers drawn at their camp near Brandy Station, Virginia.

9 March 1864

Washington In an early-afternnon ceremony attended by the cabinet, U S Grant is officially given his commission as lieutenant general, thus becoming commander of all the Union armies. In some embarrassment, Grant stumbles through a hastily-written speech which makes neither of the points Lincoln has asked him to. Soon afterward Grant and the president have their first private talk, which Grant recounts in his memoirs: 'He stated to me that he had never professed to be a military man or to know how campaigns should be conducted, and never wanted to interfere in them; but that procrastination on the part of commanders, and the pressure from the people in the North and from Congress, *which was always with him*, forced him into issuing his series of Military Orders . . . He did not know that they were not all wrong, and did know that some of them were. All he wanted, or had ever wanted, was some one who would take the responsibility and act, and call on him for all the assistance needed.' It is clear that Lincoln believes he has at last found a commander in whom he can have complete faith. He goes so far as to say to Grant he does not want to know what the general plans to do. After his interview with the president Grant immediately leaves Washington for Brandy Station, Virginia, headquarters of the Army of the Potomac.

10 March 1864

Eastern Theater Grant confers with General Meade, commander of the Army of the Potomac, at Brandy Station. This is the beginning of what will become a close and fruitful association.

Trans-Mississippi, Red River Campaign In the first move of the Federal Red River campaign, General A J Smith's command leaves Vicksburg heading down the Mississippi River toward the Red River which runs through northwestern Louisiana. Smith's troops are escorted by a formidable force in-

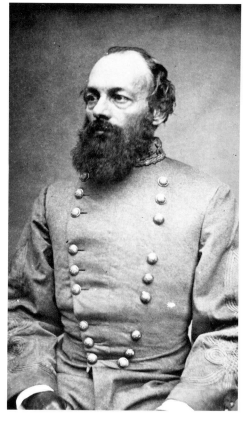

Above: The South's General Edmund Kirby Smith had some 30,000 men to oppose the North's forces on the Red River.

cluding 13 ironclads and seven gunboats. This expedition has been planned for some months, and the intention is to establish Union control in Louisiana and eastern Texas. The plans have been largely promoted and drawn by General in Chief Halleck (soon to be demoted), over the objections of Generals Grant, Sherman and Banks, who feel operations against the enemy in Mobile, Alabama, should be given priority. Nonetheless, Banks, as commander of the Depart-

ment of the Gulf, is ordered to coordinate the expedition: he is to take 17,000 troops to link up with 10,000 of Sherman's men and 15,000 of Steele's in Alexandria, Louisiana, or thereabouts. (Steele, commander of the Department of Arkansas, will start so late and proceed so slowly as to miss the campaign.) Opposing the expedition are around 30,000 Confederate troops under Kirby Smith; other obstacles are low water, inhospitable country and the depredations of snipers. From the beginning, Federal efforts will be further hampered by lack of cooperation among the forces and by an insatiable desire for the seizure of valuable cotton by naval and military personnel.

12 March 1864

Trans-Mississippi, Red River Campaign The Federal fleet and troop transports reach the mouth of the Red River and head upriver toward Alexandria, Louisiana.

14 March 1864

Trans-Mississippi, Red River Campaign Moving up the river, Union forces easily overwhelm the partially-completed Confederate Fort de Russy near Simsport, Louisiana, from the land side, capturing 210 prisoners and several guns. Meanwhile, the Federal fleet bursts through a dam nine miles below and proceeds up the river.

15 March 1864

Washington Transferring power from the military to the new civil governor of Louisiana, Lincoln takes another step in his reconstruction of that state, a model for his postwar plans.

16 March 1864

Trans-Mississippi, Red River Campaign Nine Union gunboats have arrived in Alexandria, Louisiana; Federal troops occupy the town and await the arrival of further land forces. Elsewhere, a 10-day Federal reconnaissance begins in Missouri.

17 March 1864

Western Theater Grant and Sherman confer in Nashville, Tennessee, on their plan of attack on General Johnston and the Confederate army in Dalton, Georgia. Formally receiving command of the Union armies on this date, Grant announces, 'Headquarters will be in the field, and, until further orders, will be with the Army of the Potomac.' In short, Grant is turning his primary attention to Lee and his Army of Northern Virginia.

18 March 1864

Trans-Mississippi A convention in Arkansas ratifies a pro-Union constitution and abolishes slavery.

19 March 1864

The Confederacy In Georgia, the state legislature gives a vote of confidence to President Davis and suggests that after any significant Confederate military victory a peace proposal should be made to Washington, the proposal predicated on Southern independence.

Trans-Mississippi, Red River Campaign Federal cavalry under Banks begin to arrive at Alexandria, Louisiana, but the whole force will not be assembled until the 26th. The next few days see small-scale Confederate attacks on the Federal advance guard.

21 March 1864

Trans-Mississippi, Red River Campaign Federal General J A Mower surprises Confederate General Richard Taylor near Henderson's Hill, Louisiana, capturing nearly 250 men, 200 horses and four guns. This action deprives the Confederates for the time being of their means of scouting.

23 March 1864

Washington Back in the capital after conferring with Sherman, Grant prepares for the simultaneous advance of all his armies.

Trans-Mississippi, Red River Campaign Continuing the planned massing of forces, Federal troops under Frederick Steele move south from Little Rock, Arkansas, to join Banks and his forces on the Red River.

24 March 1864

Washington Grant and Lincoln confer at the White House.

Western Theater Confederate cavalry under Nathan Bedford Forrest capture Union City in west Tennessee.

Trans-Mississippi, Red River Campaign Federal General Banks, commander of the

Below: General Nathaniel Banks, commander of the Union's Department of the Gulf, was placed in charge of the Red River campaign.

Department of the Gulf and leader of the campaign, arrives in Alexandria, Louisiana, only to discover two new snags in the operation: first, he is ordered to return Sherman's troops – 10.000 men under A J Smith – to that general by 15 April, for the Atlanta campaign; second, it becomes clear that the river is so low as to make it barely possible for his fleet to move away from Alexandria. Nonetheless, Banks issues orders to his troops for an advance to Shreveport.

25 March 1864

Western Theater Following his capture of Union City in Tennessee, Forrest attacks Paducah, Kentucky, on the banks of the Ohio, entering the city but not capturing the Federal garrison there.

26 March 1864

Western Theater Threatened by cavalry sent by Sherman, Forrest's Confederates withdraw from Paducah, Kentucky, toward Fort Pillow on the Mississippi River.

28 March 1864

The North A group of Copperheads attack Federal soldiers in Charleston, Illinois. In the worst anti-war outbreak since the July 1863 Draft Riots of New York City, five are killed and 20 wounded as more Union troops are called out to quell the disturbance.

Trans-Mississippi, Red River Campaign Confederate troops begin to mass under General Richard Taylor, preparing to resist the advance of Federal forces up the river.

29 March 1864

Washington Responding to press criticism of his handling of Gettysburg, Meade has contemplated requesting a court of inquiry; Lincoln, wishing to avoid the potential divisiveness of such a move, dissuades Meade from the request.

Trans-Mississippi, Red River Campaign Before the arrival of the Federal forces, who are advancing toward Shreveport, Confederates set fire to 10 miles of cottonfields along the riverbank.

3 April 1864

Trans-Mississippi, Red River Campaign The river is rising slightly, but it is still so low that Federal ships have barely been able to pass through the rapids above Alexandria until today, when the last of the 13 gunboats and 30 transports make the passage. Seven gunboats and several large transports remain behind in Alexandria; the supplies largely have to be landed before the rapids, hauled around in wagons, and reshipped. The supply line for this expedition is becoming increasingly difficult and thin. During the day Federal forces concentrate near Natchitoches.

4 April 1864

Washington President Lincoln writes: 'I am naturally anti-slavery. If slavery is not wrong, nothing is wrong . . . And yet I have never understood the presidency conferred upon me an unrestricted right to act officially upon this judgment and feeling.' Concerned about French interests in Mexico and their possible repercussions in Texas – one of the reasons for the Red River campaign – the

House of Representatives passes a resolution saying the United States will not tolerate a monarchy in Mexico. In fact, this monarchy is already decreed; it is to be a puppet regime of France's Napoleon III, who invaded Mexico in 1862. And this regime does in fact have its eye on Texas, though its army will be kept occupied by Juarez until that leader's final victory.

5 April 1864

Trans-Mississippi, Red River Campaign Confederate General Taylor and his army of 16,000 fall back from the Federal advance and group around Mansfield, Louisiana, placing themselves between Banks and his goal, Shreveport. The Federal land forces by this time are marching in a thin line on a single narrow road, encumbered by a wagon train of ammunition and provisions that stretches for 12 miles through the barren, enemy-held wilderness. The Union fighting ships and transports, meanwhile, continue to make poor headway up the low waters of the Red River.

6 April 1864

Western Theater Meeting in New Orleans, a Union convention adopts a new state constitution and abolishes slavery.

7 April 1864

The Confederacy The government orders General Longstreet to move northward and rejoin Lee's Army of Northern Virginia. Longstreet has been in Tennessee since last winter, where he participated in the Chatta-

nooga and Knoxville campaigns. Lee is beginning to prepare his response to Grant's anticipated next move.

8 April 1864

Washington By a vote of 38 to six, the Senate passes the 13th Amendment to the Constitution, abolishing slavery in the United States and all areas under its jurisdiction. While this amendment would have been unlikely before the war, the vote shows that by now the North clearly perceives the importance and moral significance of the gesture.

Trans-Mississippi, Red River Campaign Confederate General Taylor moves his army from Mansfield, Louisiana, forward to Sabine Crossroads to meet the advance of Banks' ground forces, who are moving toward Shreveport. The armies face one another most of the afternoon, reluctant to enter battle. Union Colonel R B Irwin describes the action that ensues: 'About 4 o'clock, when the two lines had been skirmishing and looking at each other for a couple of hours, Taylor suddenly delivered his attack by a vigorous charge of Mouton's division on the left of the Pleasant Hill Road . . . Walker followed astride and on the right of the road, with Bee's brigade of cavalry on his right. The Federal line formed on the cleared slope, about 4500 in all, met with

Below: Soldiers of the Union's 69th New York Infantry Regiment attend Sunday morning mass with members of their families. Religious services in the field were commonplace.

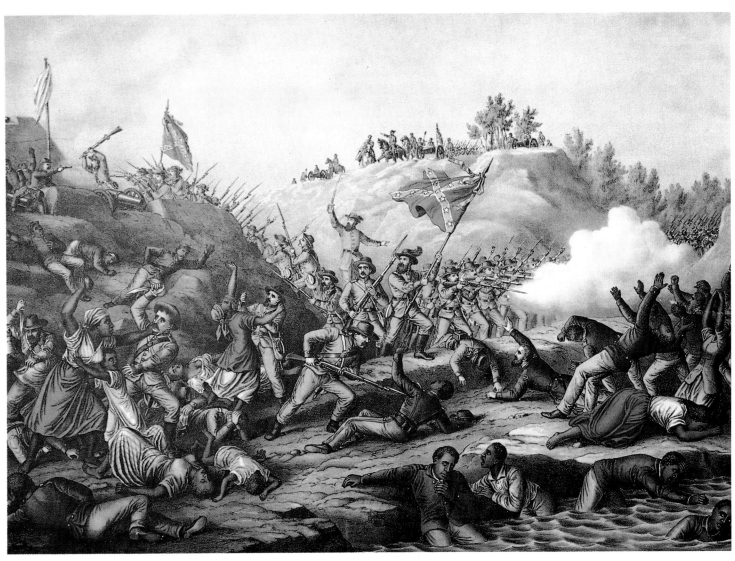

Above: The Fort Pillow Massacre, perpetrated by Bedford Forrest's command, remains one of the most controversial events of the war.

spirit the fierce onset of more than double their numbers, but were soon overcome. The artillery was powerless in the woods . . . Franklin received Banks' orders to move to the front at a quarter-past three. He at once sent for Emory and led forward Cameron, whose division, advancing at the double-quick, arrived on the field, five miles away, an hour later, just in time to witness and for a brief interval to check the disaster, but not to retrieve it. The whole Union line was again driven back. To complete the confusion, a wild panic ensued among the teamsters of the cavalry train, which was close behind. This order of march has been severely criticized, but . . . it did not cause but only aggravated a disaster really brought about by accepting battle at the head of a column 20 miles long, at the hands of an enemy formed in complete order of battle, in a position previously chosen by him, where our artillery could not be used. Taylor's army pursues the retreating Federals, but Emory's division makes a successful stand and covers the retreat, saving the Union army from disaster.

After the Battle of Sabine Crossroads the Federal army withdraws and forms another defensive line at Pleasant Hill; one soldier writes of this withdrawal as 'our skedaddle from the rebs.' The Federals have lost 113 killed, 581 wounded and 1541 missing, for a total of 2235 out of 12,000 engaged – a very high percentage; Southern losses are 1000 killed and wounded out of 8800 engaged.

9 April 1864

Washington　General U S Grant begins to issue orders pursuant to his grand strategy of advancing against Southern armies on all fronts: Banks is directed to advance on Alabama; Sherman will move against Johnston and the Army of Tennessee in Georgia; Sigel will move down the Shenandoah Valley in Virginia; Butler will turn toward Richmond; and the Army of the Potomac will advance inexorably against Lee and the Army of Northern Virginia. Grant tells Meade: 'Wherever Lee goes, there you will go also.'

Trans-Mississippi, Red River Campaign At daylight, Confederate General Taylor orders his whole army forward in pursuit of the retreating Federal forces. In the afternoon contact is made with the Union line at Pleasant Hill. The Confederates open their attack around 1700 hours, at first driving back the Union left flank and killing Colonel Benedict, the brigade commander. But as the Confederates turn toward the center, a Federal counterattack repulses them, after which the Union army advances successfully, driving the enemy away in some confusion.

Banks at first wants to continue the advance toward Shreveport but in the absence of support from Steele (who is obstructed by enemy actions in Arkansas), finally decides to withdraw to Grand Ecore, Louisiana. While the day's battle has been technically a Northern victory, it has in fact halted the progress of the Red River Campaign, which has been plagued by problems and mistakes from the beginning. Moreover, General Banks has probably erred in withdrawing now. A report to President Davis from Confederate Trans-Mississippi commander Kirby Smith, who arrives late at night, states: 'Taylor's troops were repulsed and thrown into confusion . . . the Missouri and Arkansas troops . . . were broken and scattered. The enemy recovered artillery which we had taken, and two of our pieces were left in his hands . . . To my great relief I found in the morning that the enemy had fallen back in the night . . . Our troops were completely paralyzed.' But now the Union army faces great difficulties in withdrawing its large force. The end of Federal efforts on the Red River marks the last important operation by either side in Louisiana – Confederate forces will hold the state west of the Mississippi River until the end of the war. The failure of the expedition also means Banks will be delayed in his planned support of Sherman.

10 April 1864

Trans-Mississippi, Red River Campaign The Union expedition under Steele, which had departed Little Rock to aid Banks in Louisiana, returns under Confederate fire to Little

Rock. Taylor's Confederates move back from Pleasant Hill to Mansfield while the Federals gather at Grand Ecore.

11 April 1864

Trans-Mississippi, Red River Campaign
The gunboats and transports of the Federal flotilla now face the problem of retreat on the lowering waters of the river. They begin to withdraw to the accompaniment of shelling from Confederate shore batteries and rifle fire. Meanwhile, a pro-Union state government is inaugurated in Little Rock, Arkansas.

12 April 1864

Western Theater Confederates under Nathan Bedford Forrest, on a raiding expedition against Federal operations in Tennessee and Kentucky, surround Union Fort Pillow on the Mississippi in Tennessee. The fort is held by about 557 troops, nearly half of them black. Forrest arrives at midmorning to take command and deploys his men in positions from which they can attack the fort without exposing themselves to fire. This done, he sends an ultimatum to the fort's commander, Major W F Bradford, who at length declines to surrender. The ensuing Southern attack is swift and successful, with only 14 Confederates killed and 86 wounded. But what sends shockwaves through the country, shockwaves that will reverberate for years, are the Union casualties and the disputed reasons for those casualties. Southern accounts claim that the Federal losses – 231 killed, 100 wounded, 168 whites and only 58 blacks captured – occur because the Federals refuse to surrender in the face of certain defeat and try to fight their way out of the fort. The Northern report, which history will in some degree vindicate, states that the fort surrendered almost immediatley, and that what followed was a massacre by Confederates of defense-

Below: By 1864 hospital facilities in the North were far superior to those available in the Confederacy.

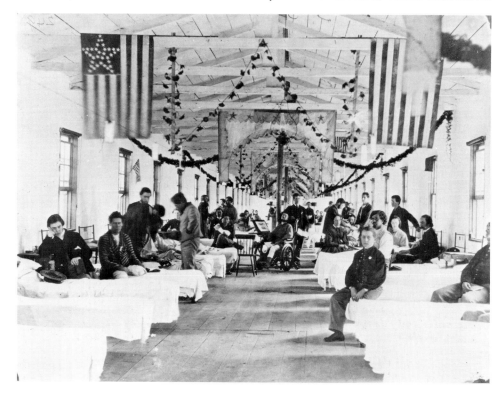

less Union troops, especially blacks. Grant, in his memoirs, quotes a portion of a letter by Forrest which states: 'The river was dyed with the blood of the slaughtered for 200 yards . . . It is hoped that these facts will demonstrate to the Northern people that Negro soldiers cannot cope with Southerners.' Whatever is the true extent of Southern atrocities in this action, the accusations will inflame the North.

Trans-Mississippi, Red River Campaign
Retreating Union gunboats and troop transports are ambushed near Blair's Landing; after a brisk exchange, the Confederates are driven off, losing their commander but inflicting 57 casualties on Union soldiers.

15 April 1864

Western Theater Andrew Johnson, head of the new pro-Union government of Tennessee, makes a speech (in Knoxville) supporting emancipation.

Trans-Mississippi, Red River Campaign
Union ships gather along with land forces at Grand Ecore, Louisiana, whence they will depart under enemy fire toward Alexandria.

17 April 1864

Washington In a move that puts increased pressure on the dwindling supply of manpower for the Southern army, Grant decides to exchange no more prisoners with the South until such releases are balanced equally, as they have not been previously. He also announces: 'No distinction whatever will be made in the exchange between white and colored prisoners.' Currently the North holds about 146,634 Southern prisoners.

19 April 1864

Washington Congress authorizes an act permitting the Nebraska Territory to join the Union.

Western Theater The USS *Smithfield*, principal support of the Federal garrison in Plymouth, North Carolina, is rammed and sunk by the CSS *Albemarle*, which then moves

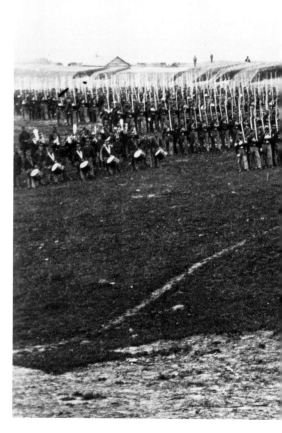

effectively against other Union ships operating in the area.

20 April 1864

Western Theater The Confederate force under R F Hoke that has surrounded the Federal garrison at Plymouth, North Carolina, completes its capture of the city. Federals lose 2500 men and large quantities of supplies. This is the first Southern victory in the area in a while, and it raises Confederate spirits considerably; nonetheless the city has little strategic significance, and Grant has already concluded it is not worth defending – if the major military moves of the summer succeed, Plymouth and nearby Washington, North Carolina, will revert to Federal control naturally. Thus, after Plymouth falls, Grant orders the abandonment of Washington but strengthens the strategically valuable port of New Berne.

21 April 1864

Trans-Mississippi, Red River Campaign
Continuing his withdrawal from the disastrous campaign, Federal General Banks moves his land forces out of Grand Ecore and marches 32 miles nonstop to Cloutiersville, Louisiana. Meanwhile, the Federal rear guard is driven from Natchitoches by Confederate cavalry commander J A Wharton, who continues pursuing the Federals as they move toward Cloutiersville. A Southern force under General H P Bee tries to block Banks' retreat near Cloutiersville, but this group is driven off by a Union frontal attack. Federals arrive at the town in good condition but still in serious danger. The vessel *Eastport*, largest of the ironclads in the Federal fleet on the Red River, is refloated after having been sunk by a torpedo on 15 April.

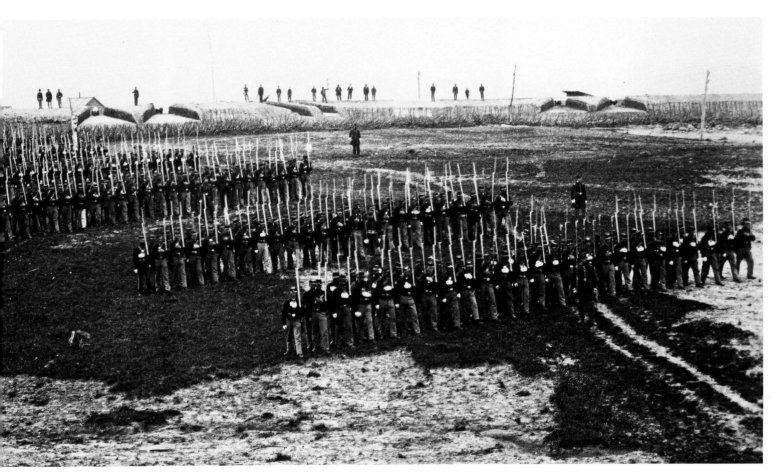

22 April 1864

Washington Following an act of Congress, the phrase 'In God We Trust' begins to be stamped on Federal coins.

The Confederacy Now that black troops are beginning to be used regularly by the Northern army – one example being the soldiers at Fort Pillow – the Confederacy turns its attention to dealing with black prisoners. President Davis writes: 'If the negro [prisoners] are escaped slaves, they should be held safely for recovery by their owners. If otherwise, inform me.'

25 April 1864

Trans-Mississippi, Red River Campaign Banks' retreating army begins arriving at Alexandria, Louisiana. An order arrives from Grant officially terminating the operation, but these orders are to be suspended on 30 April.

26 April 1864

Western Theater Pursuant to Grant's order after the fall of the Federal garrison at Plymouth, North Carolina, Union soldiers begin to pull out of nearby Washington.

Trans-Mississippi, Red River Campaign Federal troops and some of the fleet have arrived relatively unhurt in Alexandria, but the navy remains in an extremely hazardous situation, with several of the ships stuck above the rapids near Alexandria. Union Lieutenant Colonel Joseph Bailey proposes an extraordinary plan for freeing the ships from the river, which by now has fallen in places to three feet in depth: a series of dams will be built to raise the river; when the required seven feet of depth is reached, chutes will be opened for the ships to move through. Meanwhile this day, the ironclad *Eastport*,

sunk on 15 April and raised on 21 April, runs aground several times and is finally blown up by its crew above the rapids leading to Alexandria. Immediately thereafter, the crew is attacked by Confederate infantry, who are at length driven off. As Union gunboats proceed down the river they run into Southern artillery, which hits the gunboat *Cricket* with 19 shells; the ship loses 31 of her crew of 50 before escaping. Two Federal pumpboats are also destroyed before the ships move out of range; one, the *Champion 3*, explodes from a hit in the boiler and scalds to death 200 black crewmen. (This type of tragedy is not uncommon in steamships during the war.)

27 April 1864

Washington The plans are made, the armies poised, and Grant issues his orders. He would later describe this event in his memoirs: 'By the 27th of April spring had so far advanced as to justify me in fixing a day for the great move. On that day Burnside left Annapolis to occupy Meade's position between Bull Run and the Rappahannock. Meade was notified and directed to bring his troops forward to his advance; on the following day Butler was notified of my intended advance on the 4th May, and he was directed to move, the night of the same day, and get as far up the James River as possible by daylight, and push on from there to accomplish the task given him. He was also notified that reinforcements were being collected in Washington, which would be forwarded to him should the enemy fall back into the trenches at Richmond. The same day Sherman was directed to get his forces up ready to advance on the 5th. Sigel, at Winchester, was notified to move in conjunction with the others.'

Above: The 26th New York Infantry Regiment on parade outside Fort Lyons, one of many armed camps defending the Northern capital.

28 April 1864

Eastern Theater As they have been since late 1863, Federal batteries continue their shelling of Fort Sumter in Charleston Harbor, sending 510 rounds into the fort over the next seven days in the one-sided battle.

30 April 1864

The Confederacy President Davis reinforces his previous statement about black Federal prisoners: 'Captured slaves should be returned to their masters on proof and payment of charges.' On this same day, Davis' young son Joe dies from a fall off the Confederate White House.

Trans-Mississippi, Red River Campaign One of the most imaginative engineering feats in military history commences as work is begun on the dams that are intended to float the stranded Federal fleet over the rapids above Alexandria on the Red River. The work will be completed in 10 days.

1 May 1864

Washington Brigadier General John P Hatch replaces Major General Q A Gillmore as commander of the Federal Department of the South.

Western Theater Skirmishing breaks out between Sherman's and Johnston's troops at Stone Church, Georgia.

2 May 1864

The Confederacy In his speech at the opening session of the Second Confederate Congress, President Jefferson Davis accuses Federal troops of 'barbarism.'

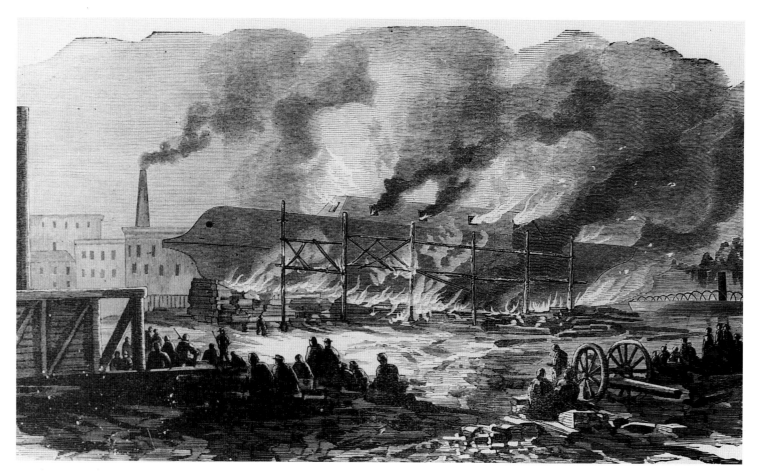

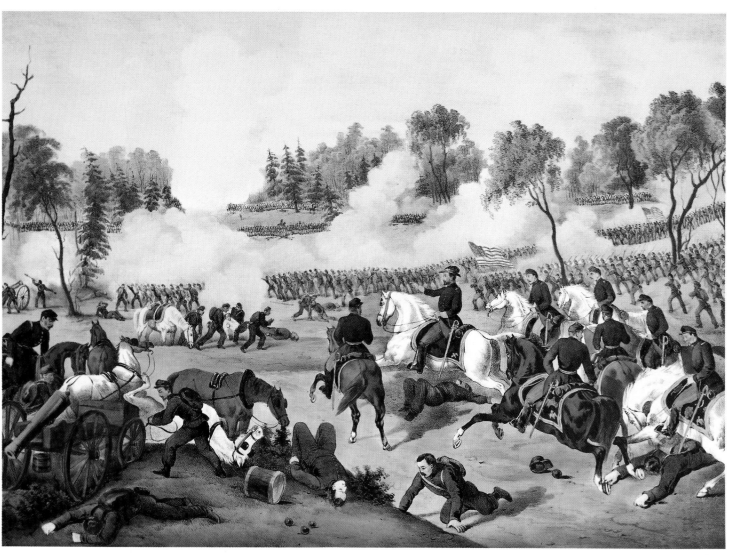

Above: Grant issuing orders during the fighting in the Wilderness, 5 May 1864.
Left: Confederates burn the Navy yard at Savannah as Sherman's army closes in.
Below left: Union troops on the offensive in the Wilderness. The fighting was bitter and confused, made worse by the fires that broke out in the undergrowth.
Below: Calvary and infantry clash during the Wilderness battle. Grant's attempt to deliver a knock-out against Lee failed, with both sides losing heavily.

Trans-Mississippi, Red River Campaign
Confederates harass Banks' withdrawing army at Well's Plantation, Wilson's Landing and Bayou Pierre as the Federals continue their retreat toward Alexandria, Louisiana. Work continues on the dams that are intended to float the Union fleet down the lowered river. Minor actions are seen at Kneelands Prairie in California, and at Bee Creek, Missouri.

3 May 1864

Eastern Theater, Wilderness Campaign
The Army of the Potomac, still nominally under Meade but in fact directed by Grant, is on the eve of its long-awaited move against Lee's Army of Northern Virginia. A few days before, Grant has written Chief of Staff Halleck: 'The Army of the Potomac is in splendid condition and evidently feels like whipping somebody.' How and where to do the whipping is a subject of contention within the Union staff. Grant wishes to move against the Confederate right flank, using the easy access to water transportation from the junction of the Rappahannock and Rapidan, while Meade wants to attack the Rebel left flank, which will avoid the risk of fighting in the Wilderness and cut off Lee from further northward excursions toward Washington. By attacking across the Wilderness – an area in northern Virginia that takes its name from the dense forest and underbrush that makes it virtually uninhabitable – Grant hopes to cut

Lee off from Richmond, and perhaps capture his whole army. Grant's view prevails, and the Army of the Potomac is ordered to cross the Rapidan on the morning of 4 May.
Trans-Mississippi Steele's forces finally arrive back in Little Rock, Arkansas, after their bungled attempt to aid the also bungled Red River Campaign.

4 May 1864

Washington The House of Representatives passes, over Lincoln's objections, the Wade-Davis Reconstruction Bill, which contains several stiffly punitive measures directed toward the South. If put into law, it will destroy Lincoln's more moderate reconstruction plans; nonetheless, the bill is opposed by extreme Radical Republicans like Thaddeus Stevens, for whom it is insufficiently severe.
Eastern Theater, Wilderness Campaign
The Army of the Potomac crosses the Rapidan toward Lee, its forces 122,000 strong to Lee's contingent of 66,000 hungry and ill-clad men. The Union corps are under the direction of Generals Hancock, Warren, Sedgwick and Burnside. Grant has intended to march through the heavy forest of the Wilderness so as to gain open territory for battle, but he is forced to stop just on the edge of the Wilderness and wait for his supply train to catch up. Lee, who has anticipated Grant's move this time, as he will so often in the future, moves his army up quickly so as to catch the Federals in the Wilderness. This is familiar terri-

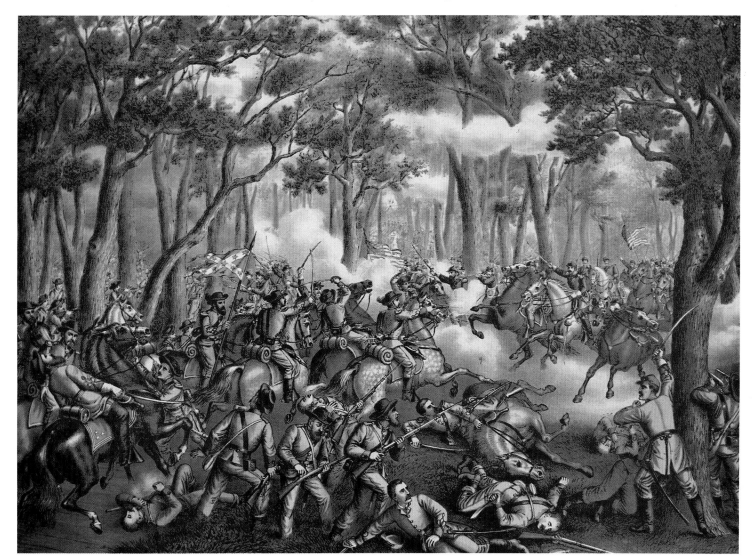

tory for the Confederates, and within the tangled trees and brush, uneven ground, and numberless pits and gullies, the superior numbers of the Federal troops will be ineffective and their artillery will be nearly useless. The Confederate forces are carefully positioned, General Ewell on the Orange Turnpike and General A P Hill on the Plank Road; Longstreet's corps and Stuart's cavalry are ordered to move in. During the day there is some fighting in front of the Union advance, but as both armies settle down for the night neither is quite sure of the other's position, and Grant does not yet understand that Lee is going to force him to fight in the Wilderness. Meanwhile, another element of Grant's master plan against the Confederacy is set in motion as troops under General Benjamin Butler assemble near the James River, preparing to move farther upriver toward Richmond.

Western Theater In Chattanooga, Sherman prepares his part of Grant's plan, readying his troops for their march to Atlanta. There is light, inconclusive skirmishing at Varnell's Station in Georgia.

Trans-Mississippi, Red River Campaign Harassment of the Union fleet on the river continues as Confederates destroy a steamer and capture two others at David's Ferry, Louisiana.

5 May 1864

Eastern Theater, Battle of the Wilderness Federal General Warren notifies Grant and Meade of an enemy force – Ewell's – on

Below: The 125th Regiment of Illinois Volunteer Infantry encamped at Edgefield, Tennessee, with the city of Nashville in the background.

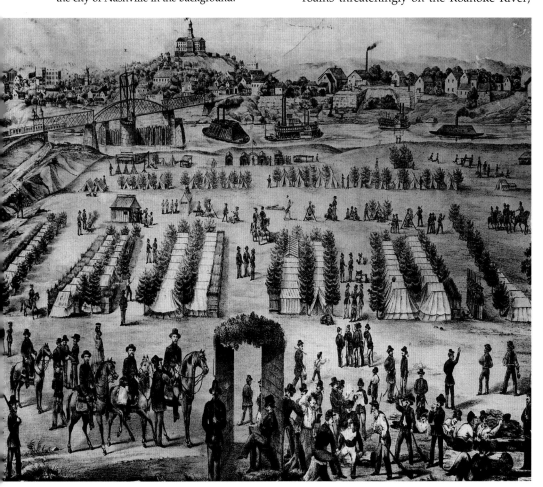

the Orange Turnpike; thinking that this is only a division, Grant orders Warren to attack. These forces quickly join in a fierce battle, and it becomes clear that Lee's army is opposing the Federals in force. Because of the thick woods, the men often grapple at almost point-blank range; the battlelines become confused in the smoke-filled forest, regiments losing contact with one another. Soldiers and leaders follow the battle by the sound of firing, and often find themselves shooting at an enemy they can see only by the flashing of guns. Late in the afternoon Confederate General Hill's advance along the Plank Road is met by Hancock; a separate and equally desperate contest ensues. Again the fighting is at close quarters, often hand-to-hand with bayonets and clubbed muskets, the artillery silent for fear of doing harm to unseen friendly troops. All day the fighting surges back and forth, but as evening falls nothing significant has been gained by either side, and the forces retire to await the next day's battle. During the night, troops of both sides frequently wander into enemy lines.

Also on this day, General Butler and 40,000 men land at Bermuda Hundred, in the 'bottle' formed by the James and Appomattox Rivers. Though Butler's plan has been supervised by Grant, it is a poor one: Bermuda Hundred is excellent for a defensive position, but is not properly situated for an offensive.

Western Theater After the Confederates' occupation of Plymouth and Washington, North Carolina, they move against the port of New Berne, which Grant has ordered held at all costs. The attack on New Berne today is turned back by Federal defenders, but the Confederate ironclad ram CSS *Albemarle* roams threateningly on the Roanoke River,

fighting to a draw with seven Federal blockading ships and disabling the USS *Sassacus*.

Trans-Mississippi, Red River Campaign Confederate shore batteries destroy two Federal wooden gunboats and a transport on the river near Dunn's Bayou. The Union fleet is still marooned above Alexandria.

6 May 1864

The Confederacy President Davis writes anxiously to General Beauregard, instructing him to meet Butler's threat on Petersburg from the South.

Eastern Theater, Battle of the Wilderness During the night Grant orders a general attack by Sedgwick, Warren and Hancock, to commence at 0500 hours. Reinforcements are moved up on both sides. Before the Union advance can be launched, however, rebels attack Sedgwick on the Union right flank, and the firing gradually spreads along the line. Federal General Hancock moves against the weak positions of Hill, who has unwisely failed to entrench his forces. Hill's lines are soon enveloped on the Orange Plank Road and are in danger of being routed. But at the critical moment, Longstreet's reinforcements, awaited by Hill since the previous day, make a dramatic appearance, moving down the Orange Plank Road at a trot. Soon the Union advance is checked and the Federals thrown back to their original breastworks; a further Confederate advance captures these works, but is not able to break the Union line.

About 1000, after turning back the Union advance, Longstreet decides to take the offensive against the Federal left flank. He finds an unfinished railroad cut that provides a clear route to the Federal flank and sends four brigades to the attack. Before noon the Federals are overwhelmed by these forces; the Union left is rolled up northward in confusion. But then disaster strikes the Confederate advance, as recounted by Southern General E M Law: 'General Longstreet rode forward and prepared to press his advantage . . . Longstreet and Kershaw rode with General Jenkins at the head of his brigade as it pressed forward, when suddenly the quiet that had reigned for some moments was broken by a few scattering shots on the north of the road, which were answered by a volley from Mahone's line on the south side. The firing in their front, and the appearance of troops on the road whom they failed to recognize as friends through the intervening timber, had drawn a single volley, which lost to them all the fruits of the splendid work they had just done. General Jenkins was killed and Longstreet seriously wounded by our own men.' (This occurs within five miles of where Stonewall Jackson was mortally wounded by his own men a year before.) As he is taken from the battlefield, Longstreet orders General Field to press the attack, but the Confederate forces are in confusion after the accident; Lee comes forward to organize the forces and prepare a new offensive, but the impetus has been lost and the Federals have time to regroup and fortify their positions. A Confederate attack later in the afternoon is halted at the Union breastworks.

Elsewhere during the day Sheridan's and Stuart's cavalry have clashed inconclusively at Todd's Tavern. Confederate General John

Above: Thaddeus Stevens was a radical Republican who opposed the Wade-Davis Reconstruction Bill, believing it was too lenient on the South.

B Gordon, having ascertained that the Federal right flank is close at hand and quite exposed, has spent all day seeking Ewell's permission for an attack. Permission is given by Lee late in the afternoon, and two brigades move out, overlapping the right of Sedgwick's corps. The surprised Federals are driven from a large portion of their works, losing 600 in captured, including Generals Seymour and Shaler. The Union army is now in imminent danger of being cut off from its supply line on the Rapidan. Receiving the increasingly serious, and often exaggerated, reports of this crisis, Grant issues orders with his usual calm demeanor, but, as one of his generals reports: 'when all proper measures had been taken, Grant went into his tent, threw himself face down on his cot and gave way to the greatest emotion . . . [He] was stirred to the very depths of his soul . . . and not till it became apparent that the enemy was not pressing his advantage did he recover his perfect composure.' Had Gordon attacked earlier in the day he might have pressed his advantage home; but the Confederate move is halted by darkness.

Casualties in the two days of fighting have been staggering: the North has lost 2246 killed, 12,037 wounded, and 3383 missing, a total of 17,666 of 100,000 engaged; the Confederate losses, from the usual incomplete records kept on Southern casualties, are something over 7500 of 60,000 engaged; the Union losses are thus more than twice the Confederate, but the North has lost only a slightly larger percentage of its army than has the South. Although the troops do not yet know it as they entrench in the evening, the Battle of the Wilderness is over. But the tragedy is not quite over as darkness falls. Brush fires have broken out in the thick woods; several times during the day the fighting has stopped by mutual consent while soldiers of both armies work side by side to move their wounded out of the burn-

ing woods. During the night the forest fires rage, and while the entrenched armies listen to the screams of the trapped, 200 Federal wounded die in the flames.

Between the James and Appomattox Rivers, meanwhile, Butler's troops begin their entrenchment on a three-mile line north to south across the neck of the peninsula formed by the two rivers. The Federals are within sight of the steeples of Petersburg, seven miles away; Richmond lies fifteen miles to the north. At this point the Confederates have less than 10,000 men in the area around Petersburg and Richmond; the Federal force is four times that number. A small force of Confederates under Beauregard repel 1000 Union troops who, on Butler's orders, attempt to cut the Richmond and Petersburg Railroad line. This is the first action in Butler's campaign on Richmond.

7 May 1864

Eastern Theater, Wilderness Campaign By dawn the weather around the Wilderness is rainy, the troops not moving out of their en-

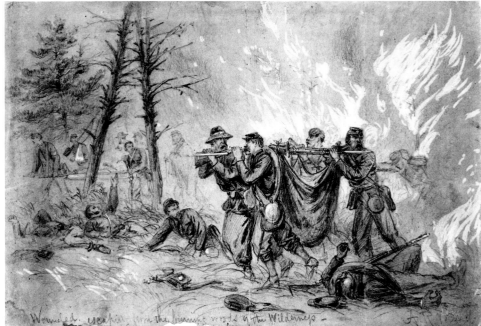

Above: Using a makeshift stretcher, a group of Union soldiers rescue a wounded comrade from the fires of the Wilderness.

trenchments. Early in the morning a reporter observes the following: 'Grant and Meade had retired a little from the crowd and stood by the roadside in earnest conversation – Grant, thoughtful, a cigar in his mouth, a knife in one hand and a stick in the other, which he was whittling to a point. He whittled slowly toward him. His thoughts were not yet crystallized. Suddenly he commenced on the other end of the stick, whittled energetically from him, and word was at once sent to General Warren and the other corps to move in the direction of Spotsylvania.' Grant, sure that Lee is retreating south, has decided on the bold stroke of attempting again to flank Lee on the Confederate left, moving round the Army of North Virginia

Below: A Confederate firing line, supported by an artillery battery, prepares to receive a Union attack in the Wilderness.

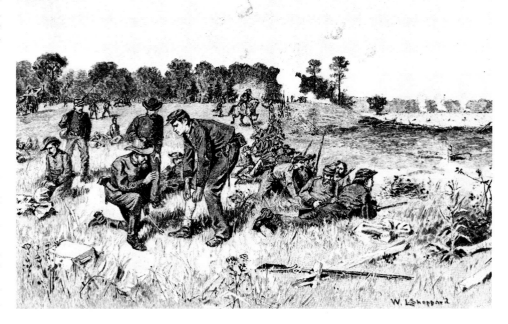

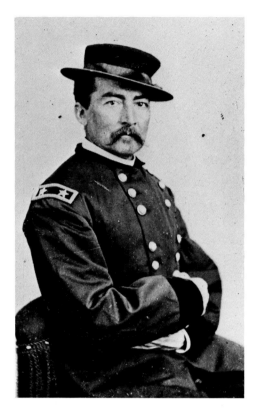

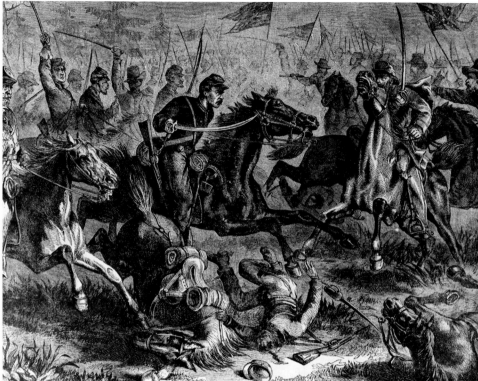

Above: Philip Sheridan became the finest Union commander of cavalry in the war, launching many attacks on Southern supply lines.

toward Richmond. But Grant is doubly mistaken; Lee has not retreated, and the Federal flanking movement is no surprise. On this morning Lee observes to General Gordon: 'General Grant is not going to retreat. He will move his army to Spotsylvania . . . I am so sure of his next move that I have already made arrangements to march by the shortest practicable route, so that we may meet him there.' During the day marching orders are issued to both armies. The Battle of the

Below: The Bloody Angle at Spotsylvania saw some of the heaviest fighting of the whole war, losses were high on both sides.

Wilderness has been a draw, and the race to the vital Confederate crossroad of Spotsylvania has begun.

To the south in Virginia, another effort by 8000 of Butler's men on the Richmond and Petersburg Railroad is rebuffed at Port Walthall Junction by a force of some 2700 Confederates. Federals are already beginning to refer to their campaign as a 'stationary advance.'

Western Theater, Atlanta Campaign Since November of 1863 the two great armies of the West have been stationary, Sherman's Federals in Chattanooga and Johnston's Army of Tennessee in nearby Dalton, Georgia. As part of Grant's overall plan, Sherman has been ordered 'to move against Johnston's army, to break it up and to get into the interior of the enemy's country as far as you

Above: The Battle of Yellow Tavern, 11 May 1864. The action saw the death of 'Jeb' Stuart, a victim of a shot fired at close range by a Union trooper.

can, inflicting all the damage you can against their war resources.' Sherman's success in his mission, surpassing all expectations, will leave him with a reputation as perhaps the greatest Federal commander of the war. Sherman's first goal in his disruption of the Confederacy is the vital supply, manufacturing and communications center of Atlanta. He has assembled a conglomeration of several armies, including the stolid but effective General Thomas's Army of the Cumberland, McPherson's Army of the Tennessee and Schofield's Army of the Ohio, a total of over 100,000 men. His opponent, leader of the Confederate Army of Tennessee, is General J E Johnston, an erratic but effective leader whose fine strategic sense is often offset by poor administrative work and lack of attention to detail. Johnston is also liable to quarrel with superiors, and has never been liked by President Davis. His subordinates include corps commanders Hardee, Hood and, soon to arrive, Polk; including Wheeler's 2000 cavalry, Johnston's forces number about 62,000. This day Sherman begins his advance with a move toward Johnston's left flank, the enemy's defenses in Dalton, Georgia, being too strong to attack directly. Pursuing this strategy, a corps under Palmer drives Confederate outposts from Tunnel Hill, pushing them to Buzzard's Roost.

8 May 1864

Eastern Theater, Spotsylvania Campaign Warren's troops, exhausted from four days of fighting in the Wilderness, arrive at the end

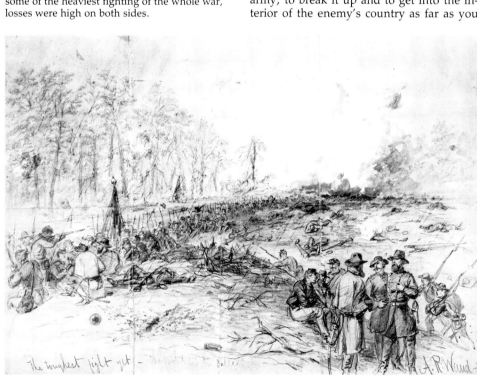

Above right and right: The Battle of Spotsylvania involved some of the worst action of the civil war, particularly around a line of breastworks known as the Bloody Angle.

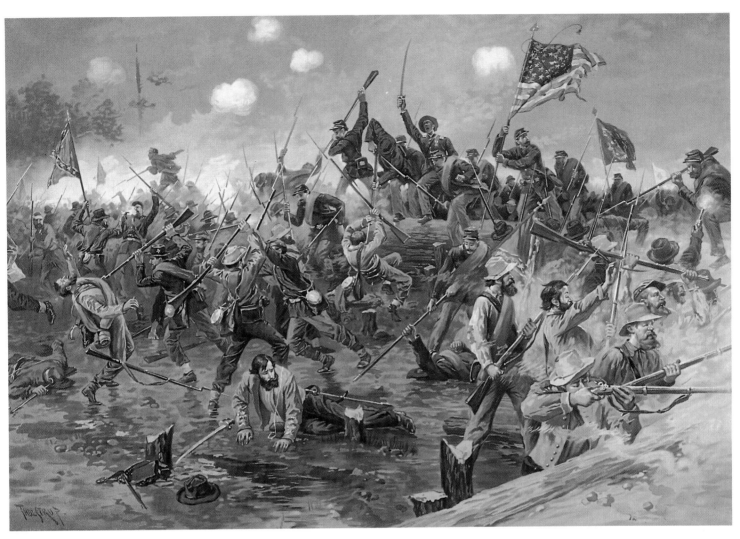

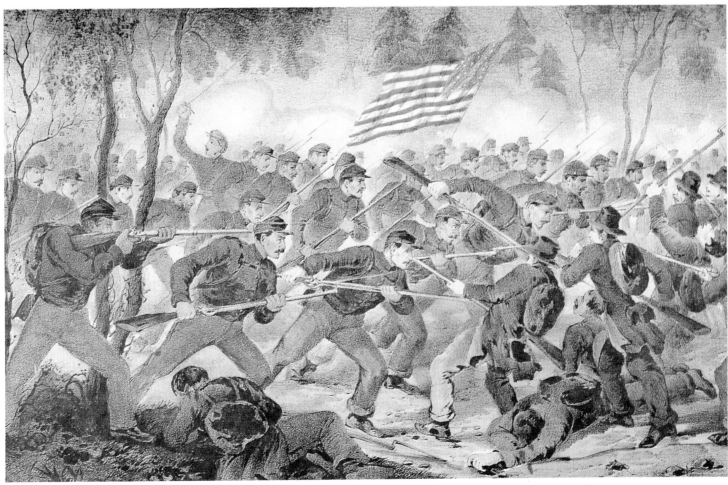

Above: Union General Warren oversees the construction of a line of earthworks across the Weldon Railroad to trap Lee.

of their long forced march to find that, instead of being in retreat toward Richmond, the rebels are in their path and ready to fight in force. The Confederates have won the race to Spotsylvania. Warren's Federal cavalry arrive at Spotsylvania about 0800 hours and clash with Stuart's cavalry, who are blocking the Brock road. Stuart immediately calls for assistance from Anderson, whose men are resting nearby. Soon the head of Warren's column is thrown back. Frustrated by their unexpected collision with the enemy, Meade and Sheridan have a violent quarrel in the afternoon, Meade accusing Sheridan's cavalry of being in the way of Warren's forces and crucially impeding them. Sheridan replies that he did not order the cavalry into position, that Meade himself must have done it; the cavalry officer concludes by telling Meade to order the cavalry himself. Following this quarrel, Sheridan convinces Grant to let him make a raid around Lee's army that will disrupt supply lines, take on Jeb Stuart and join Butler in moving on Richmond. Thus begins Sheridan's Richmond Raid.

It is clear to both armies that battle is about to be resumed. Meanwhile, Sedgwick arrives to reinforce Warren and in the late afternoon forces of the two generals assault Anderson's right wing, but the Confederates, aided by the arrival of Ewell's men, repulse this attack with heavy losses on the Union side. Both sides now begin building entrenchments and await the remainder of their forces.
Western Theater, Atlanta Campaign Sherman's men probe the forces of the Army of Tennessee in several locations around Confederate positions on Rocky Face Ridge. Union troops move on the Confederates at

Buzzard Gap, and a similar unsuccessful attempt is made along the Lafayette-Dalton road at Dug Gap.

9 May 1864

Eastern Theater, Spotsylvania Campaign
The armies continue their entrenching operations on a day of light fighting. Lee has laid his lines out to utilize the brows of the slopes in the open fields. In the middle of his east-to-west lines is a curved salient of breastworks that looks somewhat like a horseshoe. It will be known to history as the 'Bloody Angle.' During this day the Union loses one of its finest leaders when corps commander General John Sedgwick is felled by a Southern sharpshooter. (Sedgwick's last words, addressed to a dodging soldier, are, 'They couldn't hit an elephant at this distance.') Also during the day, Sheridan's cavalry leaves on their Richmond raid, pursued by Stuart's cavalry. Sheridan's men damage Southern supply lines at Beaver Dam Station.

Elsewhere, Butler again lumbers into action in the direction of Petersburg, sending his whole army against communication lines and the railroad, some of which are destroyed. Finding the enemy strongly entrenched at Swift Creek, Generals Smith and Gillmore suggest to Butler that they place a pontoon bridge across the Appomattox. This plan could bring considerable Union strength against Petersburg, but it is summarily rejected by Butler, whose criticism of the plan is to stop advice from his staff.
Western Theater, Atlanta Campaign Five Federal assaults are repulsed from the crest of Dug Gap by Johnston's men. Federal cavalry are also driven back from Poplar Place with heavy losses. Sherman's General McPherson routs a small Confederate force at Snake Creek Gap and presses on nearly to Resaca, bringing his men behind Johnston's lines.

However, finding strong defenses at Resaca, McPherson pulls back to Snake Creek Gap, for which he is severely criticized by Sherman. While he has failed to cut Johnston's line of retreat, McPherson's effort will convince the Army of Tennessee to abandon Dalton.
Trans-Mississippi, Red River Campaign
The Union gunboat *Lexington* passes through a gap in a Union-built dam above Alexandria, the first ship of the flotilla to make it through the rapids. During the next few days the rest of the fleet will follow.

10 May 1864

Eastern Theater, Spotsylvania Campaign
Lee has directed solid breastworks and entrenchments to be made all along his line, but he faces battle with two of his three corps commanders out of action – Longstreet is wounded, replaced by Anderson, and an ailing A P Hill is replaced by Jubal Early. During the day the Union corps of Warren, Hancock and Wright (who has replaced Sedgwick) are thrown against the Confederate left and left-center; all of these attacks are repulsed with heavy Federal losses. Meanwhile, Sheridan finishes his work at Beaver Dam Station, having destroyed two locomotives, over 100 railroad cars, 10 miles of track, medical stores and a large quantity of rations. Sheridan's subordinate, General George Custer, releases 378 Union prisoners who had been taken in the Battle of the Wilderness. Sheridan's men move on toward Richmond; Confederate cavalry commander Jeb Stuart rides to intercept them.

In southeast Virginia, Federal General Butler's men destroy a few more railroad tracks before being ordered back into their 'bottle,' the defenses on the peninsula at Bermuda Hundred. The withdrawal allows Beauregard time to send six brigades to defend nearby Drewry's Bluff.
Western Theater, Atlanta Campaign Polk's corps from Mississippi is en route to reinforce Johnston's Confederates as the commander learns of McPherson's penetration of his defenses at Snake Creek Gap. Sherman, meanwhile, decides to move his whole army through the vulnerable gap.

11 May 1864

Eastern Theater, Spotsylvania Campaign
On a day of heavy rain there is no fighting. Movements along Federal lines lead General Lee to wonder if Grant is not beginning yet another flanking movement. To prepare his response to that possibility, Lee orders artillery moved from his left and center, including the horseshoe salient; thus his potentially strongest defensive position is left without artillery. It is on that position that Grant orders Hancock to move at dawn tomorrow. During the day Grant also writes to Chief of Staff Halleck, 'I . . . propose to fight it out on this line if it takes all summer.' In Blacksburg, in southwest Virginia, Federals skirmish during a raid on Confederate railroads. But there is fighting elsewhere today. Jeb Stuart and his cavalry reach Yellow Tavern in the morning and position themselves to block Sheridan's way to Richmond. Sheridan's cavalry arrive before noon and mount a few probing attacks on the Confederate line. In the late afternoon the Federals attack in force. During this attack General Jeb Stuart, at the

age of 31 one of the most colorful and effective of Southern cavalry leaders, is mortally wounded while firing at the enemy from his horse; he dies in Richmond the following day. Federals also mortally wound General James B Gordon and drive the Rebel cavalry back. But the engagement gives the Confederates time to strengthen Richmond, and Sheridan, realizing that it would be unwise to move on the Confederate capital, begins to ride south toward the James, to link up with Butler.

12 May 1864

Eastern Theater, Spotsylvania Campaign
At 0400 hours on what is to become one of the bloodiest days of the war, Confederates within the horseshoe salient hear the sound of commands and jumbled voices from the Federal lines. Suddenly through the torrential rain a wave of 20,000 Federals charges directly at the front of the salient; the defenders see only a solid wall of blue pouring toward and then over their breastworks, which are taken with little resistance. Federals capture over 2000 enemy, including many from the Stonewall Brigade, several officers and 20 cannon, which have been moved up this morning only to be captured. The remaining Confederates fall back to a second line of breastworks on the neck of the salient, and, regrouping there, begin to pour a murderous fire into the advancing Federals while Lee, realizing the imminent danger to his whole army, quickly moves up reinforcements under General Gordon.

By 1000 the Confederates have moved into place every man that can be spared from the

entire army, and the Federals are driven back to a stand on the north side of the horseshoe salient. There follows a truly terrible day of fighting, with both sides making a series of fruitless and costly attempts to advance.

During the night, Lee orders his forces out of the salient. In the fighting for this small piece of territory the Union has suffered 6800 casualties to the South's 5000, and the salient has earned its historic name of 'Bloody Angle.' At the end of the day a Yankee soldier says simply, 'This has been the most terrible day I have ever lived.'

To the southeast, Sheridan, riding to join

Above: A pencil sketch showing the center of the Union position at Spotsylvania Court House, Virginia, on 9 May 1864.

Butler, is attacked by troops moved out from Richmond to trap him against the Chickahominy River. Below Richmond, Federal General Butler begins advancing toward Confederate positions at Drewry's Bluff, which is being steadily strengthened by General Beauregard.

Below: The death of Sedgwick during the Battle of Spotsylvania, 9 May 1864.

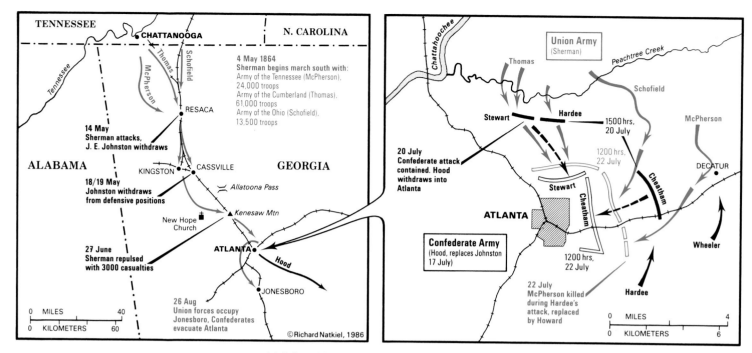

Above: The movement of the rival forces during the Atlanta campaign.

Western Theater, Atlanta Campaign
During the night General Johnston moves the Army of Tennessee out of Dalton, establishing new defenses north and west of Resaca, Georgia, just in front of Sherman's advancing forces. The two generals have established the pattern of the whole campaign; as if in a formal dance, Sherman will move his superior forces to one flank or the other of his enemy, and Johnston will execute a graceful retreat.

13 May 1864

The North Horace Greeley, reflecting the feelings of many Northern Republicans dissatisfied with Lincoln, writes in his New York *Tribune:* 'Our own conviction is . . . that it is advisable for the Union Party to nominate for President some other among its able and true men than Mr. Lincoln.'
Eastern Theater, Spotsylvania Campaign
Union troops shift to the south and east, again sidling toward Richmond around the right flank of the enemy. There is no fighting, but both sides deal with their wounded and dead.
 Along the Chickahominy, Sheridan escapes from Southern attackers and moves toward Butler, who is this day engaged in slowly moving his forces into position at Drewry's Bluff.
Western Theater Skirmishes break out as the armies of Sherman and Johnston move into position around Resaca, Georgia. In Charleston Harbor, South Carolina, yet another major Federal bombardment begins on Fort Sumter.
Trans-Mississippi, Red River Campaign
The last Federal gunboats move past the dams erected on the river, heading toward the Mississippi while Banks' troops march out of Alexandria toward Simsport. It has been a notable recovery from what has otherwise been a humiliating failure for the North. Meanwhile, Confederates under Jo Shelby begin a series of raids north of the Arkansas River that will go on through the month.

14 May 1864

Eastern Theater, Spotsylvania Campaign
Grant has orderd an attack on Lee's right flank today, but slow preparations and heavy rain give Lee time to oppose the attack and it is canceled. Meanwhile, Sheridan's cavalry make contact with Butler's forces. Another element of Grant's master plan takes shape in Virginia's Shenandoah Valley; German-born General Franz Sigel (who often leads German-American troops, thus the slogan 'I fights mit Sigel') moves south toward the Confederate cavalry of General J D Imboden. Rebel reinforcements under Breckinridge are on the way.
Western Theater, Atlanta Campaign There is heavy fighting all along the line as Sherman's men unsuccessfully try to crack Johnston's defenses around Resaca, Georgia. By the end of the day the lines have not significantly changed, and Johnston is confident enough of his defenses to stay where he is.

15 May 1864

Eastern Theater, Spotsylvania Campaign
The only action today is a skirmish at Piney Branch Church. During the night the Federals entrench across from the Confederate right flank. Meanwhile, Sigel moves his army of 6500 men south down the Shenandoah Valley, one of the primary storehouses of Southern food supplies. Sigel runs into Imboden's cavalry, who delay his advance until the arrival of Confederate reinforcements under Breckinridge at New Market. By 1100 hours Sigel's forces have been pushed back about a half mile. A series of costly but increasingly effective Southern assaults follow, and at 1600 Sigel orders a general retreat. Of 5150 engaged, the Federals lose 93 killed, 482 wounded and 256 missing, totaling 831 casualties; the Confederates lose approximately 42 killed, 522 wounded and 256 missing, totaling 820 from about 5000 engaged.
 Elsewhere, Butler has planned an attack on Drewry's Bluff today, but delays it to arrange his defensive measures, which include stringing wire entanglements between stumps in his front, this being among the first uses of these entanglements in war (they

have been tried, with little success, by Burnside in Knoxville). There is not enough wire, however, to extend the obstacles as far as is needed.
Western Theater, Atlanta Campaign A second day of sharp fighting round Resaca begins with a clash between the advancing Federal corps of General Hooker and advancing Confederates under General Hood. During a day of heavy but inconclusive fighting Sherman is unable to break through the Confederate defenses. However, Johnston learns that the Federals have crossed the Oostenaula River and are moving on his rear and accordingly he immediately orders another retreat. Southern forces pull back.

16 May 1864

Eastern Theater, Battle of Drewry's Bluff In an early morning of thick fog with visibility about 15 feet, 10 hastily assembled brigades of Confederates under General Beauregard attack Butler's lines on the right; Federals under General K A Heckman repulse five charges before they are overwhelmed and Heckman captured along with 400 men. Other Union troops on the right become disorganized in the fog; but the fighting on the Federal left is inconclusive, the center holds, and wire entanglements are devastatingly effective in stopping advancing Confederates. Nonetheless, Butler at length gives up and orders a retreat in what is by now a heavy rainstorm. Beauregard has planned a pursuit but it does not take shape; thus is lost the opportunity to strike a serious blow at the enemy. By next morning the Federals will be safely back at Bermuda Hundred; there they will be, in Grant's phrase, 'bottled up' by Beauregard to the east and by the James and Appomattox Rivers to the north and south. Thus, in two days, two major elements of Grant's master plan have failed miserably, the Red River campaign having previously done likewise; Grant himself has been stymied by Lee. Only Sherman in Georgia is fulfilling his assigned role. Furthermore, in Virginia Butler has lost over one-quarter of his 15,800 men engaged since 12 May, to Beauregard's 2506 of 18,025 en-

gaged. Butler's bumbling exploits are to continue, but he is so influential in the North that Lincoln is afraid to relieve him until after the presidential election.

18 May 1864

Eastern Theater, Spotsylvania Campaign A new Federal attack is mounted at 0400 hours on the strengthened breastworks that were at the neck of the Bloody Angle and are now the Confederate left (Lee's lines now stretch north-south). After brief fighting the attempt is abandoned, as is an ensuing effort by Burnside on the Federal left. Following this, Grant once more begins sidling to his left, trying to get around Lee's right flank. Sheridan has begun a hazardous journey from near Richmond to rejoin the Army of the Potomac.

19 May 1864

Eastern Theater, Spotsylvania Campaign Trying to find if Grant is again moving to the Confederate right, Lee sends General Ewell to make contact at Harris' Farm. The armies meet and the rebels are repulsed but reinforcements help Ewell to hold out until dark. In the Spotsylvania campaign now drawing to a close, Federal casualties have been 17,500 out of 110,000 engaged; Grant's losses since the beginning of the Wilderness campaign have been over 33,000. Confederate losses at Spotsylvania are uncertain.

Western Theater, Atlanta Campaign Johnston again stops his army near Cassville, Georgia, with Sherman in pursuit. Deciding to strike at the Federals, Johnston orders General J B Hood, his best combat leader and worst enemy on his staff, to mount an assault on the Union center. But Hood, brilliant as a leader but blundering as a strategist, turns from his attack to face a supposed Federal threat on his right. He is mistaken about the threat, and his move spoils the timing of Johnston's plan. Finding the Union forces moving around both his flanks, Johnston again withdraws to the south.

Trans-Mississippi, Red River Campaign The failed Federal expedition comes to an end as troops cross the Atchafalaya River on a bridge made of steamboats. Elsewhere, Shelby's cavalry continue their raiding in Arkansas.

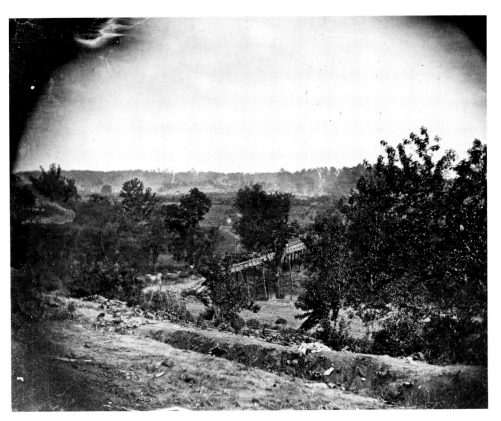

20 May 1864

Eastern Theater Grant sends Hancock's corps along the railroad toward Hanover Junction in Virginia, hoping to draw Lee's army into an offensive; the Federals with their greatly superior numbers could crush Lee before he entrenches. But once again Lee second-guesses his foe, and moves to entrench across Grant's path in Hanover Junction. The armies are again racing to the east and south, toward Richmond.

22 May 1864

Eastern Theater In the morning Confederate General Ewell arrives ahead of Grant's forces at Hanover Junction and begins to entrench; Anderson arrives at noon. Grant is still moving the main body of his force.

Western Theater, Atlanta Campaign Sherman again flanks Johnston's army, going around the Confederate left at Altoona and heading toward Dallas, Georgia.

Above: Cavalry crossing the North Anna River, Virginia, the scene of heavy fighting between 23-25 May 1864.

23 May 1864

Eastern Theater General A P Hill arrives early and adds his troops to the Confederate entrenchments on the south side of the North Anna River between Hanover Junction and the water. Lee arranges his army in a wedge, with the point on the river. In the afternoon Federals under Warren cross the stream to the north and are engaged by Hill, who advances slightly in severe but indecisive fighting. Meanwhile, Hancock's corps have moved southward to the north bank to confront the right side of the Confederate wedge opposite. Now the Union army is split in two,

Below: A panoramic view of Union positions near Spotsylvania as seen from the headquarters of General Warren.

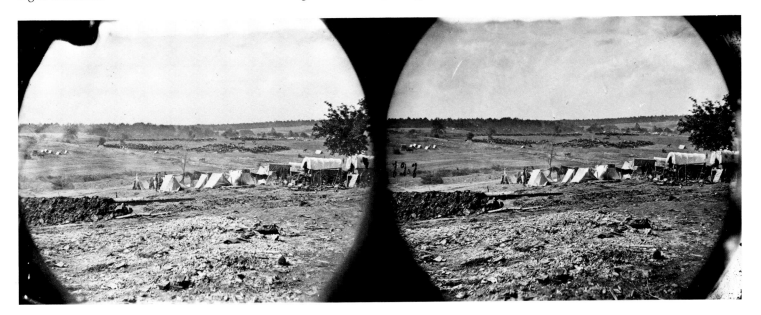

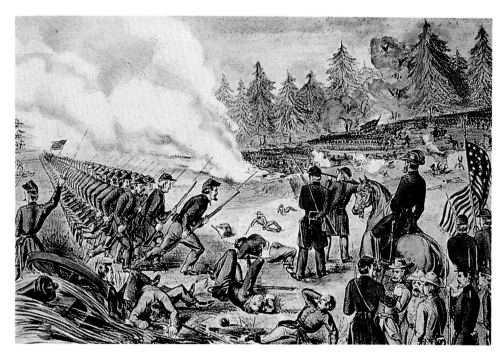

Above: The three-day Battle of Cold Harbor saw both sides lose heavily for little tangible military advantage.

and Lee thus has a rare opportunity to deal Grant a serious blow. But on this day Lee is ill, delirious with fever and confined to his tent. During the day the Confederates receive reinforcements led by Pickett, Hoke and Breckinridge, the latter fresh from his defeat of Sigel near Richmond.

24 May 1864

Eastern Theater The Battle of the North Anna River continues. Federal General Warren is reinforced on one side of the Confederate wedge while Hancock crosses the river toward the other side. Meanwhile, Burnside arrives on the north side of the river and begins to cross amid skirmishing at Ox Ford, the point of the Confederate wedge on

Below: In an attempt to outflank Lee's forces around Cold Harbor, Grant dispatched his troops across the Pamunkey River.

the opposite bank. Now the Union army is split into three parts, but Lee is still feverish and not able to direct his troops in pressing this advantage. Sheridan arrives back at the Army of the Potomac after his cavalry raid completely around Lee's army, during which he has not moved on Richmond but has nonetheless destroyed vital supplies, won four engagements and killed Jeb Stuart.

Western Theater, Atlanta Campaign Realizing that Sherman is moving around him toward Dallas, Georgia, General Johnston orders his forces out of Altoona toward Dallas in order to remain in front of the Union army. Fighting breaks out at several nearby towns, with Southern cavalry under Wheeler harassing Federal supply wagons.

25 May 1864

Eastern Theater The Battle of the North Anna River continues. Grant begins a series of fruitless attempts to find a vulnerable point in the Confederate lines.

Western Theater, Atlanta Campaign Johnston's army awaits Sherman's approach,

Hood at New Hope Church on the road from Altoona, Polk on his left, Hardee on his right. Federals under Hooker attack Hood's corps, but are turned back after two hours by murderous fire from 16 cannon and 5000 rebel muskets. Union losses are heavy.

26 May 1864

Washington Major General J G Foster assumes command of the Federal Department of the South.

Eastern Theater Failing to find a weakness in Lee's entrenchments, Grant and Meade late at night move the Army of the Potomac northward back across the river and for the fourth time begin sidling around Lee's right, this time toward Hanovertown, 18 miles away. In the Shenandoah the new Federal commander of the Department of West Virginia, General David Hunter, heads toward Staunton with 16,000 men. Opposing this move is Breckinridge's replacement, General W E 'Grumble' Jones.

Western Theater, Atlanta Campaign After a day of skirmishing along their line of advance, Sherman's men halt for the moment and begin entrenching in the New Hope-Dallas area.

27 May 1864

Eastern Theater Early in the day, Federals, led by Sheridan's cavalry, put two pontoon bridges across the Pamunkey River and occupied Hanovertown. Cavalry skirmishes erupt in several locations as the rest of the Army of the Potomac moves into Hanovertown during the day. To the south, Lee begins moving to head off the Federals.

Western Theater, Atlanta Campaign Heavy fighting is seen around the New Hope-Dallas line as the opposing forces jockey for position. Sherman loses 1400 casualties in an unsuccessful attempt to turn the rebel right. Confederate losses are light. In the evening Johnston directs Hood to attack the end of the Federal left flank the next morning.

Trans-Mississippi Confederate raider Jo Shelby, campaigning in Arkansas, is named commander of Confederate troops north of the Arkansas River.

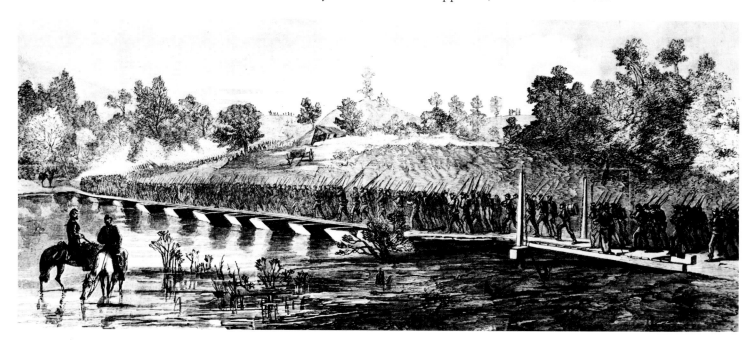

28 May 1864

Eastern Theater Lee's Army of Northern Virginia hurries to get in front of Grant, moving toward Cold Harbor as the Federals cross the Pamunkey River near Hanovertown.

Western Theater, Atlanta Campaign Hood, ordered to attack around Sherman's left flank, reports to Johnston that the Union flank is guarded by entrenchments at right angles to the front. Johnston cancels the attack.

29 May 1864

Eastern Theater Having crossed the Pamunkey River, Grant and Meade's Army of the Potomac march southwest toward Richmond. Between them and the Confederate capital stretch Lee's lines.

30 May 1864

Eastern Theater Grant's forces begin arriving at the north bank of the Totopotomoy River, facing Lee's line across the river and north of the Chickahominy. The Federals are now within 10 miles of Richmond. Another day's skirmishing is seen in the area. Federals are reinforced by two corps under the contentious General W F 'Baldy' Smith.

Western Theater Confederate raider John Hunt Morgan, in action again after his escape from a Federal war prison in Ohio, begins attacking Sherman's distant supply lines in Kentucky.

31 May 1864

The North A group of Radical Republicans hostile to Lincoln's conduct of the war, emancipation and reconstruction meets in Cleveland, Ohio, to nominate their own presidential candidate, General John Charles Frémont.

Eastern Theater Grant, still trying to move around Lee's right, sends some of his forces south toward Cold Harbor. Lee moves again to cut him off. Skirmishes again mark the day's fighting.

Western Theater, Atlanta Campaign The running battle between Sherman's forces and Johnston's Army of Tennessee has by now claimed about 9000 casualties on each side during May. Hostilities continue around the New Hope-Dallas area.

1 June 1864

Eastern Theater, Battle of Cold Harbor Lee begins to shift forces to meet Grant's new threat, moving men out of Richmond north to the rivers near Cold Harbor. Before dawn Lee moves against Federal troops holding the important road junction of Cold Harbor, wishing to turn Grant's flank before he can attack the Confederate left. But two badly-managed Southern attacks are repulsed, partly by Sheridan's cavalry using the new Spencer repeating rifles. Lee then orders reinforcements to his right flank, and three strong Federal advances against the right and center are turned back late in the day, Smith on the Federal side having been delayed in moving up by a mistake in orders. The attacks show that the Confederates have dug in with their usual efficiency and are able to direct a heavy fire all along their lines. Grant moves Hancock's corps southward to his left and orders an attack tomorrow morning.

Western Theater, Atlanta Campaign The

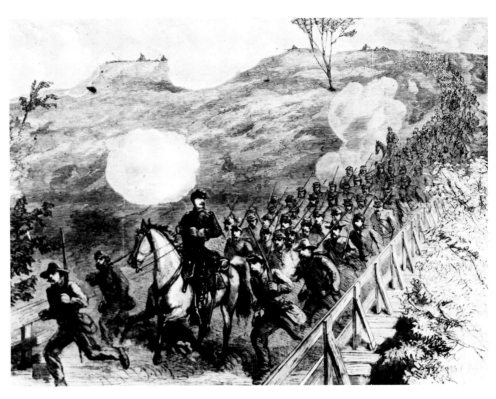

success of Sherman's advance toward Atlanta is absolutely dependent on his ever-lengthening supply line, and his careful planning and protection of that line are to mark the entire campaign. This day the vital connection between Chattanooga and the Federals' current position near Dallas, Georgia, is secured by General George Stoneman's cavalry, who capture Altoona Pass and its railroad line. Now Sherman will begin moving his troops away from the Dallas area northwestward to his lifeline along the railroad. At the same time, Sherman orders operations to protect the distant reaches of his supply line, particularly against the depredations of General Forrest, who is now gathering his forces in Tupelo, Mississippi. Sherman says, with his customary ferocity: 'That devil Forrest . . . must be hunted down and killed if it costs 10,000 lives and bankrupts the Federal treasury.' To this end, Union General S D Sturgis is sent with 3000 cavalry, 4800 infantry and 18 guns to deal with Forrest; Sturgis today leaves Memphis and heads toward Ripley, Mississippi. Meanwhile, rebel raider John Hunt Morgan is active against Sherman's supply lines in Kentucky, today engaging in a skirmish near Pound Gap.

2 June 1864

Eastern Theater, Battle of Cold Harbor Grant's general assault on Lee's lines, ordered for the early morning, is delayed by slow troop movements, fatigue and supply problems. After a heavy rain begins in the afternoon, the attack is again delayed until tomorrow morning. Union soldiers see all too clearly what such a charge directly on strong fortifications will entail. Walking through the troops in the evening, General Horace Porter discovers an awesome sight: 'I noticed that many of the soldiers had taken off their coats and seemed to be engaged in sewing up rents in them. On closer examination it was found that the men were calmly writing their names and addresses on slips of paper and pinning

Above: The fighting at Cold Harbor was characterized by a series of fruitless attacks as both sides sought to outflank each other.

them on the backs of their coats, so that their dead bodies might be recognized and their fate made known to their families at home.' After an abortive attack during the day, Lee's officers during the evening carefully lay out and strengthen their defenses for the expected attack. In the Shenandoah Valley, Sigel's replacement General David Hunter sees action against Confederates under W E Jones at Covington, Virginia. Hunter, ordered by Grant to do what Sigel failed to do and sweep the valley, is headed south for Staunton with 16,000 men, opposed by Jones's 8500 infantry and cavalry.

3 June 1864

Eastern Theater, Battle of Cold Harbor Grant has determined to make a decisive blow on Lee's army, hammering his lines in a direct assault like the one that initially overran the Bloody Angle at Spotsylvania. The charge is to be led by the corps of Hancock, Wright and Smith, later to be reinforced by Warren and Burnside, on the center and right of Lee's lines under Anderson and Hill. The attack is intended to be pressed regardless of cost. It begins at 0430 hours, countless thousands of Union soldiers rising from their entrenchments and marching straight toward the fortifications of the enemy. Then, 'there rang out suddenly on the summer air such a crash of artillery and musketry as is seldom heard in war.' The dead and wounded fall in waves like mown wheat. For a short time the Confederate breastworks are reached, but then a murderous countercharge sends the Federals back.

Within the space of a half hour 7000 Federal troops are killed and wounded, their bodies blanketing the ground before the enemy breastworks. Each of the three Union corps commanders complains to Meade that the other two have failed to protect his troops

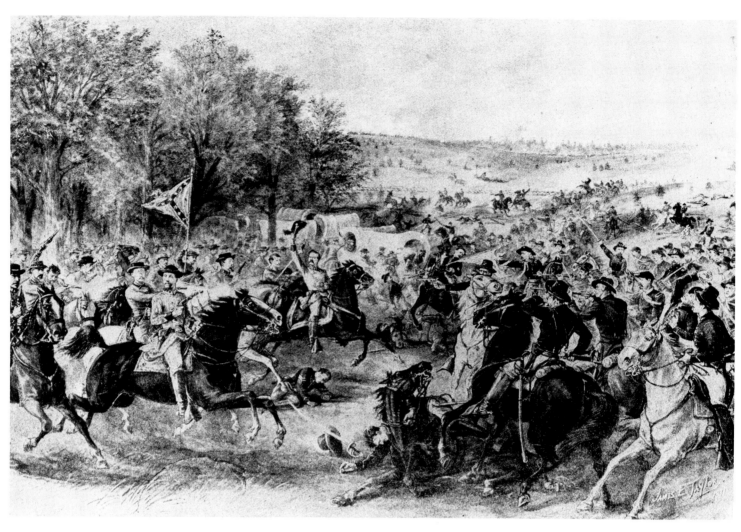

Above: Sheridan's cavalry launch a furious but ultimately unsuccessful attack on Southern positions at Trevilian Station, 12 June 1864.

from enfilade fire; this is because the three corps have attacked on diverging lines toward the defenses, thus opening their flanks to fire. Incredibly, after the devastated troops have fallen back from the first attack, the order comes from Grant for a second general assault, this time by corps without reference to others, thus sacrificing unity of attack. This charge is mounted raggedly, with many troops holding back, and it is repulsed, leaving fresh heaps of dead and wounded. Finally Grant orders a third advance. This order is essentially ignored. In the evening Grant admits, 'I regret this assault more than any one I have ever ordered.' A later commentator puts it more directly: 'Cold Harbor represents a horrible failure of Federal generalship.' But the failure continues. A Union observer writes: 'The groans and moaning of the wounded, all our own, who were between the lines, were heartrending.' These wounded are simply to be abandoned. For three days Grant will make no effort to propose a truce to collect his wounded; to go out between the lines without a truce is suicidal, though some Confederates risk their lives to bring in nearby Union wounded. Not until 7 June will Union stretcher parties actually be sent out. By this time all but two men of those thousands have died, horribly, of wounds, thirst, hunger and exposure, all in full sight of both lines. The reason for this callous abandonment is

partly, perhaps, the tradition that says the first commander asking permission of the enemy to bring in wounded is the loser, and Grant will not admit to being the loser.

When Grant calls off the attack at noon, Federal killed and wounded for 3 June total around 7000, added to the 5000 casualties of 1 and 2 June. The day's Confederate losses are probably under 1500. Grant will observe in his memoirs: 'No advantage whatever was gained from the heavy loss we sustained.' A Northern observer notes that the Army of the Potomac 'has literally marched in blood and agony from the Rapidan to the James.' The

men have marched, slept, and fought for one month in the same blood- and sweat-stiffened uniforms; the roads of their march are strewn with the carcasses of 6000 horses. Federal casualties in the month of incessant campaigning have been 50,000, 41 percent of their original strength; the South has lost 32,000, 46 percent of its strength, and these losses are irreplacable.

Below: The Southern city of Petersburg, a rail center, was the major objective of Grant's forces during the summer of 1864; it finally fell on 3 April 1865.

4 June 1864

Eastern Theater The armies of Grant and Lee lie quietly in their entrenchments, listening to the groans and entreaties of the Union wounded. Hunter's Federals, moving down the Shenandoah, skirmish at Port Republic and Harrisonburg, Virginia.

Western Theater, Atlanta Campaign Realizing that Sherman is flanking him again, moving northeast toward the Atlanta-Chattanooga railroad, Johnston during the night moves the Army of Tennessee out of the New Hope-Dallas area toward his already-made lines in the mountains before Marietta. There are engagements at Big Shanty and Acworth, Georgia.

5 June 1864

Eastern Theater Confederate General W E Jones makes his stand against Hunter's advance toward Staunton, Virginia, turning 5000 men toward Hunter's main body. But the Federals drive Jones back to his defenses at Piedmont, where he is pounded by Union artillery. A series of attacks and counterattacks ensues, which finally sends the Confederates into a rout during which Jones is killed. Hunter loses 780 men to the South's 1600, of whom 1000 are taken prisoner. Tomorrow Hunter will enter Staunton unopposed.

7 June 1864

The North The National Union Convention – essentially the Republican Party but with some Democrats who support the war – opens in Baltimore with Lincoln the unanimous candidate for president, but with some question about the vice-presidency and with the anticipated wrangles between Radical and mainstream Republicans.

Eastern Theater The opposing armies still lie in their entrenchments at Cold Harbor, Union men finally moving out to pick up their dead; only two of the wounded have survived since the battle of 3 June. Grant and his staff are despondent at their failure to overwhelm Lee; clearly, the direct-assault tactic will not work. Grant slowly accepts the inevitable next move – he must move his army south across the James to threaten Petersburg, the back door to Richmond. As a diversion for his coming move, Grant sends Sheridan's cavalry west to join Hunter at Charlottesville and operate against railroads from there to Hanover Junction. This will become known as Sheridan's Trevilian raid (so named after a town where some of the action occurred).

8 June 1864

The North By a large majority Lincoln is nominated for president by the National Union Convention in Baltimore. In a surprising move never quite explained – Lincoln claims he is neutral on the issue – Democrat Andrew Johnson of Tennessee is nominated for vice-president over the incumbent Hannibal Hamlin. It is perhaps felt that a Southern Democrat who supports the war will be useful to the ticket. The party platform calls for reunification, pursuing the war to its end, no compromise with the South and a constitutional amendment forbidding slavery.

Western Theater Sherman's men gather around the Western and Atlantic Railroad,

Above: A number of pontoon bridges built across the James River allowed the four corps of Grant's command to close on Petersburg.

ready to close in with Johnston before Marietta, Georgia. Sherman has increasingly to weaken his forces to protect his supply line, now including the railroad back to Chattanooga. In Kentucky, John Hunt Morgan captures a Federal garrison at Mount Sterling, and in the action his raiders help themselves to $18,000 from the local bank.

9 June 1864

Eastern Theater General Benjamin Butler makes yet another mismanaged attempt on Petersburg. Beauregard sends the Federals packing, despite having only 2500 defenders to Butler's 4500 troops.

Western Theater Confederate raider Morgan and his men are routed from Mount Sterling, Kentucky.

10 June 1864

The Confederacy The Confederate Congress authorizes military service for all ages from 17 to 50.

Eastern Theater A Union force of 8000 men under General S D Sturgis, sent by Sherman to take care of Forrest, meet their assigned foe at Brice's Crossroads in Mississippi. The Confederate leader has learned the preceding evening of this advance, and beats the Federals to the crossroad. While his pickets hold the enemy, Forrest moves up his artillery and men, and when the Federals arrive in strength, tired from a forced march in fierce heat, they find themselves immediately under attack. Forrest pressures both Union flanks, which begin to give way late in the afternoon. Finally the Federals panic and run, leaving behind so much equipment that the Confederates have trouble getting around it to chase the fleeing ememy. Sturgis has been defeated by a force less then half as large as his own and has lost 227 killed, 394 wounded and 1623 captured, plus leaving 16 of his 18 guns and his entire supply train of 250 vehicles. Forrest reports losing 492 of 3500 engaged. It is one of 'that devil' Forrest's finest moments. At the end of the day the Federals are still running and rebels still pursuing. Elsewhere, Morgan's increasingly riotous raiders burn a Federal depot and stables in Lexington, Kentucky. In Georgia, Sherman's men move toward Johnston's mountain positions northwest of Marietta.

11 June 1864

Eastern Theater General Robert E Lee has dispatched his nephew, General Fitzhugh 'Fitz' Lee, and General Wade Hampton, Stuart's successor as cavalry commander, to stop Sheridan's depredations in Virginia, in fact a diversion from the planned movement of the Army of the Potomac on Petersburg. Hampton makes contact with Sheridan near Louisa. During the ensuing fight, Hampton is told that Federals are in his rear; these prove to be Custer's men, who have with their usual boldness struck between Hampton's and Fitz Lee's columns, capturing for the moment many Confederate horses and vehicles. Hampton turns to attack Custer with his own column, and after a confused battle Custer is fought back to Trevilian Station, by which time other Federals have driven Fitz Lee to Louisa. Elsewhere in Virginia, Hunter's men engage in depredations in and around Lexington, including burning the Virginia Military Institute. Robert E Lee dispatches General Jubal Early to deal with Hunter.

Western Theater Fighting off Forrest's men, Sturgis and his beaten Federals straggle back toward Memphis, where they will arrive on 13 June. Following this debacle, Sturgis will finish the war 'awaiting orders.'

Naval The CSS *Alabama*, most successful of Confederate seagoing raiders, sails into Cherbourg, France, for a period of much-needed refitting.

12 June 1864

Eastern Theater, Petersburg Campaign After several days of careful and secretive preparations, the four corps of the Federal Army of the Potomac pull quietly out of their positions at Cold Harbor and steal toward the

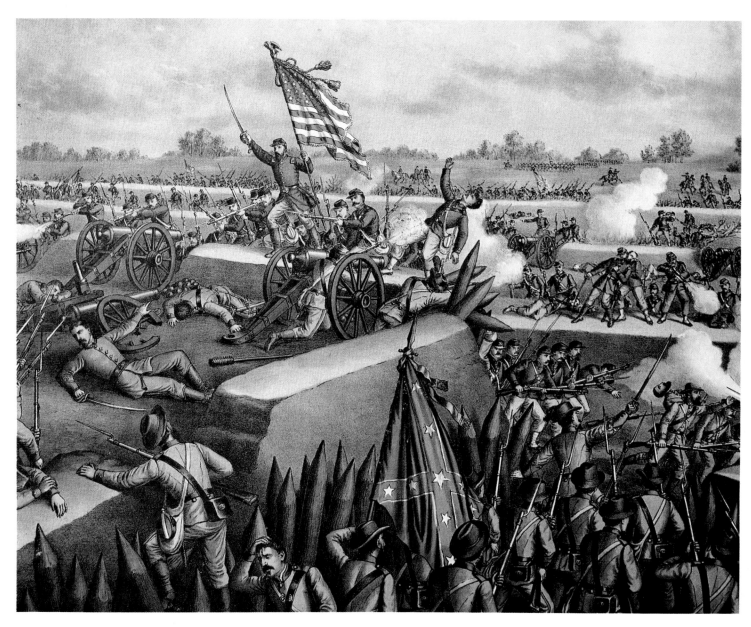

Above: Union troops attempt to storm the defenses outside Petersburg, 18 June 1864. All of the attacks were easily repulsed.

James River on roads and bridges, several of which have been built within the week – including a massive pontoon bridge across the James, 2100 feet long, to be built in a half day on 14 June. By 16 June the entire army will have been moved to the south shore of the James. Meanwhile, Warren's corps stays behind to screen the movement on the left flank. In this brilliantly planned and executed maneuver, Grant seems for once to have outsmarted Lee, who does not discover the move for several days, thus leaving largely undefended the goal of Grant's march – Petersburg. At Trevilian Station Sheridan mounts a furious attack against Hampton's entrenchments, but the attack is thrown back with heavy losses. Sheridan decides at length that he will not try to join Hunter in the valley as planned, but will move to rejoin Grant. After their repulse, Sheridan and his men begin moving back the way they came, having lost 1007 casualties of 8000 engaged (Confederate losses are uncertain but probably comparable.)

Western Theater Confederate raider Morgan and his 1300 men, having the previous day taken Cynthiana, Kentucky, are met and defeated in that town by 1500 Federals under General Burbridge. The Confederates lose nearly half their party. Morgan and his remaining troops flee toward Abingdon, Virginia, where he arrives on 20 June. In Mississippi, Forrest continues his pursuit of Sturgis.

13 June 1864

Eastern Theater, Petersburg Campaign
Lee, realizing the Federals have moved but not yet certain of the import of the move, guesses wrongly that the enemy's object is Richmond. Lee therefore moves southward to cut off approaches to the capital; this will have no effect on Grant. The Army of the Potomac smoothly continues its massive movement.

14 June 1864

Eastern Theater, Petersburg Campaign As the Army of the Potomac nears completion of its crossing of the James, Grant sends General W F 'Baldy' Smith's corps by water to Bermuda Hundred to join Butler in his 'bottle.' Grant goes along himself to plan an attack on Petersburg by Butler and Smith. Lee still does not perceive Grant's move and thus has not reinforced Petersburg.

Western Theater, Atlanta Campaign
During a conference of Johnston's staff at their position on the summit of Pine Mountain near Marietta, Georgia, Federal Parrott guns send a few shells toward the summit from Sherman's new position nearby. One of the shells hits General Leonidas Polk and kills him instantly.

Naval The USS *Kearsarge* moves toward Cherbourg, France, to blockade the raider CSS *Alabama*.

15 June 1864

Washington The House votes 95 to 66 against a joint resolution abolishing slavery.

The North Notorious Copperhead Clement L Vallandigham returns to Dayton, Ohio, from Canada to add his voice to the Democratic election efforts.

Eastern Theater, Petersburg Campaign
Having urgently requested reinforcements from Lee, Beauregard's messenger is told by Lee that Beauregard is in error in thinking a large force of Federals are south of the James. Ironically, at that same moment Beauregard's force of some 5400 defending Petersburg is under assault by W F 'Baldy' Smith's whole corps of 16,000 men. Lee still does not understand Grant's move, and Petersburg is thus in serious danger. But the Federals have had

a day of mishaps: Smith's attack, scheduled for early morning with reinforcement from Hancock, is delayed until 1900 hours by Smith's slowness; meanwhile, Hancock is being delayed by a combination of faulty maps, hazy orders from Grant and an unnecessary stop for provisions. Nonetheless, Smith's attack in the evening makes good headway, not surprising since his force is three times the enemy's. When Hancock finally arrives, he suggests that both he and Smith use the moonlit night to press the attack on Petersburg. Success is in fact very likely. Then, making one of the great blunders of the war, 'Baldy' Smith decides against this. Instead, he asks Hancock to occupy the captured trenches while he withdraws. Hancock, though he is senior to Smith, agrees, thus perhaps prolonging the war by many months. During the night, Beauregard decides to abandon his position facing Butler in Bermuda Hundred and use the men to reinforce Petersburg.

Western Theater, Atlanta Campaign Sherman's corps under Thomas, McPherson and Schofield close in amid skirmishes on Johnston's position near Marietta, Georgia.

16 June 1864

Eastern Theater, Petersburg Campaign
Confederate commander Beauregard, having pulled in most of his Bermuda Hundred line, now has 14,000 men to defend Petersburg. By now the entire Union Army of the Potomac except for Wright's corps is across the James and at the door of Petersburg. Grant and Meade, arriving in the morning, direct the day's renewed assaults, which by late evening have with many losses captured several positions. Meanwhile, in the afternoon Federals overrun the remaining 1000 Confederates at Bermuda Hundred. Lee, still not aware of the threat to the city, sends replacements not to Petersburg but to Bermuda Hundred.

17 June 1864

Eastern Theater, Petersburg Campaign
Another series of Federal attacks on Petersburg make slow and costly headway, and late in the day Beauregard actually recaptures

some positions. During the night the defenders pull back into a tighter and tougher position. Lee, perceiving at last the Federal threat, orders Hill and Anderson to Petersburg. Meade orders another attack for tomorrow.

18 June 1864

Eastern Theater, Petersburg Campaign
During the day a series of badly-coordinated assaults are launched against Petersburg as Confederate reinforcements begin to arrive from Lee. All the early Federal efforts meet with costly repulses. A major Union attack beginning at 1400 hours makes some progress but is terribly costly – in 30 minutes one regiment loses 632 of 900 engaged, the highest casualties of any Union regiment in a single battle during the war. As the fighting ends with darkness, Grant gives up the idea of making an assault. In four days of storming the entrenchments, the North has lost 1688 killed, 8513 wounded, and 1185 captured and missing, a total of 11,386 casualties of 63,797 engaged; Confederate losses are unknown in the 41,499 engaged by the end of the day. The opportunity of taking Petersburg when it was weak has been lost; reinforcements have arrived along with Lee himself, and the city is now effectively impregnable. The only course hereafter is a siege, and Grant begins preparations to that effect. Grant has over 110,000 men to work with, to Beauregard's 50,000, and the North holds two rail lines and several roads. But poor Union leadership will mark the ensuing siege, and so will the continuing brilliance of Lee's defense. Meanwhile outside Lynchburg, Hunter is repulsed in an attack on Breckinridge and some of Early's corps. Finding Early is moving toward him in force, Hunter retreats, eventually to end up in Parkersburg and Martinsburg, Virginia. Having dispensed with Hunter, Early is now freed for other excursions.

19 June 1864

Naval As crowds of observers watch from nearby cliffs and from a British yacht, the CSS *Alabama* under Captain Raphael Semmes sallies out near Cherbourg, France, to meet the

USS *Kearsarge* under Captain John A Winslow. A fierce battle ensues, the ships circling closer and closer while blazing away with their cannon. At length the *Alabama* is crippled and limps toward shore, striking its colors as it settles. The English yacht, the *Deerhound*, is given permission by Captain Winslow to pick up survivors as the *Alabama* goes down. While the men watch from the *Kearsarge*, the yacht picks up a number of sailors, including Captain Semmes, and proceeds to steam rapidly out of reach; thus the defeated captain and some crew make a getaway to neutral England. The Confederates have nine killed and 21 wounded to the Union ship's three wounded. This ends the high-seas career of the Southern commerce raider *Alabama*, which has taken 65 Federal merchant ships in the course of the war.

21 June 1864

Eastern Theater, Petersburg Campaign
Wishing to extend his siege into a semicircle around Petersburg and cut Southern supply lines, Grant orders General Birney (who has replaced the wound-troubled Hancock) to seize the Weldon Railroad, and General Wright to cut the road to Lynchburg. Later in the day, Grant and the visiting President Lincoln tour the siege lines on horseback. Lincoln's visit to the area will conclude tomorrow after a talk with General Butler.

22 June 1864

Eastern Theater, Petersburg Campaign
Pursuing their previous day's orders from Grant, Generals Birney and Wright move out on their separate operations around Petersburg. But both are met by Confederate divisions under A P Hill. Birney is attacked and driven back with 2962 casualties including 1600 prisoners, in an engagement on the Jerusalem Plank Road. Meanwhile, Wright's forces are blocked and Federal cavalry under Wilson are turned back amid heavy skirmish-

Below left: The fighting around Petersburg between the 15th and 18th of June.
Below: The destruction of the Southern *Alabama* by the USS *Kearsarge*, 19 June 1864. The battle took place off the French coast.

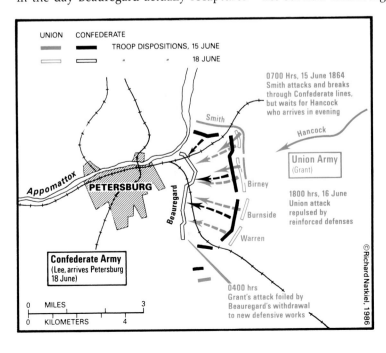

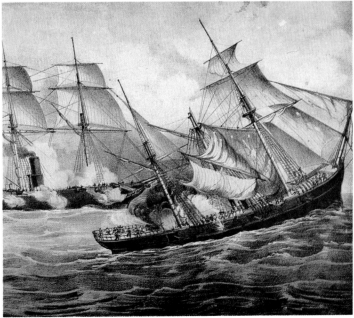

ing after destroying some railroad track. Although these Union efforts to extend the siege lines have largely failed, Federal forces do next day gain a foothold on the Jerusalem Plank Road.

Western Theater, Atlanta Campaign Sherman's men have now closed in on Johnston's positions northwest of Marietta, Georgia. Today Confederate General Hood makes a determined but unsuccessful attack on the Federals near Zion Church.

23 June 1864

Eastern Theater, Petersburg Campaign Union cavalry briefly hold a section of the Weldon Railroad near Petersburg, but are driven off. Federal cavalry under Wilson, moving against Confederate supply lines on the South Side Railroad, are in action at Nottoway Court House. Federal cavalry commander Sheridan moves toward Grant's army with a huge wagon train. In the Shenandoah, Confederate General Jubal Early moves north from Lynchburg while skirmishing with Hunter's retreating army.

Western Theater, Atlanta Campaign Two weeks of rain have kept action down between the armies of Sherman and Johnston near Marietta. As the rains end Sherman begins to gather his forces for a new effort. After his highly successful flanking maneuvers, Sherman has decided on a general assault on the strongly entrenched Confederates.

25 June 1864

Eastern Theater, Petersburg Campaign Based on an innovative plan by mining engineer Colonel Henry Pleasants, enthusiastically supported by Burnside and approved without enthusiasm by Grant, Federals begin digging a tunnel toward the Confederate earthworks at Petersburg. Eventually the mine is to be filled with powder and a crater blown in the Confederate fortifica-

Below: Union infantry and artillery wait for the order to assault the Confederate lines around Petersburg.

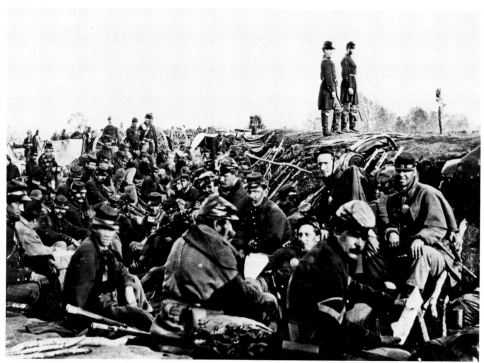

tions. The 511-foot shaft will be completed on 23 July. Also today, after a skirmish with Confederate cavalry on 24 June, Sheridan's cavalry and wagon train are back from their Trevilian raid and nearing reunion with the Army of the Potomac.

27 June 1864

Washington Lincoln formally accepts the nomination for president.

Eastern Theater, Petersburg Campaign At Staunton, Virginia, Confederate General Jubal Early organizes his army of 10,000 into two corps. Early plans an invasion of the North.

Western Theater, Atlanta Campaign The day has arrived for Sherman's general assault on Johnston's positions at Kennesaw Mountain near Marietta, Georgia. Sherman will describe the results in his memoirs: 'About 9 o'clock AM of the day appointed, the troops moved to the assault, and all along our lines for 10 miles a furious fire of artillery and musketry was kept up. At all points the enemy met us with determined courage and in great force . . . By 11:30 the assault was over, and had failed.' In three major uphill assaults into a hail of shot and shell, the Federal troops capture not one breastwork. A Southern soldier will recollect: 'A solid line of blue came up the hill. My pen is unable to describe the scene of carnage that ensued in the next two hours. Column after column of Federal soldiers were crowded upon that line. No sooner would a regiment mount our works than they were shot down or surrendered. Yet still they came . . . I am satisfied that every man in our regiment killed . . . fivescore men. All that was necessary was to lead and shoot. In fact, I will ever think that the reason they did not capture our works was the impossibility of their living men to pass over the bodies of their dead.' Federal losses in the battle are 1999 killed and wounded and 52 missing, over 2000 casualties out of a total of 16,229 attackers; Confederates numbered some 17,733, their losses 270 killed and wounded and 172 missing.

30 June 1864

Washington Radical Republican Secretary of the Treasury Salmon P Chase, after a number of wrangles with Lincoln, submits another in a series of resignations. This time, to Chase's apparent surprise, Lincoln accepts the resignation and begins looking for a new secretary.

Eastern Theater, Early's Washington Raid Putting in motion his projected invasion of the North, Confederate General Jubal Early moves his army to New Market, Virginia.

2 July 1864

Eastern Theater, Early's Washington Raid Early's column heads north toward the Potomac, meeting little resistance as it moves into Winchester, Virginia.

Western Theater, Atlanta Campaign Realizing that, after his failed assault, Sherman is returning to his flanking tactics, Johnston pulls his army back south of Marietta, again to lines already prepared. In Charleston Harbor, South Carolina, Federal troops establish a beachhead on James Island prior to further attacks on the city's defenses.

3 July 1864

Eastern Theater, Early's Washington Raid The Confederates meet forces under Franz Sigel and over two days drive them back near Harper's Ferry. Panic begins to spread among civilians north of the Potomac.

Western Theater In Charleston, two Union attacks on Confederate forts on the outskirts of the town are turned back.

4 July 1864

Washington Receiving the radically-inspired Wade-Davis Bill just passed by the Senate, with its punitive plans for reconstruction, Lincoln pocket-vetoes the measure. In the storm of protest that follows, Lincoln will stand firmly by his more lenient policies, which he is now putting into effect in Louisiana and Arkansas.

Western Theater, Atlanta Campaign Finding Sherman about to get between his army and Atlanta, Johnston again pulls back, this time to the Chattahoochee River northwest of Atlanta.

5 July 1864

Eastern Theater, Early's Washington Raid Avoiding Sigel's forces at Harper's Ferry, Early begins crossing the Potomac into Maryland at Shepherdstown. As consternation breaks out in Washington, Grant and Chief of Staff Halleck begin to take Early seriously, dispatching reinforcements on the morrow. Meanwhile, militia are called up to defend Maryland.

Western Theater Another Federal expedition against Confederate raider Forrest commences; Union troops leave LaGrange, Tennessee, under command of General A J Smith.

6 July 1864

Eastern Theater, Early's Washington Raid The Confederates finish crossing the Potomac and easily capture Hagerstown, Maryland, where $20,000 is demanded of the citizens, nominally in reparation for Hunter's raids in June.

7 July 1864

Eastern Theater, Early's Washington Raid Federal reinforcements arrive in Washington and Baltimore as Early's 'invading army' skirmishes in several places around Middletown.

Western Theater In Charleston Harbor, Federals are driven from their beachhead on James Island. In 10 days of fighting in the area, Union forces have lost 330 to the South's 163. Still another Federal bombardment begins on the rubble of Fort Sumter.

8 July 1864

Western Theater, Atlanta Campaign Against the wishes of President Davis, Johnston responds to new Union flanking movements by ordering the Army of Tennessee back south of the Chattahoochee River to the gates of Atlanta. Tomorrow Bragg will arrive, sent by Davis for consultation. Sherman is rapidly accumulating forces and supplies for the assault on Atlanta, and orders operations on Southern railroad lines between Columbus, Georgia, and Montgomery, Alabama; these are carried out by 22 July.

9 July 1864

Eastern Theater, Early's Washington Raid Arriving at the Monocacy River near Frederick, Early finds in his path a force of 6000 Federals under General Lew Wallace. A series of largely unplanned Confederate

Below: As the *Alabama* sinks beneath the waves, an English yacht moves in to pick up survivors from the stricken vessel.

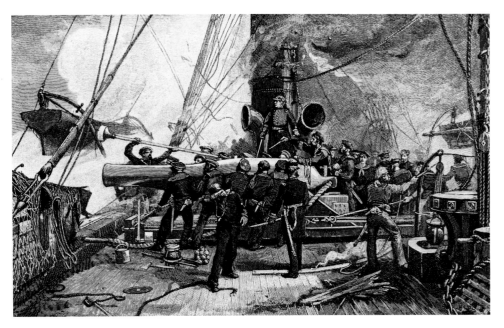

attacks eventually routs the hastily-assembled Union forces, many of whom are inexperienced and untrained. Confederate casualties are around 700 of 14,000 engaged; Union casualties are put at nearly 2000, most of them 'missing.' Rather than wasting forces in pursuit, Early presses on toward Washington, stopping to demand a $200,000 levy in Frederick. By now Washington is seriously worried: 'long guns sprouted with bayonets are going about in company with short clerks . . . and every body is tugging some sort of death-dealing tool.'

Above: The scene on the deck of the *Kearsarge* during the encounter with the *Alabama* – the crew of a cannon prepare to fire.

10 July 1864

Washington Lincoln, seemingly unperturbed by Early's approach, tells a group in Baltimore: 'Let us be vigilant but keep cool. I hope neither Baltimore nor Washington will be sacked.' Nevertheless, Early's deep thrust toward the Northern capital provokes widespread fear among the civilian population in and around Washington.

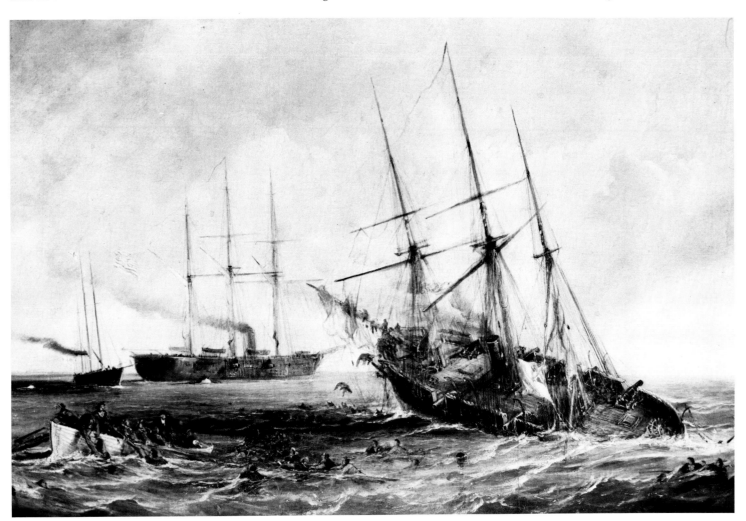

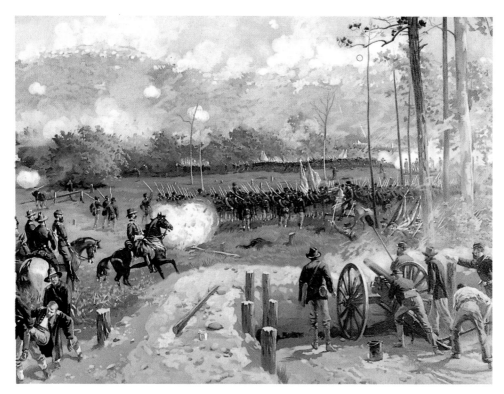

Above: Union artillery provides covering fire as Sherman's men launch their attack on Kennesaw Mountain, Georgia.

11 July 1864

Eastern Theater, Early's Washington Raid By noon Early's army arrives at Silver Springs, Maryland, on the outskirts of Washington. Confederates spend the day reconnoitering for the proposed attack tomorrow. Skirmishing flares at Frederick and at Fort Stevens near Washington, where the president and his wife are sightseeing the battle; Lincoln at one point is under fire as he looks over the parapets. But Early begins to observe reinforcements moving into the capital from Grant's army – Wright arrives with a corps during the day. Many of the rest of the defenders are raw troops, however. Finally, during the night Early decides to give up the attack. Whether he could have actually taken the capital remains uncertain but some of his soldiers are sure he could have, and a correspondent inside the city observes: 'I have always wondered at Early's inaction. Washington was never more helpless. Our lines . . . could have been carried at any point.'

12 July 1864

Eastern Theater, Early's Washington Raid Having decided to give up his assault on Washington, Early's men skirmish on the outskirts before pulling out at night. During action at Fort Stevens, Lincoln again stands up to watch, prompting an officer to shout, 'Get down, you fool!' Before their withdrawal, the Confederates burn the home of Postmaster General Montgomery Blair.

13 July 1864

Eastern Theater Early's forces retreat toward the Potomac at Leesburg; in pursuit is a force of 15,000 under General Horatio Wright.
Western Theater In their campaign to stop General Forrest and his raids on Sherman's all-important supply lines, Federals under A J Smith near their quarry at Tupelo, Mississippi. Forrest's men move up for an attack, and there are minor actions during the day.

14 July 1864

Eastern Theater Early's forces safely cross the Potomac at Leesburg; Wright informs Washington that he does not advise pursuing the enemy into Virginia.
Western Theater At Tupelo, Mississippi, Smith has established strong entrenchments on his front, and against these Forrest and General S D Lee throw a series of assaults that are turned back with heavy losses. The Confederates withdraw by noon while the Federals stay in their positions all day; an evening attempt by Forrest to envelop the enemy left is also unsuccessful. Of Smith's 14,000 men, there are 674 casualties to Forrest's 1347 of 9500 engaged. Plans are made to renew the battle tomorrow.

15 July 1864

Western Theater A further Southern assault on Smith's entrenchments is repulsed with little loss to either side. A worse problem is the heat, from which many soldiers are collapsing. Around noon a further Confederate advance reveals that Smith, worried about short supplies, is retreating. The Confederates follow amid skirmishing but are repulsed, Forrest being slightly wounded. While this action at Tupelo has been nominally a Federal victory, it has been a defensive one when the point was to mount an offensive. Thus Forrest is still fully at large, though Smith does manage to protect the Nashville to Chattanooga railroad.

16 July 1864

Eastern Theater Early and his men are moving with little immediate opposition back toward the Shenandoah Valley, where they will engage in a busy summer's raiding.
Western Theater, Atlanta Campaign Johnston works on his fortification around Atlanta, planning to attack the enemy if opportunity presents. Sherman's army is moving across the Chattahoochee on pontoon bridges; McPherson is sent on a wide enveloping movement through Decatur, Georgia.

17 July 1864

Eastern Theater, Atlanta Campaign A telegram arrives from President Davis relieving the cautious Johnston from command of the Army of Tennessee, and replacing him with General John Bell Hood. Although Hood has the reputation of being a fighting commander, he faces immense difficulties in holding on to Atlanta.

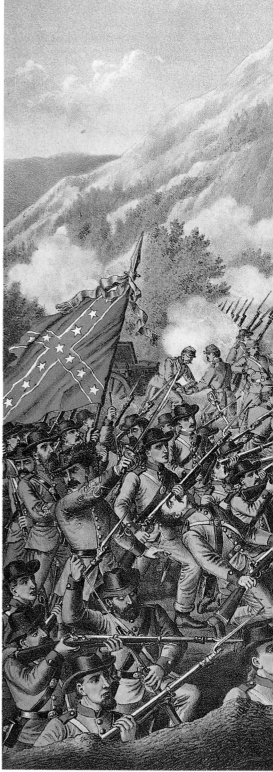

19 July 1864

Eastern Theater Federals catch up with Early's forces near Berryville and a sharp series of skirmishes ensues in the area. After a repulse at Berry's Ford and the news of Union troops threatening his supply train, Early retreats toward Strasburg.

Western Theater, Atlanta Campaign Sherman closes his forces on Atlanta, McPherson on one wing moving through Decatur to the east, Thomas on the other wing pushing across Peachtree Creek to the north, and Schofield advancing in the center. Sherman finds such feeble resistance that he wonders if the Confederates are evacuating. But Hood is readying his forces to fall on Thomas.

20 July 1864

Eastern Theater Federals continue to harass Early's retreat on Strasburg, Virginia. There are many fierce, small-scale engagements. At Stephenson's Depot, near Winchester, a division of Confederates under S D Ramseur are defeated by Federal General W W Averell, who captures 250 men. But Early's main body is till intact.

Western Theater, Atlanta Campaign Sherman's men are today introduced to what will be Hood's tactics for the remainder of the campaign. Federal General Thomas's Army of the Cumberland is resting in the afternoon after crossing Peachtree Creek, when Confederates under Hardee attack in force. The fighting is desperate and often hand-to-hand. Soon Thomas moves up cannon and as they begin firing he directs his resistance from the front, arranging a devastating enfilade fire. After two hours of frantic assault, the Confederates fall back with losses of 4796 from 20,000; Federal losses are about 1779 from the same number engaged. Hood has failed in his first test, and Thomas has preserved the reputation he gained as the 'Rock of Chickamauga.'

Below: One of many Union assaults on the lines of Southern breastworks on the slopes of Kennesaw Mountain. The Union attacks were repulsed with heavy losses.

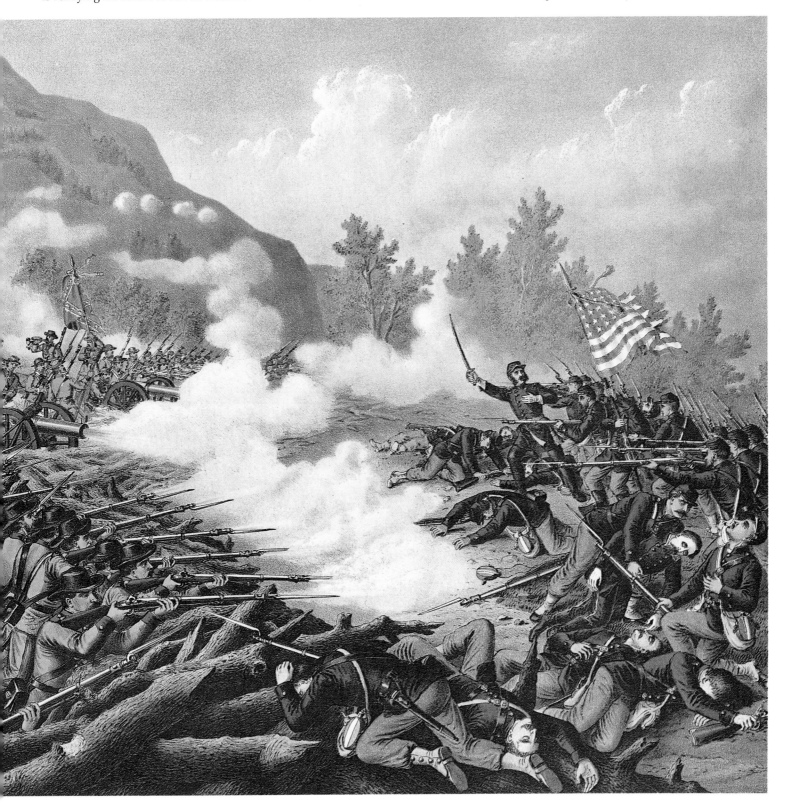

Above: Southern General Jubal Early led an inspired raid against Washington in mid-1864, but stopped short of the Northern capital when larger Union forces closed in.

21 July 1864

Eastern Theater, Atlanta Campaign Determined to press an offensive, Southern commander Hood sends Wheeler and Hardee toward McPherson's Army of the Tennessee; these Federals are in an exposed position near Decatur, from where they are moving to form Sherman's left wing around the south of Atlanta. Sherman's middle and right under Schofield and Thomas are in position.

22 July 1864

Western Theater, Battle of Atlanta About noon McPherson and Sherman are conferring when firing is heard from the left; McPherson rides off to investigate the action. After a 15-mile march, Hardee has made his attack, which is intended to flank McPherson and get in the rear of the Union forces. A furious assault initially causes consternation in the Federal ranks, but McPherson arrives just as a successful counterattack is mounted. Having seen this success, the general is riding to direct other positions when he is intercepted by Confederate skirmishers, who silently signal him to surrender. McPherson tips his hat to the enemy and bolts; he is shot from his horse and killed instantly. New charges by the Confederates then gain some ground, but by 1500 hours these attacks are being halted. Realizing this, Hood orders General Cheatham to make another attack closer to the Federal center. This action makes some headway before being repulsed by a Federal counterattack. Meanwhile, Confederate cavalry under Wheeler are moving unsuccessfully against Federals in Decatur.

As evening falls, Hood's men have made no gains; failing for the second time to dislodge Sherman, they sink back to their entrenchments. Federal casualties for the day are 430 killed, 1559 wounded, 1733 missing, for 3722 casualties out of over 30,000 engaged. Sherman, now in effect besieging Atlanta, will next turn his attention to Hood's supply lines.

24 July 1864

Eastern Theater At Kernstown, Virginia, Jubal Early's army attacks a group of Federals under General George Crook. A rout ensues, and the Federals flee to Bunker Hill, West Virginia, with 1185 casualties to light losses for the Confederates. Early's cavalry will pursue Crook northward on the 25th, when the Federals will repulse their pursuers at Williamsport on the Potomac.

25 July 1864

Eastern Theater, Petersburg Campaign Grant attempts to tighten his hold on the city by sending forces against the railroads leading toward Richmond.

27 July 1864

Eastern Theater, Petersburg Campaign Work having been completed as of 23 July on the mine under the Confederate entrenchments, preparations are being made for its detonation on 30 July. The mine is being filled with 320 kegs of powder, and Burnside's black troops are engaged in special training for the assault, when they will run through the crater blasted into Southern positions. In the northern Shenandoah, Early's men destroy Union rail lines and prepare to recross the Potomac.

Naval The Union navy under Admiral Farragut engages in reconnaissance preparatory to an attack on Mobile Bay, Alabama.

28 July 1864

Eastern Theater, Atlanta Campaign Following up Stoneman's and McCook's raids around Atlanta, Sherman sends Howard and the Army of the Tennessee south of Atlanta to move against the vital railroads supplying the city from the south. Again the aggressive Hood takes the offensive, sending corps under General S D Lee against the Federals at Ezra Church. Howard digs in and repulses the enemy, and Hood's third sortie is turned back with losses of up to 5000. But the Federals have been prevented from cutting the railroad.

29 July 1864

Eastern Theater Once more Early crosses the Potomac west of Williamsport and spreads consternation into Maryland and

Pennsylvania. His men are engaged in fighting at Harper's Ferry, West Virginia, Hagerstown and Clear Spring, Maryland and Mercersburg, Pennsylvania.

30 July 1864

Eastern Theater, Petersburg Mine Assault It is perhaps significant that two of the most incompetent Federal generals of the war, Butler and Burnside, are both attracted to novel methods of warfare. One of Butler's pet ideas, the wire entanglements used at his otherwise deplorable Drewry's Bluff action, has at least proved effective. Burnside's mine, planned by Colonel Pleasants to blow a crater into the enemy works through which an attack can be mounted, is in fact an innovative idea of possibly great consequence in the siege of Petersburg. Today after a month's work the detonation is scheduled and the troops are ready. However, the previous day Meade with Grant's approval has decided that the black troops of Ferrero's IX Corps, the only ones specially trained to pursue the mission, are not to lead the attack, since if it fails the Union will be accused of callously misusing its black soldiers (which, given the experimental nature of the operation, is very possibly the case). After this rebuff, Burnside is chagrined and proceeds with some indifference, drawing straws to select who will lead the assault (Ledlie, 1st Division, loses) and being a little hesitant about final preparations and instructions. The explosion is set for 0300 hours. At that moment every Federal eye strains toward the fortifications. Nothing happens. An investigation by two volunteers finds the fuse has gone out. They relight it. At 0445 one of the largest explosions ever seen on the American continent sends flames, earth, cannon, bodies and parts of bodies 100 feet into the air in the midst of a mushroom-shaped cloud. When all this has descended and settled, there is a crater 170 feet long, 60 to 80 feet wide and 30 feet deep stretching well into the Southern positions. At least 278 Confederates have been killed in the explosion or smothered in the debris. For the time being the defenders have fled the area as Union

Below: Confederate troops attempt to storm hastily constructed Union defenses during the Battle of Ezra Church, 28 July 1864.

attackers descend into the hole. Finding themselves in a maze of trenches and pits, the men falter. Meanwhile, their commander, Ledlie, is cowering in a bombproof shelter behind his lines. Soon the Confederates collect themselves and in an exemplary manner begin to train their artillery into the hole; finding themselves somewhat sheltered from this fire, the ostensible attackers are even less disposed to pursue their assault. By the time 15,000 men have been herded into the crater, the enemy fire has become truly murderous and the Federal attackers are only interested in hiding. The Union army is now quite literally at the feet of the enemy. Finally, in desperation, the black troops originally slated to head the attack are ordered in; after dispatching them, their commander, Ferrero, joins Ledlie in the bombproof shelter. The black troops advance quickly and resolutely, followed by not one white soldier, and are cut to pieces on the other end. The whole inglorious affair ends with a confused melee of surviving Union soldiers rushing devil-take-the-hindmost back to their own lines. The North has lost 3748 casualties of 20,708 engaged, the Confederates about 1500 of 11,466.

Also on this day, Confederate cavalry from Early's forces ride into Chambersburg, Pennsylvania, and offer not to burn down the town if $500,000 in cash or $100,000 in gold can be raised, to help the raiders meet expenses and serve as more 'reparations' for Hunter's Federal raids in the Shenandoah. The sum is not obtainable, however, and the town is duly put to the torch. The rebels

move on west to McConnellsburg, pursued at some distance by Averell.

Western Theater, Atlanta Campaign Sherman's raiders Stoneman and McCook, engaged in disrupting operations on Confederate supply lines around Atlanta, both run into trouble. Stoneman and 700 men are captured by the enemy on the outskirts of Macon; McCook has to fight his way out of a Confederate encirclement at Newman, and loses 500 men and many supplies.

1 August 1864

Eastern Theater, Valley Campaign Grant gives cavalry commander Philip H Sheridan the mission of clearing the enemy, especially Early, out of the Shenandoah Valley. Early's cavalry leader McCausland is now seriously threatened by Averell's pursuit.

3 August 1864

Western Theater, Atlanta Campaign Sherman dispatches A J Smith for another crack at Forrest. Smith leaves today for Oxford, Mississippi, preparing for a movement on Columbus.
Naval Preparing for the naval move on Mobile Bay, Federal troops attack, but do not yet capture, Fort Gaines on Dauphin Island, one of the Confederate forts guarding the bay. Meanwhile, Federal Admiral Farragut's fleet is ready to move.

5 August 1864

Washington Furious at Lincoln's pocket-veto of their punitive reconstruction bill, Senator Benjamin Wade and Representative

Above: Union forces launch an attack in the wake of the explosion of a mine under the Southern defenses around Petersburg.

H W Davis issue what is called the Wade-Davis Manifesto, proclaiming 'their right and duty to check the encroachments of the Executive on the Authority of Congress.' At issue is whether Lincoln or Congress will control reconstruction.
Naval, Battle of Mobile Bay At 0600 hours Admiral David Farragut's fleet begins to run past the three Confederate forts into the important Southern port of Mobile Bay and head for the Confederate defending ships – the mighty ironclad ram *Tennessee* and three wooden gunboats under Admiral Franklin Buchanan. Soon the Federal ships come under fire from Fort Morgan and the gunboats, and are also heading toward a treacherous maze of underwater mines (known as torpedos at this time). After 0700 Federal ironclad *Tecumseh* is sunk by a torpedo, and it is after this that the 63-year-old Farragut, standing high in the rigging of his flagship *Hartford*, is supposed to have exclaimed, 'Damn the torpedos, full speed ahead!' Whether or not this was said, the Union fleet does just that, led into the bay by the *Hartford* with little further damage from the forts or from torpedos. After repeatedly being rammed and shelled, the CSS *Tennessee* is disabled and surrenders, and the bay is secured. Federals have lost 145 killed (including 93 drowned in the *Tecumseh*), 170 wounded, and four captured. The Confederates lose few killed and wounded, but 270 men are taken

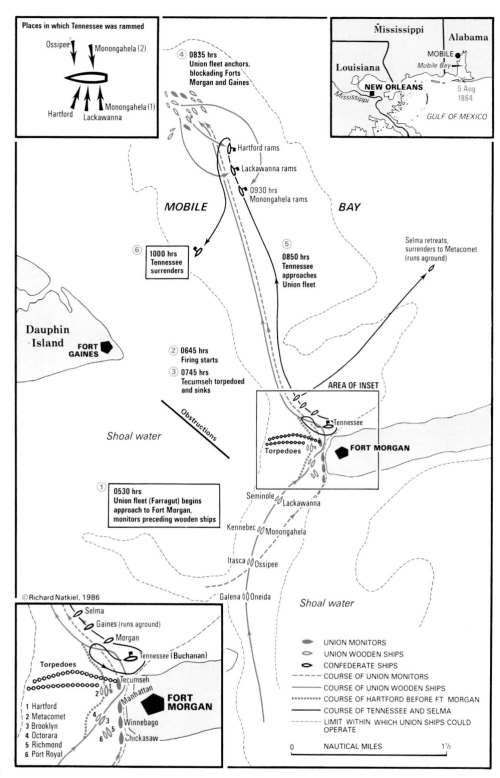

Places in which Tennessee was rammed

Ossipee Monongahela (2)

Hartford Monongahela (1)
 Lackawanna

④ 0835 hrs
Union fleet anchors,
blockading Forts
Morgan and Gaines

MOBILE BAY

Hartford rams

Lackawanna rams

0930 hrs
Monongahela rams

⑥ 1000 hrs
Tennessee
surrenders

⑤ 0850 hrs
Tennessee
approaches
Union fleet

Selma retreats,
surrenders to Metacomet
(runs aground)

Dauphin
Island FORT
GAINES

② 0645 hrs
Firing starts

③ 0745 hrs
Tecumseh torpedoed
and sinks

AREA OF INSET

Tennessee

Obstructions

Shoal water

Torpedoes

FORT MORGAN

① 0530 hrs
Union fleet (Farragut) begins
approach to Fort Morgan,
monitors preceding wooden ships

Seminole Lackawanna

Kennebec Monongahela

© Richard Natkiel, 1986

Itasca Ossipee

Galena Oneida

Shoal water

Selma

Gaines (runs aground)

Morgan

Torpedoes

Tennessee (Buchanan)

Tecumseh

1 Hartford
2 Metacomet
3 Brooklyn
4 Octorara
5 Richmond
6 Port Royal

Manhattan

Winnebago

Chickasaw

FORT
MORGAN

⬭ UNION MONITORS
⬬ UNION WOODEN SHIPS
⬯ CONFEDERATE SHIPS
- - - COURSE OF UNION MONITORS
——— COURSE OF UNION WOODEN SHIPS
•••••• COURSE OF HARTFORD BEFORE FT. MORGAN
▬▬▬ COURSE OF TENNESSEE AND SELMA
- - - LIMIT WITHIN WHICH UNION SHIPS COULD
 OPERATE

0 NAUTICAL MILES 1½

Mississippi Alabama

Louisiana MOBILE
 Mobile Bay

New Orleans 5 Aug
 1864

 GULF OF MEXICO

Above: The Battle of Mobile Bay, 5 August 1864,
ended in a significant Union victory.

(including Admiral Buchanan) and all ships
sunk or captured. Besides removing a valua-
ble port from the Confederacy, the action
gives the Union army a staging area for
planned operations against Mobile. Federal
bombardment from the water will lead to the
fall of Forts Gaines and Powell over the next
few days; Fort Morgan will hold out until the
end of the month.

7 August 1864

Eastern Theater Part of Early's cavalry
under McCausland are finally attacked in
force by W W Averell at Moorefield, West
Virginia. Federals capture 420 men.

9 August 1864

Eastern Theater, Petersburg Campaign
The siege remains quiet, and the defenders
have already repaired the damage to their
works caused by the Federal mine detonated
on 30 July.
Valley Campaign Sheridan prepares to
move from Halltown and Harper's Ferry,
West Virginia, to confront Early. Elsewhere,
rebel raider John S Mosby steps up his activi-
ties in the Federal-held part of Virginia.
Western Theater, Atlanta Campaign As
the siege of Atlanta continues, opposing
commanders Sherman and Hood probe, raid
and search for ways in and out. On Mobile
Bay Federal troops begin a siege of Fort Mor-
gan, the last remaining Confederate works
on the bay.

10 August 1864

Eastern Theater, Atlanta Campaign Con-
federate commander Hood dispatches much
of his cavalry under Wheeler to raid Sher-
man's rail lines above the city. Wheeler will
be active until 10 September in various loca-
tions but this action is in fact another blunder
by Hood. Sherman already has the supplies
he requires for the moment, and now the
Confederate army is without cavalry.

12 August 1864

Eastern Theater, Valley Campaign Sheri-
dan moves toward Early, who is entrenched
south of Winchester along Cedar Creek,
where there is a small skirmish during the
day. Small actions will go on until Sheridan
withdraws on 14 August. It will be some
weeks before the antagonists do much more
than follow in one another's footsteps.
Naval In a week of heavy raiding the Con-
federate crusier *Tallahassee* takes six Union
vessels off New York and seven off Sandy
Hook, New Jersey.

15 August 1864

Eastern Theater, Valley Campaign After
further skirmishing with Early near Cedar
Creek, Sheridan withdraws toward Win-
chester pending the arrival of supplies.
Western Theater, Atlanta Campaign
Wheeler's Confederate cavalry raid Sher-
man's supply lines on Tennessee railroads.
Naval Confederate raider *Tallahassee* takes
six more Federal ships off New England; four
more will be captured on the 16th.

17 August 1864

Eastern Theater, Valley Campaign Early's
forces pursue the withdrawing Sheridan; a
sharp action breaks out near Winchester,
Virginia.

18 August 1864

Washington Grant refuses a second Con-
federate request to exchange prisoners, thus
cutting off Confederate reinforcements but
also condemning to slow starvation many
Federal prisoners in the South, who can
scarcely be fed by their captors when the
Confederate army is itself hungry.
Eastern Theater, Petersburg Campaign In
the first action since the mine disaster, Fed-
erals move to extend their lines around the
city. A corps under Warren occupies a mile of
the important Weldon Railroad, fighting suc-
cessfully at Globe Tavern, Yellow House and
Blick's Station before being halted by the
enemy in the evening.
Western Theater, Atlanta Campaign Hop-
ing to force the enemy out of Atlanta, Sher-
man sends two brigades under General
Judson Kilpatrick to raid Hood's lines of com-
munication south of the city. Strong Con-
federate resistance will interfere with this
raid, and Kilpatrick returns to Decatur on 23
August having had little success.

19 August 1864

Eastern Theater, Petersburg Campaign
Warren's infantry is attacked by Confeder-
ates under A P Hill south of Petersburg, and
the Federals with heavy losses are forced
back to their position at Globe Tavern. How-
ever, the North still controls the important
Weldon Railroad.

Valley Campaign Sheridan and Early continue skirmishing around Winchester.

21 August 1864

Eastern Theater, Petersburg Campaign In a final desperate attempt to dislodge Federals from the much-needed Weldon Railroad, A P Hill attacks Warren's forces south of Petersburg. The attack fails and the South has lost 1600 of the 14,000 in action around the railroad; Federal casualties are 4455 of 20,000.

Valley Campaign Early and R H Anderson have planned a dual attack on Sheridan today, but it fails to develop and the day sees minor skirmishing in several places around Charles Town. At night Sheridan withdraws to strong positions near Harper's Ferry.

Western Theater General Forrest makes another bold move, taking Memphis, Tennessee, for the day and capturing several officers; Federal Generals Hurlbut and Washburn barely escape. Smith tries and fails to cut off Forrest's retreat, and then is called back. Forrest is now free to operate against Sherman's supply lines. Nearly two months of attempts against him have largely resulted in Federal embarrassments such as this.

23 August 1864

Naval Fort Morgan falls, the last of the three Confederate forts on Mobile Bay. Now the Union controls one of the last two major ports that had been left for Southern blockade-running. Only Wilmington, North Carolina, now remains.

25 August 1864

Eastern Theater, Petersburg Campaign After several days of destroying track along the Weldon Railroad, Hancock's Federals are assaulted at Ream's Station by a reinforced A P Hill, who drives them back from the railroad in heavy fighting. Federals lose 2742 men, mostly in captured and missing, and

Below: Union ironclads and gunboats run the gauntlet of Confederate shore batteries during the action at Mobile Bay.

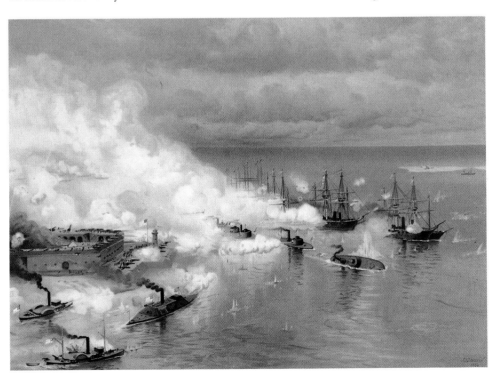

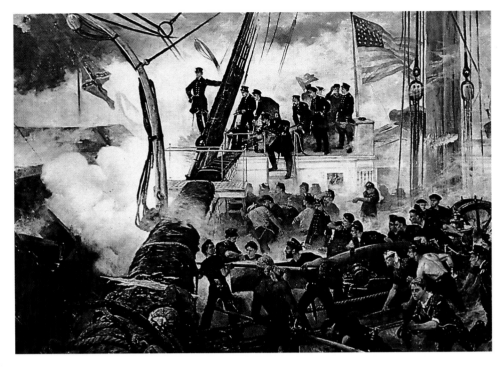

many armaments. Hill's men then withdraw to Petersburg, and the rail line remains broken.

Valley Campaign With Sheridan entrenched on the Potomac, Early leaves a force to hold him there and resumes his roaming in West Virginia, threatening a new invasion of Maryland and Pennsylvania.

Naval CSS *Talahassee* pulls into port at Wilmington, North Carolina, having captured 31 Union vessels in three weeks.

27 August 1864

Western Theater, Atlanta Campaign The time has come to begin the final act of the Atlanta campaign. Sherman pulls two corps out of his trenches on a wide circuit of the city. The Confederates think Sherman is retreating; the message 'the Yankees are gone' is telegraphed all over the South. But Sherman's men are moving to choke off Hood's

Above: David Farragut leads the Union forces at Mobile Bay from the rigging of his flagship, the *Hartford.*

last rail lines into the city, especially the Macon Railroad at Jonesboro. Several previous expeditions have failed to accomplish this task but this effort will not fail.

29 August 1864

The North The Democratic National convention meets in Chicago, with the keynote address given by Copperhead activist Clement Vallandigham. Another speaker proclaims: 'Four years of misrule by a sectional, fanatical and corrupt party have brought our country to the verge of ruin.'

Eastern Theater, Valley Campaign Sheridan is on the move again against Early, winning an engagement at Smithfield crossing on the Opequon Creek.

Trans-Mississippi A Confederate expedition prepares at Princeton, Arkansas, under General Sterling Price. Its object is to retake Missouri.

30 August 1864

The North As expected, the Democratic National Convention prepares to nominate General George B McClellan for president. The Peace Democrat and Copperhead dominated platform asserts that, 'justice, humanity, liberty and the public welfare demand that immediate efforts be made for a cessation of hostilities.' The platform also assails Lincoln's 'usurpation of extraordinary and dangerous powers not granted by the Constitution' and says, 'the aim and object of the Democratic Party is to preserve the Union and rights of the State unimpaired.'

Western Theater, Atlanta Campaign Sherman's Generals Thomas and Howard cut one of Hood's two remaining rail lines, the Montgomery and Atlanta, in two places. Schofield is moving toward the second, the Macon and Weston Railroad. Still thinking that Wheeler's raids have forced Sherman to retreat for lack of supplies, Hood orders an attack on the Federals at Jonesboro.

Above: A view of the Confederate entrenchments just north of the Georgia Railroad on the outskirts of Atlanta.

31 August 1864

The North In the convention at Chicago General McClellan is nominated as the Democratic candidate for president.

Western Theater, Atlanta Campaign Hood's attack on Howard's Army of the Tennessee near Jonesboro is turned back with heavy losses – 1725 Southern casualties to Howard's 170. Meanwhile, Schofield cuts the Confederates' last railroad line at the town of Rough and Ready, Georgia. During the night Sherman orders General Slocum to try to enter the city on 1 September. In more ways than military, Atlanta is doomed.

1 September 1864

Eastern Theater, Valley Campaign Elements of Sheridan's army clash with Jubal Early's Confederates at Opequon Creek.

Western Theater, Atlanta Campaign General Hood and the Army of Tennessee evacuate Atlanta. Unable to carry off the munitions and stores, the Confederate rearguard blows up the much-needed supplies as they leave, sending billows of smoke and fire into the night air and shock waves reverberating to Union lines on the outskirts of the city. In Jonesboro, Union troops renew their counterattack against the enemy and, at the end of the day, Hardee withdraws his men to Lovejoy Station, where they rendezvous with the army leaving Atlanta.

2 September 1864

The Confederacy Worried over the South's chronic shortage of manpower, General Lee suggests to Jefferson Davis that Confederate leaders replace white laborers in the army with black slaves to free a greater number of whites for combat service. Lee also argues that stringent new regulations governing exemptions and a more vigorous enlistment policy are necessary to offset the constant losses to battle and disease.

Western Theater, Atlanta Campaign Led by General Henry Slocum's XX Corps, Federal troops begin to move into Atlanta in the morning. Sherman informs Lincoln of the successful completion of his four-week siege of the city with terse exultation: 'So Atlanta is ours, and fairly won.'

3 September 1864

Washington President Lincoln, responding to the news from Sherman of the fall of Atlanta, and also in recognition of Admiral Farragut's victory at Mobile Bay in August, declares 5 September a national day of celebration.

Eastern Theater, Valley Campaign Answering Lee's request to return troops on loan from Richmond, Jubal Early sends General Richard H Anderson's corps toward the Confederate capital. At Berryville, though, they run into a part of Sheridan's

army and, after some hard fighting, retreat to the shelter of the main body of Confederate troops at Winchester.

4 September 1864

Western Theater Union troops commanded by General A C Gillem surround the celebrated Confederate raider, John Hunt Morgan, while he and his men are bivouacked at Greenville, Tennessee. Morgan, the commander of the Department of Southwest Virginia since his escape from an Ohio penitentiary last year, is less successful this time in eluding his captors and he is shot and killed as he tries to flee from the trap. One hundred Confederates are killed in the action and another 75 are taken prisoner.

Naval A 60-day bombardment of Fort Sumter, at Charleston, South Carolina, ends.

5 September 1864

Eastern Theater, Valley Campaign Though General Early yesterday moved his army south from its former position, Confederate troops continue to clash with the enemy along the Opequon Creek.

Western Theater Following the procedure President Lincoln had outlined for the readmission of the state to the Union, those citizens of Louisiana who have taken the loyalty oath renouncing secession go to the polls and ratify a new constitution abolishing slavery in the state.

6 September 1864

Naval Federal ships again open fire on Fort Sumter. This latest bombardment will continue for the next nine days.

7 September 1864

Eastern Theater, Valley Campaign Sheridan's and Early's armies continue to skirmish near Winchester, Virginia.

Western Theater General Sherman issues an order for the evacuation of all civilians

Below: A Northern cartoon showing the dangers of compromise with the South – Jefferson Davis shakes hands with a wounded Union soldier.

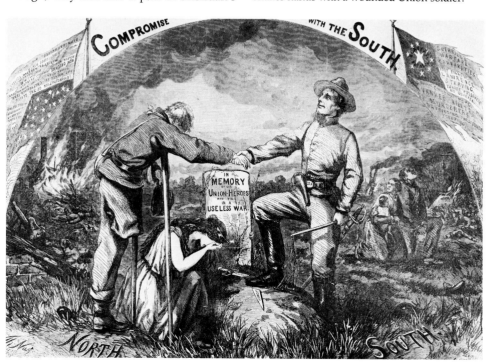

from Atlanta. The order will provoke an angry exchange between the Union general and General Hood, as well as protests from the citizens of the town, but Sherman remains obdurate.

Trans-Mississippi Fighting occurs at Centralia, Missouri, between Federal soldiers and Confederates.

8 September 1864

The North General George B McClellan formally accepts the Democratic nomination for president. In his letter of acceptance, however, McClellan refuses to accept that part of the Democratic platform which labels the war a failure: 'I could not,' he writes, 'look in the face of my gallant comrades of the army and navy, who have survived so many bloody battles and tell them that their labor and sacrifice had been in vain.' Although he separates himself from the Copperhead faction of the party by this remark, McClellan makes it clear that his own ideas concerning the basis for peace between North and South are considerably different from those of the Republicans. In contrast to their demand for the unconditional surrender of the Confederacy and recognition of emancipation, the Democratic nominee insists only on reunion, and maintains that when 'any one State is willing to return to the Union, it should be received at once, with a full guarantee of all its constitutional rights.'

Naval Following up last month's victory at Mobile Bay, Federals destroy over 50 Confederate furnaces at Salt House Point.

Below: A scene of the destruction that greeted Sherman's men when they entered Atlanta on 2 September 1864.

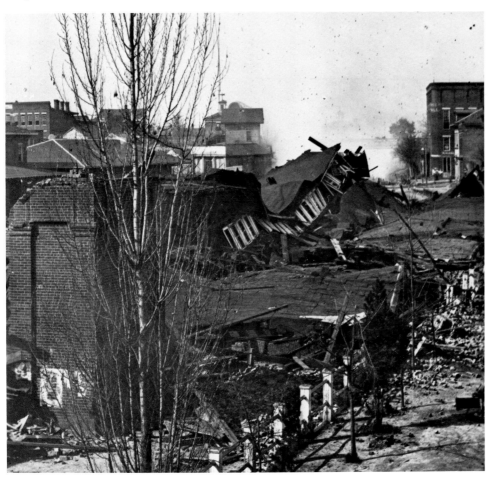

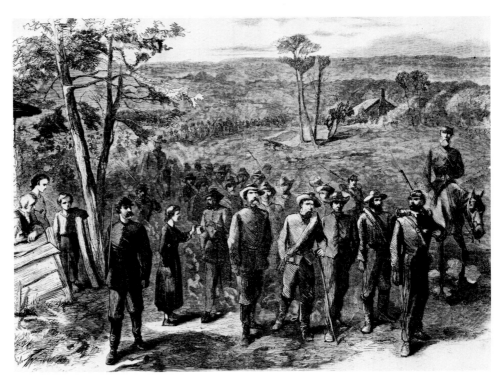

9 September 1864

Trans-Mississippi Federals clash with the enemy near Warrensburg, Missouri, and in Arkansas Confederates attack the *J D Perry* at Clarendon.

10 September 1864

Western Theater Grant sends Sherman a telegram urging him to begin a new drive against the enemy as soon as possible. Although no definite decision has yet been made as to what Sherman's next move will

Above: Dejected Southern prisoners trudge into captivity after being defeated by Union troops under Howard at Jonesboro.

be, both Union generals still see Hood's army as the primary target.

11 September 1864

Western Theater Generals Sherman and Hood enter into a 10-day truce to allow for the removal of civilians from Atlanta. A citizens' committee in the occupied city draws up and presents a formal protest to Sherman against his policy of removal. The Union leader, however, will answer the petition with characteristic bluntness: 'You might as well appeal against the thunderstorm,' he will tell them, 'as against these terrible hardships of war.' In the next 10 days, 446 families will leave the city to take up residence either to the north or south.

12 September 1864

Eastern Theater, Valley Campaign President Lincoln, anxious to break the stalemate between Sheridan and Early's army, suggests to Grant the possibility of 'quietly but suddenly' transferring troops to Sheridan to allow him to strike at the enemy.

13 September 1864

Eastern Theater, Valley Campaign The two armies in the Valley continue to skirmish with engagements today at Bunker Hill and at two fords at Opequon Creek.

14 September 1864

Eastern Theater, Valley Campaign After one unsuccessful attempt already, General Richard H Anderson's corps leave Early's army to rejoin Lee at Petersburg. The loss of these troops substantially weakens the Confederate forces in the Valley.

16 September 1864

Eastern Theater, Siege of Petersburg South of the James River, General Wade Hampton and his force of Confederate cavalry engage a

group of Federals herding cattle and, after defeating them, lead over 2400 head of beef back to the hungry army at Petersburg.

Valley Campaign Generals Grant and Sheridan meet at Charles Town, West Virginia, to discuss the military situation at Winchester. Sheridan, who is aware that some of Early's troops have recently left the area for Richmond, proposes offensive action against the Confederates. Grant approves the plans for ousting Early's force.

Western Theater With some 4500 men, General Nathan B Forrest leaves Verona, Mississippi to operate against Sherman's supply and communication lines. Until the beginning of November, Forrest will continue to harass Union outposts in northern Alabama and Tennessee.

17 September 1864

The North John C Frémont, who had been nominated as a candidate for president in the spring by a convention of Radical Republicans dissatisfied with Lincoln's handling of the war, announces his intention to withdraw from the race. Though he still feels that Lincoln's administration is a failure, he fears a Democratic victory would lead to either a recognition of the Confederacy or at the very least a re-establishment of slavery. To prevent this and to work for emancipation, he pledges his support to Lincoln.

Eastern Theater, Valley Campaign Though outnumbered by more than three to one, Jubal Early begins to move his troops northward in the direction of Sheridan's army in order to operate against the Baltimore and

Below: The Battle of Winchester ended when Sheridan's men stormed the breastworks held by Jubal Early's troops.

Ohio Railroad. In West Virginia there is some fighting around Buckhanon.

18 September 1864

Eastern Theater, Valley Campaign After encountering enemy cavalry, Confederate troops in the valley under General Early fall back slightly toward Winchester again. The 12,000 man force, however, is somewhat widely scattered and in poor defensive position. Informed of this, Union General Sheridan decides to attack the Confederates in the morning.

19 September 1864

The North, The Lake Erie Conspiracy Two Confederate agents put into action their plan to capture the US gunboat *Michigan* and then free Confederate prisoners being held at Johnson's Island on Lake Erie. Once freed, they hope to organize the men into an army which will operate in the area. Captain John Yates Beall of the Confederate navy, accompanied by a band of men he had recruited across the border in Canada, commandeers the steamer *Philo Parsons* and the *Island Queen*, but the other agent, Charles H Cole, who had managed to plant himself on board the *Michigan*, is discovered and arrested before he can give the signal to his cohorts to board the ship. Beall scuttles the *Philo Parsons* and escapes but later will be captured and hanged as a spy.

Eastern Theater, Valley Campaign Sheridan attacks the Confederates at Winchester. In the morning, bottlenecks develop as the Union troops try to cross the Opequon to engage the enemy and for a time it appears as though the outnumbered Southern army might successfully repulse the attack. As the day progresses, however, Sheridan is able to

bring a larger number of his troops to bear against the Confederate breastworks. By the end of the day the Federals are forcing Early's troops into a full retreat. Union losses are 653 killed, 3719 wounded and 618 missing. The Southern army leaves 3000 of their wounded in Winchester as they flee the city and suffer the loss of another 2000 taken prisoner during the day. News of the victory will be greeted with jubilation throughout the North but particularly by Republicans who see battle victories as indispensable if they are to win the political elections in November. Referring to the battle and its impact on the political climate of the North, Republican James Garfield will write that 'Phil Sheridan has made a speech in the Shenandoah Valley more powerful and valuable to the Union cause than all the stumpers of the Republic can make.'

Trans-Mississippi General Sterling Price leads a cavalry force of 12,000 men into Missouri. Since the failure of the Federal Red River expedition last April, Confederate authorities and General Edmund Kirby Smith had talked of launching a campaign to recover Missouri for the Confederacy. The South, however, will never be able to marshal a force necessary to implement such an ambitious plan, and Price's raid is to be the last offensive move by the South into Missouri. They cross into Missouri from Indian Territory. Just before entering the state, the Confederates capture a Federal supply train near Cabin Creek and then continue their advance northward.

20 September 1864

Eastern Theater, Valley Campaign A Union cavalry force pursues Early's fleeing troops as they move southward after yester-

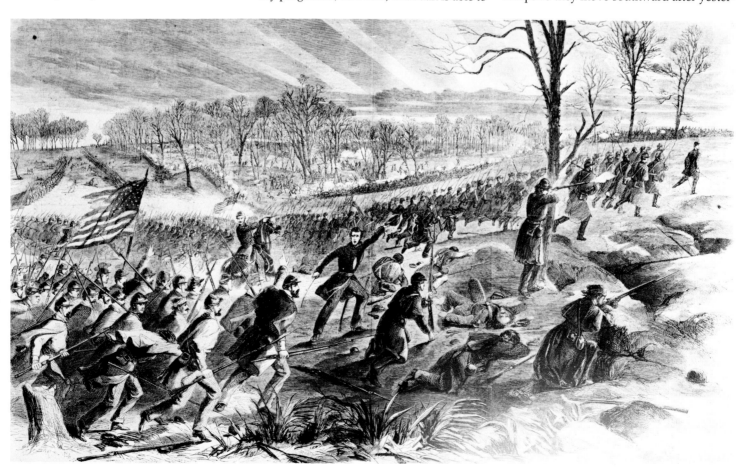

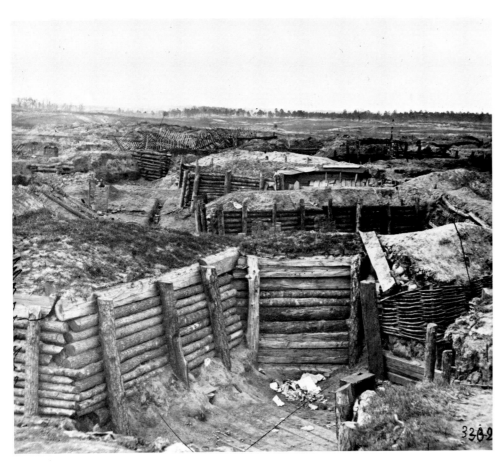

Above: Abandoned Southern trenches outside Petersburg. On 29 September troops under General Stannard captured Fort Harrison.

day's defeat. The Union horsemen clash with the Southern reaguard at Middletown, Strasburg and Cedarville.

Trans-Mississippi As Price's Confederate cavalry moves toward St Louis, fighting occurs with Federals at Keytesville and on the Little Black River in Missouri.

21 September 1864

Eastern Theater, Valley Campaign General Early's troops dig in at Fisher's Hill after halting their retreat from Winchester. Sheridan's army, following the Confederates, fortifies its own positions just north of Fisher's Hill.

22 September 1864

Easter Theater, Valley Campaign After following Early's fleeing army for two days, Sheridan again throws his troops against the enemy at Fisher's Hill. The battle develops into a complete rout and the Southerners plunge into headlong retreat further up the Valley. 'I do not think there ever was an army so badly beaten,' Sheridan gloats in his message to Grant of the battle. Despite the exaggeration, Fisher's Hill is both decisive and one-sided. Federal losses in the battle are only 528, while the Confederates lose 1235 men as well as 12 artillery pieces. It will be almost a month before Early's troops are again prepared to fight.

Trans-Mississippi There is skirmishing at Patterson and Sikeston, Missouri.

23 September 1864

Eastern Theater, Valley Campaign Though Confederate cavalry battles Federals at Mount Jackson, Front Royal and Woodstock, Sheridan's army does not follow Early's troops up the Valley.

Western Theater General Nathan Forrest and his cavalry force attack a Federal garrison at Athens, Alabama. Forrest's raid into northern Alabama is part of a concerted Confederate effort to harass Sherman's line of communications to Atlanta.

24 September 1864

Eastern Theater, Valley Campaign Having defeated Early in two decisive battles and forced his army to retreat up the Valley, Sheridan begins to turn his attention to destroying the vast food resources of the Shenandoah Valley. 'If the war is to last another year,' Grant has written Sheridan, 'we want the Shenandoah Valley to remain a barren waste.'

25 September 1864

Western Theater, Franklin and Nashville Campaign Jefferson Davis arrives in Palmetto, Georgia, where he talks with General John B Hood about campaign strategy against Sherman in Atlanta. To the north, General Forrest attacks Federal railroad lines, capturing Sulfur Branch Trestle in northern Alabama. There is also fighting today at Johnsonville, Tennessee, and near Henderson, Kentucky.

Trans-Mississippi Price's men skirmish with the enemy at Farmington and Huntsville, Missouri.

26 September 1864

Eastern Theater, Valley Campaign Elements of Sheridan's cavalry harass Early's army near Port Republic, Virginia.

Western Theater Now in Tennessee, Forrest and his troops assault a Federal garrison near Pulaski.

27 September 1864

Trans-Mississippi Sterling Price and his cavalry force continue their advance northward through Missouri. At Pilot Knob, they attack a Federal garrison under the command of Thomas Ewing Jr. The Union forces, though badly outnumbered, beat off the attack, inflicting some 1500 casualties, and then escape under cover of darkness. Meanwhile, a small band of Confederate guerrillas led by 'Bloody' Bill Anderson ride into Centralia, Missouri, looting and burning many of the town's buildings. They then capture a train as it pulls into the town and kill over 20 unarmed Federals on board. Later the band ambushes a column of Union cavalry sent out to intercept the raiders, killing another 100 enemy soldiers.

28 September 1864

Western Theater There is scattered fighting at Brownsville, Mississippi, and at Wells Hill and Rheatown, Tennessee.

29 September 1864

Eastern Theater, Siege of Petersburg Grant orders an attack on Forts Harrison and Gilmore, enemy fortifications in front of the Petersburg-Richmond lines. Troops under General George Stannard succeed in capturing Fort Harrison but the move against Fort Gilmore fails and that outpost remains in Confederate hands. Meanwhile, south of Petersburg, 16,000 Federal soldiers try to extend Union lines westward to capture Boydton Plank Road and the Southside Railroad, two important routes leading into that city.

Valley Campaign Elements of Sheridan's and Early's armies clash near the town of Waynesborough.

Trans-Mississippi Federals fight Price's advancing cavalry at Leasburg and Cuba, Missouri.

30 September 1864

Eastern Theater, Siege of Petersburg Confederate troops commanded by General Richard H Anderson try to retake Fort Harrison, lost to the Federals in yesterday's action. The assault fails. In the two days of fighting af the fort, Federal losses are 929 killed or wounded and 1756 missing. The Confederates lose a total of 2800, including 300 prisoners. Fighting also continues southwest of Petersburg, near Peebles' Farm, as a vigorous counter attack by Ambrose P Hill pushes back the advancing Federal columns.

1 October 1864

Eastern Theater, Siege of Petersburg Fighting continues around Peebles' Farm as Union troops try to extend their lines encircling Petersburg. In the Valley, meanwhile, General Sheridan prepares to move his army north to Cedar Creek from its present position in Harrisonburg. Also a Federal expedition into southwest Virginia and east Tennessee fights two small engagements at Clinch Mountain and Laurel Creek Gap in Tennessee.

Western Theater, Franklin and Nashville Campaign General Hood moves his army around Atlanta to strike Sherman's railroad line, assaulting Union troops at Salt Springs. In support of Hood's army General Forrest and his cavalry continue to hit at positions in

Above: Sherman directs his assault troops from Kennesaw Mountain during the renewed fighting around Atlanta.

Sherman's rear. Forrest and his men skirmish with Federal troops at Athens and Huntsville, Alabama, and also capture a number of Union blockhouses at Carters Creek Station in Tennessee.

Naval The *Condor*, a British blockade-runner, is grounded near Fort Fisher, North Carolina, as it is being chased by the USS *Niphon*. On board the *Condor* is Mrs Rose O'Neal, a Confederate spy, who to avoid capture tries to escape in a small boat with her secret dispatches and $2000 in gold. The boat capsizes in the heavy seas and Mrs O'Neal drowns.

2 October 1864

The Confederacy President Davis gives General Pierre Gustave Toutant Beauregard command of the two armies in the west under Hood and Richard Taylor. Beauregard is to direct the overall strategy and coordinate the activities of the two armies but is not to interfere with field operations when visiting either of them.

Eastern Theater, Siege of Petersburg Four days of fighting at Peebles' Farm comes to an end as the Confederates withdraw to their entrenchments. Between 30 September and the end of this day, Union forces have succeeded in extending their lines three miles westward.

Valley Campaign Skirmishing takes place between elements of Jubal Early's army and that of Sheridan at Mount Crawford and Bridgewater. In southwest Virginia, a Federal raid designed to destroy Confederate salt mines in the region is repulsed near Saltville. After the engagement, the Southern defenders put to death over 100 prisoners, most of whom are blacks. Although Lee will order a full investigation when he hears of the atrocity, only one man will be brought to justice, and he primarily for the murder of a white officer.

Trans-Mississippi General Sterling Price, still moving northward through Missouri, occupies the town of Washington in the face of growing Southern resistance.

3 October 1864

Eastern Theater, Valley Campaign Confederate cavalry hit at Sheridan's army near Harrisonburg.

Western Theater, Franklin and Nashville Campaign The Army of Tennessee continues to disrupt Sherman's supply lines forcing him to send more troops from Atlanta to protect his trains. Meanwhile, General George Thomas, whom Sherman had directed to Nashville to protect that city from a possible attack by Hood's army, reaches the city and begins to prepare its defenses.

Trans-Mississippi Sterling Price's men engage Federal troops at Hermann and Miller's Station, to the west of St Louis. Though the citizens of that town had been considerably alarmed by the Confederate raid into Missouri, Price's foray has caused Union officials to deploy General A J Smith's corps, originally intended to reinforce Thomas in Tennessee, to St Louis to meet the new danger to the Trans-Mississippi area.

4 October 1864

Western Theater, Franklin and Nashville Campaign There is more action between Confederate and Union forces in Georgia, with engagements at Acworth, Mom's Station and near Lost Mountain. General Sherman moves his headquarters to Kennesaw Mountain to place himself in a better position to strike against Hood's army.

Trans-Mississippi Price, unwilling to strike directly at freshly reinforced St Louis begins to swing his troops to the west and away from the city. The raiders engage Federal forces at Richwoods, Missouri.

5 October 1864

The Confederacy Jefferson Davis gives a speech in Augusta, Georgia. He attempts to rekindle the spirit of the people by assuring them that he has never been more confident that with determined and vigorous effort, the

Below: General John Bell Hood, one of the South's ablest commanders, confronted Sherman around Franklin and Nashville.

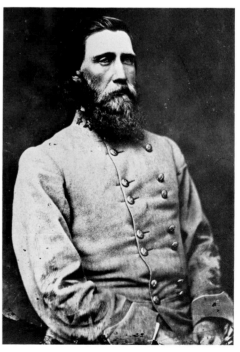

South can drive the enemy from its territory.

Western Theater, Franklin and Nashville Campaign In an attack that will later gain much publicity, Confederate troops under General Samuel G French strike a Federal position at Altoona, Georgia, hoping to destroy a railroad bridge there. General Sherman sends the commander at Altoona a message telling him to hold his position ('General Sherman says hold fast. We are coming.'), and though promised reinforcements never arrive, the Federals fight a heroic defense, beating off the enemy attack. Federal losses are 706, while the Confederates lose 799.

6 October 1864

Eastern Theater, Valley Campaign Though twice severely beaten last month, Confederates in the Valley still refuse to give up completely. Cavalry under Confederate General Thomas L Rosser hit General George Custer's cavalry at Brook's Gap, near Fisher's Hill. Custer's troops succeed in beating off the attack.

Western Theater General Forrest continues to plague Union forces in Sherman's rear, fighting an engagement with Federals at Florence, Alabama.

7 October 1864

Eastern Theater, Siege of Petersburg Confederate troops north of Richmond try to push back Federal troops and the two sides clash on the roads leading to Darbyville and New Market. The attack fails, though, as the Southerners are forced to retreat.

Valley Campaign Sheridan's cavalry continues its work destroying crops and rounding up livestock. Sheridan writes Grant that so far his men have burned 2000 barns filled with wheat, hay and farm implements, destroyed in excess of 70 flour mills, driven off 4000 head of livestock and killed over 3000 sheep to feed the army. When he is through, he adds, the area between Winchester and Staunton 'will have little in it for man or beast.'

Western Theater, Franklin and Nashville Campaign Elements of Hood's and Sherman's armies collide at Dallas, Georgia, as the Confederate general tries to maneuver his troops toward Alabama.

Naval The USS *Wachusett* traps and then captures the CSS *Florida* at the Brazilian port of Bahia. The Brazilians protest and even fire at the USS vessel, but it still makes off with its prize. To mollify the Brazilians, Secretary of State William H Seward will later condemn the Union captain's action as unlawful.

8 October 1864

Eastern Theater, Valley Campaign Union and Confederate cavalry skirmish at Tom's Brook and in the Luray Valley.

Naval The Confederate *Shenandoah*, or *Sea King*, sails from London and on 19 October will be commissioned as a roving commerce destroyer.

9 October 1864

Eastern Theater, Valley Campaign After suffering Confederate cavalry attacks for the past few days, Sheridan turns his cavalry divisions led by George Custer and Wesley Merritt against the enemy's horsemen. The Confederates flee up the Valley after an en-

gagement in which they lose 300 prisoners and suffer another 57 casualties. There is also fighting in Fauquier Country, Virginia, just to the east of the Valley.

Trans-Mississippi Sterling Price and his men continue northwestward away from St Louis capturing the Missouri towns of Boonville, Russellville and California.

10 October 1864

Eastern Theater, Valley Campaign Sheridan withdraws his army north to Cedar Creek. At the same time his VI Corps starts out toward Washington.

Western Theater, Franklin and Nashville Campaign Hood's and Sherman's men skirmish near Rome, Georgia, as the Confederate army continues to move westward. Meanwhile, a Federal expedition tries to attack General Forrest at Eastport, Mississippi, by ferrying soldiers up the river by boat. The Confederates, however, disable the Union vessel, and the Northern troops are left stranded, able to do little more than make good their escape.

11 October 1864

Western Theater, Franklin and Nashville Campaign Sherman concentrates his troops at Rome, Georgia, after receiving word that Hood's army is just south of the city. Federal and Southern troops clash along the road between Atlanta and Flat Creek. Farther north, Confederate cavalry raid Fort Donelson, the site of a black recruiting station, but are driven off by Northern soldiers after a brief battle.

Trans-Mississippi Sterling Price and his men continue to slash their way northwestward through Missouri, skirmishing with Federals at Boonville and Brunswick.

12 October 1864

Western Theater, Franklin and Nashville Campaign Parts of Hood's and Sherman's armies clash at Reseca, La Fayette and on the Coosaville Road near Rome, Georgia, while farther north there is some fighting at Greeneville, Tennessee.

Naval Rear Admiral David D Porter assumes command of the North Atlantic Blockading Squadron relieving acting Rear Admiral Samuel P Lee. Porter, who was only a lieutenant at the outbreak of war, won renown for the role he played at New Orleans, and with Grant at Forts Henry and Doneslon and at Vicksburg.

13 October 1864

Eastern Theater, Valley Campaign Taking advantage of Sheridan's withdrawal to Cedar Creek, Jubal Early moves his army back to its old position at Fisher's Hill. Fighting breaks out as the advancing Confederates probe enemy lines. Farther north, John S Mosby and his band of partisan rangers derail a passenger train near Kearneyville. They rob two Federal paymasters on board of nearly $173,000 and then burn the train before making their escape.

Western Theater, Franklin and Nashville Campaign Hood's troops seize control of the railroad north of Reseca, Georgia, leading to Tunnel Hill, and there are a number of isolated engagements with Union detachments along the rail line.

Above: Joseph Shelby was one of the most daring Southern guerrilla leaders and gained fame for the capture of Glasgow, Missouri.

14 October 1864

Eastern Theater, Valley Campaign Sporadic fighting continues between elements of Early's and Sheridan's armies as the two forces probe each other's lines at Cedar Creek.

Trans-Mississippi Sterling Price calls on the people of Missouri to help him redeem the state. His men fight Federal soldiers near Glasgow. There is also an action at Danville, Missouri.

15 October 1864

Trans-Mississippi Shelby's 'Iron Brigade,' part of Price's cavalry, captures the town of Glasgow, Missouri, forcing the surrender of more than 400 Federals under the command of Colonel Chester Harding Jr. Shelby's men also occupy Sedalia after 700 defenders flee the town.

16 October 1864

Eastern Theater, Valley Campaign General Philip Sheridan leaves his army at Cedar Creek for a conference with President Lincoln and General Grant on the military situation in the Valley.

Western Theater Elements of the two armies in northern Georgia continue to clash as the Confederates harass the Union supply lines.

Trans-Mississippi In Missouri, Price and his men reach the town of Ridgely and occupy it as they continue to move northwestward along the Missouri River.

17 October 1864

Western Theater General Beauregard assumes command of the Confederate armies east of the Mississippi. In northern Georgia General Hood and his army move toward Gadsden, Alabama, breaking off, for

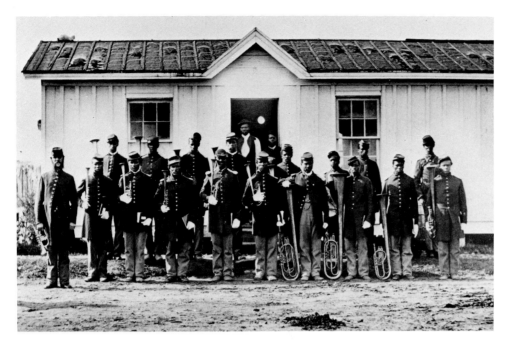

Above: Members of the band of the US 107th Colored Infantry Regiment pose for a photograph outside their camp.

the most part, their attacks on Sherman's supply lines. The Confederate general hopes that by heading north and eventually into Tennessee, he will be able to force Sherman to do the same, thus freeing Georgia of the invading army.

Trans-Mississippi Fighting continues with Federals both to the rear and in front of Price as the cavalry rides toward Lexington in northwest Missouri. Federal forces are now closing in on the Confederate raiders from three directions: General Samuel R Curtis, commander of the Department of Kansas, approaching from the west; Alfred Pleasonton and his cavalry pursuing from the rear; and General Alfred J Smith coming up from the south. The Confederate cavalry burns Smithville as it passes through the town and also occupies Carrolton during the day.

18 October 1864

Eastern Theater, Valley Campaign General Jubal Early and his staff plan an all-out attack on the Federals at Cedar Creek to be launched in the morning.

19 October 1864

The North A small group of Confederate raiders, led by Lieutenant Bennet H Young and composed mainly of escaped prisoners, crosses the Canadian border and descends upon the small Vermont town of St Albans. The men rob three local banks of over $200,000 but resistance by local citizens prevents them from carrying out their plans to burn the town. Eleven of the raiders escape back over the border where they will later be arrested and then released by Canadian officials after that government decides it lacks jurisdiction.

Eastern Theater, Valley Campaign Concealed by Three Top Mountain and early morning fog, the three divisions of Early's corps attack the left flank of the Union army commanded by General George Crook. Completely surprised, the Federal flank falls back in disarray with one division forming a new

line north of Middletown while the rest regroup to the west of the town. General Sheridan, on his way back from a conference in Washington, has spent last night in Winchester. He hears the sound of battle and meets streams of stragglers retreating down the Valley Pike as he rides toward Cedar Creek. Turning his men around, he gallops on, arriving at the front at about 1030 hours. Meanwhile the Confederate charge slows to a stop as soldiers fall out of line to loot the enemy's camp. The Confederates fail to follow up their surprise attack and at 1600 the Union forces counterattack, forcing them to flee in disorganized retreat. Although Union casualties are higher (5665 for the North compared to an estimated 2910 for the South), they decisively win the battle, forcing the enemy from the field.

20 October 1864

Washington President Lincoln formally establishes Thanksgiving as a national holiday.

Eastern Theater, Valley Campaign In the wake of General Early's defeat at Cedar Creek, elements of Sheridan's army strike at the Confederates as they retreat toward Fisher's Hill.

21 October 1864

Trans-Mississippi There is more fighting between Federals and advancing Confederate troops under Sterling Price at the Little Blue River. The Union troops again fall back to the west.

22 October 1864

Western Theater, Franklin and Nashville Campaign General Hood's army is in Gadsden, Alabama, preparing to go to Guntersville and from there on to Tennessee. General Sherman's troops are in Gaylesville, Alabama, just west of Rome, Georgia. From this position, the Union general feels he can protect both Chattanooga and Atlanta from the Confederates.

Trans-Mississippi Deciding that his best chances of survival lie in defeating the various enemy forces closing in on him before they can unite, General Price orders

Shelby's troops to attack the Federals in front while John S Marmaduke holds off the enemy to the rear. After Shelby's men have completed their work, Price plans to turn his entire force around to meet Alfred Pleasonton's pursuing cavalry. Shelby hits the enemy and, finding an exposed flank, forces the Northerners under General Samuel Curtis to fall back to Bush Creek near Westport, where they form a new line.

23 October 1864

Trans-Mississippi Following up its success of yesterday, Shelby's cavalry again strikes at General Curtis' troops, now near Westport, Missouri. The Federals check this assault, though, and launch a powerful counterattack. While this is going on, Pleasonton's Union cavalry breaks through General Marmaduke's rearguard defense, forcing the harried Southerners from the field. Pleasonton then closes in on Shelby's Confederates from the rear, who in turn are forced to retreat. The Battle of Westport, involving some 20,000 Federal troops and over 8000 Confederates, results in about 1500 casualties for each side and will mark the end of the last serious threat to Union control of Missouri.

24 October 1864

Trans-Mississippi Sterling Price retreats south along the border between Kansas and Missouri with a long train of plunder which his men have captured in their month-long raid through Missouri. After some delay, the bulk of the Union cavalry pursues the fleeing Confederates.

25 October 1864

Western Theater, Franklin and Nashville Campaign Elements of Hood's army, still in northern Alabama, clash with Union troops near Round Mountain, in Turkeytown and on the Gadsden Road.

Trans-Mississippi Federal cavalry catch up with Price's retreating columns at Marais des Cygnes, Kansas. In the fight that ensues, they capture two Confederate generals (including John Marmaduke), four colonels and 1000 men. The Southerners also lose ten pieces of artillery in the engagement.

26 October 1864

Western Theater, Franklin and Nashville Campaign The Army of Tennessee arrives at Decatur, Alabama, which is held by Federal troops. Hood had originally hoped to launch his invasion of Tennessee from here but finds that General Forrest and his cavalry have been delayed. After some artillery fire against Federal positions at Decatur, Hood moves his army farther west.

Trans-Mississippi Union troops ambush and kill the notorious 'Bloody' Bill Anderson near Richmond, Missouri. Anderson had once ridden with William Quantrill.

27 October 1864

Eastern Theater, Siege of Petersburg General Grant orders an assault on enemy positions to gain control of the Boydton Road and Southside Railroad southwest of Petersburg. A strong defense under the leadership of General Ambrose P Hill, however, frustrates the Union drive. Unable to get necessary reinforcements, the Federals withdraw,

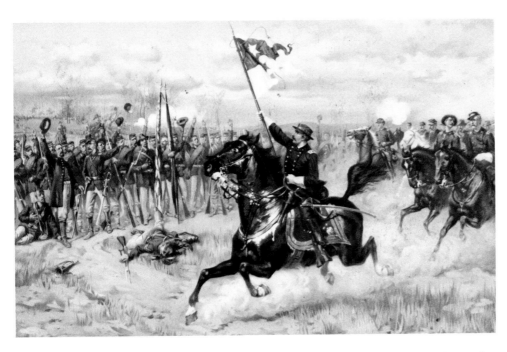

Above: Sheridan arrives at Cedar Creek to save the beleaguered Union forces from defeat.

28 October 1864

Trans-Mississippi Troops under General Samuel Curtis again catch up with Price's fleeing troops and attack the Confederates at Newtonia, Missouri. The timely arrival of Federal reinforcements during the engagement again forces Price to withdraw.

29 October 1864

Western Theater Cooperating with Abraham Buford, who had built a trap for Federal boats on the Tennessee River near Fort Heiman and Fort Henry, General Forrest and his men capture the steamer *Mazeppa*. Meanwhile, Hood, still waiting for Forrest to join his army so he can launch his planned invasion into Tennessee, continues to move his army westward.

30 October 1864

Western Theater, Franklin and Nashville Campaign The Army of Tennessee moves into Tuscumbia, Alabama. The Confederates also cross the Tennessee River and seize the town of Florence. Forrest, continuing to operate against Federal vessels, captures two transports and the gunboat *Undine* from the enemy. Meanwhile, Federal troops move from Chattanooga to Pulaski, Tennessee, as

leaving the transport lines still in the hands of the Confederates. The assault involves over 40,000 Federal troops and 20,000 Southerners, with the former suffering 1194 killed or wounded and 564 missing. Confederate casualties are not recorded.

Naval During the night, an expedition of 15 men led by Lieutenent William B Cushing ascends the Roanoke River in a steam craft and blows up the Confederate ram *Albemarle* by smashing through its protective log boom and then exploding a torpedo against the *Albemarle*'s hull. For planning and executing this bold scheme, Cushing will be promoted to the rank of lieutenant commander.

Below: General Sheridan leads his cavalry in a charge against Confederate positions at Cedar Creek, 19 October 1864. Although the North lost heavily, the Southern forces retreated.

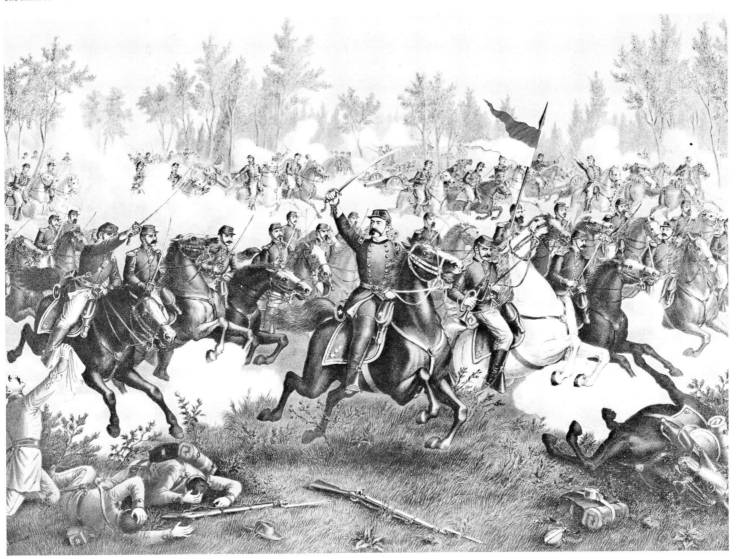

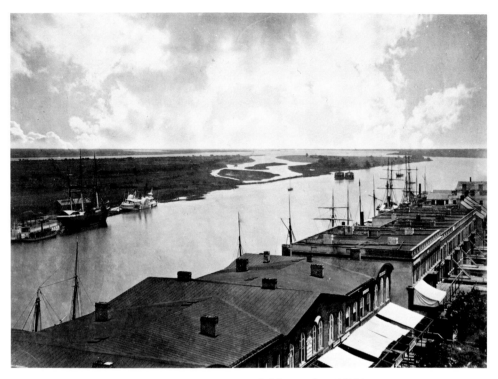

Above: The Confederate port of Savannah was the main objective of Sherman's March to the Sea which began on 16 November 1864.

General George Thomas prepares to meet an invasion into Tennessee.
Naval The CSS *Olustee* runs the Federal blockade outside Wilmington, North Carolina, and begins to prey on enemy shipping.

31 October 1864

The North Nevada enters the Union as the 36th state. Although Lincoln was considerably reassured by the elections held earlier in the month in Pennsylvania, Ohio and Indiana, he still believes the presidential election will be very close. Nevada, which is felt to be safely Republican, can now contribute three electoral votes to the election because of its statehood.
Naval Seven Federal vessels under the command of William H Macomb capture Plymouth, North Carolina.

1 November 1864

Western Theater, Franklin and Nashville Campaign General Alfred J Smith, who has been in Missouri to check Price's invasion, moves his men to Nashville, where they will reinforce General George Thomas. Thomas is preparing his defenses to meet a threatened attack by Hood's army. Meanwhile, General Forrest takes his makeshift navy of captured Federal vessels up-river to Reynoldsville Island, just south of Johnsonville, Tennessee, where he prepares another ambush.

2 November 1864

The North Secretary of State William H Seward warns the mayor of New York of rumors that Confederate agents in Canada are planning to set fire to New York City on election day.
Western Theater Federals recapture the *Venus* from Forrest just south of Johnsonville, Tennessee. The *Venus* is one of the boats that Forrest's men had taken at their 'trap' downstream a few days earlier.

3 November 1864

Western Theater The Federal IV Corps arrive in Pulaski, Tennessee. These troops had been sent by General Thomas to strengthen the detachment of troops already at the town against the threatened invasion by the Confederate Army of Tennessee.

4 November 1864

Western Theater Federal gunboats close in on Forrest's ambush station at Reynoldsville Island, from the north and south, forcing the Confederates to burn the captured *Undine* to prevent its recapture. Forrest then moves his force to the outskirts of Johnsonville where they shell a Federal naval supply depot causing heavy damage.

6 November 1864

The North Colonel Benjamin Sweet and his men arrest close to 100 men in Chicago on charges of plotting against the US. Confederate agents and Copperhead sympathizers, according to the alleged plans, were to release prisoners being held at Camp Douglas on election day. The prisoners then would seize the polls, stuff the ballot boxes and burn the city of Chicago. Although the plot will never be entirely substantiated, many of those arrested are heavily armed, and at the home of one of the conspirators a large cache of arms and ammunition is found.
Trans-Mississippi Price's men, who have now retreated out of Missouri, fight Federal troops at Cane Hill, Arkansas. There is also fighting between Union soldiers and Indians in the Nebraska Territory.

8 November 1864

The North It is election day in the North. President Lincoln is elected to a second term over General George B McClellan. With Tennessee war-governor Andrew Johnson as his new running mate, Lincoln wins over 55 percent of the popular vote and carries every participating state except Delaware, Kentucky and New Jersey. His strongest support comes from the soldiers on active duty who give 'Old Abe' 119,754 out of slightly more than 154,000 votes. In the electoral college, Lincoln gets 212 votes to McClellan's 21.

9 November 1864

Western Theater General Sherman in Kingston, Georgia, issues preliminary orders in preparation for a 'march to the sea.' Although Hood had hoped that by invading Tennessee he could draw Sherman northward, the Union general believes that Thomas' troops in and around Nashville will be able to handle the Army of Tennessee.

10 November 1864

Washington President Lincoln addresses a crowd at the White House gathered to help him celebrate his recent victory at the polls. He tells the audience that he believes the results vindicate Americans' belief in democracy, and urges a united effort to save the country.
Eastern Theater, Valley Campaign Despite his recent defeat at Cedar Creek, Jubal Early moves his shattered army down the Valley toward Sheridan to continue harassing the Federals.
Western Theater, March to the Sea Destroying all property which might be of use to the Confederates, Sherman's army leaves Kingston for Atlanta. He also gives orders for the destruction of railroad lines around Atlanta as well as those going north from Reseca, Georgia.

11 November 1864

Western Theater Union troops in Rome, Georgia, destroy everything that might be of military use in that city and then move south to join the rest of the army at Atlanta. Meanwhile, skirmishing continues between Federals and elements of Hood's army near Shoal Creek, Alabama; and in eastern Tennessee there is fighting at Russellville.

13 November 1864

Eastern Theater, Valley Campaign Early moves his army back to New Market and part of his troops set off for Richmond and Petersburg to reinforce General Lee's troops.
Trans-Mississippi There is fighting between Indians and Federal soldiers near Fort Larned, Kansas, while in Missouri Northern troops scour Pemiscot County in search of enemy guerrillas.

14 November 1864

Western Theater, March to the Sea With Sherman's army now returned to Atlanta, soldiers continue their work tearing up railroad lines, burning bridges and destroying anything else of use to the enemy. Meanwhile, in Tennessee, General John M Schofield arrives in Pulaski to assume command of the forces in that city, the first line of defense against Hood.

15 November 1864

Western Theater, March to the Sea Confederate militia and Federals clash around Atlanta while other Northern soldiers complete the destruction of the city in preparation for the march to Savannah. In northern Alabama, Hood's army continues to skirmish with Federals near Shoal Creek on the Tennessee River.

16 November 1864

Western Theater, March to the Sea About seven in the morning, General William T Sherman and his army leave Atlanta for Savannah carrying 20 days rations with them. By and large, however, the 62,000-man army is to live off the land, foraging liberally throughout the Georgia countryside. Sherman has also instructed his division commanders that they should take any livestock that they might deem necessary from the inhabitants and if they meet resistance 'should order and enforce a devastation more or less relentless.' To oppose them, the Confederates have about 13,000 men including 3000 state militia under the command of George W Smith and a 10,000-man cavalry force led by Joseph Wheeler. These troops are concentrated around Lovejoy Station. Sherman's army marches out in two wings, the right heading down the Macon Railroad toward Lovejoy Station while the left wing moves along the Georgia Railroad toward Augusta. By deploying his troops along two diverging paths, Sherman hopes to deceive the enemy as to his true destination. As the right wing approaches Lovejoy Station, the Confederates there, except two cavalry brigades, move south toward Macon. The Union cavalry defeats the remaining troops, pursuing them to Beaver Creek station where they capture 50 prisoners. In northern Alabama, Hood's army continues to battle Federal units at Shoal Creek as General Forrest and his cavalry finally arrive to reinforce the Army of Tennessee. Forrest's cavalry were intended

to compensate for the loss of Wheeler's troops now harassing the Federals in Georgia. In eastern Tennessee, Breckenridge and his raiders skirmish with Federals at Strawberry Plain before he withdraws toward southwest Virginia.

17 November 1864

The Confederacy Jefferson Davis writes a letter to several Georgia state senators denouncing all plans involving individual states negotiating for peace with the North.
Western Theater, March to the Sea The two wings of Sherman's army continue to diverge, one going east and the other south. There is some fighting along the way at Towalega Bridge. Davis meanwhile orders General William J Hardee to assume command of all troops in Georgia. To the north, there is increased fighting in northern Alabama with clashes occurring at Maysville and at New Market.

18 November 1864

Western Theater, March to the Sea At Macon, Georgia, President Davis orders Howell Cobb, commander of the Georgia reserves, to get out every man he can to oppose Sherman's army. He also tells him to employ black slaves to help obstruct roads in the path of the Federal army.
Trans-Mississippi Even with Price driven from Missouri, Confederate bands and guerrilla units continue to harass Federal troops. Today there is fighting at Fayette between the two sides.

19 November 1864

Trans-Mississippi Federal soldiers continue to battle Indians in the Nebraska Territory, today at Plum Creek Station.
Naval President Lincoln lifts the Federal blockade at Norfolk, Virginia, and at Fernandina and Pensacola, Florida. These ports are now under the control of Union forces.

20 November 1864

Western Theater, March to the Sea Sherman's troops continue their progress, fighting enemy cavalry, home-guards and state militia at Clinton, Walnut Creek, East Macon and Griswoldsville, Georgia.

21 November 1864

Western Theater, Franklin and Nashville Campaign Hood moves his Army of Tennessee out of Florence, Alabama, northeastward toward Tennessee. His force includes 30,000 infantry and 8000 cavalry. The Confederate general had originally hoped to launch his invasion from Decatur as long as three weeks ago but for a variety of reasons (including the belated arrival of General Forrest and his cavalry) he delayed. During this period General Thomas has had time to improve his defenses and strengthen his army in and around Nashville as well as to reinforce Federal outposts at Pulaski and Columbia, Tennessee. Now on the move,

Below: General Sherman reviews the cavalry of Kilpatrick outside the town of Marietta, Georgia, on 15 November 1864.

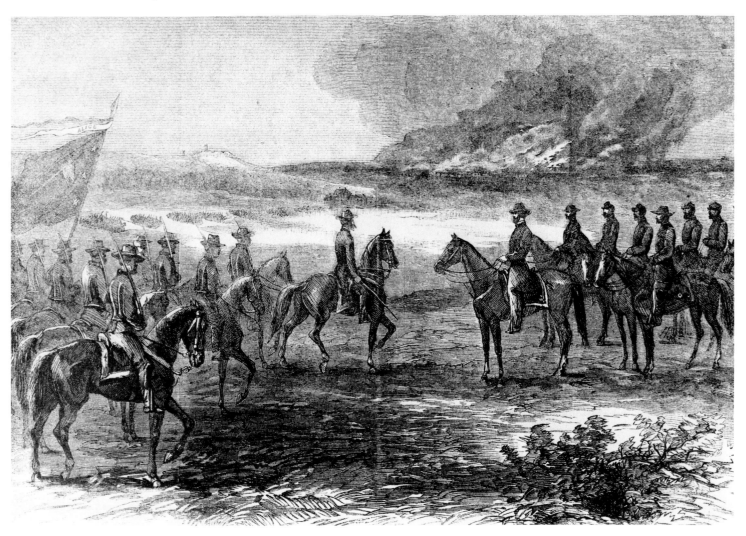

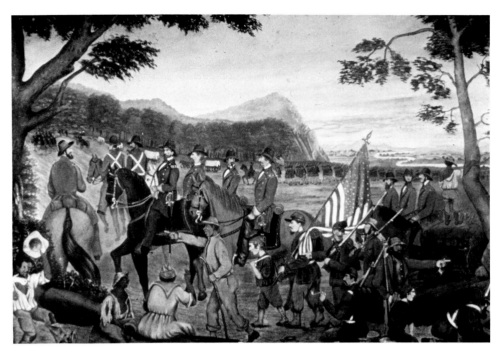

Above: A rendition of the campaign in Georgia. The march involved the wholesale destruction of Southern property and industry.

though, Hood plans to place his army between that of General Schofield in Pulaski and the body of Federals to the north.
March to the Sea General William J Hardee arrives in Macon to oversee the defenses of Georgia. From the disposition of the two wings of the enemy's army, he decides that Augusta or Savannah and not Macon must be the objective of the Northern army. He orders General Smith to move his troops eastward to oppose the advance of the Federal right wing. General Wheeler, meanwhile, is to continue to use his cavalry to strike at the enemy's rear columns.

22 November 1864

Western Theater, Franklin and Nashville Campaign Hood's army moves northeastward toward Columbia, hoping to capture that city and cut off Union General Schofield's troops in Pulaski from the rest of the Federals to the north. Schofield, however, realizing what is afoot, begins to evacuate his troops northward to Columbia.
Western Theater, March to the Sea In Millegeville, the Georgia state legislature issues a call for troops to check Sherman's invasion and then flees the state capital just before Sherman's left wing, commanded by General Henry W Slocum, occupies the city. The Georgia state militia attacks the Union right wing in a vain effort to halt its progress.

23 November 1864

Western Theater, Franklin and Nashville Campaign Skirmishing breaks out at Fouche Springs, Henryville and Mount Pleasant, Tennessee, as Hood's army continues to march toward Columbia.
Western Theater, March to the Sea In Georgia, the two wings of Sherman's army reunite in Millegeville, where there is more fighting between Federals and state militia. Fighting also takes place at Ball's Ferry and at a railroad bridge belonging to the Georgia Central over the Oconee River.

24 November 1864

Western Theater, Franklin and Nashville Campaign The front column of General Schofield's troops under the command of General Jacob D Cox arrives in Columbia, Tennessee, just in time to help Federals already there drive off General Forrest's Confederate cavalry. By the end of the day, the rest of Schofield's men arrive and dig in south of the Duck River.

25 November 1864

The North Southern arsonists, acting under orders from agents in Canada, set fire to 10 hotels in New York City, including the Belmont, Metropolitan, Saint James and Astor House. Alarms also go off in two downtown theaters and a fire is set at Barnum's Museum. Strangely, none of the fires does serious damage and all are quickly extinguished. Later R C Kennedy will be arrested and executed for setting the blaze at Barnum's Museum.
Western Theater, March to the Sea Cavalry under General Joseph Wheeler battle Federals outside Sanderson, Georgia, before the Federals succeed in occupying the town.

26 November 1864

Western Theater, Franklin and Nashville Campaign Hood's Army of Tennessee arrives outside Columbia only to find Federal troops well-entrenched both south and north of the Duck River.
March to the Sea Fighting continues between Confederates and elements of Sherman's army at Sanderson, Georgia.
Trans-Mississippi The Nebraska Territory is again the scene of fighting between Federal soldiers and Indians, this time near Plum Creek Station and at Spring Creek.

27 November 1864

Eastern Theater, The Siege of Petersburg The steamer *Greyhound*, General Benjamin Butler's floating headquarters, blows up on the James River, apparently an act of Southern sabotage. In West Virginia, Federal soldiers skirmish with the enemy at the town of Moorefield.

Western Theater, Franklin and Nashville Campaign Believing that Hood's army will attack from south of Columbia, General Schofield moves his troops north of the Duck River in the evening, burning the bridges behind him and digging in to prepare for the assault.
March to the Sea At Waynesboro, Georgia, Sherman's march is interrupted as the Confederate cavalry strike at the Union army.

28 November 1864

Eastern Theater, Valley Campaign Confederate General Thomas L Rosser leads his cavalry on a raid into Maryland where they destroy a bridge on the Baltimore and Ohio Railroad and then retreat back up the Valley into Virginia.
Western Theater, Franklin and Nashville Campaign With troops under Stephen D Lee staying at Columbia to create the impression that an attack will come from the south, General Hood moves the rest of his troops east of that city, planning to cross the Duck River north of the Federal army and cut off its retreat. During the afternoon Forrest's cavalry cross the river about 10 miles north of the Federals near Spring Hill, driving the Union cavalry north toward Franklin.
Western Theater, March to the Sea Fighting in Georgia occurs along Sherman's advance at Buckhead Church and Buckhead Creek. There are also cavalry engagements at Davisborough and Waynesboro.

29 November 1864

Western Theater, Franklin and Nashville Campaign Having been driven off to Franklin by enemy cavalry, General James H Wilson, Schofield's cavalry commander, sends back word to his commander at Columbia that the enemy has crossed at Spring Hill and the Federal army is in danger of being cut off to the north. Schofield still believes that he is to be attacked from the south but he does send some troops up to Spring Hill to investigate Wilson's report. Meanwhile, in the morning hours, Confederate infantry begin to cross over the Duck River north of the Federal army, with more following in the afternoon. Reports of these activities come back to Schofield from his reconnaissance troops and around 1500 hours the Union general starts his army north to Franklin. Although Confederate troops arrive at Spring Hill before him and Hood himself is on hand over an hour before dark, Schofield somehow manages to get his whole army past the enemy during the night.
Trans-Mississippi, Sand Hill Massacre Colorado militia under the command of Colonel John M Chivington descend upon the Cheyenne village at Sand Creek, Colorado Territory, without warning, killing almost one-third of its residents and torturing and mutilating many of their victims. A large proportion of the dead are women and children. For some time previous, there have been raids by Indians against gold miners and other settlers in the area. Although the Cheyenne, under the leadership of Chief Black Kettle, deny that they were involved in the raids and are under the protection of the Federal garrison at Fort Lyon, Chivington and his men decide to launch a reprisal on the settlement for the past attacks. The massacre

will be later officially condemned by the Federal government.

30 November 1864

Western Theater, Franklin and Nashville Campaign Escaping the trap the Confederates had planned for him, General Schofield arrives in Franklin with his 32,000-man force in the morning. The Union general deploys his troops in a long arc south and west of Franklin (nestled in a bend of the Harpeth River) while he works to get his supply train north of the river. The Confederates are slow to pursue the Federals but by 1530 hours the Army of Tennessee has arrived south of the city and launches a full-scale assault over two miles of open field and against entrenched positions. Bloody hand-to-hand fighting develops as the Southerners several times reach the enemy lines only to be repulsed with heavy losses. While the infantry assaults are in progress, cavalry units from the two armies also fight each other both to the west and to the east of the city. On both flanks, however, the Confederates are ultimately forced to withdraw. At 2100 Hood finally calls off his attacks and, during the night, Schofield withdraws his men across the river and toward Nashville. During the battle, 27,939

Union soldiers are engaged in fighting while the Confederates have 26,897 men in the field. Northern casualties are 2326, including 1104 missing, while the South loses 6252 men of whom 702 are missing.

Western Theater, March to the Sea In Georgia, Sherman continues his march southeastward with a skirmish at Louisville. At Hilton Head, South Carolina, Federal troops launch an attack aimed at cutting the Charleston and Savannah Railroad. The Georgia militia, however, meets these troops at Honeyhill and forces them to withdraw.

1 December 1864

Western Theater, Franklin and Nashville Campaign Schofield's army reaches Nashville where it joins the troops already there under the command of General George Thomas. Hood's army follows quickly on the Federals' heels and encamps southeast of the city. Both sides are preparing themselves for battle around Nashville.

2 December 1864

Western Theater, Franklin and Nashville Campaign Too weak to attack the strong Federal lines after its severe losses at Franklin, Hood's Army of Tennessee begins to for-

tify its own position southeast of Nashville. The Union lines, carefully prepared by Thomas during the last month, ring the Tennessee capital extending north on both sides to the Cumberland River. During the day, Confederate cavalry carry out raids against isolated positions on the Federal lines.

3 December 1864

Western Theater, March to the Sea The four corps of Sherman's army continue their march toward Savannah. They meet some resistance during the day from Southern soldiers at Thomas Station.

4 December 1864

Western Theater, March to the Sea Federal cavalry under General Hugh J Kilpatrick are struck by Confederate cavalry as they guard railroad wrecking crews near Waynesboro, Georgia. After some sharp fighting, the Federals finally force the enemy to retreat. More fighting breaks out at Statesborough, Lumpkin Station, along the Georgia Central Railroad, and on the Little Ogeechee River as the

Below: The Battle of Franklin ended when Hood's Confederates were unable to pierce the defense lines held by General Schofield's troops.

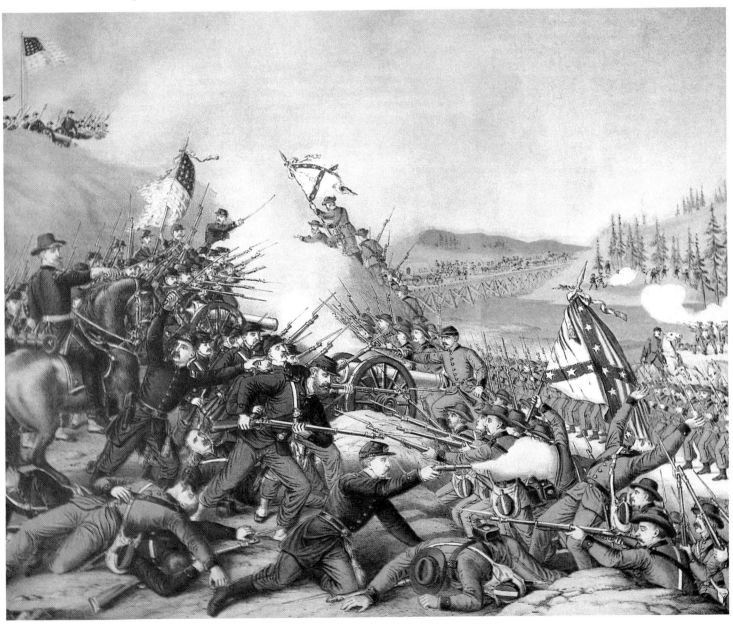

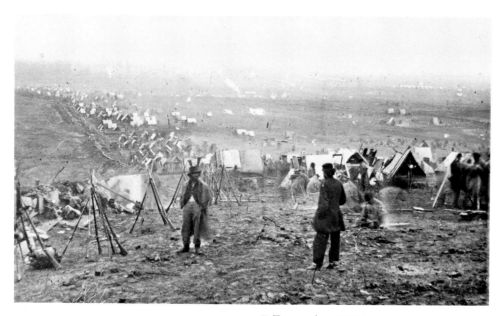

Above: By early December 1864, Hood's men had been forced back into Nashville, a city circled by strong Union entrenchments.

badly outnumbered Confederates continue to harass the enemy army.

Franklin and Nashville Campaign Around Nashville, Confederate cavalry strike at enemy outposts at White's Station and Bell's Mills. During the next week Confederate horsemen will have little opposition in the area, as General George Thomas busies his cavalry in rounding up horses for several thousand soldiers without mounts.

Below: Kilpatrick's cavalry launch their final charge against Southern troops guarding a vital railroad near Waynesboro, Georgia.

5 December 1864

Western Theater, Franklin and Nashville Campaign General Hood sends Nathan B Forrest with his cavalry and a division of infantry to Murfreesboro where they are to operate against some 10,000 Federal troops garrisoned there under the command of General L H Rosseau.

6 December 1864

Western Theater, Franklin and Nashville Campaign General Grant, who has been urging Thomas to attack the Confederates as soon as possible ever since they arrived south of Nashville, now sends him a direct order to 'attack Hood at once.' Many of Thomas' cavalrymen, though, are still without mounts and he has been delaying until enough

horses can be found. He warns Grant that an attack would be risky without cavalry. Confederates, meanwhile, launch a raid from Paris, Tennessee, to Hopkinsville, Kentucky.

7 December 1864

Western Theater, Franklin and Nashville Campaign In Murfreesboro, General L H Rosseau orders Robert L Milroy to make a reconnaissance in force against enemy troops commanded by General Forrest, who has been sent by Hood two days earlier to operate against Federals in the Murfreesboro area. Milroy defeats Forrest's men, forcing them from the field and capturing over 200 men and 14 guns.

8 December 1864

Eastern Theater, Siege of Petersburg Skirmishing takes place along Hatcher's Run, south of Petersburg, as Federal expeditions scout that area.

Western Theater, March to the Sea In Georgia, Sherman's army, nearing Savannah, skirmishes at Ebenezer Creek and near Bryan Court House.

Naval General Benjamin Butler takes 6500 men down the James River to Fort Monroe to join a naval expedition aimed at destroying Fort Fisher and closing the vital Southern port of Wilmington.

9 December 1864

Eastern Theater, Siege of Petersburg More fighting takes place between Federal reconnaissance troops and the Confederates along Hatcher's Run, south of Petersburg.

Western Theater, Franklin and Nashville Campaign Grant issues an order replacing General George Thomas with John Schofield as commander of Union troops in Nashville.

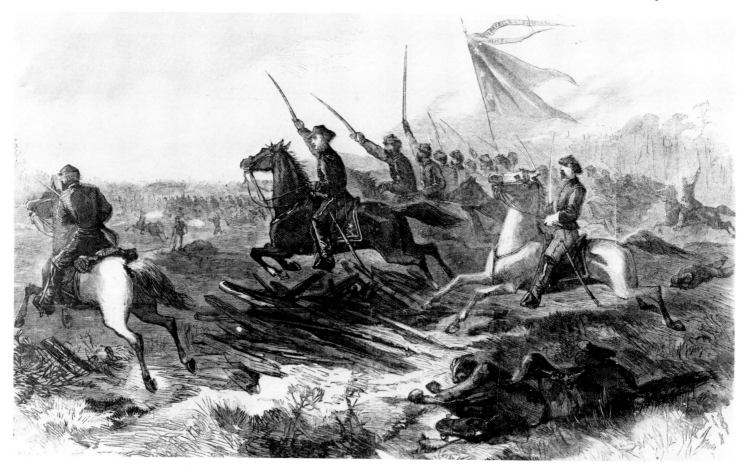

The general in chief suspends the order, however, when Thomas tells him that he had intended to attack on 10 December but a severe storm of freezing rain has forced him to alter his plans. To the south, fighting breaks out at the Ogeechee Canal, at Monteith Swamp and at Cuyler's Plantation.

10 December 1864

Eastern Theater, Siege of Petersburg Skirmishing occurs at Fort Holly, near Petersburg.

Western Theater, March to the Sea General William T Sherman and his army of 60,000 men arrive south of Savannah. In and around the city there are 18,000 well-entrenched Confederates under the command of General William J Hardee. The Southerners have flooded the rice fields around Savannah so that there are only five narrow strips of land over which a Federal attack could be launched. Sherman, surveying the situation, rejects an assault and instead decides to besiege the city. His army, now stationary, must worry about providing itself with necessary supplies. Although his men have adequate food, forage for horses is a daily concern. For this reason, Fort McAllister, located on the coast south of Savannah, is of vital importance. If the Federals can capture this fort, it will reopen contact with the navy and allow for the provisioning of Sherman's army. In Knoxville, a Federal expedition sets out under the command of General George Stoneman aimed at destroying enemy salt and lead mines in southwest Virginia and eliminating enemy troops in the area.

Naval Union troops capture and burn the Confederate steamer *Ida* on the Savannah River.

11 December 1864

Western Theater, Franklin and Nashville Campaign Thomas is again bombarded by messages from Grant telling him to strike the

Below: Fort Monroe, Virginia, was the target of a Union operation begun on 8 December 1864.

Above: A Confederate 100-pounder gun in position at Fort Fisher, a work defending the seaways near Wilmington.

enemy. He replies that he will do so as soon as weather permits.

Western Theater, March to the Sea Along the coast of Georgia, Federal soldiers rebuild the King's Bridge, which the Confederates destroyed, in preparation for an attack on Fort McAllister.

12 December 1864

Western Theater, Franklin and Nashville Campaign In Nashville, Thomas sends General Halleck a message telling him he will attack as soon as the ice on the ground melts sufficiently to allow troop movements. In eastern Tennessee, General George Stoneman and his cavalry force skirmish with the enemy at Big Creek near Rogersville.

13 December 1864

Western Theater, March to the Sea Federal troops charge across a field strewn with mines and other obstacles and capture Fort McAllister from the 230 Confederates garri-

soning the fort. The fall of Fort McAllister to Northern troops reopens communication and supply lines to Sherman's army. In Tennessee, meanwhile, part of General Stoneman's force defeats Confederate troops commanded by General Basil W Duke at Kingsport.

Franklin and Nashville Campaign Today also, Grant orders Major General John A Logan to proceed to Nashville to assume command of the army in that city. Grant himself leaves for Washington, intending to go on to Nashville to speed up operations there. While these proposed changes in the Union command are in the works, Confederates attack a railroad train near Murfreesboro.

Naval A naval expedition designed to reduce Fort Fisher, sails from Fort Monroe for the North Carolina port of Wilmington.

14 December 1864

Western Theater, Franklin and Nashville Campaign General Thomas wires Washington that he plans to attack Hood's army on the 15th. To the east, Stoneman's Union raiders again encounter the enemy, this time at Bristol, Tennessee. After a fight they capture 300 Confederates.

Naval US naval vessels begin a bombardment of Forts Rosedew and Beaulieu on the Vernon River. The action will continue for a week.

15 December 1864

Western Theater, Franklin and Nashville Campaign Union troops at Nashville attack the Army of Tennessee. Using troops commanded by General James B Steedman to hit the enemy's right and divert Hood's attention in that direction, General Thomas throws the bulk of his army's strength at the Confederate left in an attempt to envelop it from the west. Outnumbered two to one, Hood's army also fights the battle without the aid of most of its cavalry (which is away at Murfreesboro). During the day, the Confederates gradually contract their lines as the

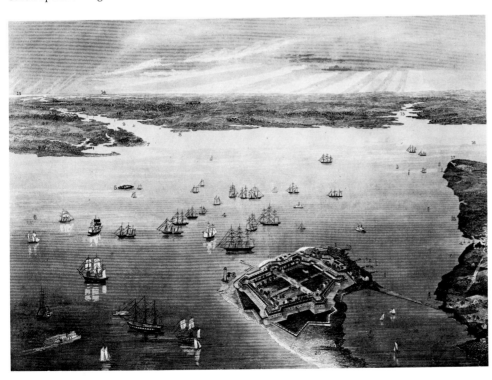

Above: Union officers and their families stand for the camera on top of a new railroad bridge.

Union assault pushes them from their original positions and to the south. The Federals gain considerable ground but by nightfall the enemy army, though bruised, is still intact. Thomas believes the enemy will withdraw, however, during the night. General Stoneman's raiders, meanwhile, again strike the enemy at Abingdon and Glade Springs, Virginia.

16 December 1864

Western Theater, Franklin and Nashville Campaign Morning finds the Confederate army still drawn up southeast of Nashville. After some initial probing, the Union army follows up its successes of yesterday by basically repeating the same battle plan. With Steedman's troops again holding the Confederate right, the bulk of the Northern army is thrown against the enemy's left. As Union soldiers finally succeed in turning the left flank, the Confederate center also collapses and Hood's shattered army flees in disorganized retreat. The right flank fights off the Federals with a desperate rearguard action as the Southern army plunges south toward Franklin. Close to 50,000 Federal troops see action in the two days of fighting while the Confederates have only slightly more than 23,000 in the field. Casualties are surprisingly light (387 killed, 2562 wounded and 112 missing for the Federals; probably not more than 1500 killed and wounded for the South). However, General Thomas reports capturing 4462 enemy soldiers. What is more, the battle effectively destroys the fight-

ing capacity of the Confederacy's Army of Tennessee and it will be the last major battle it will fight during the war.
Western Theater, March to the Sea In Georgia, Sherman's troops skirmish at Hinesville. To the east, Stoneman's cavalry capture Wytheville, Virginia, during the day and also fight the enemy at Marion.
Trans-Mississippi Fighting is reported during the day at Dudley Lake in Arkansas.

17 December 1864

Western Theater, Franklin and Nashville Campaign In Tennessee, Union cavalry under General James H Wilson pursue the fleeing Army of Tennessee, skirmishing with its rearguard at Hollow Tree Gap, the West Harpeth River and Franklin. The Confederates are still without most of their cavalry as Forrest's men have not yet rejoined the army. General James Chalmers's cavalry units, which were badly cut up at Nashville, are the only horsemen available to help fend off the Federals.
Western Theater, March to the Sea In Savannah, General William J Hardee receives word from Jefferson Davis that Lee cannot spare troops from the trenches around Petersburg to reinforce him against Sherman. Sherman, meanwhile, sends the Confederate commander at Savannah a message demanding the surrender of his troops.

18 December 1864

Washington President Lincoln issues a call for 300,000 additional troops to help put down the rebellion.
Western Theater, Franklin and Nashville Campaign At Spring Hill, Federal cavalry again skirmish with Hood's retreating army.

Western Theater, March to the Sea In Savannah, Hardee refuses Sherman's demand for a surrender of the Southern troops in the city.
Naval A fleet of ships commanded by Rear Admiral David Porter joins General Benjamin F Butler's force of 6500 men and together they sail toward Wilmington, North Carolina, where they hope either to capture or destroy Fort Fisher and thus close the port to Confederate blockade-runners.

19 December 1864

Eastern Theater, Valley Campaign In response to Grant's orders, General Sheridan sends General Alfred Thomas A Torbert with 8000 men to operate against the Virginia Central Railroad. They will meet strong resistance from Southern troops along the line and will withdraw on 23 December. Although Early and Sheridan remain in the Shenandoah, their armies are considerably reduced as troops on both sides have been sent off to reinforce the armies in Petersburg.

20 December 1864

Western Theater, Franklin and Nashville Campaign In Tennessee, elements of General Thomas's army pursuing Hood's army pause to build a bridge over the rainswollen Rutherford Creek and then continue on the trail of the Confederates. The two sides skirmish at Columbia.
Western Theater, March to the Sea As the Federal left moves to encircle Savannah and cut off the Confederates' escape route, General Hardee moves his army out of the city northward toward South Carolina, where he hopes to be reinforced by troops in that state.

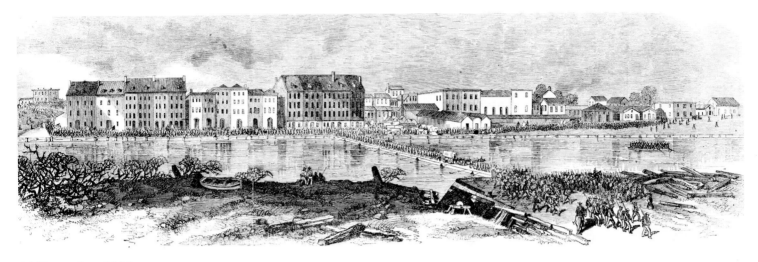

21 December 1864

Western Theater, March to the Sea Federal troops occupy the city of Savannah. Tomorrow, Sherman will send Lincoln his memorable message: 'I beg to present you, as a Christmas gift, the city of Savannah.' In southwest Virginia, Stoneman and his cavalry, after accomplishing their mission to destroy enemy salt and lead mines and drive enemy troops from the region, begin to withdraw back toward east Tennessee.

23 December 1864

Western Theater, Franklin and Nashville Campaign Hood's army continues its retreat southward and Federal cavalry continue their pursuit. Both yesterday and today skirmishing occurs between the two sides in the vicinity of Columbus, Tennessee.
Naval After battling storm-tossed seas for several days, Rear Admiral Porter's fleet arrives off Wilmington. General Benjamin F Butler, commander of the landing force, has his men pack an old ship with over 200 tons of gunpowder and then explode it near Fort Fisher, hoping the fort will be destroyed in the blast. The plan fails, though, as the explosion does little but wake the fort's sleepy inhabitants.

24 December 1864

Western Theater, Franklin and Nashville Campaign There are slight skirmishes between Federals and Hood's retreating army near the towns of Lynnville and Richland Creek, Tennessee.
Naval The naval armada under Rear Admiral Porter begins its bombardment of Fort Fisher. By depriving the Confederates of this fortress, the Union command believes it can effectively shut the last major port available to Confederate blockade-runners. During the day, troop transports also arrive. The plan is to storm and capture the fort after the naval bombardment has sufficiently weakened its defenses.

25 December 1864

Western Theater, Franklin and Nashville Campaign Federals skirmish with elements of the Army of Tennessee at Richland Creek, Devil's Gap and White's Station, Tennessee. The Confederates finally reach the Tennessee River.
Naval With close to 60 ships bombarding the fort, Federal troops commanded by General Butler land north of Fort Fisher and

move to within 75 yards of the fort, capturing Half Moon Battery as they advance. A strong fire from the 500 Confederates garrisoning the fortress checks the Union advance, though, and the Federals never renew the attack. Instead, after hearing that Confederate reinforcements (which General Lee had sent on 18 December) are within five miles of the fort, Butler decides an assault will be too costly and he withdraws his men. They will be transported back to Hampton Roads.

26 December 1864

Washington President Lincoln sends a message to General Sherman congratulating him on his success in Savannah and also for Thomas's victory at Nashville. The president admits that he had been apprehensive about the march to the sea, but deferred to the general's judgment. For that reason, he explains, all the honor for the victory must go to Sherman himself.
Western Theater, Franklin and Nashville Campaign Hood's army begins to cross the Tennessee River. There is some fighting at Sugar Creek. The retreat of the Confederates back over the Tennessee both symbolically and effectively brings to an end Hood's bold plan to take his army all the way to the Ohio River.

27 December 1864

Western Theater, Franklin and Nashville Campaign The Confederate Army of Tennessee finishes crossing the Tennessee River and then marches toward the town of Tupelo, Mississippi.

Above: Southern troops abandon Savannah to Sherman's command on 21 December 1864.

28 December 1864

Washington President Lincoln, disappointed by the Federal failure at Fort Fisher, asks Grant for his comments on the ill-fated expedition. The general in chief, who has been calling for Butler's dismissal since summer, is very decided on whom he feels is responsible for the 'gross and culpable failure.'

30 December 1864

Washington In a cabinet meeting, President Lincoln suggests that Butler should be relieved of his command of the Army of the James. Butler's superiors have long felt that he is militarily inept, but Lincoln until now has hesitated to relieve this politically influential general. The expedition to Fort Fisher, however, is an embarrassment to the administration and – some will later explain – in the wake of the recent election, Lincoln's position is less tenuous.
The Confederacy Francis P Blair, an aging but still powerful political figure from Maryland, writes to Jefferson Davis asking for a meeting with the Confederate leader in Richmond. Blair hints broadly that he is interested in exploring possible avenues for peace. This interview will lead directly to the Hampton Roads Conference next month between Lincoln and Confederate Vice-President Alexander Stephens.

Below: The naval yards at Savannah were burnt before they could fall into Northern hands.

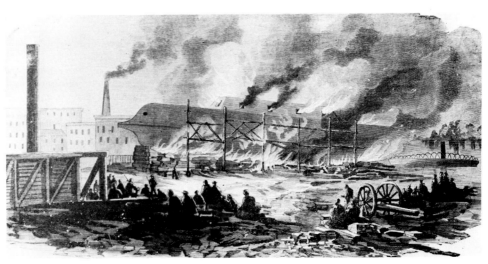

1 January 1865

Eastern Theater, Siege of Petersburg A work crew under the direction of General Butler sets off a large charge of gunpowder on the James River designed to clear away the last remaining portion of a canal being constructed to allow Federal vessels to bypass a large bend in the river. The huge explosion fails to clear the ditch, however, and the ambitious project will remain uncompleted. **Trans-Mississippi** Union soldiers, trying to clear Arkansas of its troublesome and ubiquitous guerrilla bands, skirmish with the enemy at Bentonville.

3 January 1865

Western Theater, Carolinas Campaign General Sherman transfers a portion of his army north to Beaufort, South Carolina, in preparation for his campaign through the Carolinas. Skirmishing breaks out along the way at Hardeeville, South Carolina.

4 January 1865

Naval Union troops leave from Bermuda Hundred for a new assault on Fort Fisher. Although most of the 8000 soldiers on this latest expedition against the Confederate fortress at Wilmington, North Carolina, have also been on the unsuccessful mission in December, General Alfred H Terry rather than Butler is now commanding the men who are to launch the land assault against this important enemy position.
Western Theater Union troops operating against the Mobile & Ohio Railroad skirmish with the enemy at Ponds in Mississippi.

5 January 1865

Washington President Lincoln issues a pass through Union lines to James W Singleton. Singleton, like several others, hopes that through unofficial channels he may be able to instigate peace negotiations between the two governments and bring an end to the fighting. Although Lincoln doubts that a peace can be negotiated through the auspices of the Confederate government consistent with the North's demand for reunion, he does not interfere with Singleton's mission and, to the extent of issuing the safe conduct pass, condones the unofficial peace-feeler.

6 January 1865

Washington In the House of Representatives, debate turns to the proposed Constitutional amendment abolishing slavery. Although passed by the Senate at the last session, it had failed to receive the necessary two-thirds vote in the House. The fall elections have increased the Union-Republican majority in the 39th Congress, but it is not scheduled to sit until December of 1865 and Republicans are anxious that the amendment pass before that time. They now set to work to convince enough Democrats to change their vote so that the amendment can be passed in the House and sent to the states for ratification.
The Confederacy Jefferson Davis writes a letter to Alexander Stephens, his continuous and outspoken vice-president, criticizing him for actively working to undermine the people's confidence in their president. Stephens, a long-time critic of the Confederate chief executive and currently active in the

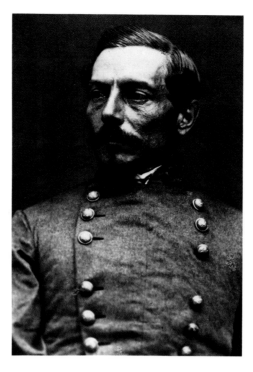

Above: Southern General Beauregard was placed in overall command of Confederate troops in Florida, Georgia and South Carolina in 1865.

Georgia peace movement, has accused Davis of secretly favoring the re-election of Lincoln over McClellan in the recent Northern presidential race.
Trans-Mississippi Federal soldiers skirmish with a group of Confederates at Huntsville, Arkansas.

7 January 1865

Washington The War Office issues an order relieving General Benjamin F Butler of command of the Army of the James and of the Department of Virginia and North Carolina. Major General Edward Ord is named to fill the vacated posts.
Eastern Theater, Valley Campaign More troops from General Philip Sheridan's dwindling army leave the Shenandoah Valley to reinforce the Union army besieging the city of Petersburg.
Trans-Mississippi Federal soldiers battle Indians in the Colorado Territory at Julesburg and Valley Station.
Naval The Danish ironclad *Sphinx* sets sail from Copenhagen to Quiberon Bay, France. The Confederate government has already secretly bought the *Sphinx*, and it will become the CSS *Stonewall*.

8 January 1865

Naval The army forces of General Alfred Terry join up with a large naval fleet commanded by Rear Admiral Porter off the coast of Beaufort, North Carolina. This Federal expedition is aimed at seizing the Confederate position known as Fort Fisher.

9 January 1865

Washington Moses Odell, a Democratic representative from New York, comes out in favor of the proposed constitutional amendment abolishing slavery. Odell will be one of the key Democrats whose vote will make its passage possible.
Western Theater, Franklin and Nashville

Campaign Hood's Army of Tennessee, after its long retreat from Nashville, arrives in Tupelo, Mississippi. In Tupelo, Confederate officials hope somehow to reassemble the broken army after its disastrous campaign in Tennessee. Davis also hopes to be able to transfer troops from Hood's army to reinforce Hardee's men opposing Sherman in the Carolinas.
Carolinas Campaign Secretary of War Edwin Stanton arrives in Savannah, Georgia, to confer with General Sherman on military matters. Stanton also plans to investigate charges made against Sherman of his alleged 'criminal' mistreatment of black freedmen.

10 January 1865

Washington Debate continues in the House of Representatives on the fate of the proposed constitutional amendment abolishing slavery throughout the country. Fernando Wood of New York, arguing against the amendment, tells Congress that passage of the amendment would destroy any chances for securing peace with the South.
Trans-Mississippi Federal soldiers battle Confederates near Glasgow, Missouri.

11 January 1865

Eastern Theater Riding in icy cold weather and deep snow, Confederate General Thomas L Rosser leads 300 men from his cavalry unit on a daring raid into West Virginia. The raiders attack unsuspecting Ohio troops stationed in Beverly, killing or wounding 25 Federals, and then retire with 583 prisoners.

12 January 1865

The Confederacy Francis P Blair, an important Maryland political figure, meets Jefferson Davis in Richmond to discuss possible avenues for peace between North and South. Blair's personal scheme calls for the two sides to join together to expel the French from Mexico. Such a course he feels would not only root out a dangerous incursion against the Monroe Doctrine, but would also help revive a feeling of brotherhood between North and South. Although the scheme does not meet the approval of either Davis or Lincoln, the Confederate president does promise to send a representative to discuss peace with Lincoln. This meeting will take place on 3 February.
Western Theater Davis sends a message to General Richard Taylor urging him to send troops from Tupelo, Mississippi, to reinforce Hardee in his operations against Sherman in the Carolinas. Meanwhile, in Savannah, Secretary of War Edwin Stanton calls a meeting of about 20 of 'the most intelligent of the Negroes' in that city to ask them how they feel blacks could best maintain their newly acquired freedom. Their spokesman, Garrison Frazier, tells Stanton that blacks should be placed on land to farm until they can afford to buy it. He also tells Stanton that because of deepseated prejudice against them, he feels his people would be better off living by themselves rather than among whites. Because of charges concerning Sherman's alleged mistreatment of blacks, Stanton also asks the group what their attitude is toward Sherman. Instead of complaints, however, Frazier tells Stanton, 'We have con-

fidence in General Sherman, and think that what concerns us could not be under better hands.'

13 January 1865

Naval Just after midnight, Admiral Porter's fleet of 59 ships begins its bombardment of Fort Fisher. Having reinforced the fort since the last attack in December, the Confederates now have close to 2000 soldiers and 47 guns in and around the fort itself and another 6000 men at the northern end of the peninsula, commanded by General Braxton Bragg, to oppose any attempted landing by the enemy. In midafternoon, however, Union troops under the command of General Terry establish a beachhead north of Fort Fisher and during the night dig in opposite Bragg's force and prepare to fend off any attack from that quarter.

14 January 1865

Western Theater, Carolinas Campaign Some troops under Sherman's command move from Beaufort to Pocotaligo, South Carolina. In Tupelo, Mississippi, General Pierre G T Beauregard assumes temporary command of the Army of Tennessee; this force will be turned over to General Richard Taylor on 23 January.
Naval General Terry's troops continue to prepare for their attack on Fort Fisher while they also work to secure their position against Bragg's Confederates. With Admiral Porter's fleet pounding away at the fort itself, Colonel William Lamb, commanding the Southern garrison there, sends urgent appeals to Bragg to turn his men loose on the Federal landing expedition which is to the north of the fort.

15 January 1865

Naval At 0800 hours, Admiral Porter's powerful armada opens up again on Fort Fisher, this time at point-blank range. Throughout the morning, the Federals pour a withering fire at the fort and its defenders. In midafternoon, Northern troops launch a twin attack against the fortress: one, composed of 2261 sailors and marines, strikes from the ocean side; the other, 3300 of General Terry's 8000-man landing force, assails the fort from the northwest. The remaining 4700, meanwhile, remain entrenched opposite General Bragg's Confederates to prevent them from interfering in the operation. The fort's defenders repel the assault from the sea but are unable to resist the land attack and at 2200 are forced to surrender. Confederate casualties are about 500, while the combined Union losses are 1341. The Federals, however, take over 1900 prisoners, including General William H Whiting and Colonel William Lamb. Bragg will come under severe criticism from both these men for failing to attack the landing party during the operations.

16 January 1865

Washington Back in Washington, Francis P Blair gives President Lincoln a detailed report on his recent discussion with Jefferson Davis over possibilities for peace between North and South. Later, Lincoln will turn down Blair's scheme for a combined effort to expel France from Mexico, but the Marylander's trip between Richmond and Washington does succeed in getting both sides to agree to meet with one another.
The Confederacy In a move that is widely seen as a direct challenge to Davis' control over military matters, the Confederate Senate passes a resolution (by a vote of 14 to 2) advising the president to appoint Lee as general in chief, to give Joseph Johnston his old command of the Army of Tennessee and to make Beauregard overall commander in Florida, Georgia and South Carolina.
Naval At Fort Fisher, two drunken sailors, looking for loot in the newly captured fortress, stumble into a magazine with their torches and explode 13,000 pounds of gunpowder. Twenty-five Federals die in the blast and another 66 are wounded. Some Confederates, captured in last night's battle, are also killed in the explosion. Meanwhile, Davis, learning of the loss of the fort, sends General Bragg a message urging him to retake the fort if at all possible.
Western Theater To provide for the 10,000 black refugees that had followed his army through Georgia on its March to the Sea, General Sherman issues *Special Field Order Number 15*. The order sets aside all abandoned or confiscated land along the coast of Georgia, including islands, for the settlement of freedmen. Families are to be given 'possessory title' to not more than 40 acres until Congress regulates their title. Although Sherman will later insist that the order was intended as nothing more than a temporary war measure, and almost all of the land will eventually revert to its former owners, many blacks hope this order represents the determination of the government to make land available to the new freedmen.

Below: Confederate batteries in Fort Fisher come under fire from gunboats of Admiral David Porter's fleet, 15 January 1865. Later, after heavy infantry assault, the fort fell.

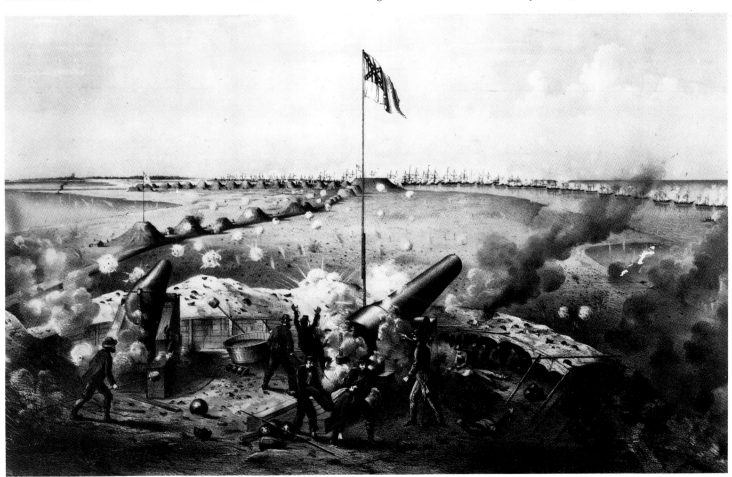

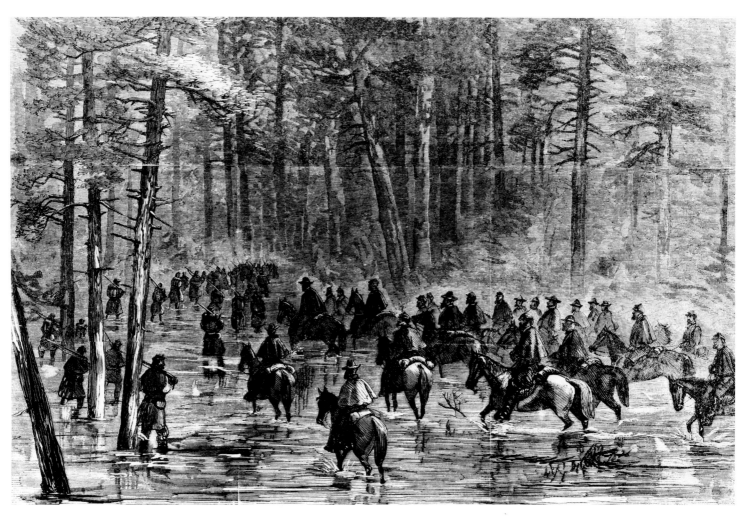

Above: Sherman's troops move through a swamp during their advance from McPhersonville, South Carolina, on 1 February 1865.

19 January 1865

The Confederacy After much prodding from Davis, General Robert E Lee agrees to accept the position of general in chief of all the armies of the Confederacy. Davis is anxious to head off mounting criticism of his control of the armies by acceding to Congress' 'advice' to appoint Lee as military commander of all Confederate forces.

Western Theater, Carolinas Campaign General Sherman issues orders commanding the units of his army to begin their march into South Carolina. Heavy rains will delay the march until early February, but some troop movement commences.

20 January 1865

Western Theater, Carolinas Campaign Sherman's army in the vicinity of Savannah continues preparations for its northward march.

Trans-Mississippi There is a fight near Fort Larned, Kansas, between Federal troops and Indians.

21 January 1865

Western Theater, Carolinas Campaign General Sherman moves his headquarters out of Savannah toward Beaufort, South Carolina.

23 January 1865

The Confederacy To help mollify elements in Congress critical of his handling of military matters, Davis signs into law a bill passed by

Congress last week creating the position of general in chief. Both Congress and Davis are agreed that Lee is to fill the new post.

Western Theater In Mississippi, General Richard Taylor assumes command of the Army of Tennessee. Because many of the troops formerly with this army have been transferred east to reinforce General Hardee in South Carolina, the Army of Tennessee now has fewer than 18,000 soldiers.

Naval Eleven Southern ships set sail down the James River, hoping to attack the Federal squadron off the coast. Four of the ships, however, run aground and the Confederates are forced to abandon the project.

26 January 1865

Western Theater, Carolinas Campaign Although Sherman intends to march his army to Goldsboro, North Carolina, he wants to deceive the enemy as to his real objective. To do so, he sends an expedition out toward Charleston to create the impression that his army will head in that direction. The troops skirmish with the enemy near Pocotaligo, South Carolina. Farther west, there is also fighting near Paint Rock, Alabama.

27 January 1865

Western Theater Fighting breaks out between Union and Confederate troops in DeKalb County, Alabama.

28 January 1865

The Confederacy To represent the South in the upcoming peace talks with President Lincoln, Jefferson Davis appoints Vice-President Alexander Stephens, Robert M T Hunter,

president *pro tempore* of the Senate, and Assistant Secretary of War John A Campbell.

Western Theater, Carolinas Campaign There is skirmishing along the Combahee River in South Carolina between elements of Sherman's army and defending Confederates.

30 January 1865

Western Theater, Carolinas Campaign Reinforcements from the Army of Tennessee from Tupelo, Mississippi, begin to arrive in Augusta, Georgia. Altogether some 4000 soldiers will arrive from Tupelo to help General Hardee defend the Carolinas against Sherman's army. Meanwhile, fighting breaks out between the two sides at Lawtonville, South Carolina, as elements of Sherman's army continue their activities in the lower part of the state. In Kentucky, there is fighting at Chaplintown, as Confederates harass Union troops in the state.

31 January 1865

Washington By a vote of 119 to 56, the House of Representatives passes the proposed constitutional amendment abolishing slavery throughout the United States. The amendment will now go to the states. It must be ratified by three-fourths of them before it will become a part of the Constitution. A critical question is whether any of the states formerly or presently in rebellion should be included in ratification calculations. A number of Republicans believe that the rebellious states must first be accepted into the Union as new states, and until they are, should have no influence over the ratification process. This view, of course, improves the chances

for adoption of the amendment. Today also, Lincoln gives Secretary of State William H Seward instructions concerning his upcoming conference with the Confederate peace commissioners. President Lincoln insists that recognition of Federal authority is a necessary precondition to peace, while Davis still clings to independence as the only basis of negotiations.

1 February 1865

The North Illinois ratifies the 13th Amendment, becoming the first state to do so since its passage in the House of Representatives yesterday.

Western Theater, Carolinas Campaign After having been delayed for almost two weeks by heavy rains, Sherman's Union army sets out in earnest on its march through the Carolinas. By again dividing his army – his right wing making a feint toward Charleston while the left wing moves in the direction of Augusta – Sherman hopes to confound the enemy as to his true objective. As the army begins its march through South Carolina, many of the soldiers seem determined to make the state, which they see as the heart and soul of secession and rebellion, suffer for its treason. Aside from the official work of destruction, the Federals also burn and destroy much private property. Although such destruction is against orders, Sherman seems to have anticipated South Carolina's fate in a letter he had written to General Halleck in December: 'The whole army is burning with an insatiable desire to wreak vengeance upon South Carolina,' he wrote. 'I almost tremble

at her fate, but feel that she deserves all that seems in store for her.'

2 February 1865

Washington President Lincoln leaves the capital for Hampton Roads, Virginia, where tomorrow he plans to meet with Confederate peace commissioners.

The North Rhode Island and Michigan become the second and third states to ratify the 13th Amendment.

Western Theater, Carolinas Campaign Hindered by fallen trees and burned bridges, Union troops under General Sherman continue their march through South Carolina. To oppose them, the South has 22,500 soldiers brought in from various theaters of the war. About 12,500 of these are concentrated in and around Augusta, Georgia, and the remainder lie between Port Royal Sound and Charleston on the Carolina coast. With the two wings of the Federal army aimed in different directions, the Confederates are unaware that its true objective is Columbia.

3 February 1865

Washington President Lincoln and Secretary of State Seward meet with Stephens, Hunter and Campbell on board the *River Queen*, off Hampton Roads, to discuss possibilities for peace between North and South. The talks, which last about four hours, produce no positive results, however, as the Confederate agents want an armistice first and all talk of reunion postponed until later, while Lincoln insists on recognition of Federal authority as an essential first step toward

peace. The president also informs the Southerners of the recent passage of the 13th Amendment in Congress and expresses confidence that it will soon be ratified by the states.

The North Maryland, New York and West Virginia ratify the 13th Amendment. To date, six states have done so.

Western Theater, Carolinas Campaign As Sherman's right wing continues to move in the direction of Charleston, Federal troops battle Confederates at Rivers' Bridge and at Dillingham's Cross Roads beside the Salkehatchie River.

4 February 1865

Washington President Lincoln returns to the White House after his unsuccessful peace mission to Hampton Roads, Virginia.

Western Theater, Carolinas Campaign Fighting occurs along Sherman's advance at Angley's Post Office and Buford's Bridge.

5 February 1865

Washington President Lincoln presents a plan to his cabinet pledging the Federal government to pay $400,000,000 to the slave states if they lay down their arms before 1 April. The cabinet, though, is united in opposition to the scheme and the matter drops.

Eastern Theater, Siege of Petersburg In another attempt to extend his lines westward, General Grant orders part of his army

Below: The scene in the House of Representatives after the passage of the resolution to abolish slavery, 31 January 1865.

to move in the direction of Boydton Plank Road to stop Confederate wagon trains from using that road to supply Petersburg. This movement, which will continue for the next three days, will be the last major move by Grant to push his lines westward prior to the final assault.

6 February 1865

The Confederacy Davis also reports to Congress on the meeting at Hampton Roads between Lincoln and the three Confederate peace commissioners. Lincoln, he says, insists upon unqualified submission as his terms for peace.

Eastern Theater, Siege of Petersburg Heavy fighting occurs south of Petersburg, near Dabney Mills, as Confederate troops led by General John Pegram attack the positions Union troops had taken up on 5 February. Federals repel the attack and Pegram is killed in the assault.

Western Theater, Carolinas Campaign Fighting takes place at Fishburn's Plantation, on the Little Salkehatchie and near Barnwell as Confederates continue to operate against Sherman's advancing columns in South Carolina.

7 February 1865

The North Maine and Kansas both ratify the 13th Amendment. In the Delaware legislature, however, it fails to receive enough votes for passage.

Eastern Theater, Siege of Petersburg In the third day of action around Hatcher's Run, south of Petersburg, Union troops fall back

Below: Fires break out in the city of Columbia, South Carolina, after it has been occupied by Sherman's troops.

from the Boydton Plank Road after Confederate reinforcements arrive on the scene. In three days, the Union troops have succeeded in extending their lines to Hatcher's Run at the Vaughan Road crossing. The movement costs the North 1512 casualties. Southern casualties during the action are unreported.

Western Theater, Carolinas Campaign Fighting swamps and swollen rivers, Sherman's troops continue their progress toward Columbia. Some fighting takes place during the day at Blackville, South Carolina.

8 February 1865

Western Theater, Carolinas Campaign At Williston on the Edisto River and along the banks of the South Edisto, Sherman's Union troops again battle Confederates. Sherman responds to a complaint from Confederate cavalry leader Joseph Wheeler that Union soldiers are ruthlessly destroying private property along their path: 'I hope you will burn all cotton and save us the trouble,' Sherman tells Wheeler. 'All you don't burn I will. As to private houses occupied by peaceful families, my orders are not to molest or disturb them, and I think my orders are obeyed. Vacant houses being of no use to anybody, I care little about. I don't want them destroyed but do not take much care to preserve them.'

9 February 1865

The Confederacy General Robert E Lee assumes the position of general in chief of the Confederate armies. He suggests a pardon be given all deserters who report back to their commands within 30 days. Davis approves the plan.

Western Theater, Carolinas Campaign General John M Schofield assumes his duties as commander of the Department of North

Carolina and troops under his command arrive at Fort Fisher in preparation for an assault on Wilmington. Schofield's assignment is to move his troops westward, restoring communications, to provide Sherman's army with a shorter supply line than would be necessary if it were to continue to draw provisions from Savannah. Sherman's army, still marching northward, skirmishes with the enemy at Binnaker's Bridge and at Holman's Bridge in South Carolina.

10 February 1865

Western Theater, Carolinas Campaign There is fighting around Charleston Harbor at James Island and at Johnson Station. Confederates in the city are still not sure whether Sherman's army intends to attack them and are forced to maintain defenses against both land and sea assault.

11 February 1865

Eastern Theater, Siege of Petersburg Some fighting occurs near Williamsburg, Virginia.

Western Theater, Carolinas Campaign Sherman's army reaches the Augusta and Charleston Railroad, thus placing itself directly between Confederate forces in and around Augusta and those on the coast of South Carolina near Charleston. Some action takes place at Aiken, Johnson's Station and around Orangeburg, South Carolina. In Charleston, General William J Hardee, who is now separated from potential reinforcements from the west, still believes the Federal army intends to strike at that city.

12 February 1865

Washington The electoral college meets and, by a vote of 212 to 21, Lincoln is declared president. Although Tennessee and Loui-

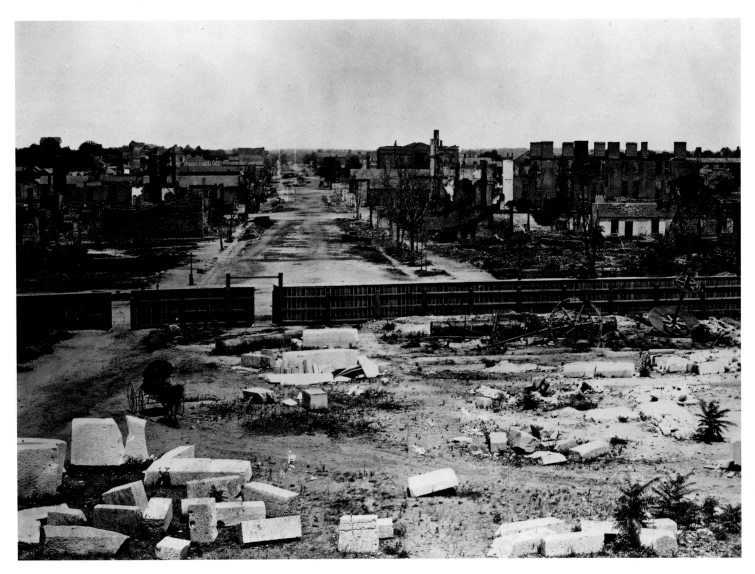

siana had both voted in the November election, Vice-President Hannibal Hamlin, presiding over the college, does not present the votes of these states.

Western Theater, Carolinas Campaign Sherman's army repulses Southern defenders at the Orangeburg Bridge on the North Edisto River and continues its northward march toward Columbia.

13 February 1865

International Lord John Russell complains to US commissioners of United States activities on the Great Lakes. Britain and Canada are particularly upset at the military buildup in that area. The Lincoln administration, however, believes it is necessary to counter raids by Confederate agents operating out of Canada. The Saint Albans raid of October 1864, in particular, has generated a good deal of animosity between the US and its northern neighbor. The raid not only originated in Canada but the Canadian government later released the perpetrators from jail for lack of jurisdiction.

14 February 1865

Western Theater, Carolinas Campaign Sherman's troops cross the Congaree River and then both wings turn toward Columbia, South Carolina. Meanwhile, Jefferson Davis urges General Hardee, who is still expecting the Union army to attack Charleston, to delay evacuating that city as long as possible. He

does, however, leave the final decision to Hardee and Beauregard who, he admits, are better aquainted with the situation.

15 February 1865

Western Theater, Carolinas Campaign Fighting flares up along the Congaree Creek and Savannah Creek and also at Bates Ferry on the Congaree River as Confederates try to slow Sherman's march toward Columbia. There is also fighting during the day at Red Bank Creek and Two League Cross Roads in South Carolina. In addition to the continuing attacks by Southern cavalry, the Union army must contend with deep swamps and rain-swollen waterways.

16 February 1865

Western Theater, Carolinas Campaign Sherman's army arrives at the Congaree River just south of Columbia, South Carolina. Both General Beauregard and Confederate cavalry leader Wade Hampton are in the city during the day, but are powerless to resist the Northern army. Beauregard tells Lee that there is nothing to be done to save the state capital and then in midafternoon leaves Columbia. To the east, in Charleston, General William J Hardee makes preparations to evacuate his troops from that city. With Sherman's army between him and potential reinforcements in Augusta, and with a formidable threat from the sea as well, Hardee's position is clearly untenable.

Above: The scene in Columbia after the fires had died down. Large areas of the city were destroyed in the conflagration.

17 February 1865

Western Theater, Carolinas Campaign In the morning, town officials of Columbia, South Carolina, ride out to surrender the city formally to the Union General William T Sherman and his army. As the remainder of the Southern cavalry flee the capital, the Northern troops occupy it and the officers and staff settle into a few of the fine mansions that grace the city. Some time during the night fire breaks out in a number of homes and, though many of the town's 20,000 residents battle the flames, the wind-fanned blazes quickly spread to neighboring structures. By morning two-thirds of Columbia will lie smoldering in ashes. Sherman is quick to blame the fleeing enemy soldiers for the fires, but for residents of the town and for Southerners in general, the burning of Columbia will long stand as a symbol of the savage cruelty of Sherman's marauding army. Among the homes destroyed during the night is the magnificent mansion of General Wade Hampton, commander of the Southern cavalry opposing Sherman's march. Meanwhile, General Hardee evacuates Charleston, moving his troops northwestward to Cheraw, South Carolina. After the long siege Fort Sumter finally falls into Federal hands.

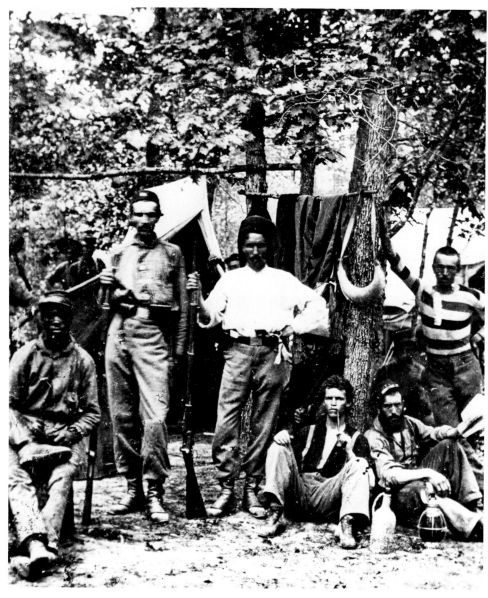

Above: Casually dressed members of the 23rd New York Infantry Regiment have a photograph taken with their black servants.

18 February 1865

The Confederacy In a letter to Mississippi Congressman Ethelbert Barksdale, General Lee endorses the idea of arming slaves to help the South win independence. The idea, which has gained considerable support in the Confederate Congress since its new session opened in November, was recently incorporated in a bill introduced by Barksdale in the Confederate House of Representatives. Lee tells Barksdale that he believes blacks would make efficient soldiers, but they should fight as free men.

Western Theater, Carolinas Campaign General Sherman orders the destruction of all railroad depots, supply houses and industries in Columbia not already destroyed in yesterday's fire. Near Wilmington, North Carolina, Federal forces bombard Fort Anderson from the sea while troops under the command of General Jacob Cox land south of the city and then begin to move westward hoping to outflank Confederate troops there. To the west, Confederates raid Fort Jones, Kentucky.

Naval After several days of refitting, the CSS *Shenandoah* leaves Melbourne, Australia.

19 February 1865

Western Theater, Carolinas Campaign As Union troops try to outflank Confederate forces in Wilmington, North Carolina, by marching around the city from the south, fighting breaks out along the way, including one action at Town Creek. The Federal navy meanwhile, continues its bombardment of Fort Anderson, and during the night the Southern garrison evacuates that place. In Columbia, South Carolina, as Union soldiers finish their work of destroying everything of military use in that city, units of Sherman's army begin their march northward toward Goldsboro, North Carolina. In Alabama, Federals continue an expedition aimed at Selma and encounter enemy soldiers.

20 February 1865

The Confederacy The Confederate House of Representatives passes a bill authorizing the use of slaves as soldiers. Since Jefferson Davis's November message to Congress calling for the increased use of slaves as laborers in the military, debate in the South has increasingly turned to suggestions of actually arming the blacks.

Western Theater, Carolinas Campaign General Jacob Cox's Union troops continue their flanking maneuver on the east bank of the Cape Fear River near Wilmington.

21 February 1865

The Confederacy The Confederate Senate votes to postpone consideration of the House bill authorizing the arming of slaves.

Eastern Theater, Siege of Petersburg General Lee writes Secretary of War John Breckenridge that if it becomes necessary to abandon Richmond, he will move his army to Burkeville, Virginia, where it could stay in contact with Confederate troops in the Carolinas, and possibly join forces for a combined assault on either Grant's or Sherman's army if the opportunity occurs.

Western Theater, Carolinas Campaign General Braxton Bragg orders the evacuation of Southern troops from Wilmington, North Carolina, the last major Confederate port. With enemy pressure from the sea, and Union General Jacob Cox's troops closing in from the west, the Confederates in the city begin destroying all supplies there which they cannot carry with them. Meanwhile, there is fighting at Eagle Island and Fort Strong as Federals keep up pressure on the enemy.

22 February 1865

Western Theater, Carolinas Campaign Union troops enter the city of Wilmington, which General Braxton Bragg's troops had evacuated last night. In their campaign against the city, the North lost 200 casualties. Farther south, there is fighting at Camden, South Carolina, and again on the Wateree River as Sherman's army continues its march northward.

23 February 1865

Western Theater, Carolinas Campaign Fighting again erupts near Camden, South Carolina, between elements of Sherman's army and Confederate troops.

24 February 1865

Western Theater, Carolinas Campaign As Union troops continue to wreak their vengeance on South Carolina as the birthplace of secession through unofficial acts of destruction, General Sherman complains to Confederate cavalry General Wade Hampton of the murder of Union foragers by Southern soldiers. Hampton will reply that while he is unaware of the specific episode to which Sherman refers, he has ordered his men to shoot on sight any Northerners caught burning people's homes. And, he will tell Sherman, 'This order shall remain in force so long as you disgrace the profession of arms by allowing your men to destroy private dwellings.' More fighting occurs between the two sides at Camden, South Carolina.

26 February 1865

Western Theater, Carolinas Campaign Sherman's troops again encounter the enemy, today at Lynch Creek and Stroud's Mill, South Carolina. The Federal XX Corps reaches Hanging Rock.

27 February 1865

Eastern Theater, Valley Campaign In response to Grant's orders, Sheridan sends a 10,000 men cavalry force under General Wesley Merritt to destroy the Virginia Central Railroad and James River Canal. They are then to take the city of Lynchburg, Virginia.

Western Theater, Carolinas Campaign There is fighting along Sherman's path at Mount Elon and Cloud's House, South Carolina. Southern troops also skirmish with Northerners at Spring Place, Georgia.

28 February 1865

Western Theater, Carolinas Campaign Rocky Mount and Cheraw, South Carolina, are the scene of fighting as Sherman's troops continue their march toward North Carolina.

1 March 1865

Eastern Theater, Valley Campaign Union cavalry engage the enemy at Mount Crawford.

2 March 1865

Eastern Theater, Siege of Petersburg Lee, as general in chief of the Confederate forces, sends a message through the lines to General Grant suggesting that the two of them hold a 'military convention' to try to reach 'a satisfactory adjustment of the present unhappy difficulties.' Lee's peace overture is the result of a conversation between General James Longstreet and General Edward Ord in which the latter reportedly said that the Union general in chief would respond favorably to such an invitation.

Valley Campaign At Waynesborough a Union cavalry force led by General George A Custer attacks the remnant of Jubal Early's Confederate army and completely routs it, breaking up and scattering the shattered enemy force. Although Early and his staff manage to escape, more than 1000 Southern soldiers are taken prisoner. The Federals herd their prisoners and over 200 wagons of supplies northward down the Shenandoah Valley with an escort and then head toward Charlottesville, Virginia. Meanwhile, Jubal Early and those of his command who had managed to escape capture, begin to make their way back to Richmond. The Battle of Waynesborough marks the end of the last campaign in the Shenandoah Valley.

Western Theater, Carolinas Campaign The Federal XX Corps, one of the four corps of Sherman's army, reaches Chesterfield, South Carolina, after battling Southern troops at nearby Thompson's Creek.

3 March 1865

Washington Congress passes an act setting up the Bureau of Refugees, Freedmen and Abandoned Lands. The body, which will be known more commonly as the Freedmen's Bureau, is to have overall supervisory powers over those in the South dislocated by the war and in need of temporary assistance. A large part of its responsibility will be in aiding and providing work for the newly freed black population. After passing this important reconstruction bill, the 38th Congress adjourns.

Eastern Theater, Siege of Petersburg General Grant receives instructions from President Lincoln concerning Lee's peace overture of yesterday. The president directs his general in chief not to have any conference with Lee unless it is to accept the surrender of his troops 'or on some minor or purely military matter.' All political questions, Lincoln makes it clear, are to be settled by him personally. Tomorrow, Grant will relay the substance of this message to General Lee, thus completely laying to rest all talk of peace negotiations between the two commanding generals. To the west, Sheridan's troops, now riding east toward Petersburg, occupy the town of Charlottesville, Virginia.

Western Theater, Carolinas Campaign Sherman's troops enter Cheraw, South Carolina, while Confederate defenders fall back across the Pee Dee River. The Federal advance, however, is interrupted during the day by fighting at Thompson's Creek and Big Black Creek.

4 March 1865

Washington President Lincoln is inaugurated for his second term of office, taking his oath from the newly appointed Chief Justice Salmon P Chase. Before taking the oath, Lincoln delivers an inaugural speech in which he tells the audience: 'Fondly do we hope – fervently do we pray – that this mighty scourge of war may speedily pass away. Yet, if God wills that it continue, until all the wealth piled by the bondman's two hundred and fifty years of unrequited toil shall be sunk,

Below: Elements of the 1st Tennessee Artillery Battery detrain before going into action against Southern troops.

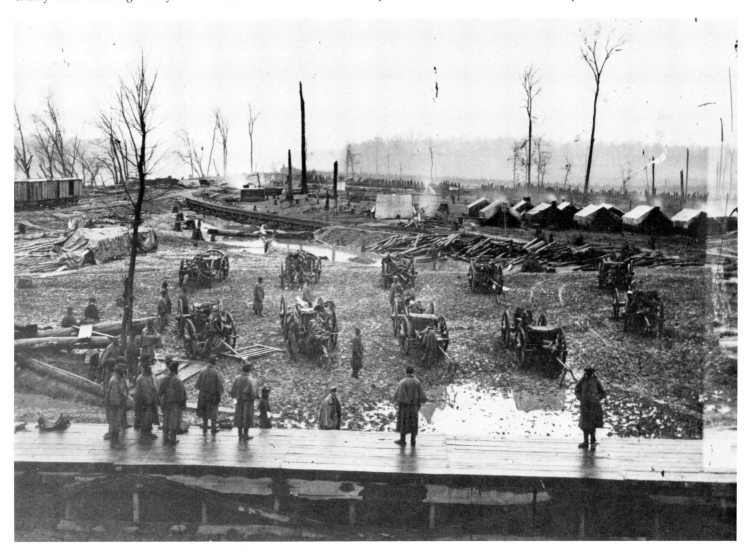

Above: Clement L Vallandigham, leader of the Northern faction called the Copperheads, or Peace Democrats, who strongly opposed the Civil War.

and until every drop of blood drawn with the lash, shall be paid by another drawn with the sword, as was said three thousand years ago, so still it must be said "the judgements of the Lord are true and righteous altogether."' With an eye to the future, the president then gives the crowd his view of a proper peace: 'With malice toward none; with charity toward all; with firmness in the right, as God gives us to see the right, let us strive on to finish the work we are in; to bind up the nation's wounds . . . to do all which may achieve a just, and a lasting peace, among ourselves, and with all nations.'

7 March 1865

Western Theater, Carolinas Campaign Federal troops commanded by General Jacob Cox work to repair railroad lines running from New Berne to Goldsboro, North Carolina. Cox and his immediate superior, General John M Schofield, plan to meet Sherman's army at Goldsboro; by restoring the rail lines to that city, they will provide a short supply line to Sherman's men from the North Carolina coast. Reinforcements arrive at Kinston, North Carolina, today from the Confederate Army of Tennessee. Generals Braxton Bragg and Johnston hope to use these

new men with those already under Bragg's command to launch an attack on Union General Cox's force moving westward.

8 March 1865

Eastern Theater Sheridan's cavalry force, still moving eastward to join up with Grant in Petersburg, fights the enemy at Duguidsville, Virginia.

Western Theater, Carolinas Campaign Using the troops just arrived from the Army of Tennessee to supplement his own force, General Braxton Bragg attacks Federals under the command of General Jacob Cox just outside of Kinston, North Carolina. One brigade of new Federal recruits break under the Confederate assault, but their battle-hardened comrades repulse the Southerners. Fighting will continue for the next two days as Bragg tries to destroy Cox's Federals before they can link up with Sherman's army moving north toward Goldsboro.

9 March 1865

Washington Lincoln accepts the resignation of John P Usher as secretary of the interior. It will take effect on 15 May.

The North Vermont ratifies the 13th Amendment abolishing slavery in the United States.

Western Theater, Carolinas Campaign Confederate cavalry under the command of Generals Wade Hampton and Joseph

Wheeler launch a surprise attack on General Judson Kilpatrick at Solemn Grove and Monroe's Cross Roads in the late evening. Many of the Federals are caught in their beds, and Kilpatrick only narrowly avoids that fate himself. The Union soldiers, however, rally and beat off the attackers. Fighting continues outside of Kinston, as Confederate General Bragg tries to defeat Union General Cox's troops before they can link up with Sherman's advancing army. Cox, however, is bolstered by reinforcements rushed to his aid from the east, while Bragg fails to receive additional troops that he had been promised. The Federals are able successfully to maintain their positions.

10 March 1865

Western Theater, Carolinas Campaign Bragg withdraws his troops to Kinston, North Carolina, after failing to defeat or turn back Federal troops advancing westward from New Berne. From Kinston, Bragg will move to Goldsboro where he plans to unite his forces with those of Joseph Johnston in preparation for an attack on part of Sherman's advancing columns. At Monroe's Cross Roads, South Carolina, General Judson Kilpatrick's men counterattack the enemy after being surprised in camp by them last night. The Federals defeat the Southern cavalry of Hampton and drive them off.

11 March 1865

Eastern Theater Sheridan's cavalry reaches Goochland Court House on its way to rejoin Grant in Petersburg.

Western Theater, Carolinas Campaign Sherman's army arrives at Fayetteville, North Carolina, where he plans to rest for a couple of days.

Trans-Mississippi Fighting takes place today at the Little Blue River in Missouri as well as Washington, Arkansas.

12 March 1865

Western Theater, Carolinas Campaign Soldiers in Sherman's army busy themselves in Fayetteville destroying all machinery, industries and transport facilities which might be of use to the Confederates. Sherman plans to remain in Fayetteville until 15 March and then head his army toward Goldsboro after making a feint toward Raleigh. He orders General Schofield, who is marching troops in from the east, to take them directly to Goldsboro. To the west, fighting takes place at Morganza Bend, Louisiana.

13 March 1865

The Confederacy The Confederate Congress sends to Davis the bill calling for the arming of black slaves for use in the Southern armies. The law, as finally passed, leaves to the states the ultimate decision on whether the black soldiers should be freed, but it is the consensus that they will be liberated. Davis immediately signs the bill into law, but at the same time chastises Congress for its delay and calls for more legislation designed to close conscription loopholes.

14 March 1865

Eastern Theater General Sheridan, still on his way to Petersburg with his cavalry, engages the enemy at the South Anna Bridge in

Virginia. In West Virginia, Federal expeditions near Moorefield and Philippi comb those areas for bands of Confederates.

Western Theater, Carolinas Campaign General Jacob Cox's troops reach Kinston, North Carolina, on their way to Goldsboro where they will join up with Sherman's army. Cox's men are repairing railroad lines along their path to provide Union troops operating in the state with a short supply line to the coast.

15 March 1865

Western Theater, Carolinas Campaign As General Sherman moves his troops out of Fayetteville, fighting erupts along his advance at Smith's Mills and on the Black River. The Federal army moves northward in three columns, with the left wing commanded by General Henry Slocum making a feint toward Raleigh. The Confederate commander, Joseph Johnston, meanwhile, is trying to concentrate his troops north of Sherman's advance and hopes to defeat the segments of the Union army before they can unite.

16 March 1865

Western Theater, Carolinas Campaign Union General Slocum's advancing column meets enemy troops blocking its path on a bridge near Averasborough, North Carolina. The Federals attack the Confederate troops, pushing them back but failing to completely sweep them out of the path. During the night, however, the Confederate commander, General Hardee, withdraws his troops to Bentonville where they rejoin the main body of Southern troops under Johnston. In the Battle of Averasborough, the Federals lose 682 men while Confederate casualties are near 865.

17 March 1865

Western Theater, Mobile Campaign Troops led by General Edward R Canby, commander of the Department of West Mississippi, begin their campaign to capture the city of Mobile, Alabama. Canby has some 45,000 men under his command, while the Confederate garrison defending the city numbers about 10,000. The Federals plan to approach the city from two directions, with one column advancing from Pensacola while the other winds its way up the east side of Mobile Bay from Mobile Point.

18 March 1865

Western Theater, Carolinas Campaign As Sherman's left wing, commanded by General Henry Slocum, approaches the city of Bentonville it skirmishes with Wade Hampton's Confederate cavalry. Hampton is trying to slow the Union troops' advance long enough to give Johnston time to concentrate his force at Bentonville.

Mobile Campaign Some 1700 Federal troops feint to the west side of Mobile Bay to create the impression that the attack will come from that direction. In fact, the main Union assault is to take place on the eastern side of the bay.

19 March 1865

Eastern Theater After completing its mission to destroy the Virginia Central Railroad and the James Canal, Sheridan's Union cavalry arrives at White House on the Pamunkey River. Soon, Sheridan plans to join Grant's army south of Petersburg.

Western Theater, Carolinas Campaign As the left wing of Sherman's army, commanded by General Henry Slocum, marches toward Bentonville, it again fights Wade Hampton's cavalry, pushing the Confeder-

Above: Union General Judson Kilpatrick narrowly avoided capture at the hands of Hampton's men on 9 March 1865.

ates back as it advances. Joseph Johnston's 20,000 men then counterattack the Federals, forcing the latter to fall back and entrench. Slocum's men manage to repulse several more full-scale assaults before nightfall. Meanwhile, as word of the battle reaches the other two columns of Sherman's army on the

Below: A contemporary rendering of the scene at Sherman's headquarters during his drive south.

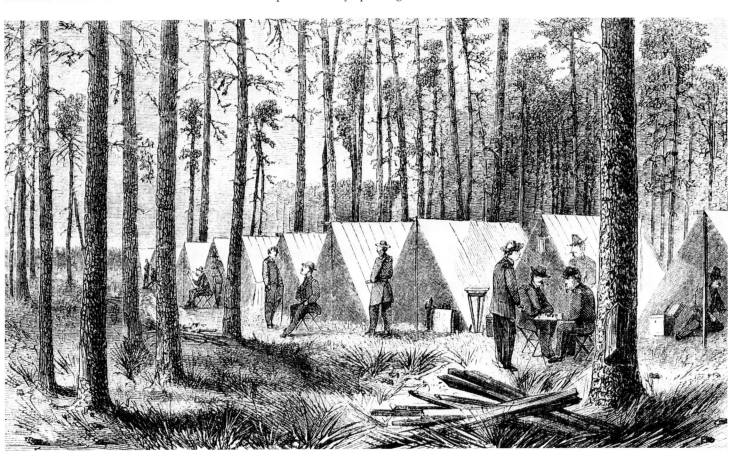

Above: General George Pickett. His defeat at Five Forks on 1 April sealed the fate of Lee's remaining troops.

right, they turn west to concentrate against the enemy. During the night, after failing to overwhelm the enemy, Johnston has his men fortify their positions opposite the Federals. To the east, General Schofield and his Union troops marching toward Goldsboro, North Carolina, from the coast, engage several enemy forces at the Neuse River Bridge and also near Cox's Bridge.

20 March 1865

Western Theater, Carolinas Campaign With both Johnston's Confederates and Slocum's Union troops dug in at Bentonville, the rest of Sherman's army arrives and concentrates against the Southern force. Johnston had hoped that he could defeat Slocum's 30,000 before the remainder of the Northern troops could come to his support. Now his Confederates, numbering 20,000, face an enemy army of nearly 100,000. During the day, some skirmishing takes place, but neither side launches an all-out assault. To the west, General George Stoneman leads a cavalry force of 4000 Union soldiers from Jonesborough in east Tennessee toward North Carolina. Stoneman's raid, which is designed in part to destroy enemy transport lines, is also intended to aid Sherman's campaign.

21 March 1865

Western Theater, Carolinas Campaign While some of his troops attack the enemy lines, Sherman sends another force around the rear of Johnston's army to capture Mill Creek Bridge and cut off the Confederates' retreat. Johnston, however, detects the maneuver and blocks the Federals while at the same time holding off the frontal attacks. During the night, he withdraws his troops to Smithfield. Despite the disparate manpower of the two forces, those engaged during the day are fairly balanced, with about 16,127 Federals seeing action compared with 16,895 Confederates. In the three days of fighting, the Federals suffer 1646 casualties while Johnston loses 2606. Bentonville will be the last major attempt by the Confederates to check Sherman's advance.

22 March 1865

Western Theater, Raid to Selma General James H Wilson leads a force of Union cavalry south from the Tennessee River toward Selma, Alabama. Selma is one of the last remaining manufacturing centers left to the Confederacy. By depriving the South of its munitions factories, Union officials believe they can significantly handicap the enemy war effort. Thanks to the efforts of the North's numerous blockade squadrons operating along the coast, the South is already short of raw materials.

23 March 1865

Washington President Lincoln leaves the national capital for City Point, Virginia with his wife and son. In addition to a conference with Grant and Sherman, Lincoln hopes the trip will provide some time for rest and relaxation. Lincoln will stay close to the front lines until 8 April.

Western Theater, Carolinas Campaign Sherman's army reaches Goldsboro, North Carolina, joining Schofield's Union force which has come into the city from the coast. The Union march from Savannah to Goldsboro, some 425 miles, has been accomplished in 50 days and will give Sherman a reputation as one of the greatest generals.

24 March 1865

Washington President Lincoln arrives at Fort Monroe to confer with Grant.

Eastern Theater, Siege of Petersburg Confederates prepare to launch a full-scale attack on the Union right. Lee hopes that, by capturing Fort Steedman, he can cut the Federal supply line to City Point and perhaps force Grant to contract his lines.

Naval The CSS *Stonewall* leaves Ferrol, Spain, and encounters two Union frigates. The Northern wooden vessels refuse the *Stonewall*'s challenge to fight.

25 March 1865

Eastern Theater, Siege of Petersburg Confederate troops led by General John B Gordon launch a full-scale assault on Fort Steedman and nearby Federal lines. Union troops are caught completely by surprise and the Southern troops easily capture the Federal stronghold as well as the enemy entrenchments next to the fort. The initial success quickly evaporates as Northern troops counterattack later in the day and drive the Confederates out of all their newly acquired positions, including the fort itself. During the day the North suffers close to 1150 casualties, while the South loses nearly 4000, many of whom are taken prisoner.

Western Theater, Mobile Campaign General Edward Canby's Union troops arrive outside of Spanish Fort, after marching along the east side of Mobile Bay. Spanish Fort is one of the important fortifications protecting the city of Mobile.

26 March 1865

Eastern Theater, Siege of Petersburg In the wake of the failure at Fort Steedman, Lee tells Davis that he doubts that it will be possible to prevent Grant's and Sherman's armies from joining up and it would be unwise for the Army of Northern Virginia to remain where it is until the two Union forces do connect. Meanwhile, Sheridan's Union cavalry arrives at the Petersburg front to reinforce Grant's army.

Western Theater, Mobile Campaign Fighting takes place at Spanish Fort as Federals prepare to lay siege to that crucial Southern fortification.

27 March 1865

Washington At City Point, Virginia, Lincoln confers with Generals Grant and Sherman (who has come up from Goldsboro, North Carolina, for the talks) and Admiral David Porter. The discussions will continue

through the 28th. It is at these talks, Sherman will later say, that Lincoln discusses the topic of reconstruction. According to Sherman, Lincoln tells him that as soon as Southerners lay down their arms, he is willing to grant them full citizenship rights. (The general will refer to this discussion of reconstruction to justify the peace agreement he makes with General Johnston in April.)

28 March 1865

Western Theater, Raid to Selma Wilson's Union cavalry fight Confederates at Elyton, Alabama, as it continues to move toward Selma. In North Carolina, Stoneman's cavalry fights at Snow Hill and Boone after crossing into that state from east Tennessee.

29 March 1865

Eastern Theater, Appomattox Campaign In what will develop into the final major campaign in the Civil War, Grant sends the newly arrived cavalry under Sheridan, together with some infantry units, to try to envelop the Confederate right flank to the southwest of Petersburg. If successful, Grant can not only cut the Southside Railroad, an important Confederate supply line, but also threaten the Southern escape route to the west. Anticipating such a move, Lee sends Generals George Pickett and Fitzhugh Lee to block any such Federal movements. The two sides clash at the crossing of Quaker and Boydton Roads and also on the Vaughan. The Federal advance, however, slows in the evening as rains hamper movement.

Western Theater As Stoneman's cavalry continues its penetration of North Carolina, it battles Confederates at Wilkesborough.

30 March 1865

Eastern Theater, Appomattox Campaign Heavy rains interfere with Union plans to outflank the enemy on the right of the Confederate siege lines, but both sides continue to mass troops in the area. Fitzhugh Lee's Southern cavalry is successful during the day in repulsing an advance at Five Forks.

Western Theater, Raid to Selma Wilson's expedition of Federal troops battles enemy cavalry from General Forrest's command at Montevallo, Alabama. Tomorrow, the Federals will destroy important iron and coal works near that town.

31 March 1865

Eastern Theater, Appomattox Campaign As the rains end, Union troops under the command of Generals Sheridan and Gouverneur Warren assault enemy positions around White Oak Road and Dinwiddie Court House, southwest of Petersburg. Outnumbered nearly five to one in the area, Confederates succeed in repelling the Federal advance; but in the evening, feeling the Union force is too powerful, General Pickett moves his troops back to Five Forks. Although it is not yet absolutely determined, the fact is that this move is the beginning of the end for the Confederate forces, because their retreat from the defenses of Petersburg will soon force Lee to abandon the nearby capital of the Confederacy and this will lead to the surrender at Appomattox.

1 April 1865

Eastern Theater, Appomattox Campaign Convinced that the loss of Five Forks would threaten the Confederate line of retreat, General Lee sends Pickett a message commanding him to hold that position 'at all costs.' Federal troops under the command of General Sheridan and Gouverneur Warren (whom Sheridan relieves during the day for allegedly moving too slowly) completely overpower and crush Pickett's troops, however, not only seizing the vital Southern position but isolating Pickett's command from the remainder of the Southern army. Southern troops engaged in the action are probably fewer than 10,000; the Federals, on the other hand, have about 53,000 men available, with about 27,000 of these seeing action during the day. Northern casualties are estimated at 1000 while almost half of the Confederate troops are captured.

Western Theater, Carolinas Campaign Fighting occurs at Snow Hill, North Carolina, between elements of Sherman's army and Southern defenders.

Mobile Campaign General Edward Canby's operation against Mobile, Alabama, leads to fighting today at Blakely. The Union monitor *Rodolph,* one of the fleet supporting Canby's expedition, hits a torpedo in Blakely River and sinks.

Raid to Selma Wilson's Union cavalry force continues to move toward Selma, engaging enemy cavalry at several points between Randolph and Trion. General Forrest, who is directing the Southern resistance to Wilson's operations, is trying to delay the Federals long enough to allow reinforcements to arrive at Selma.

Below: Southern troops and civilians abandon Richmond, Virginia, to the flames in the face of strong Union pressure.

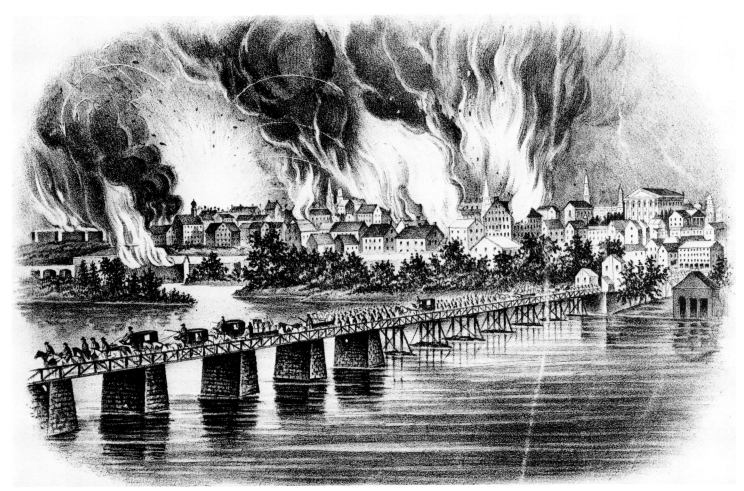

Naval After several days of operations against Northern whaling vessels in the Pacific, the CSS *Shenandoah* arrives at a harbor in the Eastern Carolines.

2 April 1865

The Confederacy While attending church in Richmond, Jefferson Davis receives a message from General Lee telling him that he will have to evacuate the Confederate capital immediately because the Confederate troops are being forced to abandon the defense of Petersburg. Davis quietly leaves the church and in the evening he and several members of his cabinet board a special train bound for Danville, Virginia. Back in the capital, factories, warehouses and arsenals are destroyed and whole sections of the city gutted by flames as Confederate soldiers prepare to abandon the place to Federal troops.

Eastern Theater, Appomattox Campaign Learning from Confederate deserters that Lee has severely weakened his defense to reinforce his right flank at Five Forks, General Grant orders a full-scale assault on the Confederate siege lines. The Federals break through at several points but the most crucial success comes when General Horatio G Wright's VI Corps seizes Southern entrenchments around Fort Fisher and rolls up the right flank. During the night Lee, who had already told Davis in the morning that the army would have to evacuate its position, leads his troops out of Petersburg and toward Amelia Court House. James Longstreet's and John B Gordon's troops hold Petersburg until the rest of the army can make its escape. During the day 63,299 Federals engage 18,579 Confederates, with the former suffering 3361 casualties; Southern casualties are not recorded, but include among the dead General Ambrose P Hill.

Western Theater, Mobile Campaign Federals, already besieging Spanish Fort, now begin to lay siege to Fort Blakely. Both forts are important positions in the Confederate fortifications protecting Mobile.

Below: After many months of siege, Petersburg finally fell to Union forces under Grant on 3 April 1865.

Raid to Selma After breaking through strong defensive fortifications held by 5000 Southerners under Forrest's command, Federal troops occupy the city of Selma, Alabama. Forrest and General Richard Taylor, both in the city, narrowly avoid capture but the Union troops bag some 2700 Confederate prisoners and a large store of enemy supplies.

3 April 1865

The Confederacy Jefferson Davis and members of his cabinet arrive in Danville, Virginia, after fleeing Richmond last night.

Eastern Theater At 0815 hours Union General Godfrey Weitzel formally accepts the surrender of Richmond. After four years of repeated threats from the enemy, the Confederate capital has finally fallen to Federal troops. Richmond is not just important as the seat of government, however, but is a vital manufacturing center as well. The Tredeger Iron Works, located in Richmond, has been the South's most important munitions factory. To the south, Union troops have also occupied the city of Petersburg.

Western Theater, Raid to Selma Wilson's Union cavalry clash with elements of Forrest's command outside Tuscaloosa, Alabama. To the north, there is also fighting between Union and Confederate troops at Mount Pleasant, Tennessee.

4 April 1865

Washington President Lincoln goes to Richmond and is cheered by crowds of Union soldiers and Richmond blacks as he tours that city after traveling up the James River from City Point, Virginia. Lincoln has been with Federal troops around Petersburg since 24 March and was on hand to witness Grant's final assault on Lee's defensive lines on 2 April.

The Confederacy From Danville, Virginia, Jefferson Davis issues a proclamation to the people of the South admitting the great loss the Confederacy has suffered in the fall of Richmond; he tells them that while the struggle is entering a new phase, they should not abandon the fight.

Eastern Theater, Appomattox Campaign

Lee's army clashes with pursuing Federals at Tabernacle Church and Amelia Court House. Hoped-for supplies do not arrive at the latter place and Lee is forced to feed his army off the surrounding countryside. Meanwhile, Sheridan's cavalry arrives at Jetersville, on the Danville Railroad, cutting off the possibility of further retreat by the enemy along that line. Lee's army is now effectively trapped between Meade's troops from the east and Sheridan's from the south and west.

5 April 1865

Washington In Richmond, President Lincoln confers with Confederate Assistant Secretary of War John Campbell on the subject of peace. The president tells Campbell (who had been one of the three Confederate agents at the Hampton Roads Conference in February) that he will not back down on the abolition of slavery and to secure peace the South must first submit to the authority of the Federal government. In Washington, Secretary of State William H Seward is severely injured in a carriage accident. Seward will still be confined to bed over a week later when the president is assassinated.

Eastern Theater, Appomattox Campaign Without supplies and with further retreat along the Danville Railroad blocked, Lee moves his army toward Farmville where he hopes to be able to feed his hungry forces. As the Army of Virginia moves westward, it skirmishes with Federals at Amelia Springs and Paine's Cross Roads.

6 April 1865

Eastern Theater, Appomattox Campaign As Lee's army approaches Farmville, it accidently diverges into two segments, each heading off in a different direction. The Federals, in pursuit of the fleeing Confederates, strike the divided enemy at Sayler's Creek, completely overwhelming each of the two wings. In the battle, the Confederates lose almost one-third of their total strength as prisoners (close to 8000 are captured during the

Below: A lone Union infantryman surveys the ruins of Richmond with the Southern White House in the distance.

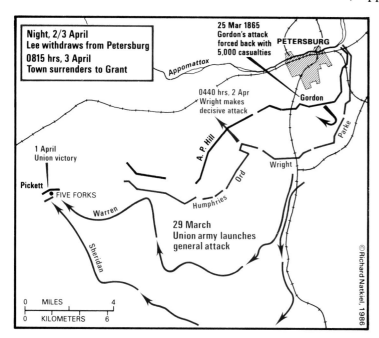

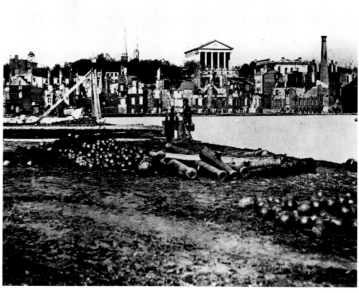

Above: Joyous crowds greet President Lincoln as he visits the former residence of Jefferson Davis on 4 April 1865.

battle). Federal losses, meanwhile, are recorded as about 1180.

Western Theater, Raid to Selma At Lanier's Mills, Sipsey Creek and King's Store, Alabama, Wilson's Union cavalry continues to battle several elements of Forrest's command.

7 April 1865

Washington Hearing through General Sheridan that Lee might surrender if pressed, President Lincoln tells Grant: 'Let the *thing* be pressed.'

Eastern Theater, Appomattox Campaign Grant sends General Lee a message asking him to surrender his army to prevent 'any further effusion of blood.' Lee responds to the message by inquiring what would be the terms of such a surrender. Meanwhile, heavy fighting at Farmville delays the Confederate army's flight. Although the Federal assaults are repulsed, Sheridan's cavalry is allowed enough time to circle around the south of the Army of Northern Virginia and place itself directly in the path of the Southern army's final retreat.

International The US opens negotiations with Britain over claims resulting from damage inflicted by the CSS *Alabama*. Since the *Alabama* was built in Britain, the US government holds Britain accountable for such damage as inflicted by the *Alabama* during the course of the war.

8 April 1865

Washington President Lincoln, who has been in the Petersburg-Richmond area since the end of last month, returns to the capital.

Eastern Theater, Appomattox Campaign General Grant writes Lee that his one condition of surrender is 'that the men and officers surrendered shall be disqualified from taking up arms against the Government of the United States until properly exchanged.' Although his staff is divided on the question, Lee turns down the idea of surrender for the time being and in the evening decides to try to break through Union troops blocking his path at Appomattox Court House.

Western Theater, Mobile Campaign Following a heavy bombardment, Federals charge Spanish Fort, an important Confederate fortification protecting Mobile. After an initial repulse, the Union troops succeed in breaking through the Southern defenses. The Confederate garrison manages to avoid capture, however, by slipping out of the fort during the night.

9 April 1865

Eastern Theater, Appomattox Campaign In the early morning, the Confederate Army of Virginia launches an attack on Federal troops blocking their path to the south. The Confederates succeed in breaking through the Federal cavalry but are unable to penetrate the infantry units behind it. The Union infantry instead begins to advance against the Southerners while other Northern troops in the rear begins to push in Lee's rearguard. As the morning wears on, Lee realizes that further resistance is futile, so he orders that a white flag (actually, a towel is used) be carried through the Union lines with a request for a cease fire until he can work out terms of surrender with Grant. In the early afternoon, the two generals in chief meet at the home of a Wilbur McLean in Appomattox Court House. Lee agrees to turn over all munitions and supplies (sidearms excepted) to the Federal army and to send his soldiers home where they could not return to fight until 'properly exchanged' (that is, until a Union prisoner is exchanged for each, an eventuality both generals know will never take place). Grant writes down the terms of surrender in his own hand and, at Lee's request, adds: 'let all men who claim to own a horse or mule take the animals home with them to work their little farms.' After signing the surrender, Lee mounts his faithful old horse Traveler and rides back to his men, whom he then tells: 'Go to your homes and resume your occupations. Obey the laws and become as good citizens as you were soldiers.'

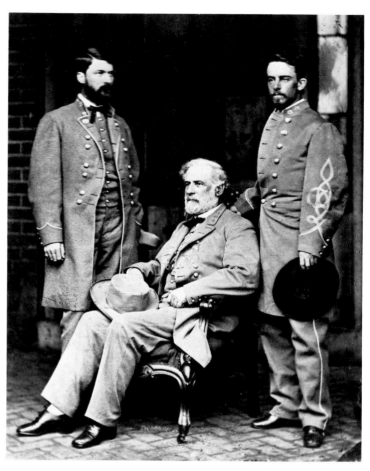

Western Theater, Mobile Campaign Federal forces capture Fort Blakely, another important fortification guarding Mobile, Alabama.

10 April 1865

Washington A brass band leads 3000 people to the White House as news of Lee's surrender sweeps through the city. Called on to make a speech, Lincoln tells the crowd that he will do so tomorrow. Lincoln then asks the band to play 'Dixie' remarking that it had always been a favorite of his, and although the South had claimed it as theirs, it now belongs to the Union.

The Confederacy Learning of Lee's surrender at Appomattox, Davis and those members of his cabinet who had followed him to Danville set out for Greensborough, North Carolina, where they hope to be more secure from Federal cavalry.

Eastern Theater General Robert E Lee gives his formal farewell to the Army of Northern Virginia. Applauding their valor and courage, Lee tells his men that he feels the time has arrived when any more sacrifice by them could produce nothing that would compensate for the loss that would be suffered. He tells them to go home until properly ex-

Above left: With his exhausted troops virtually surrounded, Lee was forced to seek peace terms with Grant at Appomattox Court House on 9 April 1865. By all accounts the meeting was amicable. Both men desired a swift end to hostilities.
Above: A picture taken after the surrender ceremony with General Robert E Lee (center).
Below: Union troops standing outside Appomattox Court House after the meeting of Grant and Lee had ended.
Right: The front page of the *New York Times* announces the surrender of Lee. However, other Southern commanders did, for a time, continue the struggle.

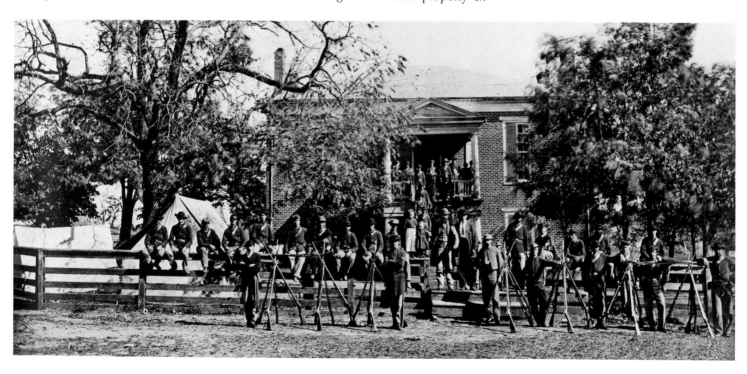

The New-York Times.

VOL. XIV......NO. 4225. NEW-YORK, MONDAY, APRIL 10, 1865. PRICE FOUR CENTS

HANG OUT YOUR BANNERS

UNION

VICTORY!

PEACE!

Surrender of General Lee and His Whole Army.

THE WORK OF PALM SUNDAY.

Final Triumph of the Army of the Potomac.

The Strategy and Diplomacy of Lieut.-Gen. Grant.

Terms and Conditions of the Surrender.

The Rebel Arms, Artillery, and Public Property Surrendered.

Rebel Officers Retain Their Side Arms and Private Property.

Officers and Men Paroled and Allowed to Return to Their Homes.

The Correspondence Between Grant and Lee.

OFFICIAL.

War Department, Washington,
April 9, 1865—9 o'clock P. M.

To Maj.-Gen. Dix:

This department has received the official report of the SURRENDER, THIS DAY, OF GEN. LEE AND HIS ARMY TO LIEUT. GEN. GRANT, on the terms proposed by Gen. Grant.

Details will be given as speedily as possible.

EDWIN M. STANTON,
Secretary of War.

Headquarters Armies of the United States,
4.30 P. M., April 9.

Hon. Edwin M. Stanton, Secretary of War:

GEN. LEE SURRENDERED THE ARMY OF NORTHERN VIRGINIA THIS AFTERNOON, upon the terms proposed by myself.

The accompanying additional correspondence will show the conditions fully.

(Signed) U. S. GRANT, Lieut.-Gen'l.

Sunday, April 9, 1865.

General—I received your note of this morning, on the picket line, whither I had come to meet you and ascertain definitely what terms were embraced in your proposition of yesterday with reference to the surrender of this army.

I now request an interview in accordance with the offer contained in your letter of yesterday for that purpose.

Very respectfully, your obedient servant,
R. E. LEE, General.

To Lieut.-Gen. GRANT, Commanding United States Armies.

Sunday, April 9, 1865.

Gen. R. E. Lee, Commanding Confederate States Armies:

Your note of this date is but this moment, 11.50 A. M., received.

In consequence of my having passed from the Richmond and Lynchburgh road to the Farmville and Lynchburgh road, I am at this writing about four miles West of Walter's church, and will push forward to the front for the purpose of meeting you.

Notice sent to me, on this road, where you wish the interview to take place, will meet me.

Very respectfully, your ob'd't servant,
U. S. GRANT,
Lieutenant-General.

Appomattox Court House, April 9, 1865.

General R. E. Lee, Commanding C. S. A.:

In accordance with the substance of my letter to you of the 8th inst., I propose to receive the surrender of the Army of Northern Virginia on the following terms, to wit:

Rolls of all the officers and men to be made in duplicate, one copy to be given to an officer designated by me, the other to be retained by such officers as you may designate.

The officers to give their individual paroles not to take arms against the Government of the United States until properly exchanged, and each company or regimental commander sign a like parole for the men of their commands.

The arms, artillery and public property to be parked and stacked and turned over to the officers appointed by me to receive them.

This will not embrace the side-arms of the officers, nor their private horses or baggage.

This done, EACH OFFICER AND MAN WILL BE ALLOWED TO RETURN TO THEIR HOMES, not to be disturbed by United States authority so long as they observe their parole and the laws in force where they reside.

Very respectfully,
U. S. GRANT, Lieutenant-General.

Headquarters Army of Northern Virginia,
April 9, 1865.

Lieut.-Gen. U. S. Grant, Commanding U. S. A.:

General: I have received your letter of this date, CONTAINING THE TERMS OF SURRENDER OF THE ARMY OF NORTHERN VIRGINIA, as proposed by you. As they are substantially the same as those expressed in your letter of the 8th inst., THEY ARE ACCEPTED. I will proceed to designate the proper officers to carry the stipulations into effect.

Very respectfully,
Your obedient servant,
R. E. LEE, General.

THE PRELIMINARY CORRESPONDENCE.

The following is the previous correspondence between Lieut.-Gen. GRANT and Gen. LEE, referred to in the foregoing telegram to the Secretary of War:

Custom House, Va., April 9, 1865.

Hon. Edwin M. Stanton, Secretary of War:

The following correspondence has taken place between Gen. Lee and myself. There has been no relaxation in the pursuit during its pendency.

U. S. GRANT, Lieutenant-General.

April 7, 1865.

Gen. R. E. Lee, Commanding C. S. A.:

General: The result of the last week must convince you of the hopelessness of further resistance on the part of the Army of Northern Virginia in this struggle. I feel that it is so and regard it as my duty to shift from myself the responsibility of any further effusion of blood, by asking of you the surrender of that portion of the Confederate States Army, known as the Army of Northern Virginia.

Very Respectfully,
Your obedient servant,
U. S. GRANT,
Lieutenant-General.

Commanding Armies of the United States.

April 7, 1865.

General: I have received your note of this date.

Though not entirely of the opinion you express of the hopelessness of further resistance on the part of the Army of Northern Virginia, I reciprocate your desire to avoid useless effusion of blood, and therefore, before considering your proposition, ask the terms you will offer, on condition of its surrender.

R. E. LEE, General.

To Lieut.-Gen. U. S. GRANT, Commanding armies of the United States.

April 8, 1865.

To Gen. R. E. Lee, Commanding C. S. A.:

General: Your note of last evening in reply to mine of same date, asking the conditions on which I will accept the surrender of the Army of Northern Virginia, is just received.

In reply I would say that peace being my first desire, there is but one condition that I would upon, viz:

That the men surrendered shall be disqualified for taking up arms again against the Government of the United States until properly exchanged.

I will meet you, or designate officers to meet any officers you may name, for the same purpose, at any point agreeable to you, for the purpose of arranging definitely the terms upon which the surrender of the Army of Northern Virginia will be received.

Very respectfully, your obedient servant,
U. S. GRANT, Lieut.-General,
Commanding armies of the United States.

April 8, 1865.

General: I received, at a late hour, your note of to-day, in answer to mine of yesterday.

I did not intend to propose the surrender of the Army of Northern Virginia, but to ask the terms of your proposition. To be frank, I do not think the emergency has arisen to call for the surrender.

But as the restoration of peace should be the sole object of all, I desire to know whether your proposals would tend to that end.

I cannot, therefore, meet you with a view to surrender the Army of Northern Virginia, but as far as your proposition may affect the Confederate States forces under my command, and tend to the restoration of peace, I should be pleased to meet you at 10 A. M., to-morrow, on the old stage road to Richmond, between the picket lines of the two armies.

Very respectfully, your obedient servant,
R. E. LEE,
General, C. S. A.

To Lieut.-Gen. GRANT, Commanding Armies of the United States.

April 9, 1865.

General R. E. Lee, commanding C. S. A.:

General: Your note of yesterday is received. As I have no authority to treat on the subject of peace the meeting proposed for 10 A. M., to-day could lead to no good. I will state, however, General, that I am equally anxious for peace with yourself; and the whole North entertain the same feeling. The terms upon which peace can be had are well understood. By the South laying down their arms, they will hasten that most desirable event, save thousands of human lives, and hundreds of millions of property not yet destroyed.

Sincerely hoping that all our difficulties may be settled without the loss of another life, I subscribe myself,

Very respectfully,
Your obedient servant,
U. S. GRANT,
Lieutenant-General, United States Army.

REJOICINGS.

Washington, D. C., Sunday, April 9.

Washington is in an uproar and blaze of glory, rejoicing over the greatest of victories yet achieved by our arms. Guns are firing, bells are ringing, and a large procession is proceeding through the streets. Such an excitement was never before witnessed in this city.

Albany, Monday, April 10—1 A. M.

There is great rejoicing here over the news of the surrender of Gen. Lee and his army.

The news was received at about 9 P. M., and at old midnight bells and Pearl streets were filled with people anxiously awaiting the particulars. The bells are ringing, cannon firing, while the multitude are indulging in fireworks.

The Governor was waited on and briefly addressed the throng around his residence.

The State House and most private residences are illuminated.

Philadelphia, April 9.

The glorious announcement of Lee's surrender was received here about nine o'clock. It was telegraphed to all sections of the city, and was announced in the several churches. The Ledger office was illuminated in five minutes. The bell of Independence Hall was rung by the order of the Mayor. The firemen immediately assembled and blocked up the streets. Bonfires were fired, and the editions of the steam-engines and the cheers of the assembled multitudes made the whole city ring.

Worcester, Mass., Monday, April 9.

The news of the surrender of Lee and his army created an intense excitement here to-night. The bells were rung, guns were fired, bonfires kindled, and the fire companies turned out, and many stores and buildings were illuminated.

Pittsburgh, Pa., Sunday, April 9.

The news to-night brought nearly the entire population into the streets. The recruiting booths were turned into bonfires, salutes were fired, speeches were made, and bands playing.

Trenton, N. J., Sunday, April 9.

The glorious news was received here with cheering and ringing of bells. The people are turning out en masse to receive and rejoice over the glad tidings.

Providence, R. I., Sunday, April 9—Midnight.

Bells are ringing, cannon are firing, and the citizens are out rejoicing over the news of Lee's surrender. A large bonfire is burning on Weybosset bridge.

FROM THE PACIFIC COAST.

Juarez said to be Coming to Washington by way of San Francisco—French Forces in Sinaloa—French War Steamers in California Ports—The Overland Mails.

San Francisco, Friday, April 7.

The steamer John L. Stephens, from Mazatlan, brings $43,000 in treasure and a thousand bags of silver ore.

The Mazatlan Times, the Imperialist organ, the report that Juarez was en route for Cape St. Lucas, whence he would sail for San Francisco on his way to Washington.

A French naval expedition had sailed, it was supposed, for Guaymas.

An Imperial force has moved to Sinaloa.

A correspondent of the San Francisco Bulletin, writing from Mazatlan, March 4, says that Juarez is still at Chihuahua with his ministers raising troops, though money, arms, and ammunition are scarce.

The French war steamer Victorie and transport Du Blanc was at Santa Barbara, on the coast of California. They hope to obtain supplies of coal at San Francisco.

The small Overland Mail, known as Salt Lake, resumed its trips yesterday. The first mail this way since the interruption arrived last night.

The annual meeting in behalf of the Christian Sanitary Commission, recently in attendance, by telegraph, within the past few days, of $41,000 in gold.

The scarcity of flour and wheat continues. Extreme prices are obtained, and consequently trade does not improve much.

The Union Convention of Washington Territory have nominated A. A. Dowd as Congressional Delegate.

Military celebrations for the national victories were held throughout the State to-day.

THE VICTORY.

Thanks to God, the Giver of Victory.

Honors to Gen. Grant and His Gallant Army.

A NATIONAL SALUTE ORDERED.

Two Hundred Guns to be Fired at the Headquarters of Every Army, Department, Post and Arsenal.

[OFFICIAL.]

War Department, Washington, D. C.,
April 9, 1865—9.30 P. M.

Lieut.-Gen. Grant:

Thanks be to Almighty God for the great victory with which he has this day crowned you and the gallant armies under your command.

The thanks of this Department and of the Government, and of the People of the United States—their reverence and honor have been deserved—will be rendered to you and the brave and gallant officers and soldiers of your army for all time.

EDWIN M. STANTON, Secretary of War.

War Department, Washington, D. C.,
April 9, 1865—10 o'clock P. M.

Ordered: That a salute of two hundred guns be fired at the headquarters of every army and department, and at every post and arsenal in the United States, and at the Military Academy at West Point on the day of the receipt of this order, in commemoration of the surrender of Gen. Robert E. Lee and the Army of Northern Virginia to Lieut.-Gen. Grant and the army under his command. Report of the receipt and execution of this order to be made to the Adjutant-General at Washington.

EDWIN M. STANTON,
Secretary of War.

FROM RICHMOND.

Perils and Excitements of a Voyage Up the James—Scenes and Incidents Along the River.

From Our Own Correspondent.

Richmond, Va., Wednesday, April 5.

The inspiration of the scene and the scope of the theme before us are far beyond the feeble descriptive powers of or the pen of your correspondent. No brilliant rhetoric, no vivid word-painting, no oratorical eloquence can portray the sublimity and immensity of the great victory. It is almost beyond the power of the human mind to comprehend its extent, and when you begin to descend to detail, the task is simply appalling in its magnitude. Think of a time of operations, held defensively and operated from offensively with such success, thirty-nine miles long from fank to fank, thoroughly fortified throughout its entire length! Think of the cities captured, of the fortifications stormed and taken, with their hundreds of guns, great and small, of the materiel of war in our hands, yet beyond the possibility of computation of the terrible battles, and the overwhelming defeat, and rout of the rebel army of the rebellion, of the prisoners captured. Count by the tens of thousands of the terrible flight of the arch-traitor and his band—a desperate mixture of the triumphant entry of Abraham Lincoln into treason's fallen capital! Let every lover of his country depict the vast scenes in his own imagination for words to fitly describe it fails altogether.

Through the courtesy of Provost Marshal Gen. Patrick I enjoyed an exceedingly pleasant sail from City Point to the Richmond wharves this morning, on his fleet flag-ship, the Mattine. Accompanying the General were Hon. C. H. Dana, Assistant Secretary of War, his wife and son, and Hon. Reuben Conkling, member of Congress from New-York. The snake-like bends of the James between City Point and Varina Landing, were quickly passed, and at the latter place assurance was given that the river was clear for our vessel to the fiery rocks of Richmond; but I can assure you that the navigation of the tortuous channel of the James thence to Richmond, thickly sown with obstructions and supposed torpedoes, was as exceedingly delicate task, and not without excitement. Our pilot knew the channel of old, but he knew not the warlike devices of the enemy.

We were, however, very fortunate, and the approach to the city, especially during the last eight miles from Drewy's Bluff, was full of the intensest interest, for over these waters the Union flag had never before floated during the war. When we leave Dutch Gap and that famous canal, which looks as though it might have been washed out by a billow, we at once came upon the lines held by the enemy. Howlett House Battery, famous for its determined resistance to our engineering operations on the north side of the river, stands abandoned and gloomy, with its twelve large guns still in the embrasures, but all silent as we steamed rapidly by. Another long and large earthwork appears on the left bank, mounting eight or ten guns, and bearing directly upon the mouth of the canal. This, too, like the rest, is abandoned, with its armament untouched. We next pass the wreck of the rebel gunboat, blown up by our batteries during the effort made to run through our fleet some months ago.

The next point of interest is Fort Brady, on the north bank of the river, and the left of the position of our Army of the James. What strikes one as very remarkable here is the fact that owing to the intricate windings of the James there are two rebel batteries, Howlett House and another, absolutely in the rear of this former position of our army. Fort Brady is the point where Gen. Grace expected in the retreating rebel rams. Had there been large guns at his disposal, the James is so good that they would have stood a poor chance of escape.

We are now fairly in that part of the river held solely by the enemy, and a knowledge of the channel and obstructions is absolutely necessary at every voyage. The sunken torpedo is the most dreaded of all, and as acting our information a pilot who has been up and down to attend with much politeness.

From Our Own Correspondent.

Richmond, Thursday, April 6, 1865.

So many thousand facts are presented to the mind of the visitor here in such a very short space of time, that to record them systematically is almost impossible. The great issues of the evacuation, the surrender of our troops, the conflagration, the President's visit and reception, have already been forwarded to you in detail by your correspondent who came in with the troops, and I will, therefore, allude to them only in a general way.

Let me say, though, at the outset, that the best part of the city is a ruin. That the awful fire kindled by the enemy, and which at first promised to consume but a few buildings, was so destroyed, by rising wind, thanks to it could be got under subjection, thirty squares, comprising not less than eight hundred buildings in the best and most valuable business part of Richmond were in ashes. What the pecuniary loss is no one can state. Friends, to whom there have given all, and to whose tyranny they hang exhausted, with even cheerfulness, is the cause of far deeper gloom among many men than that produced by the loss of the city or the defeat of their army. It is apparent indeed that the interior of the city to the Union flag was not only not distasteful to a very large portion of the people, many of them among the best classes, but even highly gratifying. No captured city, not even Savannah nor Columbia, one present the ruin apparent here to Richmond. It will only in the painful evidences for half a score of years, and the only thing which will speedily alleviate the distress that must prevail, and give the city a chance for a speedy recovery from its present degradation, is immediate peace. It is Richmond's only salvation. The origin of the fire and the incendiaries are so well and positively known that no extended investigation on those points is required. It was Gen. Lee was not responsible for it, but that Jeff. Davis and the Secretary of War, Breckinridge, were. The destruction of the supplies and the arsenal involved the destruction of the city, and it was so ordered by the leading citizens. Gen. Ewell and Maj. Cameronton both protested against it in the most earnest manner, as did also a committee of citizens, and Breckinridge, in reply, maintained that he didn't care a d—d if every house in Richmond was consumed, the warehouse must be burned. That the wretched Davis is likewise a powerful position with no compunctions, is responsible for the dreadful ruin, and his master Davis is likewise responsible, because he slightly compromised it.

The fire was started in several places by our fly warehouses near the wharves, and at the Danville Depot, where there were 1,500 hogsheads of tobacco belonging to the Confederate Government. That consumed the Danville Depot, also the Petersburgh Depot, and the bridge over the James to Manchester. The famed Libby Prison, and Castle Thunder, had it already destroyed year, were not burned. They were reserved for a far more appropriate use. I visited them yesterday, and found within their black prisoners, caught for want of opportunity. The military and civil offices of rebeldom, while the Libby contained 300 rebel prisoners, officers and privates, temporarily placed together. They passed through the inevitable ordeal, while the Union guard outside seemed to thoroughly enjoy the transition that the famous building had undergone, evidently having been thus kindled.

A close inspection of Castle Thunder revealed the most hideous dungeons that could be conceived. We failed to see it, however, to all its filth and malignances, for a street burns at the outlet of the past three years. The corporal of the guard who conducted us through, pointed out a spot on the floor on one or the main hall, not yet cleansed, where the dirt was then inches thick, and where the temporary occupant had been compelled to sleep either upon the dirt or upon piles of decaying straw.

But I will not descend further upon the suffering of the rebellion. In course to the well known, the prisoners confined here, it will be recollected, were those against whom especial vengeance was directed, prisoners of State, persons charged with harboring Union prisoners, Union officers charged with being spies, blockade-runners, &c. Well has it been said that I condemned in Castle Thunder his treatment of the tortures of the damned.

This building, together with the Libby belongs to the estate of Jesse Evans, and was leased by the rebel Government. They were originally built for stores, but subsequently turned into tobacco manufactories. But their base uses are now at an end.

This is the fourth day of the Union occupation, and the confusion in the city necessarily attendant upon such an evacuation and such an conquest, is gradually subsiding. Could the ruins of the fire be removed from sight, Richmond would present its attractive appearance, for it is really a handsome city; but, after all, the saddest scenes are at the headquarters of the Provost-Marshal, the Commissioners of Subsistence, and the office of Sanitary Commission, the latter being already established here. Gen. Warren had become established here more than thousands of citizens besiege him for rations. And as the city is now shut out from all supplies from the country, the crowd of applicants for subsistence is rapidly increasing. It is one small lot caught by surprise. The Capitol, the City Hall and the Capitol-square are filled with a throng of all classes, condition, sexes and ages, with a basket in hand and the anxious expression of face. What the regulations yet are in regard to the issue of rations to the citizens, I do not know, but a limited quantity is being supplied them at present.

In order to study this peculiar social feature of the rebellion, I mingled with these crowds this morning for a short time, to observe their temper, desires and condition. There were, of course, largely made up of what appeared to be the poorer classes, and many negroes were among them. Some for subsistence we found more where intelligent expression of countenance, fair features and attempted genility of dress, indicated that they were of the higher classes, on whom the demands of want and hunger were as taken upon those of less position. I noticed several ladies genteelly attired, and with their faces so closely veiled as to defy the gaze of the keenest eye. They spoke in such wondering tones when giving their names as too foreign to them as the hunger they now sought to appease had been in days gone by. Many of the wealthiest families, however, who had the means, have far larger supplies of provisions on hand than was considered with the present appeals of Confederate officials for such to spare from their bounty to feed the army.

The exodus of prominent citizens was confined mainly to those connected with the rebel government, and a few who had made themselves very conspicuous in rebel politics—all the rebel Cabinet and their chief assistants, though not much of their clerical force, and away. The preparations for the evacuation of Richmond were quietly among the officials, none of thereby the immediate records of the departments were hurried up and carried to the depot; but very little suspicion was excited among the citizens as to the real state of the case. A strong guard was stationed at the Danville depot, and four trains were got ready, the first of which left, with Davis on board, at seven o'clock in the evening, and the last at midnight. Davis's family left upon the country on the Friday preceding, but not because of any apprehension that the city was to be given up. Very few families left the city, and there are very few vacant houses, the mansions of Jeff. Davis and Gov. Billy Smith being among those now in want of tenants. The family of Gen. Lee, consisting of his wife, who is an invalid, and three daughters, are among those who remain. They occupy a stylish house on Franklin-street, and for their protection and well disciplined guard is placed at the dwelling, and the family were scrupulously protected from annoyance of any character; the staring gaze of the passer-by hardly being allowed. This is the second time that Mrs. Gen. Lee has been in our hands. She was once captured by our cavalry near White House, in 1862, and sent through our lines to Richmond under flag of truce, by order of Gen. McClellan.

L. L. CROUNSE.

First Impressions of Richmond—The Great Conflagration in the City—Who Was Responsible for it?—The Libby and Castle Thunder—Suffering for Food—Distribution of Rations—Lee's Family.

From Our Own Correspondent.

Richmond, Friday, April 7, 1865.

I can give you news, to-day, which will gratify the heart of every loyal American. Virginia will return to the Union, and that right speedily. Destined to ascertain the exact truth with reference to the alleged existence of a strong Union sentiment in the city, I availed myself of an opportunity to call upon certain gentlemen here whom I had heard alluded to by secessionists as Union men, and I must say, that I have met two of the happiest hours of my life in full and free conversation with many of the most thorough and radical Union men in the country. Richmond has not been what we supposed. The faith has never wavered for an instant, and who, notwithstanding, as they are, Around the Vagrant glad to have had one in these trenches of the Union occupation, and its master Davis is likewise responsible, because he slightly compromised it.

Union Sentiment in Richmond—Prospects of Reconstruction—Distinguished Visitors—Recruited Negro Troops—The Truth about Rebel Enlistment of Negroes.

From Our Own Correspondent.

Richmond, Friday, April 7, 1865.

[text continues in right column, largely illegible]

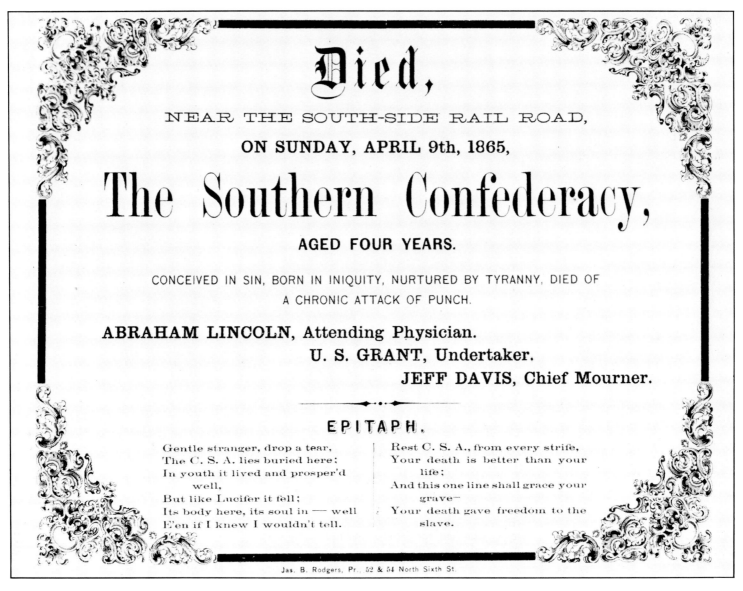

Died,

NEAR THE SOUTH-SIDE RAIL ROAD,

ON SUNDAY, APRIL 9th, 1865,

The Southern Confederacy,

AGED FOUR YEARS.

CONCEIVED IN SIN, BORN IN INIQUITY, NURTURED BY TYRANNY, DIED OF
A CHRONIC ATTACK OF PUNCH.

ABRAHAM LINCOLN, Attending Physician.
U. S. GRANT, Undertaker.
JEFF DAVIS, Chief Mourner.

EPITAPH.

Gentle stranger, drop a tear,
The C. S. A. lies buried here;
In youth it lived and prosper'd
well,
But like Lucifer it fell;
Its body here, its soul in — well
E'en if I knew I wouldn't tell.

Rest C. S. A., from every strife,
Your death is better than your
life;
And this one line shall grace your
grave—
Your death gave freedom to the
slave.

Jas. B. Rodgers, Pr., 52 & 54 North Sixth St.

Above: A hand bill published shortly after Lee's surrender at Appomattox celebrates the defeat of the South.

changed and then bids them good-bye: 'With an increasing admiration of your constancy and devotion to your country, and a grateful rememberance of your kind and generous consideration of myself, I bid you an affectionate farewell.'
Western Theater, Carolinas Campaign General Sherman marches toward Raleigh, North Carolina, where most of Joseph Johnston's force of Confederates is located.

11 April 1865

Washington Lincoln addresses a crowd gathered outside the White House on the subject of reconstruction. Although he defends the newly created state government in Louisiana, he admits that he would have preferred the vote to be given black soldiers as well as the 'most intelligent' of that race. He also tells his audience that reconstruction plans must remain flexible. This is to be Lincoln's last speech.
Western Theater, Carolinas Campaign Sherman's troops continue their march toward Raleigh, battling the enemy at Smithfield, Pikeville and Beulah, North Carolina.
Mobile Campaign Confederates abandon Fort Hugar and Fort Tracy, the last remaining

fortifications blocking Union troops from Mobile, Alabama. During the night, Confederates also pull out of Mobile itself.

12 April 1865

Eastern Theater At Appomattox Court House, a formal surrender ceremony takes place – although neither Lee nor Grant attend. General Joshua Chamberlain of Maine, who had distinguished himself in the last days of fighting, is accorded the honor of accepting the arms and flags of the Confederate Army of Northern Virginia. Chamberlain has his Union troops lining the roads; as the Confederate column, led by General John B Gordon, approaches, Chamberlain gives the command, 'Carry arms!' and the surprised Gordon orders the same, 'honor answering honor.' The Confederate units then fold and lay down their flags and stack their arms. For all practical purposes, the war is over.
Western Theater, Carolinas Campaign Sherman's troops battle Southern resistance in the outskirts of Raleigh, North Carolina. Meanwhile, General Stoneman and his Union cavalry, riding eastward through North Carolina, capture the city of Salisbury and take over 1700 enemy soldiers prisoner.
Mobile Campaign Federal troops occupy the city of Mobile, Alabama. The campaign against Mobile has cost the Federals 1578 casualties and came at a time, Grant would

later write, 'when its possession was of no importance.'
Raid to Selma Wilson's Union cavalry occupy Montgomery, Alabama, after skirmishing on Columbus Road.

13 April 1865

Washington As part of a demobilization program, Lincoln halts the draft and reduces requisitions for war supplies.
Western Theater, Carolinas Campaign Sherman's army occupies Raleigh, the state capital of North Carolina, on its way to Greensborough, now the temporary seat of the Confederate government.

14 April 1865

Washington After conferring with his cabinet and General Grant during the day, Lincoln goes to the play, *Our American Cousin,* at Ford's Theater. He is accompanied by his wife and by Clara Harris, daughter of a senator, and her fiancé, Major Henry Rathbone. About 2200 hours that evening, John Wilkes Booth enters the president's box through the door in the rear. Booth is an actor in a family of famous actors, but where the other Booths sympathize with the North, John has long supported the Confederacy. Always an egomaniac and somewhat unstable, he has already failed at a plot to kidnap Lincoln. Now Booth walks up to the president and

shoots him behind the ear; he stabs Rathbone and then hurls himself over the balcony onto the stage, breaking his left leg on impact and yelling (according to some) *Sic semper tyrannus!'* ('Thus be it ever to tyrants!'). Booth then exits from a side door and rides off on a horse. The president is carried out of the theater to a house across the street where doctors examine him and pronounce his wound mortal.

Meanwhile, Lewis Payne (or Powell), an accomplice of Booth's, forces his way into the home of Secretary of State William Seward, still in bed recuperating from his carriage accident. Payne stabs Seward several times, but Seward's son and a male nurse fight off Payne who manages to escape. As news of the attacks on Lincoln and Seward reach the townspeople, Washington is seized by panic. (As it is, Booth's fellow conspirator who has been assigned to kill Vice-President Johnson has lost his nerve.) Secretary of War Edwin Stanton quickly declares martial law throughout the District and sets a dragnet to round up all suspects. Booth and another of his conspirators, David Herold, succeed in fleeing the city and during the night will reach the home of a Dr Samuel Mudd, who will set Booth's broken leg. (Later Mudd will be found guilty of aiding Booth but he will insist that he knew nothing of the events of this evening and was simply doing his duty as a doctor.)

Western Theater, Carolinas Campaign
Sherman, marching with his army from Raleigh toward Durham Station, receives a message from Confederate commander Joseph Johnston requesting a temporary cessation of hostilities until a peace can be worked out. To the south, at Fort Sumter, South Carolina, during the day Federal officers and a number of distinguished guests hold a flag-raising ceremony at the fort where

Below: Andrew Johnson took the oath of office to become Lincoln's successor as president at 1100 hours on 15 April 1865.

the war had begun four years before (and which had returned to Federal control only on 17 February). General Robert Anderson, who had surrendered the fort to the Confederates in 1861, is on hand to see the Stars and Stripes again raised over Fort Sumter.
Naval The CSS *Shenandoah* leaves the East Caroline Islands in the Pacific and heads toward the Kurile Islands.

15 April 1865

Washington At 0722 hours, with his son Robert, Senator Charles Sumner, Secretary Stanton, and others gathered at his bedside, President Lincoln dies. Andrew Johnson takes the oath at 1100 and assumes the office of president.
The Confederacy Jefferson Davis and members of his cabinet leave Greensborough, North Carolina, on horseback, accompanied by a small bodyguard. Tomorrow they will arrive at Lexington.
Eastern Theater Some fighting takes place in West Virginia.

16 April 1865

Washington John Wilkes Booth and David Herold arrive at Rich Hill, Maryland, southeast of Washington.
Western Theater, Raid to Selma Wilson's Union Cavalry moves eastward into Georgia, capturing the city of Columbus and West Point. Before crossing the border, the Northern cavalry skirmishes with the enemy at Crawford and Opelika, Alabama.

17 April 1865

Washington Lincoln's body is brought to the East Room of the White House where it will lie in state until the funeral ceremony on

Above: John Wilkes Booth, a Southern sympathizer, carried out the assassination of Lincoln at Ford's Theater on 14 April 1865.

19 April. Southeast of the city, Booth and Herold arrive at Port Tobacco on the banks of the Potomac where they hope to find some means to cross the river into Virginia.
Western Theater, Carolinas Campaign
Generals Sherman and Johnston meet at Durham Station to discuss peace. Unlike the talks between Grant and Lee, this conference looks beyond the surrender of Johnston's army to questions involving a peace settlement between North and South.

18 April 1865

Western Theater, Carolinas Campaign
Generals Sherman and Johnston meet again to discuss peace and sign a broad political peace agreement. It not only calls for the cessation of all hostilities, but also promises a general amnesty for all Southerners and pledges the Federal government to recognize all the state governments of the South as soon as their officials take an oath of allegiance. Both men realize that the agreement will have to receive approval from their governments, but Sherman apparently is unprepared for the severe criticism that he will be subjected to because of his central part in the agreement.

19 April 1865

Washington Funeral services are held for the dead president in the East Room of the White House. Afterward a long and solemn funeral procession escorts the casket to the Capitol rotunda where the public will view it during the day.

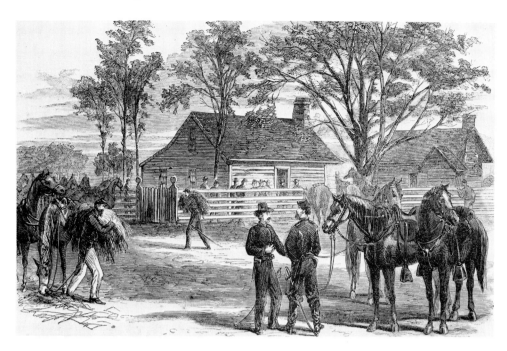

Above: One of the final dramas of the war was the surrender of General Johnston to Sherman at Durham Station on 17-18 April 1865.

The Confederacy Davis and his party arrive in Charlotte, North Carolina, where they will spend the next few days. Here, the Confederate president hears of Lincoln's assassination for the first time. General Wade Hampton writes to Davis suggesting that the Confederacy continue its struggle from west of the Mississippi.

Trans-Mississippi General John Pope writes to Confederate General Edmund Kirby Smith suggesting a surrender of all Southern troops west of the Mississippi on the same terms given General Lee.

20 April 1865

The Confederacy Lee writes Jefferson Davis telling the Confederate president that he is opposed to the continuation of hostilities through guerrilla warfare and recommends an end to all fighting. For some time, Davis has believed that partisan warfare should be the second stage of Southern resistance to the North.

21 April 1865

Washington The casket bearing the body of President Lincoln is taken from the Capitol rotunda and put on board a special funeral train bound for Springfield, Illinois.

Eastern Theater John S Mosby, the famed 'Gray Ghost,' disbands his troops. Most of the partisans then go in to the nearest Federal outpost and apply for parole.

22 April 1865

Washington After several days of hiding our near Port Tobacco, Booth and Herold finally are able to cross the Potomac in a small fishing craft.

Western Theater Wilson's Federal cavalry is still active, taking the town of Talledega, Alabama, during the day.

23 April 1865

Western Theater Stoneman's and Wilson's cavalry are still active, with Stoneman's troops fighting a skirmish near Henderson, North Carolina, while Wilson's men clash with Confederates at Munford's Station, Alabama.

24 April 1865

Washington Federal troops under the direction of Secretary of War Stanton continue their search for Booth and any other persons connected with Lincoln's assassination or the attack on Seward. Booth and Herold arrive at Port Conway, Virginia.

The Confederacy Unaware what response the Sherman-Johnston peace agreement has received in Washington, Davis sends Johnston his approval of the plan. Even after Lee's surrender, Davis had for a time held out hope that the struggle might continue, and as late as yesterday he had told his wife that he thought a return to the Union would bring oppression to the South.

Western Theater Grant arrives in Raleigh, North Carolina, where he informs Sherman that his peace agreement with Johnston has been rejected by President Johnson. Sherman is particularly stung by criticism that he exceeded his authority in agreeing to such terms as are included in the peace package. The Union generals immediately notify Johnston that the truce will end in 48 hours.

25 April 1865

Washington Federal soldiers pursuing Booth and Herold trace the two fugitives to the farm of Richard H Garrett, south of the Rappahannock River in Virginia.

Western Theater Generals Johnston and Sherman agree to meet again to discuss peace.

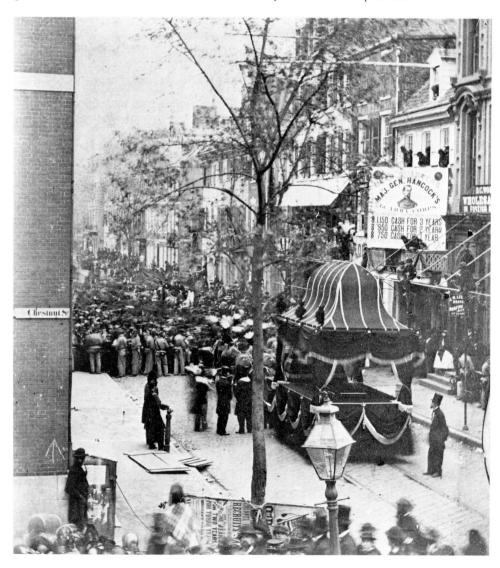

Below: Lincoln's funeral cortege moves through central Washington on its journey to Springfield, Illinois. Vast crowds turned out to pay their respects to the former president.

26 April 1865

Washington In the early morning, Federal soldiers following Booth and Herold surround the Garrett barn and call out to the two fugitives to surrender. Herold comes out but Booth refuses. The soldiers then set fire to the barn and as it begins to burn a shot is fired. Booth falls mortally wounded. He is dragged from the barn and dies soon afterward. (Whether the gunshot was fired by a soldier or self-inflicted will never be completely settled.) Booth's body is taken back to Washington for an autopsy and will be buried at Arsenal Penitentiary.

The Confederacy Davis meets with his cabinet in Charlotte, North Carolina, and they agree to leave the state to try and get across the Mississippi.

Western Theater General Johnston surrenders his army of nearly 30,000 men on terms virtually the same as those given Lee. Sherman, however, does agree that the Federal government will provide transport home to those soldiers who need it.

27 April 1865

Western Theater The *Sultana*, a steam-powered riverboat, catches fire and burns after one of its boilers explodes. On board are some 2031 passengers, mostly Federal soldiers recently released from Southern prisoner of war camps. At least 1238, and perhaps more, die in the mishap, the worst ever on the Mississippi.

28 April 1865

The North Lincoln's funeral train reaches Cleveland, Ohio, where over 50,000 citizens view the president's body.

29 April 1865

The Confederacy Davis and those members of his cabinet who are still traveling with him reach Yorksville, South Carolina.

Below: Lewis Wallace, better known as the author of *Ben Hur*, was one of the men appointed to conduct the trials of the Lincoln conspirators.

Above: David Herold, seen here in captivity at Washington Naval Yard, was apprehended by Union troops in Virginia.

30 April 1865

Western Theater Generals Edward Canby and Richard Taylor meet near Mobile, Alabama, and agree to a truce to arrange for the surrender of all Confederate troops in Alabama and Mississippi. The armies of Taylor and Edmund Kirby Smith are the only large bodies of Southern troops which have still not surrendered.

1 May 1865

Washington President Johnson orders the appointment of nine army officers as commissioners in the trial of those accused of conspiring to kill President Lincoln.

The Confederacy Jefferson Davis and his party, still moving south, reach Cokesbury, South Carolina. Davis hopes to be able to get to the coast of Florida and from there go by boat to Texas.

2 May 1865

Washington Accusing the Confederate government of complicity in the murder of Lincoln, President Andrew Johnson offers a $100,000 reward for the capture of Jefferson Davis.

The Confederacy President Davis, a number of cabinet members and their armed escort reach Abbeville, South Carolina. With the rejection of the first Sherman-Johnston peace agreement by President Johnson, the course that Davis and his advisors should pursue is extremely uncertain. That they are fugitives is sure. But whether they should surrender themselves to Federal authorities, seek refuge in a foreign country or try to maintain the struggle from west of the Mississippi is still unsettled. Davis seems to favor the last option but his cabinet advisors disagree.

3 May 1865

The North Lincoln's funeral train reaches Springfield, Illinois, where tomorrow the president will be buried.

The Confederacy Judah P Benjamin, Davis' secretary of state, separates from the small band of fugitives fleeing toward Texas. Benjamin will eventually escape to Britain.

4 May 1865

Western Theater Richard Taylor, commander of Confederate troops in Alabama, Mississippi and east Louisiana, surrenders to General Edward Canby at Citronelle, Alabama. Canby offers Taylor substantially the same terms as Grant gave Lee. In addition, though, Taylor is allowed to maintain the use of railways and transport ships to return his men to their homes.

Trans-Mississippi West of the Mississippi, Confederate forces are still officially at war. There is fighting near Lexington, Missouri.

5 May 1865

The North Connecticut ratifies the 13th Amendment, abolishing slavery in the United States.

6 May 1865

Washington Secretary of War Edwin Stanton appoints the commissioners to conduct the trial of those accused of conspiring to assassinate Lincoln. Among those appointed are David Hunter, Lew Wallace (who will later write *Ben Hur*) and August Kautz. Joseph Holt, the judge advocate-general of the army, is to be the chief prosecutor.

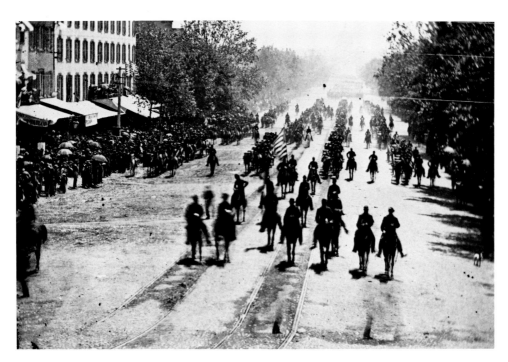

Above: A view of the grand parade of the Army of the Potomac on 23 May 1865, part of the victory celebrations in the North that took place after the South's surrender.

8 May 1865

Trans-Mississippi Federals clash with Confederates near Readsville, Missouri.

9 May 1865

The Confederacy Jefferson Davis, still moving southward with his small party of fugitives, joins forces with his wife at Dublin, Georgia. Meanwhile, Northern troops, who have been searching for the Confederate president, begin to close in on Davis and his fellow-travelers.

Western Theater General Nathan B Forrest disbands his troops.

10 May 1865

Washington President Johnson tells the people of the country that armed insurrection against the authority of the Federal government can be considered 'virtually at an end.'

The Confederacy President Davis, his wife, Postmaster-General Reagan, and Burton Harrison, the president's secretary, are captured by the 4th Michigan Cavalry near Irwinville, Georgia. The prisoners are escorted to Nashville, Tennessee, under heavy guard. From there, Davis will be sent to Richmond, Virginia.

Western Theater General Samuel Jones surrenders his command at Tallahassee, Florida. To the north, William Clarke Quantrill, the most notorious of all Confederate guerrillas, is mortally wounded near Taylorsville, Kentucky. He and a small group of followers have been looting in that state recently. (Included among those who rode with Quantrill during the war are Frank and Jesse James and Cole Younger, among the most celebrated outlaws the West will produce.)

11 May 1865

Trans-Mississippi General M Jeff Thompson, the famous Southern military leader of the Missouri-Arkansas region, surrenders the remnant of his command at Chalk Bluffs,

Arkansas. Thompson is given the same terms that Grant gave Lee at Appomattox.

Naval The CSS *Stonewall* sails into Havana harbor, Cuba.

12 May 1865

Washington President Johnson appoints General Oliver O Howard to head the Bureau of Refugees, Freedmen and Abandoned Lands. The Freedmen's Bureau will oversee the care of Southern refugees in the postwar period and also be charged with helping the newly freed blacks adjust to their freedom. Under the Bureau's supervision, too, are extensive tracts of land confiscated by the Federal government during the war. The eight defendants charged with conspiring to assassinate Lincoln plead not guilty today.

Trans-Mississippi Federals under the command of Colonel Theodore H Barrett attack and capture the Southern camp at Palmitto Ranch on the Rio Grande. Fearing a counterattack, the Union troops abandon the ranch in the evening.

13 May 1865

Trans-Mississippi The Confederate governors of Arkansas, Mississippi and Louisiana meet with Edmund Kirby Smith, overall commander in the Trans-Mississippi area, and advise him to surrender under terms which they outline for him. Others in the western part of the Confederacy, including Jo Shelby, threaten to arrest Smith unless he continues the struggle against the North. In the second day of fighting at Palmitto Ranch, in Texas, Northern troops return to the Southern encampment, again driving away enemy resistance. Later in the day, however, Confederates led by Colonel John S Ford launch an attack on the Federals there and force them to withdraw. The Battle of Palmitto Ranch is to be the last significant land battle of the war.

17 May 1865

Washington General Philip Sheridan is appointed commander of the district west of the Mississippi and south of the Arkansas River. Because of Sheridan's reputation for

wholesale destruction, stemming from his campaign in the Shenandoah Valley, there is considerable Southern resistance to this appointment.

19 May 1865

Naval The CSS *Stonewall* surrenders to Federal officials in Havana harbor.

22 May 1865

Washington President Johnson declares that as of 1 July all Southern seaports except four in Texas will be opened for trade. Also effective that date, all restrictions on civilian trade east of the Mississippi will be lifted except on contraband of war.

The Confederacy Jefferson Davis arrives at Fort Monroe, Virginia, where he is put in chains and locked in a cell. Although Davis will never be brought to trial, many Northerners at this time, especially in the wake of Lincoln's assassination, are inclined to feel vindictive toward the Southern leader.

23 May 1865

Washington The nation's capital holds a grand review for the Army of the Potomac. As General George Meade's army marches past throngs of cheering Washingtonians, the flags in the city fly at full mast for the first time in four years.

The North The loyal government of Virginia (also known as the Pierpont Government) moves to Richmond, Virginia, the state capital. During the war, the pro-Union government of this state has been located in Federally-controlled northern Virginia.

24 May 1865

Washington Washington officially receives the North's other major army as the grand legions of William T Sherman march through the streets of the capital. Many are struck by the contrast between the polished Army of the Potomac and this more casual army from the west.

Trans-Mississippi Federals continue to operate against guerrilla bands in the west, with some skirmishing near the town of Rocheport, Missouri.

25 May 1865

Western Theater In Mobile, Alabama, close to 20 tons of gunpowder captured from the Confederacy explodes, destroying buildings and boats along the docks of the city. There are some 300 casualties resulting from the blast.

26 May 1865

Trans-Mississippi General Simon B Buckner, as agent for General Edmund Kirby Smith and General Peter J Osterhaus, a representative of General Edward Canby, meet to discuss the surrender of all Confederate troops west of the Mississippi. The two agree on terms basically the same as those offered Lee at Appomattox. Smith will approve these terms on 2 June. Smith's force is the last major body of Southern troops to surrender. Some of these Trans-Mississippi Confederates, most notably Jo Shelby and the remnants of his Iron Brigade, will refuse to accept defeat and instead will cross over the border to Mexico in the hope of continuing the struggle.

27 May 1865

Washington With only a few exceptions, President Johnson orders the release of all persons held in prison by the Northern military authorities.

29 May 1865

Washington President Johnson issues a proclamation giving a general amnesty to those who have participated in the rebellion against Federal authority. Excepted from the provisions of the general amnesty are several special classes of Southerners, principally those who own more than $20,000 worth of property and those who held high rank in either the Confederate government or military; these must apply individually to the president for a pardon. (The president will be very liberal in granting these individual pardons.) An important implication of the executive action is that, once an oath is taken, all property rights, except those in slaves, will be fully restored. The large tracts of confiscated lands now held by the Federal government (much of it being farmed by black freedmen) will be turned over to the former owners.

Right and far right: Two of the men implicated in the Lincoln plot – Michael O'Laughlin and Samuel Arnold.
Below: The execution of the Lincoln conspirators at the Old Penitentiary, Washington.

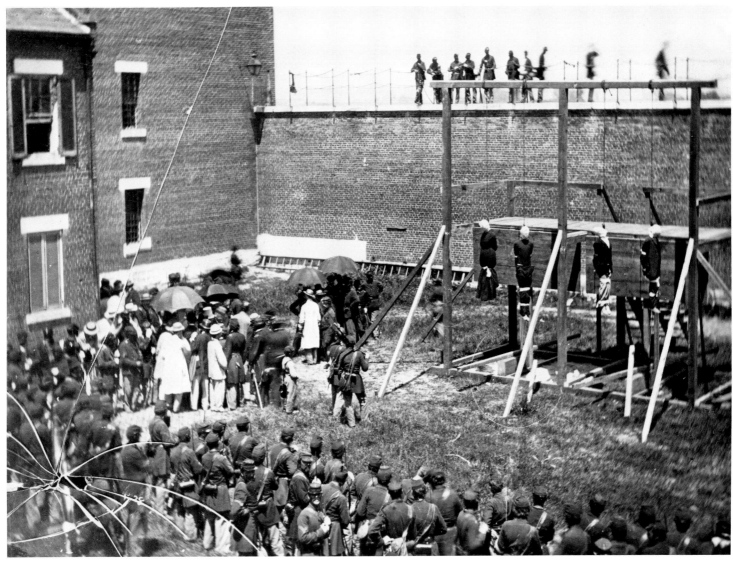

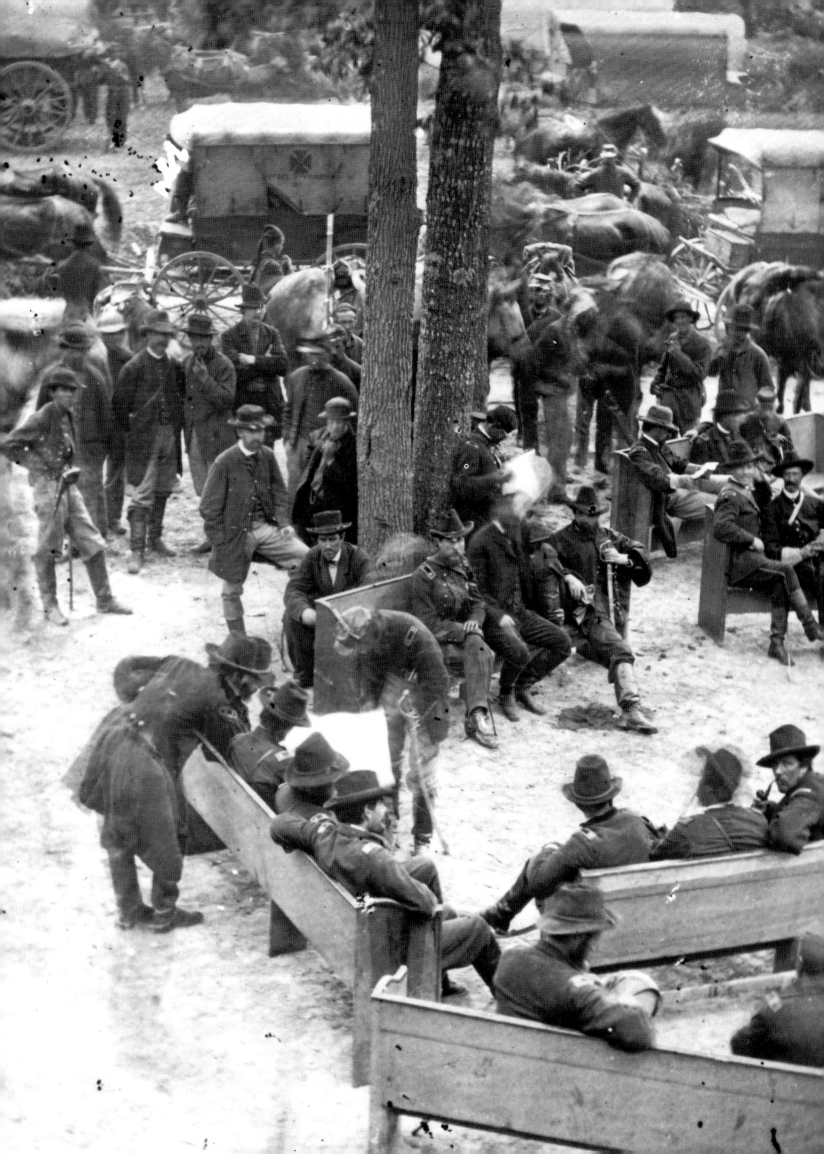

An Illustrated
ENCYCLOPEDIA
of the
CIVIL WAR

Opposite: Massaponax Church, Va. "Council of War:" Gen. Ulysses S. Grant
examining map held by Gen. George G. Meade, 21 May 1864.

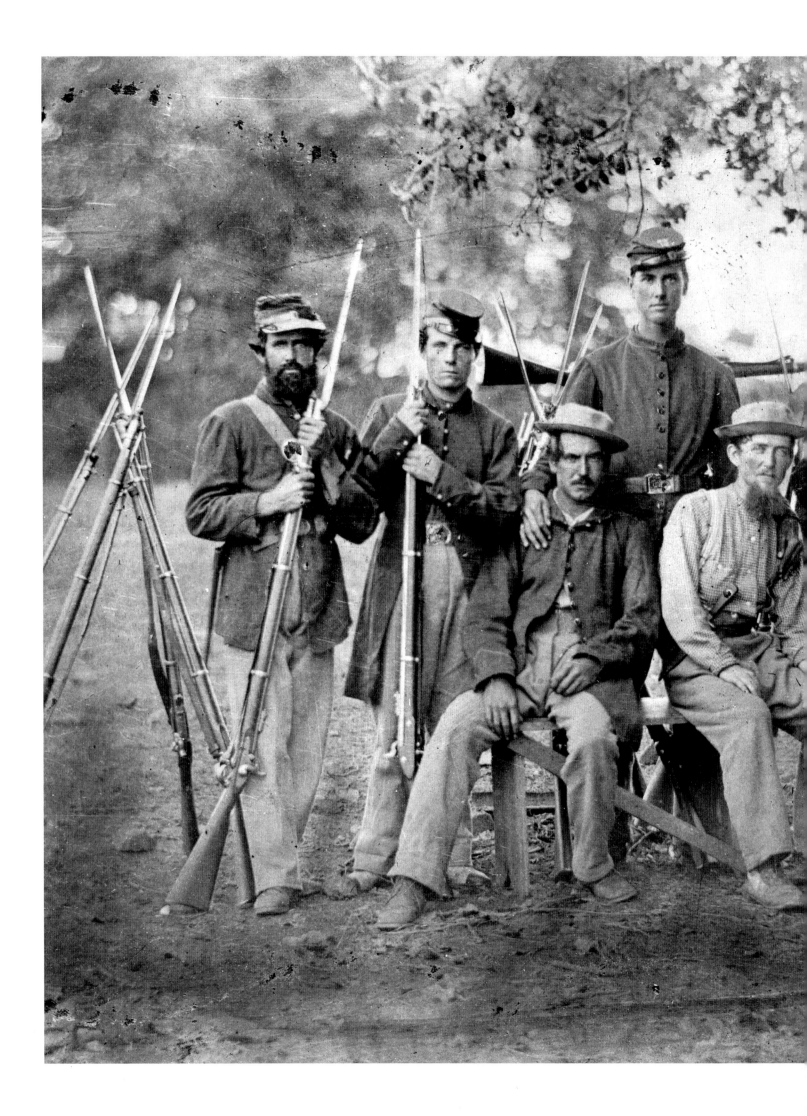

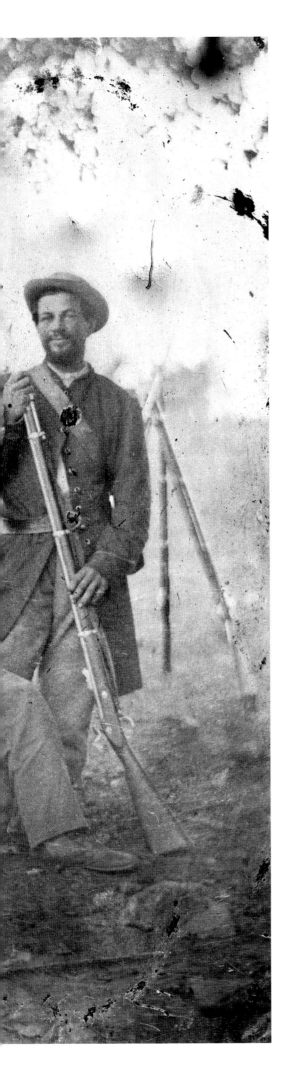

Prefatory Note

he organization of this Encyclopedia is, in the formal sense of the term, discursive – that is, a hierarchy of interlocking entries. The longest entries deal with the broadest topics (the major campaigns, the greatest leaders, the most important issues and policies). As entries decrease in length, they tend to become more narrowly focused and summary in nature. This implies that the reader will usually be rewarded by doing a little commonsense cross-referencing. For example, the entry on Joshua Lawrence Chamberlain notes that he was awarded a Medal of Honor for 'his brilliant defense of Little Round Top at Gettysburg on July 2, 1863.' If the reader wishes to know more – where Little Round Top was located on the battlefield, why it was important, and how Chamberlain defended it – these and other details may be found in the longer entry on the Gettysburg Campaign and Battle. Only in cases where the reader might not necessarily assume that a cross-reference exists is the notation *(See)* employed. On other matters, such as the spellings of certain place names, or whether a particular military engagement was important enough to be dignified by the title 'Battle of,' the authors have in all cases been content to follow the most common usage, though they freely acknowledge that variants exist.

That having been said, it remains only to add that the authors hope the reader may find this Encyclopedia not only useful and informative, but also enjoyable simply for casual reading, for they intended that as well.

Left: Soldier group, from the Brady Civil War Photograph Collection, Library of Congress.

Abercrombie, John Joseph
(1802-1877) **Union general.**

Tennessee-born Abercrombie, an infantry veteran, was commissioned colonel in 1861. He commanded a brigade in the Peninsular Campaign, Abercrombie's Division in the defense of Washington, and the Fredericksburg depots before being mustered out in June 1864.

Ableman vs Booth

In March 1859 the US Supreme Court ruled that state courts may not free federal prisoners, overturning a Wisconsin ruling. The state had released a man named Booth who had been convicted of rescuing a fugitive slave. The ruling thus upheld the Fugitive Slave Act of 1850, and the federal government returned Booth to prison.

Citizens of Worcester, Massachusetts, in the 1830s gather on the town common to listen to an anti-slavery speech delivered by a local spokesman for the abolitionist movement.

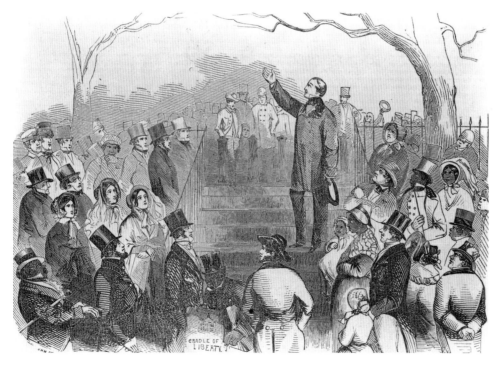

Abolitionism

Abolitionists were those pre- and early-war antislavery radicals who favored immediate, uncompensated emancipation. The movement was divided in its aims and methods, encompassing such extremes as John Brown's violence and the moral suasion of Harriet Beecher Stowe's powerful novel *Uncle Tom's Cabin*. William Lloyd Garrison was a major influence on the rise of abolitionism in the 1830s, as were such periodicals as the *Liberator* and the *Emancipator* and the development of such national organizations as the American Anti-Slavery Society (founded 1833). Among many other orators, writers, and activists, Wendell Phillips, Frederick Douglass, Horace Greeley, and Harriet Tubman agitated for abolition through the 1830s and 1840s. In time, the Liberty Party (founded 1839), the Free-Soil Party (1848) and the Republican Party (1854) came to afford a broader-based political platform for the later phases of the antislavery struggle, and organized abolitionism was somewhat in decline in the years just before the outbreak of the Civil War.

Adams, Charles Francis
(1807-1886) **Diplomat.**

Son of John Quincy Adams, he was US minister to Great Britain from 1861 to 1868. In this crucial post his success in maintaining the neutrality of England (and thus Europe) was regarded as the diplomatic equivalent of winning a major military victory at home.

Adams, Daniel Weisiger
(1821-1872) **Confederate general.**

A Kentucky-born lawyer, he commanded the 1st Louisiana Regulars at Shiloh, then led a brigade at the battles of Perryville, Corinth, Murfreesboro, and Chickamauga, where he was wounded and captured. Eventually exchanged, he commanded the District of Central Alabama during the final months of the war.

Adams Revolver

Several thousand copies of this British service revolver were made under license in Massachusetts, though Union forces bought only an estimated 600. A potent sidearm, it did not need to be cocked; unlike the more widely used Colt, the Adams could be fired simply by pulling the trigger.

Ager Battery Gun

An early machine gun, the Ager used a crank-operated breech mechanism to deliver rapid fire from a single barrel. The designer claimed the gun could fire 100 rounds per minute. Union officials were unconvinced of its capabilities, however, and only about 50 were sold.

Alabama, CSS, and *Alabama* Claims

A Confederate raiding ship built at Laird's shipyard in England in 1862, the *Alabama* spent 22 months under Captain Raphael Semmes attacking Federal shipping in the Atlantic and Indian oceans. Powered by steam and sail and armed with eight guns (the largest of which was a 100-pounder rifled Blakely), she was by far the most successful of the Confederate commerce raiders, making a total of 66 captures, 53 of which she sank. She was sunk by the sloop-of-war USS *Kearsarge (See)* off Cherbourg, France, in June 1864. Partly because of the *Alabama*'s depredations, the US, during and after the war, initiated claims against England for the nearly $20 million in damage done to Union shipping by vessels built or outfitted in that supposedly neutral country. Britain finally paid the US $15.5 million in 1873.

Albemarle, CSS **Confederate ram.**

Operating on the Roanoke River, the *Albemarle*, James W. Cooke commanding, aided in the capture of Plymouth, NC, *(See)* in April 1864 and fought a seven-ship Federal blockading squadron to a standoff the following month. She was sunk in a daring midnight torpedo raid commanded by a Union Lieutenant named William B. Cushing *(See)* on October 27, 1864.

Aldie, *Virginia*

Federal cavalry under General Alfred Pleasonton attacked Fitz Lee's cavalry brigade, of James Longstreet's command, here on June 17, 1863. The bluecoats made a series of spirited attempts on enemy defensive positions, and the Confederates withdrew after dark. The Northern losses were 305, the Southern around 100.

Alexander, Edward Porter
(1835-1910) **Confederate general.**

A Georgian graduate of West Point, he fought at First Bull Run, in the Peninsular and Antietam campaigns, and commanded the artillery on Marye's Heights at Fredericksburg. He commanded James Longstreet's reserve artillery at Gettysburg. As Longstreet's chief gunner he also fought at

Spotsylvania, Cold Harbor, and Petersburg. He published his *Military Memoirs of a Confederate* in 1907.

Alexandria, *Louisiana*

As part of the Red River Campaign (*See*), Union General Nathaniel Banks had withdrawn his troops to Alexandria by May 1, 1864, covering his fleet's efforts to withdraw on the low river. There was a series of skirmishes around town through the 8th, as Richard Taylor's Confederates made probing attacks on land and on the water. Most notably, Southern cavalry captured or destroyed four enemy ships.

Alexandria Line

This was the name given Confederate defenses in Northern Virginia in the early weeks of the war. The Confederate government assigned 43-year-old General P. G. T. Beauregard to command the Alexandria Line on May 31, 1861.

Allatoona, *Georgia*

As part of Confederate General John Bell Hood's 1864 Franklin and Nashville Campaign, graycoats under Samuel G. French struck the Union supply depot at Allatoona on October 5. The battle, in which the Union garrison held out bravely against furious enemy assaults, became famous for W. T. Sherman's flag-signaled message as he marched to reinforce; this was roughly recounted as, 'Hold the fort. I am coming.' (Actually, French withdrew before Federal reinforcements arrived next day.)

Right: Charles Francis Adams, the singularly effective US minister to Great Britain from 1861 to 1868, played a key role in the Union effort to keep the British from extending diplomatic recognition to the Confederacy.
Below: The Southern raider *Alabama* attacks the *Hatteras* (foregound) in 1863. The Union complained bitterly about Britain's building such raiders for the Confederacy.

Allen, Henry Watkins *(1820-1866)*
Confederate general.

Allen was a Louisiana lawyer, planter, and legislator who fought at the battles of Shiloh, Vicksburg, and Baton Rouge, where he was badly wounded. Inaugurated governor of Louisiana in 1864, he restored the state's shattered economy by establishing trade routes through Mexico.

Amendments to Constitution

Since slavery was implicitly sanctioned by the Constitution, amendments were necessary to extend constitutional protection to blacks after the war. The 13th Amendment, enacted in December 1865, abolished slavery. The 14th Amendment, bolstering the Civil Rights Act of 1866, defined US citizenship to include blacks, forbade states to curtail federally mandated rights, and abrogated the 'three-fifths' clause of the Constitution. When Southern states objected, their readmission to the Union was made contingent on ratification. Ratification was announced in July 1868. The 15th Amendment guaranteed voting rights to every citizen regardless of race, color, or previous condition of servitude. Designed to end Reconstruction abuses, it went into effect in March 1870. (*See* also CONSTITUTION).

America

The Confederates used this famous yacht, which won the 'America's Cup' from the British in 1851, as a dispatch boat. Federal naval forces raised her sunken hull from a South Carolina River in 1862, and *America* again raced a successful cup defense in 1870.

The famous racing yacht *America*. In 1851 she beat a field of 18 other yachts to win what would afterwards be called the America's Cup.

American Colonization Society

Antislavery activists established the society in 1816 to promote the return of blacks to Africa. Early returnees established the West African nation of Liberia, but by 1831 fewer than 1500 blacks had been resettled there.

American Flag Dispatch

Amid growing secessionist defiance in the South, US Treasury Secretary John A. Dix learned on January 29, 1861, that the captain of the revenue cutter *McClelland* had refused to surrender to federal authorities in New Orleans. Dix ordered the captain's arrest, adding, 'If anyone attempts to haul down the American flag, shoot him on the spot.'

Members of the American Colonization Society in Washington, DC, listen to an address by Massachusetts statesmen, educator and orator Edward Everett.

Ames, Adelbert *(1835-1933)*
Union general.

Wounded at First Bull Run ten weeks after his West Point graduation, Ames went on to participate in the Peninsular, Antietam, Fredericksburg, Chancellorsville, and Gettysburg campaigns; he led divisions in the Army of the Potomac in Virginia and North Carolina in 1864-65. He was a Reconstruction era governor of Mississippi.

Amistad Case

In August 1839, 53 Africans being transported between Cuban ports on the Spanish slave ship *Amistad* mutinied. They spared the lives of two crew members in order to reach North America, where a US warship escorted them into a Connecticut port. American courts rejected Spain's demand for the return of the slaves; in March 1841 the US Supreme Court upheld the lower court's decisions, and the Africans, freed, were returned to their homes in Africa.

Amnesty

On May 29, 1865, President Andrew Johnson proclaimed general amnesty to most participants on the Confederate side in the Civil War. Excepted were former-Rebels with property worth more than $20,000 and high ranking civil and military officers; these were required to apply individually to the president for a pardon. In the event, Johnson rarely refused such pardons, and with the pardons individuals' property rights (except for slaves) were restored.

Anaconda Plan

In order to avoid what he foresaw would be a bloody conflict, early in the war General Win-

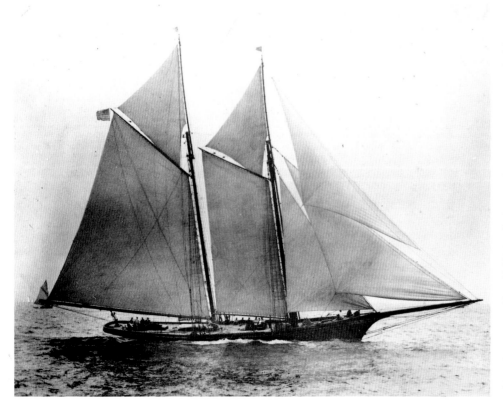

field Scott proposed a Northern strategy of completely blockading the South. His plan called for both a coastal blockade and a line of 60,000 troops supported by gunboats along the entire length of the Mississippi to constrict the South like a 5000-mile-long snake. Derided as 'Scott's Anaconda,' the plan's value was proven by the general effectiveness of the coastal blockade adopted by Lincoln in 1861.

Anderson, 'Bloody' Bill (d.1864)
Confederate guerilla.

His band of near-criminals looted Centralia, Missouri, on September 27, 1864, murdering 24 unarmed Federals there. Two hours later, the gang ambushed a Union cavalry detachment, killing 124 troopers in what became known as the Centralia Massacre (*See*). Federals caught and killed Anderson near Richmond, Missouri, in late October.

Anderson, George Burgwyn
(1831-1862) **Confederate general.**

An 1852 West Point graduate from North Carolina, he led a brigade of home-state troops during the Seven Days' Battles of 1862 and was wounded at Malvern Hill. Wounded in the ankle while leading a brigade at Antietam in September, he died after an amputation on October 16, 1862.

Anderson, Richard Heron
(1821-1879) **Confederate general.**

In 1861 this South Carolinian career soldier joined the 1st South Carolina in time to support the bombardment of Fort Sumter; he won steady promotions, fighting in virtually every campaign of the Army of Northern Virginia – the Peninsular Campaign, Second Bull Run, Antietam, Fredericksburg, Chancellorsville, Gettysburg, the Wilderness, Spotsylvania, and the Shenandoah Valley Campaign of 1864. His greatest achievement was his role in the securing of Spotsylvania for Robert E. Lee in May 1864.

Anderson, Robert *(1805-1871)*
Union general.

This Kentucky-born career soldier taught artillery tactics at West Point and fought in the Seminole and Mexican Wars. After South Carolina seceded in December 1860, as commander of Charleston harbor he moved the garrison from Fort Moultrie to Fort Sumter, where he underwent the first bombardment of the war. Anderson commanded the Departments of Kentucky and the Cumberland before retiring as the result of physical disabilities in 1863.

Andersonville Prison

The most atrocious prison of the war was the Confederacy's Andersonville Prison, established at that Georgia town in February 1864 to house Union enlisted-men prisoners. In a stockade that eventually totalled 26 acres, over 30,000 prisoners were held at a time, most living in the open air with appalling sanitary conditions and inadequate diet. Disease, exposure, and general crowding killed over 13,000 prisoners before the end of the war. The Southern commander of the prison, Captain Henry Wirz, was hanged by the Union in November 1865, the only man to be tried and condemned for war crimes after the Civil War.

Then-Major Robert Anderson commanded Fort Sumter at the outbreak of the Civil War.

Andrews Raid

'The Great Locomotive Chase'

On April 12, 1862, Union spy James Andrews and a party of 21 Federal volunteers slipped into enemy territory to cut the important rail-

Ragged Union prisoners of war in 1864 await the distribution of rations at Andersonville, the South's most notorious prison camp.

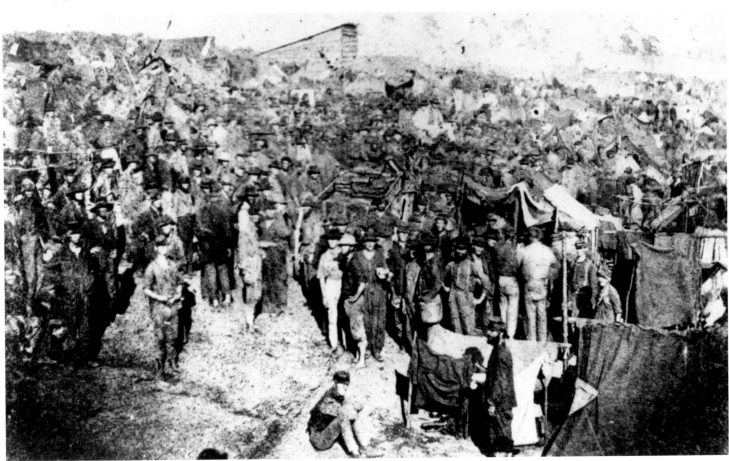

road line between Chattanooga, Tennessee, and Marietta, Georgia. Near present Kenesaw, Georgia, the raiders seized the engine *General* and steamed toward Chattanooga. Southerners pursued in the engine *Texas*. Finally, near Graysville, the Federals ran out of wood for the boiler and bolted on foot. All were captured, Andrews and seven others to be hanged as spies and 14 others to be imprisoned. Of the latter, eight eventually escaped and the rest were paroled in 1863. The classic Buster Keaton film *The General* was loosely based on this incident.

Antietam, Campaign and Battle

(In Confederate chronicles called the Battle of Sharpsburg.)

Following the Confederate forces' successes in Virginia during the Seven Days battles and Second Bull Run, General Robert E. Lee decided that the time was propitious to take his Army of Northern Virginia into Maryland in an invasion of the North. He notified CSA President Jefferson Davis of his intention on September 3, 1862, and Davis approved the plan. In the next days Lee's forces began crossing the Potomac River and concentrating in Frederick, Maryland. With this invasion Lee did not necessarily expect a quick victory, but he did expect to gain some important advantages: galvanizing anti-war sentiment in the North; perhaps arousing Maryland to join the Confederacy; tying up Federal troops that would be needed to protect Washington; moving the fighting out of Virginia; and, not least, impressing European governments, who might then be willing to recognize the Confederacy as a country rather than a rebellious territory, and therefore unlock the flow of weapons and supplies that the South desperately needed.

Marching into enemy territory, Lee took a bold gamble and divided his forces, sending Stonewall Jackson south with six divisions to capture the Federal garrison at Harper's Ferry, the gateway to Virginia's Shenandoah Valley. Subduing that garrison would allow supplies to reach Lee's army from the rich farmland of the Shenandoah, and conversely would give him an avenue of retreat if needed. After the garrison was secured, Jackson was to rejoin Lee. This strategy, however, came close to disaster: General George B. McClellan, commander of the Federal Army of the Potomac, got hold of Lee's order detailing the disposition of the divided Confederate forces.

On September 13 a Northern soldier had found Lee's Special Order No. 191 lying in a field, inside an envelope and wrapped around two cigars. (Which of Lee's officers lost the order has never been discovered.) Perusing the captured order, General McClellan crowed, 'Here is a paper with which, if I cannot whip Bobby Lee, I will be willing to go home.' In characteristic fashion,

A Union army map shows the positions of the opposing armies at the end of September 17, 1862, the bloodiest day the US had ever seen.

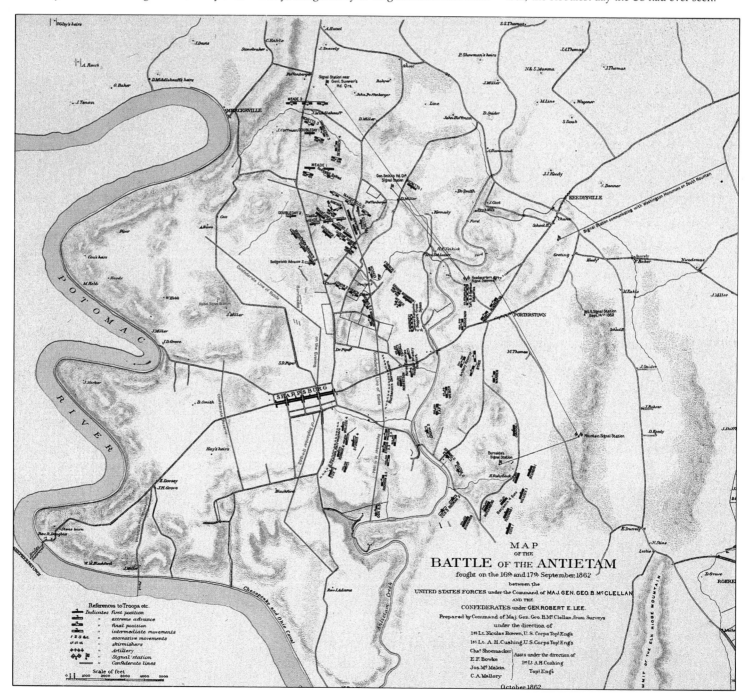

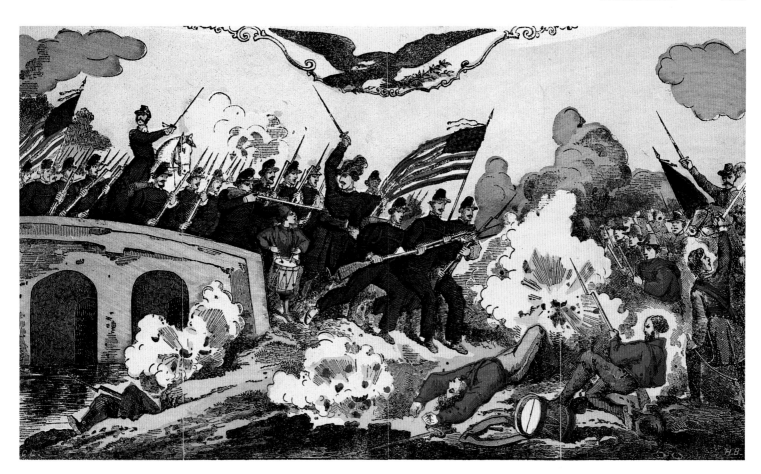

McClellan then proceeded to waste this golden opportunity by inching cautiously toward the enemy, thereby giving Lee time to discover that the order had been intercepted and to begin to march his troops toward Jackson's divisions.

On September 15 Jackson easily took Harper's Ferry, but that same day McClellan's army began to pull into position on the east bank of Antietam Creek, near Sharpsburg, Maryland. Across the creek stood 19,000 men of Lee's Army of Northern Virginia, their backs to the Potomac, while Jackson's 40,000 were still nearly a day's march away. Yet Lee, taking the measure of his opponent, elected to stand and fight. Thus the stage was set for the Battle of Antietam. The battle was not fought on the 16th, however, for McClellan spent the whole day positioning his forces rather than making an immediate attack.

No one is quite sure what McClellan's tactical plan was, and it seems to have been hazy to his officers at the time. In any event, the battle unfolded in three stages. The first began at dawn on the 17th when Union General Joseph Hooker led the three divisions of I Corps against Lee's left – one division south along the Hagerstown Turnpike, another moving into a cornfield, the third pushing through the East Wood. Their goal was to reach a little white church of the Dunker sect. All three divisions were soon fighting for their lives.

In the cornfield the opposing forces collided blindly in the dense head-high stalks, men grappling hand-to-hand, falling in waves from fire coming through the leaves. Fighting on the Federal right surged back and forth between the East Wood and West Wood, always centred on the cornfield. Finally, a jumbled collection of Federal troops broke free and swarmed toward Dunker Church, but before they reached it a searing counterattack by John B. Hood's Texas Brigade sent the Northerners reeling back. By that time Hooker's corps had suffered nearly 2500 casualties, and Hooker himself was wounded, but Lee's losses were painfully heavy as well.

About 7:00 in the morning Union General Joseph Mansfield moved his XII Corps through the East Wood into the cornfield, supposedly in support of Hooker but too late to be of much help. Mansfield was fatally wounded as they reached the cornfield, and once again the fighting swept back and forth across the field to neither side's advantage. General George S. Greene's Federal division, Union General Ambrose Burnside fights his way over the bridge that would later bear his name during the Battle of Antietam.

on Mansfield's right, made it past the Dunker Church and seriously threatened Lee's line, but Greene had to withdraw for lack of reinforcements from McClellan. That ended the first stage of the battle, leaving the Union I Corps devastated.

The next act began in the center, with Union General Edwin V. Sumner leading the II Corps at a right angle to Hooker's line of

An A. R. Waud sketch of a skirmish between the 14th Brooklyn and Confederate cavalry at the Battle of Antietam.

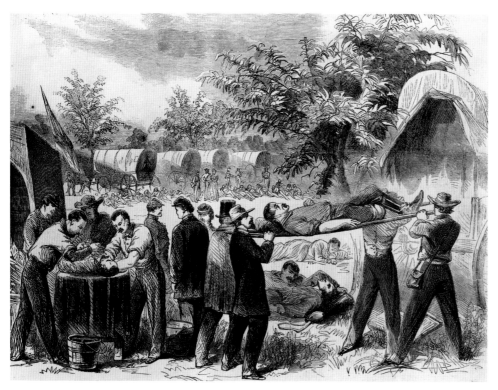

An engraving made from an on-the-scene A. R. Waud sketch shows doctors attending to the wounded at Antietam. Combined casualties in the battle numbered well over 23,000.

attack, through the cornfield and the West Wood. They met little resistance at first; to shore up his middle, Lee was desperately stripping men from his right, where the Federals were also pressing, and throwing in troops that had begun to arrive from Harper's Ferry. As the men of Union General John Sedgwick's division emerged confidently from the West Wood into open fields and stopped to dress their lines, they were met by withering fire from left, front, and rear. In ten minutes 500 Federals fell without having fired a shot. The Northerners fled back through the woods and cornfield, suffering some 2500 casualties in about 15 minutes. By 9:30 in the morning nearly 12,000 men on both sides had fallen within a thousand-yard-square area. But the fighting in the middle was not yet finished.

South of Segwick's debacle, Federals under Greene mounted an assault on D. H. Hill's men, who were well-protected in a sunken road. The Union troops were thrown back in attack after attack, but with the help of reinforcements, and spearheaded by the Irish Brigade, they gained the sunken road, to find it choked with Southern dead. History remembers that little stretch of country road as 'Bloody Lane.'

McClellan and his Army of the Potomac were now on the verge of swamping Lee's army. The Southern line was ragged and shaky; Hood reported to Lee that his division was 'dead on the field.' James Longstreet's men, now out of bullets, turned back a Union charge with two cannons alone. But McClellan failed to grasp his advantage or to press it home in the center, where Southern lines were weakest. Instead, the Federal commander let the thrust of the battle shift to his right, where General Ambrose E. Burnside had spent the morning trying to get his forces

over a bridge every inch of which was covered by Southern gunfire.

Burnside is remembered in history as one of the most incompetent generals of all time, but he would end this day as a hero because, after suffering galling casualties, he at last got his men across the bridge at 1:00 in the afternoon. Unfortunately for Burnside's reputation, someone discovered later that Antietam Creek was so shallow that the Federals could have waded across at nearly any point and out of the way of enemy guns.

Nevertheless, his men pushed the Southerners back to the edge of Sharpsburg, and by 3:00 pm were advancing hard on Lee's vulnerable left. At that critical moment, however, Burnside's forces were blind-sided by Confederates under A. P. Hill, who had just arrived from Harper's Ferry after a 17-mile

forced march. The Federal advance faltered and collapsed, Burnside failing to commit two unused divisions. By evening both armies lay devastated and exhausted around the creek, neither having gained a clear advantage. The North had lost 2108 dead, 9549 wounded, and 753 missing of 75,316 effectives (McClellan had not committed another 24,000 troops); Southern losses were 2700 dead, 9024 wounded, 2000 missing. In all, nearly 25,000 men were dead or injured; the war would never see a worse day.

Lee stayed in position on September 18, daring McClellan to attack and actually planning a counterattack (Jackson and Longstreet had to talk their commander out of the idea). Later that day the Army of Northern Virginia began to withdraw across the Potomac, the invasion over and McClellan the nominal victor. Not worrying about the details, the North joyously celebrated its first major victory. But President Lincoln was not fooled by his general's performance. It would be McClellan's last battle, except for the one he fought, and almost won, as Lincoln's opponent in the election of 1864.

But Lincoln astutely took advantage of the victory at Antietam, however ambigious, to release the Emancipation Proclamation, which transformed the war into the appearance of a crusade against slavery and therefore ended most of the South's hopes of gaining sympathy and support from Europe. Though the Proclamation actually freed no slaves at the time, it would in fact mark the beginning of the end of slavery in America.

Appomattox, Campaign and Surrender

Following the fall of Petersburg on April 2, 1865, General Robert E. Lee and the Confederate Army of Northern Virginia, by then reduced to 35,000 starving men, fled Peters-

In the house belonging to Wilmer McLean in Appomattox Court House, Va., General Robert E. Lee surrenders on April 9, 1865.

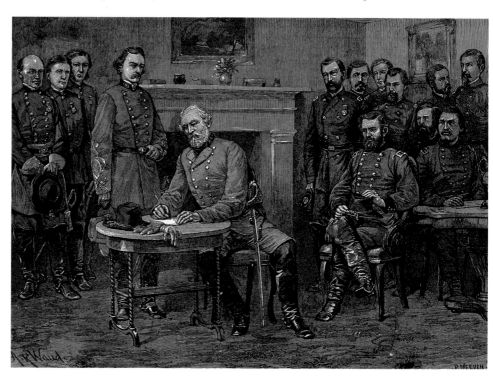

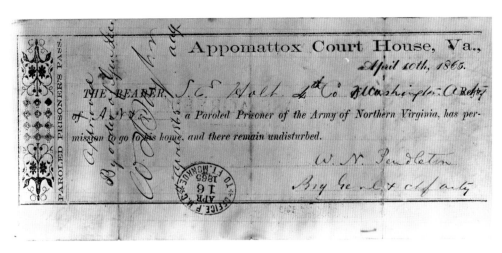

This pass, releasing a Union prisoner of the Army of Northern Virginia, was issued one day after Lee's surrender at Appomattox.

burg and Richmond and headed west. Lee was aiming for Amelia Court House, where he hoped to find a shipment of food and to put his army on the Danville Railroad for South Carolina. There he planned to join the army of Joseph E. Johnston and continue the fight for the Confederacy. In fact, both the army and the Confederacy were falling apart hour by hour. The collapse of Petersburg and departure of Lee had left the capital at Richmond defenseless, and the government there was fleeing as well. Meanwhile, Southern soldiers were deserting in hundreds.

Things were going as Union general-in-chief Ulysses S. Grant had hoped. He knew that William Tecumseh Sherman would arrive in the area with his army by the end of April, but he did not want to wait that long to run Lee to ground. 'I mean to end the business here,' he told his cavalry commander, Philip Sheridan. When the Rebel army bolted from Petersburg, Grant intended above all to keep Lee away from union with the forces of Joseph Johnston, so he sent Sheridan with cavalry and three infantry corps to shadow Lee's army. Sheridan cut the Danville Railroad on April 5, a day after President Lincoln had walked the streets of Richmond, accompanied by newly-freed slaves.

With his rail escape cut off and the food shipment having not arrived, Lee desperately struggled on toward the Shenandoah Valley, with Federals nipping at his heels. At Sayler's Creek on April 6 Union forces cut off and captured CSA General Richard Ewell's 6000 men, a quarter of Lee's remaining forces. On the next day Grant sent a surrender demand under flag of truce; Lee inquired after terms, but he was not ready to surrender yet. The army kept marching, dissolving as it went. Finally, on April 9, the spent Confederates arrived at the town of Appomattox Court House, there to find Sheridan's horsemen blocking the road. Lee would not give up without a fight. He ordered a cavalry charge that broke through for a moment; then lines of blue-clad infantry marched in to fill the gap, and two Federal infantry corps closed in on the Southern rear. The Army of Northern Virginia was now both surrounded and outnumbered.

At the last minute one of the Confederate staff suggested the desperate expedient of ordering the army to disperse and head for the hills, to fight on as guerrillas. Lee declined, saying that guerrillas 'would become mere bands of marauders,' and that rounding them up might devastate Virginia. Lee continued, 'There is nothing left for me to do but go and see General Grant, and I would rather die a thousand deaths.' A few moments later, now poised for a counter-attack, the men of the North saw a Southern rider galloping toward them waving a white flag of surrender.

Lee and Grant had already exchanged several notes regarding surrender and terms, and now Lee, finally submitting to the inevitable, agreed to meet Grant at the brick home of Wilmer McLean in Appomattox. (MccLean had earlier given up a house that had been shelled during First Bull Run and had come to Appomattox to escape the war, only to have the war now end in his parlor.)

Lee arrived first with his secretary, Charles Marshall, and an orderly. Grant arrived soon after with his staff; all were finally assembled in the parlor at about 1:30 in the afternoon. In history and legend, much would be made of the dress of the opposing commanders: Lee resplendent in dress uniform and jewelled sword (in fact, his field clothing had been destroyed in the retreat); Grant in his usual private's uniform, splattered with mud. In time the Confederate commander would come to represent the embodiment of the old chivalric tradition in war and of the old Virginia aristocracy. His opposite, a one-time failure and nobody who had raised himself to the highest responsibility by his own bootstraps, would represent the new age – rough, democratic, and ruthlessly efficient.

For a while the two men chatted about the weather and the past; Lee politely pretended to remember Grant from the Mexican War. Finally Lee asked for the surrender terms. They were discussed briefly, Lee seeing that the terms (which Lincoln had roughly outlined at the end of March in a meeting with Grant and Sherman) were generous: surrendered Southern soldiers would not be prosecuted as traitors and could go home, 'not to be disturbed by US authority so long as they observe their paroles and the laws in force where they may reside.'

Reading over the agreement, Lee dropped a hint that he wished all his cavalry and artillery might keep their horses, since most owned their own animals. Grant generously took the hint, and Lee responded, 'This will have the best possible effect upon the men . . . and will do much toward conciliating our people.'

While Grant's terms and Lee's letter of response were being copied out, Grant introduced Lee to his staff; Lee, visibly startled when he came to Colonel Ely Parker, a full-blooded Seneca Indian, finally said, 'I am glad to see one real American here.' 'We are all Americans here,' Ely replied.

Grant offered to send 25,000 provisions to the hungry Southern troops, and Lee said eagerly that 'it will be a great relief, I assure you.' After a few more minutes of conversation on matters both practical and aimless, Grant, Lee, and other officers signed the surrender agreement and Lee took his leave. As he mounted, Grant and the other Federal

In an unsigned sketch, probably by A. R. Waud, Union troops salute Lee as he rides away from the surrender site at Appomattox.

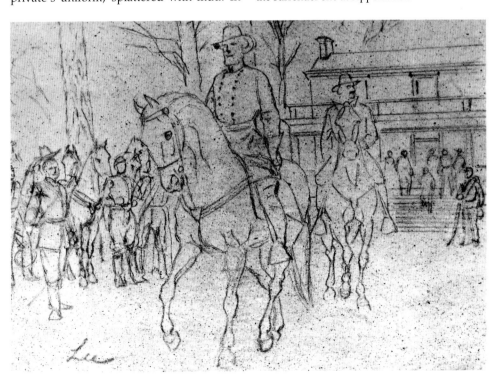

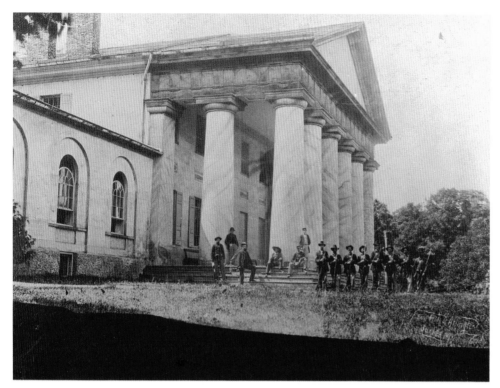

Union troops in 1864 pose before Robert E. Lee's confiscated home in Arlington, Va. Now called the Lee Mansion National Memorial, it is a part of Arlington National Cemetary.

officers saluted their great former enemy – saluted not militarily, but with a civilian tip of the hat. Lee responded in kind and rode back to his army.

At the formal surrender ceremony on April 12 the remaining men of the Army of Northern Virginia stacked their arms and banners before the ranks of a silent, and in many cases tearful, Federal Army of the Potomac. Though Johnston's and a few smaller Confederate armies had not yet given up, it was clear that the surrender of Lee had effectively ended the Civil War. The North was exploding in celebrations. President Lincoln, already making plans for the reconstruction of the South, had only a few days to live.

Arkansas Campaign of 1864

In support of Union General Nathaniel Banks's Red River Campaign, General Frederick Steele was given 12,000 infantry and cavalry troops and ordered to contain enemy forces in southwestern Arkansas, away from Banks. Steel's immediate goal was to tie up two Southern infantry divisions under Sterling Price, after which he planned to deal with three cavalry divisions in the area. In the end, the Confederate cavalry would rule much of the campaign.

W. T. Sherman had directed Steele to start at the beginning of March 1864, but the Federal column did not get out of Little Rock until nearly the end of the month. By that time, the Southern infantry divisions had marched to Louisiana to help CSA General Richard Taylor deflect Banks from his intended capture of Shreveport – exactly what Steele was in Arkansas to prevent. The Red River Campaign would never really recover from this initial setback.

As Steele's Federals marched south, they were continually harried by Southern cavalry; the end of March and the beginning of April saw a running series of skirmishes. On the night of April 9-10 Steele was reinforced near Elkin's Ford by troops under John M. Thayer; together they marched toward Spring Hill, hoping to draw Confederate cavalry after them. On April 15 Steele turned east and occupied Camden, Arkansas, where he learned that Banks had failed to take Shreveport. Meanwhile, Edmund Kirby Smith, commander of the Confederate Department of the Trans-Mississippi, was marching to attack Steele with several divisions of infantry. At Camden, on April 25, Kirby Smith sent a detachment to cut Steele's supply line; they captured a train of 211 wagons. Steele then retreated from Camden, suffering further losses in an attack at Jenkin's Ferry on April 29-30. After a thoroughly disastrous campaign, Steele arrived back in Little Rock on May 3. At that point the equally disastrous Red River Campaign was marooned by low water above Alexandria, Louisiana.

Arkansas Post (Fort Hindman)

Confederates used this Arkansas River fort as a base for gunboat forays on to the Mississippi River. Union Major General John A. McClernand captured it on January 11, 1863, after a brief campaign. Annoyed that McClernand should have been permitted by his political sponsors in Washington to undertake this campaign without reference to larger issues of strategy, Ulysses Grant had McClernand transferred and placed under Grant's command before Vicksburg.

Arlington, *Virginia*

The federal government confiscated Robert E. Lee's Arlington estate when he quit the Union army in 1861. The property, returned to the Lee family after the war, is the site of Arlington National Cemetery. ·

Armies

There was a certain looseness in what was defined as an 'army' during the Civil War; armies could range from relatively small ad hoc collections of troops to full-fledged, organized military units. Several Federal organizataions, such as the Armies of the Potomac and of the Mississippi, were named after rivers; others took their names from states, military departments, or regions (for example, the Armies of the Cumberland and of the Ohio). Southern armies tended to be named after regions, states, or departments: Army of Northern Virginia, Army of the Northwest, the Trans-Mississippi Department, etc. Similarities, such as the Army of the Tennessee (USA) and the Army of Tennessee (CSA), could, however, be confusing. During the course of the war there were about 16 in the North, 23 in the South.

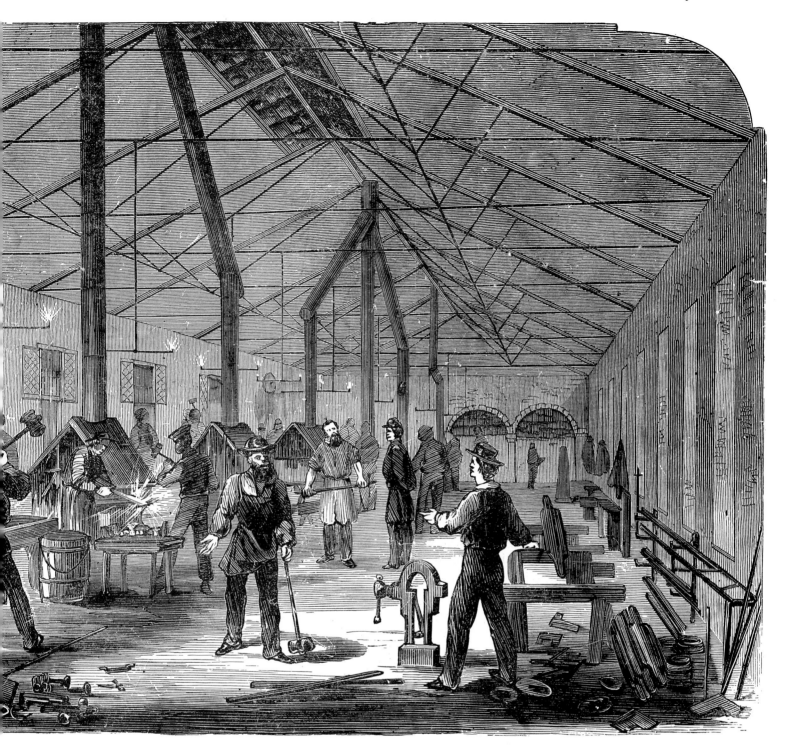

Armistead, Lewis Addison
(1817-1863) **Confederate general.**

This scion of a distinguished North Carolina military family is chiefly remembered for the poignant symbolism surrounding his death at the Battle of Gettysburg. The brigade he commanded in George Pickett's division supposedly made the deepest penetration of the Federal line during the doomed 'Pickett's Charge' on the last day of the battle. Commanding the defending troops in this part of the line was Union General Winfield Scott Hancock, Armistead's best friend; Hancock would later have the sad duty of sending the fallen Armistead's spurs to his family. The inscription on the monument that today stands on the spot where Armistead fell refers to it as marking 'the high tide' of the Confederacy, though some other Rebel brigades may have penetrated equally far.

Armstrong Guns

One version of these technically-advanced English breech-loading rifled cannon could fire a projectile weighing as much as 600 pounds. Smaller field pieces fired a three-inch projectile, and models firing four-inch and 16-pounder shells were also used. Armstrongs were widely distributed in the Union forces; the Confederates acquired far fewer of these sophisticated weapons.

Arsenals (Armories)

These terms, loosely defined in popular usage, are generally used interchangeably to mean places of manufacture, repair, storage, and/or issue of ordnance and ordnance stores. Strictly speaking, however, an arsenal was a depository. It would have charge of an armory to manufacture arms; of a depot to

Ironwork for gun carriages being forged in the armory (*ie.*, the manufacturing sub-division) of the Union's Watervliet Arsenal in West Troy, New York.

collect, repair, and issue arms; and of a laboratory to make ammunition and develop standards and procedures. In practice, arsenals and depots often overlapped in their functions.

Artillery

The Civil War conclusively demonstrated the tactical effectiveness of long-range mounted guns. The dozens of types of artillery were classified by tactical use (primarily field, seacoast, and siege), by bore, by loading mechanism, by caliber, and by construction; the guns ranged from cannon (*See*) to howitzers (*See*) to mortars (*See*), and projectiles

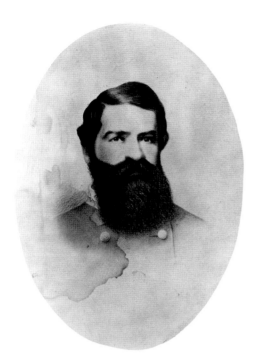

Above: Though not a professional soldier, Turner Ashby was so good a leader of cavalry that by May 1862 the Confederacy had raised him to the rank of brigadier general.
Right: Field headquarters for correspondents of the *New York Herald*.

ranged from solid shot to shrapnel. Among important technological innovations were breech loading and the rifling of artillery for greater range and accuracy.

Artists, Writers, and the Civil War

Many of America's greatest writers lived through at least parts of the Civil War: Nathaniel Hawthorne (d. 1864), Herman Melville, Mark Twain, William Dean Howells, Henry James. Yet curiously none of them chose to deal with the war except in tangential ways. Indeed, it was left to a young man who was born after the war (1871) to write what is generally regarded as the finest novel inspired by the war – Stephen Crane's *The Red Badge of Courage* (1895).

Poets did not do much better: with the notable exception of Walt Whitman (*See*), few nineteenth-century poets were successful in conveying in words the great passions of the war. Twentieth-century American poets have occasionally turned to the Civil War for inspiration, but it is hard to think of a Civil War poem that many Americans know as well as, say, Longfellow's poems about the Colonial and Revolutionary periods.

Although many American graphic artists were active during the war and its aftermath, of the major painters only Winslow Homer (*See*) tried to make serious art out of the experience. Fortunately for history, some talented minor artist-journalists such as Alfred and William Waud, Edwin Forbes, Henri Lovie, and Arthur Lumley have left us compelling sketches and engravings of wartime scenes and personalities. As to sculpture, perhaps the only work of real distinction is Augustus Saint-Gauden's memorial to Robert Gould Shaw (*See*) and the black troops he led into battle.

The same general situation applies to music and drama. The war produced a rich legacy of popular music (*See* MUSIC OF THE CIVIL WAR) but little in the way of serious concert or operatic composition. And if there have been a few notable plays and films about the Civil War, they were, virtually without exception, presented long after the event.

Why artists should have drawn so little inspiration from what was probably the most traumatic, emotive, and important episode in American history is unclear. One possibility is that the war produced so many moving first-person memoirs, accounts, letters, and journals, so many graphic photographs, so many memorable songs, that artists may have felt they could not find ways adequately to transfigure a reality so overwhelming and – even today – so vividly alive.

Ashby, Turner *(1828-1862)*
Confederate general.

A Shenandoah Valley planter and politician, Ashby favored slavery but opposed secession. When Virginia seceded, however, he raised and led a mounted troop which, as part of the 7th Virginia Cavalry, defended the upper Potomac border, participating in First Bull Run. As Jackson's cavalry commander, he played an important role in the Shenandoah Valley Campaign of Jackson. He was killed in a rearguard action protecting Jackson's retreat from the Shenandoah Valley on June 6, 1862.

An artist-war correspondent at work. Since high-speed photography was not yet possible, artists still had a monopoly on all graphic images that involved action.

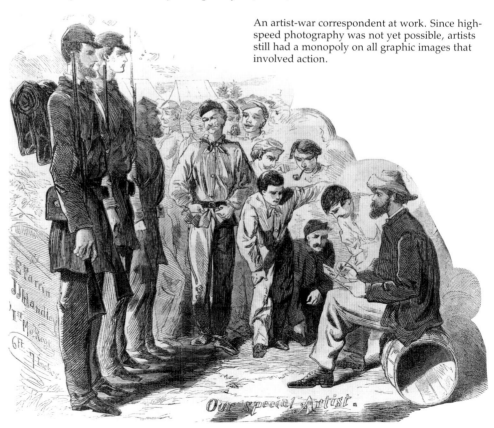

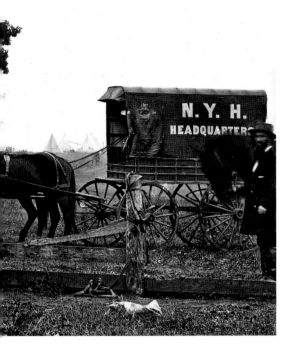

Atlanta, Campaign and Battle

After losing the vital cities of Vicksburg and Chattanooga in 1863, the South had only two comparable centers left – the Confederate capital at Richmond, Virginia, and the manufacturing and rail center of Atlanta, Georgia. In the spring of 1864, when General Ulysses S. Grant began his great offensive against Richmond, his long-time partner, General William Tecumseh Sherman, was assigned to take Atlanta. Sherman's opponent, General Joseph E. Johnston, had returned the Confederate Army of Tennessee to fighting form, 62,000 strong, after their rout in the Battle of Chattanooga (*See*).

As usual in the war, the Federals fielded the larger army; Sherman commanded 100,000 men of the combined Armies of the Cumberland, the Ohio, and the Tennessee. Unlike many Federal generals, however, Sherman knew how to handle his superior forces. On May 7, 1864, the Federals moved against Johnston's left flank near Chattanooga, and the Southerners pulled back. That would set the pattern of the ensuing campaign: as in a formal dance, Sherman would move to one flank or another of his opponent, forcing the Confederates to withdraw to prepared positions farther south, each a step nearer Atlanta. Johnston knew that unless Sherman made an enormous blunder there was no way to resist this strategy, and Sherman was no blunderer. Still, Johnston also knew that his fighting withdrawal had a purpose that was highly promising: if Atlanta could hold out until the November presidential elections in the North there was a very good chance that Abraham Lincoln would be defeated, to be replaced by a Democrat who might make peace on something like the Conefederacy's terms.

While May wore into June the flanking-and-withdrawing dance continued slowly south through Georgia, with small encounters at Snake Creek Gap, Allatoona, and Dallas. Only once did Sherman make a serious mistake. At Kennesaw Mountain on June 27 an impatient Sherman mounted a frontal assault on well-prepared Southern positions. The result was a slaughter, the North losing 2000 men to the South's 442. A few days later Sherman resumed his flanking maneuvers, forcing Johnston back to the Chattahoochie River, the last Southern defensive position before the massive fortifications of Atlanta itself. At that point Confederate President Jefferson Davis stepped into the picture.

Rejecting the campaign of retreat, Davis abruptly removed Johnston from command and replaced him with General John B. Hood, a hard-fighting veteran of Lee's army. Hood was expected to take a more aggressive tack and did so – which was exactly what Sherman wanted.

On July 20 Hood mounted a surprise attack on an isolated Federal detachment at Peachtree Creek, nearly cutting off a sizable part of Sherman's army. But commanding there was dogged Union General George H. Thomas, the 'Rock of Chickamauga,' who in four hours of sharp fighting pulled his forces together and drove the Confederates back to Atlanta with heavy losses. Two days later, on July 22, the Battle of Atlanta opened when Hood's forces struck the left flank of Union General James B. McPherson's forces, who were trying to cut rail lines into the city. While his men were repulsing this attack, McPherson himself, riding out from Sherman's headquarters, ran afoul of some enemy scouts and was shot dead from his horse. When the body was brought to him, Sherman wept openly.

After his attack on the Union left faltered, Hood pitched into the enemy center, and for a time made progress before the Federals brought to bear a devastating artillery barrage. This was the turning point of the battle: torn by 17,000 rifles and several batteries belching grapeshot and canister, the center of the Southern line vanished and the rest withdrew. With losses of 8000 men compared to the Federals' 3722, Hood pulled back into the elaborate defenses of Atlanta, to which Sherman now lay siege.

As the election approached, with Lincoln's chances against his opponent General McClellan looking dark, Sherman methodically tightened his grip around the city. On August 31 Hood's last-ditch attack on Feder-

Federal soldiers destroy railroad tracks in Atlanta after the capture of the city by W. T. Sherman in September 1864.

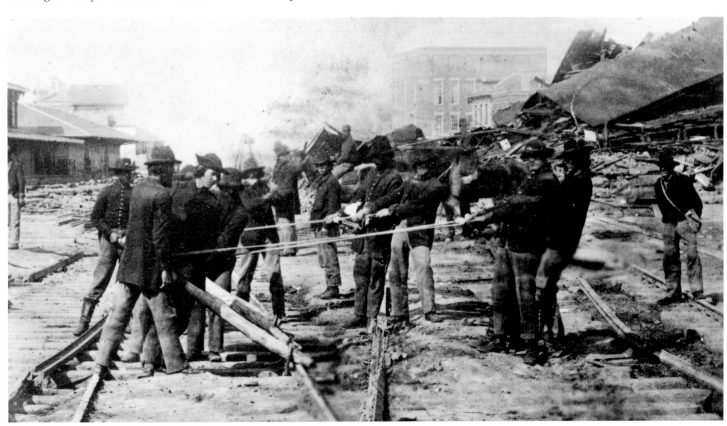

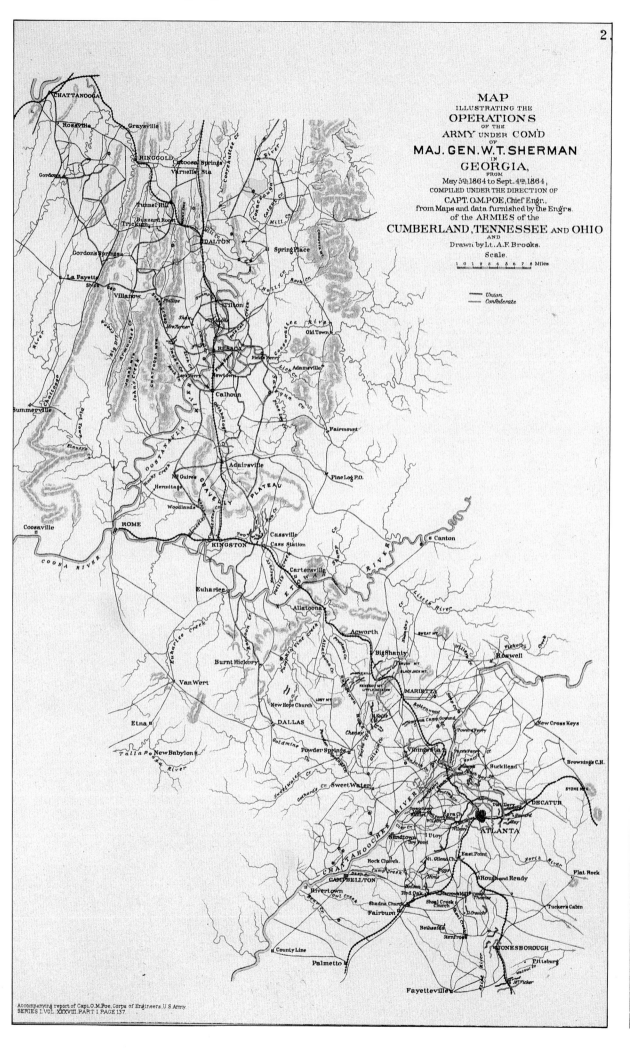

MAP
ILLUSTRATING THE
OPERATIONS
OF THE
ARMY UNDER COMD
OF
MAJ. GEN. W. T. SHERMAN
IN
GEORGIA,
FROM
May 5th 1864 to Sept. 4th 1864,
COMPILED UNDER THE DIRECTION OF
CAPT. O.M. POE, Chief Engr.
from Maps and data furnished by the Engrs.
of the ARMIES of the
CUMBERLAND, TENNESSEE AND OHIO
AND
Drawn by Lt. A.F. Brooks.
Scale.

Accompanying report of Capt. O.M. Poe, Corps of Engineers, U.S. Army.
SERIES I. VOL. XXXVIII. PART I. PAGE 137.

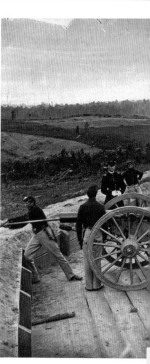

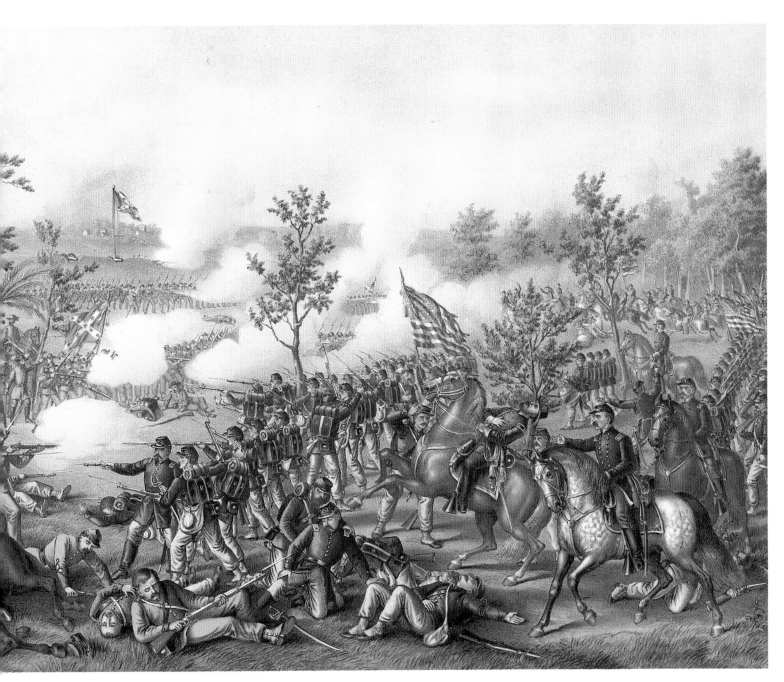

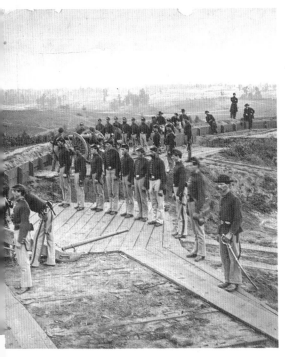

Opposite: Sherman's route from Chattanooga to Atlanta is traced on this US Army map.
Above: The death of Union General James B. McPherson at the Battle of Atlanta, as shown on a Kurz & Allison color print.
Left: Federal troops man a battery emplaced in a redoubt on the northern side of what had formerly been the Confederate defenses of Atlanta. In the background, leaning on the parapet, is General Sherman.

als near Jonesboro failed; on the same day, Union forces cut the last rail line into Atlanta. That left Hood with no choices but surrender or precipitate flight.

On September 1 the remains of the Confederate army pulled out of Atlanta and marched south. Sherman telegraphed Lincoln, 'Atlanta is ours, and fairly won.' With that stunning Union victory the election turned around; Lincoln would win handily in November. Now Sherman would turn his ruthless attention to making sure Atlanta would never be of use to the Confederacy again, and from the ruins of the city he would set out on his famous March to the Sea in November.

Augur, Christopher Colombus (1821-98) Union general.

Augur, a New York-born career officer, fought on the Rappahannock and at the Battle of Cedar Mountain, was second in command under Nathaniel Banks in the 1862 New Orleans Campaign, commanded the District of Baton Rouge, and left field service in October 1863 to command the Department of Washington and XXII Corps.

Averell, William Woods (1832-1900) Union general.

New York State-born, a West Point graduate, and a pre-war Indian fighter, he proved to be one of the Army of the Potomac's more accomplished young cavalry leaders. He brought the Union cavalry its first taste of success in the engagement at Kelly's Ford (*See*) in March 1863, was one of George Stoneman's lieutenants at Chancellorsville, and served with distinction in the Shenandoah Valley Campaign of Sheridan in 1864. He ended the war a major general.

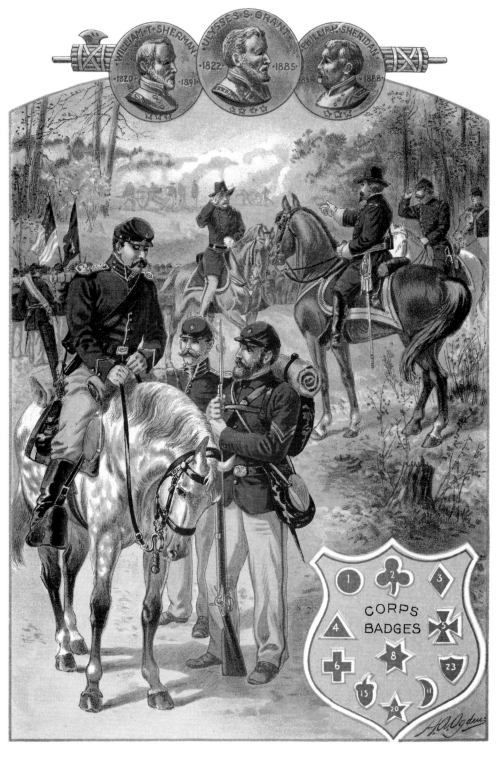

Various typical *shapes* of Union corps badges are shown above, but it should be noted that some corps symbols changed over time and that some corps used the same symbols.

Babcock, Orville *(1836-1884)*
Union army engineer.

An 1861 West Point graduate from Vermont, he worked on the Washington defense lines, fought in the Peninsular Campaign, and held senior engineering appointments in the army districts of Ohio and Kentucky. He served as Grant's aide-de-camp at the Wilderness, Spotsylvania, Cold Harbor, and Petersburg.

Badges

Devices used to identify members of Union corps, colored flannel badges were attached prominently to soldiers' caps. On Joseph Hooker's order, the Army of the Potomac adopted them in spring 1863; the West adopted them in 1864. Of the 25 Union corps, 23 wore badges in distinctive shapes such as stars, arrows, and lozenges. Eventually divisions were also designated by badges of red, white, blue, or green. Confederate corps did not wear badges.

Bagby, Arthur Pendleton *(1832-1921)* **Confederate officer.**

An Alabama-born West Pointer (1852) who quit the army to practice law in Texas, he led Texas troops at Galveston and in western Louisiana from 1861-63. He commanded a brigade in the Red River Campaign of March-May 1864 and saw action at Mansfield and Pleasant Hill.

Bailey, Theodorus *(1805-1877)*
Union naval officer.

A New Yorker, Bailey was a career officer who participated in the blockade of Pensacola and was second in command under Farragut at New Orleans. From November 1862 he led the East Gulf blockading squadron in intercepting 150 blockade runners; ill-health forced him ashore in 1864.

Baker, Edward Dickinson *(1811-1861)* **Union officer.**

An Englishman who became an Illinois lawyer and intimate and advisor of Lincoln, Baker declined a brigadier general's commis-

sion in 1861 to retain his Oregon Senate seat. As colonel of a Pennsylvania regiment, he was killed at Ball's Bluff (*See*) in October 1861.

Baker, La Fayette Curry *(1826-1868)* **US secret service chief.**

This New Yorker, a former San Francisco Vigilante, was a Union special agent throughout the war; his intelligence-gathering against Confederates, conspirators, and bounty-jumpers sometimes involved unconstitutional searches and arrests. Baker organized the pursuit and capture of John Wilkes Booth.

Baker, Laurence Simmons *(1830-1907)* **Confederate general.**

This West Point graduate left frontier Indian fighting for the North Carolina cavalry in

May 1861. He fought in the Army of Northern Virginia in the Peninsular, Antietam, Fredericksburg, and Gettysburg campaigns. He assumed a North Carolina territorial command in 1864.

Balloons

In June 1861 President Lincoln observed an ascent by hot-air balloonist Thaddeus Lowe, who proposed the still-novel airships for scouting purposes. The Union experimented with balloons during the war, sending observers aloft during battle, but this had little impact either on the fighting or on the course of the war.

Ball's Bluff, *Virginia*

A raid across the Potomac here on October 21, 1861, blundered into a Confederate ambush that cost more than 900 Union casualties, including the Federal commander, President Lincoln's friend and advisor, Colonel Edward Baker, who was killed. Rebel casualties were fewer than 150.

Ball's Ferry, *Georgia*

In late November 1864, during W. T. Sherman's famous March to the Sea, a mixed force of Confederate cavalry and infantry briefly held up the right wing of Sherman's Savannah-bound army at this Oconee River crossing. A Federal detachment crossed two miles upstream by flying bridge and turned the Rebels' flank, permitting the March to the Sea to resume.

Baltimore Crossroads

(also called Crump's Crossroads)

As the main opposing armies were fighting at Gettysburg on July 1-2, 1863, 6000 Federals under Erasmus Keyes (*See*) made a feint at Richmond. On the 2nd a Northern rearguard detachment was attacked at the crossroads.

Baltimore Riot

On April 19, 1861, as the first Northern regiment – the 6th Massachusetts – passed through the city en route to Washington, it was attacked by a pro-Confederate mob.

Their railroad cars surrounded, the militiamen were forced to march amid a hail of bricks and bullets; they returned fire indiscriminately. At least 13 people died, with dozens more wounded. Worried state officials forced a change in the military routes leading into Washington.

Banks, Nathaniel Prentiss
(1816-1894) **Union general.**

Massachusetts-born Banks interrupted a long Congressional career to fight in the war. He commanded the Department of Annapolis, led V Corps during the Shenandoah Valley Campaign of Jackson in 1862, and II Corps at the Battle of Cedar Mountain in August of that year. Appointed to replace B. F. Butler in New Orleans late in 1862, he cooperated with Ulysses Grant in opening the Mississippi and was mainly responsible for the capture of Port Hudson, the last Rebel stronghold on the river, which fell in July 1863, soon after Grant's victory at Vicksburg. As commander of the Department of the Gulf, Banks led the Red River Campaigns of 1863-64. After the war Banks again served as a Representative from Massachusetts.

Barbee's Crossroads, *Virginia*

Union and Confederate cavalry tangled three times at this country road-crossing southeast of Manassas Gap. The most notable encounter took place on November 5, 1862, when Union General Alfred Pleasanton, with 1500 troopers, attacked 3000 Rebels under Wade Hampton with inconclusive results.

Above: The Union's Nathaniel Banks was a 'political general' who fought in numerous campaigns, seldom very successfully.
Below: Men of the 6th Massachusetts confront pro-Confederate rioters in Baltimore, Md., on April 19, 1861.

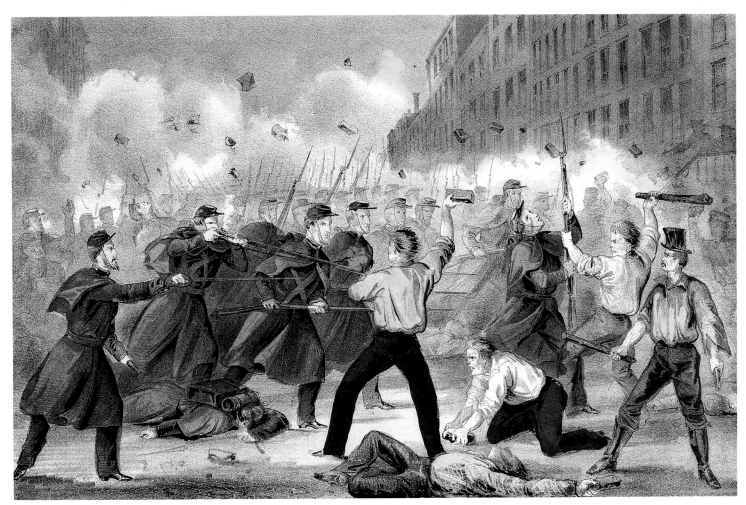

Small cavalry forces also skirmished here on July 25 and September 1, 1863.

Bardstown, *Kentucky*

Several skirmishes were fought here in October 1862 during CSA General Braxton Bragg's Kentucky Campaign (*See*). On July 5, 1863, Confederates under R. C. Morgan surrounded a detachment of the 4th US Cavalry at Bardstown and, after a 24-hour standoff, forced the Federals to surrender.

Barker, Mrs. Stephen
Sanitary Commission worker.

She accompanied her husband, chaplain to the 14th Massachusetts, to the war. A nurse attached to the 1st Heavy Artillery at Fort Albany for two years, she became the Sanitary Commission superintendent of several Washington hospitals in 1864.

Barksdale's Mississippi Brigade

Former US Congressman William Barksdale's hard-fighting Mississippians defended Marye's Heights against Union assaults at Fredericksburg in December 1862, holding the position with a loss of about 240 men. Federal attackers evicted the depleted brigade from Marye's Heights during the Chancellorsville Campaign in May 1863. Barksdale's losses in the latter action were nearly 600 killed, wounded, and missing.

Hospital worker and founder of the American Red Cross, Clara Barton did front-line duty not only in the Civil War but also in the Franco-Prussian and Spanish-American wars.

Union General Francis Barlow won distinction at Antietam, Gettysburg and the Wilderness.

Barlow, Francis Channing
(1834-1896) **Union general.**

He was a Harvard-educated New York lawyer. Despite several serious wounds requiring long recuperations, Barlow fought in most of the major campaigns of the Army of the Potomac from the siege of Yorktown to Sayler's Creek. He was a founder of the American Bar Association.

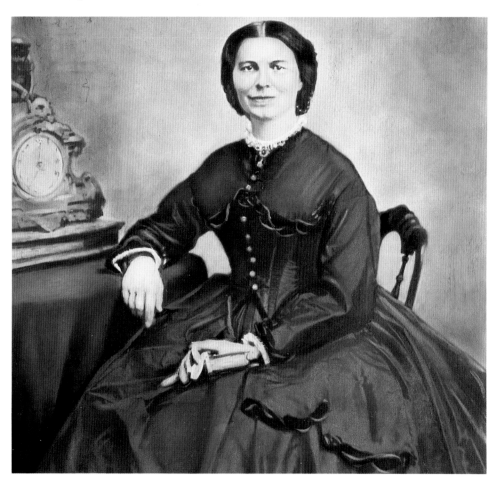

Barnard, John Gross *(1815-1882)*
Union general.

This Massachusetts-born army engineer specialized in coastal defenses, but as chief engineer successively of Washington, of the Army of the Potomac, and of the Armies of the Field, he also designed Washington's defenses and supervised Union engineering at First Bull Run, at the siege of Yorktown, and during William Tecumseh Sherman's Carolinas Campaign.

Barnett's Ford, *Virginia*

On February 6, 1864, Federal cavalry under Wesley Merritt drove enemy pickets back from the Robertson River to the Rapidan River, where Southern cavalry showed up to resist. The next morning saw an engagement as the reinforced Confederates prevented Merritt from crossing the river and inflicted 20 casualties.

Barry, John D. *(1839-1867)*
Confederate general.

A veteran of the Seven Days, Second Bull Run, and Antietam, he is believed to have given the order to fire that caused the mortal wounding of Stonewall Jackson at Chancellorsville. He led the 18th North Carolina in Pickett's Charge at Gettysburg. He briefly commanded a brigade in 1864-65.

Barton, Clara *(1821-1912)*
Humanitarian.

After the outbreak of war she left her clerkship in the Patent Office to provide nursing care and medical supplies to sick and wounded Federal troops, working behind the lines and earning the nickname 'the angel of the battlefields.' She supervised the hospitals of the Union Army of the James in 1864 and, at Lincoln's request, organized the postwar search for missing Union soldiers. Founder of the American Red Cross (1881), she worked extensively with the International Red Cross.

Baseball and the Civil War

American boys (and girls) and young men had already been playing games involving bats, balls, and bases for many decades when, in the 1840s, teams of young men in the Northeast began to try to introduce some rules that would make baseball a real game of skill and orderly contest. By the late 1850s, the so-called New York rules had generally prevailed, and representatives from 25 of the 60 to 100 teams – all in the Northeast or northern Middle West – that played by the New York rules formed the National Association of Base Ball Players. By 1860 these teams were even playing for an unofficial 'championship of the United States.'

With the advent of the Civil War organized civilian baseball, as might be expected, languished, though the game itself continued to be played informally in countless cities and towns. But at the same time, the game began to flourish within the military, for thousands of young men – often with plenty of time on their hands between the bloody battles – now

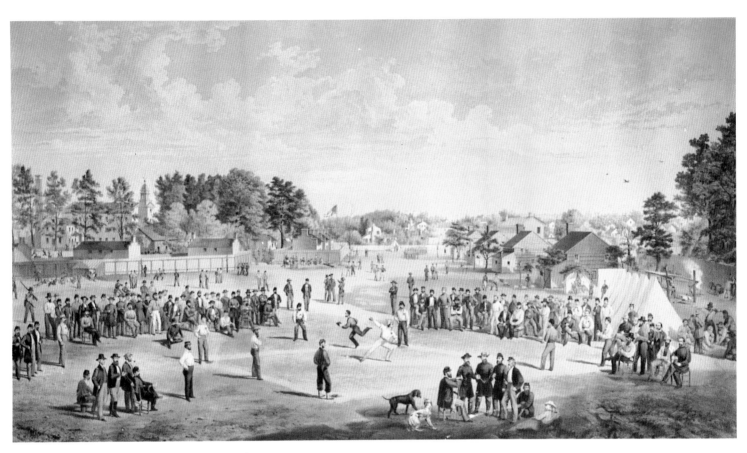

A baseball game in the Union army camp. One of the Civil War's better side-effects was to spread baseball's popularity nationwide.

took to playing baseball, and many US Army units formed their own teams and challenged those of other units. On Christmas Day in 1862 some 40,000 Union soldiers watched a game between an All-Star Union team and one from the 165th New York Volunteer Infantry: it is thought to have been the largest crowd at any sporting event in the nineteenth century.

It was largely via the prison camps, both Union and Confederate, that the South was introduced to the 'New York game,' for there Southern soldiers, as well as youths from the more remote communities of the still-youthful United States, could watch teams organized by Northeasterners play. (There is a famous contemporary lithograph of a Union team playing in a Confederate prison camp before a rapt crowd of their captors.) When the war ended, youths from all parts of the USA – and from all social classes and occupations – returned to their home towns and were soon introducing 'the New York game,' the new, more competitive version of the casual game they had formerly played. Thus, if the Civil War did not by itself make baseball into America's national sport, it certainly speeded the process amazingly.

Bate, William Brimage
(1826-1905) **Confederate general.**

Bate, a public servant and ardent secessionist in Tennessee, rose from private in the 2nd Tennessee to major general in four years. He was wounded three times in fighting at Shiloh, Stone's River, Missionary Ridge, and in both the Atlanta and Franklin and Nashville Campaigns.

Bates, Edward *(1793-1869)*
Union attorney general.

A Virginian by birth, Bates was a lawyer and moderate Republican political force in Missouri before the war. He lost his initial influence as Lincoln's attorney general by opposing Union military policies and what he considered the erosion of constitutional rights, and he resigned in November 1864.

Baton Rouge, *Louisiana*

On August 5, 1862, Confederate General Earl Van Dorn massed infantry, cavalry, artillery, and naval forces to attack Thomas Williams's 2500 Federals in Baton Rouge. Though the Federals were pushed back at first, the failure

of Confederate naval support doomed the attack, and Van Dorn withdrew.

Battery Guns

These were primitive machine guns, usually multiple barrels mounted on a gun carriage and fired together. The Vandenberg, one such weapon, consisted of as many as 120 rifle barrels. Reloading so many barrels was slow work, and few Vandenbergs were manufactured. More successful types were the Ager Battery Gun (*See*) and the Billinghurst-Requa Volley Gun (*See*).

At the Battle of Baton Rouge, August 1861, one of the Rebel generals, John Breckenridge, was a former (1856-60) US vice president.

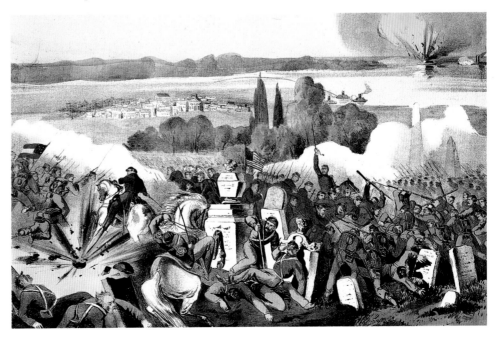

Battle Above the Clouds
(*See* Lookout Mountain)

Battle Hymn of the Republic

Probably the best-known song to survive from the Civil War is 'The Battle Hymn of the Republic,' with the words written by Julia Ward Howe (*See*) in 1861 after she had visited the Union Army camps around Washington, DC. Her words were published in the spring of 1862 in the *Atlantic Monthly*, and its editor actually assigned the poem its name. This much is widely recognized in standard reference books. But what of the stirring music? The composer was long ignored and then forgotten, but now he is generally conceded to have been William Steffe, an otherwise obscure early nineteenth-century composer who originally used the music for a hymn known as 'Fort Warren.' By the 1850s the music had been borrowed for a more widely sung spiritual known as 'Say, Brothers, Will You Meet Me?' Then in 1861, when the Massachusetts volunteers were marching through Baltimore on the way to the front, they are said to have been the first Union troops to introduce the new words, 'John Brown's body lies a-moldering in the grave' and soon this song was being printed and sung under the title, 'Glory Hallelujah.' And it was with this melody and those words in mind that Julia Ward Howe set out to write her own new verses – the ones that have endured (even in the face of endless parodies) over the decades. Some of Howe's other poems can be found in her 1878 collection *From Sunset Ridge: Poems Old and New*.

Union troops with fixed bayonets. Although bayonet charges were rare in the war, they could, as at Gettysburg, be devastating.

Battle Mountain, *Virginia*

Here Federal cavalry commander George Armstrong Custer's men struck the flank of James Longstreet's retreating forces on July 24, 1863, following the Confederate defeat at Gettysburg. The Southerners had to stop and fight a sharp rearguard action before pulling away to safety.

Baxter Springs, *Kansas*

On October 6, 1863, Confederate raiders under the ferocious guerrilla leader William Clarke Quantrill, all dressed in Federal uniforms, ambushed a small Union force here, killing 65, some atrociously.

Bayonet

Most Civil War soldiers carried this edged steel weapon, but it accounted for a very small proportion of casualties. Fewer than 1000 of 250,000 wounded men treated in Union hospitals were injured by bayonet or saber, according to Fox's *Regimental Losses*. Bayonet attacks were even rarer than bayonet wounds – only a few are recorded.

Bayou Teche, *Louisiana*

The war saw three minor actions in this town, all in support of the Union effort to bring the lower Mississippi River under Federal control. On November 3, 1862, there was indecisive fighting involving five Union gunboats and the 21st Indiana Volunteer Regiment. On January 14, 1863, four Union gunboats were engaged with the new Confederate XIX Corps. For the action of April 1863, *See* IRISH BEND AND FORT BISLAND.

Beale, Richard Lee Turberville (1819-1893) **Confederate general.**

A Virginia legislator, Beale joined 'Lee's Light Horse' as a first lieutenant in 1861 and won early and rapid promotions, fighting in every campaign of the Army of Northern Virginia. In March 1864 his troops intercepted Ulric Dahlgren and discovered the Dahlgren Papers (*See*).

Bean's Station, *Tennessee*

Following his failed attack on the city in his 1863 Knoxville Campaign, Confederate General James Longstreet attempted on December 15 to capture three enemy cavalry brigades at Bean's Station. Due to the mistakes of some of Longstreet's subordinates – or so Longstreet maintained – the blue troopers escaped.

Beardslee Telegraph

This portable field telegraph enabled senior Union commanders to communicate when fog or battlesmoke obscured visual signals. A hand-cranked magneto powered the telegraph, which used an alphabet dial and pointed to send a message over a range of about ten miles. Unfortunately, the dials on the sending and receiving machines did not always synchronize, and gibberish could all too easily result.

Beauregard, Pierre Gustave Toutant (1818-1893)
Confederate general.

Beauregard, who officiated on the Confederate side at the beginning of the war, was born to a prosperous old Creole family in Loui-

siana. He was graduated from West Point and, after distinguished service in the Mexican War and years with the Corps of Engineers, became superintendent of West Point in January 1861. Within five days he was removed for saying that he would serve the South if it seceded. Soon he had his chance, being appointed the first brigadier general in the Confederate army (he would design the familiar Confederate flag).

As commander of the forces in Charleston, South Carolina, that opened hostilities and took Fort Sumter in April 1861, Beauregard reigned briefly as the South's first war hero. He went on to lead his forces to victory at the First Battle of Bull Run. Then his career foundered on two losses in 1862, the battles of Shiloh and Corinth. Relieved of command after the latter by President Jefferson Davis, he was sent to oversee the defenses of the coast from North Carolina to Georgia. At the end of the war Beauregard came to prominence again, defeating Union General Benjamin Butler at the Battle of Drewry's Bluff and turning back the first Union attempts on Petersburg in April 1864. After the surrender he worked in Louisiana in railroads and public works and wrote some important commentaries on the war.

Below: Union General W. W. Belknap, who would become Grant's war secretary.

Beaver Dam Station, *Virginia*

As part of Sheridan's 1864 Richmond Raid (*See*), on May 9-10 Federal cavalry under George A. Custer struck Lee's supply line at this place, destroying two locomotives, 10 miles of track, over 100 railroad cars, medical supplies, and hundreds of thousands of rations, in the process setting free 378 Union prisoners.

Bee, Barnard E. *(1824-1861)*
Confederate general.

A brigade commander at First Bull Run on July 22, 1861, he gave Thomas J. Jackson his nom de guerre during that battle. 'Look at Jackson's brigade – it stands like a stone wall!' Bee shouted, 'Rally behind the Virginians!' Mortally wounded shortly thereafter, he died the next day.

'Beecher's Bibles'

This was the ironic name for the Sharps carbines (*See*) smuggled into Kansas during the troubles over slavery there in the 1850s. The weapons allegedly were shipped in crates marked 'Bibles;' antislavery activist Lyman Ward Beecher believed slaveholders would have more respect for a single rifle than for a hundred bibles.

Above: Confederate General P. G. T. Beaugard. He won early fame as the commander of the Confederate forces at Fort Sumter and then as the victorious co-commander at First Bull Run.

Belknap, William Worth *(1829-1890)* **Union general.**

A pre-war lawyer and Democratic politician, he served with Iowa troops at Shiloh and fought at Corinth and Vicksburg. He led a brigade in W. T. Sherman's Atlanta Campaign. Belknap was accused of corruption as President Ulysses S. Grant's secretary of war from 1869-76, but the charges were eventually dropped.

Belle Isle

This Confederate prison on the James River in Richmond, Virginia, held 10,000 Union soldiers by the end of 1863. Union General Judson Kilpatrick led a cavalry raid on the prison in late February 1864; its failure cost the Federals 340 troopers, more than 500 horses, and hundreds of weapons. The Belle Isle prisoners were then moved to the notorious prison at Andersonville, Georgia.

Belmont *(Missouri)*, Battle of

In his first major operation of the war, General Ulysses S. Grant was ordered, in November 1861, to move his forces out of Cairo, Illinois, and down the Mississipi River in a diversion supporting a Union offensive in Missouri. On November 7 Grant landed one contigent of 3114 troops from river transports at Belmont, Missouri, to make a demonstration on the town. Hearing a report – erroneous, in fact – that enemy forces were heading for the area, Grant decided to turn his demonstration into an attack. His men

overran Confederate camps near town, then stopped because of enemy cannons threatening from nearby Columbus (the men also gave in to the temptation to loot and burn the camps). Soon Grant found Confederate General Leonidas Polk trying to get some 10,000 troops between the Federals and their transports, and the bluecoats had to make a dash back to the river with a few captured prisoners and supplies. In the better part of the day of fighting the North suffered around 600 casualties and the South about 650 of 4000 engaged. It was an inauspicious beginning for Grant, but he soon made up for it with his campaigns against Fort Henry and Fort Donelson (*See*).

Benjamin, Judah Philip
(1811-1884) Confederate cabinet officer.

Born in the British West Indies, he became a sugar planter, New Orleans lawyer, and, as a US Senator, an early secessionist. Appointed first Confederate attorney general, then secretary of war (September 17, 1861) and secretary of state (March 18, 1862), he was a pragmatist who, by 1864, was advising Jefferson Davis to arm and emancipate the slaves to win the war. After the war he emigrated to England, where he pursued a highly successful legal career.

Benning, Henry Lewis
(1814-1875) Confederate general.

Benning, a Georgia lawyer and legislator, was an early and extreme secessionist. In his military career he fought with distinction, if not brilliance, in nearly every campaign of the Army of Northern Virginia from Malvern Hill through Appomattox. Fort Benning, Georgia is named after him.

Shrewd and able, Judah P. Benjamin was easily the best of Confederate President Jefferson Davis's otherwise mediocre cabinet officers.

Benson, Eugene *(1839-1908)*
War correspondent and painter.

Benson trained at the National Academy of Design in the 1850s. In 1861, assigned by *Frank Leslie's Illustrated Newspaper* to sketch Charleston and its fortifications, he arrived just before the bombardment of Fort Sumter. After the war he painted and exhibited widely in Europe.

Bentonville *(North Carolina)*, Battle of

During W. T. Sherman's 1865 Carolinas Campaign, Confederate General Joseph Johnston massed 21,000 men at Bentonville to strike General Henry Slocum's isolated wing of Sherman's army. Slocum made contact on March 19 and held off fierce assaults. On the following day Sherman arrived with the rest of his force of around 100,000. Under attack and in danger of being cut off, Johnston pulled back on the 21st. This would be Johnston's last major attempt to contest Sherman's advance.

Bermuda Line

In mid-May 1864, after failing to take Drewry's Bluff (*See*) on the James River below Richmond, Virginia, Union General Benjamin Butler withdrew his Army of the James into defensive lines at Bermuda Hundred. Confederate forces followed up closely, effectively pinning the inept Butler's army in its own defenses and making it unable to assist Grant in his campaign against Richmond.

Berryville, *Virginia*

On the march to Gettysburg in mid-June 1863 a Confederate force of infantry and cavalry under Robert Rodes moved to trap an isolated Union cavalry brigade here. A Federal reconnaissance detected the move; the brigade commander, Colonel A. T. McReynolds, managed to withdraw most of his force, including the supply train.

Bickerdyke, Mary Ann Ball *(1817-1901)*
Sanitary Commission worker.

A trained nurse, 'Mother Bickerdyke' ran field hospitals with Grant's army in Tennessee and Mississippi and then with Sherman's

Protected from Union attack by Britain's neutrality, Confederate blockade runners congregate in St. George harbor, Bermuda.

army in the Chattanooga and the Atlanta campaigns. Resourceful and efficient, she initiated army laundries and tirelessly nursed, foraged, and cooked through 19 battles.

Big Bethel *(Virginia)*, Battle of

This was the site of the first land battle of the war. On June 10, 1861, Union General B. F. Butler, whose division had recently arrived to reinforce the garrison at Fort Monroe, Virginia, ordered an assault on an enemy outpost at Big Bethel Church. The Rebels easily repulsed the clumsy attack. The Federals, with 4000 troops engaged, reported 76 casualties, the Confederates lost 11 of about 1400.

Billinghurst-Requa Volley Gun

This weapon, manufactured by a Rochester, NY, gunsmith named William Billinghurst, mounted 24 .60-caliber rifle barrels that took cartridges loaded from the breech. It fired an intimidating, if ragged, volley but never was produced in great quantities, though individual regiments made independent purchases of the weapon.

Birney, David Bell *(1825-1864)*
Union general.

Son of the abolitionist leader James G. Birney, this Philadelphia lawyer led a brigade in Philip Kearny's division in the Peninsular and Second Bull Run Campaigns, and then the division itself at Fredericksburg, Chancellorsville, and Gettysburg, where he also assumed Daniel Sickles's command after the latter was wounded. He died of malaria in October 1864.

Black Codes

Beginning with Mississippi on November 24, 1865, Reconstruction legislatures in Southern states passed a body of discriminatory laws regulating the conduct of newly freed blacks. These apprenticeship and vagrancy laws, penal codes, and guidelines for punishment restricted the opportunities of Southern blacks and codified their second-class status. Southern whites continued to apply many of

these black codes until the Supreme Court ordered the integration of schools in 1954, forcing legal change.

Black Troops

The idea of using black soldiers on the Northern side met with great resistance at the beginning of the war, even though many freemen were eager to enlist. The pioneer units were organized in the fall of 1862, the first official one being the 1st Louisiana National Guard. Soon one state after another began calling for black volunteers. Lincoln was at first leery of this development, but after issuing the Emancipation Proclamation the president changed his mind and embraced the idea. In all black units during the war, officers were white. The first unit to see action was the 79th US Colored Infantry, in an engagement at Island Mounds, Missouri, in October 1862. After the gallant but doomed attack on Fort Wagner (July 1863 – *See*), in which the 54th Massachusetts Colored Infantry led the charge and lost 25 percent of its men, including commander Robert Gould Shaw, the *Atlantic Monthly* wrote, 'the manhood of the colored race shines before many eyes that would not see.' To those who still resisted black troops in the North and were indifferent to slavery Lincoln wrote, 'You say you will not fight to free negroes. Some of them seem willing to fight for you.' In the last months of the war a desperate Confederate government issued a call for the drafting of slaves, but the war ended before any saw action.

Blackburn's Ford, *Virginia*

On July 18, 1861, a Union reconnaissance in force bumped into two Confederate brigades guarding this Virginia ford on Bull Run. The Rebels repulsed the Federals, inflicting 78 casualties. Confederate losses were 68; they claimed this preliminary to the First Battle of Bull Run as an important victory.

English-born Elizabeth Blackwell, the first woman to receive a US medical degree.

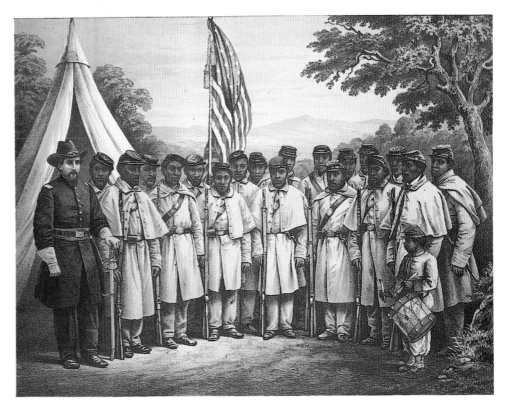

A poster issued by the Union's Supervisory Committee for Recruiting Black Regiments. In all, about 186,000 black troops would serve in 140 Federal regiments.

Blackford's Ford, *Virginia*

As Lee retreated into Virginia from the 1862 Antietam battle, Federal units crossed the Potomac at this ford on September 19 and captured four guns of Lee's reserve artillery. Confederate General A. P. Hill counterattacked the next day, driving the bluecoats away. Federal losses were 92 killed, 131 wounded, 103 missing.

Blackwell, Elizabeth *(1821-1910)*
Physician.

The first-ever woman medical school graduate (1849), this Englishwoman helped found the New York Infirmary for Women and Children. Her initiative in organizing women's relief work in 1861 led to the establishment of the Sanitary Commission (*See*). She later became a prominent gynecologist and obstetrician in London and wrote numerous books and articles on health and education.

Blair, Francis Preston Jr. *(1821-1975)* **Union general.**

Kentucky-born Blair organized the Free-Soil and Republican Parties in Missouri and saved Missouri and Kentucky for the Union by seizing the St. Louis Arsenal in May 1861. He raised seven regiments and participated in the Yazoo expedition and the Chattanooga and Atlanta campaigns.

Blakely *(Alabama)*, Battle of

The last infantry battle of the war opened on April 1, 1865, when Federal cavalry, fighting dismounted, attacked Rebel outposts here. A Union force of 10,000 then besieged the town. Over the next few days new Union forces arrived, and on April 9 General Edward Canby attacked with 16,000 men, taking the town, more than 3400 Confederate prisoners, and some 40 guns.

Blakely Guns

Confederate forces bought small numbers of these rifled cannon of English design. The largest models – one Blakely fired a 12.75-inch shell from a barrel that weighed 27 tons – were used for coastal defense. Blakely field artillery pieces fired 3.1- and 8-inch solid and explosive projectiles.

'Bleeding Kansas'

Five years of intermittent warfare between pro- and antislavery factions followed the passage of the Kansas-Nebraska Act in 1854, which left the slavery question to the settlers' vote. Both factions sponsored immigration into the territory. John Brown and his followers killed several pro-slavery Kansans at Pottawatamie in 1856; pitched battles were fought at Franklin, Fort Saunders, and Hickory Point.

Blockade

The Union naval blockade of the Confederacy sometimes seemed ineffective in the short run, but during the course of the war it proved a potent means of choking off supplies to the South. President Lincoln first declared a blockade of Southern ports in April 1861. Though at first the Union fleet was ragtag and small, by the second year of the war the blockade was having a measurable effect. Eventually the 3550 miles of Southern coastline were patrolled by some 600 Union ships. Statistics tell the story: in 1861 only about one in ten Southern blockade-running ships was captured; in 1864 one in three such Confederate vessels was intercepted, out of a considerably reduced total.

'Bloody Angle'

Also known as 'the Salient,' this horseshoe-shaped bulge in the Confederate line at the Battle of Spotsylvania became one of the war's great killing grounds. At dawn on May 12, 1864, Union General Winfield Hancock's II Corps stormed the center of the position, taking 2000 prisoners and 20 guns. The Federals followed up with attacks on both flanks, but these lost heavily and failed to make ground. Hancock's troops held their gains against a ferocious Confederate counter-attack late in the day.

'Bloody Lane'

After hard fighting, Union troops took this stretch of sunken farm road in the center of the Confederate line at the Battle of Antietam on September 17, 1862. The Rebels fell back in disorder, but a shaken Union General George McClellan failed to follow up with his reserves. Lee reformed the line, then withdrew his army in good order the following night, September 18.

Blue Springs, *Tennessee*

In a preliminary to Confederate General James Longstreet's Knoxville Campaign 1700 Confederates under J. S. Williams occupied this eastern Tennessee town in late September 1863. Ambrose Burnside's Union forces attacked on October 10, forcing Williams to retreat into western Virginia with a loss of about 250 men.

'Bonnie Blue Flag'

This Confederate patriotic song, author unknown, was first sung in Richmond and New Orleans in 1861. The title refers to an early version of the Rebel flag, later replaced by the 'Stars and Bars.' (*See* also MUSIC OF THE CIVIL WAR).

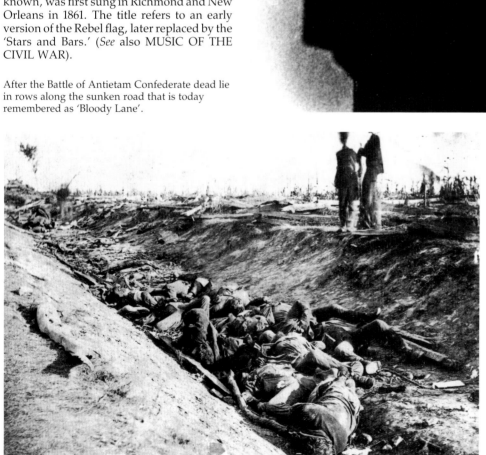

After the Battle of Antietam Confederate dead lie in rows along the sunken road that is today remembered as 'Bloody Lane'.

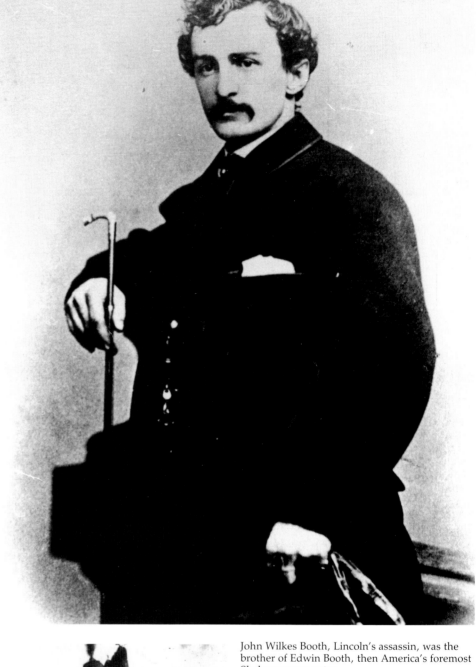

John Wilkes Booth, Lincoln's assassin, was the brother of Edwin Booth, then America's foremost Shakespearean actor.

Booneville *(Mississippi)*, Battle of

A large force of Confederate cavalry under J. R. Chalmers attacked Philip Sheridan's 2nd Cavalry Brigade at this halt on the Mobile & Ohio Railroad on July 1, 1862. Though heavily outnumbered, Sheridan counterattacked and routed Chalmers's troopers. His reward: a brigadier general's commission.

Booth, John Wilkes *(1838-1865)*

Born into an acting family and brother of famed Shakespearean Edwin Booth, John Wilkes Booth followed the family trade with some success before entering history as the assassin of Abraham Lincoln. Born in Maryland, he acted Shakespearean roles before seeing service with the Virginia militia that attacked John Brown at Harper's Ferry. During the war, while continuing his acting

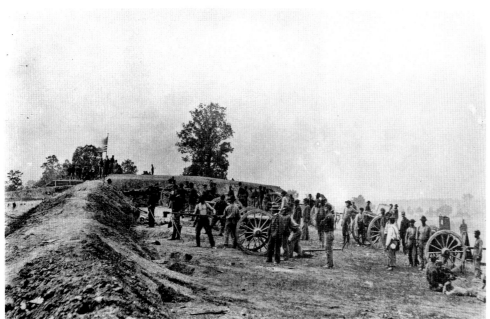

The great photographer Mathew Brady (wearing the straw hat) watches a Union battery fire on Rebel positions at Petersburg in 1864.

career, he became a fanatical Southern patriot, toward the end of the war plotting without success to kidnap President Lincoln.

After the fall of Richmond and the imminent end of the war, an hysterical Booth gathered a group of conspirators to assassinate the president and other leaders, hoping this deed would inspire the South to fight on. Having enlisted accomplices also to kill Vice-President Andrew Johnson and Secretary of State William Seward (neither succeeded, though Seward was seriously injured), Booth slipped into Ford's Theater in Washington on the night of April 14, 1865, where Lincoln and his wife were watching a play, and mortally wounded the president (See LINCOLN ASSASSINATION).

Booth, fleeing with a broken leg, and co-conspirator David Herold were run to ground on April 26 in a barn near Bowling Green, Virginia. Herold surrendered, but Booth remained defiant. During the ensuing shoot-out the pursuers set the barn afire; when Booth emerged he was shot dead. Herold and three other accomplices were hanged in July 1865. For decades a rumor persisted that Booth had survived and lived in the South, but this was entirely fanciful.

Border States

After the 13 slave-holding states had seceded to form the Confederacy, four other slave-holding states remained, shakily loyal to the Union – Delaware, Kentucky, Maryland, and Missouri. These plus Virginia, which did secede, had been known as Border States because they divided free and slaveholding regions. Added to this group later in 1861 was West Virginia, an area sympathetic to the Union, that broke off after the rest of Virginia seceded. Especially in the early part of the war, the border states were considered potential allies by both sides and were thus vitally important. (Had four more states gone to the South, the Confederacy's chances of victory would have been vastly improved.) It

was therefore a great concern of President Lincoln to keep the remaining border states at least neutral. This was a primary reason for his early policy of fighting the war over secession rather than slavery: he could not afford to threaten the border-state slaveholders. By an adroit combination of coddling and periodic military action Lincoln managed to keep all these states from seceding, despite the Confederate sympathies of large minorities of their populations.

Bormann Fuse

Gunners used this Belgian-designed time fuse on explosive shells fired from field pieces and siege artillery but complained of its unreliability.

Bounties

Both armies, as well as state and local agencies, offered bounty payments as an inducement to volunteer. Congress voted a $100 bounty for three-year enlistees as early

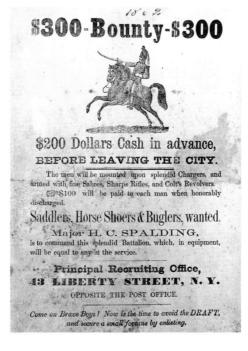

as July 1861; by war's end, the federal government alone had paid out an estimated $300 million. The Confederate government generally offered a $50 bounty.

Bowie Knife

The name of Indian fighter James Bowie was given to almost any knife a Confederate soldier carried as a sidearm, but these various knives were all but useless in battle, and veterans learned quickly to toss them aside.

Boyd, Belle *(1844-1900)*
Confederate spy.

As a courier for P. G. T. Beauregard and Stonewall Jackson, this young Virginian was an intelligence agent and smuggler who proved especially useful to the Confederacy at the Battle of Front Royal. Three times arrested, she escaped to England in 1864, became an actress, and published a racy account of her espionage career.

Bradley, Amy Morris *(1823-1904)*
Sanitary Commission worker.

A regimental nurse at First Bull Run, Bradley later supervised hospital ships in the Peninsular Campaign. After December 1862 she transformed Camp Distribution, a squalid convalescent camp, into a clean, efficient operation and edited the *Soldiers' Journal*, a paper intended to disseminate practical information to Federal troops.

Brady, Mathew B. *(1823-1896)*
Photographer.

A highly acclaimed portrait photographer, he got Lincoln's authorization to photograph camp and battle scenes. Accompanying Federal troops with cumbersome wet-plate

Below left: A typical poster offering bounty payments to men willing to volunteer for service in the Union cavalry.
Below: The celebrated Rebel spy Belle Boyd helped Jackson during his Valley Campaign.

cameras, often a great personal risk, Brady and his assistants compiled a documentary record of 3500 photographs, preserving some of our most enuring and valuable images of the Civil War.

Bragg, Braxton *(1817-1876)*
Confederate general.

North Carolinian Bragg was graduated from West Point (1837), fighting in the Seminole and Mexican Wars and on the frontier before retiring to a Louisiana plantation in 1856. He commanded southern coastal defenses and, promoted to major general, served as Albert S. Johnston's chief of staff and commanded II Corps at Shiloh. A full general after April 1862, Bragg commanded the Tennessee Army through Bragg's Invasion of Kentucky, Perryville, Stone's River, the Tullahoma Campaign, Chickamauga, and Chattanooga. Replaced by Joseph E. Johnston after repeated misjudgments and failures to capitalize on battlefield gains, he became Jefferson Davis's military advisor and was captured with Davis in May 1865. Bragg was an intelligent military planner, but his war career was hampered by indecision, frequent illness, and personal unpopularity.

The high point of Rebel General Braxton Bragg's wartime career was probably his victory at Chickamauga in September 1863.

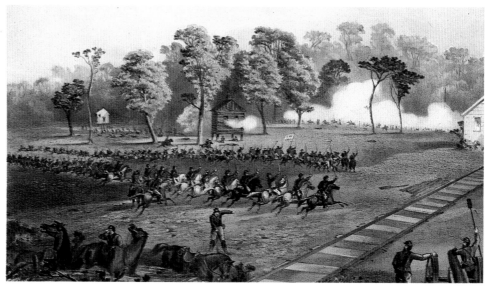

Bragg's Invasion of Kentucky

The slaveholding state of Kentucky had remained with the Union at the beginning of the war, despite its many Southern sympathizers. The Richmond government, wanting to make use of that sympathy to win the state for the Confederacy, acceded to General Braxton Bragg's plan for an invasion. Bragg, with 30,000 men, left from Chattanooga and arrived in Glasgow, Kentucky, on September

The Battle of Brandy Station in June 1863 was the war's first major cavalry action. Here, a charge by the 6th New York Cavalry.

13, 1861, then occupied Munfordville (*See*). (Meanwhile, CSA General Edmund Kirby Smith had left Knoxville and marched into Kentucky with his Confederate forces, planning on linking up with Bragg.) As Bragg moved north, however, the expected recruits and popular uprising failed to materialize, even after a Confederate governor was proclaimed at Frankfort on October 4. Finally, slow-moving Union General Don Carlos Buell assembled a large force and caught up with Bragg at Perryville. The ensuing battle on October 8 persuaded Bragg to give up the invasion.

Brandy Station *(Virginia)*, Battle of

Following the 1863 battle of Chancellorsville, as Robert E. Lee was gearing up for the Gettysburg Campaign, Federal Army of the Potomac commander Joseph Hooker sent cavalry under General Alfred Pleasonton to make a reconnaissance in force. The result, on June 9th, was the Battle of Brandy Station, the first true cavalry combat of the war and the largest. The Federals began with a surprise assault, and after a day of fierce fighting, much of it with sabers, the Union troopers had lost 936, Confederate General J. E. B. Stuart's cavalry 523. Though results of the fight were inconclusive, the action was perceived as something of a humiliation for Jeb Stuart and his Southern horsemen.

Breckinridge, John Cabell *(1821-1875)*
Confederate general and secretary of war.

A Kentucky politician, he was President James Buchanan's vice president and ran against Lincoln in 1860. Natural leadership outweighing his inexperience, Breckinridge fought at Shiloh, Stone's River, and Vicksburg, as well as with Braxton Bragg at Chickamauga and Missionary Ridge. Summoned by Robert E. Lee to the Shenandoah Valley, he won at New Market (*See*) in 1864. He served as the Confederate secretary of war after February 1865.

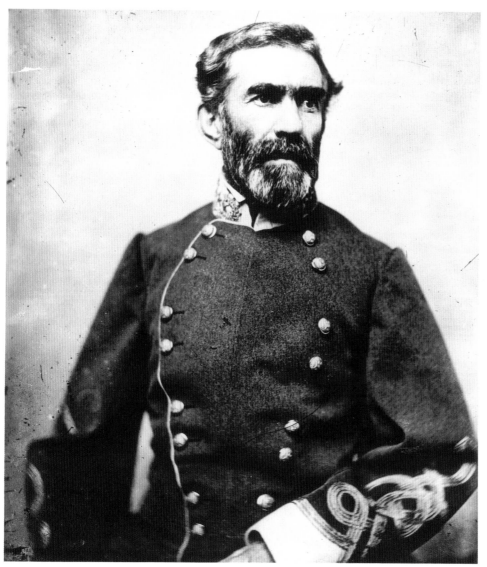

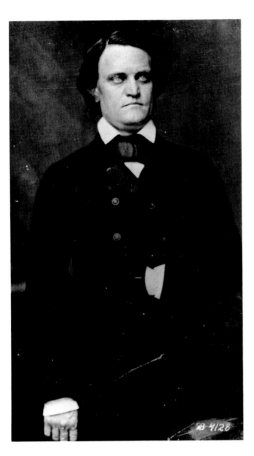

A Mathew Brady portrait of the Confederate general and statesman John C. Breckenridge.

Brentwood, *Tennessee*

On March 25, 1863, the Confederate cavalry commander Nathan B. Forrest surprised and surrounded a Union outpost held by the 22nd Wisconsin, then drove off reinforcements sent to rescue the captured Federals. Forrest reported taking more than 750 Union prisoners.

Brevet Rank

An honorary title awarded for gallant or meritorious action in war, a brevet rank carried none of the increases in authority, pay, or precedence of a real promotion. Brevet officers could occasionally claim the privileges of rank, but rules governing brevet rank were so vague that officers' titles and uniforms often failed to indicate their actual positions, and disputes were common. Abuses eventually caused the abandonment of the system.

Brice's Crossroads (*Mississippi*), Battle of

During his 1864 Atlanta Campaign, Federal General W. T. Sherman sent Samuel D. Sturgis and a mixed force of nearly 8000 to destroy Nathan Bedford Forrest's raiders, who had been wrecking Sherman's supply lines. With 4713 men, Forrest assaulted Sturgis's cavalry advance at the crossroad on June 10. As Union infantry arrived, exhausted from a forced march in severe heat, Forrest kept up the pressure; then, massing his forces, Forrest broke through the blue center and followed that with attacks on both flanks. Soon the Federals were fleeing in panic; the gray-coats chased them all night and into the next day. With half the numbers of his opponent, Forrest had captured large quantities of supplies and arms and had inflicted over 2000 casualties (most in captured).

Brigades

These army formations consisted of two or more regiments; two or more brigades composed a division. Union brigades, designated by number (*i.e.*, 1st Brigade, 2nd Division) generally averaged about 2000 men. Confederate brigades, named for their commanding officers, were usually smaller. Two famous units were the Union 'Iron Brigade' of midwestern regiments and the Confederate Stonewall Brigade of Virginians.

Bristoe Campaign

This is the name given to a series of maneuvers and relatively small clashes between the Union Army of the Potomac and Robert E. Lee's Army of Northern Virginia in the autumn of 1863. After the Battle of Gettysburg the Confederate army had settled into Culpeper, Virginia, the Federals nearby across the Rappahannock River. By autumn both armies were somewhat weakened, having sent detachments to other theaters. Learning that his opponent, George Meade, had sent two corps to Chattanooga, Lee began the Bristoe Campaign to cut off the Federals; this produced a series of inconclusive engagements from mid-October through November: Bristoe Station, Catlett's Station, Buckland Mills, Rappahannock Bridge and Mine Run (*See* under each engagement). Meade, meanwhile, managed to pull his army back to a strong defensive position on the Bull Run, and by early December both armies had settled into winter quarters. The campaign is chiefly interesting as a demonstration of how Lee's losses at Gettysburg had deprived him of the ability to mount any further meaningful offensive operations.

Bristoe Station (*Virginia*), Battle of

As part of Robert E. Lee's attempts to cut off Union General George Meade in the Bristoe Campaign (*See*), Lee's lieutenant A. P. Hill sent a corps against the supposedly isolated Federal III Corps near Bristoe Station, Virginia. As the Confederates attacked, however, they were struck by the nearby Union II Corps; rather than retreat, they charged into the strong blue positions and were severely repulsed. In the day's fighting Lee suffered some 1900 casualties to the Union's 548.

Brooke Guns

This rifled artillery weapon, designed by the Confederate naval officer John Brooke, resembled the Parrott cannon widely used by both sides. The 3-inch field gun version fired a 10-pound projectile at a range of more than two miles.

Brooke, John Rutter (*1838-1926*)
Union general.

This Pennsylvanian led troops in virtually every campaign of the Army of the Potomac from the Peninsular to Cold Harbor, twice suffering serious wounds. He later commanded a division in the Army of the Shenandoah, and after the war joined the Regular Army.

Brooklyn, USS

Union commanders kept this wooden-hulled sloop-of-war, based at Norfolk, Virginia, on standby to reinforce Fort Sumter during the secession crisis of the winter of 1861, but for diplomatic reasons General Winfield Scott sent the unarmed *Star of the West* (*See*) in-

Just before the Battle of Bristoe Station (October 14, 1863) Union General George Meade hurries his men across Kettle Run. The battle would be a defeat for Robert E. Lee.

stead. The *Brooklyn* later served on blockade duty and took part in Admiral David Farragut's victories at both New Orleans and Mobile Bay.

Brooks, William Thomas Harbaugh *(1821-1870)* Union general.

An Ohio-born West Point graduate (1841), he fought in the Mexican War (under Robert E. Lee) and on the frontier. He led a division in the Peninsular Campaign and at Antietam in 1862, and at Drewry's Bluff, Bermuda Hundred, and Cold Harbor in 1864. He commanded X Corps during the Petersburg siege before resigning as the result of ill health in July 1864.

Brooks-Sumner Affair

On May 22, 1856, South Carolina Representative Preston Brooks delivered a savage caning to abolitionist Senator Charles Sumner, who had insulted Brooks's kinsman, a South Carolina Senator, in an antislavery speech two days before. Sumner suffered from the effects of the beating for three years, although he continued to represent Massachusetts in the Senate.

Brown, John *(1800-1859)*
Abolitionist.

Active in antislavery work throughout an itinerant early life, Brown was swept into radical activism in Kansas in 1855. He became leader of the Ossawatomie colony, gaining

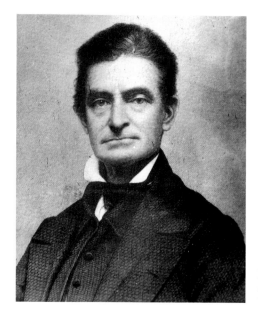

Fanatical abolitionist John Brown, author of the famous 1859 raid at Harpers Ferry.

national notoriety after massacring five pro-slavery men at Pottawatamie in May 1856. Claiming to be an instrument of God, and supported by leading Eastern abolitionists, Brown devised a plan to invade the South and free the slaves. He began by attacking Harper's Ferry (*See*) with 21 men in October 1859, occupying the town and its armory before being captured by Colonel Robert E. Lee. Convicted of treason, Brown was hanged in December and promptly became an abolitionist martyr. Passionate and eloquent, Brown was by some accounts insane; Emerson, however, praised him as 'a pure idealist of artless goodness.'

Brown, Joseph Emerson *(1821-1894)*
Confederate governor of Georgia.

Born in South Carolina and educated at Yale, Brown was a leglislator, judge, and, from 1857-65, governor of Georgia. A strong states' rights advocate, he opposed Jefferson Davis's centralization of the Confederate government. After the war Georgians deplored Brown's active support for Radical Reconstruction measures as opportunistic.

Brownell, Kady *(b.1842)*
Vivandiere.

Daughter of a British soldier, she accompanied her American husband to war and fought with his Rhode Island regiments at First Bull run, where she carried the colors, and at New Bern, where her husband was wounded. General Ambrose Burnside signed her discharge, and she received an army pension.

Brownlow, William Gannaway *(1805-1877)* Tennessee unionist.

A Virginia-born itinerant preacher, Brownlow edited influential Whig newspapers in Tennessee, notably the *Knoxville Whig*, and united the eastern Tennessee Unionists. Briefly imprisoned by the Confederates in 1861 for treason, he lectured in the North in 1862-63 and was elected Tennessee's governor in 1865.

Buchanan, James *(1791-1868)*
Fifteenth president of the United States.

Buchanan, a Democrat, became president in 1857. A states' rights advocate, he nevertheless opposed secession, yet his indecisiveness when Fort Sumter was threatened and Southern states seceded left Lincoln facing imminent war upon his inauguration. Historians judge Buchanan as politically unwise, but hardly as responsible for the war.

Buckner, Simon Bolivar *(1823-1914)* Confederate general.

An 1844 graduate of West Point, Buckner resigned from the army in 1855, settling into a business career in his native Kentucky. He organized and trained the state militia in 1860, meanwhile working to preserve Kentucky's neutrality. After the Federals invaded Kentucky, however, Buckner joined the Confederates. In February 1862 he surrendered Fort Donelson to Ulysses Grant. Exchanged in August and promoted to major general, he participated in Braxton Bragg's invasion of Kentucky, fortified Mobile, commanded East Tennessee during the summer of 1863, and led a corps at Chickamauga. Commanding the District of Louisiana after 1864, Buckner saw little further action, but after Appomattox he helped negotiate the surrender of the Trans-Mississippi armies.

Buell, Don Carlos *(1818-1898)*
Union general.

Buell, an Ohio native, was raised in Indiana, was graduated from West Point, and fought

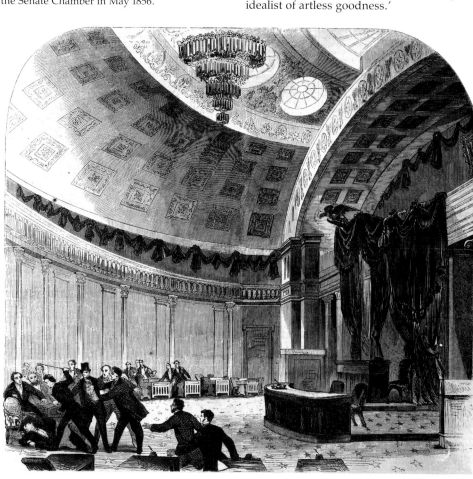

South Carolina Congressman Preston Brooks attacks Massachusetts Senator Charles Sumner in the Senate Chamber in May 1856.

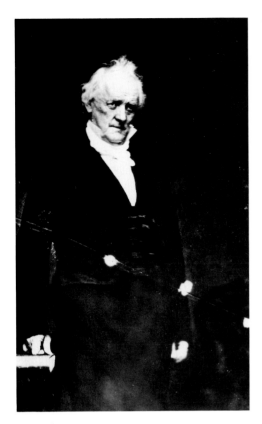

A Mathew Brady portrait photograph of the last prewar president, James Buchanan.

in the Mexican War. He was commissioned brigadier general in 1861 and initially organized troops of the Army of the Potomac. Appointed commander of the Army of the Ohio in November, Buell moved to retake eastern Tennessee, occupying Bowling Green and Nashville and then forcing the Confederate retreat at Shiloh. After an unsuccessful expedition toward Chattanooga early in 1862 he led the Stone's River Campaign, in which his disappointing performance led to his replacement by William S. Rosecrans. After a seven-month investigation into his Tennessee and Kentucky Campaign, Buell resigned in June 1864. Though a solid general, Buell's early promise was unrealized. His reserved temperament neither inspired his troops nor allowed him to function effectively in the highly charged political climate of the Civil War.

Buford, Abraham (1820-1894)
Confederate general.

Born in Kentucky, he was graduated from West Point (1841), served in the Mexican War, and joined the Confederate Army in September 1862. He commanded a brigade at Stone's River, and fought with Nathan B. Forrest at the head of a cavalry brigade until he was wounded at Lindville in December 1864.

Buford, John (1826-1863)
Union general.

An 1848 West Point graduate from Kentucky, he commanded the Union cavalry screen that intercepted Confederate forces marching toward Gettysburg, Pennsylvania, on July 1, 1863. His decision to defend the town brought on the great battle there. Buford died of typhoid fever on December 16, 1863.

Built-up Guns

In this manufacturing method, the main components of cannon were produced separately, then joined by welding or other processes. Armstrong, Blakely, Brooke, Parrott, and Whitworth guns were made in this way. In the alternative method, cannon were cast in one piece.

Bull Run, First Battle of
(In Confederate chronicles called First Manassas)

In July 1861 General P. G. T. Beauregard commanded a Confederate army encamped at Manassas Junction, Virginia, some 25 miles southwest of Washington. President Lincoln ordered General Irvin McDowell to drive Beauregard away from that important rail junction. On the 16th McDowell advanced from Washington with 30,600 troops, primarily three-month volunteers and militia, many of them due to go home shortly (and thus less disposed to risk their lives). Having learned of the advance from spies in Washington, Beauregard called for reinforcements, and Confederate President Jefferson Davis ordered General Joseph E. Johnston to bring his 11,000 men by railroad from Virginia's Shenandoah Valley. (This was the first large movement of troops by rail in history.) Everyone expected a major battle; many expected it would decide the war.

The forces collided briefly on July 18th in a spirited skirmish at Blackburn's Ford on the Bull Run River, where General James Longstreet drove away a Federal reconaissance party. McDowell's green troops had marched slowly from Washington. The resulting delay in attacking allowed time for Johnston's reinforcements to arrive, giving Beauregard a force of well over 30,000 in his position west of the Bull Run. Both generals, who had been classmates at West Point, made identical plans for battle: feint with the left, attack on the right. If both had been successful, the two armies would have brushed past each other

like a swinging door. In practice, however, the battle turned into a free-for-all.

At dawn on July 21 McDowell set his plan in motion with an artillery barrage. His strategy then fell apart, due largely to the slowness and inexperience of the Federal troops, who had insufficient drill and marching experience. McDowell made his feint on his left at a bridge on the Warrenton Turnpike, followed by a secondary attack on the enemy center. But to mount his flank attack on the right he had to march a detachment six miles through rough terrain. By the time these men had struggled to the enemy left Southern Colonel Nathan Evans had spotted the dust of the Union column on the march and had alerted Beauregard of the danger to his flank. By the time the bluecoats attacked two extra enemy brigades had been moved up to receive them.

Still, the badly outnumbered Southerners were slowly forced back in two hours of severe but confused fighting. At that point neither army was able to perform effective battlefield maneuvers. Finally the Confederates were pushed across the turnpike and up Henry House Hill, where hours of inconclusive fighting surged back and forth. As it began to appear that the exhausted Southerners were about to break and run, brigade commander Thomas J. Jackson moved up and formed his fresh troops into a defensive nucleus on the hilltop. It was then that Southern General Bernard E. Bee entered history in his last few moments of life, shouting to his men, 'Look at Jackson's Brigade – it stands like a stone wall! Rally behind the Virginians!' Soon the Confederate line had firmed up behind Jackson, who stopped the Union advance on the crest of the hill. From then on, the laconic, eccentric man who turned the tide of the battle would be called Stonewall Jackson, his troops the Stonewall Brigade.

Colonel (and soon-to-be General) Ambrose Burnside rallies his Rhode Island Brigade at the First Battle of Bull Run in this on-the-scene sketch by A. R. Waud.

Beauregard followed with a counterattack all along the line, using nearly every reserve he had (McDowell failed to commit two reserve brigades). As the Southerners drove into the Federals the eerie, frightening wail of the 'Rebel yell' was heard for the first time by most of the Northerners. Later a veteran would write of it, 'The peculiar corkscrew sensation that it sends down your backbone under these circumstances can never be told. You have to feel it.' The Northern men fell back in the face of the onslaught.

At dusk the Federals began an orderly retreat, with no pursuit from the exhausted and disorganized Confederates. Mixed in with the Federal troops were a number of civilians who had come to watch the battle, bringing picnic lunches. Suddenly a Southern battery fired some shells into the mass of Northern soldiers and civilians near a bridge over the Bull Run that constricted the column. A panic resulted, the retreat becoming a rout, everyone trying to get over the bridge at once.

The South had won its first major victory.

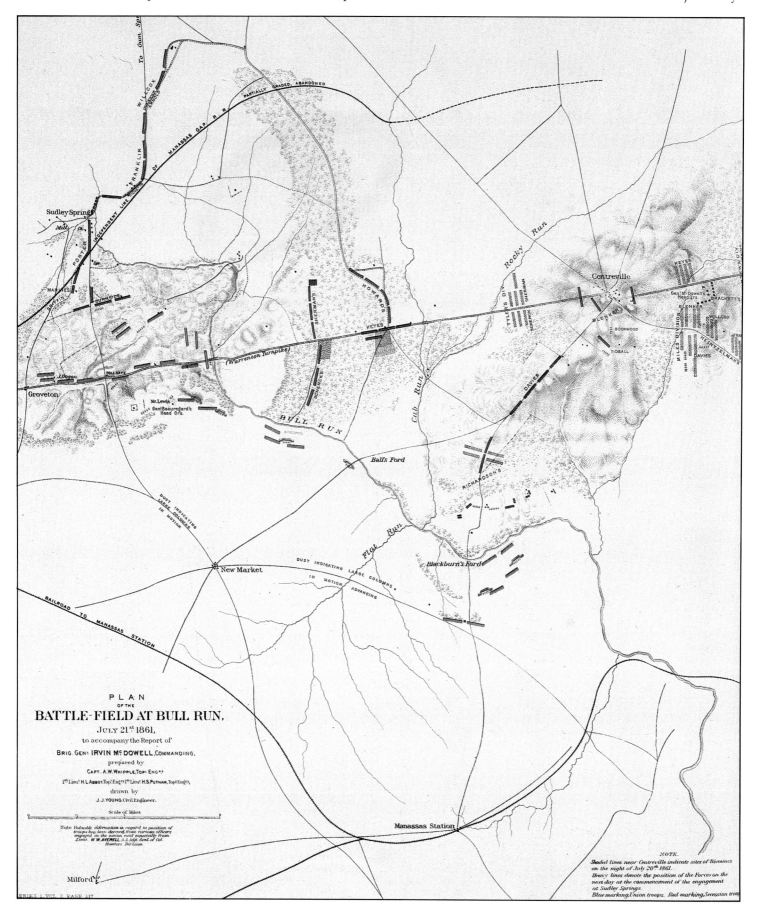

PLAN
OF THE
BATTLE-FIELD AT BULL RUN,
JULY 21ˢᵗ 1861,
to accompany the Report of
BRIG. GENˡ IRVIN McDOWELL, COMMANDING,
prepared by
CAPT. A.W. WHIPPLE, Topˡ Engˢ
1ˢᵗ Lieuᵗ H.L. Abbot,Topˡ Engˢ & 1ˢᵗ Lieuᵗ H.S. Putnam, Topˡ Engˢ,
drawn by
J.J. YOUNG, Civil Engineer.

Scale of Miles

That night Washington learned of the disaster when the troops that had marched grandly off to battle returned to the city a dirty, demoralized rabble. The North was horrified, and none more so than President Lincoln. Newspaperman and Republican stalward Horace Greeley would write Lincoln that week, 'If it is best for the country and for mankind that we make peace with the rebels, and on their own terms, do not shrink even from that.' The South, naturally, erupted in celebration, though there were some bitter words about the army's 'failure' to march into Washington. Many in the South assumed the North would give up in short order, and nearly everyone gained an unrealistic sense of the Confederacy's fighting prowess. A Richmond newspaper wrote, 'The breakdown of the Yankee race, their unfitness for empire, forces dominion on the South. We are compelled to take the sceptre of power.' Against all resistance from both sides, Lincoln overrode his own despair and uncertainty and began to arrange for an extended war.

By the end of the First Battle of Bull Run about 18,000 troops had been engaged on each side. The North lost about 625 killed, 950 wounded, and over 1200 captured, the South some 400 killed and 1600 wounded. Among the other future luminaries of the war who fought in the battle were J. E. B. ('Jeb') Stuart and Wade Hampton for the South, and William Tecumseh Sherman, Oliver O. Howard, and Ambrose E. Burnside for the North. It would be eight months before the North tried anything major in Virginia again. An incidental outcome of the battle had to do with flags: noting that the original Confederate battle flag could be mistaken for the Union flag in the heat of action – there had been much confusion of sides in the fighting – General Beauregard designed the new flag of the Confederacy, white stars on a blue St. Andrew's cross on a field of red.

Bull Run, Second Battle of

(In Confederate chronicles called Second Manassas.)

After the successes of the Shenandoah Valley Campaign of Stonewall Jackson, in which three separate commands had failed to bring the rampaging Confederates to ground, Washington decided to combine those three armies into one – the short-lived Army of Virginia. Its commander, General John Pope, transferred from the Army of the Mississippi, starting off badly with a blustering address that began, 'Let us understand each other. I have come to you from the West, where we have always seen the backs of our enemies . . . I am sorry to find so much in vogue

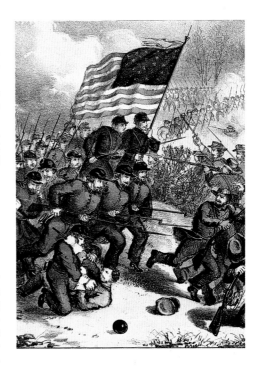

Above: The Second Battle of Bull Run as it was imagined by Currier & Ives.
Opposite: Union army map of First Bull Run.
Below: A map showing what Union General Pope believed were the positions of Rebel forces two days before Second Bull Run.

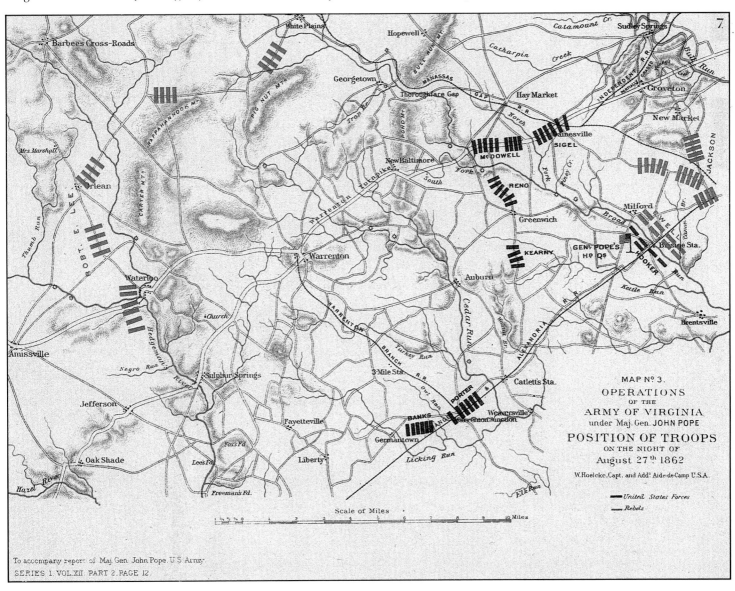

The armies had skirmished around Manassas long before Second Bull Run. These Rebel redoubts were photographed there in March.

amongst you . . . certain phrases [like] . . . 'lines of retreat' and 'bases of supplies' . . . Let us study the probable lines of retreat of our opponents, and leave our own to take care of themselves . . . Success and glory are in the advance, disaster and shame lurk in the rear.'

General Fitz-John Porter, on whom Pope would soon be shifting blame for his own mistakes, said of Pope's debut that he had 'written himself down, what the military world had long known, an Ass.' Pope's tendancy to sign his dispatches 'Headquarters in the saddle' prompted some to observe that his headquarters were where his hindquarters belonged. Of the same opinion was General George B. McClellan, who at the end of July 1862 was ordered to join his forces to Pope's after the failure of the Peninsular Campaign. For his part, Pope considered McClellan incompetent and useless.

Confederate General Robert E. Lee, in Richmond following the Seven Days' Battles, was also outraged by Pope's ungentlemanly behavior in war. 'The miscreant Pope,' Lee proclaimed, must be 'suppressed.' More practically, he knew that the uniting of McClellan's 90,000-man Army of the Potomac and Pope's 50,000 troops must be prevented at all costs; even with two blundering and feuding generals in command, such a gigantic force would still be a serious threat to the Confederacy.

Lee had already grouped his still-new command into the organization that would lead the Army of Northern Virginia to victory time and again: Stonewall Jacakson, his strong right arm; his other division commanders James Longstreet, A. P. Hill, and D. H. Hill; and in command of cavalry the brilliant Jeb Stuart. In early August, Lee dispatched the commands of Jackson and A. P. Hill to deal with Pope before McClellan could reach him.

Jackson planned to strike the Federal advance units of the Union Army of Virginia and defeat them one corps at a time. But that plan was stymied when the opposing forces collided on August 9 at the Battle of Cedar Mountain, Virginia (*See*). There Federals under Nathaniel Banks drove back Jackson's men, and only a last-minute counterattack by A. P. Hill saved the day. A week later McClellan began to pull his Federal troops away from the Richmond area and ship them toward union with Pope. Now that Federal forces no longer threatened the Confederate capital Lee could move Longstreet's command from Richmond to back up Jackson and A. P. Hill.

For the first of several times Lee violated the old military maxim that forbids dividing forces in the face of equal or superior enemy numbers. Longstreet was ordered to spread his command along the Rappahannock River and hold the Federals in place while Jackson went on a wide envelopment. After marching over 50 miles in two days, on August 27 Jackson destroyed a Union supply dump at Manassas, Virginia, in Pope's rear, and then disappeared. The furious Northern commander put his army on the march in a futile attempt to find and destroy Jackson, whom he assumed to be fleeing. By the next day the Federals had reached nearby Groveton, where Jackson had concealed his men in a railroad cut. At that point the Southern commander faced a dilemma: he had only a third of Pope's strength, and Lee and Longstreet were still some distance away; yet if the Federals moved into strong defenses at Centreville, they could hold out until McClellan arrived. Taking a historic gamble, Jackson feinted at Pope on the evening of the 28th, deliberately revealing his position.

Pope gleefully gave orders to smash Jackson next day, meanwhile ignoring intelligence reports warning of Longstreet's approach. The Second Battle of Bull Run broke out in the morning of August 29 when 62,000 Federals made a series of uncoordinated frontal assaults on Jackson's 20,000 men. Well protected in the railroad cut, the Confederates turned back wave after wave throughout the morning. Though Jackson's lines nearly broke several times, the outcome became primarily a question of whether the Southerners would run out of ammunition before Longstreet arrived. Jackson rode back and forth behind his lines, entreating his men to hold out a little longer.

At 11:00 in the morning Longstreet's forces appeared and mounted a probing attack in the Federal center, relieving the pressure on Jackson. Pope persisted in ignoring Longstreet's presence and maintained that Jackson was about to retreat. On the next day the Federal commander learned better. After letting the Federals strike Jackson's left, Lee sent Longstreet on a crushing assault into the opposite Union flank, catching Pope in a pincers. The Northerners had no choice but to fall back. At Henry House Hill, scene of the hardest fighting in the First Battle of Bull Run, the battered Federals made a stand that stopped the Southern pursuit, but the next day Pope began a retreat toward Washington. On September 1 the Union rearguard turned back a Confederate attack at Chantilly, 20 miles from the Union capital; Washington broke into panic. In five days of fighting the Union had suffered 16,000 casualties of 65,000 engaged, to Lee's losses of 10,000 out of 55,000. Pope's army was merged into the Army of the Potomac, with McClellan still in command, and the hapless Pope was exiled to Minnesota to pacify fractious Indians.

When Lee had taken command of the Army of Northern Virginia in June, McClellan had been at the gates of Richmond. Since then, Lee had defeated two superior Federal armies and virtually cleared Virginia of enemy forces. Now the Confederate general was only 25 miles from Washington. He began to plan an invasion of the North, which would come to its conclusion at the Battle of Antietam.

Bulloch, James Dunwoody (1823-1901) Confederate naval officer.

This Georgian served in the US Navy from 1839 to 1854. As a wartime Confederate naval officer, he served in England and France, outfitting such ships as the *Alabama*, *Florida*, *Shenandoah*, and *Stonewall*. He later published a book about the Confederacy's secret foreign service.

Burnett, Henry Lawrence (1838-1916) Union officer.

This Ohio lawyer enlisted in 1861 and fought in Missouri and Kentucky. In 1863 Burnett became judge advocate for the Department of the Ohio. He prosecuted the Knights of the Golden Circle in Indiana, Chicago conspirators to free Confederate prisoners, and Lincoln's assassins.

Burns, John (1793-1872) 'The Old Hero of Gettysburg.'

The Union army repeatedly rejected Burns, a war veteran in his seventies who persistently tried to enlist. He walked onto the battlefield at Gettysburg; fighting all three days with various regiments, he was wounded three times. He later received a Congressionally mandated pension.

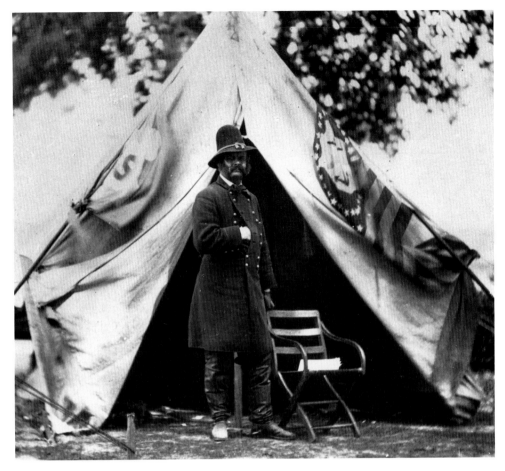

Union General Ambrose Burnside's legendary ineptitude is a part of military folklore.

Burnside, Ambrose Everett
(1824-1881)
Union general.

West Pointer Burnside led troops in the first Battle of Bull Run and carried out the successful Expedition to North Carolina (*See* BURNSIDE'S EXPEDITION. . . .). He was then given a major command in the Army of the Potomac, whose left wing he led ineffectively at Antietam, and finally he was given command of the entire army, which he led into the disaster of Fredericksburg. Despite this colossal failure and his ensuing resignation, Burnside remained in important posts until his final and definitive debacle in the Petersburg Mine Assault. He would come out of the war still popular, and like many former soldiers would enter politics, going on to become governor of Rhode Island and a US Senator. History would remember Burnside, however, mainly for two things: that 'sideburns' were named for his facial whiskers; and for being one of the worst generals of all time. After the Petersburg failure, legend has Lincoln saying, 'Only Burnside could have managed such a coup: to wring one last spectacular defeat from the jaws of victory.'

Burnside Carbine

Union General Ambrose E. Burnside designed and patented an experimental carbine in 1856. During the war Union forces bought more than 55,000 of a successor design, a .54-caliber breechloader that weighed seven pounds. Burnside's company failed in 1860, and his patents assigned to creditors.

Burnside's Expedition to North Carolina

General Ambrose E. Burnside, who had been a Union brigade commander at the First Battle of Bull Run, received permission in October 1861 to create an amphibious division for coastal operations. While his troops were training at Annapolis, Maryland, he went to New York to assemble a flotilla for the operations; this turned out to be a motley collection of vessels ranging from gunboats to passenger ships to coal scows. Burnside's objective was to capture harbors in Virginia and North Carolina.

Setting out in January with 12,000 soldiers on board, the flotilla nearly came to grief before it saw action; on the 13th a gale off Cape Hatteras, North Carolina, scattered the ships and wrecked three. The expedition waited out two weeks of bad weather in Hatteras Inlet. Finally the weather calmed, and on February 7 Burnside reached Roanoke Island, his first target, with 65 vessels, 1666 men, and a 20-ship naval force under Admiral Louis M. Goldsborough. On the island, which controlled the passage between Pamlico and Albemarle Sounds, were 3000 Confederates and four artillery batteries under Henry A. Wise, who also had an inadequate 'mosquito fleet' of gunboats. Wise had pleaded for reinforcements from Richmond, but none had been sent; Confederate authorities seem to have no sense of the importance of keeping Southern ports open to frustrate the Union blockade.

Just before noon on the 6th Goldsborough's fleet began to shell the enemy forts and gunboats. That afternoon and evening Burnside landed 7500 troops on Roanoke Island. On the next day, having waded through swamps and over entrenchments, the Federals overwhelmed Wise's forces, capturing over 2500 prisoners with losses of only 264. Leaving occupying forces on the island, Burnside went on to take New Berne, North Carolina, on March 14 and Beaufort on April 11. From New Berne further Union operations were sent out along the coast. At very little cost Burnside's amphibious expedition had secured all but one North Carolina harbor, considerably tightening the Union blockade of the Confederacy and providing

Although too old for service in the Union army, septuagenarian John Burns insisted on fighting at Gettysburg anyway.

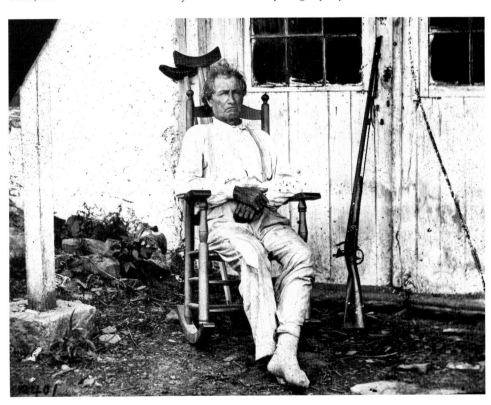

bases for further tightening. By April 1862 every major port on the Atlantic Coast except for Wilmington and Charleston would be closed to Southern blockade-running ships.

The feeble Southern effort to protect its ports caused a political firestorm in Richmond that led to the resignation of Confederate Secretary of War Judah Benjamin (his friend President Jefferson Davis immediately made Benjamin secretary of state). Meanwhile the North had a cheering victory and a new hero, Burnside, who would be promoted to major general. In July he would be sent with 7500 men to join McClellan's Peninsular Campaign in Virginia. Unfortunately for the Union, Burnside had not revealed his true capacities in the North Carolina expedition, which succeeded mainly due to the flimsiness of enemy resistance. The bewhiskered general's ensuing efforts – at Antietam, at Fredericksburg, and in the Petersburg Mine Assault – would add up to a career of legendary incompetence.

Bushwhacker

Sometimes spelled 'bushwacker'.

This word existed before the Civil War and refers to someone who beats down ('whacks') or clears away brush or vegetation to prepare a field for grazing; from this, it came to refer to someone who lives in or frequents the woods. During the war, it was applied specifically to Confederate supporters who engaged in guerrilla warfare, as did William Quantrill. It was also used to refer to deserters or draft dodgers who became outlaws – both during and after the war.

Union General Benjamin Butler (fifth from left, seated). Though an inept officer, he had a successful postwar political career.

Butler, Benjamin Franklin
(1818-1893) **Union general.**

This New Hampshire native was a nationally influential Boston criminal lawyer and Democratic politician whose war career upheld his reputation for controversy. His 8th Massachusetts helped to garrison Washington after the Fall of Fort Sumter in 1861, then, commanding the District of Annapolis, he peacefully occupied Baltimore later that year. He was then disastrously engaged at Big Bethel before turning south, taking Forts Hatteras and Clark and, in May 1862, New Orleans. Butler proved an arbitrary and corrupt military governor there, issuing the notorious 'Woman Order' (*See*) and hanging a man for taking down a Union flag. Removed after international protests, Butler took over the Army of the James, and in October 1864 went to New York in anticipation of election riots. Incompetence at Petersburg and Fort Fisher finally cost him his command. Butler is considered typical of the politically-appointed generals who made such a generally dubious contribution to the Union war effort.

Butler Medal

In a private act, Union General Benjamin F. Butler ordered 200 medals from Tiffany's and awarded them to black troops of XXV Corps for valor at New Market Heights and Chafin's Farm, Virginia, in September 1864.

Butterfield, Daniel *(1831-1901)*
Union general.

A New York merchant, Butterfield led the 12th New York, the first Union regiment to reach Virginia. He fought in West Virginia, in the Peninsular Campaign, and at Fredericks-

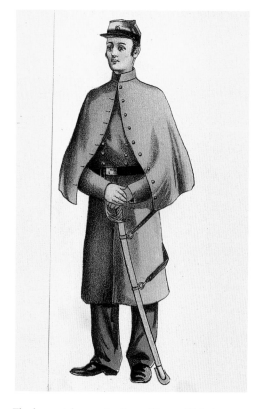

The brownish-gray 'butternut' hue of Rebel uniforms is well captured in this old print.

burg and was Chief of Staff to both Joseph Hooker and George Meade. He designed the corps badge system.

Butternuts

This nickname for Confederate troops derived from the color of their uniforms, a butternut brown. A dye made from walnut hulls produced the gray-brown hue.

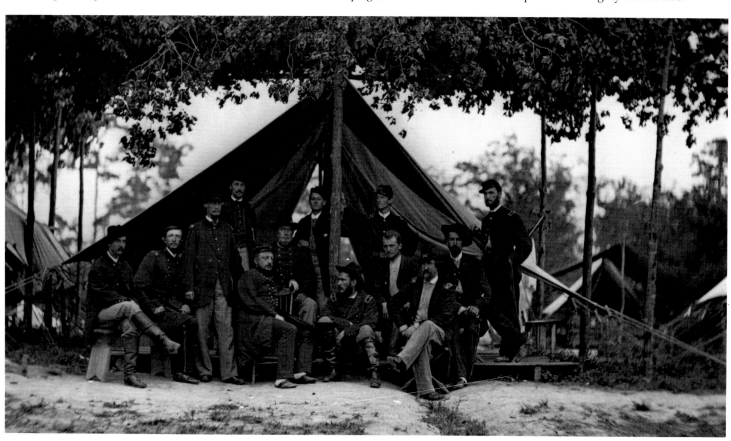

C

Cabell, William Lewis *(1827-1911)*
Confederate general.

This Virginian West Point graduate organized the Confederate commissary and ordnance departments and was quartermaster to P. G. T. Beauregard and both Albert and Joseph Johnston. As brigadier general he fought in the Trans-Mississippi and, commanding northwest Arkansas, organized a first-rate cavalry brigade. Cabell was captured at Marais des Cygnes (*See*) in October 1864 and was imprisoned.

Cahaba Prison, *Alabama*

The Confederates used a decrepit, partially covered cotton shed here as a prison for Federal captives beginning in early 1864. By late in the year the shed, with 500 beds, and the stockade around it, held more than 2000 Yankees in a state of wretched squalor.

South Carolina statesman John Calhoun, the leading architect of secessionist theory.

Calhoun, John Caldwell *(1782-1850)* **Southern statesman.**

An immensely influential state's rights advocate from South Carolina, he served as vice president of the United States under both John Quincy Adams and Andrew Jackson. He resigned the latter vice presidency in 1832 to enter the Senate and argue his theory of nullification – in effect, the declaration of a state's right to void any federal law it deemed in violation of the voluntary agreement that formed the Union. As abolitionism waxed in the North, Calhoun also became increasingly outspoken in his defense of the institution of slavery. He thus articulated, more influentially than any man of his time, the legal, political, and moral assumptions that would ultimately lead the South to secession and plunge the nation into civil war.

Caliber

A measure of the diameter of the bore of a firearm or of the diameter of a projectile. For small arms, caliber measurements were in inches or millimeters (*e.g.* the Springfield musket had a caliber of .58 inches). Cannon often were designated both by the projectile's weight in pounds and by the caliber of the bore or projectile; thus the common 12-pounder Napoleon cannon measured 4.62 inches in caliber.

California Column

Commanded by Colonel J. H. Carleton (*See*), this Union column – 11 companies of infantry, two of cavalry, and two artillery batteries – was ordered to join General Edward Canby in New Mexico. It left California on April 13, 1862, reaching Santa Fe on September 20 after a march through hostile Indian territory. Confederate General Henry H. Sibley, already in retreat from his ill-fated invasion of New Mexico (*See*), ordered a further withdrawal to San Antonio on hearing of the Californians' arrival.

Cameron, Simon *(1799-1889)*
Union secretary of war.

As US Senator, Cameron organized the new Republican Party in Pennsylvania and became a lifelong political force there. As Lincoln's first secretary of war he presided over widespread fraud and corruption in military appointments and procurement; Lincoln transferred him to a diplomatic post in January 1862.

Camp Chase, *Ohio*

Initially a Federal training camp, this facility west of Columbus later held Confederate prisoners of war. By 1863 more than 8000 Rebels were imprisoned there.

Camp Douglas, *Illinois*

This camp south of Chicago, used at first to train Federal enlistees, became a prison after the fall of Fort Donelson, Kentucky, in February 1862. It eventually held about 30,000 Confederate prisoners of war.

Camp Ford, *Texas*

A Confederate prison near Tyler, it held Union officers and men from 1863 until the war's end. Captives built log dwellings, and though food, water, and sanitary arrangements were acceptable at first, later, as the camp became overcrowded with prisoners from the Red River campaign of 1864, conditions deteriorated badly.

Camp Groce, *Texas*

An open field with guard lines, this Confederate prison near Hempstead held Union officers and enlisted men from 1863 until the end of hostilities. Little else is known about the camp.

A photograph of Confederate prisoners of war confined in Camp Chase, Ohio.

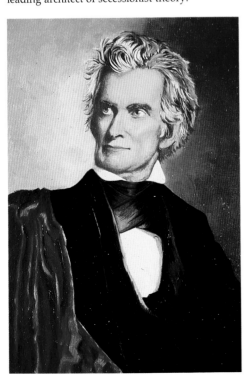

Camp Jackson, *Missouri*

On May 10, 1861, Union troops under Nathaniel Lyon (*See*) captured a brigade of proconfederate militia encamped at Lindell Grove outside St. Louis. There were no casualties in the operation, but on the return march to the St. Louis arsenal Union troops fired into violent pro-Rebel crowds, killing 28 people. Among the observers that day were Ulysses S. Grant, an Illinois mustering officer, and William Tecumseh Sherman, who had not yet re-entered the army.

Camp Lawton, *Georgia*

The Confederates built this 42-acre stockade near Millen in the summer of 1864 to take the overflow from nearby Andersonville Prison (*See*). By the end of 1864 more than 10,000 Union prisoners were held here. They built their own huts from branches and other material left over from construction of the stockade and survived in great discomfort.

Camp Morton, *Indiana*

This former Indianapolis fairground became a Federal prisoner of war camp. The prison barracks, with no floors and rickety walls, were cold and drafty in the winter, and the Confederate inmates lived in dirty and uncomfortable conditions.

Campbell, John Archibald
(1811-1889) **Confederate statesman.**

Campbell, a Georgian, resigned from the US Supreme Court in 1861. From October 1862 until the war's end he was the Confederate assistant secretary of war and administrator of the conscription law. He was a commissioner at the Hampton Roads Peace Conference in 1865.

The war's classic field artillery pieces were the 12-pounder Napoleons, some of which are shown here on an ordnance wharf.

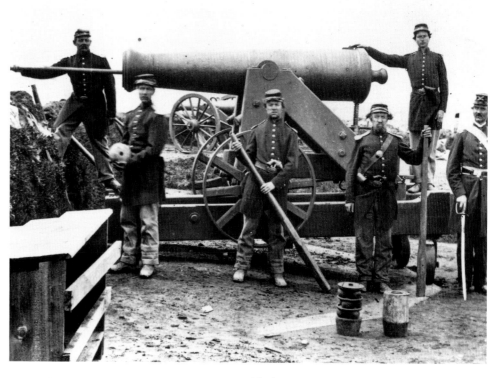

Campbell's Station, *Tennessee*

On November 16, 1863, Federal troops beat LaFayette McLaws's Confederate division to a crossroads here, enabling Union General Ambrose Burnside to move his supply trains safely into Knoxville (*See*). The covering action cost the Federals 318 casualties; the Rebels lost 174 men.

Canby, Edward *(1817-1873)*
Union general.

A career soldier (West Point, 1839), the Kentucky-born Canby held New Mexico (*See*) for the Union at the outbreak of the war. After serving in a staff appointment in Washington, DC, he commanded troops in New York

The largest siege cannon at the beginning of the war was the 24-pounder muzzle-loader. A smoothbore gun, it weighed 10,155 pounds.

City in the wake of the 1863 draft riots there. From May 1864 to May 1865 he commanded the Military District of Western Mississippi. Canby led the attack on Mobile and, at the war's end, accepted the surrender of Confederate forces in the district.

Cane Hill, *Arkansas*

When James Blunt's 1st Division of the Union Army of the Frontier surprised a force of 8000 Confederate cavalry under John Marmaduke here on November 28, 1862, the Rebels retreated into the Boston Mountains. Fearing

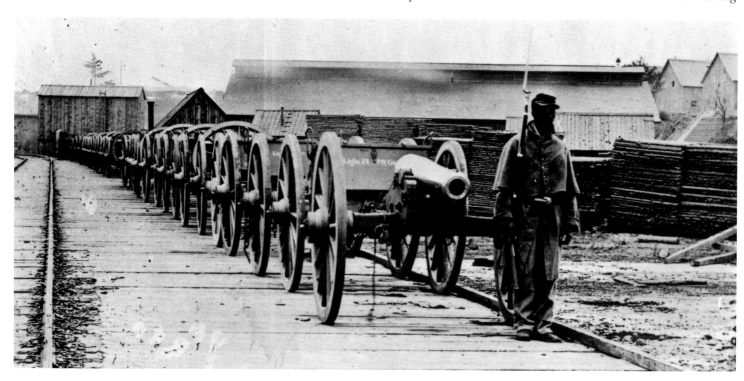

ambush, Blunt did not pursue. He reported 40 Federal casualties and a Confederate loss of 435 men.

Canister

A short-range defensive munition, this simple artillery projectile consisted of a tin can filled with iron or lead bullets, packed in sawdust. The can burst when it left the cannon's mouth, spraying its contents over a wide area. Canister could be used with effect up to a maximum range of 400 yards.

Cannon

The term describes all large firearms; the basic classifications, defined by their trajectories, are guns (flat), howitzers (angled), and mortars (arching). Iron, steel, and brass cannon were manufactured in a wide variety of sizes, with both smooth and rifled barrels, and for many specialized purposes. The most common field piece in both armies was the 12-pounder Napoleon gun-howitzer (*See*), a muzzle-loading smoothbore. There were at least 20 other standard types of field artillery, as well as many types of siege and coastal artillery. (*See* also ARMSTRONG GUNS, BLAKELY GUNS, BROOKE GUNS, COLUMBIAD, DAHLGREN GUNS, NAPOLEON GUN, PARROTT GUNS, RODMAN GUNS and WHITWORTH GUNS).

Cap-and-ball Firearms

These were percussion small arms that succeeded outmoded flintlock pistols, muskets, and rifles in the 1840s and 1850s, though in principle both methods of firing were similar. The newer weapons used a percussion cap, fitted onto the nipple of the chamber, to ignite the powder that propelled the ball or bullet out of the barrel.

Carcass

A hollow cast-iron artillery projectile filled with combustible material, this primitive incendiary device shot flame from four fuse holes to ignite fires where it landed.

Carleton, James Henry
(1814-1873) **Union general.**

A Maine native, Carleton was a career army officer whose frontier and western service continued through the war. In 1862 he raised the California Column (*See*) and led it to New Mexico. He commanded the Department of New Mexico from 1862 to 1865.

Carlisle, *Pennsylvania*

The Confederate cavalry commander J. E. B. Stuart shelled this town late in the afternoon of July 1, 1863, while in search of Richard Ewell's Confederate corps, then in action at Gettysburg. At Carlisle, Stuart finally learned of Lee's position and set off to rejoin the main army. He arrived too late to be of any use to the Confederates in the Battle of Gettysburg.

Carnifex Ferry, *West Virginia*

As part of the campaign to clear western Virginia of rebels, Union General William Rosecrans, with 7000 men, attacked 5800 Confederates under J. B. Floyd here on September 10, 1861. The Rebels were concealed in thick woods, and the attacks were inconclusive. Floyd withdrew during the night after a loss of 20 wounded. Federal casualties were 150 men.

Carolinas Campaign

Even though William Tecumseh Sherman's March to the Sea through Georgia would remain the operation most associated with him, the Carolinas Campaign that followed was actually more difficult and more significant in helping to end the war. After finishing his march to Savannah in December 1864, Sherman proposed to General-in-Chief Ulysses S. Grant that his army begin a similar and even more destructive campaign across the Carolinas, which had so far been largely untouched by the war. Grant agreed that Sherman should march north, laying waste as he went, and come up from the rear at Petersburg to help Grant 'wipe out Lee.' The latter part of the mission, it turned out, would be taken care of before Sherman reached Virginia.

The North had a particular sense of vendetta against South Carolina, which had led the Confederate states in seceding. 'The whole army is burning with an insatiable desire to wreak vengeance on South Carolina,' Sherman wrote with his customary ferocity; 'I almost tremble at her fate, but feel that she deserves all that seems to be in store for her.' While the March to the Sea had largely spared Georgia's private dwellings, this Carolina march would leave smoking ruins and thousands of refugees in its path.

Sherman was to begin in mid-January 1865, but heavy rains (which would bedevil the whole campaign) delayed the start until February 1. Then the Federals pulled out of Savannah with 60,000 men. No major Confederate forces could be spared to oppose them, only scattered units amounting to some 22,500, including 6700 cavalry troops under Joseph Wheeler. Nearly half these forces were left for some time protecting Augusta and Charleston, South Carolina; rather than attacking, Sherman simply bypassed both cities. It would take the Southern forces in the area, eventually commanded by Joseph E. Johnston, until mid-March to organize any resistance to Sherman other than token skirmishing. By then it would be too little and too late. Meanwhile, Sherman sent detachments to occupy two coastal towns through which his supplies could come; Alfred Terry captured Fort Fisher on January 15, and Jacob Cox took New Bern on March 10.

As the Federals spread their trail of destruction through South Carolina they had to contend with numerous river, stream, and swamp crossings under the wettest conditions in two decades. Some roads had become streams themselves and had to be scouted by canoe. Confederate leaders were sure that Sherman could never get an army through the state. In fact, the Federals made a steady 10 or so miles a day, just as they had over much easier land in Georgia. Ahead of

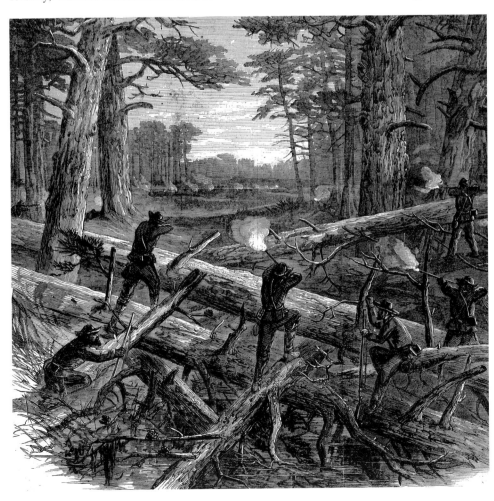

Union and Rebel troops exchange fire in a South Carolina swamp during W. T. Sherman's brilliantly conducted Carolinas Campaign.

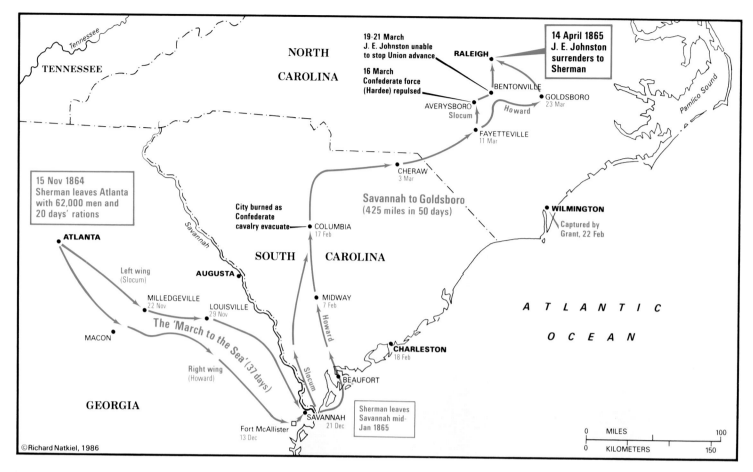

15 Nov 1864
Sherman leaves Atlanta
with 62,000 men and
20 days' rations

TENNESSEE

NORTH CAROLINA

19-21 March
J. E. Johnston unable
to stop Union advance

16 March
Confederate force
(Hardee) repulsed

RALEIGH

14 April 1865
J. E. Johnston
surrenders to
Sherman

BENTONVILLE

AVERYSBORO
Slocum

Howard

GOLDSBORO
23 Mar

FAYETTEVILLE
11 Mar

CHERAW
3 Mar

City burned as
Confederate
cavalry evacuate

COLUMBIA
17 Feb

Savannah to Goldsboro
(425 miles in 50 days)

WILMINGTON
Captured by
Grant, 22 Feb

SOUTH CAROLINA

Savannah

ATLANTA

AUGUSTA

Left wing
(Slocum)

MILLEDGEVILLE
22 Nov

LOUISVILLE
29 Nov

The 'March to the Sea' (37 days)

MACON

Right wing
(Howard)

GEORGIA

MIDWAY
7 Feb

Howard

Slocum

CHARLESTON
18 Feb

A T L A N T I C

O C E A N

BEAUFORT

Sherman leaves
Savannah mid-
Jan 1865

SAVANNAH
21 Dec

Fort McAllister
13 Dec

Pamlico Sound

©Richard Natkiel, 1986

| 0 | MILES | 100 |
| 0 | KILOMETERS | 150 |

the army spread a wave of engineers and workmen, including many escaped slaves, who built bridges, felled trees to make corduroy roads, and erected causeways. At times Federal units waded out in water that was up to their armpits and full of snakes and alligators in order to drive away Wheeler's cavalry.

On February 17 Sherman's men arrived at Columbia, the capital of South Carolina, and Wade Hampton's Rebel cavalry pulled out just before the Yankees entered. That night fires consumed two-thirds of the city. It would never be certain just who was responsible for this, the worst episode of the Carolinas Campaign. Sherman blamed the fires on cotton bales set alight by Hampton's evacuating troops, but at least some other fires were probably the work of Federal soldiers who had located stores of liquor in the town and had made use of them. Nevertheless, it must be acknowledged that Sherman organized his forces to fight the fires throughout the night and that he personally took part in the effort, even though he did order the destruction of several installations of military importance the following day.

On February 19 units began to pull out of Columbia, heading for Goldsboro, North Carolina, where 30,000 more Northern soldiers were waiting. By March 16 Sherman was well into North Carolina, having fought a running series of skirmishes but without meeting any determined resistance. But Johnston had finally organized his Southern forces, and that day at Averasborough two Rebel divisions fought a delaying action against the Federals. But after suffering 865 casualties to the Union's 682 the Confederates fell back to Bentonville, where Johnston hoped to bring some 21,000 troops to bear against one of Sherman's two wings. That

effort, the largest battle of the campaign, flared up on March 19. The Federals drove Johnston's men back somewhat, but could not dislodge them until the other Northern wing appeared in support three days later. With Sherman's full force now threatening him, Johnston was forced to withdraw.

Above: By 1865 standards Sherman's advance over the difficult terrain of the Carolinas was remarkable. In slightly more than two months he effectively conquered two states.
Below: Sherman enters Columbia, the South Carolina capital, on February 17, 1865. That night a fire would destroy much of the city. How it started is still a matter of debate.

Rather than giving chase, Sherman continued his march toward Goldsboro. In three days of fighting at Bentonville, Johnston had lost 2606 men to Sherman's 1646. On April 9, the day Robert E. Lee surrendered at Appomattox, the bluecoats were marching on Raleigh with 80,000 men. The speed with which Sherman had moved through the Carolinas had been one of the major factors in forcing Lee to bolt from Petersburg and thus in setting him on the path to surrender.

Johnston held out until April 14, when he requested an armistice. Sherman was harshly criticized in the North for offering too-lenient surrender terms, which included a broad general amnesty for all Confederates and quick integration of existing Southern state governments into the Union. While these terms probably reflected Lincoln's ideas, expressed earlier to Sherman and Grant, Lincoln was now dead and the new adminstration in Washington rescinded Sherman's original surrender agreement. Johnston formally surrendered his 30,000 remaining men on April 26, on terms similar to those given Lee. Sherman would be bitter over the affair for the rest of his life; it was one of the main reasons he rejected all overtures to bring him into politics.

Carondelet, USS

A Union ironclad steamer carrying 13 guns, she fought at Forts Henry and Donelson in the winter of 1862. In April of that year *Carondelet* ran past Confederate batteries at Island No. 10 in the Mississippi River, forcing the Rebels to abandon the strongpoint.

A Democratic cartoon blames President Grant for the South's miseries under a carpetbag rule that is supported by federal troops.

Carpetbaggers

During the Radical Republican Reconstruction, some Northerners in search of financial opportunities streamed south. They collaborated with like-minded Southern politicians (*See* SCALAWAGS) to gain control of state and local governments in order to increase their personal fortunes; their self-serving behavior contributed greatly to the political chaos that afflicted the postwar South. Their nickname was inspired by the familiar sight of their luggage, or 'carpetbags.'

Carr, Eugene Asa *(1830-1910)*
Union general.

Carr was a New Yorker and West Point graduate whose long career as an Indian fighter was interupted by the war. He fought at Wilson's Creek and Pea Ridge, commanded divisions in the Vicksburg and Mobile campaigns, and eventually commanded the District of Little Rock.

Carrick's Ford, *West Virginia*

In the Western Virginia Campaign of McClellan (*See*) this rear-guard action along the Cheat River during a Confederate retreat from Laurel Hill on July 13, 1861, cost the Rebels some 40 supply wagons and about 80 casualties. In another skirmish nearby, Union forces killed the Rebel commander, General Robert Garnett. He was the first Civil War general to die in battle.

Carrington, Henry Beebee *(1824-1912)* **Union general.**

In 1857 this Ohio lawyer and abolitionist reorganized the state militia, which was pre-

pared for duty in 1861 before any volunteers were ready. During the war he recruited 100,000 troops in Indiana.

Carroll, Anna Ella *(1815-1893)*
Union pamphleteer.

Encouraged by a war department official, she published pamphlets in 1861-62 justifying Lincoln's wartime assumption of executive prerogative. She spent the rest of her life unsuccessfully demanding payment for that service and for military strategy she claimed to have supplied the government.

Carson, Christopher *(1809-1868)*
Union officer and Indian fighter.

'Kit' Carson, a famous frontier fighter, trapper, and guide from Kentucky, guided John C. Frémont's expeditions of exploration in the 1830s and 1840s and fought in the Mexican War. In 1861 he organized a New Mexico regiment and spent the war fighting Indians in New Mexico and Texas. He was breveted a brigadier general in 1865.

Carter, Samuel Powhatan *(1819-1891)* **Union general.**

A Tennessee native, Carter interrupted his naval career for wartime army service, eventually holding a unique double rank: major general and rear admiral. He organized eastern Tennessee troops and held a series of field commands in the Ohio and Cumberland armies, finally commanding XXIII Corps. He is perhaps best remembered for a series of successful cavalry raids he con-

Propagandist Anna Carroll began her career as a publicist for the Know-Nothing Party.

ducted on Rebel supply lines in the upper Tennessee Valley in December 1862, a prelude to the Battle of Stone's River.

Case Shot

Grape, canister, and shrapnel were the three main types of case shot. All three types scattered small projectiles over wide areas at varying ranges. The term is sometimes used, imprecisely, as a synonym for canister and shrapnel.

Casey, Silas *(1807-1882)*
Union general.

A Rhode Island-born career soldier, his *Casey's Tactics* was a standard infantry manual. He was wounded in the Peninsular Campaign, then commanded a divison defending Washington. He also examined prospective officers of black troops. His son Silas fought in the navy at Fort Sumter and in Charleston harbor.

Cass, Lewis *(1782-1866)* Statesman.

He rose to national prominence as governor of Michigan Territory (1813-31) and was afterwards a secretary of war and a US Senator. A strong unionist, Cass was President James Buchanan's secretary of state, eventually resigning over the president's failure to reinforce the Charleston forts.

Cast Metal Homogeneous

This method of gun construction, used to produce the Columbiad, Rodman, and Napoleon cannon, was obsolescent by the time of the Civil War. Modern technique in-

Lewis Cass was a state governor, a senator, a secretary of war and a secretary of state.

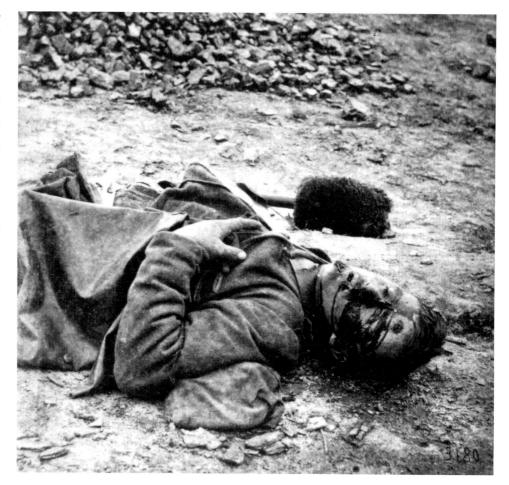

volved building the main parts separately, then joining them by welding, shrinking or screwing. The Armstrong and Parrott guns were produced by the newer 'built up' method.

Castle Pinckney, *South Carolina*

A Charleston harbor fort turned Confederate prison, it held mostly enlisted men, although some officers were also imprisoned there.

Castle Thunder, *Virginia*

Confederate prisons in Richmond and Petersburg, Virginia, both converted tobacco warehouses, carried this name. The Richmond prison held political prisoners and suspected spies, while the Petersburg prison held Union prisoners of war.

Casualties during the War

Casualties are defined as losses in manpower from all sources – not only killed in action, but also wounded, captured, deserted, died from disease, and so on. As to deaths in the Civil War, it should be borne in mind that over three times the number of soldiers died from disease than were killed in battle, that (roughly) 5.5 more men were wounded in battle for every one killed, and that of the wounded an estimated one out of seven eventually died (a far higher percentage than in modern wars). The total number of dead in the war has been estimated at 359,528 for the North, 258,000 for the South, some 618,000 in all, totalling about 33 percent and 40 percent of the active forces respectively. It was the costliest American war to date.

Civil War-related casualties were huge. The estimated 618,000 Americans killed exceeds by 33 percent those killed in World War II.

Catlett's Station, *Virginia*

This Virginia town was the site of two cavalry actions. First, on August 22, 1862, J. E. B. Stuart and 1500 troopers rode out to operate against Union General John Pope's supply lines. That night they raided a Federal camp near Catlett's Station, scattering the bluecoats and stealing supplies, including Pope's baggage and dress coat. Information gained from captured papers helped position Lee's forces for the Second Bull Run Battle. The second action at Catlett's Station occurred over a year later and also involved Stuart, who, on October 14, 1863, attacked several regiments of the Union II Corps in the area. The Federals withstood the assault, reporting 24 casualties and taking 28 prisoners.

Cedar Creek *(Virginia)*, Battle of

During his Shenandoah Valley Campaign of 1864 Federal General Philip Sheridan had routed Southern forces under Jubal Early at Fisher's Hill and Tom's Brook in the first weeks of October. Assuming that he had ended the threat from Early, Sheridan went to Washington on October 16 to confer with his superiors. On the way back two days later, he stopped for the night in Winchester, some 14 miles from where his army was encamped at Cedar Creek, near Middletown. On the next morning, October 19, Sheridan awoke to the sound of firing in the distance. An orderly told him it was probably skirmishing, so the general did not hurry. But as the

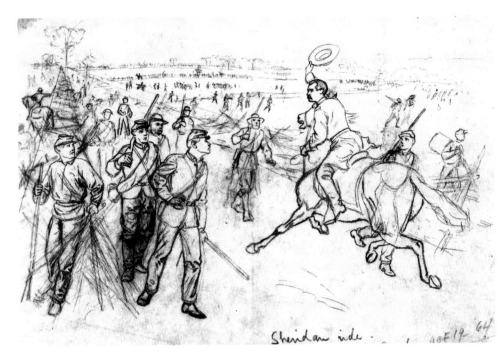

Of the many pictures of Sheridan's famous ride at Cedar Creek, this sketch by A. R. Waud may be the most authentic.

shooting continued, Sheridan mounted his charger, Rienzi, and took to the road in growing concern, stopping occasionally to listen. Close to Cedar Creek, he suddenly realized that the firing was approaching him faster than he was approaching it; that could only mean that his army was retreating under pursuit. Now thoroughly alarmed, he spurred his horse into a gallop.

Riding over the last ridge at about 10:30 in the morning, Sheridan saw his army coming toward him in full flight, the fields and roads covered by a tangle of men, horses, and wagons. Early had mounted a surprise attack on the left flank of the sleeping Federals at Cedar Hill, and four divisions had bolted out of camp and run for their lives. In a ride that would become legendary, Sheridan charged down the road waving his hat and shouting to cheering troops in his usual profane style: 'God damn you, don't cheer me! If you love your country, come up to the front. There's lots of fight in you men yet!' Word of his return spread out through the scattered army, electrifying the troops. Many of the veterans

had stopped to brew coffee along the road while they waited for orders, and the cavalry and VI Corps had not scattered. As Sheridan rode by, men began to kick over their coffeepots, pick up their rifles, and head back to the front. It took several hours of painstaking work before the army was rounded up and formed into line of battle. Many of Early's men, meanwhile, had stopped at the captured Yankee camps to sample the abundant food and liquor. At about 4:00 pm Sheridan rode down the battle line waving a banner, and the Federals swept out to the attack; in short order the surprised and disorganized Confederates were running for their lives. In the battle Sheridan lost some 5665 of 30,829 engaged, Early 2910 of 18,410, plus most of his artillery and wagon train. It was effectively the end of Early's army and of major Confederate military presence in the vital Shenandoah Valley.

Cedar Mountain, Battle of

This is a name given to the opening engagement of the 1862 Second Bull Run Battle. On August 9 Stonewall Jackson and about 17,000 Confederates were moving toward Culpeper, Virginia, to strike John Pope's

advance units, when Jackson found himself under attack at Cedar Mountain by 8000 Federals under Nathaniel Banks. Jackson's men were retreating when A. P. Hill arrived with reinforcements and mounted a counterattack that drove the Northerners back and inflicted heavy losses on them.

Cemetery Ridge

The main line of the Union Army of the Potomac ran along this southeastern Pennsylvania ridge on July 2, 1863, the second day of the Battle of Gettysburg. In the shape of an inverted fish hook, it stretched, north to south, from Culp's Hill to Little Round Top. Both ends of the line were scenes of heavy fighting on the second day.

Centralia (Missouri) Massacre

On September 27, 1864, William ('Bloody Bill') Anderson (See) and his Confederate guerrillas captured a stagecoach in Centralia at 11:00 am. Half an hour later they hijacked and robbed a westbound train, murdering 24 unarmed Federal soldiers and two passengers on board. Major A. E. V. Johnson arrived in the afternoon with three companies of the 39th Missouri and led a dismounted attack; 124 of his 147 men were killed by Anderson's marauders.

Chain Shot

This missile, consisting of two balls linked by a chain, was used against the masts and rigging of ships. Its cousin, bar shot, consisted of two balls connected by a bar.

Chamberlain, Joshua Lawrence (1828-1914) Union general.

In August 1862 he left a professorship at Bowdoin College, Maine, to become lieutenant colonel of the newly raised 20th Maine. Chamberlain fought at Antietam and Fredericksburg, and conducted a brilliant defense of Little Round Top at Gettysburg on July 2, 1863; he received the Medal of Honor for this last action. He led a brigade at Spotsylvania

War artist Edwin Forbes made this sketch of the Battle of Cedar Mountain, the prelude to the Second Battle of Bull Run.

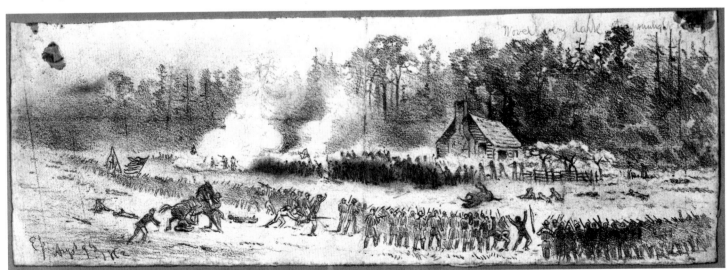

and Petersburg (where he was severely wounded) and during the Appomattox Campaign of April 1865. He returned to Bowdoin and eventually became its president (1871-83), after having served as governor of Maine (1867-71). His memoir of the war – especially his account of the surrender at Appomattox Court House – is widely quoted.

Chambersburg, *Pennsylvania*

Confederate General Jubal Early set fire to this town on July 30, 1864, after residents failed to pay a levy – demanded as reparation for Union damage to private property in Virginia – of $100,000 in gold or $500,000 in paper money. The 3000 inhabitants were evacuated late in the evening, and fire destroyed about two-thirds of the town.

Chambersburg Raid of Stuart

On his second ride around McClellan's Federal Army of the Potomac, October 9-12, 1862, J. E. B. Stuart and 1800 riders crossed the Potomac west of Williamsport, reaching Chambersburg, Pennsylvania, on the 9th. There they destroyed supplies and machinery useful to the North and left town next day with 500 captured horses. Stuart arrived in Leesburg, Virginia, on the 12th, having ridden 126 miles in four days, the last 80 miles of the journey nonstop.

Right: The South's two greatest commanders, Robert E. Lee and Stonewall Jackson, confer during the battle that will be remembered as their masterpiece, Chancellorsville.
Below: A Union army map of the Battle of Chancellorsville shows Jackson's undetected leftward shift to attack the Union XI Corps.

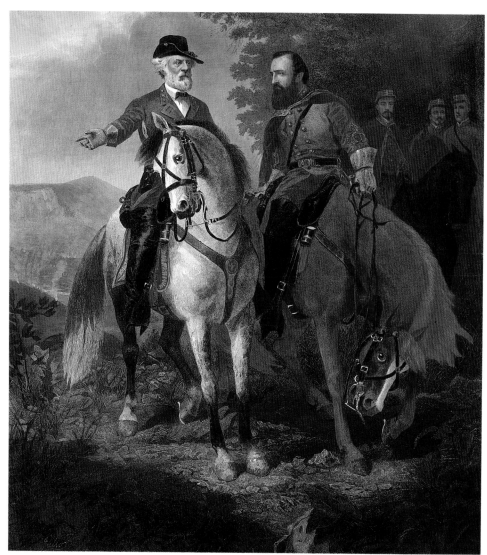

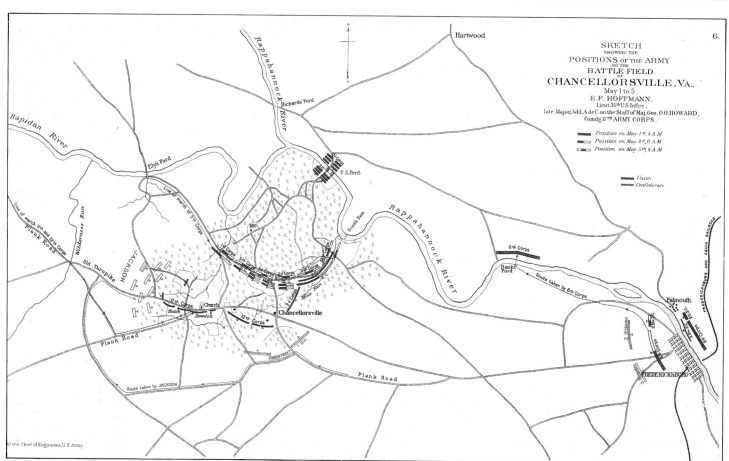

Champion's Hill, (Mississippi), Battle of

On May 16, 1863, 29,000 Union troops defeated 22,000 Confederates under John Pemberton here in a key battle in Ulysses S. Grant's Vicksburg Campaign. The hill, which dominated roads leading to the town from the east, changed hands several times before Federal forces under James McPherson prevailed. The Federals lost 2441 men; Confederate casualties exceeded 3800. This defeat obliged Pemberton to pull his forces back behind the Vicksburg defenses.

Chancellorsville, Campaign and Battle

At the end of January 1863 command of the Union Army of the Potomac passed from the hapless General Ambrose Burnside, who had just presided over the debacle at Fredericksburg, to General Joseph Hooker. After the army's latest defeats, 'Fighting Joe' was the only man who seemed to want the job of heading the Union's most important army and trying to bring down Robert E. Lee. Taking command, Hooker meticulously rebuilt the Army of the Potomac to fighting trim while evolving his plan of attack: he would leave a detachment to keep Lee's Army of Northern Virginia in their present position at Fredericksburg, meanwhile marching his major forces in a wide envelopment to come in behind the enemy from the west. It was a

sound plan and might well have worked – if Lee had been willing to follow it.

Hooker had paid particular attention to building up his cavalry, which had never achieved the confidence and dash of Southern horsemen. In mid-April 12,000 cavalry under General George Stoneman were dispatched to tear up the Confederate supply lines. This raid, however, proved ineffectual, and Lee's cavalry head, J. E. B. Stuart, largely ignored it.

Hooker put his plan into motion on April 27, 1863, pulling 80,000 men of the Army of the Potomac out of their camps across the river from Fredericksburg and leaving 40,000 under John Sedgwick to hold the Army of Northern Virginia in their positions around the town. Lee had been waiting for some such move. Soon Jeb Stuart reported that the main body of Federals was gathering in the Southern rear, at a little road-crossing and clearing called Chancellorsville. Lee had sent two divisions out to forage and had on hand 60,000 men, about half Hooker's strength. As he had at Antietam, Lee took stock and decided to stake everything on his opponent's incompetence. Leaving a screening force of 10,000 at Fredericksburg, with orders to build many fires at night to fool the enemy, Lee marched the main body of his army toward Chancellorsville to meet Hooker.

Part of the Union general's strategy had been to push past the thick woods – called the Wilderness – that surrounded Chancellorsville and to engage Lee in open territory,

where superior Union artillery could have clear lines of fire and the army room to maneuver. On May 1 the Union army was beginning to march out of the Wilderness as planned. Then, at mid-morning, skirmishers on the Federal advance unexpectedly ran into a line of Confederates blocking their way.

Hooker's generals pulled their units up into line of battle. After several hours of inexplicable silence, Hooker issued the astonishing order to pull back into the Wilderness and build defensive positions. His generals were outraged but did as ordered. As the Army of the Potomac entrenched in the Wilderness during the afternoon, Jeb Stuart's cavalry roamed around, looking for a weak spot in the Federal positions. Finally Stuart found it: the Union XI Corps, positioned on the Union right, was unprotected on the flank – 'in the air,' as it was called. Late that night Lee and Stonewall Jackson sat on cracker boxes, warming their hands over a fire and planning the next day's work.

That day, May 2, reached noon with no activity. General Hooker began to speculate that Lee was retreating. Reports came in about enemy movement across the Union front; some Federal troops even went out and captured some men from Jackson's division,

Jackson is fatally hit at Chancellorsville. He was not, as this Kurz & Allison print has it, killed in full battle but was hit by 'friendly fire' while riding in semi-darkness.

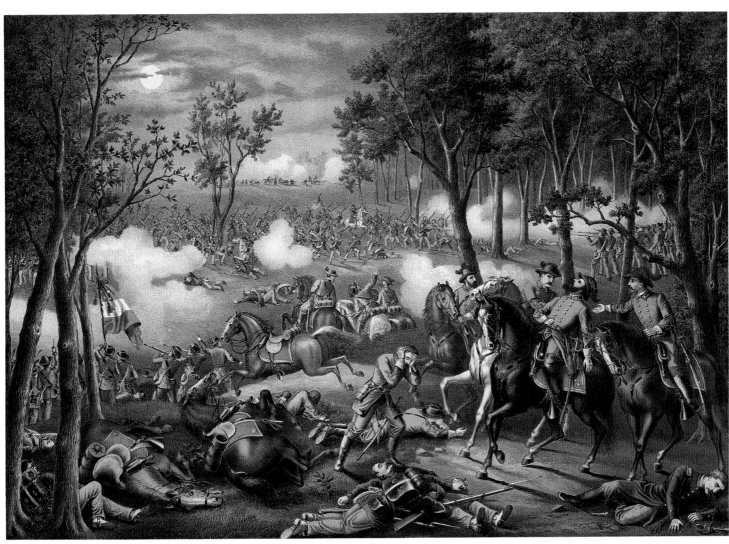

one of whom jeered, 'You wait until Jackson gets around on your right!' Hooker dismissed these clues, thereby failing to realize that Jackson was marching 30,000 men 12 miles on a small lane right in front of Union lines, out of sight in the dense woods, to assault the unprotected XI Corps on the Union right. If the Northern general had made any effort, he could have scattered Jackson's strung-out forces or swamped Lee's remaining 15,000; but as Lee had expected, the cowed Hooker did nothing.

About six o'clock in the afternoon of May 2, a wave of rabbits and deer suddenly poured into the positions of the XI Corps. They were followed by a screaming onslaught of Jackson's men, who swept up the confused Federal flank like a broom. Hooker learned of the disaster when a rabble of terrified survivors began pouring into the Chancellorsville clearing. The Union commander jumped on his horse and rode toward the right, organizing resistance as he went. Some Pennsylvania cavalrymen made a suicidal charge into the middle of the Southern advance that bought some critical moments; eventually dozens of cannon were pouring shot and shell into the Confederates. That barrage and the coming of darkness brought the Southern advance to a halt before it routed the entire Union army. Then, at nine o'clock that night, disaster struck Lee's army.

Stonewall Jackson had ridden out with some other officers to reconnoiter in the dark and had roused some Northerners, who opened fire as Jackson and the others galloped back toward their own lines. Hearing guns and approaching horsemen, Confederates on both sides of the road began firing into the dark; three bullets from his own men hit Jackson. He was taken away in an ambulance, and doctors subsequently amputated his left arm; within a few days a fatal case of pneumonia would set in. Also that night, hundreds of wounded men died in flames that the battle had started during the day.

The next morning, with Jeb Stuart now leading Jackson's command, the Confederates renewed the attack and began driving Federal units back toward the Rappahannock River. Hooker seemed confused and despondent as shells burst around his headquarters in a mansion at Chancellorsville. Meanwhile, to the east at Fredericksburg, Federals under Sedgwick stormed over weak Southern positions on the heights and headed west to reinforce Hooker. As Hooker waited on the porch for Sedgwick's arrival, a cannonball splintered a column and the concussion knocked him to the ground. Dazed, Hooker ordered a withdrawal to trenches already prepared between and the Rapidan and Rappahannock. With the Confederates swarming around them, the Army of the Potomac pulled back to the trenches.

Sedgwick would never make it. Lee, leaving 25,000 men to hold Hooker's retreating 75,000, sent 20,000 troops to meet the new Federal contingent. By the next morning Sedgwick found himself surrounded on three sides and fled back to the Rappahannock. With characteristic aggressiveness Lee planned to assault the Federal entrenchments on May 6, which might have proved disastrous for the South. But he never got the chance; Hooker withdrew his beaten and demoralized army across the Rappahannock on the night of May 5.

Hooker had gone into battle with twice the strength of his enemy and had let himself be outnumbered in every part of the engagement. Of 133,868 men, the Army of the Potomac had lost 17,278, to Lee's 12,821, out of 60,892 on the field. Chancellorsville was Lee's masterpiece and one of the most brilliant tactical achievements in military history. On the other hand, Lee had lost Jackson, his 'strong right arm.' On May 10 the wounded Stonewall Jackson cried out in delirium from his bed, 'Order A. P. Hill to prepare for action – pass the infantry to the front rapidly – tell Major Hawks . . .' Then, after a silence, came his last, oddly peaceful words: 'No, let us cross over the river and rest under the shade of the trees.'

Charleston, *South Carolina*

Charleston was at the forefront of Southern resistance before the war. The palmetto flag was raised there the day after Lincoln's election, and when South Carolina became the first state to secede six weeks later, the city's streets were wild with celebration. Part of Charleston's belligerence centered on its custody of Federal forts and arsenals; it is no accident that the war began here, at Fort Sumter.

Charleston (*South Carolina*), Naval Assault on

The advent of the ironclad ship raised hopes in the Union navy that large coastal forts might now be vulnerable to capture from the sea – a near impossibility for wooden-hulled warships. The theory was tested on April 7, 1863, when a Union squadron of nine ironclads attacked Fort Sumter and Fort Moultrie in Charleston Harbor. In the event, fire from the forts proved far too daunting for the assailants. Six of the ironclads were heavily damaged, one, USS *Keokuk*, so badly that it sank the next day. The squadron commander, Flag Officer Samuel DuPont, was forced to withdraw, having accomplished nothing save to demonstrate that the capture of big coastal forts was still, as in the past, properly a subject for combined operations.

Union Treasury Secretary Salmon P. Chase.

Chase, Salmon Portland
(1808-1873) **Union statesman and secretary of the treasury.**

Born in New Hampshire, he practiced law in Ohio, where he defended escaped slaves and led the Liberty Party, serving as US Senator and governor. As Lincoln's secretary of the treasury Chase had to finance the war; with the help of private financiers such as Jay Cooke, Chase managed the job fairly well, though in the process he was obliged to print 'greenback' paper currency that was inadequately backed by specie. An ambitious Radical Republican who was forever dissatisfied with what he considered Lincoln's undue moderation, Chase on several occasions came close to disloyalty to his president. Nevertheless, after Chase finally resigned from his cabinet post in mid-1864 Lincoln soon appointed him to fill the vacancy created by the death of Chief Justice of the Supreme Court Roger Taney, a post in which Chase served until his death.

Unable to take Charleston by naval assault in April 1863, the Union tried a combined operation in August. It also failed.

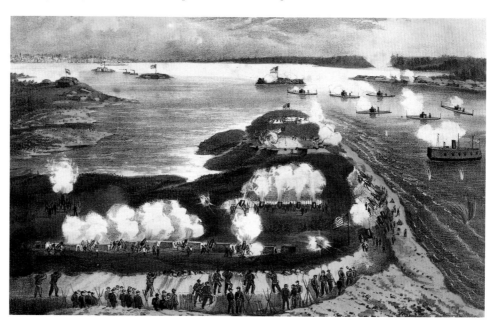

Chattahoochie River, *Georgia*

Confederate General Joseph Johnston, continuing his resistance to W. T. Sherman's 1864 Atlanta Campaign, pulled back on July 4 from Smyrna to a bridgehead north of the Chattahoochie River, northwest of Atlanta. Sherman ordered General George Thomas to hold Johnston in place while Sherman sent other forces to cross upstream. Threatened once again by envelopment, Johnston withdrew to the outskirts of Atlanta on the 9th.

Chattanooga Campaign

Following the devastating Union defeat at Chickamauga in September 1863 the Federal Army of the Cumberland had been besieged in Chattanooga by Braxton Bragg's Confederate Army of Tennessee. Even though the Union army thus held that vital rail center, it did them little good when they were trapped and starving. Meanwhile, their commanding general, William S. Rosecrans, seemed to be, in Lincoln's words, 'confused and stunned like a duck hit on the head' after his rout at Chickamauga. Lincoln and his advisors decided that someone else had to take over the job of lifting the siege.

On October 24, 1863, General Ulysses S. Grant arrived in Chattanooga with the command of the new Federal Division of the Mississippi, which included everything from that river to the Appalachian mountains. The route over which he had come to Chattanooga, a tortuous trail from Bridgeport, Alabama, was the only one left open to his army. Grant brought with him orders placing General George H. Thomas, the 'Rock of Chickamauga,' in immediate command, relieving Rosecrans. The new commanders faced a daunting challenge: Chattanooga lay in a bowl-shaped depression surrounded by hills and ridges on whose heights Braxton Bragg's men had dug in and had emplaced dozens of cannons.

Food, not fighting, was the first military objective. Grant put into motion a plan (actually originated by Rosecrans) for opening a supply route along the Tennessee River. The soldiers would call it the 'cracker line,' after the ubiquitous military biscuit. At the same time, Grant ordered 20,000 reinforcements under Joseph Hooker to march from Bridgeport, Alabama, where they had been stuck for two weeks after being moved there on trains from the Army of the Potomac (the fastest movement of a large body of troops ever seen before the twentieth century). Soon thereafter William Tecumseh Sherman would bring in 17,000 men of the Army of the Tennessee. As Hooker's men slipped into the city in the middle of the night, Union detachments drove Confederates from positions overlooking the river. Then, on the morning of October 30, the little ship *Chattanooga* steamed into town with 40,000 rations and tons of animal feed. The cracker line was open, and soon the Northerners would be in shape to fight.

A few days later Confederate President Jefferson Davis unwittingly helped Grant when he ordered Bragg to send 15,000 men under James Longstreet to join other Confederate forces in attacking Union-occupied Knoxville, Tennessee. Not only did this ill-advised

campaign fail, it deprived Bragg of a quarter of his forces. But the situation also created a problem for the Federals: to relieve the pressure on Knoxville, Grant had to attack Bragg soon. Despite the growing number of Federals accumulating in the city, Bragg still felt sanguine about his hilltop position, assuring an anxious citizen that 'There are not enough Yankees in Chattanooga to come up here. Those are all my prisoners.' It seemed a realistic assessment of the situation: as Robert E. Lee had found at Gettysburg, it is virtually impossible for an army to attack uphill into well-fortified positions.

Grant organized his forces and made his battle plans. On the morning of November 23 Union batteries opened up against the main enemy positions along Missionary Ridge; Southern cannons responded. From the city marched 20,000 Federal troops in dress uni-

On the outskirts of besieged Chattanooga Union pickets discover a Confederate patrol camouflaged as cedar bushes.

form, their ranks perfectly aligned. To the Confederates on the heights it looked like a parade until the ranks suddenly began charging up the slopes. The Battle of Chattanooga was underway, the Union army easily taking Orchard Knob, a hill between Missionary Ridge and the city, that would become Grant's command post.

During the night Sherman moved four divisions across the Tennessee River on a pontoon bridge, and the next day he attacked the northern end of Missionary Ridge. At the

A panoramic view, looking south, of the key Confederate rail center at Chattanooga. In the far background is Lookout Mountain.

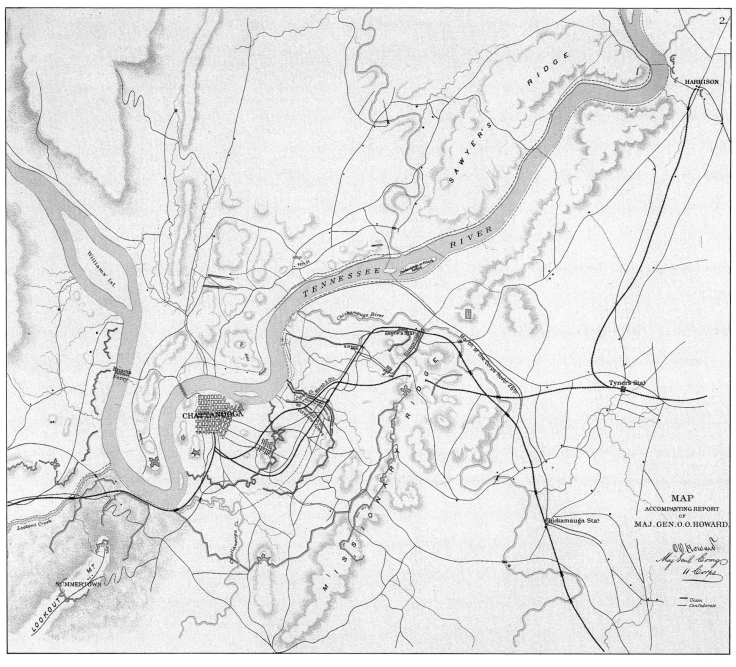

Above: A union army map shows the relative locations of Chattanooga, Lookout Mountain, Missionary Ridge and the Tennessee River.
Left: The Missionary Ridge battlefield.

same time, Hooker was ordered to make a demonstration on the opposite flank at Lookout Mountain, part of a long ridge stretching south into Georgia. Due to the intermittent fog as Hooker's men scrambled up the slopes, the engagement would be dubbed the 'Battle Above the Clouds.' In fact, it was not much of a battle; the few Confederates in residence were easily driven away with fewer than 500 Federal casualties. On the left wing, Sherman seized enemy outposts on what his map told him was the northern end of Missionary Ridge, only to discover that he was stuck on an outlying hill with a ravine blocking the way to the ridge.

Dawn on November 25 revealed a huge Stars and Stripes flying from the summit of Lookout Mountain. Down in the city the Northerners cheered the sight amidst their preparations for battle. Grant had ordered Hooker and Sherman to press the main attack

on the enemy flanks north and south of Missionary Ridge, but as the morning wore on neither general made much headway. After hours of indecisive fighting, in mid-afternoon Grant ordered Thomas's 23,000 men to advance on the center of the ridge, the heart of enemy strength, mainly as a demonstration to prevent Bragg from sending reinforcements to his flanks. To that end, and because a full-scale assault appeared suicidal, Grant ordered Thomas's forces to stop and regroup halfway up the ridge. What happened instead left everyone on both sides stunned with disbelief.

Thomas's men quickly overran the first line of Confederate rifle pits, partly because their occupants had received confusing orders from Bragg, and as the Southerners pulled out and ran, the Federals followed in pursuit, in the process overrunning the next line of defenses. An astonished Grant, watching from Orchard Knob with his staff, saw his troops continuing uphill in violation of orders. To Thomas he growled, 'Who ordered those men up the ridge?' The stolid Thomas replied that it wasn't he. 'Someone will suffer for it, if it turns out badly,' the lowering Grant warned.

By then Rebels all along the slopes had been swept up into flight, with Federals still hard on their heels. As they drove the enemy before them, the exultant Northern men began to chant the name of their recent humiliation: 'Chickamauga! Chickamauga!' By a combination of valor, luck, and the incompetence of their enemy, they were about to accomplish the impossible. Defenders at the top of the ridge found that they could not fire down the slopes without hitting their own men. For that reason, the Federals were quick to realize that their safest position was right behind the enemy. Moreover, Bragg's engineers had positioned their batteries on the very top of the ridge, whence they could not even be trained on to the slopes. Finally, the Southern troops had long lost faith in their commander, Bragg, and were more than ready to leave town. The Union assault rolled right over the fortifications at the top of the ridge and sent the Confederates running into Georgia. Rearguard forces stopped the Yankee advance, but the Rebels did not stop to regroup for 30 miles.

Casualties were relatively low for such a major battle; Union forces lost 5824 of 56,359 effectives, to the South's 6667 of 64,165. Besides taking one of the last remaining rail centers from the Confederacy, the Battle of Chattanooga dealt one more bitter blow to the sinking morale of the South and elevated U.S. Grant to the highest level of the Northern military command. His next opponent would be Robert E. Lee, in Virginia.

Cheat Mountain *(West Virginia)*, Battle of

In his first campaign of the war, Confederate General Robert E. Lee was ordered to recapture parts of West Virginia that had been lost to the Confederacy in George B. McClellan's West Virginia Campaign *(See)*. Lee's men first made contact with the Federals – under J. J. Reynolds – near Elkwater on September 10, 1861. Lee's complicated plans went astray over the next days due to wet weather,

the loss of surprise, and a Federal defensive position on Cheat Mountain that was made out to be much stronger than it actually was. Lee finally withdrew on the 15th; it was a dismal debut for the greatest of the war's field commanders.

Chesnuts, Mary and James

South Carolina-born James Chesnut Jr. (1815-1885) resigned his US Senate seat in November 1860, later sitting in the Confederate Congress. He was aide-de-camp to P. G. T. Beauregard at Fort Sumter and later to Jefferson Davis. Requesting field service in 1864, he commanded the South Carolina reserves. The Richmond journal of his wife Mary Boykin Miller Chesnut (1823-1886), one of the most sensitive chronicles of the wartime Confederacy, was published in 1905 under the title of *Diary from Dixie*.

Chickamauga, Campaign and Battle

The decisive year 1863 began in the middle of the Battle of Stone's River, near Murfreesboro in west Tennessee. This was a bloody but inconclusive three-day contest between the Federal Army of the Cumberland under William S. Rosecrans and Braxton Bragg's Confederate Army of Tennessee. At the beginning of summer, Washington ordered Rosecrans to start a new campaign to take the strategically vital rail center of Chattanooga and sweep Confederate forces out of Tennessee, a state that from the beginning had contained a strong contingent of Union sympathizers. To achieve his objective Rosecrans had to drive Bragg across the state, since Bragg would certainly fall back eastward to protect Chattanooga.

At the end of June, Rosecrans began his brief Tullahoma Campaign with a brilliant strategic coup, feinting at Bragg's left flank near Tullahoma. When the Southern general tried to respond, he discovered that two Union corps had gotten behind his right. Bragg had to pull back, and he decided to march all the way across the state to the strong defensive positions in Chattanooga, a nexus of rail lines running to the points of the compass. (During the Civil War, railroads became for the first time in history a vital element of strategy and logistics, moving troops and supplies at unprecedented speeds.)

The Confederate government at Richmond, worried about Bragg's position, took General James Longstreet and his men from Lee's army in Virginia and dispatched them by rail to Chattanooga. Before Longstreet arrived Rosecrans tried another strategic maneuver to get Bragg out of Chattanooga, diverting the Confederates with troops spread along the Tennessee River and then threatening the Southern rear again. In early September, Bragg pulled his forces from the city and headed south across the mountains and into Georgia. That same week, a hundred miles to the north, a Union army occupied Knoxville without firing a shot. Rosecrans now concluded that Bragg's forces were abandoning Tennessee and sent his men after them.

But the Federals were marching into a trap. Pursuing the supposedly fleeing enemy, Rosecrans divided his army to cross three mountain gaps some 50 miles apart. Meanwhile, Bragg was concentrating his forces in Lafayette, Georgia, whence they could strike

Nathan Bedford Forrest (right) was one of the two main leaders of Confederate cavalry at the Battle of Chickamauga.

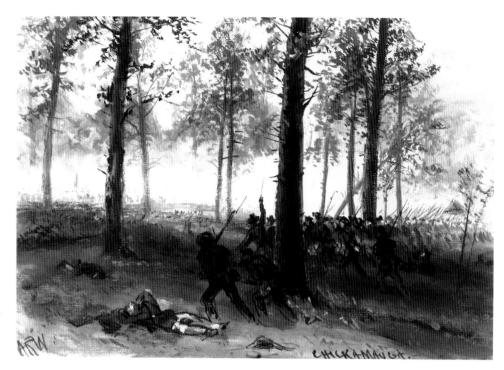

This evocative sketch of the opposing lines of battle at Chickamauga was drawn by the ubiquitious war artist A. R. Waud.

each of the Northern contingents separately and overwhelm them one at a time. Bragg fumbled this opportunity, however, due mainly to the resistance of his subordinates, who disliked their choleric commander. Between September 10 and 13, Bragg's generals failed three times to attack as ordered. Meanwhile, Rosecrans finally realized why he kept running into parties of Confederates, all of whom seemed to be withdrawing toward Lafayette; sensing the danger he was in, the Federal commander ordered his three detachments to pull together on the west bank of Chickamauga Creek, near Lafayette. This was precisely the area where Bragg was awaiting the imminent arrival of Longstreet's forces, which would at last give him numerical superiority.

The Southern commander ordered a major attack on September 18, while the Union line was still highly vulnerable. Once again the attack failed to develop. By the evening of the 18th both commanders were ready to fight along Chickamauga Creek, whose Cherokee Indian name was said to mean 'River of Death.' Bragg intended to concentrate his next day's attack on the Union left and to cut off the Federals' only path of retreat, a road to Chattanooga. Rosecrans had anticipated this strategy and made sure his left flank was the strongest, the key position there being the steep horseshoe ridge of Snodgrass Hill where General George H. Thomas had been placed in command.

On the 19th the Battle of Chickamauga flared up by accident when a group of Federal cavalry scouts stumbled across some of Nathan Bedford Forrest's men north of the creek; the Confederates retreated under fire, and then Southern infantry pushed forward. Gradually the shooting spread down the line. There followed a bloody but disorganized day of fighting, during which a two-mile gap in the Union line remained undiscovered by Bragg. Thomas kept asking Rosecrans for re-

inforcements and gradually extended the Union left flank to protect the road to Chattanooga. For a time Confederates under John B. Hood (the first of Longstreet's forces to arrive) got on to the road, but then Thomas drove them away.

The costly but indecisive fighting ended in late afternoon with the Union line still in place. That evening Longstreet arrived with two more divisions, experienced veterans of Robert E. Lee's army, and now Bragg had the numerical upper hand. He ordered Leonidas Polk to begin at dawn with a strong assault on Thomas at Snodgrass Hill; after Polk's move on the Union left, the rest of the Southern forces were to join in successively down the line. Meanwhile, across the way, Union troops spent the night building log breastworks. Rosecrans met with his generals, cautioning them above all to keep closed up to the left. That was the beginning of a chain of coincidences adding up to disaster for the Federal Army of the Cumberland.

At dawn, with fog blanketing the thick woods, Bragg waited for Polk's attack. After an hour of silence a messenger was dis-

patched; he found Polk having a leisurely breakfast in a farmhouse. After vociferous prodding from Bragg, Polk finally assailed Thomas and slowly began to push the Union left flank back toward the critical road to Chattanooga.

Responding to urgent requests from Thomas for more reinforcements, Rosecrans ordered in J. S. Negley's reserve unit. But now confusion began to creep into Union deployments, for it was discovered that Negley was actually in line of battle and T. J. Wood was in reserve, where Negley was thought to be. As Negley's men were pulled out and sent to shore up Thomas on the left, and Wood was moved into line of battle on the right, the confusion snowballed. Negley and his men got lost, wandering over to Rossville; meanwhile, Rosecrans assumed that Negley had joined Thomas.

These confusions in deployment came to a head when an excited scout arrived to tell Rosecrans that there was a quarter-mile gap in the Federal line between the divisions of Wood and J. J. Reynolds. To seal that dangerous gap Rosecrans sent an order to Wood to 'close up on and support' Reynolds. This baffled Wood, since the scout had been mistaken: the line of battle in that area was Wood/Brannan/Reynolds, just as it was supposed to be; the woods and fog were so thick that the scout had not seen J. M. Brannan's division and had *assumed* there was a gap. Puzzling over the order, Wood decided that Rosecrans must mean for him to pull out of line and march behind Brannan to join Reynolds. Thus, as he pulled his troops out of line, Wood really did create gap.

At that moment, in Southern lines opposite the gap, apparently by sheer coincidence Longstreet moved to the attack. A column of Confederates charged straight into the gap, wheeled to the north, and in short order the whole Union right wing was fleeing up the road toward Chattanooga. During the rout the North lost thousands in dead, wounded, and captured. Among those retreating was Rosecrans, who ran into Negley and drew

Parts of the Rebel line in the Chickamauga Woods. This battle, which cost the South nearly 18,000 in dead or wounded, was to be the Confederacy's last major victory.

the mistaken conclusion that Negley had been with Thomas and thus that the left wing had broken as well. Thinking his whole army was on the run, the despairing Rosecrans continued on to Chattanooga.

But the Union army had not been entirely routed. General Thomas was still holding on as Longstreet's forces swarmed around the steep slopes of Snodgrass Hill. When ammunition ran low in late afternoon, however, it looked like the end, and Thomas ordered his men to fix bayonets. Then, at the last possible minute, a column of troops appeared in the Union rear. For a few moments Thomas was unsure if they were friend or foe; they turned out to be reserves under General Gordon Granger, who had violated Rosecrans's order to stay put and had marched to reinforce Thomas. With Granger's help Thomas was able to fight until nightfall and then make an orderly withdrawal to Chattanooga. The Confederates had won the field, but Thomas was the hero of the battle; forever after he would be the 'Rock of Chickamauga.'

Losses in the two days of battle were among the worst of the war: of 58,222 Federals engaged there were 1657 dead and 9756 wounded; of 66,326 Confederates, 3212 were dead and 14,674 wounded. Bragg failed to follow up his victory and pursue the enemy. By the time the Southern commander finally dispatched troops to Chattanooga on September 21 he found the enemy in strong defensive positions. Bragg dug his forces onto the heights around the city and settled down to starve the Yankees out. There things stayed until the arrival of U. S. Grant in October. (*See* CHATTANOOGA CAMPAIGN.)

Chickasaw Bluffs (*Mississippi*), Battle of

As part of his early (and unsuccessful) attempt to take Vicksburg, Mississippi, during late 1862 Ulysses S. Grant ordered two corps under the command of W. T. Sherman to attack Chickasaw Bluffs, a Confederate strongpoint north of the city overlooking Chickasaw Bayou and the Yazoo River. Meanwhile, Grant was to take another

detachment overland along a railroad line to operate against the city. Due to enemy raids on his Holly Springs supply depot, however, Grant had to call off his overland advance, which gave John Pemberton in Vicksburg the chance to shift forces to meet Sherman's threat. Because Union telegraph lines had also been destroyed, Grant was not able to get a word to Sherman to call off his attack.

Sherman landed his troops from the Yazoo, spent two days working some 20,000 men across the tangle of waterways and swamps of the bayou, and ordered the assault on Chickasaw Bluffs for December 29 at noon. The attack never had a chance, being repulsed by fierce enemy artillery fire from the heights. Sherman called off the attack after suffering some 1800 casualties (to the enemy's 207). It would be next spring before more promising approaches to the city presented themselves.

Churchill, Thomas James (*1824-1905*) **Confederate general.**

This Kentucky native was an Arkansas planter who raised a regiment and fought at Wilson's Creek, surrendered to Union General John McClernand at Arkansas Post, then fought again in the Red River Campaign of 1864 and at Jenkins's Ferry. He finally surrendered reluctantly in Texas in 1865.

Civil Rights Acts of 1866 and 1875

The Civil Rights Act of 1866 superseded the Dred Scott decision(*See*) by granting American-born blacks citizenship and guaranteeing their civil rights (while excluding Indians and upholding state segregation laws). Concern over its constitutionality led to passage of the 14th Amendment (*See*). The Civil Rights Act of 1875 guaranteed equal rights to whites and blacks in public places and forbade blacks' exclusion from jury duty. In 1883 the Supreme Court ruled this act invalid since it protected social rather than political rights, ruling further that the 14th Amendment protected civil rights from infringement by states, but not by individuals. Racial discrimination by individuals was legal until the Civil Rights Act of 1964.

Clark, William Thomas (*1831-1905*) **Union general.**

A Connecticut-born Iowa lawyer, he raised the 13th Iowa and fought at Shiloh, Corinth, Port Gibson, Champion's Hill and Vicksburg. From February 1863 to April 1865 he was James McPherson's adjutant general. After the war Clark was a 'carpetbagger' Representative from Texas.

Clay, Cassius Marcellus (*1810-1903*) **Union general.**

Clay was a staunchly abolitionist editor, lawyer, and politician in Kentucky. On his way to a ministerial posting in Russia in 1861 he paused to organize troops to defend Washington. In 1862-63 he briefly suspended his diplomatic appointment to accept a commission, but he refused to fight until slavery was abolished.

Clay, Henry (*1777-1852*) **Statesman.**

Representing Kentucky in Congress, Clay was an eloquent voice for moderation, from the Missouri Compromise of 1820, of which he was the chief sponsor, through his own compromise resolutions of 1850 (*See* COMPROMISES OF 1820 AND 1850). He was also the author of the compromise Tariff of 1833, which de-fused the dangerous Nullification Crisis of the preceding year (*See* NULLIFICATION DOCTRINE). Facing increasing sectionalism in the 1850s, he urged gradual emancipation and warned against the dangers of secession.

Cleburne, Patrick Ronayne (*1828-1864*) **Confederate general.**

Irish born, this Arkansas druggist and lawyer seized the Little Rock arsenal with a militia in 1861. The 'Stonewall Jackson of the West' performed impressively at Shiloh, Richmond (Kentucky) and Perryville, Stone's River, Chickamauga, Chattanooga, and in the Atlanta Campaign, but he hurt his chances of promotion by advocating arming the slaves.

Kentucky-born Henry Clay was 'The Great Compromiser' of the prewar years.

General George Thomas directs the heroic defense of the Union left at Chickamauga.

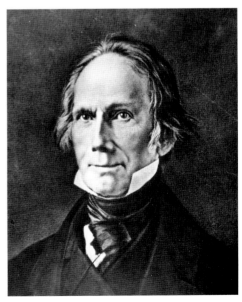

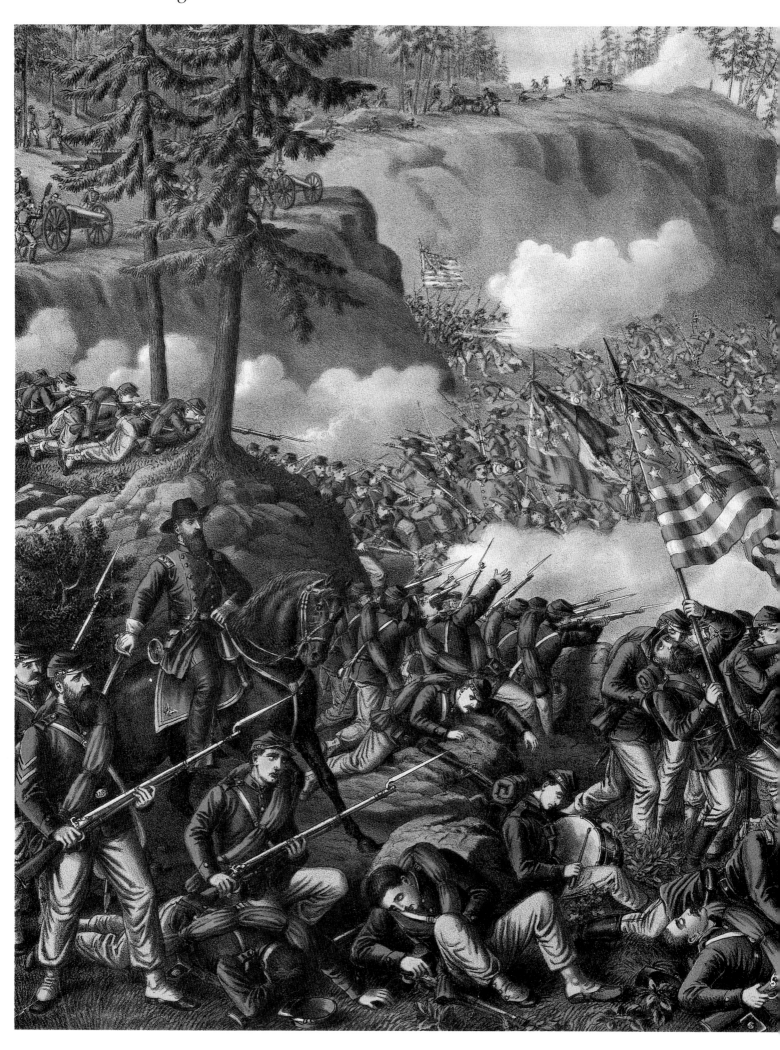

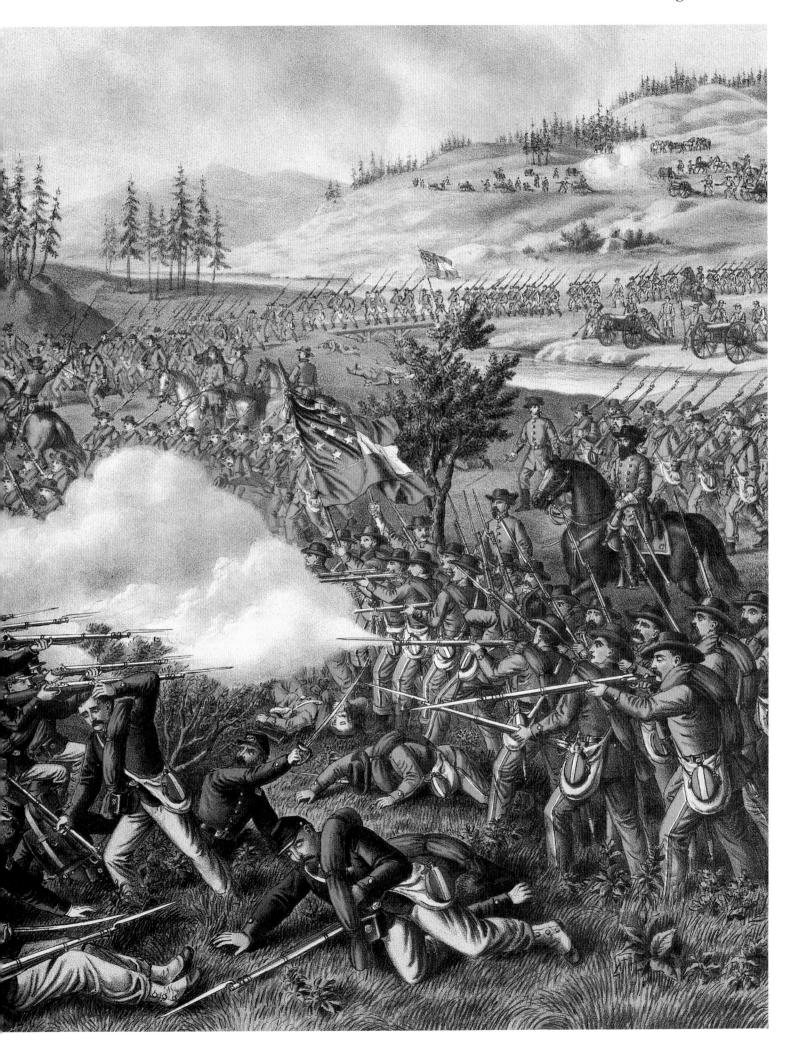

Cobb, Howell *(1815-1868)*
Confederate general.

He was a Georgia-born lawyer, US Representative, governor of Georgia (1851-54), and Buchanan's secretary of the treasury (1857). A Unionist, he became a secessionist after Lincoln's election and chaired the Montgomery Convention (*See*). He organized the 16th Georgia and, despite his lack of military training, achieved a distinguished war career, fighting at Shiloh and Antietam and commanding Georgia's reserve forces and then the District of Georgia. His brother, lawyer and author Thomas Reade Rootes Cobb (1823-1862), was killed at Fredericksburg.

Coehorn Mortar

Union forces employed this light, portable weapon, named for its seventeenth-century Dutch inventor, in siege operations. A 24-pounder version weighed only 164 pounds, used powder sparingly, was easy to site, aim, and fire, and was accurate at ranges of up to 1200 yards.

Cold Harbor, Battle of

After the inconclusive Wilderness Battle (*See*) of early May, 1864, that began his campaign against Robert E. Lee and the Confederate Army of Northern Virginia, General Ulysses S. Grant had written defiantly to Washington, 'I propose to fight it out on this line if it takes all summer.' Since failing to overwhelm Lee for a second time at Spotsylvania, Grant had repeated the same maneuver for the third time, slipping around Lee's right flank in an effort to reach Richmond. As before, Lee had anticipated the move and had put his army in the way at the North Anna River.

The Southern lines there lay in a wedge-shaped formation; on May 23 Grant's Army of the Potomac made probing attacks and split in half along the wedge. Lee then had a rare opportunity to strike at the halves of his enemy's army in succession, but at that point

Previous pages: The Battle of Chickamauga, as depicted by Kurz & Allison.
Below: A battery of the Union's VI Corps in action at Cold Harbor in June 1864.

he was bedridden with fever and could not direct his forces. After two more days of indecisive fighting along the North Anna, Grant again 'sidled' the army of the Potomac to the left, flanking Lee, while the Confederates shadowed the move.

On May 31 Philip Sheridan's Federal cavalry found enemy cavalry at the crossroads of Cold Harbor, and a spirited fight broke out, leaving the Northerners in control of the road junction. The next day saw some fruitless Southern infantry attacks on the position. On the night of June 1 both armies entrenched on a line seven miles long between the Topopotomy and Chickahominy rivers. By that time the Federals had 109,000 men available, Lee 59,000. Grant ordered assaults for the next day, but slow troop movements and rain forced a postponement. The Union commander apparently was frustrated; three battles in a month had failed to crack his opponent's lines. Yet he now believed the Southerners to be exhausted and demoralized. So Grant decided to send his army in full strength against the Cold Harbor breastworks and try to overwhelm them in one blow. This would prove the most disastrous decision he ever made. The impossibility of the assignment was plain to the soldiers; the night before the battle many were seen sewing name tags on their clothes so their bodies could be identified.

The Battle of Cold Harbor on June 3 was in essence a series of charges on Confederate positions that were all but invulnerable, a maze of zig-zagging 'works within works and works without works.' The first assault struck the right and center of the Southern line at 4:30am. As the Federals approached, an observer recalled, 'there rang out suddenly on the summer air such a crash of artillery and musketry as is seldom heard in war.' Union men fell in waves. For a few minutes this first charge reached the outer trenches, but a countercharge drove the Federals back. Within the first half hour of fighting thousands of bluecoats dropped before the gray line. Yet after that devastating repulse Grant ordered a second general assault. It was carried out raggedly, with many troops holding back, and failed. A third order to attack produced no more than a token attempt.

By the time Grant ended the attacks at

noon Union casualties totalled some 7000, added to 5000 from the previous two days. Lee meanwhile had lost less than 1500. And the horror continued. Apparently neither general was willing to imply that he was beaten by asking for the usual truce to collect the wounded. As a result, no stretcher parties went out for four days, and hundreds of men died, in full view of both lines, of wounds, exposure, and thirst.

Grant would admit at the end of June 3, 'I regret this assault more than any one I have ever ordered.' A later commentator would more bluntly call the day, 'a horrible failure of Federal generalship.' General George Meade, still nominally in command of the Army of the Potomac, wrote to his wife, 'I think Grant has had his eyes opened, and is willing to admit now that Virginia and Lee's army is not Tennessee and Bragg's army.' (*See* CHATTANOOGA CAMPAIGN.) The army, for its part, was not likely to countenance further orders to attack breastworks.

Yet the Union cause had nonetheless been furthered in the last four inconclusive battles. In a month of ceaseless marching and fighting the Federal Army of the Potomac had suffered 50,000 casualties, 41 percent of its original strength, and numbers of men had experienced physical and mental breakdowns from the stress. Yet while the losses of Lee's Army of Northern Virginia had been numerically less, 32,000, that represented 46 percent of Confederate strength. Though Grant had been forced into a game of attrition only by Lee's continuing resistance, the Federal general well knew that as long as he stayed in the field the war could be decided by the simple and brutal matter of numbers. Union losses could be replaced, and Confedrate losses could not; the South was reaching its last reserves of manpower. Having failed four times to hammer Lee into submission in open battle, however, now Grant would change his strategy of inching toward the Confederate capital and fighting Lee in the trenches and barricades as he went. Now he would turn for Petersburg, the back door to Richmond.

Cold Spring Foundry

Under the supervision of Robert P. Parrott (*See*), this plant across the Hudson from the US Military Academy produced some 1700 guns and 3 million projectiles during the war. It was also called the West Point Foundry.

Colquitt, Alfred Holt *(1824-1894)*
Confederate general.

Colquitt was a Georgia lawyer, planter and extreme states' rights politician who fought in the Peninsular Campaign and led Colquitt's Brigade at Antietam, Fredericksburg, Chancellorsville, the Wilderness, Spotsylvania, and Petersburg.

Colt Revolvers and Rifles

From 1848 on, Samuel Colt produced several successful cap-and-ball (*See*) revolver models for US forces, the most famous Civil War types being the .36-caliber Model 1851 and 1861 'Navy' weapons and the .44-caliber Model 1860 'Army' weapon; the war depart-

Capt Stevens battery on the 6th Corps skirmish line HR Wa...

ment bought more than 100,000 examples of the Model 1860, which became the official US Army pistol.

Columbia (*South Carolina*), Burning of

(*See* CAROLINAS CAMPAIGN)

Columbiad

This large cannon, first fired in the War of 1812, was produced in calibers of 8, 10, and 15 inches and was used for coastal defense. The 15-inch version, weighing nearly 50,000 pounds, fired a 320-pound shell.

Compromises of 1820 and 1850

For over a generation before the Civil War, indeed from the time of the Revolution, the rising tensions between the slave-holding and free regions of the United States had been heavily focused on the problem of what the status of states newly admitted to the Union should be, since this directly affected the voting power of the two regions in Congress. The first major test of the question came in 1820. At that time the free and slave regions were exactly balanced, each being composed of 11 states; but now it was proposed that Maine, a free territory, be admitted as a 23rd state. Southern objections to this upsetting of the balance were so extreme that in the end a compromise was adopted whereby Missouri would be admitted as a slave

state in 1821. Another provision of this compromise, alternatively known as the Compromise of 1820 or the Missouri Compromise, barred the extension of slavery elsewhere in the territory of the Louisiana Purchase above 30° 30' N.

But the problems surrounding the admission of new states became steadily more complex and envenomed in the years that followed, and particularly after the annexation of Texas and the large acquisition of new territory following the Mexican War. Matters came to a boil again in 1849 with the proposed admission of California as a free state. In

The Union attack at Cold Harbor was bloodily repulsed. Grant later said he regretted the assault more than any he ever ordered.

1850, largely thanks to the efforts of Senators Henry Clay and Stephen A. Douglas, a new series of compromise measures (known collectively as the Compromise of 1850) was passed to allay the crisis: California would

A selection of revolvers typical of the kind being produced by Samuel Colt's factory in Hartford, Connecticut, in the 1850s. Colt received his first patent for a 'revolving gun' in 1836.

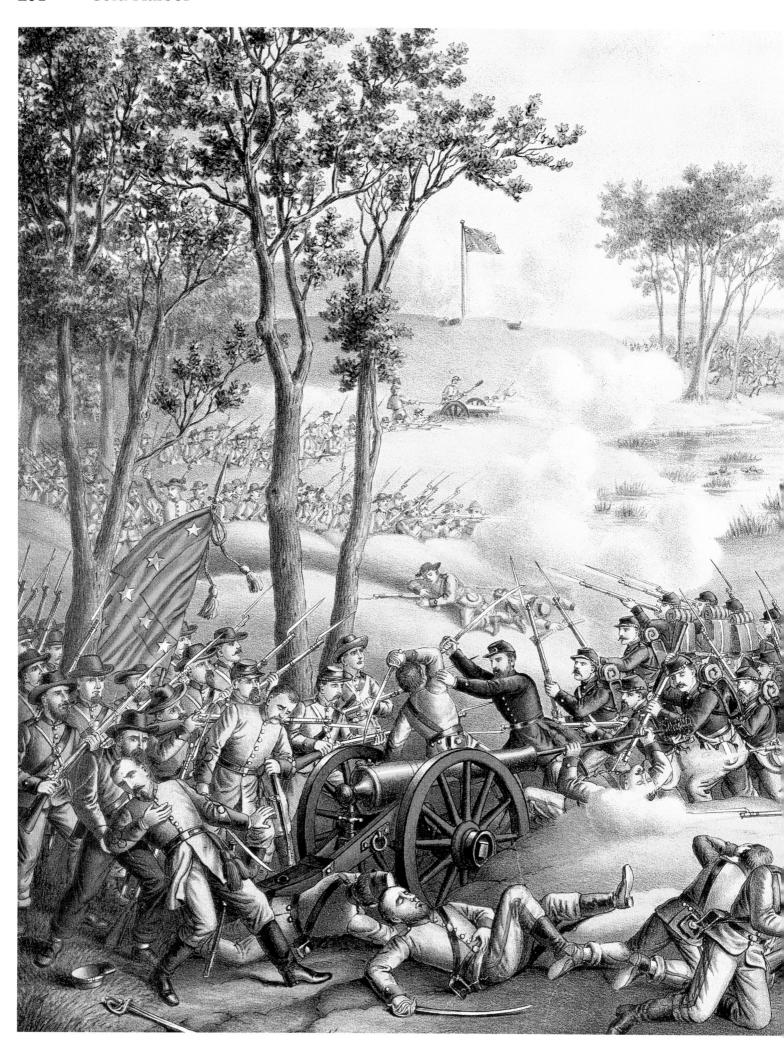

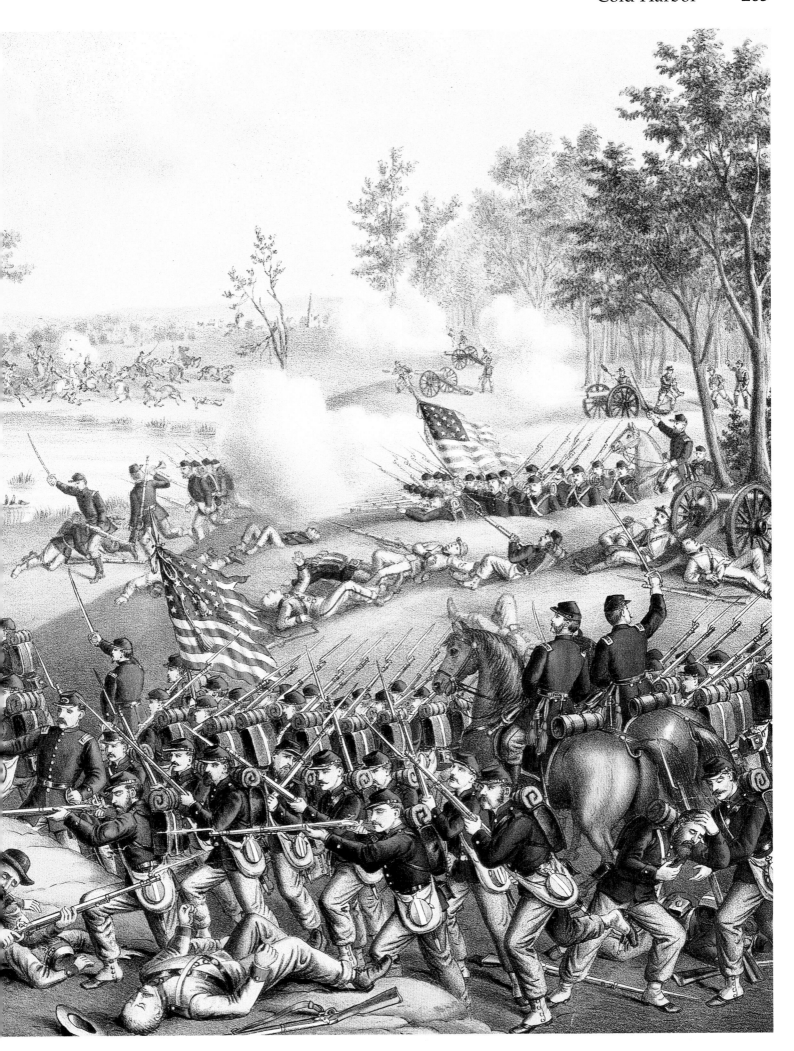

enter as a free state, the territories of Utah and New Mexico would decide their status by local vote, slavery would be abolished in the District of Columbia, and the provisions and enforcement of the Fugitive Slave Acts would be strengthened. Although these measures placated majorities in both regions temporarily, no one was really satisfied, and the work of this last great federal effort at compromise would soon be undone by the effects of the Kansas-Nebraska Act, the Dred Scott Decision, and other divisive occurences that multiplied in the 1850s.

Confederate Army

There never was an official standing Confederate army; the collection of volunteers called the Provisional Army was established by President Jefferson Davis in February and March of 1861. Estimates of men fighting for the South during the war are highly speculative; one estimate has been 1,082,119. Only 174,223 were left to surrender at the end of the war, most of the depreciation being due to desertion.

Confederate Flags

The original 'Stars and Bars,' the first of four Confederate flags, had two horizontal red stripes with a white one in between, seven white stars in a circle, and a blue field. After First Bull Run, General P. G. T. Beauregard introduced the more familiar blue St. Andrew's cross on a red field, with 13 stars superimposed on the blue. A 'National Flag,' adopted in May 1863, was white with Beauregard's battle flag in the upper corner. In March 1865 a vertical bar was added to the edge of the National Flag.

Confederate Money

Beginning with a $1 million authorization in March 1861, the Confederate government issued paper notes payable six months after the ratification of a peace treaty. More than $1.5 billion was eventually issued. The money depreciated steadily. In December 1861 a Confederate dollar was worth 80 cents in gold; by the surrender at Appomattox it took up to $1000 in Confederate notes to buy $1 in gold or Union paper.

Representative of Confederate army units was Charleston's Palmetto Battery.

Confederate Navy

The Confederate navy was nonexistent in 1861, with no ships, no navy yards or manufacturing to build a fleet, and few officers or merchant seamen. Confederate Navy Secretary Stephen R. Mallory devised a resourceful strategy of coastal and river defense using ironclads, mines, and submarines, and he provided for blockade-running and commercial raiding by using converted small craft and British-built cruisers. The Southerners succeeded in disrupting Northern commerce and, at least to some extent, in puncturing the Union blockade.

Confederate States of America

The Confederate States of America was the name adopted by the 11 states that seceded from the US between December 1860, and June 1861. There were also separate Confederate 'governments' in sympathetic regions of two slaveholding but unseceded states, Kentucky and Missouri. The Confederacy, in short, proposed to be a separate country that differed from the US primarily in protecting the institution of slavery.

Previous pages: The Battle of Cold Harbor.
Above: By early 1865 Confederate paper money was worth less than are these facsimiles now.

The theoretical basis for the idea of secession was the concept of States' Rights, which held that individual states had the right to nullify Federal laws – especially antislavery laws – to which they objected, and in extreme cases to withdraw from the Union. Southern states held the election of Abraham Lincoln to the presidency to be such an extreme case: Lincoln had long been an eloquent voice of the antislavery movement, and the newly-formed Republican Party he represented was part of that movement.

The first state to secede was South Carolina, on December 20, 1860, two weeks after Lincoln's election. The ordinance of secession concluded: 'the union now subsisting between South Carolina and other States, under the name of "The United States of America,"is hereby dissolved.' By the time Lincoln took office on March 4, 1861, six other states had followed suit: in order, Mississippi, Florida, Alabama, Georgia, Louisiana, and Texas. After the fall of Fort Sumter in mid-April, four other states from the upper

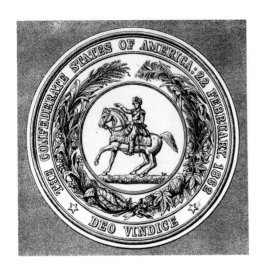

This design was intended to be the great seal of the Confederate States of America.

South would secede – Virginia, Arkansas, North Carolina, and Tennessee.

Delegates from six of the original seven states (the Texas delegation arrived late) met in provisional congress on February 4 at Montgomery, Alabama. On the 8th a provisional constitution was adopted, closely resembling the US Constitution in the organization of government, but with strong provisions protecting slavery and the rights of individual states. The following day Jefferson Davis was elected provisional president and Alexander Stevens vice-president. The provisional congress also declared that any US laws not directly contradicting stated Confederate laws were still to be in force. Davis, who learned of his election after the fact, was sworn in on February 18 and on the next day announced a cabinet.

On the 28th the congress directed Davis to call for 12-month military volunteers; he would ask for 100,000. By the fall of Fort Sumter in mid-April the Confederate army con-

Confederate President Jefferson Davis (at left end of table, seated) and his cabinet get a battle report from Robert E. Lee.

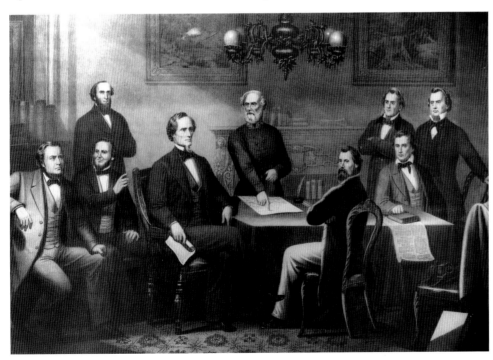

sisted of some 35,000 men. The Confederate capital would be moved to Richmond, Virginia, on May 20, 1861, where it would remain until the end of the war.

The Confederate government proved to be fractious and inefficient, both because of the nature of the government and the character of its members. Davis, a former US Senator and secretary of war, was an able man dedicated to his cause, but he was personally cold, humorless, and unskilled in the persuasions and manipulations of politics. Chronic and painful illnesses exacerbated these problems. He also overrated his military abilities, directing the Confederate war effort himself rather than appointing a general-in-chief. Especially in the South, he thereby hobbled his armies by his tendency to favor weaker generals (such as Braxton Bragg) and hold down outstanding ones (notably Nathan B. Forrest).

The very states-rights basis of the Confederacy made concerted action by the government difficult and often impossible, since representatives of each state tended to insist on their own interests and independence. Representatives were also taken from a population given to fights and duels to settle matters, and this made for tumultuous debates. In the later stages of the war the government proved unable to stem shortages of food and other civilian supplies or to combat massive inflation of Confederate currency. Moreover, Davis had a great deal of trouble every time he stepped on the prerogatives of delegates and/or states; thus there were bitter wrangles over such vital issues as drafting soldiers, taxes, and emergency suspension of civil laws. Davis was also beset by the resistance of his vice-president to many of his policies; after a while Stevens virtually cut off communication and worked steadily against the president.

One of the few things the Confederate government turned out to be good at was supplying its armies with military equipment. By a combination of manufacturing and foreign purchases, the government managed to keep ample arms and ammunition

flowing to its forces for the duration of the war. Notable in the cabinet was Secretary of the Navy Stephen R. Mallory, who virtually created a Confederate navy out of thin air, organized a brilliantly effective blockade-running fleet, and led the way in the historic development of ironclad ships. At the same time, the government was shockingly lax in other important elements of military logistics, notably in providing clothing and food; Rebel soldiers often marched and fought ragged, barefoot, and hungry, even when supplies were available in the South. On the whole, it is probably safe to say that Confederate military fortunes prospered as long as they did in the war less because of the government than despite it.

Confiscation Acts

A set of three Congressional measures approved in 1861-62, they declared freedom for slaves used in the transportation of military goods or the construction of military facilities. The acts also proclaimed that all slaves who lived in areas occupied by Union forces would be freed.

Congressional Medal of Honor

The highest award for valor given to US forces, Congress authorized it for Navy enlistees in December 1861 and for soldier enlistees in July 1862. In March 1863 Army officers were made eligible. (Navy and Marine officers did not become eligible until 1915.) More than 1200 such medals were given during the Civil War; award standards for later wars were much more strict.

Conner, James *(1829-1883)*
Confederate general.

A South Carolina lawyer and secessionist, he joined Wade Hampton's Legion in May 1861. He fought at First Bull Run, on the Peninsula, and at Chancellorsville and Gettysburg. After court martial duty, he commanded brigades during the Petersburg Campaign and the Shenandoah Valley Campaign of Sheridan, ending field service after losing a leg at the Battle of Fisher's Hill in September 1864.

Constitution

The US Constitution, drafted in 1787, appeared to sanction slavery by counting each slave equal to three-fifths of a white person in calculating Congressional representation; by permitting the slave trade to operate until 1808; and by providing for the return of fugitive slaves to their owners. The Bill of Rights (1791) guaranteed the rights of white Americans only. Three Amendments to the Constitution (*See*) passed after the Civil War extended Constitutional protection to black Americans.

'Contrabands'

General B. F. Butler coined the term in May 1861 when he denied a Virginia slaveholder's request for the return of three runaway slaves who had sought refuge in Fortress Monroe. The word eventually became slang usage for any slave or freedman.

Cook, Philip (1817-1894)
Confederate general.

A Georgia lawyer, Cook fought with the 4th Georgia in the Seven Days' Battles, at Antietam, at Fredericksburg, and at Chancellorsville. He sat in the state legislature briefly in 1863-64, returning to fight with Jubal Early in the Shenandoah Valley in 1864. He was wounded and captured by Union forces at Petersburg in April 1865.

Cooke, John Esten (1830-1886)
Confederate general.

This Virginian, a nationally known writer, served throughout the war. He was J. E. B. Stuart's ordnance officer and Robert E. Lee's inspector general of the Horse Artillery. He surrendered with Lee at Appomattox. Cooke published biographies of Stonewall Jackson and Lee, among other books about the war.

Cooke, John Rogers (1833-1891)
Confederate general.

A Missouri-born, Harvard-educated engineer, he resigned from US Army frontier duty in 1861 to raise a Confederate artillery company. Cooke fought at First Bull Run, Seven Pines, Fredericksburg, Bristoe Station, and the Wilderness, suffering several wounds. His father, Philip St. George Cooke, was a Union officer.

Cooper, Joseph Alexander (1823-1910) Union general.

This Mexican War veteran, a Tennessee farmer, recruited and trained Union troops in Tennessee. He fought at Stone's River, Chickamauga, and Chattanooga. Rapidly promoted, he led a brigade at Atlanta and participated in eastern Tennessee operations until the end of the war.

Peace Democrats in the form of copperhead snakes assail Columbia, spirit of the Union, with (presumably poisonous) peace proposals in this Northern cartoon.

A lightly-constructed corduroy road runs up the main thoroughfare of these 1862 Union army winter quarters (a former Confederate camp) in Centreville, Virginia.

Cooper, Samuel (1798-1876)
Confederate general.

Cooper, a New Jersey-born career officer and West Point graduate, was married to a Virginian and offered his valuable administrative experience to the Confederates in 1861. A full general, he was their highest ranking officer serving as adjutant- and inspector-general.

Copperheads

(Also known as Peace Democrats)

These Northern Democrats opposed the war, advocating a negotiated peace and restoration of the Union largely on Southern terms. They influenced the adoption of a peace plank in the Democratic platform for the 1864 presidential election. Particularly strong in Ohio, Illinois, and Indiana, their leaders included Alexander Long, Fernando Wood, and Clement L. Vallandigham (*See*). Their

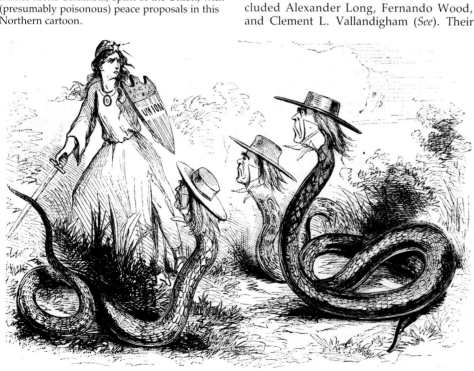

name derived from their identifying badges: the head of Liberty cut from copper pennies.

Corcoran Legion

Michael Corcoran, an Irish-born Union officer, raised this brigade, composed of the 155th, 164th, 170th, and 182nd New York, in November 1862. After serving for nearly a year in the Washington, DC, area, the legion joined the II Corps of the Army of the Potomac in May 1864.

Corduroy Road

A road with large branches or tree trunks laid side-by-side on top, it permitted passage for troops and vehicles over soft ground.

Corinth (Mississippi), Battles of

The first major military operations around Corinth followed the battle of Shiloh, from the end of April to mid-June 1862. General Henry Halleck, commanding the Federal Department of the Mississippi, effectively relieved Ulysses S. Grant from command of the Army of the Tennessee, despite Grant's victory at Shiloh; the ostensible reason was Grant's falling victim to the surprise attack that opened, and nearly ended, that battle. Naming Grant to the functionless position of second in command, Halleck personally took charge of the three Union armies in the area – of the Tennessee, Ohio, and Mississippi – and marched on Corinth, Mississippi, where the army of P. G. T. Beauregard, the loser at Shiloh, was located.

So obsessed with detail and so cautious was Halleck, however, that his march from the Shiloh battlefield area to Corinth proceeded at the snail's pace of 20 miles per day, from April 29 to May 25. On the way there had been minor skirmishing, but nothing to

seriously impede the Federals. Arriving on the outskirts of town, Halleck prepared to lay siege. Beauregard saw that even with the 70,000 men he had collected (many wounded or sick) he could do little to resist a Federal army of 110,000; so he pulled his forces out of town during the night of May 29-30 and marched for Tupelo, Mississippi. Halleck decided not to mount a major pursuit but rather decided that he would consolidate his position in Tennessee.

Because of this victory by way of maneuver and his earlier writings on military strategy, Lincoln and his advisers decided that Halleck was the man to run the war. In July the general was called to Washington to become general-in-chief – not a very effective one, in the end. Beauregard's career would never recover from his loss at Shiloh and his withdrawal from Corinth.

By October of 1862 Federal forces were dispersed in four contingents around the area, with 23,000 men holding Corinth under the command of General William Rosecrans. Confederate forces in the area, having escaped Grant's attempt to swamp them at the Battle of Iuka (*See*), were organized by General Earl Van Dorn for a strike at Rosecrans. Van Dorn, commander of the Confederate District of Mississippi, got off to an inauspicious start by underestimating Federal strength in the city; in fact, the Federals outnumbered his forces by 1000. Scouts informed Grant of Van Dorn's approach, but the Union general could not discover which of his four contingents the enemy was planning to strike.

The Battle of Corinth broke out in the morning of October 3, when Van Dorn mounted an attack that drove the Federals back two miles into their inner line of breastworks. Through a day of desperate enemy onslaughts the Union lines held. Grant, learning of the attack in the morning, dispatched reinforcements. On the 4th Van Dorn mounted another assault, but in heavy fighting made no headway. The battle was over by afternoon, when Federal reinforcements began to arrive.

Grant hoped to catch Van Dorn in a pincers between the reinforcements and Rosecrans's men moving out of town. But because of the slowness of Rosecrans (or so Grant believed), Van Dorn got away with most of his forces, though he lost 300 men captured when he was caught crossing the Hatchie River. The Federals broke off pursuit at Ripley, and Van Dorn continued by Holly Springs. By the end of the battle and ensuing retreat the Union had lost 2520 men, the South 2470 dead or wounded and 1763 missing and captured. Though Grant was disappointed that Van Dorn got away, and was thereafter cool to Rosecrans, the battle was a considerable strategic victory. From then on Grant would hold most of the cards in the Mississippi theater, and his campaign against the strategically crucial city of Vicksburg could go forward.

Corps

An organizational unit consisting of two or more army divisions. Unofficial Union corps early in the war relied on the use of numerals I through VI, identifying themselves further by the army to which they belonged. Union corps were officially authorized on July 17, 1862. Commanded by major generals, their numbers reached to XXV Corps. Confederate corps, commanded by lieutenant generals, were authorized on September 18, 1862; before then divisions were for the most part simply grouped under a commander's name – *e.g.*, 'Longstreet's Wing.'

Corse, Montgomery Dent
(1816-1895) **Confederate general.**

This Virginia banker fought at First Bull Run, on the Peninsula, at Second Bull Run, and at Antietam; his own regiment reduced to seven men, he took over Pickett's brigade and participated at Fredericksburg, Gettysburg, Chickamauga, the Wilderness, and in the Appomattox Campaign. He was captured with Richard Ewell at Sayler's Creek.

A Kurz & Allison version of the Battle of Corinth, fought on October 3 and 4, 1862. A strategic, rather than tactical, victory for the Union, it seriously weakened Rebel strength in what would soon become the war's pivotal theater, the Mississippi.

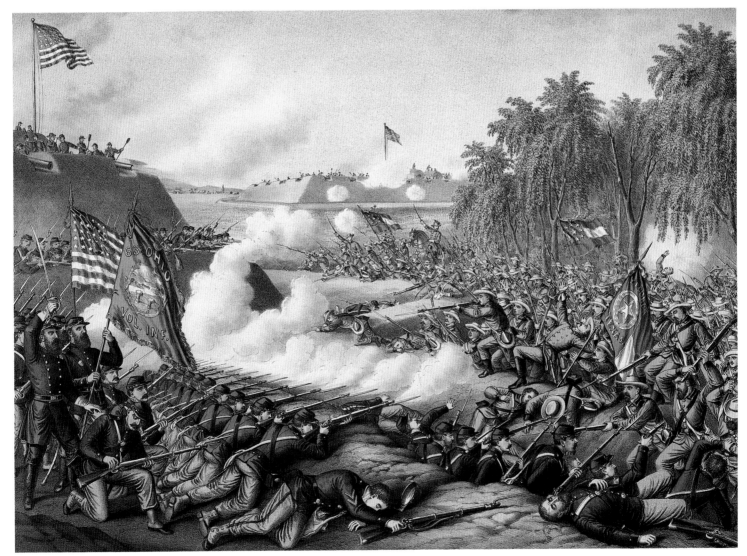

Rebels burn cotton to prevent its falling into the hands of approaching Federals. By the war's end cotton was relatively scarce.

Cotton

The importance of the institution of slavery to the South lay largely in its provision of unpaid labor to grow cotton, the region's principal crop, so that it could be exported at competitive prices. Through the 1850s demand and production of cotton skyrocketed, until some Southerners proclaimed that 'King Cotten' made them 'the controlling power of the world.' By 1860 the South was producing some 5 million bales of cotton annually. But this specialization was to exact a price in self-sufficiency during the war, since the expansion of cotton farming had been at the expense of raising edible crops. Confederate authorities at first confidently predicted that Europe would be forced both to trade with the South and to recognize secession in order to maintain its supply of cotton, but this was not the case. After running through its considerable surplus stocks of raw cotton, Europe simply turned to alternative suppliers such as Egypt and India.

Cox, Jacob Dolson *(1828-1900)* Union general.

An Ohio lawyer, legislator and radical anti-slavery activist before the war, Cox fought in the Kanawha Valley Campaign (*See*) and at South Mountain and Antietam. He commanded the Department of West Virginia and District of Ohio, and led divisions in the Atlanta and Franklin and Nashville Campaigns.

'Cracker Line'

(*See* CHATTANOOGA CAMPAIGN)

Crater, Battle of the

(*See* PETERSBURG SIEGE)

Crawford, Samuel Wylie *(1829-1892)* Union general.

A Pennsylvanian, this army surgeon led a battery at Fort Sumter and, as a brigadier general, fought at Winchester, Cedar Mountain, Antietam, and Gettysburg. He participated in all the Potomac Army operations of 1864-65 and was present at the Appomattox surrender.

Crittenden, John Jordan *(1787-1863)* Statesman.

Kentucky-born governor of Kentucky, US attorney general and US Senator, Crittenden was an anti-secessionist who supported Lincoln and worked to keep Kentucky in the Union. On December 18, 1861, he offered the Senate the Crittenden Compromise, proposing the extension of the Missouri Compromise line to the Pacific, but this peace-keeping measure was rejected by both sides.

Crook, George *(1829-1890)* Union general.

Crook was a West Point graduate from Ohio who suspended his outstanding career as an Indian fighter long enough to compile a successful Civil War record. He fought at South Mountain, Antietam, and Chickamauga and in the Shenandoah Valley Campaign of Sheridan and the Appomattox Campaign.

Cross Keys (or Union Church) and Port Republic *(Virginia),* Battles of

These were the climactic battles of the 1862 Shenandoah Valley Campaign of Jackson. On June 7 Thomas J. Jackson found himself between two pursuing Federal forces under John Frémont and James Shields. On the 8th Frémont advanced from Cross Keys, but Jackson's lieutenant, Richard Ewell, stopped the 10,500 bluecoats with only 6500 Rebel troops. On the next day, keeping Frémont at bay with a burned bridge and a screening force, Jackson massed most of his troops and after several hours of bloody fighting drove Shields from Port Republic.

Cullum, George Washington *(1809-1892)* Union general.

A New Yorker, this army engineer published numerous works on engineering and military history. He held staff positions under Winfield Scott and Henry Halleck and was chief engineer of the Departments of Missouri and Mississippi. At the end of the war he was superintendent of West Point.

Culp's Hill

The northeastern anchor of the Union position at the Battle of Gettysburg, it was the scene of especially heavy action on the second and third days of the battle.

Cumberland Gap

This strategic mountain pass on the Tennessee-Virginia line changed hands several times during the war. Federal forces under Ambrose Burnside took it for good on September 10, 1863, capturing a Confederate garrison of 2500 men and 36 guns and severing direct Confederate rail communications between Chattanooga and the east.

Cumming, Alfred *(1829-1910)* Confederate general.

A Georgia-born West Point graduate, Cumming resigned from frontier duty in 1861 and commanded Confederate troops in the Peninsula. He led brigades at Antietam, Mobile, and the siege of Vicksburg; captured and exchanged, he fought at Chattanooga and in the Atlanta Campaign. He was wounded at Jonesboro and discharged.

Curtis, Newton Martin *(1835-1910)* Union general.

Curtis was a New York farmer and lawyer who fought as a captain in the 16th New York at First Bull Run. Steadily promoted, he fought at Cold Harbor, Petersburg, and Fort Fisher, where he was badly wounded and earned a Medal of Honor.

Union general George Crook won postwar fame as an able (and enlightened) Indian fighter.

The Union so valued spy Pauline Cushman's work that she was made an honorary major.

Curtis, Samuel Ryan *(1805-1866)*
Union general.

This West Point graduate and civil engineer resigned his Iowa Congressional seat in 1861. As commander of the Army of the Southwest, he won at Pea Ridge and occupied

Still a lieutenant when this photograph was taken, cavalry leader George Custer would be promoted faster than any Union officer, rising to the rank of major general by 1865 and becoming a national celebrity.

Helena, then commanded successively the Departments of Missouri, Kansas, and the Northwest.

Cushing, William Barker
(1842-1874) **Union naval officer.**

He resigned from Annapolis in 1861 and joined the North Atlantic blockading squadron. Cushing performed brilliantly in Florida and the Carolinas, destroyed the Confederate ram *Albemarle* in a daring night torpedo attack made in a small boat in October 1864 and led an assault of sailors at Fort Fisher.

Cushman, Pauline *(1835-1893)*
Union spy.

Born in Louisiana and raised in Michigan, this actress turned spy and was sent south in 1863 to gather military intelligence. Arrested near Tullahoma, Tennessee, and sentenced to death by the Confederates, she was spared by their sudden retreat and so was able to pass on valuable information to Union General William Rosecrans during his Tullahoma Campaign in mid-1863.

Custer, George Armstrong
(1839-1876) **Union general.**

Young, flamboyant, and controversial, Custer compiled an outstanding war career, fighting in virtually every battle of Army of the Potomac from First Bull Run until the surrender at Appomattox. His greatest triumph was his relentless pursuit of Lee's retreating army in April 1865: Custer accepted the Confederate truce flag. His postwar campaigns on the plains ended in the fatal 1876 ambush at the Little Big Horn. (*See* also BATTLE MOUNTAIN, BEAVER DAM STATION, NAMOZINE CHURCH, and WAYNES-BORO).

Dabney's Mills
(Also called Hatcher's Run and Boydton Road

During the siege phase of his Petersburg Campaign, Ulysses S. Grant ordered D. M. Gregg's Federal cavalry to strike enemy supply wagons on the Boydton Plank Road; Gregg had no success. From February 5-7, 1865, there was fighting in the area, particularly on the 6th, when Confederates attacked Gouveneur Warren's division near Dabney's Mills and inflicted 2300 casualties. By the 7th the Federal siege lines extended to Hatcher's Run at the Vaughan Road.

Dahlgren Guns

Admiral John Dahlgren designed this weapon, dubbed the 'soda water bottle' on account of its shape. Primarily a naval gun, Dahlgrens were manufactured in 9-, 11-, 15- and 20-inch calibers. All the Dahlgren guns were smoothbores but were designed to fire either solid or explosive ammunition.

Dahlgren, John Adolphus
Bernard *(1809-1870)* **Union admiral.**

Son of the Swedish consul in Philadelphia, he became a US naval ordnance officer. He invented the Dahlgren Gun (*See*). Dahlgren was appointed commander of the Washington Naval Yard in 1861 and in 1862 was named chief of the Ordnance Bureau. After July 1863 he commanded the South Atlantic Blockading Squadron, sealing Charleston and helping capture Savannah before finally entering Charleston in February 1865. Ulric Dahlgren (*See*) was his son.

Dahlgren, Ulric *(1842-1864)*
Union army officer.

The son of the admiral who invented a widely used naval gun, he served as a staff officer with Ambrose Burnside, Joseph Hooker, and George Meade successively. Wounded after Gettysburg, he had a leg amputated. He was killed during the notorious Kilpatrick-Dahlgren raid (*See*), of which he was the co-leader, in March 1864.

Dahlgren Papers

These documents, which detailed a plan to assassinate Jefferson Davis and his cabinet, were allegedly found on the body of Colonel Ulric Dahlgren (See), killed in the Kilpatrick-Dahlgren Raid of late February-early March 1864 (See). There were claims the papers had been forged, but recent research suggests they were authentic.

Dallas (*Georgia*), Battle of

Confederate General Joseph Johnston, continuing his resistance to W. T. Sherman's 1864 Atlanta Campaign, threw his forces in the path of Federals attempting to envelop him through Dallas. In heavy fighting on June 25 the Federals failed to break through. On the 27th another several hours of battle were inconclusive but costly, including some 1400 Federal casualties. Frustrated in his envelopment, Sherman then tried a disastrous direct assault the same day on Johnston's position at Kenesaw Mountain (See).

Dalton (*Georgia*) Federal Demonstration on

On February 22, 1864, Union General George Thomas's Federals in Chattanooga began a reconnaisance of Joseph Johnston's Confederate army at Dalton, Georgia, to see if Johnston was still at full strength. After driving Confederates from Varnell's Station and Tunnel Hill, the Federals failed to break through Buzzard Roost Gap on the 25th. Finding that the Confederates were still strong, the bluecoats withdrew on the 26th. W. T. Sherman's Atlanta Campaign followed soon after this action.

'Damn the Torpedoes'

Admiral David Farragut is said to have made the comment as his fleet ran past Fort Gaines and Fort Morgan during the Battle of Mobile Bay on August 5, 1864.

In October 1864, outside Petersburg on the Darbytown Road, Union troops repel a Rebel attempt to turn the Federal flank.

Dana, Napoleon Tecumseh Jackson (*1822-1905*) Union general.

This West Point graduate and Mexican War veteran became a Minnesota banker. He fought at Ball's Bluff, on the Peninsula, and at Antietam. He commanded Philadelphia's defenses during the Gettysburg Campaign. He also led a successful expedition against the Texas coast in 1863.

Darbytown and New Market Roads, *Virginia*

During the 1864 Federal siege in the Petersburg Campaign, Robert E. Lee's Confederates made an unsuccessful attempt on October 7 to recapture Union-held positions on these roads.

Davidson, John Wynn (*1823-1881*) Union general.

A Virginian, West Point graduate and career cavalryman, Davidson declined a Confederate commission in 1861. He fought with the Federals on the Peninsula and commanded Missouri districts and departments, a cavalry division in the Arkansas expedition, and the Division of the West Mississippi.

Davis & Davis Escape from Harper's Ferry

During the Antietam Campaign, Dixon S. Miles's Union forces were surrounded at Harper's Ferry. On September 14, 1862, Colonel B. F. Davis of the 8th New York Cavalry and Lieutenant Colonel Hasbrouck Davis of the 12th Illinois Cavalry led a column of 1300 Federal cavalry in a spectacular escape; they reached Greencastle, Pennsylvania, without losing a man, incidentally capturing a Confederate ammunition train with a 600-strong escort along the way.

Davis, Charles Henry (*1807-1877*) Union admiral.

This Massachusetts-born naval officer helped plan Union naval war strategy. He held commands in the Port Royal Expedition and in

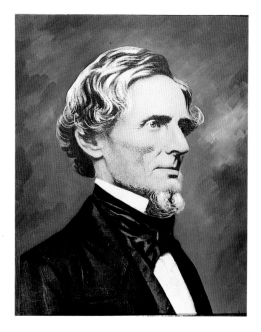

CSA President Jefferson Davis was a mixed blessing to the Confederacy, dedicated and brave but also quarrelsome and inflexible

the upper Mississippi gunboat flotilla, fighting at Memphis and Vicksburg and on the Yazoo River. Davis was chief of the Bureau of Navigation from July 1862 throughout the remainder of the war.

Davis, Edmund Jackson (*1827-1883*) Union general.

A Texas lawyer stung by losing an election for the secessionist convention, Davis organized a Unionist regiment in Mexico which spent most of the war in Louisiana, unsuccessfully attacking Laredo in 1864. Elected governor of Texas in 1869, Davis presided over a notoriously corrupt carpetbag administration.

Davis, George (*1820-1896*) Confederate attorney general.

He was a North Carolina lawyer who participated in the Peace Conference in Washington in February 1861 but afterward denounced its recommendations. A Confederate Senator and advisor to Jefferson Davis, he became the CSA's attorney general in January 1864.

Davis, Jefferson (*1808-1889*) Confederate president.

One-time United States secretary of war, Congressman, and Senator, Jefferson Davis ended his political career as the president of the Confederacy. In his public and private life he seemed to embody many of the elements that both made and unmade the Southern cause. Born in Kentucky, he was taken as a child to Mississippi, where his father was a farmer. In 1824 he gained an appointment to the US Military Academy.

After graduation in 1828 Davis served as an officer in remote posts in Wisconsin and Illinois, seeing a little action in the Black Hawk Indian War of 1832. The former commandant at one of his early posts was future President Zachary Taylor, whose daughter Davis married against her father's wishes;

she died within three months. For the next decade Davis remained in isolation, running a plantation in Mississippi. During this period he came to identify with the Southern plantation mentality – the social system (including slavery), pride in one's State, and a feeling that the South must be allowed to choose its own ways. Encouraged by an older brother, Joseph, a man of some wealth and influence, Davis ran successfully for the House of Representatives in 1845. In the same year he married Varina Howell, daughter of one of the local planter aristocrats.

Davis was in Washington only a few months before he resigned his seat to fight in the Mexican War; he saved the day at the Battle of Buena Vista, gaining national attention and confirming his vision of himself as an outstanding military man. In 1847 he returned to Washington as a Senator; he became a staunch defender of slaveholding and advocated extending slavery into new territories. President Franklin Pierce appointed Davis secretary of war in 1853, and during an active and successful tenure Davis took an expansionist approach to foreign affairs, one that he saw as consonant with the Southern desire to extend slavery. He then returned to the Senate.

For all his defense of slavery and the Southern way of life, Davis was opposed to seces-

President and Mrs. Jefferson Davis, as they appeared soon after the war's end. He was at this time still under arrest.

sion and continued through the Democratic conventions of 1860 to urge some type of compromise. With the election of Lincoln, however, and upon the new president's declaration that he was opposed to adding more slaveholding territories, Davis saw no alternative to going along with secession and formally withdrew from the Senate on January 21, 1861.

His ambition was to command the Southern armies, but he was soon asked to become the Confederacy's provisional president – mainly because the delegates could not agree on any other candidate – and was inaugurated on February 18, 1861, becoming regular president the next year. He faced immense challenges. The Southern states were unprepared for war, lacked weapons and resources for large military enterprises, and were subject to a Union blockade that gradually choked off supplies from abroad. Moreover, the states-rights basis of the Confederacy made the position of the central government weak and ambiguous when it attempted to take such necessary actions as drafting troops and levying taxes.

Davis faced other problems, among them his own inflexible nature, hot temper, and ill health. His wife called him 'a mere mass of throbbing nerves.' Nearly everything that transpired during his presidency exacerbated these difficulties. He quarreled constantly with other leaders civilian and military, and with his friends – such as cabinet secretary Judah Benjamin – and tended to be unpopu-

lar with Southerners. He often elevated mediocre generals (such as Braxton Bragg) and held down outstanding ones (such as Nathan B. Forrest), and, overrating his own military prowess, insisted on telling his generals how to run the war, the notable exception to this being Robert E. Lee, whom Davis trusted thoroughly. Toward the end of the war, with the Confederacy on the brink of collapse, Davis caused widespread outrage with a proposal to draft 40,000 slaves and free them after the war – in other words, to emancipate these slaves.

Davis put up a brave and hopeful front to the end, even declaring, as the Confederate government fled Richmond, that victory was assured. Davis was soon captured by Federal forces, on May 10 near Irwinville, Georgia, and clapped in irons at Fort Monroe, Virginia. Before long, however, he was given comfortable quarters that he shared with his wife. Despite many demands for it, he was never prosecuted for treason but simply released on bond in May 1867. His home, health, and fortune lost, he spent some time traveling in Europe and eventually regained some equilibrium. He settled with his family at an estate on the Gulf of Mexico, where he wrote an account and defense of the Confederacy. Mississippi wanted to return him to the Senate, but could not because he refused to request an official pardon from the Federal government – a position typical of his inflexible sense of honor. He died in New Orleans on December 6, 1889.

Davis, Varina Howell (1826-1906)

Wife of Jefferson Davis.

Born in Mississippi, she married Davis in 1845 and forged an intellectual and political partnership with him. As first lady of the Confederacy she was controversial because of her Northern ancestry and considerable political influence.

The inauguration of Jefferson Davis at the statehouse in Montgomery, Alabama, in 1861.

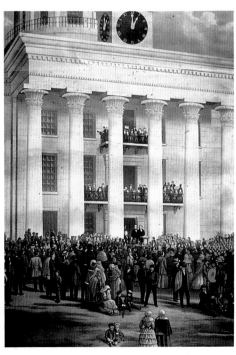

Dayton, *Virginia*

In October 1864, in retribution for the murder of one of his staff officers, Union General Philip Sheridan ordered the burning of all houses within fives miles of this Shenandoah Valley village. He calmed down and changed his mind, however, and ordered instead the taking of all able-bodied men in the area as prisoners of war.

Decorations

The Civil War saw the creation of the first individual military decorations to award gallantry or merit, including the Medal of Honor. Other Federal decorations included the Fort Sumter and Fort Pickens Medals, the Kearny Medal and Kearny Cross, and the Butler Medal, awarded to black troops. The Confederate government was unable to supply medals and emblems for the decorations it planned and instead simply published a Roll of Honor after each battle.

Deep Bottom Run *(Virginia),* Battles of

The first battle of Deep Bottom Run, Virginia, was a Union operation to draw off Southern troops prior to the Petersburg Mine Assault and/or to fight into Richmond, if feasible. Federal units attacked along Deep Bottom Run on July 27, 1864, but stiff Southern resistance frustrated the advance. On the 28th Philip Sheridan's cavalrymen made some gains, enough to draw Rebel strength from Petersburg as planned, but made no headway toward Richmond. The second operation, also part of the Petersburg siege, came the next month. It involved another Federal attack in force on supposedly weak defenses at Deep Bottom. In a series of encounters beginning on August 13 Confederate defenses once again proved unexpectedly strong, and the Union offensive gained nothing significant. By the 20th the North had suffered 2899 casualties, the South probably less than half that.

Democratic Party

The modern Democratic Party grew out of the political organization that Andrew Jackson assembled when he gained the presidency in 1828; during the next three decades Democrats tended to control both the presidency and Congress. Although the party was fairly well united in its belief in states' rights and limited central government, its varied supporters did not agree on much else. Particularly divisive was the issue of slavery, and despite the efforts of leading Democrats to work out compromises, the party was clearly splitting into Northern and Southern wings. In 1860 the Northerners nominated Stephen A. Douglas, but the Southern Democrats went off and nominated John C. Breckinridge. This allowed the candidate of the recently formed Republican Party, Abraham Lincoln, to gain the presidency. During the war, 'Peace Democrats' opposed Lincoln and the war, while 'War Democrats' supported both. With the end of the war and the institution of Reconstruction policies by Republicans, the South in general adopted the Democratic Party as its own, giving rise to a 'Solid (*i.e.,* solidly Democratic) South' that would survive until the 1970s.

Denver, James William *(1817-1892)* Union general.

By 1861 he had been a lawyer, newspaper editor, California legislator, and Kansas Territory Representative and governor. He held commands in Kansas and the Army of the Tennessee and fought at Shiloh and Corinth, resigning in March 1863. Denver, Colorado was named after him.

Departments

Both Union and Confederate armies organized territory into departments, generally naming their field armies after the departments they operated in. A department could consist of all or part of a single state (Department of Maryland); a group of states (Department of New England); a broad geographical area (Department of the West); or a key city or region (Department of Norfolk, Department of the Potomac). Departments were grouped into larger territorial units called divisions.

Desertions

Wartime desertions were numerous on both sides as a result of inadequate food and clothing, the impoverishment of soldiers' families, the Union bounty system (*See* BOUNTY JUMPERS), and, among the Confederates, the inevitability of defeat. Neither conscription nor amnesties on both sides were able to solve the manpower problem: Union desertions totalled 268,000 men, while Confederate absenteeism rose steadily, an estimated two-thirds of Southern soldiers having abandoned their ranks by 1864.

Devall's Bluff, *Arkansas*

Several minor actions were fought at this place on the White River. On July 6, 1862, 2000 Federal troops broke up a body of 400 Confederate cavalry, inflicting more than 80 casualties. In early January 1863 about 10,000 Federals advanced westward up the White River while Union cavalry approached from the opposite direction, a pincer operation that yielded both supplies and prisoners.

Devens, Charles *(1820-1891)* Union general.

A Harvard-educated lawyer and Massachusetts public official, Devens was a commander in the Army of the Potomac. He was wounded at Ball's Bluff, Fair Oaks and Chancellorsville, fought at Fredericksburg and Cold Harbor, and led the advance on Richmond. Camp Devens, Massachusetts, is named for him.

Dewey, George *(1837-1917)* Union naval officer.

This Vermont-born Annapolis graduate held junior commands on the old side-wheeler *Mississippi* at New Orleans and Port Hudson, on Farragut's lower Mississippi flagship *Monongahela*, and on the *Colorado* at Fort Fisher. He later achieved international fame by his great victory at Manila Bay in 1898.

'Dictator'

The Union army used this 13-inch seacoast mortar in the siege of Petersburg in 1864. The Dictator could sent a 200-pound projectile a maximum 4325 yards. From July 9 to 31, 1864, it sent 45 rounds into the Petersburg lines from its flatcar mount on the Petersburg & City Point Railroad.

Divers, Bridget Union Army nurse.

This vigorous Irishwoman accompanied her husband to war with the 1st Michigan Cavalry. A vivandière, nurse, and Sanitary Commission agent, 'Michigan Bridget' fre

A captured Union deserter is hanged outside Petersburg in June 1864. Despite the threat of such punishment the rate of desertion in both armies mounted steadily.

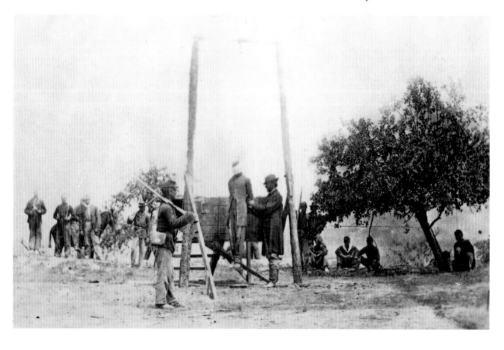

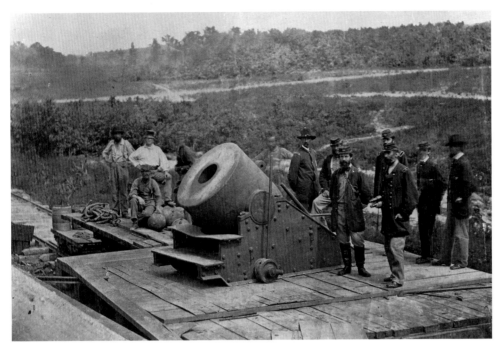

The Dictator, the big flatcar-mounted Union mortar used in the siege of Petersburg.

quently fought with her regiment and at Cedar Creek rode through enemy lines.

Dix, Dorothea Lynde *(1802-1887)*
Social reformer.

She reformed the treatment of the insane, establishing many state hospitals for their care. Superintendent of Women Nurses throughout the war, she hired and closely supervised female nurses. Her authoritarian style, lack of administrative experience, and broad interpretation of her duties made her a controversial figure.

Dorothea Dix began her crusade to reform treatment of the insane in the 1840s when she wrote an influential memorial about the subject to the Massachusetts legislature.

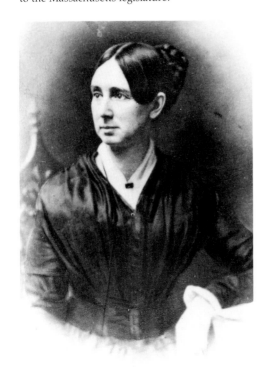

Dix, John Adams *(1798-1879)*
Union secretary of the treasury and general.

Dix was a powerful lawyer and Democratic force in New York. As Lincoln's secretary of the treasury (January-March 1861) he laid a sound basis for financing the war and issued the American Flag Dispatch (*See*). Commissioned a major general, he later commanded VII Corps and the Departments of Virginia and of the East.

'Dixie'

The origins of this common name for the South are obscure. The song of this title was composed by Daniel Emmett, a minstrel and son of an Ohio abolitionist, who first performed it in New York in 1859. The Confederacy appropriated 'Dixie' as a war song, first playing it officially at Jefferson Davis's inauguration in February 1861. The song was also popular in the North. Indeed, it was reported to have been one of President Abraham Lincoln's favorite melodies.

Dodge, Grenville Mellen *(1831-1916)* **Union general.**

A Massachusetts native, he was an Iowa engineer and merchant whose important contributions to the Federal army included construction of numerous bridges and railroads. Dodge held a series of commands in the Armies of Southwest Missouri and the Tennessee. He was wounded at both Pea Ridge and Atlanta.

Donelson, Daniel Smith *(1801-1863)* **Confederate general.**

A West Point graduate, Donelson was a Tennessee planter and secessionist legislator who built Fort Donelson (*See*) while in the provisional army. As a brigadier general he led brigades in West Virginia and at Perryville, Stone's River, and Shelbyville before commanding the Department of East Tennessee. Sources disagree on the place and circumstances of his death.

Double Shotting

In a crisis the charge of canister, grape, or even solid shot fired from an artillery piece could be doubled. 'Double shot those guns and give 'em hell,' General Zachary Taylor was said to have ordered Captain Braxton Bragg at the Mexican War Battle of Buena Vista in 1847.

Doubleday, Abner *(1819-1893)*
Union general.

This Mexican and Seminole Wars veteran aimed the Federals' first shot from Fort Sumter. He won successive promotions through the Shenandoah Valley Campaign of Jackson, Second Bull Run, South Mountain, Antietam, and Fredericksburg. At Gettysburg he led John Reynolds's corps after the latter was killed, but, failing to get the permanent command, he served out the war in administration. Historians agree that Doubleday had nothing of any significance to do with baseball, although he is popularly credited with 'inventing' the game in 1839.

Douglas, Stephen Arnold *(1813-1861)* **Statesman.**

Born in Vermont, he was a Democratic Senator from Illinois whose brilliant oratory made him the nation's foremost advocate of compromise in the prewar years. He was, along with Henry Clay, instrumental in confecting the Compromise of 1850, and his chairmanship of the Committee on Territories put him at the heart of the national debate on slavery; he articulated the doctrine of popular sovereignty (*See*) during the Kansas-

Stephen A. Douglas, one of the few truly great US statesmen of the prewar era.

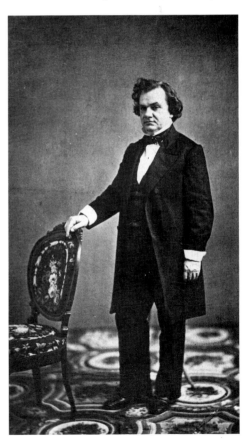

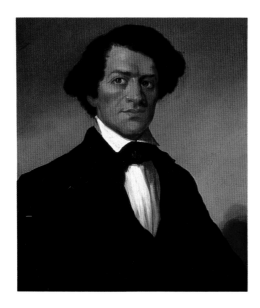

Born a slave, Frederick Douglass ended his exemplary career as US minister to Haiti.

A PUBLIC MEETING WILL BE HELD ON THURSDAY EVENING, 2D INSTANT, at 7 o'clock, in ISRAEL CHURCH, to consider the atrocious decision of the Supreme Court in the DRED SCOTT CASE, and other outrages to which the colored people are subject under the Constitution of the United States. C. L. REMOND, ROBERT PURVIS, and others will be speakers on the occasion. Mrs. MOTT, Mr. M'KIM and B. S. JONES of Ohio, have also accepted invitations to be present. All persons are invited to attend. Admittance free.

Nebraska Act debates (1854). Although he won a Senate race against Lincoln in 1858, their debates propelled his unknown opponent to national prominence. After losing the 1860 presidential race Douglas made public shows of support for Lincoln, finally abandoning his compromise stance after the attack on Fort Sumter and endorsing the president's call for volunteers. He died of typhoid fever on a northwestern tour to rally support for the war.

Douglass, Frederick (c. 1817-1895)
Abolitionist.

Douglass was born into slavery as Frederick Augustus Washington Bailey. Having been taught to read by his master's wife, he escaped in 1838, becoming a Massachusetts Anti-Slavery Society lecturer. He published an autobiography in 1845, then, famous and fearful of arrest as a fugitive slave, went to England, returning in 1847 to buy his freedom and found the abolitionist paper *North Star*. Douglass persuaded Lincoln to allow blacks to fight in the Civil War and personally recruited black troops. The most famous black man of his age, Douglass remained a powerful champion of civil rights until his death in 1895.

Draft Riots

In August 1862 President Lincoln authorized states to fill their enlistment quotas with draftees if there were not enough volunteers. This led to some unrest in the North, but nothing like what happened after the Enrollment Act of March 3, 1863, which mandated the three-year enlistment of all able-bodied men between 20 and 45. The bill also provided that those who had the money could buy their way out of service. It was largely this provision that touched off the ensuing wave of riots.

In New York City, soon after the first draft drawing, resentment boiled over into a four-day riot that began on July 12, 1863. A mob of over 50,000 people, most of them Irish working men, swarmed into the city draft office, setting it afire and nearly killing its super-

intendent. Over the next days the rioters burned an evacuated black orphanage and the offices of Horace Greeley's pro-war *Tribune*. Increasingly, the violence was directed toward blacks, who were attacked and killed at random, but the rioters also burned and looted businesses, beat to death a Union colonel, and assaulted the home of the mayor. At length Federal troops quelled the mob, leaving over 1000 dead and wounded in the darkest homefront episode of the war and the worst race riot in American history. Less serious riots broke out in Boston and other towns in the East and in Ohio.

Dragoon

The term denotes a cavalryman who dismounts to fight. With some exceptions, American cavalry fought dragoon-style – that is to say, essentially as mounted infantry – during the Civil War.

The Supreme Court's decision in the 1857 Dred Scott case outraged many Northerners.

Drayton, Thomas Fenwick (1808-1891) Confederate general.

A South Carolina planter and legislator with substantial previous army experience, Drayton proved an ineffectual field commander. He directed the defense of Port Royal, led brigades at Second Bull Run, South Mountain, and Antietam, and, after brief court martial duty, assumed various commands in both Arkansas and Texas.

Dred Scott Decision

Scott was a slave whose Missouri master took him (from 1834 to 1838) both to Illinois, a free

Federal troops open fire on the mob during the 1862 New York City draft riot.

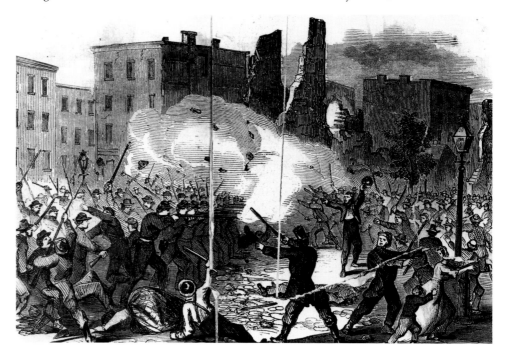

state, and to the Wisconsin Territory, where the Missouri Compromise prohibited slavery. Back in Missouri in 1846, Scott sued for his freedom, arguing that residence in free territory had annulled his enslavement. In *Scott v. Sandford* (1857) the Supreme Court ruled against Scott. Its major holdings, articulated in Chief Justice Roger B. Taney's majority opinion, were that slaves were not citizens and were not entitled to sue in US courts, and that Congress could not prohibit slavery in territories – which in effect meant that the Missouri Compromise of 1820 was unconstitutional. The Court's inflammatory endorsement of slavery in this decision hastened the coming of the Civil War.

Drewry's Bluff (*Virginia*), Battle of

As part of Ulysses S. Grant's overall plan to win the war in the summer of 1864, Federal General Benjamin Butler was ordered to take his Army of the James up the Virginia peninsula between the James and Appomattox rivers toward Richmond. Butler began landing his army from the James on May 5. At that point Richmond was highly vulnerable to attack, but Butler moved cautiously and ponderously as P. G. T. Beauregard organized Southern resistance. Arriving at the defenses of Drewry's Bluff, Butler spent the 15th arranging his own defenses – notably, for the first time in war, wire entanglements made out of scavenged telegraph wire. In a full-scale battle on the 16th the entanglements worked quite well, but Butler nevertheless ordered a retreat well before it was clear that he was actually beaten. The result was that Beauregard was able to keep Butler's army bottled up on the peninsula for the rest of the campaign.

Dumfries Raid of Stuart

This was the last and most elaborate of several raids by Confederate cavalry leader J. E. B. Stuart against supply lines of the Army of the Potomac under Ambrose Burnside. Stuart left Fredericksburg, Virginia, with 1800 men and four guns on December 26, 1862, and headed east. His columns attacked a Union garrison at Dumfries and overran enemy camps at Occoquan, meanwhile skirmishing and stealing horses and supplies. Capturing a Union telegraph at Burke's Station, Stuart sent a cable to Washington complaining about the quality of captured mules. He rejoined Robert E. Lee on the 31st, not long after the Battle of Fredericksburg, with some 200 captured prisoners, many horses, and other equipment.

Dupont, Samuel Francis (*1803-1865*) Union admiral.

Born in New Jersey, DuPont was a career naval officer. The first commander of the South Atlantic Blockading Squadron, he enforced the blockade in 13 of 14 stations, capturing Port Royal (*See*) in November 1861, seizing ships, forts, and islands, occupying the Georgia sounds, and taking Jacksonville and St. Augustine. DuPont retired after suffering the worst Union naval setback of the war in his assault on the Charleston harbor forts in April 1863.

Dutch Gap Canal

In the summer of 1864, as part of Ulysses Grant's advance on Richmond, General B. F. Butler ordered a canal to be cut at Dutch Gap, Virginia, to enable Union gunboats to bypass Confederate water batteries on the James River. Black troops were assigned most of the work. They completed the canal only in April 1865, too late to be used militarily and one more of Butler's dubious achievements.

Dyer Projectile

Made of cast iron, this 3-inch explosive projectile carried a corrugated cap at the tip that channeled flame from the propellant charge to ignite the fuse.

Early, Jubal Anderson (*1816-1894*) Confederate general.

Early was a Virginia-born West Point graduate, lawyer, and state legislator. Nicknamed 'Old Jube' or 'Jubilee,' he held commands in all the 1861-64 campaigns of the Army of Northern Virginia, after June 1864 leading an independent corps in Early's Washington Raid (*See*) and raids in the Shenandoah Valley. Defeated by Philip Sheridan and routed by George Custer at Waynesboro in March 1865, he lost his command.

Early's Washington Raid

In the summer of 1864 Robert E. Lee, besieged in Petersburg, ordered Jubal Early and 17,000 Confederates to embark on a raid toward Washington that was intended to draw Union forces from the siege. Early crossed the Potomac on July 5 and headed

The massive (and, as it turned out, useless) Dutch Gap Canal under excavation.

north through Maryland. Washington broke into panic, and an unwilling Ulysses Grant was in fact obliged to detach a few units from Petersburg. On July 11 Early reached Silver Springs, Maryland, on the outskirts of Washington. (During skirmishes around Fort Stevens, President Lincoln twice stood on the parapets and watched as the bullets flew.) Finding the defenses of the city too strong, Early withdrew on the 12th and headed back to Virginia. That in the end the raid accomplished so little was largely due to Grant's steadfast refusal to be impressed by it, but Grant did nevertheless dispatch Philip Sheridan on his Shenandoah Valley Campaign the following month in part to ensure that no such future raids would occur.

Eaton, John Jr. *(1829-?)*
Union officer.

He entered the service as chaplain of the 27th Ohio in August 1861. Ulysses Grant chose him in November 1862 to direct aid programs for contrabands (*See*) in the departments Tennessee and Arkansas. He later became Freedman's Bureau commissioner for Washington, DC, Maryland, and parts of Virginia.

Echols, John *(1823-1896)*
Confederate general.

Echols was a Harvard-educated Virginia lawyer. He fought at First Bull Run, in the Shenandoah Valley Campaign of Jackson, at New Market, and at Cold Harbor and commanded the District of Southwest Virginia and the West Virginia Department.

Edged Weapons

This classification includes bayonets, sabers, swords, cutlasses, knives, pikes, and lances. Even bayonets (*See*) and cavalry sabers, the

Below: Elmer E. Ellsworth.
Below right: A commemorative version of the Emancipation Proclamation.

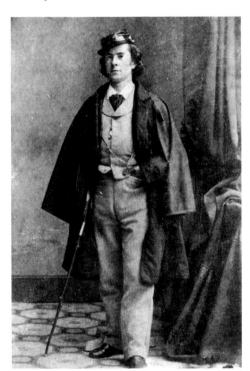

most widely used edged weapons, inflicted few casualties during the Civil War. In practical terms, a sword's chief purpose was to symbolize an officer's authority.

Edmonds, Sarah Emma Evelyn *(1841-1898)* **Union soldier.**

As a runaway adolescent Edmonds sold Bibles disguised as 'Frank Thompson,' the same name she used to join the 2nd Michigan in 1861. She fought in the 1861-62 Potomac Army campaigns, deserting in 1863; later pensioned by the army, she joined the Grand Army of the Republic.

Ellsworth, Elmer Ephraim *(1837-1861)* **Union officer.**

As a young Chicago lawyer Ellsworth organized and toured nationally with a Zouave troop before the war. In May 1861 his New York Zouave regiment helped to take Alexandria, where he was killed in a dispute. A friend and election aide of Lincoln, Ellsworth was the first prominent Union casualty of the Civil War.

Elmira (*New York*) Prison

Opened in a former Union barracks in May 1864 after the prisoner exchange system broke down, it could house only half its 10,000 Confederate captives indoors. The rest lived in tents, even in the severe upstate New York winter. The death rate at Elmira averaged about 5 percent a month.

Emancipation Proclamation

Lincoln's great proclamation pronounced all slaves in areas still in rebellion 'forever free.' Applying only to areas where Lincoln's government lacked jurisdiction, the Proclamation actually emancipated no one. It did, however, turn the war from a campaign to preserve the Union into a crusade to free the slaves. It also marked Lincoln's abandon-

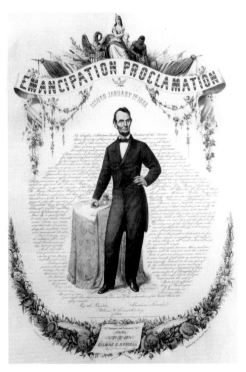

Marine engineer John Ericsson in 1865. His *Monitor*, a steam-driven ironclad vessel with a revolving gunturret, revolutionized international warship design.

ment of his own hope for gradual emancipation. The Proclamation was issued five days after the Battle of Antietam in September 1862, and took effect on January 1, 1863. Southerners and Northern conservatives were predictably outraged, but support for the Union surged in the North and abroad. The 13th Amendment, passed in December 1865, legalized national emancipation.

Enchantress Affair

The Confederate privateer *Enchantress*, carrying prize master Walter W. Smith and a crew from CSS *Jeff Davis*, was captured by Union authorities on July 22, 1861, and her crew was convicted of piracy. The Confederate secretary of war retaliated by ordering 14 Federal prisoners designated as hostages for Smith and the crew of another captured Confederate privateer. The convictions were overturned, however, the courts ruling that the Confederate crews were not pirates, but prisoners of war.

Enfield Rifle

The Union imported more than 500,000 examples of this muzzle-loading British Army rifle, and Confederate arms agents bought tens of thousands more for the Southern service. The Enfield, the British Army's standard rifle from 1855 to 1867, fired a .577-caliber bullet with remarkable accuracy at ranges of up to 1000 yards. With bayonet, it weighed 9 pounds, 3 ounces.

Enrollment Act

The US Congress approved this draft measure on March 3, 1863. It provided for the conscription, for a term of three years, of all able-bodied male citizens of ages 20 to 45. In fact, because of exemption loopholes, it supplied only 175,000 new soldiers in 1863-64. In February 1864 Lincoln called for the conscription of an additional 500,000 men.

Famed orator Edward Everett was an eminent educator, diplomat, and public servant.

Ericsson, John *(1803-1889)*
Marine engineer.

Swedish born, he moved in 1840 to America. His numerous military and naval inventions included the screw propeller and a recoil mechanism for gun carriages. Ericsson designed the *Princeton* (1840), the first warship with underwater propelling machinery, and in 1861 designed and built the *Monitor*, an ironclad ship with a revolving gun turret. After the *Monitor's* victory over the *Merrimac*, Ericsson designed other ironclads.

Etheridge, Anna Blair *(b. 1844)*
Union army nurse.

Born in Detroit, 'Gentle Annie' enlisted with the 2nd Michigan and tended Michigan regiments throughout the war, often working under fire and once being wounded. She earned the Kearney Cross for bravery.

Everett, Edward *(1794-1865)*
Statesman.

In his distinguished public service career, Everett was noted for brilliant oratory. His many wartime lectures throughout the North rallied support for the government and were

The final surrender of Confederate General Richard Ewell's corps after the Battle of Sayler's Creek, April 6, 1865.

judged by some to be Everett's primary achievement; the most famous was his two-hour speech preceding Lincoln's brief Gettysburg address.

Ewell, Richard Stoddert
(1817-1872) **Confederate general.**

Born in Washington, DC, this West Point-trained career officer, one of the South's 'fighting-est' commanders, fought at First Bull Run. As a major general he won victories at Winchester and Cross Keys in the Shenandoah Valley Campaign of Jackson and participated in the Peninsular Campaign and the Battles of Cedar Mountain and Second Bull Run. Despite losing a leg at Groveton, he led II Corps at Gettysburg, the Wilderness, and Spotsylvania. He was captured by Philip Sheridan at Sayler's Creek in April 1865.

Ewing, Thomas Jr. *(1829-1896)*
Union general.

He was a Kansas lawyer, antislavery activist, and delegate to the 1861 Peace Convention in Washington. Ewing recruited the 11th Kansas, fought in Arkansas, and as a brigadier general commanded the Border District (where he issued Order No. 11, which depopulated western Missouri) and St. Louis.

Exchange of Prisoners

Early in the war prisoners were released on parole (*See*). An agreement on the formal exchange of prisoners was concluded on July 22, 1862. Internal policy disagreements and differing policies of successive commanders-in-chief had largely halted exchanges by the time Ulysses Grant assumed command and suspended them altogether, but the South, overwhelmed by the number of Federal prisoners, began releasing them in 1864.

Ezra Chapel *(Georgia)*, Battle of

In this action of the Atlanta Campaign the Confederate commander John Bell Hood attempted to parry W. T. Sherman's bid to cut his lines of communication to the south. Heavy fighting broke out at 2:00 pm on July 28, 1864, and continued until after dark, when Hood withdrew into the Atlanta defense lines, having lost nearly 5000 men. The battle is also known as the Battle of Ezra Church and as Hood's Third Sortie.

Fair Oaks and Seven Pines *(Virginia)*, Battles of

As Union General George B. McClellan's Peninsular Campaign closed in on the Confederate capital of Richmond, Virginia, from the east in May 1862, Erasmas D. Keyes's IV Corps became isolated south of the rain-swollen Chickahominy River. Southern General Joseph E. Johnston decided to attack that isolated corps. The main thrust of the attack was given to James Longstreet, who was to envelop Keyes's right flank, cutting him off from the Federals north of the river.

The plan, however, snarled around dawn on March 31 when Longstreet took the wrong road, entangling his troops with two other units. The Southern attack finally got underway just after noon. Though disjointed, it made some headway, driving the enemy left flank back through the village of Seven Pines (which is the Confederate name for the battle). Then the Federals, with the help of reinforcements sent by McClellan (Edwin V. Sumner's II Corps), stopped the Confederates at Fair Oaks. Johnston was severely wounded in the fighting. On the next day further Confederate attacks were ordered, but in confused fighting these made no headway. By the end, of close to 42,000 engaged on both sides in the battle, the North had suffered 5031 casualties and the South 6134. At midday on June 1 a new Southern general arrived to break off the fighting and take over from the wounded Johnston. This was Robert E. Lee, who would command the Army of Northern Virginia thereafter.

Fairfax Court House, *Virginia*

While Robert E. Lee's main army was invading Pennsylvania, J. E. B. Stuart's Confederate cavalry attacked and broke up two companies of the 11th New York Cavalry here on June 27, 1863; only 18 Federals escaped death or capture. This was the largest of several small encounters that took place at Fairfax Court House during the war.

Falling Waters, *West Virginia*

Two Union cavalry divisions attacked a Confederate rearguard here on July 14, 1863,

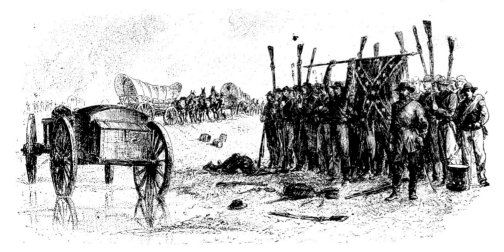

during Lee's retreat from Gettysburg. Henry Heth, the Rebel commander, managed to withdraw in fair order, even though he lost two guns and some 500 stragglers.

Farmville and High Bridge, *Virginia*

As the Confederate General James Longstreet retreated toward Farmville on the night of April 6, 1865, remnants of Richard Ewell's and Richard Anderson's beaten corps crossed the Appomattox River at nearby High Bridge (actually two bridges, one for the railroad and the other for wagons). William Mahone, commanding the covering division, waited too long to order the burning of the bridges, and Union troops rushed across, speeding the pursuit that ended on April 9 with Lee's surrender at Appomattox.

Farnsworth, Elon John
(1837-1863) **Union general.**

This Michigan native joined the 8th Illinois Cavalry in September 1861, fighting in every operation of his regiment until his death, serving as acting chief quartermaster of IV Corps and later as Alfred Pleasanton's aide-de-camp. Farnsworth was killed leading a disastrous cavalry charge on the third day at Gettysburg.

Farragut, David Glasgow
(1801-1870) **Union admiral.**

This Tennessee-born career naval officer moved north in 1861 and, despite his inexperience in war, assumed command of the vital New Orleans Expedition (*See*). In a brilliant attack in April 1862 he succeeded in opening up the Mississippi to Vicksburg, becoming an instant celebrity. He won another famous victory in Mobile Bay (*See*) in

A veteran of the War of 1812, Union Admiral David Farragut was a commander bred in the tradition of England's great Horatio Nelson.

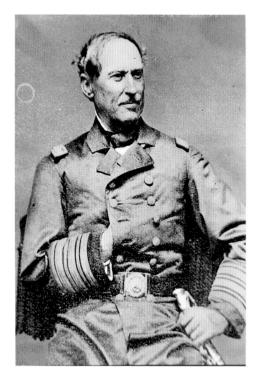

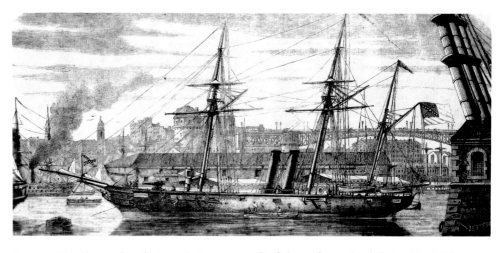

Confederate flag and jack flying, the Rebel commerce raider *Florida* lies at anchor in the neutral French port of Brest.

August 1864; the ranks of vice admiral and then admiral were created to reward him for his stellar accomplishments. Farragut was by far the greatest naval commander of the war and one of the greatest in US history.

Feint

In battle tactics a feint is a pretended attack with the deceptive purpose of drawing the enemy's attention while the real blow is delivered elsewhere.

Ferrero, Edward *(1831-1899)*
Union general.

This Spanish immigrant, a New York dancing instructor and militiaman, fought under Ambrose Burnside in North Carolina, led Potomac Army troops from Second Bull Run through Fredericksburg, and joined Ulysses S. Grant's army at Vicksburg and Knoxville. He won notoriety at the Petersburg mine assault by abandoning the black division after ordering them to charge.

Fessenden, James Deering
(1833-1882) **Union general.**

A Maine lawyer, he trained troops in Virginia in 1861, became General David Hunter's aide-de-camp in the Carolinas in March 1862, and fought at Charleston and in the Chattanooga and Atlanta Campaigns. While on Hunter's staff Fessenden organized the first black Union regiment, which the authorities, however, disbanded.

'Fire-eaters'

These were pre-war radical Southern secessionist politicians. They included Edmund Ruffin, W. L. Yancey, and R. B. Brett; none held high office in the Confederate government or military.

Fisher's Hill *(Virginia)*, Battle of

A battle in the 1864 Shenandoah Campaign of Sheridan. On September 22, after pursuing Jubal Early's fleeing Confederates for two days following the Battle of Winchester, Philip Sheridan struck strong enemy positions at Fisher's Hill with a flank attack, then moved his whole line forward. Early's men were routed once again, but would be back to fight at Cedar Creek. Federal losses were 528, Southern losses over twice that.

Five Forks *(Virginia)*, Battle of

As part of the Appomattox Campaign, in spring 1865 Ulysses Grant ordered Philip Sheridan to outflank the right wing of Robert E. Lee's defenses at Petersburg. On March 30 Rebel cavalry under Fitzhugh Lee repulsed a Federal advance on Five Forks. In the next two days Sheridan was reinforced, and as Confederate forces under George Pickett withdrew toward Five Forks on April 1 the Union general mounted an overpowering assault that captured over half of Pickett's force of some 10,000. This was the turning point of the Siege of Petersburg; on the next day Grant would break through Lee's weakened lines defending the city.

Fixed Ammunition

In this type of ammunition the projectile, propelling charge, igniter, and primer are a single unit – as, indeed, they are in all modern small-arms ammunition.

Flanking Position

As a defensive posture, a flanking position is one that forces an advancing enemy to expose his flanks or line of communications if he continues his forward movement. To assume such a position a defender needs good defensive ground, protection for his own communications, and the ability to strike the enemy on his vulnerable flanks if he continues the advance.

Flintlocks

These muskets used a flint in the hammer to strike a metal plate and produce the spark that ignited the powder. Although percussion firing had made them obsolete, flintlocks were used extensively during the early part of the Civil War.

Florida, CSS

Built for the Confederacy in a British shipyard in 1862, she raided in the Atlantic from New York to Brazil. The USS *Wachusett* captured her off Bahia, Brazil, in October 1864. The Federal vessel towed the *Florida* back to Hampton Roads, where she was scuttled.

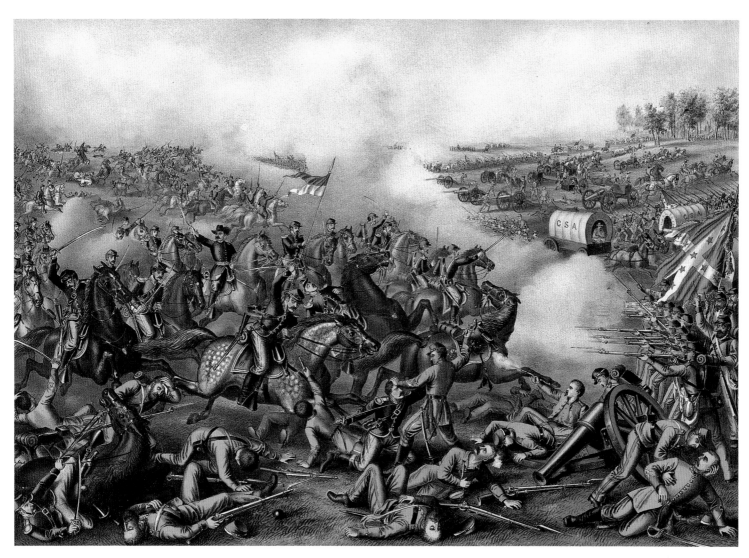

Floyd, John Buchanan
(1806-1863) **Confederate general.**

A pre-war governor of Arkansas and war secretary in President James Buchanan's cabinet from 1857 to 1860, he led a brigade in western Virginia in the early months of the war. He was in command at Fort Donelson, Kentucky, when Ulysses S. Grant approached in early 1862. Floyd turned the fort over to his next in command and had gone by the time Union forces captured the fort on February 15, 1862.

Fogg, Isabella
Sanitary Commission worker.

She joined a Maine regiment as a nurse when her son enlisted in 1861. Fogg served the Army of the Potomac in field hospitals and behind the lines from the Seven Days' Battles through the Wilderness. In January 1865 she was permanently disabled by a fall sustained on a hospital ship.

Food Shortages

Confederate troops and civilians alike were underfed during the war, a problem exacerbated by the Union forces' destruction of crops, livestock, farm implements, and mills in their Southern campaigns. A bread riot in Richmond, Virginia, on April 2, 1863, was dispersed only under threat of militia fire; on September 4 that year hungry women looted

Mobile, Alabama. The Confederate government's confiscation of food supplies in Virginia for Robert E. Lee's troops in January 1864 added to civilians' misery.

Foote, Andrew Hull *(1806-1863)*
Union admiral.

This Connecticut-born naval officer publicly opposed the slave trade in the 1850s. He commanded upper Mississippi naval operations in 1861, fighting at Forts Henry and Donelson, and, invalided, directed the Bureau of Equipment and Recruiting in 1862. Foote died in June 1863 en route to assume command of Samuel DuPont's squadron off Charleston, South Carolina.

Forbes, Edwin *(1839-1895)*
War correspondent and artist.

Sent by *Frank Leslie's Illustrated Newspaper* to illustrate the operations of the Army of the Potomac, Forbes stayed in the field from 1861 to 1864, sending back a series of sketches which he later etched as *Life Studies of the Great Army* (1876).

Force Bills

These were Congressional authorizations for executive use of force. In 1833 President Andrew Jackson asked Congress for authority to enforce the tariff, an early sectional issue dividing North and South. Con-

Union General Philip Sheridan's victory at Five Forks on April 1, 1865, ended the siege of Petersburg and thus doomed the South.

gress approved a force bill in 1870 as a means of blocking Ku Klux Klan efforts to deny blacks the right to vote.

Forrest, Nathan Bedford
(1821-1877) **Confederate general.**

A self-made Memphis businessman with little education and no military training, Forrest enlisted as a private in 1861 and emerged from the war a lieutenant general. His modest explanation of his military success ('I just . . . got there first with the most men') belied real military genius. Forrest raised and equipped a cavalry regiment and escaped with his men through enemy lines at Fort Donelson. He was seriously wounded at Shiloh before beginning a series of raids in Tennessee which made him famous. He fought at Chickamauga and figured in the infamous Fort Pillow Massacre of April 1864 (*See*). He conducted brilliant operations during the Atlanta Campaign and then swung back to participate in the Franklin and Nashville Campaign. After this spectacular string of victories he was defeated at Selma, Alabama, in April 1865 and surrendered in May. Violently pro-slavery, Forrest was Grand Wizard of the newly founded Ku Klux Klan from 1867 until 1869. (*See* also FORREST'S RAIDS and BRICE'S CROSSROADS).

Forrest's Raids

In Murfreesboro, Tennessee, in the summer of 1862, after having served under other commanders, Rebel cavalry leader Nathan Bedford Forrest was given his own command and ordered to raid Union supply lines, which would be his prime task for most of the war. On July 13 Forrest and 1000 cavalrymen surprised a Federal garrison under Thomas Crittenden at Murfreesboro. He captured the entire garrison of 1000 men, as well as supplies worth a million dollars, and wrecked the railroad that was the main Union supply line. Federals under Don Carlos Buell chased Forrest into the Cumberland Mountains and repaired the railroad, but soon the raiders reappeared to cut the line again. By the end of July, Federal operations in Tennessee, especially Buell's intended Chatanooga campaign, were seriously threatened, and Forrest had been made a brigadier general. His raiding in Tennessee would continue through the year.

In west Tennessee in 1862-3, raiding Grant's supply lines during the Federal operations on Vicksburg, Forrest's 2000 riders tore up Grant's rail supply line during the summer, defeated Federal cavalry at Lexington on December 18, and uprooted rails and telegraph lines for miles into Kentucky, meanwhile outfighting or outwitting several enemy garrisons and cavalry detachments. In the process he captured immense stores of equipment and accounted for 2000 Federal casualties. At the end of the year, at Parker's Crossroads, two blue detachments managed to catch Forrest between them. Legend says that when his officers asked him what to do, Forrest replied, 'Charge them both ways!' In any case, that is what happened, his men slowing both enemy wings long enough for the Confederates to escape. The raiding continued into the next year.

At the end of April 1863 Federal General William Rosecrans, harrassed by Forrest during Union operations in Tennessee, sent a mounted column of some 1500 men under Colonel Abel Streight to hunt Forrest down. Instead, Streight found himself under pursuit, chased out of Tennessee and into Alabama. For two weeks the Federals retreated in growing exhaustion. The Confederates were near exhaustion themselves when they found a shortcut that allowed Forrest to get in front of Streight, who then asked for a truce. As the two commanders conferred, Forrest kept his two cannons and his troops circling around; eventually Streight caved in to apparently overwhelming odds. Streight then discovered that he had surrendered his 1466 Federals to Forrest's 500 troopers.

In 1864, after serving unhappily under Braxton Bragg at Chickamauga, Forrest was again given an independent command and began a highly successful series of raids against W. T. Sherman's supply lines as the Federals in Chattanooga prepared for the Atlanta Campaign. Finally Sherman sent some 7000 cavalry under W. Sooy Smith to neutralize Forrest. On February 21 Smith's men were scattered by Forrest near West Point, Mississippi. On the following day, at Okolona, Smith's retreating troopers were overtaken by Forrest and attempted to make a stand. But the 7th Indiana, under withering assault, broke and ran. A series of delaying actions over a nine-mile line covered the Union retreat until 5:00 pm, when the Federals stood up to a Confederate cavalry charge. But this was only a delaying action, the Federals continuing to withdraw in great disorder to Memphis. (For Sherman's next effort to rid himself of Forrest's depredations *see* BRICE'S CROSSROADS).

Fort Darling, *Virginia*

This Confederate battery at Drewry's Bluff on the James River, seven miles south of Richmond, halted the advance of the Federal ironclads *Monitor* and *Galena* in May 1862. Union General Benjamin Butler failed to take the battery in his Drewry's Bluff (*See*) attack two years later in May 1864.

Fort Donelson *(Tennessee),* Capture of

Union forces under Ulysses S. Grant marched overland from Fort Henry (*See*) to invest this Cumberland River strongpoint, arriving on February 12, 1862. The defenders repulsed a gunboat attack on February 14, then tried a breakout attack the following day. When Union troops contained the attack, the Confederate Commander, General Simon B. Buckner, asked for surrender terms. Grant's return note insisted, famously, on unconditional surrender. (*See* also HENRY AND DONELSON CAMPAIGN).

Fort Fisher *(North Carolina),* Capture of

In December 1864 a Union expedition under General Benjamin Butler failed to take this strongpoint and shut down Wilmington, the most important remaining Confederate port. Ulysses Grant then assigned General A. H. Terry to mount a second expedition. On January 13, 1865, 8000 Union troops landed near the fort. The attack opened with a naval bombardment on the 15th, and at 2:00 pm Terry's infantry began to advance. Rebel resistance collapsed after several hours' hard fighting. Union troops claimed 2000 prisoners; Federal losses were about 1300, including naval forces.

Fort Henry *(Kentucky),* Capture of

Grant's 1862 invasion of the South began with the capture of this Tennessee River strongpoint on February 6, 1862. The fort, nearly awash in floodwaters, surrendered after a short bombardment by gunboats under the command of Flag Officer Andrew Foote. On February 11 Grant began his move eastward to Fort Donelson (*See*) on the Cumberland River. (*See* also HENRY AND DONELSON CAMPAIGN).

Fort Hindman (*See* ARKANSAS POST)

Fort Macon *(North Carolina),* Capture of

Federal forces under Ambrose Burnside captured this outwork on April 25, 1862, after a month-long siege. Along with the fort, the Federals took 400 Confederate prisoners.

Fort McAllister *(Georgia),* Capture of

Union General W. B. Hazen's division took this strongpoint on December 13, 1864, during W. T. Sherman's brief siege of Savannah. The action enabled Sherman's forces to reach the Atlantic coast, where they could be supplied by the Navy. The Confederates lost about 300 men, including 250 prisoners; Union casualties were 134.

Fort Pickens, *Florida*

This strongpoint on the tip of 40-mile-long Santa Rose Island guarded Pensacola Bay, the best natural harbor on the Gulf of Mexico.

A view of the interior of Fort Fisher after the devastating Union naval bombardment that was delivered on January 15, 1865.

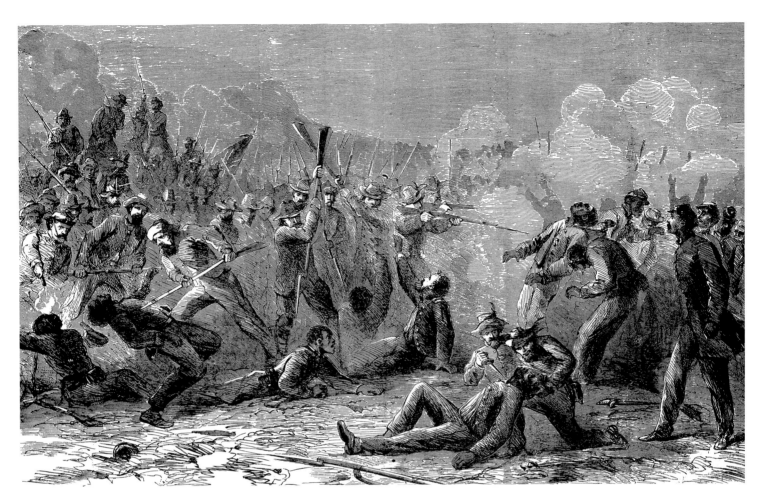

Union forces refused to surrender the fort after Florida seceded; in May 1862 the Confederates abandoned their positions on the mainland, leaving the harbor and navy yard to the Federals.

Fort Pillow Massacre

Confederate cavalry under Nathan Bedford Forrest attacked this Tennessee outpost on April 12, 1864. The 1500 Rebels took the fort with comparative ease. Union forces lost 231 killed and 100 seriously wounded out of a garrison of about 550 men, including 262 blacks.

The Federals charged that the Confederates - shouting 'No quarter! Kill the damned niggers!' – shot many soldiers – mostly black – after they had surrendered.

Fort Pulaski *(Georgia)*, Capture of

In the first action in which rifled guns were used against a masonry fort, Federal forces attacked this fort on April 10, 1862. The Confederates surrendered the next afternoon after a continuous bombardment lasting 30 hours. The rifled guns so damaged the fort that it became indefensible.

A Northern artist's version of the massacre that occurred at Fort Pillow in April 1864. It was one of the war's worst atrocities.

Fort Sanders *(Tennessee)*, Assault on

Confederate General James Longstreet sent three brigades, totalling about 3000 men, against this well-sited bastion at Knoxville on November 29, 1863. The attack failed to carry the position, and the Rebels lost more than 800 men, to about 100 for the defenders. Longstreet did not try again to penetrate Ambrose Burnside's Knoxville defenses.

Fort Stedman *(Virginia)*, Battle of

The action at this Federal bastion was Robert E. Lee's last offensive foray from Petersburg. On March 25, 1865, Confederates under John B. Gordon took the fort and some positions beyond. A Federal counterattack led by John F. Hartranft drove Gordon's troops back into Fort Stedman, where about 1900 surrendered rather than retreat through a heavy Federal crossfire. Total Rebel losses were 3500.

Fort Stevens, *District of Columbia*

Confederate General Jubal Early probed here during his raid (*See* EARLY'S RAID) of July 1864, but decided not to order a full-scale attack. Lincoln, inspecting the defenses here, twice exposed himself to fire from Early's nearby raiders.

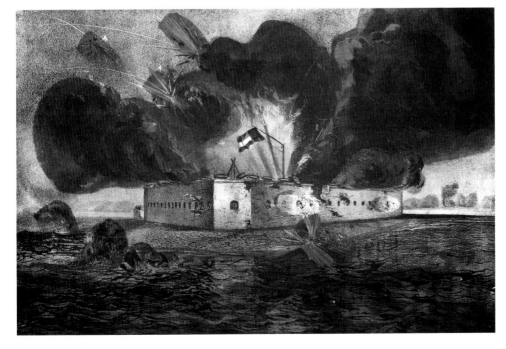

Rifled artillery of Union forces under the command of General Q. A. Gillmore bombard Fort Pulaski, Cockspur Is., Georgia, in 1862.

Fort Sumter *(South Carolina)*, Capture of

Fort Sumter, where the Civil War began, entered history as an unfinished brick stronghold three miles out in the harbor of Charleston, in South Carolina, the first Southern state to secede. In April 1861 it contained 48 guns, nine officers, 68 noncommissioned officers and privates, eight musicians, and 43 noncombatants, all under the command of Major Robert Anderson. Its significance was less military than symbolic: if the Union evacuated the garrison as the newly-formed Confederate government demanded, it would be a concession to Southern claims on Federal property within its borders – and an implicit

recognition of the existence of the Confederacy. There seemed little hope, meanwhile, that the fort could hold out if attacked; at this point it was encircled by a ring of Confederate batteries and was in addition low on food and ammunition.

Beset on all sides by conflicting opinions, President Lincoln, in a masterstroke of policy, decided neither to surrender the fort nor to initiate hostilities, but rather to ship provisions to the garrison, thereby leaving the critical decision to the other side: either the Confederacy would back down or it would initiate hostilities; in either case, the Union would win a moral and political victory even if it lost the fort. He notified the governor of South Carolina of his intention

and waited to see what the South would do. The answer came as the provision ships were en route on April 11: General P. G. T. Beauregard, Confederate commander in Charleston, sent Major Anderson a demand for surrender. Playing for time, Anderson replied that he would evacuate on the 15th unless further orders came from Washington. At 3:30 the next morning, April 12, a note arrived

Below: A US Army map showing Confederate positions in and around Fort Donelson.
Opposite top: Ulysses Grant's capture of Fort Donelson on February 16, 1862.
Opposite bottom: Confederate General James Longstreet's 1863 attack on Knoxville's Fort Sanders failed, sparing the city.

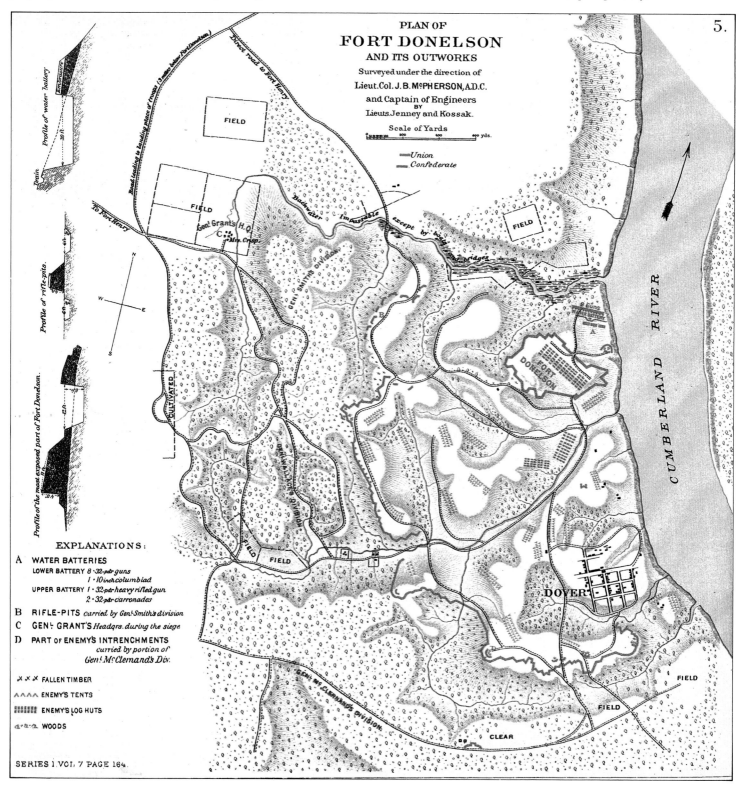

PLAN OF
FORT DONELSON
AND ITS OUTWORKS

Surveyed under the direction of
Lieut. Col. J. B. McPHERSON, A.D.C.
and Captain of Engineers
BY
Lieuts. Jenney and Kossak.

Scale of Yards

Union
Confederate

EXPLANATIONS:

A WATER BATTERIES
 LOWER BATTERY 8 · 32-pdr guns
 1 · 10 inch columbiad
 UPPER BATTERY 1 · 32-pdr heavy rifled gun
 2 · 32-pdr carronades
B RIFLE-PITS *carried by Genl Smith's division*
C GENL GRANT'S *Headqrs. during the siege*
D PART OF ENEMY'S INTRENCHMENTS
 carried by portion of
 Genl McClernand's Div.

✗✗✗ FALLEN TIMBER
∧∧∧ ENEMY'S TENTS
░░░░ ENEMY'S LOG HUTS
🌳🌳🌳 WOODS

SERIES 1 VOL 7 PAGE 164

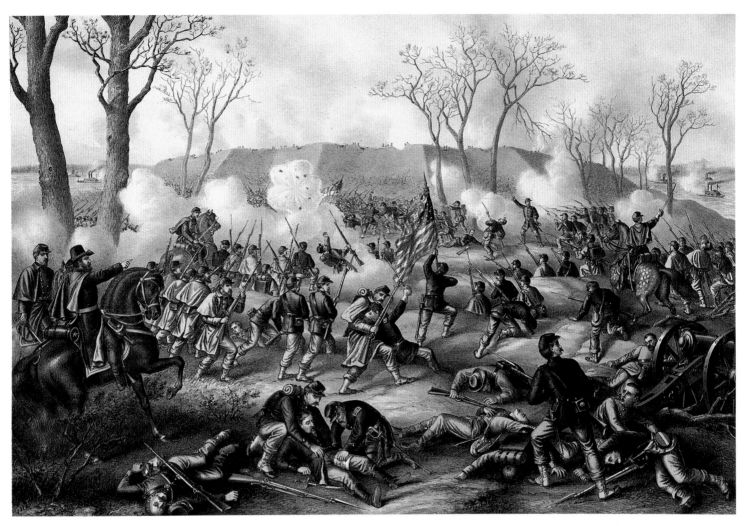

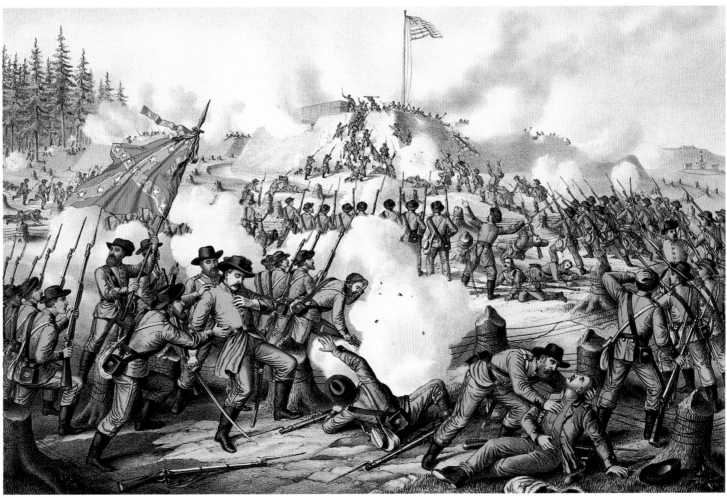

at the fort: 'We have the honor to notify you that [Beauregard] will open the fire . . . in one hour from this time' At 4:30 am on April 12, Confederate Captain George S. James pulled the lanyard of a ten-inch mortar, and the first shot of the Civil War arched into the sky.

The shell burst a hundred feet over the parade ground in the center of the fort. Immediately dozens of Confederate cannons and mortars opened up. Major Anderson did not return fire until daylight, but even then it was only token – he was outgunned and his shells could have little effect on the well-protected enemy batteries. At midmorning the Federal provision ships appeared in the harbor, saw the bombardment, and turned back. During that day's action Beauregard tried the experiment of using hot shot, cannonballs heated red-hot before firing; these set off some small fires in the fort. On the following day Beauregard used more hot shot, this time setting the Union barracks ablaze. The Federals, busy fighting the flames and trying to keep them for the magazine, could fire off only one return shot every five minutes. Clearly there was no point in continuing. Shortly after noon on the 13th Anderson ordered a white flag run up on the stump of a flagpole.

A Confederate delegation arrived at the fort; after some confused negotiations it was decided that the Federals could depart the next day after saluting their flag with cannons. At that point there had been no casualties on either side, but as Anderson's men fired their salute on April 14 sparks from the smoldering fire in the fort touched off a paper cannon cartridge as it was being loaded. The explosion claimed the first life of the war, Private Daniel Hough, and wounded five others, one of whom later died. Then, with the band playing 'Yankee Doodle' and Southerners cheering from the shore, the Northern men boarded a boat for New York, and Confederate soldiers marched into Fort Sumter.

Confederate guns in Fort Moultrie fire on Union-garrisoned Fort Sumter in Charleston harbor, thus beginning the Civil War.

On the next day Lincoln mobilized 75,000 militiamen for 90 days to put down the 'insurrection.' On both sides tens of thousands rallied to the colors and four more states – the last ones – seceded: Virginia, Arkansas, North Carolina, and Tennessee. Despite sustained Union efforts to recapture the fort, the flag of the Confederacy would not come down until the end of the war: the fort was destined to remain a powerful symbol of Southern resistance.

Fort Wagner, *South Carolina*

Federal troops unsuccessfully assaulted this strongpoint guarding Charleston Harbor on July 10 and 18, 1863. In the first try, the Federal brigade engaged lost 339 men. In the second, the black 54th Massachusetts penetrated the fort but was evicted before reinforcements could arrive. Union casualties totaled more than 1500; the 54th lost 25 percent of its strength.

Fortress Monroe, *Virginia*

Union forces retained control of this fort after secession and kept it throughout the war. Early in the war, runaway slaves sought refuge here; by July 1861 a harried General B. F. Butler reported he had more than 900 slaves in his custody.

Forts Gaines, Morgan, and Powell, *Alabama*

These forts protected the strategic Confederate port city of Mobile. On August 5, 1864, a Union fleet under Admiral David Farragut ran past the forts, opening the Battle of Mobile Bay. Forts Gaines and Powell fell quickly; Fort Morgan held out until the end of August.

'Forty Acres and a Mule'

By 1865 blacks were farming much Confederate land seized under the Federal Confiscation Acts of 1861-62, giving rise to the widespread misconception that the Federal

government would redistribute land to them permanently. The Proclamation of Amnesty restored all Southern property, except slaves, to its former owners.

Fougass

A form of land mine, it used a strong charge of gunpowder to spray an advancing enemy with stones or metal pellets. Fougass mines were often used as part of the outer defenses of fortifications.

Fowle, Elida Barker Rumsey *(1842-1919)* Philanthropist.

Too young to enlist as an army nurse, she developed a private relief effort, visiting camps and hospitals and raising money. She and her fiance founded the Soldiers' Free Library in Washington, DC, and became such famous field nurses that they were married before a joint session of Congress.

Fox, Gustavus Vasa *(1821-1883)* Union naval officer.

Born in Massachusetts and graduated from Annapolis, Fox headed an expedition in April 1861 to reinforce Fort Sumter, arriving in time to evacuate the Federals after their surrender. As first assistant secretary of the navy throughout the war, Fox proved an able planner of naval operations.

Franklin and Nashville Campaign

After being forced out of Atlanta in September, 1864, Confederate General John B. Hood did not give up hope of regaining the initiative with his Army of Tennessee. He decided to march north, around his opponent, W. T. Sherman, and invade Tennessee. If he could conquer Nashville, now occupied by Federals under George H. Thomas, Hood reasoned that he might force Sherman to withdraw from Georgia to protect Tennessee. In this strategy Hood showed both his usual aggressive style and his usual lack of judgment: he had 40,000 men left, Thomas had 60,000; and the latter had earned his nickname 'Rock of Chickamauga' for being an exceptionally able and tenacious fighter.

Hood learned that Thomas had divided his forces, some 30,000 Federals under John M. Schofield being at Pulaski, Tennessee, 75 miles south of Thomas in Nashville. In the last week of November 1864 Hood attempted to get his forces between those of Schofield and Thomas. Hood's immediate goal was Columbia, but Schofield anticipated that and pulled back to protect the town; there followed several days of inconclusive skirmishing along the Duck River near Columbia. On the 28th Hood sent Nathan B. Forrest's cavalry on a wide flanking maneuver, but Schofield again anticipated the move and fought off the gray horsemen at Spring Hill.

Opposite top: Black troops of the Union's 54th Massachusetts make an heroic attempt to take Fort Wagner on July 18, 1863.
Opposite bottom: The Battle of Franklin in November 1864 cost CSA General John Bell Hood's Army of Tennessee 7000 casualties.

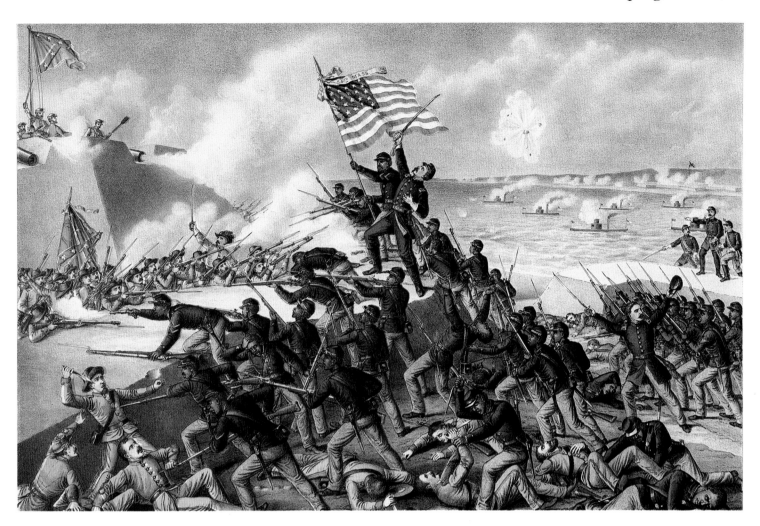

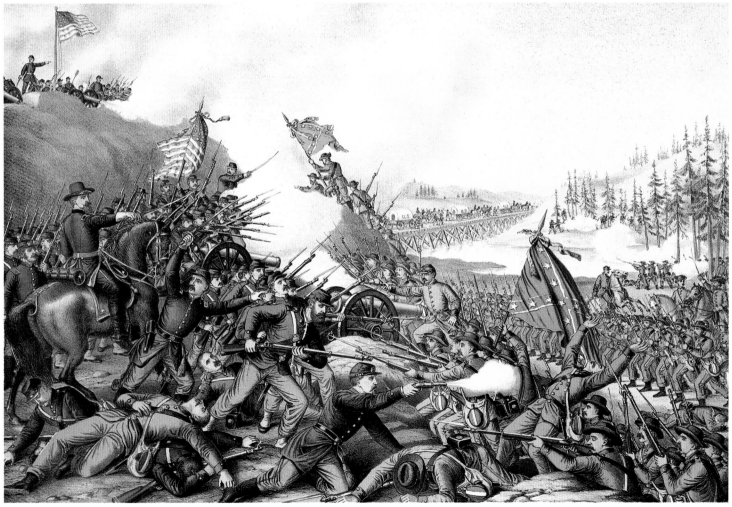

The Federal commander then pulled farther back to Franklin, Tennessee, 15 miles from Nashville, and ordered his men to entrench.

On November 30 Hood struck in typical determined but ill-considered style: in a repeat of Robert E. Lee's doomed charge on the third day of Gettysburg, but with even less chance of success, Hood had his Confederates march out in a broad front, without artillery preparation, over two miles of open ground toward carefully built enemy barricades. Although they were torn apart on the approach by artillery and rifle fire, a few segments of the advance reached and briefly held sections of the Union line, struggling hand-to-hand with the defenders before being overwhelmed. Otherwise, it was an unrelieved slaughter for six hours. When fighting ended, the Confederates had suffered some 7000 casualties, including six generals killed and 54 regimental commanders killed or wounded; Union losses were 2326.

Schofield pulled out of Franklin that night and marched to join Thomas in Nashville. Hood followed, digging in his army south of the extensive defenses of the Tennessee capital. As Thomas carefully organized his plans and forces, Ulysses Grant wired increasingly imperative orders to attack. When Thomas was finally ready, an ice storm stalled his plans. Grant, exasperated with the inactivity, sent General John A. Logan toward Nashville to replace Thomas in command; but before Logan arrived the ice had melted, and Thomas had unleashed his full force of 50,000 on Hood's 25,000.

On December 15 the Battle of Nashville began, the Federals following Thomas's plan to hold the enemy in place on the Union left while mounting a series of crushing attacks on the right. After enduring these attacks all day the Confederates pulled back to tighter lines that night, on the Brentwood Hills outside the city. On the next day Thomas followed the previous day's tactic, holding with one flank, pounding away with the other,

The camp of the 125th Illinois in Nashville, one of the Union regiments in the Franklin and Nashville Campaign of 1864.

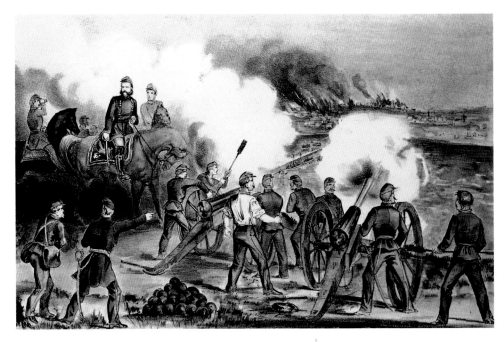

Union General Ambrose Burnside supervises artillery bombarding Fredericksburg, soon to be the site of a major Union disaster.

and finally he worked his cavalry around behind the enemy left. The Confederate line began to collapse from left to right, until thousands were surrendering and the rest were fleeing as a leaderless mob. Thomas's cavalry chased the enemy for two weeks, from Tennessee to Alabama to Mississippi.

By the time the Army of Tennessee came to rest in Tupelo, Mississippi, in January 1865, it had lost half the 40,000 men it started with. Hood, having finally battered his army to pieces against the Union juggernaut, resigned his command. Some of his men wandered off to join other armies, many returned to their homes and farms. This disaster, combined with the humiliation of Sherman's March to the Sea, was a dire blow to the South's sinking morale.

Franklin's Crossing, *Virginia*

Union General Joseph Hooker ordered a reconnaissance in force here on June 5, 1863, to determine whether the Confederates were pulling out of Fredericksburg. Units from John Sedgwick's VI Corps crossed the Rappahannock and attacked Confederate positions at Deep Run, taking 35 prisoners at a cost of 41 killed and wounded. It was a preliminary skirmish in the Gettysburg Campaign.

Fraternization

Informal truces between front-line troops were common. Opposing pickets often exchanged notes and traded in tobacco, coffee, and newspapers. Even front-line troops, as at Petersburg during the 1864 siege, sometimes negotiated informal truces, agreeing not to fire unless fired upon.

Fredericksburg, Campaign and Battle

After Robert E. Lee had retreated from Maryland following the Battle of Antietam in September 1862 President Lincoln had publicly gone along with the Northern celebrations of victory and the congratulations to General George B. McClellan, commander of the Federal Army of the Potomac. Privately, Lincoln knew better: McClellan had blundered through the battle and let Lee escape with his Army of Northern Virginia. Then, in October, Lee's cavalry under Jeb Stuart had gone on a second embarrassing ride completely around the Union army. McClellan had eventually set out after Lee at his usual slow pace, but Lincoln had seen enough; he relieved McClellan and replaced him as head of the Army of the Potomac with General Ambrose E. Burnside.

This bewhiskered officer (*sideburns* were named after him) was well-liked and was so far successful, having won a string of victories in North Carolina. Even his bungling attacks at the Antietam bridge had been interpreted as a success. Burnside himself, however, doubted his own ability to lead a major army in a major campaign, and events would more than confirm those doubts. He would end the war still popular and with a fine career in politics ahead of him, but history

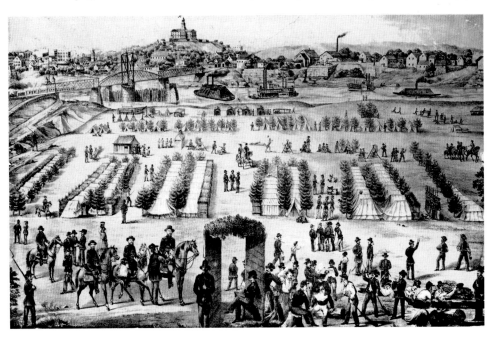

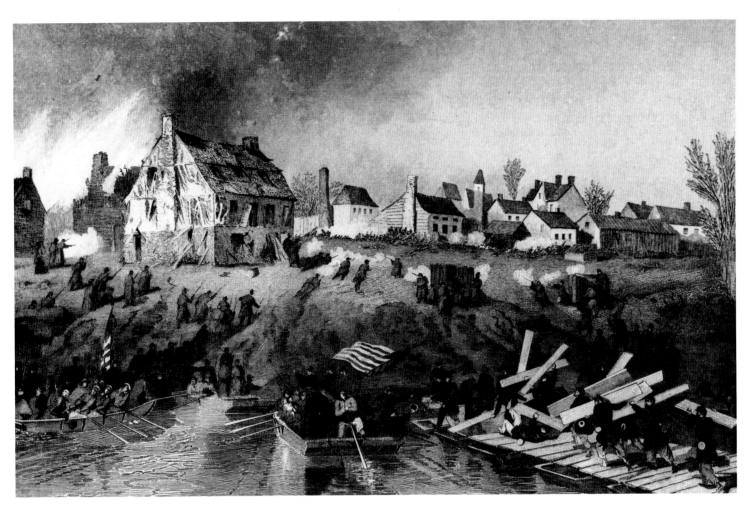

would remember him as one of the most incompetent generals of all time.

Burnside's strategy for the Army of the Potomac was simply to make straight for the Confederate capital of Richmond, en route occupying Fredericksburg, Virginia, on the Rappahannock River. It was there that Lee decided to contest the Union advance. On November 17, 1862, Federal units began to pull into Falmouth, across the river from Fredericksburg, a day before James Longstreet's command in Lee's army arrived in the town. At that point, Burnside could easily have sent his men across the river and taken Fredericksburg. Instead, he collected his forces and waited over a week for the delivery of pontoon bridges. (They had not come sooner because Washington had misunderstood Burnside's orders, which were typically vague.) During that week's delay Lee arrived with the full Army of Northern Virginia and erected virtually impregnable defenses, along Marye's Heights behind the town, and stretching southeast along the river. Although he had 78,500 men to Burnside's 122,000, Lee awaited the coming Federal attack with visible confidence.

Burnside compounded his initial delay with an incredible decision: noting that Lee was expecting Union forces to cross above or below the town, out of range of Confederate guns, Burnside ordered a crossing right in front of Lee, saying 'the enemy will be more surprised' by this move. Lee's response was less surprise than incredulity: he had the approach covered so thoroughly that, as a Confederate officer noted, 'a chicken could not live on that field when we open on it.' In fact, however, Lee was perfectly prepared to

let the Federals cross, since they apparently planned to make a frontal assault that could well cost them virtually their whole army.

On December 11 Federal troops began constructing pontoon bridges across the Rappahannock. Lee had decided to offer token resistance, posting sharpshooters in the town who claimed dozens of Union casualties

Above: Union troops cross the Rappahanock to begin their assault on Fredericksburg in December 1862. Robert E. Lee's Confederates wait for them in the hills behind the town.
Below: An Arthur Lumley sketch of Federals looting Fredericksburg just before the main battle began. The sketch was not published because Lumley's editor felt that it showed Union soldiers in a bad light.

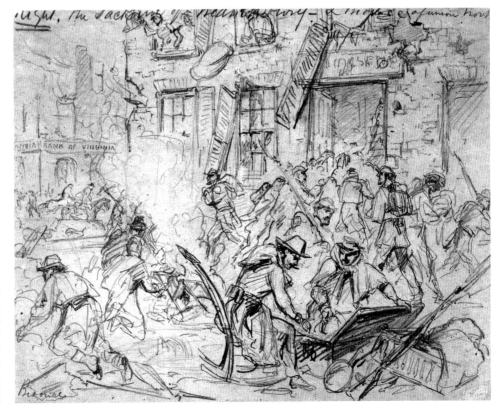

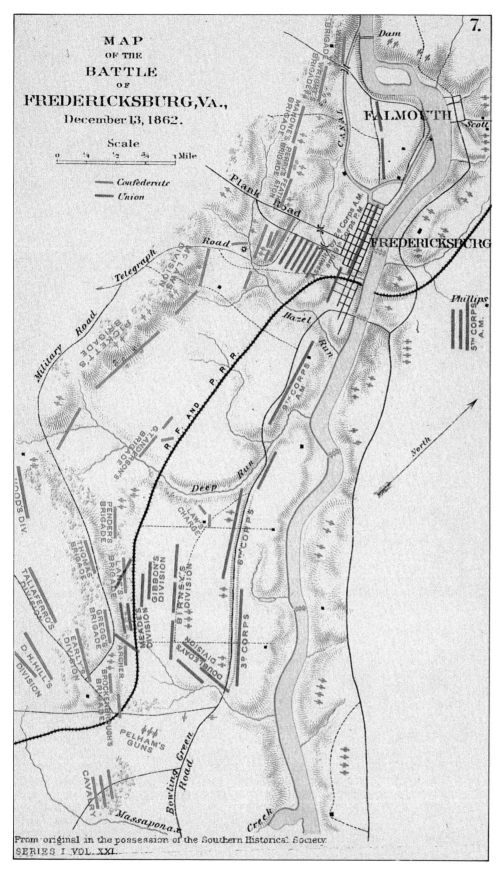

MAP
OF THE
BATTLE
OF
FREDERICKSBURG, Va.,
December 13, 1862.

Scale

0 ¼ ½ ¾ 1 Mile

—— Confederate
—— Union

From original in the possession of the Southern Historical Society.
SERIES I VOL. XXI.

A Confederate map shows the disposition of the opposing armies at Fredericksburg.

'It is well that war is so terrible – we should grow too fond of it.'

There would be no further chances for the Union that day. Wave after wave of Federals threw themselves at the enemy positions along Marye's Heights, where four ranks of defenders behind a stone wall were firing virtually at a machine-gun rate. No Federals made it closer than 50 yards from the wall. Some units lost 50 percent and more in casualties. Southern General Longstreet later wrote: 'At each attack the slaughter was so great that by the time the third attack was repulsed, the ground was so thickly strewn with dead that the bodies seriously impeded the approach of the Federals.'

By the end of the fighting the North had lost 12,700 killed and wounded of 106,000 engaged; the South lost less than half that – 5300 casualties of 72,500 engaged. Burnside had to be talked out of personally leading a suicidal charge the next day. In January he made one more attempt to dislodge Lee, ordering the Army of the Potomac to march upstream and attack from behind. Coming as it did in the middle of a thaw, the operation ground to a halt in a sea of mud. With that Mud March, as it was named, Burnside had crowned a debacle with a fiasco. He was relieved at his own request at the end of January 1863.

Hearing the reports of the defeat, Lincoln said, 'If there is a worse place than Hell, I am in it.' Across the North the disaster created widespread gloom. Washington was filled with rumors that Lincoln was going to resign or be deposed; some hoped that General George McClellan would step in and lead a military government, and the ambitious McClellan did not discourage the idea. Nonetheless, Lincoln pulled himself together to turn back challenges to his authority by Republican Senators and some of his own cabinet. The war would continue with Lincoln still holding the reins, but he and the entire North were deeply shaken.

Freedman

This term described all slaves liberated after the adoption of the 13th amendment, which abolished slavery. Some 4 million blacks were freed.

Free-Soil Party

A political party founded in the 1840s with the slogan, 'free soil, free speech, free labor, and free men.' It supported free homesteads and called for any new territories, chiefly those acquired from Mexico, to outlaw slavery. The Free-Soilers held the balance of power in the 1848 presidential election, but, their influence eroded by the expansion of the southern Democratic Party, their numbers dwindled, and they merged with the antislavery Republican Party after 1854.

Frémont, John Charles
(1813-1890) Union general.

A Georgian, Frémont earned national fame as a young western frontier explorer and soldier. In 1856 he ran unsuccessfully for the US presidency on the Republican ticket. From July 1861 he commanded the Department of the West, a difficult job made worse

during the preparations. When the bridges were finished, the Army of the Potomac poured across the river and spent the night of the 12th ransacking the town.

On the morning of December 13 the area was blanketed by thick fog. Suddenly, at 10:00 am, it swept away and revealed to the Southerners rank upon rank of bluecoats preparing to attack. On the right, William Franklin's division advanced on Stonewall Jackson's position; Jackson's artillery opened up, tearing wide holes in the Union lines. Then George Meade's division found a chink in Jackson's lines and got behind the enemy, threatening to roll up the Confederate flank; but Franklin failed to press his advantage and a Southern countercharge drove the Federals away. Watching with satisfaction from his command post, Lee uttered his famous lines:

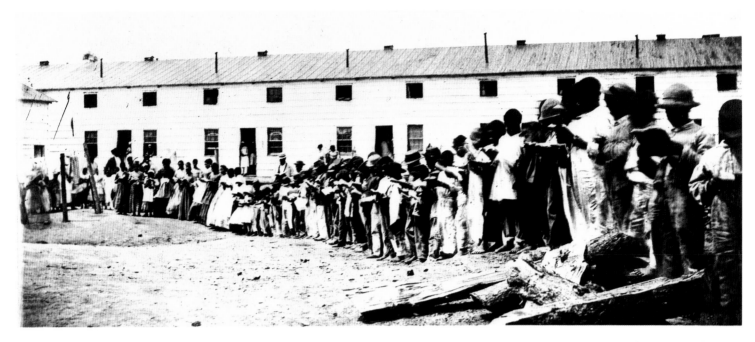

A village of freedmen (*ie.*, former slaves liberated after December 1865 by the 13th Amendment) in Arlington, Virginia.

by the flamboyance, recklessness, and corruption of his administration and by the excessive harshness of his policies toward slave-holders (which ultimately caused his removal). Sent abruptly to the Mountain Department in March 1862, Frémont failed to stop T. J. Jackson in the Shenandoah Valley Campaign of Jackson and was relieved of his

command in June when he refused to serve under his old adversary, John Pope. He was the favored candidate of the Radical Republicans to run against Lincoln in 1864, but he withdrew from the race in September. After the war both his fortunes and his reputation declined steadily.

In Union service John C. Frémont dissipated most of his heroic prewar reputation

French, William Henry
(1815-1881) **Union general.**

A Maryland-born West Point graduate and career artilleryman, he held commands in the Gulf and Washington's defenses in 1861-62 and fought on the Peninsula, at Antietam, at Fredericksburg, at Chancellorsville, and at Gettysburg. He lost his command of III Corps as the result of criticism of his performance in the Battle of the Wilderness in 1864 and saw no further field service in the war.

Frigate

A type of wooden-hulled full-riged naval ship (*i.e.,* one with three square-rigged masts and a bowsprit) that carried its main battery on a single covered deck. By the 1860s many frigates had auxiliary steam power. Although more powerful than sloops-of-war (*See*), frigates were not ranked as battleships, a class defined as having a minimum of two covered battery decks.

Fritchie, Barbara Hauer
(1766-1862) **Patriot.**

Eponymous heroine of John Greenleaf Whittier's 1863 poem. According to popular legend, as T. J. Jackson's troops marched out of Frederick, Maryland, in September 1862, the 90-year-old patriot Barbara Fritchie defiantly waved Union flags. No historical evidence exists for this encounter.

Front Royal *(Virginia)*, Battle of

A battle in the 1862 Shenandoah Valley Campaign of Stonewall Jackson. Feinting at the 7000 Federals of Nathaniel Banks's Union army in Strasburg with cavalry, T. J. Jackson took his infantry across Massanutten

Mountain and joined with Richard Ewell's forces, which raised the strength of Jackson's army to 16,000 men. With these he struck Colonel J. R. Kenly's 1000 Federals at the Front Royal on May 23, capturing most of the bluecoats. This victory put Jackson dangerously on Banks's flanks, forcing the Union general to retreat northward and eventually to leave the Valley.

Fry, Birkett Davenport
(1822-1891) **Confederate general.**

This Virginian, a Mexican War veteran and Alabama businessman, joined an Alabama infantry regiment in 1861. Fry was wounded at Seven Pines and fought at Antietam, Chancellorsville, and Gettysburg, where he was captured in Pickett's Charge. Exchanged, he fought at Cold Harbor and commanded the District of Augusta.

Fugitive Slave Act

Amending a 1793 act, the 1850 Fugitive Slave Act provided for the return of escaped slaves to their masters. The Act troubled Northerners with its strictness (inspiring *Uncle Tom's Cabin*, published in 1851) and angered Southerners, who viewed it as interference. Its constitutionality was upheld by the Supreme Court in 1859, though free states' 'personal liberty' laws (*See*) and the growing success of the underground railroad steadily eroded its effectiveness.

Fuses

Explosive artillery projectiles were fitted with three types of fuses. The shock of firing or impact set off a concussion fuse. In a percussion fuse, fulminate set off by impact exploded the charge. A time fuse, ordinarily a wooden or paper tube cut to a specific length, was lit by firing; when it burned down, it set off the charge. Civil War time fuses were, for the most part, unreliable.

Gag Rule

In May 1836 Southern representatives in Congress engineered passage of a rule aimed at blocking discussion of the slavery issue. The House approved such a rule at the start of every session through 1844, but it failed to lay the slavery debate to rest.

Gaines's Mill (Virginia), Battle of

Third of the 1862 Seven Days' Battles. On June 27 Robert E. Lee tried an assault on Union General Fitz-John Porter's new defensive position near Gaines's Mill. In heavy fighting Porter was at first driven back, but then his line firmed up and the fighting ended inconclusively. That night Porter got most of his men back across the river, where CSA General John Magruder's bluffing had held the main Union army of George McClellan at bay. The North lost some 4000 killed and wounded and 2800 captured at Gaines's Mill, but Lee lost 9000, one of his costliest days in the war. McClellan, having inflicted heavy losses on the enemy in two days of fighting, nonetheless decided to pull back to

Union batteries of 12-pounder Napoleon guns fire cannister at advancing Rebel infantry in the 1862 Battle of Gaines's Mill.

a base on the James River, giving up his attempts on Richmond. The Savage's Station battle followed (See).

Gallatin, Tennessee

Confederate cavalry under John Hunt Morgan captured the Federal garrison here during Kirby Smith's invasion of Kentucky in August 1862. Morgan's troopers took 200 prisoners and partially burned a key bridge on the Louisville & Nashville Railroad. Federal infantry chased the Rebels from the town the next day.

'Galvanized Yankees'

These were Federal prisoners of war who had taken an oath of alliegance to the Confederacy and enlisted in the Confederate service. There were such Confederates, too; Rebel prisoners filled six newly formed US infantry regiments in 1864 and saw service on the western frontier.

Galveston, Texas

Federal warships shelled this Confederate port in August 1861 but did not occupy it until October 5, 1862. On January 1, 1863, Confederates under John Magruder recaptured the town after a four-hour battle. The Federal fleet resumed the offshore blockade, and the port remained in Rebel hands until after the Confederate surrender in 1865.

Gamble, Hamilton Rowan
(1798-1864) Union governor of Missouri.

A Virginian by birth, he was a Missouri lawyer, legislator, and judge who left retirement in 1861, becoming provisional governor when secessionist officials fled the state. Gamble opposed the government's right to draft soldiers as unconstitutional but led the militia against Southern guerrillas, keeping Missouri free and in the Union.

Garfield, James Abram
(1831-1881) Union general and 20th president of the United States.

Leaving the Ohio legislature for the 42nd Ohio in 1861, Garfield earned rapid promo-

A photograph of future-President James A. Garfield when he was a Union general.

tions, leading brigades at Middle Creek, Pound Gap, and Shiloh. He was William Rosecrans's chief of staff in the Chickamauga Campaign before resigning in December 1863 to join the US Congress. He was elected president on the Republican ticket in 1880.

Garnett, Richard Brooke
(1819-1863) Confederate general.

A West Point graduate and career officer, this Virginian led the Stonewall Brigade under T. J. Jackson in the Shenandoah Valley Campaign of Jackson, Pickett's brigade in the Maryland Campaign, and his own brigade at Fredericksburg and Gettysburg. He was killed in Pickett's Charge at Gettysburg.

Garnett's and Golding's Farms, Virginia

This minor engagement in the Seven Days' Battles consisted of holding attacks south of the Chickahominy while the main event un-

William Lloyd Garrison, influential editor of the abolitionist journal The Liberator.

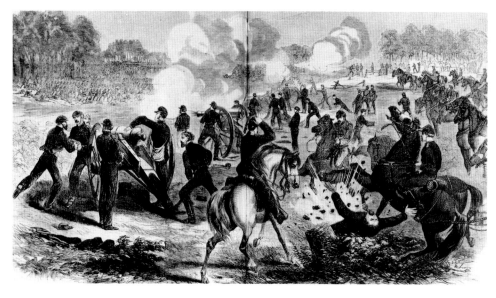

The lethality of the Gatling machine gun was never fully grasped in the Civil War.

folded at Gaines's Mill (*See*). In two days of fighting, June 27-28, 1862, the Confederates lost 461 men; Union casualties were 368.

Garrison, William Lloyd
(1805-1879) **Abolitionist.**

This Massachusetts printer-turned-editor sounded some of the earliest calls for an immediate end to slavery, which he called 'not only a crime but the sum of all criminality.' An uncompromising abolitionist, Garrison made innumerable speeches, published the influential journal *The Liberator* (1831-65) and helped found the American Anti-Slavery society in 1832. His reform agenda encompassed women's and Indians' rights, capital punishment, and prohibition.

Gatling Gun

This rapid-fire weapon, powered first by a hand crank and later by an electric motor, saw limited service in the Virginia theater during the war; the army did not formally adopt the Gatling until 1866. It fired .57-caliber and, later, .45-caliber bullets out of multiple (usually six) barrels.

General War Orders

In this extraordinary series of four presidential orders, issued from January to March 1862, Lincoln sought in vain to force General George McClellan into military action. Number One named February 22 as the date for Federal forces to move against the Confederates. Numbers Two and Three reorganized the Army of the Potomac and assigned Union troops to defend the capital. Number Four removed McClellan as general-in-chief.

'Get there first with the most'

See NATHAN BEDFORD FORREST.

Getty, George Washington
(1819-1901) **Union general.**

Born in Washington, DC, this West Point graduate and war veteran commanded artillery in the Peninsular Campaign, at South Mountain, Antietam, and Fredericksburg, constructed entrenched lines at Norfolk and Portsmouth, and fought in the Wilderness, the Shenandoah Valley Campaign of Sheridan, Petersburg, and the final pursuit of Robert E. Lee.

Gettysburg Address

At the beginning of November 1863 President Lincoln was invited to present a few words at the dedication of a new cemetery at Gettys-burg, Pennsylvania, for the dead of the battle there. The main address was to be given by the celebrated orator Edward Everett (*See*). Contrary to later legend, Lincoln's speech was not jotted on an envelope on the way to Gettysburg but rather begun two days earlier. At the ceremony on November 19 Everett spoke for two hours. Afterward, Lincoln rose to deliver what was intended as a sort of ceremonial benediction. Neither Lincoln nor anyone else realized at the time that it would become the most famous speech in American history:

'Four score and seven years ago our fathers brought forth, upon this continent, a new nation, conceived in Liberty, and dedicated to the proposition that all men are created equal.

'Now we are engaged in a great civil war, testing whether that nation, or any nation, so conceived, and so dedicated, can long endure. We are met here on a great battlefield of that war. We have come to dedicate a portion of it as a final resting place for those who here gave their lives that that nation might live. It is altogether fitting and proper that we should do this.

'But in a larger sense we cannot dedicate – we cannot consecrate – we cannot hallow – this ground. The brave men, living and dead, who struggled here, have consecrated it far above our poor power to add or detract. The world will little note, nor long remember, what we say here, but it can never forget what they did here. It is for us, the living, rather to be dedicated here to the unfinished work which they have, thus far, so nobly carried on. It is rather for us to be here dedicated to the great task remaining before us – that from these honored dead we take increased devotion to that cause for which they here

A facsimile of the manuscript of Lincoln's Gettysburg Address. The eloquent speech was not at first recognized as a masterpiece, and Lincoln supposed it to be a failure.

gave the last full measure of devotion – that we here highly resolve that these dead shall not have died in vain; that this nation shall have a new birth of freedom; and that this government of the people, by the people, for the people, shall not perish from the earth.'

Gettysburg, Campaign and Battle

Soon after his defeat of the Federal Army of the Potomac at Chancellorsville in May 1863 General Robert E. Lee decided for the second time to invade the North with his Confederate Army of Northern Virginia. There were a number of reasons for this decision. Even though Lee had just won a brilliant victory, things were bad in the Confederacy and getting worse: Ulysses S. Grant was about to secure Vicksburg for the Union, inflation was running wild in the South, badly needed European recognition had not come, the Confederate government was torn by partisan squabbles, the Union blockade along the Southern coast was growing steadily more effective, and antiwar sentiment was fading in the North. A major Confederate victory on enemy soil might ameliorate all those problems. Moreover, after their string of victories Lee and his men had begun to believe – fatally, as it turned out – that they were virtually invincible.

General James Longstreet, Lee's second in command since the death of Stonewall Jackson, objected to the invasion from the beginning. Longstreet entreated his commander to

A Confederate map of the armies' positions on the second day at Gettysburg.

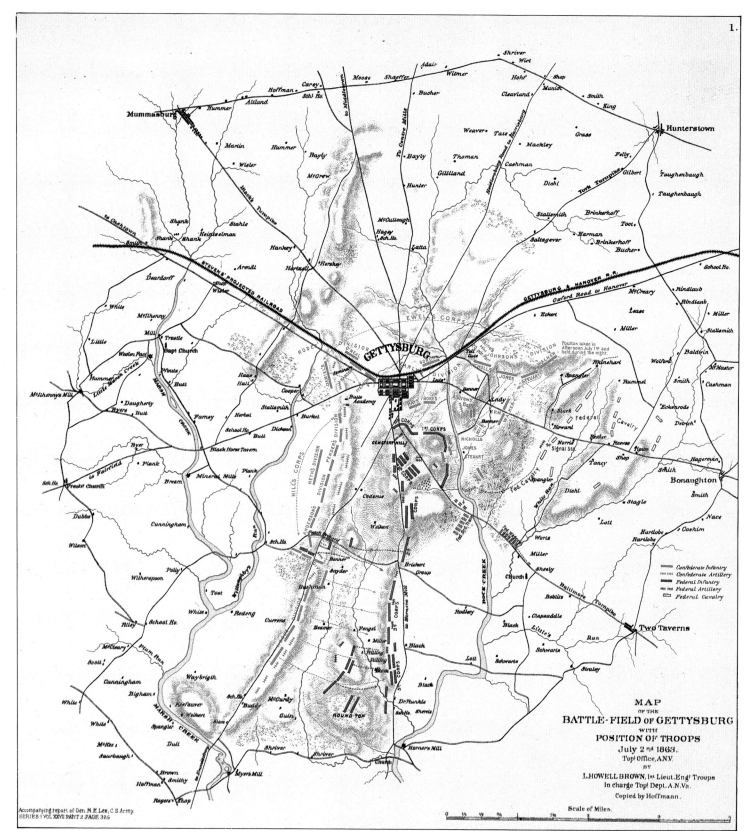

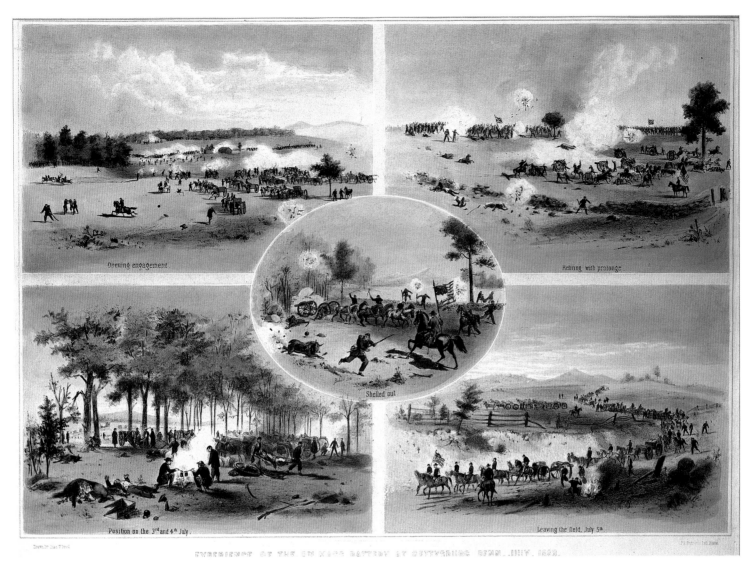

Opening engagement. Retiring with prolonge.

Shelled out.

Position on the 3rd and 4th July. Leaving the field. July 5th.

pursue a defensive strategy in Virginia and to send troops to reinforce Braxton Bragg in Tennessee; this might compel General Grant to send some of his forces to reinforce William Rosecrans's Union army in Tennessee, thus relieving the pressure on Vicksburg. Longstreet's ideas were sound, but Lee insisted on his invasion plan; his instincts invariably told him to take the offensive.

Thus, in early June 1863, the Army of Northern Virginia pulled away from Fredericksburg and headed for Pennsylvania with 89,000 men. At that point its adversary, the Federal Army of the Potomac, was still under the command of General Joseph Hooker; but after Hooker's humiliating defeat at Chancellorsville, Washington was trying to ease him out of command. Learning of the Confederate move, Hooker put his 90,000 men on the march, shadowing Lee. The two armies marched to the northwest on parallel routes, neither quite sure where the other was, the opposing cavalries fighting a running series of skirmishes that kept Rebel cavalry leader Jeb Stuart's scouts at a distance.

That disturbed Lee, who had always been able to depend on Stuart's detailed reports. Finally Lee ordered Stuart to take his cavalry on an independent ride to assess the enemy strength and position. Intepreting the ambiguously-worded order as an opportunity to ride around the Army of the Potomac as he had twice in the past, Stuart began a wide circle around the Federals, constantly detour-

ing to avoid scattered enemy forces. In the end, Stuart would be gone for ten days, not returning until a battle was in progress. With Stuart gone, Lee was marching blind in enemy territory and would stumble into a fight at a time and place not of his choosing.

On June 28 Washington countermanded an order of Hooker's, hoping the general would resign in protest; Hooker did as hoped. The new commander – appointed over his own protest – was General George

Random scenes of the Battle of Gettysburg, from the initial engagement of July 1 to the beginning of the Union pursuit on the 5th.

Gordon Meade, who had been a corps commander under Hooker. This general was as experienced as any, but he was also irascible and much troubled by a wound from the pre-

A somewhat fanciful rendering of the third day of the Battle of Gettysburg.

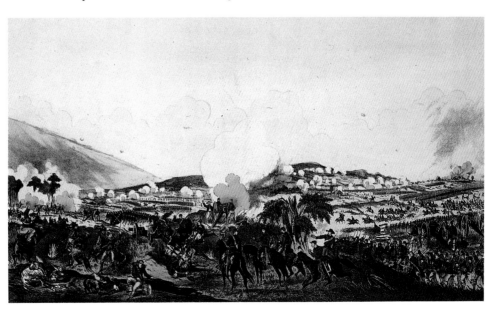

The little town of Gettysburg, as the Union XI Corps would have seen it from Cemetery Hill. The road is the Baltimore Turnpike.

vious year. Nonetheless, he would prove to be the first successful commander of the Army of the Potomac. His appointment came almost on the eve of battle; by coincidence, both commanders decided to concentrate their forces at the same small Pennsylvania town with convenient road crossings: a place called Gettysburg.

There, on July 1, Federal cavalry commander John Buford was scouting with 2500 men. From the west Buford saw a column of enemy troops marching in his direction. They were a division of A. P. Hill's corps looking for a supply of shoes rumored to be in town (many Confederate troops marched barefoot). Buford's cavalrymen spread out in a thin line and began firing with their new Spencer repeating carbines (See), and the enemy returned fire. The greatest battle ever fought on American soil had begun.

By mid-morning Southern troops were pouring into line. Union General John Reynolds arrived and hurried his I Corps forward to take over from Buford's cavalry; shortly after giving his orders, Reynolds, whom many believed the best general in the Union army, was shot dead from his horse. The fighting escalated steadily, commanders on both sides desperately pulling troops into position. As it had been at Chancellorsville, the Union XI Corps was hit by a flank attack; its men fled into the town, where hundreds were killed or captured in the streets. By evening the Federals had been driven from their original line in the west to a position south of town, on Cemetery Ridge. Just before dusk Lee asked General Richard Ewell to attack Cemetery Ridge 'if practicable.' In a fateful decision, Ewell decided that it was not practicable. In fact, Union lines were still very weak at that point; during the night, however, Meade shored them up into a formidable defensive position along the ridge.

Still, the Army of Northern Virginia had clearly won the first day's battle. Lee decided on the next day that he would attack with everything he had. Over the objections of Longstreet, who saw the strength of the Union defensive positions, Lee ordered Longstreet to make a dawn assault on the Federal left flank at Little Round Top, a hill at

the southern end of Cemetery Ridge, with Ewell supporting with a diversion at Culp's Hill, at the northeast end of the Ridge. On July 2, however, nothing went as planned: Longstreet's attack did not take shape until the afternoon, and Ewell made only mild probes at Culp's Hill. Nonetheless, Federal General Daniel Sickles handed the enemy a golden opportunity when he moved his III Corps out of position on the Federal left to slightly higher ground in front of the Ridge at the Peach Orchard. There Sickles found himself amidst a devastating barrage from Southern cannons, and his men had to fight their way back to where they began. Meanwhile, Confederate forces began closing in on Little Round Top, the linchpin of the Union left. A successful attack on that point could have spelled disaster for the entire Northern line.

Federal General Gouverneur K. Warren arrived on the rocky hillock of Little Round Top to find the enemy approaching and dangerously few defenders at the position. At the last minute, a few cannon arrived to slow the Southern advance. Then came 350 men of the 20th Maine under young Colonel Joshua Chamberlain to man the extreme left position. After the Maine men had expended all their ammunition, incredibly, they mounted a bayonet charge that sent the

startled Confederates back down the hill. (Bayonet charges were rare in the war, and much feared.) The men of Maine had saved the Army of the Potomac. A day of bloody, inconclusive fighting ended with engagements on the middle and right of the Federal line.

That night General Meade assembled his generals and took the unusual step of asking for a vote on whether the Army of the Potomac should retreat, attack, or wait to receive Lee's attack. The vote strongly advised the last; the Federals would wait.

The third day, July 3, began with a brief but intense assault by Ewell on Culp's Hill, the curving top of the hook-shaped Union line. This attack was easily repulsed, and then for some hours the battlefield was quiet. As the Union men watched, Confederate cannons began to appear opposite them to the west, on Seminary Ridge, finally amounting to 150 guns on a line two miles long. Though some Northern generals thought the guns were covering a retreat, the real answer was the opposite. Lee had decided to risk everything

An A. R. Waud sketch shows Union Lt. Col. G. H. Stevens's 5th Maine Battery in action on Culp's Hill. The large gate on Cemetery Hill is clearly visible in the distance.

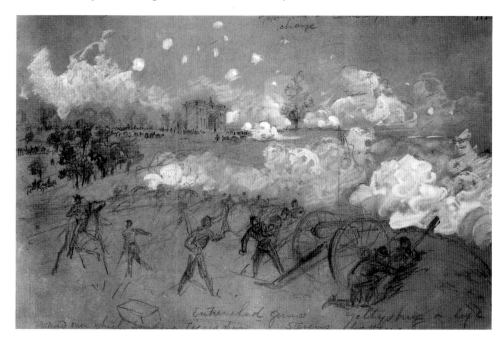

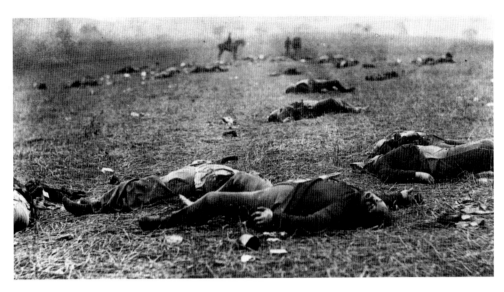

Some of the Gettysburg dead. Of the more than 51,000 combined casualties, over 7000 were killed. Lee lost a third of his army.

on a grand charge into the center of the Union line on Cemetery Ridge.

Though history would remember this as 'Pickett's Charge,' named for division commander George E. Pickett, Longstreet was actually in command. And once again Longstreet strongly opposed the offensive tactics of his commander. Their discussion ended with Lee angrily pointing with his fist and proclaiming, 'The enemy is there, and I am going to strike him!' Visibly anguished, Longstreet made arrangements for the assault; with tears in his eyes he would ask Pickett to give the final order to move out.

But before the charge began the Southern cannons all opened up together at noon, in the next hour and a half producing what may have been the heaviest barrage in history to that time. Yet this effort to soften up the Union line failed; Confederate gunners were firing slightly too high, sending most of their shots to the Union rear.

Then the guns fell silent, and the Northern soldiers in the center rose to their feet to see 15,000 men of the Army of Northern Virginia marching toward them, rifles gleaming, flags flying, bands playing, officers galloping back and forth, on a front a mile wide and three ranks deep. This picture-book spectacle ended when the Confederates came into range of Northern guns. Ragged holes soon appeared in the line as a storm of bullets and shot and shells tore into it. The Confederate right flank began to drift, and the left flank gave way. Finally a Southern spearhead of two or three hundred men crossed the low stone wall that marked the Union front. Leading was General Lewis Armistead, holding his hat aloft on his sword to show the way. That moment was the high tide of the Confederacy, its deepest penetration into enemy territory, and one of the legendary images of American history.

It did not last long. Federal reinforcements arrived and swarmed around the Southern spearhead to attack with pointblank firing, bayonets, gunstocks, and fists. Soon General Armistead was on the ground, mortally wounded, and the spearhead had turned into a rabble of frightened men, some throwing down their arms and surrendering,

others pouring back down the hill. Lee's great gamble had failed; the Battle of Gettysburg was over. On the next day, Lee began his retreat in a driving rain.

It had been by far the most terrible battle of the war. Of 88,289 Federals engaged, 3155 were killed, 14,529 wounded, and 5365 were missing, a total of 23,049 casualties. Of 75,000 engaged for the South, 3903 were killed, 18,735 wounded, and 5425 were missing, for a total of 28,063 casualties. Lee had lost over a third of his army.

Gettysburg was a monumental battle, but it was less decisive than what was simultaneously happening in the West; it was Grant's taking of Vicksburg, Mississippi, that same week that really doomed the Confederacy. Both armies would meet in battle many times more. But Gettysburg was a terrible blow to Southern morale and to Lee's reputation for invincibility. It would live in history as the greatest battle of the war and as a defining event in the consciousness of Americans, much as the battle for Troy has haunted the Greek imagination through the centuries.

Gillmore Medals

Union General Quincy Gillmore (*See*) awarded these bronze medals, carrying the inscription 'For Gallant and Meritorious Conduct,' during operations in the Charleston, South Carolina, area from July to September 1863. Some 400 medals, which were given only to enlisted soldiers, were struck.

Gilson, Helen Louise *(1835-1868)*
Sanitary Commission worker.

A Massachusetts native, she joined the Sanitary Commission in 1862, working in the campaigns of the Army of the Potomac from the Peninsula through Gettysburg, Cold Harbor and Petersburg, and organizing contraband and freed blacks to provide kitchen and other services to Union troops.

Globe Tavern *(Virginia)*, Battle of

Ulysses S. Grant's effort to extend his siege lines westward and cut off communications to Petersburg from the south led to sharp fighting here from August 18-21, 1864. Confederate forces attacked Gouverneur Warren's V Corps when it reached the Weldon

Railroad near this place on the 18th, and followed up with fresh attacks the next day and on the 21st. Union troops held their ground, with the loss of about 4400 men, including more than 3100 missing, of the 20,000 engaged. Confederate casualties were 1600 out of 14,700 involved.

Goldsborough, Louis Malesherbes *(1805-1877)*
Union naval officer.

A 45-year veteran when war broke out, he commanded Union naval forces in the highly successful joint operations with Ambrose Burnside along the North Carolina coast in August 1861. Heavily criticized in 1862 when the James River flotilla he commanded failed to reach Richmond, Virginia, he asked to be relieved of his command. He held administrative jobs for most of the rest of the war.

Gordon, John Brown *(1832-1904)*
Confederate general.

Gordon, a lawyer and mine official, worked in Alabama and his native Georgia before the war. An untrained but gifted officer, he fought at Seven Pines, Malvern Hill, Antietam, Chancellorsville, Gettysburg, and Spotsylvania, and led the assault on Fort Stedman at Petersburg. His wife, Fanny Haralson Gordon, accompanied him in the field throughout the war.

Grand Army of the Republic

Established in November 1866 in Indianapolis, Indiana, the GAR became the most influential of the Civil War veterans' organizations. The GAR often allied itself closely with Republican policies and lobbied for legislation that aided Union veterans.

Grand Review

More than 150,000 Union soldiers, members of the armies of the Potomac, the Tennessee, and Georgia, marched in review past President Andrew Johnson and other high officials in Washington, DC, on May 23-24, 1865. Afterward, the volunteers were swiftly mustered out of service.

Grant, Ulysses Simpson *(1822-1885)* Union general and 18th president of the United States.

U. S. Grant became a great commander of Federal armies and went on to be an unsatisfactory but still popular president of the United States. Grant was born in Point Pleasant, Ohio, on April 27, 1822. His father was a tanner and farmer, and the boy worked at these trades until he gained an appointment to West Point. On admission he was incorrectly listed as Ulysses S. Grant (his real first name was Hiram); rather than try to fight army bureaucracy, he accepted the new name and used it for the rest of his life. He was graduated in 1843, having distinguished himself in little but horsemanship. Two years later he led troops in the Mexican War, where he earned citations for bravery. Then his military career apparently coasted to a halt; during six years of languishing in remote

posts away from his wife, Grant began to drink heavily and in 1854 resigned, apparently to avoid being cashiered.

For the next six years Grant lived in St. Louis, fruitlessly pursuing farming and other endeavors. Finally, in 1860, he moved to Galena, Illinois, to be a clerk in his brothers' leather-goods store. On the beginning of the Civil War he was quick to look for military command; in June 1861 he became colonel of a regiment of Illinois volunteers. By September he had been made a brigadier general and was assigned to command a district with headquarters in Cairo, Illinois. He first saw action in an assault on Confederate camp at Belmont, Kentucky, that ended with his troops retreating before a counterattack. Soon after came his first successes and the beginning of his enduring fame.

In February 1862 Grant led brilliant campaigns on Forts Henry and Donelson in western Tennessee. It was during his assault on

Scenes from the military career of Ulysses S. Grant. Though not a brilliant tactician, he was probably the war's best strategist.

the latter that Grant issued his famous ultimatum to the enemy commander: 'No terms except an unconditional and immediate surrender can be accepted.' The result was the capture of nearly an entire Confederate army, the Union's first important victory, and a nickname everyone in the country knew – 'Unconditional Surrender' Grant. He was made a major general and given command of the Federal Army of the Mississippi.

The implacable drive to victory that his nickname implied would be characteristic. He was a quiet and rather shy man, awkward in gait and shabby in dress, whose face showed the effects of long struggle against failure and the bottle. He began the war with absolutely nothing to lose and an undiscovered genius. During its course, and despite some blunders, Grant would prove himself one of the great military minds of all time, able to organize vast strategic combinations to outmaneuver his opponents. In battle more the bulldog than the fox, Grant was several times outfought, ordered several disastrous assaults (notably at Cold Harbor), and was accused by his own side of being a

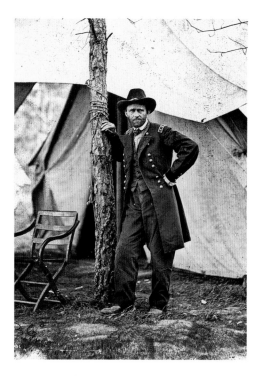

A careworn General Grant at Cold Harbor in June 1864. The errors he made in this battle haunted him the rest of his life.

butcher; but he never lost a campaign, and he captured three enemy armies whole (ending with Robert E. Lee's). The existence of the United States as it is today owes as much to him as to anyone in its history.

Fort Donelson made Grant a hero, but his next major engagement nearly ended his career. At the Battle of Shiloh in April 1862 Grant allowed his forces to be surprised and nearly overwhelmed, though on the second day he struck back to sweep the field. To demands for Grant's removal after the battle, Lincoln replied astutely, 'I can't spare this man. He fights.' Grant redeemed himself with his masterpiece, the campaign to conquer the Mississippi River city of Vicksburg. Its fall in June 1863 was arguably the single most important event of the war. Following that, late in the year, Grant took over an apparently hopelessly besieged Union army in Tennessee and by the end of the Chattanooga Campaign had put the enemy to flight.

Having risen to preeminence among Union generals, in March 1864 Grant received the rank of lieutenant general and was named general-in-chief of Union armies. In that post he planned the broad strategy that would end the war, even though several minor elements of that strategy failed: his own success and that of his friend Sherman would prove sufficient.

Rather than manning a desk, Grant took to the field with George Meade's Army of the Potomac, whose task was to run to ground Lee and his army. Grant would pursure that supremely difficult assignment for a long and bloody year, in the Wilderness, at Spotsylvania and Cold Harbor, at the siege of Petersburg, and finally at Appomattox. In that year-long campaign of attrition he would lose over half his army before he had hammered the fight out of his opponents. At the surrender of Lee on April 9, 1865, Grant offered generous terms that began, at least, the postwar era on a note of goodwill.

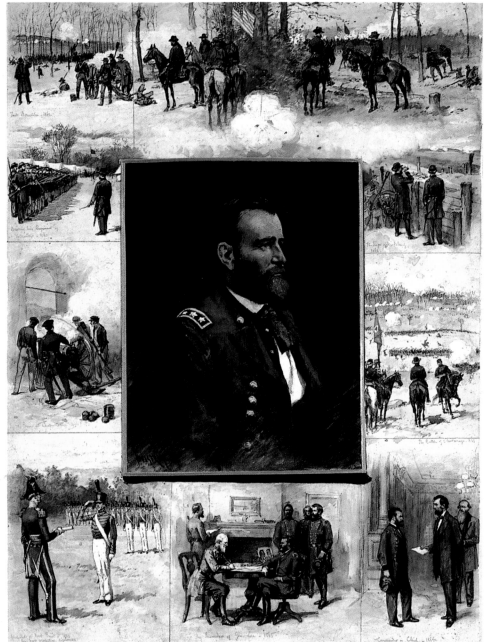

Rose O'Neal Greenhow, head of a Confederate spy ring in Washington, DC, is shown here with her daughter in a Union prison.

His career would ascend from that point in title but not in success. In 1866 Grant became the only man besides George Washington to hold the rank of full general. As head of the army he was obliged to pursue Southern reconstruction measures more punitive than he liked. Becoming the Republican presidential nominee in 1868, Grant was assured of election against the inept Andrew Johnson. But as president, the general was out of his element – aimless, bewildered with politics, innocently loyal to untrustworthy friends. As a result, his eight years in office were marked by the worst corruption and scandal Washington would see until the 1970s and 80s. Though scandals such as the Crédit Mobilier affair and the Whiskey Ring never touched Grant personally, many held him responsible for allowing his administration to

New York *Tribune* editor Horace Greeley's political views were confusingly erratic.

get out of control. To much of the nation, however, he remained America's most popular war hero throughout his term.

After leaving office and mounting a triumphant world tour that he hoped might bring him back into politics, Grant was ruined by a corrupt bank. To regain his fortune and provide for his family, he began writing about his experiences in the war. He finished his *Memoirs*, some of the finest of their kind in military literature, a few days before his death from cancer on July 23, 1885.

Grape Shot

A form of case shot (*See*), grape usually consisted of nine iron balls in an assembly of top and bottom iron plates, rings, and a connecting pin. Alternatively, the balls were lashed together with cord and encased in a canvas bag. Used at short ranges, grape gradually was replaced by the more effective canister (*See*) after 1861.

Gratiot Street Prison

A Federal prison in St. Louis, Missouri, it held Union army deserters, bounty jumpers, captured guerrillas, and Confederate prisoners of war. The building had a capacity of about 500 prisoners, but it usually held twice as many. On at least two occasions inmates set fire to the place.

Greeley, Horace (1811-1872)
Editor and politician.

Greeley founded the influential New York *Tribune* in 1841 and edited it until 1872. The newspaper was a forum for those promoting anticompromise and antislavery views and urging immediate emancipation. At first a powerful moral spokesman for the North, Greeley eroded his popular support by withholding support from Lincoln and opposing conciliatory peace policies throughout most of the war, and then, toward its end, urging Lincoln to negotiate a peace treaty favorable to the South. He ran as a Democrat in the 1872

presidential election, was soundly defeated by Ulysses Grant, and died, apparently insane, two months later.

Greene, George Sears (1801-1899)
Union general.

Rhode Island-born, this West Point graduate engineered and built railroads. He fought under Nathaniel Banks in the Shenandoah Valley Campaign of Jackson and fought at Cedar Mountain, Antietam, Chancellorsville, and Gettysburg. Seriously wounded in the Wauhatchie Night Attack in October 1863, he returned to field duty for the North Carolina Campaign.

Greenhow, Rose O'Neal (c. 1815-1864) Confederate spy.

A proslavery activist and well-connected Washington political hostess, she relayed the Federals' plans for First Bull Run to P. G. T. Beauregard and continued to transmit information after her subsequent arrest. After her release she traveled to England as a Confederate agent. She was drowned when she was returning home.

Gregg, David McMurtrie (1833-1916) Union general.

This Pennsylvanian was a West Point-trained cavalryman and Indian fighter. Commanding various Potomac Army cavalry units, he compiled a distinguished war career, seeing almost constant action from the Peninsula until his resignation in February 1865. He published an account of the activities of the 2nd Cavalry Division at the Battle of Gettysburg, during which Gregg had won special praise for foiling J. E. B. Stuart's attempt to get behind the Union lines on the third day.

Grierson, Benjamin H. (1826-1911) Union general.

A one-time Illinois music teacher who did not like horses, he won fame in perhaps the most daring Federal cavalry raid of the war. As a diversion in support of Ulysses Grant's Vicksburg Campaign, Grierson was ordered to raid south through Mississippi in mid-April 1863; he reached Baton Rouge, Louisiana, within two weeks, having inflicted 100 casualties on the enemy, taken 500 prisoners, destroyed 50 miles of railroad, and captured 1000 horses and mules, all at the cost of only 24 Union casualties. Later, he played a prominent role in W. T. Sherman's 1864 Meridan Campaign (*See*). Grierson remained in the army after the war, commanding the 10th Cavalry in Indian campaigns on the frontier.

Griffin, Charles (1825-1867)
Union general.

Ohio-born, Griffin was a West Point graduate and veteran artilleryman who fought, among many other campaigns and engagements, at First Bull Run, the Peninsula, Antietam, Fredericksburg, Chancellorsville, Gettysburg, and in the Petersburg and Appomattox Campaigns. As commander of V Corps he served as one of the surrender commissioners at Appomattox.

Habeas Corpus, Suspension of

Both Union and Confederate governments suspended this basic right, which protects citizens from being jailed without charge. Lincoln, who believed the threat to public safety outweighed the civil liberties issue, ordered the first of several suspensions on April 27, 1861, after rioting in Baltimore. On February 27, 1862, the Confederate Congress gave Jefferson Davis authority to suspend the writ of *habeas corpus*.

Hagood, Johnson *(1829-1898)*
Confederate general.

A South Carolina lawyer and planter, Hagood fought at Fort Sumter and First Bull Run, participated in the defense of Charleston and returned to the field for the Wilderness and Weldon Railroad battles and the Petersburg Campaign. He was later governor of South Carolina.

Union General Henry Halleck was better at administration than field command.

Haines's Bluff

W. T. Sherman's forces shelled Confederate positions here on April 30 and May 1, 1863, and threatened an infantry assault as a diversion from the landing of Ulysses Grant's main force at Port Gibson, Mississippi, during the Vicksburg Campaign. With Grant's army safely across the Mississippi, Sherman withdrew.

Halleck, Henry Wager *(1815-1872)* **Union general.**

Halleck, a New Yorker, was graduated third in his class at West Point in 1839; his army nickname was 'Old Brains.' He retired after Mexican War service in California's military government to establish a business career there. Appointed major general in 1861, Halleck restored honesty and order to the Missouri Department after John C. Frémont's maladministration and, thanks largely to successes won by Ulysses Grant, John Pope, and other of Halleck's field commanders, he was briefly appointed commander of the Department of the Mississippi, winning his only field victory at Corinth in April 1862. He was Lincoln's military advisor and general in chief (a position he called 'political hell') from July 1862 until March 1864, when Grant demoted him to the administrative position of army chief of staff. Austere and aloof, and inept as a strategist, Halleck nevertheless contributed substantially to the Union's wartime army administration.

Hamlin, Hannibal *(1809-1891)*
Vice president of the United States.

This Maine lawyer was an antislavery Democratic state legislator and US congressman who turned Republican in 1856 and was vice president during Lincoln's first term. Hamlin enjoyed good relations with Lincoln while promoting the Radical Republican agenda. His sons Cyrus and Charles were Union officers in the war. In 1869 Hamlin was elected by Maine voters to the US Senate and served in that capacity until 1881. From 1881 to 1882 he was the US minister to Spain.

Hampton Roads Peace Conference

On February 3, 1865, Lincoln and Secretary of State William Seward met Confederate peace commissioners aboard the *River Queen* in the Hampton Roads for peace talks. Their four-hour conference failed, largely because Lincoln, having nearly won the war, was disinclined to negotiate. He insisted on union and the abolition of slavery, while the Confederates wanted a truce to precede any substantive agreements.

Hampton-Rosser Cattle Raid

During the Petersburg siege Confederate cavalry under Wade Hampton raided a Union camp at Coggin's Point, Virginia, on September 16, 1864, and returned with 2486 cattle to feed Robert E. Lee's hungry army. Union forces suffered 400 casualties defending the corral; the Confederate losses were about 50 men.

Confederate General Wade Hampton was one of the South's best cavalry leaders.

Hampton, Wade *(1818-1902)*
Confederate general.

Born in South Carolina to wealthy planters, he held minor offices and came to doubt the economic benefits of slavery and the wisdom of Southern secession. Nevertheless, he raised the Hampton Legion, which he led at First Bull Run and in the Peninsular Campaign. He went on to fight at Antietam and Gettysburg, and succeeded J. E. B. Stuart in commanding the cavalry corps of the Army of Northern Virginia. He made his famous cattle raid on Ulysses Grant's commissariat in September 1864 (*See* HAMPTON-ROSSER CATTLE RAID), and in February 1865 he was given command of the cavalry of the Army of Tennessee, while simultaneously commanding a division of the Army of Northern Virginia. After the war he was governor of, then Senator from, South Carolina.

Hancock, Winfield Scott *(1824-1886)* **Union general.**

Pennsylvania-born, he served on the frontier and in the Mexican War after graduation from West Point in 1840. He commanded a brigade in several battles of the Peninsular Campaign, and led the 1st Division of the II Corps at Antietam and Fredericksburg. Hancock commanded the II Corps at Gettysburg and was badly wounded; though the wound troubled him long afterward, he led the corps at the Wilderness, Spotsylvania, Cold Harbor, and Petersburg. He was the unsuccessful Democratic candidate for the United States presidency in 1880.

Hanover, *Pennsylvania*

J. E. B. Stuart's cavalry attacked a body of Federal cavalry here on June 30, 1863, during the Gettysburg Campaign. After losing some prisoners and wagons, the Federals counterattacked and scattered the Rebels, nearly taking Stuart prisoner.

Hardee, William Joseph *(1815-1873)* **Confederate general.**

This Georgian, the author of a definitive infantry manual used by both sides in the

General Winfield Scott Hancock played a key role in the Union victory at Gettysburg.

war, resigned his commission when Georgia seceded and joined the Confederates. He organized 'Hardee's Brigade' in Arkansas and led a Kentucky corps at Shiloh, Perryville, and Stone's River. Hardee played a leading role in the Confederate fight against W. T. Sherman during the latter's Atlanta Campaign, March to the Sea, and Carolinas Campaign. Hardee eventually retreated to North Carolina, where he was captured near the end of the war.

Harpers Ferry Arsenal and Brown's Raid

After his murder of five pro-slavery men in a Kansas raid of 1856, fanatical abolitionist John Brown began to plan a raid in the South, hoping to unleash a massive black insurrection that would end slavery and take revenge on white Southerners in one blow. Brown believed he was directed to this task by God, who would insure its success. In fact, it was a hopeless scheme from its concept to its tragic conclusion.

Brown's first step was to capture the US Arsenal at Harpers Ferry, Virginia, a large complex containing thousands of muskets and machine shops for making weapons. With arms seized from the arsenal he would march south, gathering slaves in his column, and bring the white South to its knees. The liberated slaves would then form their own nation. He gained approval and funds from several important Eastern abolitionists (black leader Frederick Douglass refused help, saying accurately, 'you will never get out alive'); but in the end he could find only 21 men to join him. In October 1859 Brown set out for Harpers Ferry with this group, not notifying any potential recruits, without rations or escape plans, and with no strategy beyond seizing the arsenal. It is possible, in other words, that he had already decided to make himself a martyr to the abolitionist cause.

On the night of October 16 Brown arrived at the armory complex with 18 men, five of them black, and found it guarded by one watchman, who was overpowered. Brown then sent out some men to seize white hostages and recruit slaves; they returned with hostages but no black volunteers. By the next day the alarm had gone out and local militia appeared to seal off the armory. In the shooting, eight of Brown's men were killed, including two of his sons; seven other raiders escaped and three townspeople died.

That night, the 17th, a US Marine detachment arrived under the command of Colonel Robert E. Lee and Lieutenant J. E. B. Stuart. Brown had holed up in a small fire-engine house with his remaining men and hostages. The Marines attacked and broke into the engine house, killing two raiders and capturing Brown. Thus ended the insurrection, less than two days after it started. Attempting to stem reaction in and out of the South, Virginia authorities acted fast to try Brown; within six weeks he had been convicted of treason, murder, and formenting insurrection and was hanged on December 2. Six other raiders followed him to the gallows.

If he had in fact desired to shake things up and achieve martyrdom, Brown achieved his goal, not least with his eloquent and dignified behaviour during his trial and execution. He ably played the part of saint and martyr, saying at one point, 'I am worth inconceivably more to hang than for any other purpose.' The aftershocks rolled around the country. Southerners saw in his raid the spectre of their deepest fear, a slave revolt; in the ensuing revelations concerning his abolitionist supporters and admirers, the enraged South saw Northerners endorsing violence against slave-holders. To abolitionists,

At Harpers Ferry, US Marines storm the engine house where John Brown, his raiders and his remaining hostages have been surrounded.

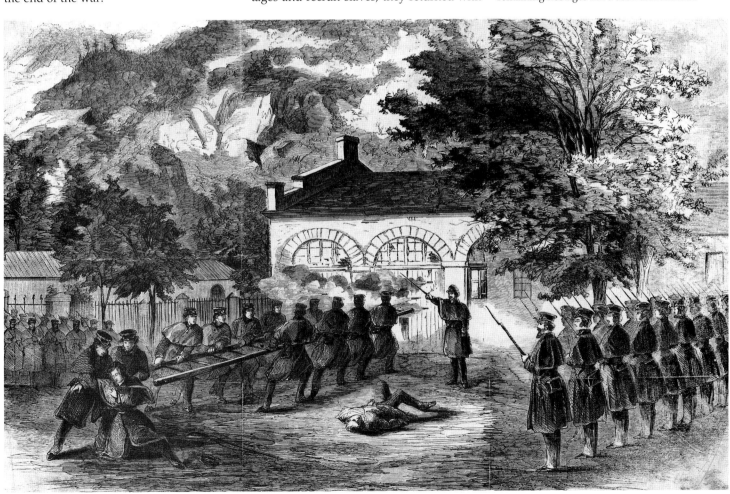

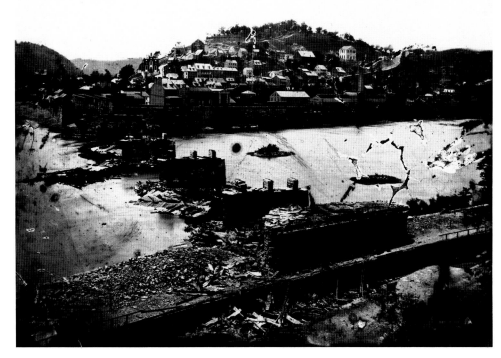

Harrison's Landing (and McClellan's Letter)

After his failure in the Peninsular Campaign, Union General George McClellan positioned his army at Harrison's Landing on the James River, where Lincoln visited him on July 8, 1862. McClellan handed the president a presumptuous letter offering advice on prosecuting the war, articulating a conservative Northern Democratic position and specifically cautioning that adherence to radical abolitionist views would cost the Union the war. The letter probably hastened McClellan's downfall.

Hartford, USS

A steam-propelled sloop-of-war built in 1858, *Hartford* was Union Admiral David Farragut's flagship at the Battles of New Orleans in

Left: A view of Harpers Ferry in 1864. The town occupied a key position at the northern end of the vital Shenandoah Valley.
Below: Future President Benjamin Harrison saw distinguished service as a general in the Union army during the Civil War.

Brown became an idol, though a troubling and ambiguous one. Quite possibly he touched off the simmering tensions that led directly to the war, whose blueclad soldiers would march to the song 'John Brown's Body.' Thoreau called Brown 'a crucified hero.' Herman Melville called him, more appropriately, 'the meteor of the war.'

Harris, Eliza
Sanitation Commission volunteer.

In addition to bringing aid and comfort to Union wounded, Harris wrote vivid newspaper accounts of life at the front which inspired financial donations to support the commission's work. She nursed wounded from First Bull Run to Gettysburg and worked in hospitals in Chattanooga and Nashville in 1863-4.

Harris, Nathaniel Harrison
(1834-1900) **Confederate general.**

In 1861 Harris organized an infantry company in Vicksburg, where he was practicing law. Joining the 19th Mississippi, he fought in the upper Shenandoah, at Williamsburg, in the Maryland Campaign, at Chancellorsville and Gettysburg, and in every main engagement from Spotsylvania through Petersburg, later participating in the defense of Richmond and in the ensuing confrontations that led to Appomattox.

Harrison, Benjamin *(1833-1901)*
Union officer and 23rd president of the United States.

An Indiana lawyer and politician, he helped raise the 70th Indiana, and, despite his inexperience, held a series of commands in the Army of the Cumberland, eventually joining W. T. Sherman for the Atlanta Campaign, March to the Sea, and Carolinas Campaign. A Republican, he was elected president of the United States in 1888.

A view of some of the 22 9-inch Dahlgrens that made up the main battery of the famous Union sloop-of-war USS *Hartford*.

April 1862 and Mobile Bay in August 1864. Wooden-hulled and equipped with a full suit of sails, she could, under both sail and steam, make 11 knots. Her main battery consisted of 22 9-inch smoothbore guns.

Hatteras Inlet, *North Carolina*

A combined Federal force under Admiral Silas Stringham captured two coastal forts here with light casualties on August 28-29, 1861. Union forces took some 670 prisoners and 35 cannon.

Hawley, Joseph Roswell
(1826-1905) Union general.

A North Carolinian by birth, he was a newspaperman and Republican organizer in Connecticut. He fought at First Bull Run, along the Confederacy's east coast, and in Virginia, led a peacekeeping force in New York during the 1864 election, and at the war's end was General Alfred Terry's chief of staff.

Hay, John Milton *(1838-1905)*
Author and statesman.

Hay was an Illinois lawyer whose Springfield connections led to his appointment as Lincoln's private secretary in 1860, a job he performed with great ability for five years. With John Nicolay, Hay later wrote the important 10-volume study, *Abraham Lincoln: A History*, published in 1890.

Hayes, Rutherford Birchard
(1822-1893) Union general and 19th president of the United States.

An Ohio lawyer and local politician, Hayes was commissioned a major in 1861 and had a varied, if undistinguished, war career, fighting in western Virginia, under John Frémont in the Shenandoah Valley Campaign of Jackson in 1862 and then in the Shenandoah Valley Campaign of Sheridan in 1864. After winning the disputed presidential election of 1876, Republican Hayes kept his promise to Southerners by withdrawing the last Union troops from the South on April 20, 1877, thus ending Reconstruction.

Henry and Donelson Campaign

In February 1862 Federal forces under Ulysses S. Grant prepared for an attack on Confederate Fort Henry (*See*) on the Tennessee River. The Federals arrived outside the fort on February 6 to find that the enemy commander had sent most of his forces to reinforce the more important Fort Donelson (*See*) on the Cumberland River in northwestern Tennessee. The 100 artillerymen left in Fort Henry, faced with Grant's 15,000 men and seven gunboats, surrendered after brief but costly resistance. Grant then marched for Fort Donelson.

The Federals besieged that 21,000-man garrison on February 13; on the next day the gunboats arrived to shell the fort, but the Donelson batteries drove them off. On the 15th, with Grant away downriver, the Confederates emerged from the fort to open up a potential escape route toward the east. At that point, however, Southern General John Floyd called in his forces and, as the Federals closed in again, fled with some 2000 men. It was assumed that General Simon B. Buckner, remaining in command inside the fort, would get favorable surrender terms from his old army acquaintance Grant.

When Buckner requested terms, however, he received the answer that would make Grant famous: 'No terms except unconditional and immediate surrender can be accepted.' With no other choice, Buckner surrendered with perhaps over 10,000 men (records are unclear) on the 16th. It was the first decisive Federal victory of the war, claiming much of Tennessee for the Union and virtually ending Confederate hopes of conquering Kentucky. The campaign also took Grant from obscurity to fame, with the nickname 'Unconditional Surrender Grant'.

Henry Repeating Rifle

This 16-round lever-action carbine used a .44-caliber rimfire cartridge. Union arms buyers favored the Spencer carbine, but state militia forces bought the Henry in quantity.

Henson, Josiah *(1789-1883)*
Black leader.

Born into slavery in Maryland, Henson escaped from a brutal master in 1830 and became an Ontario preacher and internationally renowned emancipation advocate. Having published his autobiography in 1849 and told his story to Harriet Beecher Stowe, Henson was widely regarded as the inspiration for the character Uncle Tom in *Uncle Tom's Cabin*.

Hickok, James Butler *(1837-1876)*
Union scout and spy.

'Wild Bill' Hickok, born in Illinois, was a Kansas stagecoach driver who served the Federals as a Missouri-based scout and spy in a war career characterized by dramatic adventures, arrests, and escapes. He later became an American legend as a fast-drawing Kansas marshal.

High Bridge, *Virginia*

Ulysses S. Grant ordered this bridge on Robert E. Lee's line of retreat toward Farmville (*See*) burned on April 6, 1865. Confederate defenders routed their attackers, however, capturing 780 Federals. A Confederate rear guard failed to destroy High Bridge the next day, permitting the Federals to continue their fast pursuit of Lee toward Appomattox.

Hill, Ambrose Powell *(1825-1865)*
Confederate general.

This Virginian was a hero of the Peninsular Campaign, leading 'Hill's Light Division,' so called for its fast marches, in the Seven Days' Battles. He fought at Cedar Mountain, Second Bull Run, Harpers Ferry, Antietam, and Fredericksburg. Assuming the wounded Stonewall Jackson's command at Chancellorsville, Hill led III Corps through the Gettysburg and Wilderness Campaigns. He was killed in the final assault on Petersburg.

Hill, Daniel Harvey *(1821-1889)*
Confederate general.

A West Point graduate from South Carolina, Hill was superintendent of the North Carolina Military Institute in 1861. After organizing a North Carolina instruction camp, he led the 1st North Carolina at Big Bethel and in the Peninsular and Antietam Campaigns. Prominent in the Battle of Chickamauga, he subsequently recommended Braxton Bragg's removal, earning himself demotion to a minor command in North Carolina, where he surrendered with Joseph Johnston.

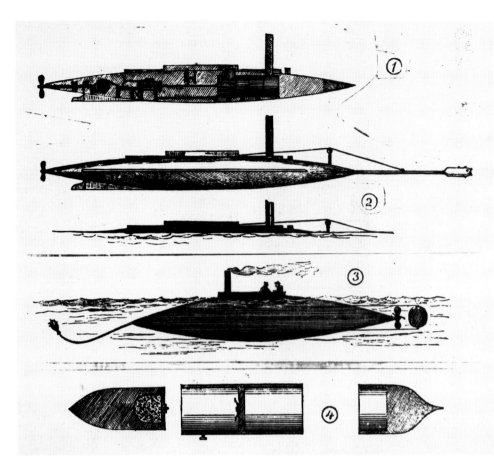

prolific than such fellow war artists as Edwin Forbes (*See*) and Alfred Waud (*See*), but, unlike them, Homer subsequently worked up a number of his sketches into full-fledged paintings, some of them (*e.g.*, *The Briarwood Pipe*, 1864, and *Prisoners from the Front*, 1866) among his most famous works.

Hood, John Bell *(1831-1879)*
Confederate general.

Kentucky-born Hood was graduated near the bottom of his West Point class in 1853 and fought on the frontier before resigning to join the Confederates. He commanded John Magruder's cavalry at Yorktown and the 'Texas Brigade' at Gaines's Mill, Second Bull Run, and Antietam. As a major general he led a division at Fredericksburg and Gettysburg (where his left arm was crippled) and James Longstreet's corps at Chickamauga (where Hood lost his right leg). Riding strapped to his horse, Hood commanded the Army of the Tennessee in the disastrous Atlanta and Franklin and Nashville Campaigns. He was relieved at his own request and fought with

Left: Sketches of the submarine CSS *Hunley*, the first such craft to sink an enemy ship.
Below: A Winslow Homer sketch was the basis for this engraving showing a sewing circle making clothes for soldiers. Lithography plainly did not enhance the artist's work.

H. L. Hunley, CSS

This Confederate submarine became the first such vessel to destroy a warship when it sank the USS *Housatonic* with a spar torpedo off Charleston, South Carolina, on February 17, 1864. Unfortunately, the blast also swamped the *Hunley*, and the submarine followed the *Housatonic* to the bottom.

Holabird, Samuel Beckley *(1826-1907)* **Union officer.**

Born in Connecticut, Holabird was a West Point-trained career officer. He served during the war as quartermaster to Robert Paterson, Nathaniel Banks, Joseph Mansfield, and A. S. Williams and, after December 1862, was chief quartermaster of the Department of the Gulf. He continued on active service in the army until 1890.

Hollins, George Nichols *(1799-1878)* **Confederate commodore.**

A Maryland native, Hollins resigned from the US Navy in 1861 to join the Confederate navy. He commanded the James River defenses, the New Orleans naval station, and the upper Mississippi naval forces. After New Orleans fell in April 1862 he sat on various naval boards.

Homer, Winslow *(1836-1910)*
Painter and war correspondent.

This great Boston-born artist began his career as a war correspondent for *Harper's Weekly*, starting in 1861. His frontline sketches, reproduced (usually to the artist's disadvantage) as lithographs in *Harper's*, won the young Homer a national reputation. He was less

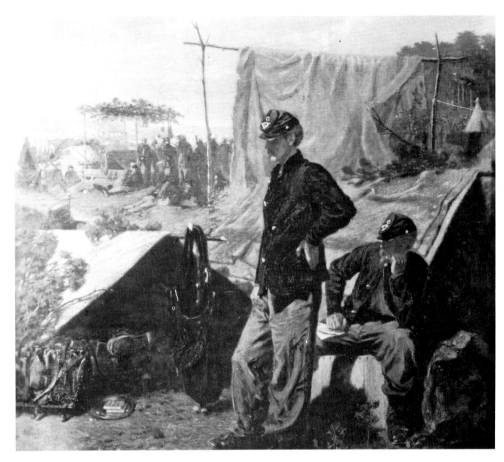

'Home, Sweet Home' was the title Winslow Homer gave this pensive painting of Union army soldiers in their camp.

P. G. T. Beauregard in Tennessee, surrendering at Natchez, Mississippi, in May 1865. 'The Gallant Hood,' though too headstrong and no match for tacticians of the stripe of W. T. Sherman, was an unparalleled brigade and division commander: 'Hood's Brigade' set a standard to which other troops aspired.

Hooker, Joseph (1814-1879)
Union general.

Born in Massachusetts and graduated from West Point (1837), Hooker resigned after the Seminole and Mexican Wars to farm in California. He participated in Washington's defenses and fought with distinction in the Peninsular and Second Bull Run Campaigns and at Chantilly. Promoted to major general, he led a corps at South Mountain and Antietam (where he was badly wounded) and commanded the Centre Grand Division at Fredericksburg. In January 1863 Hooker assumed command of the Army of the Potomac, receiving a famous letter from Lincoln frankly deploring his public criticisms of both the man he replaced, Ambrose Burnside, and the administration, and urging him to 'give us victories.' Hooker lost the Battle of Chancellorsville, however, and, after vainly seeking reinforcements, resigned his command five days before the Battle of Gettysburg. He left the field after the Chattanooga and Atlanta Campaigns. Hooker received the Thanks of Congress for defending Washington and Baltimore against Robert E. Lee. 'Fighting Joe,' a nickname he regretted, arose from typesetters' misinterpretation of a dispatch heading: 'Fighting – Joe Hooker.'

Hornet's Nest

A nickname given by Confederate troops to a position in a wooded area on the left center of the Union line on the first day (April 6, 1862) of the Battle of Shiloh.

Hot Shot

Confederate gunners used heated solid shot in the bombardment of Fort Sumter, and it could be effective in setting fire to buildings and ships. A 24-pound ball could be brought to a red heat in less than half an hour.

Hotchkiss Projectile and Gun

The projectile, designed by Union arsenal superintendent Benjamin Hotchkiss, consisted of three parts: a body, an expanding lead ring, and an iron cup. Upon firing, the iron cup drove the lead into the rifling of the gun. The projectile sometimes gave its name to the gun that fired it.

Hough, Daniel (d. 1861)
Union soldier.

On April 14, 1861, Hough, a private in Battery E, 1st US Artillery, was accidentally killed as a salute was fired before the Federal evacuation of Fort Sumter, making him the first fatality of the war. He was buried in the grounds of the fort.

Howard, Joseph Jr. (1833-1908)
War correspondent.

He sent *New York Times* dispatches from First Bull Run, but is best remembered for a journalistic hoax: in May 1864 he helped forge a presidential proclamation announcing the failure of Ulysses Grant's advance on Richmond and calling for 500,000 new Federal recruits. Two newspapers printed the story; Howard was briefly imprisoned.

Howard, Oliver Otis (1830-1909)
Union general.

Howard, a Maine native, was trained and taught at West Point. Joining the 3rd Maine, he fought at First Bull Run and in the Peninsular Campaign (where he lost an arm at Fair Oaks). After Antietam he led a division of II Corps and then led XI Corps at Chancellorsville, where his troops were routed in T. J. Jackson's famous flank attack. He served with distinction at Gettysburg, Lookout Mountain, and Missionary Ridge, then accompanied W. T. Sherman on his Atlanta Campaign, March to the Sea, and Carolinas Campaign, in the process becoming commander of the Army of the Tennessee. After the war he won more fame as an Indian fighter. A founder of Howard University (named for him), he was its president from 1869 to 1873.

Howe, Julia Ward (1819-1910)
Author and social reformer.

Born in New York City, she married Dr. Samuel Gridley Howe (1801-1876), a prominent Boston philanthropist, and with him edited the abolitionist newspaper *Commonwealth*. Although a prolific writer of both prose and verse and the first woman elected to the American Academy of Arts and Letters, she will always be best remembered as the composer of the lyrics for 'The Battle Hymn of the Republic' (*See*).

One of the 'fighting-est' Union generals of the Civil War, Oliver O. Howard was also a founder of Howard University.

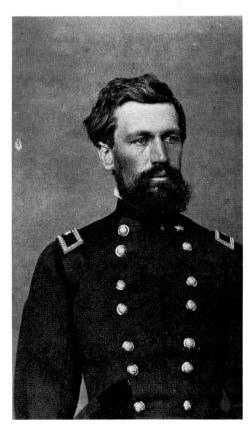

Howitzers

Designed to fire at high angles, dropping low-velocity explosive shells behind the enemy's cover, howitzers exemplified the traditional artillery that predominated during the Civil War. Wartime howitzers were smoothbores, usually bronze, and most dated from 1840s. A 12-pounder howitzer, 5 feet long, was 3.67-inch caliber and could fire 6-pound balls to 1500 yards. A battery typically consisted of four guns and two howitzers mounted on wooden carriages.

Huff, John A. *(c. 1816-1864)*
Union soldier.

A prizewinning veteran sharpshooter, Huff was a private in the 5th Michigan Cavalry when he fatally wounded Jeb Stuart at Yellow Tavern on May 11, 1864. Huff himself died of wounds received at Haw's Shop, Virginia, 17 days later.

Hunt, Henry Jackson *(1819-1889)*
Union general.

In the 1850s Hunt, a West Point graduate, helped develop the artillery tactics used throughout the war. He commanded artillery units in the Army of the Potomac from the Peninsula through Gettysburg (where he was chief of artillery) and the Wilderness, and he directed the siege at Petersburg.

Hunter, David *(1802-1886)*
Union general.

Born in Washington, DC, this West Point graduate fought at First Bull Run, commanded various departments and sat on courts martial. Hunter authorized the first black regiment (the 1st South Carolina). Lincoln annulled Hunter's unauthorized proclamation of May 1862 freeing all the slaves in the Southern Department.

Massive 8-inch gun-howitzers are mounted in Fort Corcoran, one of the fixed defenses surrounding Washington, DC.

Income Tax

The war was financed in the North largely through loans and the issue of paper money. Adding to government revenues in the war years, however, were various taxes, including an income tax. An August 1861 income tax of 3 percent on annual incomes above $800, though authorized, was never levied. However, a revised bill passed in July 1862 imposed a 3 percent charge on incomes of $600-$10,000 and 5 percent on higher incomes. By 1865 income taxes generated 20 percent of the Federal government's receipts. The Federal income tax expired in 1872, not finally to be reinstituted until 1913. The Confederate government – acknowledging its financial deterioration but angering Southerners opposed to its centralization of power – reluctantly introduced a graduated income tax in April 1863.

Indian Territory

The term defined the area that is now the state of Oklahoma, less its panhandle. Confederate forces occupied the territory through the war, and raised some Indian troops, most notably those who fought in the battle of Pea Ridge (*See*) in March 1862.

Indian Troubles

Skirmishes with Indians in the West drained Federal resources throughout the war. In August 1862 Henry Sibley's Union troops attacked the Sioux after the massacre of 450 white settlers in Minnesota. A year later Colonel 'Kit' Carson's volunteer cavalry moved against the Navaho in Arizona Territory in an operation culminating in the infamous 'Long Walk' – a 300-mile forced march to Fort Sumner, New Mexico.

Inflation

By February 1863 inflation had so weakened the Confederate dollar that its buying power had dropped to about 20 cents. In some places, bread sold for as much as $25 a loaf. The Northern war economy was also somewhat inflationary, but its tremendous agricultural and industrial production capacity meant that supply and buying power never fell critically out of balance.

Irish Bend and Fort Bisland, *Louisiana*

Union General Nathaniel Banks advanced toward Alexandria, Louisiana, with 15,000 men during his Red River Campaign of 1863. On April 13 he opened an attack on about 2700 Confederates under Richard Taylor at Fort Bisland; when the attack resumed next morning the defenders had vanished. Taylor reappeared to launch a flank attack at Irish Bend later that morning, then completed his escape. Federal pursuit was – as were all Union actions in this campaign – sluggish.

Irish Brigade

This brigade of the 1st Division, II Corps, Army of the Potomac, originally consisted of the 63rd, 69th, and 88th New York. Massachusetts and Pennsylvania regiments were added later. The brigade's best-known action came against Marye's Heights at the Battle of Fredericksburg in December 1862.

Iron Brigade of the West

Four midwestern regiments, the 19th Indiana and the 2nd, 6th, and 7th Wisconsin, formed this brigade, one of the most famous fighting units of the war. Also known as the Black Hats, the brigade lost 33 percent of its strength at Second Bull Run. With the addition of the 24th Michigan, it recovered in time to earn its nickname at Antietam. The Iron Brigade was nearly destroyed at Gettysburg, where it lost two-thirds of the 1800 engaged.

Ironclad Oath

A July 1862 act of Congress required every Federal military or civilian officeholder to declare allegiance to the Constitution and to swear that he had never fought against the Union or aided the rebellion in any other way. After the war, the oath was used to keep former Confederates out of authority.

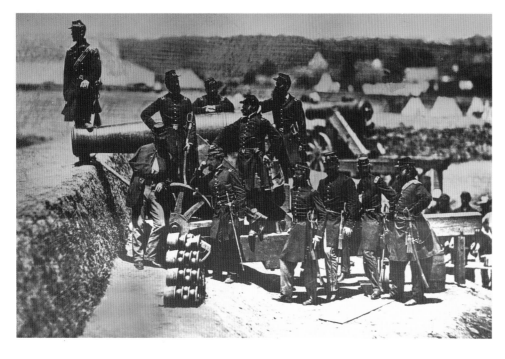

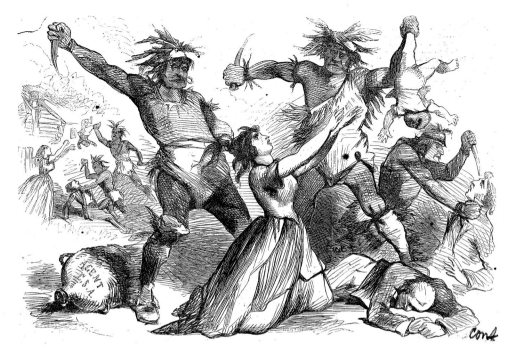

A Northern cartoon implies that Confederates were implicated in the bloody 1862 Indian uprising in Minnesota.

Ironclads

This was the generic term for vessels sheathed in protective iron armor. Both sides used armored gunboats and ocean-going warships, though the Union had a tremendous advantage in technical resources and production capacity. Probably the best-known American ironclad was USS *Monitor*, which fought a famous duel with the Confederate *Merrimac* in March 1862. Ironclads were not an American invention, the first armored ship being the French frigate *Gloire*, launched in 1858, but the Americans were the first to test the type in battle. Because ironclads proved nearly impervious to most naval (though not shore-based) gunfire, they for a time upset the traditional balance between offense and defense in naval warfare. That balance was restored only after the war with the development of high-velocity armor-piercing munitions. By then, the age of the 'wooden walls' had vanished forever.

Island No. 10

See NEW MADRID AND ISLAND NO. 10.

Iuka (*Mississippi*), Battle of

In mid-September 1862 Confederates under Sterling Price had occupied Iuka. U. S. Grant, Federal commander in the area, ordered converging forces under Edward Ord and William Rosecrans to catch Price in a pincers. The day before the intended Federal attack, however, Price moved out and struck Rosecrans; Ord, who was within supporting distance, did not hear the battle because of an 'acoustic shadow.' But Price was nevertheless outnumbered and withdrew from the town, ending plans for a contemplated Confederate invasion of Tennessee.

Iverson, Alfred (*1829-1911*)
Confederate general.

This Georgia veteran, lawyer, and businessman fought in the Seven Days' Battles, at South Mountain, and at Antietam and led a brigade at Fredericksburg, Chancellorsville, Gettysburg, and in the Atlanta Campaign, where he captured Federal General George Stoneman at Hillsboro in July 1864.

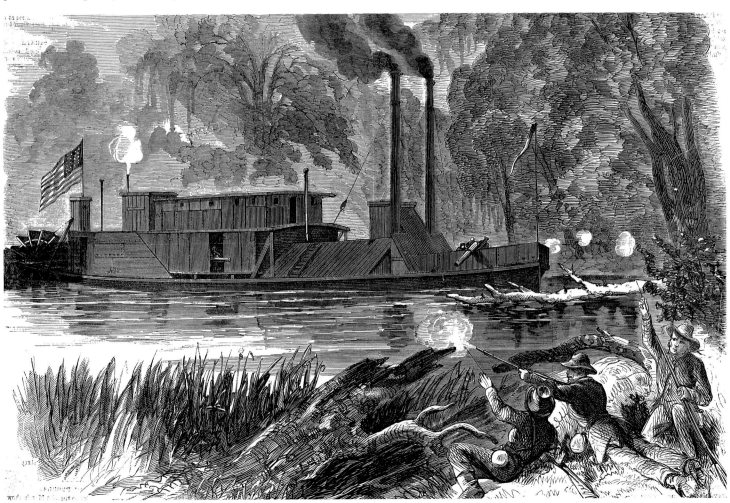

Aground on the shoals of a Louisiana river, the Union ironclad *Barritaria* is harassed by gleeful Confederate marksmen.

Jackson, *Mississippi*

Situated, as it was, due east of Vicksburg, and a base for Rebel forces, Jackson played a key role in Ulysses S. Grant's Vicksburg Campaign. After the fall of Vicksburg, Union forces under W. T. Sherman besieged the town from July 9 to 16, 1863. Rebels under J. E. Johnston withdrew without giving battle. Smaller actions were fought in or near the Mississippi capital in February and July 1864.

Jackson, *Tennessee*

Confederate cavalry under Nathan B. Forrest threatened this outpost in December 1862. With infantry reinforcements, Union troops attacked on December 19 and drove Forrest away. The Federals estimated Rebel losses at 73 and reported six casualties, including one killed, of their own. This action, also known as Salem Church, is part of Forrest's Second Raid (December-January 1862-63).

Jackson, Thomas Jonathan ('Stonewall') *(1824-1863)*
Confederate general.

Gaining his nickname from an heroic stand he and his troops made at the First Bull Run Battle, Stonewall Jackson went on to become the brilliant architect of the 1862 Shenandoah Valley Campaign that bears his name and the right-hand man of General Robert E. Lee. Born in Virginia, Jackson was graduated from West Point in 1846, fought in the Mexican War, and taught for a decade at Virginia Military Institute. Throwing his lot with the Confederacy at the beginning of the Civil War, he commanded a brigade at First Bull Run.

In 1862, now a major general, he led his fast-moving troops in the Shenandoah Valley Campaign of Jackson, a diversionary operation that would take him into military history. Afterward, joining his forces to Lee's in the Peninsular Campaign, Jackson became a corps commander in the Army of Northern Virginia. Though, because of his exhaustion, he impeded Confederate operations in the Seven Days Battles, he hit his stride again at the Second Bull Run Battle of August 1862, where he outwitted and outfought more numerous Federal forces. Further distinc-

tions followed in the great battles fought at Antietam in September and Fredericksburg in December, though Jackson did not play a central role in either.

His most remarkable and final achievement with Lee's army was at Chancellorsville in early May 1863, when Jackson marched his army secretly across the front of the Army of the Potomac and struck a devastating blow on the Union right wing. On the night of May 2, however, Jackson was wounded by his own men as he rode back from a reconnaissance. After losing an arm, Jackson steadily declined and died of pneumonia on May 10. Eccentric, obsessively pious, and ambitious, Jackson would be remembered as one of the handful of great generals in the war, a man who was always able to live up to his own primary maxim of strategy: 'Always mystify, mislead, and surprise the enemy.'

Jacksonville, *Florida*

Union forces, including black troops under Theodore Higginson (*See*), occupied this port town in late March 1863. The Federals raided upriver, taking a handful of prisoners and some horses and cotton, then burned part of the town before withdrawing on March 31.

James, Union Army of the

Organized in April 1864, it was formed by Ulysses S. Grant to threaten Richmond from south of the James River while the Army of the Potomac moved against Robert E. Lee in the north. He chose General B. F. Butler to command its two corps and single cavalry division, a total of about 20,000 troops. General E. O. C. Ord succeeded Butler, who had failed to make effective use of his forces, in January 1865.

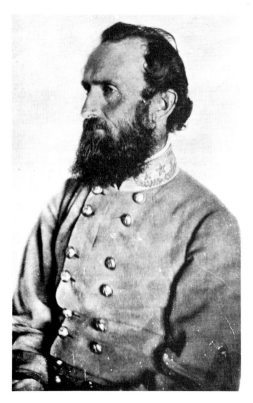

The South's second-greatest commander: the brilliant and eccentric Stonewall Jackson. His death was a heavy blow to the CSA.

James Brothers

Frank (1844-1915) and Jesse (1847-1882) James served their criminal apprenticeship in Quantrill's (*See*) guerrilla force in Missouri. Quantrill did not survive the war; the James Brothers went on to become among the most notorious outlaws of the western frontier.

James River Bridge

This Union pontoon bridge, said to be the largest continuous bridge of its type ever used in warfare, carried the Army of the Potomac across Virginia's James River toward Petersburg after the Battle of Cold Harbor in 1864. Some 450 engineers bridged the 2100-foot-wide river in the course of an eight-hour workday on June 15, 1864, using 101 pontoons and three schooners.

Johnson, Andrew *(1808-1875)*
Lincoln's vice president and 17th president of the United States.

An uneducated tailor's apprentice, Johnson settled in Tennessee and entered public service in 1830. A moderate Democrat, he was the only Southern Senator who retained his seat after secession. Lincoln rewarded him with the military governorship of Tennessee in 1862 and the vice presidential nomination in 1864. His presidency was besieged by hostile Radical Republicans, and Johnson narrowly survived impeachment in 1868 for dismissing Secretary of War Edwin M. Stanton in violation of the Tenure of Office Act. Johnson was not thereafter able to act effectively in moderating the growing harshness of Washington's Reconstruction policies. He was passed over by both parties in the 1868 presidential election, but in 1875, shortly before he died, he succeded in winning an election as Senator from Tennessee.

Johnson, Richard W. *(1827-1897)*
Union general.

An 1849 West Point graduate, he was a veteran of Indian campaigns on the prewar frontier. From 1861 on, he served in the Western Theater. As a brigade commander, he took part in the siege of Corinth. He commanded a division at Stone's River, Chickamauga, and Missionary Ridge, and during W. T. Sherman's Atlanta Campaign.

Johnson's Island, *Ohio*

A Federal prison camp in Sandusky Bay in Lake Erie, the island held about 3000 Confederate officers by the war's end.

Johnsonville, *Tennessee*

Confederate forces under Nathan B. Forrest opened fire on this Federal supply depot on the Tennessee River on November 4, 1864. The attack set off a panic among the defenders. Fires set by the shelling, by the destruction of Federal vessels and supplies to keep them from falling into Forrest's hands, and by individual looters caused an estimated $2.2 million in damage. For all the chaos and destruction they caused, Forrest's troops never actually entered the town.

Lincoln's successor, Andrew Johnson, was a man of modest capacities who had the bad luck to come into office at the time when the nation was still riven by war-bred hatreds.

Johnston, Albert Sidney
(1803-1862) **Confederate general.**

Born in Kentucky and graduated from West Point in 1826, Johnston resigned in 1835 only to rejoin the army after fighting in the Mexican War; after leading the Utah expedition (1858-60) he commanded the Pacific Department. A powerful and commanding personality, Johnston was regarded in 1861 by Jefferson Davis, among others, as 'the greatest soldier . . . then living,' an assessment not shared by later historians. He refused the Federals' offer to be Winfield Scott's second in command, instead taking charge of the Confederate Western Department as a full general. Johnston captured Bowling Green, but after losses at Logan's Cross Roads and Forts Henry and Donelson, he withdrew to Nashville, then to Corinth. He died of a leg wound at Shiloh.

Johnston, Joseph Eggleston
(1807-1891) **Confederate general.**

Though J. E. Johnston began and ended the war with considerable respect, he was largely fated to oversee losing campaigns. Virginia-born and West Point-educated, he was wounded fighting the Indians and in the Mexican War. Named quartermaster general of the US Army in 1860, he resigned next year to take a commission in the Confederacy, and was in overall command at the victorious First Bull Run Battle (though Beauregard spent more time on the scene).

Appointed to command the Department of the Potomac, Johnston was wounded at the

Confederate General Joseph E. Johnston was a fine commander fated to win few battles.

battle of Seven Pines in May 1862 and was replaced in command by Robert E. Lee. On recovery he took over the Department of the West, where his subordinates managed to lose the Vicksburg and Chattanooga Campaigns. Johnston then took over from the disastrous Braxton Bagg as head of the Army of Tennessee, but in that position he could only withdraw – which he did skillfully – before W. T. Sherman's oncoming forces in the Atlanta Campaign of 1864. Relieved in command by the unfortunate John Bell Hood, Johnston ended the war hopelessly trying to resist Sherman in the Carolinas. He surrendered to Sherman on April 26, 1865, the last significant general to do so. After years of working in railroads and insurance, and after a term in Congress, Johnston died of pneumonia contracted at Sherman's funeral (out of respect for Sherman he had stood bare-headed in an icy rain).

Joint Committee of Fifteen

This group, formally titled the Joint Congressional Committee on Reconstruction, was formed in December 1865 to develop measures for the Reconstruction of the defeated Confederate states. Radical Republicans, who favored harsh policies, dominated the committee.

Joint Committee on the Conduct of the War

This Congressional committee was established in December 1861 after a series of early Union defeats, notably Ball's Bluff, to investigate the conduct of the war. The Joint Committee interrogated officers about specific battles and campaigns and became both controversial and politicized, sometimes shaping its findings to serve political ends; but the record of its proceedings is an important resource for Civil War historians.

Jonesboro *(Georgia)*, Battle of

This was the climactic battle of W. T. Sherman's 1864 Atlanta Campaign. After O. O. Howard's Federals repulsed John Bell Hood's forces in an August 31 attack at Jonesboro, Union General John Schofield's men cut the last Confederate railroad line at the town of Rough and Ready, and Hood began evacuating Atlanta. On September 1 Hood's forces completed their evacuation, blowing up munitions and stores behind them. Fighting also continued at Jonesboro, with Sherman's men trying unsuccessfully to prevent the escape of General William Hardee's Confederates.

Jones's and Imboden's West Virginia Raid

In April 1863 Confederates William E. Jones and John Imboden set out at the same time by different routes to attack the Baltimore & Ohio Railroad, a main Federal east-west supply route. Jones, with a brigade of cavalry, carried out his part of the operation, destroying several bridges along the line and at one point threatening Wheeling and Pittsburgh. Imboden, who led a mixed force of infantry and cavalry, failed to reach the B&O.

Kanawha Valley *(West Virginia)* Campaign

In September 1862 Confederate General William Wing Loring captured several West Virginia towns, including Charleston, while Union forces were being withdrawn to check Robert E. Lee's invasion of Maryland. After the Battle of Antietam, the Federals returned and drove Loring's small Confederate force out of the state.

Kansas-Nebraska Act

Passed in May 1854, the Act divided Kansas and Nebraska into separate territories and empowered them to settle the slavery question by popular sovereignty, the erroneous assumption being that pro- and anti-slavery settlers would each choose a territory. Undoing the Compromise of 1820, the Act produced five years of political chaos and violence in Kansas (*See* BLEEDING KANSAS) and led militant antislavery groups to form the Republican Party.

Kearny, Philip *(1814-1862)*
Union general.

Kearny opposed the wishes of his socially prominent New York family to fulfill a romantic dream of being a cavalry officer. A dashing leader whose dragoons rode matched dapple-gray horses and whose troops wore distinctive scarlet, diamond-shaped 'Kearny patches,' he compiled an outstanding war record at Williamsburg, Seven Pines and Second Bull Run. He was killed while reconnoitering in September 1862. General Winfield Scott called him 'a perfect soldier.'

Kearsarge, USS

This 7-gun Union sloop-of-war sank the 8-gun Confederate raider *Alabama* off Cherbourg, France, after a sea fight on June 19, 1864. Having been cornered by *Kearsarge* in Cherbourg harbor, *Alabama*'s Captain Raphael Semmes informed *Kearsarge*'s Captain John Winslow of his intention to sortie into the open sea and fight. Winslow gladly accepted the challenge, and this second-

most-famous of Civil War single-ship duels took place, beginning at 10:57 am, on a quiet Sunday morning. The opponents were fairly evenly matched in size, speed, and armament, but the better discipline of the Union gun-crews eventually prevailed. *Alabama* slid beneath the waves at 12:24 pm. Semmes escaped capture, having been picked up and carried to England in the British yacht *Deerhound*. Union naval officers considered that Semmes's failure to surrender personally was a breach of naval etiquette.

Kelly's Ford *(Virginia)*, Battle of

On March 17, 1862, newly organized Federal Army of the Potomac cavalry were sent out

Hulled by the Union sloop *Kearsarge*, the Confederate raider *Alabama* sinks in the English Channel off Cherbourg, France.

under W. W. Averell to attack enemy cavalry around Culpeper, Virginia. With 2100 men, Averell advanced on 800 enemy under Fitzhugh Lee at Kelly's Ford on the Rappahannock. In a full day's fighting Averell's Federal forces gained about two miles, suffering 78 casualties and inflicting 133 (including mortally wounding famed Southern artillerist

Armed Southerners pour into Kansas in the 1850s to ensure that it will be pro-slavery when it attains statehood – an unintended result of the 1854 Kansas-Nebraska Act.

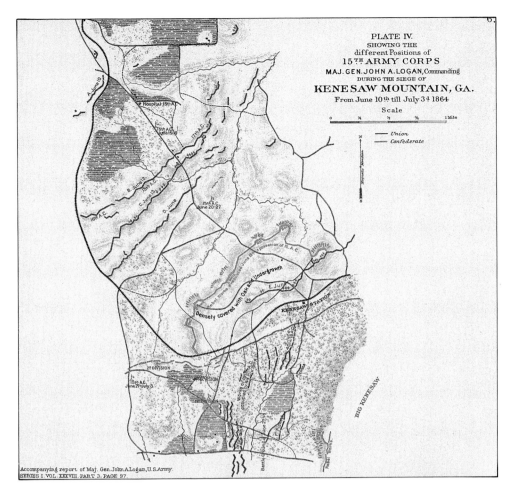

PLATE IV.
SHOWING THE
different Positions of
15TH ARMY CORPS
MAJ. GEN. JOHN A. LOGAN, Commanding
DURING THE SIEGE OF
KENESAW MOUNTAIN, GA.
From June 10th till July 3d 1864
Scale

— Union
— Confederate

Accompanying report of Maj. Gen. John A. Logan, U.S. Army.
SERIES I. VOL. XXXVIII. PART 3. PAGE 97.

A Union army map shows the disposition of opposing forces in the June 1864 Battle of Kennesaw Mountain, fought during Union General W. T. Sherman's advance on Atlanta.

John Pelham), and then withdrew. It marked the first time Northern cavalry had stood up well to Southern horsemen.

Kennesaw Mountain (*Georgia*), Battle of

During his 1864 Atlanta Campaign, General W. T. Sherman, losing patience with his slow but effective campaign of maneuver against Joseph Johnston's Confederates, decided to try a decisive blow with a frontal assault on enemy positions at Kennesaw Mountain, Georgia. On the morning of June 27, however, three Federal assaults failed to capture any of the enemy breastworks, and casualties were staggering: nearly 2000 Federals were killed or wounded of 16,225 engaged, while Southern casualties were 442 killed or wounded of 17,733 engaged. A chastened Sherman once again resumed his campaign of deliberate maneuver.

Kentucky, Invasion of

See SMITH'S INVASION OF KENTUCKY.

Kentucky, Union Department of

Both sides treated this border state as neutral ground at the start of the war. The Federals established the military department under General Robert Anderson in May 1861 but did not officially occupy the state until September fo that year.

Kernstown (*Virginia*), First and Second Battles of

There were two engagements during the war in this Virginia town, usually called 'First' and 'Second Kernstown.' The first came on March 23, 1862, at the beginning of the Shenandoah Valley Campaign of Stonewall Jackson. Ordered to keep Federal forces in the valley occupied, Jackson attacked what he thought was a small detachment of Federals under James Shields at Kernstown. In fact, the bluecoats outnumbered Jackson considerably and routed the attack. Nonethe-

less, this loss was as good as a victory for the South: it gave government leaders in Washington a fright and led them to withhold forces from reinforcing George McClellan's Peninsular Campaign, which is exactly what Jackson had hoped to accomplish. 'Second Kernstown' came on July 23-24, 1864, as part of Confederate General Jubal Early's Washington Raid. During his retreat from Washington, Early drove George Crook's Federals from the town with heavy losses.

Ketch, Bomb

These small vessels were designed to fire mortars. They were used on western rivers to bombard fixed positions, notably during Union Admiral David G. Farragut's advance up the Mississippi toward the Confederate port of New Orleans in April 1862.

Keyes, Erasmus Darwin (*1810-1895*) Union general.

Keyes, a Massachusetts-born West Point graduate and career officer, was Winfield Scott's military secretary in 1861. Commanding a brigade at First Bull Run, he led IV Corps throughout the Peninsular Campaign, notably at Seven Pines (*See* FAIR OAKS AND SEVEN PINES). During the Battle of Gettysburg he conducted a feint toward Richmond: it had little effect on the battle. He sat on an army board before retiring in May 1864.

Kilpatrick, Hugh Judson (*1836-1881*) Union general.

Known as 'Kill Cavalry,' this flamboyant officer at first served in the Virginia theater, where he led the unsuccessful Kilpatrick-Dahlgren Raid on Richmond (*See*). In April 1864 he went west at W. T. Sherman's request and commanded Sherman's cavalry during the Atlanta Campaign, the March to the Sea, and the Carolinas Campaign.

A Kurz & Allison version of the Battle of Kennesaw Mountain: this frontal assault was Sherman's only major error in the campaign.

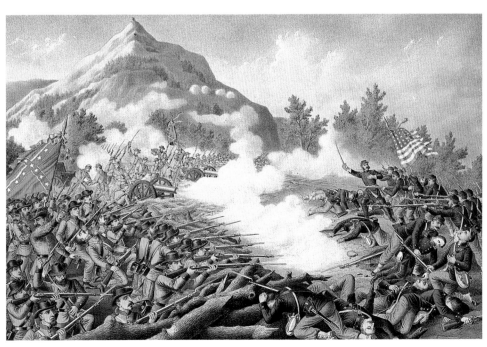

Kilpatrick-Dahlgren Raid

As Union fortunes soared at the beginning of 1864 an impetuous Federal cavalry general named Hugh Judson Kilpatrick (See) convinced President Lincoln and other superiors to back his plan for a raid into Richmond, in which his cavalry would try to create panic, release Union prisoners, and perhaps even seize the Confederate government. Kilpatrick left the Army of the Potomac on February 28, 1864, his 3584 cavalrymen heading toward Richmond in two wings. Commanding 500 men in the other wing was young Colonel Ulric Dahlgren (See), son of Navy Admiral John Dahlgren.

With little trouble Kilpatrick's wing reached the defenses north of Richmond on March 1; but after having a look he turned back and left the other wing to its fate. Dahlgren's now-divided column, meanwhile, was under heavy enemy pursuit. Within three miles of the city they were attacked and reduced to 100 riders (most of the rest escaped). On the following day, March 2, Dahlgren was ambushed and shot dead, and his remaining men were captured.

Papers found on Dahlgren's body stated, among other things, that 'The city must be destroyed and Jeff Davis and his Cabinet killed.' The South erupted in rage at this planned atrocity, and Robert E. Lee

An 1864 Republican election poster condemns the activities of the Knights of the Golden Circle as being traitorous.

demanded an explanation from Washington. None was forthcoming, and history has never discovered if the papers were authentic or who, if anyone, authorized the assassinations of Confederate officials.

King, Rufus *(1814-1876)*
Union general.

A West Point alumnus and Milwaukee newspaper editor, he organized Wisconsin's 'Iron Brigade.' King participated in Washington's defenses and led a divison at Second Bull Run, where his retreat from Gainesville on August 28 was erroneously blamed for the Federal loss. He retired in ill-health in October 1863.

Knights of the Golden Circle

Established in the South in the 1850s to promote the extension of slavery, this organization evolved into a secret Northern order of Confederate sympathizers, particularly Peace Democrats (See). Clement Vallandigham was prominent in this movement, which in 1863 became known as the Order of American Knights and then, in 1864, as the Sons of Liberty.

Knoxville Campaign

On November 4, 1863, as Ulysses S. Grant was organizing his forces in Chattanooga for the Chattanooga Campaign, Confederate General Braxton Bragg, who had been holding the Federals under siege, sent a detachment under James Longstreet to attack Union-held Knoxville, Tennessee. This campaign, planned by CSA President Jefferson Davis, was ill-advised in the extreme, given that Union forces in Chattanooga were clearly planning a breakout. It was done in part, apparently, because of friction between Bragg and Longstreet, and in part because Union General Ambrose Burnside, then in Knoxville, was preparing a march into Kentucky, an operation that Richmond was interested in stopping.

Longstreet, who at that point had 10,000 infantry and artillerymen and 5000 cavalry under youthful Joseph Wheeler, put his forces on the rails and reached Louden, Tennessee, on the 12th. On the next day Wheeler's troopers drove some blue cavalry out of Maryville, and Confederate forces began to move toward the city. Burnside responded by ordering in his outposts. At Cambell's Station on the 16th Longstreet tried and failed to cut off the enemy withdrawal. Now Burnside had all his men inside the elaborate fortifications of Knoxville.

His forces too limited to undertake a full-scale siege, Longstreet decided to concentrate on attack on a salient to the northwest that the Federals called Fort Sanders. After over a week of preparation and delays, mainly to await reinforcements, the Confed-

The Ku Klux Klan, 'an invisible empire' of Southern white-supremacist terrorists, was founded within a year of the war's end.

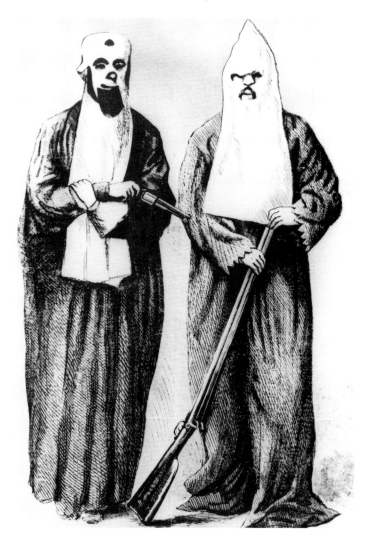

In the 1863 battle for Knoxville, Tennessee, Union troops repel a Rebel assault on Fort Sanders, a key to the city's defenses.

erate assault began on November 29. Rather than beginning with an artillery bombardment, which might have opened a breach in the steep parapet of Fort Sanders, Longstreet sent in his infantry. The advance, made in bitter cold, was slowed by Federal wire entanglements and then became bogged down in a ditch, the attackers lacking scaling ladders adequate to reach the parapet. Unable to advance, Longstreet called off the assault; the Federals captured 200 Southerners in the ditch. This mishandled effort ended the South's last chance to capture Knoxville; four days earlier, Grant's army had chased Bragg off the heights around Chattanooga.

Learning that W. T. Sherman was approaching from Chattanooga with two Federal corps to relieve Burnside, Longstreet withdrew to Greenville, Tennessee, for the winter. Showing his usual ineffectiveness, Burnside subsequently failed to drive Longstreet out of Tennessee and thus forced Grant to deploy considerable forces until next summer to keep Longstreet at bay. Having already received much criticism for failing to help William Rosecrans after the rout at Chickamauga, Burnside was now relieved at his own request, as he had been after his debacle at Fredericksburg. The bewhiskered Federal general would play one more major role in the war, as the architect of the Petersburg Mine Disaster (*See* PETERSBURG SIEGE). Longstreet brought charges against some of his officers for alleged failures in the Knoxville Campaign.

Ku Klux Klan

The Ku Klux Klan was one of several white supremacist vigilante groups organized in the South after the war. Six Confederate veterans founded the Klan in Tennessee in 1866 and adopted a constitution calling for the formation of an 'invisible empire' opposing blacks and carpetbaggers. Nathan Bedford Forrest became its first Grand Wizard. At first supported by the Democratic Party, the Klan quickly became a front for racial violence and was formally disbanded in 1869. Its clandestine activities continued, however. In two Ku Klux Klan Acts (1870, 1871) Congress outlawed the Klan's vigilante activities and attacks on blacks' voting rights. A flourishing revival in the 1920s subsided after lurid public revelations about murders and torture by Klan members.

Laird Rams

After strong Union protests, the British government on September 5, 1863, seized two ram warships being built for the Confederates at Laird's shipyard in Liverpool. Laird's also built the Confederacy's most successful commerce raider, the *Alabama*, which by late 1863 had captured or destroyed more than 60 vessels.

Lake Erie Conspiracy

A scheme by two Confederate agents to release Confederate prisoners held on Johnson's Island in Lake Erie and organize them into an army to operate in the area. The plan called for the capture of the Federal gunboat *Michigan*. Captain John Yates Beall successfully commandeered two boats on September 19, 1864, but his partner, Charles H. Cole, was discovered aboard the *Michigan* and was arrested. Beall escaped.

Lamar, Lucius Quintus Cincinnatus *(1825-1893)*
Confederate statesman.

A Mississippi lawyer and states' rights politician, he drafted his state's secession ordi-

nance. Lamar raised and led the 19th Mississippi until his health failed in 1862, later representing the Confederacy in Europe (1862-63) and serving as a judge advocate in the Army of Northern Virginia (1864-65).

Land Mines

Also called booby traps, these new weapons, usually artillery shells buried a few inches underground, exploded when stepped on. A Confederate officer appears to have been the first to introduce them, at Yorktown in May 1862, but Federal forces soon were setting booby traps of their own.

Lane, James Henry *(1833-1907)*
Confederate general.

This Virginian, a teacher educated at Virginia Military Institute, fought throughout the war with the Army of Northern Virginia, scouting before Big Bethel and surrendering at Appomattox. Three times wounded, he was a brigadier general at twenty-nine; his troops called him 'The Little General.'

Lawrence, *Kansas*

In what amounted to a terrorist attack, Confederate guerrilla William Quantrill (*See*) raided this town at dawn on August 21, 1863, killing 150 civilians and wounding about 30. Quantrill's 450 raiders then set the town afire before vanishing.

Lawrence Priming System

This disk primer magazine, patented in 1857, replaced an older priming system on Sharps rifles and carbines. The Lawrence primers were fed mechanically by the cocking of the weapon's hammer.

Lawton, Alexander Robert *(1818-1896)* **Confederate general.**

Lawton was a West Point graduate, Georgia lawyer, and secessionist legislator. He commanded the Georgia coast, took part in the

British ship-of-the-line *Majestic* guards Laird rams earmarked for the Confederacy.

Shenandoah Valley Campaign of Jackson, and fought from the Seven Days' Battles through Antietam. Wounded and reassigned, he was a reluctant but effective quartermaster general until the war's end.

Lee, Fitzhugh *(1835-1905)*
Confederate general.

Robert E. Lee's nephew, he served on the frontier in the prewar army. He served as a staff officer during the Peninsular Campaign, then led a cavalry brigade under Stuart in the Antietam, Chancellorsville and Gettysburg Campaigns. Seriously wounded at Winchester in the Shenandoah Valley Campaign of Sheridan in September 1864, he returned to command the Army of Northern Virginia's cavalry during the Appomattox Campaign. Fitzhugh Lee returned to active service in 1898, commanding the US VII Corps in Cuba during the Spanish-American War.

Lee, George Washington Custis *(1832-1913)*
Confederate general.

Robert E. Lee's eldest son, Custis Lee served for most of the war as President Jefferson Davis's aide-de-camp. He commanded Richmond's defenses during the Kilpatrick-Dahlgren Raid (*See*). In 1871 he succeeded his father as president of the institution that was then named Washington & Lee University.

Lee, Mary
Sanitation Commission Worker.

An English-born Sanitation Commission worker from Philadelphia, she served almost continuously in Union field hospitals in the Virginia theater from the Peninsular Campaign to the Confederate surrender.

The principal Confederate generals surround their great leader, Robert E. Lee.

Lee, Robert Edward *(1807-1870)*
Confederate general.

Brilliant commander of the Confederacy's most important army, Robert E. Lee emerged from the war with remarkable respect from both sides, due not only to his military genius but to his magisterial personality. Lee was born on the family estate in Westmoreland County, Virginia, on January 19, 1807, son of an old aristocratic and military Virginia family and of Revolutionary War hero 'Lighthorse Harry' Lee. Robert attended West Point and compiled a fine record, being graduated second in his class in 1829 with not one demerit on his record. He spent the next 17 years in the Engineers Corps, a prestigious post for young officers.

With many other future Civil War leaders Lee saw his first service in the Mexican War of 1846, where he distinguished himself in a series of battles and ended the war a colonel. For three years he served as superintendent

Robert E. Lee confers with his 'strong right arm', Stonewall Jackson, before the 1863 Battle of Chancellorsville.

of West Point, but left that post for cavalry service. In that capacity he led the detachment that captured abolitionist raider John Brown at Harpers Ferry (*See*).

As the Southern states began to secede at the beginning of 1861, Lee, considered by many the best man in the US army, was offered command of the Union army in the field. Despite personal objections to both slavery and secession, Lee declined; and when his home state of Virginia seceded he felt obliged to resign his commission, saying he could not raise his hand against his own people. Soon he accepted a general's commission in the new Confederate army, serving as personal military adviser to Confederate President Jefferson Davis. For a year he directed campaigns from behind the scenes, always having to defer to Davis, who largely

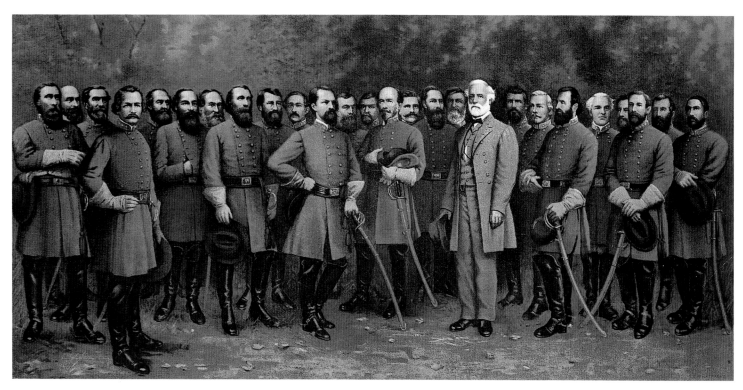

ran the Southern war effort. In his first field command Lee failed to prevent the loss of West Virginia. When General J. E. Johnston was wounded in the Battle of Fair Oaks in May 1862, Lee, at 55, took command of that army, renamed it the Army of Northern Virginia, and wrote it into military history with a brilliant series of victories over the Federal Army of the Potomac.

Though his first major engagements during the Seven Days Battles were disorganized and hardly victorious, they did serve to drive superior Federal forces out of Virginia. Lee would have the upper hand over his enemy for most of the remaining war. His string of successes began at Second Bull Run in August 1862, aided there, as later, by his extraordinary team of Stonewall Jackson and cavalryman Jeb Stuart. Lee faltered on the battlefield only when he moved into enemy territory, as he first did in September 1863, when he fought to a draw with vastly superior Union forces at the Battle of Antietam but was nevertheless obliged to pull back from his invasion of Maryland with heavy losses.

Lee was incomparable as a battlefield tactician, fiercely aggressive for all his courtly manners, able to respond to the changing conditions of battle to gain local superiority over superior enemy forces, and able to inspire his men to remarkable feats. A gambler and iconoclast, Lee in several battles (notably Chancellorsville) violated the old military maxim against dividing forces in the face of superior enemy forces. His great enemy later in the war, Ulysses S. Grant, was the better strategist, a genius at large maneuvers; but not Grant or any other Federal general was able to bring Lee to bay on the battlefield, even with twice the men. (Lee's one major defeat, at Gettysburg – another ill-advised invasion – was lost mainly by his own inexplicable decision to gamble all on Pickett's Charge (See).) Lee's primary weakness was exactly in large-scale strategy, particularly logistics – his army fought hungry, ragged, and often shoeless, even when these supplies were available. Nonetheless, such was the power of Lee's personality and leadership that time and time again his men outfought a better-fed, better-equipped, and outnumbering enemy.

Lee's masterpiece was the Battle of Chancellorsville in May 1863, but that battle also marks the summit of his success. There he lost Stonewall Jackson, his right-hand partner, and followed up that loss by another over-ambitious invasion which came to grief at Gettysburg in July 1863. (Typically, Lee took full responsibility for the defeat and offered to resign. Equally typically, the resignation was refused and his men lost none of their faith in him.)

From then on, Lee was forced into fighting a defensive war, which did not suit his aggressive style; but he did it with the same brilliance as before, fighting Grant and the Army of the Potomac to a standstill in the battles of the Wilderness, Spotsylvania, and Cold Harbor. But as Lee settled into Petersburg to withstand Grant's siege in summer 1864, he knew as well as anyone that only a miracle could save the Confederacy; the South had reached the bottom of the barrel in supplies of food, matériel, and fighting men.

When Lee was finally named general in chief of Confederate armies for the first time in February 1865, it was virtually an empty title.

Forced out of Petersburg in early April 1865, Lee doggedly attempted to escape to the Carolinas with his army, but Grant finally ran him to ground at Appomattox. On April 9 the two generals signed the surrender of the Army of Northern Virginia, which both knew was effectively the end of the war. Lee was paroled home and officially indicted for treason, but he was never brought to trial. When he applied for a pardon in June 1865, he urged his troops and all Southerners to accept the outcome and get on with rebuilding. In the campaign of 1868 some Northerners even backed Lee for president. Instead, he became president of small, destitute Washington College in Virginia (later renamed Washington and Lee). Still in that post, Lee died in Lexington, Virginia, on October 12, 1870. A Southern tradition holds that his last words were, 'Strike the tents.'

Later, many would note that Lee, the courtly Virginia aristocrat, represented perhaps the last vestige of the old chivalric tradition in war. Certainly his own time was not inclined to ask the question of how such a breathtaking gambler and such an extraordinarily aggressive killer on the battlefield could be reconciled with so mild and dignified a personality. As to the question of who was really the greatest general of the war, that will forever be debated among partisans of Lee, Grant, Jackson, Sherman, Forrest, and others; but, at least in the popular imagination, no other Civil War commander has even attained quite the same near-mythic stature as Robert E. Lee.

The text of Lee's farewell address to his beloved Army of Northern Virginia.

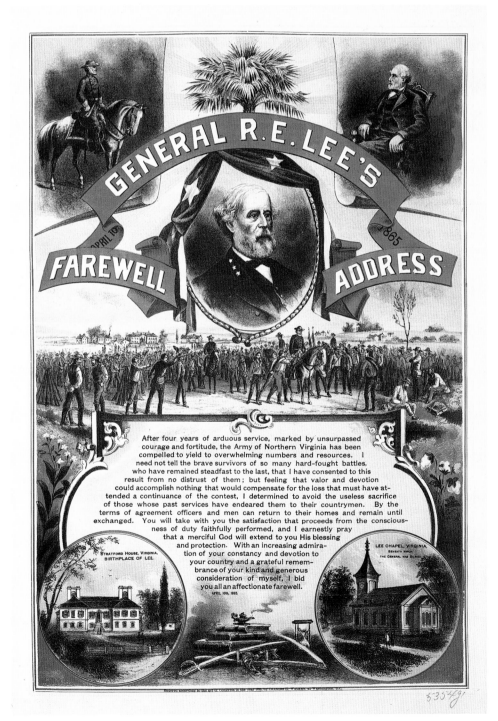

Lee, William Henry Fitzhugh
(1837-1891) **Confederate general.**

Robert E. Lee's second son, 'Rooney' Lee led W. W. Loring's cavalry during West Virginia operations of 1861. He fought with Jeb Stuart at Antietam, Fredericksburg, Chancellorsville, and Gettysburg. Taken captive while he was recovering from a wound received at Brandy Station in June 1863, he was exchanged in 1864. Rooney Lee commanded Rebel cavalry in the retreat from Petersburgh to Appomattox in the spring of 1865.

Legal Tender Acts

Congress issued treasury notes in 1862, 1863 and 1864 to help finance the war. Some $450 million-worth of these notes, called greenbacks, were printed; they circulated at fluctuating values.

Leggett, Mortimer Dormer
(1821-1896) **Union general.**

This Ohio school superintendent volunteered as George McClellan's unpaid aide-de-camp in 1861 and went on to raise the 78th Ohio, fighting at Fort Donelson, Shiloh, Corinth, and Vicksburg and participating in the Atlanta Campaign and the March to the Sea. The hill he captured and held at Atlanta was renamed Leggett's Hill.

Legion

This term describes a military formation composed of infantry, artillery, and cavalry. The Union's Corcoran (*See*) and the Confederacy's Hampton (*See*) were two notable Civil War legions.

Le Mat Revolver

A New Orleans-born physician named J. A. F. Le Mat invented this nine-shot, double-barreled pistol. He could not get the machinery to produce his weapon in the Confederacy, so he sailed to Europe on the British packet ship *Trent* (*See*) and manufactured about 3000 pistols and carbines there.

Former Confederate POW camp, Libby Prison, in 1865. A year earlier it was the scene of the war's most spectacular jailbreak.

Letters of Marque

Generally issued by a recognized government, they distinguish commerce-raiding privateers from common pirates. On April 17, 1861, President Jefferson Davis announced that the Confederate government would accept applications for letters of marque. At about the same time, Lincoln announced that Union naval forces would blockade Southern maritime ports.

Lexington, *Tennessee*

In a preliminary to the Stone's River battle, Nathan B. Forrest's Confederate cavalry attacked and routed the 11th Illinois Cavalry here on December 18, 1862. The 11th retreated toward Jackson with a loss of 124 troopers. The action was part of Forrest's Second Raid of December-January 1862-63.

Libby Prison Escape

More than 100 Union officers escaped from notorious Libby Prison on the James River in Richmond on February 9, 1864, fleeing down a tunnel they had dug. Of the 109 who escaped in this largest prison break of the war, 48 were recaptured, two drowned, and 59 reached the Federal lines.

Lincoln, Abraham *(1809-1865)*
Sixteenth president of the United States.

Every people needs its success stories, its great leaders, its saints, its martyrs. The importance and the mythical presence of Abraham Lincoln in American history results from his being all those things. Rising from obscurity to lead the nation through its greatest trial, he brought to the presidency a nobility of character and moral courage combined with a genius for politics, for statesmanship, and for soul-stirring language.

Lincoln was born in a log cabin near Hodgenville, Kentucky, on February 12, 1809, son of a barely educated frontier farmer. The family moved to Indiana when he was seven. From his youth he aspired to a life beyond small farming. Though he attended school less than a year, he studied on his own, sometimes walking miles to borrow books. His self-education led him to the study of law after he had moved to New Salem, Illinois, in

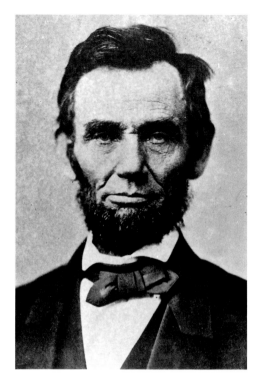

Abraham Lincoln, as he looked on November 8, 1864, 11 days before the Gettysburg Address.

1831. Reading law while he worked at various jobs, he was admitted to the bar in 1836 and moved to the state capital of Springfield to begin his practice.

His political career had already begun. Elected to the Illinois house of representatives as a Whig in 1834, he spent seven years there as a lackluster legislator. By the time he left, his law practice was prospering and he had wed Mary Todd, high-spirited if sometimes unstable daughter of a prominent family. As a circuit-riding lawyer, Lincoln gradually made himself known in political circles statewide. In 1846 he ran successfully for the US House of Representatives but after two eventless years was back in Springfield, disillusioned with politics.

It was his opposition to slavery that brought him back to politics. In 1856 he joined the new antislavery Republican Party and two years later was its candidate for the Senate against Stephen A. Douglas, who had accommodated pro-slavery forces with the Kansas-Nebraska Bill (*See*). The two began a series of debates which were to make Lincoln a national figure, even though he lost the election. His reputation bore fruit in 1860 when Lincoln gained the Republican presidential nomination and rode a split in the Democratic party to win in Electoral votes (he lacked a popular majority). As had been feared, however, some Southern states responded to his election by seceding from the Union. When Lincoln took office in February 1861, he already faced a rival slaveholding country of seven states, with its own constitution, president, and military. After the fall of Fort Sumter, six more states seceded, but three other slaveholding states nevertheless remained in the Union.

He came to Washington an unknown, with only two years of experience in national politics and those unsuccessful. His position on slavery was moderate and politically expedient: he had written, 'If slavery is not

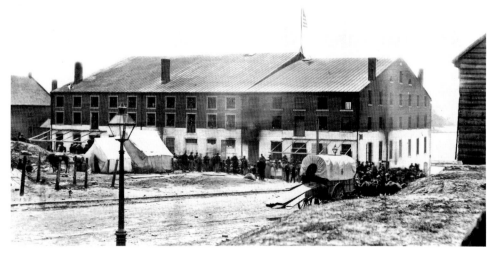

wrong, then nothing is wrong,' and, 'A house divided against itself cannot stand'; but, nonetheless, for the moment he was willing to tolerate slavery in the South to preserve the Union, but he firmly objected to its spread into new territories.

Lincoln's gift with words had made him famous, but in manner and appearance he was less inspiring. His voice was high and flat, his frame gaunt and awkward, his clothes ill-fitting, and his face rough-hewn (though there was about it an unmistakable quiet dignity and nobility). He had a disconcerting habit of cracking jokes at inappropriate moments (though the jokes were often memorable, as when he took to bed with a mild case of smallpox saying, 'At last I have something I can give everybody.') A member of his cabinet dismissed Lincoln as 'the original gorilla.' He seemed an unlikely man to save the Union.

Yet in test after test, decision after decision, political maneuver after maneuver, Lincoln would prove equal to the most daunting tasks a president ever faced. As tensions grew over Southern demands for the Union to evacuate of Fort Sumter, he made sure that if the crisis came to conflict, it would be the South that began the hostilities, thereby giving the Confederacy responsibility for starting the war. When Sumter fell Lincoln raised a Union army by decree before Congress could get a word in. He successfully placated the slaveholding Union states (and the racism of the time) by steadily maintaining that the war was entirely over secession, not slavery; then, at the politically opportune

time, January 1863, he released the Emancipation Proclamation (*See*) that indeed made the conflict a war over slavery, in the process making it morally impossible for Europe to support the Confederacy. He deliberately appointed to his cabinet strong-minded men of varying political pursuasions, several of whom aspired to replace him as president, and managed to fight off their challenges to his power while exploiting their considerable abilities. With a stubborn and often near-mutinous Congress he did likewise. In the end, this strange, homely, depressive, and elusive figure was able to secure the loyalty of most of the North and many of his former enemies, not to mention his soldiers, who voted for him overwhelmingly in the election of 1864. His immortal Gettysburg Address of November 1863 remains the most succinct and eloquent statement of American ideals.

On April 14, 1865, less than a week after Lee's surrender at Appomattox, Lincoln was assassinated by actor John Wilkes Booth at Ford's Theater in Washington (*See* LINCOLN'S ASSASSINATION). Had he lived, he would have faced a task as difficult as the war, the task of trying to secure his conciliatory vision of Southern reconstruction against the Radical Republicans who demanded revenge and supression. His second inaugural address had ended, 'With malice toward none, with charity for all, with firmness in the right as God gives us to see the right, let us strive on to . . . bind up the nation's wounds, to care for him who shall have borne the battle and for his widow and his orphan – to do all which may achieve and cherish a just and lasting peace among ourselves and with all nations.' The final tragedy of his death was that it left these great tasks to be performed by lesser men.

This Mathew Brady photograph of the much-criticized Mary Todd Lincoln was apparently made sometime in 1861.

Lincoln, Mary Todd *(1818-1882)*
Wife of Abraham Lincoln.

Born into a genteel Kentucky family, she settled in Illinois in 1839 and married Lincoln in 1842. Her close Southern family ties, political interference, and unpredictable temperament attracted criticism during Lincoln's presidency, but his affection for her was apparently unwavering.

Lincoln's Assassination

While living in Washington, actor and fanatical Southern patriot John Wilkes Booth (*See*) assembled a group of conspirators in 1864 and with them planned to abduct President Lincoln and make him a hostage in the South. None of these plots came to fruition. After Lee's surrender at Appomattox on April 9, 1865, Booth turned to the idea of assassinating the president, perhaps in hopes this would inspire the Confederacy to fight on.

Learning that Lincoln planned to attend Ford's Theatre in Washington on the night of April 14, to see a comedy called *Our American Cousin*, Booth quickly collected his current conspirators and handed out assignments: he would shoot the president, George Atzerodt would kill the vice-president, Lewis Paine (a.k.a. Powell) would kill Secretary of State William Seward, and David Herold would help Booth escape. (The slow-witted Atzerodt would lose his nerve, but Paine would seriously wound Seward in his bed.)

Arriving at the presidential box in the theater, Booth found it unguarded, slipped in, and shot Lincoln behind the ear as he sat next to his wife and amidst a party of several people. Booth then leapt from the box to the stage (in the process breaking his leg), where he apparently shouted the phrase *Sic semper tyrannus!* ('Thus be it ever for tyrants'). Lincoln died next morning in a rooming house

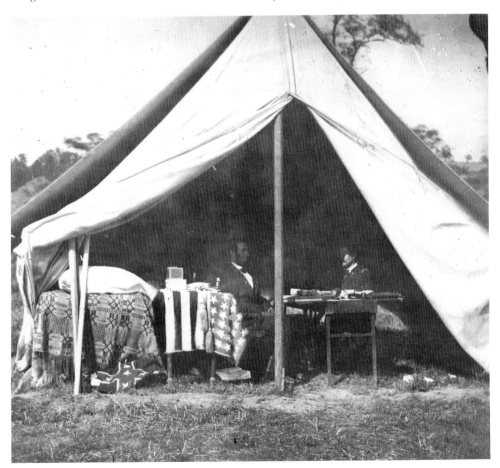

Lincoln meets with General George McClellan in the field on October 1, 1862, two weeks after the savage Battle of Antietam.

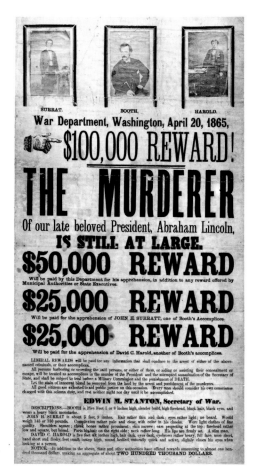

Signed by Secretary of War Stanton, this poster offers rewards for the capture of the conspirators in Lincoln's assassination.

across the street, the first president to fall victim to assassination.

With Herold, Booth fled to Virginia, where they were run to ground and Booth was killed. Later, Herold, Paine, and Atzerodt were hanged, along with Mary Surratt, Booth's landlady (who may well have been innocent). Four other supposed conspirators were sentenced to life imprisonment but received pardons in 1869.

Little Rock, *Arkansas*

Confederates captured the US arsenal here on February 8, 1861. Federal forces returned to the Arkansas capital in September 1863.

Little Round Top

A small hill lying between Cemetery Ridge and the Round Top at the southern end of the Union line at the Battle of Gettysburg, it was the pivot of battle on the second day.

Livermore, Mary Ashton Rice *(1820-1905)*

Sanitary Commission organizer.

A Chicago writer and editor when war broke out, she helped set up the Sanitary Commission's Northwestern Branch. After becoming a national director of the Sanitary Commission, she inspected battlefields and lectured widely, work that led her later into feminist activism. Her memoir, *My Story of the War*, contains much valuable information on the work of the Sanitary Commission.

Logan, John Alexander *(1826-1886)* Union general.

This Illinois Congressman left Washington to fight at First Bull Run. He participated at the capture of Fort Donelson, the Vicksburg and Atlanta Campaigns, the March to the Sea, and the Carolinas Campaign, commanding XV Corps and, briefly, the Army of the Tennessee. Logan later founded the Grand Army of the Republic and established Decoration (Memorial) Day.

Logan's Cross Roads *(Kentucky)*, Battle of

About 4000 Confederates under George B. Crittenden attacked a 4000-strong Union force under George H. Thomas here as part of the defense of the Cumberland Gap (*See*) on January 19, 1862. After a hard fight Crittenden's line broke, forcing the Rebels to retreat across a rain-swollen stream and leave their heavy equipment behind. Thomas's Federals took 12 guns, a quantity of small arms, and about 1000 horses and mules. The action is also called the Battle of Mill Springs.

'Long Tom'

The Confederates dubbed a 30-pounder Parrott captured at First Bull Run a Long Tom, and eventually it became the name for all guns of that type. US troops in World War II used the name for a 155-millimeter cannon.

Longstreet, James *(1821-1904)*
Confederate general.

South Carolina born and West Point trained, Longstreet led a Confederate brigade at First Bull Run and became Robert E. Lee's primary infantry commander in 1862; after Antietam he was promoted to lieutenant general. His record with Lee was outstanding at times, at other times less so. A man of strong convictions, he opposed Lee's plan to invade Pennsylvania and bitterly objected to 'Pickett's Charge' at Gettysburg, though he was ordered to organize that charge and did so. He was later sent south and fought with distinction in the Chickamauga Battle and with less distinction in the Knoxville Campaign before returning to Lee's army for the Wilderness Battle in 1864 (where he was seriously wounded) and for the ensuing battles and campaigns of the Army of North-

Confederate General James Longstreet.

ern Virginia up to Appomattox. His postwar years were shadowed by the South's blaming him – unfairly – for the failure of Pickett's Charge; he ended up a Republican and supporter of the presidency of his one-time enemy, Ulysses S. Grant.

Lookout Mountain *(Tennessee)*, Battle of

On Ulysses Grant's orders, Joseph Hooker assaulted this natural strongpoint, which rises 1100 feet above the Tennessee River, as part of the Chattanooga Campaign. Hooker sent two divisions up the mountain on the foggy morning of November 24, 1863. After some sharp fighting around Craven's Farm, the Rebels pulled back a few hundred yards to new positions. Attackers and defenders then settled down for the night. After midnight, the Confederate forces were withdrawn. Because of the fog, this engagement has also been called 'The Battle Above the Clouds.'

Loring-Jackson Incident

When Confederate War Secretary Judah P. Benjamin granted General William Wing Loring's appeal and overrode an order from Stonewall Jackson in western Virginia in January 1862, Jackson threatened to resign

The murder of Abraham Lincoln by John Wilkes Booth in Ford's Theatre, Washington, DC.

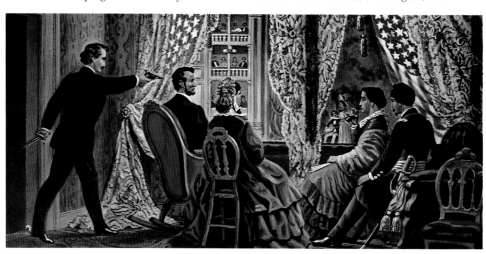

The Battle of Lookout Mountain in November 1863 was one of two actions by which Grant broke the Rebel siege of Chattanooga.

from the army. Benjamin reversed himself and backed Jackson. A few weeks later General Loring was transferred away from Jackson's command.

Loudon Rangers

The Federals recruited this force from among the German settlers around Leesburg, Virginia, in the spring of 1862. The Rangers were assigned to track the Confederate John S. Mosby's (*See*) Partisan Rangers, but were no better suited to the task than the regular Union units that constantly tried and failed to catch Mosby's men.

Lovejoy's Station, *Georgia*

John Bell Hood's Confederate army concentrated here after the evacuation of Atlanta (*See* ATLANTA CAMPAIGN) in September 1864, and here W. T. Sherman's IV and XXIII Corps attacked CSA General William Hardee's forces, which had begun to prepare defensive positions, on the morning of September 2. Skirmishing continued for another three days. Hood's main forces were in place by September 4, and on the 5th the Federals withdrew into Atlanta.

Lovell Court of Inquiry

A West Point graduate (1842), Mansfield Lovell resigned as deputy street commissioner for New York City to enter Confederate service. He commanded at New Orleans (*See*) when Union forces captured the city in April 1862. A Confederate court of inquiry concluded in 1863 that Lovell had defended New Orleans with energy and competence, given the resources at his disposal.

Union General Nathaniel Lyon (left) with Colonel (soon-to-be-General) Franz Sigel.

Lowe, Thaddeus Sobieski Coulincourt *(1832-1913)*
Aeronaut and inventor.

As a scientist investigating air currents from a hot-air balloon, Lowe was briefly arrested as a Union spy on a flight over the Carolinas in 1861. He pioneered air-to-ground telegraphy and aerial photography and became supervisor of the Union army aeronautics corps, a balloon fleet that observed the battles of the Army of the Potomac from First Bull run through Gettysburg.

Loyalties of Military Men

In 1861 only 26 of the 15,000 enlisted men in the Regular Army left to join the Confederate forces. Of the 620 officers from the North, 16 men, all married into Southern families, joined the Confederate Army. Among the Southern officers, about half of the 330 West Point graduates but only one of the 130 civilian appointees – Winfield Scott – fought on the Federal side.

Lynchburg, *Virginia*

Federal forces under David Hunter attacked and were repulsed here on June 18, 1864. Some of the Confederate defenders were newly arrived from Jubal Early's corps. When Early began his advance up the Shenandoah Valley, a preliminary to his Washington Raid (*See*), the dismayed General Hunter retreated northward in haste.

Lyon, Nathaniel *(1818-1861)*
Union general.

Born in Connecticut, this West Point-trained career soldier became a Republican polemicist while stationed in 'Bleeding Kansas.' Commanding the arsenal and then the Federal troops in St. Louis, his decisive operations against the Confederates probably saved Missouri for the Union. He was killed at Wilson's Creek in August 1861.

MacArthur, Arthur *(1845-1912)*
Union officer.

Massachusetts born, he joined the 24th Wisconsin Volunteers in August 1862 and fought at Perryville, Stone's River, and Missionary Ridge (where his conspicuous bravery won him a Medal of Honor) and in numerous battles of the Atlanta campaign, becoming one of the youngest regimental commanders of the war. He would later serve in the Spanish American War and would be the military governor of the Philippines in 1900-1901. He retired a lieutenant general. Douglas MacArthur was his son.

Machine Guns

The Civil War saw the first combat use of machine guns, but the indifference of military experts forestalled their widespread

One of the best of the war's proto-machine guns was the .58 caliber Ager 'Coffee Mill' but the Union bought only 63 examples of it.

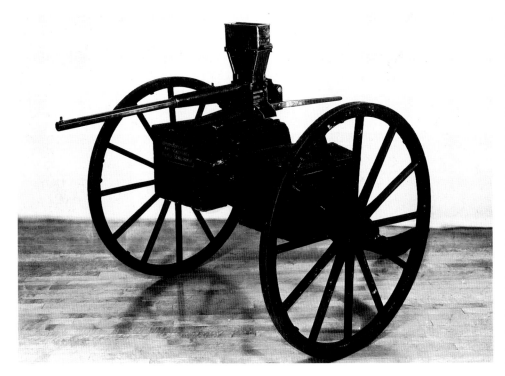

adoption. Designs included the battery gun, the Vandenberg, the mechanically loaded Ager Battery Gun and Williams Gun, and the Gatling Gun, patented in 1862. Union General Benjamin Butler bought a dozen Gatlings with his own money and used them at Petersburg, but they were not officially procured until after the war.

Mackenzie, Ranald Slidell *(1840-1889)* **Union general.**

First in his class at West Point (1862), this New Yorker compiled a distinguished war record as an engineer officer with the Potomac Army from Kelly's Ford through Petersburg and served as a commander in the Shenandoah Valley Campaign of Sheridan and the Appomattox Campaign. Ulysses S. Grant called Mackenzie 'the most promising young officer in the army.'

Maffitt, John Newland *(1819-1886)*
Confederate naval commander.

Born at sea, Maffitt was a career naval officer. Commanding the Confederate ships *Savannah*, *Florida*, and *Albemarle*, he was engaged in combat and blockade-running; he ran the Federal blockade of Mobile against nearly unsuperable odds and captured dozens of Union ships.

Magruder, John Bankhead *(1810-1871)* **Confederate general.**

Virginia-born Magruder was a West Point graduate and Mexican and Seminole Wars veteran whose courtliness earned him the nickname 'Prince John.' He failed to sustain the decisiveness he had initially shown at Big Bethel, Yorktown, Mechanicsville, and Gaines's Mill, and after he had made some critical errors late in the Peninsular Campaign he was transferred to the District of Texas, where he captured Galveston. He lectured about the war in later years.

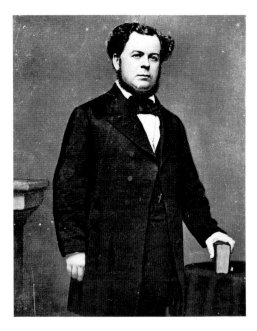

Stephen Mallory did excellent work as the Confederacy's secretary of the navy.

Mahan, Dennis Hart *(1802-1871)*
Military educator.

A New Yorker trained in engineering at West Point, he taught civil and military engineering there for 40 years. Among his numerous publications, the treatises *Field Fortification* (1836) and *Advance-Guard, Out-Post . . .* (1847) were standard military texts for officers on both sides throughout the Civil War. His son, Alfred Thayer Mahan (1840-1914), who served as a Union naval officer during the war, eventually became one of the world's greatest naval historians.

Mahone, William *(1826-1895)*
Confederate general.

A Virginia railroad president in 1861, 'Little Billy' commanded the Norfolk District and fought in the Army of Northern Virginia virtually continuously from the Peninsula through Spotsylvania. Promoted to major general for heroism at the Petersburg crater, he led 'Mahone's Brigade,' famous for its *esprit de corps*, through Appomattox.

Mallory, Stephen Russell *(1813-1873)*
Secretary of the Confederate navy.

Raised in Florida, Mallory was a customs inspector, judge, and, by 1861, a US Senator of ten years' standing who opposed secession and the war. Nevertheless, he resigned and served as secretary of the Confederate navy throughout the war with creditable resourcefulness against great odds (*See* CONFEDERATE NAVY). Arrested with Jefferson Davis in May 1865, Mallory practiced law in Florida after his release.

Malvern Hill *(Virginia)*, Battle of

In the last of the Seven Days' Battles, on July 1, 1862, Robert E. Lee's Confederates attacked George McClellan's Army of the Potomac north of Richmond. The utterly disorganized attack was met by a withering Federal artil-

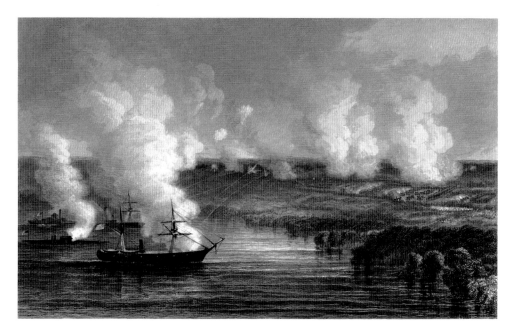

Although the Union won the 1862 Battle of Malvern Hill, General McClellan persisted in his retreat down the Virginia peninsula. Here, Union gunboats cover the retreat.

lery barrage from Malvern Hill. By the end of the day Lee had suffered 5355 casualties to the Federals' 3214; both armies had over 80,000 engaged. Though McClellan had inflicted a devastating repulse, he continued his retreat to Harrison's Landing.

Manassas, First and Second

Southern names for the two great battles that are called in Northern histories First and Second Bull Run.

Marais des Cygnes (Kansas), Battle of

On October 25, 1864 Confederate General Sterling Price's forces, retreating after their month-long raid in Missouri (See PRICE'S RAID), paused to fight a rearguard action against Federal cavalry; the fighting cost the Confederates 1000 prisoners, including Generals John Marmaduke and William Cabell and four colonels.

March to the Sea

In October 1864 Southern general John B. Hood moved his army into Tennessee to attack Federal supply lines, trying to make up his loss of Atlanta (See) by drawing enemy forces out of Georgia to protect their lifeline. After pursuing Hood for a while, his adversary, General William Tecumseh Sherman, decided to leave the Confederate army to the efforts of other Federal detachments in Tennessee, and to pursue a new campaign. This decision would make Sherman one of the great generals of the war and the most hated man in the long memory of the South. He planned to cut away from his vulnerable supply line and march his 62,000 men across Georgia to Savannah and the sea. His troops would forage for food and supplies from the population and destroy everything in their path. 'I will make Georgia howl,' Sherman wrote. In the process he would show the

South and the world that the Confederacy was powerless to stop him.

Atlanta experienced a foretaste of what was coming. Sherman turned the city into a Federal military camp, commandeered its food, and burned all buildings of possible military importance, along with a good many private homes. Half the inhabitants were evicted, and streams of refugees poured out of the city. To protests from Atlanta officials Sherman declared, 'War is cruelty, and you cannot refine it; and those who brought war into our country deserve all the curses and maledictions a people can pour out. . . . You might as well appeal against the thunder-

storm as against these terrible hardships of war. . . . the only way the people of Atlanta can hope once more to live in peace . . . is to stop the war.' (The most famous quote attributed to Sherman, 'War is hell,' he never quite said, but it is an accurate portrayal of the attitude of a general who refused to romanticize his profession.)

Sherman and his army set out east across Georgia on November 16, 1864, making about a dozen miles a day and cutting a 50-mile-wide swath of devastation through the state. Later Sherman described the process of foraging this way: 'Each brigade commander had authority to detail a company of foragers, usually about fifty men. . . . This party would be dispatched before daylight and . . . would proceed on foot five or six miles from the route traveled by their brigade, and then visit every plantation and farm within range. They would usually procure a wagon or family carriage, load it with bacon, corn meal, turkeys, chickens, ducks, and everything that could be used as food or forage.'

There was a good deal more to the march than that – inevitable when hardened soldiers are turned loose on civilians in enemy territory. The foragers were derisively dubbed 'bummers'; soon they took to calling themselves that, with a certain fierce pride. One Northern officer recalled the aspects of the march Sherman did not mention: 'To enter a house and find the feather bed ripped open, the wardrobes ransacked, chests stripped of all contents . . . and all the corn

Federal wagon trains move out of Atlanta in November 1864 in the beginning of General Sherman's celebrated March to the Sea.

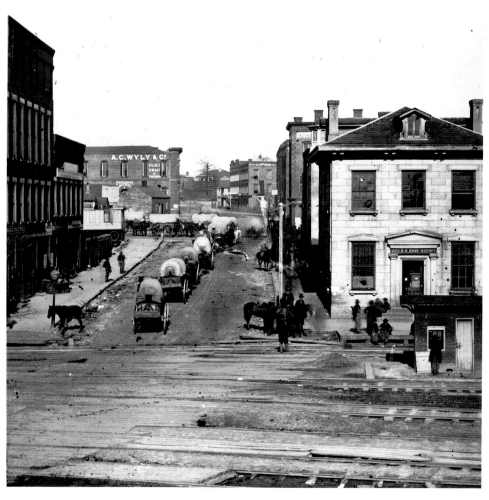

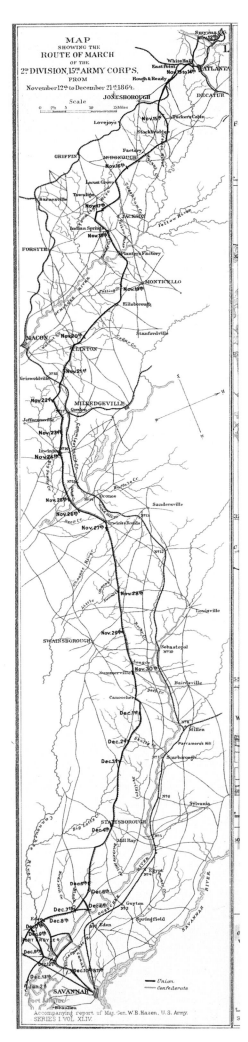

MAP
SHOWING THE
ROUTE OF MARCH
OF THE
2ᴰ DIVISION, 15ᵀᴴ ARMY CORPS,
FROM
November 12ᵗʰ to December 21ˢᵗ 1864.

meal and bacon missing, bed quilts stripped from the beds, the last jar of pickles gone, was no uncommon sight, and one to make a soldier blush with indignation.' On the periphery of the march swarmed a rabble of deserters from both sides as well as a number of liberated slaves, all burning and robbing for their private benefit or revenge.

Only a few scattered enemy units and state militia appeared to try and stay the invaders. There was constant skirmishing along the route, but no substantial engagements. By the time Sherman reached Savannah on December 10, 1864, he had proved that the Confederacy was militarily a hollow shell. The last Confederate forces evacuated Savannah on the 21st, and Sherman wired to Lincoln, 'I beg to present you, as a Christmas gift, the city of Savannah.' Lincoln replied that Sherman's march would bring 'those who sat in darkness, to see a great light.' Meanwhile, Hood had lost what was left of his Confederate army in the Franklin and Nashville Campaign (*See*). Now Sherman would turn his forces north in the Carolinas Campaign (*See*), a still more destructive march toward union with Ulysses Grant at Petersburg. In the event, the war would be over before he got there.

For all its apparently haphazard destruction, the March to the Sea had served clear military purposes: to destroy the supplies of the Rebel armies, to demoralize the population, and to demonstrate the weakness of the Confederacy. Furthermore, there had actually been few outrages against persons – none of the mass murder visited on civilians by both sides as a matter of normal strategy in World War II. In short, Sherman had done a valuable military service and had done it brilliantly and with some restraint. But by waging war on civilians, he had created an ominous precedent. Future generations would carry the process to ever greater heights of violence in the name of Total War.

Left: A US Army map traces Sherman's route from Atlanta to Savannah and the sea.
Below: Union General George B. McClellan (fourth from right) and staff in 1862.

Marmaduke, John Sappington (1833-1887) Confederate general.

Marmaduke, the son of a governor of Missouri, was graduated from West Point. He left frontier duty to join the Confederates and fought mainly in Arkansas and Missouri, most notably at Shiloh and in Price's 1864 Missouri Raid; he was captured and imprisoned after Marais des Cygnes (*See*) in October 1864.

Marshall, Humphrey (1812-1872) Confederate general.

This Kentuckian, a West Point graduate and Mexican War veteran, was a lawyer and US Representative. He fought along Big Sandy River in 1861-62 and participated in Braxton Bragg's invasion of Kentucky. Resigning in June 1863, Marshall sat in the Confederate Congress in 1864-65.

Martinsburg, *Virginia*

Confederate troops attacked this town on June 14, 1863, at the beginning of the Gettysburg Campaign. When one regiment, the 106th New York, broke under a shelling, Union forces began a confused retreat toward the Potomac. The Federals reported about 200 missing; the attackers lost three killed and wounded.

Marye's Heights

This is the name given to the range of hills behind Fredericksburg, Virginia. It formed the anchor of the Confederate position at the Battle of Fredericksburg.

Mason, James Murray (1798-1871) Confederate statesman.

This Virginia lawyer and Senator was a states' rights Democrat and prominent secessionist. As a Confederate diplomatic commissioner en route to Great Britain in 1861, he was captured by the Federals in the *Trent Affair* (*See*); despite years of diplomacy, he

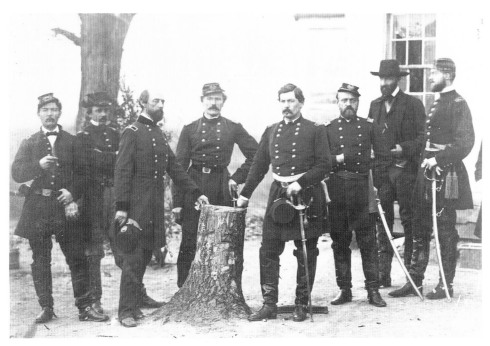

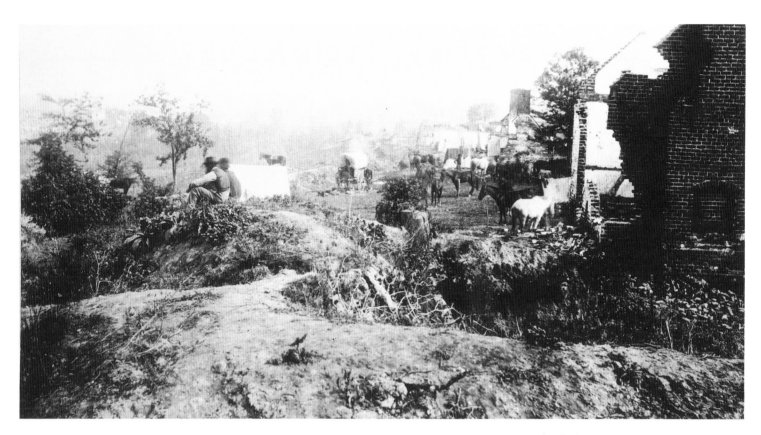

failed in the end to win British recognition of the Confederacy.

Maury, Dabney Herndon
(1822-1900) **Confederate general.**

A Virginian, Maury was a West Point graduate and professor. He fought in the Confederate cavalry at Pea Ridge, Iuka, Corinth, and Hatchie Bridge, and after July 1863 he commanded the District of the Gulf, losing Mobile to Admiral David Farragut and General Edward Canby. Matthew Fontaine Maury (*See*) was his uncle.

Maury, Matthew Fontaine
(1806-1873) **Hydrographer and Confederate naval commander.**

His sea-going career was ended by a crippling accident in 1839, and this Virginian became director of the US Naval Observatory, publishing internationally acclaimed works on navigation and oceanography. As a Confederate navy commander he represented the Confederacy abroad, purchased foreign warships, and invented a system of laying electric mines. After the war he taught physics at Virginia Military Institute. All the sophisticated and valuable pilot charts published by today's Defense Mapping Agency explicitly credit Maury's inspiration.

Maximilian Affair

Taking advantage of wartime confusion, Napoleon III placed the Austrian Archduke Maximilian (1832-1867) on the Mexican throne and ignored American demands to remove the French troops supporting him. Union diplomatic and military pressure failed to dislodge the French, who finally withdrew their forces in May 1866; unprotected, Maximilian was deposed and executed by the forces of Benito Juarez.

Maynard Carbine

The Union government bought more than 20,000 of these breechloading small arms, designed by a Washington, DC, dental surgeon named Edward Maynard. It weighed six pounds, was slightly more than three feet in length, and used a brass cartridge fired by a percussion cap.

Maynard Tape

This primer, patented in 1845, consisted of a roll of glued pellets of fulminate of mercury sandwiched between two strips of varnished paper. This tape was rolled in a coil inside a magazine located in the stock of the weapon. The cocking of the hammer drew one pellet at a time into position. When the hammer struck, the pellet exploded. The inventor of the primer, Edward Maynard, later developed the Maynard Carbine (*See*).

McCausland, John *(1836-1927)*
Confederate general.

Born in Missouri, he was graduated from the Virginia Military Institute, joined its faculty, then left for the war. McCausland fought at Fort Donelson and defended the Virginia and Tennessee Railroad. He burned Chambersburg, Pennsylvania, in retaliation for Union General David Hunter's destruction in the Shenandoah Valley.

McCoull House, *Virginia*

A landmark at the Battle of Spotsylvania, McCoull House stood at the center of the Confederate line. Confederate General Richard Ewell's troops were entrenched in a horseshoe-shaped line in front of the house, defining the area known as the 'Mule Shoe' or 'Bloody Salient,' which saw the bloodiest fighting of the 1864 battle.

From fortified positions such as these on Marye's Heights the Confederates devastated the Union army at Fredericksburg in 1862.

McClellan, George Brinton
(1826-1885) **Union general.**

It would be McClellan's achievement to build the greatest army the country had ever seen; it would be his tragedy that he was unable to lead it to a decisive victory. Pennsylvania-born and an outstanding West Point student, McClellan saw distinguished service in the Mexican War. A railroad executive when the Civil War began, he re-inlisted as a major general (at age 35) and took over the Department of Ohio. His success in keeping Kentucky and western Virginia in the Union (*See* WESTERN VIRGINIA CAMPAIGN OF MCCLELLAN) brought him to Washington in July 1861, to become commander of the Division of the Potomac and, that winter, general-in-chief of all Union armies. In Washington, McClellan created the Army of the Potomac virtually from the ground up.

But at that point his success had reached its zenith. In leading his army in the field, McClellan would prove consistently slow and indecisive, to the growing consternation of President Lincoln. Prodded into the Peninsular Campaign of summer 1862 – and meanwhile relieved as general-in-chief – McClellan took immensely superior forces to the gates of Richmond, yet somehow ended up retreating without having lost a battle. His generalship at the Battle of Antietam in September 1862 was similarly ineffective, though he was nominally the victor. Lincoln relieved McClellan in November. The general's last hurrah in national politics was his unsuccessful challenge to Lincoln for the presidency in the election of 1864.

McClellan's reputation in history is that of a brilliant administrator, a considerable strategist, and a poor fighter. He carried self-

confidence and self-importance to the brink of insubordination, yet he ended the war still a wronged hero to many, and he never lost the affection of his troops.

McClernand, John Alexander
(1812-1900) **Union general.**

An Illinois editor and Democratic politician, he proved a politically ambitious, sometimes insubordinate, and only occasionally effective officer. McClernand commanded troops at Forts Henry and Donelson and at Shiloh, and he led the controversial Arkansas Post expedition *(See)*, later leading XIII Corps in the Vicksburg and Red River Campaigns. He resigned in ill health in November 1864.

McCook Family of Ohio
('The Fighting McCooks.')

The brothers Daniel (1798-1863) and John (1806-1865) McCook and their 13 sons ('the tribe of Dan' and 'the tribe of John') all served the Union with distinction. The elder McCooks served respectively as an army paymaster and surgeon; of their sons, six became generals and three died in the war. The best known of the sons were General Alexander M. McCook, who fought at Shiloh, Perryville, Stone's River, and Chickamauga, and General Edward M. McCook, who commanded cavalry under W. T. Sherman in his Atlanta Campaign.

McDowell *(Virginia)*, Battle of

Two Federal brigades under Robert Schenck attacked Stonewall Jackson here on May 8, 1862, during the Shenandoah Valley Campaign of Jackson. Though Jackson repulsed the attack, his forces suffered nearly twice as many casualties (about 500) as Schenck's. The Federals withdrew, but Jackson was unable to mount a vigorous pursuit.

The second of Wilmer McLean's famed wartime houses was this one, at Appomattox, scene of Lee's surrender to Grant in 1865.

Union General George Meade.

McDowell, Irvin *(1818-1885)*
Union general.

Ohio-born McDowell was graduated from West Point in 1838. He returned to teach tactics there and in addition saw Mexican War, frontier, and Washington staff service. In May 1861 he received the Union's most critical command, leading the Army of the Potomac, but after his defeat at First Bull Run he was immediately demoted to division commander. His performance in leading the short-lived Army of the Rappahannock at Cedar Mountain and Rappahannock Station, and III Corps at Second Bull Run, drew strong criticism, and he was removed from command. Although an inquiry exonerated his performance, McDowell received no further field commands, serving on army boards until receiving his last wartime assignment commanding the Department of the Pacific (July 1864-June 1865). Though an ineffectual field commander, McDowell was an excellent administrator.

McKay, Charlotte Elizabeth
Union Army nurse.

McKay left Massachusetts to enlist as an army nurse in March 1862. She nursed men wounded in the Potomac Army campaigns from Winchester through Spotsylvania, serving in City Point hospital during the sieges of Petersburg and Richmond and earning the Kearny cross. After the war she worked with freed blacks in Virginia.

McLean Houses

Houses owned by Wilmer McLean were the settings for two climactic episodes of the war, one early and one late. After his house on Bull Run was damaged in the first battle there in July 1861, he moved his family to Appomattox. Robert E. Lee surrendered to Ulysses S. Grant in the parlor of McLean's Appomattox house on April 9, 1865.

Meade, George Gordon
(1815-1872) **Union general.**

Born in Spain of American parents, he was graduated from West Point in 1835 and resigned for a brief stint of civil engineering before rejoining the army in 1842 as a military engineer. A brigade leader in the Peninsular and Second Bull Run Campaigns, Meade demonstrated consistent soundness as a field commander, leading a division at Antietam and Fredericksburg and V Corps at Chancellorsville. Assuming command when Joseph Hooker resigned five days before the Battle of Gettysburg, he is deservedly credited with being the main architect of that great Northern victory. Whether he was remiss in not pursuing Robert E. Lee's retreating Rebel army more vigorously in the aftermath of Gettysburg is a much-debated point: Lee's Army of Northern Virginia was then certainly vulnerable to calamatous injury, but

Union General Irvin McDowell's reputation never recovered after his defeat in the Civil War's first major battle.

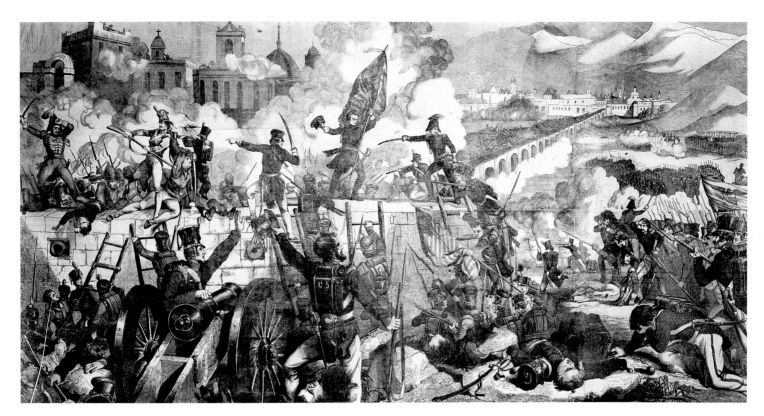

Meade insisted that the Army of the Potomac was too exhausted to seize the opportunity, and he may well have been right. He led the Army of the Potomac through the rest of the war, fighting from the Wilderness through Appomattox accompanied in the field by his superior, Ulysses S. Grant, an awkward position which by all accounts Meade, who could be temperamental, handled with admirable loyalty and skill. After the war he commanded various military departments.

Meagher, Thomas Francis *(1823-1867)* Union general.

A nationalist expelled from Ireland, Meagher became the leader of New York's Irish community. He commanded a Zouave company at First Bull Run and the Irish Brigade through the Peninsular Campaign, Second Bull Run, Antietam, Fredericksburg, and Chancellorsville, later commanding the District of Etowah and participating in the 1864 Atlanta Campaign.

Mechanicsville *(Virginia)*, Battle of

Second of the 1862 Seven Days' Battles. On June 26 Robert E. Lee sent John Magruder with 25,000 men to make a feint at the 60,000 Federals on the south bank of the Chickahominy River. With his main body, Lee hoped to overwhelm Fitz-John Porter's 30,000 Federals isolated on the north bank. But Lee's complex plan of attack foundered, due mainly to the slowness of the exhausted Stonewall Jackson and his men. Porter repulsed the attack easily near Mechanicsville.

Memminger, Christopher Gustavus *(1803-1888)* **Confederate secretary of the treasury.**

This German immigrant was a South Carolina lawyer and legislator. As Confederate secretary of the treasury (1861-64), Memminger faced difficult choices: without cotton exports, taxes, or bonds to finance the war, he issued treasury notes which became nearly worthless (*See* Confederate Currency) as the Confederacy's credit collapsed.

Memorial Day

Mississippi declared a state holiday to decorate Civil War veterans' graves on April 26, 1865; the first national observance of Decoration Day, inaugurated by John A. Logan (*See*), was May 30, 1868. State by state, beginning with New York in 1874, the holiday was renamed Memorial Day and was broadened to commemorate all who had fallen in American wars throughout the nation's history.

Meridian Campaign

In preparation for the 1864 Red River Campaign, Federal General W. T. Sherman decided to operate against enemy railroads and resources in central Mississippi. Starting from Vicksburg on February 3, 1864, Sherman got as far as Meridian on the 14th, after a series of skirmishes. After destroying enemy facilities there, he withdrew to Canton to await a supporting force under Sooy Smith. Finding that Smith had been routed by Nathan B. Forrest at West Point, Mississippi, on the 21st, Sherman returned to Vicksburg.

Merritt, Wesley *(1834-1910)* **Union general.**

A young West Point graduate when war broke out, this New Yorker was aide-de-camp to Philip St. George Cooke and George Stoneman. Leading a cavalry brigade and then the Cavalry Corps of the Shenandoah Army, he saw nearly continuous action for the last two years of the war, winning numerous brevets.

Chapultepec, Mexico, is stormed by US troops on September 13, 1847. Many veterans of the Mexican War held high commands in the Civil War, including Lee, Grant, Jackson, Sherman. both Johnstons, Thomas, Meade, and McClellan.

Messes

Early in the war cooking duty rotated among everyone in the military, the men preparing food and eating individually or in squads. Tradition claims that the rotation passed to whoever complained first about the food. In March 1863 Congress ordered food preparation to be shifted to company level, but foraging and cooking by individuals and squads continued throughout the war.

Mexican War

The United States fought a war with Mexico (1846-1848) that had considerable bearing on the Civil War. To begin with, many of the Americans who were most intent on pursuing the war with Mexico tended to be those interested in acquiring more land that could be used by slave-holders, so disagreements over the war tended to reinforce the split already existing between free- and slave-state advocates. When the war ended and the United States found itself with so much new territory, the debate many people hoped had been resolved by the Compromise of 1820 broke out anew: should new slave states be allowed into the Union? The result was the Compromise of 1850, with its recognition of 'popular sovereignty' – effectively saying that each new state could decide for itself whether to be free or slave. From that point on the nation seemed headed down a road to civil war. In another way, too, the Mexican War affected the Civil War: many of the leading Federal and Confederate officers had gained their combat experience fighting side-by-side in the Mexican War – among them, Ulysses S. Grant and Robert E. Lee.

Middleburg, *Virginia*

One of Union General Alfred Pleasanton's cavalry brigades chased Jeb Stuart's forces out of this place after a hot charge by the 4th Pennsylvania Cavalry on June 19, 1863. This early clash in the Gettysburg Campaign cost 99 Federal casualties; Stuart reported 40 of his troopers missing.

Miles Court of Inquiry

On August 10, 1861, this court ruled that insufficient evidence existed to convict Union Col. D. S. Miles of drunkenness during the Battle of First Bull Run. I. B. Richardson brought the charge after Miles ordered changes in the dispositions of two of Richardson's regiments during the battle.

Miles, Nelson Appleton
(1839-1925) **Union general.**

This Boston store clerk received a commission in a Massachusetts regiment in September 1861 and earned rapid promotion. Wounded at Fair Oaks during the Peninsular Campaign, he recovered in time to command the 61st New York at Antietam. He was

wounded at Fredericksburg; he also fought at Chancellorsville, the Wilderness, and Spotsylvania. From July 1864 until the war's end Miles led a division in the II Corps. He commanded the guard over Jefferson Davis, imprisoned after the war in Fortress Monroe. In later years he won fame as an Indian fighter. He became commander-in-chief of the army in 1895 and played a prominent role in the Spanish-American War of 1898.

Mill Springs, Battle of

See LOGAN'S CROSS ROADS

Mine Run, *Virginia*

This was the culminating engagement – or, rather, non-engagement – of the Bristoe Campaign (*See*), in which Robert E. Lee feebly tried to regain some measure of initiative against the Army of the Potomac after Gettysburg. By the end of November 1863 it was clear that Lee's offensive maneuverings had come to nothing, his Army of Northern Virginia had gone back to the defensive, and Union General George Meade was considering a counter-stroke. On November 30 the two armies faced each other across a small brook called Mine Run, and what might be a major, possibly decisive, battle seemed in the offing. But at the last minute the Union field commander, Gouverneur Warren, declined to attack, judging the Rebel positions too

strong. Soon thereafter, both armies went into winter quarters, and Mine Run became one more of history's countless, fascinating 'might-have-beens.'

Minie Ball or Bullet

A French army officer named Minié designed this bullet-shaped projectile to be fired from a muzzle-loading rifle. It had a shallow depression in its after end, which trapped expanding powder gasses and forced the soft-sided bullet hard into the rifling grooves of the barrel, thus eliminating windage and giving the bullet improved accuracy. From its appearance in 1849 the Minie (American soldiers pronounced it 'minnie') substantially increased the deadliness of rifle fire.

Minnesota Sioux Uprising

A six-week uprising of reservation Sioux began on August 17, 1862. Rebellious tribesmen killed nearly 300 white settlers before Union General H. H. Sibley managed to put down the outbreak. On December 6, Lincoln ordered the execution of 39 Sioux; 38 tribesmen were hanged on December 26.

Missionary Ridge *(Tennessee),* Battle of

Ulysses Grant's Union forces assaulted Braxton Bragg's main defenses here on November

The Battle of Missionary Ridge, which broke the Confederate siege of Chattanooga, was freakish in that it was won by an assault that the Union command had not ordered.

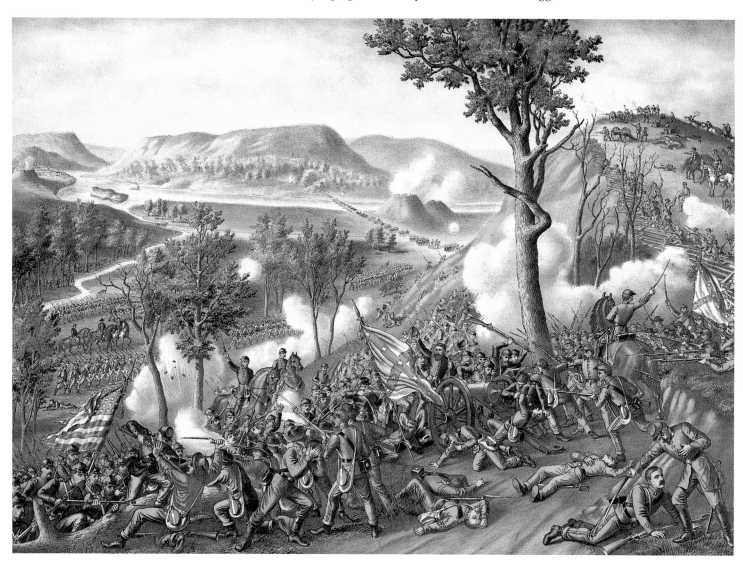

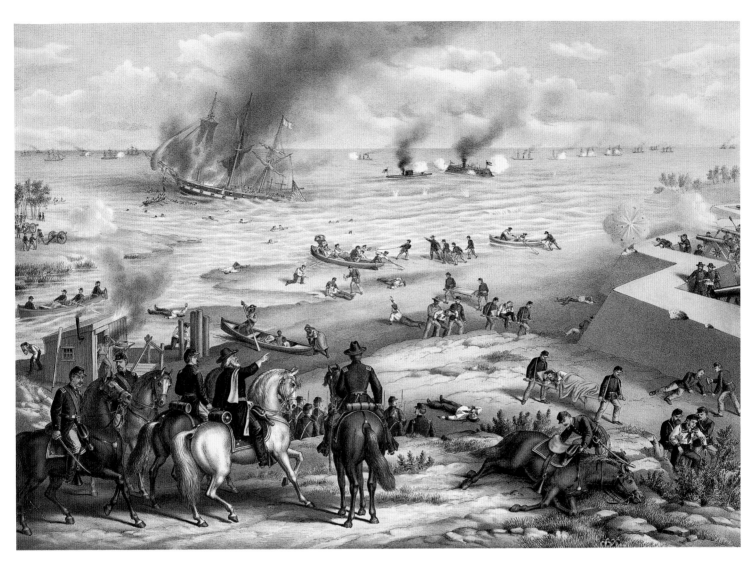

The historic duel between the ironclads, USS *Monitor vs* CSS *Virginia* (ex-*Merrimac*), may have ended the age of fighting sail, but it has somehow drifted into the background in this busy Kurz & Allison print.

25, 1863, in the decisive battle of the Chattanooga Campaign. W. T. Sherman's attack on the Confederate left, planned as the main effort, made little progress, and late in the day Grant ordered an assault on the center. Two divisions each of the IV and XIV Corps moved forward and easily captured the first defensive line. Though they had been ordered to halt there, the attackers pressed forward on their own initiative and drove Bragg's forces off the summit. The defeat sealed the Confederate loss of Chattanooga, a vital east-west communications link, and opened the way for William Tecumseh Sherman's Atlanta Campaign.

Mississippi Rifle

This US Army rifle, introduced in 1841, fired a round ball from a .54-caliber barrel. The weapon was so named because it armed Jefferson Davis's Mississippi Volunteers during the Mexican War.

Missouri Compromise

See COMPROMISES OF 1820 AND 1850.

Mobile Bay, Naval Battle of

By the autumn of 1864 Union naval operations had shut down most Confederate ports, the major one remaining being that of Mobile Bay, Alabama. On August 5 a Union fleet under Admiral David Farragut steamed in to claim the bay. The admiral led on his flagship *Hartford*, followed by 14 wooden steamships and four *Monitor*-class ironclads. The defending Southern fleet consisted of three wooden gunboats and a powerful new ironclad of the *Merrimac* type, the *Tennessee*. The Confederates placed their main hopes on two forts guarding the bay, Forts Gaines and Morgan, and in a number of mines (then called torpedoes) in the water.

The forts' batteries opened up as Farragut approached; then one of the Union ironclads, USS *Tecumseh*, hit a torpedo and sank immediately. Seeing his seamen shaken by that, Farragut roared his famous words of defiance: 'Damn the torpedoes! Full speed ahead!' The Union ships continued into the bay. For a half hour Union ships circled the *Tennessee* at close range, pounding the ship's armor with gunfire and ramming; finally the ironclad, her steering damaged, gave up. With the loss of their main warship, the Confederates were forced to capitulate. Casualties were high for a naval engagement in the war – the Union lost 319 sailors (93 drowned in the *Tecumseh*) and the South 312. With the closing of the port the South lost one of its last sources of food and supplies.

Mobile Campaign

During March 17-April 12, 1865, Federal General E. R. S. Canby closed in on Mobile, Alabama, with a divided force of 45,000 men. After taking enemy garrisons in the area with considerable losses, his men occupied Mobile on April 12. Ulysses Grant later noted in his memoirs that the capture of the town was costly and too late to be of military importance, since Robert E. Lee had already surrendered at Appomattox.

Monacacy, *Maryland*

As part of Jubal Early's Washington Raid (*See*), Confederate raider Early arrived at the Monacacy River near Frederick on July 9, 1864, to find Lew Wallace's 6000 Federals in his path. A series of largely unplanned Confederate attacks routed the mostly green Union troops; the bulk of the 2000 Federal casualties were listed as 'missing.' Rather than wasting time in pursuit, Early pressed on toward Washington.

Monitor

This generic term described a type of shallow-draft, low-freeboard ironclad Union warship that carried its guns in one or two revolving turrets. The name was taken from USS *Monitor* (*See*), which fought its famous duel with the big Confederate ironclad ram *Merrimac* in March 1862.

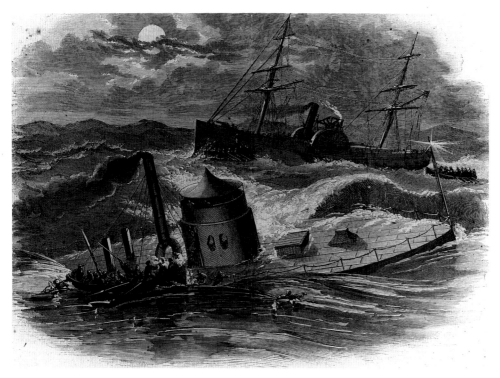

A *Harper's Weekly* version of the sinking of USS *Monitor* in a storm. The craft depicted is, however, another type of monitor.

Monitor and *Merrimac*, Battle of

At the beginning of the war both sides knew that the newly developed armored warship would radically change naval warfare, for ironclad ships would be nearly impervious to the fire of existing naval weapons. The initial step toward an ironclad fleet was taken by Confederate Secretary of the Navy Stephen R. Mallory, who had been forced, by the South's lack of materials and industry, to be resourceful. In April 1861 the Union had to abandon its Norfolk, Virginia, Navy Yard, leaving behind the partly-burned steam frigate USS *Merrimac*. The Confederates salvaged the ship with hull and engines intact and rebuilt it into a completely ironclad vessel, 263 feet long, with a sloping citadel made of 24-inch-thick oak and pine covered by two inches of railroad iron. She carried four rifled guns (two 6.4-inchers and two 7-inchers) and six 9-inch smoothbores, and a 1500-pound iron ramming prow projected from her bow. Sailing with her armored decks awash, the ship rather resembled a floating barn roof with smoking stovepipe. She was rechristened the CSS *Virginia*, but history has persisted in calling her the *Merrimac*.

Washington heard of the Southern ironclad project soon after it began, and Union Navy Secretary Gideon Welles made haste to build comparable armored ships. Swedish-born inventor John Ericsson had been working on the idea for some time already and had developed a sophisticated design featuring a hull that was flat on top and covered with iron plates and that floated only a few feet above the waterline. Rising from this iron raft were a stubby pilothouse in front, a short smokestack to the rear, and in the middle a heavily armored rotating iron turret some 9 feet high and 140 tons in weight. The ship was armed with only two 11-inch Dahlgren smoothbore cannons, but the turret enabled them to fire in any direction. The odd-looking result, called the *Monitor*, was finished in January 1862.

It was ready none too soon. On March 8, 1862, the *Merrimac* made a devastating first appearance off the coast of Virginia, at Hampton Roads, where she attacked a Union blockading fleet of wooden ships, sank the 30-gun sloop-of-war *Cumberland* and crippled the 50-gun frigate *Congress*. Union commanders could see their cannonballs bouncing off the *Merrimac* like marbles off a brick wall. In late afternoon the cumbersome ironclad lumbered off with little damage, though the ramming prow had broken off and her captain, Franklin Buchanan, had been injured. Lieutenant Catesby ap Roger Jones took over command.

When the Confederate ironclad steamed out on March 9 to finish off the Federal fleet, however, her sailors saw a bizarre object slip around a grounded Union ship and head for them. They took it for a boiler going for repairs on a raft, until the oncoming *Monitor* fired her first shot.

The two ships closed in, at times touching and firing point-blank, both trying without success to find a weak spot. Several times the *Merrimac* tried to ram the smaller *Monitor*, but Federal Captain Lorimer Worden was easily able to outmaneuver his slow-moving opponent. In the first two hours of fighting the *Monitor* took 21 hits without serious damage; sailors in the sweltering turret were threatened mainly by large screwheads that came loose and richocheted around the chamber with every hit. Federal cannonfire was able to crack but not penetrate the armor of the formidable *Merrimac*.

Just after noon the historic battle trailed off indecisively. Over the next few days the *Monitor* challenged the *Merrimac* several times, but it had been decided not to risk another engagement with the Union ship. She had already done her primary job of preserving the Union fleet in the area.

Neither ship survived the war. The unseaworthy *Merrimac* had to be destroyed by the Confederates when they abandoned Norfolk in May 1862. The *Monitor* was swamped and went down in a gale off Cape Hatteras in December 1862. As the North and South began building more ironclads on the model of these prototypes, governments around the world realized that their wooden fleets had become obsolete in a single afternoon.

Montgomery Convention

A provisional Confederate Congress met in the Alabama capital in February 1861. On February 8 the convention adopted a provisional constitution patterned on the US Constitution. Among other changes, however, it guaranteed the right to own slaves. The following day it elected Jefferson Davis provisional president of the Confederacy.

Morgan, George Washington (1820-1893) Union general.

A Pennsylvanian who attended West Point but was not graduated, he served in the Mexican War and then entered the diplomatic service. Upon the outbreak of the Civil War he was made a brigadier general, served under Don Carlos Buell in Tennessee, led a division in the Yazoo Expedition, and led XIII Corps in the capture of Arkansas Post. Ill health forced his resignation in June 1863.

Morgan, John Hunt (1825-1864) and Morgan's Raids
Confederate general.

A Mexican War veteran, he commanded a squadron of Kentucky cavalry at the start of the war. Promoted to brigade command in April 1862, he embarked the first of three famous raids in July, working in conjunction with Nathan B. Forrest's raids on Union General Don Carlos Buell's supply lines in Kentucky after the battle of Shiloh. Morgan and 800 men captured four Union cavalry

Confederate cavalry leader John Hunt Morgan, famed for his raids behind Union lines.

companies in Tomkinsville and depots at Glasgow and Lebanon, and skirmished with local militia in Cynthiana, returning to Tennessee with some 1200 prisoners. In his second raid, in October 1862, Morgan took Lexington and a number of smaller Federal outposts in Kentucky. The third raid stretched through the end of that year and into January 1863, as Morgan raided William Rosecrans's supply lines in Tennessee and destroyed some $2 million-worth of Federal supplies while taking 1887 prisoners; his own losses totalled two dead and 24 wounded. After these successes, however, Morgan came to grief in the Ohio Raid of July 1863, in which he took some 2500 men on a destructive but fairly random raid around that state. Meanwhile, Federal forces gradually gathered around him, finally running Morgan and his 300 remaining men to ground at New Lisbon, where he was captured on July 26. He escaped from Federal prison, got back go Confederate lines, and resumed his raiding. While making a raid on Greenville, Tennessee, he was surrounded and killed by Union troops in September 1864.

Mortars

These stubby-barreled artillery weapons that fire their munitions in high, arcing trajectories were used to throw heavy shells into enemy fortifications. Field armies carried 8- to 10-inch mortars; heavier ones were used as seacoast artillery and in static siege operations. A 13-inch mortar weighed 20,000 pounds and fired a 220-pound bomb.

Mosby, John Singleton
(1833-1916)
Confederate raider.

A lawyer before the war, Mosby rode for a time with Jeb Stuart's Confederate cavalry before creating a band that would have the

The guerrilla cavalry leader John Singleton Mosby (standing, fifth from left), posing with some of his Confederate irregulars.

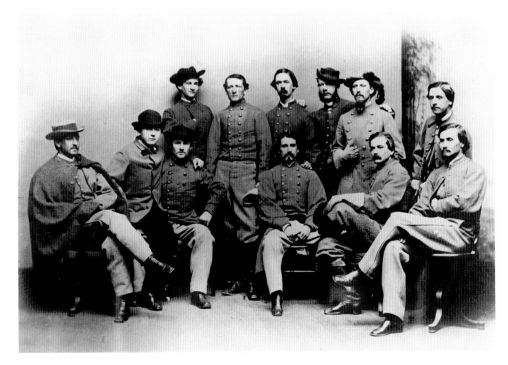

most success of the war's various guerrilla groups. In January 1863 Mosby and his Partisan Rangers commenced operations in Virginia. They would become known as Mosby's Irregulars, their area of operations in Virginia was called Mosby's Confederacy and their leader 'The Gray Ghost.'

They retained a loose association with Stuart's cavalry, doing advance scouting for him and stealing Union horses. Most of the time they managed to steal all the supplies they needed for themselves from the enemy. Their main business was to impede Federal operations. Mosby and his men first hit the headlines in March 1863 with a raid on a Union camp at Fairfax Court House that netted them the commanding blue general and some 30 other prisoners, plus 58 horses. Eventually Mosby had some 1000 mounted men in his command, but in most of his raids used fewer than 300. He continued operations to the end of the war. Later Mosby became a friend and an ardent political supporter of Ulysses S. Grant, who had once ordered him hanged.

Mud March

Union General Ambrose Burnside's second attempt to cross the Rappahannock after his terrible defeat at Fredericksburg ended in farce. The army started out for Banks's Ford on January 20, 1863, aiming to cross there and turn Robert E. Lee's flank, but two days of heavy rain left the men bogged down in a quagmire. Burnside called off the march on January 23. Lincoln relieved him of command of the Army of the Potomac shortly thereafter, replacing him with the almost as luckless General Joseph Hooker.

Mudd, Dr. Samuel *(1833-1883)*
Physician.

A Maryland physician who set John Wilkes Booth's broken leg after the Lincoln assassination, he was alleged to have been part of the murder conspiracy. Tried, convicted and sentenced to life imprisonment in the Dry

Tortugas off the Florida Keys, he cared for the garrison and prisoners during a severe yellow fever outbreak. Mudd was at last pardoned in 1869.

'Mule Charge'

Confederate General Braxton Bragg ordered a night raid on Joseph Hooker's Union forces carrying out Cracker Line operations (*See*) near Chattanooga on October 28-29, 1863. The Federals turned back the attackers in a confused battle, one of the rare night actions of the war. The legend of the 'mule charge' evidently grew out of the stampede toward the Confederate lines of some animals in the Federal supply train.

Munfordville, *Kentucky*

Confederate General Braxton Bragg surrounded the 4100-strong Federal garrison here during Bragg's Kentucky invasion (*See*) of September 1862. Asked to surrender, the inexperienced Federal commander, an Indiana manufacturer named J. T. Wilder, met under a flag of truce with Bragg's lieutenant, General Simon B. Buckner, to seek advice on what to do. Buckner made no suggestions, but he did permit Wilder to count the Confederate cannon. Wilder surrendered the garrison shortly thereafter.

Murfreesboro, Battle of

See STONE'S RIVER.

Murfreesboro, *Tennessee*

Near this Tennessee town on December 7, 1864, Federals under Robert L. Milroy struck the forces of Nathan Bedford Forrest, who had been ordered by General John B. Hood to raid the area in support of the Franklin and Nashville Campaign. Milroy forced Forrest from the field, in the process capturing over 200 men and 14 guns.

Music in the Civil War

It is safe to say that the entire Civil War was carried on accompanied by music. It was heard on the march, in camp, even in battle: armies marched to the attack to the heroic rhythms of drums and often of brass bands. The fear and tedium of sieges was eased by nightly band concerts, which often featured requests shouted from both sides of the lines. Around camp there was usually a fiddler or guitarist or banjo player at work, and voices to sing the favorite songs of the era.

Songs of the war covered every aspect of the conflict and every feeling about it. There were the patriotic songs for each side: the North's 'John Brown's Body' that Julia Ward Howe made into 'The Battle Hymn of the Republic'; the South's 'Dixie' (originally a prewar minstrel-show song). The slaves had their tradition of songs of hope: 'Follow the Drinking Gourd,' the words said guardedly – meaning follow the Big Dipper north to the Underground Railroad and freedom.

Soldiers sang sentimental tunes about distant love – the popular 'Lorena' and 'Aura Lee' (which in this century became 'Love Me Tender') and 'The Yellow Rose of Texas' –

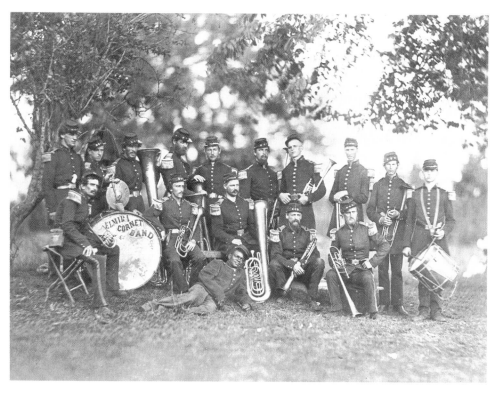

A group portrait of the band of the 8th New York State Militia taken in 1861. Military bands played an important role in the Civil War, both in camp and in battle.

and songs of loss such as 'The Vacant Chair.' Other tunes commemorated victory – 'Marching Through Georgia' was a vibrant evocation of Sherman's March to the Sea. Soldiers marched to the rollicking 'Eatin' Goober Peas'; they vented their war-weariness with 'Hard Times'; they sang about their life in 'Tenting Tonight on the Old Camp Ground'; they were buried to the soulful keening of 'Taps,' written for the dead of both sides in the Seven Days' Battles. When the guns stopped, the survivors returned to

Part of the cover of a song composed in honor of Union General mcClellan.

the haunting strains of 'When Johnny Comes Marching Home.'

After Robert E. Lee surrendered, Lincoln, on one of the last days of his life, asked a Northern band to play 'Dixie,' saying it had always been one of his favorite tunes. No one could miss the meaning of this gesture of reconciliation, expressed by music.

Mutinies

These were comparatively rare, given the large numbers of volunteer soldiers raised by both sides. On August 14, 1861, troops of the 79th New York mutinied after they were denied furlough; several men were arrested. George McClellan dealt severely with minor outbreaks in the Army of the Potomac in the autumn of 1861. Confederate troops at Fort Jackson, Louisiana, part of the New Orleans defenses, mutinied on April 27, 1862, and many fled into the swamps before their officers surrendered the fort next day.

Muzzle-Loaders

At the beginning of the war most cannon, muskets, and rifles were loaded from the muzzle, which not only meant that the loading process was slow but that the weapons were necessarily single-shot. Gradually large numbers of more efficient breech-loading cannon and small arms, both single- and multiple-shot, came into service.

Myer, Albert James *(1829-1880)*
Union officer.

This New York-born army surgeon helped develop the 'wigwag' flag-signal system. The army's first signal officer, he served on the staffs of Benjamin Butler, Irvin McDowell, and George McClellan and directed the Signal Corps (*See* SIGNAL COMMUNICATIONS) before being assigned as signal officer along the Mississippi. Fort Myer, Virginia, is named after him.

Namozine Church and Willicomack Creek, *Virginia*

After the Five Forks Battle, Federal cavalry from George A. Custer's division caught retreating Confederates at Willicomack Creek on April 3, 1862. Charging dismounted, the Federal troopers took the position, capturing most of a Confederate brigade, and continued the pursuit to Namozine Church. There they paused for the night to wait for the infantry to come up.

Napoleon Gun Howitzer

This 12-pounder muzzle-loader, the most widely-used field gun in both armies, fired a 4.62-caliber shell from a smoothbore barrel at a maximum effective range of over 1000 yards. Its rate of fire was about two rounds per minute. It also fired short-range canister and grape shot. The US Army adopted the Napoleon in 1857; the Confederates captured large numbers on the battlefield, and also manufactured their own copies. The gun's name derived from the fact that its design was credited to Louis-Napoleon of France.

Nashville, Battle of

See FRANKLIN AND NASHVILLE CAMPAIGN

Nashville Convention

In June 1850 leaders from nine Southern states met to discuss the slavery issue, and some spoke openly of secession. The delegates approved a resolution calling for the extension of slavery to the Pacific Ocean south of 36°, 30' – the Missouri Compromise line.

National Union Party

Pro-Lincoln Republicans contested the 1864 national election under this banner to attract the votes of 'loyal' Democrats, the term 'Republican' having acquired an extremist connotation which had cost the party in the midterm elections. The name was resurrected in 1866 by Andrew Johnson supporters who were seeking to mobilize opposition to the Radical Republicans.

A beautifully preserved example of a 12-pounder Napoleon gun, the most widely used artillery weapon in the Civil War.

Naval War

The Civil War was mostly a ground conflict, but the naval arm still played a vital role. The Union began the war with a substandard navy consisting of around 9000 officers and men (some of whom defected to the Confederacy) and 90 vessels, many in poor repair; the loss of the Norfolk Navy Yard in April 1861 further reduced the Union fleet. Under Navy Secretary Gideon Welles, however, the North built back up to 641 vessels, including several ironclads. The Confederate Navy, meanwhile, started from nothing under Secretary Stephen R. Mallory, and also had no shipbuilding capacity. Mallory's main procedure was having ships built in supposedly neutral England and Europe. For more specifics of the war afloat, refer to individual entries, including Blockade, *Monitor-Merrimac*, Burnside's Expedition to North Carolina, New Orleans, Mobile Bay, *Kearsarge*, and *Alabama*. In many land battles, gunboats accompanied infantry operations onshore, contributing substantially, for example, to the Union comeback at Shiloh.

New Bern, *North Carolina*

Federal forces captured this port city on March 14, 1862, during Ambrose Burnside's North Carolina Expedition. The Confederates were never able to recapture the place.

New Madrid (*Missouri*) and Island No. 10

These contained two Confederate garrisons on the Mississippi River, whose batteries forestalled Union operations on the river. On March 13, 1862, the defenders evacuated New Madrid after ten days of siege by Federal General John Pope. The Federals then turned to Island No. 10, capturing its 3500 men on April 7. This opened a long stretch of the Mississippi to the Union and gave Pope a high reputation for the moment, a reputation he would soon lose in his humiliating defeat at the Second Bull Run Battle.

New Market (*Virginia*), Battle of

Confederate forces under John C. Breckinridge attacked 5100 Union troops under Franz Sigel here late in the morning of May 15, 1864, during the fighting that took place in the aftermath of the Battle of Spotsylvania. The assault gradually forced the Federals back, and at 4:00 pm Sigel ordered a general retreat. Federal casualties were 831; the attackers lost 577 out of 5000 engaged. In the aftermath Sigel was relieved of his command.

New Market Heights (*Virginia*),

(also called Chafin's Farm, Laurel Hill, Forts Harrison and Gilmer)

As part of his 1864 Petersburg Campaign, Ulysses Grant sent troops on a surprise attack on Forts Harrison and Gilmer, part of the city's defenses. In heavy fighting on September 29, Federals captured Harrison but not Gilmer; Robert E. Lee's Confederates failed in an attempt to retake Harrison the following day. Losses in two days of fighting were over 2500 for the North (mostly missing) and 2800 for the South (300 taken prisoner).

New Mexico and Arizona Operations

Action in these territories during the Civil War, though something of a sideshow, arose

A US Army map showing Rebel and Union forces around New Madrid and Island No. 10.

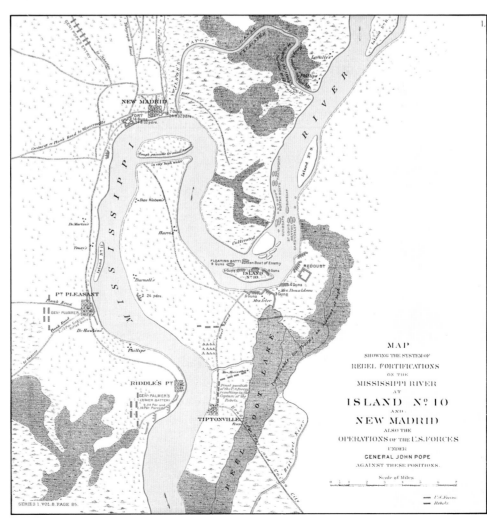

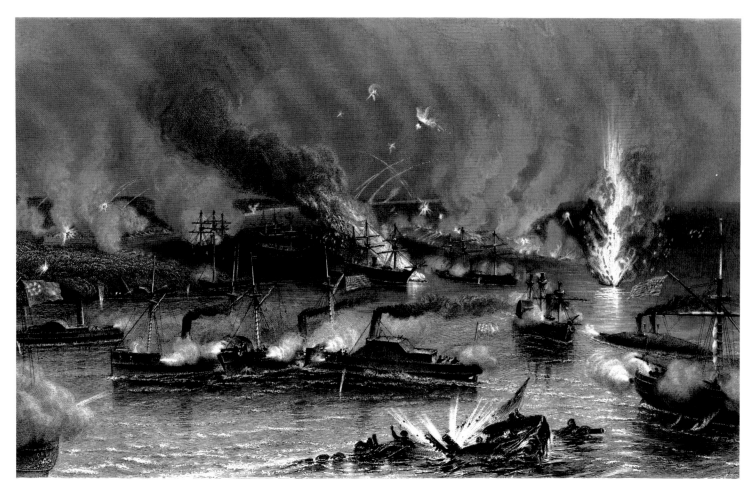

Farragut's daring run past the New Orleans forts in April 1862. Farragut's flagship, USS *Hartford* (upper center), is shown being assailed by a Confederate fireship.

because of an attempt to claim them for the Confederacy. In 1861 John Baylor organized the Confederate Department of Texas. In July of that year he occupied Fort Bliss in El Paso with 300 men; then, at the end of the month, he and 200 men captured a Federal garrison of 700 at Fort Fillmore, after which Baylor proclaimed himself governor of the new Confederate Territory of Arizona.

At the end of 1861 CSA General H. H. Sibley got together a force he called the Army of New Mexico and combined them with Baylor's men for operations against E. R. S. Canby's Federal Department of New Mexico. Sibley's operations began auspiciously when he won the Battle of Valverde (*See*) on February 21, 1862. Sibley then marched his forces, some 2600 men, toward Sante Fe to capture the Union supply depot there. He occupied the town on May 23, only to find the supplies had been withdrawn, and continued on toward Fort Union under increasing harassment from Federal forces organized by Canby. Finally, at the end of March, after losing two skirmishes with the outnumbering bluecoats and failing to secure the supplies he needed, Sibley decided it was time to retreat. He reached Fort Bliss in early May without pursuit from Canby. There he learned that another Federal column was approaching and so continued on to San Antonio, reaching it with less than a thousand men. This effectively put an end to major Confederate efforts to secure the New Mexico and Arizona territories.

New Orleans Campaign

In 1862 New Orleans, Louisiana, was both the South's greatest commercial port and the key to Confederate power in the lower Mississippi Valley. In April of that year Union Admiral David G. Farragut led a combined operation against the city. His forces consisted of a naval squadron – made up of four steam sloops-of-war, an elderly steam frigate, three smaller sailing vessels, and numerous gunboats and towed mortar schooners – and 15,000 army troops led by Benjamin Butler. The city's floating defenses were centered on the formidable ironclad CSS *Louisiana*, the ram *Manassas*, and a large number of gunboats and floating batteries, but far more important were two fixed defenses, Forts Jackson and St. Philip, which stood on opposite sides of the main channel downriver from New Orleans. Farragut tried for a week to reduce these delta forts by naval bombardment, but he got nowhere and in the end was driven to the risky expedient of trying to run his squadron past the forts in darkness. The attempt was made on the night of April 23-24 and nearly came to grief. Fire from the forts was intense and most of the Rebel naval vessels sortied to do battle. Farragut's flagship, *Hartford*, temporarily ran aground and was badly shot up, the sloop-of-war *Brooklyn* was all but sunk by gunfire from *Louisiana* and ramming by *Manassas*, and most of the other Union warships suffered varying degrees of damage. But somehow the squadron got through, the Rebel vessels were one by one silenced, and New Orleans, defended by only a small garrison, was now open for the taking. Butler formally occupied the city on May 1, Forts Jackson and St. Philip

having surrendered two days earlier. (Butler would soon earn international notoriety for his behavior as the city's heavy-handed military governor – *See* 'WOMAN ORDER').

The strategic consequences of this campaign were out of all proportion to the relatively light casualties suffered on both sides. Not only had the South lost its greatest port, the way was now open for the Union conquest of the entire Mississippi. When this would finally be accomplished, over a year later at Vicksburg, the Old South would be completely surrounded and vulnerable to invasion from the west.

New York Draft Riots

Of the nationwide eruptions following the March 1863 draft act, the New York City riots of July 13-16, 1863, were the most violent. As the draftees' names were drawn, a 50,000-strong mob, mostly Irish working men, burned offices and threatened military men, eventually attacking blacks at random in a full-blown race riot. A dozen people died before the Army of the Potomac restored order – at the cost of 1000 casualties.

Norfolk, *Virginia*

The Federals burned the important Gosport Navy Yard here on April 20, 1861, to keep it from falling into Confederate hands, although, in fact, when they occupied the area, the Confederates were able to salvage much useful war matériel that had escaped destruction. Thereafter, Norfolk was closely blockaded by Union ships. In November 1864 the port came under Union control, and Lincoln ordered the blockade to be lifted.

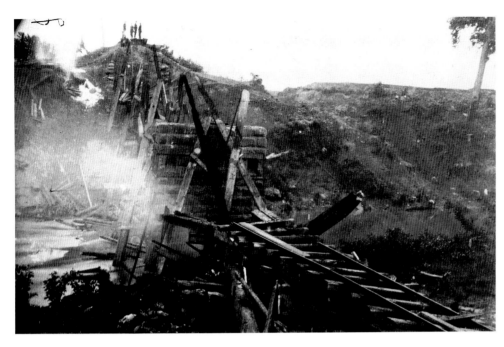

One of the casualties of the inconclusive May 1864 Battle of North Anna River was this demolished railroad bridge.

North Anna River *(Virginia),* Battle of

After the Battle of Spotsylvania in May 1864 Ulysses Grant hoped to turn R. E. Lee's flank along the North Anna River line. Lee, however, anticipated the move and entrenched his troops at Hanover Junction across Grant's line of advance. Federal forces under Gouverneur Warren crossed the river and attacked the Confederate positions on May 23 without effect. On the following day more Federal forces under Winfield Hancock and Horatio Wright crossed the river, but Lee managed to slip between them and prevent them from joining, thus stalemating them as well. The battle, also known as Jericho Mills, ended in a draw. Grant concluded that Lee's positions were too strong, and he began another turning movement that culminated in the Battle of Cold Harbor.

North Carolina, Department of

The Federal high command created this military district on January 7, 1862, at the start of Burnside's North Carolina Expedition. In mid-July 1863 it was consolidated with the Department of Virginia; it became an independent district again in January 1865.

Northern Virginia, Confederate Department of

Jefferson Davis's government created this military district on October 22, 1861. General J.E. Johnston was its first commander. The district comprised the chief operating area of the Army of Northern Virginia, commanded by Robert E. Lee from June 1, 1862, until his surrender at Appomattox.

Northwest Conspiracy

This abortive operation was to have freed and armed 10,000 Confederate prisoners at Camp Douglas, Illinois, for an attack on Chicago in July 1864. Benjamin J. Sweet, the Union commander of Camp Douglas, discovered the conspiracy and had its leaders arrested.

Nullification Doctrine

South Carolina politician John C. Calhoun argued that the states had a constitutional right to declare null and void any federal law deemed to violate the agreement of Union. He advanced the theory initially as an argument in the debate in 1832 over the Nullification Crisis, in which Andrew Jackson's federal government was threatening military action against South Carolina for having declared the tariff's of 1828 and 1832 void within the state; the dispute was finally settled in a compromise engineered by Henry Clay. The Calhoun doctrine was an early suggestion that states dissatisfied with the federal arrangement might secede.

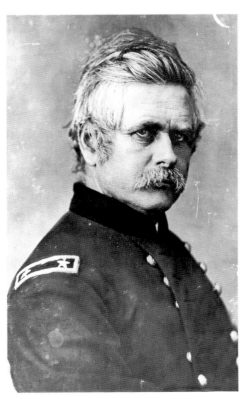

Oak Grove *(Virginia),* Battle of
(also called Henrico, King's School House, The Orchards)

This was the opening engagement of the 1862 Seven Days' Battles. Preparing his assault on Richmond, Federal General George McClellan ordered a reconnaissance on June 25. In heavy skirmishing, Union General Joseph Hooker's division drove back Southern outposts near Oak Grove. There were some 500 casualties on each side. The Mechanicsville Battle followed.

Old Capitol Prison

This Washington, DC, prison, formerly the temporary replacement for the US Capitol burned in the War of 1812, held prisoners of war, deserters, and suspected spies.

'Old Fuss and Feathers'

This nickname for General Winfield Scott, commander-in-chief of the US Army at the start of the war, referred to Scott's fondness for military pageantry.

Olustee, *Florida*

On February 20 Confederate forces attacked and routed a Union division under Truman Seymour at this place, about 20 miles inland from Jacksonville. The Union commander lost more than 1800 of his 5115-man division; Confederate casualties were 934 out of about 5200 engaged.

Ord, Edward Otho Cresap *(1818-1883)* Union general.

This Maryland native, a West Point graduate and 20-year veteran, defended Washington and fought at Dranesville, Iuka, and Hatchie. Ord was a corps commander at Vicksburg, Jackson, and Fort Harrison, and at the Petersburg Siege and in the Appomattox campaign. Several times wounded, he was repeatedly cited for bravery.

Often-breveted Union General Edward Ord was eventually rewarded with the command of the Army of the James in 1865.

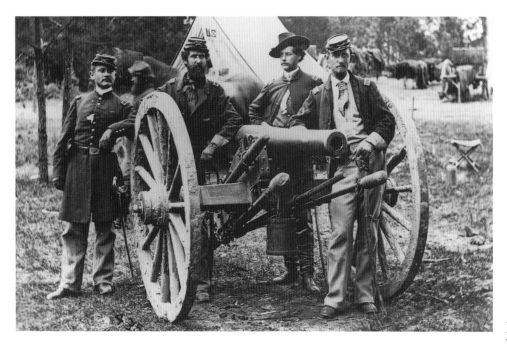

Above: A 3-inch Ordnance gun belonging to the Union's 2nd Artillery.
Left: Recovered from President Lincoln's box in Ford's Theatre after his assassination was this playbill for the evening's feature presentation, *Our American Cousin*.

Ordnance Gun

Developed by the US Ordnance Department in 1863, this 3-inch rifled gun was widely used by the horse artillery. Also called the Rodman rifle, it had a maximum range of about 4000 yards.

Organization of Armies

On both sides, Civil War land forces were assigned either to territorial organizations, of which departments were the largest category, or to operational organizations, of which armies were the largest subdivision. Armies were composed of two or more corps; corps of two or more divisions; divisions of two or more brigades; and brigades of two or more regiments. Federals generally named their armies after rivers in their areas of operation (the Army of the Potomac); Confederates named theirs after states or regions (the Army of Northern Virginia).

Osterhaus, Peter *(1823-1917)*
Union general.

Prussian-born, he emmigrated to the United States in 1848. He served in Missouri regiments early in the war, and commanded a brigade at Pea Ridge in March 1862. He led a division during the Vicksburg Campaign and the Chattanooga Campaign. From September 1864 to January 1865, he commanded the XV Corps of the Army of the Tennessee.

Our American Cousin

Lincoln was watching a performance of this light comedy at Ford's Theatre the night he was assassinated. The play, written by the English dramatist Tom Taylor, was originally produced in London in 1858; Laura Keene starred in the Washington production.

Page, Charles Anderson
1838-1873 **War correspondent.**

A young Treasury official released for war reporting, Page became famous for fast, accurate, and vivid dispatches to the New York *Tribune*. He covered the Peninsula, Second Bull Run, the Wilderness, Spotsylvania, and the Petersburg siege and was one of the first reporters into Richmond in April 1865.

Paine, Charles Jackson
(1833-1916) **Union general.**

A Harvard-trained Massachusetts lawyer, Paine recruited a company in September 1861 and served on the staff of Benjamin F. Butler. He commanded troops at Port Hudson and, as a brigadier general, at New Market and Fort Fisher.

Palmer, John McAuley
(1817-1900) **Union general.**

Palmer was a Kentucky lawyer, legislator, and 1861 Peace Convention delegate. Joining the 14th Illinois, he commanded troops in the Mississippi, Ohio, and Cumberland Armies, fighting at New Madrid, Point Pleasant, and Island No. 10 and distinguishing himself at Stone's River and Chickamauga.

Palmetto Arms

Ten years before secession South Carolina officials created a small arms industry in the state, awarding rifle, musket, pistol, and saber contracts to the Palmetto Iron Works in Columbia. The factory, renamed the Palmetto Armory, made copies of US arms during the 1850s. During the war, bombs, cannonballs, and Minie balls were manufactured there.

Palmitto Ranch, *Texas*

On May 12, 1865, in the last significant land action of the war, Federals under T.H. Barrett captured a Southern camp at Palmitto Ranch on the Rio Grande, but then withdrew in fear of a counterattack. On the next day the Federals fought their way into the camp again but were repulsed by J.S. Ford's Rebel forces.

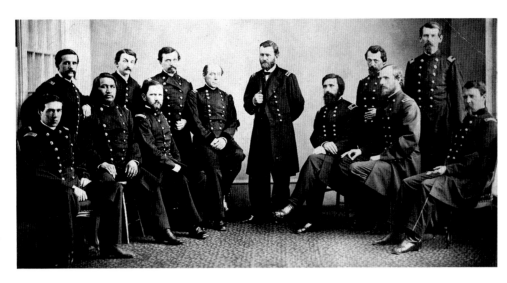

A portrait of Grant's staff includes (third from left) Seneca chief Ely S. Parker.

Panada

This hot gruel, invented by Sanitation Commission worker Eliza Harris, was a concoction of army crackers mashed in boiling water, ginger, and wine. An alternate name was bully soup.

Parker, Ely Samuel (1828-1895)
Union officer.

A Seneca chief, Parker trained as a lawyer and then, when refused admission to the bar, as an engineer. He was commissioned captain of engineers in May 1863, serving as J.E. Smith's division engineer and as military secretary to Ulysses S. Grant, a personal friend; Parker transcribed the official copies of Robert E. Lee's surrender.

Parole

Prisoners of war were often released on their pledge of honor not to take up arms again until they had been exchanged. This pledge was commonly called a parole.

Parrott Guns

R. P. Parrott designed a series of rifled guns ranging in size from those firing a 3-inch, 10-pound shell to those firing a 10-inch, 250-pound shell. These muzzle-loaders were more accurate and could fire at greater ranges than smoothbore types.

Partisan Rangers

John S. Mosby first raised this Virginia guerrilla force in January 1863. The rangers specialized in swift raids against Federal rearward supply trains and depots; after an attack, they would disappear into the countryside. Despite intensive effort, the Federals never managed to break up Mosby's band of riders.

Patrick, Marsena Rudolph (1811-1888) **Union general.**

A New Yorker, this West Point graduate and war veteran resigned a college presidency to enlist. After serving on George McClellan's staff and in Washington's defenses, he fought at Second Bull Run, Chantilly, South Mountain, and Antietam; he served as the provost marshal general of the Union army after October 1862.

Pay

Union privates received $13 per month until June 1864, when they were granted a $3 per-month raise. Confederates got $11 per month, raised to $18 in June 1864. A Federal second lieutenant got $105.50 per month; a major general, $457. Confederate officers' monthly pay was slightly less. In both armies, pay was slow and irregular, and this was especially true for private soldiers.

Payne, William Henry Fitzhugh (1830-1904) **Confederate general.**

This Virginia lawyer and public servant commanded cavalrymen at Williamsburg and Chancellorsville, on Stuart's Pennsylvania raid, in Early's Raid on Washington, and at Richmond; he was repeatedly wounded and was captured three times, the last time at the Battle of Five Forks.

Pea Ridge (Arkansas), Battle of (also called Elkhorn Tavern)

In this two-day battle, March 7-8, 1862, Federals under Samuel R. Curtis at Pea Ridge (or Elkhorn Tavern) were assaulted by scraped-together Rebel forces (including Indians) under Earl Van Dorn. Curtis, alerted by scout 'Wild Bill' Hickok of the enemy approach, formed a line of battle on high ground. In the first day of fighting Van Dorn's men got behind Curtis, but the bluecoats faced about and held on; on the other end of the line there was also fierce fighting at Elkhorn Tavern. On the 8th the fighting centered around Elkhorn Tavern and ended in a Northern charge that routed the graycoats. The North suffered about 1384 casualties of 11,250 engaged, the South some 800 of 14,000. Van Dorn had hoped ultimately to be able to march on St. Louis, but this defeat frustrated his plans.

Peace Convention

On February 4, 1861, peace-seeking delegates from 21 Union states (but none of the seceded states) convened in Washington at Virginia's instigation. Led in debate by former President John Tyler, they sincerely but ineffectually tried to save the Union, submitting the Crittenden Compromise (*See*) and six proposed constitutional amendments to Congress on February 27. None of these was – or could have been – accepted.

Peace Democrats

This influential antiwar group within the Democratic Party succeeded in incorporating a peace plank in the platform for the 1864 presidential election. Although Democratic nominee George McClellan and the majority of the party disavowed it, the peace plank damaged the Democrats on election day.

This photograph of a 10-pounder Parrott gun shows both the rifling and the reinforced breech typical of Parrott's weapons.

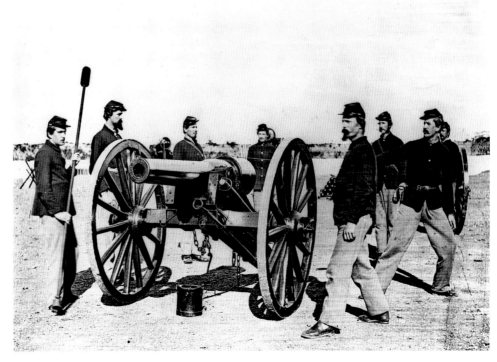

Peach Orchard

This lightly wooded area west of Cemetery Ridge was the scene of heavy fighting on the second day (July 2, 1863) of the Battle of Gettysburg when General Daniel Sickles made it the apex of his ill-judged salient in the Union line.

Peach Tree Creek (Georgia), Battle of

Confederate General John B. Hood, taking over from Joseph Johnston the responsibility for Confederate resistance to William T. Sherman's 1864 Atlanta Campaign, made his debut on July 20 with a surprise attack on George Thomas's Federal army at Peachtree Creek. After desperate fighting, often hand-to-hand, Thomas moved up artillery which turned back two hours of desperate Southern assaults. By the end, Hood's forces had sustained nearly 5000 casualties, while Thomas's forces suffered but 1779.

'Peculiar Institution'

This was Southerners' delicate term for slavery. It was coined by John C. Calhoun, who referred to slavery as the 'peculiar domestic institution' in 1830. He intended it to mean 'distinctive' or 'unique,' but many people since then have misinterpreted it to mean 'unusual' or 'strange.'

Southerners often used the euphemism 'our peculiar institution' when speaking of slavery.

Pegram, John (1832-1865)
Confederal general.

The Virginian Pegram, a West Point graduate and career soldier, fought a varied war: after surrendering to George McClellan at Rich Mountain during the latter's western Virginia Campaign of 1861, he was an engineer under P.G.T. Beauregard and Braxton Bragg and fought under Kirby Smith, Richard Ewell, and Jubal Early. He was killed in February 1865 at Hatcher's Run.

Pemberton, John Clifford
(1814-1881) **Confederate general.**

Born into a Pennsylvania Quaker family and married to a Virginian, he was a West Point graduate who fought for the Confederacy. Rapidly promoted, he commanded Southern departments; after he surrendered Vicksburg in July 1863, however, he never received another major command.

Pender, William Dorsey
(1834-1863) **Confederate general.**

A North Carolinian and West Point graduate (1854), he served on the Northwest frontier until the war began. He earned distinction as a division commander at Antietam and Chancellorsville and, but for his youth, would probably have been given a corps at Gettysburg, where he was mortally wounded on the second day of the fighting. So highly regarded was Pender that some of his admirers compared him to Jackson.

Peninsular Campaign

The progress of the Civil War in the Eastern Theater would largely be in the hands of two armies, the Federal Army of the Potomac and the Confederate Army of Northern Virginia. In the summer of 1862 these armies (the Southern one at that point called the Confederate Army of the Potomac) began their long series of engagements.

Commanding the Southern army at the beginning of 1862 was General Joseph E. Johnston, leader of the victorious forces at the First Bull Run Battle. At the head of the Federal Army of the Potomac was the man who built it, General George B. McClellan. In December 1861, in addition to commanding his forces in the field, McClellan had been named to succeed aged Winfield Scott as general-in-chief of all Union armies. McClellan, a small, ambitious, and energetic man, had created an impressive fighting force, but in the end he would not prove able to lead it to victory. His thoroughness and attention to detail, as well as his fatherly attitude toward his men, proved his greatest liabilities on the battlefield: his elaborate caution and protective attitude toward his army made him ponderous and indecisive whenever he went into action.

In the first months of 1862 General Johnston's Confederate Army of the Potomac lay at Centreville, Virginia, only 30 miles from Washington. On February 22 President Lincoln issued the General War Order No. 1, mandating a movement against the enemy. General McClellan stalled, worrying over his arrangements and alarmed by the erroneous reports of his chief of intelligence, Alan Pinkerton, that enemy forces in Virginia vastly outnumbered Federal strength. (Pinkerton's exaggerated estimates of enemy strength would impede the Union war effort during most of 1862.) Lincoln wanted the Federal Army of the Potomac to advance from the North by land and push Johnston away, staying between the enemy and Washington. Instead, McClellan produced an ingenious plan to move against the Confederate capital at Richmond from the south, by water; he reasoned that Washington's defenses were adequate to any eventuality and that Johnston would be obliged to follow and contest any Federal movement. When Johnston withdrew to Culpeper, Virginia, Lincoln, though still concerned about Washington's vulnerability, consented to McClellan's plan. However, to allow McClellan to concentrate on the campaign, and also because of growing worries about his general, Lincoln relieved McClellan as overall Union commander and took on those duties himself. (Until he found a winning general – Ulysses S. Grant, in March 1864 – Lincoln would involve himself overmuch in army matters.)

McClellan's Peninsular Campaign, aimed at both Johnston and Richmond, began in March 1862, with some 100,000 men, 25,000 animals, 300 cannons, and mountains of supplies beginning the journey on 400 ships to land on the toe of the peninsula between the James and York rivers, about 70 miles southeast of Richmond. McClellan was expecting to be reinforced by the corps of Generals Irvin McDowell and Nathaniel Banks, moving over from their positions in Virginia's

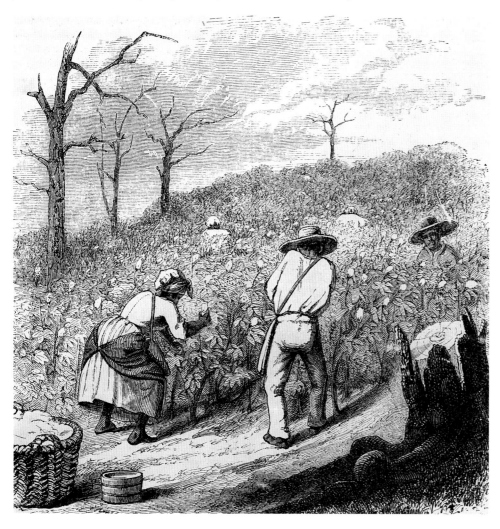

Shenandoah Valley; but during the landing word came from Lincoln that due to the disruptions caused by the Shenandoah Valley Campaign of Stonewall Jackson, McDowell and Banks must stay where they were. This was precisely what Jackson's campaign had meant to accomplish.

Furious at losing the two corps, still convinced by exaggerated estimates of enemy strength, and seeing clearly that Jackson's campaign was intended to tie up Union forces, McClellan fired off a steady stream of letters to Washington demanding reinforcements. In early April, reluctantly, he began

inching his army up the peninsula toward Richmond, but then he stopped in front of Confederate defenses that stretched from Yorktown across the peninsula. These lines

A Union army map shows the main theater in which the Peninsular Campaign was fought.

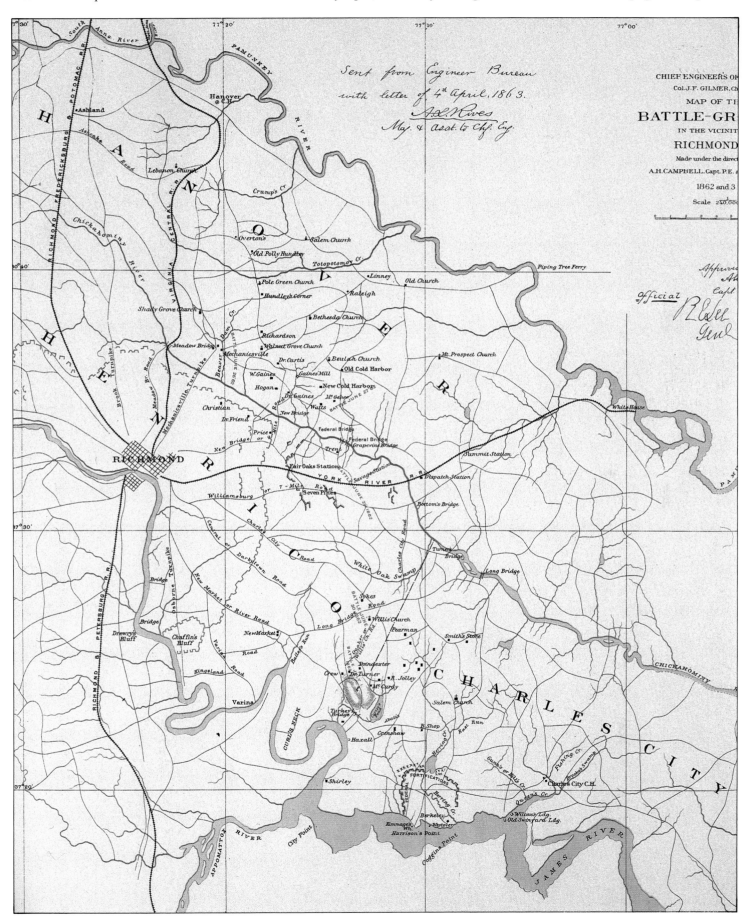

Union troops land on the Virginia Peninsula in 1862. Brilliantly planned, the campaign was wretchedly executed.

were actually manned by less than 13,000 Southerners, but McClellan called this thin defense 'one of the most extensive known to modern times' and spent a month arranging a siege. General John B. Magruder, commanding the Confederate defenses at Yorktown, was an amateur actor, and he produced a splendid show for the enemy, marching the same regiments in and out of various positions to deceive McClellan about the actual numbers. The Union commander was quite ready to swallow these deceptions.

Meanwhile, Federal slowness gave the Confederates plenty of time to make preparations. The plans were formulated by General Robert E. Lee, then serving as military advisor to Confederate President Jefferson Davis. During April, Johnston was given 60,000 men to oppose the Union advance; meanwhile, strong defenses were erected to protect Richmond proper. These defenses completed, Johnston pulled back from Yorktown to Richmond on May 3. On the next day McClellan finally unleashed his attack on the defenses at Yorktown, only to find them nearly deserted. On the 5th, at Williamsburg, advancing Federal forces suffered 2200 casualties in being turned back by the Southern rear guard; this allowed the Confederates to pull away with all their supplies. McClellan then began inching cautiously up the peninsula, beset by an unusually rainy spring and muddy roads.

For a while, Federal prospects of getting to Richmond looked better by way of the James River. As Union gunboats advanced, Confederates were forced to destroy their naval yard at Norfolk, including blowing up the ironclad *Merrimac (See MONITOR AND MER-RIMAC BATTLE)*. Before the Union fleet could reach Richmond, however, it was stopped on May 15 by Southern batteries at Drewry's Bluff. That left it solely up to McClellan to try and take Richmond.

In late May 1862 the Federal Army of the Potomac had reached the outskirts of Rich-

mond, some eight miles away, but it was dangerously straddling the rain-swollen Chickahominy River. Confederate General Johnston, finding the Union left wing isolated south of the river, decided to attack there on March 31. The two-day Battle of Fair Oaks and Seven Pines was mishandled by the Confederate commanders but nonetheless had two important benefits for the South: it made McClellan still more cautious, even at the gates of Richmond; and General Johnston was wounded, to be replaced in command by General Robert E. Lee. Lee renamed his forces the Army of Northern Virginia and began the series of operations that would make him the scourge of the North and a celebrated name in history.

McClellan's Peninsular Campaign had now passed its zenith. In June, Lee's chief of cavalry J.E.B. ('Jeb') Stuart took his troopers on a scouting and raiding ride completely around the Army of the Potomac, in the process finding that Fitz-John Porter's Federal V Corps was isolated on the north bank of the

Chickahominy. Lee decided to strike this contingent. The operations related to that offensive began at Oak Grove on June 25, the first of the Seven Days' Battles (*See*).

Though in these subsequent operations Lee would fail to destroy McClellan's forces, they did serve to convince the Federal commander to withdraw down the peninsula to Harrison's Landing. In fact, the Army of the Potomac had fought well throughout the Seven Days and were still in good fighting shape, perhaps better than Lee's forces. But McClellan was already defeated in his mind, and bitterly blaming Washington for everything. The Peninsular Campaign drifted to its conclusion in early August, when the Army of the Potomac began to move northward in support of John Pope's ill-fated forces, then preparing to advance to disaster at the Second Battle of Bull Run.

Pensacola Bay, *Florida*

This bay offered the best natural anchorage in the Gulf of Mexico. Its aged commanding officer surrendered the US Navy Yard there to secessionists in April 1861, but Federal forces continued to occupy outlying positions. When Confederate forces withdrew in May 1862, Pensacola Bay became the headquarters for the Union Navy's West Gulf Squadron during the blockade.

Percussion Caps

These were small, powder-filled wafer-shaped metal objects that were placed on the nipple of a rifle or revolver. When the hammer struck the cap, the powder exploded and set off the charge, propelling the bullet out of the gun. Percussion caps operated more rapidly and reliably than the flintlock firing mechanisms they replaced, and they added considerably to the general rise in firepower that made the Civil War so much more lethal than any earlier wars.

One junior Union officer who did well on the peninsula was Lt. George Custer, shown here in a Waud sketch fording a stream.

Perryville (Kentucky), Battle of
(also called Chaplin Hills)

Ordered to halt Braxton Bragg's 1862 invasion of Kentucky (See), Federal General Don Carlos Buell marched from Louisville with 60,000 men. Early on October 8, Federals under Philip Sheridan drove back enemy positions near Perryville as blue forces moved into line. In the afternoon, Confederates under Leonidas Polk routed the Union left, but at the same time, Sheridan attacked from the right and drove the enemy back through the town. Buell, nearby with half his Federal army, did not hear the fighting because of an 'acoustic shadow,' and darkness prevented him from following up Sheridan's success. By the next morning Bragg had withdrawn in the face of superior forces; he would soon thereafter abandon his Kentucky Campaign entirely.

Personal Liberty Laws

These laws were adopted in 10 Northern states in reaction to US government's Fugitive Slave Law. They prohibited state officers from aiding in the capture of runaway slaves, denied the use of state jails to hold escaped slaves, and required jury trials before runaways could be returned.

Petard

Military engineers had for centuries used this kind of explosive charge to blow open gates and to knock down walls. It often consisted of an iron receptacle filled with powder and ball, and generally was attached by hooks to a gate or wall before being detonated.

Petersburg, Campaign and Siege

By the summer of 1864 the Confederacy was sinking toward defeat. It had lost most of its important cities and ports, a substantial number of its fighting men, and much of its grip on the slave-labor system that had supported its economy. Already there was talk of enlisting freed slaves in the Confederate army, a manifestly desperate course for the South.

Robert E. Lee and the Confederate Army of Northern Virginia, however, had survived everything Ulysses S. Grant could throw at them and remained a serious impediment to Union hopes of quick victory. After the devastating repulse of Federal forces at Cold Harbor, Virginia, Lee expected his opponent to repeat his previous tactics, slipping around the Confederate flank and again marching on Richmond. Instead, in one of his most brilliant tactical moves, Grant for once surprised his enemy: on the evening of June 12, 1864, the Federal Army of the Potomac quietly pulled out of position at Cold Harbor and headed south for Petersburg. This town protected the southern route to the capital and its vital rail lines. If Petersburg were taken, Richmond would inevitably fall.

Commanding at Petersburg was General P. G. T. Beauregard. For the past month he had been keeping at bay the Union army of General Benjamin Butler, who had been ordered to support Grant by marching toward Richmond from the south. Instead, the inept Union general was thoroughly

the troops storming the foot on the ... on Wednesday evening June ... of the rebel line in front of ... around the ... column June 15th 1864. S.A.

Union troops win a surprise victory over the Rebels at Petersburg on June 15, 1864, but will blunder badly by not following it up.

bottled up by the enemy on the peninsula between the York and James rivers, scene of McClellan's earlier ill-fated Peninsular Campaign. Beauregard, realizing that Grant was heading for his 5400 defenders in the city with the full Army of the Potomac, began sending Lee urgent requests for reinforcements. For some days, however, Lee refused to believe that Grant had given him the slip.

On June 15, 1864, 16,000 men of the Union army arrived at Petersburg under General William F. Smith, who had been ordered to attack immediately. At that point Beauregard had not been reinforced and the city was at the Federals' mercy. But the attack was bungled. Smith was slow on the march, and Federal reinforcements got lost on the way, finally arriving at the city in the evening. An assault was nonetheless mounted and made good headway as darkness came on. Then, in a decision that may have prolonged the war for nearly a year, Smith ordered his men to break off for the night. By next morning Beauregard had pulled nearly 10,000 reinforcements off the peninsula into Petersburg, and Lee had finally recognized the threat posed by Grant's maneuver.

As more of the Army of the Potomac arrived during the following days, Grant ordered new assaults on the Petersburg defenses. These costly attacks achieved little; troops and officers alike, drained by weeks of incessant fighting, fell into discouragement and disorganization. On June 18 Lee arrived with the Army of Northern Virginia. Meanwhile, in his futile assaults on the defenses, Grant had suffered over 11,000 casualties. Petersburg was now virtually immune to direct assault. It would have to be reduced by the slow, gruelling process of a siege. Grant now spread his lines east of the city, and in subsequent weeks and months he would extend his stranglehold to the west. Lee's men would contest every Federal move. Meanwhile, at the end of June, Lee sent Jubal Early on his Washington Raid in an attempt, only briefly successful, to force Grant to send some of his troops to the capital.

In July came a glimmer of hope for a quick resolution, but it turned into another dis-

aster. Under the direction of hapless General Ambrose E. Burnside, engineers dug a gigantic mine under the defenses of Petersburg and filled it with powder. When it was touched off on July 30th the largest explosion in American history sent a geyser of earth, guns, and men into the sky, leaving a crater leading straight into the city and a unique chance to storm in while the defenders were still in shock. However, the Federal black troops who had been specifically trained to lead the assault had been withdrawn at the last minute by General George Meade (still nominally in command of the Army of the Potomac), who feared criticism for using the still-controversial black units on such an experimental operation. Discouraged by that change of plans, Burnside was desultory about his orders for the attack. The result was that thousands of unprepared troops were shoveled into the crater and ended up literally at the feet of an aroused enemy. The Union suffered 3748 casualties of 20,708 engaged before the survivors fled. In a bitter irony, the worst struck were the black units originally slated to lead the attack, for they had been thrown in at the end, only to meet devastating fire from the enemy. Legend says that a dismayed President Lincoln responded to reports of Petersburg Mine Assault thus: 'Only Burnside could have managed such a coup, wringing one last spectacular defeat from the jaws of victory.'

So the siege went on, men dying one by one in the trenches and earthworks from the continual depredations of sharpshooters, mortars, and cannons. Finally, in August 1864, Grant sent a detachment under Gouverneur Warren to seize the Weldon Railroad south of Petersburg. The Federals occupied the line on the 18th, and two attacks by A.P. Hill's Confederates could not dislodge them, though the North suffered 4455 casualties to the South's 1600. Now only one Confederate lifeline was left – the South Side Railroad on the west. The next spring, on March 29, 1865,

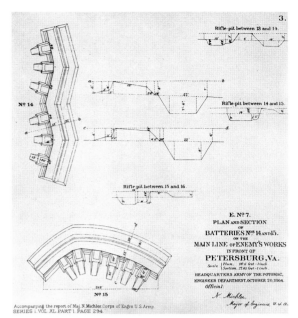

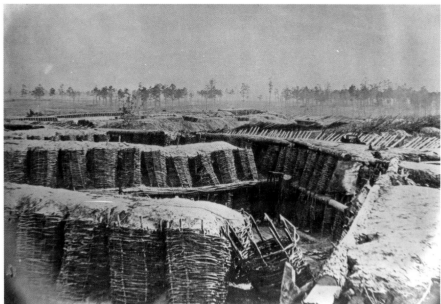

Above: A Union engineers' plan of two of the many batteries (plus intervening rifle pits) that made up the Confederate defensive line during the siege of Petersburg.
Above right: A section of the ambitious trenches built by the Confederate forces to protect Petersburg.
Right: A Union map showing a major segment of the opposing lines at Petersburg.

Union General Philip Sheridan led a force of infantry and cavalry to occupy Dinwiddie Court House, near that railroad, and prepared to cut the lifeline of the Army of the Northern Virginia. By then the Army of the Potomac had closed around most of the city, and Lee had failed in a March 25 attempt to break through Union lines at Fort Stedman.

Lee sent out George Pickett with 19,000 men to drive Sheridan away and hold the railroad 'at all costs.' After two days of heavy fighting, March 31 to June 1, around Dinwiddie Court House and Five Forks, the Federals had captured nearly half of Pickett's men and had driven the rest back into Petersburg. On the next day Lee informed President Jefferson Davis that his last rail line had been cut and that the army would have to evacuate Petersburg immediately – which doomed Richmond as well. On April 2, as Grant unleashed attacks that broke through Lee's defenses in several places, the Confederate government evacuated Richmond and fled to Danville, Virginia. Meanwhile, Southern troops blew up factories and munitions works in the capital, touching off fires that consumed much of the city. In the day's fighting at Petersburg, A.P. Hill, one of Lee's ablest commanders, was killed; Lee was visibly shaken by the news.

On the night of April 2 Lee and the starved and exhausted remaining 35,000 soldiers of the Army of Northern Virginia slipped out of the city and marched west toward Amelia Court House, where Lee hoped to put his men on the Danville Railroad for South Carolina to join forces with J.E. Johnston. On the following day Abraham Lincoln walked in the streets of Richmond, to the accompaniment of cheering slaves just freed. In the Appomattox Campaign of the next week, Ulysses S. Grant would finally run his old enemy to ground.

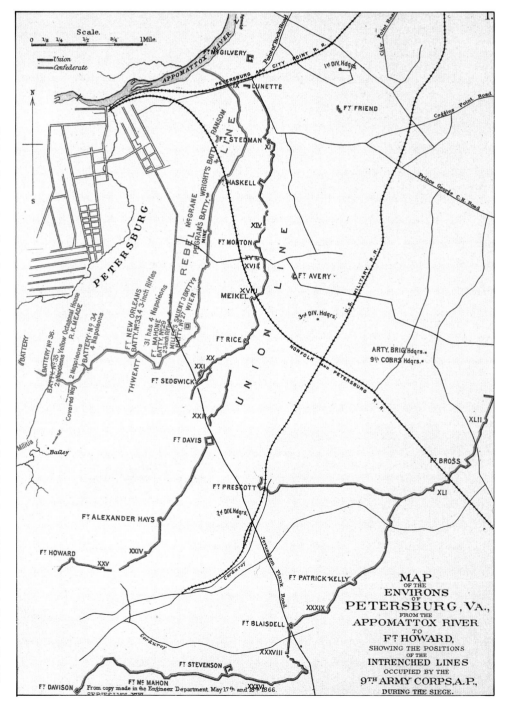

MAP
OF THE
ENVIRONS
OF
PETERSBURG, VA.,
FROM THE
APPOMATTOX RIVER
TO
FT HOWARD,
SHOWING THE POSITIONS
OF THE
INTRENCHED LINES
OCCUPIED BY THE
9TH ARMY CORPS, A.P.,
DURING THE SIEGE.

Petersburg Mine Assault

(or Petersburg Crater)
See PETERSBURG, CAMPAIGN AND SIEGE

Pettigrew, James Johnston
1828-1863 **Confederate general.**

This North Carolinian, who had been graduated with the highest marks of anyone who had ever attended the University of North Carolina, led a brigade on the Peninsula, where he was wounded and captured. He was exchanged and at Gettysburg led one of the three divisions (George Pickett and Isaac Trimble led the other two) that made 'Pickett's Charge' on the third day of the battle. He was killed during the retreat from Gettysburg.

Philippi Races

In the opening engagement of the Western Virginia Campaign of McClellan (*See*), at Philippi, West Virginia, on June 3, 1861, Federal troops surprised a force of 1500 Confederates in their sleep and routed them. The derisive term, coined by Northern newspapers, describes their hasty withdrawal.

Pickets

Small detachments of soldiers who guarded the outskirts of a military camp or defensive position. At various times during the war Union and Confederate pickets, away from their officers, would arrange informal truces; they often carried on a brisk trade in coveted goods, Confederates exchanging tobacco for coffee, for example.

Pickett, George Edward
(1825-1875) **Confederate general.**

Virginia-born Pickett resigned his Union captaincy in June 1861, led the Confederate 'Game Cock Brigade' at Williamsburg and

CSA General George Pickett did not in fact order the Gettysburg charge named for him.

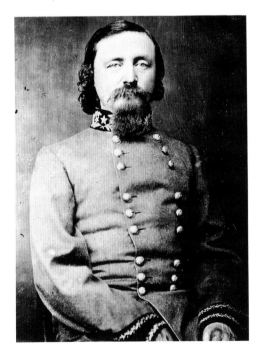

Seven Pines, and participated in Gaines's Mill, Fredericksburg, Gettysburg, Drewry's Bluff, and the Petersburg and Appomattox Campaigns. Defeated at Five Forks and Sayler's Creek, he surrendered with Longstreet at Appomattox. The misnamed 'Pickett's Charge' came on the third day of the Battle of Gettysburg, July 3, 1863: James Longstreet, on Lee's command, ordered the disastrous charge, Pickett merely directing the attacking brigades' placement and then taking part in the charge.

Piedmont *(Virginia)*, Battle of

After the Federal defeat at New Market (*See*) in May 1864, Union General David Hunter replaced Franz Sigel and advanced down the Shenandoah toward Staunton, Virginia. He met Confederate forces under W.E. Jones at Piedmont on the morning of June 5 and, after a sharp fight, routed them. Confederate casualties were about 1600, including 1000 prisoners; Union forces lost 780 men. The Federals entered Staunton the next day.

Pierpont, Francis Harrison
(1814-1899) **Governor of Virginia.**

A Virginia lawyer and businessman, Pierpont was a Unionist who supported Lincoln in 1860. After Virginia's secession he organized the pro-Union forces that declared West Virginia a separate state in 1862 (it was admitted to the Union as such in 1863) and served as wartime governor of the Virginia counties under Federal control.

Pike, Albert *(1809-1891)*
Confederate general.

A wealthy newspaperman, he entered Confederate service in August 1861, commanding the Department of Indian Territory. He led Indian troops at the Battle of Pea Ridge (*See*) in March 1862. He resigned his command later in 1862 after being publicly reprimanded by President Jefferson Davis for airing complaints about his political treatment. Out of favor in both North and South, he fled to Canada in 1865 but was pardoned by President Andrew Johnson in 1867.

Secret Service head Allan Pinkerton (seated right) hindered the Union's 1862 Peninsular Campaign with flawed intelligence reports.

Pillow, Gideon Johnson
(1806-1878) **Confederate general.**

This Mexican War veteran was a Tennessee criminal lawyer and moderate Democratic politician. Second in command at Fort Donelson, he and his superior, John B. Floyd, relinquished their commands and fled, leaving Simon B. Buckner to surrender to Ulysses Grant. Pillow was reprimanded and received no further significant commands.

Pinkerton, Allan *(1819-1884)*
Detective and secret service chief.

A Scottish emigrant to Illinois, Pinkerton opened America's first private detective agency in 1850. Recruited in 1861 to set up the Federal army's secret service, he worked under George McClellan in the Ohio Department and then in Washington, where he directed counter-espionage activities. The poor quality of the intelligence information and analyses he gave McClellan during the Peninsular Campaign doubtless contributed to the Union general's lackluster performance in that dismal operation. Pinkerton left government service when McClellan was relieved in November 1862. He expanded his agency after the war, winning a controversial reputation as a 'labor union buster'.

Plank Road

Roads on campaign routes were made passable by laying down planks over boggy or otherwise muddy surfaces. The method produced a hasty and impermanent wartime version of the corduroy road. (*See*).

Pleasant Hill *(Louisiana)*, Battle of

After their victory at the Battle of Sabine Crossroads during the Red River Campaign, Confederate forces under General Richard Taylor attacked the retreating Union troops of Nathaniel Banks here on April 9, 1864. Taylor's late-afternoon assault made good pro-

As Union engineers became adept at building ponton (or pontoon) bridges, the speed of Federal troop movements greatly improved.

gress at first, but a Union counterassault drove the Confederates back. Nevertheless, Federal forces withdrew during the night. Federal casualties were 1369 out of 12,200 engaged; the Confederates lost about 1500 of their own 14,300 engaged.

Pleasonton, Alfred *(1824-1897)*
Union general.

Born in Washington, DC, Pleasonton was graduated from West Point and enjoyed a long military career. He led cavalry throughout the Potomac Army's campaigns from the Peninsula through Gettysburg, earning promotion to brigadier general for his role at the Battle of Chancellorsville, distinguishing himself at Brandy Station, and commanding the Union cavalry at the Battle of Gettysburg. In 1864 he routed Sterling Price in Missouri (*See* PRICE'S RAID IN MISSOURI) at the Battles of Westport and Marais de Cygnes.

Plymouth, *North Carolina*

Three Confederate brigades, supported by the ironclad ram *Albemarle (See)*, attacked the Federal garrison here on April 17, 1864. The *Albemarle* sank one Federal warship, disabled a second, and scattered the rest; the garrison, unreinforced, surrendered on April 20. Federal losses exceeded 2800, many of this total being prisoners.

Point Lookout Prison, *Maryland*

This Federal prison opened in August 1863 on the Potomac where the river empties into Chesapeake Bay. There were no barracks, and all the prisoners – Point Lookout held as many as 20,000 Confederate enlisted men – lived in tents.

Polignac, Prince Camille Armand Jules Marie de *(1832-1913)*
Confederate general.

This French Crimean War veteran was the only alien to hold high rank (major general) in the Confederate army. Polignac was P. G.

T. Beauregard's chief of staff and fought at Corinth and in the 1864 Red River Campaign. After unsuccessfully seeking French aid for the Confederacy, he retired in 1865.

Polk, Leonidas Lafayette *(1806-1864)* **Confederate general.**

Born to a prominent North Carolina family related to President James Polk, he was graduated from West Point in 1827. He soon entered the Episcopal ministry, however, and was ordained Bishop of Louisiana in 1841. Hoping to bolster Southern morale, Jefferson Davis persuaded him to accept a commission in June 1861, and Major General Polk took a western departmental command. Belying the largely symbolic nature of this assignment, Polk directed the Mississippi River defenses, occupied Columbus, Kentucky, defeated Ulysses Grant at Belmont, and led four charges at Shiloh. He was second in command at Perryville and, promoted to lieutenant general, fought at Stone's River and Chickamauga. Polk was killed while on a reconnaissance mission during the Atlanta Campaign.

Ponton or Pontoon

Though most Civil War literature and popular usage favor 'pontoon,' 'ponton' (pronounced PON-ton) is the correct modern military spelling for a boat or other floating structure supporting a temporary bridge over a river. The army engineers' ability to construct these rapidly was vital to troop movements and supply lines.

Pope, John *(1822-1892)*
Union general.

One of several Union generals who started out with some success and proclamations of future victory and then ran afoul of Robert E. Lee, Pope was a West Point man who by early 1862 was commanding the Army of the Mississippi. After leading several successful operations along the Mississippi River, he was named by Lincoln in June 1862 to head the new Army of Virginia.

Taking command, Pope immediately aroused enmity and ridicule on both sides by a blustering address that included, 'Let us

understand each other. I have come to you from the West, where we have always seen the backs of our enemies.' At the Second Battle of Bull Run in August, Pope was thoroughly outwitted and defeated by Lee and Stonewall Jackson. He responded by blaming the loss on subordinates. Relieved of his command shortly after the battle, he spent the rest of the war commanding the Department of the Northwest.

Poplar Springs Church, *Virginia*

During the Petersburg siege, Ulysses Grant ordered a reconnaissance in force in late September 1864 in an effort to force Robert E. Lee to extend his lines westward from Petersburg. After three days of intermittent fighting, the Federal V Corps under Gouverneur Warren consolidated its positions and linked up with the Federal line to the east, thus achieving Grant's objective of further stretching the enemy's Petersburg defenses. Federal losses in the operation, from September 30 to October 2, 1864, were more than 2800. Confederate casualties are not known.

Popular Sovereignty

In American usage during the pre-Civil War period this term referred primarily to the doctrine that slavery was a matter for the people of individual territories to decide – in other words, was a local rather than a moral or national issue. Senator Lewis Cass articulated the doctrine in 1847. Stephen A. Douglas promoted it in the Compromise of 1850, in the Kansas-Nebraska Act (1854), and in his 1858 debates with Lincoln. Popular sovereignty, understood in this sense, thus became the crux of the explosive North-South split over what the legal status of slavery should be in states newly admitted to the Union.

Arrogant Union General John Pope was taught a lesson in humility at Second Bull Run.

Port Hudson, *Louisiana*

Union forces had unsuccessfully attacked this Confederate Mississippi River strong-point several times in 1863 before Nathaniel Banks's XIX Corps besieged the place, beginning on May 27, 1863. The garrison finally surrendered on July 9, five days after the upriver fortress of Vicksburg had fallen to Ulysses Grant. The Confederates lost 7200 men, two steamers, 60 guns, and substantial amounts of small arms and ammunition, but the real significance of Port Hudson's fall lay in the fact that it was the last Rebel stronghold on the entire Mississippi River, the last possible impediment to a Union invasion of the Deep South from the west.

Port Royal Expedition

In a large combined operation, a Union fleet of 77 vessels under the command of Flag Officer Samuel DuPont transported 12,000 troops under Thomas W. Sherman to attack the Confederate coastal stronghold of Port Royal, North Carolina, in 1861. The expedition left Hampton Roads, Virginia, on October 29, was nearly undone by violent storms en route, but finally entered Port Royal Sound on November 7. Naval bombardment soon reduced Port Royal's primary defenses, Forts Beauregard and Wagner, which were then occupied by Sherman's troops. This success gave the Union both a strategically important toehold on the Southern coast between Charleston and Savannah and a useful new refueling depot for its naval blockade ships.

Porter, David Dixon *(1813-1891)*
Union admiral.

As a youth he went to sea with his father, Commodore David Porter, a hero of the War of 1812. He joined the Mexican navy at 13 and the US Navy at 16, receiving his first command in the Mexican War. In the Civil War, after aborting his April 1861 expedition to relieve Fort Pickens, he joined the blockade of southern ports. The following spring Porter's mortar flotilla supported David Farragut's operations in the New Orleans Campaign. Given command of the Mississippi Squadron in October 1862, Porter took Arkansas Post with W.T. Sherman and supported Ulysses Grant's assault on Vicksburg. As a rear admiral commanding the lower Mississippi, he led the naval force accompanying Nathaniel Banks's Red River Campaign of 1864 before joining the North Atlantic Squadron and taking Fort Fisher in January 1865. Porter received the Thanks of Congress three times.

Porter, Fitz-John *(1822-1901)*
Union general.

A New Hampshire-born West Point graduate, Porter commanded the siege of Yorktown, fought in the Shenandoah Campaign of Jackson, and led V Corps in the Peninsula (where he distinguished himself at Malvern Hill), Second Bull Run, and Antietam. Cashiered in January 1863 on a charge of having disobeyed orders at Second Bull Run, he tried for 23 years to clear his record, finally winning reappointment in 1886.

Flag Officer David Porter commanded the US Navy's Mississippi Squadron at Vicksburg.

Potomac, Confederate Army of the

Originally referring to P. G. T. Beauregard's troops in the Department of the Potomac after July 20, 1861, this designation included J. E. Johnston's Army of the Shenandoah. After Beauregard went west early in 1862, the term referred only to Johnston's troops in the Peninsula (those in the Valley being called the Army of the North); Robert E. Lee named these combined forces the Army of Northern Virginia on assuming command June 1, 1862.

Potomac, Union Army of the

Named for the Department of the Potomac, created August 15, 1861, this army was the major Union fighting force in the Eastern Theater. The primary succession of commanders included George McClellan, August 15, 1861 – November 9, 1862 (Peninsular and Antietam Campaigns); Ambrose Burnside, until January 26, 1863 (Fredericks-

burg Campaign); Joseph Hooker, until June 28, 1863 (Chancellorsville Campaign); and George Meade, until June 27, 1865 (Gettysburg to Appomattox).

Powell, Lewis *(d. 1865)*
Confederate Conspirator.

One of John Wilkes Booth's conspirators in the Lincoln assassination (he was calling himself Lewis Paine at the time), he gravely wounded Secretary of State Seward. He was hanged on July 7, 1865.

Prairie Grove, *Arkansas*

Confederate General Thomas C. Hindman had scraped together a force to defend Little Rock and northern Arkansas. At Prairie Grove on December 7, 1862, Hindman planned to attack Federals under James G. Blunt but instead got himself and his unreliable troops caught between three converging enemy divisions and was forced to withdraw without a fight.

Price, Sterling *(1809-1867)*
Confederate general.

A Missouri lawyer, farmer, and Congressman, he commanded the Missouri State Guard at the Battle of Wilson's Creek in 1861 and later fought at Iuka, Cornith, Helen, and in the Red River Campaign. In 1864 he mounted an unsuccessful raid into Missouri (*See* PRICE'S RAID IN MISSOURI), after which he retreated into Mexico and oblivion.

Price's Raid in Missouri

In September 1864 Confederate General Sterling Price and a somewhat ragtag band of 12,000 cavalry began a guerrilla campaign against Union forces in Missouri. The state had long seen violence between slaveholding

At a review of the cavalry of the Army of the Potomac, Federal General John Buford watches his troopers ride past.

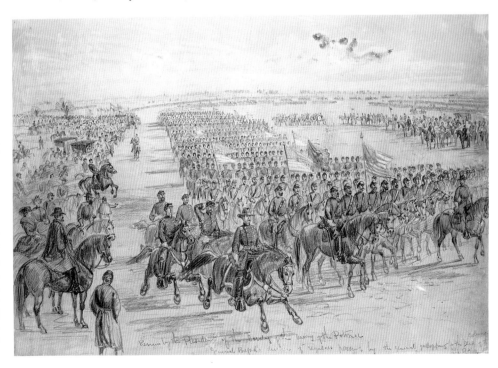

and abolitionist factions, and some of Price's men followed the bloody pattern of that conflict – as when a group including Frank and Jesse James slaughtered two dozen unarmed Federal soldiers from a captured train. That same day, September 27, Price was repulsed with heavy losses in an attempt to take Fort Davidson. Price rode on west, laying waste as he went, as resistance from Union forces under Samuel Curtis, Alfred Pleasanton, and Alfred Smith, as well as local militia, gathered momentum. Finally Price was defeated by Pleasanton at the Battle of Westport on October 23, and again at Marais de Cygnes on the 25th, after which Price was chased into Arkansas with half the forces he started with. Though Price tried to paint the operation as a success, it was clearly a disaster and proved to be the last significant Confederate operation in Missouri.

Prisoners of War

The US Record Office records a total of 462,634 Confederates and 211,411 Federals captured by their enemies during the war. Many were freed by parole or exchange, but hundreds of thousands were held in prison camps where appalling sanitation, diet, disease, and crowding contributed to a death rate among prisoners on both sides of roughly 15 percent. By suspending prisoner exchanges in April 1864, Ulysses Grant increased the Northern death toll.

Privateer

A privateer is a merchant ship given official permission to prey upon enemy shipping for its own profit – in other words, a form of legal

A swarm of Confederate soldiers captured at Spotsylvania in 1864 awaits transport back to Union prisoner-of-war camps.

piracy. Outlawed internationally, privateering was revived by the Confederate government during the war. When the Union captured two privateers – the *Enchantress* and *Savannah* – and condemned the officers as pirates, the Confederacy threatened to hang an equal number of prisoners. The North relented and imprisoned the officers.

Proclamation of Amnesty

President Andrew Johnson issued a proclamation on May 29, 1865, offering a general amnesty to any Confederates who pledged allegiance to the Constitution. This amnesty excluded, among others, high-ranking Confederate military and government officers and wealthy property-owners, who had to apply for individual presidential pardons.

Promotion

Fewer than 150 of the 1080 regular officers serving in 1861 achieved general's rank in the Union army, which followed policy of freezing officers in regular units rather than assigning them in ones and twos to volunteer formations. West Point graduates who had left the army before the war broke out fared better; an even half of the 102 academy graduates who returned to serve in the volunteer forces became generals.

Pryor, Roger Atkinson
(1828-1919) **Confederate general.**

Pryor was a newspaper editor, US Representative, and influential Virginia secessionist. As a brigadier general he fought at Williamsburg, Seven Pines, and Antietam. He resigned after losing his brigade and fought as a private in Fitzhugh Lee's cavalry. Pryor was captured near Petersburg in November 1864.

Quaker Road, *Virginia*

The van of the Federal V Corps, moving to envelop the Petersburg defenses at the opening of the Appomattox Campaign on March 29, 1865, met stiff Confederate resistance here. Charles Griffin's 1st Division troops held off Confederate counterattacks at a sawmill beyond the stream, then advanced to the Boydton Plank Road and dug in for the night. Federal casualties were about 370 dead and wounded. The Confederates lost 130 dead and about 200 prisoners.

Quakers

Members of this pacifist religious sect were early abolitionists, opposing slavery and the slave trade from the 18th century on. Many Quakers manned stations on the Underground Railroad.

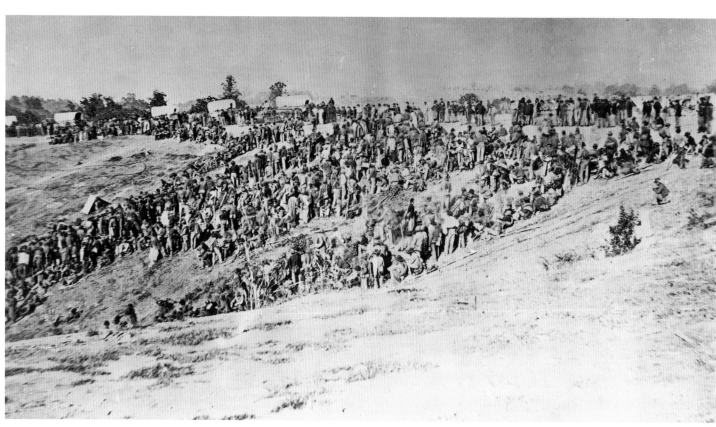

Perhaps the most barbarous guerrilla leader of the war was Rebel William Quantrill.

Quantrill, William Clarke
(1837-1865) **Confederate irregular.**

Quantrill, a onetime schoolteacher, was a frontier thief and gambler. Alias 'Charley Hart,' he drifted into the Kansas and Missouri border skirmishing. He parlayed his involvement in murders, robberies, and raids into a Confederate captaincy after taking Independence, Missouri, in August 1862. While his troops continued raiding in Kansas and Missouri, Quantrill's own operations included the August 1863 pillaging of the free-state stronghold of Lawrence, Kansas, where he killed at least 150 people, and, a few months later, the murder of 17 noncombatants after defeating Federal cavalry at Baxter Springs. He was killed by Union troops in May 1865 en route to Washington to assassinate President Lincoln.

One effect of railroads on the war was to confer mobility on heavy artillery.

Radical Republicans

These extremist Republicans called for emancipation of the slaves early in the war and for a peace settlement that would punish the rebellious states. The Radicals, led by Charles Sumner, Benjamin Wade, and Thaddeus Stevens, advocated the destruction of Southern economic and political power. They led the move to impeach President Johnson, primarily because they considered his Reconstruction policies too lenient.

Railroads

The Civil War was the first conflict in history in which railroads played an indispensable role in moving men and supplies. At the beginning of the war the North had a marked advantage in railroad mileage – some 21,000 miles compared to the South's 9000 – and though this ratio remained roughly the same throughout the war, the North gained a further advantage from the steady improvements it made in operating efficiencies. All this had an important effect on the war's outcome. Whereas throughout previous history troops had moved on foot or horseback, now,

from the first major battle at Bull Run, troops, weapons, and supplies could be rapidly shifted on trains. Rail transportation played a major role in many campaigns of the war, and rail centers such as Chattanooga became strategic targets as important as any. In the sieges of both Atlanta and Petersburg the cutting of the rail supply lines into the cities doomed their resistance.

Rains, Gabriel James (1803-1881)
Confederate general.

A North Carolinian, this West Point graduate and career soldier directed the first-ever use of land mines and booby traps in the Peninsula Campaign and further developed other innovative weapons as head of the torpedo bureau. His brother, George Washington Rains, was also one of the leading Confederate munitions specialists.

Rams

These warships, usually ironclad, were fitted with a heavy iron prow that could be driven into the hull of an enemy. The South authorized construction of 14 ironclad rams, the most famous of which was CSS *Virginia* (also known as *Merrimac*).

Ransom, Robert Jr. (1828-1892)
Confederate general.

Born in North Carolina, Ransom was a West Point-trained cavalryman. He organized the western cavalry; led troops at the Seven Days' Battles, Harper's Ferry, Antietam, Fredericksburg, Bermuda Hundred, and Drewry's Bluff; and participated in the Weldon Railroad defense and Early's Washington Raid. His brother, Matt Whitaker Ransom, was also a Confederate general.

Ransom, Thomas Edward Greenfield (1834-1864)
Union general.

He left an Illinois business career for the war. Wounded at Charleston, Fort Donelson, and Shiloh, he participated in the Battle of Corinth and in the Vicksburg, Red River, and Atlanta Campaigns. He died of illness. Ulysses Grant later called him 'the best man I have ever had to send on expeditions.'

Rappahannock Bridge and Kelly's Ford (Virginia), Battles of

During the 1863 Bristoe Campaign (*See*), Union General George Meade sent troops under John Sedgwick to attack a Rappahannock River bridge over which Robert E. Lee was retreating. On November 7, in one of the rare night actions of the war (and including a still rarer bayonet charge), the Federals overran the defenders of the bridge. Meanwhile at Kelly's Ford, two Southern regiments were captured. The losses of some 2023 shocked the Southern army.

Rations

The Union ration – one soldier's food for one day – was a 16-ounce biscuit or 22 ounces of bread or flour and 1¼ pounds of meat or ¾

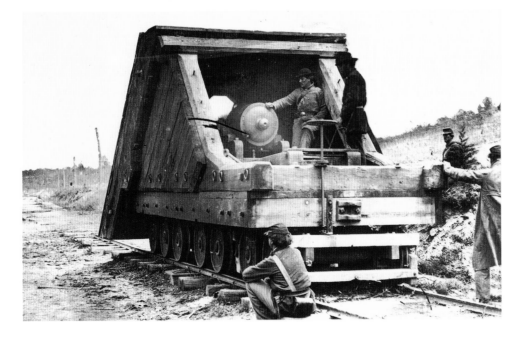

pound of bacon, with additional allocations of beans, rice or hominy, coffee, sugar, vinegar, and salt. Initially adopting the Union ration, the Confederates reduced it in 1862. In reality, soldiers often went without rations, relying on food from home and from sutlers.

Rawlins, John Aaron *(1831-1869)*
Union general.

A Democratic Illinois politician, he joined the army in August 1861 and became Ulysses Grant's 'most nearly indispensable' advisor. Trusted for his intelligence, honesty, and sound judgment, Rawlins was promoted in tandem with Grant, becoming chief of staff of the US Army in March 1865.

Reagan, John Henninger *(1818-1905)* **Confederate politician.**

A Texas legislator, he became postmaster general of the Confederacy in March 1861. In the Confederacy's final months he was treasury secretary. Captured with President Jefferson Davis, Reagan was held in Fort Warren until October 1865. He later served in the US Senate (1887-91).

Reams's Station *(Virginia)*, Battle of

During the Petersburg siege, when Federal forces under Winfield Hancock moved up to cut the Weldon Railroad in late August 1864, Confederates moved to the attack. On August 25 strong forces under A. P. Hill routed John Gibbon's inexperienced division; fresh troops sent into the battle 'could neither be made to go forward nor fire.' The Federals lost more than 2700 men, including 2000 captured, in the action.

Rebel Yell

Confederates on the offensive used this piercing shriek to great psychological effect. Said to derive from a Southern fox hunter's shout, it was first sounded at the First Battle of Bull Run in July 1861.

Reconnaissance in Force

This is an attack by a large force with the mission of finding and testing an enemy's strength. The cavalry clash at Brandy Station, Virginia, on June 9, 1863, during the Gettysburg Campaign is an example.

Reconstruction

The term refers broadly to the North's postwar policies toward the conquered Southern states and to the roughly 10-year period during which those policies were most markedly in effect. The question of under what conditions the Southern states should eventually be re-admitted to the Union had of course been much debated in Washington during the war. The Radical Republicans tended to favor policies of enforcement rather than conciliation, and on the key issue of how fast and in what manner the newly-emancipated black population should be integrated into the mainstream of Southern society, the radicals were dogmatic: integra-

tion must be immediate and complete, regardless of the social disruptions such a course might foster. Lincoln's position was more moderate: in his view the North's general approach should be more conciliatory than punitive, and, with respect to integration, all legal impediments to it should at once be removed, but the North should be wary of trying to force the pace of social change too rapidly, lest the result be counterproductive. Because Lincoln was assassinated almost at the moment of the Union's victory, it was left to his vice president and successor, Andrew Johnson, to try to realize Lincoln's policy.

Johnson moved swiftly but incautiously. Following his Amnesty Proclamation of May 29, 1865, and while Congress was still in adjournment, he rushed ahead with a program in which Southern state governors, appointed by Johnson, would hold conventions that would void their states' ordinances

Reconstruction-era black members of Congress. On the left is H. R. Revels of Mississippi, the first black US Senator.

of secession, abolish slavery, and repudiate Confederate debts. They would then elect new legislatures whose first order of business would be to ratify the 13th Amendment. The Southern states responded well to this plan, and by the year's end all save Texas had new civil governments in operation.

But Johnson's program had been more lenient than well-thought-out. It had made good the emancipation of Southern blacks, but it had done almost nothing to protect their civil rights, and especially their right to vote. Most of the Southern states were quick to take advantage of this, putting into effect a

Ex-Confederate soldiers are administered the Oath of Allegiance to the United States in the Senate Chamber at Richmond, Virginia.

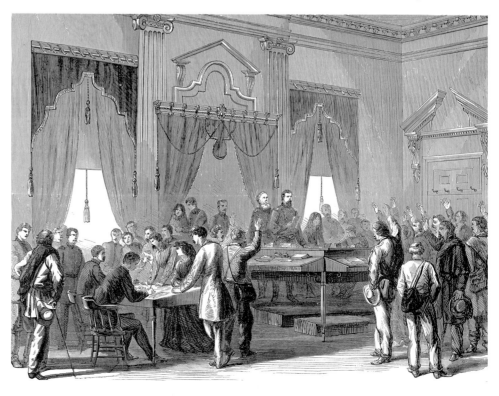

variety of so-called Black Codes which denied Southern blacks access to the polls, to equal economic opportunity, or to anything approaching social justice.

Predictably, this ill-judged show of Southern recalcitrance infuriated the US Congress, which became rapidly more radicalized and activist, and set it on a path towards wresting from Johnson's hands the initiative in the framing of Reconstruction policy. Johnson's efforts to slow this process with vetoes were soon undone by the introduction of the 14th Amendment (proposed in June 1866; ratified in July 1868), which left no room for cavil in its definition of civil rights or in its grant of power to Congress to enforce them.

The culmination of Congress's victory in taking control of Reconstruction policy came with the passage of the Reconstruction Act of March 2, 1867. In this, and ancillary legislation, the South was carved up into five military districts in which army authority would be supreme until new state constitutions satisfactory to Congress were written, and the re-admission of the states would then be contingent on their ratifying the 14th Amendment. The effects of this bulldozer policy on the South were considerable. While ex-Confederates remained largely disenfranchised, new black voters were not yet sufficiently organized or sophisticated to take effective control of local governments. Into the political vacuum poured a host of exploiters – 'carpetbaggers,' 'scalawags,' and the like – who added much to the South's already grave political, economic, and social woes.

By 1870 all the Southern states had been re-admitted, though some Federal troops still remained stationed in the region. But Congress's radical Reconstruction policy had, as Lincoln had feared, created a potent backlash. The Republican Party was all but banished from Southern politics, resentment against the North ran high, and the South's inter-race relations had become almost hopelessly envenomed.

Thanks to the revival of the Democratic Party's national power, Reconstruction effectively ended after the presidential election of 1876, but the after-effects of its failures would persist. Black civil rights would be steadily eroded and would not again make any significant advances until the 1960s. Indeed, whether what the radical Reconstructionists hoped to accomplish, and so mishandled, has yet been fully achieved is moot.

Red River Campaign

As part of Ulysses Grant's overall plan of March 1864 to finish the war, (*See* WILDERNESS CAMPAIGN), the Red River Campaign was assigned to Nathaniel Banks, a politically-appointed general with little battlefield success to his credit. Banks had been gearing up for an operation against Mobile, Alabama, with his Army of the Gulf, but he was diverted from that for this campaign, being directed to move up Louisiana's Red River to expand Union control in the state and seize stores of cotton; only after doing that was he to turn again toward Mobile. In fact, Grant had inherited the plan when he took overall command, and neither he nor W.T. Sherman – or Banks, for that matter – approved of it; all of them felt the

A view of the Union fleet on the Red River, stranded in shallow water above the rapids near Alexandria, Louisiana, in 1864.

move on Mobile should have priority. President Lincoln, however, pushed the campaign through. Thus it began with little military support or justification and was to be led by a weak general.

The plan called for Banks to take 17,000 troops to link up in Louisiana with 10,000 of Sherman's troops from Tennessee under A.J. Smith, plus 15,000 coming from Arkansas under Frederick Steele (the latter would never make it to Louisiana – *See* ARKANSAS CAMPAIGN.) Accompanying the ground forces marching along the Red River would be a formidable flotilla that included 13 ironclads and seven gunboats under Admiral David Dixon Porter. Obstacles the expedition faced included low water, inhospitable country, and Confederate forces under General Richard Taylor.

Smith's troops left Vicksburg on March 10, taken onto the Red River by the Union flotilla. On the 18th Smith and the fleet arrived at Alexandria, Louisiana, without obstruction from Taylor, and Banks's forces arrived a week later. Despite low water on the river and orders to return Smith to Sherman by April 15, Banks continued on to his next objective, the taking of Shreveport. His land forces ended up marching in a thin line on a narrow road, encumbered by a wagon train stretching 12 miles through enemy-held wilderness; meanwhile the ships were making poor headway through the shallow waters of the Red River.

Taylor, having massed his Confederate forces, finally made an appearance in force on April 8, moving his troops out of Mansfield to obstruct the Federal advance at the communications hub of Sabine Crossroads. There a battle broke out in late afternoon, and it ended in a rout of the Union forces. Banks withdrew to a defensive line at Pleasant Hill, where his troops decisively repulsed a full-scale assault by Taylor on the 9th. With the Southern troops now in disarray, Banks had the upper hand, but in light of Steele's failure in Arkansas, the unnerved Federal general decided to pull back. The Red River Campaign was now in retreat, but that would also prove to be a difficult proposition.

As the Union forces withdrew, they were

steadily harassed by the enemy on both land and water. One of the ironclads, struck by a mine, had to be destroyed. The Federals began to arrive in Alexandria on April 25, relatively intact but in serious danger. The Red River was now so low that a number of ships were marooned above the rapids near town. On the 26th Southern artillery hit the gunboat *Cricket* with 19 shells; the ship lost 31 of her 50-man crew before the others escaped. Two Federal pumpboats were also destroyed; one, the *Champion*, exploded from a hit in the boiler and some 200 black crewmen – runaway slaves – died in the scalding steam. It seemed that Porter's massive fleet had become a collection of sitting ducks. Then Union Lieutenant Colonel Joseph Bailey stepped in with an extraordinarily imaginative scheme to free the fleet.

Bailey used an old lumberjack trick to raise the Red River: a series of wooden dams with gates that could be swung open in the middle to spill water and boats down the river. At the end of April, under fire, the troops began to build these wing dams and then wait for the water to rise behind them. From the first to the eighth of May Confederate depredations came down heavily on the Federals, destroying five Union boats. Finally, on May 9, the first Union ship spilled through a gate; the rest of the surviving fleet would follow over the next few days. Banks continued his retreat with constant skirmishing. Bailey produced one more engineering feat in the middle of May, using steamers to create a 600-yard bridge across the Atchafalaya River, over which the Federal wagon train and troops crossed. By May 26th the expedition had at last reached comparative safety in Donaldsonville, Louisiana.

The Red River Campaign turned out an unmitigated disaster. The Mobile Campaign had to be aborted, Smith's command never made it back to rejoin Sherman, and Southern troops were thereafter available to reinforce Sherman's opponent, Joseph Johnston, in Georgia during Sherman's Atlanta

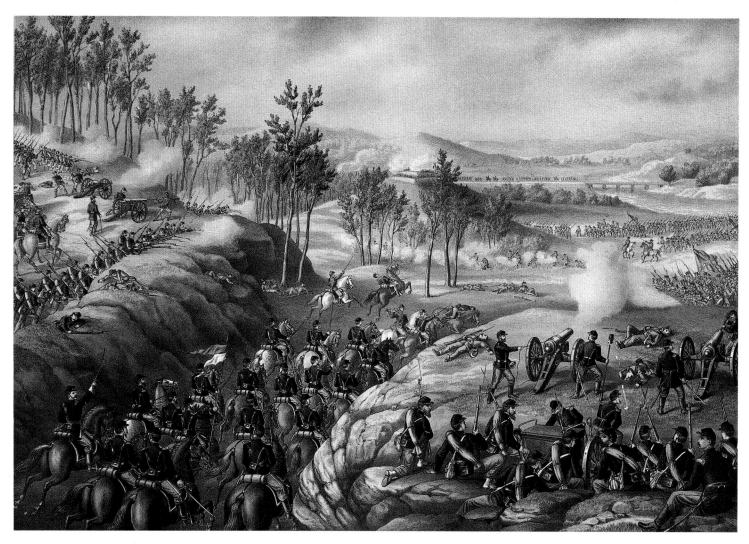

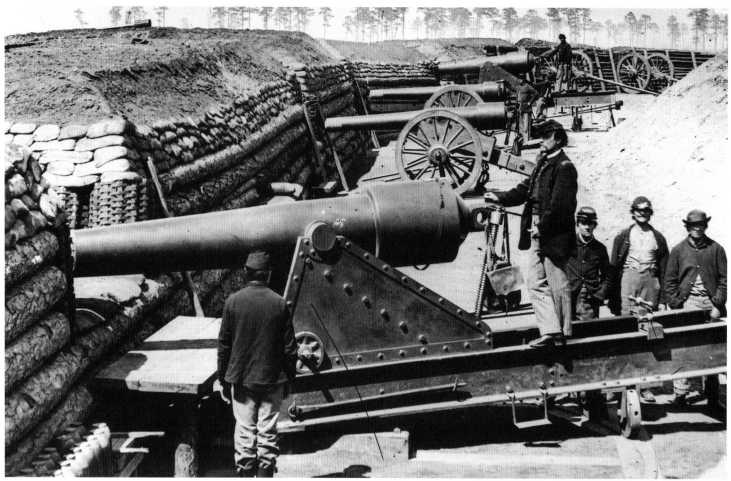

Campaign. It would be Banks's last field command; he also had to undergo a Congressional investigation and official censure. To be sure, the current of the war was now running inexorably against the South, but this ill-advised campaign had made no contribution to the Union's success.

Reed Projectile

Similar to the projectile fired from the Parrott Gun, it was named after the Alabama doctor who developed it in the late 1850s. It was widely used in the Confederate service.

Regular Army

The United States Army in 1861 consisted of 1080 officers on active service and approximately 15,000 enlisted men, most of them in scattered garrisons on the frontier. Only a handful of private soldiers deserted on the outbreak of war, but nearly a third of the the regular army officers resigned to join the Confederate service.

Remington Carbine

Developed in 1863 and in service late in the war, this single-shot weapon fired a .50-caliber Spencer (*See*) cartridge.

Reno, Marcus Albert *(1835-1889)* Union officer.

An 1857 West Point graduate from Illinois, he served as a cavalry officer and was wounded at Kelly's Ford, Virginia, in March 1863. A court of inquiry would later investigate his conduct during George Armstrong Custer's defeat by the Sioux in 1876.

Republican Party

The Kansas-Nebraska Act of 1854 was a catalyst for the formation of this party, which drew Free-Soil and antislavery adherents into its membership. Republicans steadily gained strength through the 1856 and 1858 elections, finally electing Lincoln president in 1860 and 1864. Anti-Southern Radicals dominated the party after Lincoln's death. By the time the Republicans lost the White House in the election of 1876, a new, solidly Democratic South had emerged.

Resaca *(Georgia)*, Battle of
(also called Sugar Valley, Oostenaula)

Early in his 1864 Atlanta Campaign, W.T. Sherman struck Joseph Johnston's defenses at Resaca. There was skirmishing on May 13th, then heavy fighting on the following day as Sherman tried unsuccessfully to crack the enemy lines. On the 15th the action was renewed, inconclusively until Johnston discovered that Federals had crossed the Oostenaula River and were moving on his rear, forcing him to withdraw.

Opposite top: The first battle in Sherman's relentless advance on Atlanta began on May 13,1864, at Resaca, Georgia.
Opposite bottom: Revetments of earth, logs, sandbags and gabions protect this battery of big Union Parrott guns.

Revetments

These are walls that support the sides of trenches, gun emplacements, or other fortifications. During the Civil War, they were often made of wire and wooden posts, woven brushwork, or sandbags.

Revolvers

Many varieties of handgun saw service on both sides. The several models of Colt cap-and-ball pistols were probably the most widely used; Federal ordnance officers bought 146,000 of Colt's 1861 .44 caliber Army revolver and his .36 caliber Navy model, which appeared in 1862.

Reynolds, Alexander *(1817-1876)* Confederate general.

A pre-war regular officer (West Point, 1838), he was dismissed in 1855 for discrepancies in his accounts. He was reinstated, then dismissed again in 1861 after he left his post to join the Confederate service. He commanded a brigade at Vicksburg and Chattanooga and during the Atlanta Campaign.

Reynolds, John Fulton *(1820-1863)* Union general.

A Pennsylvanian, he was graduated from West Point in 1841 and fought with distinction in the Mexican War. In July 1862 he was captured at Gaines's Mill during the Seven Days' Battles but was exchanged in time to lead a division at Second Bull Run. As commander of the Army of the Potomac's I Corps he fought at Fredericksburg and Chancellorsville. He was killed on the first day of the Battle of Gettysburg while directing the Union defense to the west of the town. Reynolds enjoyed a very high reputation in the Union army, and many believed that he, rather than George Meade, should have been appointed to replace Joseph Hooker as commander of the Army of the Potomac.

When John Reynolds was killed at Gettysburg the North lost one of its best generals.

Reynolds, Joseph Jones *(1822-1899)* Union general.

An Indiana businessman when the war broke out, this West Point alumnus secured West Virginia for the Union at Cheat Mountain. He led divisions at Hoover's Gap and Chickamauga, was chief of staff of the Cumberland Army at Chattanooga, and, among other commands, led VII and XIX Corps and the Department of Arkansas.

Rhett, Robert Barnwell *(1800-1876)* Confederate politician.

A South Carolina planter and legislator, this 'Father of Secession' was an influential secessionist from the 1850s onward, agitating in South Carolina and helping draft the Confederate constitution. He spent the war years promoting extremist, anti-Davis views in the *Charleston Mercury*.

Rhodes, Elisha Hunt *(1842-1917)*

The son of a sea captain, he left his job as a harness-maker's clerk to enlist in the 2nd Rhode Island Volunteers in June 1861. He was 19. Rhodes kept a detailed and eloquent diary of his war service, in which he saw action at Bull Run, on the Virginia Peninsula, and at Antietam, Fredericksburg, Gettysburg, Petersburg, and Appomattox.

Rice Station, *Virginia*

During the Appomattox Campaign, Confederate General James Longstreet's command reached this place on April 6, 1865, while the balance of the Army of Northern Virginia fought at Sayler's Creek (*See*). Though Longstreet's forces made contact with the enemy, there was little fighting before he withdrew toward Farmville (*See*).

Richardson, Albert Deane *(1833-1869)* War correspondent.

The Massachusetts-born Richardson reported the troubles in Kansas in 1857, accompanied an expedition to Pike's Peak, traveled clandestinely in the South during the secession crisis, and covered the war in Virginia and the West. Captured near Vicksburg, he spent 18 months in a Southern prison before he escaped and walked 400 miles to his freedom. His adventures came to an abrupt and violent end in the office of the New York *Tribune* when he was shot and mortally wounded by a jealous husband.

Richmond *(Kentucky)*, Battle of

Two hastily-assembled Federal brigades under William Nelson were sent to defend this town from General Kirby Smith's invading Confederates (*See* SMITH'S INVASION OF KENTUCKY) in August 1862. In a powerful attack on August 30 Smith's forces routed one of the brigades and sent the second retreating in confusion. The Federals lost 5300 of 6500 engaged, including 4300 missing. Confederate casualties were about 450. Smith would have a few more successes, but his final objective, the capture of Kentucky, would never be realized.

Richmond, *Virginia*

Capital of both Virginia and of the Confederacy, Richmond was the ultimate target of every major Union offensive in the Eastern theater throughout the Civil War. The city finally fell to the Union on April 3, 1865, as a result of the collapse of the Confederate defense of Petersburg.

Richmond Armory and Arsenal

This Virginia facility produced roughly half of all the ordnance supplied to Confederate land forces. In four years of war the arsenal issued more than 300 big guns, 1300 field pieces, 323,000 infantry arms, more than 900,000 rounds of artillery ammunition, and 72,500,000 rounds of small arms ammunition. The totals include work done by contractors, including the Tredegar Iron Works (*See*), also in Richmond.

Rifle

Rifles are single-shot firearms distinguished by grooves cut into the bore, spinning the projectile and giving it a more accurate flight. At the beginning of the war military inventories included both old flintlock and the newer percussion rifles. The war stimulated the emergence of breech-loading rifles like those designed by Sharps, Smith, Maynard, and Burnside and of repeating rifles: the Spencer and Henry (later called the Winchester) were developed during these years. (*See* also US REGULATION SHOULDER ARMS).

Rifle Pits

Soldiers dug these shallow holes on the battlefield to give themselves minimal protection from enemy fire. In later American wars they were called fox holes.

This line of Union rifle pits is so closely spaced that it forms a semi-trench.

Robertson, Jerome Bonaparte
(1815-1891) **Confederate general.**

A Texas doctor, public official, and Indian fighter, Robertson led Texans in the Seven Days' Battles, Second Bull Run, Boonsboro Gap, Fredericksburg, Gettysburg, and Chickamauga, suffering three wounds in 40 battles. A mediocre general, he was twice relieved of his brigade command; he eventually led the Texas reserves.

Robinson, John Cleveland
(1817-1897) **Union general.**

A New Yorker, this career officer led troops continuously and gallantly in the Potomac Army's operations from the Peninsula through Spotsylvania, where he lost a leg and left field service. His valiant stand at Gettysburg is commemorated by a statue on that battlefield.

Rock Island Prison

This Federal prison, on an island on the Mississippi between Rock Island, Illinois, and Davenport, Iowa, opened in December 1863. It held as many as 8000 Confederate soldiers who lived in 84 poorly heated barracks.

'Rock of Chickamauga'

Union General George H. Thomas earned this nickname for his XIV Corps' stubborn stand on the left wing at Chickamauga in September 1863 while the rest of William Rosecrans' Federal army was giving way before the Confederate advance. Thomas's soldiers had another nickname for him: Pap.

Rocky Face Ridge, *Georgia*

Opening his 1864 Atlanta Campaign, Federal General William T. Sherman ordered a series of actions to dislodge his opponent, Joseph Johnston, from strong positions at Rocky

Legend wrongly credits author Edmund Ruffin with firing the Civil War's first shot.

Face Ridge. Individual engagements were called Tunnel Hill, Mill Creek Gap, Buzzard Roost, Snake Creek Gap, and Varnell's Station, as well as an unnamed action near Dalton. These efforts failed in their attempt to cut Johnston's line of retreat, but they did force him to withdraw from Dalton.

Rodman Guns

Guns of this type were manufactured by casting iron cast around a water- or air-chilled core. This left the metal stronger and more capable of standing the pressure of repeated firing. The method, named after T.J. Rodman, who developed it, was used mainly for large-caliber smoothbores such as the Columbiad (*See*).

Romney Campaign

Stonewall Jackson's forces left Winchester, Virginia, in early January 1862 to attack the Baltimore & Ohio Railroad and locks on the Chesapeake & Ohio Canal. Federal forces moved down from Maryland to protect these communications lines; they met in a series of skirmishes in what is sometimes called the Romney Campaign.

Rosecrans, William Starke
(1819-1898) **Union general.**

This Ohio-born West Point alumnus (1842) and professor resigned from the army in 1854 to pursue various business interests. He joined George McClellan's staff in April 1861 and soon assumed a Western Virginia command, winning an early victory at Rich Mountain and helping bring West Virginia to statehood. Succeeding John Pope in June

1862, 'Old Rosy' led the Mississippi Army at Iuka and Corinth and then led the Cumberland Army through Stone's River (for which he received the Thanks of Congress) and the Tullahoma Campaign. A mistake in an order to the front at Chickamauga cost the Federals the battle and Rosecrans his command; he saw no further significant action. Rosecrans was nevertheless a gifted strategist.

Rosser, Thomas (1836-1910)
Confederate general.

He quit West Point after Fort Sumter and fought at First Bull Run. After the Peninsular Campaign, in which he was wounded, he was named to command the 5th Virginia Cavalry, which he led at Second Bull Run, Chancellorsville, and Gettysburg. As a brigade commander, Rosser clashed in the Shenandoah and during the Appomattox Campaign with Union forces led by his friend George A. Custer. Rosser was adept at raiding, and a series of three raids he led into West Virginia – January 1864, November 1864, and January 1865 – is remembered as 'Rosser's Raids.'

Round Top

The hill at the extreme southern end of the Union position at the Battle of Gettysburg.

Rousseau, Lovell Harrison (1818-1869) Union general.

A lawyer and legislator in Indiana and then Kentucky, this Unionist held commands in the Armies of the Ohio and the Cumberland, figuring prominently at Shiloh, Perryville, and Chickamauga. From November 1863 to July 1865 Rousseau commanded the District of Nashville.

But for his defeat at Chickamauga, Federal General William Rosecrans would probably be remembered as an outstanding commander.

Ruffin, Edmund (1794-1865)
Secessionist.

This Virginian, an agriculturist, author, and early secessionist, joined the Palmetto Guard before the attack on Fort Sumter, where some sources erroneously state he fired the first shot. Too old for field service, Ruffin shuttled between his plantations and Charleston until June 1865, when, distraught after the surrender, he committed suicide.

Ruggles, Daniel (1810-1897)
Confederate general.

A Massachusetts-born career officer trained at West Point, Ruggles joined the Confederate army in 1861 and served along the Potomac and at New Orleans; he fought at Shiloh and commanded the Department of the Mississippi. In 1865 he was commissary general of prisoners.

Russell, David Allen (1820-1864)
Union general.

A West Point-trained frontier veteran, this New Yorker led the 7th Massachusetts in the Peninsula, at South Mountain, and at Antietam. As a brigadier general he subsequently commanded troops at Fredericksburg, Gettysburg, Rappahannock Bridge, the Wilderness and Petersburg. After joining Philip Sheridan in the latter's Shenandoah Valley Campaign he was killed at the Battle of Winchester in September 1864.

Russell, Sir William Howard (1820-1907) War correspondent.

An English war correspondent famous for his Crimean War dispatches, he covered the Civil War for the pro-Confederate London *Times* in 1861-62. Russell's account of the Federal rout at First Bull Run made him unpopular in the North, but in fact Russell soon became a Union sympathizer.

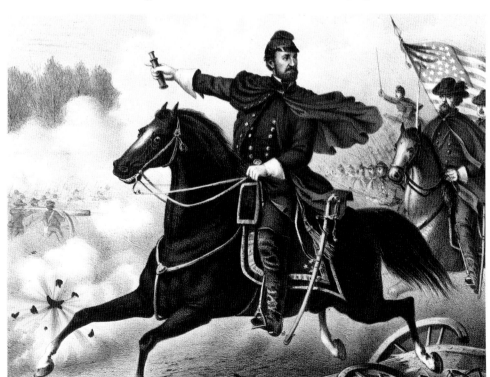

Sabine Crossroads (Louisiana), Battle of (or Mansfield)

As part of his 1864 Red River Campaign, Nathaniel Banks's Federal ground forces had reached Sabine Crossroads, near Mansfield, Louisiana, on April 8; there they ran into Richard Taylor's defensive lines, involving nearly 9000 troops. In the late afternoon Taylor moved forward, crumpling both Federal flanks. Fighting ended with the Union line retreating under pursuit to Pleasant Hill, where Taylor was repulsed the next day. The crossroads would be Banks's farthest point of advance in the ill-fated campaign.

Sabine Pass, Texas

A combined land-sea Federal assault failed here on September 8, 1863. When Confederate fire from land batteries disabled two of the Union gunboats (they eventually surrendered), William B. Franklin, the Federal commander, called off the operation.

St. Albans (Vermont) Raid

On October 19, 1864, a band of Confederate raiders, mostly escaped prisoners of war, crossed the border from Canada into St. Albans, Vermont. Intending to burn the town, they succeeded only in robbing three banks. Eleven who escaped back to Canada were arrested but released, the Canadians disavowing jurisdiction. Such raids forced Lincoln to maintain troops along the border and contributed to tensions among the US, Canada, and Britain.

Salem Church (Virginia), Battle of

During the Battle of Chancellorsville in May 1863 beleaguered Union General Joseph Hooker ordered John Sedgwick to take his VI Corps from its defensive position at Fredericksburg and move on Robert E. Lee's rear at Chancellorsville. Sedgwick started out, making fairly good headway at first, but Lee, taking the risk of dividing his army, sent a powerful 20,000-man force to intercept Sedgwick, which it did on the afternoon of May 3 at Salem Church. By the following morning

Sedgwick was nearly surrounded and was Obliged to retreat northward to Banks's Ford, where he withdrew across the Rappahannock on the night of May 4. Hooker followed him in retreat the next day.

'Salient, The'

See 'BLOODY ANGLE.'

Salisbury Prison, *North Carolina*

The Confederates converted a former cotton factory here into a prison in November 1861. By March 1862 about 1500 Federal soldiers were being held in reasonably good conditions. By late in the war, however, conditions had seriously deteriorated; in the prison it is estimated that more than 3400 Union prisoners died in Salisbury between October 1864 and February 1865.

Salm-Salm, Prince and Princess

Felix Constantin Alexander Johann Nepomuk, Prince Salm-Salm (1828-70), a Prussian veteran, sailed to America in 1861 to fight for the North, serving as aide-de-camp to Louis Blenker, commander of a 'German' division, and fighting with various New York regiments. His wife Agnes (1840-1912), a one-time circus performer, accompanied him in the field, eventually earning a captaincy for her hospital service.

Salomon Brothers

They were Prussian refugees from the 1848 revolution. Carl Eberhard and Frederick Sigel Salomon became Union officers, Frederick rising to the rank of brigadier general. A third brother, Edward S., wartime governor of Wisconsin, was a conspicuously successful military recruiter.

US Sanitary Commission field quarters. The humanitarian work done by the Commission was on a scale unprecedented in US history.

Salt Beef

Standard soldiers' ration, the meat was preserved in such a strong brine solution that it had to be thoroughly soaked in water before it could be eaten. Soldiers also called it salt horse (a term long used by sailors).

Sanitary Commission

Founded in 1861 by Henry Whitney Bellows and William H. Van Buren, the Sanitary Commission was one of the great triumphs of private humanitarian enterprise during the Civil War. It was created to make up for the grievous shortcomings of the Union army's small and inefficient Medical Bureau, and the Commission, along with its impressive women's auxiliary, soon became the largest and most advanced national agency devoted to the care of casualties of war, supplying ambulances and medicines, staffing hospitals with doctors and nurses, inspecting camps, and much else. Among its distinguished commissioners were Cornelius R. Agnew, Alexander D. Burke, Wolcott Gibbs, Elisha Harris, and Frederick Law Olmstead. Its energetic treasurer, George Templeton Strong, raised nearly $5 million for the Commission during the war.

Santa Rosa Island, *Florida*

Confederate General R. H. Anderson led a raid on Union positions on Pensacola Bay on the night of October 8-9, 1861. About 1000 raiders landed undetected and surprised the 6th New York Zouaves in camp, but returned to their boats and withdrew when Federal forces marched out of Fort Pickens (*See*) to counterattack.

Sap Roller

Engineers building a trench toward an enemy's lines would roll this cylindrical device, often made of woven branches and

saplings, ahead of them to provide cover from hostile fire.

Savage's Station and Allen's Farm *(Virginia)*, Battle of
(Also called Peach Orchard)

On the fifth day of the 1862 Seven Days' Battles, June 29, the Army of the Potomac was withdrawing in good order to the southeast. That day at Savage's Station, three miles south of the Chickahominy, Rebel General John Magruder made a weak attack on George McClellan's rear guard, with Stonewall Jackson straggling some distance behind and no use to Magruder.

Sawyer Projectile and Gun

This specialized weapon fired a projectile fitted with six rectangular ribs that matched corresponding grooves in the bore of the gun, thus guaranteeing the projectile's spin.

Sayler's Creek *(Virginia)*, Battle of

Strong Federal forces attacked Richard Ewell's and John Gordon's corps of Robert E. Lee's weakened army here on April 6, 1865, in one of the concluding battles of the Appomattox Campaign. The outnumbered Confederates lost more than 7000 men, perhaps a third of Lee's remaining effective strength. The Federals, under Philip Sheridan and Horatio Wright, reported losses of fewer than 1200 killed or wounded.

Scammon, Eliakim Parker *(1816-1894)* Union general.

Born in Maine, this West Point-trained war veteran and educator was promoted to brigadier general in October 1862 for gallantry at South Mountain. He held commands in West Virginia, Missouri, and the Carolinas, his field service being interrupted by capture in 1864 and imprisonment at Libby Prison.

Schofield, John McAllister *(1831-1906)* Union general.

An 1853 West Point graduate, this successful Federal soldier served in Missouri early in the war and fought at Wilson's Creek (*See*). He commanded the XXIII Corps, Army of the Ohio, during the Atlanta Campaign in 1864, during the Franklin and Nashville Campaign late in 1864, and during Sherman's Carolinas Campaign in early 1865. He was Andrew Johnson's secretary of war in 1868-69 and by 1888 had risen to the command of the US Army. He retired a lieutenant general in 1895.

Schurz, Carl *(1829-1906)* Union general.

He settled in Wisconsin after fleeing his native Germany when the Revolution of 1848 failed. He commanded a division at Second Bull Run, fought at Chancellorsville, Gettysburg, and Chattanooga, ultimately commanding XI Corps in the Army of the Cumberland. He campaigned extensively for Lincoln during the election of 1864. In later

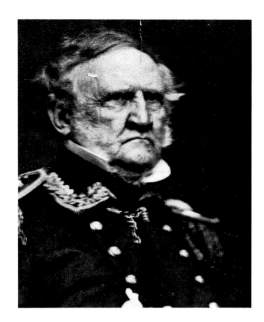

Union General Winfield Scott.

life he became a US Senator and served as secretary of the interior in the administration of Rutherford B. Hayes. As a writer and political and social reformer he continued to hold a position of great influence and respect into the early years of the twentieth century.

Scott, Winfield (1786-1866)
Union general.

Scott, a national hero after the War of 1812 and the Mexican War, had by 1861 served as general-in-chief of the army for 20 years and had become the first American lieutenant general since George Washington. Experienced in diplomacy and public affairs, Scott early foresaw the enormity of the coming war; he unsuccessfully urged President James Buchanan to reinforce Southern forts in 1860, himself raised and trained an army to defend Washington, and devised the strategically-crucial Anaconda Plan (*See*). Of the officers not trained at West Point, this Virginian was the only Southerner who stayed in the Union army. He was too aged and ill to direct the war, however, and retired in November 1861.

Secession, Sequence of

South Carolina became the first state to secede, on December 20, 1860. Following were: Mississippi, January 9, 1861; Alabama, January 11, 1861; Georgia, January 19, 1861; Louisiana, January 26, 1861; Texas, February 1, 1861; Virginia, April 17, 1861; Arkansas, May 6, 1861; North Carolina, May 20, 1861; and Tennessee, June 8, 1861. The Confederate States formed a provisional government in early February 1861.

Secessionville, *South Carolina*

A subordinate Federal commander, H. W. Benham, ignored orders not to undertake offensive operations and sent two divisions against Confederate positions here on James Island in Charleston Harbor on June 16, 1862. The assaults failed, with a loss of nearly 700 men; Benham was relieved of his command in consequence.

Sedgwick, John (1813-1864)
Union general.

This career officer was born in Connecticut and educated at West Point. His men affectionately called him 'Uncle John.' Competent and hard-fighting, he early won recognition in the Peninsular Campaign, where he was wounded. He was wounded again (twice) at Antietam but recovered in time to serve with distinction at Fredericksburg. As a major general commanding VI Corps, he tried unsuccessfully to reinforce Joseph Hooker at Chancellorsville (*See* SALEM CHURCH), and he commanded the Union left wing on the third day of the Battle of Gettysburg. He soldiered on until May 1864, when he was killed by a Rebel sharpshooter at the Battle of Spotsylvania.

Selma Raid

Union General James H. Wilson led three cavalry divisions from Tennessee against Selma, Alabama, one of the last important Confederate military centers, in late March 1865. There Wilson attacked Nathan B. Forrest, who had 2500 cavalry and 2500 militia in strong positions, on April 2. The militia fled, and Forrest's troopers escaped during the night. Wilson went on to capture Montgomery on April 12, then crossed into Georgia. It was in Macon, on April 20, that he learned that the war had ended.

South Carolina's Ordinance of Secession. The first state to secede and the first to fire a shot, South Carolina would be marked out by Sherman for reprisal in 1865.

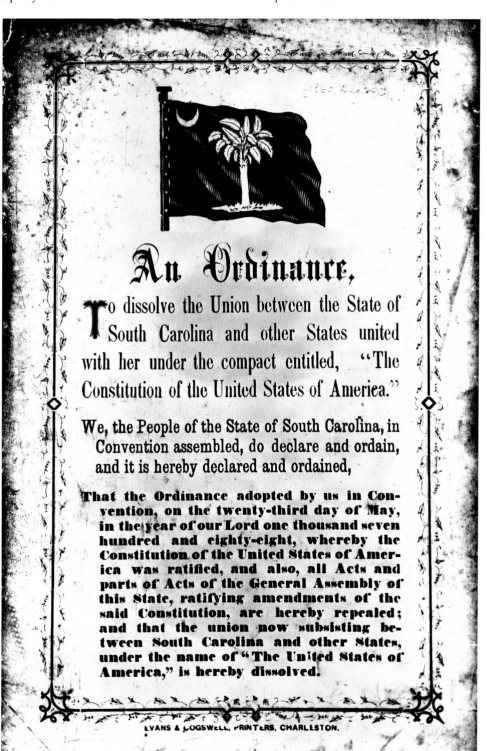

An Ordinance,

To dissolve the Union between the State of South Carolina and other States united with her under the compact entitled, "The Constitution of the United States of America."

We, the People of the State of South Carolina, in Convention assembled, do declare and ordain, and it is hereby declared and ordained,

That the Ordinance adopted by us in Convention, on the twenty-third day of May, in the year of our Lord one thousand seven hundred and eighty-eight, whereby the Constitution of the United States of America was ratified, and also, all Acts and parts of Acts of the General Assembly of this State, ratifying amendments of the said Constitution, are hereby repealed; and that the union now subsisting between South Carolina and other States, under the name of "The United States of America," is hereby dissolved.

EVANS & COGSWELL, PRINTERS, CHARLESTON.

Raphael Semmes, captain of the Confederate commerce raider *Alabama*, in 1864.

Semmes, Raphael *(1809-1877)*
Confederate naval officer.

An Alabama resident, this US naval officer resigned after secession. He became a Confederate hero as a commerce raider in the Atlantic and Indian oceans. As commander of the raiders *Sumter* and *Alabama*, Semmes captured or destroyed a total of 82 Northern merchantmen valued at more than $6 million before being defeated off Cherbourg by the USS *Kearsarge* in June 1864. He later commanded the James River squadron.

Seven Days' Battles

When, in the midst of the Peninsular Campaign, Robert E. Lee took command of the most important of the Confederate armies after the Battle of Fair Oaks on May 31, 1862, he renamed his forces the Army of Northern Virginia. Under that name, Lee and his army

would engineer a remarkable series of victories, usually against superior Union forces, over the next two years. However, Lee's first major engagements during the so-called Seven Days' Battles, did not show the dash and coordination of his later ones, though they did produce the desired effect of driving the enemy from the gates of Richmond.

After the Battle of Fair Oaks, General George B. McClellan and his Federal Army of the Potomac remained along the Chickahominy River near Richmond, most of the men on the south bank, but Fitz-John Porter's V Corps to the north of the river. Thus, as he had done before Fair Oaks, McClellan had left a detachment of his army dangerously unsupported on the opposite bank of the river. On June 12 Lee asked his flamboyant cavalry leader, Jeb Stuart, to scout the enemy's exposed wing. Stuart responded to the order by riding completely around the Army of the Potomac, raiding as he went. He returned to inform Lee of Porter's position and strength. Lee decided to hold the 75,000 Federals on the south bank with a screening force of only 27,000 under John Magruder, and use most of his strength, 60,000 men, in an attempt to annihilate Porter's 30,000. Lee now had the services of Stonewall Jackson, just arrived from his brilliant but exhausting Shenandoah Valley Campaign.

As Lee prepared to attack, the always-cautious McClellan, convinced enemy strength was 200,000, ordered a reconnaissance toward Richmond, in the process touching off the Seven Days' Battles. At Oak Grove, on June 25, McClellan's men ran into some Confederate outposts and a spirited skirmish broke out, producing some 500 casualties on both sides. In the next day's Battle of Mechanicsville, Lee took the initiative, first sending Magruder to make a feint against the much larger Union contingent on the south bank. Jackson was then supposed to strike Porter's flank in force. But throughout this week of fighting Jackson would prove to be uncharacteristically ineffectual, probably due to profound fatigue from his recent campaign in the Shenandoah; several times he would be found asleep in the midst of battle. On the 26th Jackson failed to engage Porter at all. In late afternoon A. P. Hill

ordered his men to attack Porter's well-entrenched forces near Mechanicsville and suffered 1500 casualties to the Union's 360. Despite this easy repulse, that night McClellan decided to retreat, pulling his forces back to a base on the James River and abandoning his plan to besiege Richmond. Though his attacks in the next days would falter, Lee had already gained the initiative.

On the following day, June 27, Lee tried an assault on Porter's new defensive position in the Battle of Gaines's Mill. In heavy fighting, with Jackson again lethargic, Porter was driven back before his line firmed up and the fighting ended inconclusively. That night Porter got most of his men across the river to rejoin the main body, which had been kept in place by Magruder's bluffing with his skimpy forces – marching in circles, making feints, shouting orders to nonexistent troops. So effective was Magruder that McClellan and his generals were convinced they were under attack by superior numbers on both sides of the river. The North had lost some 4000 killed and wounded and 2800 captured that day at Gaines's Mill, but Lee had lost 9000, in what would be one of his most costly days in the entire course of the war.

June 28 saw minor skirmishes at Garnett's and Golding's Farms, west of Richmond. By the next day the Army of the Potomac was withdrawing in good order to the southeast. Over the next three days Lee tried to turn that retreat into a rout, ordering a concentric series of attacks that failed to produce much effect, due to a combination of poor coordination, Jackson's maddening slowness, and strong Federal resistance. At Savage's Station on June 29, three miles south of the Chickahominy, Magruder made a weak attack on McClellan's rear guard, while Jackson straggled behind. The following day, at White Oak Swamp, Union forces pulled together to repulse another uncoordinated attack by James Longstreet and A. P. Hill; in fierce fighting, the Southerners took 1000 prisoners but suffered 3500 casualties. Once again, a seemingly sleepwalking Jackson failed to move his forces into action.

The Seven Days' Battles ended on July 1 with a battlefield disaster for the South. Lee, sensing McClellan's demoralization but failing to sense the ample fighting spirit left in the Army of the Potomac, threw his forces into a withering Union artillery barrage from the heights of Malvern Hill. Few Confederate units even made it within rifle range of the enemy; rarely in the war would artillery play such a commanding role. That day the South suffered 5500 casualties to less that half that for the North.

Lee and his generals had bungled most of the fighting in the Seven Days and had lost 20,000 men, a quarter of the army, to 16,000 for the Army of the Potomac, which was still not seriously damaged. Yet the South won the campaign for the simple reason that General McClellan considered himself defeated and on the brink of disaster; he wired Washington that he had been 'overpowered' by superior enemy numbers and was settling into a defensive position at Harrison's Landing on the James River. Lee had successfully driven the enemy from Richmond; McClellan had come within sight of the capital with immensely superior forces

During the first big encounter of the Seven Days' Battles in 1862 Rebel troops evacuate Mechanicsville, Va., under Union fire.

The June 27, 1862, Battle of Gaines's Mill. Lee won none of the Seven Days' Battles yet, thanks to McClellan, won the campaign.

but then had let himself be maneuvered into retreat while winning nearly every engagement. Assessing the weakness of his command structure during the fighting, Lee banished some ineffective generals and reorganized the Army of Northern Virginia into two large infantry corps under Longstreet and Jackson (correctly seeing Jackson's real potential despite his failures in the Seven Days), plus Stuart's cavalry. In short, Lee emerged from the tactical defeats of the Seven Days with a strategic victory and a command structure that would take him to triumph on the battlefield again and again, until finally, in 1863, the Army of the Potomac would find the generals it needed.

Seven Pines

See FAIR OAKS AND SEVEN PINES

Seward, William Henry
(1801-1872) **Union statesman.**

A strong opponent of slavery in the US Senate, he joined the newly formed Republican Party in 1856. He twice tried and failed to win the party's presidential nomination. Seward was an able secretary of state for Lincoln during the war years, particularly on issues involving Britain, which built warships and provided other aid to the Confederacy. He was seriously wounded in the Lincoln assassination plot, but he continued to serve in his cabinet post throughout the administration of Andrew Johnson. His bargain-price purchase of Alaska from Russia in 1867 was dubbed 'Seward's Folly.'

Seward-Meigs-Porter Affair

Bureaucratic confusion in Washington led to embarrassment on the eve of the war when, in April 1861, the Union was still debating whether to reinforce specific Federal outposts in the South. Secretary of State William Seward, on his own authority, sent the USS *Powhatan*, with naval forces under Lieutenant David Dixon Porter and troops under Captain Montgomery Meigs, to support Fort Pickins on the Gulf coast of Florida. This precipitate action, made at a time when government policy had not yet been decided, resulted in the *Powhatan*'s being unavailable for the relief of Fort Sumter.

Seymour, Truman *(1824-1891)*
Union general.

A Vermonter, Seymour was a professional officer trained at West Point. In a varied war career from Fort Sumter through Sayler's Creek he was seriously wounded at Fort Wagner, suffered defeat at Olustee, and was captured in the Wilderness.

Union cannon pour withering fire on Rebels attacking Malvern Hill on July 1, 1862.

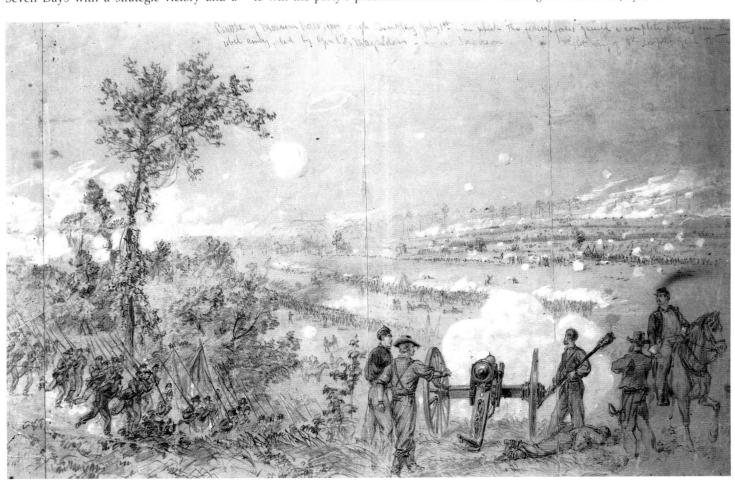

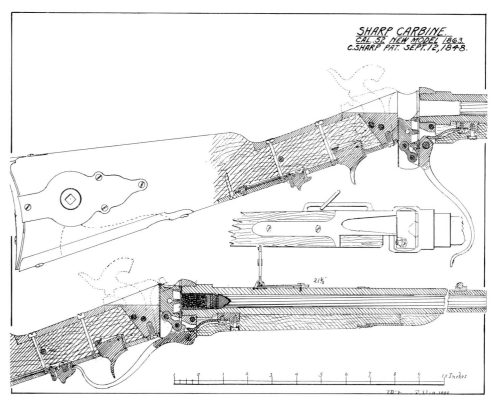

A patent drawing of the action of the Sharps carbine, activated by the trigger guard.

Sharps Carbine and Rifle

The Sharps weapons were the most advanced breechloaders in America when the war began. The Union bought 9100 Sharps rifles and more than 80,000 Sharps carbines during the war. Confederate forces bought small numbers of these weapons. The rifles were used by the US Sharpshooters, while the carbine was mainly a cavalry weapon. Both were single-shot, were accurate up to 600 yards, and could fire at a rate of about 10 rounds per minute.

Sharpsburg, Battle of

See ANTIETAM

Sharpshooters, Regiments of

Union Colonel Hiram Berdan proposed forming units of outstanding riflemen, largely equipped with Sharps rifles, in 1861, and as a result the 1st and 2nd regiments of US Sharpshooters were organized. The 1st Sharpshooters fought on the Peninsula and at Chancellorsville and Gettysburg. The 2nd Sharpshooters' first significant action was at Antietam. Both regiments fought at the Wilderness and Spotsylvania. For the entire war, both units had casualty rates approaching 40 percent.

Shaw, Robert Gould *(1837-1863)*
Union officer.

This Boston abolitionist's son organized and led the Union's first black regiment, the 54th Massachusetts Colored Infantry, which left Boston on May 28, 1863. Shaw was killed amid the heavy Federal losses at Fort Wagner on July 18. As a mark of contempt for this white officer's championing blacks, Confed-erates threw his body into a common burial pit with the bodies of his black troops.

Shelby, Joseph Orville
(1830-1897) **Confederate general.**

'Jo' Shelby, a wealthy Kentuckian, joined the Confederate army as a cavalry captain and fought at Wilson's Creek, Lexington, and Pea Ridge. He later participated in many raids and skirmishes in Arkansas and Missouri. Rather than surrender at the war's end, he led his brigade into Mexico to join Emperor Maximilian's forces.

Shell

The term, casually used to describe any type of artillery projectile, refers specifically to one that contains a bursting powder charge. In the Civil War shells were sometimes ineffective, either because of poor fuses or because the charges were insufficiently powerful to break up and scatter the cast iron casing.

Shenandoah, CSS

The Confederacy purchased this commerce-raiding cruiser in England in September 1864. Fitted out in Madeira under Captain James Waddell, the *Shenandoah* set out for the Pacific, where she captured or destroyed 36 vessels, together valued at $1.4 million, much of this damage being inflicted after the war was over (a fact of which Waddell was unaware). *Shenandoah*'s depredations figured prominently in the *Alabama* Claims (*See*).

Shenandoah Valley Campaign of Jackson

In March 1862 General George B. McClellan began his Peninsular Campaign with the Federal Army of the Potomac, the goal being to capture the Confederate capital at Richmond. Confederate President Jefferson Davis knew that McClellan had the strength to do that unless extraordinary measures were taken (few yet suspected the timidity that would hobble all McClellan's campaigns). Besides organizing forces to protect the capital itself, Robert E. Lee, then an advisor to Davis, ordered a diversionary campaign in Virginia's Shenandoah Valley. This campaign was assigned to General Thomas J. ('Stonewall') Jackson, who was already in the valley with his Stonewall Brigade. The result was one of the legendary operations of military history.

The Shenandoah was critically important to the Confederacy. Its fertile farmland made it the South's breadbasket, and it was also the ideal route for Confederate armies marching north. Because of its strategic importance, the Union had sent forces there under Nathaniel Banks, a politically-appointed general with little battlefield skill. In March 1862 Banks had chased Jackson's men from Winchester and occupied the town, along with nearby Strasburg. From there Banks planned to march east to join McClellan's campaign to take Richmond. Jackson's assignment was to tie up the Federal forces of Banks and General Irvin McDowell and keep them in the Shenandoah, away from McClellan.

Just before being ordered on his diversion, Jackson had suffered a major defeat in the valley. On March 22 he had sent cavalry to attack a detachment of Banks's army at Kernstown; on the next day he sent in his infantry. Initially the attack made progress, but then Banks counterattacked with superior numbers and sent the graycoats running. Jackson lost 700 of 4200 men engaged at Kernston, the Union 590 of 9000. Nonetheless, this defeat turned out to be as good as a victory from the Confederate point of view.

A sketch of T. J. 'Stonewall' Jackson made six months after his Shenandoah Campaign.

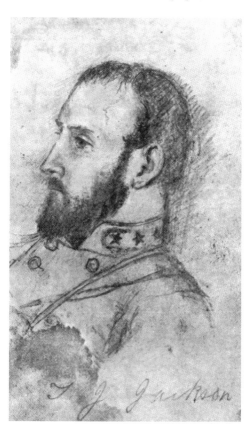

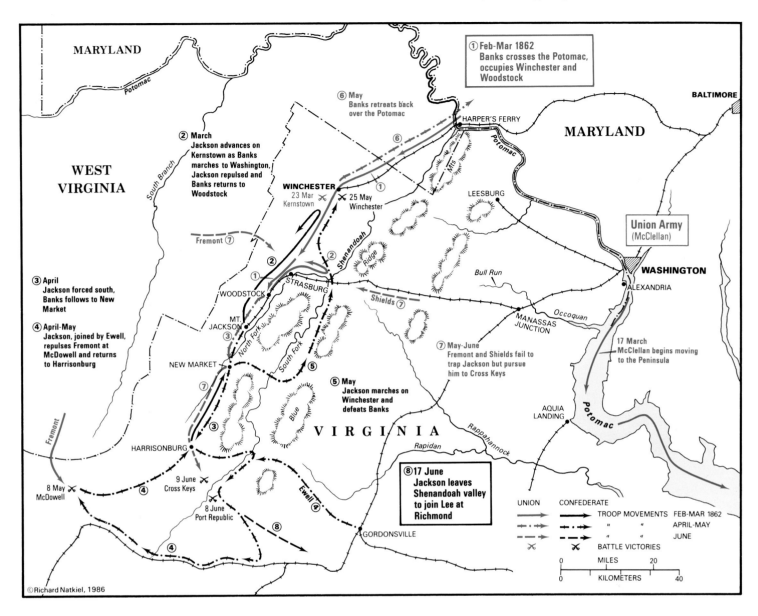

MARYLAND

① Feb-Mar 1862
Banks crosses the Potomac, occupies Winchester and Woodstock

⑥ May
Banks retreats back over the Potomac

BALTIMORE

HARPER'S FERRY

MARYLAND

② March
Jackson advances on Kernstown as Banks marches to Washington, Jackson repulsed and Banks returns to Woodstock

WEST VIRGINIA

LEESBURG

WINCHESTER
23 Mar Kernstown
✕ 25 May Winchester

Union Army (McClellan)

③ April
Jackson forced south, Banks follows to New Market

Fremont ⑦

WOODSTOCK

STRASBURG

Bull Run

WASHINGTON
ALEXANDRIA

Shields ⑦

④ April-May
Jackson, joined by Ewell, repulses Fremont at McDowell and returns to Harrisonburg

MT JACKSON

MANASSAS JUNCTION

Occoquan

17 March
McClellan begins moving to the Peninsula

NEW MARKET

⑦

⑦ May-June
Fremont and Shields fail to trap Jackson but pursue him to Cross Keys

⑤

⑤ May
Jackson marches on Winchester and defeats Banks

AQUIA LANDING

Fremont

③

VIRGINIA

Rappahannock

Rapidan

HARRISONBURG

8 May ✕ McDowell

9 June ✕ Cross Keys

④

④

8 June Port Republic

⑧

Ewell ④

⑧ 17 June
Jackson leaves Shenandoah valley to join Lee at Richmond

UNION CONFEDERATE

TROOP MOVEMENTS FEB-MAR 1862
" " APRIL-MAY
" " JUNE
BATTLE VICTORIES

0 MILES 20
0 KILOMETERS 40

④

GORDONSVILLE

©Richard Natkiel, 1986

That was because in Washington, President Lincoln and his cabinet were shaken by this enemy show of strength in the Shenandoah and immediate reversed the orders for Banks and McDowell to reinforce McClellan. In turn, McClellan became even more cautious and tentative than usual, with fatal consequences for his campaign. Thus, in the end, Jackson's defeat at Kernstown may well have preserved Richmond and prolonged the war by three years. His ensuing diversionary campaign would be marked by an unbroken string of victories.

Washington ordered the separate commands of Banks, McDowell, and, to the west, General John C. Frémont to deal with Jackson. Unfortunately for the Union, none of the three would prove equal to his opponent. With Banks beginning a cautious pursuit and the other Federal contingents advancing, Jackson withdrew south (which was considered *up* the valley) with his 6000 men, developing his strategy as he went. Jackson was a strange, secretive man, shabby in his dress, devoutly religious (he tried not to fight on Sunday), suspected of insanity by his own officers, and a wildcat on the battlefield. Robert E. Lee wrote approvingly of him, 'A man he is of contrasts so complete that he appears on one day a Presbyterian deacon . . . and, the next, a reincarnated Joshua. He

lives by the New Testament and fights by the Old.' The heart of his concept of strategy, Jackson said, was, 'Always mystify, mislead, and surprise the enemy.' His Valley Campaign would be the perfect demonstration of that maxim.

As Banks marched in pursuit, Jackson

Above: A map showing the movements of the armies during Jackson's masterly Shenandoah Valley Campaign of 1862.
Below: A portrait of Jackson superimposed on a scene of his boyhood home. It was the Shenandoah Valley Campaign that first gave rise to the larger-than-life Jackson legend, a legend seemingly confirmed at Chancellorsville.

made a forced march to Swift Run Gap, in the eastern mountains, which placed him on Banks's flank and forced the Northern general to stop and protect his supply line. Meanwhile, Jackson was reinforced by Richard Ewell, bringing his total command to 17,000 men, which would be its maximum strength. His operation went into high gear when Jackson learned that Frémont's force was about to join Banks. That had to be prevented. Ordering some cavalry feints to hold Banks, Jackson took the rest of his men to Staunton, putting out the word that he was retreating (his own men believed so until they reached Staunton). In fact, Jackson was taking a roundabout route to the town of McDowell, to which he went from Staunton by forced march. So fast did his troops march – up to 30 miles a day – that they took to calling themselves 'foot cavalry.'

At McDowell, on May 8, Jackson confronted some 6000 Federals who were on their way to join Frémont. The bluecoats attacked Jackson's force of 10,000, but the Confederates struck back and chased the enemy into West Virginia. Jackson then headed his men for Harrisonburg. At that point, as far as the Northerners were concerned, Jackson disappeared into thin air. On May 23, with his full contingent, he reappeared to strike Union troops at Front Royal; his men captured or killed 904 of the 1063-man garrison.

Learning of the disaster at Front Royal, Banks pulled his men back from Strasburg to high ground at Winchester. Before they could dig in, however, Jackson was on them – after an all-night forced march. Jackson

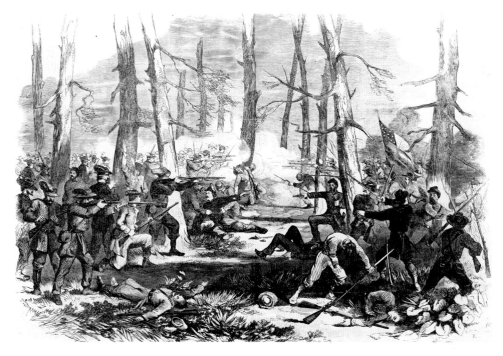

So fast did Jackson's infantry march in the Valley, they called themselves 'foot cavalry'.

attacked the Federals on both flanks and dealt the final blow in the center. Banks then withdrew across the Potomac and out of the Shenandoah for good; he had lost 3000 of the 8000 in his command; Jackson's casualties were about 400 of 16,000. After resting a couple of days, Jackson marched to the northern end of the valley near Harpers Ferry, a feint to convince the enemy he was going to cross the Potomac. There he was threatened by converging forces under Frémont and James Shields (the latter dispatched by McDowell).

Jackson ordered the Stonewall Brigade to prevent Banks from recrossing the Potomac and pulled the rest of his men south on May 30. When his forces were widely scattered, he learned that the two enemy generals were approaching fast. He responded by sending detachments to hold them up, concentrating his forces, and continuing south with 15,000 men and a double wagon train of captured supplies seven miles long. His pursuers could make only weak strikes on Jackson's rear; he had burned all the bridges. Finally, by June 7, Frémont and Shields had caught Jackson squarely between them and began to fire on both Southern flanks. The most remarkable achievement of the campaign followed. On June 8 Frémont advanced from Cross Keys in the west, but Ewell's 6500 graycoats stopped these 10,500 in their tracks. With Frémont kept at bay by a burned bridge and a token force, Jackson on the next day struck Shields, who was somewhat to the east at Port Republic, with nearly his full forces. After putting up stiff resistance, the heavily outnumbered Federals were soundly defeated and driven back.

With some 17,000 men Jackson had bested 33,000 Union troops, outmaneuvering and usually outnumbering his opponents in every engagement; in military terms he had 'defeated the enemy in detail.' Moreover, in one month his men had marched 300 miles, had fought four pitched battles and constant skirmishes, and had captured more than 400 prisoners and enormous quantities of arms and supplies. It had been an historic demonstration of mobile striking power – one that

A skirmish between Jackson's men and Union troops on June 7, 1862. In the next 48 hours Jackson would beat two Union armies in turn.

the Germans would study with profit before World War II. As Jackson marched his men east to rejoin Robert E. Lee in Virginia, the war in the Eastern Theater was firmly under Confederate control. And though Jackson and his men would stumble unaccountably in the coming Seven Days' Battles, this commander had proved his irreplaceable value to the Southern cause.

Shenandoah Valley Campaign of Sheridan

As Ulysses S. Grant began the siege of Petersburg, Virginia, in summer of 1864, General Philip Sheridan and the cavalry of the Army of the Potomac spent weeks making minor raids on Southern rail lines. Meanwhile, Grant became increasingly concerned about the presence in Virginia's Shenandoah Valley of Confederate General Jubal Early, who, both before and again after his Raid on Washington (*See*), had cleared the valley of Union troops. The fertile farms of the Shenandoah thus continued to feed all the Southern armies.

So in August, Grant created the Army of the Shenandoah, 48,000 infantrymen, cavalrymen, and artillerymen, and sent them into the valley under the ambitious and energetic Sheridan. Their immediate objective was to take care of Early and, if possible, raider John Singleton Mosby as well. The larger task, however, would be to wreck farms, burn crops, and confiscate livestock. Grant ordered Sheridan to turn the Shenandoah 'into a barren waste . . . so that crows flying over it for the balance of this season will have to carry their provender with them.' If that could be done, the South and her armies would begin to starve in earnest.

On September 19, pushing into the Shenandoah, Sheridan located Early at Winchester and moved to the attack. Unused to leading a combination of mounted troops and infantry, Sheridan nearly let his slippery

opponent get away, but finally the Confederates were in battered retreat south, with Union cavalry in pursuit. Three days later Sheridan attacked Early again at Fisher's Hill, where the graycoats had dug in strongly. Sheridan hit the enemy flank first and then personally led a frontal attack with his full force. The Confederates were routed again. With Early apparently subdued for the moment, the Federals resumed their progress through the valley, beginning their intended work of destruction. By October 7 Sheridan could report to Grant that his men had 'destroyed over 2000 barns filled with wheat, hay, and farming implements; over seventy mills filled with flour and wheat; have driven in front of the army 4000 head of stock, and have killed and issued to the troops not less than 3000 sheep.'

But his opponent had not given up. Collecting men and supplies for a new offensive, Early set his men to nipping at the heels of the enemy, much to Sheridan's irritation. After dismissing one of his generals for lack of aggressiveness, Sheridan ordered his cavalry commander, Alfred Torbert, to 'Whip the enemy or be whipped yourself!' Taking Sheridan at his word, Torbert and his men proceeded to thrash Early's cavalry at Tom's Brook on October 9.

Again assuming that he had ended the threat from Early, Sheridan went to Washington on October 16 to confer with his superiors. On the way back two days later, he stopped off for the night in Winchester, some 20 miles from where his army was encamped at Cedar Creek, near Middletown. On the following morning Sheridan awoke to the sound of firing in the distance. An orderly told him it was probably skirmishing, so the general did not hurry his preparations. But the shooting continued, and Sheridan mounted his charger Rienzi and took to the road in growing concern, stopping occasionally to put his ear to the ground and listen (the earth could carry the sounds of battle better than air). As he approached Cedar Creek he realized that the firing was approaching him faster than he was approaching it: that could only mean that his army was retreating under pursuit. Now he spurred Rienzi to a gallop.

Riding over the last ridge, Sheridan saw his army coming toward him in full flight, the fields and roads covered by a tangle of men, horses, and wagons. Early had mounted a surprise attack on the left flank of the sleeping Federals at Cedar Hill, and four divisions had bolted out of camp and run for their lives. Sheridan saw numerous officers and men marching in their underwear, but to his satisfaction he noticed that nearly everyone had a rifle in hand. He charged down the road waving his hat, the soldiers beaking into cheers as he rode by. In response, he rose up in his saddle and shouted in his usual profane style, 'God damn you, don't cheer me! If you love your country, come up to the front. There's lots of fight in you men yet!'

Word of his return spread out through the scattered army, electrifying the troops. A participant later wrote, 'Such a scene as his presence and such emotion as it awoke cannot be realized but once in a century.' Many of the veterans had stopped to brew coffee along the road while they waited for orders,

A half-finished sketch of Federal General Philip Sheridan on his famous ride.

and the cavalry and VI Corps had not scattered. As Sheridan rode by, men began to kick over their coffeepots, pick up their rifles, and head back to the front.

Sheridan's ride to Cedar Creek would be one of the legendary moments of the war,

Sheridan's Union troops move relentlessly up the Shenandoah Valley in the winter of 1864. They would conquer it all by March 1865.

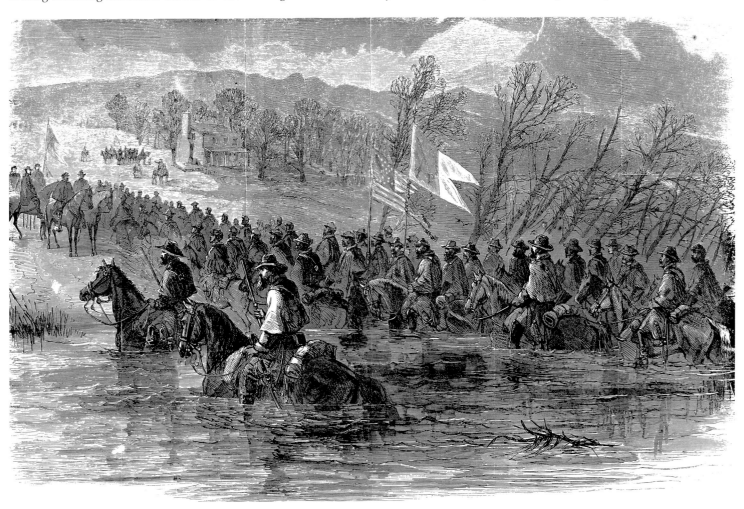

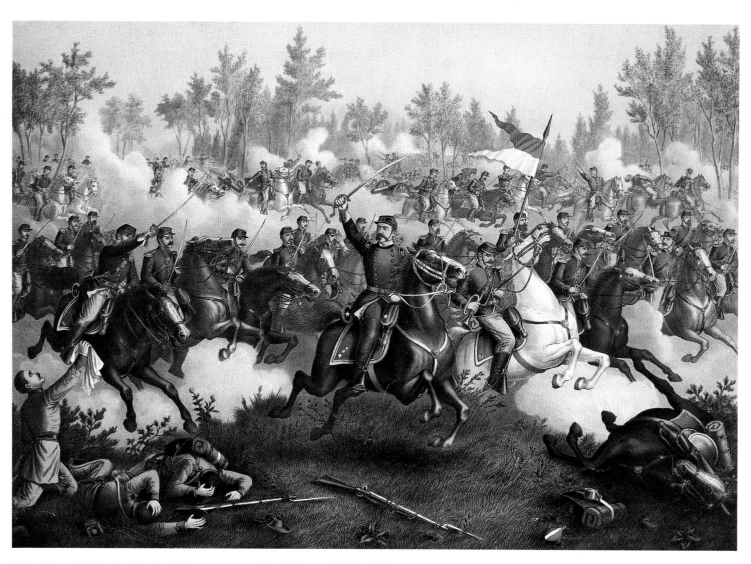

Union General Philip Sheridan leads his men to victory over Jubal Early's Confederates at Cedar Creek, Va., on October 19, 1864.

material for poetry and song, but it was not a matter of riding down the road and creating an immediate charge. It took some two hours of painstaking work before the army was rounded up and formed into line of battle. Many of Early's men, meanwhile, had stopped at the captured Yankee camps to sample the abundant food and liquor. When his troops were ready to attack, Sheridan rode down the battle line waving a banner and shouting, 'We've got the goddamndest twist on them you ever saw!' The Federals swept out to the attack; in short order the surprised and disorganized Confederates were running for their lives, losing a thousand men who were taken prisoner and most of their artillery and their supplies.

The Battle of Cedar Creek finally ended Jubal Early's power in the Shenandoah. In early March of 1865 George A. Custer's cavalry wiped out the remains of the Confederate forces in the valley at Waynesboro; Early and two officers escaped with only 20 men. By that time Sheridan had completed the sacking of the valley, destroying or confiscating its farms, crops, animals, mills, powder works, barns, tanneries, and railroads. He had failed only in rounding up Mosby. Then Sheridan and his men headed back to join Grant in the final acts of the war, at Petersburg and Appomattox.

Sheridan, Philip Henry
(1831-1888) Union general.

After an undistinguished education at West Point and undistinguished service in Texas and the Northwest, New York State-born Sheridan began the Civil War in desk jobs. However, when the short and feisty Sheridan was given combat duty his career sky-

rocketed, one of his early commanders describing him as 'worth his weight in gold.' His immense energy and fierce fighting spirit would take him to the command of the Army of the Potomac's cavalry, a post in which he

An heroic version of Sheridan, astride his horse Rienzi, rallying his retreating men before the Battle of Cedar Creek.

Sheridan (left) and staff. Wesley Merritt is in the center, George Custer on the right.

would soon become General Ulysses Grant's strong right arm.

His combat career in the Civil War began in May 1862 when he was appointed colonel of the 2nd Michigan cavalry and took part in the Union advance on Corinth, Mississippi, winning the Battle of Booneville over Rebel cavalry in July. He was subsequently made a brigadier general and given a division in the Army of the Ohio. He distinguished himself at the Battle of Perryville in October 1862 and at the Battle of Stone's River in December. In the Chattanooga Campaign of 1863 he played important roles in both the Battle of Chickamauga and the Battle of Missionary Ridge. In April 1864 Grant gave him command of all the cavalry of the Army of the Potomac, and within a month, during the Wilderness Campaign, Sheridan was making a raid on Richmond (May 9-24) that, among other things, produced the Battle of Yellow Tavern, in which the South lost its own premier cavalry leader, J. E. B. Stuart. From August 1864 to early 1865 Sheridan was engaged in his most famous wartime operation, his Shenandoah Valley Campaign. Soon after he had rejoined Grant before Petersburg, his victory at the Battle of Five Forks precipitated the end of the lengthy Petersburg siege. In the aftermath of the fall of Richmond he closely pursued the retreating Army of Northern Virginia, finally forcing Robert E. Lee's surrender at Appomattox Court House.

He held various military commands after the war, mainly in the South and West, and in 1884 he succeeded W. T. Sherman as commander-in-chief of the US Army. Though not quite on a par with such master strategists as Grant and Sherman, he is remembered as a brilliant tactician, a formidable warrior, and by far the greatest cavalry commander produced by the Union during the war.

Sheridan's Ride

See SHENANDOAH VALLEY CAMPAIGN OF SHERIDAN

Sherman, William Tecumseh (1820-1891) Union general.

Sherman ended the war with two distinct reputations: in the North, as one of the most admired generals, in the South, as the most hated enemy of all. He was born on February 8, 1820, in Lancaster, Ohio, and, orphaned, was largely reared by a family friend, a prominent state politician. He was graduated from West Point and first saw action in the Mexican War. After the Civil War began he fought as a colonel of infantry in the First Bull Run Battle of July 1861; that August he was promoted to brigadier general and briefly assigned to Kentucky.

Soon thereafter Sherman took over the Department of the Cumberland, but he soon quarreled both with his superiors and with the press, mainly due to his obstinate insistence (entirely correct, as it turned out) that it was going to be a long war that required far more commitments of men and matériel than the North had yet made. In response, the army declared Sherman unstable and removed him from command, at which point he did indeed have some sort of nervous breakdown and considered suicide. By March 1862 he was judged recovered and given command of a division of the Army of the Tennessee under Ulysses S. Grant. There he became the prime partner of the Union's greatest general; their combined leadership would profoundly affect the war.

In the Battle of Shiloh in April 1862 Sherman and his division were instrumental in preventing a total rout after the initial surprise Rebel attack; Grant issued Sherman a commendation. Given command of the District of Memphis, Sherman fought alongside Grant in the long and ultimately triumphant Vicksburg Campaign. When Grant was given command of the Department of the Mississippi, Sherman stepped into his partner's shoes as head of the Department of the Tennessee; together, they directed the breakout of Federal forces in the Chattanooga Campaign. Grant then being elevated to general-in-chief of Union armies, Sherman took over his vacated post once again.

As a vital part of Grant's overall strategy to win the war, articulated in March 1864, Sherman was ordered to begin his Atlanta Campaign. Moving out of Chattanooga in May, he proceeded in a brilliant series of maneuvers against the Confederate forces of Joseph E. Johnston, steadily driving his opponent south. By early September, Southern forces (now under John B. Hood) had been forced out of Atlanta. Sherman moved in and ordered the destruction of all buildings and matériel of potential military importance, turning a good deal of Atlanta into a ruin, streams of refugees pouring from the city. Then, proclaiming 'I will make Georgia howl,' Sherman set out on the campaign that would take him into history – the famous March to the Sea.

In this campaign Sherman followed Grant's lead in the later stages of the Vicksburg Campaign, cutting his army away from supply lines and having his men forage off the enemy countryside, seizing all the food that could be found in his path. This had two primary objectives: it avoided the problem of having to strip his forces to protect a steadily lengthening supply line, and it struck a blow at the spirit of the enemy people, showing that the Confederacy was unable to protect its populace. Though Sherman ordered that there be no looting, destruction of private property, or violation of persons, all those things occurred in the course of what amounted to systematic stealing on a grand scale (there were, however, relatively few atrocities by the standards of later wars). The South, naturally indifferent to the valid mili-

William Tecumseh Sherman, by George Healy. National Portrait Gallery, Washington, DC.

Above: Union General W. T. Sherman reads the terms of surrender to his old adversary, Joseph E. Johnston, in April 1865.
Below: A Union Wisconsin regiment attacks a New Orleans battery on the second day of the Battle of Shiloh, April 7, 1862.

Carolinas, marching his army north with the intention of joining Grant in striking Robert E. Lee at Petersburg. In terms of difficulty this campaign was a far greater challenge than the March to the Sea, it was even harsher in its conduct, and, by putting pressure on Lee, it probably had a greater impact on the outcome of the war; yet for some reason history has chosen to dwell almost exclusively on the Georgia episode. Together, the two campaigns probably did more to break the South's will to fight than anything that had happened previously, and it is at least arguable that in so doing they may have saved a good many thousands of lives.

Lee surrendered in April 1865, while Sherman was still in North Carolina; Johnston surrendered the last major Confederate army to Sherman later in April. The generous surrender terms Sherman offered to Johnston were bitterly criticized and rejected by Washington; Johnston surrendered anyway, under terms similar to Lee's, but Sherman was outraged by the criticism and never forgot it. The affair was one of the main reasons he stayed away from politics after the war (his brother John was a prominent Senator). To admirers who wanted to draft him for the presidency in 1884, Sherman replied succinctly: 'If nominated I will not accept. If elected I will not serve.'

After the war Sherman once again suc-

tary purposes of the campaign, would remember Sherman with a hatred it would feel for no other Northern figure.

After reaching the end of his march at Savannah in December 1864 Sherman, in February 1865, launched a campaign into the

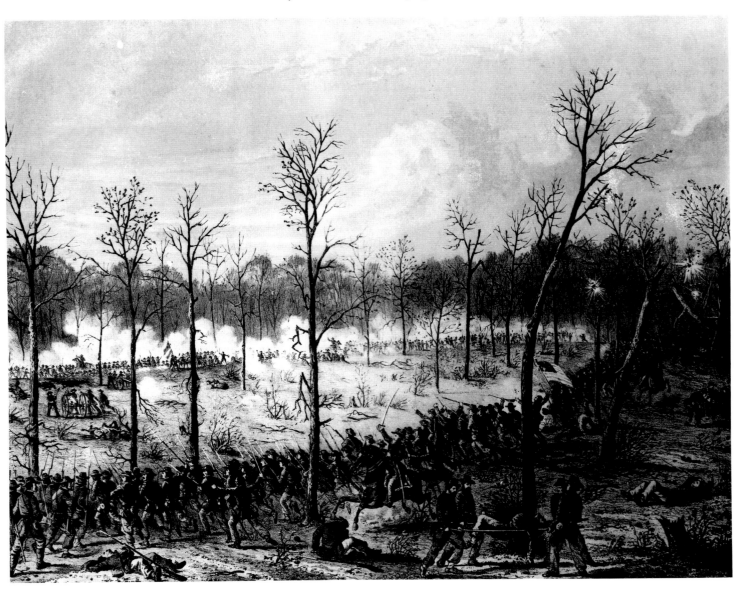

ceeded Grant, in 1869 becoming commander-in-chief of the US Army. He died in New York City on February 14, 1891. One of the many mourners at his funeral was Joseph E. Johnston. Despite the warnings of friends, the old Confederate general insisted on standing bareheaded in a cold rain as Sherman's casket passed. As a result, he contracted penumonia and died soon thereafter. But as Johnston had no doubt rightly said, Sherman would never have remained covered at *his*, Johnston's, funeral.

Throughout his career Sherman rejected any glorification of war; thus his most famous statements: 'War is barbarism; you cannot refine it,' and 'War . . . is all hell.' Whether these were examples of anti-romantic wisdom or means of justifying his own ferociously effective strategy is a question for historians. He has been called the prophet of what came to be called Total War, the practice of waging war on enemy populations as a whole, but whether he would in fact have endorsed such methods as the terror bombing of civilians carried on by most great powers in the twentieth century is by no means certain.

Shiloh, Campaign and Battle

By the middle of 1862 Robert E. Lee and his Army of Northern Virginia were dominating the Eastern theater of the war. In the Western theater, which included most of the Deep South, there were no comparable Southern commanders of major armies. And in the first full year of fighting the linked disciplines of strategy, tactics, and intelligence-gathering had not reached the level they would later attain on both sides. An example of the situation early in the war is the Battle of Shiloh, which set the pattern of Union dominance in the Western theater.

Many in the North, hoping for a quick victory, had not yet realized that, in order to win, the Federal armies had to invade and occupy the South. Washington's first major task toward that end would be to split the Confederacy from north to south by gaining control of the Mississippi River. To this end, and fresh from his celebrated victories at Forts Henry and Donelson, Union General Ulysses S. Grant was preparing for new operations in the South during March 1862. The bulk of his Army of the Mississippi was encamped on the western bank of the Tennessee River near Pittsburg Landing, Tennessee, awaiting reinforcements from Don Carlos Buell's Army of the Ohio.

Meanwhile, in nearby Corinth, Mississippi, Confederate General Albert Sidney Johnston had assembled an army of 40,000 men for the purpose of destroying Grant. Second in command there was General P. G. T. Beauregard. Johnston's plan was to spring a surprise attack, to envelop the Union left flank by the river (cutting off Buell's reinforcements), and then to drive the Federals back against Owl Creek for the kill.

Before dawn on April 6, 1862, Grant left Pittsburg Landing and his 33,000 troops (most of them green) to confer with General Buell in Savannah, Tennessee. Grant and his close subordinate W. T. Sherman knew about the enemy concentration in Corinth and were planning an eventual offensive against it, but Grant was confident that the enemy would not strike him first. He had recently written to Henry Halleck, the new Union general-in-chief, 'I scarcely have the faintest idea of an attack . . . being made on us.'

He was wrong. Soon after Grant left, on April 6, Johnston's attack smashed into the camps of the sleeping Federals, driving many of them toward the river in panic. It appeared that a rout was imminent. But over on the left flank, where Johnston had planned his envelopment, Sherman organized his men to stand their ground and fight back. The surprised Confederates pulled up, thus slowing the whole advance.

Thousands of raw Northern recruits saw their first action and ran that day, yet by mid-morning scattered bands were, on their own, beginning to contest the Confederate onslaught. Johnston allowed his attack to become disorganized – units intermingled, commands became confused, and the intended envelopment became a disorderly piecemeal advance. Meanwhile, Grant had arrived back at Pittsburg Landing and begun to organize his resistance: Lewis Wallace was ordered to rush his 5000 troops down from their position five miles north at Crump's Landing. Buell was urged to hurry, and Union stragglers were rounded up at gunpoint. On the left center a group of 4500 bluecoats under Benjamin Prentiss fought back so fiercely that the Confederates dubbed the area the 'Hornet's Nest.' Grant ordered Prentiss to hold out as long as possible. The initial Southern impetus was finally lost in mid-afternoon, when A.S. Johnston, whom the Confederacy considered one of its finest generals, bled to death after a stray bullet cut an artery in his leg. His replacement, General Beauregard, was ailing.

As the afternoon ended Grant's army re-

The 'Hornet's Nest,' the key to the Union's defense on the first day at Shiloh.

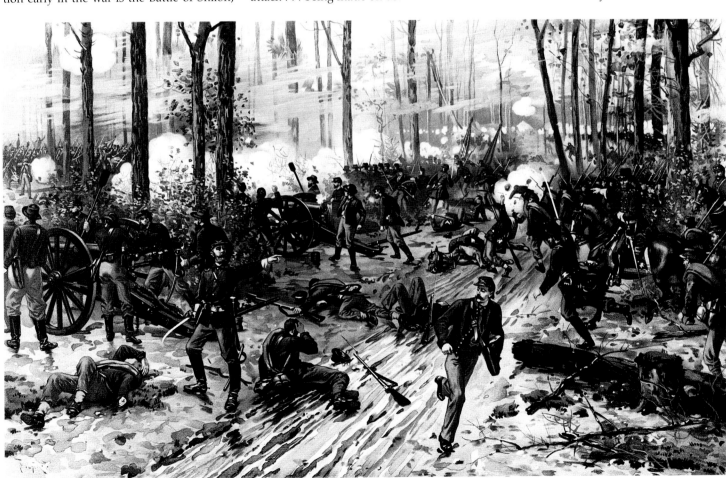

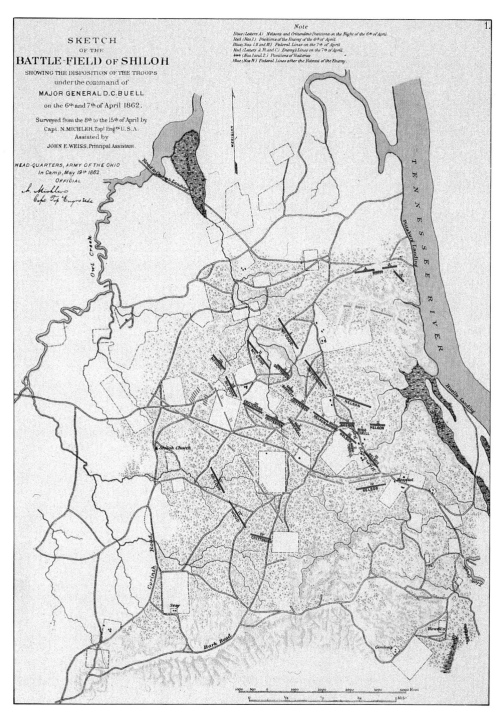

SKETCH
OF THE
BATTLE-FIELD OF SHILOH
SHOWING THE DISPOSITION OF THE TROOPS
under the command of
MAJOR GENERAL D.C.BUELL
on the 6th and 7th of April 1862.

Surveyed from the 8th to the 15th of April by
Capt. N.MICHLER, Top! Eng rs U.S.A.
Assisted by
JOHN E.WEISS, Principal Assistant.

HEAD-QUARTERS, ARMY OF THE OHIO
In Camp, May 19th 1862.
OFFICIAL

A Union map of the Battle of Shiloh.

mained in desperate shape. The left had been driven back almost to Pittsburg Landing, where Buell's reinforcements had yet to come in from across the river. The Hornet's Nest had been overrun after 11 enemy charges; Prentiss finally surrendered in late afternoon. But the effort it took to round up Prentiss's 2200 surviving troops wasted valuable time for the South. By the time the Confederates made their last push of the day Union batteries and two gunboats were in position to slow the advance. At the same time, Buell's reinforcements arrived on the opposite bank and began crossing on boats; not knowing of that, Beauregard called off the fighting at about 6:00 in the evening. The decision probably cost him the battle. That night the Confederates slept in the captured enemy camps, convinced that the next day would cement their victory. All through a rainy and miserable night, however, Grant

was busy organizing his forces, including 25,000 reinforcements from Buell, for a counterattack.

Early on the morning of April 7 Grant unleashed his attack, and by early afternoon his men had recaptured their camps. For a time the Southerners mounted fierce resistance near Beauregard's headquarters at Shiloh Church, which would give the battle its name. But the Confederate commander had only 20,000 troops left fighting, and reinforcements from the west had been halted by high water on the Mississippi. At 2:30 in the afternoon Beauregard gave the order to retreat to Corinth.

The Battle of Shiloh was the bloodiest in the war to that time: 1754 Federals were killed and 8408 wounded of 62,682 engaged; the South lost 1723 killed and 8012 wounded of 40,335 engaged. None of the top commanders had managed his troops particularly well, although Grant had mounted a brilliant counterattack after being surprised

on the first day. On the whole, Shiloh was a 'soldier's battle,' a matter of the courage and resourcefulness of individual leaders and units. And the Union victory proved incomplete, since the Southern forces had escaped (it was more Grant's style in those days to swallow enemy armies whole).

Yet as a result of the Battle of Shiloh the Confederacy would never be as strong in Tennessee as it had been before, and the North was one step closer to conquering the Mississippi River. Though Grant's reputation suffered as a result of his initial surprise, President Lincoln would be quick to perceive this general's value. To demands for Grant's head, Lincoln replied 'I can't spare this man. He fights.' As for Grant and many other Union leaders, Shiloh led them to realize that this was not going to be a quick war; later, Grant wrote that after the Battle of Shiloh he 'gave up all idea of saving the Union except by complete conquest.'

Shoddy

This name for the material used in making Union uniforms at the start of the war soon became a synonym for cheapness. 'Soldiers, on their first day's march or in the earliest storm, found their clothes, overcoats and blankets scattering to the wind in rags, or dissolving into their primitive elements of dust under the pelting rain,' the magazine *Harper's Monthly* reported.

Shot

Unlike the term 'shell,' this refers to a solid artillery projectile that contains no explosive. Shot can be spherical, for use in smoothbore cannon, or oblong, for use in rifled cannon. In the days before delayed-action fuses had been perfected it was often the preferred munition to be used against fortifications and armor plate.

Shrapnel

This hollow projectile was filled with lead bullets. A fuse-detonated explosive charge burst the cast-iron shell and scattered the balls, to deadly effect. It was also, more loosely, called case shot (*See*).

Sibley, Henry Hastings (1811-1891) Union general.

A Michigan-born lawyer and fur trader, he worked for the organization of a Minnesota Territory. He represented it in Washington, and when it became a state (1858), he was elected the first governor of Minnesota. He was commissioned a brigadier general of volunteers in September 1862. He led a brigade against the Sioux in the Indian rebellion of 1862 (*See*). Taking 2000 prisoners, Sibley tried 400 Sioux by court martial and executed 38 of them on December 26, 1862.

Sibley Henry Hopkins (1816-1886) Confederate general.

This Louisiana-born Indian fighter was made commander of the Army of New Mexico early in the war and conducted the South's generally unsuccessful New Mexico and

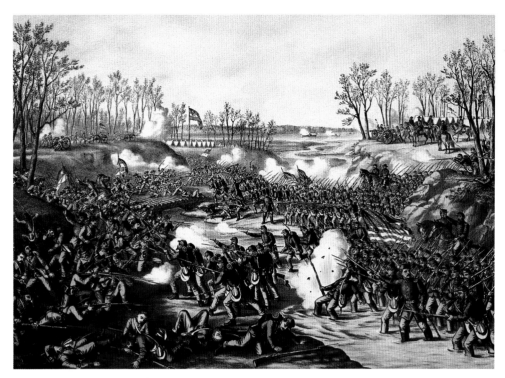

Although Shiloh was a Union victory, that the Rebel attack had taken Grant by surprise was a fact much criticized by his superiors.

Arizona operations (*See*) in 1862. He subsequently led various commands in Louisiana, south of the Red River. He is perhaps best remembered as the inventor of the Sibley tent.

Sibley Tent

This lightweight conical tent could shelter 12 soldiers and their equipment. It was designed before the war by then-Major Henry Hopkins Sibley (*See*).

Sickles, Daniel Edgar *(1825-1914)*
Union general.

A New York lawyer, diplomat, and US Senator, Sickles raised the Excelsior Brigade of New York City and led it in the Peninsular Campaign, at Antietam, and at Fredericksburg; he led III Corps with distinction at Chancellorsville and at Gettysburg, where he advanced his unit ahead of the Union line without authorization, helping to stop the Confederate advance but seeing his troops decimated and losing his leg. He was instrumental in later making Gettysburg battlefield a national park.

Sigel, Franz *(1824-1902)*
Union general.

The German-born Sigel emigrated to the US after the Revolution of 1848. Director of schools in St. Louis at the start of the war, he received a commission as brigadier general of volunteers in May 1861 and fought at Wilson's Creek and, with some distinction, at Pea Ridge. Sigel held a series of senior commands in the Shenandoah, where he suffered a serious defeat at New Market, and in West Virginia before he resigned in May 1865. Though considered a mediocre general, he recruited thousands of German immigrants for the Union forces.

Signal Communications

The Civil War saw many signal 'firsts': the first signal corps, the first air-to-ground telegraph, the first field-telegraph system, and the earliest extensive use of electrical telegraphy. The Union Signal Corps, established on June 21, 1860, was eventually restricted to visual signals, losing a struggle for primacy with the elaborate Military Telegraph System (*See* TELEGRAPHY). The Confederate Signal Corps, which was not established until 1862, developed a comparatively primitive set of communications systems.

Slavery

The causes of the American Civil War were many and complex, but most of them surged around the issue of human slavery, visited on black people in America for two centuries before the war. In 1860 the Southern states of the US were among the last places in the Western world to maintain the institution of slavery. The Dutch had first brought African slaves to America in the early seventeenth century; by the time of the American Revolution, there were half a million slaves in the country, most of them shipped under brutal conditions by the British slave trade. In the South, where three-quarters of the country's slaves lived, they made up 40 per cent of the total population.

The contradiction between American ideals and slavery was too manifest to be ignored forever, though it caused little overt political friction until the second decade of the nineteenth century. In the Declaration of Independence, the second sentence had proclaimed 'all Men are created equal.' America had been the first country in history to erect that principal as the foundation of a state, yet by protecting slavery the US Constitution denied that very principal. The resulting moral (and ultimately political) dilemma troubled the founding fathers; Thomas Jefferson said, 'I tremble for my country' at the thought of what slavery was leading to. Yet Jefferson owned slaves; like most Southern planters, he could not imagine how else to work his land.

Unwittingly, Jefferson provided the ideological basis that extended the life of slavery – his idea of States' Rights. He saw the primacy of state governments as the bastion of democracy. During the nineteenth century, that idea would be taken up by political theorists such as South Carolinian John C. Calhoun and made into the means of protecting slavery: it was a matter for each state to decide, and the federal government had no right to interfere. If the national government passed laws objectionable to a state, that state had the right to nullify them – or to secede from the Union if Federal interference went too far.

The legal tensions aroused by slavery and the nullification doctrine grew steadily during the nineteenth century. Beginning with the Quakers around the time of the Revolution, an abolitionist movement grew up. Congress began to chip away at the institution, starting by abolishing the overseas slave trade in 1808. A series of Congressional compromises – that fully satisfied no one – protected slavery in the South but placed barriers to its spread into new territories. Begin-

Military communications improved steadily during the war. This log platform near the battlefield at Antietam was part of a chain of Union semaphore signal stations.

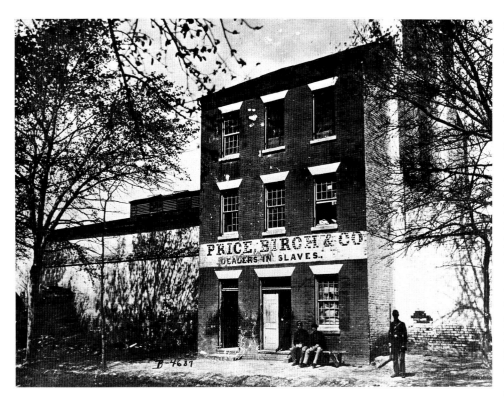

A sense of what Hannah Arendt called 'the banality of evil' pervades this chilling Brady photograph of a slave pen in Alexandria, Va.

ning with Rhode Island in 1774, states north of the Mason-Dixon line had abolished slavery by 1846, and territories north of the Ohio River entered the Union as 'free' states. Meanwhile, the population of slaves in the South increased to over four million by 1860, a third of the population (though less than a third of Southern whites owned slaves). Slaves were considered the indispensable foundation of the region's agrarian economy, which had become firmly based on cotton after the invention of the cotton gin in the early part of the nineteenth century.

Well aware of the economic facts, the South became steadily more defiant in its defense of both its slavery and its culture. Southerners took to calling themselves 'Southrens'; they imagined their society as superior to that of the North, a chivalrous land full of bold cavaliers and elegantly re-fined ladies. As the uncompromising section-alism of the South grew, so did the fury of antislavery sentiment in the North; the fulmi-nations of abolitionists such as Boston minis-ter William Lloyd Garrison became increas-ingly violent. Educated blacks such as Frederick Douglass, who had escaped from slavery, wrote eloquent and heartfelt attacks on the institution. The Underground Rail-road was organized to give slaves a means of escaping north to freedom – a humanitarian effort entirely illegal by existing laws. In 1852 Harriet Beecher Stowe's novel *Uncle Tom's Cabin* electrified the North and outraged the South with its indictment of slavery.

Stowe and others exposed the old South-ern myth that blacks were happy and well-treated under slavery and did not yearn for freedom. In reality, treatment of slaves ranged from mild and paternalistic to cruel and sadistic; but in all cases slaves had no legal means of protesting any treatment whatever. Nor did they have any recourse

when families were broken apart, when owners attempted to breed slaves as if they were livestock, or when whites took slaves as mistresses or simply raped them – as occurred regularly. The latter practices created a large mixed-race population in the country, all of whom, no matter how minute the black ancestry, were considered Negro. Abolitionist literature was replete with stories of women and men being sold into slavery for having one-sixteenth or less of black blood, and these stories were more often than not true.

Uncle Tom's Cabin, or rather, the climate of rising indignation it represented, was part of the web of events that led inexorably toward war. Its publication followed by two years the Fugitive Slave Act, which alarmed abolition-ist forces by mandating stringent penalties, even in the North, for aiding fugitive slaves in the Underground Railroad or otherwise. In 1857 came the Dred Scott Decision by the con-servative Supreme Court; it defined slaves as subhuman property, with no rights of citizenship. In the mid-1850s a virtual war raged in the territory of Kansas between pro- and antislavery factions. And finally and most ominously of all, came the spectre of the South's greatest fear, that of a slave revolt: in October 1859 fanatical abolitionist John Brown led an armed group of blacks and whites to seize the Federal arsenal at Harpers Ferry, Virginia, to realize his dream of ignit-ing a general uprising of slaves. Brown was quickly captured and hanged, but the story of his exploit broke over the entire country like a thunderclap.

By then a new political party had formed, the first one explicitly to oppose slavery. The emerging leader of this Republican Party was an Illinois lawyer named Abraham Lincoln. His election as president in November 1861, precipitated the secession from the United States of most of the slave states in the country, who would thenceforth call them-selves the Confederate States of America. The years of political maneuver and com-promise were now over, and violence would decide the future of slavery.

Slidell, John *(1793-1871)*
Confederate diplomat.

A New Yorker by birth, this New Orleans lawyer was an influential Democratic polit-ician. In 1861 he was captured on a diplomatic mission to seek French recognition for the Confederacy (*See* TRENT AFFAIR), a goal he never achieved. His nephew, Ranald Slidell MacKenzie, was a Union general.

Five generations of slaves on a plantation in Beaufort, South Carolina, pose – or, more probably, are compelled to pose – for a gloomy family portrait.

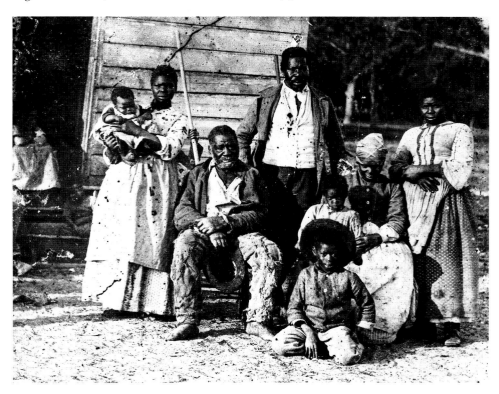

Slocum, Henry Warner
(1827-1894) **Union general.**

A West Point alumnus, he was a New York lawyer and legislator. He commanded a division at First Bull Run, where he was wounded, fought through the Peninsular Campaign, and commanded V, XI, and XII Corps at Fredericksburg, XII Corps at Chancellorsville, and XII Corps at Gettysburg, where he held the Union right wing. In 1864, toward the end of the Atlanta Campaign, he took over XX Corps from Joseph Hooker and then continued to serve under W.T. Sherman during the March to the Sea and the Carolinas Campaign. After the war he resigned his commission and returned once again to the practice of law.

Sloop-of-War

Not a sloop in the modern sense, this was a type of wooden-hulled full-rigged naval ship (*i.e.*, one with three square-rigged masts and a bowsprit) that carried its main battery uncovered on its uppermost deck. Many Civil War sloops-of-war had auxiliary steam power and were sometimes called 'steam sloops' or 'screw sloops.' They were less powerful than frigates (*See*). Although not a term then used in the US Navy, the designation 'corvette' referred to essentially the same type of ship.

Smith, Andrew Jackson
(1815-1897) **Union general.**

A Pennsylvania-born West Pointer (1838), he served on the frontier and in the Mexican War. He led a division during the Vicksburg Campaign and the right wing of XVI Corps during the Red River Campaign of 1864. Smith also led large formations at the Battle of Nashville in December 1864 and in operations around Mobile in 1865.

Confederate General Edmund Kirby Smith.

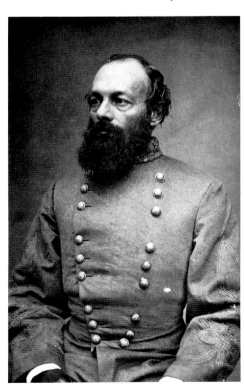

Smith, Edmund Kirby
(1824-1893) **Confederate general.**

A Floridian, Smith was graduated from West Point (1845), participating in the Mexican War and Indian fighting and teaching at the Military Academy before the war. He helped organize the Shenandoah Army before leading a brigade at First Bull Run, where he was wounded. Promoted to major general and commanding the Department of East Tennessee, he led Smith's Invasion of Kentucky (*See*) and fought at Perryville, earning the Thanks of the Confederate Congress. He commanded the Trans-Mississippi Department after February 1863. There he repulsed Nathaniel Banks's Red River Campaign of 1864, led the Arkansas Campaign, and, cut off from the east, effectively governed what became known as 'Kirby Smithdom.' Smith's surrender on June 2, 1865, was the last of the war.

Smith, Gustavus W. *(1822-1896)*
Confederate statesman and general.

A Mexican War veteran, he was street commissioner in New York City when the war began. He joined the Confederate service in 1861 and was secretary of war briefly in November 1862. Smith resigned from the army in 1863 when several generals were promoted over his head. Commanding Georgia militia in 1864, he retreated before W.T. Sherman's March to the Sea. Smith surrendered at Macon, Georgia, in April 1865.

Smith, William ('Extra Billy') *(1796-1887)*
Confederate general and politician.

A Congressman and governor (1846-49) of Virginia, his nickname referred to the extra government payments he received to subsidize his mail-coach service from Washington to Milledgeville, Georgia. He led the 49th Virginia at First Bull Run, in the Peninsular Campaign, and at Antietam. He led a brigade at Gettysburg. He took office a second time as governor of Virginia in January 1864.

Smith, William Farrar *(1824-1903)*
Union general.

Trained at West Point as an engineer, he fought at First Bull Run and led a brigade and then a division during the Peninsular Campaign. He commanded the VI Corps at Fredericksburg in 1862. When the Senate refused to approve his major general's commission, he reverted to divisional command. Sent to the West in 1863, Smith organized Grant's defenses at Chattanooga and helped open the 'Cracker Line' (*See*). Returning east, he led the XVIII Corps in the initial assault on Petersburg in June 1864, but he performed poorly and was relieved in consequence. It was Smith's last command of the war.

The Smith & Wesson .32 caliber Army Model 2, one of the first true cartridge revolvers.

Smith & Wesson Revolvers

These cartridge revolvers were introduced in 1857, but were of too small a caliber to be of much use in combat. The Smith & Wesson 'Number One,' for example, was only .22 caliber, and a direct short-range hit was needed to disable an enemy. The company developed a .32 caliber revolver later in the war, but it, too, saw little service.

Smith's Invasion of Kentucky

In August-September 1862 Confederate forces under Kirby Smith were ordered to march from Knoxville, Tennessee, and drive George Washington Morgan's 8000 Federals from Cumberland Gap. Arriving at Cumberland Gap on August 18, Smith decided that Morgan's main body was too strong to attack; instead, marching to Richmond, Kentucky (*See*), he routed enemy troops on August 30, then occupied Lexington. Smith then planned to join forces with Braxton Bragg during the latter's invasion of Kentucky (*See*).

South Anna River, *Virginia*

Federal forces conducted diversions here during the Gettysburg Campaign in late June 1863 in an effort to force Robert E. Lee to divert forces southward. There was some fighting around bridges over the South Anna, but local forces were adequate to contain the Federals, and Lee did not detach troops from the main army.

Spanish Fort, *Alabama*

Federal forces under Edward Canby besieged this strongpoint near Mobile beginning on March 27, 1865. On April 8, a brigade led by the 8th Iowa pierced a section of the Confederate works, taking 500 prisoners; the rest of the defenders then withdrew into Mobile.

Spencer Repeating Carbine

A Connecticut gunsmith, Christopher M. Spencer, patented this breech-loading repeater, by far the most advanced weapon of its kind, in 1860. By 1864 it had become the standard Federal cavalry weapon. The Spencer weighed 8¼ pounds, was 39 inches long, and carried a seven-cartridge magazine in its stock. After each shot a new cartridge could be fed from the magazine into the

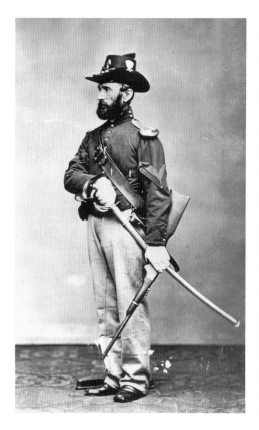

Above: A Union cavalryman poses with his saber and his Spencer repeating carbine.
Below: Confederate and Union troops clash at Laurel Hill during the inconclusive but bloody Battle of Spotsylvania in May 1864.

breech simply by flipping an operating lever that doubled as a trigger guard. By the end of 1865 the government had bought more than 77,000 Spencer carbines.

Spiking Cannon

A gun could be disabled by driving a spike or a large nail into the vent (and/or by wedging a shot into the bottom of the bore). Sometimes a cannon could be unspiked by blowing the obstruction out with a charge of powder.

Spotsylvania, Battle of

Following the Battle of the Wilderness of May 5-6, 1864, General Ulysses S. Grant slipped his Army of the Potomac around the right flank of Robert E. Lee's Army of Northern Virginia and headed toward the Confederate capital of Richmond. Lee, anticipating the move, put his forces on the march to confront the Northerners at a little Virginia road crossing called Spotsylvania Court House. Shooting broke out briefly when the Federals reached Spotsylvania on May 8, but the bluecoats were too tired to mount a serious attack. That night and the next day both armies built strong breastworks. The following two days saw mainly light skirmishing, though on the 10th Lee's troops drove back a somewhat more coordinated enemy move directed against the Southern left.

Lee's lines followed the shape they had fallen into during the fighting on the 8th – a large, irregular crescent. In the middle was a bulging salient the soldiers dubbed the 'mule shoe'; history would remember it as 'Bloody Angle.' On the evening of the 10th young Colonel Emory Upton convinced Grant to let him try a charge on the salient. Grant agreed, and Upton led out a brigade at the run. His spearhead drove through a hail of bullets right over the breastworks, the very center of the Confederate line. Finally, when Southern artillery turned back blue reinforcements, Upton was forced to withdraw. Impressed, Grant decided to send a corps against the salient. The next day Grant sent his famous telegram to Washington: 'I propose to fight it out on this line if it takes all summer.' In the end it would take a good deal more time and blood than anyone could have imagined, given the desperate state of the Confederacy by that summer.

The attack came on the rainy dawn of May 12, when 20,000 bluecoats of Winfield Hancock's II Corps rolled out of the fog and, despite hundreds of casualties, flowed over the breastworks of the salient. Lee, listening at the base of the salient, realized that the center of his line was about to be broken. He found Virginia reserves moving out under James B. Gordon and rode to the head of the column, intending to lead them into battle himself. Immediately he was surrounded by troops shouting, 'General Lee to the rear!' They virtually carried their commander to the rear, horse and all, then moved forward. Their counterattack fell heavily onto the disorganized Federals in the salient, driving them back over the breastworks. Instead of

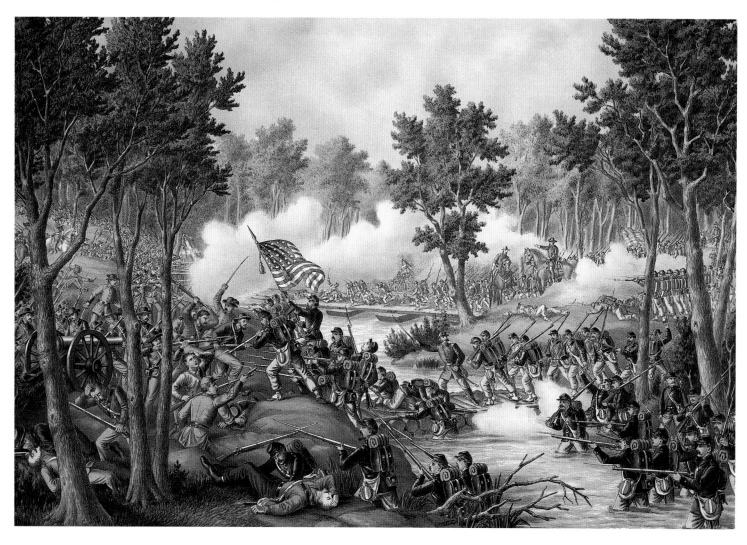

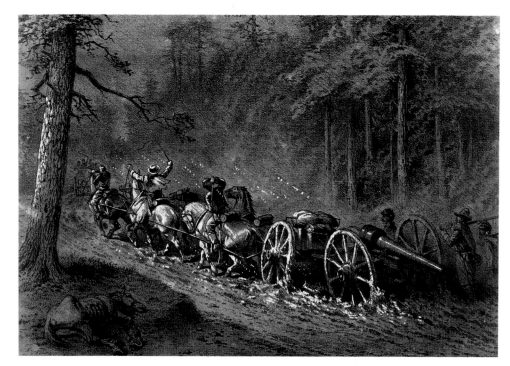

A Union Parrott battery struggles through rain and mud toward Spotsylvania in this engraving by war artist Edwin Forbes.

fleeing, however, the bluecoats turned and fought on the other side of the works. The result, mainly at the Bloody Angle, was a day of fighting as nightmarish as anything ever seen in warfare: a savage hand-to-hand fight in driving rain across the log barricades.

Rank after rank was riddled by shot and shell and by bayonet-thrusts through the works, the dead and wounded trampled into the mud as fresh troops moved up. Cannons were run up close to the parapet, and double charges of cannister were discharged pointblank. The fence-rails and logs in the breastworks were shattered into splinters, and in some places trees over a foot and a half in diameter were cut in two solely by rifle fire. It went on for 18 hours. A Union survivor later wrote, 'I never expect to be fully believed when I tell what I saw of the horrors of Spotsylvania, because I should be loath to believe it myself were the case reversed.'

At 3:00 in the morning the Confederates pulled back to a new line across the base of the salient, and the Union claimed the breastworks and their chest-high heaps of dead and wounded. The Union had suffered 6800 casualties to the South's 5000; once again, the Army of Northern Virginia had survived the full power of the outnumbering Army of the Potomac. Skirmishing and maneuvering continued at Spotsylvania for another seven days. Then, on May 19, Grant once again slipped around Lee's right flank toward Richmond, and once again Lee raced to block the way. They would soon meet again at the Battles of North Anna and Cold Harbor.

Springfield Arsenal, *Massachusetts*

This was the North's main small arms factory. By the end of June 1864 it was producing 300,000 'Springfield' rifles a year. The arsenal manufactured nearly 800,000 rifles from 1861 to 1865.

Stanton, Edwin McMasters *(1814-1869)* Union secretary of war.

Ohio-born Stanton was a US government special counsel and President James Buchanan's attorney general. An outstanding executive, he was Lincoln's secretary of war from January 1862 onward; he efficiently manned, equipped, and reorganized the military, rooted out fraud and corruption, and instituted harsh security measures such as press censorship and arbitrary arrests. Initially opposed to Lincoln, Stanton became one of his most loyal supporters. When, in 1868, President Andrew Johnson dismissed Stanton from his cabinet post in defiance of the Tenure of Office Act, Stanton's Radical Republican colleagues in Congress used the action as an excuse to vote the impeachment of the president, with whom they had long been at odds over Reconstruction policy.

Wary of Lincoln at first, Secretary of War Edwin Stanton came to admire him greatly.

Star of the West

South Carolina troops fired on this unarmed steamer on January 9, 1861, as she attempted to resupply the besieged garrison at Fort Sumter – among the first shots of what would soon become the Civil War. Confederate forces captured the vessel later in 1861 and eventually sank her in the Tallahatchie River in 1863 in an effort to bar the Federals' passage during the Vicksburg Campaign.

Starr Army Percussion Revolver

The US government bought nearly 48,000 examples of this .44 caliber, six-shot revolver during the war. Nearly a foot long and weighing about three pounds, the Starr fired a cartridge but also could be loaded with loose powder and ball.

States' Rights

The debate over the balance between federal and state powers began with the framers of the Constitution. John C. Calhoun used this term to refer to the doctrine of state sovereignty, particularly with regard to regulating slavery, and it became the rallying cry of the Southern states to justify secession.

Steedman, James Blair *(1817-1873)* Union general.

Steedman, an Ohio newspaper editor and legislator, fought at Perryville, Stone's River, and in the Tullahoma Campaign, and later with great gallantry at Chickamauga, where his division provided crucial aid to George Thomas in his defense of the Union left wing. He later commanded the post of Chattanooga, and during the Battle of Nashville he led the District of Etowah.

Steele, Frederick *(1819-1868)* Union general.

A New York-born veteran of the Mexican War, he was a major at the outbreak of the Civil War. He was made a major general in 1862 and served with some distinction in Missouri and, in the following year, under Ulysses Grant at Vicksburg. He led the generally disastrous Arkansas Campaign of 1864 (*See*) and finished the war assisting in the final operations around Mobile.

Stephens, Alexander Hamilton *(1812-1883)* Confederate vice president.

This Georgia lawyer and Congressman, a prominent Unionist, remained a voice of moderation as Jefferson Davis's vice president, working for prisoner exchanges and opposing Davis's centralization of power and the suspension of civil rights. He published a constitutional study of the war (1868-70).

Stevens, Thaddeus *(1792-1868)* Union politician.

A strongly abolitionist Pennsylvania lawyer and Congressman, Stevens was a founder of the Radical Republicans (*See*). As wartime chairman of the House Ways and Means Committee, he controlled military appropria-

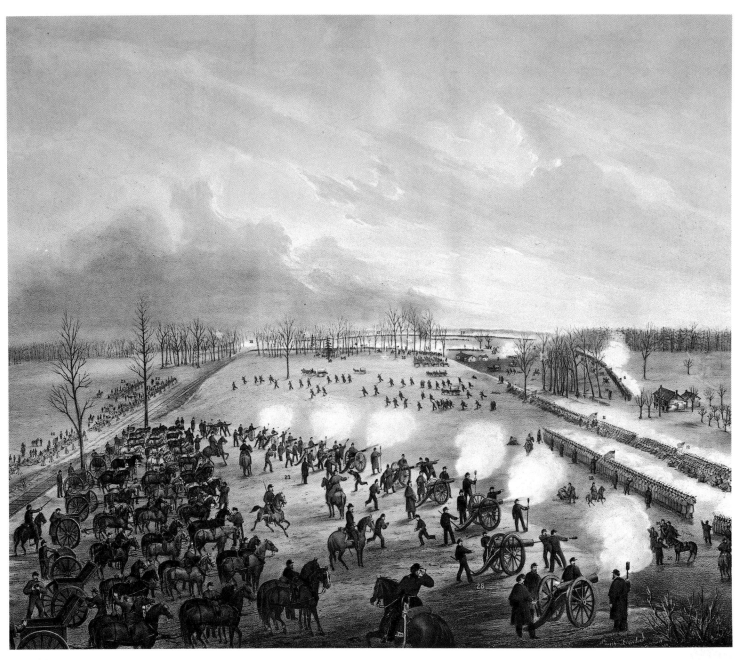

The year 1863, the most decisive of the war, began with the indecisive Battle of Stone's River, near Murfreesborno, Tennessee.

tions, providing the government critical support. He was later instrumental in passing the radical Reconstruction Acts and in the impeachment of President Johnson.

Stevenson, Carter Littlepage (1817-1888) Confederate general.

A Virginian, Stevenson was trained at West Point and was a Mexican War and frontier veteran. After fighting with Braxton Bragg in Tennessee and Kentucky, he commanded Confederate troops in the Vicksburg Campaign, at Chickamauga and Missionary Ridge, and in the Atlanta, Nashville, and Carolinas Campaigns.

Stone Fleets

In a bid to close Southern ports to blockade runners, the US Navy filled small vessels with stones and sank them in harbor entrances. The project failed, however, for the ships' timbers soon rotted and the stones sank in the harbor mud.

Stoneman, George (1822-1894)
Union general.

An 1846 West Point graduate, he had served in the Mexican War and on the frontier. He commanded the Army of the Potomac's cavalry division during the Peninsular Campaign, III Corps at Fredericksburg, and the newly established Cavalry Corps during the Chancellorsville Campaign. Stoneman led W. T. Sherman's cavalry during the Atlanta campaign until he and 700 of his troopers were taken prisoner in what is known as Stoneman's and (Edward) McCook's Raid to Macon. Freed a few months later, he led cavalry strikes in support of the Franklin and Nashville Campaign and throughout the Carolinas Campaign.

Stone's River (Murfreesboro), Battle of

The year 1863, the critical one of the war, began with the costly but inconclusive battle of Stone's River, near Murfreesboro in western Tennessee. The forces involved were the Federal Army of the Cumberland under William S. Rosecrans and the Confederate Army of Tennessee under Braxton Bragg. The latter had just been thwarted in an attempted invasion of Kentucky, but he still controlled Tennessee.

On December 31, 1862, the battle began at dawn when Southerners struck Rosecrans's right wing. Heavy fighting surged back and forth for hours before the Union line was pushed back on the pivot of the left flank. From that point the Federals fought desperately to hold their line against successive Confederate attacks.

The next day saw minor skirmishing. On January 2 graycoats drove Federals from the top of a hill to the north, but in attempting to pursue they were mowed down by blue artillery and forced to withdraw. That ended the battle in a bloody draw: Rosecrans had suffered 12,906 casualties of 41,400 Federals engaged, Bragg, 11,379 of 34,739. The two armies would rest and maneuver for months before meeting again in the autumn at the Battle of Chickamauga.

Stonewall Brigade

Thomas Jonathan Jackson trained and was the first commander of this famous Confederate fighting formation. Both it and its great commander won the sobriquet 'Stonewall' at First Bull Run. It fought in the Shenandoah Valley Campaign of Jackson, at Antietam, at Fredericksburg, at Chancellorsville, at Gettysburg, in the Wilderness, and at Spotsylvania. The original brigade, 4500 strong, consisted of the 2nd, 4th, 5th, 27th, and 33rd Virginia infantry.

Stowe, Harriet Beecher
(1811-1896) **Abolitionist author.**

Her antislavery novel *Uncle Tom's Cabin* (1851-52 – *See*) sold over a million copies in ten years and became a potent abolitionist weapon. Reviled by Southerners, the novel made Stowe an international celebrity, a position she used to raise large sums for the antislavery movement.

Stuart, James Ewell Brown
(1833-1864) **Confederate general.**

Probably only Robert E. Lee and Stonewall Jackson stand higher in the South's pantheon of Civil War heroes than does this lengendary cavalry commander. A Virginian and West Point graduate (1854), 'Jeb' Stuart served in 'Bloody Kansas' and as Lee's aide-de-camp at Harpers Ferry. As colonel of the 1st Virginia Cavalry he fought at First Bull Run and was made a brigadier general soon thereafter. During the Peninsular Campaign he per-

formed the first of his famous 'Rides Around McClellan,' in three days (June 12-15, 1862) leading 1200 troopers in a complete circuit of the Union army, the while raiding and gathering valuable intelligence. In the following month he was given command of all the cavalry of the Army of Northern Virginia. He fought in the Battles of Second Bull Run (before which he made his celebrated Catlett's Station Raid – *See*) and Antietam, and he made his 'Second Ride Around McClellan' in October (*See* CHAMBERSBURG RAID OF STUART). Following the Battle of Fredericksburg in December 1862 he made yet another daring raid on the Army of the Potomac's supply lines (*See* DUMFRIES RAID OF STUART). After Jackson's death at Chancellorsville, Stuart briefly took over II Corps, but he soon returned to cavalry operations in the Gettysburg Campaign, receiving his first major setback at the Battle of Brandy Station and, due to unclear orders, embarking on a long reconnaissance that, though spectacular in itself, kept him from taking part in the crucial Battle of Gettysburg. In 1864 he played an active role in the Battle of the Wilderness, but soon afterward, on May 11, he was fatally wounded in a battle with Philip Sheridan's Union troopers at Yellow Tavern.

Stuart's reputation as the embodiment of the South's romantic ideal of dash and chivalry was already high at the time of his death, and it has grown ever since. He has been called a 'gay knight-errant of the elder time' and the 'flower of cavaliers.' Fortunately, such excesses of adulation have not been sufficient to obscure his very real accomplishments.

The dashing James Ewell Brown (Jeb) Stuart, the South's most famous cavalry leader.

Sturgis, Samuel Davis *(1822-1889)*
Union general.

This Pennsylvania-born veteran, a West Point alumnus, saved Fort Smith, Arkansas, for the Union in April 1861. He held commands in the Armies of the Potomac and the Ohio, drawing criticism for his actions at Wilson's Creek and an investigation for his disastrous loss to Nathan B. Forrest at Brice's Cross Roads.

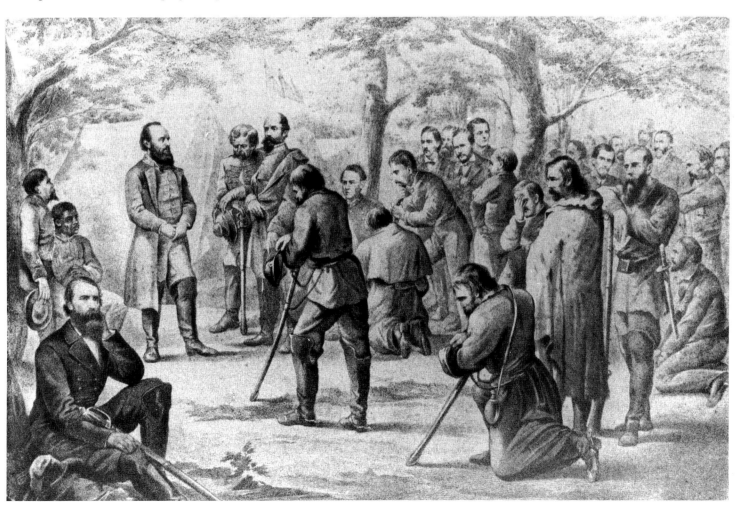

T. J. Jackson leads the Stonewall Brigade in prayer. Seated lower left is A. P. Hill. Second from Jackson's left is R. S. Ewell.

Confederate *David*-type torpedo boats were semi-submersible, making them very difficult targets. They carried an explosive charge or 'torpedo' on a spar mounted on the bow.

Submarines/Submersibles

Experimental submersible vessels in the US dated back to the Revolution, but Confederate attempts to make the idea workable had scant success. At Charleston Harbor in October 1863 the steam-powered semi-submersible *David* damaged a Union warship with a torpedo on a spar – but sank itself in the process. The little hand-cranked experimental sub *Hunley* dove with its crew in several trials before it sank the USS *Housatonic*, as well as itself, in February 1864. In the end, Southern subs proved more dangerous to their crews than to Union shipping.

Suffolk, *Virginia*

With two divisions, Confederate General James Longstreet invested this town, occupied by as many as 25,000 Federals, for a few weeks in April and May 1863. The place proved too strong to take, but Longstreet foraged the surrounding farm districts for much-needed supplies.

Sumner, Charles *(1811-1874)*
Union politician.

Massachusetts Senator Sumner was an uncompromising abolitionist whose uninhibited oratory made him profoundly influential. Narrowly surviving a retaliatory beating on the Senate floor in 1856 after denouncing a South Carolina member, Sumner maintained his staunch advocacy of emancipation and equal rights for blacks throughout the war.

Surratt, John and Mary

A Confederate spy and an alleged conspirator in Lincoln's assassination, John Surrat avoided arrest by fleeing to Canada. He returned to the United States in 1867; his trial ended in a hung jury. His mother, Mary, ran the Washington boardinghouse in which John Wilkes Booth and his conspirators plotted the president's murder. She was tried, convicted, and hanged for her role in the conspiracy in 1865.

Surrender Dates

Robert E. Lee asked for an armistice and surrendered to Ulysses S. Grant at Appomattox on April 9, 1865. J. E. Johnston signed an armistice on April 18, surrendering to W. T. Sherman on April 26. Confederate General Richard Taylor sealed Union victory east of the Mississippi by surrendering to E. R. S. Canby on May 2 (officially, May 4), while the Trans-Mississippi Department was surrendered to Canby by E. Kirby Smith on May 26. In the last significant Confederate surrender, Brigadier General Stand Watie surrendered a Cherokee battalion in the Oklahoma Territory on June 23, 1865.

Swamp Angel

This was the nickname for an 8-inch Parrott gun with which the Federals shelled Charleston, South Carolina, on August 22-23, 1863. The gun, fired from Morris Island at a range of 7900 yards, blew up after the 36th round.

Swinton, William *(1833-1892)*
War correspondent.

The New York *Times* sent Swinton to the front as a special war correspondent. His constant verbal attacks on generals and his underhanded methods of newsgathering – including eavesdropping on a Meade-Grant conference during the 1864 Virginia campaign – finally led the war department to ban him from the field.

Sykes, George *(1822-1880)*
Union general.

A Delaware-born veteran of the Seminole and Mexican Wars, he led a division in the Army of the Potomac's V Corps and, intermittantly, the corps itself, notably at the Battle of Gettysburg. In the autumn of 1864 he commanded the District of South Kansas.

Taliaferro, William Booth *(1822-1898)* **Confederate general.**

This Virginia veteran and legislator served with distinction under Stonewall Jackson in the Shenandoah Valley and led the Stonewall Brigade at Cedar Mountain, Second Bull Run, and Fredericksburg. He later commanded at Fort Wagner and James Island. He surrendered with J.E. Johnston in North Carolina in April 1865.

Taney, Roger Brooke *(1777-1864)*
Chief Justice of the Supreme Court.

Presiding over the Supreme Court from 1836 until his death, Taney ruled on cases that highlighted the growing North-South rift. The most explosive of these was *Dred Scott v. Sandford* (1857 – See), generally regarded as a major cause of the Civil War.

Controversial Chief Justice of the Supreme Court Roger Brook Taney.

Tattnall, Josiah *(1795-1871)*
Confederate commodore.

This Georgian, a career naval officer, directed the Confederate naval defenses of Georgia and South Carolina and then of Virginia, where he commanded CSS *Virginia* (formerly *Merrimac*) after her fight with USS *Monitor,* later ordering her destruction during the evacuation of Norfolk. Tattnall later challenged the Federal blockade and defended the Savannah River until W. T. Sherman took the city in December 1864.

Taxation

Both sides levied taxes to pay for the war. On August 2, 1861, seeking to raise $500 million, Congress authorized tariffs and the first-ever income tax, which was not levied until a revised bill of July 1, 1862, specified a graduated rate of 3 percent to 5 percent. The Southern tax bill of April 24, 1863, called for a graduated income tax and taxes on agricultural products, licenses, food, clothing, and iron.

Taylor, Richard *(1826-1879)*
Confederate general.

Zachary Taylor's son, he was a Louisiana planter and secessionist. He fought in Jackson's Shenandoah Valley Campaign and the Peninsular Campaign, later commanding armies in the Gulf, where he stopped Nathaniel Banks's Red River Campaign of 1864. Taylor surrendered the last Confederate army east of the Mississippi to Edward Canby in May 1865.

Telegraphy

Field and long-distance telegraphy were vital to the Union army. American Telegraph Co. and Western Union constructed the exten-

A Union field telegraph station. Telegraphy revolutionized military communication.

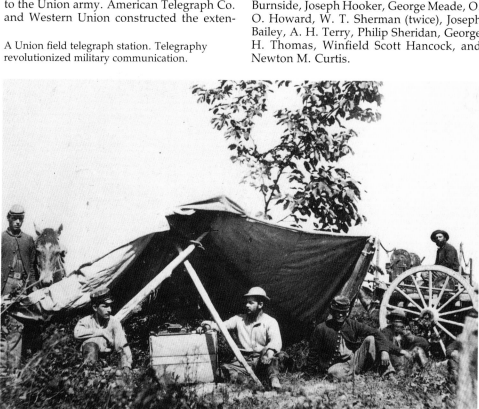

sive Military Telegraph System for the war department. Run by civilians reporting to the secretary of war, this system employed 12,000 civilian telegraphers, laid 15,000 miles of wire, and, by 1862, was handling 3300 messages a day. The semi-independent Confederate telegraph system was much smaller, employing only 1500 workers. (*See also* SIGNAL COMMUNICATIONS.)

Tennessee, CSS

Union forces captured this ironclad ram during the Battle of Mobile Bay on August 5, 1864. The 209-foot vessel, commissioned in Mobile in February 1864, carried six heavy Brooke rifled cannon and was sheathed in armor six inches thick.

Terry, Alfred Howe *(1827-1890)*
Union general.

This Connecticut lawyer served at First Bull Run, led the 7th Connecticut in the Port Royal Expedition, and led a division in the attack on Fort Wagner. He later held James Army corps commands in Virginia and the Carolinas. He received the Thanks of Congress for taking Fort Fisher in January 1865. After the war he won fame as an Indian fighter; George Custer commanded cavalry under Terry in the 1876 campaign against the Sioux in which Custer was killed.

Thanks of Congress

Fifteen Union officers were voted the Thanks of Congress during the war. The first was Nathaniel Lyon, for the victory at Wilson's Creek, Missouri, in December 1861. Others thanked included William Rosecrans, Ulysses Grant, Nathaniel P. Banks, Ambrose Burnside, Joseph Hooker, George Meade, O. O. Howard, W. T. Sherman (twice), Joseph Bailey, A. H. Terry, Philip Sheridan, George H. Thomas, Winfield Scott Hancock, and Newton M. Curtis.

Union General George H. Thomas won fame as 'The Rock of Chickamauga'.

Thayer, Sylvanus *(1785-1872)*
Military engineer and 'Father of the Military Academy.'

A West Point alumnus (1808), Thayer superintended the Academy (1817-33) and engineered east-coast harbor improvements (1833-66). His insistence on excellence and enduring reform of procedures and curriculum at West Point influenced the US Army through generations of graduates.

Thomas, George Henry *(1816-1870)* **Union general.**

A Virginia-born career soldier who elected to serve the Union rather than the Confederacy, Thomas proved to be one of the Civil War's most effective commanders. A West Point graduate (1840), he was a veteran of the Seminole War and the Mexican War. Appointed brigadier general in 1861, he won his first notable victory at the Battle of Logan's Cross Roads in January 1862. He served under Don Carlos Buell at Shiloh, Corinth, and Perryville and commanded XIV Corps at Stone's River. He won national fame as 'The Rock of Chickamauga' for his gallant defense of the Union left wing in that disastrous battle. He played a prominent role in the Battles of Lookout Mountain and Missionary Ridge and led the Army of the Cumberland in W. T. Sherman's Atlanta Campaign. At the end of the Franklin and Nashville Campaigns he all but destroyed John Bell Hood's Army of Tennessee at the Battle of Nashville. He remained in the army after the war, dying while still in command of the Military Division of the Pacific.

Thompson's Station *(Tennessee)*, Battle of

Confederate cavalry under Earl Van Dorn surrounded two Union brigades here on March 4-5, 1863. The Union cavalry escaped the trap, but an infantry brigade and a battery of artillery were forced to surrender. The Federals reported total casualties of about 1700, including 1300 missing.

Todd's Tavern, *Virginia*

Cavalry clashed at this place, which lay about a mile from the southern edge of the Wilderness, during the Wilderness and Spotsylvania Campaigns of May 1864. Union cavalry under James Wilson and David Gregg encountered Thomas Rosser's Confederate cavalry here on May 5. In a skirmish on May 8 Gregg's 2nd Cavalry Division reported 250 casualties and estimated enemy losses at about the same.

Tom's Brook, *Virginia*

Philip Sheridan ordered his cavalry to turn and fight the Confederates here during his Shenandoah Valley Campaign of 1864. On October 9 Union troopers under Alfred Torbert routed the Confederate divisions of Thomas Rosser and L. L. Lomax while Sheridan watched from a nearby hilltop. Federals called the action the 'Woodstock Races.'

Toombs, Robert Augustus (1810-1885)
Confederate statesman and general.

A Georgia planter, lawyer, and politician, Toombs was briefly and unhappily Confederate secretary of state in 1861 before joining the army. Opposed to the South's defensive strategy and denied promotion after Malvern Hill and Antietam, he resigned in March 1863, later serving in the Georgia militia.

Torpedo

These were what are now called land and sea mines. Sea mines could be detonated either by striking the hull of a ship or by an electric current from shore.

US officers remove two CSA commissioners from the British ship *Trent* in 1861.

Townsend, George Alfred (1841-1914) **War correspondent.**

He reported the Seven Days' Battles and Cedar Mountain for the *New York Herald* and became famous for his fine New York *World* coverage of the last battles of the war and Lincoln's assassination. Townsend later erected a monument at South Mountain to 157 Civil War correspondents.

Tragic Era

This was Southerners' term for Reconstruction (*See*), in which federal authority oversaw the restoration of civil government in the Confederacy and the readmission of the defeated states to the Union.

Tredegar Iron Works

This Richmond, Virginia, foundry and machine shop manufactured revolvers and gun carriages before the war, and made cannon, machinery, and ship's armor for the Confederacy after hostilities broke out. The works were just west of the Richmond Armory and Arsenal (*See*).

Trent Affair

On November 8, 1861, the British mail steamer *Trent* was stopped by a Union warship off Havana. Two Confederate commissioners, James Mason and John Slidell, traveling to Europe to seek British and French support for the Confederacy were taken off and held in Boston. While popular with the Northern public, this illegal seizure precipitated an international crisis that threatened war. Secretary of State William Seward, acting on the instructions of an alarmed cabinet, eventually ruled the detention improper, and the commissioners were released into British custody on December 30.

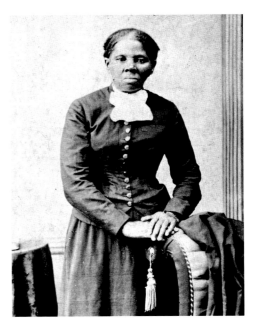

Black abolitionist Harriet Tubman.

Trevilian Raid

Ulysses S. Grant ordered Philip Sheridan to lead a Union cavalry diversion as a cover for Grant's move from Cold Harbor across the James River toward Petersburg in June 1864. Robert E. Lee sent two Confederate cavalry divisions under Wade Hampton and Fitzhugh Lee to shadow Sheridan's command, also two divisions, as it moved north and west of Richmond. The two forces clashed at Trevilian Station on June 11 in a confused and inconclusive battle. On the 12th, Sheridan attacked the now entrenched Confederates and was checked. With Hampton astride his line of advance, Sheridan called off the westward raid and rejoined Grant.

Trimble, Isaac Ridgeway (1802-1888) **Confederate general.**

Raised in Kentucky and educated at West Point, Trimble disrupted Union supplies in 1861 by destroying railroad bridges north of Baltimore. He later constructed batteries along the Potomac and fought in the Peninsular, Second Bull Run, and Gettysburg Campaigns. At Gettysburg he led one of the three divisions in 'Pickett's Charge.'

Tubman, Harriet (*c. 1821-1913*)
Abolitionist.

Born a slave named 'Araminta' in Maryland, she escaped to the North in 1849 and, working in the Underground Railroad (*See*), helped more than 300 slaves to freedom. Tubman nursed Federal soldiers in South Carolina during the war and occasionally spied behind enemy lines.

Tucker, John Randolph (1812-1883)
Confederate naval commander.

The Virginian Tucker, a professional naval officer, directed the James River defenses, commanding the *Patrick Henry* at Hampton Roads. He later attacked the Federal blockade and commanded the squadron at Charleston

and the fleet off Drewry's Bluff. Tucker fought on shore as well, in Robert E. Lee's army at Sayler's Creek.

Tullahoma Campaign

Following the Stone's River Battle at the beginning of 1863 (*See*), Federal General William Rosecrans was ordered to operate against Braxton Bragg's Confederate army, to keep them occupied in Tennessee and unable to send reinforcements elsewhere. With an effective series of maneuvers on June 23-30, Rosecrans feinted at Bragg's left; deceived, Bragg responded, only to find two blue corps behind his right. The Southern commander was forced to pull back to Tullahoma, and soon after to Chattanooga; Chickamauga and the Chattanooga Campaign followed.

Tupelo, *Mississippi*

William Tecumseh Sherman, making an attempt to stop Nathan Bedford Forrest's raids on his supply line during the 1864 Atlanta Campaign, sent some 14,000 men under A.J. Smith to deal with Forrest. The forces met in light skirmishing on July 13 at Tupelo; over the next two days Forrest mounted a series of costly and unsuccessful assaults on the blue line. Despite inflicting over 1300 casualties to his own 700, Smith pulled back on the 15th, leaving Forrest slightly wounded but still at large.

Turchin, John Basil *(1822-1901)*
Union general.

This Russian immigrant, a Crimean War veteran, fought in Missouri, Kentucky, and Alabama, notably at Stone's River, Chickamauga, and Missionary Ridge, before resigning in October 1864. Turchin's wife accom-

The capture of Nat Turner, who, in 1831, led one of the most serious of the slave revolts in the antebellum South.

panied him as a nurse throughout his campaigns, once even leading a Northern regiment into battle.

Turkey Ridge, *Virginia*

Late in the Peninsular Campaign, Confederates attempting to envelop the Federal south flank during the Battle of White Oak Swamp (*See*) attacked here on June 30, 1862. George Sykes's division, supported by Federal gunboats, checked the attempt. There were minor engagements here before and after the Malvern Hill Battle (*See*) of July 1.

Turner, Nat *(1800-1831)*

This slave preacher led a slave uprising in Southampton County, Virginia, in August 1831. Around 55 whites were killed before troops crushed the rebellion. Turner and 16 of his followers were subsequently condemned and put to death.

Twenty Negro Law

Passed on October 11, 1862, this law reflected the Confederates' concern with internal security by exempting owners of twenty slaves – 12 percent of the Southern population – from military service. Conscription, introduced on April 9, 1862, provoked spirited opposition throughout the South; the slaveholders' exemption was especially unpopular with non-slaveholding whites, who viewed it as proof that the conflict was a 'rich man's war and a poor man's fight.'

Twiggs, David *(1790-1862)*
Confederate general.

A War of 1812 veteran, he also fought in the Seminole and Mexican Wars. In February 1861 he surrendered all Union forces in Texas to the Confederates, then resigned and joined the Confederate service. In poor health, he died in July 1862.

Uncle Tom's Cabin

Harriet Beecher Stowe's antislavery novel, published in 1851-2 and popularly dramatized, was enormously influential. Captivated by characters who were to become American icons – Simon Legree, Little Eva, Uncle Tom, and Eliza – millions rallied to the antislavery cause: Lincoln called Stowe the 'little lady' who caused the Civil War.

Underground Railroad

Neither underground nor a railroad, this was a network of individuals who helped slaves to escape from the South to the North and then – since legally they could be returned from the North – often into Canada. Although individual slaves had been escaping over many decades, the term 'under-

Little Eva and Topsy, two of the characters in Harriet Beecher Stowe's influential 1852 antislavery novel *Uncle Tom's Cabin*.

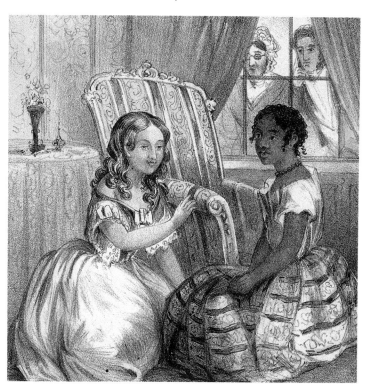

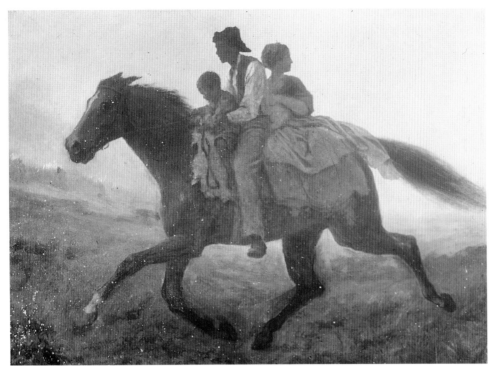

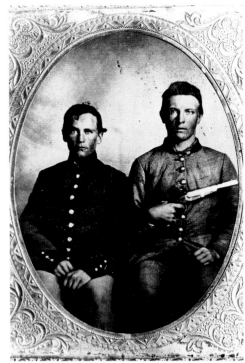

Above: *A Ride for Liberty: Fugitive Slaves*, by
Eastman Johnson.
Above right: Confederate privates' uniforms. Note
the differences in the tone of the colors.
Right: Union officers' uniforms.

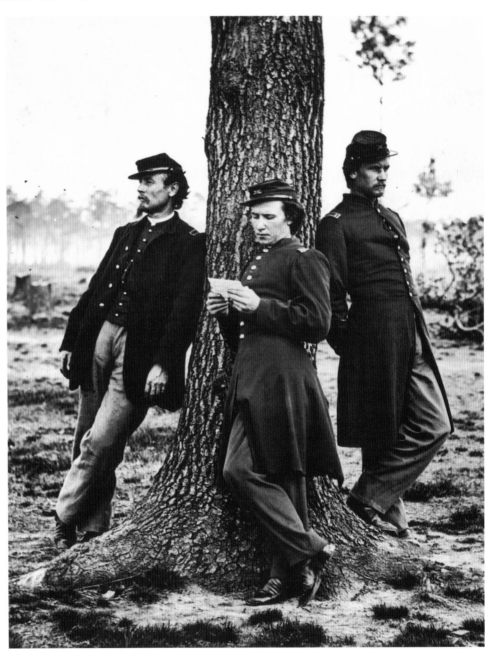

ground railway' and the system itself did not
really come into use until about 1830. Special
well-traveled routes soon developed, much
like railroad lines. Enhancing the image of a
railroad, designated hiding places for escap-
ing slaves were known as 'stations,' and
those who actively guided the runaway
slaves north were known as 'conductors' –
the best known of these being Harriet Tub-
man (*See*). Thousands of slaves escaped this
way between 1830 and 1861, usually traveling
at night and fed and supported by abolition-
ists and others determined to undermine the
institution of slavery.

Uniforms

In the early years of the war soldiers' dress on
both sides was characterized by a random
assortment of styles and colors that were in-
appropriate for field service and confusing on
the battlefield. The Confederates soon pre-
scribed gray uniforms, but because various
dyes were used, the hue sometimes tended
toward brown. In any case, as the war pro-
gressed privation caused CSA uniforms to
become increasingly non-standard. The blue
Union uniform, prescribed early in 1862, was
finally standard issue by winter 1863.

Upperville, *Virginia*

Union pressure drove J. E. B. Stuart's four
Confederate cavalry brigades back toward
Robert E. Lee's army as it was advancing
north toward Gettysburg in June 1863. On
June 21 Union infantry and cavalry attacked
Stuart here. Though one regiment broke
under the pressure, countercharges held off
the Union attackers, and Stuart managed to
withdraw into a strong defensive position in
the vicinity of Ashby's Gap.

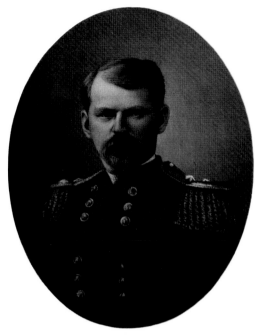

Union General Emory Upton.

Upton, Emory (1839-1881)
Union general.

Commissioned second lieutenant upon his 1861 West Point graduation, this New Yorker earned steady promotions in action with the Army of the Potomac from First Bull Run through Spotsylvania, Cold Harbor, and Petersburg, later fighting at Opequon and in Alabama and Georgia. Several times wounded, Upton was repeatedly breveted.

US Regulation Shoulder Arms

Although many types of shoulder arms were used by both sides in the Civil War, the Union authorities attempted to maintain a degree of standardization by designating certain widely-produced infantry shoulder arms as 'US Regulation' weapons. Such weapons were mainly produced by Federal arsenals, such as those at Harpers Ferry, Virginia, and Springfield, Massachusetts, but in some cases their manufacture was also subcontracted to private firms. Among the principal types of regulation infantry shoulder arms used in the war were the US Model 1855 percussion rifle, the US Model 1861 rifle musket, and the US Model 1863 rifle musket. Of these – all single-shot rifled muzzle-loaders – the Model 1861 was numerically the most important, around 700,000 examples having been produced by the war's end; it used a simple percussion cap mechanism and fired a .58 caliber bullet from a 40-inch barrel.

Utoy Creek (Georgia), Battle of

During his 1864 Atlanta Campaign, W.T. Sherman made a second attempt (the first being at Ezra Chapel – See) to envelop the left flank of his Confederate opponent, John B. Hood. On August 5-6, the forces of John Schofield, George Thomas, and Oliver Howard attacked enemy positions around Utoy Creek, but Hood's lines held firm. At the end of the month Sherman would drive Hood out of Atlanta as the result of Union success in the Jonesboro Battle (See).

Vallandigham, Clement Laird (1820-1871) Politican and lawyer.

He was an Ohio lawyer, journalist, and politician who strenuously opposed the war and tried, as a US Congressman, to obstruct war-related legislation. He was prominent among the Copperheads (See). Lincoln banished him to the South after his conviction for treason by a military commission in 1863. Vallandigham re-entered the North via Canada and campaigned vigorously against Lincoln's re-election in 1864, but his influence on both political parties and on the public at large was waning and would in fact never revive.

Valverde (New Mexico), Battle of

The Confederate Army of New Mexico moved up the Rio Grande in early 1862 (See NEW MEXICO AND ARIZONA OPERATIONS) and challenged the Federal garrison at Valverde under Edward Canby to a battle. After a two-hour action on February 21 the

Lincoln banished Copperhead leader Clement Vallandigham to the South in 1863.

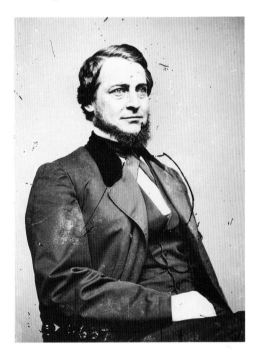

Confederates routed the Federals and captured a battery. Federal casualties were about 260 out of 3800 engaged; Confederate losses were fewer than 200 out of a force of 2600.

Van Dorn, Earl (1820-1863)
Confederate general.

A veteran of the Mexican War and many Indian battles, he commanded the Confederate Department of Texas at the start of the war and captured the Star of the West (See) at Galveston. He later fought at Pea Ridge and at Corinth. On May 8, 1863, he was shot and killed at Spring Hill by a local man who had accused Van Dorn of being involved in an affair with his wife.

Van Lew, Elizabeth L. (1818-1900)
Union spy.

A Virginian educated in Philadelphia, she early opposed slavery. Openly Unionist, Van Lew was the Federals' link with Richmond throughout the war. Besides relief work at Libby Prison, she gathered intelligence and helped Union prisoners to escape.

Velasquez, Loreta Janeta (1842?-1897)
Confederate officer and spy.

Cuban-born and educated in New Orleans, she followed her American husband into the Confederate army by posing as a man. She fought at First Bull Run and Fort Donelson, continuing to fight after her husband's death and spying behind enemy lines.

Veteran Reserve Corps

This organization grew out of an Invalid Corps, formed in April 1863, of wounded or ill Union soldiers who had recovered sufficiently to take on light duties as guards, nurses, and cooks. By September more than 20,000 men were assigned to the corps. The name change came in March 1864.

Vicksburg, Campaign and Siege

Vicksburg, Mississippi, situated on bluffs overlooking the Mississippi River, was one of the two strategically most vital cities of the Confederacy (the other being the rail center of Chattanooga). From the West through Vicksburg poured a stream of food, cotton, and other supplies necessary to keep the South alive and fighting. If that supply line could be cut the Confederacy would begin to wither on the vine; and if the nation's greatest river were in Federal hands a path would be open to the Union to mount an offensive from the West that could effectively cut the Old South in half.

The city became the objective of Ulysses S. Grant in late October 1862, when he took command of the Federal Department of the Tennessee. A week later he set his Army of the Tennessee marching down a railroad line toward Vicksburg. The advance soon ran into trouble – Confederate cavalry destroyed Grant's supply depot at Holly Springs, and Nathan Bedford Forrest's men tore up 50 miles of railroad that the Union army needed for resupply. At around the same time forces

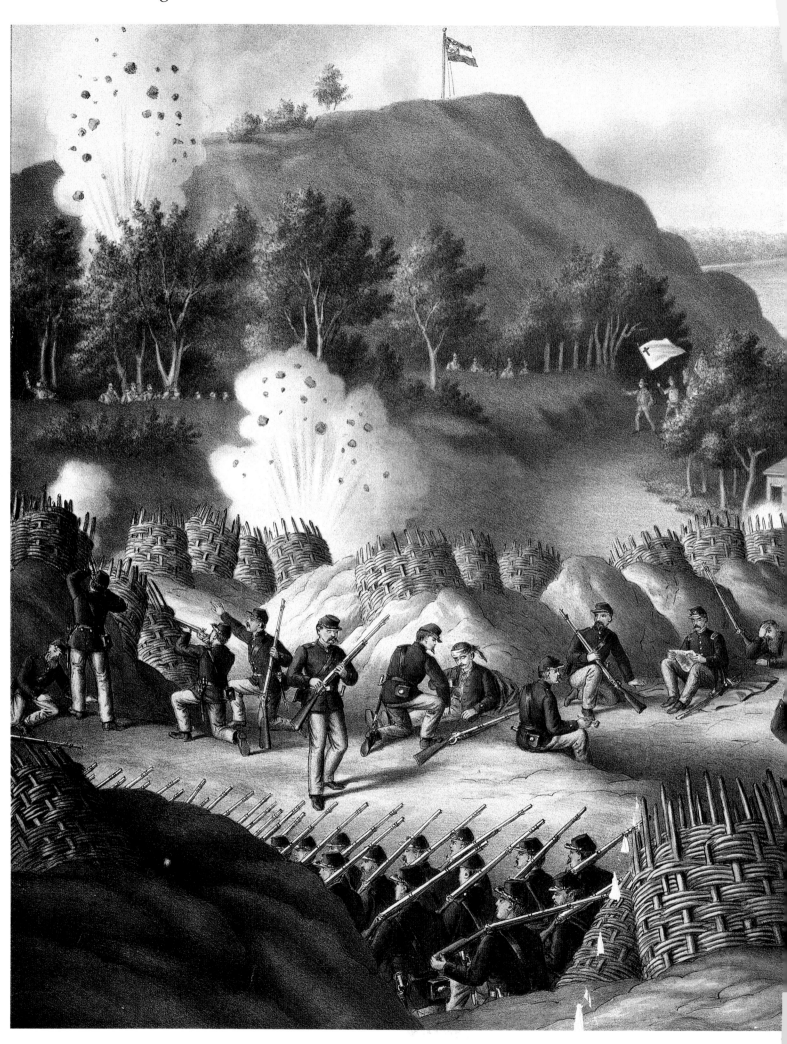

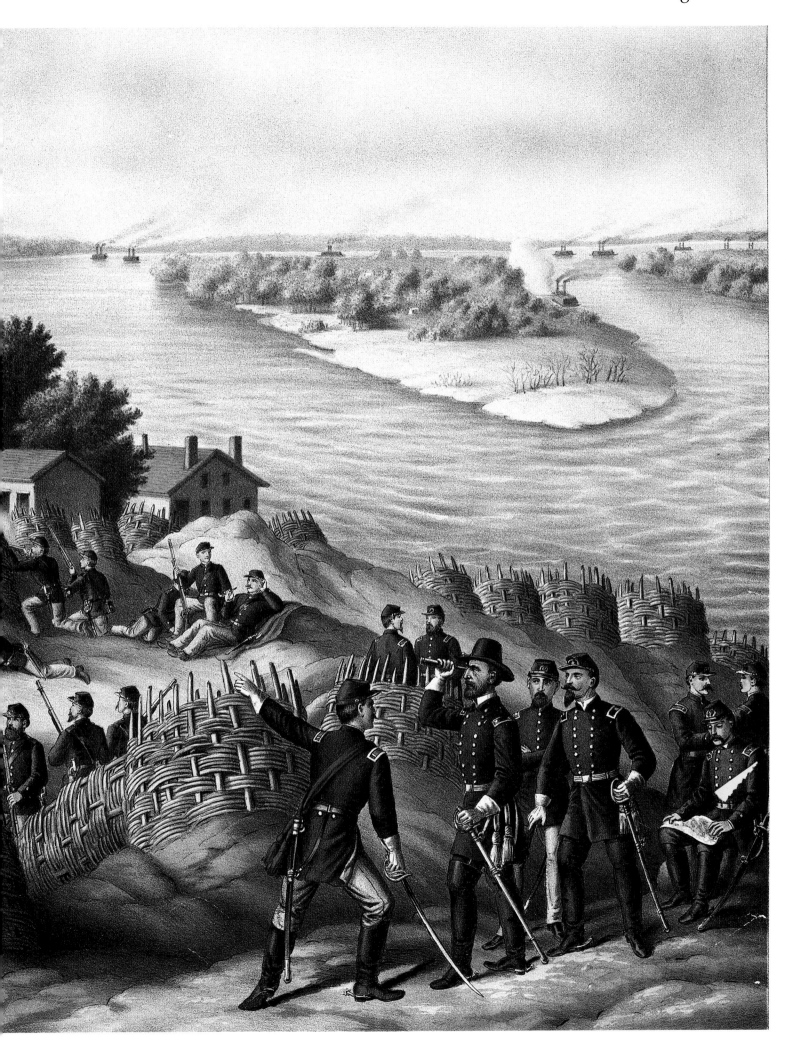

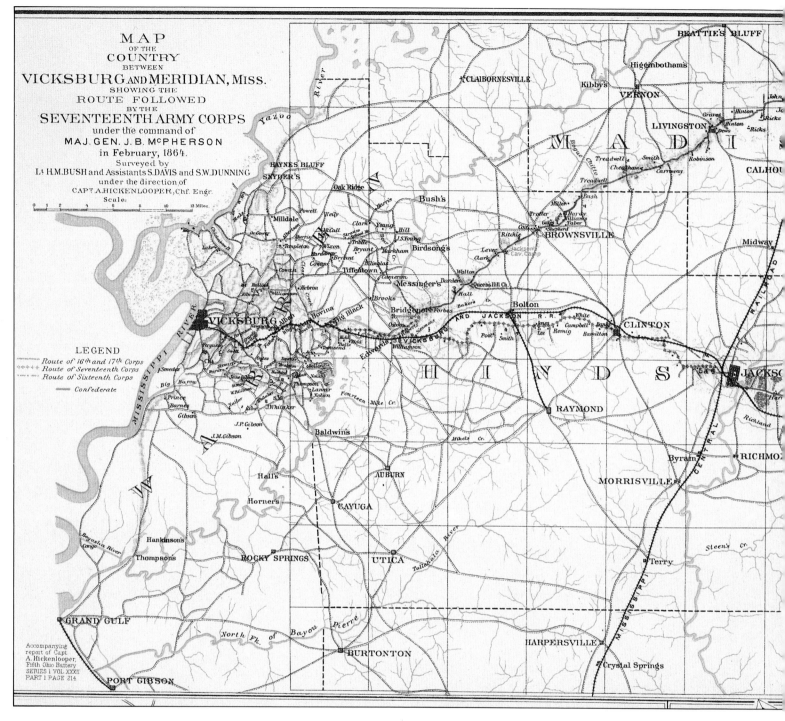

Previous pages: The surrender of Vicksburg.
Above: The Vicksburg-Jackson region, where
Grant conducted his 1863 Vicksburg Campaign.

under Grant's subordinate, William Tecum-
seh Sherman, suffered a costly repulse in
attempting to attack the bluffs overlooking
Chickasaw Bayou, north of Vicksburg. That
ended Grant's hopes of taking the city with
relative dispatch.

As winter settled in Grant faced an un-
promising situation. He had learned that he
could not simply march in and besiege Vicks-
burg; besides the enemy forces in Missis-
sippi, there was the barrier of swampy land
surrounding the area, made worse by a rainy
winter. The city could only be attacked from
high and dry ground to the east – that is, from
enemy territory. Meanwhile, hundreds of
Grant's soldiers were dying from swamp-
born diseases. Yet Washington was not likely
to countenance letting Grant spend the

winter doing nothing, and neither would the
Northern press, which was becoming ever
more critical of him. Finally Grant shifted his
base to a point nearly opposite Vicksburg on
the western (Louisiana) bank of the river and
commenced a series of experiments.

The Federal navy had already secured
most of the other major river towns – Mem-
phis, to the north, and Baton Rouge and New
Orleans, to the south. To be useful for
Grant's operations, the Union flotilla, then
north of Vicksburg, had to get downriver
past the extensive batteries trained on the
river from city. For that purpose Grant first
had the army dig a canal so that the fleet
could bypass the batteries; but the canal
turned out to be too shallow to float the ships.
At the same time, he sent a corps to try to
open a passage from Lake Providence that
would put Federal vessels on to waters south
of Vicksburg. This operation was abandoned
in favor of a more promising one in the Yazoo

Delta, 400 river-miles to the north. Cutting
through a levee to enter the Tallahatchie
River, the Union fleet made some progress,
but an inconveniently-located Confederate
fort then drove the ships away. In the spring
Grant tried the last of his experiments, trying
to move the fleet through a tangled mass of
streams and backwaters called Steele's
Bayou. In that nightmarish operation the
ships were slowed by trees felled by the
enemy and attacked from shore by Rebel
infantry, while the Union sailors had to con-
tend with snakes and wildcats that fell on
them from overhanging trees. Finally Sher-
man's infantry had to come and rescue the
fleet, which barely made it out of the water-
way, steaming backwards for miles.

Having tried every conceivable rounda-
bout way to bypass Vicksburg, and with
summer coming on, Grant now set a bold
new plan in motion. The ground had dried
out just enough to allow his army to march

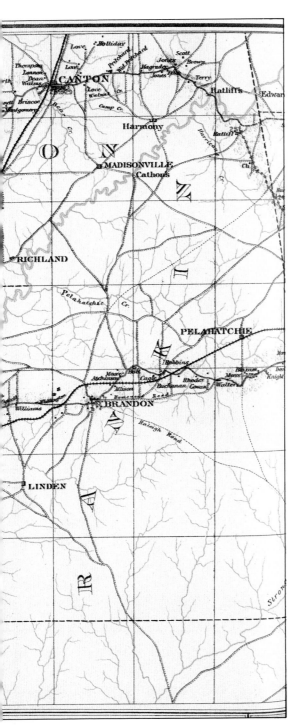

The first and most daunting element, running the batteries, began just before midnight on April 16, 1863. Admiral Porter's fleet floated quietly downstream, boilers damped to prevent telltale sparks. The ships were protected by barges towed alongside and by bales of cotton lashed along the hulls. But when flotilla reached Vicksburg it was spotted from the shore, and the guns opened up. The ships put on steam for the final dash. In the end, the fleet made it through with losses of only one ship and a few barges. Admiral Porter came to rest at Hard Times, Louisiana, where Grant's army was gathering after their march down the western shore. A few days later more Union ships ran the gauntlet of the the batteries.

Sherman then made his feint on Haines's Bluff with equal success: General John C.

Pemberton, commanding in Vicksburg, was convinced that Sherman's was the main assault on the city. His job done, Sherman marched south to join Grant. Pemberton was further confused when Colonel Benjamin H. Grierson's 1700-man Federal cavalry brigade set off on their diversion, riding south through Mississippi in mid-April and raiding as they went. For over two weeks, Confederate riders tried in vain to round up the Federal horsemen. By the time Grierson and his men arrived in Baton Rouge, they had accounted for 100 enemy casualties, taken 500 prisoners, destroyed 50 miles of railroad, captured 1000 horses and mules, and

This Union army map of the Siege of Vicksburg shows both the disposition of US forces and the formidable ring of Rebel fortifications.

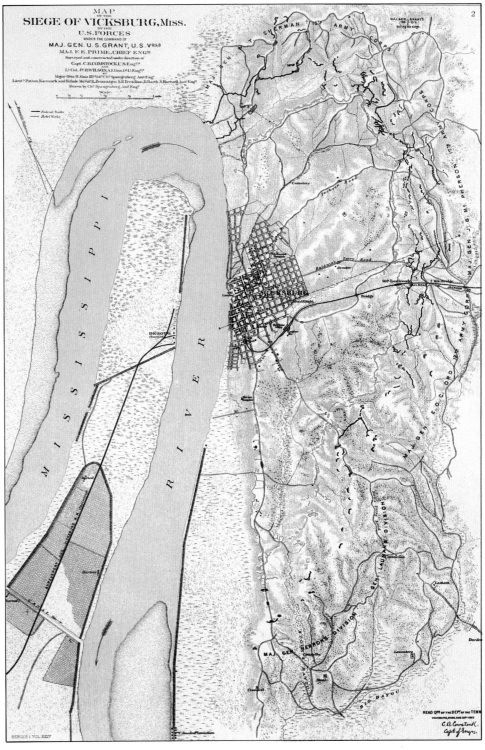

south on the Louisiana side of the river. Once the infantry troops were south of Vicksburg, the Federal fleet might be able to ferry them across the river. But this would mean that Admiral David Dixon Porter would have to run his ships downriver past the formidable Vicksburg batteries. In addition, the enemy's attention would have to be diverted from what was going on. To mask his troop movement Grant would order two diversionary operations, one by Sherman's corps attacking Haines's Bluff near Vicksburg, the other, a showy cavalry raid south through Mississippi. But after all that, Grant would still face the daunting task of taking the city. In short, Grant's strategy consisted of four separate operations involving thousands of men and horses and dozens of ships, all of whom had to work in perfect concert if the campaign were not to fail. He issued his orders over the objections of Sherman and, indeed, the entire staff.

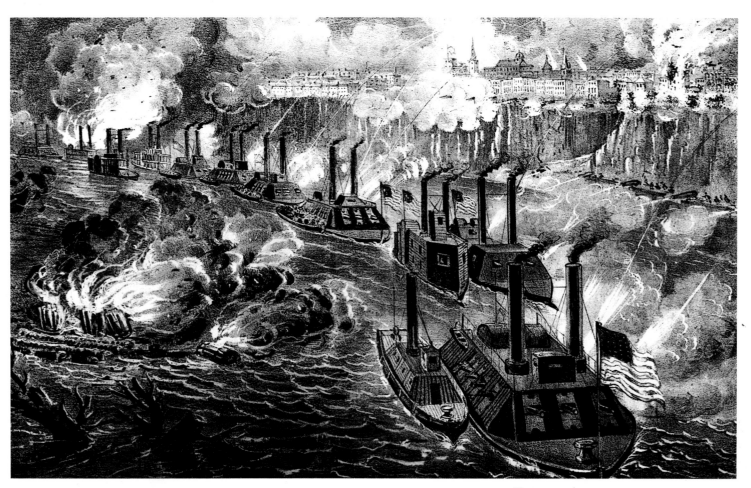

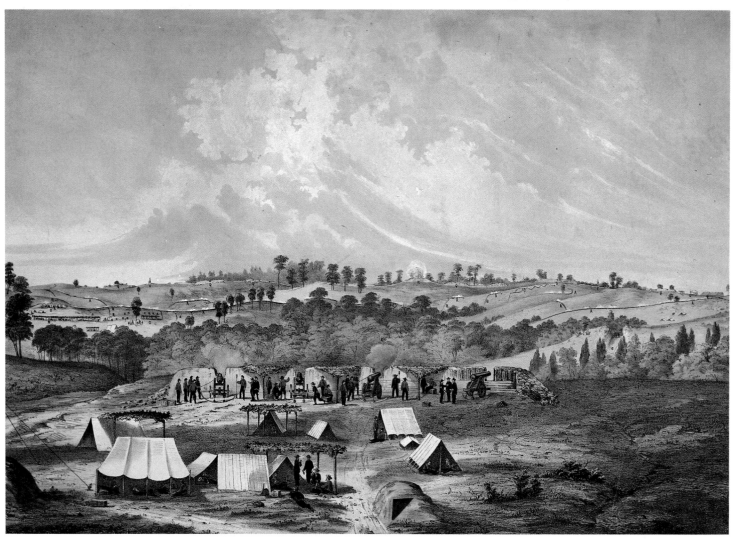

suffered only 24 casualties of their own, while riding 600 miles through hostile territory. Grierson's raid would count as one of the finest cavalry exploits of the war.

Now three parts of Grant's four-pronged strategy had come to fruition. The hardest part remained – moving over enemy ground to conquer a well-fortified city, and doing it before Southern reinforcements could reach Pemberton. On May 1 Grant finished ferrying his army across the river unopposed. At that point his orders from Washington instructed him not to move on Vicksburg yet; he was supposed to march south and join General Nathaniel Banks in attacking Port Hudson on the Mississippi. After that town fell he and Banks were to return to Vicksburg together. But upon learning that Banks was busy instead with the elaborate (and ill-fated) Red River Campaign (*See*), Grant made a bold and historic change of plans: he would cut away from his supply and communications lines – something almost never heard of in warfare – and move east across the state to occupy Jackson, the capital of Mississippi, thus discouraging enemy reinforcements from advancing from that direction. Then he would march west and besiege Vicksburg. Throughout the operation his army would move with only the supplies they could carry and would forage whatever else they needed from the surrounding countryside. A year later Grant's subordinate, Sherman, would adopt the same tactics in Georgia.

Sending Sherman to make a feint at Vicksburg, Grant headed west and arrived at Jackson on May 13. Inside the city were General Joseph E. Johnston and 6000 men; they were supposed to be helping Pemberton in Vicksburg, and more Southern reinforcements were on the way. As the bluecoats gathered around the city, Johnston wrote to Pemberton ordering him to cut Grant's supply line and then attack from the rear with his whole

Opposite top: Union Admiral Porter's fleet runs past the Vicksburg batteries.
Opposite bottom: The Siege of Vicksburg.
Below: River-borne supplies reach Grant as he prepares his offensive against Vicksburg.

force. Refusing to leave the city unoccupied, the Vicksburg commander wasted a day marching a detachment back and forth in an effort to find the nonexistent Union supply line. By the time Pemberton gave up and marched the detachment east to attack Grant, Jackson had fallen. Grant then sent his forces out to meet Pemberton.

Some 22,000 Confederates ran into 29,000 of Grant's soldiers at Champion's Hill on May 16, and the biggest battle of the campaign broke out. After hours of heavy but indecisive fighting that claimed well over 2000 casualties on both sides, the Northerners threatened the only Southern road of retreat, and Pemberton pulled his men back toward the city. On the next day Grant tried to cut off Pemberton's retreat at the Big Black River Bridge but captured only 1700 men. Pemberton finally reached Vicksburg with most of his forces.

The city's fortifications were perhaps the strongest in the Confederacy: a line of works

A Vicksburg woman, reduced to living in a cave to escape the dangers presented by the incessant Union bombardment of the besieged city, prays for safe deliverance.

and trenches nine miles long, with nine forts as strongpoints; broken ground in the area also worked to the advantage of the Confederates. Nevertheless, Grant mounted a full-scale assault on May 19; it gained only a few yards. Impatient with the prospect of a siege, he ordered another attempt a few days later; it failed, costing 3200 Union casualties to Pemberton's 500. Grant would later admit that these assaults were bad mistakes.

The Northerners then settled into a siege, gradually extending their lines around the city. Inside Vicksburg the slowly-starving soldiers and civilians dug into the hills to escape incessant shelling from Union batteries and gunboats. The end came on July 3, 1863, when white flags appeared on the ramparts. Pemberton and Grant, who were old army acquaintances, sat on a hillside and came to terms. The defenders would surrender on July 4, and Grant would parole them until they could be exchanged, rather than making them prisoners (such paroling was still fairly common at that stage in the war).

As he had done previously at Fort Donelson, Grant had captured an entire Confederate army. He had also conducted one of the most complex and brilliant strategic campaigns of the war, as well as one that was, on the tactical level, comparable to Robert E. Lee's maneuvering at Chancellorsville and Stonewall Jackson's in his Shenandoah Valley Campaign. As the 30,000 ragged and hungry Southern soldiers filed out of the city on July 4 Grant forbade any victory celebration by his troops. Far to the east, the South had lost another critical battle that week, at Gettysburg, but it was in Vicksburg that the fate of the Confederacy was decided. After Port Hudson – now something of a footnote – fell to Banks on July 8 the Mississippi River belonged entirely to the Union and the South was broken in two. 'The Father of Waters,' wrote Lincoln, 'runs unvexed to the sea.'

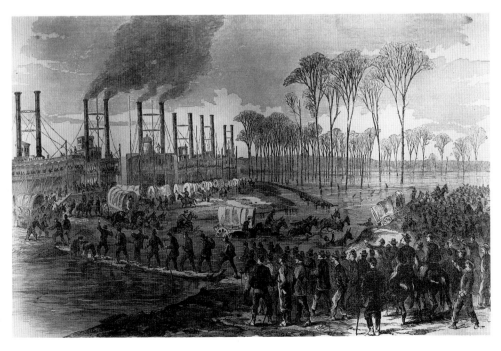

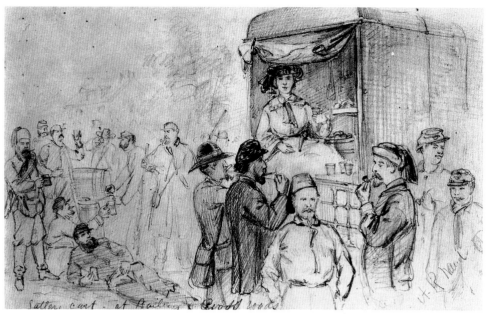

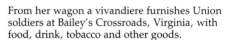

From her wagon a vivandiere furnishes Union soldiers at Bailey's Crossroads, Virginia, with food, drink, tobacco and other goods.

Vicksburg, Union Naval Bombardment of

Before Ulysses S. Grant's Vicksburg Campaign began, the Union attempted to reduce that strategic confederate stronghold on the Mississippi by naval bombardment, Union warships under Flag Officer David Farragut attacking Vicksburg from May 18 to July 26, 1862. Cruisers and gunboats began the shelling and were later reinforced by mortar vessels. The defenders refused to give in under the bombardment, however, and casualties were light – only 22 killed or wounded inside the fortress. Eventually heat, illness, and low water forced Farragut to return to New Orleans. It was now clear that there could be no quick, easy, or inexpensive way of capturing well-defended Vicksburg.

Villard, Henry (1835-1900)
Journalist.

A Bavarian-born war correspondent, he reported in 1861 for the Cincinnati *Commercial* that War Secretary Simon Cameron considered W.T. Sherman, then commanding in Kentucky, insane. The report led to quarrels that were, at least in part, responsible for Sherman's dismissal from that command. Villard later joined the staff of Greeley's (*See*) New York *Tribune* and became one of the war's outstanding correspondents. He married William Lloyd Garrison's daughter.

Virginia, CSS

See MONITOR AND MERRIMAC

Vivandiere

This was the female attendant who accompanied regiments in many European armies. Frequently a soldier's wife, she served as nurse and/or provider of food and liquids. Far from a camp follower, she was a respectable woman with an acknowledged position in the regiment. A few vivandières served in the Civil War, generally with regiments of foreign-born troops. The word is taken from the French term for such a person; the English equivalent is 'sutler.'

Volunteers

The Union and Confederate armies consisted overwhelmingly of volunteers, organized by the states and mustered into the national service. At first volunteers enlisted for periods as brief as three months; by mid-1861 Lincoln had issued his first call for hundreds of thousands of three-year enlistees.

Von Steinwehr, Adolph (1822-1877) Union general.

Prussian-born, he came to America to fight in the Mexican War and eventually settled down to farming in Connecticut. He became colonel of the all-German 29th New York at the start of the war. He led a brigade at Second Bull Run and a division at Chancellorsville and Gettysburg. He briefly commanded the XI Corps in Virginia and, later, during the Chattanooga Campaign.

W

Wade-Davis Manifesto

In 1864 Radical Republicans Benjamin F. Wade and Henry W. Davis issued this call for a harsh Reconstruction in the defeated Southern states. Both men fought the moderate Reconstruction policies of Lincoln and, after the assasination, Andrew Johnson. It has been suggested that one reason Wade pressed for Johnson's impeachment was that Wade, as president of the Senate, stood next in line for the US presidency.

Walker, Leroy Pope (1817-1884)
Confederate general and secretary of war.

A lawyer and powerful Democrat in Alabama, he was Confederate secretary of war from February to September 1861. Inexperienced and overwhelmed, he resigned and was commissioned a brigadier general, but, denied an active command, he soon resigned. He thereafter sat on a military court until the war's end.

Three Confederate volunteers in the Third Georgia Infantry. Two, half-brothers, would be killed in the Seven Days' Battles.

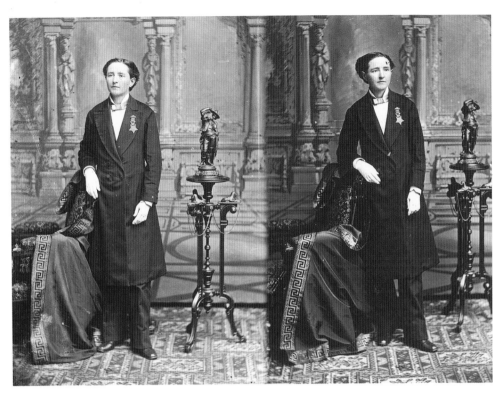

A double portrait of Dr. Mary Walker, the first woman surgeon in the US Army.

Walker, Mary Edwards (1831-1919) Union surgeon.

This New Yorker received her medical certification in 1855. Early in the war she was an army nurse and sometime spy; in 1864 she was commissioned as the first woman surgeon in the US Army. After the war she was a physician, inventor, and active suffragist.

Wallace, Lewis (1827-1905) Union general.

Wallace had a varied career before the war; in 1861 he was adjutant-general of Indiana. He fought at Romney and Harpers Ferry and, rapidly promoted, led divisions at Fort Donelson and Shiloh and VIII Corps at Monocacy. His substantial administrative service included the courts martial of Lincoln's assassins and Henry Wirz. A prolific author, he wrote *Ben Hur* (1880) while serving as governor of New Mexico.

War Democrats

This faction of the Northern Democratic Party, led by Stephen A. Douglas and Andrew Johnson, supported Union war policy. The opposing faction, the 'Peace Democrats,' called for a negotiated settlement with the rebellious states.

Warren, Gouverneur Kemble (1830-1882) Union general.

An 1850 West Point graduate, he served in the pre-war army as an engineer. He led the 5th New York at the start of the Peninsular Campaign, then commanded a brigade in the 2nd Division, V Corps, from Second Bull Run to Fredericksburg. As the Army of the Potomac's chief engineer Warren played a decisive role at Gettysburg by directing reinforcements to the threatened Union left at Little Round Top on the second day of the battle. He commanded the V Corps at the Wilderness, Spotsylvania, Petersburg, and in the start of the Appomattox Campaign. In a celebrated incident, Philip Sheridan sacked him for lack of aggressiveness after the battle of Five Forks only a few days before Robert E. Lee's surrender. Fourteen years later a court of inquiry cleared Warren of Sheridan's charges. Warren died less than a year later.

Washington Artillery

Wealthy, socially prominent men of New Orleans filled the ranks of this famous Confederate unit. Formed in 1838, the battalion saw service in the Mexican War; it was mustered into the Confederate Army in May 1861. Four batteries fought with the Army of Northern Virginia, while a fifth served in the West in the Army of Tennessee.

Waud, Alfred R. (1828-1891) War correspondent.

As the principal war artist for *Harper's Weekly*, Waud produced hundreds of frontline sketches of some of the war's most important events (as, more modestly, did his less talented and prolific brother, William). Because of the state of mid-nineteenth-century printing technology, however, few of Waud's contemporaries ever saw the sketches themselves, but only hasty and often coarse wood-block prints made from them by the periodical's engravers. Fortunately, many of the original sketches have survived, together forming an invaluable graphic record of the Civil War.

Wauhatchie Night Attack

During the Chattanooga Campaign on the night of October 28, 1863, Confederate General Braxton Bragg sent forces under James Longstreet to attack an isolated division of Joseph Hooker's army at Wauhatchie. The action, one of the rare night attacks of the war, was extremely confused, officers of both sides hardly knowing the enemy from their own. After intensive fighting, each side suffering over 400 casualties, the Confederates were driven back. This victory secured protection for the 'cracker line' that would supply the besieged Union forces in Chattanooga. A legend of the battle was that some terrified Union mules stampeded toward Confederate troops, who fled, thinking that they were being charged by cavalry. This led to the wry suggestion that the mules should be declared honorary horses.

Waynesboro, *Georgia*

On November 26, 1864, early in his March to the Sea, W. T. Sherman sent Hugh Judson Kilpatrick's Federal cavalry to destroy a railroad bridge near Waynesboro. Harrassed from the outset by Joseph Wheeler's Con-

Harper's Weekly's noted war artist Alfred R. Waud is shown sketching at Gettysburg in this photograph by Timothy O'Sullivan.

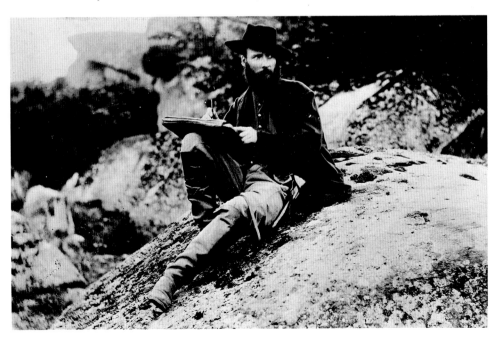

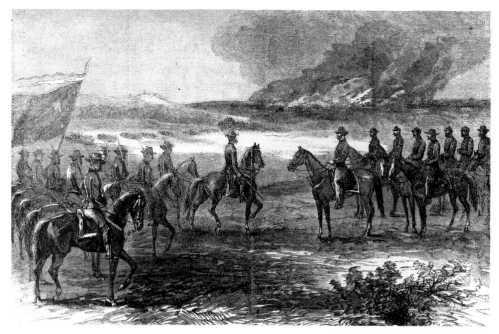

General Sherman reviews H. J. Kilpatrick's cavalry division before sending it out to burn the Waynesboro railroad bridge in 1864.

federate cavalry, the blue horsemen abandoned the operation; on the 28th one division had to fight their way through Wheeler's entire corps. They were finally able to rejoin Sherman on the following day.

Waynesboro (*Virginia*), Battle of

Union General Philip Sheridan finished off the remnants of Jubal Early's Confederates here on March 2, 1865, during the concluding phase of the Sheridan's Shenandoah Valley Campaign. George A. Custer's 4800-strong Union cavalry division overwhelmed a force of about 1000 Confederates; only Early and about 20 others managed to escape.

Weldon Railroad Expedition

During the Petersburg siege, Union General Gouverneur Warren's V Corps, with an extra infantry divison and a cavalry division attached, broke up the railroad to Hicksford 40 miles south of Petersburg in a neat operation conducted between December 7 and 11, 1864. Confederate General A. P. Hill led out a force to protect the vital rail line, but Warren had completed the work of destruction before Hill could arrive.

Welles, Gideon (*1802-1878*)
Union secretary of the navy.

A Hartford newspaper proprietor, he became secretary of the navy in 1861 and, despite his inexperience, served ably throughout the war. Welles quickly assembled a navy, defined strategy, and promoted new technology, the success of his naval operations making him an important member of Lincoln's cabinet.

West Point, *Mississippi*

In February 1864, as part of the Meridian Campaign, some 7000 Federal cavalry under William Sooy Smith set out from Memphis, Tennessee, to break up the Mobile & Ohio Railroad from Okolona, Mississippi, southward and then to join W. T. Sherman in Meridian. The Federals made contact with Nathan B. Forrest's Confederate cavalry at West Point on February 20, and after a minor skirmish on the 21st Smith ordered a withdrawal. Another skirmish at Okolona on the 22nd ended in a Federal rout, though portions of two brigades turned to face Forrest at a place called Ivey Hills – a stand that ended what had been an aggressive Confederate pursuit. Sherman later censured Sooy Smith for his handling of the operation.

West Virginia

As frontier farming country, the western part of Virginia was economically and culturally divergent from the aristocratic plantation society in the east, and as early as 1776 western Virginians had petitioned for their own

Though inexperienced, Gideon Welles proved an excellent Union secretary of the navy.

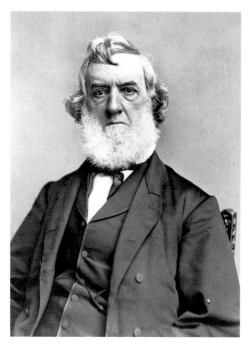

government. Western loyalists refused to recognize Virginia's secession in April 1861. At three conventions at Wheeling from May to August they elected their own US Senators and loyalist Governor Francis Pierpont, and called for the formation of a separate state. Their new constitution, drafted in November, provided for the abolition of slavery. The 50 counties of West Virginia were admitted to the Union as the 35th state in June 1863.

Western Virginia Campaign of McClellan

When, soon after the fall of Fort Sumter in April 1861, the Virginia State Convention passed an ordinance of secession, it began to appear that the large and generally pro-Union western part of the state might not be willing to follow Richmond's lead. To exploit this situation, and to protect the vital B&O railroad lines in western Virginia, young General George McClellan, then commander of the Department of the Ohio, mounted an expedition into the region. On June 3 one of his lieutenants, General T. A. Morris, routed a Confederate force at Philippi – a small fight but a big propaganda victory (Northern newspapers dubbed the Rebel flight 'the Philippi races') that so encouraged western Virginia Unionists that they declared Richmond's ordinance of secession void. By now alarmed, the Confederate government rushed a new commander, Robert S. Garnett, into the area but failed to give him adequate men and supplies for the task at hand. Garnett attempted to set up a defensive line based on Rich and Laurel Mountains, but on July 11 another of McClellan's lieutenants, General William S. Rosecrans, overran the Rich Mountain position, and Garnett's right flank at Laurel Mountain inevitably collapsed soon thereafter. McClellan caught up with the retreating Garnett on the 13th at Carrick's Ford; in the ensuing action Garnett's small force was badly mauled and Garnett himself was killed. McClellan then occupied Beverly and was all for pushing on, but at that point Washington intervened, calling a halt to the campaign on the grounds that its objectives had already been accomplished.

The historical consequences of this militarily minor campaign were considerable. Not only was West Virginia permanently lost to Virginia and the Confederacy (it would be admitted to the Union as a new state in 1863), the campaign had so enhanced George McClellan's reputation that it would seem only logical to Washington, in the aftermath of Irvin McDowell's disaster at First Bull Run, to name McClellan the general-in-chief of all the Union armies. It thus would be McClellan who, in 1862, would preside over the even more disastrous Peninsular Campaign.

Westport (*Missouri*), Battle of

Federal forces defeated the Confederates of Price's Raid (*See*) here on October 23, 1864. Sterling Price with 9000 men initiated the battle, attacking Samuel G. Curtis's Army of the Border in positions along Brush Creek. Curtis counterattacked, forcing Price to withdraw. At this point Alfred Pleasanton's Federal cavalry fell on the Rebels, turning their withdrawal into a rout.

Wheat, Chatham *(1826-1862)*
Confederate officer.

The adventuring son of an Episcopal minister, he fought in the Mexican War, then served as a mercenary officer in the Mexican Army and with Garibaldi's insurgents in Italy. Wheat led the Louisiana Tigers at First Bull Run. He was mortally wounded at the Battle of Gaines's Mill during the Peninsular Campaign.

Wheat Field

This patch of cultivated ground halfway between Little Round Top and the Peach Orchard was the scene of heavy fighting on the second day of the Battle of Gettysburg.

Wheeler, Joseph *(1836-1906)*
Confederate general.

A Georgian West Point graduate, Wheeler left frontier fighting when war broke out. He fought at Shiloh, Perryville, and Stone's River, commanded the Army of the Mississippi's cavalry and led raids against Federal communications; one such raid on Federal supply lines, conducted between October 1 and 9, 1863, during the Chattanooga Campaign, was so successful that it came close to forcing the besieged Union troops in Chattanooga to evacuate the city. He subsequently participated in the Knoxville and Atlanta campaigns and fought W.T. Sherman during his March to the Sea. 'Fightin' Joe' was said to have fought in 1000 engagements and skirmishes before his capture in May 1865. He later played a prominent role in the Spanish-American War.

'Whistling Dick'

This famous gun defended the Confederate fortress of Vicksburg on the Mississippi. Built as a smoothbore, the subsequent rifling of the barrel put a spin on its projectiles that produced a weird sound in flight. 'Whistling Dick' sent the Federal gunboat *Cincinnati* to the bottom on May 27, 1863.

The 18-pounder 'Whistling Dick', most famous of the Rebel guns defending Vicksburg.

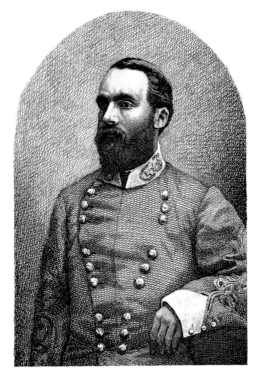

Pugnacious Rebel General Joseph Wheeler well deserved his nickname, 'Fighting Joe'.

White Oak Swamp *(Virginia)*, Battle of

In this sixth engagement of the Seven Days' Battles on June 30, 1862, Robert E. Lee made an elaborate plan to strike the retreating Army of the Potomac, but once again his generals were ineffective, and only two of the seven divisions got into action. James Longstreet's and A. P. Hill's divisions did fight fierce engagements, but by nightfall they had gained little ground. Federal casualties were 2853 for the day, Southern 3615. That night McClellan withdrew to Malvern Hill (*See*).

Whiting, William Henry *(1824-1865)* **Confederate general.**

An 1845 West Point graduate, he served as an engineer officer in the prewar army. He joined the Confederate service in the spring of 1861 and fought at First Bull Run. Whiting commanded a division under T.J. Jackson in the latter's Shenandoah Valley Campaign. He subsequently served as commander of the military district of Wilmington on the North Carolina coast; he was mortally wounded at Fort Fisher on January 15, 1865.

Whitman, Walt *(1819-1892)* Poet.

Already mildly notorious for his poetry, Whitman went to Washington, DC, in December 1862 to assist his wounded brother; he stayed for the duration, serving as a volunteer nurse in military hospitals. His war poems were published as *Drum-Taps* (1865) and *Sequel to Drum-Taps* (1865-6). His most celebrated masterpiece, *Leaves of Grass*, was published in 1871.

Whitworth Gun and Rifle

Confederates used small numbers of the English-made Whitworth rifled gun, including 6-, 12-, and 70-pounder types. One authority called the accurate and powerful Whitworth the best gun in either army, but it was somewhat prone to jamming. Small numbers of the muzzle-loading Whitworth rifle were used by Rebel marksmen.

Wickham, Williams Carter *(1820-1888)* **Confederate general.**

A Virginia planter, lawyer, and anti-secessionist legislator, he fought steadily in the Eastern Theater from First Bull Run to Cold Harbor, joining Jubal Early for the fighting in the Shenandoah Valley in 1864 before resigning from the army in November 1864 to sit in the Confederate Congress.

Wigwag

Union signal officer A. J. Myer and E. P. Alexander, who would serve as a senior Confederate artillery officer, developed this semaphore signal communication system when they served together in the 1850s.

American poet Walt Whitman.

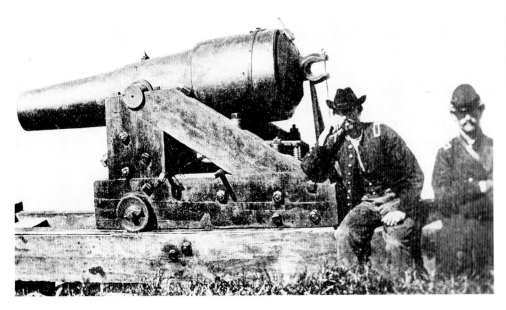

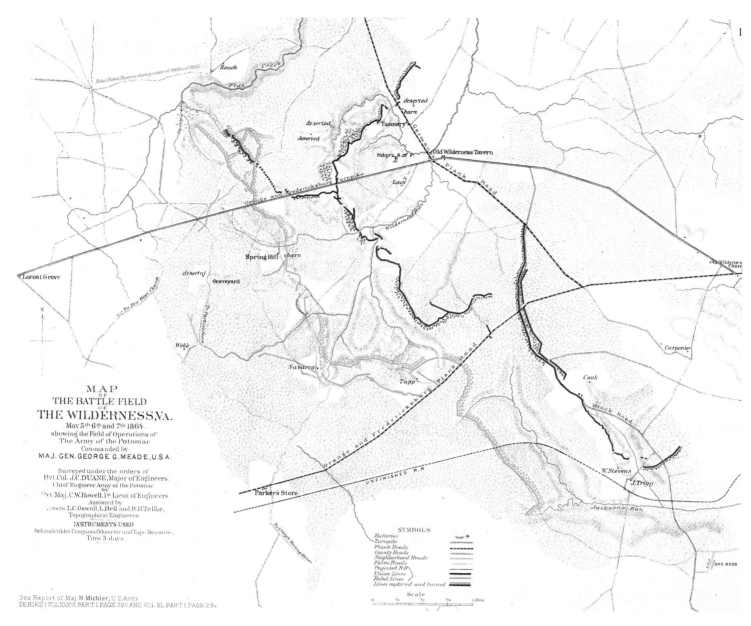

MAP
OF
THE BATTLE-FIELD
OF
THE WILDERNESS,VA.
May 5th 6th and 7th 1864.
showing the Field of Operations of
The Army of the Potomac
Commanded by
MAJ. GEN. GEORGE G.MEADE, U.S.A.

Surveyed under the orders of
Bvt.Col. J.C.DUANE, Major of Engineers.
Chief Engineer Army of the Potomac
BY
Bvt.Maj. C.W.Howell, 1st Lieut.of Engineers
Assisted by
Messrs.L.C.Oswell,L.Bell and R.B.Talfor,
Topographical Engineers
INSTRUMENTS USED
Schmalcalder Compass,Odometer and Tape Measure;
Time 3 days.

See Report of Maj. N.Michler, U.S.Army
SERIES 1 VOL.XXXVI PART I PAGE 295 AND VOL. XL.PART 1 PAGE 294

SYMBOLS
Batteries
Turnpike
Plank Roads
County Roads
Neighborhood Roads
Farm Roads
Projected R.R.
Union Lines
Rebel Lines
Lines captured and turned

Scale
0 ¼ ½ ¾ 1 Mile

The positions of Lee's and Grant's armies at the beginning of the confused, bloody Battle of the Wilderness in May 1864.

Wilderness, Campaign and Battle

On May 4, 1864, General Ulysses S. Grant and the Federal Army of the Potomac reached the edge of the Virginia Wilderness, scene of the previous year's humiliation of the army in the Battle of Chancellorsville. Grant had just been named commander of the entire Federal war effort, but he decided that his headquarters would be in the field with the primary Union army. His goal was to capture the Confederate capital of Richmond; but before that he would have to subdue Robert E. Lee and the Army of Northern Virginia. He planned to meet Lee on open ground south of the Wilderness. In that assumption Grant fell prey to his main weakness as a commander: planning his own strategy without adequately considering what his enemy was doing in the meantime.

Meanwhile, as part of Grant's overall strategy for winning the war, General Benjamin Butler had been ordered to move on Richmond from the south, Franz Sigel was to march through Virginia's Shenandoah Val-

ley, and W.T. Sherman was to head for Atlanta. Of those three operations, only Sherman's would be successful, but it would be a very great success (*See* ATLANTA CAMPAIGN).

At that point in early May the Army of the Potomac had 115,000 well-fed and well-equipped soldiers to Lee's 66,000 ragged and hungry ones. Nonetheless, Lee was prepared to ambush Grant in the Wilderness, knowing that the impediments of thick trees and brush and uneven ground would compensate for much of his enemy's numerical superiorty. On May 5, marching into the woods, General Gouverneur Warren notified Grant that an enemy force was on the Orange Turnpike. Thinking it was an isolated detachment, Grant ordered Warren to attack, but he then found himself fighting with an enemy in force. As the battle developed through a day of severe fighting, units on both sides grappled nearly blind in the thick brush. Opposing lines mingled in the confusion, both sides often firing on their own men. One participant recalled that the fighting was 'simply bushwacking on a grand scale . . . I knew a Wisconsin infantryman named Holmes who walked right into the Rebel skirmish line. He surrendered, and a Rebel was sent to the rear with him. In two minutes Holmes and his

guard walked right into our own lines, and that in broad daylight.'

Late in the afternoon Southern General A. P. Hill's advance along the Plank Road was met by Union General Winfield Scott Hancock; a separate and equally desperate contest ensued. As evening fell neither side had made significant progress. During the night troops of both sides frequently wandered into enemy lines. Grant had ordered a general attack for 5:00 in the morning, but before that could get underway Confederates struck the Union right flank. This was actually a diversion – Lee was waiting for James Longstreet to move up and spearhead the main effort on the Union left flank. Soon the fighting had spread along the line, and the superior Union forces drove the Confederates steadily back.

As the Union men pressed forward, however, they became disorganized due to the tangled thickets and swamps. For a time, Federal General Hancock enveloped the weakened forces of A. P. Hill along the Orange Plank Road. Finally the Federals arrived at the clearing containing Lee's headquarters. But as Hancock paused to regroup, Longstreet's men, having just arrived in the area, made a dramatic appearance, moving up the Plank Road at a trot and pitching into

the enemy. Lee had to be dissuaded from personally leading Longstreet's advance units. In short order Hancock was being pushed back. Learning of an unfinished railroad cut that led to the Union left flank, Longstreet sent a detachment along it to the attack; they devastated the enemy forces they encountered and soon were in position to roll up and destroy the Northern line.

The tide of battle quickly swung again when Longstreet was seriously wounded by his own men firing blindly into the woods, some three miles from where the same thing had happened to Stonewall Jackson the year before. As Longstreet was carried from the field the Southern attack faltered. Grant ordered a new attack on the middle and right of the enemy line for 6:00 am. But again Lee got the jump; the Confederates pushed forward and claimed part of the breastworks erected by the Federals – partly because the log barricades had caught fire, forcing the bluecoats to fight the enemy and the fire at the same time. Meanwhile, repeated Union attacks on the north flank had failed to breach Southern positions. In the process, John Sedgwick's Union corps had drifted off, leaving itself 'in the air.' Late in the afternoon

Right: Frustrated by Lee in the Wilderness and at Spotsylvania, Grant (left, leaning over Meade's shoulder) unwisely elected to 'fight it out' at Cold Harbor in June 1864.
Below: The Battle of the Wilderness.

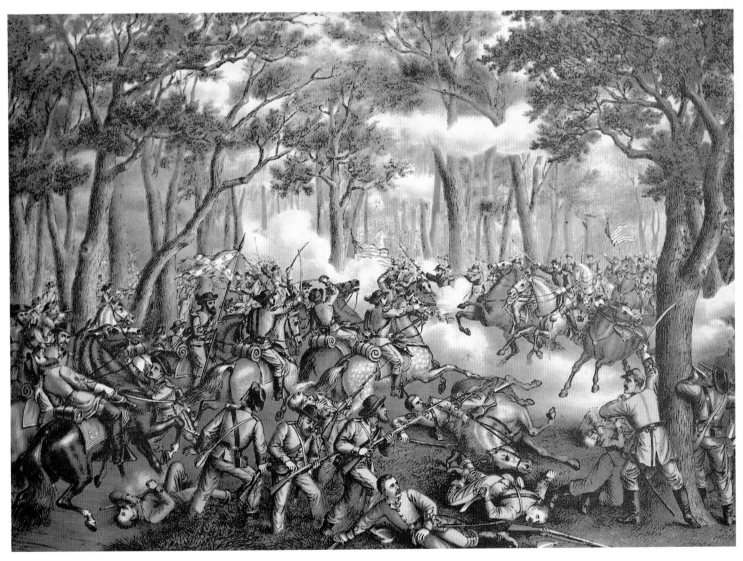

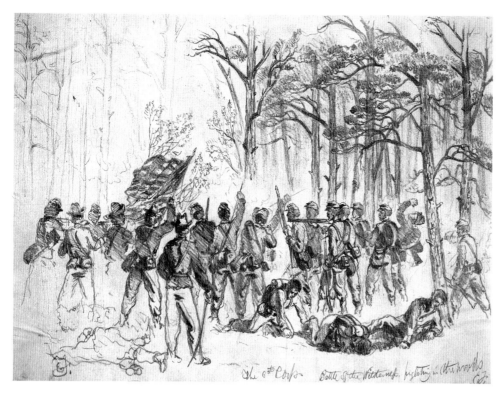

An Edwin Forbes sketch of Union troops in the Wilderness. The area's dense woods made organized maneuver nearly impossible.

John Gordon's division of Confederates fell onto Sedgwick's flank, again endangering the whole Union line. This time the Union was saved by the coming of night, which ended Gordon's assault and the battle.

In two days of inconclusive fighting in the Wilderness casualties had been staggering for both sides. The North had lost 2246 killed and 12,073 wounded of 101,895 involved; Confederate casualties were estimated at 7750 of 61,025 engaged. As had happened at the Battle of Chancellorsville, hundreds of wounded men died during the night in forest fires that had started during the battle.

After their previous battle at Gettysburg, both armies had spent months in recovery and tentative maneuvering. This time Grant was determined not to let up the pressure. He issued orders to slip around Lee's right flank and resume the advance toward Richmond. Lee, guessing what Grant would do, put his forces on the march to stop the enemy at Spotsylvania. The Wilderness Battle, as it turned out, was only the beginning of a long summer of incessant and devastating struggle between the two armies.

Wilkes, Charles *(1798-1877)*
Union naval officer.

He entered the Navy as a midshipman in 1818. In 1838, he led a six-ship squadron carrying a scientific expedition to Antarctica. As captain of the USS *San Jacinto*, Wilkes stopped the British steamer *Trent* route to England on November 8, 1861, and arrested Confederate commissioners Mason and Slidell, precipitating a diplomatic crisis with Britain (*See* TRENT AFFAIR). Wilkes later won considerable acclaim as commander of the 'flying squadron,' a naval flotilla which captured a number of Rebel blockade-runners in West Indian waters.

Williams Rapid-Fire Gun

This was the first true machine gun to be fired successfully in battle – by Confederate gunners at Seven Pines on May 31, 1862. Designed by a Confederate army captain, it was a 1-pounder breech-loader that fired 18-20 rounds per minute at a range of 2000 yards. Several batteries of the Williams saw service.

Williamsburg *(Virginia)*, Battle of

Federal cavalry, with two infantry divisions trailing, followed John B. Magruder's Confederates to this colonial town after they withdrew from Yorktown during the Peninsular Campaign of 1862. Union forces attacked on May 5. After a hard fight the Confederates continued their withdrawal up the Peninsula that night. The Federals reported 2239 casualties out of more than 40,000 engaged; the Confederates lost 1603 out of about 31,900 committed to the battle.

Union naval Captain Charles Wilkes.

Wilmot Proviso

Introduced in Congress in 1846 by Representative David Wilmot of Pennsylvania, this clause in a Mexican War appropriation bill outlawed slavery in any territory acquired from Mexico. Passed by the House in 1846 and 1847, it failed in the Senate. John C. Calhoun implicitly rejected the Compromise of 1820 in the Senate debate on the Wilmot Proviso, enraging Free Soil partisans and deepening the North-South rift.

Wilson, James Harrison *(1837-1925)* **Union general.**

Graduated from West Point in 1860, this Illinois native was a major general by 1865, having served under W. T. Sherman, David Hunter, and George McClellan, directed the Cavalry Bureau, and, in 1864-65, led a cavalry corps. His troops captured Jefferson Davis in May 1865 after his (Wilson's) Selma Raid (*See*). In a notable earlier raid during the Petersburg siege, Wilson and August V. Kautz had taken 5000 troopers to attack the Southside Railroad, one of the city's main supply lines; between June 22 and July 1, 1864, they destroyed many miles of vital railroad track, but they were eventually beaten off by the Confederate defenders, having suffered some 1500 casualties.

Wilson's Creek, Campaign and Battle

In an effort to stymie Confederate operations designed to take control of Missouri, Federal General Nathaniel Lyon attacked Benjamin McCulloch's Rebel forces at Wilson's Creek, near Springfield, Missouri, on August 10, 1861. The early morning attack made progress at first, but then a gray counterattack checked the Federals. Fighting raged all morning, the now-outnumbered bluecoats on Oak Hill repulsing three Confederate charges; during the first two Lyon was wounded twice, then killed. Despite his line's holding, Major Samuel D. Sturgis, who had succeeded Lyon, ordered a retreat, for which he would be much criticized. It was one of the hardest-fought battles of the war: the 5400 Federals suffered 1235 casualties; the Confederates 1184 of 11,600 engaged.

Winchester, Battles of

On May 25, 1862, the first Battle of Winchester, Virginia, took place as part of the Shenandoah Valley Campaign of Stonewall Jackson. Union General Nathaniel Banks, assigned by Washington to deal with Jackson, was at Strasburg when he learned of the Confederate attack at Front Royal. Though he did not at first realize the threat posed to his forces, Banks withdrew to high ground south and west of Winchester, thereby probably preserving his army from a worse disaster than occurred; after taking the garrison at Front Royal, Jackson was on the Federal flank with twice Banks's numbers.

Jackson drove his forces all night to reach Winchester, slowed both by the weariness of his men and by Turner Ashby's undisciplined Rebel cavalry, which stopped to loot a captured wagon train. Jackson's attack on the

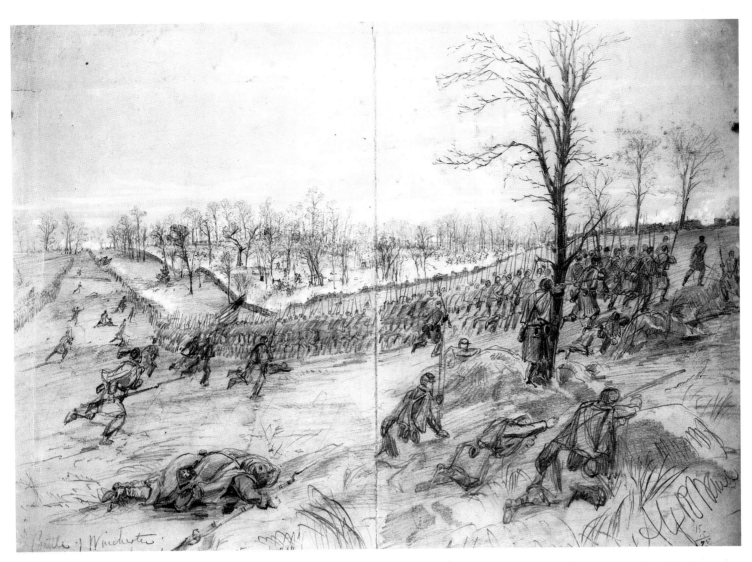

Federal left came at dawn, before the enemy had been able to fortify their positions on the hills. The attack made little progress at first, but about 7:30 Southern units under Richard Taylor and Richard Ewell gained both Federal flanks; Taylor drove into the left flank, and then Jackson moved forward with his center and right. Soon the Federals broke into full flight toward the Potomac. Jackson was unable to pursue due to the slowness of some of his officers. Of over 8000 effectives, Banks had lost some 3000 in the battle, while Jackson lost only 400. The Federal general and his men crossed the Potomac to safety, out of the campaign for good. Jackson rested his men for a couple of days before marching north toward Harpers Ferry to continue his astonishing Valley campaign.

The Second Battle of Winchester took place on June 13-15, 1863. In support of Lee's invasion of Pennsylvania (*See* GETTYSBURG CAMPAIGN), Southern General Richard Ewell was dispatched to subdue an enemy garrison at Winchester under General Robert H. Milroy. The Federals had two primary sets of fortifications on the hills west of town, called the Main and Star Forts. Ewell began by driving in some enemy outposts, then, on the 14th, made some demonstrations in front of the forts to divert the enemy while he sent a detachment around to attack from the rear. In the early evening that detachment opened up its cannons from the west and captured Milroy's artillery post. The Union general pulled his men into the Main Fort and

decided to retreat in the morning, which was just what Ewell had prepared for. On the next day the retreating Federals ran into heavy fire and were overwhelmed. Over the three days Ewell had captured 3500 bluecoats and killed or wounded over a thousand

Above: Federal troops try to drive Rebels from behind a stone wall in the disastrous (for the Union) First Battle of Winchester, which was fought on May 25, 1862.
Below: An impressionistic A. R. Waud sketch of the Third (here called Second) Battle of Winchester, fought on September 19, 1864.

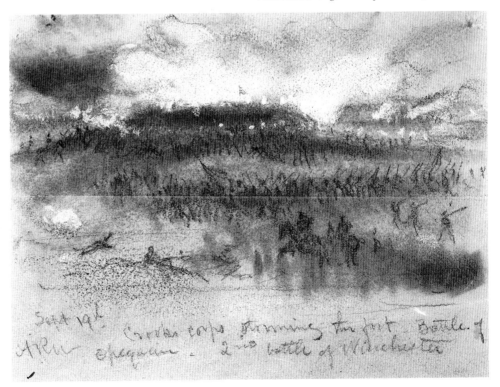

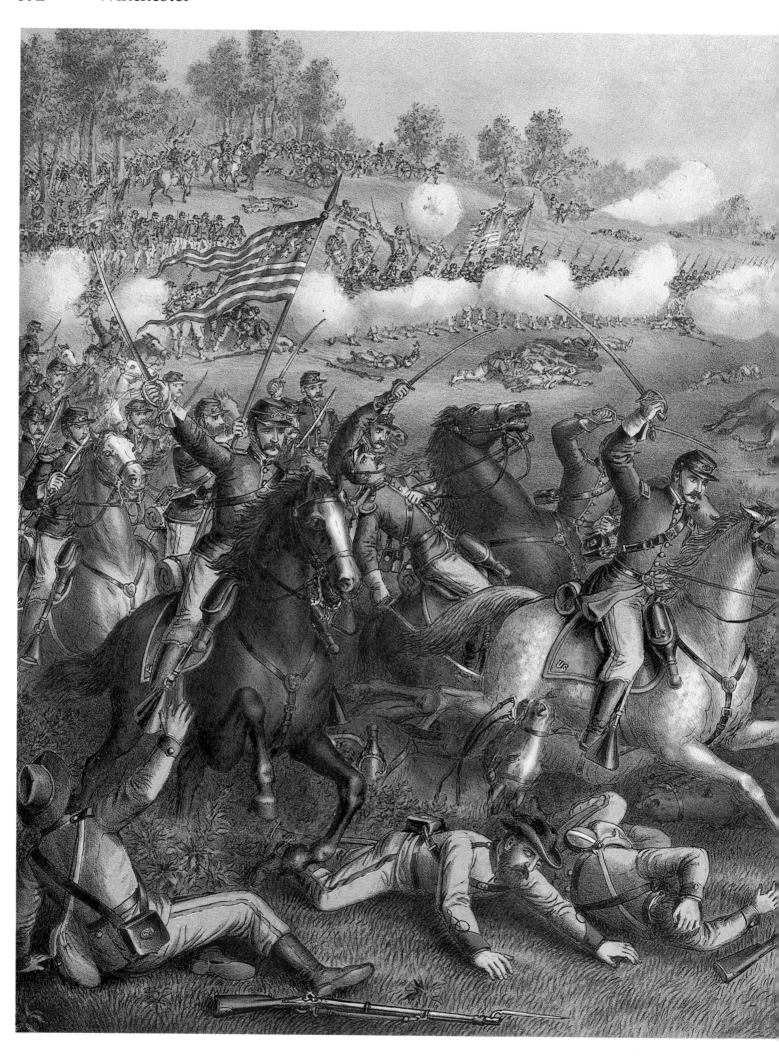

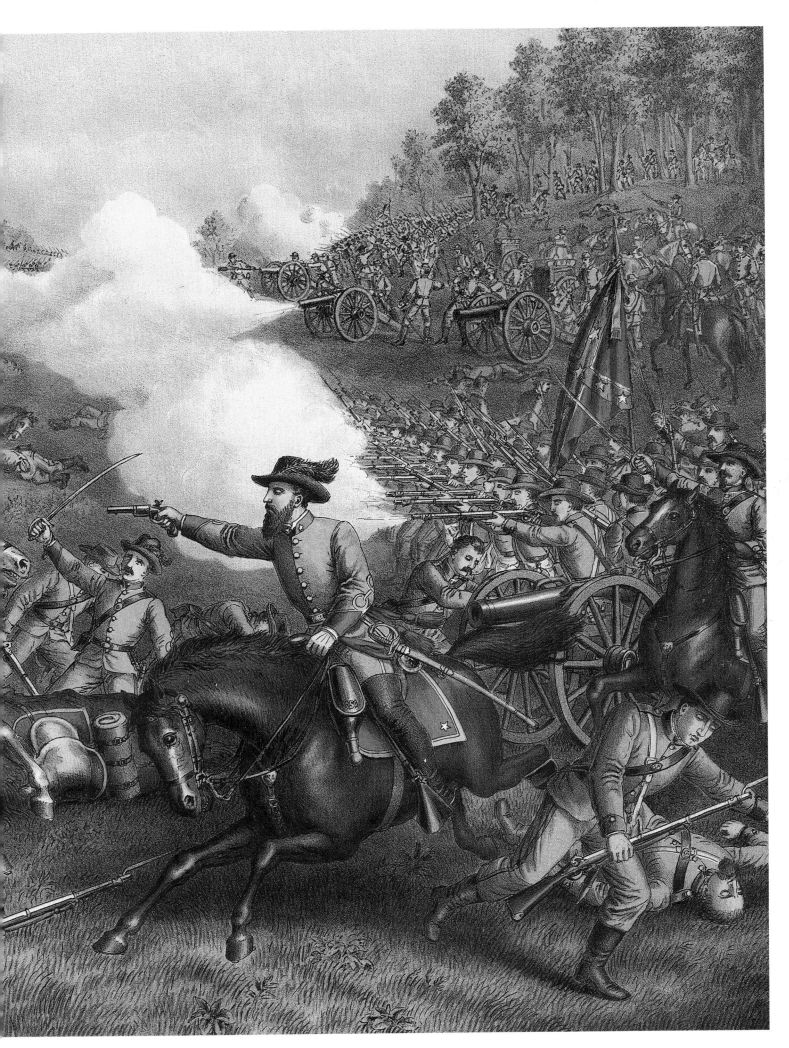

more, while losing some 269 of his own troops. Milroy later had to defend himself at a court of inquiry but was acquitted. Nevertheless, he had overseen what amounted to a serious setback for the Union.

The Third Battle of Winchester took place on September 19, 1864. The most severe of the struggles around Winchester, it was the opening battle of the Shenandoah Valley Campaign of Sheridan. For some weeks Philip Sheridan, the pugnacious Federal general, had submitted to Ulysses Grant's orders to move carefully with his Army of the Shenandoah and follow a defensive strategy against his opponent, Jubal Early. Then Sheridan learned from one of his spies, a Quaker schoolteacher named Rebecca West, that Early had sent one of his divisions to Robert E. Lee, who was then besieged at Petersburg. With Grant's two-word approval – 'Go in' – Sheridan marched to strike the weakened Early at Winchester.

Early, for his part, had deduced from Sheridan's previous caution that his opponent was the timid sort. He would learn otherwise. With his 33,600 infantry and 6400 cavalry, Sheridan ordered a concentric attack on Early's 8500 infantry and 2900 cavalry, who were scattered in various units north to southeast of the town. The bluecoats moved

Previous pages: Third Battle of Winchester.
Below: The execution of Confederate prison commandant Henry Wirz in November 1865.

to the attack on the wings as planned, but then the main attack in the center faltered when the troops of one unit got tangled in the wagon train of another. The confusion created a gap in Federal lines, toward which Early's men struck just before noon; after some fierce and confused fighting, the gap was filled, and the Confederates were driven back. But so far, cavalryman Sheridan, unused to commanding a mixture of infantry, cavalry, and artillery, had not been able to move his considerably superior forces effectively against the Confederate position.

Yet as dusk approached Early's units had been forced back to a tight line northeast of town, and Sheridan had reorganized his forces. Then a broad Federal attack along the line inevitably sent the smaller number of Southerners running. The Northern cavalry made good use of their repeating carbines, but also captured hundreds of graycoats with an old-fashioned saber charge. The Union men suffered a heavy 5018 casualties of 37,711 engaged, but Early was deprived of a quarter of his army – of some 16,377 engaged, he lost about 4000, nearly half of them captured, including three important officers killed and two others wounded.

Sheridan would follow up this victory with an easier and equally decisive one at Fisher's Hill on September 22. Both victories considerably raised the spirits of the North and Lincoln's sagging electoral campaign against General George B. McClellan. A Northern

commentator wrote that week, 'Sheridan has knocked down gold and G.B. McClellan together. The former is below 200 and the later is nowhere.' (In fact Lincoln's election was only finally secured by the fall of Atlanta in September.)

Winder, John Henry *(1800-1865)*
Confederate provost marshal general.

Born in Maryland, Winder was a West Point graduate and professional officer who commanded Libby, Belle Isle, and Andersonville Prisons and eventually became commissary general of all prisoners of war in the east. The degree of Winder's responsibility for the appalling conditions in prisons under his perview remains a controversial issue.

Wire Entanglements

Used for the first time in any war – by the Union forces at Fort Sanders November 29, 1863 – this was smooth telegraph wire stretched among trees and stumps; it caught the Confederates off guard, as it did again at Drewry's Bluff. It would eventually be replaced by barbed wire.

Wirz, Henry *(1822-1865)*
Confederate officer.

Swiss-born Wirz was a Louisiana physician. First a clerk in Libby Prison, he was wounded

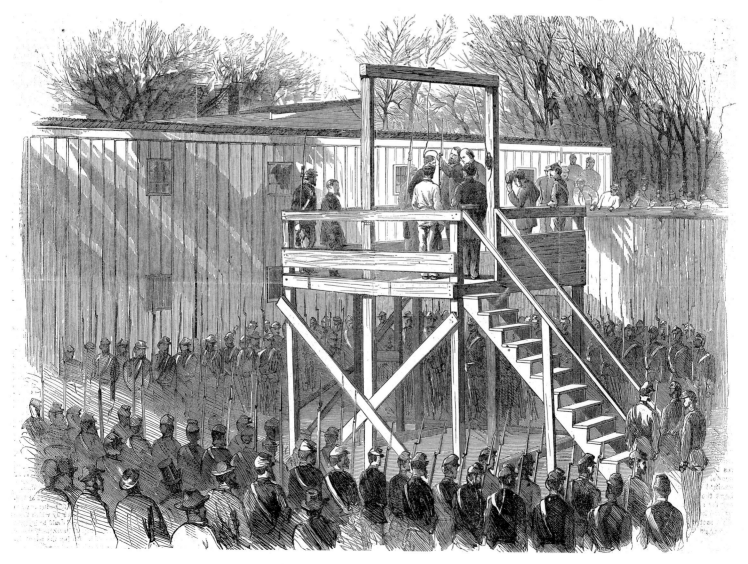

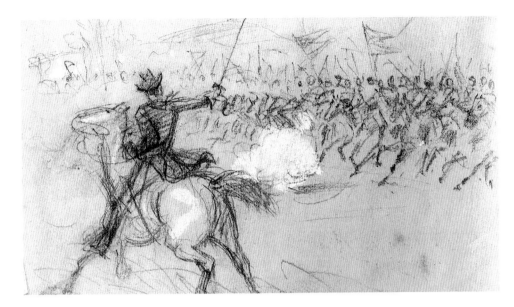

A Union cavalry charge at the Third Battle of Winchester (Opequon) in 1864.

at Seven Pines and became Confederate messenger and purchasing agent in Europe in summer 1863, returning in January 1864 to become commandant of Andersonville Prison, where he stayed until the war's end. In the only postwar execution for war crimes, he was hanged in November 1865 for atrocious cruelty to prisoners.

Wise, Henry Alexander
(1806-1876) **Confederate general.**

A lawyer, he served as a Congressman from Virginia and was governor of the state in 1858 when John Brown carried out his famous raid (he signed Brown's death warrant). Commissioned a brigadier general in the Confederate Army in June 1861, he served in the South Carolina coastal defenses and, later, in Richmond, at Petersburg, and during the 1865 Appomattox Campaign.

'Woman Order'

The nickname given to the notorious General Order No. 28, issued on May 12, 1862, by

Commander of the *Monitor* John Worden.

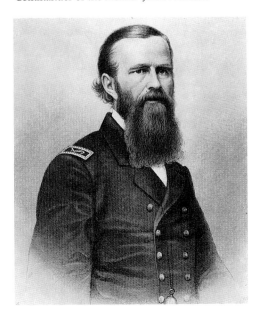

Union General Benjamin Butler when he was commanding the occupied city of New Orleans. He warned that any women in New Orleans who 'by word, gesture, or movement insult or show contempt' for any Federal soldier would be treated as prostitutes.

Wood, Thomas John *(1823-1906)*
Union general.

A Kentucky West Point alumnus and frontier fighter, he commanded an Ohio Army division at Shiloh, Corinth, and Perryville, then fought in the Army of the Cumberland at Stone's River, the Tullahoma Campaign, Chickamauga, Missionary Ridge, Knoxville, and the Atlanta Campaign. He commanded IV Corps at Nashville.

Wool, John Ellis *(1784-1869)*
Union general.

A veteran of the War of 1812 and a Mexican War hero, Wool lived to become the fourth-ranking Union general in the Civil War. He occupied Norfolk and Portsmouth after the Confederate evacuation and commanded the Department of the East, the Middle Department, and VIII Corps, retiring from active duty in August 1863.

Worden, John Lorimer
(1818-1897) **Union naval officer.**

This New Yorker, a career naval officer, earned national celebrity after commanding the *Monitor* against the *Merrimac*. Worden also commanded the USS *Montauk* in the South Atlantic Blockading Squadron early in 1863 and spent the remainder of the war supervising the construction of ironclad warships in New York.

Wright, Horatio Gouverneur
(1820-1899) **Union general.**

A Connecticut-born army engineer, he was Chief Engineer for the expedition to destroy Norfolk Navy Yard and served at First Bull Run and on the Port Royal expedition. Wright fought in South Carolina and Florida, at Rappahannock Bridge, and on the Bristoe Campaign; he led VI Corps from the Wilderness through Appomattox.

Yancey, William Lowndes
(1814-1863) **Confederate politician.**

This Alabama planter resigned his Congressional seat in 1848 to agitate for states' rights. A leader of the 'Fire-Eaters' (*See*), Yancey was a pivotal figure in the secessionist movement. He was a Confederate commissioner to Europe in 1861. He died in office in the Confederate Senate in 1863.

Yazoo Expedition

As part of Ulysses S. Grant's Vicksburg Campaign, what is called Sherman's Yazoo Expedition was an operation involving 32,000 men (W. T. Sherman's and John McClernand's corps) who were shipped up the Yazoo River north of Vicksburg and ended by failing to take the heights in the battle of Chickasaw Bluffs (*See*).

William L. Yancey, an ardent secessionist, served the Confederacy in Europe.

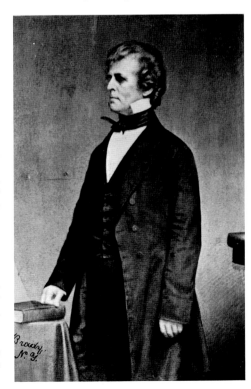

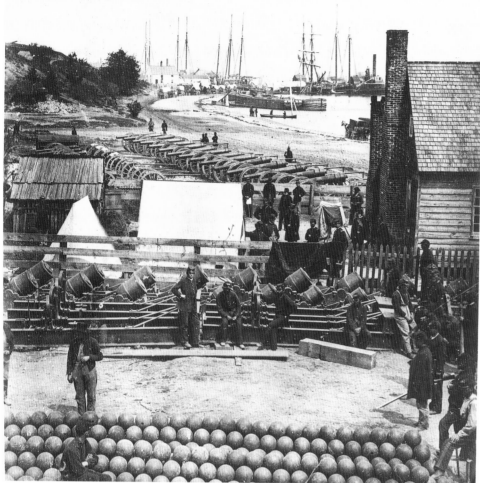

Federal ordnance destined for Union General George McClellan's Peninsular Campaign is stockpiled in Yorktown, Va., in 1862.

Yellow Tavern (*Virginia*), Battle of

During Philip Sheridan's 1864 Richmond Raid, Federal cavalry ran into J. E. B. Stuart's troopers at Yellow Tavern on May 11. The fighting had surged back and forth for several hours when Union Private J. A. Huff took a potshot at an enemy officer sitting on a horse. The officer turned out to be Stuart, who was

A Confederate gun that burst while in action during the somewhat pointless Union siege of Yorktown in the spring of 1862.

taken off the battlefield mortally wounded and died next day. The fighting ended with a Southern retreat.

Yorktown, *Virginia*

In the Peninsular Campaign to take Richmond, Union General George McClellan's strategy called for first taking Yorktown, located on the coast near the southeastern tip of the peninsula. Union troops arrived outside Yorktown by April 4, 1862; although greatly outnumbering the Confederate forces, the Federals settled in for a formal siege, which dragged on until the Confederates evacuated Yorktown on May 3 – another of McClellan's time-consuming and ultimately hollow victories.

Zollicoffer, Felix Kirk (*1812-1862*)
Confederate general.

Born in Tennessee, he fought in the Seminole War, held several offices in Tennessee, was a US Congressman, and attended the 1861 Peace Conference in Washington (*See*). Appointed a brigadier general, he was killed in his first major battle, Logan's Cross Roads.

Zouaves

Originally Zouaves were French colonial Algerian troops noted for their exotic uniforms and flashy drill routines. Both before and during the War certain Northern and Southern regiments adopted the look of these Zouaves – baggy trousers, turban or fez, even in some instances shaved heads – as well as the elaborate drill. Early in the War, however, it was realized that the Zouaves' attention-getting uniforms were a real liability on the battlefield; the wearing of the uniforms was soon relegated to parade functions, and in time this colorful form of dress passed out of US military use entirely.

Below: The death of Rebel General Felix K. Zollicoffer at Logan's Cross Roads in 1862.
Opposite top: Zouaves of the Union's 114th Pennsylvania Infantry Regiment.
Opposite bottom: The Philadelphia Zouave Corps parades in their colorful uniforms.

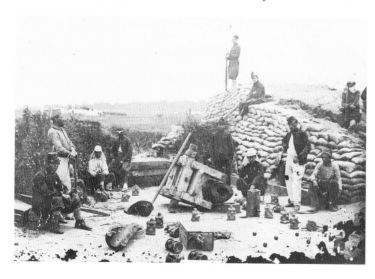

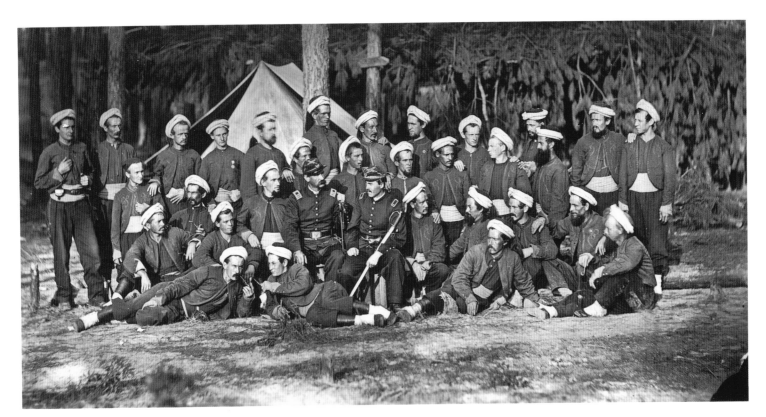

Printed in Oil Colors by P.S. Duval & Son. Phila

James pinx't del.

Aug Fournier lith.

PHILADELPHIA ZOUAVE CORPS.
PENNSYLVANIA VOLUNTEERS.

INDEX TO THE ALMANAC

Page numbers in *italics* refer to illustrations.